ART Since MID-CENTURY
1945 to the Present

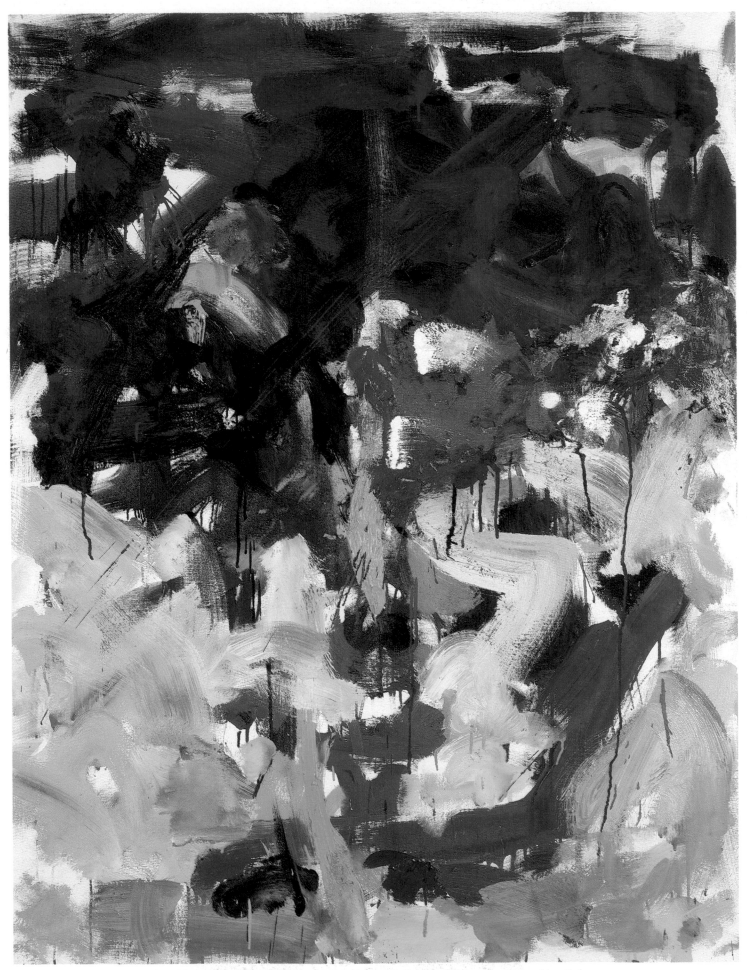

Joan Mitchell. *Border*. 1989. Oil on canvas, 45½ x 35". Courtesy Robert Miller Gallery, New York.

Daniel Wheeler

ART Since MID-CENTURY
1945 to the Present

Prentice-Hall, Inc., Englewood Cliffs, New Jersey

The Vendome Press, New York · Paris

For Dena, Anne, and Margaret, in fondest memory

Photographic credits In addition to the caption credits, the following photographers, agents, and archives are gratefully acknowledged as the sources of the images cited by figure number. Further, it should be noted that many of the art works reproduced in this volume are subject to claims of copyright in the United States and throughout the world, particularly for those artists represented by ADAGP and SPADEM, both located in Paris and exclusively represented in the United States by Artists Rights Society (ARS), New York. For other artists, mainly American, the copyright agent is VAGA, New York.

Jon Abbott, N.Y.: 481; Harry N. Abrams, N.Y.: 163, 575; Brian Albert, N.Y.: 454; Janet Anderson, London: 509; Shigeo Anzai, N.Y.: 158; Peter Bellamy, N.Y.: 389; E. Irving Blomstrann, Hartford: 113; Ferdinand Bolsch, N.Y.: 381; Rudolph Burckhardt, N.Y.: 259, 292, 362; Bureau Soviétique d'Information, Paris: 13; Leo Castelli, N.Y.: 244; Geoffrey Clements, N.Y.: 296, 297, 312, 335, 360, 401, 413, 457, 495, 568, 569, 585; John Cliett, N.Y.: 507, 508; Paula Court, N.Y.: 491; Dennis Cowley, N.Y.: 662; Bevan Davies, N.Y.: 466; D. James Dee, N.Y.: 536, 543, 561, 583, 599, 641; Walter Drayer, London: 393; Eeva-Inkeri, N.Y.: 303, 482, 550, 607; Rolf u. Hanne Epha, Duisburg: 101; Fabbri Editori, Milan: 1, 4, 21, 30, 39, 62, 70, 75, 82, 93, 95, 98, 102, 105, 106, 116, 118, 120, 121, 134, 139, 143, 154, 159, 166, 168, 171, 172, 173, 178, 183, 191, 192, 194, 197, 221, 223, 232, 233, 240, 241, 246, 247, 249, 254, 255, 275, 285, 289, 290, 291, 293, 301, 312, 315, 333, 337, 344, 385, 403, 412, 422, 435, 436, 453; David Farrell, London: 190; Richard L. Feigen & Co., New York: 160; Fine Art Photography, Chicago: 305; Allan Finkelman, N.Y.: 559; Sidney Geist, N.Y.: 378; Giraudon/Art Resource, N.Y.: 3, 9, 23; Gianfranco Gorgoni ©, Contact Press Images, N.Y.: 502; Carmela Guadagno, N.Y.: 336; David Heald, N.Y.: 505, 646; Hickey and Robertson, Houston: 77, 211, 363; George Holzer, N.Y.: 245; Sidney Janis Gallery/Allan Finkelman, New York: 38; Walter Klein, Düsseldorf: 96, 103, 112, 249; Jean-Dominique Lajoux, Paris: 302; Steve Lopez, N.Y.: 538; David Lubarsky, N.Y.: 645; Robert E. Mates, N.Y.: 109, 120, 326, 380, 417, 443; Ursula Meyer, N.Y.: 467; Middendorf Gallery, Wash., D.C.: 496; John Mills, Liverpool: 142, 387; Al Mozell, N.Y.: 552; Jeffrey Nintzel, Hanover, N.H.: 263; Fotostudio Otto, Vienna: 122; Douglas M. Parker Studio, L.A.: 639; Phillips/Schwab, New York: Frontispiece; Vincenzo Pirozzi, Rome: 431; Eric Pollitzer, N.Y.: 236, 310, 545; Rheinisches Bildarchiv, Cologne: 286; Burt Roberts, Brooklyn: 517; Runco Photo Studios, Buffalo: 332; Service de Documentation Photographique, Centre National d'Art et de Culture Georges Pompidou, Paris: 16, 27; Harry Shunk ©, N.Y.: 460, 478, 516, 551, 554; Steven Sloman Fine Arts Photography, N.Y.: 501; Sotheby's, N.Y.: 34, 42, 46, 76, 153, 230; Glenn Steigelman, N.Y.: 219; Ezra Stoller, N.Y.: 181; Joseph Szaszfai, New Haven: 52; Ivan Dalla Tana, N.Y.: 548, 623, 625; Jerry L. Thompson, N.Y.: 155, 598; Tom Vinetz, L.A.: 503; Karen Wilkin, N.Y.: 199; Gareth Winters Studios, London: 468; Dorothy Zeidman, N.Y.: 476; Zindman/Fremont, N.Y.: 619, 643, 655, 656.

Excerpt from "Sweeney Among the Nightingales" in *Collected Poems 1909–1962* by T.S. Eliot, copyright 1936 by Harcourt Brace Jovanovitch, Inc., copyright © 1963, 1964 by T.S. Eliot, reprinted by permission of the publisher.

Front cover: James Rosenquist. *Pistil Packin' Ladies* (detail). 1984. Oil on canvas, 5'6" x 7'6". Collection Art Enterprises, Ltd., Chicago.

Back cover: Rebecca Horn. *Oracle*. 1988. Copper twine and pigment in glass and metal box, 27½ x 39½ x 7½". Courtesy Marian Goodman Gallery, New York.

Cover design: Marlene Rothkin Vine

Typesetting: Rainsford Type, Danbury, Ct., and TGA Communications, New York

Copyright © 1991 Daniel Wheeler
Hard-cover trade edition first published in the United States of America by
The Vendome Press, 515 Madison Avenue, New York, NY 10022

Paperback textbook edition first published in the United States of America by
Prentice-Hall, Englewood Cliffs, NJ 07632

Library of Congress Cataloging-in-Publication Data
Wheeler, Daniel
 Art since mid-century, 1945 to the present / Daniel Wheeler
 p. cm.
 Includes bibliographical references and index.
 ISBN 0–13–047598–X (Prentice-Hall)
 1. Art, Modern—20th century. I. Title.
N6490.W444 1992
709'.04'5—dc20 92-14703
 CIP

Printed and bound by Fabbri Editori, Milan, Italy

Further acknowledgments Owing to its synthetic character, *Art Since Mid-Century* could not be annotated, requiring as this would a superscript number at the end of every phrase, an unfeasible situation for an art-history survey jammed with text, images, and captions. All the more reason, therefore, that I make special acknowledgment of the writers cited in the extensive bibliography, beginning on page 337. Among these, I should like, in addition, to single out Irving Sandler, whose writings on the New York School in the 1940s, 50s, and 60s are the indispensable point of departure for anyone preparing to address the art of the postwar era. While composing Chapter 1, "Modernism and Its Origins," I incurred substantial debts to Robert Rosenblum's chapters in *19th-Century Art* (co-authored with H.W. Janson), Kirk Varnedoe's *A Fine Disregard*, Robert Herbert's *Impressionism*, and, particularly, Richard Shiff's *Cézanne and the End of Impressionism*. Also in bibliographical matters, I drew heavily on the patience and goodwill of the librarians at the Museum of Modern Art in New York: Clive Phillpot (director), Janis Ekdahl, Paula Baxter, Daniel Starr, Trevor Hadley, Hikmet Dogu, Eumie Imm, Thomas Micchelli, and Daniel Fermon. Again at MoMA, this time in the Rights and Reproductions Department, I pay tribute to Richard Tooke and Thomas D. Grischkowsky, for their ready response to my several problems—some of them quite severe—with vagrant images or last-minute needs. At the Whitney Museum of American Art, Anita Duquette performed miracles in cutting through red tape to give us photographs in time to meet unreasonable deadlines. The Solomon R. Guggenheim Museum treated us equally well, in both the library and the rights department. In London, Iain Bain and Helen Davies of Tate Gallery Publications proved accommodating beyond the call of duty, as did Lee Stalsworth, Katherine Hopper, and Mary O'Neill at the Hirshhorn Museum and Sculpture Garden in Washington, D.C. The Archives of American Art in New York could not have been more hospitable. Given the contemporary focus of *Art Since Mid-Century*, I needed and gratefully received the generous assistance of numerous artists and their representatives, all identified in the captions. But among those I pestered the most, I should like to mention Massimo Audiello; Ron Warren (Mary Boone); Louise Eastman, Anne Clergue, and Laura Marie Leopardo (Leo Castelli); Cass Stackelberg (Paula Cooper); Susan Yung (Ronald Feldman); Jay Tobler (Barbara Gladstone); Jeffrey Figley (Sidney Janis); Marella Consolini and Carol Corey (Knoedler); Bonnie Rubenstein (Lisson); Jane Hart (Marlborough); Diana Bulman (Robert Miller); Tanya Bonakdar (Anthony d'Offay); Sally Lebwohl (Pace); Carla Panicali; Josie Brown (Max Protetch); Frau Monika Schmela (Sonnabend); Larry Beck; Holly Solomon; Tracy Goodnow (Sperone Westwater); Caroline Smulders (Daniel Templon); Sarah Shott (Waddington); and Elyse Goldberg, Joseph Massaferro, and Jeff Levine (John Weber). Barbara Lyons generously allowed me a raid or two on the vast picture archives of Harry N. Abrams. The publishers and I enjoyed superior service from our compositors, in the persons of Dennis Pistone and Mary Costello at Rainsford Type and Tom Dunk, Tiina Alleman, Sally Dricks, and John Allen at TGA Communications. In proofreading, I benefited from the excellent work of not only Mary Laing, mentioned earlier, but also Jacqueline Edwards and Doris Sullivan. Susan Sherman did most of the index, which Mary Laing then finished, and I thank them both. Jessamy Tomlinson helped put my research in order, as well as the bibliography, much of which she typed. At The Vendome Press, I enjoyed endless assistance and the moral support of mollifying humor, especially from Jeanne Gross, Billie Luck, Bernice Gelzer, and Charles Granowitz. At Fabbri, our printers in Milan, I must express my gratitude for the expertise and kindness of Diana Benusiglio, Victoria Scaramuzza, Pietro Bellochio, and Virginia Prina. Closer by, I offer my warmest thanks to art historians and treasured friends Beryl Barr-Sharrar, who read, advised, and sympathized; Marian Burleigh-Motley, who helped with Malevich and the "new art history"; Sabine Rewald, who lent knowledge and image alike for both Friedrich and Balthus; Sidney Geist, who saved the day for my bit on Brancusi; and Maddy Fidell Beaufort, who, in Paris, provided crucial aid in obtaining key materials from the Soviet Union as well as from France. I am much beholden to Michael Brenson for comments on sculpture in the 1980s, to Harriet Senie for help in obtaining the right photograph of Serra's *Tilted Arc*, and to Karen Wilkin for a slide of David Smith's *Blackburn*. Finally, but most particularly, to Tillie McCullough I give thanks not only for reading but also for the spirit to go on. DW

Supplementary caption credits Fig. 49: Gift of Julien Levy for Maro and Natasha Gorky in memory of their father. Fig. 360: Gift of Mr. and Mrs. Eugene M. Schwartz and purchase, with funds from the John I.H. Baur Purchase Fund; the Charles and Anita Blatt Fund; Peter M. Brant; B.H. Friedman; the Gilman Foundation, Inc.; Susan Morse Hilles; The Lauder Foundation; Frances and Sydney Lewis; the Albert A. List Fund; Philip Morris Incorporated; Sandra Payson; Mr. and Mrs. Albrecht Saalfield; Mrs. Percy Uris; Warner Communications, Inc.; and the National Endowment for the Arts.

Preface and Acknowledgments

In offering *Art Since Mid-Century*, I hope to satisfy, at least partially, what for several years has impressed me as an urgent, yet unrequited need, a need, that is, for a comprehensive, one-volume history of late-modern and post-modern art characterized by something like the fullness of account and illustration long available for earlier modernism. During the near half-century since World War II, American and European painters, sculptors, and Conceptual artists have generated a body of significant work so immense, complex, and distinctive that now it all but overwhelms the forty-year tradition of the prewar 20th-century modernism from which it grew, like the foliated branches of a great oak obscuring the solid, splendid trunk that supports them. Nevertheless, art-historical overviews of the postwar era have been little more than afterthoughts appended to larger histories devoted primarily to the period's antecedents, or, where the subject of an independent volume, treated almost as meagerly as an appendix, in text or image or both. Meanwhile, there is no dearth of serious writing on every aspect of the art to be considered here, virtually all of it, however, in the form of monographs, critical essays, exhibition catalogues, reviews, or even surveys concerned with individual movements, decades, themes, artists, or groups. Indeed, it is thanks to these abundant resources that a broad, though relatively detailed history such as the present one can even be contemplated. Moreover, instead of a personal, thesis-determined interpretation of known trends and works, I have wanted *Art Since Mid-Century* to be a fresh, carefully balanced synthesis of the best available literature, shaped into a chronological narrative with enough verve and clarity of expression to engage the interest of nonspecialist readers and college students. If I have succeeded in this, it is because—despite a long professional life in art history—researching and writing the book evolved into a major learning experience for me, a process of discovery and enlightenment that I hope unfolds on the page in a way the intended audience can share. At the same time, it seemed important not to oversimplify, and so, mindful of the ever-more intricate relationship between visual and verbal languages, I have been bold enough to introduce essential terms, and therefore ideas, now common mainly in advanced art-critical discourse, all the while taking care to explain the unfamiliar upon its first appearance or to employ it in self-explanatory contexts. Although eager to help readers derive greater benefit from their encounters with leading, or even more obscure, art journals, I have also been at pains to avoid falling into the kind of dense, coded jargon intelligible only to the coterie world of graduate seminars and art insiders.

As these remarks suggest, I have organized the book's content in the traditional, diachronic manner, for the overriding reason that this is how I experienced the art of our time, beginning with what my generation, while still in its teens, regarded as the secular miracle of Abstract Expressionism and continuing through the increasingly less romantic revelations brought by Pop, Minimalism, Conceptual Art, and the Neoisms of recent times. Along the way, however, readers will find the synchronic in full play, since, owing to my studies with Robert Rosenblum, it has never occurred to me that a painting, a sculpture, or whatever might not be more than an oedipal exercise in formal innovation—that it might be other than deeply embedded within a matrix of social, economic, cultural, intellectual, and political, as well as historical, circumstance. For this writer, therefore, the "new art history" is old art history, albeit with important differences, which prompt me to declare, straight out, that however successful I may have been in making my arguments coherent, there is nothing absolute, total, closed, or "canonic" about them. Rather, the text, and even the choice of illustrations, should be understood as no more than one set of logical possibilities among numerous alternatives available to anyone prepared to deal with evidence in an informed and imaginative fashion. As for originality—the post-modernist's *bête noire*—I disclaim it in the interests of my desire to provide a middle-of-the-road, consensus report on or view of the period and its art. Except here and in quotations, the first person singular—the egocentric "I"—cannot be found between the two covers of *Art Since Mid-Century*. However, I realize that, in these disabused, *fin-de-siècle* days, neutrality of the sort I might wish is neither credible nor attainable, especially from someone, like myself, in whom familiarity with an artist and his/her work tends to breed not contempt but, on the contrary, an avid sense of identification. And this identification obtains even for the post-modern critique of late modernism, although, to my mind, that critique belongs with the history of post-modernism, where, for purposes of this book, it emerges full force. But just as post-modernists have drawn much of their compelling vigor from skepticism about modernist claims to purist self-sufficiency—dispersing would-be autonomy in a semiotic discourse among wayward signifiers—the Abstract Expressionists of both Europe and America, during the war-haunted decade after 1945, found tremendous empowerment in the notion or myth of an art existentially self-regenerated with every color-laden stroke. Thus, for the sake of examining late modernism within its own context, I have used hindsight research and assessments mainly to comprehend how that art proved so meaningful and polysemous to so many, until the search for transcendence within presence mutated into "what-you-see-is-what-you-see" presentness. Not only have I not attempted to deconstruct late modernism, leaving that to its patricidal adversaries taken up in the second half of *Art Since Mid-Century*; I also do not consider an artist's intentions irrelevant to one's understanding of the work in question. Nor am I prepared to assert my text as more than a modest proposal, remote from that aspect of the new art-historical project engaged in "leveling artistry into criticality and elevating criticality into artistry," as Donald Kuspit wrote in 1987. Most problematic of all perhaps, I rate it a virtue rather than a vice actually to take pleasure in a work of art, to appreciate its special, aesthetic qualities, even while "reading" it as an index of larger sociopolitical realities.

At a time when art history seems positively terrorized by ideological and methodological disputes, it has not been without a few *crises de courage* that I have made my way through *Art Since Mid-Century*. That I prevailed at all is thanks to the support of many well-wishers, beginning with the faculty under whom I studied at the Institute of Fine Arts, New York University: Colin Eisler, the late Robert Goldwater, Jim Jordan, Theodore Reff, Robert Rosenblum, William Rubin, the late, sorely missed Gert Schiff, and Kirk Varnedoe. Indeed, my debts of gratitude are so numerous and so great that the acknowledgment of them must be continued on page 4, though not before I have expressed warmest thanks to Dr. Ruth Kaufmann, knowing and helpful reader as well as peerless advisor on recent art; Professor Noel Frackman, who used an early, manuscript version of the text in teaching a course at the State University of New York, Purchase; Professor June Hargrove, University of Maryland, who very kindly reviewed the brief, opening text on 19th-century modernism; Mary Laing, faithful editor/proofreader throughout some very rough passages; and my long-suffering but steadfast publishers: Alexis Gregory of The Vendome Press, Bud Therien at Prentice-Hall, and Thomas Neurath at Thames and Hudson in London. Needless to say, none of these good people can be held responsible for my mistakes, which, finally, may constitute the most "original" elements in *Art Since Mid-Century*. DW, New York City, March 1991

Contents

Modernism and Its Origins

Long before mid-20th-century semioticians theorized the process in terms of verbal language, major shifts in cultural expression sought to define themselves by citing their reformatory differences from whatever tradition they had challenged and finally supplanted. Simultaneously, the new structure tended also to court self-validation through alignment with some more distant era, a period formerly despised but now seen afresh in all its pristine splendor. Thus, while the Italian Renaissance abjured the highly spiritualized art and architecture of the preceding millennium as "benighted," it claimed identity with the rational-seeming works of Greco-Roman antiquity, a humanist civilization laid low by barbarian vandalism until "reborn" in early-15th-century Florence, following a dark "middle age" separating the bright new Classical era from the old one. But once again there was a difference that made all the difference, for at the same time that Renaissance form-givers repossessed the harmonious, human-centered vision characteristic of Classicism, they also endowed it with Christianized neo-Platonic meaning, a religious, otherworldly concern almost as intense as that evinced throughout the Middle Ages. Four hundred years later, virtually the reverse occurred, when Romantics revived medieval imagery and forms as an antidote to the scientific Enlightenment, while often emptying them of orthodox Catholic content in favor of highly subjective, almost pagan, pantheistic feeling. This was at the dawn of what we presently call modernism, yet it seems likely that living people have never viewed their existence as other than "bound up with now." Indeed, from the Renaissance onward, Westerners have consistently and quite self-consciously thought themselves modern, a sense reinforced by steady, accelerating advances in science and technology. Then, come the Industrial Revolution followed by political revolution in both America and France, all in the 18th century, few living in Western Europe or the United States could doubt their modernity, severed as humanity appeared to be from the whole of history, from an age-old civilization unified and secured by its members' common, albeit hierarchical relationship to a feudal, agrarian system based on land tenure—thus, to the world of nature. Nonetheless, artists, writers, and politicians alike continued to articulate the present in the language of the past, celebrating the Bill of Rights and the Rights of Man in metaphors and monuments derived from Periclean Athens or Republican Rome. By the mid-19th century, however, the old symbology—whether political or religious—had lost its hold on the creative imagination, captivated as this was by the overwhelming presence of the new urban, secular culture, with all its mesmerizing array of wonders and horrors. In this constructed world, utterly removed from nature, individuals found themselves emancipated from shared traditions but obliged to compete with, while at the same time adapting to, mass collectivity like none ever seen before. To explore and express this unprecedented condition, artists found innovation itself to be highly emblematic, especially since it now involved charging images, objects, tempos, techniques, and physical as well as social perspectives from the everyday world with aesthetic significance, until they would constitute conventions as endlessly malleable and regenerative of both forms and meanings as those of the Classical/Renaissance orders. Very quickly, the old pyramidal hierarchies—spatial, conceptual, societal—collapsed in a visual field as dispersed as the anonymous-appearing contemporary scene, yet vibrant throughout with rival, accidental points of interest as demanding as the individual liberties promised by a would-be egalitarian society (fig. 11). Thus, if the world since the mid-19th century has succeeded in co-opting the term "modern" as its very own period designation, it was, in substantial part, because those who seemed most tellingly to represent the age in cultural forms discovered a model, not in remote history, but in the ever-more insistent, urbanized present, especially as experienced in the city of Paris and its environs. Of course, the painters and sculptors who created modern art—"unquestionably the signal, defining cultural invention of our epoch," as Kirk Varnedoe put it—were themselves the products of history. However, Manet and the Impressionists—primarily Monet, Renoir, Degas, and Pissarro—exploited this legacy not in the revivalist manner of the Renaissance/Baroque or Romantic/Neoclassical eras; rather, they worked in the pragmatic way of science, industry, or the opportunistic, bourgeois metropolis, taking whatever lay immediately at hand—camera optics, Japanese woodcuts, "primitive" art, caricature and fashion, Delacroix's color, Barbizon naturalism, the theater-like spectacle of Haussmannian Paris—and playing with its forms, means, and rules until they yielded whole complexes of new possibilities. Thanks to this risk-prone, experimental frame of mind, the Impressionist circle not only became the "painters of modern life," as the poet/critic Charles Baudelaire had counseled; they also produced something like a group style that, paradoxically, contained within its apparent simplicity and directness the seeds of the entire fecund variety of modern art, from exact transcriptions of what the eye sees to free, expressionist eruptions of hedonism and rage, Cubist structure, collages of found images, social critique, Dada irony, Surrealist fantasy, and purist abstractions signifying visions of sublime transcendence.

All these distinctively modern impulses would find what so far have been their culminating moments in the years following World War II, the period whose achievements in painting and sculpture are the focus of this book. So rich has been the artistic production of recent decades—a time coincident at least in part with the life of everyone reading these pages—that as a subject it can scarcely be introduced, let alone plumbed, even in a volume numbering 344 pages and 665 images. Yet, as the words "culminating moments" imply, the art to be considered here sought and attained its significance largely in relation to the great tradition that began almost a century earlier, in the 1860s, when Baudelaire coined the term "modernity" to characterize a cultural change so radical that it called for an art as "original"—as contemporary in both subject and form—as the paintings then being exhibited by a thirty-one-year-old newcomer named Édouard Manet (fig. 9). This was at the outset of the so-called "heroic" phase of modern art, launched by Manet in the spring of 1863 when he exhibited his enormous canvas entitled *Déjeuner sur l'herbe,* or *Luncheon on the Grass,* an eye-opening scene of dressed and undressed Parisians picnicking in a wooded suburb. With the iconoclastic *Déjeuner,* which broke virtually every rule of established aesthetic and social decorum, Manet tapped a wellspring of creative energy so powerful that, during the next seventy-five years, it fueled wave after wave of artistic experiment, rolling on through the historic cavalcade of Impressionism, Post-Impressionism, Fauvism, Expressionism, Cubism, Dada, and Surrealism, until arrested by the outbreak of hostilities in 1939. In wartime New York, however, the mainstreams of European modern-

ism—Expressionism, Cubism, and Surrealism—looked all the more heroic by virtue of their oppression by the Nazis, not to mention the refugee presence of such leading exponents as Mondrian, Léger, Ernst, Dali, and Masson. Inspired by windfall exposure to this remarkable patrimony, the local avant-garde—led by Jackson Pollock, Willem de Kooning, Mark Rothko, Barnett Newman, and Robert Motherwell—synthesized and so recharged it with American vigor, ambition, rawness, and sense of open space that the modernist aesthetic assumed heroic qualities—qualities of scale, abstract form, and subjective content—far in excess of anything ever attempted or desired in Europe. To distinguish these "heroics" from those of the prewar tradition inaugurated by Ma-

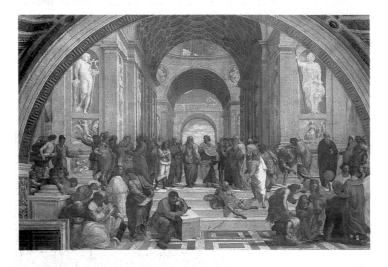

net, New York-style Abstract Expressionism and its aftermath in Color-Field Painting and Minimalism have come to be known as "late modernism," an hegemonic force that held sway until undone, at the end of the sixties, by its tendency to self-refine to the point of self-elimination, even while gracing the world with beautiful and impressive works. In the meantime, as the Abstract Expressionists' search for form commensurate with an ineffably tragic vision played out as a search for autonomous form untainted by the vulgar world, their concern, like Manet's, for contemporary content articulated in contemporary language found renewal in Pop Art, a neo-Dada movement initiated by Robert Rauschenberg and Jasper Johns in 1958. Not only did Pop reject the notion of aloof, self-sufficient art, it also insisted upon art's ineluctable contingency, demonstrating the principle in paintings and sculptures made from images and objects discovered in the real, everyday world. When this social/aesthetic critique fused with Minimalism's auto-critique, the result was Conceptual Art, which, beginning in 1968–70, triggered the ongoing phenomenon known as "post-modernism," a development so averse to late-modernist obsessions—with originality, autonomy, universality, progress, form, quality, and the heroic pursuit of them, to ever-more purist extremes—that many post-modernists make art by appropriating modernist styles in a context of popular reference as a device for "deconstructing" everything they signify. Ironically, this may be seen as a backhanded tribute to modernism, for while parasitizing its achievements, post-modernists also exploit—sometimes even revivify—them with unmistakably modernist energy and imagination, endowing the late 20th century with an abundance of visually as well as conceptually engaging art works. To understand how both late modernism and post-modernism thus shared in the modernist process of making art merely by finding it, one needs to place them in the context of that earlier, heroic modernism, which is the issue of this introductory chapter, beginning with a brief look at the grand European tradition that Manet and the Impressionists contested.

From the vantage point of today, modernism might seem a venerable tradition, having endured well over a century, but Manet and the Impressionists, in order to come into their own as "painters of modern life," had to prevail against a Renaissance aesthetic still dominant in European

left: 1. Raphael Sanzio. *The School of Athens.* 1509–11. Wall fresco. Stanza della Segnatura, Vatican, Rome.

above left: 2. Giovanni Battista Tiepolo. Ceiling fresco, Kaisersaal (detail). 1751. Episcopal Palace, Würzburg.

above right: 3. Mathias Grünewald. *Temptation of Saint Anthony, Isenheim Altarpiece.* Completed 1515. Panel, c. 8'8⅜" x 4'6¾". Musée d'Unterlinden, Colmar.

art after more than four hundred years. As brought to full glory by, for instance, Raphael (1483–1520), in his magisterial *School of Athens* (fig. 1), Renaissance illusionism—the product of such newfound "sciences" as chiaroscuro modeling, foreshortening, and linear as well as aerial perspective—enabled painters to make a flat, opaque wall appear transparent, like a window opening onto a world of solid-seeming figures and objects set within a lucid, convincing volume of space. As the lines of perspective converge towards the central vanishing point, they form a visual cone, which in turn becomes a compositional triangle or pyramid at the apex of which stand Plato, gesturing towards Heaven as the source of ideas for all earthly things, and Aristotle, pointing to the earth as the object of all observation. Anchoring this conceptual as well as structural hierarchy are representations of Pythagoras in the lower left and Euclid in the lower right. For the 16th century, this was thrillingly modern art, an art, moreover, whose seamless union of the real and the ideal proved so ripe with potential, for variations in both form and meaning, that it became the *lingua franca* of European civilization for many generations.

Inevitably, from time to time over the years, Renaissance mastery degenerated into mannerism, only to inspire new talents capable of reforming and reviving it, as did Caravaggio (1571–1610) at the turn of the 17th century. When the robust, grandly Baroque art that followed softened into the intimacy and artifice of 18th-century Rococo painting, Jacques-Louis David (1748–1825) arrived as the new savior of the Classical tradition (fig. 4). However, this French Neoclassicist had his work cut out for him, involving as it did the "correction" of the deliciously seductive *fêtes champêtres* so cherished by the *ancien régime*. Also to be tamed were the huge trompe-l'oeil extravaganzas designed to "fool," and delight, the eye by seeming to dissolve thick, impenetrable vaults and expand into vast spaces soaring aloft or rushing into some limitless depth, the whole activated by billowing clouds and miraculously flying figures (fig. 2). As this demonstrates, the same system devised for representing the world in a rational, objective manner could also—thanks to one-point perspective's dependence upon the very particular, therefore subjective stance of a single viewer—be made to project quite the opposite, that is, irrational flights of fantasy, heavenly apotheosis, or even willful perversity. So thoroughly did David purge such Mannerist or Rococo "excesses" that his *Oath of the Horatii* has been called a "pictorial call to arms," its exhibition in 1785 an artistic event whose electrifying effect on Paris all but forecast the storming of the Bastille four years later. Yet, while recovering Classical clarity and coherence, to the point where his life-size allegory appears to be continuous with the viewer's

own space, thus all the more persuasive in its didactic message, David also undermined the very principles he ostensibly revived, both those of style and those of text. Disposing his Horatii—in an episode from Roman history concerning a family torn by stern resolve on the one hand and emotional disarray on the other—as if they were actors in a staged play, he contained recession within a shallow box-like space, thereby occluding infinity, aligned his figures across the frontal plane, as in a frieze, and drew them in such clean-edged, close-focus detail that, however monumentally scaled, they appear oddly miniaturized and flattened. By means of this sort, David commenced the modernist process of abandoning the representational ''tricks'' invented by the Renaissance, which absolutist rulers had transformed into an instrument of authoritarian power, and of acknowledging the three-dimensional world in some manner that would not also evade the reality—the flatness and opacity—of the painting surface. If this shattered the grand unity so brilliantly articulated by Raphael, it nonetheless offered the virtue of reflecting the ever-greater contradiction and instability of modern life.

Perhaps only a Northerner, like David, could have undermined Renaissance breadth and volume by elaborating them with an anti-classical love of minutely observed surface incident. Within such graphism lay dormant but still very much alive a kind of wild energy whose fountainhead, for modern art, may be found in the *Isenheim Altarpiece*, painted by Mathias Grünewald (d.1528) about the same time as Raphael's *School of Athens* (fig. 3). An enormous polyptych commissioned for a monastic hospital in German-speaking Isenheim, near Colmar, on the French side of the Rhine, this ''Sistine Ceiling of the North'' comforted the sick and dying not through an image of the real rendered ideal but through a visionary transfiguration of the real into the supernatural. Hallucinatory and galvanic as this very Gothic masterpiece may be, it also evinces a Renaissance command not only of perspective but also of human psychology, particularly as the several scenes shift from sorrow to jubilation, wonder, or terror, always with an intensity of feeling that rings as true in the modern world as it surely did in late-medieval Europe.

Grünewald, the artist, may have disappeared from history until rediscovered in this century, but his vibrant spirit so prevailed among northern Europeans that it even fed what might be considered the antithetical values of the Italian Renaissance. The French, for example, virtually guaranteed the fruitful, though ultimately sterile, longevity of those values by intellectualizing them into the canons of the Royal Academy, founded in Paris in 1648, with a Roman branch added in 1666. Based on Italian initiatives dating back to the time of Michelangelo, and intended both to teach and to endow fine artists with the status of liberal, rather than mechanical, artists, the French Academy (now the École des Beaux-Arts) not only codified the hierarchy among themes and styles, hence the professional/social ranking of their exponents; the all-powerful, state-controlled institution also reserved to itself the privilege of public exhibition, with everything that meant for the economic well-being of those, like the Impressionists, too venturesome to abide by academic standards. At the pinnacle of the subject-matter scale stood history painting, devoted to such ennobling concerns as antique mythology, Biblical episodes, and important persons or events from the past. Next, in descending order, followed portraiture, landscape, still life, and genre (realistic scenes of ordinary life). Along with this thematic ladder came a second hierarchy, which graded the available expressive devices as, first, composition, line (drawing), and chiaroscuro, then color and brushwork. If the so-called ''minor'' categories of artistic production—motifs as well as means—counted the least, it was because they involved artists in the greatest degree of sensuous, unpremeditated, and thus unpredictable experience. Yet, for this very reason, they offered a permissible way out once higher academic practice decayed into dry formula, despite the sterling success of David and his brilliant pupil, Jean-Auguste-Dominique Ingres (1780–1867), in making history painting relevant to their own age. And the desire to escape routine became increasingly urgent once nascent industrialization struck many, in the wake of Jean-Jacques Rousseau (1712–78), as the lethal foe of ''natural man,'' the creative person whose essential instinct or vital force could scarcely be expected to flourish in a world dominated by standardized products and regimented labor. Moreover, it took no great leap of the imagination to perceive that academicism—wherein originality or creativity entailed the clever but laborious reworking of established models—constituted the aesthetic equivalent of the monotonous, repressive factory system.

Traditionally, ambitious painters allowed themselves the freedom of quick oil or watercolor studies only in preparation for achieving higher levels of refinement leading to pictures finished until they looked embalmed (fig. 8). However, as the search for artistic renewal intensified, it activated a taste for color sketches, with their rough, *non-fini* state appreciated as evidence of directness, spontaneity, and therefore truth. Aiding this trend was the academically respected authority of the great Renaissance Venetians—Giorgione, Titian, and Veronese—whose painterly, luminary, oil-on-canvas colorism had, from the start, provided an opulent alternative to the more linear, ideated, tectonic frescoes of the Florentine/Roman school led by Raphael and Michelangelo. Not for nothing did Venice lie in the north of Italy, a sea-faring city with ready access to the 15th-century Netherlands, the source of oil technique as well as land-

4. Jacques-Louis David. *Oath of the Horatii.* 1784. Oil on canvas, 10'10" × 14'. Louvre, Paris.

5. Nicolas Poussin. *Landscape with St. John on Patmos.* 1640. Oil on canvas, 3'5⅛" × 4'5¼". Art Institute of Chicago (A.A. Munger Collection).

6. Caspar David Friedrich. *Monk by the Sea.* 1809–10. Oil on canvas, 3'6½" × 5'7". Staatliche Museen, Preussischer Kulturbesitz, Nationalgalerie, Berlin.

7. J.M.W. Turner. *Rockets and Blue Lights (Close at Hand) to Warn Steamboats of Shoal Water.* 1840. Oil on canvas, 3'1½" × 4'. Sterling and Francine Clark Art Institute, Williamstown, Mass.

scape, still-life, and genre themes, all of which, in combination, would prove decisive for rebellious painters struggling to liberate themselves from a moribund academic system. Long under way, the development can be traced through the non-Italian heirs to Venetian painting: Rubens, Rembrandt, Hals, and Velázquez, in the 17th century, and, in the 18th, Watteau, Boucher, and Fragonard, whose *fêtes galantes,* or *fêtes champêtres,* revisualized Venetian *poesie*—mood paintings, often featuring nudes in a landscape—through the deliquescent manner of courtly, Rococo France. Like his co-generationist David, Francisco Goya sloughed Rococo themes; yet he also retained his breathtaking repertoire of painterly means—his bravura command of both color and chiaroscuro—to pronounce a bitter conviction, that human behavior could never be governed by Enlightenment rationality but, on the contrary, by a pre-Freudian nightmare of monsters, furies, and primal fears. Consequently, Goya might be seen as a modernist before his time, as well as a master in line of succession to Grünewald, even though the most direct route to modernism would lie through landscape rendered with scintillating color and brushwork. Here, the process began with Nicolas Poussin (1594–1665), France's Rome-based "Raphael of landscape painting," whose lucidly structured, "philosophical" views of nature and Classical ruins evinced a "grand manner" that made them the first paintings to be called "heroic" (fig. 5). It continued with Claude Lorraine, Poussin's French contemporary in Rome, 17th-century Dutch masters like van Ruysdael and Hobbema, and that quartet of great Romantics: Germany's Caspar David Friedrich (1774–1840; fig. 6), England's J.M.W. Turner (1775–1851; fig. 7) and John Constable, and France's Eugène Delacroix.

Thereafter, in the first half of the 19th century, the most progressive French artists forfeited the security of academic training, as well as the official patronage it promised, for a cherished doctrine of freedom—freedom to cultivate self-expression, to spurn the claims of social utility, and to prosper without resorting to the money-grubbing activities of the shop- and factory-owning classes. This took Corot, Diaz, Daubigny, Théodore Rousseau, and Millet into such salubrious climes as Fontainebleau Forest, the fields near Barbizon, and the Seine valley, the better to liberate their natural, creative impulses through direct involvement with nature itself, taken as their primary subject and source of inspiration. Emancipation also meant the freedom to compete, willy-nilly, in the open marketplace, since artists working outside the pale of academic aesthetics and government approval often found their work rejected by the annual Salon, a kind of vast group exhibition held in the Louvre, at various intervals, since the reign of Louis XIV and still, throughout the 19th century, the principal venue for the sale of new painting and sculpture. A climactic moment in this early drive towards professional independence arrived when the supremely self-confident, anti-Romantic Gustave Courbet (1819–77) set up his own pavilion just outside Paris' 1855 Universal Exhibition, simultaneously as he also exhibited a large group of paintings at the concurrent Salon. Commenting on Courbet's bold display of artistic freebooting, the critic Jules Champfleury wrote, in a letter to novelist George Sand: "It is an incredibly audacious act; it is the subversion of all institutions associated with the jury; it is a direct appeal to the public, it is liberty. . . ."

Manet and the Impressionists

Édouard Manet (1823–83) emerged as the first true painter of modern life through a process of mastering Renaissance conventions until he could work the irony of translating their literalized fiction, like that in *Nymphs and Satyr* by William-Adolphe Bouguereau (1825–1905; fig. 8), into a witty and original poetics of fact, seen here, at its most splendid, in *Déjeuner sur l'herbe* (fig. 9). The paintings of Bouguereau gratified the conservative Salon public for the very good reason that, by making a scene of pseudo-innocent, Arcadian frolic look as real as a tinted photograph, they afforded the male members of a repressed, hypocritical society the occasion to savor ripe feminine flesh under the pretext of appreciating the pure, uplifting world of Classical antiquity. More important, however, the pictorial make-believe of the kind provided by

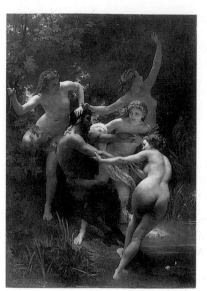

left: 8. William-Adolphe Bouguereau. *Nymphs and Satyr.* 1873. Oil on canvas, 8'6⅜" × 5'10⅞". Sterling and Francine Clark Art Institute, Williamstown, Mass.

opposite: 9. Édouard Manet. *Déjeuner sur l'herbe.* 1863. Oil on canvas, 6'9" × 8'10". Louvre, Paris.

Bouguereau, or by Manet's own teacher, the celebrated academician Thomas Couture, also did much to reinforce some of the more duplicitous policies of Napoleon III. As carried out by the Emperor's Prefect, Baron Haussmann, these would gradually transform Paris into a Neoclassical façade or spectacle so dazzling—in its new radiating network of airy, light-filled parks, fountain-studded *places,* and broad, straight boulevards lined with glittering shops, cafés, and theaters—that an illegitimate, autocratic régime might hope to gain prestige and conceal or contain whatever social unrest continued to fester in post-Revolutionary France. Such were the distractions of this unprecedentedly glamorous world of pleasure and entertainment—the wonderful *ville lumière* still with us today—that it brought into being a whole new class of society, composed of the well-off, impeccably turned-out dandy or *flâneur* and the bold, clever *femmes fatales* the "stroller" liked to consort with but never marry. Dandy as well as *flâneur,* Manet found himself completely at home in Haussmann's modern, brilliantly planned, man-made world, endlessly reconnoitering its avenues, arcades, bowers, and brasseries, infinitely curious but detached, and forever storing up observations for eventual use in paintings like *Déjeuner sur l'herbe.* For this monumental work he would have gone not only to the Bois de Boulogne—or perhaps to the suburban banks of the Seine, like so many Parisians seeking relief from the metropolitan crush—but also, very likely, to a performance of Offenbach's *Orphée aux enfers (Orpheus in the Underworld),* the very kind of *opéra bouffe* most favored by the Empire, even though it parodied Greek mythology just as Manet would mock both academic painting and the *grand bourgeois* ambience that was his birthright. Thus, for nymphs and satyrs bathed by the caressing mist of a sylvan grotto, Manet substituted an unmistakably modern and naked woman accompanied by a pair of fully clothed dandies and a second, scantily clad female, their foursome presented like picnickers in the aftermath of a meal as well as a dip in the country water. And far from rewarding prurience with the subterfuge of Greco-Roman mythology, Manet made his principal "nymph" stare down and fix the viewer with brazen directness, a trick that presumably could have been mastered only by a "professional," one of those courtesans or *grandes horizontales* so familiar at the time that they seemed a perfect metaphor for the parvenu Second Empire, not to mention the capitalist speculation that financed Haussmannian Paris. In reality, the three foreground figures were merely the artist's favorite model, Victorine Meurent, his brother, and his future brother-in-law; however, if they seemed so threatening that the painting became one of the great scandals of art history, it was in large part thanks to formal audacities equal to the candor of Victorine's unblinking gaze. Instead of softening, rounding, and distancing his principal trio of weekenders, Manet pressed them forward near the frontal plane and illuminated the nude with such a blaze of light, as if the party had been caught in the flash

of a tabloid camera, that contemporaries saw the image as shockingly flat, like a Queen of Spades on a playing card. Further, the composition, although stabilized, like Raphael's *School of Athens,* by a classical triangle whose apex is the bather in the distance, appears less unified in the traditional sense than assembled from an array of totally different pictures—a still life, a landscape, and four separately observed figures. This accounts for the size of the reargound bather, a giantess so out of scale with the distance implied by her diminutive environment that she seems to advance and thus collapse the pictorial space, just as the shallow modeling flattens the forms.

Having thwarted coherent recession towards a single vanishing point, and having further scattered focus by painting the beautiful still life with the same Velázquez-like virtuosity he lavished on the central nude, Manet fatally sabotaged the harmonizing values and clear hierarchies of classical, Renaissance order. However, he replaced them with a new kind of coherence, based upon what the artist called the simple virtue of having "merely tried to be himself and not someone else." As Manet wrote in the catalogue to the one-man show he organized when excluded from the 1867 International Exhibition in Paris: "The artist does not say today, 'Come and see faultless work,' but 'come and see sincere work.' This sincerity gives the work its character of protest, albeit the painter merely thought of rendering his impressions." If *Déjeuner sur l'herbe* seems even more disjointed than David's *Oath of the Horatii,* then it could be said to mirror the still more conflicted world in which it was painted. And if Manet simply reports the condition of that world, as a journalist would, objectively and without high-minded, moral commentary, then he did it with riveting, all-over interest and all-embracing, passionate love of the means for carrying out his enterprise. The evidence, no less dispersed than the focus, is everywhere, in the elegance of the pale silhouette set against velvety blacks, the variations of green on green that evoke a bosky dell, the bravura suavity with which the modeling of the nude has been executed, even though so abridged that, with all middle tones omitted, it appears to be little more than a pliant contour line, like that in Japanese prints, a recently discovered art form often credited with having fostered the advent of abstraction in European painting. But along with the wit and sparkle of its myriad aesthetic delights, *Déjeuner sur l'herbe* craftily signals its compositional source, in a detail of river gods from an engraving by Marcantonio Raimondi after Raphael's *Judgment of Paris,* and yields an irreverent symbol, as would Offenbach's *La Belle Hélène* the following year, implying that in a new context, modern Paris has awarded the prize not to a goddess but, rather, to a saucy, independent young woman who dared "to be of her time."

As a send-up of history painting, *Déjeuner sur l'herbe* rather overshot its mark, prompting the defenders of tradition to punish Manet by rejecting his masterpiece for the Salon of 1863, a year of so many exclusions that the Emperor allowed a "Salon des Refusés" to be mounted. There, with the sincerity of the artist's impressions all too apparent in what hostile eyes saw not so much as innovative as far from "faultless work," *Déjeuner sur l'herbe* became the butt of the most unbridled ridicule, transforming the Refusés into a three-ring circus, attended on a Sunday by as many as 4,000 sensation-seekers. Foremost among the picture's few enlightened critics was the novelist Émile Zola, who would penetrate the very heart of modernist concerns when, in response to painting like Manet's, he defined the work of art as "a bit of nature seen through a temperament." By this, Zola signified that Manet evinced what Richard Shiff has termed the "double origin," since he appeared not so much to "make" his art—carefully calculating in the standard academic manner—as to "find" it, by avoiding artistic precedent and seeking truth solely in nature, including human nature, and in his own feeling for it. With nature and personal instinct as his exclusive sources of inspiration, Manet became, in the context of his time, not only anti-academic but also "doubly original," for, as Zola later wrote, by way of epitomizing the artist's achievement: "In beginning a picture, he could never say how it would come out." Yet, while Manet may not have worked through many preparatory studies, prefiguring the *Déjeuner* now before us, the artist, as this text has suggested, nonetheless considered

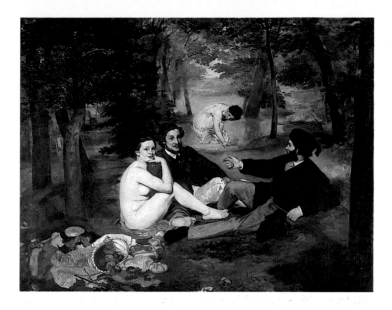

matters of form and content, in his own subversive fashion, quite as deliberately as Bouguereau would have. However, instead of demonstrating a gift for original interpretation of academic formula, Manet chose to develop a technique for manifesting originality of a totally different order, an order more sensitive than ever to such Romantic, or indeed Realist/Naturalist, qualities as "sincerity," "truth," and "self-expression." These, of course, are profoundly human values, remote from the cool inhumanity often ascribed to modernist abstraction, the genesis of whose systematic development art history tends to locate in Manet's startling departures from academic practice. Thereafter, modernism unfolded in an ever-more addictive thirst for originality, creativity, or "authenticity," if not in regard to self and nature, then, increasingly, to self and medium, forever eliminating old or even current possibilities while searching for new ones until, in the postwar years covered by this book, options would narrow virtually to zero. Prior to this dénouement, however, modernists had usually counted less as more, to paraphrase a famous dictum of the Bauhaus architect Mies van der Rohe, whose rationale reflected a near-religious conviction on the part of like-minded artists that the more they purified the language, or form, of their work—engaged in a problem-solving, ever-more self-referential formalism—the better the art might serve society by providing a Utopian paradigm for dealing with its ever-greater complexity. Such therefore was the energizing power of the modernist *myth,* for clearly art could not be totally pure, original, or autonomous if the work originated twice over in something other than itself. Rather, it must be understood as a representation of the paired models or originals, a translation of nature into culture whose success depended upon the artist's ability to discover a technique or formal language capable of communicating to the world at large meanings recognizably unlike, in some essential way, anything ever seen before. Manet, in his "productive play of finding and making," as Shiff characterized the modernist process, demonstrated originality not only through his "faulty," anti-hierarchical composition and critical content but also through the delicious spontaneity of his painterly handling. Among all the paradoxes cited in this paragraph, none seems more remarkable than the clairvoyance of a reactionary critic, Ernest Chesneau, who, alarmed over sketchy execution, even in the quick, preliminary essays recommended by the École des Beaux-Arts, wrote in 1864 that if such a trend continued, the world would see, as it eventually did, paintings consisting of nothing but two broadly brushed areas of color.

However ironic and bemused, Manet displayed sufficient regard for the human figure, historical art, and Old Masterish brushwork, at least in the academically approved tradition of Hals and Velázquez, to assure him an occasional place within the hallowed precincts of the official Salon. Not so for the Impressionists, to whom Manet played mentor, without, however, participating in their shows or adopting their far more

maverick approach to the challenge of becoming painters of modern life. Indeed, Monet, Renoir, Degas, and Pissarro, by virtue of their bolder inventions, suffered so consistently at the hands of retrograde juries (even those of the more democratic Third Republic, which followed the Second Empire after its collapse during the Franco-Prussian War of 1870) that they collaborated with similarly disallowed progressives, among them Alfred Sisley, Berthe Morisot, and Paul Cézanne, to pool resources and mount their own exhibition in the studio of the commercial photographer Félix Nadar. The affair, which opened in April 1874 and quickly became one of the most famous in the history of art, brought before a largely derisive public a group of pictures whose brightly colored, dynamically stroked scenes of the new Paris, its environs, and nearby resorts—subjects previously addressed mainly by illustrators and caricaturists like Daumier—so shocked an unprepared critic that he called the painters mere "Impressionists," to suggest their unconscionable lack of finish. However, it was this very quality—this *non fini*—that constituted the chief symptom of the artists' search for greater immediacy and truth than, for long, had been possible within the confines of Beaux-

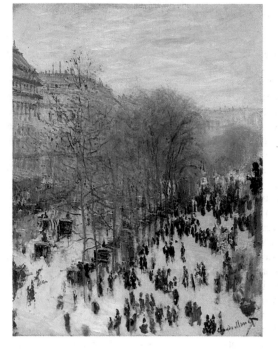

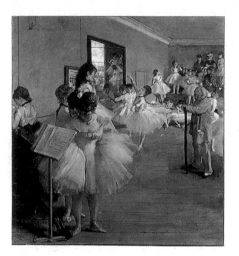

left: 10. Edgar Degas. *Dance Class.* c. 1876. Oil on canvas, 32⅝ × 29⅞". Metropolitan Museum of Art, New York (gift of Mrs. Harry Payne Bingham).

right: 11. Claude Monet. *Boulevard des Capucines, Paris.* 1873. Oil on canvas, 31¾ × 23¾". Nelson-Atkins Museum of Art, Kansas City (Kenneth A. and Helen F. Spencer Foundation Acquisition Fund.)

Arts practice. As a result, the Impressionists' joint debut turned into an event the likes of which would recur throughout the next century and more. That is, it consisted of daringly independent art independently presented by a beleaguered band of self-confident innovators, scandalized public and press, and the coining of an "ism" to designate a certain kind of radical form. Because of their commonly shared technique—their effervescent color and brushwork—the Impressionists are often thought to have evolved a group style, and to a degree they did. But while the technique could be learned or "made," as its prevalence among the leading exhibitors in Nadar's studio proved, style emerged from the unique, unavoidably singular way each of the artists inflected what was essentially a painterly means of conveying the effect of direct, personal response—unmediated by received convention—to a slice of vital, present life seized, upon the moment and unaware, as if by a candid camera. Thus style, together with the themes separately preferred by the Impressionists, became the "found" element, the spontaneous expression of an individual temperament guaranteeing the sense of dual originality—of fidelity to both nature and self—so treasured by 19th-century modernists. At their extremes, the variations among the possibilities discovered by Manet's followers may be best represented, on the one hand, by Claude Monet (1840–1926), an ambitious provincial from Le Havre, devoid of irony and determined to make his way up the bourgeois ladder, and, on the other hand, by Edgar Degas (1834–1917; fig.10), Parisianborn to aristocratic privilege but embittered by his family's financial decline and bitingly ironic in his focus on the bizarre tensions or vulnerabilities of contemporary existence. For the want of space, only Monet can be considered here in any detail. Like Cézanne, who said "Monet is merely an eye, but what an eye," generations of viewers believed that this exemplary Impressionist had developed a formal vo-

cabulary of high-key color, broken brushwork, and dynamic compositions for the sole purpose of celebrating the instantaneous quality of vision, the beauties of nature, and the expressive potential of color-impregnated medium (fig. 11). Dedicated to working *plein-air*—that is, out of doors—he would abandon a canvas once atmospheric conditions changed and take it up again only when similar light and weather prevailed. According to this orthodoxy, Monet concerned himself only with the fleeting effects of natural phenomena and the vagaries as well as pleasures of visual sensation, which became the content of his art, leaving it otherwise innocent of ideas and broader issues. Yet, even from the start, paintings like *Boulevard des Capucines, Paris,* could divulge more complex meanings, as they did to Frédéric Chevalier, a not altogether convinced critic who wrote in 1877:

The disturbing ensemble of contradictory qualities . . . which distinguish . . . the Impressionists, . . . the crude application of paint, the down to earth subjects, . . . the appearance of spontaneity, . . . the conscious incoherence, the bold colors, the contempt for form, the childish naïveté that they mix heedlessly with exquisite refinements, . . . all of this is not without analogy to the chaos of contradictory forces that trouble our era.

Turning Realism into venturous experiment, Monet acted on an intuition about the mechanics of vision, dispensed with the craftsmanly finish so prized by academics like Bouguereau—its blended colors, silken chiaroscuro modeling, exquisitely accurate drawing—and substituted facture whose unifying principle is sketchiness and spontaneity, a canvas enlivened by a generalized, all-over crust of colored spots. If such painting offended the majority of Parisians who first saw it, the explanation may lie in their discomfort at sensing how the molecularized surface became an analogue for the increasing anonymity and atomization of modern life, at the same time that it also pushed art frighteningly far towards abstraction, still more than had the most unfettered works of Delacroix, Courbet, and Manet. But casual and extemporized as the paint application may appear, Monet had carefully, albeit swiftly, deliberated every stroke, so that simultaneously each small, separate deposit of relatively pure hue would represent a point of light, a moment of perception, a particle of atmosphere or form in space, and a tessera within the mosaic structure of a surface design. Images resolve within this storm of vivacious handling not as a consequence of neatly delineated shapes filled with local color blended on the palette, but rather as a product of the way minute, juxtaposed dabs of unmixed hue complement one another to blend in the eye, yielding the impression of reality apprehended in a brisk moment of time.

Post-Impressionism

By the early 1880s, Impressionism as an aesthetic of instantaneity had begun to seem too ephemeral and formless, a "crisis" acknowledged first by the Impressionists themselves. Pierre-Auguste Renoir (1841–1919), in a letter to the dealer Ambroise Vollard, later wrote: "A short break . . . came in my work about 1883. I had wrung Impressionism dry, and I finally came to the conclusion that I know neither how to paint nor to draw. In a word, Impressionism was a blind alley." Thereafter, during the *fin-de-siècle* years, detachment and directness towards the contemporary world virtually disappeared from advanced painting, as one ingenious artist after another elaborated or simplified Impressionism's so-called "group" style into a variety of new "corrective" possibilities. With this, European art entered its "Post-Impressionist" phase, although not labeled as such until Roger Fry published the term in 1910. Together but each in his very particular way, the leading Post-Impressionists—Seurat, Gauguin, van Gogh, and Cézanne—launched, in earnest, the characteristic modernist, oedipal process of continuous self-regeneration through practical or analytical self-criticism. In *A Sunday on the Grande-Jatte* (fig. 12), for instance, Georges Seurat (1859–91) endowed quicksilver Impressionism with grave, though wonderfully luminous, monumentality, an accomplishment that seems all the more awesome for being concerned, as Monet's *Boulevard des Capucines* was, with a throng of Parisians in a public space, actually a park on a strip-like island in the middle of the Seine along Paris' northern edge. Departing from convention even more radically than Monet, Seurat derived his style as well as technique from science and his content from socially progressive thought. Indeed, the entrancing marvel of the *Grande-Jatte* wells up, in part, from an absolute oneness of means and meaning, since the work's amusingly robotic, toy-like society seems to celebrate the mechanized Utopia supposedly brought by industrialization, whose methodical ways Seurat did not flee, as had the Romantics and the Impressionists, but, instead, transformed into high art and transcendent mystery. From the writings of Ogden Rood, Charles Blanc, and Eugène Chevreul, Seurat learned how intuitions like those of the Impressionists had been theorized and scientifically proved, making it possible to extract from pigment on canvas optical sensations of light and color even more vibrant than those of *Boulevard des Capucines*. Thus prepared, the artist evolved what he called "divisionism," which meant treating his palette as if it were white light divided into prismatic or rainbow components, working with these rather than with blended colors, and heightening every hue by the simul-

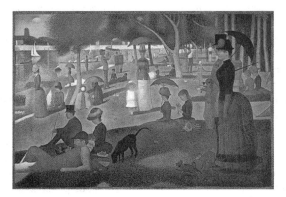

taneous presence of its complementary—green in the case of red, for instance. To exercise still greater control, for the paradoxical goal of even more volatile effects, he also developed "pointillism," applying his virgin tube colors, not in the free, rapid, somewhat haphazard manner of the Impressionists, but rather as a tight, meticulously constructed screen of relatively uniform, minute brushstrokes. Inevitably, it seems, the *Grande-Jatte* would inspire the term "Neo-Impressionism," first used in 1886 by the sympathetic critic Félix Fénéon, whose anarchist affiliations established a link between radical aesthetics and radical politics that endures to this day.

Before Georges Seurat died at the age of thirty-one, he had demonstrated in other large, painstakingly structured compositions yet more scientific ideas, these from Charles Henry and having to do with the emotional, symbolic values of art's most essential elements. Convinced that the rules of harmony could function in painting very much as they did in music, Seurat exploited descending lines, dark tones, and cold tints to effect sadness in *La Parade* (1887) and rising lines, light tones, and warm colors to engender gaiety in *Le Chahut* (1889–90). Now, he had compounded quasi-science with Symbolism, whose great hero was Paul Gauguin (1848–1903), an artist so hostile to science, other than its Theosophical variant, that he derided Seurat as "the little green chemist." Yet, though more attuned to poetry and the "primitive" than to empirical observation, Gauguin too regarded his painting as a kind of visual music, its message directly communicable, without libretto, through the affective potential of a sensuous surface. A rebel and outsider born, in Paris but of a mother from Peru, Gauguin had led a rather nomadic existence until his early twenties, when he settled in Paris, became a stockbroker, married, fathered five children, and, for recreation, took up Sunday painting. By 1881 he could bear middle-class respectability no longer and left a job lucrative enough to support his habit of collecting avant-garde art. Declaring "from now on I will paint every day," at first in an idiosyncratic brand of Impressionism, Gauguin abandoned his family and repaired to Pont-Aven, a fishing village in Brittany where Parisians mistakenly imagined they might commune with a primitive—that is, unspoiled—pre-industrial world of pious, simple, picturesque peasants. There, in collaboration with the much younger Émile Bernard, Gauguin fashioned an aggressively anti-naturalist, "naïve," or "folk" style intended to mirror not so much the visible world as the invisible, deeper, inner world of ideas, emotions, and magic—"the mysterious centers of thought." Called "Synthetism," this magpie form-language combined caricatural figuration, the cropped and collapsed spaces of Degas' theater views, and flat fields of bright, indeed "synthetic" color contoured by heavy black lines ("cloisons") reminiscent of Gothic stained-glass windows, as well as Japanese woodcuts. Cursing what he regarded as Western decadence and its refusal to heed the messianic message of his art, Gauguin set sail for Polynesia in 1891, there, as he announced, to "immerse myself in virgin nature, see no one but savages, live their life, with no other thought in mind but to render, the way a child would, the concepts formed in my brain, and to do this with nothing but the primitive means of art, the only means that are good and true." However, in Tahiti, and later in the Marquesas, Gauguin discovered not so much a fresh way of painting as a new exotic world to trigger private fantasies as remote from cultural reality as those the artist recorded in Brittany (fig. 13). For *"Eh quoi, es-tu jalouse?"* he simplified as well as amplified the archaic devices already evident in his Breton work, which made the picture seen here a pastiche of two solidly modeled, dark-skinned beauties, juxtaposed and observed from a raised angle, as Degas often did in his studies of nudes; a broad, shadowless, abstract ground of sensuously nuanced rose; and passages, at both top and bottom, of pure design, their

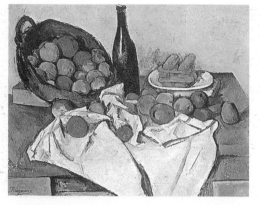

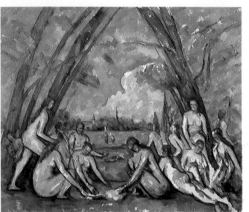

above: 14.
Paul Cézanne.
Still Life with Basket of Apples. 1890–94.
Oil on canvas,
24⅜ × 31″. Art
Institute of Chicago
(Helen Birch
Bartlett Memorial
Collection).

left: 15.
Paul Cézanne.
Large Bathers. 1906.
Oil on canvas,
6′10″ × 8′3″.
Philadelphia
Museum of Art
(W.P. Wilstach
Collection).

chaos of post-feudal existence. After participating in the first and third Impressionist exhibitions (1874, 1877), the shy, painfully insecure Cézanne had retired to his wealthy father's estate near Aix-en-Provence, there to paint in solitude and overcome the mockery of critics who long continued to think him a deluded primitive or psychopath. And indeed some of the pictures he first showed appeared to justify such an assessment, inasmuch as they fairly seethed, in both image and facture, with frustrated sexual longing. Yet, for all their heavy, dark ineptitude, the canvases displayed formal distortions of a parallel and contrasting sort that, as the inevitable product of a unique aesthetic vision and its expressive needs, would mature into the hallmarks of Cézanne's most accomplished art. The process began under the tutelage of Pissarro, mentor to so many, who perceived his pupil's latent power and helped the *sauvage raffiné* to work "with all his might to regulate his temperament and to impose upon it the control of cold conscience." Gradually, Cézanne came to depend less on his lurid imagination and more on the bright, external world of sight. Before a still life or landscape—a *motif*, as he called it, empty of human activity and thus free of all the disturbing associations such activity held for him—the artist could discover his own logic through the logic of nature and communicate it, not in imagery borrowed from religion, history, literature, or the contemporary social scene, but rather in the language of painting itself, in "plastic equivalents and colors" (fig. 14). Cézanne then proceeded to "read," probe, and search the subject for "the cylinder, the sphere, the cone," by which poetic expression he intended the structuring abstractions he sensed within the variegated shapes, forms, and concretions of visible reality. Having thus dismantled and fragmented the scene, Cézanne could next "realize his sensations" in a "construction after nature"—the painting. And he did so by means of his recently mastered Impressionist color, using it, however, with all the force and drama that he once poured into erotic fancy. For the sake of "something other than reality," Cézanne sought to evoke "flat depth" through all manner of innovative strategies, beginning with a steep view, which tilts the horizontal plane of a tabletop up, more congruent with the picture plane itself. But while the widened mouth of an elliptical bowl also makes the motif seem viewed from above, thus more "squared" with the painting surface, the apples in the foreground may be represented as if resting at eye level. Thwarted perspective continues in the handling of color, where plane after plane of juxtaposed and overlapped pigment structures the apples as dense, compact forms, albeit with segmentally stroked contours that, instead of containing, rupture. While this flattens the modulated volumes, it also allows them to "bleed" or "pass" into one another, thereby tethering fore and aft, surface and distance. To stress the plasticity of the picture as a whole, Cézanne often warped his drawing, as for a wine bottle swelling, in "sympathy," towards a basket of apples, the formal, synthetic continuity of which counterbalances the discontinuity, from left to right, of the tabletop's front and back edges. Having upset nature's balance by factoring it through his own heightened sensibility, Cézanne invented formal irrationalities so as to reorganize the motif into pictorial logic of a superior kind. Thus, the final composition, while alive with tension, possesses a serene poise in which we feel the measured rhythms and solidity characteristic of all great classical painting. "Form," according to the artist, "is at its fullest when color is at its richest." Cézanne, together with the Impressionists, had long since noted that nature seen under full illumination was "the antithesis of modeling"; it resembled, rather, the brilliantly patterned tapestry or patchwork that contemporaries often described upon seeing works like *Large Bathers* (fig. 15).

While Cézanne, from 1895 to his death in 1906, was being deified by young artists who would redefine modernism for the 20th century, Monet succeeded in making himself the unofficial national painter of France by remaining loyal to Impressionist principles but challenging them to meet new expressive needs. In his own way, therefore, he too resolved the "crisis" that had caused so many, including Renoir and Pissarro, to renounce spontaneity for more deliberated form and content. With unfailing instinct, Monet seemed to become ever-more conscious of what science would call the principle of complementarity, which

slow arabesque lines much less heavy than the Breton cloisons and now lovingly traced about floral, Art-Nouveau-like patches of the most resonant color. From figures to ground to pattern, the painting leads the eye and the mind from the portrait-like particular to the general and the universal—from the perceptual to the conceptual—an aesthetic journey that Gauguin made in the hope of releasing humanity from the constraints of social convention and into the freedom of authentic feeling. If the means did seem primitive—jury-rigged or makeshift—so much the better for serving as an agency of honest, unimpeded aspiration. In 1890, Maurice Denis, a twenty-year-old disciple, would embark upon a long career in art theory and criticism with an article whose first line has often been read as both a summary of Gauguin's Synthetist/Symbolist aesthetics and the opening chord of 20th-century abstraction: "Remember that a picture, before being a warhorse, a female nude, or some anecdote, is essentially a flat surface covered with colors arranged in a certain order."

By the turn of the century, however, it was Paul Cézanne (1839–1906) whom Denis, together with a cohort of other theory-minded artists and writers, would see as the very model of a painter so doubly original—so true to self and nature—that his work might, paradoxically, become a classic of its kind. In answer to questions from Émile Bernard, the elderly master wrote that he had wanted "to do Poussin over again, after nature," the better "to make of Impressionism something solid and durable like the art of the museums." By this, Cézanne meant that he had struggled, in every sense of the word, to produce an art of monumental clarity and calm by bringing into equilibrium a whole array of warring objectives: the orderliness of ideal form and the accidentality of nature, the synthetic on the one hand and the imitative on the other, the immutable and the momentary, naïveté and refinement, subjective feeling and objective observation. For Cézanne, the word "heroic" seems once again summoned, not only because of his lofty ambition but also because of the discrepancy between his exceptional genius and the rather awkward, unyielding talent with which he had to cope. The glory of the consequent paintings is that they seem so manifestly to be the record of a great soul mortally engaged in winning dominion over his own conflicted nature, which, thanks to the dynamic complexities of the art, becomes an expansive trope for modern civilization striving to wrest order from the

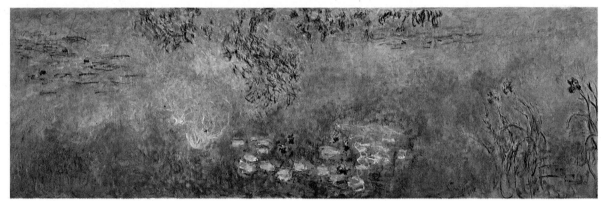

right: 16.
Claude Monet.
*Waterlilies: The Irises
(Nymphéas: Les Iris).* 1916–23.
Oil on canvas, 6′6¾″ × 11′4¼″.
Kunsthaus, Zurich.

below: 17.
Auguste Rodin. *The
Burghers of Calais.* 1884–88.
Bronze, 7′11″ × 8′2″ × 6′6″.
Hirshhorn Museum and
Sculpture Garden,
Smithsonian Institution,
Washington, D.C.

holds the observed world to be so contingent upon the observer and his way of observing that the serious, truthful artist ends by painting a "self" as the pretext for painting "nature." Now, the aging Monet withdrew not merely from urban subjects but also from found nature and into a nature of his own making, the water garden he created next to his property in the village of Giverny north of Paris (fig. 16). There he could look down upon a shimmering, horizonless surface afloat with lily pads, lotus blossoms, and reflections of the sky above, a piece of the real world but a remote, timeless one that excluded all except unsullied, though artificial, nature and an ever-fluctuating pattern of light and color. With this, "his Impressionism," as Robert Rosenblum has written, "went through the looking glass of the objective world and became part of the Symbolist aesthetic," complete with the blue and mauve tonalities so beloved by the soulful *fin de siècle.* The grand, mural-like image this yielded seems to reach across the decades—from Monet's death in 1926, three years before the arrival of Jackson Pollock in New York—to the late 1940s, when the American would achieve a similarly all-over, indivisible, "holistic," but now entirely abstract image. In late modernism, subject and object would indeed fuse, which Pollock affirmed when, admonished by Hans Hofmann to consult nature, he snapped: "I am nature."

By the end of the 19th century, the only modernist to rival Monet as a French national treasure was Auguste Rodin (1840–1917), an exact contemporary, whose achievement must be judged all the more remarkable for having been realized in monumental sculpture, a form so involved with public taste, as well as with costly materials and procedures, that it made aesthetic experiment a much riskier affair than in painting or writing. For Rodin, sculpture could never be the same again once he understood that what counts is not finish or completion but the degree to which the work of art evinces the process of its own creation—the miracle of dead matter becoming quick in the artist's hands. Because gifted with miracle-working hands, Rodin overcame entrenched resistance and won several major governmental commissions, all of them, however, plagued by conflict between the artist's unconventional vision and the expectations of hidebound patronage. Finally, he managed to endow the dismayed city of Calais with one of modern art's triumphs within the difficult domain of public monuments (fig. 17). The subject came from

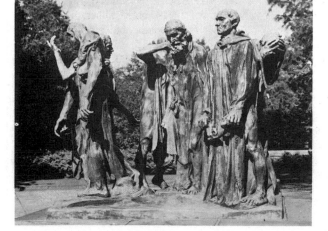

Froissart's 14th-century *Chronicles,* which tell of six leading citizens of Calais who, during the Hundred Years' War, voluntarily surrendered themselves, clad in sackcloth, with ropes tied round their necks, in order to break the long siege then being laid by the English. Despite the literary, historical, and even mythic character of his assigned theme, Rodin chose to interpret it with strategies that could only prove far more disruptive of traditional narrative, illusion, and wholeness than were the similar methods employed by Degas, whose oddly angled, cropped, and dispersed compositions appeared, at least, to be sanctioned by photography (fig.10). Rodin, from the residue of the famous *Gates of Hell,* his forever-unfinished masterpiece, maintained a huge inventory of anatomical parts modeled in plaster by, as always, his own hand. With these he made many "partial sculptures" that seem especially evocative of human frailty or emotional incompleteness by reason of their fragmentary condition. At the same time, he also combined, recombined, or yet twinned figures into couples that clutch and paw one another inconsolably like emblems of modern estrangement and futility. For *The Burghers of Calais,* Rodin again made modular, piecemeal use of fragmentation and repetition as a means of giving expressive form to fraught social/psychological dilemma, this time on a truly heroic scale. Instead of summing up the story in the old hierarchical manner, with one climactic figure or gesture serving to universalize the particular realities of six individuals preparing for martyrdom, Rodin decided to treat the figures more or less equally, not only by placing them on common ground but, further, by giving the same head to two of the images and the face of this head to a third. From his "lavish palette of recombinant possibilities," as Kirk Varnedoe put it, he also duplicated fingers, hands, and feet, never failing, however, to modify them by flexion or orientation. With their recurrent features and the steady beat of their pendulous sackcloth, Rodin's Burghers leave no doubt about their collective destiny, even while their centrifugal round of outward-turning attitudes discloses them as vessels of private emotion, each, perhaps, like a frame in a cinematic sequence of unresolved inner conflict. The technique of making art by patchwork or serial recycling of found, modular fragments would have a long life in modernism, as artists became increasingly aware that such units, like words and signs, assume new meanings with every change of context, to the point even of revitalizing old ones as in *The Burghers of Calais.*

Fauvism and Expressionism

It has been said that after the 19th century, in its ineffable urge to progress, replaced God with nature, the 20th century took revenge and replaced nature with art. Certainly the latter shift may be seen at work in the painting of Henri Matisse (1869–1954), the "King of the Fauves," as he became known in the autumn of 1905 during an exhibition of canvases so spankingly fresh in their blazing, arbitrary colors that a sardonic writer thought himself in a *cage des fauves* ("cage of wild beasts"). With this, the new era could boast its first new, critically acknowledged "movement": Fauvism. To present eyes, however, even the most tuned-up Fauve paintings seem less feral than exquisitely decorative, and the hysterical reaction to them more indicative of contemporary popular taste

than anything actually hung in what was a gallery at Paris' Autumn Salon. At thirty-six, Matisse was already the professorial, deeply philosophical painter that he would always remain, while the other principal Fauves, the much younger André Derain and Maurice de Vlaminck, virtually matched him in their middle-class backgrounds and seriousness of purpose. For the most part, the Fauves—an informal association that promulgated no manifestoes, as more self-conscious groups would later do, and held together only for the years 1905–07—reserved wildness for their chromatic harmonies, energetic brushwork, and liberated drawing, incited by such ''violent'' themes as idyllic landscapes and marines, buoyant crowd scenes, sensual figure studies, still lifes, and portraits. And only Matisse had so pondered the principles of his art that, well after most of the ''bestial'' circle had banished color as indeed too wild and untamable, he would steadily, on his own throughout an exceptionally long and illustrious career, reconfirm color as the essential means by which to elevate painting to unprecedented heights of limpidity and logic. In Fauvism, meanwhile, Matisse set the stage for the whole of 20th-century art through canvases that appeared to emerge almost inevitably from everything that had occurred in advanced French painting since Delacroix, especially the progressive brightening of the palette (fig. 18).

Great artist that he was, Matisse looked to the past not in submission but as a seeker after light to guide him into the dim reaches of the future. And he soon found it, for as Gustave Moreau, his academic though liberal-minded teacher, had advised him: ''You are destined to simplify painting.'' Unfortunately, *Bonheur de vivre*, or *Joy of Life* (fig. 19), the Fauve masterpiece in which Matisse began genuinely to realize this destiny, may not be reproduced in color. Still, even in a black-and-white reproduction one can appreciate the most striking among the formal innovations of *Bonheur de vivre*: the linear draftsmanship. Realized in free-flowing, arabesque configurations, it recalls the drawing of both Ingres and Gauguin, as well as the motifs of Art Nouveau decoration, but it is also more varied, pervasive, and purposeful than any of the prototypes. From the outset of his Fauve experiments, Matisse had been concerned to develop a form of drawing both comparable and appropriate to flattened areas of color. A vast salon machine dedicated to Baudelaire's *luxe, calme et volupté*, thus to the ancient Golden Age celebrated in the pastorals and bacchanals of Giorgione, Titian, and France's Rococo masters, *Bonheur de vivre* helped him calm the excitement of his direct involvement with nature and realize his dream of spontaneous feeling preserved and monumentalized but not eliminated. To dare the creative distortions, of space, line, and color, seen in *Bonheur de vivre*, the artist found inspiration not only in Cézanne but also, and even more momentously, in African art, which he had now begun to collect, perhaps earlier than anyone else in the Parisian avant-garde.

From Cézanne, Matisse understood, far better than his contemporaries, that color alone could yield the full range of effects which other

pictorial elements separately evoke—depth as well as flatness, contours as well as planes, the substantive as well as the illusory. Altogether color made available a purely optical or pictorial kind of reality, and once Matisse had taken possession of this fact, he rarely relinquished it in the art of his mature career. In *The Red Studio* of 1911 (fig. 18), at New York's Museum of Modern Art (hereafter cited, usually, as MoMA), he brought his Fauve infatuation with color to climax in a work of such uncompromising pictorial rigor that it must be seen not only as a pinnacle of colorist opticality but also as a born colorist's answer to the challenge of Cubism's more overt structuralism, then in full ascendancy among Parisian vanguardists. This time the subject has become, even more than Monet's water garden, a work of the artist's own making—his studio—where the Renaissance window onto nature has been blocked off entirely. Replacing nature are a single twining plant and numerous representations—all known paintings and sculptures by Matisse—scattered about an interior space whose shape and depth are acknowledged no more than schematically, but enough for them to be fully sensed, by the thinnest of outlines relieved in a continuous sheet of fiery brick red. Not only did

Matisse flood his pictorial space with a flat, monochromatic lake at full saturation, swamping the studio's oblique angle; in addition, he treated everything three-dimensional as nothing more than inscribed contours. Meanwhile, the only objects allowed full color or modeling come across as conceptually flat by virtue of their being in themselves flat—that is, the circular plate in the foreground and the paintings hung on the wall or stacked against it. Impressionism, with its relatively uniform, crust-like texture and generalized distribution of color, had asserted the tangibility of the picture plane in a way that made it an inescapable priority for much modernist painting. But the equalized nature of Impressionist color and handling also produced the effect of a soft atmospheric screen inviting visual entrance into a world beyond. Matisse, by seeking pictorial order in the interaction of flat, strongly contrasted hues, made light seem not a gentle emanation from within an atmosphere but a reflection from the open spread of a taut membrane. Thus, he realized much more of Impressionism's own potential for abstract, planar organization. As treated by Matisse, the picture surface resists optical penetration but invites the eye to cross and recross, taking in but never violating its unity. To make this possible, the artist simplified ruthlessly, as Moreau had predicted, and did so ''even at the risk of sacrificing . . . pleasing qualities.'' In *Notes of a Painter* (1908) Matisse revealed something of the lucid reasoning that supported the formal dislocations of his art:

What I am after, above all, is expression. . . . I am unable to distinguish between the feeling I have for life and my way of expressing. . . . Expression to my way of thinking does not consist of the passion mirrored upon a human face or betrayed by a violent gesture. The whole arrangement of my pictures is expressive. The

left: 18. Henri Matisse. *The Red Studio*. 1911. Oil on canvas, 5'11¼" × 7'2¼". Museum of Modern Art, New York (Mrs. Simon Guggenheim Fund).

above: 19. Henri Matisse. *Bonheur de vivre (Joy of Life)*. 1905–06. Oil on canvas, 5'8½" × 7'9¾". Barnes Foundation, Merion, Pa.

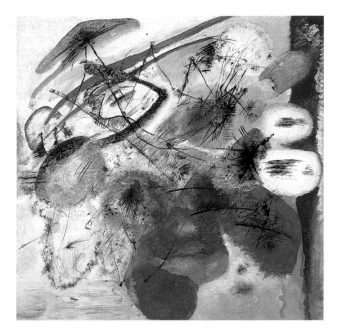

place occupied by figures or objects, the empty spaces around them, the proportions, everything plays a part.

Fauvism became a beacon for numerous young artists in Germany eager to wrest German painting from the stranglehold of academic Impressionism and propel it, at high speed, into the 20th century. When this occurred, however, what counted most for *Die Brücke*, a group of Dresden artists attempting to "bridge" the gap between themselves and the forward-thinking everywhere, was how Matisse had found in sub-Saharan and Oceanic art models for returning art to primal origins, that is, for renewing expression through brutally simplified means. Whereas the French tended to diffuse "savagery" in formal or decorative invention, Ernst Ludwig Kirchner (1880–1938)—the undisputed leader of the Brücke, or Bridge, from its first exhibition in 1905 to its dissolution in 1913 in Berlin—assumed the role of savage moralist reacting to a corrupt society. Playing it to the hilt, he adopted a "primitive" life style, attempted to capture in painting psychic states like those sensed in tribal sculpture, and filled his studio with batiks, tapa cloths, and rough furniture carpentered by himself. Much of this is reflected in *Self-Portrait with Model* (fig. 20), where Kirchner transformed the Cézannean notion of painting as a brilliantly colored tapestry into an image of barbaric splendor, its jammed, richly patterned chromatics dense and weighty rather than luminous, fiercely contrasted and impetuously applied without much concern for the niceties of pictorial structure. Still, like Matisse in *The Red Studio*, he disclosed his modernity by allowing imagery to be cropped at the edges of the format, with which volume seems, as a result, to become coincident and thus flattened. Unlike Matisse, who portrayed himself in *The Red Studio* through the distancing proxy of his own paintings and sculptures, Kirchner in person stands full front within his studio and the full height of his big picture, leaving little question about the acute egocentricity of his creative enterprise. Naked under a gaudy caftan and holding his red-tipped brush as if it were a phallus or glowing wand, the mask-faced artist approaches the canvas like a shaman, driven by a muse who could be a Kurfürstendam version of Manet's nude picnicker, the kind of gimlet-eyed wildcat that Kirchner thought the perfect symbol of modern Berlin, an urban "jungle" remote from the *luxe, calme et volupté* of Matisse's imagined Arcadia.

While the Bridge artists achieved Expressionism through primitive subject matter and dramatic emphasis, as well as formal distortions, a contemporary group of Expressionists in the culturally sophisticated city of Munich began to see in the abstract means of art—lines and colors, brushstrokes and textures, size and scale—a fully sufficient language for testifying not to the world of urban *Angst* but rather to the immaterial, subjective world of spiritual necessity. Vassily Kandinsky (1866–1944),

Gabriele Münter, Franz Marc, August Macke, Alexej von Jawlensky, Paul Klee, and other members of *Der Blaue Reiter* believed it essential to test their means and urges while gradually fashioning a controlled, symbolic idiom through which to communicate a personal sense of sublime meaning. Not surprisingly, Kandinsky, the guiding genius and chief theorist of *Der Blaue Reiter*, as well as its most radical inventor of plastic form, was already a more mature artist than Kirchner when he and his associates decided to assure themselves exhibition by organizing shows and publishing a serial almanac under the aegis of "The Blue Rider." According to Kandinsky, he and Marc "both loved blue, Marc also loved horses, and I horsemen." It should also be added that blue, a color rhapsodized by Mallarmé in his poem *L'Azur,* had dominated Symbolist, *fin-de-siècle* art, especially that touched by occult Theosophy and Rosicrucianism, as the most ethereal or mystical of all hues. As early as 1896, the Russian Kandinsky, then a practicing attorney in Moscow, had foreseen the logical implications of the modernist quest for origins—for the double originality of "nature seen through a temperament"—when he came upon one of Monet's Grainstack paintings. "Deep inside me," he later wrote, "was born the first faint doubt as to the importance of an 'object' as the necessary element of painting." Soon thereafter Kandinsky moved to Munich, devoted himself entirely to painting, and then entered the vanguard mainstream during a year, 1906–07, spent in Paris, where Fauvism convinced him anew of the expressive potential of liberated color and drawing. To develop this notion further, Kandinsky joined Gabriele Münter in emulating the brilliant colorism, peasant manner, and spiritual purity of the *Hinterglasmalerei* ("under-glass painting") traditional around the village of Murnau in the Bavarian Alps. From 1909 until war broke out in August 1914, the artist steadily forged ahead in an enthralling series of Impressions, Improvisations, and Compositions, all part of a dynamic spiritual adventure leading deep into virgin territory. It culminated, at the end of 1913, in what may very well

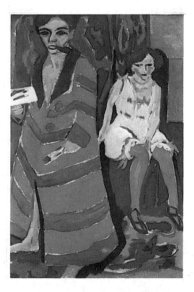

right: 20.
Ernst Ludwig Kirchner.
Self-Portrait with Model. 1910/26.
Oil on canvas, 4'10⅝" × 3'3".
Kunsthalle, Hamburg.

above: 21.
Vassily Kandinsky. *Black Lines.*
1913. Oil on canvas, 4'3" × 4'3⅝".
Solomon R. Guggenheim
Museum, New York
(gift, Solomon R. Guggenheim).

have been the first *free*-form, largely nonobjective paintings ever produced by a European modernist (fig. 21). Progressively abstracted from forms in nature until they resemble cosmic landscapes, paintings like the one seen here visually explode with the artist's signature vocabulary of floral bursts and floating boomerangs, giving effect to an otherworldly fantasia of incandescent, Oriental color stitched together with a lacework overlay of dark lines. For cognoscenti, Kandinsky's strange new language is magically decipherable, not only as a vision of apocalypse on the eve of the Great War, but also as a dream-like self-portrait in which the artist becomes the blue rider hounded by a mysterious power to explore an unknown terrain, filled with intimations of mountains, valleys, rivers, and church steeples, all of which invite discovery but finally elude it even as their concrete colors and forms point to a yet indiscernible coherence of all being.

Cubism

It might be argued that once the Romantics, followed by Manet and the Impressionists, sought truth as much in the temperament of the individual artist as in his subject matter, virtually all advanced art since Goya, Friedrich, Turner, and Delacroix is fundamentally Expressionist. Certainly, Cubism, ostensibly the most objective, formalist, and even classicizing of all the new visual languages, as well as the very mother tongue of 20th-century modernism, originated, at least to some degree, in one of the most violently disruptive and Expressionist pictures ever painted: Picasso's *Les Demoiselles d'Avignon* (fig. 22). A Spaniard from Barcelona who spent the whole of his adult life in France, Pablo Picasso (1881–1973) was the only artist of sufficient accomplishment to challenge Matisse, twelve years senior but an acknowledged rival, as the era's preeminent master of modernist painting. Yet, the two giants were so different as to be complementary opposites: the elder one a late starter, meditative, and methodical in his revolutionary boldness; the younger, precocious and mercurial, passionate and improvisational, charismatic and gregarious. While Picasso innovated ceaselessly, in style as well as in technique, and motivated whole movements, beginning with Cubism, Matisse stood apart after Fauvism, grew gradually and continuously until, in a final release of creative energy during and after World War II, he helped open late modernism to a flood tide of new color abstraction. Being so different yet so sovereign within their respective domains, Matisse and Picasso could not but influence one another, as in *The Red Studio* already seen and now in the *Demoiselles*. Academically trained in the best sense of the word and as universally gifted as a Renaissance master, Picasso had quickly made his own almost every style and mood then available to contemporary art, notably in the Blue Period canvases, with their *fin-de-siècle* sadness, and in the poignantly romantic Rose Period paintings of circus performers. By 1906, however, he had discovered pre-Christian Iberian sculpture and, under this influence, had begun to assert his independence in terra-cotta-colored nudes whose blocky, heavily plastic masses disclosed a bent for conceptual form. This, finally, would leave him alert to all manner of models, emanating from or searching for primitive, primary instinct, among them Cézanne's Bathers, Matisse's *Bonheur de vivre* and, most of all, *l'art nègre*. The entire lot, and much more, would be stirred into the *Demoiselles*, a cauldron of a painting that Picasso labored upon in early 1907 "during long days and as many nights giving concrete expression," as André Salmon wrote, "to abstract ideas and reducing the results to their fundamentals." Named for a red-light street in Barcelona, *Les Demoiselles d'Avignon* appears to have objectified, like an exorcism, Picasso's *femme-fatale*

fixation, inasmuch as the women's "barbaric" faces conjure up what William Rubin has called "something that transcends our sense of civilized experience, something ominous and monstrous such as Conrad's Kurtz discovered in the heart of darkness." As for the genesis of Cubism, that story is best told through other paintings, however much the *Demoiselles* may have registered the degree of Picasso's ambition and readiness to reconstrue painting in the most radical way possible.

In view of the *Demoiselles*, one must believe Picasso when he said: "What forces our interest is Cézanne's anxiety." Meanwhile, Georges Braque (1882–1963), from Le Havre, saw Cézanne as the "modern Poussin," an artist "as great for his clumsiness as for his genius." The conservative Braque, trained only as a house painter/decorator and determined to formulate a post-Cézanne classicism all his own, would make the perfect foil for the pyrotechnical Picasso, once the two of them entered upon a collaboration, "like two mountain climbers roped together," and gradually realized the kind of fully seasoned, infinitely subtle Cubism seen in *The Portuguese*, painted by Braque in 1911 (fig. 23). Three years earlier, however, Braque on his own had formulated the essential grammar and syntax of the Cubist language, to the point where a group of his new landscapes had so thoroughly redone Cézanne, this time according to the essential, geometric order sensed by the Aix master within organic nature's randomness, that he provoked Matisse into exclaiming: *Toujours des cubes!* With this, Cubism had been christened, even though the style would become modernism's new *lingua franca* only after Picasso, beginning in 1909, coupled his eruptive genius with the earnest, systematic spirit of Braque in one of the most bounteous joint ventures ever to have unfolded in the history of art. It worked because the participants approached their common style from diametrically opposite positions. While Picasso would define Cubism as "an art dealing primarily with forms," Braque held that Cubism "was the materialization of a new space," the "visual space" he felt separating "objects from each other." That is, Spaniard and Frenchman complemented one another to resolve the pictorial issues raised by Cézanne and the sculptural ones taken up by Picasso in his fascination with Iberian and African figures. What Braque did in 1907–08, in order to attain a more conceptual, rather than perceptual, image of reality was concentrate on landscape (actually hillside villagescape), a motif more conducive to disinterested, or purely aesthetic, deformation because free of the Expressionist, psychological subjectivity implicit in the human face and figure. He then adopted a view so steep that, as in Monet's late Waterlilies, the horizon disappeared and the ground plane became a continuous spread of simplified architectural forms, interspersed with equally abstract vegetation, that appeared not so much to recede as, on the contrary, to spill towards the viewer.

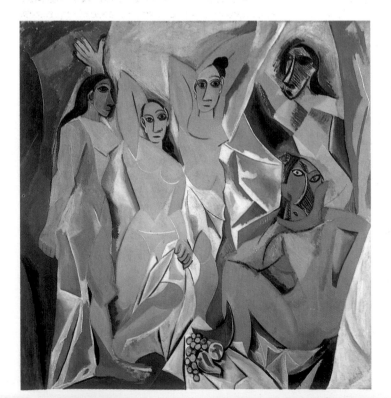

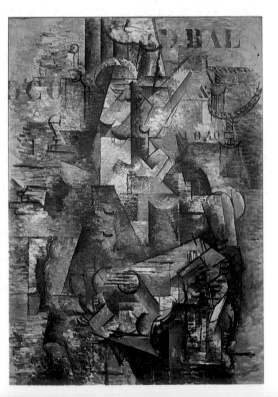

left: 22.
Pablo Picasso.
Les Demoiselles d'Avignon. 1907.
Oil on canvas,
8′ × 7′8″.
Museum of
Modern Art,
New York
(acquired through
the Lillie P.
Bliss Bequest).

right: 23.
Georges Braque.
The Portuguese.
1911–12.
Oil on canvas,
45⅛ × 32⅛″.
Kunstmuseum,
Basel.

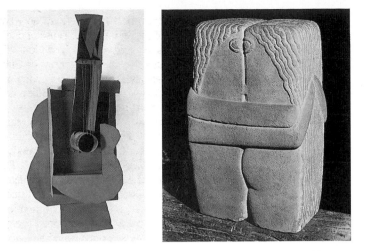
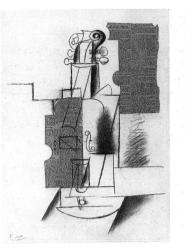
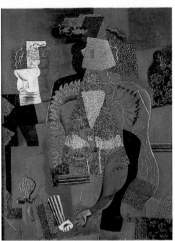

far left: 24. Pablo Picasso. *Guitar.* 1912–13.
Sheet metal and wire, 30½ × 13⅛ × 7⅝".
Museum of Modern Art, New York (gift of the artist).

left: 25. Constantin Brancusi. *The Kiss.* c. 1912.
Limestone, 23 × 13 × 10". Philadelphia Museum of Art
(Louise and Walter Arensberg Collection).

above: 26. Pablo Picasso. *Violin.* 1912.
Pasted paper and charcoal drawing on paper, 24⅜ × 18½".
Musée National d'Art Moderne, Paris.

right: 27. Pablo Picasso. *Portrait of a Young Girl.* 1914.
Oil on canvas, 4'3¼" × 3'2⅛". Musée National d'Art Moderne, Paris.

More important yet, for the sake of all-over two- and three-dimensional unity, was the pioneer use that Braque made of Cézanne's *passage* technique, with the result that as the structural planes tumbled forward, they appeared to breech their own contours and slide, "bleed," or indeed "pass," into one another. Beckoned by pervasive elision, the eye finds itself gliding from plane to plane, traveling into fictive depth while simultaneously exploring the palpable presence of the real, painted surface. By the time of *The Portuguese*, Cubism's co-founders had learned to work so analytically—with Picasso breaking down and reconceiving form in terms of its planar components, while Braque materialized space in an analogous array of shifting shard-like elements—that the sophisticated, iconoclastic art they invented came to be known as Analytic Cubism. And having gained complete mastery of their means, they could also reapproach the human image and analyze its freestanding mass even more thoroughly than Braque had landscape, yet so render the subject that, far from appearing mutilated, he or she comes forth looking ennobled and grandly mysterious, like a figure in a portrait by Rembrandt, albeit one that has been fractured and reassembled into a fragile, frontalized network of silvery slivers tilting to and fro within the smoky atmosphere of a shallow, ambiguous space. Rendered transparent by their shuffled elisions and intersections, the angled planes cluster at points and resolve into the features of a guitar-playing male; elsewhere, they fail to focus and become absorbed into the overall screen of facets, which, as abstract drawing, serves to reiterate the format's major, grid-like axes and thus structure the painting as a kind of architectural scaffolding. Being composite, an image represented in this fashion seemed miraculously at one with the new, scientific knowledge that human perception derives not from a single, all-encompassing glance but, instead, from a succession of "takes," from experience stored in memory, and from the intellect's capacity to conceptualize form. As early as 1913, the poet/critic Guillaume Apollinaire compared the Cubists' fusion of various perspectives—its "simultaneity"—to the space/time, or four-dimensional, continuum posited by Einstein in the physics of relativity. Finally, it would seem, modernists had liberated painting from the Renaissance world of nature observed by means of the arbitrary principle of mathematical perspective.

In some of Picasso's pictures of 1910, the irresolution among the tremulous, tissue-thin shingles all but dissolved the image in a sea of hermetic nonobjectivity. At this point Braque as well as Picasso pulled back towards external reality, preferring their art to be "drenched in humanity" rather than severed from palpable life and given over, like Kandinsky's Improvisations of 1913–14, to the realm of pure mind or spirit. The better to link their increasingly abstract art to quotidian existence, the collaborators forged an iconography out of their own intimate world—friends, lovers, and admired café performers; vacation landscapes; studio clutter such as palettes, guitars, music, and wine bottles. In *The Portuguese*, Braque asserted the paradoxical nature of his art by imposing upon the delicate Analytic Cubist web such blatant mundanity as trompe-l'oeil lengths of rope and stenciled numbers as well as letters, both kinds of representation reviving skills the artist had acquired through his early training in commercial and decorative art. Yet while anchoring a vaporous configuration to material, legible reality, the stenciled features are not images but, instead, signs and symbols that could only confirm the rigid, opaque, two-dimensional fact of the painting surface. By thus stressing what the Renaissance had striven to deny, Picasso and Braque defined the modern picture as a *tableau-objet*, a constructed object, among other objects in the world, and a universe unto itself, not mirroring "nature" but re-creating it in an entirely new form, complete with its own internal light, beamed not from without but generated from within the cells of what appears to be a crystallized substance.

The Cubist fathers' novel assimilation into high art of such concrete bits of low-life reality as stenciled words and numbers prophesied the move that Picasso and Braque would make to translate their already highly conceptualized Cubist language into a still less imitative and more purely symbolic, yet paradoxically more concrete, mode of expression. The next step came in 1912 when Picasso literalized Analytic Cubism's plane geometry in the first constructed, open-work sculpture, assembled from industrial sheet metal cut and wired in the form of a guitar (fig. 24). This disarmingly modest little piece has been called, with justice as we shall discover, "one of the two or three most seminal works in modern sculpture." With characteristic quick-wittedness, Picasso had seen in the protruding eyes of a Grebo mask the structural principle of inversion or contradiction, whereby something may be represented by its opposite. Thus, the body of the guitar became a void, making it necessary to project the sound hole as a cylinder. The radicality of the relief becomes stunningly evident in relation to the sculptures of Rodin and Constantin Brancusi (1876–1957), which, for all their genuine modernism, remained as closed and monolithic as sculpture had always been. While Rodin modeled his famous "lump and hollow" surfaces in order to generate a play of light and shadow connoting a sense of subsurface vitality, Brancusi carved—wood, marble, limestone—until he had reduced the natural and the organic to smooth, ideal essences (figs. 25, 151). Although cube-like, *The Kiss* could scarcely be more remote from Cubism's idiom of intersecting planes, which represented sexual intercourse emblematically, as a cylinder combining orifice and shaft in one.

Modernism and Its Origins

Meanwhile, Brancusi evoked the primal act not only through charmingly abstracted but nonetheless conventional figuration; he also conveyed it through the folkloric primitivism of his modernist form.

Shortly after cutting and assembling *Guitar,* Picasso made the momentous breakthrough to collage, without which it would be impossible to imagine the remaining history of 20th-century art. With collage—so called from the French verb *coller,* meaning "to glue"—the artist no longer sought to analyze a subject into a skeletal, vaporized semblance; he would now cobble it together from "found" parts and materials—labels, newsprint, wallpaper, etc.—that by virtue of their context within the art work do not so much describe an object, figure, or scene as merely

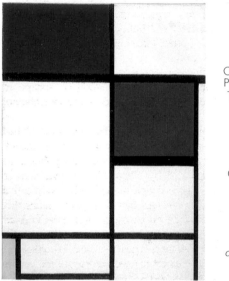

left: 28.
Piet Mondrian.
Composition (Blue, Red, and Yellow). 1930.
Oil on canvas, 28½ × 21¼".
Private collection; courtesy
Thomas Ammann, Zurich.

right: 29.
Charles Biederman.
#8,5/1938. 1938.
Oil on wood,
22½ × 15½ × 4½".
Courtesy Grace Borgenicht
Gallery, New York.

far right: 30.
Giacomo Balla.
Mercury Passing before the Sun as Seen through a Telescope. 1914. Tempera
on paper, 47¼ × 39".
Private collection, Milan.

signify it through a kind of synecdoche, as when a part is sufficient to speak for the whole (fig. 26). By this odd yet fertile economy, an oval support assumes the role of a café table once overlaid with oilcloth printed to simulate caning and thus signify chairs, especially if supplemented with the pasted-on or stenciled letters JOU, the first syllable of JOURNAL, meaning the newspaper likely to be read by whoever may be seated at the table and drinking from the goblet painted or drawn by the artist's actual hand. The drawn or painted passage, being a traditional means of representation, even if realized in the Cubist manner, served in 1912 to legitimize the new symbolic language, its emergence uncannily coincident with the structural linguistics, or semiotics (the science of signs), then being formulated by Ferdinand de Saussure, whose historic *Course in General Linguistics* first appeared in Paris in 1916.

If this brought 20th-century art to the threshold of post-modernism, the space it opened would not be fully inhabited for another half-century. Meanwhile, having dismembered illusion into its constituent elements, the task of Analytic Cubism, and replaced them with collaged signs, Picasso and Braque felt free to reclaim all those lost factors for painting—especially color and deep space—through the same figure/ground, negative/positive structure innovated in collage (fig. 27). As in collage, the artists composed less by breaking down forms than by building them up, a constructive and therefore synthetic, rather than analytic, process that resulted in a new style and a new label: Synthetic Cubism. In this witty, colorful form—its resolute, decorative, monumental flatness equal to Matisse's *The Red Studio* but mechanized by comparison with the onetime Fauve's arabesque opulence—Cubism became far more accessible, to other artists and the world in general, than the erudite Analytic phase exemplified by Braque's *The Portuguese.* In Paris, Frank Kupka, Robert Delaunay, and Fernand Léger conveyed full-color Cubism along three different routes to nonobjectivity, colonizing territory that Picasso and Braque had refused to occupy for longer than a moment, and doing so in the years 1910–13, probably even before Kandinsky. Meanwhile, Piet Mondrian (1872–1944), from the Netherlands, drew

on his Theosophical tenets to perceive that "Cubism did not accept the logical consequences of its own discoveries; it was not developing towards its own goal, the expression of pure plastics." Aiming for what he called Neoplasticism, Mondrian ceased to abstract from nature and began constructing his pictures from a universal vocabulary cleansed of all but the primary colors red, yellow, and blue, plus those polar values black and white, the Platonic square and rectangle (fig. 28). Eager that his asymmetrical, "dynamic equilibrium of opposites" provide a blueprint for the era of purity transcending all material concerns—towards which Theosophists like himself and Kandinsky believed their art might contribute—Mondrian in 1917 joined De Stijl, a Dutch group that strove to beautify the human environment by extending Neoplasticism into architecture and the decorative arts. By the mid-1930s, the influence of Mondrian himself had extended across the Atlantic to New York, where artists like Charles Biederman (1906—) felt the emotional fullness within Neoplasticism's gleaming, ascetic perfection and attempted to make it their own, sometimes in the literalized form of a relief (fig. 29).

Cubism had a profound effect on both the Bridge and the Blue Rider in Germany, while in Italy it so inspired a rebellious group of younger artists that they chose Paris as the place to proclaim themselves Futurists, publish their first manifesto (1909), and exhibit works that translated Analytic Cubism's sense of modern flux and discontinuity into abstract signs of speed and mechanical energy. Overwhelmed by the splendor of Italy's ancient heritage, Umberto Boccioni, Luigi Russolo, Gino Severini, and, eventually, Giacomo Balla (1871–1958) joined with the poet Filippo Tommaso Marinetti in an aggressive, highly nationalistic campaign to repudiate the past and bring on the future, showing the way in paintings whose dynamic play of interpenetrating planes, arcs, and lines of force celebrated, in oddly romantic, Nietzschean terms, the Machine Age and its Superman (fig. 30). Quite simply, the Futurists called for a new cult of beauty in which "a racing car . . . is more beautiful than the *Victory of Samothrace.*"

In far-off, pre-Revolutionary Russia, a small group of intrepid artists—aided no doubt by the legacy of abstraction fundamental to their culture's icons and patterned folk art—assimilated the latest European innovations with stunning swiftness and completion, then carried them to the absolutist conclusions beyond anything seen in Paris, or elsewhere until several years after World War II. Initially, Kasimir Malevich (1878–1935) formulated what he called Cubo-Futurism, first exhibited in 1913, but then, by 1915, moved on to Suprematism. Here he purified painting to the supremely elemental state of a black square, or later, in 1918, a white one, imposed upon the tabula rasa of a white square ground, the shape chosen because its straight lines could never be found in nature (fig. 31). Like Kandinsky in Munich, Malevich in Petrograd took inspiration from mysticism's search for cosmic unity; however, he found his energy not in personal emotion but rather in an objective, Utopian vision of a brave new world. Determined to break with material reality, Malevich became one of the very first Western-oriented artists to

31.
Kasimir Malevich.
Suprematist Composition: White on White. 1918. Oil on canvas, 31¼″ square. Museum of Modern Art, New York.

reject the process of abstracting from nature in favor of inventing directly, which in his oeuvre frequently yielded a planetary image redolent of sublime boundlessness. Come the Revolution of October 1917, the Russian instinct for abstract form would harness Cubo-Futurist-Suprematist aesthetics to science and technology for the purpose of creating a revolutionary art capable of serving as well as symbolizing the revolutionary society then in rapid evolution. And so, after enriching modernism with some of its most memorable paintings and sculptures, Vladimir Tatlin, Alexander Rodchenko, Liubov Popova, and Olga Rozanova, for instance, repudiated the whole notion of a "fine" art in favor of exercising Cubist logic and clarity in such socially useful fields as graphic design, photography, mass production, and architectural engineering. However, once this Utilitarian or Productivist move "into real space and real materials" became political orthodoxy in 1920-22, other Russian avant-gardists emigrated abroad, benefiting Western civilization in ways that Soviet citizens would never know, mired as their nation soon became in the didactic banalities of Stalinist Social or Socialist Realism. Before they departed, the brothers Naum Gabo (1890–1977) and Antoine Pevsner stated their dissenting position in *The Realist Manifesto* (1920), where they argued for a Constructivist art concerned with nothing but space and time, made evident through "real" industrial materials. As construed and practiced by Gabo, Constructivism meant building a "stereometric" object out of simple planes so intersected as to create a balanced, geometrical structure in which the primary determinant of form would be space rather than mass (fig. 154). It was this "intellectualist" instead of the "utilitarian" brand of Utopian Constructivism, blended with De Stijl, that formed the core ideology of the Bauhaus School in Germany from 1919 until the advent of the Nazis in 1933. Thereafter, Constructivist or Bauhaus space/time aesthetics would survive vigorously, well beyond 1945, in a great variety of geometric, light, and kinetic works, but also, monumentalized and simplified, in Minimalism.

Dada and Surrealism

While the guns of August 1914 may have been welcomed by the Futurists, as the new mechanized broom needed to sweep Europe clean of its heavily encumbered past, they shattered the vanguard world described in these pages, along with every other aspect of Western culture. Among the dispersed fragments gathered in neutral Zurich was a band of intellectuals, writers, musicians, and artists from various corners of Europe—the Germans Hugo Ball, Hans Richter, and Richard Huelsenbeck, the Romanians Tristan Tzara and Marcel Janco, the Alsatian Jean Arp—who found themselves so appalled by the mindless slaughter, as well as by the blind rationality and materialism believed to have unleashed it, that, almost by spontaneous combustion, they joined in a campaign of attacking cultural conventions and bourgeois standards of good taste, always by the most outrageous parodies and provocations. If total war was the logical outcome of the old order, then anarchy must

be preferred. Beginning in February 1916, the center for the Zurich refugees' "artistic entertainment" was the Cabaret Voltaire, in a "slightly disreputable quarter of [a] highly reputable town," where, for six months, the young and creative brought their ideas, recited their poems, hung their pictures, sang, danced, and played music. Convinced that a hot new movement had been launched, Ball and Huelsenbeck decided to name it, significantly by "chance," which occurred when, leafing through a German-French dictionary, they fell upon the word "dada." "It's just made for our purpose," Tzara said. "The child's first sound expresses the primitiveness, the beginning at zero, the new in our art." As this would suggest, Dada proved richer in memorable gestures than in permanent art works, because art, being dependent upon a society then in the throes of apocalyptic self-annihilation, seemed scarcely worth the effort to save or perpetuate it. Thus, by a complex kind of irony, Dada existed to commit suicide, in a mood of "buffoonery and requiem," as Ball put it. Rather than a unified style, like Impressionism or Cubism, Dada might be called a "state of mind," a mentality that Dawn Ades brought into focus by suggesting that Man Ray's *Gift*, a flatiron with a row of sharp-pointed tacks projecting from its bottom, be juxtaposed with Duchamp's idea for a "Reciprocal Ready-made—use a Rembrandt as an ironing board."

After the war, Dada converged upon Paris, but not before it had stirred things up in New York and various German cities. Huelsenbeck took Dada to Berlin, where the movement became radically political, its program of shock tactics supported by Raoul Haussmann, George Grosz, John Heartfield, and Hannah Höch through what they called "photomontages," kaleidoscopic collages of cut-up photographs that captured the grim reality of life in the German capital during the Weimar Republic (1919–33). From Hanover, Kurt Schwitters (1887–1948) viewed the same scene with affectionate, lyrical distance, in collages of anonymous urban rubbish redeemed by painted colors and the artist's consummate sense of classical, Cubist design. To name these Dadaist collisions of chance discards, Schwitters coined *Merzbild*, a "meaningless" term arrived at by chance when *Commerz- und Privatbank* turned up on a letterhead the artist was fitting into a typical grab-bag *Bild*, or "picture." While the Merz collages offered a glorious referent for Robert Rauschenberg's Pop Art celebrations of urban waste, the *Merzbau*, or "building," that Schwitters spent years assembling in his home expanded packrat aesthetics to architectural scale, thereby providing a poetic model for the Environments of the 1960s.

Although named in Zurich in early 1916, Dada as a "state of mind" intent upon "beginning at zero" had already sparked in 1913, when the French artist Marcel Duchamp (1887–1968), one of the century's most influential and legendary figures, took the next step beyond Cubist collage and isolated its "found" elements as "ready-made" sculptures. Contemptuous of "retinal" painting, such as Impressionism, since it appeared to stimulate the senses more than the mind, Duchamp later said: "I was interested in ideas—not merely in visual products." He preferred

32. Marcel Duchamp. *The Bride Stripped Bare by Her Bachelors, Even (The Large Glass).* 1915–23. Oil, lead, wire, foil, dust, and varnish on glass; 9′1½″ × 5′9⅛″. Philadelphia Museum of Art (Katherine S. Dreier Bequest).

"an intellectual expression. . . . to [being] an animal," adding: "I am sick of the expression *bête comme un peintre*—stupid as a painter." A skeptic and ironist not only eager to desanctify art—to dispel Romanticism's "pathetic fallacy" still lingering even in Analytic Cubism—but also to investigate the nature of art and the individual's response to it, Duchamp insisted "that the choice of the ready-mades was never dictated by an aesthetic delectation. The choice was based on a reaction of visual *indifference*, with at the same time a total absence of good or bad taste, in fact a complete anesthesia." To accomplish his goal, he was prepared to shock, as in New York in 1917, when he purchased a white porcelain urinal from Mott Works, placed it wall side down with the interior facing the viewer and titled it *Fountain* for exhibition at the Society of Independents show, signed pseudonymously and dated: "R. Mutt/1917." Needless to say, given the mores of the time, the piece suffered rejection, not merely for what it was but also for the potent visual pun it had become, androgynously suggestive of both male and female sexual/reproductive organs. Helplessly addicted to witty visual/verbal play, Duchamp adopted a feminine alter ego whom he named "Rrose Sélavy," a reordering of the French cliché *la vie en rose* ("life on a bed of roses") that decodes as *Érôs, c'est la vie* ("Eros is life") to imply the erotic basis or meaning of all life and therefore art.

An evocative art/sex/machine analogy had been tantalizing Duchamp since about 1911, when he saw a theater piece, based on Raymond Roussel's novel *Impressions of Africa*, featuring a series of fantastic contraptions that made "art." In thoroughly mechanized New York—a city only recently jolted awake, by the historic 1913 Armory Show, to the latest in European painting and sculpture—Duchamp began materializing his grand metaphor or triple entendre in what would give an unexpected twist to the old term "salon machine." This was in late 1915, a time when the presence of Duchamp and Francis Picabia, also from France, together with such American ironists as the photographer/painter Man Ray and the sculptor/painter Morton Schamberg, made New York a center of Dada-like activities several months before the Zurich refugees found a name for the new anti-art movement. As the esoteric title *The Bride Stripped Bare by Her Bachelors, Even* attests, Duchamp was fully prepared to desacralize traditional painting through the mischievous process of creating an alternative so replete with conundrums that every effort to demystify *them* merely compounds the enigma of what is the ultimate Dada masterpiece, a work that looks as clear as its glass support and lucid stereometric drawing, yet remains stubbornly opaque to precise meaning (fig. 32). And this is true despite Duchamp's help in simplifying the title to *The Large* (or *Great*) *Glass* and providing a set of notes for his "marriage of mental and physical realities." A transparent, window-like structure made of two double-thick panes and diagramming in oil, wire relief, and tin foil, *The Large Glass* divides across

the center into an upper zone occupied by the Bride disrobing to attract her Bachelors in the lower zone. In her desperate signaling, the Bride emits a wide floating "Milky Way" the shapes of whose three "draft pistons" or "triple ciphers" Duchamp allowed to be determined by the "chance" appearance of square-cut cheesecloth hung in an open window. Below, the equally frantic Bachelors—a Bachelor Machine composed of nine chocolate or "malic" molds (signifying a delivery boy, policeman, undertaker, priest, station master, etc.) suspended in a "Cemetery of Uniforms and Liveries" over a "Glider"—urge their "Water Mill" to activate, through a pair of scissors, the "Chocolate Grinder." But strenuously as they may grind, the Bachelors could never project their "frosty gas" beyond the prophylactic bar that separates the upper and lower panes. With the Bride forever condemned to tease and the Bachelors to self-stimulate, *The Large Glass* refuses closure and thus solicits interpretations, which have arrived in legion numbers, ranging from the metaphysical and alchemical to the linguistic, the Freudian, and the quantum. What seems obvious enough, however, is that Duchamp saw in modern mechanics not a symbol of power and perfection, as did the Futurists, but rather a trope for failure and frustration, similar to universal, human experience in sexual matters, the comedy and indignity of which struck the artist as paralleled in the false hopes and real disappointments generated by modern engineering. Having sent up academic or "made" art with his prodigious craftsmanship, Duchamp then took care of modernism, by allowing chance to operate as a surrogate for spontaneity, as well as by rendering the picture plane transparent, or visually absent, rather than present, which simultaneously literalized Renaissance trompe-l'oeil aesthetics. In a final coup de grace, true accidentality intervened in 1926 when *The Large Glass* cracked while being returned to its owner following an exhibition. Delighted with the network of fissures, which created new relations between the Bride and her Bachelors without in any way increasing their intimacy, Duchamp in 1936 clamped the top and bottom panels between two sheets of new, heavier glass and declared the composition completed "by the laws of chance."

Duchamp had painted in oil on canvas for the last time in 1918, when he produced *Tu m'*, a mural-like work bristling with irony and visual conceit (fig. 33). Because it includes shadows "cast" by several of his ready-mades, as well as the profiles of his three "standard stoppages," the artist came to think of the picture as a kind of "resumé" and thus a bore, which may account for the title, completable as *Tu m'emmerdes*, or "You bore me," rudely put. As if to make a visual pun on the famous 1890 dictum of Maurice Denis, quoted earlier—"Remember that a picture, before being a warhorse, a female nude, or some anecdote, is essentially a flat surface covered with colors arranged in a certain order"—Duchamp introduced an assortment of color samples, by painting them to look as genuine as the actual bolt that appears to secure the shadow-casting sheets. Here, prophet to the last, Duchamp made himself an ancestor of sixties-style Color-Field or Hard-Edge painting, the very kind of "retinal" art he most despised, an art that—irony again—emerged almost simultaneously with its victorious rival, Pop Art, whose inventors, Rauschenberg and Johns, would canonize Duchamp as the saint he has remained for essentially the whole of post-modernism.

above: **33.** Marcel Duchamp. *Tu m'*. 1918. Oil and graphite on canvas, with bottle-washing brush, safety pins, nut, and bolt; 2'3½" × 10'2¾". Yale University Art Gallery, New Haven (Katherine S. Dreier Bequest).

far left: **34.** Francis Picabia. *Dispar.* c. 1924. Oil on plywood, 4'11¼" × 3'1½". Private collection.

left: **35.** Joan Miró. *Carnival of Harlequin.* 1924–25. Oil on canvas, 26 × 36⅝". Albright-Knox Art Gallery, Buffalo (Room of Contemporary Art Fund).

By 1922 Dada had lived up to its promise and committed suicide. Helping it from within were three young poets, Louis Aragon, André Breton, and Philippe Soupault, all associated with the journal *Littérature*, who envisioned continuing Dada's attack on traditional culture but in a more constructive, optimistic spirit, replacing anarchy with theory and principles. Breton quickly took the lead, in part because of his obsession with the word *surréaliste*, which, as coined for Apollinaire's play *The Breasts of Tiresias* (1918), seemed to characterize the reality beyond reality that he believed available to minds charged with energy from the unconscious. For Breton, the evidence lay not only in Freud's *Interpretation of Dreams* but also in his own wartime experience as a medical orderly among soldiers driven by shell shock to reshape reality according to their own most extreme desires. The poet longed to tap that energy for the sake of attaining a higher, unedited truth and of translating this into an art ripe with an all-encompassing hunger for liberty, for escape from the chains of banal existence. Following Freud, Breton and the Surrealists would cultivate "psychic automatism," a free-associational process of writing, drawing, or painting so spontaneous as to become a direct outpouring of the imagination in its most primitive state, uncensored by the critical faculties. Again after the example of Freud, they would also explore the world of dreams, believing it capable of yielding images more authentic and relevatory—more "marvelous"—than any generated by conscious endeavor. Consequently, the Surrealists stressed the need for passive acquiescence to subliminal urges, sometimes comparing themselves to mediums, although the "beyond" they sought had nothing to do with the supernatural realm inhabited by the spirits of the dead. Rather, the Surrealist beyond lay among those unspoken desires best expressed in vivid metaphors ignited by the accidental encounter within the imagination of two distinct realities, as in an oft-cited line from a poem by the Comte de Lautréamont (1846–80): "As beautiful as the chance meeting on a dissecting table of a sewing machine and an umbrella." Clearly, such a metaphor lent itself to visual expression quite as much as to the verbal, which Picabia demonstrated in his beautiful Transparencies (fig. 34). Thus, while Surrealism originated among writers involved mainly with poetry, philosophy, and politics, it also, as a program for breaking down frontiers, acknowledged the power of the plastic arts to disclose the true nature of anyone plumbing the "labyrinth" for that "certain point of the mind at which life and death, the real and the imaginary, the past and the future, the communicable and the incommunicable, the heights and the depths, ceased to be perceived contradictorily."

Surrealist art could boast a distinguished ancestry, beginning with Grünewald, continuing with Goya at the beginning of the 19th century, as well as with Redon and Ensor, or even Degas, at the end, and embracing, more recently, France's great *naïf* Henri Rousseau and Italy's Giorgio de Chirico (1888-1978). At the height of Futurism's clamorous assault on tradition, de Chirico had painted bright, hallucinatory, trancelike vistas upon an ominously empty Classical world disturbed only by, for example, the distant, silent passage of a modern train, its stealthy presence announced by puffs of spooky white smoke. Convinced, like Nietzsche, "that underneath this reality in which we live and have our being, another and altogether different reality lies concealed," de Chirico addressed his art to what he called the "troubling connection that exists between perspective and metaphysics." For the Surrealists, his innocently Freudian, Metaphysical pictures constituted the immediate forerunners of their own painted "dreamscapes."

At first, however, it was the emancipating technique of psychic automatism that enthralled painters, especially Max Ernst from Cologne, the Parisian artist André Masson, and the latter's next-door neighbor Joan Miró (1893–1983) from Catalonia. In Miró, Surrealism gained its most important painter, albeit one too independent to follow the dictates of the authoritarian Breton. After the example of Masson, Miró did not so much paint automatically as use automatism as a means to deliver himself from a rather tight, Cubist style of representation (fig. 35). "I begin painting," Miró said, "and as I paint the picture begins to assert itself, or suggest itself, under my brush. The form becomes a sign for a woman or a bird as I work. . . . The first stage is free, unconscious." However, he added, "the second stage is carefully calculated." To "find" and then "make" his painting, Miró characteristically started by washing color onto the canvas "in a random manner," using a medium-soaked sponge or rags on lightly primed burlap. Over this abstract field, he improvised lines and flat patches of color, gradually developing them, through elision and evocative association, into freely moving, cursive calligraphy and ideographs, flat biomorphic forms and emblems, together with hybrid creatures conjured up from the artist's dreams and childhood fantasies, from memories of Catalan folk art, children's art, and the paintings of Hieronymus Bosch. Sometimes, the dispersed, all-over imagery became a kind of dancing, brilliantly detailed, insectile phantasmagoria filled with what could be animated toys and gaudy baubles, as if, Sam Hunter wrote, "the nursery had sprung to vigorous life."

Alongside Surrealism's "passively" spontaneous automatists were painters engaged in the aggressively deliberate recitation of dreams, among them the Frenchman Yves Tanguy and the Belgians René Magritte and Paul Delvaux. For better or for worse, the most celebrated practitioner of the "hand-painted dream photograph" was Salvador Dali (1904–1989), who claimed influence from de Chirico for his haunting oneiric scenes and his academically exact way of rendering them. But far from unconscious, as in de Chirico, Dali's sexual symbolism derived from erotic self-dramatization so deliberate and so informed by reading in psychology that the pictures could almost be mistaken for illustrations to texts by Krafft-Ebing. Although Dali represented everything the Abstract Expressionist generation was to loathe, Pop Art and postmodernism, being the obverse of formalist art, would find more to appreciate in the old Surrealist's "paranoiac-critical" activity. Perhaps a "deconstructionist" before his time, Dali debunked "originality," openly admitting that he merely simulated madness—with publicity-crazed flair, one might add—while remaining cold-bloodedly sane. By paranoia, moreover, he meant not psychopathology but his capacity to visualize two images in one, rather like interlocking rebuses, the results of which may resemble that explosive encounter of alien realities so besought by Surrealists, even though chance—for Breton, an essential ingredient—had little to do with achieving the effect. Thus, Dali painted not the surreality of actual dreams but, instead, carefully studied simulacra, which many anti-romantic post-modernists would insist is the condition of all cultural products, whatever the claims for their "presentness."

Dreamers also found their opportunity in the ready-made, for whereas Duchamp had proposed it as a means to eliminate subjectivity from the artistic process, Breton saw "nominated" works as materializations of the artist's unconscious desire chanced upon in the real world. However, Alberto Giacometti (1901–66), the most notable new sculptor to emerge in the 1930s, discovered his objects of desire not in the public domain but ready-made in his head. "The sculptures presented themselves to my

mind entirely accomplished," after which the execution, he wrote, "was almost a bore. . . . I had to see them realized, but realization itself was irritating." Further, it was important that the finished work, as an objectification of libidinal energy rather than a product of conscious craft, bear no evidence of the artist's touch. To assure this in *The Palace at 4 A.M.* (fig. 36), Giacometti constructed the work as a cage assembled from thin wooden rods, glass, wire, and string. While the open form gives visual access to a theater- or stage-like situation, it also sets the drama apart, a surreality shaped by forces transcending the everyday reality whose space and condition it shares. According to his own private account, Giacometti represented himself at the center, in a symbolic combination of sphere and phallic stele, flanked on the left by a mother figure and, on the right, by a dangling spinal column below and a skeletal bird above, each in its own separate cage or frame. Altogether, *The Palace at 4 A.M.* would appear to offer a narrative of human existence, from procreation through life to death.

Picasso, with his sense of painting as an exorcism and his promiscuously eclectic interests, fell in comfortably, if not officially, with the Surrealists, and they with him, especially since Analytic Cubism and collage had both pioneered the very kind of "fragmentation and dislocation" essential to metaphors fired by the coupling synapses of unrelated images or objects. By the end of the 1920s, Picasso made the long-inherent surreality of his art dramatically evident in a series of welded-metal sculptures (fig. 37), utilizing, with characteristic virtuosity, a technique learned from the Spanish sculptor Julio González, whose own skill with the oxyacetylene torch had been acquired at a war plant. In these watershed works, Picasso returned to sculpture, for the first time since 1916, and opened up form, well beyond the innovations of the 1912 *Guitar*, until volumes became almost entirely virtual, rather than actual, defined by neither mass nor plane but instead by a linear armature that transforms sculpture-in-the-round into "drawing in space," as González called it. Now, sculpture could become not only freestanding as never before—a self-sufficient form requiring no base or support other than the preexistent surface it rested upon—but also transparent, spontaneously expressive, and fantastic in ways, abstract or figurative, unimaginable in the multi-stage, time-consuming processes—carving, modeling, casting—to which this most plastic of all the arts had been confined since remote antiquity.

Surrealism climaxed in 1938 with a large international show at Paris' Galerie des Beaux-Arts. By this time, the movement had become thoroughly politicized, in response to the rise of Fascism and the threat of war, which had already erupted in Spain between the elected Republican government and the forces of reaction led by Francisco Franco. In 1937, Picasso painted a vast mural for the Spanish Pavilion at the Paris World's Fair, taking as his subject the destruction of a defenseless Basque village

by German bombers acting on behalf of Spain's Fascist insurgents. For *Guernica*—a now talismanic work of protest art in which advanced aesthetics demonstrated their power to make public utterance—Picasso fused Cubist form with Surrealist content in an image of mass brutality and suffering. Shortly after the Fair opened, the Spanish master starred at another major art event, this one in Munich, where the Nazi regime inaugurated *Entartete Kunst*, a blockbuster exhibition of "Degenerate Art" meant to win popular, philistine support for Hitler's new "wholesome" society by humiliating the avant-garde, the principal threat of which was its symbolic role as a force for human freedom. Several years earlier Stalin had already purged modernist art in the Soviet Union, replacing it with Socialist Realism of the very sort that the Nazis would mandate for the Third Reich. The great Emil Nolde, himself a member of the Nazi Party, suffered the "degenerate" stigma and survived, as did many other German modernists, through "inner emigration"—that is, by working in such deep retirement as to be virtually underground. Still others thought it wiser to emigrate; thus, while Paul Klee retreated to Switzerland and Vassily Kandinsky to Paris, George Grosz and Max Beckmann took ship for the United States where they became incalculably valuable teachers of the germinating New York School. Grosz, called Berlin's "Propagandada," truly had no choice but to flee, since his *Neuesachlichkeit*, or "New Realism" (also "New Objectivity"), reveled in harsh, corrosive satire aimed at the very kind of social pathology represented by the Nazis. Max Beckmann (1884–1950), a less topical and more isolated artist than Grosz, expressed his anxieties about German life between the wars in vehemently painted, figurative pictures jammed with black-contoured victims who seem all the more alienated for being as enigmatically juxtaposed as the cohabitants of a Surrealist dream (fig. 38). Meanwhile, the Surrealist dream itself, like that in Picasso's *Guernica*, had become a nightmare in which the strange and the diverse no longer "ceased to be perceived contradictorily," as Breton had hoped back in 1924; instead, they often seemed forever locked in mutual antagonism and reciprocal violence.

Equally distressed but more symptomatic of the future was the Lithuanian-born Parisian Chaim Soutine (1894-1943), whose troubled existence and frenzied Expressionism made the French think him *maudit* or "cursed," like Gauguin, van Gogh, Modigliani, and Utrillo (fig. 39). As a Jew in flight from the oppressions of family, religion, and endemic prejudice, Soutine suffered not only manic-depressive swings and extreme poverty but also, after 1940, the menace of the Nazis' genocidal racism. Yet, while he painted with true Expressionist fury, even exceeding that of Kirchner and Beckmann, Soutine betrayed none of the Germans' moral outrage or social commitment. Rather, he slathered on thick, fatty pigments from edge to edge, allowing them, as well as his still-life, landscape, and portrait imagery, to slip and slide, as if artist, medium, and theme were engaged in mortal contest between what Sartre was to call "being and nonbeing." As an Existentialist before the fact, Soutine became a lodestar to postwar Expressionists, most of whom would exceed him to discover in *matière* and gesture themselves subject enough for an art meant to rival the Old Masters. In this ambition too, Soutine, with his almost parodistic homages to Rembrandt, El Greco, and Courbet, provided a model for such later artists as Willem de Kooning, Nicolas de Staël, Francis Bacon, and Larry Rivers. Even Clement Greenberg, the chief apologist for a late-modern art of "purity" and "independence," would admit its ultimate and inescapable contingency: "Nothing could be further from the authentic art of our time than the idea of a rupture of continuity. Art is, among other things, continuity. Without the past of art, and without the need and compulsion to maintain past standards of excellence, such a thing as Modernist art would be impossible."

far left: **38.** Max Beckmann. *Departure* (left side panel). 1932–33. Oil on canvas, 7'3/4" × 39 1/4". Museum of Modern Art, New York (given anonymously, by exchange).

left: **39.** Chaim Soutine. *The Communicant.* 1927. Oil on canvas, 24 3/8 × 20 1/4". Private collection.

The New York School: Abstract Expressionism: 1945–60

When the production of new art began to revive in 1945, it had undergone not only a six-year interruption but also a major sea change. Both occurred as consequences of the Second World War, which had driven the European avant-garde from their natural habitat in Paris and into exile across the Atlantic in New York. There, with the arrival of such luminaries of high modernism as Dali, Ernst, Léger, Lipchitz, Masson, Matta, Mondrian, Tanguy, and the Surrealist "pope" himself, André Breton, the American city became, for the first time in its three-hundred-year history, the world capital of international art. Suddenly, and for the duration of the Nazis' presence in Paris, progressive members of the local artistic community—a tiny, sorely isolated, and undervalued lot—found themselves surrounded by the living exemplars of a glorious tradition that the Americans, despite the impediment of great distance, had long taken as their primary inspiration. Of course, the tradition and its future development would eventually have returned to France, along with the homing émigrés themselves, had the Americans not been fully prepared, through a fortuitous combination of rather unpromising factors, to accept the challenge posed by their distinguished guests and carry it to new, more logical or moving conclusions than those proposed elsewhere in the postwar world. However, thanks both to their own readiness and to the stimulus they received from direct exposure to European modernism at its cutting edge, the more ambitious and visionary of the younger American artists finally succeeded in surmounting their inherited handicaps—provincialism, over-reliance on half-understood European models, nonexistent or unsupportive critics, an indifferent or even hostile public—and liberated their art into an expressive force of stunning power and independence (fig. 41).

Almost as if it were necessary for art to step back in order to jump farther ahead, such sudden and unexpected leaps had occurred before in unlikely outposts remote from modernism's generative center in Paris. As we have seen, the early vanguardists of 20th-century Russia scored an all-out aesthetic revolution several years ahead of their nation's fateful political rebellion. Then, as later in the United States, influences from Western Europe cross-fertilized with native preparedness to generate experiments that very quickly propelled long-evolving international trends to goals well beyond those imagined, or desired, by their most daring previous exponents. Like their Russian antecedents, the Americans had long struggled to come into their own artistically, only to fall depressingly short of it, defeated by, on the one hand, an uncertain assimilation of European prototypes or, on the other, a reactionary withdrawal into chauvinistic subject matter and outmoded stylistics. Yet, a handful of Americans, like the Russian innovators, had gained a tempered strength through resistance to the banality that surrounded them and the bitter alienation this imposed. No less paradoxically, they also derived advantage from certain indigenous, even archaic traditions, the very primitivism of which permitted them to detect in the conceptual nature of Cubism the potential for a new, utterly transcendent kind of art. Barbara Novak, in her wide-ranging studies of American painting, has concluded that, from the limners on, American artists had, in their inevitable awkwardness, demonstrated an overriding concern for the integrity of material things, to the point where reality, once obsessively or scientifically measured, delineated, or even dissolved, entered the realm of the ideal, thereupon becoming a vehicle of feeling, intuition, or metaphysical meaning. And so when forward-looking American artists found themselves, ironically, the beneficiaries of the catastrophic 1930s and 40s, they seized on their opportunities and, as had Malevich before them, realized a breakthrough to total abstraction, but an abstraction steeped in mythic content. Toughened by adversity to test and master every new idea and to remain independent in their exploitation of it, the artists who became the New York School realized works that, by virtue of their highly original, monumentally scaled synthesis of modernism's main trends—Cubism, Expressionism, and Dada-Surrealism—achieved an art of truly heroic grandeur. In time, and aided by the growing world presence of the United States, as well as by the cultural appetites of an expansive, freshly affluent middle class, the new American art would leave little doubt about its quality or importance, its legitimacy as successor to the best in European modernism, or the genuine Americanness of its vigor, boldness, and simple integrity.

Like so many other terms in the history of modern art—Fauvism and Cubism among them—"Abstract Expressionism" has become current enough to be useful, even though it remains rather too narrow as a description of works that range from the essentially figurative, albeit truly expressionist, paintings of Willem de Kooning to the genuinely abstract but nonpainterly canvases of Barnett Newman. Alfred Barr coined the epithet in 1929 to distinguish the early Improvisations of Kandinsky, but it found a permanent place in the art-critical vocabulary only around 1952, when the New York painters had come sufficiently into their own to be regarded as a movement with an undeniably distinctive character. From the outset, however, the artists themselves resented and resisted such attempts at stylistic classification, for the very good reason that the startling audacity of their formal innovations—the factor that, superficially, seemed to set them apart as a group with common interests—emerged less from a devotion to form per se than from deeply felt personal responses to what has been called "a crisis of subject matter." This was none other than the artists' own urgent sense of need for new values in a problem-fraught world where every solution—Marxist, nationalist, Utopian—seemed to have failed, along with all the art, whether representational or nonobjective, that had accompanied it. Confronted with apparent ideological and aesthetic bankruptcy, the New York artists came to believe that they had nothing to rely on but their own private insights and whatever myths or symbolic forms these might inspire as new and more valid means of giving epochal expression to profound social, psychological, and moral concerns.

The context in which the future Abstract Expressionists—the so-called New York School—first emerged was that of the terrible Depression Decade, when thinking Americans agonized over not only the economic collapse at home but also the rise of Fascism abroad. Like the American people in general, most artists responded to the troubled times either by espousing a nostalgic, isolationist revival of long-lost small-town, agrarian norms or by advocating revolutionary action designed to replace faltering capitalism with an untried socialist system. But however divergent their motives, right-wing Regional-

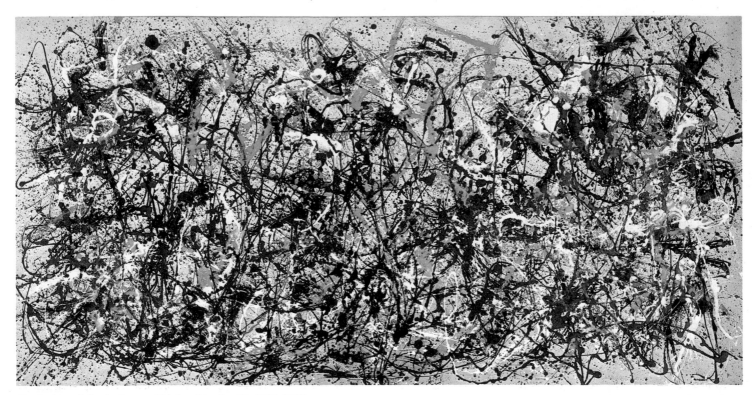

41. Jackson Pollock. *Autumn Rhythm: Number 30, 1950.* 1950.
Oil on canvas, 8'10½" × 17'8". Metropolitan Museum of Art, New York (George A. Hearn Fund, 1957).

ists, such as Thomas Hart Benton, John Steuart Curry, and Grant Wood, and left-wing Social Realists, among them William Gropper and Ben Shahn, joined hands in their common preference for broadly popular, illustrational styles and their consequent abhorrence of "high-brow" European formalism. A similarly literal and propagandistic spirit inhabited the manifestly stronger, overtly Marxist art of the Mexican muralists—Rivera, Siqueiros, and Orozco. But despite the great prestige enjoyed by these masters in the United States during the thirties, the young New Yorkers rejected the Mexicans' aesthetics, along with those of the Regionalists and Social Realists—together known as the American Scene painters—as too exhausted to bear the expressive burden imposed by problems unique to the modern world. This decision became increasingly imperative as the liberal-minded American intelligentsia, with which most vanguard artists identified, suffered the disillusionment of seeing their Marxist ideals subverted by cynical Soviet behavior, beginning with the Moscow Trials of 1936–37 and continuing with the Hitler-Stalin Non-Aggression Pact of 1939. Almost as if to express what one writer has recently called "the de-Marxification of the American avant-garde," Arshile Gorky declared his opposition to "poor art for poor people," and led the way as he and sympathetic colleagues resolved to validate their work by deriving it not from politics, but rather from personal experience universalized through embodiment in contemporary forms. To achieve this, they would retain the social consciousness and mural scale of the period's political art, but otherwise seek to realize their objectives by restudying and assimilating the whole of the modernist tradition. Thanks to a mastery of its principles more thorough than that of any other artists of their time, the painters who would become the Abstract Expressionists found their way out of visually debilitated ideas and into vital new departures, directions that would continue to unfold for the next quarter of a century.

In a society where they had been tolerated at best, American artists—especially the younger, unestablished ones with alien notions—might very well have found themselves pushed over the edge by the economic crisis that came in the wake of the 1929 Crash. Incredibly, however, it was the devastating poverty of the Great Depression that gave the new generation of American painters and sculptors a kind of

special advantage never before known in the United States. Beginning in 1935, with the Federal Art Project instituted under the WPA (Works Progress Administration), all needy artists—even those without evidence of professional achievement—could earn a government-paid subsistence living as artists. Their only obligation was to work a modest number of hours every month on assigned projects, usually involving some sort of team effort, or in their own studios on paintings and sculptures executed in whatever style they might choose. Laboring together on Post Office and airport murals, the FAP artists acquired a new sense of community; left free to research and experiment without fear of starvation, they also won a new sense of personal possibilities. Moreover, they were—thanks to the Federal Art Project—quite simply acknowledged as worthy of public concern, which was no small factor among the many that permitted American painters and sculptors to survive the horrors of the 1930s vastly bolstered in both art and spirit. As Holger Cahill, the director of the Project would later write: " . . . the experience of the depression years suggested to the artists that however marginal an afterthought art was to others, it was essential to them."

As the sense of community emerged, it became particularly strong in New York, traditionally America's chief magnet for the creative and the revolutionary. And so just as Paris had provided a nurturing environment for such foreign talents as Picasso, Gris, and Miró, Kandinsky and Mondrian, Modigliani and de Chirico, Chagall, Lipchitz, Soutine, and Ernst, along with its host of native French masters, New York drew a cosmopolitan assortment of aspiring painters and sculptors. Arshile Gorky arrived in 1925, after having fled the Turkish persecution of his native Armenia. One year later the twenty-two-year-old Dutchman Willem de Kooning appeared, a stowaway on a ship out of Rotterdam. Meanwhile, Mark Rothko had immigrated from Russia by way of Portland, Oregon. In 1930, the Wyoming-born, California-reared Jackson Pollock entered the Art Students League for study under Thomas Hart Benton. The American West also sent Robert Motherwell from San Francisco and Clyfford Still from Spokane, Washington. Somewhat less distant were the origins of David Smith in Indiana and Franz Kline in the coal-mining country of Pennsylvania. For native talent, the future New York

School would have Lee Krasner, Barnett Newman, Adolph Gottlieb, and Ad Reinhardt. Unlike earlier American artists, with their loner instincts, these would-be avant-gardists sought one another out, exchanged ideas, shared their discoveries, and debated whatever they found in the latest issues of *Cahiers d'art* and *Minotaure*, both imported from France. Meeting in dingy downtown lofts, rancid all-night cafeterias, or simply on the park benches of Washington Square, they created a bohemia all their own, a local Depression equivalent of the café-studio life of Paris. Like the sophisticated denizens of that more salubrious and civilized scene, the New Yorkers took comfort in one another and generally made a virtue of their removal from the philistine world outside. Most of all, they fended off demands that they "paint American" or "paint Proletarian" for the sake of their very real political and humanitarian interests.

Both the hectoring demands and the stubborn resistance to them were symptomatic of the era's growing radicalism, which proved all the more powerful for being a swing back from the conservative reaction—the 1920s "return to order"—that had set in following the violent upheaval of World War I and its prelude of revolutionary events. Among the latter had been the Armory Show of 1913, which introduced a largely innocent American public to advanced European art on such a massive scale and with such rude suddenness that it became one of the great "scandals" of modern art history. But while the Armory Show provided a field day for sensation-seekers, it had a shattering effect on American artists, overwhelmed as they were, especially in their own eyes, by the sheer authority of the imported works. Consequently, after a precocious start in the teens—made by Arthur Dove, Georgia O'Keeffe, the Synchromists, among others—no American produced totally abstract paintings for a decade, until Stuart Davis began his Eggbeater series in 1927. But along with Davis' Cubist-based work came the beginning of a new determination on the part of independent American artists to throw off the yoke of provincialism and enter the mainstream flowing from the rich heritage of European modernism. Aiding them in this enterprise was the growing accessibility of that heritage in great public collections. Opened in 1929, the all-important Museum of Modern Art in New York immediately launched upon an ambitious program of exhibitions that, during the thirties, would survey European modernism from the Post-Impressionists through Cubism, the art of Matisse, and the Bauhaus to Dada and Surrealism. Almost as important were the Gallatin Collection, with its Neoplasticist and Constructivist canvases on display, from 1927 to 1943, at New York University, and the Museum of Non-Objective Painting (later the Solomon R. Guggenheim Museum), which began exhibiting its huge collection of Kandinskys as early as 1936. Meanwhile, the Société Anonyme had been promoting the study of modern art and ideas since its founding in 1920 by Katherine Dreier, Marcel Duchamp, and Man Ray.

Resurgent American abstract art, although little more than a frail sapling planted in the wilderness of rhetorical Realism, could be seen with greater regularity after 1936, when the AAA (American Abstract Artists) organized and began mounting annual exhibitions. Helping it succeed, however modestly, was the international revival of nonobjective expressions, which had already crested in Paris under the broad stylistic umbrella of Abstraction-Création and in London among artists associated with the Hepworth-Moore-Nicholson circle. While some of the New York abstractionists favored the organic morphologies of Arp, Kandinsky, Klee, Picasso, and Miró, most, as we saw in the case of Charles Biederman, found their lodestar in Piet Mondrian, whose Neoplasticism offered not only a set of rules for translating Cubism into pure abstraction, but also a Utopian rationale attractive to socially conscious artists eager for an alternative to Marxism and chauvinist nationalism. Among the founding Abstract Expressionists,

however, only Lee Krasner and Ad Reinhardt ever joined or showed with the AAA, for admirable as the commitment to the "universally significant" may have been, the AAA's near-doctrinaire bias towards nonobjectivity, realized in flat colors and clean-edged forms, could not long satisfy artists determined to expand their possibilities rather than limit them. Conversely, no less a dead-end seemed to have been reached in the Matisse-derived colorism of Milton Avery and the Futurist dynamism of John Marin, this time however because of the artists' perceived dependence on extrapictorial reality.

Of all the fruit gathered up by the Americans when Hitler shook Europe's apple tree, the most nourishing for the New York School may have been a teacher from Germany, the great Hans Hofmann (1880–1966). As Clement Greenberg, an eyewitness, would later write: "You could learn more about Matisse's color from Hofmann than from Matisse himself," and "no one in this country, then or since, understood Cubism as thoroughly as Hofmann did." When Hofmann arrived in 1932 and shortly thereafter opened his own painting school, he brought with him an unrivaled ability to explain and demonstrate the principles of Matisse's color and Picasso's drawing, acquired not only through direct participation in the Paris avant-garde during its epochal 1904–14 period, but also from years of teaching at his own internationally famous school in Munich. It was there, of course, that Kandinsky, only shortly before Hofmann's appearance in 1915, had formulated the tenets of a subjective, Expressionist abstraction totally different from the objective, formalist variety achieved by Delaunay in Paris about 1912. And so, even as Hofmann, a peerless technician, focused on the mechanics of painting, he also stressed that "the quality of the work originates in [the] transposition of reality into the purely spiritual." As for the procedures, the German master harked back to Cézanne and taught that, having grasped the laws of nature and the characteristics of medium, the artist should then take account of his own inner life and, thus prepared, so handle his means—drawing and color—that the completed picture would evoke a sense of depth while also affirming the two-dimensionality of its actual surface. Such a "dialectic"—between flatness and spatiality—would be achieved by translating nature's volumes into planes of color that by their temperature (the hot or cold characteristics that make a given hue seem to advance or recede, expand or contract) tend to collapse solids and fill voids. Once organized into "complexes," the planes would not only structure the field Cubistically, but also set up an all-important "push-pull" relationship among one another, thereby allowing the acknowledged flatness and rigidity of the painting surface to generate, in purely abstract, modern terms, a sensation of breathing, pulsating life—of dynamic plasticity and spatial fullness (fig. 42). Rich

42. Hans Hofmann.
Composition. 1942.
Oil on board, 35½ × 41½". Private collection.

top: 43. Hans Hofmann. *Spring*. c.1944–45.
Oil on wood panel, 11¼ × 14⅛".
Museum of Modern Art, New York (gift of Mr. and Mrs. Peter A. Rübel).

above: 44. John D. Graham. *Blue Abstraction (Still Life)*. 1931.
Oil on canvas, 26 × 36". Phillips Collection, Washington, D.C.

talent may lie in the fact that, after having helped inspire the extraordinary accomplishments of his American disciples, the aged teacher himself would take fire and, as we shall see, bring his own ideas to their boldest fruition only in the last fifteen years of his long and incredibly productive career (fig. 88). As the relatively early paintings seen here indicate, the genius of Hans Hofmann resided not only in his intellect and teaching but also in his ability to make color coherent and intelligible the instant it encountered the canvas surface, however he may have applied the medium, by dribbling, by splashing, or even by traditional, loaded-brush stroking.

Reinforcing and extending, or complementing, the influence of Hofmann was another catalytic figure from Europe, the aristocrat and dandified John Graham (*né* Ivan Dabrovsky; 1881–1961), who arrived in the United States in 1920, from the Russia of Gabo and Lissitzky, and subsequently helped the New Yorkers see the feasibility of mating formal abstraction with mythic imagery. Of the many roles played by this charismatic and truly Renaissance man—artist, aesthete, dealer, connoisseur, amateur anthropologist, mystic, theorist—the most important was surely that of a sophisticated, if idiosyncratic, transmitter of Europe's most evolved thinking to the world of advanced American art during the 1930s and early 40s. While this occurred most directly through his personal friendship with Davis, Gorky, de Kooning, and David Smith, it had a profound effect on a much wider circle after 1937, when Graham published *Systems and Dialectics of Art*, a treatise on aesthetics in which the author asserted that art should reveal nature "in terms of pure form." Close as this may seem to Hofmann, Graham departed from the German master in opting not for total abstraction but rather for a flattened "essence," somewhat like Picasso's figural abstraction, realized in lineated, self-contained entities (fig. 44). Moreover, he looked to Jung and Freud, because the artist, he declared, had to "re-establish a lost contact with the unconscious . . . with the primordial racial past . . . in order to bring to the conscious mind the throbbing events of the unconscious mind." Clearly, this put Graham in touch with Surrealism, which Hofmann despised. Thus, while rejecting Surrealism's contempt for form and its love of illustration and literary symbolism, Graham urged the Surrealist technique of automatic writing, for the power of gesture to give "honest and free" expression to the artist's unique "unconscious mind." This, along with the model provided by the abstract Surrealists themselves, led Gorky, de Kooning, Gottlieb, and, most of all, Pollock to discover their own fabled, emotion-laden, and distinctive styles of painterly drawing.

Steeped in the modernism they had absorbed from journals, the museums and collections, the AAA, Hofmann, and Graham, the ambitious new generation of artists just emerging in New York on the eve of World War II had become the most knowledgeable and intelligently open in the world, particularly about Kandinsky and Mondrian, masters still little known in Paris even though they had lived there throughout most of the 1930s. The breadth of this painting culture can be seen in the art of Lee Krasner (1911–84), one of the truly sophisticated painters then active in America and a conduit for the latest ideas almost as effective as John Graham. By 1939, well before the other pioneer Abstract Expressionists (except Ad Reinhardt), Krasner had arrived at a fully autonomous style, doing so through a rare dialectical balance of Picasso's cloisonné Synthetic Cubism, Matisse's sensuous, Expressionist color, and the Constructivism of Mondrian, all integrated by means of her own special vocabulary of floral shapes and broadly baroque, rhythmic gesture (fig. 45). Owing to her voracious intellectual curiosity and resolute avant-gardism, Krasner, alone among the original Abstract Expressionists, both exhibited with the AAA and studied directly under Hans Hofmann. For the same reason, she paced her peers in posing and solving the aesthetic problems that engaged the New York School throughout the forties and fifties. Meanwhile, as we shall see (fig. 89), the very solidity of her grounding in the traditions of both academic art and Cubism, as well as her feminist distrust of Surrealism, with its invincible misogyny, made it

in content but entirely self-sufficient—that is, free of explicit or extra-aesthetic, Utopian aspiration or political dogma—the art espoused by Hans Hofmann would prove irresistible to a radical, socially aroused generation vowed to create an emotionally and ideologically engaged yet independent art.

Decisive as Hofmann's influence was, however, for some years it affected the future Abstract Expressionists only indirectly, since the sole member of the original group who actually studied under the German master was Lee Krasner. In New York, moreover, Hofmann exhibited none of his own art until 1944, fearing it might cause students to imitate his manner rather than innovate from within their own sensibilities. Meanwhile, about half the membership in the AAA took classes at the Hans Hofmann School of Fine Arts and actively circulated the principles taught there, as did Krasner. In 1942 this artist introduced Jackson Pollock to Hofmann, about the time the older man was exploring the aesthetic, if not the psychological, implications of the unfettered spontaneity—the automatism—advocated by the Surrealists (fig. 43). The experiment led Hofmann to drip, spill, or pour a brief series of small paintings whose nonobjectivity and open, all-over web of meandering lines prophesied the great "breakthrough" pictures that Pollock would paint in the golden years of 1947–50. But the surest testament to the fecundity of Hofmann's thought, spirit, and

impossible for Krasner to relinquish control and give way to the powerful feeling that charges the big, classic Abstract Expressionist picture—until after the violent death in 1956 of her husband and firmest supporter, Jackson Pollock.

Thus prepared, the American vanguard could reconsider Surrealism, without feeling threatened in their own values, when that movement arrived in force, brought by the dominant faction among the émigrés fleeing Nazi-occupied Paris. With its literary bias and its preoccupation with psychology, philosophy, and politics, Surrealism had tended to scorn formalism in painting as inhuman and to advocate the hard, literal illusionism of such artists as Magritte, Delvaux, and Dali, especially the latter's "hand-painted dream photographs," which the Americans abjured as little better than the retardataire academicism of the Regionalists and Social Realists. But as the holocaust in Europe assumed global proportions, it exposed all too cruelly the essential fragility of the human race, governed as it now seemed to be, not by the Utopian rationality projected by the immaculate and measured works of the Constructivists, but rather the dark, irrational, and sinister in nature, which the Freudian Surrealists understood only too well. Readily convinced of this, the Depression-scarred New Yorkers followed the Surrealists and probed within themselves for the taproots of their innermost feelings, which, because irreducibly human, they assumed to be representative of humanity at large. And when Freud's dream psychology proved overly alien or scientific for their purposes, the Americans had the sense to seek out Jung, with his theories of archetypes and the collective unconscious. But if the Surrealists helped the New Yorkers in their search for significant content, they also offered a powerful methodology for giving it form. Here was the "psychic automatism" recommended by Breton in the first Surrealist Manifesto of 1924, and thereafter practiced intermittently by Masson, Miró, Ernst, and Matta, especially the last at the time of the Surrealists' appearance in New York. Simultaneously as this graphic equivalent of free association permitted artists to draw on pre- or subconscious impulses, and thus promised all the freshness and urgency of individual handwriting, it also virtually guaranteed an image

45. Lee Krasner. *Untitled.* c. 1940.
Oil on canvas, 30 × 25″. Courtesy Robert Miller Gallery, New York.

both abstract and biomorphic—liberated, organic, and infinitely human, unlike the machined purity and perfection of Constructivist art. Once again, however, the Americans maintained their hard-won independence and insisted that, for the sake of the quality necessary to universal expressivity, art must be aesthetically coherent as well as emotionally vital. So, along with the Europeans' hauteur and condescension, they dismissed pure automatism as too likely to produce mere psychiatric documents, and then proceeded to develop what Motherwell called "plastic automatism," meaning an "incantatory" technique for discovering new forms freely and directly. It also meant factoring these forms through sensibilities now thoroughly schooled in the firm pictorial structure—the flat depth and all-over configuration—established by Cubism as the unavoidably authentic syntax of 20th-century painting. Once in command of their own special dialectic—the tense interchange and equilibrium between primal release and intellectual control—the Abstract Expressionists would eventually succeed in transforming artistic process into a metaphor for self-revelation, and this in turn into a sublime, even romantic and grandiose symbol of the existential, ambiguous, ultimately tragic nature of the human condition.

Finally, one of the most golden of Europe's apples to fall into the lap of the New Yorkers was Peggy Guggenheim, a repatriating American and the very sort of avid, venturesome collector who had made the tenuous life of the Parisian avant-garde possible. Astute in her assessment of the situation in New York, Miss Guggenheim not only continued to collect there, but even opened a gallery-museum called Art of This Century. At the now-historic inauguration she wore one earring designed by Tanguy and another by Calder—to show her "impartiality between Surrealist and abstract art." Given this breadth of taste, Guggenheim had little difficulty responding to artists who were by then making boldly original syntheses of the period's two major trends. And so before long she put Pollock under contract, gave the sixty-seven-year-old Hofmann his first one-man show in New York, and began exhibiting Baziotes, Motherwell, Rothko, Gottlieb, Still, David Hare, Reinhardt, and Richard Pousette-Dart, right along with her glittering stable of star performers from Europe. By the time this intrepid patron packed up in 1947 and returned to Europe, the New York School had been well and permanently launched.

Illuminating as it may be to generalize about the sociocultural environment and artistic aspirations shared by all the Abstract Expressionists, such an approach breaks down when it comes time to examine the actual work of the artists, each of whom was, in the words of Harold Rosenberg, "fatally aware that only what he constructs for himself will ever be real to him"—or to anybody else, one might add. Even though most of the New York School met on the common ground of their desire to create something new, distinctively American, yet universally valid out of the modernism inherited from Europe, each artist was convinced that this could be accomplished only by acting on personal intuition, by choosing from an infinite set of options, and by straining after his own direction. Inevitably, therefore, the paintings they produced exhibit dramatic differences in both form and feeling, the consequence of the individual divergences effected by each artist from the underlying range of shared assumptions. However, by concentrating on the artists' process—always a crucial element in modern art—viewers have been able to discern clustering affinities, which make it possible to divide the group between those members who revealed themselves in an extroverted, energetic, gestural, or painterly kind of calligraphy and those who practiced a more reflective, cerebral, or discreet application, yielding open fields of flat or atmospheric color.

Action Painting

For several years, after Harold Rosenberg invented the term in 1952, "Action Painting" was taken to be a virtual synonym for Abstract Expressionism, which the critic viewed as having arrived when:

At a certain moment the canvas began to appear to one American painter after another as an arena in which to act—rather than as a space in which to reproduce, re-design, analyze or "express" an object, actual or imagined. What was to go on the canvas was not a picture but an event.

However, quite apart from the failure of "Action Painting" to characterize the process or appearance of the art created by those members of the New York School more interested in contemplation than action, Rosenberg carried the concept too far when he declared the new American painting to be an all-out revolt against tradition, including that of modernism itself, and to be valid precisely because it represented nothing but the artist's existential, even moral struggle to dis-

46. Arshile Gorky. *Landscape in the Manner of Cézanne.* c. 1927. Oil on canvas, 20 × 16". Private collection.

cover and re-create his authentic, liberated self by "gesturing with materials." Rosenberg actually went on to say that "form, color, composition, drawing, are auxiliaries . . . [which] can be dispensed with. What matters always is the revelation contained in the act." In the postwar years, when these words were written, the New York painters had certainly become attuned to the spirit, if not the exact philosophy, of Jean-Paul Sartre's Existentialism, and indeed they considered themselves very much engaged in emotional discovery rather than mere aesthetic performance. Moreover, they had largely broken free of the Synthetic Cubist canon of "closed" forms—discrete, clearly circumscribed planes deliberately composed in relation to one another and the canvas—in favor of an "open-form," all-over field of color or mass of free, interpenetrating strokes, lines, or shapes. However, far from discarding the art of the recent past, they took it and the ideas contained therein as their point of departure, often as a standard of artistic measure. If, for instance, the so-called Action painters adopted a gestural, painterly manner, it was in part because such masters as Kandinsky, in his pre-1914 Improvisations, had shown how this, more than rationalized Cubist geometry, could connote freshness and a certain kind of exalted, romantic feeling. And while all the Abstract Expressionists gave primacy to content, believing that if feeling and execution were sincere, the form would prove expressive and thus significant, none of the painters gave up making aesthetic judgments or testing their work, and that of others, for quality. Nowhere is the assimilation and transcendence of modernist precedent in the service of a genuinely original style—a style made powerful by deep personal meaning and universalized by a willed magnificence of abstract painterly form—more evident than in the art of the first member of the New York School to achieve real distinction: Arshile Gorky.

Arshile Gorky (1904–48) has usually been considered a transitional artist, a figure claimed by the exiled Surrealists, but also a participant in every experience important to the New York School, except a life long enough to realize the absolute fullness of his superbly demonstrated potential. Yet, "transitional" hardly seems adequate when applied to a painter whose mature works appear more accomplished with each passing year, and who in fact forged a crucial link between European modernism and its foremost progeny, the Abstract Expressionism that transformed American painting in the immediate postwar period. If the somewhat slighting label has stuck, it is in large part because Gorky humbly—albeit daringly for the time—underwent a self-imposed apprenticeship so protracted that, in the eyes of some, he seemed permanently fated to excel mainly as a gifted imitator of his own revered models—Cézanne, Picasso, Matisse, Miró, and, finally, Kandinsky. Thanks, however, to this long saturation in advanced art at its highest level, Gorky became the first of the New York painters to discover in Surrealist automatism, brought by the wartime émigrés from Paris, his own personal means of transforming Cubist structure into a dazzlingly new, romantic expression comparable to the best in the grand tradition it aspired to extend. Meanwhile, if Gorky's paintings never cease to reveal new qualities, at the same time that they become more entrancingly mysterious, it may be owing to the very real possibility that the artist used his brilliantly free, yet controlled color and line as a kind of secret language for coding into the pictures what has been called a "hidden agenda," hidden within abstract or semi-abstract imagery because too painful or precious to confront otherwise. This was nothing less than Gorky's own extraordinary life, which began obscurely, sustained a brutalizing series of calamities, embraced great ambitions and uncompromising values, survived on hope and love, and ended tragically at the early age of forty-four. Since the life and its traumatic events formed the substance of the art—its always acknowledged "poetic content"—and fueled the artist's tireless search for suitable aesthetic equivalents, biography assumes particular importance in any discourse related to Arshile Gorky.

Born Vosdanik Manoog Adoian in 1904 in the village of Kharkom on the Dzore River in Armenia, Gorky grew up in the reign of terror unleashed upon the Armenian people by their Turkish overlords before and during World War I. To avoid conscription into the hated Turkish army, Adoian *père* fled to America in 1908, leaving his family to endure hardships so severe—not only war but also famine and genocide—that in 1919 the son saw his revered thirty-eight-year-old mother die of starvation. According to one of the artist's sisters, Gorky did not begin to speak until the age of five or six, when the first word he articulated was a nonsense vocable: *Alkoura*. Characteristically, it would become the title of a painting. By 1920, when all remaining members of the Adoian family were in the United States, Gorky had already made his life commitment to art, which he pursued as best he could while shuttling between an older sister in Watertown, Massachusetts, and his father in Providence, Rhode Island. So precocious was his talent, however, that soon after enrolling in Boston's New School of Design, Gorky was made a part-time instructor, an experience that would repeat itself in New York, where the young artist arrived in 1924 and in 1925 enrolled at the Grand Central School of Art. Now, in an act that forecast the "dissembling" that he would consistently practice in both art and life, the isolated and insecure refugee changed his name to Arshile Gorky, the former a variant of Achilles and the latter a Russian word for "the bitter one." In this way, "the bitter Achilles" associated himself with a Homeric hero of his own Asia Minor and simultaneously claimed to be "a cousin of the famous writer, Maxime Gorky." Here, as Harry Rand has pointed out, in a brilliantly insightful but controversial study, the artist established a pattern whereby he would legitimize both his anomalous existence and his embrace of revolutionary aesthetics by establishing a pedigree for himself in Old World culture. It also allowed Gorky to effect a glittering public form, in his persona as well as in his painting, de-

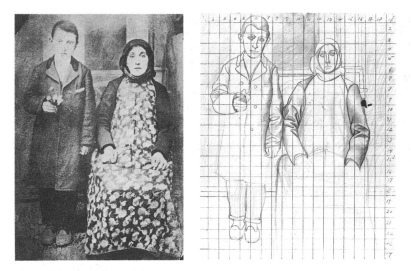

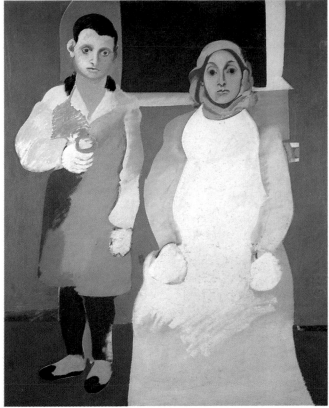

far left: 47. Arshile Gorky and his mother in Van, Armenia. 1912.

left: 48. Arshile Gorky. *The Artist and His Mother.* 1934.
Pencil on squared paper, 24 × 19". National Gallery of Art,
Washington, D.C. (Ailsa Mellon Bruce Fund, 1979).

below: 49. Arshile Gorky. *The Artist and His Mother.*
c. 1926–34. Oil on canvas, 5' × 4'2".
Whitney Museum of American Art, New York.

signed to seduce the world at large, and yet express while also concealing a whole array of ineffable private realities. Subsequently, he would also boast of having studied at the Rhode Island School of Design and, before that, with Kandinsky in Paris. In fact, Gorky seems to have been largely self-taught, which, in the light of the art he eventually produced, must be regarded as conceivably more beneficial than disabling. Even by 1929, he had succeeded in becoming a full-time professional artist, supported by his teaching, his private pupils, and the glimmer of a reputation. By 1931, however, Gorky had been engulfed by the rising tide of economic failure set off by the Crash of 1929. With his poet's gift for expression, despite an unidiomatic command of English, he found the eloquence to characterize the plight of unemployed and impoverished American artists. "If a human being managed to emerge from such a period," Gorky said in an oft-quoted statement, "it could not be as a whole man and . . . there was no recovery from the blows and wounds of such a struggle to survive."

Gorky survived with at least his artistic integrity intact, for throughout the 1930s he continued, as he had earlier, to immerse himself in the art of the moderns, beginning with Impressionism and, for the sake of more substantial form, progressing to Cézanne, with whom he remained throughout most of the later twenties. As *Landscape in the Manner of Cézanne* reveals (fig. 46), Gorky had all but made himself a clone of the Aix master, emulating not only his blue-green-ochre palette and his loosely hatched brushwork, but also his knowing use of the bare canvas as a positive element of pictorial design and inner luminosity. He had even begun to discover the secret of *passage*, the technique through which the great Post-Impressionist opened contours and allowed planes to "pass" or "bleed" into one another, thereby unifying surface and depth in an all-over pattern of faceted strokes.

In 1926, when interviewed by the *New York Evening Post*, on the occasion of his appointment at the Grand Central School of Art, Gorky proclaimed Cézanne to have been the greatest artist who ever lived, for he, more than any other, had been able to capture the formal essence and mood of a subject, thereby transforming it into a timeless, universally expressive image. Cézanne's monumentalizing way with the human face and figure must have been very much on Gorky's mind when, around 1926, the artist began what would become his most ambitious work before the mid-thirties. Significantly, this was a double portrait of himself at the age of eight standing beside his seated, smock-clad, and kerchiefed mother. Based on a touchingly melancholy photograph, made in Armenia (fig. 47), the theme would hold the artist's attention for a full decade, all the while generating countless preparatory drawings and several full paintings in various stages of completion. Analyzing his motif part by part as well as in whole compositional studies, some of them squared for transfer to canvas (fig. 48), Gorky proceeded as carefully and systematically as a tradi-

tional history painter, and indeed he has been called a modern history painter, with the history painted that of his own life. Along the way he also recapitulated the history of modern art, as he sought visual forms strong, fresh, and poignant enough to carry the emotive weight of his meditation on a treasured document from a martyred and eternally mourned past. Thus, Gorky worked and reworked the subject and its details in the manner of his chosen mentors, among them Vermeer, Ingres, Matisse, Miró, and Picasso, as if to warm and reclaim a moment frozen in time by transferring it stepwise into the aesthetic present. The most finished or resolved version (fig. 49) could be seen as a summation of this effort, for at the same time that the simplifications worked upon the original motif—suppressed details, flattened volumes, clarified contours—echo Synthetic Cubism, they also give the image an ageless quality, making it seem as iconic and mysterious as the sacred illuminations once cherished by Gorky in old Armenia, or as the portraits of Cézanne. Meanwhile, modernism and medieval devotional image—a Madonna offered flowers by an adoring acolyte—have been humanized through painterly handling of the broad areas of color, as well as by the silvery blond palette, a subtle harmony of gray, buff, pink, blue, black, and white, providing a foretaste of the brilliant chromaticism yet to come. Notable among the changes effected for compositional, stylistic, and expressive purposes are the space introduced between the figures and the realignment of the boy's feet, away from the mother and more parallel to the picture plane. While both modifications symbolize a very real separation in life, they also yield the long, sinuous lines and shapes, supple curves and countercurves that the artist would make a hallmark of his mature style. Another significant anticipation is the dark rectangle suspended from the top of the format and surrounding the oval of the mother's head like a Con-

The New York School: Abstract Expressionism

50. Arshile Gorky. *Garden at Sochi*. 1941–44.
Oil on canvas, 31 × 39". Museum of Modern Art, New York
(acquired through the Lillie P. Bliss Bequest).

half-buried in the black earth with a few patches of moss placed here and there like fallen clouds. But from where came all the shadows in constant battle like the lancers of Paolo Uccello's painting? This garden was identified as the Garden of Wish Fulfillment and often I had seen my mother and other village women opening their bosoms and taking their soft and dependent breasts in their hands to rub them on the rock. Above all this stood an enormous tree all bleached under the sun, the rain, the cold, and deprived of leaves. This was the Holy Tree. I myself do not know why this tree was holy but I had witnessed many people, whoever did pass by, that would tear voluntarily a strip of their clothes and attach this to the tree. Thus through many years of the same act, like a veritable parade of banners under the pressure of wind all these personal inscriptions of signatures, very softly to my innocent ear used to give echo to the sh-h-h-sh-h of silver leaves of the poplars.

Most of the features cited have been discerned in one or another of the phantom forms traced out by Gorky's graceful, dynamic calligraphy. Certainly, the porcupines' quills, as well as the wild carrots' flowering tops and tapering roots, have their analogy in a number of attenuated lines and shapes, especially when overlapped with patchy applications of orange or brown and black color. More telling, however, is the silhouette in the lower left of a shawled woman wearing a broad, floppy-brimmed hat and seen from behind as she squats, perhaps to rub her breasts on the "blue rock half-buried in the black earth" in Kharkom's Garden of Wish Fulfillment. Meanwhile, the Holy Tree seems to stand denuded and reed-thin in the upper right, the strips of clothing attached to its limbs flying like banners in a brisk wind. Here may be the source of the painting's title, for, as Harry Rand has revealed, *Sos* or *Sosi* is the Armenian word for "poplar," the tree most favored in Armenia, whose people believe the rustle, or "sh-h-h-sh-h," of its silver leaves contains an augury of the future. Word and sound combine to make "Sochi," a name that diverts the viewer to Russia from Armenia and thus from the tender, wounded, private feeling the artist attached to his homeland. The altered geography also makes the subject seem less improbable, or more alluring, just as the pictorial treatment ennobles, while also obscuring, it with an audacious, modern formulation, notable as much for its disengagement of line and color as for its indeterminate space. Still more intriguing and complex is the fanciful dominant shape at the center of the composition, a shape that appears to offer no parallel with objects mentioned by Gorky. To some, it suggests a boot or one of the "beautiful Armenian slippers" that Gorky said he and his father had worn in Kharkom. By isolating the shoe and painting it with more elaborate care than those in *The Artist and His Mother*, Gorky raised the image to the power of cultural myth as well as biographical symbol.

In the years 1942–43 Gorky came quite surely into his own as a mature, self-confident artist, a painter with a genius for transforming carefully chosen influences into an expression of authentic originality and, moreover, great beauty, the latter quality unabashedly cherished by Gorky's Old World, Armenian soul. This can be seen in the 1944 *Water of the Flowery Mill* (fig. 51), one of the most lyrical and liberated, yet elegantly controlled, pictures the artist ever realized. It is a triumph of proud, painterly deftness, a breathtaking display of passionate colorism, brought to sparkling life by deep, somber accents applied over a whitened ground glowing beneath translucent washes of fiery reds and oranges, lavender, forest green, and blue, all miraculously thinned to the fluid consistency of watercolor. Plumes, clouds, lakes, cascades, and trajectories of luminous pigment hover together in a boundless space, yielding a wealth of varied, open forms, the richly articulated vocabulary of a consistent and coherent pictorial language. Even as they merge and intersect, the buoyant, abstract images remain lucid and airy, supported by a firmly sensed but unseen post-Cubist structure within what could be mistaken for a purely spontaneous performance, but which in fact flowed from a series of intensive preparatory studies.

Most immediately, such studies began in direct contact with open landscape, encountered at the estate of Gorky's in-laws in Virginia and in Connecticut, where the artist and his family eventually moved. And the more Gorky examined nature, for its details, its overall sweep, its

structivist halo, a combination of forms that would often recur, refined into pure abstract signs, emblems evidently connoting the presence of Gorky's "beloved ones." In the decade that he devoted to this subject, the artist focused ever-more tightly on the source of his inspiration— a private predicament filled with sorrow and longing—while broadening his command of means. In this way Gorky established the foundations of his mature art: deeply felt personal content memorialized, sheltered, and rendered universal through expression in a distinguished vocabulary of modern forms.

In the late 1930s, when the American economy gradually regained a measure of vitality, Gorky too found his situation improving, thanks in considerable part to a major WPA commission for a mural cycle at the Newark Airport, which emerged as the first abstract mural art ever to be executed in the United States. Then, in 1940–42, came the sympathetic support of the Surrealists soon after their arrival from German-occupied Paris. Furthermore, an exhibition of his art at the San Francisco Museum in the fall of 1941 brought him not only a new audience but, in addition, a cross-country journey, and with this a rediscovery of nature. Along the way, he also ended his years of loneliness by marrying a traveling companion, the American Agnes Magruder, and began joyously to anticipate the warm gratifications of family life. For Gorky, the pleasures of landscape and marriage seemed all the sweeter for the nostalgic reveries they evoked of his halcyon childhood in remote, rural Armenia. This can be seen in a pivotal series of works during whose execution the painter progressively moved from his early, relatively derivative period into a subsequent burst of radiant, mature independence. Begun in about 1938 and continued until as late as 1944, the Garden at Sochi pictures find Gorky breaking free of Cubism's grid-like armature and beginning to float his ever-more abstract forms in a fluid, poetically suggestive, but imprecise space (fig. 50). As always in this artist's work, the imagery, again Miróesque in its swelling, fluctuating biomorphism, beckons interpretation even as the virtuoso play of seemingly pure formal invention frustrates it. But the suspicions of meaningful, if fugitive, content are justified by a statement from Gorky made to MoMA at the time it acquired the *Garden at Sochi* seen here:

About 194 feet away from our house on the road to the spring, my father had a little garden with a few apple trees which had retired from giving fruit. There was a ground constantly in shade where grew incalculable amounts of wild carrots, and porcupines had made their nests. There was a blue rock

processes, and for the first time since 1925, the more it stimulated his dreams of Armenia. With this came a renewed desire to capture something of his ancient land's spiritually rich, pantheistic involvement with the organic world of eternal flux and redefinition. In 1944 Gorky wrote to his sister:

I am destroying confinement of the inert wall to achieve fluidity, motion, warmth in expressing feelingness, the pulsation of nature as it throbs. Dearest ones, my art is therefore a growth art where forms, planes, shapes, memories of Armenia germinate, breathe, expand and contract, multiply and thereby create new paths for exploration. The past, the mind, the present are aesthetically alive and unified and because they cannot rest, are insoluble and inseparable from the future and exist to infinity.

But Gorky being Gorky, he used landscape in the same way he did his shrewdly chosen models of modern art, as an all-important springboard for launching into his own fresh, inventive sequence of exercises in formal eloquence. The rare drawing reproduced in fig. 52 provides a glimpse of how Gorky, relying on some internal interaction of vision, imagination, memory, feeling, and extemporized, doodling gesture, could so dislodge concrete forms from their natural context as to render them almost totally autonomous, albeit still weighted with the emotions the artist experienced while engaged in the process of abstracting from reality. Aiding him in this enterprise was his rediscovery of the highly stylized figurative illuminations of late-medieval Armenia and Kandinsky's pre-1914 Improvisations, works that now seem to have been the true precursors of such developed paintings as *Water of the Flowery Mill.* Also important for helping Gorky to clarify his ideas and master his craft were the classes he had been teaching, as part of the war effort, in camouflage. Here the artist would have brought to focus his awareness that the same formal elements used to describe objects could, conversely, be employed to conceal them, even as these remain present as the primary cause, within an independent and overriding arrangement of dislocated lines, colors, and textures. Mindful of this principle, Harry Rand has been able to decipher something of the "hidden agenda" in the painting seen here, most significantly a full-length portrait of Gorky's mother gesturing from just beyond the dark "bridge" that ascends along a strong diagonal from the lower left edge of the canvas. Even the title of the work reflects Gorky's poetic ability to free-associate words and the color-forms through which he coded his ardently felt, private subject matter into the public realm of elusive visual imagery. In an attributed remark, Gorky said: "Down the road, by the stream, that old mill, it used to grind corn, now it is covered with vines, birds, and flowers. Flour Mill—Flowery Mill. That's funny! I like that idea."

Surrealism too played a key role in Gorky's late success, especially in the person of the young émigré artist Matta Echaurren, who encouraged Gorky to dilute his pigments and exploit their accidental running and dribbling as part of an "automatic" technique for discovering strange, oneiric relationships of form and content. But while Matta engaged in pure fantasy, achieving "inscapes" of some vast galactic cosmos engulfed in molten, perpetual metamorphoses, Gorky looked to the earthly landscape about him and extracted from it the intimate, visual poetry of his all-too-real personal history. Then, by 1944, André Breton himself had discovered Gorky, and in 1945 he claimed the Armenian-American for Surrealism, declaring him to be "the first painter to whom the secret has been completely revealed." This was because in his "hybrid" images Gorky, alone among all painters, had made direct contact with nature, penetrating its secrets to grasp the "guiding thread" that binds together "the innumerable physical and mental structures." Certainly Gorky shared with the abstract Surrealists—Miró, Masson, and Matta—their devotion to the biomorphic image, made important by detachment from its natural environment and set adrift in an aqueous, dream-like space. In the end, however, he kept to his own course, for while Gorky welcomed support from the Surrealists, he also rejected their faith in the unconscious, maintaining that it produced anarchy rather than art, which he insisted "must be a facet of the thinking mind." Finally, the Surrealists' flippant cynicism and largely anti-aesthetic stance ran altogether counter to the reverence for beauty and the seriousness so native to Gorky. "One does not laugh at a loved one," he insisted.

Beginning with his marriage and San Francisco exhibition, Gorky enjoyed some five years of relative happiness, marked by the birth of two daughters and slow but sure professional advancement. The climax of this fulfilling interlude may have been his first one-man show in New York at the Julien Levy Gallery in March 1945, its catalogue published with a foreword by André Breton. Then, in early 1946, the hammer blows of misfortune began once again to fall upon the ill-fated artist. First, a fire in his Connecticut studio destroyed most of the work he had prepared for his next exhibition. A mere three weeks

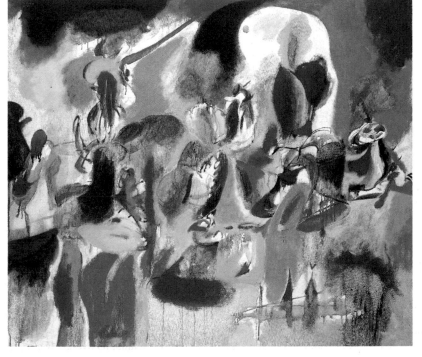

left: 51. Arshile Gorky.
Water of the Flowery Mill. 1944.
Oil on canvas, 3'6½" × 4'¾".
Metropolitan Museum of Art,
New York (George A. Hearn Fund, 1956).

above: 52. Arshile Gorky. *Drawing.* 1946.
Pencil on paper, 18⅞ × 24⅞".
Yale University Art Gallery,
New Haven, Conn. (gift of Julien Levy).

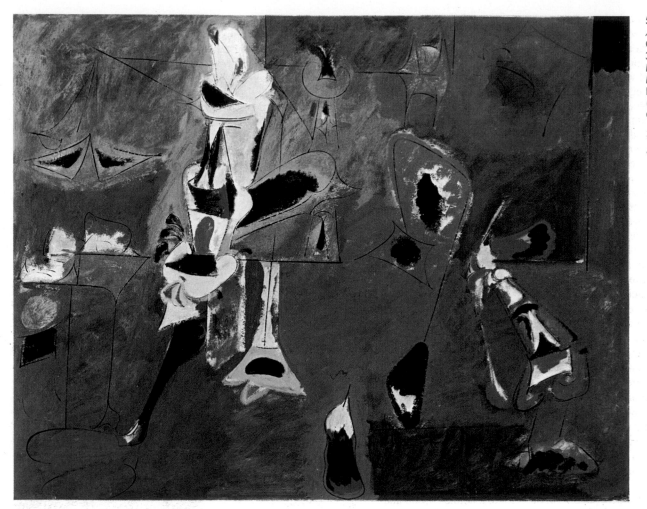

53. Arshile Gorky. *Agony.* 1947. Oil on canvas, 3'4" × 4'2". Museum of Modern Art, New York (A. Conger Goodyear Fund).

later Gorky underwent surgery for cancer, in a hospital where he would return in June 1948, now with a broken neck suffered in an automobile driven by Julien Levy. When severe depression overcame the painter following this new disaster, his wife took their two little girls and departed. On July 21 Arshile Gorky hanged himself in a woodshed near his house in Sherman, Connecticut. On a wall close by he had scrawled in his inimitable Armenian English: "Goodbye My Loveds."

Given the diaristic nature of the art just reviewed, Harry Rand has seen in *Agony* (fig. 53) not the erotic preoccupations—"'strange, soft organisms and insidious slits and smudges . . . a jungle of limp bodily parts, intestinal fists, pubic discs, pudenda . . . ' "—so often suggested by Gorky's sensual draftsmanship, opulent palette, and swelling forms, but rather an ominous premonition of the personal doom that, inexorably, would soon grind to its terrible conclusion. Here the scene has moved from the refulgent landscape openness of the rainbow-hued *Water of the Flowery Mill* to a dark, enclosed, box-like interior, its space and contents defined by a thin, taut line, exquisitely pliant as always but now stretched to painful lengths, squeezed together at intersections, and pinched off at the end. Gone is the sumptuous radiance of 1944, replaced by a rather dry, turgid surface, hatched or feathered in scarlet, mustard yellow, earthy brown, and black. In the middle of the field, below a blood-red, sable-centered solar disk in the upper right, one frontally iconic stick figure stands back on the threshold, while another, profiled figure leans forward in the lower right foreground. Both would seem to stare—perhaps in horror—at the elaborately articulated, schematic image dangled in the left half of the picture, from its top edge all the way to the bottom. What William Seitz long ago characterized as "a fearful hybrid resembling a dentist's chair, an animated machine, a primitive feathered fetish or a hu-

man figure hanging on the rack, its rib cage hollow and its groin adorned with petals" Rand more recently identified as "the pitiful suspended corpse" of Gorky himself. In light of this grim reinterpretation, *Agony* may be understood as a meditation undertaken by an immensely gifted, sensitive, and afflicted artist on the shocking prospects of his own suicide.

Gorky remained, to some significant degree, a modernist of the Old World—exquisitely discriminating, refined, patrician—and never aspired to, or did not live long enough to attain, the radicality—the extreme abstraction, the heroic scale and drama—that would come with the full flowering of Abstract Expressionism. Nevertheless, he was the first New York artist to assimilate the influences which bore upon that school and the first to display the traits that would later distinguish its greatest achievements. Furthermore, he was the earliest in his time and place to solve the pictorial problem of an original, symbolic or nonallusive surface arrangement that would satisfactorily reconcile the contrary demands of private need and public accessibility. Alas, he also led the way among the several members of the so-called First Generation who met an untimely and tragic end. For all these reasons, plus the sheer quality of his art, Gorky has come increasingly to be considered not merely a transitional figure but actually the first of the Abstract Expressionists. As Adolph Gottlieb would write in 1950, Gorky recognized that "the vital task was a wedding of abstraction and surrealism. Out of these opposites something new could emerge, and Gorky's work is part of the evidence that this is true."

Another New Yorker with an Old World background and a rich, eclectic grasp of the modernist heritage was Gorky's close friend Willem de Kooning (1904—), who arrived from the Netherlands in 1926 after having stowed away for the express purpose of jumping ship in the United States. Here, like so many other immigrants, he hoped to

make money but, instead, suffered privations altogether as severe as those endured by Gorky. De Kooning, however, brought with him a hardier constitution and a less fragile sense of self, thanks in part to his stable, if complicated upbringing, as well as to eight years of rigorous night-school training at the Rotterdam Academy of Fine Arts and Techniques, begun at age twelve during the same year the youth took a full-time job in commercial art. With this solid foundation under him, the brilliant, articulate, charismatic de Kooning not only survived the vicissitudes of the Depression and war years; he also developed into one of the true giants of Action Painting, an artist of resurgent power even today. In the tight little underground world of New York's 1930s avant-garde, de Kooning, along with Gorky, became a leading figure well before he had exhibited anything. Even in his earliest known and most tentative American art, produced while earning a bare subsistence living as a house painter, window dresser, or WPA muralist, de Kooning displayed the touch of a master and an unmistakable, albeit devastatingly self-critical, genius. Already he was a legend for an art whose fluidity of form and ambiguity of content betrayed an anxious but determined attempt to include everything—graceful, incisive draftsmanship as well as muscular, liberated painterliness, representation as well as abstraction, tradition as well as innovation, austere analysis along with technical bravado. But what truly set de Kooning apart and makes his art inexhaustibly rewarding is the dramatic irresolution of the open paradox that he allowed to reign among his contradictory elements (figs. 54–59). Still more than most modernists, from Manet onward, de Kooning viewed art, as well as life, as an ongoing enterprise of counterbalancing the possibilities or necessities of contentious ideas and means, all the while candidly disclosing the struggle and its inconclusiveness as fundamental to the very content, meaning, and validity of his work. As he willfully frustrated his extraordinary facility and allowed the unpremeditated act of painting, rather than professional expertise, to gain control, de Kooning came to seem the true existentialist hero, risking all—including the very real chance of failure—to redefine himself and

his art in the personal drama of an improvisatory creative process. If this made his painting vulnerable to raw, worrisome uncertainty, it also guaranteed freshness and deliverance from artifice or deadly mannerism. And, if it left his dense, passionate, motile pictures looking like battlegrounds of nagging alternatives, fought to a draw, it also turned them into authentic seismographs of the restless, violent, overcrowded urban world in which they were painted.

As de Kooning gradually matured in the late 1930s, he pursued his theme of ambiguity—his open-ended dialectic of opposites—in two parallel, somewhat overlapping series, one abstract and the other denotative. Although later famous for his Women images, the artist began with Men, the figures all displaying a slightly haunted, lost, exiled look, as if to project the feelings of an artist troubled about his alien and illegal status (fig. 54). While the male countenances somewhat recall the "psychic" heads of John Graham, then a mentor to de Kooning as well as to Gorky, they also seem to anticipate, for one knowing observer, T. S. Eliot's unemployed "hollow men." And hol-

right: 54.
Willem de Kooning.
Seated Figure (Classic Male).
c. 1940. Oil and charcoal
on plywood, 4'6¾" × 3'.
Sarah Campbell Blaffer
Foundation, Houston.

left: 55.
Willem de Kooning.
Pink Angels. c. 1945.
Oil and charcoal
on canvas, 4'4" × 3'4".
Weisman Family Collection,
Beverly Hills, Calif.

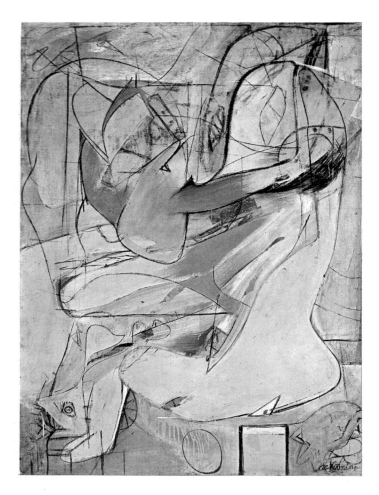

low they do appear, since the flat, sunken eyes echo the colors of the backgrounds, making them look like holes drilled straight through to the wall behind. Something similar happens in the hues chosen for modeling and shading, with the result that the ground seems to absorb the figure and drain its volume. Meanwhile, the relatively tight drawing of the chest seen here implies that the artist began with fairly exact anatomical definition and then progressively became involved with some "problem." This could have been the contour of a shoulder or the fall of the creases in trousers, but whatever the issue, de Kooning investigated it by scraping down and repainting, until the variant available solutions became the actual subject of the work, transforming it into a semi-abstract study, unfinished or unresolved perhaps, yet all the more evocative for that reason. Adding to the sense of Surreal strangeness and alienation are the ghosts of earlier trials, *pentimenti* now so free of descriptive function that they seem little more than organic analogies of the flat, rectilinear shapes—drawings tacked to the studio wall?—that section the ground, Cubist fashion, and tie it to the overall plane of the painting surface.

In the abstractions that evolved concurrently with his subject-matter paintings, de Kooning simply gave full reign to his fascination with isolated anatomical details. Now he not only fragmented the figure but also reassembled its dismembered parts into collage-like compositions, autonomous arrangements whose sensuous, whiplash curves and high-key, pink-and-yellow palette nonetheless register an all-important obsession with the warm, pulsating, distinctly female human presence (fig. 55). This was precisely how the original Cubists found

The New York School: Abstract Expressionism

their way to abstraction, but they never took it so far as de Kooning, who went the whole distance, emancipated by, among other things, Surrealist automatism, the example of Mondrian, a fellow Dutchman in New York during the years 1940–44, and the growing confidence of the American avant-garde. Gradually, like Picasso and Braque in their Analytic Cubist phase, de Kooning even leached color from his paintings (fig. 56), not however for the sake of emphasizing form at the expense of feeling, as his illustrious predecessors had done, but rather to increase the sense of dynamic conflict, of positive and negative shapes—of light and dark forces—caught up in a never-ending process of metamorphosing into one another. Even though black dominates in paintings like *Night Square*, the work just cited, it is shot through with electric traceries and volatile sweeps or bursts of dazzling white. To Thomas Hess such a painting evinces ''an extraordinary lucidity—and ambiguity. It is as if two philosophers were having a discussion about Black and White, but each property could only be cited in terms of its opposite.'' And never would de Kooning's sinuous line and painterly stroke appear more beautiful, displaying an almost European savor of *matière* and *métier*, even though the artist once declared: ''I never was interested in how to make a good painting. . . . I didn't work on it with the idea of perfection, but to see how far one could go—but not with the idea of really doing it. With anxiousness and dedication to fright maybe, or ecstasy.''

Within an art as dynamic as de Kooning's, where opposites constantly reverse, white on black gradually yielded to black on white (fig. 57), at the same time that bits of color reappeared, ''like crushed jewels'' glittering through the interstices of a complex, impacted weave of heavily laden strokes, applied in campaign after campaign of frenzied brushwork. Now that the whites of a masterpiece like *Excavation* have turned to cream, the fleshy tonality joins with the voluptuous contours and erotic surfaces to disclose the artist's continuing romance with Woman. The manifest heat and velocity of the execution would suggest that it had actually increased, even as the fragmented physiognomy became little more than abstract vectors of human meaning. A solidly professional, virtuoso technician, de Kooning maintained this contradictory ''likeness'' by means of an open, exploratory variation on the collage process. Characteristically,

he would do drawings on translucent tracing paper, scramble them on top of one another, make a new drawing from this, turn it upside down, tear the sheet in half, shift the alignments, and, finally perhaps, superimpose the result on yet another drawing—all in search of forms and relationships remote from external reality but still charged with its emotive content. Sometimes de Kooning would use the composite drawing as a template for transferring the image to canvas, or he might simply leave it there and paint right over, mixing charcoal, paint, canvas, line, and stroke until drawing fused with painting in a new kind of all-over abstract configuration, just as it did in the celebrated ''drip'' paintings then being created by Jackson Pollock (fig. 41). Considerably more than in Pollock, however, one can sense in *Excavation* the shuffled, layered planarity and firm infrastructure inherited from Cubism, but now so organicized, activated, and paradoxically jammed that, even in their radical flatness, the imploding shapes and intervals connote a plenitude recalling the great Netherlandish tradition of Rubens, Rembrandt, Hals, and van Gogh. Simultaneously, the

above: 56. Willem de Kooning. *Night Square*. 1950–51. Oil on Masonite, 30 × 40″. Collection Mr. and Mrs. S.I. Newhouse, Jr., New York.

left: 57. Willem de Kooning. *Excavation*. 1950. Oil and enamel on canvas, 6′8⅛″ × 8′4⅛″. Art Institute of Chicago (Mr. and Mrs. Frank G. Logan Purchase Prize; gift of Edgar Kaufman, Jr., and Mr. and Mrs. Noah Goldowsky).

opposite: 58. Willem de Kooning. *Woman and Bicycle*. 1952–53. Oil on canvas, 6′4½″ × 4′1″. Whitney Museum of American Art, New York.

teeming composition also evokes the very present, conflicted, flesh-pot world of urbanized New York, and along with his "depthless space" de Kooning sometimes used simple numbers or words—"no-things" or "no-figures" appropriated from anonymous graffiti scrawled on tenement walls—as a device for symbolizing the alienated "no-environment" of the modern metropolis. But while a "wall of musculature," as William Seitz unforgettably characterized paintings like *Excavation*, reflects the violence of the city, it also implies that existential man can raise his fist, or powerful brush, and assert his individuality even as overwhelming forces threaten to nullify it.

When de Kooning finally emerged from the underground in his first one-man shows at the Egan Gallery in 1948 and 1951 and at the Venice Biennale in 1950, it was with paintings like *Night Square* and *Excavation*. In 1951, after the latter work was installed as the climactic piece in MoMA's "Abstract Painting and Sculpture in America" show and then went on to win first prize at the Chicago Art Institute's six-tieth "annual," the sheer visceral power of the work seemed, in the minds of doctrinaire modernists, to clinch the argument for abstraction as the only kind of pictorial language acceptable in the postwar era. However, de Kooning, with his mastery of collage and the openness this gave him to life's eternal dynamic among colliding incompatibles, subscribed to no such restricted view. Indeed, at the time of the MoMA exhibition, he wrote in the Museum's *Bulletin*:

> Art never seems to make me peaceful or pure. I always seem to be wrapped in the melodrama of vulgarity. . . . Some painters, including myself, do not care what chair they are sitting on. It does not even have to be a comfortable one. They are too nervous to find out where they ought to sit. They do not want to "sit in style." Rather, they have found that painting—any kind of painting, any style of painting—to be painting at all, in fact—is a way of living today, so to speak.

Already, as soon as *Excavation* left his studio, de Kooning had begun to allow the voluptuous, covert presence and the orgiastic feelings it had stirred in that epochal painting to reassert themselves in the overt form of a recognizable, albeit vehemently distorted, figure. This occurred on an enormous canvas, now called *Woman I* and owned by MoMA, that became, in the course of the artist's struggle with his contradictory drives, as much the battleground of a prolonged standoff engagement as Picasso's *Les Demoiselles d'Avignon*. Like Picasso, moreover, de Kooning required two campaigns of work to bring the picture to its present, if not actually "finished," state, and these extended over two years, during which the artist, with the accelerated bravura unique to him, repainted the canvas literally hundreds of times, all the while making scores upon scores of studies in oil, pastel, and other media. As in *Les Demoiselles*, the subject was the war of the sexes, but rather than deal with, or exorcise, the agony of fear and desire by fracturing, flattening, or primitivizing the *femme fatale* image, de Kooning reconstituted his dark heroine—"the idol, the Venus, the nude"—from the parts he had previously dismembered, bulked her out with some of the "fattest" strokes in all of painting, and finally undermined the fierce eroticism of his theme with a comic, decidedly American, billboard- or cartoon-like grossness. In the sober, intellectualized atmosphere of 1950s abstraction, when the New York School still felt uncertain about its own achievement, humor seemed as shamelessly counter-revolutionary as figuration. And so de Kooning found himself informed by the critic Clement Greenberg, a fervent admirer of works like *Night Square* and *Excavation*, that "it is impossible today to paint a face." To which de Kooning replied: "That's right, and it's impossible not to"—if this was where the search for universal expression within the artist's own subjective feelings actually led. The wit too kept turning up along the way, especially in variations like *Woman and Bicycle* (fig. 58), where the bosomy, galumphing goddess with the wide, staring eyes of a Mesopotamian cult statue rolls in on wheels wearing a necklace of teeth like those in the shark's grin spread across the face above. In other Women pictures, de Kooning even clipped a smiling, lipsticked mouth from a cigarette advertisement and collaged it, like a visual

pun, directly onto the subject's face (fig. 212), or permitted random offset images of type and space ads to remain on the painting surface from sheets of newspaper spread to keep the wet medium from drying overnight. While these strategies, which served to incorporate the world of banal, popular reality into the realm of high art, had been initiated long before by the Cubists and the Dadaists, de Kooning's rediscovery of them anticipated their full-scale revival by the Pop figures of the late 1950s and the 1960s. Also aiding the artist in his attempts to counterbalance the grand and the grotesque were such prototypes as Picasso's *Girl before the Mirror*, a masterpiece acquired by MoMA in 1938, and the art of Chaim Soutine, whose turbulently gestural, tragically anxious paintings had been exhibited by MoMA in 1950. Thus, while de Kooning mocked his shockingly unexpected and unwelcome theme, he also ennobled it with his sweeping, baroque manner and virulent, tuned-up colors, a fire-and-ice palette of pinks, yellows, blues, and greens inspired by the Metropolitan Museum's Pompeiian frescoes and then toughened with slashes of sanguinary red and gritty, charcoal black. Mingling the buttery pigments in furious, broom-wide strokes that combine personal intensity with plastic finesse, de Kooning created what he called a "nice, juicy, greasy surface," a richly textured field on which the hieratic image looms up—hilariously terrifying—from an uneasy fusion of sensuality and violence.

De Kooning continued his Women steadily throughout the years 1953–55, took them up again in the 1960s, and at all other times has never ceased to make the obsessions they embody a key component of his work, even at its most abstract. In 1969–74 he gave the figures three-dimensional form, modeled in clay and cast in bronze or polyester resin, like freestanding icons of rippling, twisting, uncoordi-

nated energy. Inevitably, however, given his tendency to deconstruct even as he creates, de Kooning re-embraced abstraction, gradually expanding the female, or sometimes male, image and releasing its pent-up energies into the "no-environment" with which it had always been integral. Meanwhile, this environment slowly modulated from the congested, jumpy urbanscape of old to the tranquil, slowly undulating marine world of Long Island (fig. 59), where the painter began spending summers and where he finally moved in 1963, once his improved financial condition permitted. The new nonobjective pictures brought great relief to de Kooning's longtime admirers, many of whom had disdained the Women as a perverse relapse into retardataire neohumanism, rather than the assertion of personal freedom they actually were. Increasingly, the mood now became almost tender, the field flatter, more open and luminous, the rhythms gentler, and the gestures fewer as well as simpler, often with a soothing emphasis on the horizontals of a low-lying, pastoral landscape. In these rapturous vistas of flesh pink, lemon yellow, white light, cerulean blue, and sea green, de Kooning enlarged the "intimate proportions"—the dilated anatomical details of his earlier work—until they engulfed the viewer like the later Waterlilies of Monet. Lately, he has developed an old-age style, as serene and radiant as those of Rubens, Rembrandt, Titian, and Matisse, its lyrical, sweetly chromatic, deliquescent grandeur remote from the claustrophobic density and crisis of *Excavation* and the earlier Women. Nothing could be more logical, even though unpredictable, in the oeuvre of an artist with a career-long, inclusive appetite for confronting and countering the dualities of his own nature and of life at large.

The verbal and accessible de Kooning, with his dramatic struggle to re-create his art with each new stroke, with his European sense of tradition and his openness to figuration as well as to abstraction, seemed the surest point of departure for many of the ambitious younger artists—the early Pop figures as well as the second-generation abstractionists—who emerged in New York during the 1950s. But of all the remarkable talents touched by de Kooning and his achievement, the most important to be immediately affected was Franz Kline (1910–62), only five years younger than the Dutchman and early enough in his arrival at a powerfully independent Action style to win a secure place in the front rank of the original New York School. Like de Kooning and every other member of the "gestural" group, Kline created a novel, emotionally potent art by enlarging the small-scale, relatively descriptive linearism and concentrated feeling of his work

on paper until drawing became monumental abstract painting on canvas. But Kline exceeded them all in the bluntness of his statement, as this climaxed during 1950–56 in severe, muscularly realized black-and-white forms or planes locked together, rather than superimposed, in what seems a state of thunderous reciprocity (fig. 62).

Such Manichaean opposition of elemental, light-and-dark forces could be seen as the manifestation of an outwardly genial, spirited artist who simultaneously viewed himself as a tragic clown, a view fueled, moreover, by the starkest of biographical facts. Born to a German-American father and an English mother in Wilkes-Barre, Pennsylvania, six-year-old Franz Kline entered Girard College in Philadelphia, a free boarding school for orphaned boys, after his father committed suicide in 1917. At the age of fourteen, however, Kline rejoined his mother, brother, sister, and new stepfather in Lehighton, a railroad and mining center in eastern Pennsylvania whose wintry, snow-laden slopes sectioned by coal-blackened industrial structures would find a permanent place in Kline's mature art. It also appears to have translated into an early penchant for the monochromatic medium of drawing, an almost nonstop activity rendered fluent and graceful by the fledgling artist's natural and accomplished athleticism. With his draftsmanly gifts and pressing economic need, Kline made commercial art, in the form of illustration or cartooning, his career choice, rather than painting, and set out in 1931 to study first in Boston (1931–35) and then in London at Heatherley's School of Fine Art (1936–38), scraping through on whatever odd jobs he could pick up. After the deepening crisis in Europe drove him back to the United States, Kline in late 1938 finally arrived in New York, where, with the English girl who would become his wife, he settled into a chronically uncertain but productive bohemian existence in Greenwich Village. To survive, he produced many "buckeye paintings" for sale at the annual Washington Square outdoor art shows and undertook potboiling mural commissions for Village taverns, supper clubs, and jazz joints, as well as for the New York World's Fair. While all such exercises brought little money and even less glory, they nonetheless stretched the artist, prompting him to replace pen and ink with brush and oil color and to seek the simplified shapes and clear relationships required for large-scale painting.

Meanwhile, Kline also proceeded towards reductive color and form, but even more in the service of romantically melancholy feeling, as he produced a series of sketches and oils portraying the head of the dancer Nijinsky in his greatest role: Petrouchka (fig. 60). That the outgoing and affable Kline—he of the body once likened to the "Hermes of Praxiteles"—ironically identified with this poignant subject is borne out not only by the number of times he interpreted it, over a period of ten years, but also by a statement he made early in his career: "I have always felt that I'm like a clown and that my life might work out as a tragedy, a clown's tragedy." By the time the artist painted the version seen here, his wife, a onetime ballerina and the person who had given him the old photograph used for the Petrouchka works, was confined to a state hospital, after having suffered a mental breakdown, brought on in part by the hardship of their lives during the war. The sadness and loss of the situation would seem clearly to have its counterpart in the 1948 *Nijinsky as Petrouchka*, where the exaggerated tilt of the head, the masklike face, the painterly generalization of the ruff, the reduced modeling and flattened volumes all connote absence in a heartrending presence. Figurative as the image is, it nonetheless verges on nonliteral form, in the ways just cited, of course, but also in the bleached, largely monochromatic palette actually retained from the photographic model. And where color appears it has the synthetic but soulful, pastel character of Picasso's Rose Period circus performers, except in the eyes, reddened like an inflamed consciousness seeping through the artificial façade of a professional funny man.

In certain works, beginning in 1947, Kline had plunged much more deeply into the experimental waters of nonobjective form, mainly by broadening and deflating his color image until the entire painting surface assumed the patterned, planar look of a Synthetic

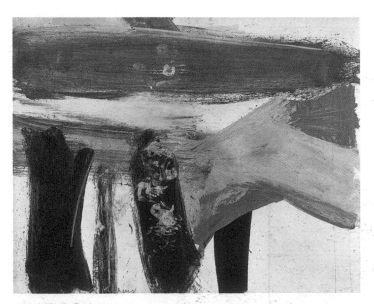

59. Willem de Kooning.
Lisbeth's Painting. 1958. Oil on canvas, 4'1¾" × 5'3¾".
Virginia Museum of Fine Arts,
Richmond (gift of Sydney and Frances Lewis).

Cubist work realized with a saturated, expressionist brush. But whatever his interest, appearances or essences, the artist studied it in a steady stream of drawings, executed usually in black ink on pages often torn from an outdated telephone book (fig. 61). Thus, when in 1949–50 Kline made his definitive commitment to abstraction and discovered his celebrated signature style, it was through drawing (fig. 62). And while the journey to the great black-and-white paintings of the 1950s had obviously been gradual, the arrival itself came almost in a flash, like a sudden revelation, when Kline saw some of his quick sketches blown up by means of a Bell-Opticon projector in the studio of Willem de Kooning, then in the midst of his own light-and-dark series. As Elaine de Kooning has written: "A four by five inch brush drawing of the rocking chair . . . loomed in gigantic black strokes which eradicated any image, the strokes expanding as entities in themselves, unrelated to any reality but that of their own existence. . . . From that day, Franz Kline's style of painting changed completely." Here was one master's indispensable model of abstract gesture painting—Action Painting—on a grand scale, its autonomous vectors urgent with the directness and drama sought by every member of the New York School. Right away, Elaine de Kooning has also told us, "[Kline] began to work on sheets of newspaper with a three-inch housepainter's brush and black enamel. The size of the newspaper, almost immediately, was unbearably confining. Then came the six- or eight-inch brushes, the five-gallon cans of paint and the big, black images with the bulk and force and the momentum of the old-fashioned

engines that used to roar through the town where he was born." Throughout, however, and to the end of his career, the artist normally worked from small to large, with even the most spontaneous effects of his monumental canvases first essayed in a drawing and then transferred, by visual comparison, to canvas. The powerful sense of improvisation generated by the final work arises, in large measure, from the unfailing freshness and vitality of the handling. As a result, the mighty black struts seem literally to collide and career as they hurtle towards one another from the outer edges of the format, all the while that their overpainted, scumbled edges splinter or smudge into the ambient white shapes and thus fuse with them on the same plane.

In this wedding of figure and ground collapses the analogy often drawn between Kline's black-and-white gestural abstractions and Oriental sumi-ink calligraphy, an ancient art form whose graceful, liquid lines flow gently over a pale and passive support implying infinite depth. Having translated the wrist action of intimate drawing into the full-arm action of mural-size painting, Kline endowed both black and white not only with raw energy but also with an aggressive, all-over up-frontness quite alien to Chinese and Japanese ideographic writing. On his uniformly activated field, where positive and negative join together as uneasy coefficients of one another, variety emerges from the acrobatic juggling of the large, simple shapes, as well as from abrupt shifts in the velocity, direction, and texture of the strokes that give them life. The ancestry of Kline's mature art lies not in the Orient but rather in the chiaroscuro tradition of Velázquez, Manet, Whistler, Albert Pinkham Ryder, and even Mondrian, whose pristine geometries suggested an antecedent to observers who characterized certain Klines as "melted Mondrians." It also embraces English and American commercial draftsmen, but the tough grittiness and dynamic, trestled structures are unique to Kline, salvaged from the industrial and urbanized environments, as well as the all-night hours—the artificially illuminated penumbra—in which he spent his life. Titles like *Monitor*, *Chief*, and *Diamond*, all taken from once-famous crack trains, and *Mahoning, Shenandoah*, and *Hazelton*, each a place name from eastern Pennsylvania, evince an Abstract Expressionist will to transform personal geography into a realm of myth.

Kline's world may seem remote from Sophoclean Greece, but the artist achieved something genuinely Olympian or classic in his greatest paintings, to such a degree that, even though de Kooning, Pollock, Motherwell, and others worked largely without color around 1950, "black and white" seems virtually synonymous with the art of Franz

above left: 60.
Franz Kline. *Nijinsky as Petrouchka*. c. 1948. Oil on canvas, 33 × 28". Collection Mr. and Mrs. I. David Orr.

above right: 61.
Franz Kline. *Untitled, II.* c. 1952. Brush and ink, and tempera, on cut and pasted paper; 11 × 9¼". Museum of Modern Art, New York (purchase).

right: 62.
Franz Kline. *Monitor.* 1956. Oil on canvas, 6'6" × 9'6⅝". Private collection, Milan.

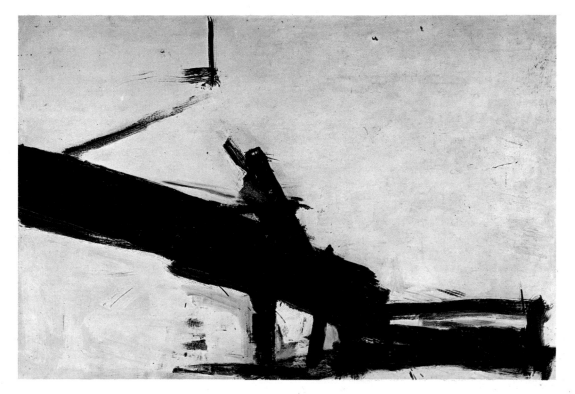

Kline. If his painting has made so indelible an impression, perhaps it is because he, more than anyone else, used dramatic gesture and austere monochromy to induce sensations comparable to the turmoil and cartharsis of Greek tragedy. And if such wrenching polarities of experience inhabit his paintings, they also dogged the artist in life, for while riding the crest of his long-delayed success, Kline suffered a heart attack and died at the age of fifty-two.

"Pollock broke the ice," de Kooning once said, meaning that it was Jackson Pollock (1912–56) who, before anyone else, discovered within personal, American experience the possibilities for applying the logic of European modernism to new problems and for making it yield exalted, original solutions like those already seen in the work of Gorky, de Kooning, and Kline. Moreover, it was the now-legendary Pollock, the youngest of the leading Action painters, who achieved the most revolutionary departures from European precedent, and yet revalidated that legacy by carrying its principles to a sublimity of expression never attained, or even attempted, in 20th-century Europe. Like many great artists, Pollock acknowledged the wracking divisions within his own nature, as well as in the world about him, and, through a rigorous, critical dialogue with his work, projected them into aesthetic objects whose daringly balanced, dynamic harmony of opposites evokes that of the universe itself. However, the inner, as well as outer, conflicts that Pollock had to cope with were profound indeed, to the point of ultimate, tragic fatality. Blessedly, they included an integrity of artistic purpose so absolute that in the great silver "poured" or "dripped" paintings of 1947–50 Pollock eliminated all but necessity and risked everything to register this at an unwavering pitch of authentic feeling (figs. 41, 67). Finally, doubt and confidence, raging instinct and controlling intelligence, rawness and refinement coalesced and found their formal equivalence in an all-over array of spilled and spattered pigments, a racing, convoluted, yet serenely choreographic image where surface and depth, drawing and painting, tradition and innovation had been unified on a scale and with a splendor never before seen in totally abstract art. The unity, moreover, was of a uniquely monolithic order, the issue of an infinitely varied line spun out in an expansive, web-like interlacement as if from one continuous flow of inspiration. In this becalmed storm of "energy made visible," Pollock brought forth a pictorial statement so complex and yet so clear, so liberated and yet so logically determined that it placed his art at the pinnacle not only of gestural Action Painting but also of Abstract Expressionism's quietist branch, the Color-Field Painting soon to be encountered.

Inevitably, it seems, an art as stunning as this would attract immediate attention, if not, alas, for its manifold subtleties, then for its galvanic directness, passion, and, most of all, the sensational iconoclasm of the painting process. And so while one philistine critic of the popular press called Pollock "Jack the Dripper," other more convinced, but scarcely less misguided, writers seized upon the epic force of the big, open pourings and began to cast Pollock in the role of American archetype or hero-martyr, the inarticulate cowboy-genius standing tall but solitary and unappreciated amidst an ignorant, derisive society. Such a romantic view could only grow apace, in ballad and fanciful biography alike, following the artist's violent and untimely death in 1956, before ever his work could earn him a decent living. In a life and an art as significant as Pollock's, however, fable proves especially troublesome, since it obscures and thus trivializes facts that, on their own, are far more compelling. First of all, Pollock was a sophisticated artist—"lucid and intelligent," to use Lee Krasner's words—with a thorough, even erudite command of historical art and culture. Second, he enjoyed the respect of serious, perceptive artists and critics—was almost held in awe by some of them—from the very start. Finally, there are the paintings, which even in the late 1930s seemed destined, by virtue of the unequivocal strength with which Pollock took possession of the modern picture, to make American art a true rival, at last, of the best in the touchstone European tradition. Meanwhile, however, this most complicated of artists also had a dark,

saturnine, brooding side to his character, a deep, inner turbulence that, when ignited by acute alcoholism, could erupt in lacerating insecurity and boorish, destructive behavior.

As the myth-makers like to stress, Jackson Pollock was born in Cody, Wyoming, a "Wild West" town founded by Buffalo Bill, but it could not have meant much to the artist, since his family very soon moved to California. There, as well as in Arizona, Pollock and his four older brothers grew up helping their father work one meager truck farm after another. Materially destitute as this life was, it left Jackson with an abiding love of earth, open spaces, and growing things, as well as an independent spirit, a keen, if sternly self-critical sense of his own worth, and mystical leanings. Moreover, the impoverished but enlightened senior Pollocks endowed all their sons with intellectual curiosity and even aspirations for careers in art. Thus, despite provincial isolation, the boys knew about advanced art in Europe and learned more as they left, one by one, to study in Los Angeles or New York. So serious was Jackson about education that it brought out his native rebelliousness and got him expelled for protesting his school's alleged over-emphasis on athletics. Following a second expulsion, the gifted, dedicated, but combustible youth left for New York with two brothers and in 1930, at the age of seventeen, enrolled in the class of Thomas Hart Benton at the Art Students League, determined to discover whether "i have it in me."

Years later Pollock would write: "My work with Benton was important as something against which to react very strongly, later on; in this, it was better to have worked with him than with a less resistant personality who would have provided a much less strong opposition." The strong opposition sprang from the great Regionalist's scornful rejection of European modernism, a rejection carried out with the missionary zeal of a soul gratefully born again following an early submission to the "decadent" foreign ways he now despised. As we have seen, Benton had been a Synchromist, as well as a member of the Stieglitz circle, until around 1920, when he, along with John Steuart Curry and Grant Wood, rediscovered the American Scene and began glorifying its homely virtues, doing so with a pictorial rhetoric derived, ironically, from the European past, complete with musclebound Michelangelesque figures and such Baroque devices as agitated handling, dramatic chiaroscuro, gyrating rhythms, and sweeping, abstract design. In the long run, Pollock, far from resisting, actually absorbed almost all of this, except the pronounced figuration and illusionism, and at the outset he abjured only the picturesque chauvinism, replacing it with his own melancholy sense of supernatural mystery (fig. 63). Here he found reinforcement in his love of Rembrandt, El Greco, and, especially, Albert Pinkham Ryder, "the only American master who interests me," as he was to write in 1944. But

63. Jackson Pollock. *Going West.* c. 1934–35. Oil on fiberboard, 15⅛ × 20¾". National Museum of American Art, Smithsonian Institution, Washington, D.C. (gift of Thomas Hart Benton).

while Pollock, like the late-19th-century Ryder in his romantic, visionary scenes of moonlight and mysticism, painted and repainted until objectivity all but disappeared in a crust of obsessive brushwork and symbolic shapes, he did so with an impetuousness that took his pictures to the very edge of Expressionist abstraction. Similarly, he would progressively work toward the mural scale and ramified undulations of Benton, but amplify the former while intensifying the latter until his painting assumed a different order of life, remote from the teacher's parochialism. Still, by the time Pollock ceased regular attendance at the Art Students League in 1933, the pedagogically open-minded Benton had come to sense that his student, despite struggles with drawing, was indeed "some kind of artist." Upon this artist, meanwhile, the older man had deeply imprinted his own conception of art as a higher calling.

Thanks to Benton the muralist as well as his own teenage involvement with leftist politics, Pollock would have been particularly susceptible to the period's enthusiasm for the Mexican masters, Rivera, Orozco, and Siqueiros, whose colossal frescoes, with their Expressionist fervor and social activism, moved many a young artist in the Depression decade. Soon after Siqueiros opened his "experimental workshop" on Union Square in 1936, Pollock joined and began investigating such unorthodox, industrial means and materials as spray guns, airbrushes, and various synthetic paints and lacquers. Here, probably for the first time, he came upon not only Duco but also the idea of "controlled accident," both of which would play key roles in the contained explosiveness of his mature works. The aesthetic and expressive potential of such encounters could only have become clearer once Pollock met John Graham, whose 1937 article "Primitive Art and Picasso" so stirred Pollock that he wrote to the author, thereby initiating one of the most important relationships of his career. Not only did Graham follow Freud and Jung in valuing the unconscious mind as the source of all human creativity; he also believed the creative impulse to be most truly revealed in gesture or "automatic 'écriture'." Soon, automatism became an indispensable tool in Pollock's arsenal of graphic techniques during the treatments for alcoholism the artist was undergoing with two Jungian analysts, who, as Donald Gordon has written, "encouraged him to accept the babblings and doodlings of his unconscious as part of his personal identity and ineluctable fate as an artist." Thus, with the "automatic" works of André Masson as an additional, Surrealist guide, if only through the medium of *Cahiers d'art* and *Minotaure*, Pollock struggled to probe and harness the chaotic energy of his inner life and, while expelling its demons, exploit their origin as a rich, upwelling source of formal invention and fresh archetypal imagery. Equally important was the evident reality that by becoming so vibrantly engaged with his own primal depths, he was better able to assimilate outside influences and make them authentically his own. Of all the numerous models beckoning ambitious American artists in the 1930s, the most significant for the future was certainly the School of Paris, and what set Pollock apart—permitting him to "break the ice," as de Kooning said—was his eventual but pioneer success in mastering the logic of Paris-based modernism, rather than merely the appearances that grace the works of earlier American progressives. The European who in the late 1930s most challenged Pollock and other artist-members of the New York vanguard was Pablo Picasso, especially the Synthetic Cubist, Expressionist, Surrealist Picasso of the *Guernica* period. Something of the complex of influences that Pollock absorbed and synthesized by factoring it through his own tumultuous sensibility can be seen in a painting like *Composition with Donkey Head* (fig. 64). While the powerfully chiaroscuro draftsmanship, frightened animal image, and wide format recall *Guernica*, the transmutation of the ass's head into a pair of upside-down, superimposed human masks, or severed heads, and all of these into the surrounding miasma of swirling lines evinces the dream-nightmare world of a preconscious imagination, conjured through the psychic automatism urged by Graham, the Surrealists, and the artist's Jungian analysts.

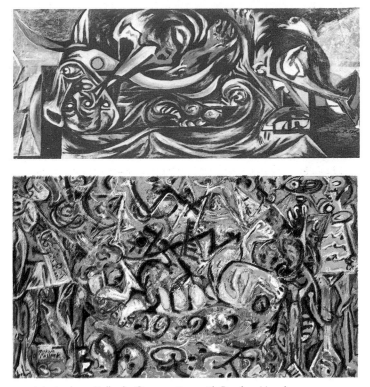

top: 64. Jackson Pollock. *Composition with Donkey Head.* c. 1938–41. Oil on canvas, 1'9⅞" × 4'2". Estate of Lee Krasner Pollock. Courtesy Jason McCoy Gallery, New York.

above: 65. Jackson Pollock. *Pasiphaë.* c. 1943. Oil on canvas, 4'8⅛" × 8'. Metropolitan Museum of Art, New York (purchase).

Composition with Donkey Head represents the state of Pollock's art when the twenty-nine-year-old painter made his debut in the commercial world of New York galleries. This occurred in January 1941, thanks to John Graham, who organized an exhibition for McMillen Inc., the well-known interior design firm, and, along with paintings by Picasso, Matisse, Braque, Bonnard, and Modigliani, included works by several Americans, among them Stuart Davis, Walt Kuhn, and such unknowns as Pollock, de Kooning, and Krasner. The occasion also marked the beginning of the life-long relationship that Pollock would have with Lee Krasner, through whom he met other members of the future Abstract Expressionist group and learned still more about Cubism and Surrealism. Together the friends joined Motherwell, Baziotes, and their wives for evenings spent writing automatist poetry, while during the day Pollock did janitorial service at the Museum of Non-Objective Painting (now the Solomon R. Guggenheim Museum), to make up for the slender stipend he lost when the WPA was terminated in 1943. Meanwhile, Motherwell introduced Pollock to Peggy Guggenheim, recently returned to New York from war-torn Europe and prepared to exhibit new American art alongside the Europeans' latest abstract and Surrealist works at her museum-gallery, Art of This Century. Towards the end of 1943 Guggenheim gave Pollock a year's contract and his first one-man show, two events that constituted the first big career breakthrough to be realized by a member of the yet-to-be-named Abstract Expressionist group. And such were the scale, resolute boldness, and protean invention of the work Pollock now offered that the paintings not only survived exposure in the most sophisticated setting of their time but even triumphed, prompting Clement Greenberg to write of the "surprise and fulfillment in Jackson Pollock's not so abstract abstractions." Having "gone through the influence of Miró, Picasso, Mexican painting, and what not," Pollock had, the critic continued, "come out on the other side at the age of thirty-one, painting mostly with his own brush."

A major Pollock of 1943, though not exhibited until 1944, is *Pasiphaë* (fig. 65), an 8-foot-wide canvas as ambiguous in form and pro-

foundly original in feeling as any noted by Greenberg. A key to both form and feeling, however, and a confirmation of their mythopoetic nature can be found in the title, which evokes the ancient Moon Goddess who, after falling in love with the beautiful white bull given to her husband, King Minos of Crete, by Poseidon, god of the sea, managed to consummate the taboo passion while hidden inside a wooden cow. The issue of the affair was the Minotaur, the hybrid creature, compounded of a bull's head and a man's body, that carried such symbolic import for the Surrealists. Yet beyond the title itself lies the vital fact that Pollock, as was his wont, christened the painting only after he had finished it. Furthermore, the name finally chosen came from someone else, who thought it evocative of the image emerging, like a chimera, from within the phantasmagoria of wildly scrawling lines and savage colors, more evocative, at least, than *Moby Dick*, the title first suggested to the artist by his own work. Either way, theme and expression combine to leave little doubt that the painting concerns sex, power, and bestiality, although the name *Pasiphaë*, to a still greater degree than *Moby Dick*, implies a deep and violent stirring of racial memory, or what Jung had termed the "collective unconscious." Certainly, insofar as the jagged, gyrating, graffiti-like markings achieve closure at the center of the field, they imply not a white whale but rather the charged profile of an animal lying on its back while convulsed as if from sexual congress. Like the ideographic "writing" and the American Indian palette of red, ochre, black, and white on a blue ground, such an image seems reminiscent of prehistoric cave painting, and all the more so by reason of the masked "guardian" figures that appear to stand the full height of the canvas at its lateral edges. But these totemic presences also arrest the outward rush of energy, as do the border-like patterns that zigzag and spiral along the upper and lower reaches of the format. Meanwhile, the figural definitions remain so vague that they scarcely interrupt the overall riot of miscellaneous accents; thus, even though set down with the force of a battering ram, they adhere to the measured Cubist system of fragmented form spread more or less consistently throughout, but well within, a shallow, bas-relief space delimited by the shape of the canvas at its perimeters. If John Graham had written about *Pasiphaë* he might well have said, as he did in the 1937 article Pollock found so persuasive, that this painting, like Picasso's, "has the same ease of access to the unconscious as have primitive artists plus a conscious intelligence." Although capable of a vast range of expression, including delicacy and infinite, even sparkling nuance, Pollock had to begin with the particulars of his own truth; finding this brutal and chaotic, he worked brutally and chaotically until the particulars had been pulverized and thereby transformed into the general. Here a sorely divided nature could find solace in an ambivalent unity of ferociously individualized glyphs so evenly dispersed that the plastic and the symbolic, the personal and the universal fuse in an all-over singleness of statement. Like Picasso almost forty years earlier, Pollock might well have said: "If we give spirits a form, we become independent."

True independence came to Pollock after 1945, when he and Lee Krasner, now married, moved to a farmhouse near the village of Springs, about 110 miles from New York City in the rural, coastal reaches of Long Island. There, as urban pressures eased, so did the artist's drinking, and as the dark phantoms subsided, Pollock rediscovered nature, not only in the bucolic world about him but also within, the internalized "racial memory" of the open farmlands of his childhood in the Far West. When Hans Hofmann, several years earlier, first saw Pollock's paintings, he remarked that the younger artist clearly "worked from the heart," but would perhaps do better to work also from nature. To this Pollock snapped: "I am nature." And so now, after he had pushed expressionism to the point where it all but dissolved even the most abstract figuration, Pollock found that the need to depict had gradually disappeared. More and more, from 1945–46 onward, he would "veil" his mythic concerns not in abstracted figuration but rather in pure gesture, made symbolic through the ritualized act of painting itself. In *Shimmering Substance*, for example (fig.

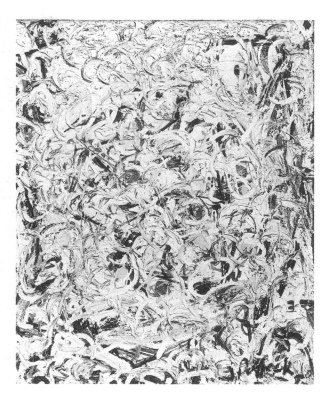

66), the all-overness inherited from Analytic Cubism and implicit in Pollock's work from the start became both explicit and paramount. Here the artist extruded viscous medium directly from the tube and, in William Rubin's words, allowed his line to form "a series of looped and arabesqued patterns *all roughly similar in character and in approximate size* and *more or less in density over the whole surface* of the picture." In this lyrical swarm of pure gesture the Cubist grid has been swallowed up, only to remain as an intuited presence both in the continuing respect paid to the canvas boundaries and in the regular weave, or endlessly varied repetition, of vermicular strokes. Also gone, or perhaps assimilated and generalized, are the overt symbols and hierarchical design that Cubism had sanctioned, while the archetypal content they embodied has been expressed more immediately than ever before in the universal language of abstract form. Should there be any question of this, we have only to consider the lugubrious underpainting that here and there peeps through the frontalized screen of lacework paint, ominous reminders of old anxieties, of the seeds of destruction that germinate even in a rhapsodic image of burgeoning June.

Once Pollock had attained totally abstract all-over painting in works like *Shimmering Substance*, only a short step was required for him to make a major move into the culminating phase of his art, a phase that produced the heroic, even classic "drip" paintings of 1947–50 (figs. 41, 67). Contrary to popular fiction, this development did not come from a noble, existential savage acting out of mindless spontaneity, but rather from a boldly discriminating artist deliberately seeking to realize the full potential of rhythmic, centrifugal all-overness and the automatic process that produced it. This meant coming into possession of means sufficiently free and fluid that they could respond simultaneously to both necessity and choice—that is, to the deepest impulses of the unconscious as well as to the lightning dictates of conscious aesthetic decision. Such seemingly inimical purposes, moreover, had not only to be fused; they also had to be satisfied on a tremendously enhanced scale, for inherent in Pollock's circular movements was the pent-up urge to expand, to relieve or validate passionate personal feeling by endowing it with something like the impersonality of cosmic dimension. Thus, when handwrought brush, knife, or tube work proved too slow and inhibiting, Pollock returned to the drip technique he had been investigating since 1936 and, aided by sticks, hard-

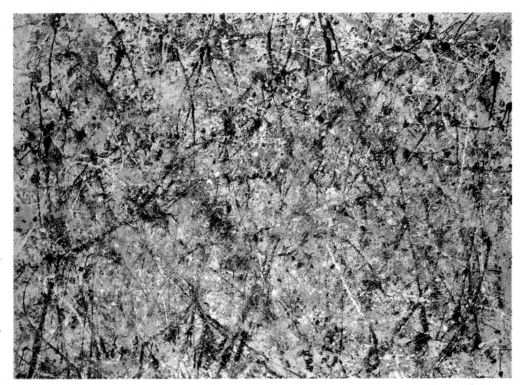

ened brushes, and garden trowels, began dribbling liquid Duco enamel, aluminum, and oil paint directly from cans onto giant lengths of sized, unprimed canvas tacked to the floor of his barn studio in Springs. Since the technique responded to authentic need, it proved to be an epiphany not only for Pollock and his generation, but also for the whole of what is now called the late-modern period. Working so large and on the floor, the artist could step quite literally into his painting and there, without ever touching brush to canvas, immerse himself in the creative process as no one had ever done before (fig. 68). With the fluidity allowed by spilling liquid medium, he found it possible to continue his line endlessly, free of the constraining starts and stops of traditional methods, and, at the same time, inflect its arabesques with infinite grace and subtlety. While casting out large, lazy arcs, Pollock might also miniaturize and lace together a configuration of intricate, almost rococo delicacy. Often the trajectories would seem to race with the speed of an arrow, shooting straight through puddles or moraines of spreading pigment, their presence providing harbors of mystery and menace, like the dark visionary poetry of the Surrealist "eyes" in *Composition with Donkey Head*. As the poet Frank O'Hara wrote in 1959, Pollock developed an "amazing ability to quicken a line by thinning it, to slow it by flooding, to elaborate that simplest of

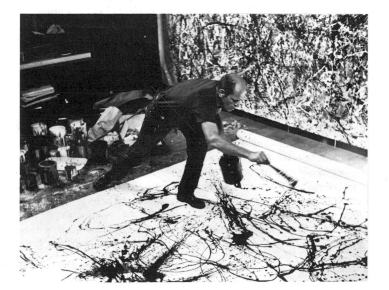

elements, the line—to change, to reinvigorate, to extend, to build up an embarrassment of riches in the mass of drawing alone.'' Altogether, pouring and scale allowed Pollock to bring to mural-size art all the intimacy and intensity of easel painting, while investing these with full-blooded baroque drama. Now the once dour, troubled artist found himself working with sovereign, surprising ease and confidence. In 1947 he put it this way:

When I am in my painting, I'm not aware of what I'm doing. It is only after a sort of "get acquainted" period that I see what I have been about. I have no fears about making changes, destroying the image, etc., because the painting has a life of its own. I try to let it come through. It is only when I lose contact with the painting that the result is a mess. Otherwise there is pure harmony, an easy give and take, and the painting comes out well.

The generous, uninterrupted flux of energy that made the painting come out well—that permitted harmony rather than conflict to reign among the "give and take" of opposites—stemmed as much from the artist's now magisterial command of formalist principles as from his fearless conjuring of irrational drives. If the remarks just quoted leave Pollock seeming too much the inspired primitive, it should be noted that he also said in 1950: "When I am painting I have a general notion as to what I am about. I can control the flow of paint: there is no accident." There could be nothing totally fortuitous because the artist cultivated and, with virtuoso brilliance, transformed accidents into aesthetic or expressive coherence, a phenomenon that, even more than the pouring, outraged a public steeped in traditional expectations of what painting should be. But as reflection and unpremeditated reflex meshed and stimulated one another, Pollock seemed to take flight, giving effect to painting after painting that more and more became formal signs of spiritual and physical regeneration. The conditions of the art-making virtually assured that none of the works would lapse into formula, even though all the great "spill and spatter" canvases came forth resembling vast, airy webs or starry firmaments. However repetitious the tossed and turning skeins, they never become anonymous decoration, but constantly renew themselves, as the line rips, skips, meanders, bites, or bleeds its way across and around the field, finally into a calligraphic *perpetuum mobile* whose maze- or vortex-like image has often been seen as a metaphor for universal genesis. In *Full Fathom Five* one could indeed be looking into green watery depths on the First Day, a realm swimming with trails of dark marine

The New York School: Abstract Expressionism

vegetation but lit from below by ghostly phosphorescent forms and fiery Rheingold nuggets. *Lavender Mist*, on the other hand (fig. 67), shimmers with spidery sprays and atomized clusters, its tender, romantic haze of pale mauve, silver, and black the product of turbulence become exaltation, of an earthy, encrusted surface optically metamorphosed into gauzy luminescence, like a midsummer's night alive with glowworms, shooting stars, and first love. The painting known as *Mural on Indian Red Ground* embodies a more theatrical encounter, its rope dance of powerfully contrasted colors set against a ground of rich sienna, reminding us that Pollock once expressed admiration for the magic content of the Hopi Indians' "sand paintings," made by ritualistically spilling colored soil. A master draftsman, Pollock characteristically favored chiaroscuro effects, but while using color sparely, he always infused it with poetic import, as in the elegiac *Autumn Rhythm*, where isolated notes of sky blue provide counterpoints of private feeling to the massed choirs of black, beige, and white (fig. 41).

The wealth of painting culture with which Pollock counterbalanced his ecstatic outpourings of 1947–50 included not only the later Picasso, Surrealist automatism, Jungian myth, and tribal sand painting already cited, but also Kandinsky in his pre-1914 Improvisations, prime examples of which the artist would have seen at the Museum of Non-Objective Art, especially during his custodial service there in 1942. In their spatial fluidity, romantic Expressionism, and appearance of extreme abstraction, the Kandinskys now seem direct forebears of Pollock's drip paintings. They may even have helped the American artist look beyond the riveting drama of Picasso in his *Guernica* period and back to the classically restrained, smoky masterpieces that Picasso and Braque created in the 1908–11 era of their Analytic Cubism. It was as if Pollock, with a freshness of vision unique

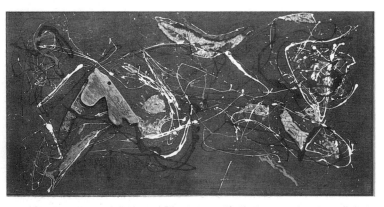

above: 69. Jackson Pollock. *The Wooden Horse.* 1948. Collage, oil on canvas, 2'11¾" × 5'9⅜". Moderna Museet, Stockholm.

below: 70. Jackson Pollock. *Number 27, 1951.* 1951. Enamel on canvas, 4'7¾" × 6'1". Private collection.

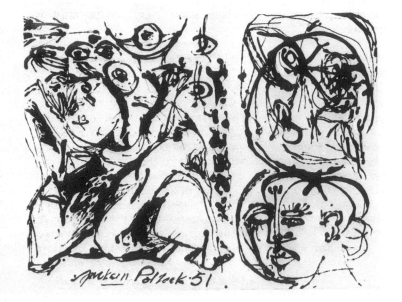

to him at this time, saw in Analytic Cubist all-overness, created by a reduction of both form and space to a dense, interpenetrated array of analogous, rectangular planes, the possibility of a grander, more uncompromising statement. The founding Cubists had felt their work to be "drenched in humanity" and thus stopped short of pushing it across the line into the highly spiritualized world of pure abstraction. Pollock, with his desperate belief in the redemptive efficacy of painting, felt compelled to go the whole way. And so, fired by psychic automatism and the pouring process, he melted the Cubist grid, liquified its myriad right angles into one ongoing, undulant flow, and translated the small, localized, step-by-step fluidity of its shuffled planes and eliding *passage* into the vast, surging continuum of the drip paintings. But if Cubist scaffolding has been exploded, its structure and clarity can still be sensed, subsumed in webs that seem prodigiously elaborated, arabesque versions of the old rectilinear coordinates. It can also be detected in the way the ever-revolving lines respect the reality of the painting support, never venturing beyond the frame but, instead, rebounding towards the interior. Moreover, they reify the surface by seeming to hover there as if within a shallow space in front of and free from the background, the uniform color of which suggests infinite depth, or a near plane, like that in the recess of a bas-relief.

While such a conception does nothing to draw one into a fictive pictorial world, like that of trompe-l'oeil or illusionistic Renaissance painting, the tremendously augmented scale upon which it is projected embraces the viewer by invading his own space and kinesthetically involving him in its dynamic, all-over image and the mood this generates. In their environmental size and homogeneity of surface, the drip paintings had another, albeit unknown, antecedent in the wall-size Waterlily canvases painted by Claude Monet in the final decade of his long life, which ended in 1926, less than four years before the arrival of Pollock in New York. By focusing exclusively on a lucent sheet of pond water afloat with lily pads, lotus blossoms, and fluctuating reflections of the sky above, Monet had found a motif—a piece of the real world—that offered exact synonymy with Impressionism's generally uniform molecularization of the painting surface, where each small tessera in the overall mosaic of paint deposits represents nothing so much as a momentary sensation of light, color, and feeling. Although the Waterlilies had no direct influence on Pollock, the affinity between those immense, atmospherically abstracted works and the drip paintings was so great that Pollock's achievement alerted painters and critics to the importance and originality of Monet's late art, with notable consequences for the Color-Field Painting yet to come.

For all their expansive energy and viewer-enveloping, environmental scale, however, Pollock's webbings do not run on, like patterned wallpaper or yard goods, but turn upon themselves and, as in all great painting, create a universe of their own, albeit one evoking a sense of sublime boundlessness. This monolithic completion and its easy, natural grandeur spring from the continuity of the improvisational, but richly informed, process that created them, that played out an unbroken filament of paint, which, by virtue of its self-renewing momentum, retains a dominant personality even as the spilling modulates through circuits as unforeseeable as, finally, they seem inevitable. In an art of unabating invention, subtle, persistent surprise is so omnipresent that it surpasses traditional variety to become the essence of an astonishingly classical, cohesive unity. Here, all-overness, while not original to the drip paintings, attained a radicality of expression that has been called "holistic." Working from above canvas spread on the floor, Pollock could "literally be in the painting," move about within it, and thus give equal emphasis to every area. In this way he brought to a culminating moment modernism's long-developing tendency to avoid hierarchies or climaxes and to seek a single, characteristic image articulating the whole of the visual field as an evenly packed continuum. Although anticipated by the Impressionists and advanced by the Analytic Cubists, the "holism" achieved by Pollock was something new in modern art. Confronted with his labyrinthine

complexity, the eye gives up following along endless convolutions and accepts the indivisibility of the total configuration. Unlike "relational" compositions, where unity derives from an assemblage of intimately related parts—a traditional system that prevailed even in the highly unified art of Mondrian—Pollock's holism reconstrued the picture as a single undifferentiated image without segregable parts.

Contributing to this singleness of image is the fact that line and color have merged, thereby converting drawing into painting; and wherever stained directly into unprimed canvas, their joint effect is to close the age-old gap between figure and ground. The unitary, allover, two-dimensional space thus yielded by the created image has also been called "optical." Together, line and color, emancipated from their traditional obligation to contour or describe planes and volumes, elements capable of overlapping or receding in depth, have become autonomous, therefore free to lead the eye through an entrancing exploration of surface but never beyond it, where a more physical or tactile experience would be evoked. Yet this sense of pure opticality, or immateriality, has been produced by an almost erotically present and material surface, a place where tangled nets of medium look aerated and lucid, where thick paint blotches connote galactic bursts and flung aluminum enamel the arching phrases of music. This is what Elizabeth Frank, in her eloquent monograph on Pollock, has termed the "polymorphous potency" of the artist's line—its "capacity to be everywhere at once, to serve [in purely abstract terms] the ends of illusion and materiality." Like Braque and Picasso in 1911–12, when they stenciled numbers and words on their Analytic Cubist abstractions or made abstract compositions from collages of found materials or objects, Pollock sought to anchor his abstract art in reality, sometimes by slapping the canvas with his own handprints or by studding the surface with such flotsam as cigarette butts, matches, buttons, combs, and keys. He too, from an expressionist desire to communicate, found it important to keep a rarefied image from slipping clear of sensuous human experience and into some unreachable sphere of pure mind or spirit. In *The Wooden Horse* Pollock (fig. 69) fitted into the tracery of one of his most airborne, lyrical skeins the head of a hobbyhorse, as if to demonstrate that his abstract drawing-painting could easily reverse into the figuration where it originated.

In 1950, at the height of his critical success, Pollock declared that "new needs need new techniques." About this time, after ten years of uninterrupted growth, the artist did not so much change methods as discover that automatism and pouring were delivering from his unconscious a kind of image and mood quite different from the heroic abstractions of 1947–50 (fig. 70). If these soaring works looked like symbols of order wrested from chaos, the new paintings struck critics as symptoms of chaos both revived and vengeful. For the most advanced painter of his time to backslide into figuration seemed a heresy, even more so than in the case of de Kooning, whose art had never broken quite so decisively with the past. And Pollock himself appeared to be mourning his "lapse," since he now restricted his means to black enamel stained directly into unprimed white canvas. Of course, the artist had always been a draftsmanly chiaroscuro painter; moreover, he continued, for the most part, to avoid contouring, with its implications of sculpturesque volume, and simply allowed the spectral, ambiguous images to emerge from, as well as sink back into, a maelstrom of autonomous drawing-painting. Even this internal oscillation between figuration and abstraction could be seen as part of the ongoing dialectic carried out by an artist who, in the true spirit of modernism, refused to repeat himself and never ceased to challenge the terms of his own achievement. And troubling as the black paintings have always been for admirers of the large drip abstractions, they had their impact on significant future developments, especially in the later Color-Field Painting ushered in by Helen Frankenthaler and Morris Louis. Perhaps more important, they dispel the unfortunate notion, initially fostered by the critic Harold Rosenberg, that Pollock viewed his canvas "as an arena in which to act" and what went on it as "not a picture but an event." If nothing else, the variant receptions

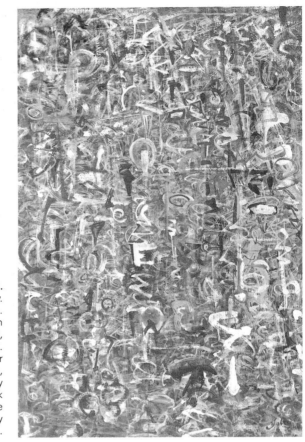

71.
Mark Tobey.
Tundra. 1944.
Tempera on board, 24 × 16½".
Neuberger Museum, State University of New York at Purchase (gift of Roy R. Neuberger).

accorded the drip paintings and the black works indicate that no art can succeed other than as an aesthetic object capable of bearing whatever expressive burden may be placed upon it. Since Pollock himself was not confused on this issue, he eventually returned to pouring large-scale abstractions, and even produced a number of masterpieces, none of them, however, with the singing freedom of 1947–50.

If Pollock began to mourn in 1950, it may have been for the drinking he resumed after two years of sobriety. It has even been suggested that his Calvinist soul suffered guilt feelings about success, which, commercially as well as critically, was at least sufficient to win him major gallery representation after Peggy Guggenheim closed Art of This Century in 1947 and moved back to Europe. By 1956 the alcoholism had become unmanageable, and on the night of August 11 Pollock died at the age of forty-four when the automobile he was driving, while under the influence, ran off the road and crashed into a stand of trees. Although his art never earned him more than a frugal livelihood, he had already become a near-mythic figure, and by 1970 the *Artforum* critic Philip Leider could write: " . . . it is as if his work was the last achievement of whose status every serious artist is convinced."

A distinguished American painter who seemed to have heralded Pollock's holism and opticality, complete with an all-over, charged network of wiry, nonallusive lines, was Mark Tobey (1890–1976; fig. 71). Once this has been said, however, the analogy ceases, for not only was Tobey much older than the Abstract Expressionists, having already exhibited in 1917, but he also worked in intimate, cabinet-size formats consistent with his inspiration in Oriental calligraphy and Zen Buddhism. Moreover, he spent long periods abroad and had only brief, intermittent contacts with New York, where, however, his mature art could be seen with some regularity from 1944 onward. One of the most independent, even isolated, of all modernists, the Wisconsin-born Tobey began his journey towards a pioneer abstract style when in 1918, while working as an interior designer in New York, he converted to Baha'i, a religion whose meditative search for the oneness within the apparent multiplicity of life seemed to provide a refuge

The New York School: Abstract Expressionism

from the dehumanizing effects of American industrialization and its materialist spirit. This led Tobey to study Chinese brush calligraphy, then to tour the Far East and spend a month in a Zen monastery in Kyoto. Meanwhile, from 1930 until 1938, he lectured and served as artist-in-residence at Dartington Hall in Devonshire, England. There, in 1936, upon his return from the Orient, he began his "white writing," the key feature of the signature style he would explore and refine for the rest of his life. Progressively, after Tobey repatriated to Seattle in 1938, his line became more purely calligraphic, until it abandoned all descriptive function and merged into a field-wide fretwork of intricate, autonomous drawing, an image expressing the artist's deep, religious conviction that space, far from being a vacuum, is as vital with spiritual and physical energy as solid matter (fig. 71). Thus, with their generalized array of abstract gesture conveying a sense of profound content, Tobey's white-writing pictures seem at home among the works of the Action painters, except for the all-important fact of their delicate facture and the wrist movements that produced it, which are remote from the raw, full-bodied vehemence and heroic grandeur of the Abstract Expressionists. Moreover, Tobey had no interest in the Freudian-Jungian-Surrealist origins of the New Yorkers' automatist process. Instead, he believed that "painting should come through the avenues of meditation rather than the canals of action." In his mysticism and refinement, Tobey seems more immediately akin to such earlier abstractionists as Kandinsky, Malevich, Mondrian, and Klee. It should not surprise therefore that in the postwar years this American enjoyed a major reputation in Europe, where he lived, in Klee's old house in Basel, from 1960 until his death seventeen years later.

Color-Field Painting

More given to reflection than action, the painters who would create the Color-Field branch of Abstract Expressionism took longer to arrive at their mature styles, achieving them only around 1950. And this was true even though Clyfford Still, Mark Rothko, and Barnett Newman—the major figures in the group—were, on average, slightly older than the gesture painters and shared the same romantic attitude as those artists. Moreover, they too had mastered Cubist space, understood Surrealist process, displayed an even stronger preoccupation with myth and symbol, and were equally determined to create a passionate, original, abstract art soaked in transcendental meaning. Indeed, the draftsmanly, semifigural manner first developed by these artists made their work scarcely distinguishable from that of the Gorky-de Kooning-Pollock faction right up to 1947–48. Thenceforth, however, their search for forms capable of translating a deeply personal, tragic vision into sublime or suprapersonal revelation began leading them away from linear spontaneity and dramatic chiaroscuro towards immense, open expanses of relatively undifferentiated color, the spread of continuous hue saved from formlessness and made coherent or expressive by its total identification with the shape and flatness of the canvas. Since this yielded autonomous images of even greater holism, clarity, or unitariness than Pollock's all-over cosmic gyres, it represented a still more radical departure from the past than anything wrought by the Action painters.

Yet however revolutionary their formal innovations, Still, Rothko, and Newman, like all the Abstract Expressionists, considered style an attribute of content, which for these artists assumed an importance that all but passed over into the realm of religion. More systematically intellectual and certainly more literary than the Action painters, Newman and Rothko wrote graceful, cogent essays leaving no doubt about the mystical purposes of their art and the direct, overpowering emotional impact they hoped its monumental reductiveness would have, an impact comparable to that of the "naïve" but spiritually potent simplifications of primitive art. At the outset of a piece he wrote in 1947 for a catalogue to an exhibition entitled "The Ideographic Picture," Newman stated: "The Kwakiutl artist painting on a hide did not concern himself with the inconsequentials that made up

the opulent social rivalries of the Northwest Coast Indian scene, nor did he, in the name of a higher purity, renounce the living world for the meaningless materialism of design. The abstract shape he used, his entire plastic language, was directed by a ritualistic will towards metaphysical understanding." Then, in his conclusion, Newman wrote: "Spontaneous, and emerging from several points, there has arisen during the war years a new force in American painting that is the modern counterpart of the primitive impulse. . . . " In a 1948 essay Newman developed the idea further by asserting that the desire for the infinite had remained urgent in Western culture despite millennia of its having been equated with Greek-spawned notions of beauty: the sensuous, material world idealized through measure and proportion. Thus, "even Mondrian, in his attempts to destroy the Renaissance picture by his insistence on pure subject matter, succeeded only in raising the white plane and the right angle into a realm of sublimity, where the sublime paradoxically becomes an absolute of perfect sensations. The geometry (perfection) swallowed up his metaphysics (his exaltation)." However, Newman went on, "I believe that here in America, some of us, free from the weight of European culture, are finding the answer, by completely denying that art has any concern with the problem of beauty and where to find it. . . .

We are reasserting man's natural desire for the exalted, for a concern with our relationship to the absolute emotions. We do not need the obsolete props of an outmoded and antiquated legend. We are creating images whose reality is self-evident and which are devoid of the props and crutches that evoke associations with outmoded images, both sublime and beautiful. We are freeing ourselves of the impediments of memory, association, nostalgia, legend, myth, or what have you, that have been the devices of Western European painting. Instead of making cathedrals out of Christ, man, or "life," we are making it out of ourselves, out of our own feelings. The image we produce is the self-evident one of revelation, real and concrete, that can be understood by anyone who will look at it without the nostalgic glasses of history.

Seeking a metaphor for the sacred, at a secular moment when traditional signs of faith had lost their power to inspire, Still, Rothko, and Newman repudiated all previous systems, including those of Cubism, as too formulaic and thus too predictable to yield images likely to evoke transcendence. Even Surrealist automatism struck them as so autographic as to limit the possibilities for generating an aura of universal mystery. Only an art stripped of everything received or familiar—drawing, modeling, value contrasts, figuration, symbolism, gesture—could satisfy their desire for an image sufficiently free of external influences to soar above the commonplace. "With us," a curmudgeonly Still once said, "the disguise must be complete. The familiar identity of things has to be pulverized in order to destroy the finite associations with which our society increasingly enshrines every aspect of our environment." The "disguise," moreover, had to be grand enough in scale to overwhelm or stun the viewer, detaching him from all preconceptions and replacing these with a sense of the elementary and the boundless. When this was done with little more than flat, rectangular canvas and relatively unmodulated color, the results were Color-Field Painting. It moved viewers because, oddly enough, the ultimate effect of an enveloping, environmental stretch of color is less awesomeness than intimacy, for as Rothko stated in 1951: "The reason I paint [large pictures] . . . is precisely because I want to be very intimate and human. To paint a small picture is to place yourself outside your experience, to look upon an experience as a stereopticon view or reducing glass. However you paint the larger picture, you are in it. It isn't something you command."

Since even the most revolutionary art seems inevitably to evolve, rather than break altogether with precedent, forerunners of Color-Field Painting could be seen in at least three mighty 20th-century chromaticists—Matisse, Miró, and the American Milton Avery—all of whom, unlike the improvisational Kandinsky, worked in a serenely deliberative fashion and favored imagery formed with broad planes of fresh, synthetic color. Spiritually, however, the Color-Field painters were more akin to Kandinsky—and formally as well as spiritually to

Malevich and other members of the early Russian avant-garde, whose work the New Yorkers could not have known. And so the direct precursors seem rather earth-bound or hedonist compared to the great leap of faith taken by Still, Rothko, and Newman. Because the springboard of their vaulting aspiration lay within the individual artist's most personal, interior life, the abstract image could not but be as distinctive as a signature, but when this had been achieved, the Color-Field painter felt comfortable repeating it in series of endless, subtle variations. After all, art that attempted to express an unqualified act did not have to be reinvented with each new stroke, as in the more existential, process-involved work of the Action painters.

At the one-man show Betty Parsons gave him in New York during the winter of 1947, Clyfford Still (1904–80) became the first to exhibit what would later be known as Color-Field Painting (fig. 72). Once this has been said, however, it should be admitted that Still, by force of his extreme originality, was probably the artist whose work least conforms to the characteristics—especially the serene surface and monolithic image—normally attributed to the style he helped establish. Rugged, pioneer independence and even isolation marked the whole of the life as well as the art of Clyfford Still, born on the flatlands of North Dakota and raised in Washington State and Alberta, Canada, where, according to Dore Ashton, he claimed to have had arms "bloody to the elbows shucking wheat" while riding a horse five miles by night "to bang out Brahms and look at art magazines." Except for several brief excursions to New York, Still remained in the Far West until 1943, studying and teaching at Washington State University, among other activities. By the time he arrived in the East, first to teach at Virginia's Richmond Professional Institute and then to try his luck in New York in 1945, Still had already begun to forge his own colorful, crankily self-reliant, xenophobic persona. Approaching art as if it were America's new frontier, he excoriated the homage paid to European aesthetic traditions as "a celebration of death," called the New York art world "an arrogant farce," and declared himself the one who, with "a single stroke of paint, backed by work and a mind that understood its potency and implications, could restore to man the freedom lost in twenty centuries of apology and devices for subjugation." Given such rhetoric, uttered with puritanical fervor at various moments over the next thirty years, it is little wonder that Still came to be known as a "Prairie Coriolanus" or, in Robert Motherwell's words, "the John Brown of art." Such epithets would never have been coined, however, had Still not deserved serious, awestruck notice for having backed his jeremiads and pretensions with heroically scaled canvases whose stark, innovative color-forms, soaring spaces, and rude, Wagnerian power left no doubt concerning the absoluteness and sublimity of their content.

Little is known about Still's early painting, although the artist assures us that by the end of his twenty-fifth year he had "seen and studied deeply the works and acts of those men of art presented in museums and books as masters," only to conclude "that very few of them merited the admiration they received and those few often achieved true worth after they had defied their means and mores." Foremost among the latter he counted Turner, Matisse, and, above all, that fellow solipsist Gauguin. For the Cubists he reserved a special scorn, believing them to be the authors of mechanically produced parlor art, while their progeny at the Bauhaus had formulated an authoritarian program capable of enslaving the human race, indeed of having "briskly herded [it] into a cool, universal Buchenwald." Violently opposed to "the collectivist rationale" and the omnivorous "totalitarian mind," Still wanted to create an art that would "emancipate," and the "organic lesson" he had learned from his researches suggested that this "exalted responsibility" would be fulfilled "totally and directly through my own life and hands." Thus, in the 1930s "the work of clarifying, excising, extending and reviewing was pressed during all the time and with all the energy I could order. Until those symbols of obeisance to—or illustration of—vested social structures, from antiquity through Cubism and Surrealism to my then

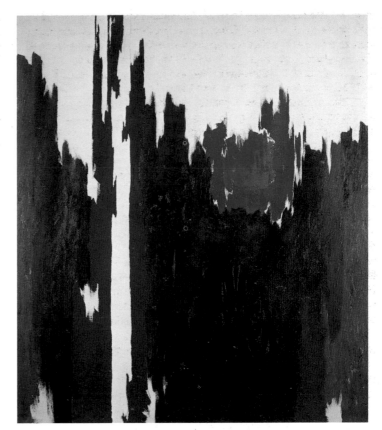

72. Clyfford Still. *1960-R.* 1960. Oil on canvas, 9' × 7'8", Hirshhorn Museum and Sculpture Garden, Smithsonian Institution, Washington, D.C. (gift of the artist, 1969).

immediate contemporaries, were impaled and their sycophancy exposed on the blade of my identity." While yet involved with figuration, Still seems to have sought his unique identity in two primary images, the wide-open landscape of the American West and, set against this empty vastness, a single human being, or a couple, standing isolated and solitary as if free to make of the environmental *tabula rasa* a heaven or a hell. Progressively distilling the themes, he realized them in the late 1930s as somewhat Picassoid or Orozco-like totems. By 1944, however, he had largely eliminated all explicit references to observable phenomena, producing, perhaps under the influence of Miró's abstract Surrealism, an early version of the tall, flaming or monkey-wrench imagery that would remain a constant throughout his mature oeuvre.

In 1947, as we have noted, Still succeeded in giving effect to his vision, in every way, that is, except the mural dimensions that would make it far more theatrically communicable or expressive than the aloof artist seemed prepared to expect. And when this came in 1949 it was gigantic, intensifying the impression of some glacial, mythic terrain, open, outwardly expansive, and boundless (fig. 72). The thunderbolt contrasts remained, however, now formed as flat, elongated zones of differentiated hue shafted into one another from both top and bottom of the format, their splintered edges locking them together to form a continuous, albeit patchy, plane of color. Thus suspended in tension, the forms do not separate optically into positive-negative or figure-ground relationships, but partake of an indivisible, holistic field, simply cut off at the edges and thus, by inference, continuing beyond the arbitrary limits of the support. Adding to the sense of unity is the all-over tarry or bark-like texture of the pigment, a surface entirely at one with the jagged character of the abstract drawing and the frequent dourness of the colors. Occasionally a hook or wrench shape curls toward the horizontal, but never with enough emphasis or consistency to become coordinate with the verticals and thus re-establish the sort of articulated Cubist grid so detested by Still. The structure

The New York School: Abstract Expressionism

here—and secure it is—adheres to an altogether different order, the organic, vaulting Gothicism of northern, Romantic Europe rather than the calm, architectonic Baroque of the Classical Mediterranean world. Still himself stated it clearly when he voiced his preference for "the vertical rather than the horizontal, the single projection, instead of polarities, the thrust of the flame instead of the oscillation of the wave." Viewers staggered by the rearing stalagmites and vertiginous falls of color—the cavernous blacks, the laking, cataracting blues, the desert-wide oranges, vermilions, or whites—often see abstract re-creations of the epic vistas—the Grand Canyon or Yosemite—painted by such 19th-century American landscapists as Frederic Church and Albert Bierstadt and, of course, well known to Still. But the paintings, with their sense of sublime, pantheistic immanence and portent, express something larger, which, given the artist's metaphysical engagement, may be nothing less than the freedom and release of heaven's own spaces. In this, as well as in the grandiose, anti-Cubist raggedness, they seem to be the direct, even if accidental, descendants of the frankly religious abstractions painted in the 1920s, 30s, and 40s by another American maverick, Augustus Vincent Tack. Of his own artistic and spiritual Pilgrim's Progress, Still wrote, in Hell-fire utterance worthy of a Calvinist divine: "It was a journey that one must make, walking straight and alone. . . . Until one had crossed the darkened and wasted valleys and come at last into clear air and could stand on a high and limitless plain. Imagination, no longer fettered by the laws of fear, became as one with Vision. And the Act, intrinsic and absolute, was its meaning, and the bearer of its passion."

The most celebrated, and thus for many viewers the most representative, Color-Field painter was Mark Rothko (1903–70), born Marcus Rothkowitz in Czarist Russia and forever haunted by the light-and-dark, good-and-evil obsessions so native to Russian souls, especially those of Jewish heritage. A longing for resolution of such painful opposites seems to have become permanently lodged in Rothko after 1910, when at the age of seven he immigrated with his family from the pogrom-ridden Old World to the relatively virgin, innocent environment of Oregon. Hardly had he arrived when the boy, with his bookish, Talmudic background, suffered the loss of his pharmacist father and had to work at various menial jobs while attending public school in Portland. Now young Rothko evinced an abiding interest in music, literature, and anarchist politics, but so excelled even in mathematics and science that he won a full scholarship to Yale,

which he entered in 1921 and then left in 1923 without graduating. In New York shortly thereafter he discovered his vocation in art, quite by chance as he wandered into a life-drawing class where a friend had enrolled. Right away Rothko took whatever piecemeal employment he could find and began studying at the Art Students League, under first George Bridgman and finally the veteran American modernist Max Weber, continuing with the latter until 1926. But without earlier and more orthodox training, particularly in draftsmanship, Rothko would always remain something of an autodidact. Far from a handicap, this limitation simply persuaded him, long before he encountered Surrealism, that significant art arose not from technical finesse but rather from deeply felt, universally relevant content. It also made him capable of teaching children, a part-time job he undertook in 1929 at the Brooklyn Jewish Center and held, as his principal source of income, for over thirty years. The experience could only reinforce his sense of the all-important "difference between sheer skill and skill that is linked to spirit, expressiveness, and personality." Rothko never forgot that he had come to painting, not directly or with remarkable natural talent, but late, with unremitting endeavor, and through his life-long, developing love for Mozart, Schubert, Beethoven, Aeschylus, Shakespeare, Nietzsche, and Kierkegaard. So great was his passion for the theater and its classical literature that for a brief period in 1924 he joined an acting company in Portland; eventually he would even regard his forms as "actors" and his paintings as symbolic re-enactments, "without embarrassment and . . . without shame," of the exalted drama of life, its progress from birth and hope through experience and disillusionment to death and transfiguration. Mark Rothko, with his renaissance interests and aptitudes, could undoubtedly have been an outstanding engineer, philosopher, or writer, but it was art that claimed and consumed him. Years later he was to remark: "I became a painter because I wanted to raise painting to the level of poignancy of music and poetry."

Thanks in part to his study under Max Weber, Rothko escaped the banal dominance of American Scene painting and began his artistic career as a brooding, romantically introspective Expressionist with a grasp of Cubism's shifting, frontalized planes suspended in a shallow space. Given these tendencies, he soon gravitated towards a prewar circle that included Gorky, de Kooning, David Smith, Newman, and Adolph Gottlieb (figs. 80, 82). He and Gottlieb had been close since the late 1920s and would be forever linked in history for the joint letter they composed, with the help of Barnett Newman, and sent, in June 1943, to the *New York Times* in response to a negative review of the third annual Federation of Modern Painters and Sculptors exhibition. In two revealing paragraphs the authors declared:

> *We favor the simple expression of the complex thought. We are for the large shape because it has the impact of the unequivocal. We wish to reassert the picture plane. We are for flat forms because they destroy illusion and reveal truth.*
>
> *It is a widely accepted notion among painters that it does not matter what one paints as long as it is well painted. This is the essence of academicism. There is no such thing as a good painting about nothing. We assert that the subject is crucial and only that subject matter is valid which is tragic and timeless. That is why we profess spiritual kinship with primitive and archaic art.*

By this time—or even by the late 1930s—Rothko had rediscovered Nietzsche's *The Birth of Tragedy*, a treatise whose call for a rhapsodic art capable of interpreting the horrors of existence with the universality of myth and the primal immediacy of music corresponded perfectly to Rothko's own thoughts. Also stimulating his belief in irrational instinct and ancient or primitive archetypes as sources of new art was the example of the Surrealists, who, as we have seen, arrived in force after 1939–40. Rothko, moreover, had even begun to experiment with Surrealist automatism. Progressively, therefore, he abandoned the Social Realism of paintings like *Subway Scene* (1938) for the imaginative world of, for example, *The Omen of the Eagle* (fig. 73), its stratified structure reminiscent of the earlier work but its im-

left: 73. Mark Rothko. *The Omen of the Eagle*. 1942. Oil on canvas, 25¾ × 17¾". National Gallery of Art, Washington, D.C. (gift of the Mark Rothko Foundation).

right: 74. Mark Rothko. *Vessels of Magic*. 1946. Watercolor on paper, 38½ × 25¾". Brooklyn Museum, New York (Museum Collection Funds).

75.
Mark Rothko.
*Golden
Composition.*
1949.
Oil on canvas,
6'5½" × 3'5".
Private
collection.

agery serving less to imply modern humanity's hellish decline than a layering of collective memory. Separated in friezes or registers are, from top to bottom, tragic-comic masks of Greek drama conflated as if in a dream; schematic eagles possibly symbolizing Promethean sacrifice, heroic liberation, or transcendence; automatist biomorphic forms combined with what could be cornice fragments or other architectural elements; and a cluster of massive, brutish human feet, their root- or trunk-like presence endowing the whole tiered ensemble with the hybrid beast-man-god character of a Mesopotamian relief. Meanwhile, the pastel palette and flat handling continue to reflect the artist's high regard for the painting of Milton Avery. In a statement published along with a reproduction of *The Omen of the Eagle*, Rothko wrote:

The theme here is derived from the Agamemnon Trilogy of Aeschylus. The picture deals not with the particular anecdote, but rather with the Spirit of Myth, which is generic to all myths at all times. It involves a pantheism in which man, bird, beast and tree—the known as well as the knowable—merge into a single tragic idea.

Always probing in debate, in self-analysis, and in his numerous writings, Rothko never ceased the struggle to clarify his ideas and their expression in painting. And so even as he and his fellow New Yorkers steadily moved away from representational imagery towards nondepictive forms, the artist wrote in 1945:

I adhere to the material reality of the world and the substance of things. I merely enlarge the extent of the reality. . . . I insist upon the equal existence of the world engendered in the mind and the world engendered by God outside it. . . . The abstract artist has given material existence to many unseen worlds and tempi. But I repudiate his denial of the anecdote just as I repudiate the denial of the material existence of the whole of reality. For art to me is an anecdote of the spirit, and the only means of making concrete the purpose of its varied quickness and stillness.

Within the same statement, however, Rothko also said: "If I have faltered in the use of familiar objects, it is because I refuse to mutilate their appearance for the sake of an action which they are too old to serve; or for which, perhaps, they had never been intended." Gradually, reverence for all creation, reluctance to stylize or "mutilate" it,

and a growing determination to evoke the spirit of myth in distinctly modern terms prompted Rothko to relinquish even the archaic or Surreal figuration of *The Omen of the Eagle* and to stage his pictorial dramas with a cast of purely abstract forms, or "performers" as the artist liked to term them. Encouraging him in this was the example of the boldly independent Clyfford Still, whom Rothko met in the summer of 1943, during a brief sojourn in California, and subsequently came to know very much better after the doughty Westerner arrived in New York in 1945. By this time Still, as we saw earlier, had already attained a somewhat Miróesque version of his characteristic flaming, nonallusive image, if not the heroic scale of its mature form. But Miró too played a role in Rothko's rapidly evolving art, as did the liberating strategies of Max Ernst and André Masson, among other abstract Surrealists. The results could be seen as early as 1945, when Rothko exhibited, in his first one-man show at Peggy Guggenheim's Art of This Century, works that the catalogue preface, written by Howard Putzel, called "the tactile expression of the intuitions of an artist to whom the subconscious represents not the farther, but the nearer, shore of art." Even the liquid ambience of pictures like *Slow Swirl at the Edge of the Sea*, with its light, semi-transparent marine coloration and freely floated traceries, suggests a plunge into the lower fathoms of the unconscious. Tapping into it by means of the automatist process, Rothko succeeded in discovering a "middle ground between surrealism and abstraction," a place where mythic content could be expressed, not in symbols borrowed from antique or primitive cultures, but rather in a synthesis of pure color and drawing, nuanced to evoke both the natural and the supernatural without describing either. Such Gorky-like paintings seemed to demand greater luminosity, and in search of it, Rothko temporarily gave up oil and began using watercolor. The shift enabled him to produce a series of delicate biomorphic abstractions marked by unabashed beauty and even playful wit, qualities unexpected from an artist so given to solemn, anxious introspection (fig. 74). But fluctuating or ambiguous as the aquatic imagery may be, the pictorial structure in which it has been so languorously set aswim retains the same flat, frontal, banded rigor already present in the 1938 *Subway Scene* as well as in *The Omen of the Eagle*.

The compositional stability lost none of its firmness, while gaining in flexibility, even as Rothko purged his art of the linearism that once helped define its internal scaffolding. The cleansing meant that he also eliminated the vestigial figuration implicated by the calligraphic drawing in his previous watercolors and the Surrealist automatism that had produced it. Painting by painting, the artist left Surrealism behind, enlarged his format, and, with color as the sole, essential means, purified his style until, in the winter of 1949–50, he had achieved the monumental, serenely revolutionary abstractions—the sovereign, mature Color-Field works—for which he is famous. Having conquered luminosity in the watercolors, Rothko could now effect it in oil, the medium thinned, soaked directly into the very weave of the canvas, and sponged, more than brushed, over broad areas of subtly modulated flatness like those in Matisse's *The Red Studio*, a masterpiece thoroughly studied by all the Abstract Expressionists after its installation at the Museum of Modern Art in 1949. In a number of transitional oils painted during the years 1947–49 Rothko attempted to compensate for the lined tiers of old by articulating the field with colors applied in blocky, atmospheric patches and then held to the surface—that is, countered in the optical tendency of their respective temperatures to advance or recede—with halo-like surrounds (fig. 75).

Finally, Rothko broke free of this transitional "multi-form" style into his uniquely individual manner, which by the 1950s consisted of a structure as solid as Mondrian's and entirely as transcendent in meaning, but simplified, clarified, and unified into a large-scale, full-color holism never imagined by the Dutch master. Characteristically, this took the form of an oversized rectangular field, usually tall, subdivided into two or three stacked or symmetrically ordered rectangles, each glowing like a veil of color-suffused light and hung against a con-

76. Mark Rothko. *Maroon on Blue.* 1957–60. Oil on canvas, 7'8" × 5'10½". Private collection.

but also complex relationships of form and structure—and make color, reduced to its essence, become shape, volume, and light, and these, finally, a vehicle of emotion and mood. Having now expressed the material reality of abstract painting, he had also created the perfect, *neutral* means of translating private yearning into an incorporeal revelation of cosmic truth. Rothko liked to think of his color fields as gates or doors through which, imaginatively, to leave the world of dross matter and enter a purified realm of the timeless and the absolute.

Lest viewers succumb solely to the opulent, ravishing beauty of his colors—especially the yellows, oranges, violets, and reds the artist seemed most often to prefer—without being touched by the shadowy vibrato emanating from their interpenetrated contrast, Rothko warned:

I am not interested in relationships of color or form or anything else. . . . I am interested only in expressing the basic human emotions—tragedy, ecstasy, doom, and so on—and the fact that lots of people break down and cry when confronted with my pictures shows that I communicate with those basic human emotions. The people who weep before my pictures are having the same religious experience I had when I painted them. And if you, as you say, are moved only by their color relationships, then you miss the point!

Like all great colorists, Rothko used his pigments with startling originality, to the point sometimes of making red symbolize tragedy and black gaiety. As he grew older, however, his palette darkened, reflecting an ever-more pained awareness of the razor's edge upon which he felt himself perched, between the present, material world he cherished and the immaterial world of larger meaning to which he aspired, a universe, however, that appeared forever denied to a doubting modern humanity cast adrift from its mythic past. Increasingly hypersensitive, withdrawn, and troubled—perhaps even by the wealth and praise his art brought him in the 1960s—Rothko welcomed the chance to deliberate his moral and aesthetic conundrums in a series of mural-size paintings commissioned in 1964 by John and Dominique de Menil for a chapel in Houston (originally Catholic in purpose but finally interdenominational). Mindful of the delicate equipoise of his pictorial dramas, Rothko had long since wanted to control the environment in which they would be viewed, and at the Houston chapel he could even dictate the octagonal plan of the architecture—inspired by Byzantine-Romanesque baptisteries and drawn up by Philip Johnson—that would house his giant canvases, works thematically devoted to the Passion of Christ but executed in a formal idiom that verged on the most reductively abstract of this artist's career (fig. 77). Comprised of two triptychs and one panel displaying black hard-edged rectangles on maroon fields and one triptych plus four single all-black panels filtered by thin washes of maroon, the Houston series hangs, silent and solitary, in a twilit space whose simple void echoes the paintings' mournful witness to the death that inevitably brings to an end life and all its earthly promise. But the pale, evanescent illumination also rewards the attentive viewer with the inkling of a dark afterglow from deep within the paintings' color, like the last embers of some inner fire, banked but still alive although engulfed by penumbral bleakness. In this tremor of dim luminescence, it is as if the artist clung to the overriding durability of the human spirit even as he acknowledged his own mortality. Here, like Sartre, Camus, Merleau-Ponty, Beckett, Kierkegaard, and other European Existentialists whose Nietzschean writings he read in the postwar era, Rothko had come to believe that, for contemporary secular, impious man, transcendence could be achieved only through subjectivity so total that it dispensed with everything extraneous and penetrated to the very quintessence of being. In the Houston paintings, he made this spiritual or psychological experience concrete by stripping away every extrapictorial feature until the works offer neither more nor less than their irreducibly fundamental elements of color, canvas, and the emotions the artist's handling of them evokes. He had dealt with what Merleau-Ponty called "the problem of knowing how one can communicate without the help of a pre-established Nature which all men's senses open upon, the

tinuous ground, or wall, of contrasting but closely valued hue (fig. 76). By staining the undercoat directly into unprimed duck, by scumbling or overpainting the second color so lightly that its translucency allows traces of the foundation hue to filter through, by extending the large interior shapes almost to the edges of the canvas and there feathering their soft contours into the ground, Rothko etherealized the forms—still stratified as so often before in this artist's oeuvre—yet fused them visually, as well as physically, to the flatness and format of the support. Consequently, the singleness of the image, with its built-in paradox, tends to yield a strange and tantalizing complexity, especially when contemplated at length, in an intimate space, and under a soft, subdued light. Interacting in the eye, the superimposed and juxtaposed planes of tinted mist appear to vibrate, emit a radiance from within, separate and hover both in front of and behind the painted surface, and expand overall, drawing the viewer into a kind of wondrous magnetic void, an all-embracing, mesmerizing exhalation of pure color and light. If the void proved irresistible, it was because sensuous pleasures were offered along with the unsettling mysteriousness of the disembodied. Indeed Rothko considered himself a materialist and resented being called a mystic, despite his highly developed sense of metaphysics. The artist always remained aware that the uncanny effects he achieved—so hallucinating that the immaterial seemed to be rematerialized even as a reverse process would more logically have been under way—required the most practical, prolonged, sophisticated involvement with the physical properties of paint and canvas. Thanks to his mastery of color's myriad possibilities, Rothko could rid his art of everything superfluous—not only realist or mythic imagery

problem of knowing how we are grafted to the universal by that which is most our own." Having divested his art of everything familiar, Rothko achieved visual statements of unparalleled clarity, but by making his residual means—his process—yield a quality of immanence, he also endowed simplicity with the directness, power, and "poignancy" of music, thus with the magical, metaphoric capacity to appeal globally and stimulate the most complex, indeterminate thoughts. Meaning has emerged from form, or, as Sartre wrote, "trembles about it like a heat mist." In using substance to substantiate the insubstantial, Rothko aligned himself not only with his fellow Abstract Expressionists, but also, as Robert Rosenblum has shown, with a tradition that stretched back through Mondrian, Klee, Kandinsky, Malevich, and the Symbolists to a great Romantic progenitor like Caspar David Friedrich. Moreover, it was the boldly abstracted, stratified, pantheistically sublime landscapes of this German painter that Rothko seemed to describe when he declared himself attracted to " . . . pictures with a single human figure—alone in a moment of utter immobility." But for all his sloughing of precedent, Rothko also saw his Houston project as a modern counterpart of the great religion-drenched mural cycles of the Renaissance, particularly the 15th-century frescoes painted by Fra Angelico in Florence's Dominican monastery of San Marco. The Houston canvases, with their tremulous, dusky chiaroscuro concealing as much as they reveal, also recall Rembrandt, and it was with an analogy to Rembrandt that Dore Ashton concluded her long, sensitive study of Rothko's art and life. Citing the Baroque master's rootedness in everyday feeling and his contrary desire to transcend it for the sake of "universal harmony," Ashton wrote of a "late portrait . . . of a young Jewish scholar in which Rembrandt unmistakably speaks of this tension. The young man gazes from his dark atmosphere, one eye engaged with the vision of this world, the other, shadowed, rapt in another."

As the emotional cost of his effort to give epic expression to private feeling and to render the finite infinite took their toll on Rothko, the artist retired more and more into the shadowed side of his consciousness. Finally, as his paintings became blacker and blacker, progressively extinguishing the last flicker of their once glorious light, he sank into the terminal darkness of despair, and in 1970 hanged himself

in his studio, two years after he had completed the Houston murals and one year before they were installed.

So radically distilled was the Color-Field painting of Barnett Newman (1905–70) that, before the advent of Minimalism in the early 1960s, few could appreciate either the pictures' daring purity or the agonized moral and aesthetic choices that had produced them. And this was true even though the genial Newman, a native New Yorker with a sophisticated, cosmopolitan intellect, had been, from the start, an active member of what became the Abstract Expressionist group, forever visiting studios and sharing ideas, advising dealers, organizing exhibitions, writing catalogues, and offering combative, articulate support for the new art on every conceivable front. However, Newman, by reason of his anarchist politics and the slight economic advantage he found in substitute teaching, had never worked in the WPA Art Project, where the real bonding seems to have occurred within the developing avant-garde. Morever, for years, until around 1944–45, the artist had systematically destroyed his work almost before the paint could dry, convinced that he had failed to meet the challenge of his calling, which he considered the highest available to civilized humanity. As a result, the principal evidence that Newman gave of his creative involvement with painting emerged not in viewable canvases but, rather, in polemical writings and all-night dialogues with his peers. Almost always, the focus of the argument fell on, first, the issue of epically important subject matter as the crucial ingredient distinguishing significant art from mere design or decoration, and, finally, on the need for a form capable of expressing that content in modern terms as sublime, in their own way, as those of Michelangelo in the Sistine Ceiling.

From a very early age Newman wanted to be a painter, but to satisfy his father, he studied art only on the side, at the Art Students League, while taking a regular academic degree at the City University of New York and then entering the family's garment manufacturing concern, a business the young man had to take over once the Depression set in and his father's health failed. Still, Newman persevered in painting, encouraged by his loyal wife and his close friend Adolph Gottlieb, one of the most workman-like, professional artists in New York. With his acute, searching mind, Newman also continued to study, especially botany, geology, and ornithology. Simultaneously, he developed an appetite for the philosophy of Baruch Spinoza, the great 17th-century Dutchman of Sephardic descent who declared the highest form of knowledge to be that which obtains to "the essence of things," achieved through a stimulating interaction of personal intuition and rigorous logic. Soon, Newman came to believe that a work of art should be an agent for and a paradigm of such knowledge, taking the artist and his viewers from experience to insight and thence to the exalted sphere of "world thought." Meanwhile, however, he was painting what he would later call "a form of American Expressionism." "It was flat painting," he said, " . . . [and] some of my work was serious . . . but everything around bored me stiff. I was interested in serious questions. What *is* painting? Is it really *circles*? Is it really *nature*? What are we going to paint? Surrealism? Cubism? I was drifting away and casting about, involved in a search for myself and for my subject . . . in a hunger about myself."

Frustrated with his failure to clarify a still inchoate vision, Newman around 1939–40 shredded the last of his canvases and stopped making pictures altogether. Then, like a Marcel Duchamp in reverse, he spent the next five years trying to devise a strategy for getting himself back into painting. Far from wishing to affirm the dead-end where European modernism seemed to have arrived, Newman was determined to start from scratch and create a wholly new art symbolizing a new life, a new world. Intellectual that he was, Newman proceeded by analyzing the "situation," objectively and in literary form, composing a number of draft texts but also a famous series of five essays published, from 1947 to 1949, in the little magazine *Tiger's Eye*. The better to understand the present and perhaps foresee the future, he set about re-examining the past, from prehistoric and primitive art to Sur-

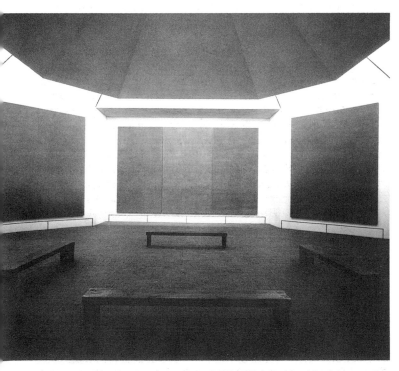

77. Mark Rothko. Northwest, north, and northeast wall paintings, Rothko Chapel, Houston. 1965–66. Oil on canvas.

realism and Neoplasticism, always with the purpose of discovering what elements or denominators might be common to all great art and how these might be recovered in forms suitable to the mid-20th century. In a long private ''monologue'' written around 1943–45 and entitled ''The Plastic Image,'' the artist stated that the new painter he saw emerging in New York ''accepts and has absorbed the plastic devices of art and has developed what perhaps is the most acute level of sensitivity to the grammar of art ever held by any painter in history.'' Now he must move on to ''an expressive art, yet not of the painter's feelings so well explored by the Expressionists. The truth is not a matter of personal indulgence, a display of emotional experience. The truth is a search for the hidden meaning of life.'' The new painter

. . . desires to transcend the plastic elements in art. He is declaring that the art of Western Europe is a voluptuous art first, an intellectual art by accident. He is reversing the situation by declaring that art is an expression of the mind first and whatever sensuous elements are involved are incidental to that expression. The new painter is therefore the true revolutionary, the real leader who is placing the artist's function on its rightful plane of the philosopher and the pure scientist who is exploring the world of ideas, not the world of the senses. Just as we get a vision of the cosmos through the symbols of a mathematical equation . . . so the artist is today giving us a vision of the world of truth in terms of visual symbols.

Citing Rothko, Gottlieb, Gorky, Pollock, and Baziotes as exemplars, Newman asserted that the new artist ''felt it was no solution for the painter dissatisfied with cheap subject matter [like that of the Social Realists and the Surrealists] to deny it entirely. . . . The problem was what kind of subject matter?'' At the same time that Newman rejected the work of the AAA group, ''who by ignoring subject matter [despite the stimulus of Mondrian], remove themselves from life to engage in a pastime of decorative art,'' he also found Expressionism to have been ''a risky esthetic because the emphasis on feeling had a tendency to shut out intellectual content.'' And so, he declared:

If it were possible to define the essence of this new [American] movement, one might say that it was an attempt to achieve feeling through intellectual content. The new pictures are therefore philosophic. In handling philosophic concepts which per se are of an abstract nature, it was inevitable that the painters' form should be abstract.

As we saw earlier, in the introductory comments on Color-Field Painting, Newman admired the primitive artist, as represented by the Northwest Coast Indians, for allowing ''his entire plastic language'' to be ''directed by a ritualistic will towards metaphysical understanding.'' But unlike his friends Rothko and Gottlieb, he did not see primitive art as a source of themes, images, or techniques, nor did he, like Picasso, want to seize upon the terror of the unknown embodied in primitive fetishes. For the civilized Newman, the tragedy of the human condition was a drama that had to be open to analysis and then apprehended, as Spinoza had apprehended the nature of God. However, this process involved not only rational review but also a leap of the imagination; thus, during the summer of 1945 Newman began to work automatically, doing so with the ease of an artist now steeped in the whole of painting culture and fully aware of the liberating possibilities of Surrealist technique. ''My idea,'' he said later, ''was that with an automatic move, you could create a world.'' And indeed generation seemed to be the very subject matter of the first images to well up, taking the form of seed, ova, and tall, growing plant shapes. Once these biomorphic themes—so natural to a long-time student of the biological and physical sciences—developed into sun-moon and, especially, vertical stripe motifs, Newman had found not only his all-important content but also the essentials of a language in which to express it. Both the solar circle and the exultant stalk or trunk can be seen in *Death of Euclid*, even the title of which celebrates the collapse of merely decorative abstract patterns and their replacement by images evincing the great theme of creation (fig. 78). The handling too—a combination of hard edges and free, painterly surfaces—registers the Spinozan duality of inspiration and intellection that yielded the newfound access to ''the essence of things.'' Already, in a modestly scaled

work, Newman had taken possession of the economical grandeur that would mark the heroic and still more mystical works to come.

The better to stress the dualities that obsessed him, Newman had begun to differentiate his motifs from the ambient ground by masking them with tape, painting over the entire field, and finally removing the tape to expose a reserve surface of clean-edged color or bare canvas. In early 1948, the technique helped him realize his long-sought breakthrough painting, when to test an alternate color, he fixed a length of narrow tape straight down the center of a small canvas already prepared with a coat of earthy cadmium dark red and then proceeded to smear cadmium light red over the tape. Immediately, the artist seems to have experienced a shock of recognition, for he stopped painting and spent the next several months studying the new work and what it meant to him. Finally, almost in reverence, he called the picture *Onement*, an invented word that suggests wholeness or harmony while, in addition, evoking such variations as *At-onement* or even *Atonement*. For Jews, of course, the latter signifies a day, Yom Kippur, to remember the dead, but for the Jewish mystics known as Kabbalists, Atonement also provides an occasion for meditating on the Messianic promise of rebirth, new life, Creation. In *Onement* Newman had found his subject in the artistic process itself and simultaneously therefore the visual diction uniquely suited to convey it. Later in 1948 he completed the experiment in a much larger and finished painting entitled *Onement II* (fig. 79). Here composition has been reduced to the equivalent of zero, consisting as it does of an all-over color plane divided by its central stripe into a bilateral symmetry as simple or archaic as a primal void. And this is precisely what it stands for—the blank that the God of Genesis, with a single, absolute gesture, made vital by separating light from darkness. The instantaneity of this first act of divine creation seems recaptured in the lightning speed with which Newman's pale ''zip''—as the artist liked to call his stripes—appears to race up and down the vertical axis, or perhaps in the free movement of the ground color as it floods evenly towards the outer edges of the format. By their very contrast, the orange zip and the mineral red-brown field provide the necessary symbolism, but, in a more subtle manner, something similar emerges from the tonal closeness of the two colors, the vibrations it sets off filling the entire canvas with a sense of light and dark suffused into an all-over dusky radiance. Enhancing the effect is the artist's new way of handling his medium, a steady, sensible touch that betrays an intense love of craft while avoiding both a soulless mechanical look and the complicated, emotional variations of the old painterliness. Clearly, color has been

78. Barnett Newman.
Death of Euclid. 1947.
Oil on canvas, 16 × 20″. Frederick R. Weisman Collection, Los Angeles.

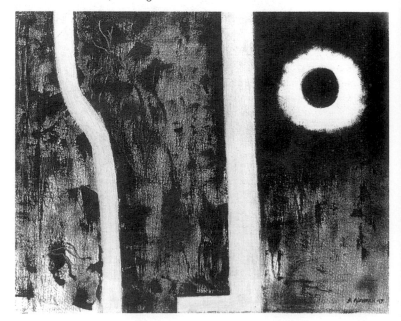

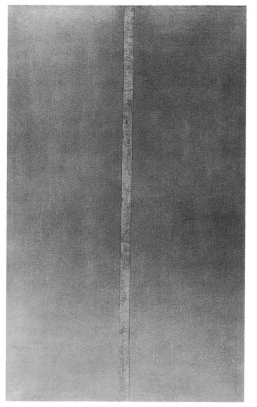

left: 79.
Barnett Newman.
Onement II.
1948. Oil
on canvas, 5 × 3'.
Wadsworth
Atheneum,
Hartford
(anonymous gift).

below: 80.
Barnett Newman.
*Vir Heroicus
Sublimis.* 1950–51.
Oil on canvas,
7'11⅜" × 17'9¼".
Museum of
Modern Art,
New York
(gift of Mr. and Mrs.
Ben Heller).

Heroicus Sublimis, begun in 1950 (fig. 80), such an image resides in what Hess termed a ''secret symmetry,'' here realized in a horizontal format that helped innovate the physical vastness so characteristic of the New York School at its peak. The image can be deciphered at, once again, dead center, this time however in the guise not of a stripe figure but in that of the void itself, a perfect 8-foot square of solid color, its existence and placement obscured by its own defining edges: two zips of different colors (one white and the other a darker value of the ground's bright cadmium red) and the upper as well as lower canvas extremities. Further mystifying this boldly simple centrality is the curious equation wherein the remaining, entirely unalike, asymmetrical spaces appear arbitrary, but in fact equal the main, all-important yet illusive square. Far from a coldly calculated diagram, however, the painting affects the viewer as a liberating surge, set off by zips or ''cuts'' that seem to soar beyond the frame, while their energy pressures the overall field to expand laterally, enveloping the viewer in a grandly intimate world of euphoric color made meaningful by a lucid albeit mysteriously ambiguous structure. In his own covert, hermetic way, Newman, it would seem, sought, as one writer described the Kabbalist method, ''to extract, I may even say distill, the perpetual life of God out of life as it is. This extracting must be an act of abstraction. It is not the fleeting here and now that is to be enjoyed, but the everlasting unity and presence of transcendence.'' The very origin of this painting's title discloses the degree to which Newman distilled essence from the substance of daily life. The phrase *Vir Heroicus Sublimis* came as a spontaneous, if erudite, response to a radio announcement that President Truman had fired General MacArthur

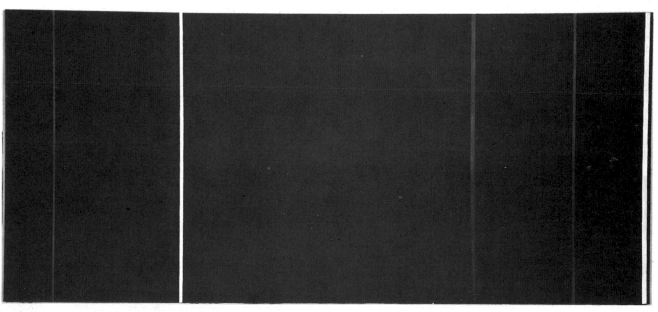

raised to a new power, for through it alone, in the condition of a tenacious mural flatness undisturbed by either drawing or the intricate relationships found in, for example, Mondrian, Newman managed to give totally abstract, emblematic form to a flesh-tone figure—Adam—standing free yet at one with the rich earth from which this first human being was made.

Although voluble on all manner of issues, Newman never did more than hint at an interest in mysticism, but according to Thomas Hess, the artist's most informed and imaginative interpreter, the hints were significant, for it is in the very nature of the Kabbalist to remain secretively silent about his own special insight into the ultimate Cause or Truth. Moreover, like Spinoza, Newman's chosen mentor, the Kabbalist arrives at this higher consciousness through reason directed by intuition, seeking refuge from an anxious present in a private image of Creation so elementary that it joins in the common stock of universal knowledge and thus becomes transparent. In the magisterial *Vir*

from his Korean command, an action the artist heartily applauded. But topical as the occasion for it may have been, the Latin title, like the monumental picture itself, nonetheless expresses a deeply rooted, personal conception of man's essential nature as heroic or elevated and a determination on the part of Newman to convey his theme in appropriately sublime, poetic language, visual or verbal.

Mixed-Style Abstract Expressionism

Given the tenet commonly held within the New York School that nothing should be excluded from art except the very idea of exclusivity, it seems inevitable that a number of leading Abstract Expressionists would achieve the grandiose holism characteristic of their work by adhering strictly to neither Action nor Field painting, but rather by combining features of both. Foremost among these artists was Adolph Gottlieb (1903–74), a native New Yorker, a long-time close associate

The New York School: Abstract Expressionism

of Newman and Rothko, and the chief instigator of the famous statement of artistic purpose that he and Rothko prepared, with the help of Newman, for publication in a June 1943 issue of the *New York Times* (see p. 48). Here, as on other signal occasions, Gottlieb played an activist or executive role, not only because he was slightly older than his colleagues, but also because his commitment to painting had come so early and so confidently that he counted, along with the Europeans Hofmann and de Kooning and the privileged Motherwell, among the few "loft rats" to have gained direct access to advanced Continental art at its source before this was cut off by war. But owing to the fulfilling depth of his "spiritual kinship with primitive and archaic art" professed in the 1943 letter, Gottlieb, after having been one of the first of his generation to attain professional status, became the last to achieve the "large shape" or the purely abstract image as the most dramatic way to effect "the simple expression of the complex thought." This in itself reflects the steadfast, self-assured independence displayed by Gottlieb from the very start, when as a teenager he defied his middle-class family and began studying at the Art Students

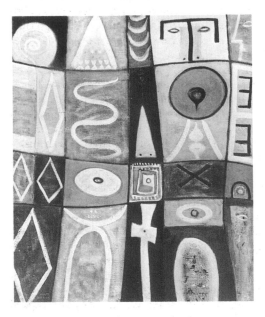

left: 81.
Adolph Gottlieb.
Pictogenic Fragments. 1946.
Oil on canvas,
36 × 30".
Hirshhorn Museum and Sculpture Garden, Smithsonian Institution, Washington, D.C. (gift of Joseph H. Hirschhorn, 1966).

right: 82.
Adolph Gottlieb.
Red Earth. 1959.
Oil on canvas,
4' 11¾" × 2' 11⅝".
Collection Cavelini, Brescia.

League, the Parsons School of Design, and Cooper Union. From Robert Henri, whose lectures he attended at the League, Gottlieb gained respect for a nonacademic approach to art and learned to cultivate freshness by painting directly on canvas, rather than from preliminary sketches, and by broadly massing form with color. Also at the League, he heard John Sloan urge students to "study the masters to learn what they did and how they did it, to find a reason for being a painter yourself." In 1921 the eighteen-year-old Gottlieb took Sloan at his word and joined the service crew on a passenger ship bound for France. Once there he was too poor to pay tuition and merely attended open life-drawing classes at the Académie de la Grande Chaumière, while spending long, intense hours at museums and galleries. He even ventured as far as Vienna, Berlin, Dresden, and Munich. Right away Gottlieb developed an appreciation of 13th- and 14th-century polyptychs, whose cellular, segmented compositions he would recall in the grid structure of his Pictographs painted in the 1940s. But by the time he arrived back in New York the artist had developed a sophisticated taste for every kind of high art, from the Renaissance to Expressionism and Cubism, all of which made him disdainful of everything provincial in American painting, especially that of the Regionalists and the Social Realists. Indeed, he had developed into what Newman called a "romantic figure . . . already a dedicated artist." Returning to Sloan at the League, Gottlieb began displaying in his pictures characteristics that would become the constants of his art: surfaces of great but subtle, Old Masterish textural variety, an *alla prima* process, sub-

ject matter re-created from the imagination, and an openness to advanced ideas and experimentation.

In 1929 Gottlieb launched his career by showing at a gallery that sponsored monthly exhibitions of young art selected by such established figures as Max Weber and Yasuo Kunioshi. Simultaneously he made friends with Mark Rothko and came to know Milton Avery, whose Matisse-like colors and drawing would have an enduring effect on both the younger men. Also in 1929 Gottlieb won a nation-wide competition that brought him his first one-man show, held at the Dudensing Gallery in New York. Throughout the early and mid-thirties he painted in a flattened Expressionist or Fauve style, effecting figural distortions similar to those in Avery's art, but with a prophetic haloing or ghosting, and a mood of melancholy alienation keyed to the Depression years and the poetry of T. S. Eliot's *The Waste Land*. Meanwhile, he joined the easel division of the WPA Federal Art Project and became intimate with John Graham, who encouraged his interest in Freud, Jung, primitive art, Cubism, and Surrealism. A fortuitous opportunity to assimilate all this, by gaining some distance from its sources, came in 1937–38, when for reasons of health Gottlieb and his wife took up residence in Arizona. There the bizarre character of the desert landscape inspired the artist to paint still lifes with radically flattened tabletop spaces containing frontal arrangements of petrified wood, dead cacti, and parched bones. With their subdued palette—filtering layers of sandy pinks, greens, and browns—the paintings seem redolent of the desert's own stillness and mystery. Al-

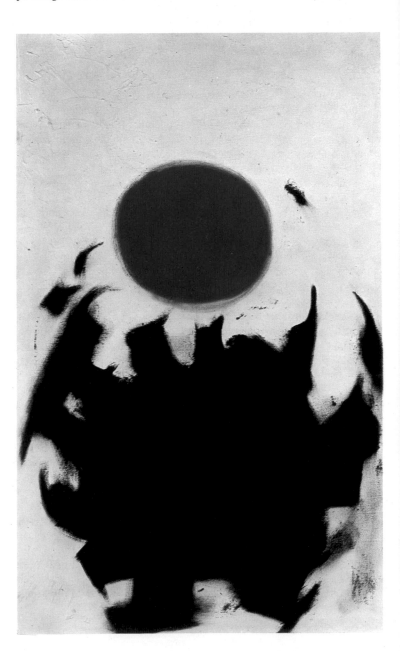

ready Gottlieb had hit upon the system that he would employ for the remainder of his life, which entailed developing a compositional format suited to the ideas he wanted to explore and repeating the format in serial variations until the concepts it embodied had been exhausted. While out West, the artist also discovered a new vein of primitive art in the American Indian forms and colors that would soon serve him so well in his first breakthrough series, the Pictographs.

The Pictographs, a long and fertile sequence that poured from the artist's studio throughout the years 1941–53 (fig. 81), came as a resolution of the crisis in which Gottlieb found his art in 1939–40. After painting a group of still lifes that, with their random marine objects placed in boxes, resembled Daliesque or Magic Realist versions of the Arizona pictures, the artist became desperate to break free or stay clear of such traps as American Regionalism, Cubism, and Surrealism. Later he would say of this time: " . . . there was some sense of crisis. I felt I had to dig into myself, find out what it was I wanted to express." To a considerable degree, the problem arose from the disturbing reality that while the horrors of war made the sunny, whimsical modernism of Avery seem inadequate to the moment, Surrealism, which did take account of humanity's darker impulses, proved too literary and anti-aesthetic to satisfy an artist eager to paint masterpieces. And so Gottlieb, along with Rothko, looked to subject matter as a means of solving the dilemma of form. But while Rothko immersed himself in Aeschylus, Gottlieb turned to the Oedipus myth, finding it a powerful symbol of man's tragic, eternal conflict with both himself and society. Having adopted the rivalry of good and evil as his theme, a theme blessed not only by Classical archetype but also by Freud and Jung, the artist sought and discovered a formal as well as procedural counterpart in the polarity of Cubism and Surrealism confronted, or cross-fertilized, into an original, complex art of immense potential. Virtually every member of the New York School would, in his own distinctive way, realize a creative fusion of the same antithetical sources, but Gottlieb, along with Gorky and Pollock, was one of the very first to succeed in a fully integrated, authoritative manner. Moreover, he did it without personal involvement with the émigré Europeans, but rather through a close relationship with Graham and Gorky. Always unfettered and improvisatory in his work, thanks to the early instruction he received under Henri and Sloan, Gottlieb now took up Surrealist automatism as a means of mining his unconscious for fresh, freely associated, biomorphic images personal enough to be authentic to him, yet sufficiently ambiguous to connect with the collective unconscious and assume the connotative qualities of universal myth. In the early, Classical phase of his Pictographs, these were mainly human body parts—phallic and breast shapes, hands and heads, but also and preeminently eyes, features so crucial to the Oedipus legend. Gradually, the artist would expand the repertoire to include such forms as the snake, the bird, the fish, the dot, and the arrow, all of an emblematic sort familiar in American Indian and primitive art. Perhaps more important, a similar vocabulary could also be found in the "primitivized" painting of Picasso, Miró, Klee, and the noted Uruguayan painter Joaquín Torres-García, as could the strong, flat, linear style in which Gottlieb chose to render his calligraphic biomorphs. But if content and its derivation represent the subjective, Surrealist aspect of the Pictographs, Gottlieb turned to Abstract Cubism for the rational order in which to present the visual evidence, containing each image within the cell of a field-wide grid drawn freehand like a fluid version of Mondrian's Neoplastic coordinates. Also echoed in the scheme would seem to be the medieval polyptychs the artist had so admired, in Europe, or indeed the boxes in his own Magic Realist still lifes of 1939–40. While the arrangement made the disparate motifs appear as hauntingly dislocated as Lautréamont's sewing machine and umbrella encountered upon a dissection table, it also yielded an evenly distributed, if multiple, focus comparable to the all-overness of Pollock's linear rhythms. Reinforcing this incipient holism is the underlying surface, its layers of thin paint skins stretched so taut that they rupture at the center and fray at the edges to reveal a palimpsest of sand-toned colors, their worn look and seepage into one another joining with the cryptic figurations to suggest an ancient stone marked with an inscrutable message of vague but clearly transcendental import. The Pictographs have been called a veritable "storehouse of culture," not only for their iconography but also for the rich, encrusted manner of their handling. An accomplished technician, Gottlieb painted these easel-size works with a love of hue and facture equal to that of Braque, Matisse, or Avery. Layering lighter shades over darker, drier brushstrokes over wetter, and tempera over oil, he created surfaces of exquisite contrast and subtle, chromatic beauty, often on unsized burlap resembling the kind of rough-woven support favored by Klee.

The dualistic theme established in the Pictographs attained its most exalted formulation in the Bursts, paintings in which Gottlieb so distilled yet amplified his forms and ideas that he entered the front rank of the Abstract Expressionists (fig. 82). However, for reasons already cited, this occurred only in 1957, when, a decade after the 1947–50 period generally regarded as the epiphanic moment for the New York School, Gottlieb initated the series—once again long and infinitely varied—that many consider the apotheosis of his career. Here, as often in the history of modernism, simplification proved liberating, for so surely did the Bursts emerge from the Pictographs that the later and larger canvases may be viewed as single cells of the older figurated works blown up to mural scale, a shift that automatically transformed complexity and intimacy into something with the breadth and openness of public statement. Not only have the intricate subdivisions of the grid been eliminated, thereby creating a unified, continuous ground or field, but the glossary of images has been reduced to a flatly stained circular shape hovering serenely, or ominously, above an explosion of vehemently swiped, chaotic brushwork. Further adding to the radical abstraction of the Bursts is their tall, iconic format, perhaps inspired by Rothko's altar-like compositions and so different from the still-life or landscape proportions of the Pictographs. Color too makes its contribution, since Gottlieb abandoned the glorious chromaticism of the previous series and restricted his palette to three hues, most frequently realizing the image as a red disk and black "blast" set against a white expanse. But by severely limiting the variables of his new heroic art, he vastly increased their expressive pressure. Thus, while the matte, smoothly contoured, ghosted ellipses and glossy, heavily textured, sharply defined splashes quite obviously combine to reflect the anxieties of the nuclear age, they also expand beyond the fireball and flash-point inference to evoke such cosmic associations as sun and sea, female and male, day and night, life and death, even the dyadic mode of human communication—I and thee—or the binary one of modern computer science. In their very complementarity, the two dramatically opposed forms become interdependent, transcend their figure-ground contrast with the overall field, and join with it to create a sense of the monumental holistic unity comparable, in its strikingly individual way, with that of both the oceanic linearity of Pollock and the atmospheric radiance of Rothko.

The artist who unequivocally cited "the development of the large format" as essential to Abstract Expressionism—a development just seen in the oeuvre of Adolph Gottlieb—was Robert Motherwell (1915—), the youngest member of the New York School, but also the best educated, the most financially independent, the best traveled, and the most thoroughly immersed in the modernist tradition, not only artistic but poetic and philosophical as well. Given such breadth of experience—and the artist's still-voracious appetite for more—it should hardly surprise that, almost from the beginning of his long painting career, the generous-spirited Motherwell has created an art marked by a dualism no less compelling than that of Gottlieb, a dualism of momentous thought and momentary feeling, of ovoid and angular shapes combined in works ranging from small, spontaneous, Zen-like calligraphs to grandly scaled, elaborately orchestrated, fugal compositions. It also seems logical that, with his great gift for lucid, fluent rhetoric, supported by an intellectual life pursued at Stanford, Harvard, Columbia, and Grenoble, Motherwell would become the lead-

ing apologist, in every kind of writing, speaking, and editing, for the entire modernist movement that began in New York during the war years. The role fell to him quite naturally, for being a scholar of Delacroix's *Journals* and a devoted reader of France's Romantic-Symbolist poets, from Baudelaire through Mallarmé, Lautréamont, and Rimbaud to Valéry, Motherwell understood, perhaps better than any other American of his time, that the mission of the true modernist was, as Baudelaire wrote in the final line of *Le Voyage*, ''To the depths of the unknown to find the new.'' Meanwhile, the French culture Motherwell so loved also taught him that, to be sustaining, the new had ''to incorporate [a] sense of the past into something that could only have been conceived of at the present.'' Erudite and ''international'' but open, wise, articulate, and outgoing, Motherwell, despite his relative youth, became a crucial link between the European avant-garde and

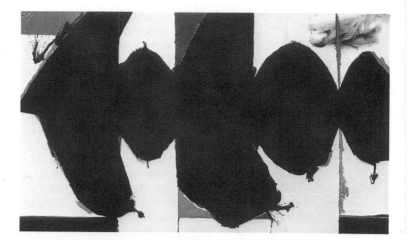

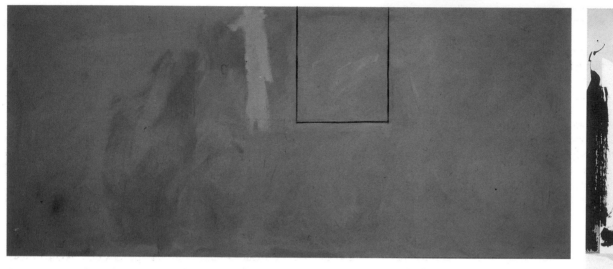

top: 83. Robert Motherwell. *Elegy to the Spanish Republic, 108.* 1965–67. Oil on canvas, 6'10" × 11'6¼". Museum of Modern Art, New York (Charles Mergentine Fund).

above: 84. Robert Motherwell. *Summer Open with Mediterranean Blue.* 1974. Oil on canvas, 4 × 9'. Collection the artist.

right: 85. Robert Motherwell. *Stravinsky Spring.* 1974. Oil and collage on canvas, 47½ × 23⅝". Private collection.

progressive American artists. Moreover, he easily bridged the gap, both socially and aesthetically, between the Action and Field, or Color-Field, branches of the New York School.

Motherwell, the only son of a San Francisco banker, made his commitment to art as early as the age of eleven, when he won a fellowship to the Otis Art Institute in Los Angeles. However, once a visit to the Michael Steins' collection of Matisses, then in San Francisco, convinced him that the kind of art instruction he wanted could not be had on the West Coast, Motherwell enrolled in philosophy at Stanford. By 1940 his studies in aesthetics had taken him to New York's Columbia University where Professor Meyer Schapiro, the distinguished art historian and eloquent proponent of modernism, introduced him to the refugee Surrealists. The encounter proved catalytic, prompting Motherwell to paint full time while also involving him in automatist exercises with, first, the Chilean Surrealist Matta and then Jackson Pollock. ''I had had a firm intuition,'' he later commented, ''that the New York painting scene was filled with technical talent, but lacked an original creative principle, so that its work appeared one step removed in origin.'' ''I found that principle,'' he continued, '' . . . in the Surrealists' own self-definition, 'psychic automatism,' by which they meant, in psychoanalytic jargon, free-association.'' However, the technique, which he called ''a plastic weapon with which to invent new forms,'' had little or nothing to do with his becoming an abstractionist, for by returning to art through philosophy and poetry, Motherwell could accept the ideas of modernism *per se* and, without

fear of sacrificing content, follow Mallarmé's dictum ''To paint, not the thing, but the effect it provides.''

An early example of how Motherwell could present a subject and his emotional grasp of it in a distinctive, largely conceptual idiom is the small painting of 1943 entitled *Pancho Villa Dead and Alive.* Here already, in tentative form, are the symbolic contrasts of light and dark, the automatist rendering of boldly juxtaposed organic and geometric shapes, the Mondrian-like planes, structure, and strong ''plastic'' feeling, the Picassoid or Goyesque sense of dark, inchoate menace that would inform much of the vast and varied work the artist has subsequently produced.

In San Francisco, Motherwell also encountered the great moral issue that would forever haunt and enrich his painting. Hearing André Malraux speak on the Spanish Civil War at a 1937 rally, he suddenly realized ''that the world could, after all, regress.'' This concern provided the subject of what he has called ''perhaps my very first mature work,'' *The Little Spanish Prison* of 1941. It also hovers in the background of *Pancho Villa Dead and Alive*, but would become overt in a small 1948 drawing that the artist made for a poem by Harold Rosenberg, only to discover within it ''an archetypal image'' potent enough to inspire his first ''public painting,'' which in turn generated the Spanish Elegies, an epic series now numbering over 150 monumental canvases (fig. 83). The image would seem to be simplicity itself, consisting as it does of two or more large Rorschach-like blots aligned with the format's long horizontal axis and wedged between wide ver-

tical members, the blots and beams all jet black against a white ground, itself as freely brushed as the planes and edges of the dark silhouettes. Occasionally brightening this stark and mysterious realm, but confirming its death-in-the-afternoon mood, are patches of ochre, green, and blue—earth, grass, sea, and sky colors—that tie the painting to the tragically riven Iberia of the artist's imagination. But however minimal or ungainly, the image has proved resonant, stimulating critics to see such elemental, totemic forms as megaliths, phalluses, and wombs, or taurine testicles, even processions of moving figures like those in the solemn Holy Week rituals at Seville. So seminal did the artist find his dialogue of formal opposites that he began to rephrase its bedrock but highly charged syntax in canvas after canvas, with each yielding new revelation and thus encitement to further exploration. When viewers actually hostile to abstract art were moved by the paintings but seemed not to know why, Motherwell said: "I think perhaps it is because the Elegies use an essential component of pictorial language that is as basic as the polyphonic rhythms of medieval or African or Oriental music." But it is also because the artist carries the spectator along in his own Mallarmé-like voyage of discovery, doing so by allowing the picture to evince the process of its own creation, a process that not only gave birth to areas, edges, and relationships, but also left a thousand quick, light, or violent, spontaneous or corrective strokes bearing witness to myriad contradictory impulses. In this way form and feeling became integral, thereupon investing abstract iconography with transcendent meaning, with a sense of the anguished love-death conflict so inalienable to human existence. Motherwell, the erudite thinker who has always trusted instinct more than ideas, once called his Spanish Elegies "a funeral song for something one cared about."

Even as he continued painting Elegies, Motherwell veered towards ever-more abstract imagery, always, however, seeking to confront and resolve divergent tendencies. In the Je t'aime series, commenced in 1955, the artist made his brushwork less descriptive by reinforcing automatism with the spontaneity of Oriental brush painting and by making the calligraphed title the central motif. With this, he managed to combine Western and Eastern metaphysics, both longtime interests, and thus merge Surrealist subjectivity into a Zen mystique of universal consciousness. A still more subtle, and at the same time more heroic, fulfillment of the same concept developed in the great Open series introduced in 1967 (fig. 84). Here, upon a vast monochrome wall of warm, amorphous color signifying Zen's absolute void, the artist drew, with charcoal or paint—or simply incised with the pointed end of a brush handle—a three-sided, sharply linear shape suspended at the center like a trapeze, an angular U, or an emblematic window, thereby animating the mystical void with a cutting symbol of Western, Aristotelian rationality. He also met the challenge of sixties-style field painting without in any way permitting Minimalist dispassion to supplant his own passionate sense of moral engagement.

Almost as a relief from the intense subjectivity of his painting, Motherwell has been an active, often brilliant collagist throughout his career (fig. 85). "To pick up a cigarette wrapper or wine label or an old letter or the end of a carton," the artist once said, "is my way of dealing with those things that do not originate in me, in my *I*. . . . [But] instead of having to fuss with drawing things and reworking and changing them, you pick up objects that are in in the room and simply put them in the picture—or take them out—whatever you like." As this would suggest, Motherwell was no proto-Pop figure, nor yet a neo-Cubist, in his collages; indeed, he remained very much an Abstract Expressionist even when working with artifacts discovered in quotidien life:

Most of the papers I use in my collages are random. Even the sheet music. In fact, I don't read music. I look at printed music as calligraphy, as beautiful details. I do not smoke Gauloises cigarettes, but that particular blue of the label happens to attract me, so I possess it. Moreover, the collages are a kind of private diary—a privately coded diary, not made with an actual autobio-

graphical intention, but one that functions in an associative way for me, like Proust's madeleine. For a painter as abstract as myself, the collages offer a way of incorporating bits of the everyday world into pictures. Some of my collages make past years and places in all their concreteness arise in my mind in a manner that the paintings do not: the paintings are more timeless.

When Bradley Walker Tomlin (1899–1953) made his breakthrough into large-scale all-over abstraction he was already old enough to grace the New York School with a touch of pre-Depression refinement and harmony. Such was the intelligence and artistic integrity of this handsome but physically frail painter that, despite his roots in the elegant, urbane world of the 1920s, he achieved true spiritual communion not only with Motherwell but also with such hard-knocks brethren as Gottlieb, Rothko, and Pollock. With an honors degree in painting from Syracuse University, Tomlin arrived in Manhattan in 1922 and entered upon a near-decade of easy success, designing magazine covers for Condé Nast, painting portraits, exhibiting watercolors in a lyrical, softly realistic mode, and traveling to Europe, the first time on a postgraduate fellowship. Around 1925, after his return from Paris, where he had met Braque and Gertrude Stein, Tomlin also took up oils and began painting flower and still-life subjects admired for their color and design but criticized for seeming derivative of such European masters as the Post-Impressionists. When the American economy collapsed, Tomlin survived by teaching, an activity he continued at Sarah Lawrence College until 1941. Meanwhile, in 1937, he saw MoMA's "Fantastic Art, Dada, and Surrealism" exhibition and found his own art so dull by comparison that he set about to reconstitute it from scratch. By 1939 he had managed to forge a sophisticated style of considerable originality, especially in its amalgamation of Cubist structure and Surreal, dream-like imagery, the latter complete with irrational juxtapositions and strange, misty atmosphere. Thanks to its manifest quality and decorative professionalism, the work brought Tomlin both moderate recognition and loyal patronage. Even so, this innately conservative artist refused to settle for easy rewards, and in 1945 he made contact with Adolph Gottlieb, whose Pictographs he had long admired and whose automatic procedures he employed in 1946 to produce his first completely abstract pictures. Gradually, Tomlin entered the circle of Pollock, Rothko, Motherwell, and Guston and became an active, respected participant in the Friday evening sessions of The Club on East Eighth Street. By 1949 he had

86. Bradley Walker Tomlin. *Number 20.* 1949.
Oil on canvas, 7'2" × 6'8¼". Museum of Modern Art, New York (gift of Philip Johnson).

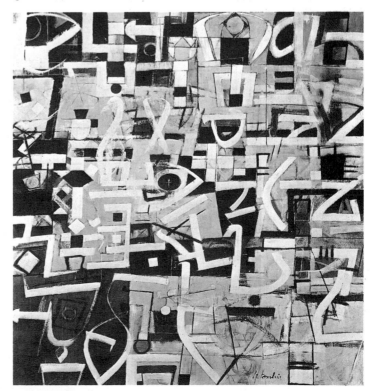

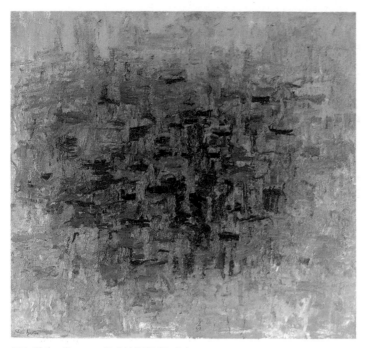

87. Philip Guston. *To B.W.T.* 1952. Oil on canvas, 4′½″ × 4′3½″.
Collection Richard E. Lang and Jane Lang Davis, Medina, Wash.

achieved his own, full-fledged Abstract Expressionist style, still a fusion of opposites but now drawn from both Action and Color-Field painting (fig. 86). At its most characteristic, the style consists of a loose, surface-wide, grid-like arrangement of color planes surpainted with ribbon strokes forming an irregular screen of abstract calligraphs. Melodious, symphonic, and complex, but so exquisitely calibrated that figure and ground mesh as an integral, holistic image, the compositions offer the additional civility of a muted palette keyed to such tertiary hues as olive, mustard, pale blue, violet, ochre, and tan, brightened by subtle contrasts of smoke white and coal black. Towards the end of his all-too-brief artistic maturity, Tomlin became still freer, much simpler, and even a bit festive, cutting his ribbons into confetti sprays of vivid hues and spreading the flakes like flower petals over a ground of continuous, and usually darker, color. An incipient Cubist grid can still be sensed, as in most Abstract Expressionist painting, lending an element of lucid, shapely order to a pictorial symbol of spiritual release. In general, however, the prevailing mood in Tomlin's art is one of sober, elegiac restraint.

Philip Guston (1913–80) shared not only a studio with Tomlin, briefly in 1949, but also a good measure of the older artist's reticence. But whereas Tomlin, in his own "cross-over" art, seemed to advance with steady, gentle consistency, Guston took drastic swings, between figuration and abstraction, refinement and raucousness, faith and irony. Even in the period of his most integrated work he created a famously evanescent, tremulous "abstract Impressionism" by making an aesthetic principle of ambivalence, doubt, and indecision (fig. 87). An early manifestation of this passive-aggressive tendency appeared when Guston joined with his fellow student Jackson Pollock to protest their Los Angeles highschool's alleged indifference to academic standards, a prank that earned him the same expulsion as that meted out to Pollock. Thereafter, the young Guston pursued an increasingly volatile and varied course of development. While a rebellious student at the Otis Art Institute, he supported himself with menial jobs, including some in the make-believe world of Hollywood, read deeply in philosophy and theology, engaged in leftist activism, and painted murals under the inspiration of Mexico's Rivera, Orozco, and Siqueiros. As his taste in art evolved, it too displayed remarkable eclecticism, ranging from the Renaissance frescoes of Masaccio and Piero della Francesca through the Douanier Rousseau and the de Chiricos in the

Arensberg collection to such popular forms as comic strips and animated cartoons. By 1935 Guston seemed to have exhausted the possibilities available to him on the West Coast, and, at the age of twenty-three, he left to join the Pollock brothers in New York, where he remained until 1941, when teaching took him to the Midwest for the next six years.

Torn between pure form and pure expression, Guston approached radical abstraction with the greatest difficulty, arriving there for certain only in 1951, after his return to New York and probing conversations with Motherwell. When finally he resolved his divergent tendencies, it was in the guise of a surface shimmering with short, richly pigmented strokes set down in right-angle relationships whose haphazard tentativeness, like their intersecting directions, registers the existential anxiety of an artist so polarized by alternative choices that every gesture seems a revision, if not an actual effacement, of a preceding one (fig. 87). As a result, the abstract image, albeit conflicted, is far from violent but, instead, tenuously becalmed or balanced, like the colors themselves, which modulate from a blond or gray surround towards delicate, roseate tonalities near but indecisively somewhat off the center. There they huddle in a squarish mass, echoing the brushwork, with its painterly evocation of Mondrian's Plus-and-Minus pictures, and reifying the rectangular flatness of the support. Meanwhile, this anchor to physical reality is uncoupled as the facture thins and frays at the edges, setting the image afloat on a sea of exposed canvas. In its very hesitancy and self-canceling ambiguity, Guston's nervously nuanced mature art seemed, for many, to embody the dilemma of a contemporary world confronted with immense opportunity and a dearth of unifying purpose.

Two other charter members of the New York School who foreshadowed the sixties by espousing aspects of both Action and Color-Field painting were Hans Hofmann and Lee Krasner, the influential teacher and his brilliant student encountered at the outset of this chapter in their pre-Abstract Expressionist work (figs. 42, 43, 45). At that juncture, both represented an advanced stage of European sophistication in American art, a sophistication, however, that proved burdensome once other Americans forged ahead by adopting Surrealist automatism as a means of emancipating their art into a whole new, exalted sense of form and feeling. In the 1950s, however, each of them caught up and glorified the New York School with some of its most distinctive and accomplished works. By this time Hofmann was already past seventy, but, *toujours vert*, he found his prodigious gifts so recharged by the example of younger Americans that he began painting with a freshness and fertility unprecedented in his long career (fig. 88). Always virtuosic, Hofmann now became spectacularly so as he enlarged his "push-pull" aesthetic to the very limit, structuring the canvas with heavily impastoed, frontalized planes of brilliant, primary color, all interacting to transform the entire field into what seems an opulent, pulsating bed of light and energy. Although still very much a European in his preference for moderately large, rather than heroic, formats and his hedonist delight in the sensuous qualities of paint and process, Hofmann was at one with his American associates in creating each picture as a universalized expression of some very particular, personal mood. For him, this was usually exuberance or joy, but occasionally a graver note would intrude, especially as the old master watched one talented Abstract Expressionist after another die well before his time.

Having been an especially strong student of Hofmann's theories, Krasner experienced untold difficulty in freeing her art not only from Cubist gridlock but also from the motif, which Hofmann always insisted had to be the point of departure for even the most nonobjective forms. For a time, her attempts to employ psychic automatism turned one canvas after another into a solid gray slab. By 1946, however, Krasner was already working entirely from imagination in her Little Image series; moreover, she had begun, at the same time as Pollock, to construe her anti-Cubist, calligraphic notations in a fluid, all-over arrangement. Contributing to this development was the deep, know-

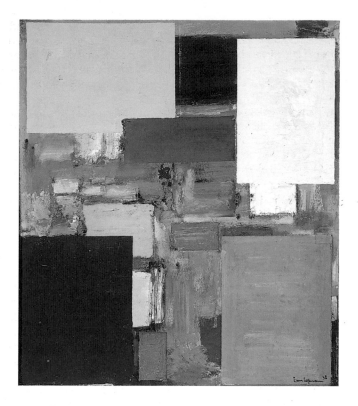

ist cage and submerged its linearism in exploding avalanches of thick white and dark-umber paint. Here was Action Painting with a vengeance, its stormy antiphonal movements and stark, thunderous monochromy yielding a large-scale, holistic unity not seen before in her work, while also evoking ice-age catastrophe like that alluded to in the title *Polar Stampede*. If the intellectualized stillness and concentration of her Little Image paintings made Krasner a kindred spirit of the Color-Field painters, the mural-size *Polar Stampede* and related works reveal the extraordinary breadth of her range, stretching all the way to the aggressive extremes of Action Painting. Over the next two decades, as she moved from strength to strength, Krasner would gradually integrate her dialectical capacity for thought and feeling, color plane and hard-edged line, tectonic structure and baroque dynamism in a monumental style unlike anyone else's.

So clairvoyantly did Ad Reinhardt (1913–67) seem to anticipate the Minimalist mood of the 1960s that art history has tended to be more fascinated by his role as godfather to the cool generation than by the no less important part he played in the great drama of his own prime: Abstract Expressionism. But however unbalanced this attitude, the artist himself virtually sanctioned it, by doing so much, through verbal polemic and biting caricature as well as radical stylistic departures, to take and keep his distance, there acting as the "scourge" of the New York School and its Nietzschean heroics. Whereas Clyfford Still, perhaps the most romantic painter within the group, reviled European modernism as "a celebration of death," Reinhardt, a self-proclaimed rationalist, derided the Abstract Expressionists themselves for what he mockingly termed their love of "transcendental nonsense and the picturing of a 'reality behind reality'." And he did it throughout the movement's golden years, aided by an education and literary skills comparable to Motherwell's and a stinging, ironic-puritan wit entirely his own. Although Reinhardt shared the WPA, liberal, anti-realist background of his fellow progressives, he early displayed an unusual bias towards extreme formal purity by joining the AAA, a step taken by only one other artist seen in this chapter: Lee Krasner. Indeed, Reinhardt made Mondrian his lodestar, for as he put it in an article, written for *The New Masses*, praising the Dutch master's content-rich painting: "What greater challenge today (in subjective and two dimensions) to disorder and insensitivity; what greater propaganda for integration, than this emotionally intense, dramatic division of space?" As a nonobjective artist in his own right,

ing admiration Krasner felt for Mondrian, particularly his Plus-and-Minus paintings of 1914–15. But the expansive sense of infinity captured by Pollock eluded her, mainly because she preferred to work smaller and close to the surface, both procedures allowing a degree of control like that provided by traditional modernism. Her need to govern, rather than trust accident and spontaneity, persisted even when she dribbled paint, in a diminutive version of Pollock's broadly swinging drip technique. However, with Pollock's violent death in 1956, accident itself became the controlling factor in Krasner's life, a shattered state that she expressed with raging vehemence in a series of works as enormous as any produced by Pollock and even more furious in their surging rhythms (fig. 89). Slapping or dragging her heavily loaded brush across the canvas, she demolished every last vestige of the Cub-

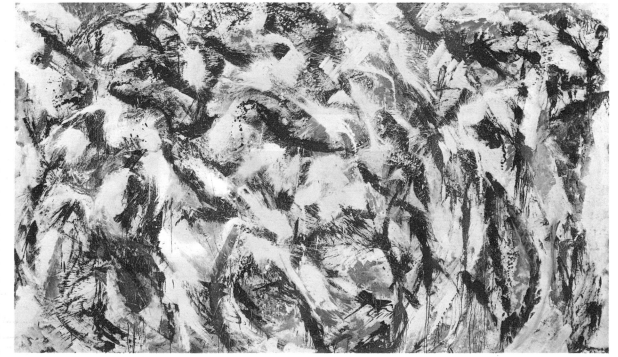

above: 88.
Hans Hofmann.
Equipoise. 1958.
Oil on canvas, 5′ × 4′4″.
Collection
Marcia S. Weisman,
Los Angeles.

right: 89.
Lee Krasner.
Polar Stampede. 1960.
Oil on cotton duck,
7′9⅝″ × 13′3¾″.
Courtesy Robert Miller
Gallery, New York.

Reinhardt seems to have achieved almost immediate artistic maturity, already in the late 1930s painting flat, vivid geometric or organic shapes interlocked on a clearly defined ground. In the 1940s, however, he would break up closed forms and render his abstract imagery in a free, calligraphic manner generally consistent with the prevailing trend in nascent Abstract Expressionism. Rigor and control began to re-emerge in 1947–49, however, with the so-called "Persian rug" paintings, a series in which all-over gesture, set against tall, narrow fields of muted monochromy, became smaller, lighter, and more regular. The return to structure accelerated in 1948–50, as the artist fused drawing and painting in brick-solid, horizontal strokes that float like autonomous planes of color over the entire surface, sometimes in an open arrangement but often densely interpenetrated. Where Reinhardt narrowed his palette towards a single key, the pictorial result suggested another kind of "abstract Impressionism," or at least a Constructivist version of Monet's late Waterlilies quite unlike the tremulous lyricism seen in Guston's "Impressionist" abstractions (fig. 90).

However strained, the analogy here is apt, for by this time Reinhardt was moving, as he would say, "beyond Mondrian," meaning that, unlike the great Neoplasticist, or indeed Malevich before him and Still, Rothko, and Newman thereafter, he no longer saw formal distillations with the subjective eyes of a northern Romantic seeking Platonic signifiers of the sublime. Instead, he was returning to a more objective, French conception, and thus began to regard pictorial autonomy as "a rigorous art-as-art experience" whole and complete in itself. Now, in order to "push painting beyond its thinkable, seeable, feelable limits," he would empty his canvas of all "non-art" content—that is everything "relational," not only gesture, with its emotive figure-ground connotations, but also composition in the hierarchical sense of asymmetry, rhythm, and contrast. What remained consisted of a 5-foot-square surface so symmetrically subdivided, or trisected, into planes by nothing more than exquisitely close shifts in an overall matte texture that the resulting equilateral, barely perceptible cruciform cannot but negate all sense of dynamic interplay, resist analysis, and unify the field to express a timeless, holistic balance (fig. 91). A born colorist, Reinhardt first carried out this late monotone scheme in red or blue, taking care to neutralize their symbolic possibilities by using ambiguous "off" colors, such as orange, hot pink, navy, purple, or gray. Finally, however, to eliminate even this variable and achieve the ultimate in pure, classic immutability, Reinhardt resorted to black (the absence of color) and then painted the same dark, light-absorbent picture again and again from 1954 to 1967, the year of his death. Here, supposedly, were "the last paintings anyone can paint"—"a pure, abstract, non-objective, timeless, spaceless, changeless, relationless, disinterested painting—an object that is self-conscious (no unconsciousness), ideal, transcendent, aware of nothing but Art (absolutely no anti-art)." However, nothing created

by a subtle ironist like Reinhardt could ever be as "simple [and] expressively clear" as it might seem. Having been executed in monolithic black, the simplicity itself becomes evident only after the closest, most prolonged peering, an experience that fosters a deep, Zen-like entrancement while at the same time it reveals a black hazy with mysterious color components and an image of unavoidable religious import. Moreover, Reinhardt sought pictorial essence with such uncompromising zeal that he tended to endow the nonobjective, totally self-referential painting with the aura of a holy object. Thus, for all his repudiation of the supernatural and his anti-romantic stance, the artist had more affinities with the mystical Malevich and Mondrian, as well as with his fellow Abstract Expressionists, than he would have wished, in the content as well as in the form of his enigmatic and radically abstract paintings. Reinhardt, as Margit Rowell suggests, appears to have wanted his black pictures to be anonymous emblems signifying the quintessence of painting. In fact, they are all handpainted with lavish craftsmanship, thus totally individual, and as distinctively personal as a fingerprint. But in striving to go "beyond Mondrian" and rid painting of all but its own ineluctable qualities, making these the sole and sufficient subject, Reinhardt dealt in values that a generation younger than his own would revere. When he said of his sable square, "it is just this and nothing else," the "black monk of American art" prophesied the literalism of Frank Stella in his famous "what you see is . . . what you see" aesthetic.

If by 1944–45 the center of gravity in Western art had shifted from Paris to New York, it was not immediately apparent on either side of the Atlantic. The émigré modernists, whose wartime presence in the North American metropolis had proved so beneficial to the future Abstract Expressionists, could scarcely wait to return home in the hope of resuming their former leadership roles in what was now an elderly, battered, but remarkably renascent world of art. Along with them went one of their most important patrons, Peggy Guggenheim, whose support of both the refugee Europeans and younger American painters had also been crucial to the emergence and survival of a genuine avant-garde in New York. Ultimately, the Pollocks in her collection, and the New York School in general, would affect postwar European painting almost as decisively as Mondrian and Masson had the fledgling American modernists of the early 1940s. But this process of reverse influence did not commence until 1948, and the full impact of the new American painting would not be felt abroad until around 1953 or even later. Meanwhile, thinking Europeans everywhere, in the aftermath of their common disaster, were turning to art as if this most human yet nonverbal of forms—and one of the forms most abused by the totalitarian powers—could somehow give utterance to the unutterable tragedy of the human condition, and thus dignify, if not actually heal, the pain of a society profoundly wounded by its past and crippled in its hope for the future. The need being great, the response was generous, as it could only have been among peoples for whom artistic creativity of the highest order had, throughout millennia, been as natural as breathing. Now, however, the traumas that gave their new art its unavoidable substance were global as well as local, and since the younger European painters had learned their aesthetic language from many of the same universal masters as those obeyed in New York, it seems almost inevitable that they would evolve a comparable vocabulary for articulating a shared and problematic vision. Drawn, in large part, from the same cultural well and responding to similar thirsts, automatist Expressionism in one degree or another of abstraction sprang up simultaneously and flourished like a volunteer growth in the New and Old Worlds alike. In Europe the labels it called forth were usually the French-derived *art informel* and *tachisme*, sometimes *matière* or "matter" painting, the significance of which will be explored later.

Such pandemic spontaneity had occurred before in the history of modern art, with the advent of *plein-air* painting during the 1860s, for instance, or the breakthrough to nonobjectivity around 1910–14. If this time, however, it was the Americans who pressed the logic of the new *lingua franca* to more radical conclusions than any seen elsewhere, it was for reasons that obtained peculiarly and uniquely among those artists. Steeped as Pollock, de Kooning, Rothko, and Newman were in the syntax of European modernism, they had appropriated it less from native precedent than from recently arrived exponents. When these departed, the Americans were left enriched but unburdened by history, and thus free to move beyond it, largely in response to an archaic, indigenous Romanticism that itself had always tended to so fix on existence, as Sartre might say, that it resolved into essence. Moreover, artists reared in the vast open spaces of the American West, maturing in the deep skyscraper canyons of New York, and painting on a

shoreline facing the infinite extent of the Atlantic Ocean might well reconceive pictorial space on a mural scale and in fluid, nonrelational, post-Cubist terms. Helping them to go the whole way and dare everything, even the image of a "charged" void, was of course the growing self-confidence of citizens—including those as alienated as "far-out" artists—whose stable, democratic nation had not only won a terrible war, but had also come through it politically powerful and physically unscathed, thus on the brink of unimaginable affluence and the means to provide a booming market for art. European artists, by contrast, could not readily escape their immense, glorious, yet bedeviled history, the acute poverty, loss, and demoralization brought upon them by vicious government and martial conflict, or the dense, long-inhabited lands from which they drew their mundane and artistic sustenance. As the Cornish painter Peter Lanyon said: "I live in a country which has been changed by men over many centuries of civilization. It's impossible for me to make a painting which has no reference to the very powerful environment in which I live." But just as the Americans had, Europe's new artists would prove resourceful enough to make a virtue of necessity, and create works capable of nourishing those of their fellow human beings starved for the stimulation of an art sufficiently free in its conception and formulation to disclose poetic but unflinching truths about life in our century. Compared with the vaunted rawness, physical ambition, gestural or chromatic power, and uncompromising abstraction of New York School works, much of Europe's postwar painting may seem undersized and timid, intricate, decorative, or overcrafted in the tradition of French *belle peinture*, but the art could hardly have been otherwise and remain authentic, given where, when, and how it was created. As a result, painters like Fautrier, Wols, de Staël, van Velde, Michaux, and Tàpies—unlike their counterparts in the United States—captured the minds and words of some of the period's greatest writers, among them Malraux, Sartre, Camus, Beckett, Ponge, and Merleau-Ponty. The English critic Herbert Read pinpointed the teasing paradox of the new European Expressionism when he wrote of Alberto Burri's collaged paintings, works made of old bandages spot-stained in sanguinary red and patched together with truly surgical elegance (fig. 119):

Burri in his works (one can hardly call them paintings) seems to assert the triumph of the creative will over the rational inferno of our technological civilization. Every patch in the sacking, every gaping wound-like hole, the charred edges and rugged cicatrices, reveal the raw sensibility of an artist outraged by the hypocrisy of a society that presumes to speak of beauty, tradition, humanism, justice and other fine virtues, and is at the same time willing to contemplate the mass destruction of the human race. The modern artist reacts to our tragic situation in many different ways—by mockery (Dada), by self-imposed silence (Marcel Duchamp), by a return to primitive animism (Moore, Dubuffet), and by the method which is Burri's: defiance. Such an artist seems to say: I will take the material which the technologist has used and rejected and out of his scrap-heap I will rescue beauty.

If it was an excess of passivity, aloofness, or conformism that had allowed Europe to be ground into dust, then art would have to defy. And it was indeed defiance that brought out European genius in full, undiminished form, yielding talents on the Olympian order of Alberto Giacometti, Jean Dubuffet, and Francis Bacon. Much too large to be

held by the niceties of a group style, however international it might be, these masters boldly accepted the reality of 1945—what the Germans called "zero hour"—and simply reinvented painting from moral, psychological, or visual positions as radical as the very different ones laid out in New York. If their imagery slipped precariously to and fro between abstraction and figuration, so much the better, yielding as it did a metaphor for European humanity astride a tightrope suspended between nostalgia for a rich, but cruelly amputated, past and fear or skepticism about a future of uncertain promise.

Old Masters of Modernism and the Regeneration of European Painting

As the lights gradually came on again, beginning with the liberation of Paris in August 1944, Europeans celebrated the end of a long, dark nightmare by trying to recover and reverence those aspects of their cultural patrimony that had suffered the most under the Nazis' barbaric rule. And in the arts nothing had been more debased than modern painting and sculpture, declared "degenerate" by the Third Reich in 1937 and then systematically interdicted, destroyed, or sold to foreign collectors. While such major masters as Klee, Schwitters, Beckmann, Hofmann, and Albers fled Germany, many others, including Nolde and Schmidt-Rottluff, resorted to "inner emigration," disappearing into the German crowd or countryside and working clandestinely. In Fascist Italy and Spain and in the occupied territories, modernism was routinely discouraged or humiliated, largely through an official campaign urging the populace to embrace the same sort of "healthy" Social Realism or Neoclassical kitsch that 20th-century authoritarians seem always to favor, whatever their political bent. In the wake of this dismal history, Picasso, who had remained in Paris throughout the Occupation, an "inner emigrant" quietly producing such poignant tributes to the human spirit as *Man with Sheep* (fig. 146), stood tall in late 1944 as the intrepid symbol of all that was right in a world besieged by wretchedness and wrong. Not only had he pro-

duced the violently anti-Fascist *Guernica*, that paradigm of engaged modernism and thus quite possibly the single most influential work among Europe's postwar painters; he was also the co-creator of Cubism, the most international of all modernist currencies and the very thing the Occupiers had taken pains to vilify. Thus, when the "Salon de la Libération" opened in Paris, only weeks after the Germans had been driven from the French capital, Picasso starred in a large cast of Fauvists, Cubists, Surrealists, and abstractionists, together representing the glories of artistic freedom once suppressed by the Nazis and now regained. Magnificent and moving though the occasion was, it paid tribute to what was, all too sadly, a long-departed and unsurpassable era of heroic achievement, of artistic giants scaling peak after peak of innovation, each an historic breakthrough and all undertaken for the sake of a better life of one kind or another. In the end, of course, art proved a frail reed of defense against the storm troops of organized evil. The curious mix of success and failure could only confuse or intimidate, even while inspiring, a younger generation of artists eager to claim their place but uncertain where to start. When it came to the Holocaust, even Picasso could not recapture the galvanic certitude of feeling and expression he had poured into *Guernica*, completed in all its colossal size and complexity, along with hundreds of sketches and related drawings, in the short space of six intense weeks in the summer of 1937. For *The Charnel House* (fig. 92), begun in late 1944 under the impact of newspaper photographs published as the abominable death camps were being discovered, Picasso labored over a period of at least a year and perhaps much longer. But awesome as the work may be, in its power to convert reportage into tragedy, and apt as it may seem as a final-act pendant to the fatal drama begun in the tragic events played out in *Guernica*, *The Charnel House* has passed into art history as little more than a footnote compared to the epochal status of *Guernica*, called "the last great history painting" and "the most powerful invective against violence in modern art." Whereas the newsprint grisaille of the earlier work seems red hot with rage, the same palette in the second canvas has a ghostly effect, as do the spectral *pentimenti* and the tangled pile of limp bodies, dead and beyond the screaming, rearing agony in *Guernica*. While this masterpiece bristles with public polemic, *The Charnel House* radiates the quiet, somber mood of a requiem. As the unfinished passages, the numerous erasures and revisions would suggest, Picasso finally gave up and allowed his clearly evident, unresolved struggle to become a metaphor for the difficulty of realizing pictorially the enormity of the situation in which the world now found itself. The problem of how to express the inexpressible was to haunt the whole postwar generation of European painters, as it did the Americans, and, of necessity, dominate their stylistic choices.

Picasso, meanwhile, in a more representative vein, would solve the problem of what and how to paint by frankly looking backward rather than forward, but undiminished in plastic vigor as he generated a tidal wave of paintings, sculptures, ceramics, and prints. During the 1950s, his most important venture in pictorial art may have been the series of variations he made on the works of such earlier masters as El Greco, Velázquez, Poussin, Delacroix, and Courbet (fig. 93), a process already justified when, in 1935, he said: "We must pick out what is good for us where we can find it—except from our own works." Always voracious in his appetite for stylistic and iconographic variety, Picasso had often been content only with an eclectic mix of diverse

France, just as he had during World War I. There he reacted to his own corporeal disability and the inhumanity of the moment by literally reinventing his art in order to make it a still more joyous, affirmative expression of humanist faith. Even while suffering from the mutilations of cancer surgery and agonized over the imprisonment of his daughter and estranged wife, for their activities in the Resistance, Matisse began painting with a simplicity and purity not seen in his work since 1916, producing canvases of such solid yet airy, effortless drawing and radiant, singing color that they seemed, to one observer, "a clarion call amid the darkness." But this was only a start, for like certain very great artists in extreme old age—Michelangelo, Titian,

opposite above: 92.
Pablo Picasso.
The Charnel House. 1944–45.
Oil and charcoal
on canvas, 6'6⅝" × 9'2½".
Museum of Modern Art,
New York (acquired through
the Mrs. Sam A. Lewisohn
Bequest [by exchange]
and Mrs. Marya Bernard
in memory of her husband
Dr. Bernard Bernard, William
Rubin; and Anonymous Funds).

opposite below: 93.
Pablo Picasso. *Portrait of
a Painter, after El Greco*. 1950.
Oil on plywood, 39⅝ × 31⅞".
Collection
Angela Rosengart, Lucerne.

94. Henri Matisse. *The Snail*. 1953. Gouache on cut and pasted paper, 9'5" square. Tate Gallery, London.

elements plundered from several different parts of his vast artistic culture. Now, he would concentrate on individual masterpieces and translate each into his own inimitable language of Surrealist-Expressionist Cubism, thereby revalidating his admired prototype while also integrating himself into the timeless but ongoing stream of historical art. He had declared long before: "There is no past or future in art. If a work cannot live always in the present, it must not be considered at all." In his variations on *Las Meninas* by Velázquez, *The Women of Algiers* by Delacroix, or El Greco's auto-portrait, the septuagenarian Picasso made past and present live through the sheer virtuosity and invention, the wit and savagery of his performance, then unparalleled even in the artist's own oeuvre and, for younger, less vital or assured artists, a dismaying model of existential self-affirmation. Uncannily, Picasso was also guaranteeing the life of his art in a future present, when his recondite variations, which had appeared formally and conceptually retardataire in the Abstract Expressionist fifties, would become forerunners of both the serialism and the appropriative passions of not only the Pop and Minimalist sixties but also the post-modernist seventies and eighties.

Sharing the limelight with Picasso at the Liberation Salon was Henri Matisse, Picasso's great peer and rival, and the artist the Nazis had labeled "the dean of degenerate art." Unlike the indestructible Spaniard, Matisse was entering a long but terminal illness when the Wehrmacht seized Paris, prompting him to take refuge in the South of

Rembrandt, Ingres, Monet, Picasso—Matisse had merely got his second wind and would soon race ahead to one final, transcendent burst of creative freedom (fig. 94). Normally, this takes the form of great spiritual or philosophical insight that seems all the more affective for being conveyed through diminished technical or physical resources. With Matisse, however, the hand could scarcely have been more fluidly secure or the conception more youthful, and it says something that the artists who best understood Matisse's late work may have been the second-generation Color-Field painters just emerging in New York towards the end of the 1950s. What they saw was an art created by a corpulent old man lying on his back, drawing with charcoal, fastened to the end of a long wand, on paper attached to the ceiling above. In this way Matisse prepared vast compositions, which he then executed by taking shears and "cutting into color," gouache color hand-stroked onto paper so that it assumes a saturated lucidity of unprecedented resonance. Once the color-shapes had been laid into the composition—sometimes figurative, though often unabashedly abstract-decorative like a carpet or tapestry, and almost always mural in scale—the resulting *découpages* or paper cut-out works became the very apotheosis of the master's initial Cézanne-inspired Fauve aesthetic. The planes of pure color, although flattened by their interlocking, jigsaw-puzzle relationships, conjure dimensionality through the fullness of their hues and the monumental simplicity of their arabesque shapes. By cutting into color, moreover, Matisse could manipulate his material

in a way that translated into pictorial terms his experience in handling clay for sculpture, a process that enabled the artist at last to achieve his career-long goal of synthesizing all his plastic ideas and means.

So universal was the new artistic potential discovered by the aged Matisse that its infectious gaiety seems fully at one not only with the jaunty, improvised rhythms and euphoric riffs of the book *Jazz* (1944–47), but also with the murals, chasubles, stained glass, and ecclesiastical furnishings the artist designed for the Rosary Chapel attached to a Dominican convent at Vence, a tiny village on the French Mediterranean coast (fig. 95). In gratitude for the care the nuns had given him during his illness, the agnostic Matisse devoted most of his energy during the years 1948–50 to this summary project, in which he brought to ultimate realization the prophecy first pronounced more than a half-century earlier by his teacher, Gustave Moreau: ''Matisse, you were born to simplify painting.'' Now, he took simplification to the point of translating a French aesthetic of hedonist sensuality into the spiritualized, disembodied medium of colored light. At the Chapelle du Rosaire the blazing luminescence of southern France, which had so enraptured van Gogh at Arles, streams through tall stained-glass windows and casts their brilliant star, floral, and vegetal patterns onto the pristine surfaces of a white-tiled interior, its gleaming chasteness and immaterial, reflected colors made all the more dramatic by figure murals executed in the purest black contour drawing. Although widely hailed as the elixir most desperately needed by an enervated Europe, Matisse's late cut-out art, like most of his earlier work, also fueled the hostility of critics who viewed anything so delightful as irrelevant to the cause of a troubled world. It was this very cause, of course, that had always motivated the endless struggle on the part of an artist consumed by a sense of moral responsibility to create the healing effects of ease and joy, to provide sensory gratification and therewith express a ''nearly religious feeling towards life.'' Such sophisticated optimism proved to be too much for all save a few European painters of the forties and fifties, but while many sixties artists would embrace the simple grandeur and reductive chromatics—the flat, smooth, yet light-filled color-shapes with scissor-sharp edges—pioneered by Matisse, the warm, humanist content of his art generally eluded them.

What spoke with great immediacy to Europe's postbellum painters were the sensuously textured, emotionally engaging surfaces that had long been a School of Paris hallmark, and could be seen to resplendent effect in the paintings of Georges Braque and Chaim Soutine, also exhibited at the Liberation Salon. In the case of Soutine, the event constituted a memorial tribute, since the *maudit* Russian artist, as we saw earlier, perished during the war, his tormented, manic-depressive existence so at one with the intuitive force of his passionate painting

below: **95.** Henri Matisse. Chapel of the Rosary of the Dominican Nuns, Vence. Consecrated June 25, 1951.

above: **96.** Georges Braques. *Atelier II.* 1949. Oil on canvas, 4'3" × 5'3⅜". Kunstsammlung Nordrhein-Westfalen, Düsseldorf.

opposite: **97.** Fernand Léger. *The Builders.* 1950. Oil on canvas, 9'10" × 6'6". Musée Fernand Léger, Biot.

style that he seems an Existentialist before the fact. Not only would de Kooning find inspiration in Soutine's extravagantly impastoed icons of tumultuous feeling—in their power to make ugliness and beauty transcend one another—but so too would Bacon in England and the Continent's new Informal Expressionists.

The innate faith in the capacity of paint and its manipulation to convey mood was about all that the serene, steady Braque shared with Soutine. Still, this was no small bond at a morally fraught moment when words themselves threatened to fail even the poets and philosophers. The co-inventor of Cubism and thus as important in 20th-century art as Picasso or Matisse, Braque was also the quintessential, lucid Frenchman, who worked from deep but quiet passion and with infinite, Chardin-like craft. Savoring his materials, he mixed them into a subtle and varied cuisine of succulent tastefulness (fig. 96). But, as in the pre-cut-out paintings of Matisse, the epicurean delectation provided by Braque's facture served the tough-minded purpose of endowing the hermetic realities of modern pictorial form with the accessible, even insistent palpability of touch and texture. While the solids and voids in a late Braque may seem to collapse into calm but irrational complexes of transparent, interpenetrating planes, then slowly accordionize their way across the field, such anti-naturalistic distortions and shifting perspectives, with their synthetic and sumptuous tan, purple, and black coloration, all hold tenaciously to the hard, physical fact of the painting surface. The cement that binds them comprises not only the artist's sophisticated harmony of contradictory visual elements, but also voluptuous, surface-declaring applications of an oil medium thickened with roughage—sand, gravel, or some other granular substance. No one felt the telluric pull of *la matière* more insistently than Braque, the journeyman master of fake wood graining and marble who long before had learned to treat tactile matter like a fortune-teller's tea leaves, believing he could ''divine things there which others cannot see.'' This appreciation of the mystery and message present within ''live'' media would make Braque one of the fathers of postwar ''matter painting.'' So too would the direction they took him from the rationality of Analytic Cubism towards the poetic, inward

and the popular or commercial art it had brought to life, particularly the comic strip and the billboards as well as electric signs of New York's Times Square. All fed into a new postwar style, once the artist recast his familiar vocabulary of forms—contrasted cylindrical and rectilinear shapes, heavy black contours, and unmodulated primary colors—into compositions of even greater stasis, flatness, and monumentality than before. *The Outing: Homage to Louis David* salutes the ultimate ancestor of French art's *engagé* revolutionaries, while using the formality of Davidian history painting to ennoble the contemporary genre theme of ordinary folk posing with their bicycles in the course of a Sunday foray into the country. Instead of looking back, the Builders series looked ahead to the 1960s, to both Roy Lichtenstein's Pop Art, that is, and to a Minimalist-inspired revival of Constructivism (fig. 97). Here, inspired by the sight of workers swarming over the steel skeleton of an electricity pylon under construction, Léger devised a scene of men laboring in harmonious collaboration for the collective benefit of the world at large. Convinced that "the people" merited the dignity of being portrayed in modernist form, and confident that he had done this with sufficient clarity, and humor, for his subjects to appreciate such a show of respect, Léger had his proletarian epic hung on the walls of the canteen in a Renault factory, only for the pictures to provoke laughter.

Humiliation at the hands of its intended beneficiaries had long been the fate of radical abstraction, and nowhere more brutally, as we have seen, than in the Soviet Union, beginning in the early 1920s, and then in Germany during the years 1937–45. While this automatically gave abstraction a moral advantage over realism of any sort, the issue was clouded by the fact that those abstractionists with the most to offer a spiritually starved postwar Europe—the mystical Kandinsky and Mondrian—had not only died during the war but also been virtually unknown in Paris during the 1930s. And this was true even though both had lived there throughout most of the decade, the Dutchman painting flower pictures to survive and the Russian making do without gallery representation. What they might have contributed can be told from the profound effect their art and its continuous accessibility had on the emergence of the New York School. In the meantime, the geometric and machine-style abstractionists dominant in Paris' prewar Abstraction-Création had generally accepted the dreadful fact of art's social futility—at least in the face of inflation, deflation, the Spanish Civil War, the Moscow Trials, Nazi inhumanity—and replaced Utopianism with largely aesthetic interests. Still, one of the founders of that group, Auguste Herbin (fig. 98), belonged to the Communist Party and thus proved all the more effective as an advocate of pure abstraction in the 1940s, even if the trend finally turned against the numerically calculated, hard-edged, planometric manner of his own

atmosphere of his magnificent, mildly Surrealizing *Ateliers*, or *Studios*, painted in the late 1930s. During the Occupation, this metaphor for human creativity darkened, even to blackness, and by 1949–54, when Braque painted a final series of *Ateliers*, the element of spontaneous fantasy found its symbol in a great bird flying about like a free spirit seeking escape from the confines of an enclosed and ordered realm (fig. 96). This wild creature, along with the somber ground lingering from the war years, would also seem to acknowledge the baffling, anxiety-ridden world without, even though it never attains dominance over but remains in equipoise with the classical *mesure* and logic so native to the artist's "sensuality of the spirit." Contributing to such mystical unity of opposites may have been Braque's late discovery of Zen Buddhism, the kind of rogue factor which once again reveals that great conservatives can often be great radicals, thus paradoxically more in step with, or indeed ahead of, the moment than the inattentive might ever have suspected.

Before these or any of the other components of the new style and content could fall into place, European artists had to refight the old battle of realism versus abstraction. The conflict became especially violent, since it pitted revolutionary aesthetics against revolutionary politics at a time when both laid claim to the moral high ground. The Communist Party, owing to its heroic and implacable resistance to Fascism, enjoyed such prestige after the Liberation that many artists and intellectuals became card-carrying Marxists, Picasso and Léger among them. In painting and sculpture, however, the Party demanded a propagandistic Realism very close in its literal-mindedness to the pseudo-classicism fostered by the despised despots of Germany, Italy, and Spain. No major or independent artist could tolerate anything so dictated or unimaginative, a situation that became rather droll when the Party felt obliged to renounce Comrade Picasso's Cubist portrait of Stalin. The less elite and more adaptable Léger, however, developed a "conceptual realism" through which he hoped to serve the cause of both common humanity and modernity. Several sojourns in the United States helped, not only during the war years but also in the 1930s, when Léger acquired a taste for America's "classless" society

98. Auguste Herbin. *Air, Fire.* 1944.
Oil on canvas, 5' × 7'8".
Musée National d'Art Moderne, Paris.

painting. Supporting Herbin and the cause of Constructivist abstraction were a new salon, the Salon des Réalités Nouvelles, initiated in Paris in 1946, and the cadre of critics who supported it. Among these was Michel Seuphor, who had edited the periodical *Cercle et Carré* before the war and in 1949 published *Abstract Art: Its Origins and First Masters*, a widely translated book whose illuminating account of modernism's heroic genesis and development could only make abstraction seem all the more alluring as the formal language most suitable to free expression. It helped bring about Europe's rediscovery of Mondrian, a master whom Seuphor then apotheosized in a book-length monograph published in 1955.

But scarcely any painter in Europe knew more about the great Dutch Neoplasticist than England's Ben Nicholson (1894–1982), who had found the essentials of his Constructivist style in the early 1930s during visits to Paris, where he and his wife, the sculptor Barbara Hepworth, joined the Abstraction-Création group and met such pioneer modernists as Picasso, Braque, Arp, Brancusi, Miró, Calder, Giacometti, and Mondrian. For a few years before the war, Nicholson, Hepworth, and Henry Moore constituted an outpost of advanced international art in Great Britain, a position that Nicholson reinforced when, in 1937, he co-edited, with Naum Gabo and J. L. Martin, the Constructivist book *Circle* and, in 1938–40, forged a relationship with Mondrian during his London sojourn. More than the Continental Constructivists, however, Nicholson remained close to nature, as English artists have traditionally done, and saw even his most autonomous forms as intimately involved with visual experience. "However 'nonfigurative' a painting may appear to be," he once observed, "it has its source in nature." It was also characteristically English that he, like his father, the 19th-century painter Sir William Nicholson, conceived of painting as the embodiment of a "poetic idea." The younger Nicholson gave poetry life in a subtly adjusted plane geometry of circles, squares, and sheer vertical-horizontal linear divisions, often executed in shallow, cardboard-thin reliefs. As if to counter the exquisite refinement of this art, so delicate in its occult balances, Nicholson scraped down the white, gray, and black surfaces to a fine, silvery texture, thereby toughening the work as a thing of perdurable, object-like quality. Only after the war, however, did Nicholson come into his full, international flower, by which time he had been living in Cornwall, mainly at St. Ives, since 1939 and, under the inspiration of that ravishing environment, had renewed painting directly from nature. Not only could the artist move freely from abstraction to figura-

tion and back again; he might also, sometimes, combine the normally rival idioms in the same painting, to the discomfort of neither and with surprising advantage to both. Nicholson's postwar art, although invariably chaste, classical, and understated, if not actually severe, gained from the "return to nature" a new lyrical, even romantic feeling, the consequence of a greater richness and variety of both color and line (fig. 99). While rhythmically inflecting the latter away from rule and compass regularity, Nicholson often betrayed his freely interpreted source in the silhouette of some form originally beheld in a still-life or landscape scene.

So full, complete, and persuasive was Nicholson's art that it became an overriding factor in the turn that younger British painters made towards abstraction in the postwar years, with a number of them establishing studios near the master in St. Ives. But while most would embrace his poetic identification with Cornwall's coastal environment, only the somewhat older Victor Pasmore (1908—) discovered new possibilities in Constructivist aesthetics. And since Pasmore was already an established artist, as noted for his theories and teaching as for the linear and atmospheric essences of his Whistlerian Thames-side views, the conversion he underwent in 1948 to the most austere kind of Bauhaus formalism caused a sensation in the British art world. But this occurred step by step as he echoed Mondrian and abstracted from trees, architecture, the spiral movements of water and Celtic ornament until, in 1952, he had achieved total nonobjectivity (fig. 100). Now the artist entered his "classic and rational" period, when, influenced by Charles Biederman's *Art as the Evolution of Visual Knowledge*, he created black and white two-dimensional and relief constructions more related, as the artist implied, to the mathematical logic of music and literature than to the evocative scene-setting of poetry and drama. But even in these pristine geometries Pasmore managed, through assemblages of clear and opaque materials, to continue the striking contrasts of definition and diffusion so essential to the lyric, Oriental beauty of his pre-abstract paintings. Although still more at odds than Nicholson with the growing taste for an expressionist accent, Pasmore employed and taught the language of abstract form with such clarity and conviction that he helped make its grammar fundamental to the whole of art and design, figurative or nonfigurative, as they would be understood in mid-century Britain. This reach for greater professionalism and aesthetic independence, at least from a traditional alliance with literature, began in the 1950s, but would have much greater impact in the 1960s, once Pasmore, Coldstream,

and others of similar mind undertook to reform basic instruction in British art schools. When combined with the breakthroughs already achieved by Moore, Hepworth, and Nicholson, as well as with other cultural developments to be mentioned shortly, it prepared British art to assume a central position in the international mainstream for the first time since Turner and Constable.

Nowhere in Europe did the objectivity-versus-abstraction debate assume greater urgency than in West Germany, a nation that by 1945 had been reduced to rubble, when so much had been lost that the moment could only be seen as a chance for a completely new start. Desperate to heal their wounds and rejoin the free world, enlightened West Germans looked to art and its restorative powers more longingly than anywhere else. What they found, however, was that not one of the great pioneer modernists who had fled oppression—Beckmann, Kandinsky, Grosz, Schwitters, Klee, Feininger, Kokoschka, Hofmann, Albers—would ever return to Germany, and those who had remained as "inner emigrants" were as isolated from international developments, after twelve years of Hitlerian misrule, as the younger generation. Within this vacuum, older artists tended to step back and recommence from where they had been in 1933, while their juniors struggled with the multiple deprivations of having never known legitimate mentors, uncensored expression, or anything else in art other than the "healthy, Aryan" banalities of Nazi-approved Social Realism. The established master who emerged from the recent ordeals strong enough to serve as a precious, vital, creative link between the glories of Germany's earlier modernism and the resurgent, if alienated and unfocused, energies of the present was Willi Baumeister (1889–1955), a veteran of and living witness to almost every advance made in European art, from the time of his graduation at the Stuttgart Academy before World War I until the Nazis dismissed him in 1933 from his teaching post at Frankfurt's Städel School. Not only had Baumeister survived domestic exile as an officially anathematized "degenerate artist"; he had also managed to remain stoically, if secretly, productive, giving birth to several important series of paintings, researching the ancient cultures, myths, legends, fables, and prehistoric art upon which they were based, and when canvas and colors ran out, writing a book that would be published in 1947 under the title *Das Unbekannte in der Kunst (The Unknown in Art)*. Here, building on Kandinsky's theories, Baumeister argued for the true sources of art in the mysterious and the primeval, penetrated by a mind regressing through long-buried layers of cultural memory in response to new sensations. Such notions, however, had their most telling demonstrations in the author's own paintings, their flattened spaces and floating, semiabstract biomorphs disclosing old affinities with both Léger and Miró (fig. 101). Meanwhile, his search through subjective experience for a universal language of archaic forms harked back to Surrealism and paralleled the mythic concerns of the New York School in the early and mid-1940s. Part of the message, however, lay in the inchoate potency of an encrusted surface, its stucco-like material derived from oil mixed with sand, plaster, or putty and speaking the poetry of matter that postwar painters would make quite particularly their own. Those in West Germany enjoyed the vociferous advocacy of Baumeister, who in a famous debate with Karl Hofer, of Berlin's Hochschule für Bildende Künste, won a polemical victory for abstraction as the only possible mode of artistic expression in an age confronted with realities so monstrous as to be beyond illustration. Despite the hostility of a public corrupted by Nazi policies, the argument carried the day with young West German artists, who saw nonobjectivity as the language of Kandinsky and the Bauhaus, of freedom ringing out against tyrannical Social Realism, once imposed by the dread Hitler and now reimposed by Russian-dominated East Germany. With its manifold possibilities for individual innovation, abstraction promised to become the new visual Esperanto, a moral as well as artistic force internationally binding on all who embraced it, and thus offering to German artists the means to gain a passionately desired re-admission into the world community of civilized nations.

War being utterly destructive, it seems to follow that certain side effects of belligerence may prove counteractive enough to become beneficent, as in the medical and technological discoveries that World War II's accelerated military research bequeathed to a convalescent peacetime world. Certainly, the reaction against the threat and fact of Axis aggression was to engender a new respect or sympathy for the intended or actual victims, and with this the avant-garde began to emerge from the underground and slowly to assume an establishment status—commercial as well as official—even more powerful than that once held by the unchallenging, academic art whose worn-out or empty values it had been at such pains to expose. "Slowly," however, must be the operative modifier in characterizing the progress by which modernism would so triumph in its late phase as to become virtually co-opted, even canonized, by the very kind of vested interests it had set out to critique. But as Baumeister's public defense of abstraction would suggest, it had become evident to many that the alert, ongoing critical process—the boldly visionary truth-seeking and -saying—sacred to modernism must never again be allowed to become so elitist or suppressed that it could not, as in the 1930s, play some significant role in the overall conduct of human affairs. Not only did the broad acceptance of the new art come about in Europe at a merely incremental, or inchworm, pace; it also started from a position almost as backward as that in the United States, whose noisy philistines were perfectly echoed in the outrage expressed in the mid-1940s by France's art establishment towards Dubuffet's experiments with Art Brut. They could also be heard in the derisive laughter with which the German public in 1952–53 greeted the Informalist abstractions of the Quadriga group, or in the words of the president of London's Royal Academy who, around 1947, boasted of how he longed to give Picasso a running kick from behind. Also at work in England, however, were the activities of the Arts Council, a government-chartered agency established in 1939 to project the best in British art and music at a time of national crisis, and then continued after the war as the most generous source of patronage that contemporary art had known in Britain since the Middle Ages. While the Arts Council organized or supported exhibitions, of both native and foreign work, built up collections, made financial awards, and subsidized studio space, among other things, the Institute of Contemporary Arts (ICA), founded in 1947, again by government grant, provided a meeting place in London for the many artists who had been scattered by the war. Comparable developments, albeit formalized in different ways, occurred throughout Europe west of the Soviet Bloc, as in the revival in 1948 of the Venice Biennale. Here Italians might compensate for their cultural isolation during the Fas-

101. Willi Baumeister. *Atlantis*. 1947. Oil on board, 31⅜ × 38⅝".
Wilhelm Lehmbruck Museum, Duisburg, West Germany.

cist decades and review the full sweep of modernism, from the French Impressionists to Henry Moore, who, in an exhibition arranged by the British Arts Council, took the International Prize for sculpture. West Germans too began to catch up on a massive scale after the establishment in 1955 of the quadrennial Documenta shows in Kassel, a series devoted to world art at its most innovative. After years of closed frontiers and fractious hostility in one degree or another, Europe opened to cosmopolitan, cross-cultural vanguardism as never before, with the result that the achievements of every country could be measured against the highest international standards. If Informal or Expressionist abstraction became the universal language of modern art, it was in large part because of vigorously pursued policies of internationalism in the exhibition programs sponsored in major centers right across Western Europe. London, for instance, saw the great Picasso and Matisse retrospectives at the Victoria & Albert Museum in 1945, or the influential de Staël show at the Matthieson Gallery in 1952. In 1948, meanwhile, a number of Continental cities, both East and West, got their first sight of the New York School when Peggy Guggenheim sent her collection on tour. During the same year, the new French and American painting could be seen together for the first time in a joint exhibition organized by the Informalist painter Georges Mathieu at the Galerie Montparnasse in Paris.

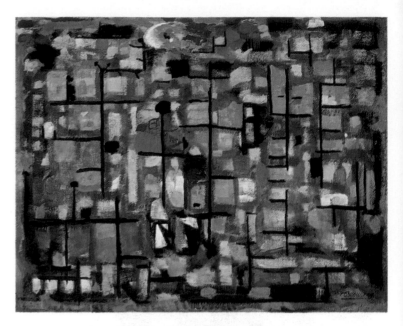

Young Painters of the French Tradition

Paris, still the glittering art capital of Europe, celebrated the new era not only with the Liberation Salon already discussed (actually the Salon d'Automne of 1944), but also with three new salons: the Salon de Mai devoted to the avant-garde in general; the Salon des Réalités Nouvelles, which would focus on Herbin-type abstraction, and the Salon des Peintres Témoins de leur Temps, built around a single figurative theme each year. More important perhaps was Paris' vital infrastructure of commercial galleries, art critics, and specialized journal publications. And this remained remarkably intact even during the Occupation, thanks to cynical self-interest on the part of the Wehrmacht. In 1941, with the idea of allowing the French to prove their own artistic "degeneracy," the Nazi overlords turned a blind side as the Galerie Braun opened an exhibition entitled "Vingt Jeunes Peintres de la Tradition Française." It presented a group of younger French painters determined to rebel against the puerilities of German-imported Social Realism. Several of the participants in the show had studied with Roger Bissière (1888–1964), a onetime professor at the Académie Ranson whose own paintings could be said to exemplify the French tradition, as it was then perceived, and thus to have foreshadowed the dominant mode within postwar European painting. Indeed, Bissière came into his own only after 1945, when, with eyesight improved by surgery, he realized a late flowering in his personal blend of Fauve color and Cubist structure (fig. 102). For the large, radiant, tapestry-like compositions this produced, Bissière "humanized" his abstract form not only by deriving it from an observed scene, often a forest, but also by preserving the expressive character of the original, even though its actual contents may have been simplified beyond all recognition. Nuanced, deliciously painterly, genteelly modern, and decorative in the best sense of the word, Bissière's scintillating all-over grids of vivid, interactive color offered the French a civilized self-image at a time when they were exceedingly grateful to have it.

Among the Bissière-inspired rebels of 1941 were Jean Bazaine (1904–75) and Alfred Manessier (1911—), who too carried School of Paris aesthetics to a degree of abstraction previously achieved perhaps by Kupka or the very late Monet but, at that time, never more than touched upon by, for instance, Matisse, Braque, Picasso, and Delaunay. Moreover, they defined themselves as a new generation by saturating their art with a content of spiritual, even religious purity not seen in French painting since the Symbolist years at the end of the 19th century. In the late 40s and the 1950s Bazaine (fig. 103) won an international reputation for a series of ambitious paintings whose layered,

above: 102. Roger Bissière. *The Forest.* 1955. Oil on canvas, 4'3⅜" × 5'4". Musée National d'Art Moderne, Paris.

left: 103. Jean Bazaine. *Moon and Night Bird.* 1947. Oil on canvas, 4'2⅝" × 3'1⅞". Kunstsammlung Nordrhein-Westfalen, Düsseldorf.

lattice structure of glowing colors, set down in large, nervous strokes, brought frequent comparisons with stained-glass windows, a medium in which the artist actually created some of his most monumental works. Like Bissière and the other members of his own group, Bazaine resisted being classified as an abstractionist, since he always worked from external reality, if only for the purpose of disclosing what he termed the "interior geometry of [its] forms." By this he meant the mysterious inner reality of rhythm and order that in his view fuses each individual thing with the totality of things, while simultaneously investing it with a distinct particularity of human feeling. A notable writer, Bazaine said in one of his most revealing statements: "True sensibility begins when the painter discovers that the eddies of a tree and the bark of the water are kin, that the stones and his own face are twins, and when as the whole world thus shrinks together he gradually sees essential signs which are at once his own truth and the truth of the universe." Manessier, shortly after the 1941 exhibition, visited the Grand Trappist Monastery northeast of Paris and underwent a reconversion to Roman Catholicism, an experience that moved him to translate reality into a highly purified, but painterly, diction of flattened signs and symbols whose jeweled colors, skeletal framework, and tall, dynamic compositions resemble Fauve-Cubist rescensions of

104.
Alfred Manessier.
*Crown of
Thorns.* 1950.
Oil on canvas,
5′3½″ × 3′2¼″.
Musée
National d′Art
Moderne, Paris.

able truths. . . . '' Truth was to be found neither in pious revivals of yesteryear′s brilliant audacities, nor yet in the idealized, therefore falsified, realism favored by academicians and authoritarian regimes, but rather in the compulsive, innocent, driven, spontaneous creations of children, the naïve, the neurotic and alienated, the graffitists scrawling violent protests over the weathered surfaces of public walls. Similarly, means could be oil and brush on canvas, of course, but also cement or Swedish putty gouged with a stick, faded or stained rags stitched together with string—whatever improvised procedures and culturally virgin ''materials of fortune'' might stir the creative instinct at its core and produce an evocative, textured surface ripe with freshly compelling human associations. When consciously adopted by intellectually sophisticated or trained artists, such preconscious spontaneity and risk-prone, random selection tended to bring forth, just as it did in New York, a totally or largely abstract, organic or nongeometric image, since the truth that demanded to be expressed was that of a desperately ambiguous moment caught between hope and despair.

The confused mood of 1945 Europe appeared to receive no more poignant expression than in the small Hostage paintings exhibited at Paris′ Galerie Drouin by Jean Fautrier (1898–1964; fig. 105). Moreover, their moving qualities could only have been enhanced by the reality that before the war their creator, a senior French artist trained in London at the Royal Academy and Slade schools, had managed to alienate almost everyone with his peculiar brand of dun-colored figurative Expressionism—everyone, that is, except two powerful critics: Jean Paulhan and André Malraux. So great was his isolation that, for the sake of survival, Fautrier took a job as an Alpine ski instructor during the years 1935–39, a situation, however, that prompted a reorganization of his painting in the more abstract form of a ''field'' crisscrossed by a ''track'' of sweeping curves. Meanwhile, he had

Gothic windows (fig. 104). An avowed mystic, Manessier said: ''The object is to put the spiritual equivalences of the exterior and the interior world into the open by authentically plastic means, and to make these equivalences intelligible by transposition and transmutation.''

Surrealism, Existentialism, and the Advent of Europe′s Abstract Expressionist Painting

Brave and effective though it may have been for Bazaine and Manessier, with their sensitive gloss on Fauve-Cubist form, to reassert the values of enlightened modernism in the face of organized benightedness, the state of the world at the end of World War II demanded more than polite nostalgia for a lost Golden Age of artistic experiment. In the aftermath of Hiroshima and Holocaust, and with the onset of the Cold War, the return to the traditions of earlier modernism became a search for new departures—new breaks with the past—at least as radical as those made by the Fauves, the Cubists, and the German Expressionists themselves. Whereas the heroes of earlier modernism had sought renewal in the example of primitive sculpture, the generation of 1945 satisfied their longing for primal origins by exploring not only the Lascaux Caves, discovered in 1940, but also the Celtic world of prehistoric Europe. One of the shrillest cries for drastic rebirth came from Antonin Artaud, the crazed poet-draftsman who had foreseen the horrors of the mid-century in the 1932 manifesto to his Theater of Cruelty. Still, in January 1947, from the stage of Paris′ Théâtre du Vieux Colombier, Artaud declaimed: ''We are not yet in the world . . . things have not yet been created, the raison d′être has not yet been found.'' For this iconoclast, as for Jean Dubuffet and André Breton, the place to look for authentic, unmediated expression was in asylums, which Artaud knew only too well and where art of aesthetic import—*l′art des fous*, or *l′art brut* as Dubuffet called it—was thought to be created by ''madmen'' like van Gogh whom ''society does not want to hear, whom it wants to prevent from uttering unbear-

105. Jean Fautrier. *Head of a Hostage, No. 1.*
1943. Oil on canvas, 13¾ × 10⅝″. Collection Panza, Varese.

also begun to develop a collage technique that, by the time of the Hostages, permitted him to produce a painting surface layered and cushioned rather like a skier's ideal bed of snow. For these works, he first primed the paper ground with white paint, drew a flesh-toned image on it, and then repeated the procedure layer after layer before gluing the whole compressed pancake stack to a canvas support and dusting the top with powdered pastel. Over this *haute-pâte* Fautrier sketched the final version of his motif, the simplest, most generalized outlines of a human face rendered in a wash of such diluted color that the ghostly presence seems as much absorbed as revealed by the underlying magma-like surface. Curious as this mixture may seem—a combination of labored craft and extemporized gesture, dense materiality and vaporous impression—it served well to convey the contradictory emotions of violence and tenderness harbored by an artist intent upon memorializing the countless anonymous victims of Nazi viciousness. During the war Fautrier did in fact suffer the horror of having taken refuge within earshot of a forest where the Occupying forces carried out their appalling massacres. And so just as his new art had grown from the imperatives of primal encounter, Fautrier found his image by allowing it to emerge from unpredictable sensations generated by prolonged, and premeditated, involvement with both searing memories and a sensuous, evocative medium. As a result, the Hostages, with their crude, near-erotic textures and delicate blue and rose colors, hover vaguely between figuration and abstraction, between form and formlessness, and, by virtue of it, seem all the more authentic as metaphors for the interface between life and death. In his preface to the exhibition catalogue for *Les Otages* Malraux wrote that Fautrier had made "the first attempt to strip the flesh off contemporary anguish to the point at which he reveals the pathos of its ideograms, and drives it, through force, into the world of the eternal today." In the Hostages—what Malraux called "hieroglyphs of pain"—the artist represented little but expressed much, by so handling the essentials of his art that freely gestural, richly impastoed, ambiguous painting might not only bear witness to immediate, personal suffering but also embody a larger, more timeless truth. With this, Fautrier became one of the fathers of both *art informel* and *tachisme*. He also prompted Malraux to make what Peter Selz has called one of the most cogent statements about the art of our time: "Modern art was undoubtedly born on the day when the idea of art and that of beauty were found to be disjoined."

As all this would suggest, younger European artists were rediscovering not only Kandinsky's Improvisations of 1910–13, thanks to Picabia in Paris and various exhibitions in Germany, but also Surrealism, which re-emerged with the homecoming of André Breton and his cohorts from their wartime refuge in New York. However, if psychic automatism meant everything to the new generation, the iconography of dreams and myths proved irrelevant, with the result that Surrealism's contribution to postwar European art flowed mainly through the all-pervading influence of Existentialism. Now Breton, the Surrealist "pope," would be replaced by the French philosopher Jean-Paul Sartre, the "pope" of Existentialism, who reigned over the Saint-Germain-des-Prés quarter on Paris' Left Bank as if it were his Holy See. There, at the center of the West's most combustive cultural ferment in the postwar era, Sartre carried forward certain Romantic ideas—ideas first advanced by Denmark's Søren Kierkegaard (1813–55), then further developed by Germany's Friedrich Nietzsche and Martin Heidegger—and articulated a philosophy of human existence that viewed modern man as alone in the world, bereft of whatever ethical or religious systems once supported or consoled him. In this solitary situation—the metaphysical void—the individual is free to make of himself what he will, reinventing his life with each act or gesture. Thus, true living comes from activated self-awareness so total that existence "passes beyond" (*outrepasser*) or transcends itself and becomes essence, a condition allowing the personal to resolve into the universal. And it is to this condition that every concerned individual aspires, since the alternative to authentic being is nonbeing, or nothingness. To partake fully of the human adventure, the intelligent, creative person must resist fixed ideas, patterns, or standards and embrace change, constantly becoming and ever prepared to be modified by new and unforeseen experiences. For many in the postwar world, such freedom and responsibility engendered chronic dread and anxiety; for others, the existential life brought fulfillment and even a sense of salvation. Transcending ego also meant losing the self in the world outside, there handling the givens of a situation in a way that they became an objectification of the existential person's own subjectivity or essence. Like the historical circumstances that produced it, this was clearly a conception of life so replete with ambiguity that verbal language itself seemed inadequate to the needs of Sartrian ideas. As the Frankfurt philosopher T. W. Adorno wrote in *Ohne Leitbild* (1967), the feeling ran high after Auschwitz that poetry would no longer be possible. Jean-Paul Sartre himself found it efficacious to demonstrate theories in the narrative or dramatic manner of novels and plays, as well as in straightforward philosophical treatises, while he and other writers—Beckett, Malraux, Ponge, Camus, Blanchot, Merleau-Ponty, Bachelard—wrote on painting, sometimes collaborated with its creators, and often included the acts of the painter in overall philosophical considerations of the human dilemma. And for good reason, given that Expressionist abstraction—the kind of free, gestural, richly surfaced painting then emerging in Europe as well as in New York—could be seen as the most Existentialist of art forms. Here was a mode of communication that, by lending itself to unconscious, preverbal impulse, offered the greatest potential for showing, as Merleau-Ponty wrote, "how we are grafted to the universal by that which is most our own."

Informalism/Tachism: Europe's New Abstract Expressionist Painting

Once the Existentialist mood made it appear that the only valid subject for postwar painting was "inner being," younger members of the School of Paris began, quite independently of developments in New York, to paint in something like the Abstract Expressionist manner already seen in the new American painting. Soon this would become the dominant trend everywhere in Europe, its engine fired by a widespread conviction that generalized feelings of angst and a rage to project or transcend them could only be expressed, not depicted. Subjectivity, of course, dictated a good measure of stylistic individuality, but the overall tendency was towards painterly freedom, a relatively extreme degree of abstraction, and spontaneous, intuitive process. Together, these factors generated a form of pictorial late modernism that came to be known as *art informel*, a term coined in 1950 by the critic Michel Tapié to distinguish the painting from the geometric or "formal," intellectually derived abstraction inherited from the 1930s and still flourishing, as Herbin's work showed, in postbellum Paris. Tapié also wrote of *Un Art autre (A Different Art),* in a book by this title published in 1951, thereby signifying the serious rupture that Informalism's peculiar combination of qualities made with precedent. Beginning in 1954, much of the same art also came to be known under the rubric *tachisme*, introduced by the French critic Charles Estienne in recognition of the loose, organic, and often strongly tactile "blots" or "patches" of color with which Informalist or Tachist artists transformed their painting surfaces into webs of complex, interactive emotion. Where texture itself became the principal carrier of feeling, especially when the impasto is dense and richly nuanced, as in Braque's painting, or built up into an *haute-pâte* like that seen in Fautrier's Hostages, or yet supplied by such granular, non-art materials as sand, cement, iron filings, or burlap sacking, the art has frequently been identified as *matière* or "matter" painting, its surface emphatic and concrete enough to make an abstract image seem the paradoxical, existential embodiment of both presence and absence.

By the time Tapié introduced the term *art informel* the painting at issue was far more dramatically unfettered in both its gesturalism and

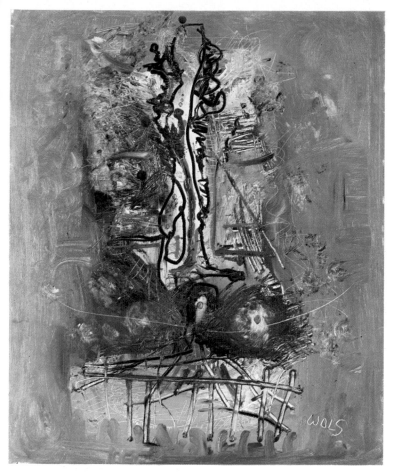

106. Wols. *Champigny Blue*. 1951. Oil on canvas, 28½ × 23⅜". Courtesy Galleria Schultz, Milan.

mote, solitary corner of the camp, Wols began to draw and also to drink, the alcoholic consumption fueling his dark, troubled imagination while the graphic production rewarded him with a sobering sense of release. Let go in 1940, but always threatened with arrest and deportation, he depended entirely on his devoted French wife to provide for his meager needs—mainly rum, paper, a rusty pen, ink, a box of watercolors—while he roamed the Mediterranean beaches examining the strange biological life, later translating it into a bizarre and convoluted iconography. It was as if he were heeding the advice given centuries earlier by Leonardo da Vinci, who urged the painter to "stop sometimes and look into the stains of walls, or mud or like places, in which, if you consider them well, you may find really marvelous ideas . . . because by indistinct things the mind is stimulated to new discoveries." Wols' imagery, although largely indecipherable, conjured a visionary world still more evil-obsessed than that of such kindred spirits as Baudelaire, Lautréamont, Rimbaud, or Artaud. Totally wrapped up in himself and isolated from society, the artist turned out hundreds of drawings, all filled with the magic of a teeming, richly associative subconscious liberated by Surrealist automatism to generate twisting hanks of fibrous, serpentine lines. In the clotted, ropy maze of their writhing movements, psychic self-revelation and objective observation of the world seem caught up in a never-ending, metamorphic process of crystallizing and decaying into one another.

The drawings, however, could not provide a living for their creator, but even as poverty, heavy drinking, and feverish work pushed his health into rapid decline, Wols accepted the oils and canvas offered by his dealer and launched upon one last great creative effort. The paintings, although larger than the drawings, seem to have engaged Wols even more completely, in a kind of physical as well as psychological *danse macabre* that yielded still greater abstraction than before, the images becoming seismographic, rather than descriptive, self-portraits of a human being already beyond the outer limits of moral and physical endurance (fig. 106). Often the calligraphy coils upon itself and sprouts a radiating set of thorns or hairy tendrils, suggesting a burnt-out crater or a heavily encrusted black wound. It festers at the center of a field of bruise blue scored deep into the quick of bone-white underpainting and lacerated with fat, vermicular trails or spills of blood red. Wols was now pouring and spattering his medium somewhat in the automatist manner then being perfected in New York by Jackson Pollock. In a small, late group of canvases, like the one seen here, the dangling, knotted threads of the artist's tracery coalesce in the general shape of a tall ship, adrift on a roiling sea, its mast splintered, its sails in tatters, its halyards tangled. The painting could be an imaginative interpretation of Rimbaud's *bateau ivre*, now buffeted at the center of a hurricane. A poet in words himself, Wols so frequently quoted the following aphorism that it could be understood as a kind of *Leitmotiv* of his approach to art: "He who draws while he is awake has knowledge of a thousand things which elude him who draws only in his sleep." Working like a "somnambulist"—that is, closing his eyes and allowing inner turmoil to guide his mobile hand—Wols transformed his art into a direct, unmediated expression of his life, a process that, inevitably it would seem, made the art expressionist and essentially abstract, what Tapié called "informal." But it also became a telling symbol of shattered Europe, betrayed by its immense past and increasingly convinced that the only viable route to self-affirmation lay in existential necessity. In Wols, writers like Sartre, Paulhan, and H. P. Roché saw the pathfinder, a draftsman/painter who, by irrevocably linking his artistic enterprise to the self-destructiveness of his own existence, demonstrated the liberating nature and overriding good of the creative act. As Roché put it: "Wols fashions his drawings as a snail does its house—in a natural and painful process." Some critics have likened Wols to Pollock, but while the unstable, alcoholic American also dribbled paint as an existential imperative, the technique liberated him to achieve a brief, three-year period of equilibrium, when the grandeur, harmony, and classical balance—the holism or "homogeneity"—of his art embodied stylistic and spiritual values

its relationship to the world without than the attenuated, albeit attractive, modernism of Fautrier, Bissière, Bazaine, and Manessier. The specific artist Tapié had in mind was Wols (Alfred Otto Wolfgang Schulze; 1913–51), whose German nationality attested to the continuing cosmopolitanism that had always given the Paris art scene its special lustre. It also helped account for the intense, emotional subjectivity and charged linearity—characteristics long familiar in German art—that permitted Wols to attain extremes of both expressionism and abstraction unimaginable in the work of his French precursors in the postwar School of Paris (fig. 106). Extremes also marked the life of this artist, who began as the privileged and prodigiously gifted son of a high Saxon official, only to become the tragic victim of political, as well as personal, chaos and eventually to die of it at the age of thirty-eight. But not before he had extracted from his torment a vast, powerfully original art so at one with the "crisis" mood of the late 1940s that Sartre considered him the Existentialist painter par excellence.

In his childhood and adolescence Wols had been a remarkable polymath, professionally accomplished in music, fish breeding, and photography. He also studied anthropology and made memorable, if brief, contacts with many greats of contemporary art—Moholy-Nagy, Klee, Dix, Grosz, Arp, Léger, Giacometti. Owing to his range of aptitudes and roving curiosity, however, the outwardly serene, successful Wols found himself "torn apart" by his lack of "homogeneity." Thus, it seems inevitable that he would be at home, as never before, once he arrived in Paris in 1932 and at the age of nineteen discovered the world of Surrealist literature and art. A visceral anti-Nazi, Wols resolved to escape Germany forever, a decision that drove him to Spain, where a refusal of his country's call to arms left him in a passportless, refugee status for the rest of his life. After war broke out, it also resulted in his internment in the South of France. There, in a re-

remote from those so movingly evinced by the small, jangled, morbidly beautiful works of Wols.

Although Wols may have inspired the term *art informel*, his compatriot Hans Hartung (1904–89) had long before—as early as 1922—arrived at a personal style sufficiently abstract and gestural to qualify as a precocious antecedent of the very movement he and Wols would help triumph in the postwar years. In between, however, Hartung studiously investigated the whole of modernist experience—van Gogh, Cézanne, and the Cubists especially—after Rembrandt's religious humanism and the German Expressionism of Kokoschka and Nolde convinced him that his true vocation lay in painting. With support from his well-established family, Hartung took courses in art history and philosophy at Leipzig, where a lecture by Kandinsky informed him about the experiments in nonobjective painting carried out by the great Russian, Klee, and others. While studying painting in Dresden, he attended the International Exhibition of 1926 and discovered French Impressionism, Fauvism, Cubism, Rouault, Henri Rousseau, Braque, and Picasso. Together, Kandinsky and the Dresden show made it obvious to him that his further development should take place at the very heart of avant-garde activity: Paris. He remained there until 1931, after which he and his Norwegian wife traveled from Majorca to Scandinavia, driven, in part, by the ominous political developments in Germany. Back in Paris in 1938, Hartung became intimate with the Abstraction-Création group and the Spanish sculptor Julio González. War brought first internment, then service in the French Foreign Legion, imprisonment in Spain, and finally action with the Foreign Legion on the Vosges front that left the artist so gravely wounded that a leg had to be amputated. In 1945 Hartung became a French citizen and soon emerged as a leading formulator of what would become Informal Art, the essential qualities of which he had already reintroduced into his painting way back in 1934. Clearly, this was where his natural bent

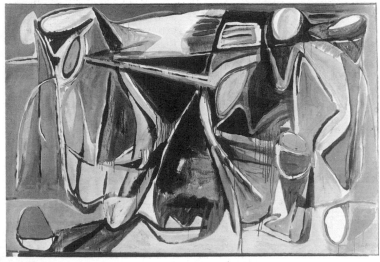

lay, and Hartung soon brought it to dazzling maturity in a series of improvisatory canvases distinguished by a pale, unified field alive with a vigorously contrasted, abstract imagery (fig. 107). Frequently, this consists of benign patches of stained, translucent color alternating with sharp, black strokes, some spinning wildly, others long, blade-shaped, crisscrossed, and bundled like tall grasses. While the continuous, recessive ground may suggest infinite space, the calligraphy, by its rectilinear coordinates or the centrifugal orientation of the scrawling movement, conforms to the shape and confirms the flatness of the actual support. Endlessly reworking this simple vocabulary of forms, Hartung succeeded in expressing the whole range of extreme feeling to which he and European society were subject in the late 40s and the 1950s, the mood of each painting heightened by the artist's love of light green, brown, lemon yellow, cerulean blue, and, of course, black. "All the inner life of a sensitive and tormented man," wrote the critic Madeleine Rousseau, "appears before our eyes, with its unfathomable complexity and the eddies which the slightest touch provokes in it."

Early apprenticed to an interior designer, Dutch-born Bram van Velde (1895–1981) showed such promising talent that his employer sent him to the well-known artist's colony at Worpswede in North Germany, where he discovered modernism in the German Expressionist mode. After 1925 van Velde lived in Paris, but moved on to Majorca in 1932, remaining there until forced to leave by the Spanish Civil War. During this time the artist combined the bright colors and freedom of attack he had brought from Germany with a dynamically abstract formalism derived from Picasso's late Cubist work. So destitute was his situation in Paris during the Occupation that van Velde ceased painting almost entirely until 1945. When he recommenced, it was in a style that Samuel Beckett considered the very emblem of brave, existential humanity daring to create even when faced with the futility of such an act (fig. 108). The message emerges from large, fluid, rather flaccidly contoured color-forms ambling over a surface in a manner to suggest that they harbor a covert figuration, only for the latent eyes, faces, figures, and objects to resist closure and frustrate all attempts at precise identification. Consistent with the sense of stubborn futility this engenders is the apparent slipshod, dribbling casualness of the execution, which almost succeeds in hiding the slow, craftsmanly care actually taken by the artist to achieve such effects. Thanks to this studiedly enigmatic, formal perversity, derived from and expressing moral dilemma, he almost succeeded in denying the beauty of his palette, flowed on in thin, translucent washes of blue, brown, and pale buff.

The Belgian poet Henri Michaux (1899–1986) had been an active member of the School of Paris almost from the time of his arrival in the French capital in 1925, when he soon adopted Surrealism's automatic drawing as a natural and necessary extension of his writing. For him, it offered a means of breaking the verbal barrier and registering subtle states of mind beyond expression in words. "To paint, to compose, to write, to explore myself. Herein lies the adventure of being alive." With this as his creed, Michaux took the *tache*—the "blot" or "original cell"—as his point of departure and allowed all manner of evocative signs and phantoms to appear on the page. The drawing became a kind of visual poetry set down by a hand under the motor control of energy released from the psychic wellsprings of the artist's innermost being. By 1948, following the shock of his wife's accidental death, Michaux had forged such a charged link between his graphic facility and his interior ferment that, according to H. P. Roché, he could commence a new gouache with his right hand and, never stopping, use his left hand to set aside the just finished previous sheet. The series, completed in a matter of weeks and entitled Meldosems, numbered several hundred pen and watercolor drawings and a set of twelve lithographs. Pursuing ever-more heightened awareness, Michaux in 1955 began creating under the influence of mescalin, an experiment that enabled him to produce his most famous group of works (fig. 109). Now his image became completely abstract, an all-over distribution of meticulously fine calligraphy that, to many viewers,

writer, polemicist, exhibition organizer, world traveler, pioneer Happener, and prodigious, high-velocity painter of canvases even more colossally scaled than those in New York.

A gifted wordsmith, Mathieu described his process with characteristic brevity and panache: "Speed, intuition, excitement: that is my method of creation." And he often demonstrated it in public, once before an audience at Paris' Théâtre Sarah Bernhardt, where in less time than it would take to perform a play, he painted a canvas measuring 12 by 4 yards. When he executed a similar feat in the basement of a large Tokyo department store, the Japanese applauded his every thrust and parry before the canvas. The collector who bought the finished work commented: "In many respects [Mathieu's] work resembles that of old Japanese art, where emphasis was placed on spirit rather than detail." Already in Paris, Malraux had declared: "At last an Occidental calligraphist!" Like Pollock, Mathieu worked on the floor, at least in part, sometimes poured his medium, and once allowed a film to be

opposite above: 107.
Hans Hartung.
Painting 51–12. 1951.
Oil on canvas, 3'1⅝" × 4'8⅞".
Kunstmuseum, Basel.

opposite bottom: 108.
Bram van Velde. *Painting*. c. 1953.
Oil on canvas, 4'3" × 6'5".
Stedelijk Museum, Amsterdam.

above: 109.
Henri Michaux. *Untitled*. 1960.
Watercolor on paper,
2'5½" × 4'1½". Solomon R.
Guggenheim Museum, New York
(anonymous gift).

right: 110.
Georges Mathieu. *Capetians
Everywhere*. 1954.
Oil on canvas, 9'8¼" × 19'8¼".
Musée National
d'Art Moderne, Paris.

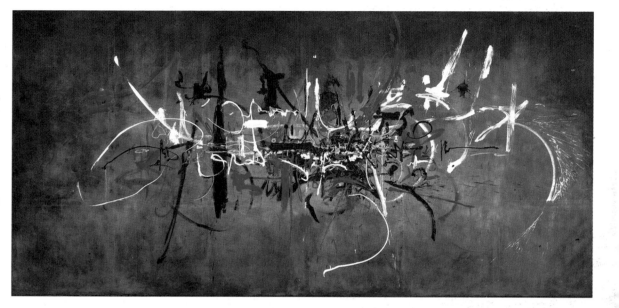

offers close, pen-and-ink parallels with the holistic styles of Jackson Pollock and Cy Twombly (fig. 335). With their continuous, tight, spiraling textures, these small sheets suggest the sensibility of an artist on the far rim of human experience, where total being and nonbeing, sign and nonsign have become inextricably mixed in a state of Informalist transcendence.

Among the younger painters influenced by Wols, Hartung, and Michaux, the one to create the greatest public sensation was Georges Mathieu (1921—), a royalist descendant of ancient French aristocracy who not only painted pictures like a medieval knight charging into battle, but also used a similar approach in his effective promotion of the whole Informal–Abstract Expressionist movement—especially his own pyrotechnic contributions to it (fig. 110). A student of languages, mathematics, philosophy, and literature, Mathieu converted from representational to totally nonobjective imagery in 1944, after his reading of Edward Crankshaw's *The Craftsmanship of Conrad* persuaded him that the true reality of art lay in pure, unmediated expression, rather than in some reality—human figure, landscape or still-life scene, anecdote—external to the artist's style, his way of treating the canvas surface. Moreover, this social-political reactionary found his own autographic, revolutionary manner almost immediately, well before wartime isolation permitted him to learn very much about contemporary art in Paris. With its electric, whiplash calligraphy exploding like fireworks at the center of a flat color field, the manner reflects a personality so perfectly integrated that the English-speaking Mathieu could juggle an active career as a publicist for the United States Lines right along with his virtuoso performance as a

made while he was in the full swing of his frenzied creative process. It shows the dapper grandee decked out in white helmet, black silk pants and jacket, and greaves cross-lashed to his shins—a daring, courtly Mousquetaire in the person of a modern existential artist. After a period spent nervously contemplating the canvas, Mathieu would typically seize several tubes of paint in each hand and, with one mighty salvo, discharge their contents onto the prone surface. Quickly, he doused it with a bottle of turpentine and then prepared the ground by falling to his knees and swabbing the canvas in swarming, all-over movements. Next, he propped the support against a wall and proceeded to add his signature blaze of elegant, lightning-bolt graffiti, once again ejecting color directly from the tube or daubing it with bravura strokes from long, rapier-like brushes. Throughout the operation Mathieu acted in the flamboyant, aggressive spirit of a Samurai swordsman, finally transforming an instantaneous outburst—a veritable paroxysm—of creative feeling into a frozen image bearing the hallmark of an imperious, idiosyncratic style. Herbert Read once called it a personal symbol with "the complexity of the serpent's nest."

Abstract the painting might be, but Mathieu saw his works as banners flown in the name of France's monarchist past and gave them such titles as *The Battle of Bovines*, commemorating a 1214 Capetian victory in which the artist's ancestors played a role, and *Montjoie Saint Denis*, the battle cry of Joan of Arc. Alone in his paradoxical commitment to both conservative politics and liberal aesthetics, Mathieu seemed the very paradigm of Sartrian man asserting total freedom even while trapped in a metaphysical void. Thus, he was alert

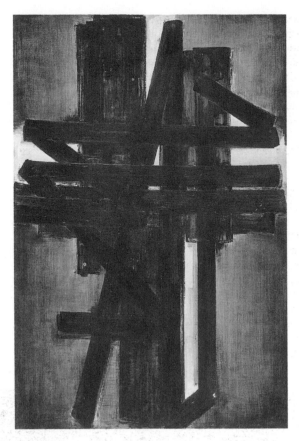

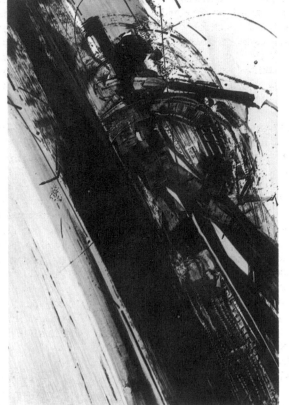

enough to become one of the first to demonstrate the formal and substantive relationship between New York's Abstract Expressionist movement and Europe's Informalism, by arranging an exhibition drawn from both schools and held in 1948 at the Galerie Montparnasse in Paris. For all his anti-egalitarianism, Mathieu showed a remarkably broad aesthetic sympathy, not only by embracing the Americans but also by his skilled ability to adapt a proudly individual style to a vast range of public situations: monumental sculpture, industrial design, advertising posters, tapestry cartoons, theater sets, commemorative coins. Although once considered a French Pollock, Mathieu, unlike the American, seemed content to go on endlessly reworking his key expressionist theme, with only the slightest variations, until, instead of renewing his art, he allowed it to become as formulaic and stylishly mannered as the geometric abstraction his live-wire gesturalism had done so much to displace.

Alongside the flash and crackle, the violent figure-ground disparity produced by Mathieu, the School of Paris could also boast the grave, nocturnal, harmoniously unified painting of Pierre Soulages (1919—), painting that James Johnson Sweeney likened to "a chord on a vast piano struck with both hands simultaneously—struck and held" (fig. 111). Still, the work is as gestural, and certainly as abstract, as anything in Informal Art, but with a solemn, sensuous, structural grandeur all its own. Moreover, it grew like a slowly gathering crescendo from deep roots in the ancient, mythic past of France's southern Massif Central near Rodez, where Soulages was born and grew up, entranced by the prehistoric Gaulish stones or menhirs in the local museum, the massive Romanesque architecture of the entire region, and the mysterious "live blackness" within the majestic nave of the Sainte-Foy pilgrimage church in nearby Conques. While visiting this great shrine many years later, Soulages confessed: "You know, it was here, at this very spot, that I decided to be a painter—not an architect, a painter." And so when he commenced to paint in his teens, Soulages would take winter trees as his subject, "never . . . trees with foliage or things like that—black trees," seeing the branches as "a kind of abstract sculpture" and the negative spaces in between as positive forms in their own right. With his natural affinity for chiaroscuro,

Soulages found himself deeply moved by the freedom and breadth of Baroque art, specifically Claude Lorraine's ink-wash drawings and the equally liquid, brown brushwork in the drawings of Rembrandt. In Paris he felt starved by the dry academic teaching at the École des Beaux-Arts, but developed a great appetite for the Louvre, Cézanne, and Picasso. After the fall of France in 1940, Soulages continued his exploration of the moderns at the Musée Fabre in Montpellier. Only with the Liberation, however, could he return to Paris and devote full time to his own painting.

Now Soulages took up the abstract calligraphic style then emerging on both sides of the Atlantic as if by spontaneous combustion. In 1947, however, he abandoned small wrist movements in favor of large arm gestures, slowly gliding across the canvas and leaving wide, straight swaths of lustrous black paint. With their thick, dragged texture and weight, the dark, oily straps stand in sliver relief against a flat, lighter ground, whose crevice-like presence seems to emit a low, warm light reminiscent of day filtering through tall lancets and softly radiating the dim interior at Sainte-Foy. Initially, the bands or planks came together as monumental ideographic signs, images of a sort that made Soulages' painting as admired in Japan as Mathieu's. Soon, though, the artist moved towards even more autonomous relationships implying a two-dimensional architecture of struts and crossbeams with the brooding aura of southern France's megaliths or menhirs. Meanwhile, there would also be overlapped, multi-directional, baroque sequences that, in contrast to Mathieu's "Paganini antics," created grandiose, symphonic ensembles once compared to a Bach largo. While occasionally lacing black with green, gray, blue, or brown to add resonance or reinforce a poetic mood, Soulages stressed the emotional directness of his works by omitting titles and merely labeling each canvas with the date of its completion. Still, the secret of the paintings' "live darkness" resides in the mystery and drama of their "hidden," Rembrandtesque glow, generated not only by a tonal range playing between dense negative saturation and gleaming lambence, but also by the reflection and diffusion of light over a richly plastic surface, a surface alternately shifting from planes of high, flat impasto to passages of thin, transparent solution.

This French feeling for the luxurious qualities of medium sets Soulages' painting quite distinctly apart from the equally black-and-white art of Franz Kline (fig. 62), with which it has often been associated, especially after the work became known and widely admired in the United States in the late 1950s. But just as Kline's American rawness is alien to European sensibilities, so too is his vehement, expansive energy, so completely at variance with Soulages' stately rhythms and embracing warmth. And as the Frenchman has liked to point out, he had already achieved his abstract, chiaroscuro style while Kline was still painting in a full-color, realist idiom. Once the artists had come into their classic forms, however, what most separated them may have been the difference in their respective conceptions of pictorial space. Whereas a vestigial depth illusionism lingers in Soulages' black-*on*-white structures, Kline's black-*and*-white shapes seem to interlock and generate the sense of a unified, holistic surface.

Germany's Danish-born K.R.H. Sonderborg (1923—) also worked primarily in black and white, but with a propulsive energy more like that of Kline or Mathieu than Soulages' stately, deliberated process (fig. 112). Indeed, Sonderborg, the son of a jazz musician, sought to represent not objects or human figures but rather the rhythm and trajectory of their movements. Thus, speed and heightened dexterity of execution assumed paramount importance as guarantees that dynamic forces at play, rather than plastic equivalents of the entities generating those forces, might become the proper subject of art in an increasingly technological world. By 1950 Sonderborg could rely on psychic automatism while applying black paint or ink on thick sheets of drawing paper, some parts of which he left blank. Next, he elaborated the image by dramatizing its internal contours with razor-incised lines, as well as by invading the adjacent white areas with marks made in India ink. Very often, the hurtling strokes follow a diagonal path, suggesting the thunderous flight of a rocket into outer space.

An Italian Informalist who combined Soulages' broad, black, structuring brushwork with the dynamism and color of Mathieu was the Venetian-born autodidact Emilio Vedova (1919—; fig. 113). This said, Vedova had only to look to Italy's own Futurism for the roots of his style, unless that earlier modernism proved too politically tainted to inspire a young, Fascist-hating artist. At the same time, he could also be viewed as a direct descendant of Venice's *fa presto*, painterly tradition, as exemplified in the glittering 18th-century decorations of Guardi and Tiepolo. Actually, Vedova seems to have worked through and integrated both Cubism and Expressionism in realizing the figurative paintings he first exhibited in 1937. After the war he took the generational step towards a purely plastic, nonreferential language, the vocabulary in his case consisting of a white field overlaid with a black, open screen of slashing, powerfully axial strokes. Further brightening this strongly contrasted light-dark scheme are patches of primary color flashing from the interstices of the dark scaffolding. Together, color, contrast, form, and the artist's energetic handling charge the work seen here with all the ebullience, or even violence, of Baroque Italy.

Baroque amplitude also survived in the Informalist painting of Afro Basaldella (1912–76) from Udine, but in a muted, harmonious, lyrical mode worlds apart from Vedova's passionate bravura (fig. 114). In his own way, however, Afro too was a worthy heir of the Venetian decorators, and indeed he had begun his artistic career in the Basaldella family business, which specialized in ceilings for Venice's great mansions. Meanwhile, he also studied at art academies in Florence and Rome as well as in Venice. By 1937 Afro had been to Paris and had largely given up decoration for full-time easel painting. In 1947, following a difficult wartime period in Italy's Partisan resistance, he began to rehabilitate his painting in favor of greater formal autonomy, a process that accelerated after a 1950 sojourn in New York and an encounter with the art of Gorky and Miró. This led to a number of landscapes in which the artist used his motif mainly as a pretext for expressing a variety of human emotions. Before the end of the decade

Afro had learned to serve the same purpose without reference to identifiable objects in nature. Instead, he employed very broad, loose, but lightly scumbling brushwork to evoke an ambiguous, atmospheric space suffused with rhythmically distributed passages of warm, luminous color. But gentle and blended as the tonal image may be, it also looks spontaneous, particularly when struck with heavier chords of black or red. James Johnson Sweeney, quoting the Goncourts, once said of Afro: "His colors are not the colors of a painter but touches of a poet."

The Portuguese-French artist Maria Elena Vieira da Silva (1908—) arrived in Paris from Lisbon in 1928 and began studying sculpture in the studios of Despiau and Bourdelle. Soon, however, she renewed her original interest in painting, under the tutelage of Friesz, Léger, and Bissière, while also taking up etching with Stanley William Hayter at Atelier 17. By 1936 Vieira da Silva had already found the essentials of her own unique style of lyrical abstraction, a labyrinthine arrangement of gridded lines or checkerboard squares whose tense, unsettling mesh of Renaissance and modern spatial conceptions entraps and absorbs whatever figure or human-made object it may contain. By the 1950s, following a wartime hiatus in Brazil, Vieira da Silva had eliminated all vestiges of figuration from her painting but not subject matter, which now became exclusively a crystalline, visionary architecture of intricate, richly contradictory, yet lucid spaces suggesting both interiors and exteriors, sometimes, as well, vast aerial

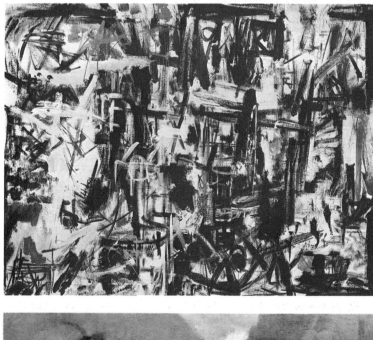

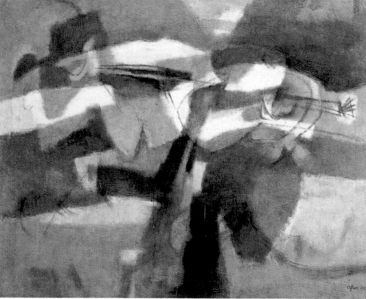

views of city plans (fig. 115). Overlaid, boxed, converged, shifted in focus or in axis, her tectonic linear webs define tilting planes, block in delicate color, and vibrate throughout with shimmering light. Believing art to be a spiritual quest, Vieira da Silva wrote: "My desire is to make pictures with many different things, with every contradiction, with the unexpected. I would like to become so agile, so sure of my movements and my voice, that nothing could escape me, neither the buoyancy of the birds, the weight of the stones, nor the gloss of metal."

below: 115. Maria Elena Vieira da Silva. *The Invisible Stroller*. 1951. Oil on canvas, 4'4" × 6'6⅜". San Francisco Museum of Art (gift of Mr. and Mrs. Wellington S. Henderson).

bottom: 116. Nicolas de Staël. *Composition of Roof Tops*. 1952. Oil on board, 6'6¾" × 4'11". Musée National d'Art Moderne, Paris.

A genuine Tachist and one whom Picasso regarded as the only new artist of merit in postwar Paris was Nicolas de Staël (1914–55). Born into an aristocratic Russian family with a name traceable to the great Romantic philosopher and novelist Germaine de Staël (1766–1817), young Nicolas suffered the trauma of the Bolshevik Revolution and the loss of his parents soon thereafter, only to find himself restored to privilege by adoption in Brussels. With these shifts and countershifts in fortune, he entered into a pattern of painful conflict that would dominate and finally decimate both his short life and his immensely distinguished career. After studying at Brussels' Académie Royale des Beaux-Arts, de Staël in 1933 began a long period of travel that would take him to the Netherlands, France, Spain, Morocco, Algeria, and Italy, a journey that left him deeply moved by his encounter with the art of such masters of painterly colorism as Rembrandt, Vermeer, Chardin, Cézanne, Matisse, Braque, and Soutine. Hardly had de Staël, with his companion, the painter Jeannine Guilloux, settled in Paris and begun to work with Léger when war broke out, prompting him to join the Foreign Legion for service in Tunisia. After demobilization in 1940, he and Guilloux tried to establish themselves in Nice, there joining a group of artists that included Alberto Magnelli, Jean Klein, Le Corbusier, Arp, and the Delaunays. However, extreme hardship caused by a lack of patronage for their work soon drove them back to Paris, where Braque, who rarely opened his door to younger artists, took a great interest in de Staël and helped him cultivate his natural affinity for the French tradition of *belle peinture*. By 1945 he was exhibiting canvases abstract enough to be shown alongside those of Kandinsky. In commenting, much later, on his transition from a descriptive to a largely nonrepresentational manner, de Staël said: " . . . little by little I began to feel ill at ease painting an object realistically, because in relation to any one object I felt bothered by the infinite number of other existing objects. One absolutely can't think about any one object whatsoever as there exist so many objects at the same time that the ability to take them in falters and fades. I have therefore sought a freer form of expression." Once matured in the mid and late 1940s, his "freer form of expression" delivered one of the most notable and seductive styles practiced by any painter of the Informal/Tachist generation (fig. 116). It consists of a surface structured as a mosaic of blocky color patches so thickly troweled on, by palette knife more often than by brush, that the image seems as much sculpted as painted, while the sheer weight of the heavily impastoed canvas borders on that of sculpture itself. In this layered and loosely assembled masonry, built up on supports sometimes scaled to mural dimensions, brilliant, contrasted colors from lower strata often seep out and roughly contour the brick-like deposits as if crushed and spread by rich overloads of succulent medium.

Like many abstractionists at this time, especially in Europe, de Staël never completely severed his art from all contact with the outside world, saying at one point: "When it is cold in winter, one does not feel at ease; the same when it is hot in summer. *We are continually influenced and penetrated by nature*. . . . I want my painting to be like a tree, like a forest. One moves from a line, from a delicate stroke, to a point, to a patch . . . just as one moves from a twig to a trunk of a tree, but everything must hold together, everything must be in its place." Beginning in 1952, at the height of his critical and commercial success, de Staël entered a period of almost Faustian struggle between his desire for essential form and the landscape, still-life, and figurative motifs that kept beckoning him. Even though the later paintings seem luminously serene in their resolution of all internal rivalry, with even the paint sometimes thinned to saturated, watercolor lightness, de Staël felt so torn by the complexities of producing subject-matter pictures, in defiance of the abstractions expected of him, that he committed suicide in 1955 at the age of forty-one. The year before he had written to the dealer Paul Rosenberg: "I know what my painting is—underneath its appearance of violence and perpetual forces at play, it is something fragile, in the good, in the sublime sense. It is as fragile as love."

Another eminent Tachist from Old Russia was Serge Poliakoff (1900–69), scion of a great land-owning family who had fled his native Moscow in 1918 and used his talent for the guitar to reach Paris, performing his way through Turkey, Bulgaria, Yugoslavia, Austria, and Germany before arriving in 1923. Thereafter, until as late as 1952, Poliakoff made his living primarily as a guitarist well known in the Russian restaurants in Paris. In 1929 he began to paint, an activity that took him to London, where he studied at the Chelsea and Slade schools during the years 1935–37. While in England, Poliakoff also learned from the Italian primitives at the National Gallery and Egyptian sculpture in the British Museum, both kinds of art exhibiting the hieraticism that would later inform his mature compositions. Back in Paris in 1937, the artist met his Russian compatriot Kandinsky and the Delaunays, all of whom influenced him to convert from a figurative to an abstract style. By 1946 he could show seasoned color abstractions that one critic found ''as agreeably variegated as a Bokara or Samarkand carpet.'' Fearful that a Russian love of color might overtake his work and render it purely decorative, Poliakoff began to tame his palette and otherwise search for a less luxurious image. When, in 1952, he discovered the highly purified Cubo-Futurist, or Suprematist, art of another pioneer Russian modernist, the great Kasimir Malevich, Poliakoff had found the structuralism that would help him resolve his style into its best-known phase (fig. 117). Now his somber,

left: 117.
Serge Poliakoff.
Abstract Composition.
1954.
Oil on canvas,
3'9¼" × 2'10⅝".
Tate Gallery,
London.

right: 118.
Jean-Paul Riopelle.
Composition.
1953.
Oil on canvas.
Private collection,
Milan.

resonant colors would sound from lavishly impastoed, quasi-geometric planes interlocked in a flat, monumentally simplified pattern, the ensemble of elements evincing an archaism and mystery reminiscent of Russian icons. Contributing to the mystical atmosphere is the base note of dark underpainting that reverberates through thin, scraped passages in the luscious texture of positive hues applied by palette knife. Here the musical analogy would seem to be correct, since Poliakoff, the life-long guitarist, once observed: ''One must listen to a form when one has seen it.''

Parisian Tachism acquired one of its leading exponents when Jean-Paul Riopelle (1923—) arrived from Montreal, where he had been a member of the Automatists, a group of young French Canadians who, like their contemporaries in New York, had adopted the Surrealist process of drawing and painting with the spontaneity of unconscious impulse. Finding no support for his Expressionist abstractions at home,

Riopelle departed for France in 1946 and quickly won the interest of André Breton, who included his work in the great International Exhibition of Surrealism held in 1947 at the Galerie Maeght in Paris. Also in 1947 but more important for the future, Riopelle was embraced by Georges Mathieu and thus gained a place among the new Lyrical Abstractionists shown at the all-important Galerie du Luxembourg exhibition. With this he distanced himself from hard-line, bureaucratic Surrealism and pursued his own independent path, which led to an immensely successful personal style that reached its first full flower in the early 1950s (fig. 118). By now Riopelle had largely set aside his brushes in favor of palette knives or spatulas, using them to knead and shape fat, separate dollops of oil color emptied onto the canvas directly from tubes. Although improvising as he worked, the artist always sought a clear pattern or design, which, despite its total abstraction, often managed to evoke the character, atmosphere, or even movements of some scene actually encountered in the natural world. The sense of pattern as well as all-over structure became even more apparent once Riopelle unified, while also activating, the entire surface with a spidery network of lines of force. Together, the thickly tufted color spotting and linear web give the effect of a shattered stained-glass window, its scrambled, glittering shards frozen in place like a brilliant, abstract version of Duchamp's *Great Glass.* In his larger, more environmental canvases, the artist also seemed to recall Monet's late Waterlilies, but factored through his own dynamic, powerfully physical sensibility. Riopelle's surfaces, although as succulent as those of de Staël, are considerably more intricate, atomized, and dispersed. Furthermore, to whatever extent they reflect the experience of landscape, the view is aerial, rather than straight on towards the horizon line often acknowledged by de Staël.

During the 1950s few European artists enjoyed greater esteem than Italy's Alberto Burri (1915—), a self-trained master with a genius for discovering eloquence in the poorest, most debased materials and for revealing it in collages as elegantly structured as Italian couture.

The European School of Painting: 1945–60

Burri's works captured the imagination of critics and public alike, not only because they combined "shock and chic" in a dramatically original manner, but also because, together, these very factors—often embodied in tattered scraps of sackcloth bandaging scarlet "cicatrices" sutured with truly surgical skill—seemed to offer authentic metaphors for a war-battered Europe struggling heroically to heal its wounds (fig. 119). Adding to this content of existential angst were the circumstances of the paintings' genesis, whereby Burri, a medical doctor in the Italian army, began spontaneously to paint in 1944, despite his lack of artistic training, while held as a prisoner of war in Texas. With this, he revived an old but long-suppressed interest, doing so in twelve-hour marathons that soon made him as desperate for art supplies as he had been for something to fill the void of his captive existence. Thus, when canvas and white paint could not be obtained, Burri seized whatever makeshift substitutes—burlap bags, toothpaste—lay at hand. Such necessity left him with a permanent taste for sensuously tactile surfaces and unconventional, cast-off materials.

Following repatriation in 1945, Burri moved from his native Umbria and settled in Rome, there devoting full time to painting, which he commenced in a traditional figurative manner executed with oil on canvas. By 1947, however, Burri had gradually evolved towards a completely autonomous image, and by 1948 he had found his essential style, a Cubist coalition of rough-edged circular and rectangular shapes defined by richly impastoed paint but even more by almost erotically varied textures cobbled together, collage fashion, from found and often damaged substances. For the *sacchi* series that brought his initial fame, Burri marshaled a whole range of faded gray and brown textiles, not only used sacking but also paint rags and remnants of every sort, joining them with the most ingenious stitchery and stiffening the assemblage with blotches of blood-red paint. Unable to forget the horrors of a battlefield hospital, with its hemorrhaging soldiery and hastily improvised dressings, Dr. Burri had transformed them into the stuff of high, emotive art.

Enraptured by his process, Burri sought ever-more compelling and innovative modes of pictorial expression. In the *combustione* he burned material—frequently thin sheets of wood—before fastening it to a support. This brought a charred black into his brown and red palette, allowing a contrast that the artist heightened with touches of white paint. In the *ferri*, or "irons," he achieved still greater variety of color as well as texture by welding together sheets of singed and rusted metal. For the *plastiche* in the 1960s, he sometimes scorched plastics, while also assembling membranes of clear plastic like veils of color floating underwater. Elsewhere Burri mixed several of his flotsam media, the better to attain even more challenging effects from juxtaposed matte and shiny, sleek and woven, shredded, tarry, and crackled surfaces. In the rich and diverse oeuvre of this artist, one can find elements of Klee and Miró, Schwitters, even Malevich and Kandinsky, certainly Picasso and Italy's own Futurists. Meanwhile, the work wielded its own influence, especially on Lucio Fontana, Conrad Marca-Relli, Yves Klein, Robert Rauschenberg, and the Arte Povera group. It also inspired a number of exalted interpretations, including that of Herbert Read quoted at the outset of this chapter (p. 61). Comparing Burri to Picasso and Schwitters in their talent for converting trash into beauty, the British critic concluded: "His compositions are bolder, ruder, still more defiant of all aesthetic conventions. And yet they subdue us by their insidious charm, haunt us with their metaphysical significance." Burri himself merely stated: "The poorness of a medium is not a symbol; it is a device for painting." This, more than anything else, may explain how he gave Tachism and "matter painting" some of their most stirring moments.

For reasons altogether as compelling as those of Burri, Catalonia's Antoni Tàpies (1923—) also forged a powerful Tachist style that re-

right: 119.
Alberto Burri.
Grande Sacco. 1954.
Mixed media
on canvas.
Private collection,
Milan.

above: 120.
Antoni Tàpies.
Great Painting. 1958.
Oil and sand on
canvas, 6'6" × 8'6⅝".
Solomon R.
Guggenheim
Museum, New York.

placed representation with the concretions of collaged mixed media and made rough, heavy, time-worn matter sing with solemn, Spanish *grandeza* (fig. 120). And like Burri, the self-trained Tàpies had conceived an early passion for art, but embraced it fully only after prolonged involvement with other disciplines, in his case literature and law. What gave Tàpies his artistic vision and unquenchable need to express was the great trauma of his adolescence: the Spanish Civil War. Many years later he would make this oft-noted statement:

The dramatic sufferings of adults and all the cruel fantasies of those of my own age, who seemed abandoned to their own impulses in the midst of so many catastrophes, appeared to inscribe themselves on the walls around me. . . . My first works of 1945 already had something of the graffiti of the streets and a whole world of protest—repressed, clandestine, but full of life— a life which was also found on the walls of my country.

By the time Tàpies attained his full artistic maturity around 1955, the concept of the painting surface as a weathered or graffiti-scarred wall had already become one of the defining characteristics of postwar Expressionist abstraction. But as no other artist, Tàpies made it quite unforgettably his own, mainly by using the image—a meditative field of granular, telluric substance dynamically crisscrossed with deep-etched splits and punctures—to transform painting into a mute, spellbinding symbol of existential conflicts fatalistically resolved and rendered quiescent.

The grave, spiritual resignation evinced by this Catalan master had grown slowly, not only from the years of tragic division in Barcelona and a long Catholic education, but also from deep reading in Nietzsche, Dostoevsky, Ibsen, Schopenhauer, and the Oriental philosophers. Tàpies also knew Existentialism through the young Catalan critic and philosopher Arnaldo Puig. Meanwhile, he had collaborated with the poet Joan Brossa, gone to Paris in 1950–51, met Picasso and Miró, and passed through both Cubism and Surrealism. If the latter phase helped emancipate his imagination to see pictorial wealth in the most miserable, randomly available materials, the former trained him to temper his intuitive, spontaneous approach with the discipline of solid, geometric organization. Seasoned and secure in his artistry, Tàpies gradually expanded beyond the scarified walls of the early 1950s towards dramatically evocative collages or relief constructions (fig. 120). These moving yet strangely minimal works—incorporating such occasional bits of rubbish as straw and old string, newspaper, cardboard, and labels, even X-ray films—were almost always assembled in a firmly structured, monumental composition and anchored upon a softly undulated, cement-like ground mixed of glue, sand, and plaster. To draw on this gritty *haute-pâte* surface, Tàpies merely used his fingers or a tool to incise the matter while still moist and malleable, sometimes to a depth that allows a glimpse of color underneath. Progressively, as Tàpies purified his art, the relief paintings became walls of contemplation, images that, while bespeaking traditional Spanish realism, seem to have unified the old opposites of energy and matter into a poetically charged statement resonant with a sense of the cosmic and the timeless. With their austere beauty and quiet charm, their lingering memory of old wounds, the late paintings were meant to solace a world wracked by violence.

In the course of the 1950s, School of Paris Informalism became a new International Style, its circle of influence expanding to virtually every country in Europe and cross-fertilizing the many local schools with endless variations on both form and process. Thus in Germany, Emil Schumacher (1912—) could prepare a ground in *haute-pâte* technique similar to that developed by Tàpies, but then engrave it with a kind of ramified calligraphy clearly derived from Wols, who, quite independently of the Spaniard, had also found meaning in the weathered craquelures of old walls. For his ''tactile objects,'' Schumacher placed such trust in their underlying plastic substance to generate the psychic improvisations needed to create a work of art that his line seems less drawn than eroded, rather like a riverbed and its tributaries reproduced on a relief map (fig. 121). But thick as the ground may be, the artist did not so much mold a relief surface as use color to produce

121. Emil Schumacher. *Ukalegon.* 1959.
Oil on canvas, 4'7⅜" × 3'1⅝". Collection Cavellini, Brescia.

the effect of one. Schumacher worked spontaneously but in a sequence of campaigns, reapproaching the same canvas only after a period of withdrawal and reflection. As a result, the finished picture may have the rich, layered look of an abstracted segment of the real world, a thing created, destroyed, and renewed many times over, rather like Germany itself in the years following the Second World War. To explain the organic nature of his procedure and the image it produced, Schumacher wrote: ''Everything that exists has its appropriate form or tends to assume form: island formations after a flood, remnants of snow after thaw, cinders after fire. Form that presupposes life—form that comprises life—is 'formless' and yet form.'' In 1953 Schumacher joined Quadriga, a group of Frankfurt painters—the original four being Karl Otto Götz, Bernard Schulze, Heinz Kreutz, and Otto Greis—who in 1952 began exhibiting together as Tachism's foremost practitioners in Germany, there inspired by Pollock and the CoBrA artists as well as by Wols, Hartung, and Riopelle in Paris.

When Informal Art reached Vienna, Expressionist abstraction rediscovered its fiercely tenacious roots as they survived in the works of Hundertwasser (Friedrich Stowasser, 1928—), a young painter who had managed to compound Gustav Klimt's richly patterned, turn-of-the-century Jugendstil with the contorted narcissism of Egon Schiele (fig. 122). But even as the conscious artfulness this entailed set him apart from the relatively uncensored flow of inspiration generally cultivated by the Informalists, Hundertwasser also fashioned genuinely Tachist surfaces, albeit with mixed media that might include gold and silver as well as wrapping paper and jute, and practiced a variety of

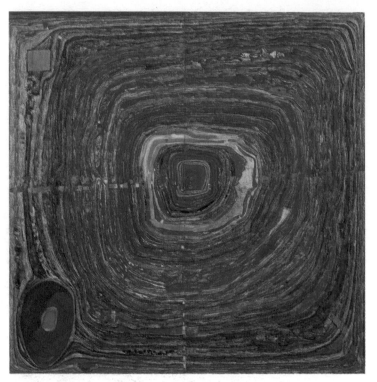

122. Hundertwasser. *The Big Way.* 1955.
Mixed media, 5'3¾" × 5'3". Österreichische Galerie, Vienna.

automatism, even if it assumed as much instinctual creativity on the part of the viewer as on that of the artist himself. Moreover, Hundertwasser arrived at his exotically hybrid and hypertrophied style as a consequence of the liberating atmosphere he found in Paris during visits made there in the early 1950s. Meanwhile, the artist remained wedded to Expressionism's original Symbolist impulse, and so when he adopted the spiral as his principal motif, it represented a moral rejection of the rational, mechanistic modern world, with its destructiveness and straight-line, Bauhaus aesthetics, in favor of a romantic, ecological, back-to-nature organicism. In the labyrinthine, gyring path that winds in even as it winds out, Hundertwasser saw an emblem of the never-ending, self-regenerative process of life itself; consistent with this folk conception, he eschewed Klimt's brilliantly suave curvilinearity and cultivated a doodled, slightly primitive manner, giving his concentric bands the look of an onion slice. And the result, with its expanding circles studded with intensely colored, gem-like forms or even vestigial bits of figuration, is as vividly ornamental as a Persian carpet or a Balkan embroidery. In his passion for the organic world, Hundertwasser saw beauty in rust, rot, and decay, thereby evincing a sensibility shared by Wols, Burri, Tàpies, and Leonardo before them. But once he went on to publicize his views with such antics as a public lecture given in the nude, he had stepped forward into the late sixties and seventies, not only with his whole-earth ideals but also with his sense of art as a Happening or a consciousness-raising performance.

Following a period of study under Bissière in Paris, England's Roger Hilton (1911–75) joined the British Army as a Commando and then spent the war years in a German prison camp. Although a master of the Frenchman's later calligraphic painterliness, Hilton also favored a flatter, simpler, more reductive image (fig. 123). In this he evinced a taste acquired not from Abstraction-Création during his Paris days but rather from a discovery of Mondrian in the early 1950s. The tendency could only have been reinforced after 1956, once he began living and working among the St. Ives Constructivists, a group led by Ben Nicholson and Barbara Hepworth. Within his relatively severe pictorial context, however, Hilton displayed a wealth of feeling, from gestural aggressiveness, reflecting a complex, almost Pollock-like personality,

to seriocomic wit reminiscent of Paul Klee. This set him somewhat apart from his close associates among Britain's postwar abstractionists—Peter Lanyon, Patrick Heron, and Bryan Winter, for instance—who too formed part of the St. Ives art colony. While these painters generally abstracted from themes found in nature, Hilton worked from within, seeking vividly expressive forms in which to communicate a vital life of idea and temperament.

The Cornish painter Peter Lanyon (1918–64) developed a rapport with the New York School at a very early date, but in his boldly abstracted art, as well as in his life, he nurtured a sense of place even more particular than that of de Staël. Having studied with Ben Nicholson and matured in the company of Britain's St. Ives masters—that stellar group which included not only Nicholson but also Barbara Hepworth and Naum Gabo—Lanyon articulated the language of international abstraction with natural, even native fluency. And he achieved it as Nicholson had, in the classical manner of working through landscape and assimilating its light, atmosphere, forms, and spaces until this reality could be metamorphosed into that of pure painting. But if Lanyon remained attached to the natural world, even in his most nonallusive canvases, it was, in part, for the very good reason that he inhabited one of the most legend-haunted and wildly beautiful regions to be found on earth—the far western coast of Cornwall. A proud Cornishman, Lanyon said, as we saw earlier: "It's impossible for me to make a painting which has no reference to the very powerful environment in which I live." How he managed to portray the local scene without literally describing it can be found in *St. Just* (fig. 124), a painting whose title identifies the subject as an actual site on the map, "an old mining town, with disused shafts all around it." The cliffside location—the last settlement in Britain before Land's End—finds its equivalent in the steep, frontalized, planar construction, while a palette of dark, damp green, carbonous black, and streaked gray provides formal analogues for a realm of cliff-top grass, coal staining, and old granite buildings. The stygian descents themselves merge at the center in a tall black shape, its forked upper section seeming to imply a Crucifixion. As an instinctive Cornish nationalist, the artist saw his poetic land as the victim of ruthless exploitation by

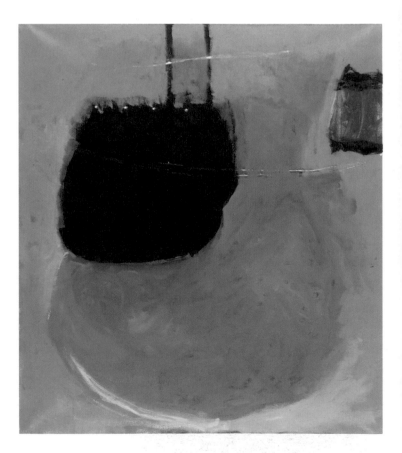

callous outside interests. In the freedom of his handling and the loose, patchwork fit of the composition—rather like intricately sectioned farmland seen from the air—Lanyon demonstrated the degree to which postwar Expressionist abstraction had helped him break out of whatever Constructivist rigidity he may have inherited from the St. Ives group, that is, should anything more have been required than the painterly example of England's own Turner and Constable. For *St. Just*, however, he fused vision not only with action but also with slow deliberation, producing richly varied, tactile surfaces—impastoed, scored, and scraped—that assured him a comfortable place among the Tachists of the Continent, as well as among his friends in New York— Kline, Motherwell, Gottlieb, and Rothko. For the sake of gaining a wider range of landscape sensations, Lanyon took up gliding in the late 1950s, a sport that caused his accidental death at the tragically early age of forty-seven.

While Lanyon made common cause with New York's Action painters, his brother St. Ivesian Patrick Heron (1920—) saw a sympathetic relationship between his own French-inspired abstractions and the American Color-Field painters, most of all Rothko with his sheets of luminous mist. Initially, Heron had been profoundly affected by the patrician *belle peinture* of Bonnard, Braque, and Matisse, calling the latter's *Red Studio*, after he saw it in 1943, "by far and away the most influential single picture in my entire career." His love of color and vibrant, sensuously manipulated surfaces soon led him towards a personal variant of Tachism, particularly after de Staël's one-man exhibition in London in 1952. Until midway through the decade Heron worked in the manner of traditional modernism, translating his experience of the natural environment into a pictorial idiom of vaguely autonomous formal relations. Then, after the opening of the Tate Gallery's Abstract Expressionist show in 1956, he enlarged his format and sought to animate it with nothing but the "pure sensation of color," still maintaining, however, that "there is no such thing as non-figuration. The best abstraction breathes reality; it is redolent of form in space, of sunlight and air." Impelled by his Matissean faith in color as paramount in painting, Heron took a radical step beyond the abstractions of his British contemporaries and launched upon a series

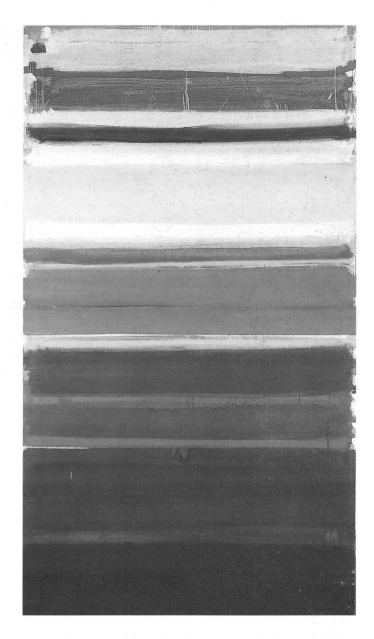

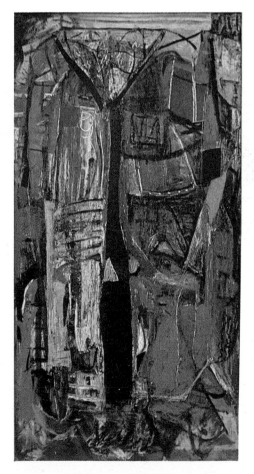

opposite: 123.
Roger Hilton. *Large Orange, Newlyn, June 1959*. 1959. Oil on canvas, 4′11½″ × 4′5⅜″. Fitzwilliam Museum, Cambridge, England.

left: 124.
Peter Lanyon. *St. Just*. 1953. Oil on canvas, 7′11⅛″ × 3′11⅝″. Private collection.

above: 125.
Patrick Heron. *Horizontal Stripe Painting: November 1956– January 1958*. Oil on canvas, 9′2″ × 5′. Tate Gallery, London.

of enormous canvases composed entirely of broad, freely brushed, strikingly contrasted color stripes running in parallel order from edge to edge along the short axis of either a vertical or a horizontal format (fig. 125). Stunning in their sheer opticality, these ambitious works may resemble Rothko crossed with Kline or Soulages, but their daring independence would soon become apparent, once the post-painterly abstractionists of the 1960s canonized stripes as the most succinct and thus effective vehicle for making color supreme in painting of ever-greater formal purity. Intellectually and verbally acute, Heron became one of Britain's most respected critics and teachers, at first championing the New York School but later denouncing its "juggernaut" domination of British art.

Before Parisian Informalism could draw far-off Scotland into its expansive net, Edinburgh-trained Alan Davie (1920—) had evolved a full-blown Abstract Expressionist style all his own, a style more related to earlier 20th-century Scottish colorism or to Pollock's totemic, pre-drip canvases than to recent developments on the Continent. Actually, Davie may well have been the very first European artist to undergo direct influence from Pollock, an effect that began in 1948 after the Scotsman visited Peggy Guggenheim's collection in Venice. Relying on his own instincts and the example of works like *Pasiphaë* (fig. 65), Davie conceived an apocalyptic vision and brought it to triumphant life in an original iconography of mixed symbols, concocted as well as ancient, formed with flailing, calligraphic brush-

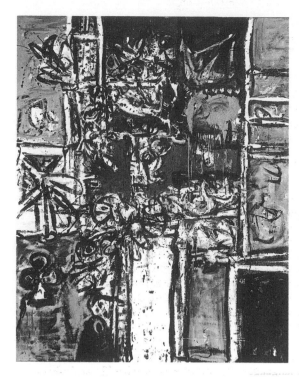

126. Alan Davie. *Imp of Clubs.* 1957. Oil on canvas, 6'11" × 5'7⅜". Ulster Museum, Belfast.

the Informal/Tachist works just seen. But Europe, to a far greater extent than the United States, possessed such masters, and from the vantage point of the 1980s, painters on the order of Dubuffet, Giacometti, and Bacon—all devoted to the human image—loom so large among their contemporaries as to make the abstraction/figuration issue virtually irrelevant. Indeed, they finessed it by formulating manners that frequently seem more conceptual than objective in their references to known or measurable life. And since this was sometimes obtained with the same kind of automatic processes and evocative, maverick materials as those employed elsewhere at the time, it represented a fusion of existence and essence, the particular and the universal fully as realized, albeit in a different way, as anything offered by the period's more autonomous expressions. The important thing was to achieve authenticity—an individual creation without precedent—whatever the visual language adopted, figurative, nonfigurative, or a synthesis of both. And this was to be done even if it meant distorting the human image as only a child, a psychotic, or a sadomasochist would, or a sculptor-painter, like the great Giacometti, obsessed, as no one ever before had been, with how to render the artist's fleeting perceptions of reality. Of course, obedience to the phenomenal world was an old European tradition that such major modernists as Picasso and Matisse generally honored even at their most abstract, viewing their art as too "drenched in humanity" to allow its slippage into a rarefied world of Platonic symbols. If the New York School proved more daring in their pursuit of radical abstraction it was in considerable part because they had access not only to Fauvism and Cubism but also to a different tradition, the Romantic, quasi-religious informal purity and Utopian aspiration of Kandinsky and Mondrian, both painters little known, as we have seen, in Europe until well after World War II. Without this ingredient in the mix of possibilities available to European painters, Sartre's contention that "Existentialism is humanism" would appear to have assumed a more literal meaning in Paris than it did in New York. This may explain how many of the Informalists could glide easily between abstraction and figuration, with relative emphasis on the latter sometimes providing the essential difference between those "abstractionists" and such "representational" painters as Dubuffet and Bacon. After all, Picasso had said: "There is no abstract art. You must start with something." Perhaps taking his cue from this dictum, the French Communist painter Jean Bouret, in the preface to the first Salon des Peintres Témoins de leur Temps, wrote: "Painting exists to bear witness, and nothing human can remain foreign to it." The hero of his argument was Bernard Buffet (1928—; fig. 127), who in the late 1940s rocketed to instant fame and fortune—the first "media" success in art—with his images of existential poverty, introspection, and despair, all stylized in a "modern," signature manner—flattened, heavily contoured, elongated, and perfect for convincing the would-be sophisticated that here was accessible yet "advanced," "important" painting. The sheer bathos and melodrama of this art simply demonstrates the rightness on the part of most postwar European artists in choosing to express rather than illustrate the fearful times in which they lived. Still, Italy's Renato Guttuso, as we shall see, understood how both leftist political commitment and a legible, descriptive style might be endowed with vigorous life and timeless dignity, even in an age of art dominated by abstraction. Whether the image is that of ruined, ghostly Berlin, an original emblem of Christian faith, budding adolescent sexuality, or the anonymous proletariat of London, the overriding issue in the works seen here is not so much to bear witness to reality as to invest it with the truthfulness of expression derived from internal necessity freed of tired, inherited convention.

One of the giants of postwar art—a man the critic Clement Greenberg called "the most original painter to have come from the School of Paris since Miró"—was France's Jean Dubuffet (1901–85). A successful wine wholesaler as well as a sometime artist and long-time intimate of the Parisian avant-garde, Dubuffet had already passed forty when, in October 1944, he mounted his first exhibition—and

work of gale-force power and drive (fig. 126). Automatist improvisation could scarcely have come more naturally to Davie, who periodically worked as a jazz musician. Nor would Surrealism's preoccupation with myth have been anything other than poetic truth for a Scotsman steeped in the romantic legends and sagas of the Celtic world. Thematic invention seems virtually to have tumbled from him, images of sex and birth, sea and moon, the witches' sabbath, sacrifice and martyrdom, just as colors poured out in sonorous chords of mauve and mustard, cobalt, crimson, yellow, and deep green, all lashed together with wildly free yet also vigorously tectonic strokes of white and black. To create this magical world halfway between joy and fear, dream and conscious endeavor, timelessness and immediacy, Davie stood back and pondered at length, but then pounced with animal energy, working rapidly on the floor, splashing paint, incorporating bits of debris, exploiting accidents, and turning wet canvases around to let the colors run. As his initial reflection and subsequent trance-like performance would suggest, Davie had read extensively in Zen Buddhism, an interest that finally led him to record a philosophy of creativity, which by its very personal nature could speak for a whole generation of artists who sought the universal through the primitive, unconscious impulses common to all humanity. In 1958 he wrote:

When I am working, I am aware of a striving, a yearning, the making of many impossible attempts at a kind of transmutation—a searching for a formula for the magical conjuring of the unknowable. Many times the end seems just within reach, only to fly to pieces before me as I reach for it. In this respect I feel very close to the alchemists of old; and like them, I have in the end reached some enlightenment in the realization that my work entails a kind of symbolic self-involvement in the very processes of life itself.

With his cryptic signs surging up as much from shamanist ritual as from cosmopolitan erudition, Davie produced works in which figures, while dramatic, are scarcely less abstract than the structure containing them. The pictures, by virtue of their ambiguity, offer a bridge across the narrow, indefinite divide between the allusive and nonallusive realms within postwar European Expressionism.

Resurgent Figuration in Postwar European Painting

Given the imperatives of transcendence in Europe's postwar art, only the very strongest painters could work against the prevailing drift towards abstraction and create figurative art even more compelling than

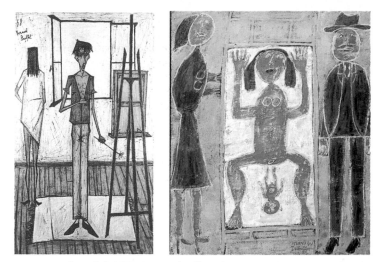

above left: 127. Bernard Buffet. *The Painter and His Model*. 1948. Oil on canvas, 6'10¼" × 3'9⅝". Musée d'Art Moderne de la Ville de Paris.

above right: 128. Jean Dubuffet. *Childbirth*. 1944. Oil on canvas, 39⅜ × 31⅞". Museum of Modern Art, New York (gift of Pierre Matisse in memory of Patricia Kane Matisse by exchange).

below: 129. Jean Dubuffet. *Blood and Fire (Corps de dames)*. 1950. Oil on canvas, 46½ × 35½". Courtesy Pierre Matisse Gallery, New York.

fairly outraged the world of institutionalized culture with paintings so brutally offensive to prevailing taste that the artist himself would characterize them by the term *l'art brut* (fig. 128). Yet, it was by virtue of his genuinely Gallic lucidity that this *bon bourgeois* from Le Havre could perceive, more clearly than anyone else at the time, that neither the metaphoric distillations of the new, or emerging, School of Paris abstraction nor the descriptive figurations demanded by an ignorant public could do more than perpetuate values already rendered false by the critical situation where society found itself in the wake of global disaster. After completing his baccalaureate, Dubuffet had attended art school in Paris for several years, made friends with Max Jacob, Suzanne Valadon, and Léger, studied art history, linguistics, metaphysics, literature, and music, become involved with Surrealism, and done meteorological work while serving in the French Army. Indeed, he could have been viewed as a sterling product of French civilization, except for his growing anxiety that "all of it was not worth very much," that in his search for "the Way" he had in fact "missed the boat." Meanwhile, the unhappy young man noted that ordinary folk—the barber, the butcher, the postman—when talking to one another seemed "much more adapted" than himself.

Their accents of joy and certainty made me envious and the idea came to me that in their disjointed conversation there was more sap, more of the unexpected, more invention, in a word more flavor. Let's use the word: there was more art—yes, more art and poetry in the words of the barber—in his life—in his head—than in those of the so-called specialist. . . .

"In the end," he went on, "I couldn't stand it any longer: I laid down my brushes, and went to work in a wine-shop and subsequently became a wine-dealer. . . . " With this Dubuffet made certain that he would never be co-opted by any system. In seeking "the Way" through the ordinary, where "the sap is richer," he did so as an outsider and thus became more exceptional than ever, for he was in no sense born or educated to the commonplace. Conversely, in 1942, when he recommended painting full-time, after a lapse of some years, Dubuffet brought to the experience a whole complex of anticultural attitudes, gained not only from commerce and Surrealism but also from his reading of Dr. Hans Prinzhorn's *Bildnerei der Geisteskranke (Artistry of the Mentally Ill)*. The latter had created a sensation upon its publication in Berlin in 1924, and a year later the book struck Dubuffet with the force of a revelation, most especially its insistence that art works executed by asylum inmates, like those of children and primi-

tive societies, may possess genuine aesthetic merit and deserve to be treated accordingly. Echoing Nietzche and Freud, as well as older Romantics going all the way back to Jean-Jacques Rousseau, Prinzhorn wrote that in his natural, precultural state man enjoys a primal harmony with the universe, a unity of being that the conventions of Western civilization can only frustrate and repress. Thus, when the neurosis this produces finds release in reactivated animal or spiritual drives, the art works flowing therefrom may not only lead to restored psychic strength, but also evince creative urges so primary as to embody a universal expressiveness far more direct or profound than that afforded by the etiolated creations of mainstream culture. With Prinzhorn as his catalyst, Dubuffet, a dazzling and prolific author in his own right, would formulate a philosophy of art that, when delivered in a speech in 1951, could be characterized by the title *Anticultural Positions*. In six key points, he rejected some of the elements most basic to Occidental culture, all the analytical or classifying processes that see things in parts rather than in organic wholes, in categories and hierarchies rather than in a dynamic, unoriented continuum where every value is relative and subject to change. Instead of codifying things according to Western notions of beauty and ugliness—concepts unknown to primitive peoples—it would be better to understand that all objects may be sources "of fascination and illumination." And just as delirium or madness may be more conducive to authentic art than the "elaborate ideas" of reason and logic, painting would seem more likely than verbal language—that instrument of scientific analysis—to capture the underground and primal stages of thought. In conclusion Dubuffet stated:

Painting operates through signs which are not abstract and incorporated like words. The signs of painting are much closer to the objects themselves. Furthermore, painting manipulates materials which are themselves living substances. That is why painting allows one to go much further than words do in approaching things.

It is peculiar to painting that it can, at will, conjure things more or less; in other words, with more or less presence, or at different stages between being and non-being.

Finally, painting can conjure things—not in isolation—but linked to all that surrounds them; a great many things simultaneously.

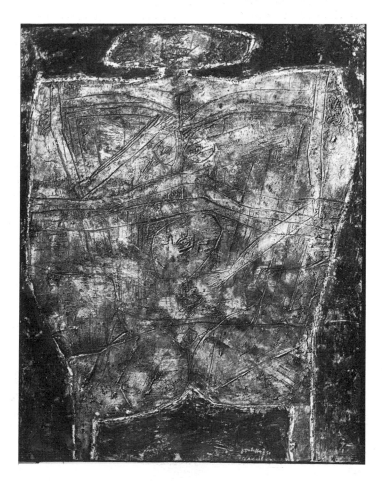

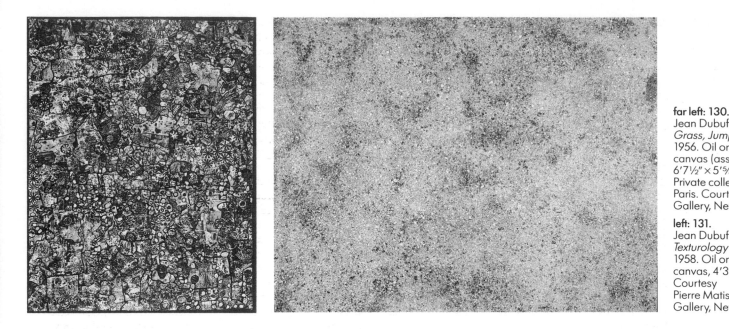

far left: 130.
Jean Dubuffet. *Run Grass, Jump Pebbles*. 1956. Oil on canvas (assemblage), 6'7½" × 5'⅝". Private collection, Paris. Courtesy Pace Gallery, New York.

left: 131.
Jean Dubuffet. *Texturology XXIX*. 1958. Oil on canvas, 4'3" × 5'3¾". Courtesy Pierre Matisse Gallery, New York.

Painting is a more immediate and direct vehicle than verbal language, much closer to the cry; or to the dance; that is why painting is a vehicle for expressing our inner voices which is more highly effective than words. . . .

Meanwhile, Dubuffet was also assembling a collection of what he called *art brut*, "works of all kinds—drawings, paintings, embroideries, modeled or sculpted, etc.—which present a spontaneous and strongly inventive character, as little indebted to contemporary art or cultural models as possible and of which the authors are obscure individuals, alien to the milieu of professional artists." Once gathered from flea markets and asylums in France and Switzerland, this assemblage of demotic expressions—corresponding "to a feverish impulse and not to some episodic stimulus or caprice where exaltation plays little part"—had the cosponsorship of André Breton, as well as that of Charles Ratton and the critics Jean Paulhan, H. P. Roché, and Michel Tapié. In 1948 it would be installed in a space lent by the Gallimard publishing house in Paris. But however close such activity and its inspiration may seem to Surrealism, Dubuffet never joined the Surrealist movement and considered its works, along with those of naïve artists like Henri Rousseau, as merely a variety of cultural or establishment art. Rather, he identified with the schizophrenic artist who, in his antisocial, self-obsessive alienation, is free to invent his own language, create solely for his own satisfaction, and engage in the unintentional therapy of projecting a fantasy world in place of the "real" one to which he cannot adapt. It was fundamental to his genius that the clear-headed, disciplined Dubuffet could construe the signs and symptoms of madness as partaking of the universal creative impulse, pure and uncontaminated by cultural restraints. For the renewal he felt art must undergo, given the dilution or corruption it had suffered during the war, Dubuffet wanted it to derive from imperatives as rude as those experienced by the psychotic artist and, if necessary, be as defiant of cultural norms and forms as the works of madmen.

Once Dubuffet had established the coordinates of his art, they would, in his hands, function like an elasticized dialectic that could stretch to all manner of extremes, through a number of different series, yet always snap back into place. And they were already in place, for the most part, by the time Dubuffet made his debut as an exhibiting artist (fig. 128). Right away he let it be known that his subjects were to be anti-heroic, nothing more than banalities of landscape, the human image, domestic animals, and ordinary man-made objects. Furthermore, he would draw them—like a radicalized Paul Klee—with the rudimentary directness or stick-figure crudity of children and graffitists, the better to jar the cultivated viewer and shake him free of aesthetic responses deadened by habit. Consistent with this vernacular approach, he would also eliminate all the traditional hierarchies of composition and perspective, thereby flattening figures and ground onto the same frontal plane and accounting for relative distance by simple stacking, rather than the usual techniques of overlapping, modeling, or foreshortening. While still working with oil, Dubuffet scratched, scored, and scraped the painted surface until it seemed as defiled as an old public wall and thus certain to offend good taste.

Sensing that the bright and relatively realistic colors of his earlier work graced the art with an unwanted decorativeness and charm, Dubuffet very soon neutralized, or iridized, this palette and coarsened his oils by creating emulsions and adulterating the sensuous medium with glue and sand. At times he resorted to such non-art materials as tar, gravel, lime, plaster, glass, asphalt, or even mud, creating an *haute-pâte* comparable to that seen in Fautrier's Hostages (fig. 105). The process of transforming luxurious, aristocratic oil into a gritty plebeian substance began as early as 1946, and by 1950 it would become a public scandal in the Corps de dames series (fig. 129). Here, monstrous fertility goddesses seem represented by nothing more than their flayed skin stretched over and pinioned to the surface like trophy hides, only for their sexuality to suffer the mockery of becoming all the more obvious than in a Classical nude. With these "celebrations" of the female as a cult object, Dubuffet deflated one more overblown tradition, at the same time that he rehabilitated it by transforming the image into a landscape, even texturing and coloring it like the earth it was originally meant to fecundate. In the Corps de dames, with their tantalizing equivocation between the conceptual and the concrete, Dubuffet realized the tense, contradictory quality he saw in the works of his Art Brut collection. In New York, meanwhile, de Kooning too had begun to send up the love-goddess myth in his Women series (fig. 58), but through what astonishingly different means! Instead of deflating the image, de Kooning bulked it with juicily colored, shambaroque fulsomeness, its "earthy" landscape character more like that of a Pop urban scene than the primitive terrain evoked by Dubuffet.

For his Tableaux d'assemblages, a series dating from 1955–57, Dubuffet worked with fragments of spattered canvas and allowed their accidental configurations or fortuitous juxtapositions to inspire collaged pictures resembling mosaics of pebbles, stones, shards of glass or marble (fig. 130). Often the technique yielded all-over abstract arrangements like those favored by the New York School, but occasionally it also generated images embedded and barely discernible in the haptic texture of a taut figure-ground continuum. Created through chance associations intuited by a "de-educated" sensibility confronting the external qualities of random materials, the Assemblages of Painted Canvas evoked a world of extreme psychic isolation, where every element would function equally well in some other

context, and nothing could be seen as bound by determined temporal, spatial, or social relations. Having observed the products of madness, Dubuffet emulated the process of their creation and achieved a totally nonrelational, delusionary vision of modern existential man's helpless anonymity, a tragic vision comparable to that of the artist's friends, the writers Camus, Beckett, and Ionesco. The all-overness and anonymity implicit in nonrelational composition became total in the Texturologies of 1957–59 (fig. 131), paintings whose maculated surfaces are so generalized in nebulous painterly incident that the viewer is left in the ambiguous state of wondering whether he sees a literal fragment of earth or the depiction of a vast, undifferentiated landscape. Formally, such pictures anticipated sixties-style Minimalism, but they surged up in the classic manner of a fifties master spontaneously engaged with his materials. But so automatically, or fortuitously, did Dubuffet's mind and hand work that they seem to have disappeared, leaving *matière*, or "matter," as the chief protagonist. In his role as "ordinary" man susceptible to the vicissitudes of everyday experience, Dubuffet courted chance and accident, insisting that:

[Art] is a duet between the artist and his medium. Each must speak freely and directly and visibly his own language. One must allow all the fortunes proper to the material to emerge. . . . To try to prevent these vagaries of fortune would be to deprive the work of all vitality.

The Texturologies, followed by the Matériologies (1958–60), brought to a climax Dubuffet's attempt to assert banal substances as potent agents of thought and feeling—thus as creative, anticultural forces. Given their source in concrete reality and their power to activate or direct the shaping process, crude, earthy "materials of fortune" offered a fertile antidote to form, that abstract product of nonmaterial cerebrations which by the 1940s had, for Dubuffet, come to seem too ideated and sterile to bear the expressive burdens presented by the late-modern world. The French scholar Max Loreau has called the Matériologies "a veritible desert of form destruction," suggesting a point beyond which further development would seem impossible—had Dubuffet been a less inventive artist. However, in 1962, while absent-mindedly doodling at the telephone, he discovered an immense new potential in the common ballpoint pen, with its ability to feed out a continuous, uniform line, free of the stops and starts, the varying weights and widths of marks made with traditional ink and paint (fig. 132). In Dubuffet's hands, this mobile, universally accessible medium generated a meandering, all-over network of tightly interlocked cellular forms, their organic shapes defined by a black contour line and by either the reserve white of the support or by infilling with red or blue, the two alternative colors then available in ballpoint pens. Once converted into painting, the proliferating abstract

image gave the artist his Hourloupe works, a series so fertile that he was still exploring it, in many different directions, at the end of his life over twenty years later. Now Dubuffet could give effect to a kind of compulsive, monotonous flux, like that generated by an irrational or pre-logical mind. And since the medium-dictated theme involved a flat vinyl support and an antinatural, nonassociative, synthetic palette, like that of Léger and Mondrian, it eliminated the sensuously variable surfaces, colors, and values of materials appropriated from external reality. In sum, the Hourloupe enabled the artist to give ultimate satisfaction to his long-held goal, which, as he phrased it, was "to erase all categories and regress towards an undifferentiated continuum." When spread over a large rectangular field, the continuum discloses that Dubuffet was also progressing towards a vastly renovated formalism, which, like that of Pollock in New York, drew energy from vernacular sources to fuse the whole of modernist experience—Expressionism, Cubism, Surrealism—into a tense but grandly cohesive harmony. In the Frenchman's art, however, this would evince the cooler, even more anti-illusionistic, and hard-edged qualities symptomatic of the 1960s. When the jigsaw mosaic also yields, on close looking, one or more of the same kind of delusionary images of ordinary phenomena—figures, coffee pots, chairs, scissors, guns—that always engaged Dubuffet, Art Brut seems to merge with the witty, ironic world of Pop. And as the doodles crawl over the same motifs realized in freestanding sculpture—made of styrofoam, plaster, or sometimes concrete in the case of giant environmental pieces—they provide literal form with a virtual, or purely visual, texture, thereby reversing the situation in the pictures, where a conceptual image acquired a concrete texture, and raising the illusion-reality conflict to a new, higher power (fig. 133). Acknowledging the multiple paradox of what might be called his "three-dimensional paintings," Dubuffet felt them to be "endowed with an equivocal status, which produces a wavering in the mind between the function of material objects and that of immaterial figurations of objects." In his urge to dismantle the edifice of categorical thought, Dubuffet, throughout his oeuvre, produced extreme perceptual uncertainty and intellectual discomfort expressed in terms of surpassing banality. At the unstable point where the coordinates of this equivocation join throbs the heart of Dubuffet's

left: 132. Jean Dubuffet. *Exchange of Views*. 1963. Oil on canvas, 7'1⅞" × 9'9". Courtesy Pace Gallery, New York.

above: 133. Jean Dubuffet. *Group of Four Trees*. 1971. Tubular steel frame with walls of aluminum, honeycombed epoxy coating, reinforced with layers of fiberglass; 40 × 16 × 16'. Museum of Modern Art, New York (courtesy Pace Gallery).

The European School of Painting: 1945–60

vital and fascinating art, setting off, as Margit Rowell has noted, an undercurrent of tragic humanism, a vision of modern man's helpless alienation and anonymity.

Alberto Giacometti (1901–66) did not so much emerge as a major master in the postwar years as re-emerge, but now in a style representing substantive and aesthetic concerns almost diametrically opposite those with which he had achieved his fame in the early 1930s as one of Surrealism's most gifted sculptors. Greatness will out, obviously, whatever the mode it may choose to be expressed in—abstraction or figuration, expressionism or formalism, sculpture or painting. In the history of sculpture, Giacometti, as we shall see in the next chapter (figs. 165–167), occupies a legendary position, especially for the later bronzes, those wiry, ravaged figures whose haunting isolation struck Sartre, Camus, Beckett, Genet, and many others as the perfect visual metaphor for Existential Man. As it turned out, however, Giacometti had his own compelling interests and the moral iron

above: 134. Alberto Giacometti. *Annette.* 1951. Oil on canvas, 31⅝ × 25⅜". Courtesy Beyeler Gallery, Basel.

right: 135. Balthus. *La Semaine des quatre jeudis.* 1949. Oil on canvas, 38½ × 33". Private collection.

to pursue them, even if this took him beyond the limited dispensations of either Surrealism or Existentialism, or indeed from sculpture into painting, where his achievement is fully as admirable, if not as celebrated, as that in sculpture. Actually, painting claimed this artist well before sculpture did, which seems natural enough considering that he had been trained by his father, Giovanni Giacometti, a noted Swiss practitioner of modernist styles from Post-Impressionism through Fauvism and Expressionism. In 1922, when Alberto arrived in Paris—to remain there the rest of his life, except for relatively brief periods in his native Switzerland—he had acquired at the Geneva Academy a Cézannian manner of structuring form with a patchwork of color slabs. After 1925, however, he all but abandoned painting, mainly because it failed to give him fresh solutions to the pictorial problem that most concerned him: how to represent imaginary volumes and the space surrounding them on the two-dimensional picture plane. Neither Surrealism's dream perspectives nor the conceptual

fields of abstraction would do, since Giacometti wanted to depict real objects perceived in real space. In 1935, when this ambition moved him to renew working from life, rather than exclusively from his imagination, Giacometti parted company with Surrealism and exhibited no new art for the next eleven years. Of necessity, it would seem, the very nature of his obsession also took him back to painting, but not with full energy until after the war (fig. 134). By this time color had disappeared almost completely from his palette, because for Giacometti, bright chromatics tended to evoke surfaces more than volumes, unlike the Analytic Cubist grisaille of brown, beige, and gray heightened in white that he now preferred. Also gone, and for much the same reason, was Cézanne's planar stroke, replaced by a sketchy linearism whose nervous repetition combines with numerous corrections and erasures to yield a painterly equivalent of the struggled, flickering touch the artist used in modeling plaster. But while in sculpture the effect was to dematerialize solid form, on the flat, opaque surface of painting it served mainly to take account of immaterial, invisible space, for now Giacometti was addressing the problem of how to render his *perception* of reality, not reality as it is known to exist. With the hand coordinated to register a thousand "takes," its multitudinous marks often break free of shapes to become abstract vectors forming webs of optical sensation. Altogether they provide a record—one that is not so much complete as merely interrupted at a certain advanced stage—of the artist's swift, unremitting eye as it scanned a scene and probed not only its palpable contents but also the intangible, yet keenly felt, phenomena of its distance, atmosphere, and the intervals between things apprehended therein.

In the early 1950s Giacometti began to frame the image in parallel lines traced along the edges of the field, creating a kind of mediator between the fictive world of the painting and the painting as a real object present in the viewer's own space. When the framing became fasces of concentric lines, it tended to transform the picture into the semblance of a mirror and the subject painted upon it into a reflection of the realm occupied by ourselves. At the same time that this acknowledges the painting surface, as modern art is wont to do, while allowing for the representation of depth, it also provides a strong existential link with the viewer. The connection becomes important in regard to the usually present figure, seated at center and in a strongly hieratic, frontal pose, like the Egyptian art Giacometti had long ad-

mired. By identifying with the figure, we can also grasp the meaning of its distortions and ghostly appearance—the small head and large limbs, the reiterating lines and colors that integrate forms with their environment even more than they define them—as fundamental to the vision of an artist who wanted to represent reality with something like the foreshortening, variable-focus lens of a camera. However, he endeavored to do this not mechanically but with all the doubts and hesitations of a poet-painter ardently devoted to a futile task. This was nothing less than a cancellation of the intellect and the making of art solely from immediate retinal experience, thus with forms that appear small and dissolved at a distance, large and resolved up close, and always enveloped in an insubstantial but insistently present space. "To render what the eye really sees is impossible," Giacometti said, but he never ceased reaching for the unattainable, since the urge to seize the truth of existence, even if only in relation to nothingness, engenders the courage to go on being.

One of Giacometti's close associates in the School of Paris was Balthus, or Balthasar Klossowski, the reclusive and self-styled Count de Rolla (1908—). This artist also had close ties to Switzerland and had emerged at a very young age within the ambience of 1930s Surrealism. But despite his romantic background, which included an art historian father, a painter mother, and the poet Rainer Maria Rilke, Balthus proved too literal-minded in his manias and too determined in his formal strategies to be held by Surrealism's fantasy world and conjuring techniques. If not a spontaneous genius, however, he did possess formidable powers as a pictorial architect, almost approaching those of his chosen models, Piero della Francesca, Poussin, and Cézanne, all of which placed him at some remove from the emotionally driven procedures cultivated by most of the artists seen in this chapter (fig. 135). But along with his stable structures of rhyming rectangles and counterbalanced diagonals, his slow build-up of smoothly scumbled, Tachist surfaces, Balthus has always indulged a furtive obsession with the erotic potential of half-aware pubescent girls. The title of the work seen here suggests that the loosely clad juvenile sprawling in the foreground merely celebrates a week of uninterrupted holiday (since French schools formerly held no classes on Thursday). Flanking this scene of innocently liberated adolescence, however, are the tense, fully clothed young woman standing watch at the window and a leering cat (no doubt an emblematic stand-in for the painter), who charge an otherwise serene atmosphere not only with illicit sexual longing but also with a kind of foreboding and menace. Thus, in a world as calmly material as Giacometti's is nervously eroded, the extremely private Balthus would seem to share the great Swiss sculptor's public concern with the individual caught in a recrudescent Europe riven with anxiety and alienation.

Also emerging from a lapsed identification with Surrealism, but in a radically different part of that particular forest, was Graham Sutherland (1903–80), England's leading representational painter in the early postwar years and the first native British painter since Turner and Constable to enjoy an international reputation during his lifetime. Properly enough, he also embodied the Romantic spirit of those earlier masters, which placed him at far remove from both the cynicism of orthodox Surrealists and the Existential doubt of Dubuffet and Giacometti. Sutherland, in fact, had undergone an early conversion to Roman Catholicism, an experience that made him particularly susceptible to the visionary power of Samuel Palmer (1805–81), whose landscape paintings transformed bucolic England into an enchanted realm of pantheistic feeling. In the 1930s Sutherland, aided by modernist license, revisualized the natural beauty of Pembrokeshire in similarly mysterious and animistic terms. For him, such organic phenomena as hollow tree trunks, branches and roots, gorse, plants, and rocks, "bear the mold of their ancestry" in divine creation. Thus while sketching them, he concentrated on "bringing out" their "anonymous personality," a process destined to endow natural forms and landscape with an anthropomorphic presence. By 1941, when he became an official war artist, Sutherland could even translate the lit-

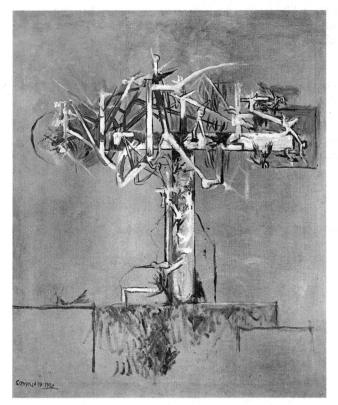

136. Graham Sutherland. *Crown of Thorns.* 1954. Oil on canvas, 43¼ × 36¼". Staatliche Museen Preussischer Kulturbesitz, Nationalgalerie, West Berlin.

eral apocalypse of the London Blitz into a grandly metaphoric one. Explaining his approach, he said: "I did not feel that my imagination was in conflict with the real, but that reality was a dispersed and disintegrated form of imagination." After the war Sutherland found himself confronted with the problem of making reality conform to the requirements of established Christian iconography—that is, in a way that the image might recover the same expressive impact it had generated in older, less secular times (fig. 136). The form he found in nature that seemed most promising as a corollary for the suffering Christ was the thorn tree, whose fierce limbs, he said, "while preserving their normal life in space by their spikes . . . arranged themselves and became something else—a sort of paraphrase of the Crucifixion—the essence of Cruelty." He used them to such dramatic effect in his commission for the Church of St. Matthew's in Northampton that this relatively traditional interpretation, along with that for rebuilt Coventry Cathedral, brought him what may be his greatest fame. It helped that he also relied on the 16th-century example of Grünewald's *Isenheim Altarpiece,* one of the older religious works violent enough to correspond to the modern world's spiritual and physical ordeals. In other works, however, including the one seen here, Sutherland followed a more purely Romantic precedent and simply trusted the thorns to rearrange themselves and become something else, a cruciform icon of piercing potency that many find even more mystical and moving than its figurated counterparts.

For many informed observers, Francis Bacon (1909—) is the late 20th century's greatest living painter; certainly, he is the ranking Old Master of contemporary European figure painting, a distinction he has held, virtually unchallenged, since the death of Picasso in 1973. And Picasso, it would seem, was the primary inspiration of this remarkable Anglo-Irishman, when, totally untaught, he first began to draw and paint in 1928. Catalyzed by the grotesque humanoids and *vagina dentata* imagery of Picasso's Surrealist period, Bacon found within himself, and would acquire even more, resources from which to develop an iconography of unique, convulsive gruesomeness. Fundamental to

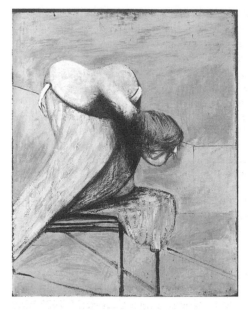 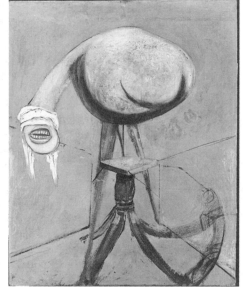 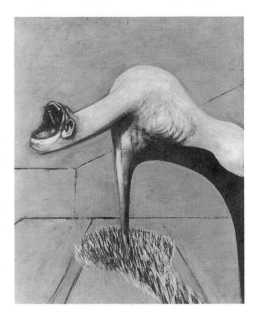

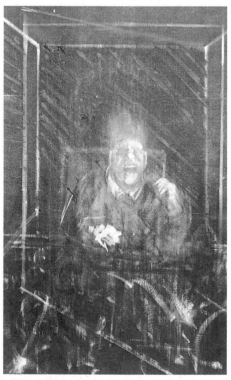

above: 137.
Francis Bacon.
*Three Studies for
Figures at the Base
of a Crucifixion.*
c. 1944. Oil on
board, each 37 × 29″.
Tate Gallery, London.

left: 138.
Francis Bacon. *Study
for a Pope.* 1954. Oil
on canvas, 5′3¾″ × 3′1″.
Private collection.

growing up English—actually a collateral descendant of the great Elizabethan philosopher Sir Francis Bacon (1561–1626)—in Sinn Fein Ireland. Already an independent spirit by the age of sixteen, he left Ireland for a long period of drifting, to London and then to the Continent. In Berlin, at the height of its wide-open Weimar Republic days, Bacon "saw something much more violent than Christopher Isherwood." Next came Paris, where he worked as an occasional interior decorator—and discovered Picasso, in an exhibition at the Paul Rosenberg Gallery. A year later, in 1929, Bacon was back in London, designing Bauhaus-like metal-tube furniture—"extremely bad copies of Le Corbusier," according to the artist—and beginning to paint in oil. By 1933 he had produced his first important pictures, one of which was a boldly Surrealist Crucifixion, a work that Herbert Read reproduced in *Art Now*. The propensity this reflected could only have been reinforced after the artist visited the "International Surrealist Exhibition" organized in 1936 by Read, Roland Penrose, and André Breton for London's Burlington Galleries. Meanwhile, Bacon also took up gambling, a passion as important to him as the role of chance in painting. After 1937, however, he painted little, but when war broke out all of life became a high-risk affair as Bacon assumed the duties of an air-raid warden during the London Blitz. He also destroyed almost all his earlier work—hundreds of paintings—and so at his re-entry into the world of art in 1945 Bacon was essentially unknown, which made the debut paintings cited above all the more startling.

Dismissing traditional realism as mere illustration and abstraction as little more than design lacking human content, Bacon has steadfastly focused on subject matter but in savagely distorted form, his purpose being to "unlock the valves of feeling and therefore return the onlooker to life more violently." Throughout most of his career, he would begin with actuality in "extreme situations," but for the historic trio of pictures exhibited in 1944, he followed Surrealist precedent and relied primarily on his imagination, an imagination already darkened by Ireland and Berlin but now charred anew from the mindless death and destruction raining down upon wartime London. The title assigned to the triptych—*Three Studies for Figures at the Base of a Crucifixion*—reveals a continuing involvement with a theme first embraced in 1933. For Bacon, however, it bore no religious significance, since he would appear to have been an Existentialist born, convinced from an early age that man "is an accident, that he is a completely futile being, that he has to play out the game without reason." The nonbelieving artist saw the Crucifixion as "just an act of man's behavior, a way of behavior to others," and thus all the more interesting for its power to illuminate one of the more lugubrious corners of existence. But he also viewed it mythically, even if in pagan

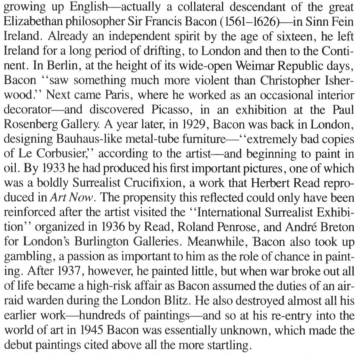

its sensational effect, however, was the manner whereby the artist could render his sadomasochistic themes with a painterly glamour worthy of Velázquez (fig. 137). Such jolting incongruity of gorgeous means and horrific message yielded a terrible beauty recalling another Spanish master, Francisco Goya, and the stir it created when Bacon first began exhibiting in 1945 was recorded by the critic John Russell: "British art has never been quite the same since the day in April . . . when three of the strangest pictures ever put on show in London were slipped without warning into an exhibition at the Lefevre Gallery. Visitors . . . were brought up short by images so unrelievedly awful that the mind shut with a snap at the sight of them." In point of fact, many of those visitors returned for further looks, as others have been increasingly drawn to Bacon's ongoing and expansive oeuvre. If far from "popular," the audience is a solid one, consisting of viewers brave enough to have their minds prized open by some of the most visually and morally challenging art works of our time.

Bacon has frequently spoken of his art as "an attempt to remake the violence of reality itself," a kind of reality he knew well from

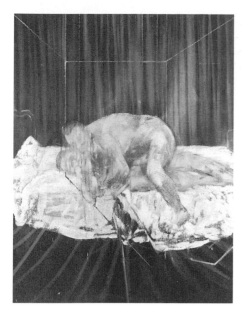

left: 139.
Francis Bacon. *Two Figures*. 1953. Oil on canvas, 5' × 3'9⅞". Private collection, London.

below: 140.
Francis Bacon. *Three Studies for a Crucifixion*. 1962. Oil with sand on canvas, triptych; each panel 6'6" × 4'11". Solomon R. Guggenheim Museum, New York.

echoes that give Bacon's art its developed and mysterious richness. If in *Three Studies* these do not yet include the ravishingly decadent, Mannerist colorism or the Baroque painterliness of later canvases, they nonetheless embrace such prototypes of harrowing Expressionist imagery as Grünewald's *Isenheim Altarpiece* and Picasso's *Guernica*, even news photos of haranguing Fascist dictators or Sartre's reinvention of the Furies as Flies in *Les Mouches* (1943).

During the next several years Bacon produced few pictures and no triptychs; instead, he painted mainly individual heads that appear to readdress the dire issues just seen in *Three Studies* but now one by one and in serial order. Increasingly his subject became a recognizable human being in extreme crisis while isolated, or trapped, in a closed space and presumably unobserved. With this experiment, beginning in 1947–49, emerged the central and most famous image of Bacon's oeuvre: the screaming Pope (fig. 138). Here, the situation may be private and the obsession altogether personal, but the motif itself derived from a surreal conflation of sources that could hardly have been more public. The most obvious of these was a reproduction of Velázquez' stately, sumptuous *Portrait of Pope Innocent X*, in Rome's Doria-Pamphili collection, and a close-up still of the wounded, panic-stricken nanny from the Odessa Steps scene in Sergei Eisenstein's 1925 film *The Battleship Potemkin*. Thus, while posing the figure with all the formal dignity due a Counter-Reformation pontiff, Bacon mercilessly exposed the inner man by depicting the head in full shriek, as if the tall gilded throne had become a switched-on electric chair. The duality this presented—the private collapse of public power—so absorbed the artist that by 1953 he had reinvented the Papal portrait in more than twenty-five canvases. Sometimes the subject is caged in an uncanny prefiguration of a glass-boothed Eichmann on trial in Jerusalem; at others he is flanked by sides of beef, thereby evoking a sense of the secular sacrifice or Crucifixion that Rembrandt in the 17th century and Soutine in the 20th discovered in butchered carcasses. And just as these earlier artists saw a dreadful, or redemptive, red and purple beauty in a flayed, strung-up ox, Bacon has more than once said that "you only need to think about the meat on your plate" in order to understand the truth about the human condition. Having acknowledged this condition, however, he could react to it with the eloquent objectivity of an Existentialist philosopher or aesthetician:

I've always been very moved by the movements of the mouth and the shape of the mouth and the teeth. People say that these have all sorts of sexual implications, and I was always very obsessed by the actual appearance of the mouth and teeth, and perhaps I have lost that obsession now, but it was a very strong thing at one time. I like, you may say, the glitter and color that comes from the mouth. . . .

terms, calling the monstrous beings in *Three Studies* "Euminides," T.S. Eliot's name for the Aeschylean Furies. And indeed the terrifying triplets—"part human, part animal, and part conundrum"—are so screwed up and literally blind with hatred, so hysterically fierce, and so evidently ravenous for revenge that they seem scarcely able to wait before pouncing upon and dismembering whoever may approach or be brought down from the Cross above. Creatures of a subconscious ignited by automatic processes, the unholy trinity display a degree of abstractness never again to be allowed by Bacon; otherwise, the artist had already in *Three Studies*—the first of his mature works—largely established the essential and distinctive elements of his art. Most striking of all—even overriding the menace and anatomical mutations inherited from Picasso and Surrealism—are the frightful mouths that transform the elongated necks in the center and right panels into penile protuberances with vulva-like heads, both dog-toothed but one bandaged, bloody-lipped, and hissing, the other stretched wide open as if in an ecstasy of hellish, orgasmic screaming. Also to become canonic is the skulking voyeurism of the harpy in the left panel, as well as the counterbalancing of the figures' bowing, craning, probing movements and their perched, stage-like placement within boxed, claustrophobic settings reminiscent of those evoked in Sartre's *Huis clos* (1944). And here too are the wide-ranging, surreally colliding cultural

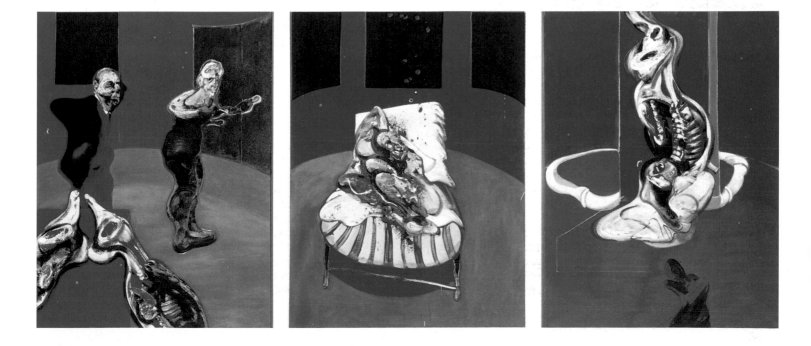

Given this sensibility, Bacon might turn his prelate inside out, but also ennoble him in the tall, flattering format of a court portrait and with increasingly deft, spontaneous brushwork. In a further twist, however, he located what could have been a remote, authoritarian figure in the immediate, vulgar world by repeating the theme, with variations, in almost cinematic sequence, as well as by exploiting his virtuoso touch to veil or blur the image somewhat like the tabloid photos of dictators whose snarling visages had offered prototypes for both the Furies and the Popes.

When the first of the Pope pictures were exhibited, Bacon commented that "painting is the pattern of one's own nervous system being projected on canvas." The remark would seem particularly apt as the artist, in 1953, turned with fresh energy to a subject—the male nude—that has never ceased to absorb him. Once again, the image would be cast in private but extreme situations, this time literally stripped bare of public disguise and its crisis often intensified by some sort of violent, or potentially violent, relationship with another figure (fig. 139). But even with the scene shifted to the bedroom, the subject

above: **141.** Francis Bacon. *Three Studies of Isabel Rawsthorne*. 1967. Oil on canvas, 3'11" × 5'. Staatliche Museen Preussischer Kulturbesitz, Nationalgalerie, West Berlin.

right: **142.** Lucian Freud. *Interior near Paddington*. 1951. Oil on canvas, 4'11½" × 3'8⅝". National Museums and Art Galleries on Merseyside, Walker Art Gallery, Liverpool.

retains some of its heroic or classical connotations, in part because of the formal grandeur with which the artist treated it, but often too because he based his nudes on photographs of unclothed athletes that once struck viewers as images of Greek statues come alive. These were stills from the sequential exposures made in the 1880s by Eadweard Muybridge and published in *The Human Figure in Motion*. Although originally intended as a scientific study, the wrestler image used here became an instrument of profoundly personal expression, transformed by Bacon into a pair of lovers grappling and grimacing like frustrated prison inmates in brutal, animalistic congress. But if the dazzlingly loose brushwork registers a subjectivity characterized by the artist as his "exhilarated despair," it also restores a sense of movement to action frozen by a high-speed camera, even in a painting realized with a grisaille palette reflecting the cool, black-and-white objectivity of an early filmic source. Contributing to the overall paradox of *Two Figures* is the platform-like bed set within a skeletonized stage space, an arrangement that makes the protagonists seem isolated from the world at large, yet tends to transform their secret act into a public performance and the viewer into voyeur.

Brilliant color had come flooding into Bacon's art by the 1960s when he returned to the triptych format and made his last exploration of the Crucifixion theme, now focusing on the victim rather than his tormentors, as seen here in an immense work of 1962 (fig. 140). Possibly to avoid the narrative implications of traditional multipartite Crucifixions, Bacon placed the Cross—at least the base of it—not at the center but in the right panel, a slaughterhouse scene approached from the far left by two men who appear to be fleeing what could be the sanguinary remains of a sacrificial lamb. The boned forearm and flayed head of the front runner would suggest that the butcher had already caught up with the pair. Scant refuge awaits them at the center, where a single naked figure has been tortured into a mangled mass of bullet-riddled flesh sprawled in shapeless contrapposto over a blood-stained mattress. Finally, in the right panel, the disemboweled corpse hangs upside down, its spine and rib cage slithering along the rood "like a worm," as Bacon once said of Cimabue's Santa Croce Christ, and its mouth locked in a rictus of agony. Macabre as the image may be, the artist painted it with a cursive, red, cream, and blue-black opulence, reminding us that he once had hoped to "make the [Pope's] mouth, with the beauty of its color and everything, look like one of the sunsets or something of Monet. . . ." By this time Bacon could do virtually anything with paint, including an expressive use of Pollock's drip and spatter technique in the center panel.

Speaking of the freedom and finesse of his mature style, Bacon said: "I rely on chance as much as possible and push the paint around until something happens. I think of myself as an instinctual painter, living as close as possible to the nervous system and the unconscious. . . ." Increasingly, he realized this could be done most effectively by relying not on the outer world of traditional themes, admired Old Masters, and documentary photographs, but rather on the inner circle of his own life. After the mid-1960s, therefore, Bacon did portraiture almost exclusively, turning to his own image and those of his

intimates. A vintage work—glorious in its fatty whorls, streams, and glissade planes of lavender and cobalt, carmine, umber, white and black—is *Three Studies of Isabel Rawsthorne*, painted in 1967 (fig. 141). Rather than a triptych, it offers a single canvas with a triple, fantasy view of a close friend trying to insert a key in an absurdly high lock while she furtively looks over her shoulder, all the while awaiting her own arrival within the dark interior and witnessing the mysterious scene from a picture frame illusionistically nailed to the wall. Equally complex is the plastic realization of each face, its features precisely true but so swiped, rotated, blotted, and dragged as to become ungraspable. To probe the emotional intricacy of his sitter and achieve a universal as well as a particular image, Bacon preferred to depend on memory or photography, instead of an actual presence, for whereas, according to the artist, a literal or "illustrational form tells you through the intelligence what the form is about," an abstracted, "non-illustrational form works first upon sensation and then slowly leaks back into the fact. . . . This may have to do with how facts themselves are ambiguous, how appearances are ambiguous, and therefore this way of recording form is nearer to the fact by its ambiguity of recording."

Here is that "someone indistinct" spoken of by T. S. Eliot and yet as present in Bacon's oeuvre as in the poet's "Sweeney Among the Nightingales":

> *The host with someone indistinct*
> *Converses at the door apart,*
> *The nightingales are singing near*
> *The Convent of the Sacred Heart,*
>
> *And sang within the bloody wood*
> *When Agamemnon cried aloud*
> *And let their liquid siftings fall*
> *To stain the stiff dishonoured shroud.*

As Dawn Ades has pointed out, the vision set forth by Bacon has much in common with that of Eliot in his early poetry, with its cinematic collage of "nostalgia for classical mythology, the abruptness of modern manners, the threat of the unseen, and the eruption of casual violence." But quite unlike the later Eliot, Bacon has never sought a solution of the human dilemma in religious faith. To the artist, "we are born and we die, but in between we give this purposeless existence meaning by our drives," even if these include a degree and range of private bestiality never before seen in the above-ground world of high art. The solution lay not in repressing the perilous facts of contemporary behavior but in acknowledging them as an inevitable presence in any true mirror held up to nature. Should this induce repugnance or despair, the artist would cancel them with acute sensation, registered in a ceremonial splendor that precludes pity, transcends shock, and, through a perverse nobility, affirms the value of finite life.

Berlin-born Lucian Freud (1922—), the grandson of the pioneer psychoanalyst, has lived in Britain since his family immigrated there in 1932, the year the Nazis gained control of Germany's Reichstag. Although a close friend of Bacon and often associated with him among the so-called School of London figure painters, Freud has always taken a totally different approach to subject matter, preferring to proceed slowly, over extended periods, and to observe the model directly, rather than filtered through memory or photography. "I am never inhibited by working from life," he has said in one of his best-known statements. "On the contrary I feel more free. I can take liberties which the tyranny of memory would not allow." In his earlier work, the liberties were those of an eye so focused on detail and a sensibility so determined to render it with meticulous, even pitiless accuracy that Herbert Read dubbed the artist "Lucian Freud—the Ingres of Existentialism" (fig. 142). But as the work here suggests, an Existentialist Ingres would probably paint in a manner reminiscent of Germany's prewar Neuesachlichkeit artists Otto Dix and Georg Grosz, complete with a figure posed in the defiant, clench-fisted stance of a trapped proletarian, his fixed, inward-looking stare directed towards the "enemy," symbolized by a tall potted palm bris-

143. Renato Guttuso. *The Discussion.* 1959–60.
Tempera, oil, and collage on canvas, 7'1⅝" × 8'¾". Tate Gallery, London.

tling with spiky, blade-like fronds. By concentrating on parts more than wholes, Freud may have endowed his figure with exaggerated extremities, but he permitted no distortion to occur in the balance between the surgical precision of his linear drawing and the smoothly tonal modeling of the forms it defines. So perfectly tuned is the overall value range that it remains constant even when the color painting has been reproduced in monochrome. Save for portraits, Freud's subjects seem always to be nameless, but thanks to the near-clinical objectivity with which they have been observed, each of them fills the pictorial space with an unmistakable human and specific identity. No less veristic is the texture of every surface—wood, carpet, fabric, flesh, hair—or the gray, flat light of London in the days before the capital was made a smoke-free zone. By the end of the 1950s Freud, as we shall discover in Chapter 12, would modify his miniaturist approach with a larger, looser touch but never his uncompromising devotion to what he sees.

In 1949 James Thrall Soby, writing for a MoMA catalogue, called the Sicilian-born Roman artist Renato Guttuso (1912–87) "very likely the best known younger painter in Europe." If no longer particularly young at that time, Guttuso certainly enjoyed a substantial reputation as postwar Italy's foremost Social Realist (fig. 143). By virtue of his vehement anti-Fascism and membership in the Fronte Nuovo, he might also be regarded as the representational counterpart of those Informal abstractionists Emilio Vedova and Afro Basaldella (figs. 113, 114). Like them, Guttuso utterly rejected the notion that his leftist humanism be expressed in an art of propagandistic illustration, but as an active Communist he was also too *engagé* to be satisfied with a purely formalist language. And so while opting for figuration as a more effective means of serving his humanitarian interests, Guttuso articulated it with a modernist accent, the only kind of utterance he deemed relevant for our time. In 1952 this passionate artist stated both his commitment and his independence when he wrote: "In order that a work live, the man who produces it must be angry and express his anger in the way that best suits that man. . . . He must act in painting as one who makes war or a revolution would act. As he, in short, who dies for something." Blessed with a generous spirit and a liberal intellect, Guttuso found subject matter everywhere—in the Mafia, in ordinary folk at work, in political conferences, or merely in landscape and still life—and he took a similarly roving attitude towards a form suitable for the conversion of his themes into painting. Although Pi-

casso's *Guernica* became a virtual talisman for him, Guttuso seemed to work through all the stages of modern European art, from Cézanne and van Gogh to Expressionism and, of course, Cubism, evidently bypassing Italy's own Futurism by reason of its lamented association with the Fascist regime. Thus, while a landscape might echo Picasso's early Cubist renderings of Horta de Ebro (1909), a painting of a committee meeting may very well recall Léger's *Smokers* (1911). But whatever the source or quotation, Guttuso invested it with a very personal kind of plenitude, usually characterized by lusty color, whittled drawing, and boldly elided passages of precise imagery and improvised, organic abstraction.

CoBrA

In its tumultuous embrace of both abstraction and figuration, the CoBrA movement proclaimed in Paris in 1948, but spawned along the shores of the North and Baltic seas, appears now to have summarized much of the Expressionist era in postwar Europe. Although the name represents nothing more than a contraction of Copenhagen, Brussels,

144. Karel Appel. *Exploded Head.* 1958. Oil on canvas, 4'8½" × 3'8½". Kunstmuseum, Winterthur, Switzerland.

and Amsterdam—the native cities of the artists involved—it nonetheless suggests something of the menace and bite, the snaking rhythms and sudden, explosive attack embodied in CoBrA painting. Indeed, CoBrA art was regarded by many critics as the European development most analogous in its rawness and violence to American Abstract Expressionism, revealing—from hindsight, of course—how little the new achievements on either side of the Atlantic were understood in 1948–50, the brief duration in which CoBrA held together. But whatever its other accomplishments, CoBrA can definitely claim the distinction of having been the only genuine, organized movement, complete with manifesto, to emerge since Surrealism. Although it became such only in November 1948, when the Belgian poet Christian Dotremont presided over a stormy conference of interested parties in Paris' Centre International de Documentation sur l'Avant-Garde,

CoBrA originated in separate outposts and in the volunteer manner of virtually all late-modern art. In Copenhagen it began with Asger Jorn and other members of an older abstract-Surrealist group, and in the Netherlands with Karel Appel, Corneille, and George Constant, who, together with equally free-spirited poets, united to share so-called "Experimentalist" ideas and publish them in a journal entitled *Reflex*. It was, however, in Brussels that Dotremont and the painter-poet Pierre Alechinsky saw the possibility of combining their efforts with those in Amsterdam and Copenhagen, and it was the Belgians who published the ten issues of the group's review *CoBrA*. Inspired by Fautrier, Dubuffet, and Wols, among others, CoBrA declared war on geometric abstraction, *la belle peinture*, and Social Realism of every stripe, but reached back to the older Expressionism of Munch and Ensor as well as to Surrealism's spontaneous methods and faith in the unconscious. Denying intellect a role in their creative efforts, the Dutch painters defined the picture as "no longer merely a construction of colors and lines, but an animal, a night, a scream, a human being, or all together." To achieve this CoBrA looked at prehistoric and folk art, children's drawings, graffiti, the art of the Vikings and Eskimos. Insisting on the freedom "that permits a man to express himself in accord with the exigencies of the instinct," CoBrA sought total liberty and the elimination of all artificial barriers, such as those between allusive and nonallusive imagery, humor and horror. It also fostered vitality so obstreperous as to be controlled only by the coherence of its own internal dynamism. CoBrA meant untrammeled exuberance, which also, like the youth of its exponents, set the movement apart from the Abstract Expressionism with which it has been so often, and unnecessarily, compared. CoBrA's historic place lies with the School of Paris, into which Appel, Jorn, and Alechinsky blended once they settled more or less permanently in the French capital while going their separate ways in art.

If Karel Appel (1921—) developed into the most Dionysiac member of CoBrA, it may well have been because as a Dutchman he had the most Apollonian of modern artists to resist: Piet Mondrian. While still a teenager, Appel had already left his native Amsterdam on a quest for self-assertion against the concrete purities and Utopian pieties of De Stijl. The journey took him not only back to Mondrian's own roots in fin-de-siècle subjectivity, but even into Belgium's dark mining country near Borinage, where van Gogh had attempted to evangelize the depressed workers and ended by painting some of Expressionism's earliest masterpieces. Fortunately, when Appel found his own artistic identity, it embraced almost as much as it rejected within the legacy passed on by earlier Netherlandish modernism (fig. 144). Thus, while he brought to CoBrA the bright primary colors sacred to Mondrian, he whipped and dragged them with a kind of ferocious energy that recalled van Gogh, but van Gogh recharged with the crude Art Brut power that Appel had now discovered in Dubuffet. For this reason, as well as a common national origin, Appel and de Kooning have often been compared, but whereas the New York Dutchman tended to find his subject matter in the present reality of contemporary Pop culture, Appel conjured images from the fantasy world long before harrowed by Bosch and Ensor. Still, in stirring up metamorphosed human or animal bodies, grimacing masks, weird, demonic figures reminiscent of Nordic mythology and folklore, Appel employed the same Surrealist automatism that had stoked Expressionist fires everywhere in the postwar world. Indeed, Appel described the process as cogently as anyone: " . . . for me, the material is the paint itself. The paint expresses itself. In the mass of paint, I find my imagination and go on to paint it. I paint the imagination I find in the material I paint." Yet, when Appel flamboyantly played the "barbarian bohemian," likened his painting tube to a rocket, and professed to produce his churned and heavily troweled surfaces through a feverish "boff!" assault on the canvas, he revealed the aesthetic as well as oceanic distance that separated CoBrA from de Kooning, with his never-ending revisions, innate grace, and solemn preoccupation with matters of form.

Sculpture at Mid-Century

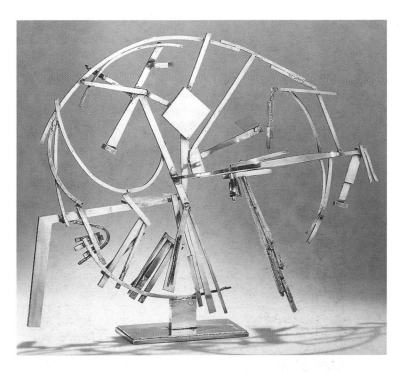

Mid-century sculptors, being as much the creatures of an existential moment as contemporary painters, tended on the whole towards the very kind of abstract, organic, and expressively accented form language already seen in the new pictorial art of both Europe and America. Indeed, the metal works of certain artists prominent in the 1950s have often been described as three-dimensional transcriptions of Abstract Expressionist canvases, with Eduardo Chillida's trees of looping iron bars likened, for instance, to the chiaroscuro, broadly gestural paintings of Kline and Soulages or Gio Pomodoro's rectangular sheets of flowing, polished material to the color-saturated fields of Mark Rothko (figs. 193, 194). Meanwhile, David Smith, one of the period's strongest and most original artists, created a genuinely Abstract Expressionist sculpture by working like the painter he always considered himself to be. Frequently Smith discovered form by freely associating, assembling, and finally welding together an array of steel rods and industrial parts laid out on a flat surface. Once aligned vertically, the network of lines and shapes this additive or Constructivist process yielded became a "drawing in space" with something like the autonomous, all-over disposition of a picture by, for example, Pollock or Vedova (fig. 145).

Still, far more than painting, sculpture continued to play host to the figure, even in the art of David Smith. And such thematic continuity seems inevitable, given the anthropomorphic connotations that

above: **145.** David Smith. *Timeless Clock.* 1957. Silver, 20⅜ × 26 × 6½". Collection Mr. and Mrs. Harry W. Anderson.

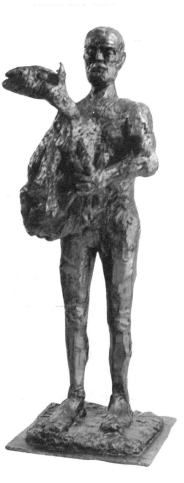

right: **146.** Pablo Picasso. *Man with Sheep.* 1944. Bronze, 7'2⅝" × 2'6¾" × 2'4⅜". Philadelphia Museum of Art (gift of R. Sturgis and Marion B.F. Ingersoll).

cling to any tall, freestanding form in the aftermath of a centuries-long, pre-modern history during which sculpture served mainly to render the mutable human image in the more everlasting guise of stone, wood, bronze, or terra-cotta statues. Picasso, with his richly informed, eclectic spirit and unfailing sense of metaphor, made poignant use of this grand humanist tradition when, at the depths of the Occupation, he countered the bestiality of that time with a gently realistic interpretation of the ancient Good Shepherd theme (fig. 146). Casting aside the open form and assemblage technique of his own direct-metal sculptures—constructions that had been David Smith's immediate inspiration—the stylistically bold and independent Picasso modeled his *Man with Sheep* in the kind of monolithic mass that his own most advanced art had done so much to dismantle as too stolid, aloof, or inert to express either the dark, conflicted realities or the bright, Utopian aspirations of the new century. In *Man with Sheep*, therefore, form joined with subject to convey a propitiatory longing for reconciliation, a desire further evinced in the synthesis the artist seems to have made of Rodin's emotive surfaces, the formal simplifications initiated by the early Maillol and Brancusi, and a mood of stoic inwardness recalling Lehmbruck or the works of Picasso's own Blue and Rose periods. Simultaneously, however, Picasso never ceased to be his old iconoclastic self, seeing sculptural possibilities in the saddle and handlebars of a derelict bicycle (fig. 147), metamorphosed through collage into the *memento mori* of a bull's skull, even as the recontextualized parts retain their own original identity, thus providing a double-entendre of the witty yet menacing sort beloved by the artist and the whole Dada-Surrealist group. For *Baboon and Young* of 1951 Picasso again employed found objects (fig. 148), this

right: 147.
Pablo Picasso.
Bull's Head. 1942.
Assemblage of bicycle
saddle and handlebars,
13½ × 17⅛ × 7½".
Musée Picasso, Paris.

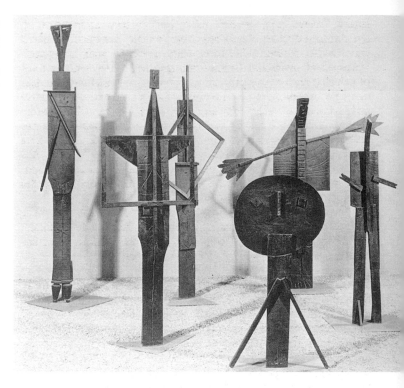

left: 148. Pablo Picasso.
Baboon and Young. 1951.
Bronze (after original
plaster with metal, ceramic
elements, and two toy cars),
21 × 13¼ × 20¾". Museum of
Modern Art, New York
(Mrs. Simon Guggenheim Fund).

right: 149. Pablo Picasso.
The Bathers. 1956. Bronze
(after carved wood), 8'7" high,
8'3¾" high, 7'¼" high, 4'5½" high,
6'6½" high, and 5'9¾" high.
National Trust for Historic
Preservation (bequest of
Nelson A. Rockefeller).

time a pair of toy cars purloined from his four-year-old son Claude, and incorporated them in a humorous parody of the statuesque, civilized presence so reverently evoked in *Man with Sheep*. By 1956, when a life-long fascination with Bathers re-emerged (fig. 149), Picasso retained his taste for assemblages of found materials, but did away with dense, modeled volume and, using plain wood slats, nailed together a set of flat, frontalized stick images whose totemic vigilance makes them seem as much modern variants of Sumerian deities as sun-worshipers on the beaches of southern France.

And so, even at this late stage of his career, Picasso could generate sculpture that virtually summarized the whole 20th-century history of the genre, much of which he himself had innovated, and set the stage for many of the important developments that would unfold in the oeuvre of younger artists coming forward in the postwar years. Again and again, he will be cited in this chapter as the point of departure for one technical, formal, or expressive idea after another. Paramount among them was the assemblage process, which had originated in the Spanish master's Cubist collages and constructions of 1912–16. Mixing and matching found objects or materials in openwork, three-dimensional structures, Picasso managed to bring the concrete world into his art without literally describing it. Moreover, he learned to unify the miscellaneous elements by so organizing them that the intervening spatial voids or virtual volumes come to seem as palpable as the solid members themselves. While the structural principles essayed by assemblage provided the basis of Russian Constructivism and its De Stijl as well as Bauhaus variants, the surprise and fantasy of unalike, vernacular elements juxtaposed in an alien, high-art context offered a strategy essential to both Dada and Surrealism. For many postwar sculptors working with hard, recalcitrant materials, collage, construction, or what soon would be called "assemblage" provided a technique almost as spontaneously responsive to the promptings of the unconscious as the automatic drawing and brushing practiced by Abstract Expressionist painters and their Informal or Tachist counter-

parts. But if younger sculptors accepted assemblage as a precious gift from both Constructivism and Surrealism, they also rejected the former's purist rationality, as well as the latter's disdain of style and love of erotically provocative objects or ready-mades. What virtually all strove to achieve, in one degree or another of abstraction and always in an autographically personal manner, was a sense of the myth and poetry, the fear and whimsy that Surrealism brought to the plastic arts. And they would attempt this even while expressing their deeply subjective, often anguished content with something like the clarity, control, and structural logic achieved by the Constructivists. The growing importance of assemblage to this objective seems suggested by the fact that, even though first developed by Picasso early in the century and thereafter used by many artists for all manner of ends, the process acquired its name only in 1953–54. This occurred when Jean Dubuffet applied the term to a series of lithographs he had made from paper collages but then expanded the concept to include small freestanding figures fashioned of such raw, organic matter as clinker, slag, roots, sponge, and charred wood (fig. 150). By working with crude yet per-

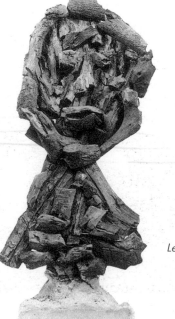

150. Jean Dubuffet.
Le Morvandiau (Man from Morvan).
1954. Charcoal, 24½" high.
Private collection. Courtesy
Fondation Jean Dubuffet, Paris.

ishable "materials of fortune" and by building them up in the primitive Art Brut manner of children or the mentally disturbed, Dubuffet endowed his diminutive but confrontational images with the mysterious aspect of totems and the sense of magic they convey with the force of palpable reality. As equivocal as Dubuffet's pictorial work in their teasing counterpoise of brutal power and fragile ephemerality, fantasy and earthy charm, anonymity and acute presence, the "Little Statues of Precarious Life" clearly partake of the common world yet seem possessed of an otherworldly force. The figure reproduced here, with its strange fusion of art and life, the conceptual and the concrete, is a near ancestor of the tremendous environmental Hourloupe encountered in the last chapter, a work that projects private enigma on the scale of a public monument (fig. 133).

Crucial as Picasso and collage, construction, or assemblage were for postwar sculptors, other influences also held sway. Foremost among them was Brancusi (fig. 151), who, as we have seen, approached abstraction from a position diametrically opposite that of Picasso. Instead of creating imaginary forms by adding together dislocated bits of external reality, Brancusi carved and modeled traditional materials—wood, marble, bronze—and progressively reduced natural, organic forms—birds, fish, the human head or torso—to their smoothly rounded, ideal essence. By this means he created platonically pure objects as closed or self-contained as the monoliths of old, but paradoxically made them richly accessible, if not through Picasso's openings and penetrations, then through polished, reflective surfaces, which visually absorb the immediate surroundings with an illusionistic effect comparable to that in painting. Brancusi, moreover, worked on a small, human scale, and while elevating his pieces on high pedestals, he carpentered the supports of blocky, rough-hewn wood, whose contrasting folkloric character nonetheless becomes integral with the gleaming, streamlined sculpture by suggesting the potent, primal life essentialized within it. During the 1950s an artist like the American Raoul Hague (1905—; fig. 152) might conflate the two parts of Brancusi's art and from a walnut trunk carve an abstract evocation of the human torso that finds its soul, so to speak, in the life of the medium itself, brought out by finishing applied with almost as much care as Brancusi lavished on his marbles and bronzes. However, very few of the sculptors to be seen here would adopt the closed form preserved by Brancusi and Hague, and even Hague departed from the older master by allowing the sense of his art to emerge from the core rather than from its surfaces. Henry Moore, Barbara Hepworth, and Isamu Noguchi all declared themselves disciples of Brancusi's formal refinement and spiritual content, but rejected the riddle of his sealed masses and mirror skins (fig. 153). And like Hague, they too sought

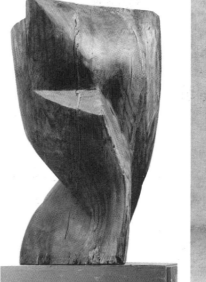

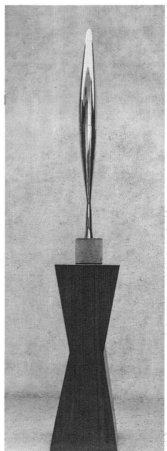

right: 151. Constantin Brancusi. *Bird in Space.* 1928(?). Bronze (unique cast), 4'6" high. Museum of Modern Art, New York (given anonymously).

below: 152. Raoul Hague. *Sawkill Walnut.* 1955. Walnut, 42' high. Whitney Museum of American Art, New York (gift of the Friends of the Whitney Museum).

meaning in a vitalist, or "truth-to-materials," notion of form made animate by a hand seeking the life within the inert matter it shapes. But whereas for Noguchi this often meant altering his medium as little as possible, both Moore and Hepworth excavated deep cavities or even holes in their otherwise inviolate solids so as to reveal the womb-like source of the energy felt to be charging the works' overall biomorphic volumes with a sense of warm, pantheistic presence.

Like all the revolutionary procedures cited above, this inside-outside interpenetration of the material and the immaterial served to renew art by engaging sculpture more intimately with realities it would no longer servilely imitate. Thus, at the same time that mid-century

153. Henry Moore. *Reclining Figure.* 1945–46. Elmwood, 6'3" long. Collection Humana Corp., Louisville, Ky.

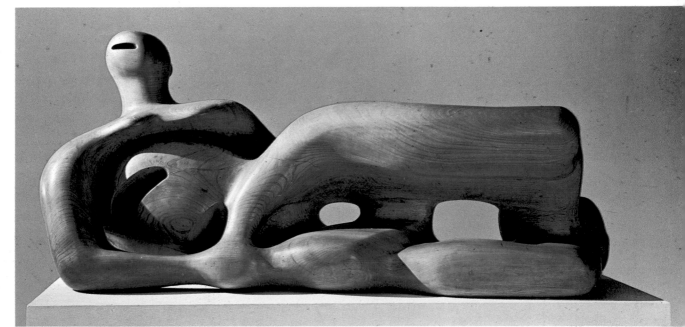

painting attempted to transcend the limitations of its two-dimensional plane and became more literally textural, as in the *haute-pâte* and collaged works of Fautrier, de Staël, Burri, Tàpies, Dubuffet, or even Pollock and de Kooning, sculpture would strive afresh to break open its dense, self-contained three-dimensionality by incorporating or reflecting both space and objects from the world outside. Given this mix of media, with sculpture becoming as colorful and "illusionistic" as painting, or visually transparent like drawings in space, it should hardly surprise that some of the greatest sculptors of the forties and fifties were trained or accomplished pictorialists, among them Giacometti, Moore, Calder, David Smith, Dubuffet, and, of course, Picasso. But once these innovators had created plastic forms that subsumed or deserted the isolating pedestal and occupied the same space as the viewer—like objects in a universe of objects—they had the wit to let the works assert an essential otherness through their resemblance to nothing else ever seen, thereby evincing a distinctive and unforgettable individuality that is the *sine qua non* of life itself. Giacometti voiced the ambition of mid-century sculptors when he spoke of his unremitting struggle to create a "double of reality," not the Surreality of his prewar works but rather a probing, authentically perceptual view of existence that would correct "yesterday's facts" with "today's truths" (fig. 165). Barnett Newman, upon first seeing the Swiss master's post-Surrealist figures, so slender and etiolated as to seem little more than abstract signs of concentrated energy, detected a quality now evident as a hallmark of the period: "Giacometti made sculptures that looked as if they were made out of spit—new things with no form, no texture, but somehow filled."

Abstract Sculpture in the Wake of Constructivism and Brancusi

As in painting, mid-century sculpture generally succumbed to the appeal of abstraction in part because it seemed, after years of ruthless demand for an art of propagandistic realism, to embody a unique moral value, offering a transcendent mode of expression in a world longing to resolve the conflicts of wars both hot and cold. Abstract sculpture, moreover, benefited from the advocacy of a resilient and ever-more visionary Naum Gabo, encountered earlier as one of the founding Constructivists. After 1946, when Gabo moved from Britain to the United States and began working with International Style architects, his creative life expanded from avant-garde obscurity into the

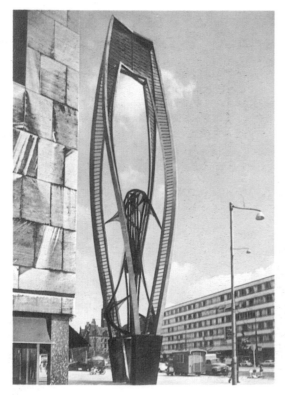

154.
Naum Gabo.
Construction for the Bijenkorf Department Store, Rotterdam. 1954–57. Steel, bronze wire, and freestone substructure; 85' high.

public domain and his works from a maquette to an environmental scale. In the colossal outdoor sculpture he designed for a commercial plaza adjoining Rotterdam's Bijenkorf department store (fig. 154), Gabo provided a veritable textbook demonstration of the Constructivist ideal, a balanced, geometrical structure in which space rather than mass has been the primary determinant of form. Gabo called his art "realistic" because it concerns nothing but space and time, which he considered "the only forms on which life is built." Moreover, the materials he used came from industry, represent only themselves, and have been so deployed as to make transparently clear not only the work's internal conception but also the process of its realization. Thus, the great pylon seen here derives from an assemblage of scrim-like vertical planes projected outward from their actual or implied intersection along a central axis. Since this all-important core consists almost entirely of openness, and the overall shape of the structure has been defined by neither surface nor mass, but instead by the edges of see-through planes, the tower stands as a virtual rather than a literal volume that offers no barrier to the flow of space and light between interior and exterior. Save in his experimental *Kinetic Construction, Vibrating Spring* of 1920, Gabo also relied on virtuality to express the fourth dimension of time, here accounted for in the rhythmic swelling and tapering of lines and shapes. At the inner core, these suggest the trunk and branches of a tree without actually illustrating them, thereby evincing the reconciliation that Constructivism could make of intuition and intellect, poetry and science, realism and idealism, the organic and the geometric. In this way, the sculpture performs its function as a model of enlightened Utopian existence.

To the degree that Gabo traveled the earth—from Russia to Germany, France, England, America—and successfully proselytized the Constructivist gospel wherever he settled, purist machine-style abstraction became a global language. If many found it less than warm-blooded, even these viewers generally surrendered to the spirited dynamism of the severe yet entrancing art created by Alexander Calder (1898–1976), who discovered truly vital new possibilities in Constructivism by exploring the temporality of movement or sequence far more exhaustively than anyone before him. With this Calder became the first 20th-century American artist to achieve an international reputation. But while both the breakthrough vision and the reputation had been gained well before World War II, it was not until the 1950s and 60s that Calder's abstract mobiles and stabiles began to expand great wafting wings and crouching legs in public spaces all over the world (figs. 156, 157). Something of their essential quality had been noted as early as 1931, when Fernand Léger characterized the Philadelphia-born artist as "American 100 percent," apparently to acknowledge the innocent ebullience and love of gadgetry that would, for the most part, remain constant throughout his oeuvre. Yet the works prompting this cultural designation had been made in Paris and were being shown there under the aegis of Abstraction-Création. Moreover, their immediate inspiration had been the fragile linearity, kidney-shaped planes, and whimsy of Miró combined with the flat primary colors and controlled structural dynamics of Mondrian. What those models sparked, however, was a creative imagination thoroughly reinforced by family precedent, educational breadth, and a unique set of well-honed gifts. Calder's father and grandfather had both been successful academic sculptors, and his mother a professional portrait painter, making a clan that delighted in the compulsion felt by their youngest member to fashion small figures of wood and wire. They also supported him when he entered Stevens Institute of Technology in Hoboken, New Jersey, and in 1919 took an honors degree in mechanical engineering. Thereafter Calder studied painting under a variety of distinguished teachers at the Art Students League in New York—Benton and Sloan among them—and then went to work as a free-lance artist for the *National Police Gazette*. In this roving job he found one of his great subjects in the circus and developed a knack for witty, caricatural imagery realized with the simplest of contour lines. Both came into full play once Calder arrived in Paris in 1926 and, while studying at

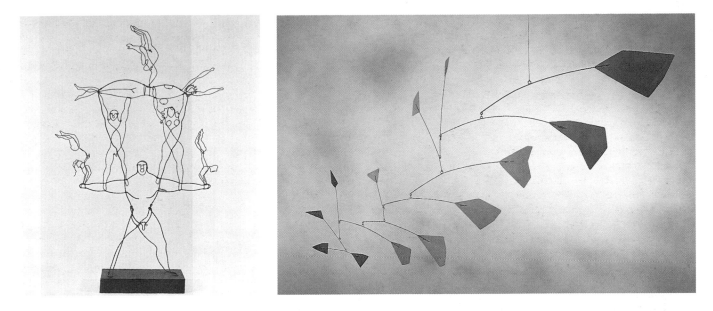

the Grande Chaumière, began to underwrite expenses by building and performing his *Circus*, a miniature arena of bareback riders, trapeze artists, sword swallowers, weight lifters, and trained dogs, all made of wire and wood for manipulation by hand or by string (fig. 155).

The *Circus* so captivated the Parisian avant-garde that its members crowded into Calder's Montparnasse studio as the artist took his marionette-toys through their various acts again and again. Since the performances unfolded in time, moved through space, and ended unpredictably, the *Circus* already had built into it the temporal, kinetic, and accidental issues that would engage Calder for the remainder of his career. Thus, it followed quite naturally that when he visited Mondrian in 1930 and succumbed to the spell of the Dutch master's abstract painting, Calder thought "how fine it would be if everything there moved," even while confessing that "Mondrian himself did not approve of this idea at all." Right away, Calder set about projecting into an art work his own fantasy of how its parts and patterns might form and re-form in actual space as he pondered it throughout a certain duration. With this he invented the "mobile," so-called by none other than Marcel Duchamp, aware, as Calder would later write, that "in addition to something that moves, in French it also means motive."

Not surprisingly, given his devotion to Mondrian, Calder made the first mobiles as motorized "paintings," their lines and brilliantly colored planes activated to glide across the two-dimensional space of an implied picture surface.

The better to make the mobiles more complete embodiments of his own consciousness and its workings, Calder by 1932 had decided to let the constructions be driven not by mechanical energy but rather by the erratic and unforeseeable force of wind, thereby reintroducing the Duchampian element of chance already seen in the *Circus*. In its developed, classic form, a Calder mobile constitutes a sustained balancing act, not only between opaque sheet-metal planes and the airy, calligraphic grace of their cascading wire linkages (fig. 156). Suspended from the ceiling or from the mast and boom of its own base, the mobile also offers a tense equilibrium between the rational clarity of an open, skeletal structure and the impenetrable mystery of its spontaneous movements. Equally opposite and no less daringly counterpoised are the transparent linearity of the artist's wire drawing and the sense of apparent or virtual volume it conjures, either by the angled intersection of two lines or by wind-generated motions that seem to displace the space they occur in. Here Calder went far beyond Ga-

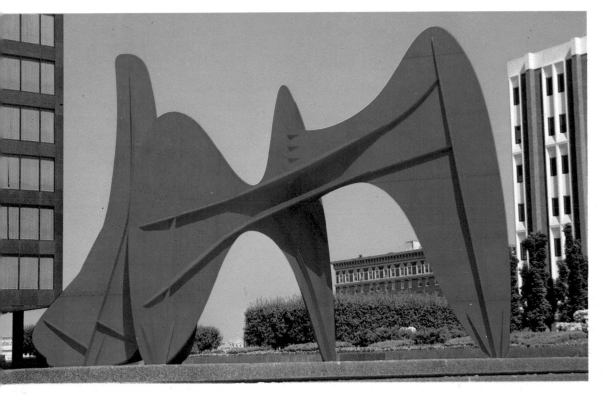

above left: 155.
Alexander Calder.
The Brass Family. 1929.
Brass wire, 5'4" × 3'5" × 8½".
Whitney Museum of American Art,
New York (gift of the artist).

above right: 156.
Alexander Calder. *Red Flock.*
c. 1949. Hanging mobile, metal;
2'10" × 5'5". Phillips Collection,
Washington, D.C.

left: 157. Alexander Calder.
La Grande Vitesse. 1969.
Painted steel, 4'7" wide. Calder
Plaza, Vandenberg Center,
Grand Rapids, Mich.

bo's *Kinetic Construction* of 1920, the ultimate ancestor of literal movement in 20th-century sculpture, which by mechanical means simply vibrated a flexible rod to give the illusion of a spiraling, luminous column set perpendicular to its fixed base. Sartre, writing in the catalogue to a 1946 Paris exhibition, recognized the originality of Calder's reinvention of Constructivism's virtual volumes, or what the French philosopher called the "scales and chords of unknown movements." He also perceived something profoundly Existential in the mobiles: "A general destiny of movement is sketched for them, and then they are left to work it out for themselves." Sartre further declared the sculptures to be "at once lyrical inventions, technical combinations of an almost mathematical quality, and sensitive symbols of Nature. . . ." But for all the analogies that might be cited in the natural world, Calder insisted that the mobiles were "abstractions which resemble nothing in life except their manner of reacting." Because it seems voluntary and sporadic, the sculptures' manner of reacting has sometimes been viewed as a metaphor for that human unconscious which provided the universal content common to so much otherwise diverse art in the postwar period.

Shortly after he had created the first mobile, Calder also gave birth to its stationary counterpart called the "stabile," this time with the christening provided by Jean Arp, whose commitment to organic abstraction, self-sufficient, pedestal-free forms, and randomly determined relationships the American shared. In static works, however, randomness could not be supplied by wind, and so Calder allowed it to emerge symbolically in occult balances (fig. 157). "Symmetry and order do not make a composition," he wrote. "It is the apparent accident to regularity which the artist actually controls by which he makes or mars a work." Like the movemented sculptures, the stabiles range in scale from the intimacy of tabletop objects to the monumentality of architecture. Indeed, some of the later stabiles can be entered like shelters, even as their sheer and curving, see-through silhouettes make the most colossal structures seem buoyant and weightless. Inescapably Calderesque are the elegant, tuxedo black or sizzling circus red applied to the artist's characteristic vocabulary of flat, biomorphic shapes, with their witty, albeit purely abstract evocations of floral, insect, or vegetal life. But far from a one-note composer, Calder could also conceive ensembles fairly bristling with menace or bowed low as if in mourning. Either way, the mobiles and stabiles brought a new lyric poetry to Constructivism's machine aesthetic, humanizing and civilizing the harsh, 20th-century language of rivets, steel plates, and welding seams.

Cosmopolitanism still broader than Calder's was the birthright of the Japanese-American sculptor Isamu Noguchi (1904–88), and few in the history of late-modern art could rival the varied and far-reaching nature of his long, distinguished career. This ranges, with abundant, Picasso-like productivity, from the 1920s to the late 1980s, from France to the Far East, and from the purest biomorphic formalism, designed for the essentially private, mandarin world of museum or private collections, to its successful extension into the ruder realms or larger scale of theater, commercial design, and public plaza. A clue to the secret of Noguchi's success in projecting significance wherever he applied his formidable talents may lie in the solution he conceived for dealing with—for deriving creative energy from—the conflicts of his personal fate as a child of two sharply different cultures. Caught in Japan during the early 1930s, remote from his Scotch-Irish American mother and rejected by his Japanese father, a university professor of art history, Noguchi found consolation making terra-cotta pieces and exploring Japanese gardens. Years later, in his autobiography, the artist would characterize this "close embrace of the earth . . . as a seeking after . . . some primal matter beyond personalities and possessions." Almost from the start, however, Noguchi found himself capable of working "as in a trance," driven by his search for values transcending the immediate and the given. By 1927 he had made such rapid progress that the Guggenheim Foundation gave him one of its first grants, for study in Paris and Asia, the better to become "an interpreter of the

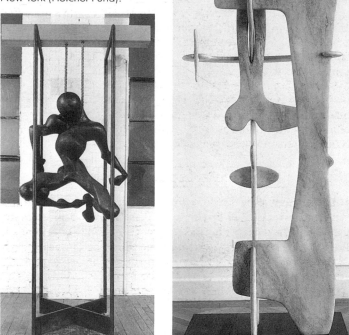

below: 158.
Isamu Noguchi. *Death*. 1934.
Monel metal, 36 × 33 × 18".
Collection the artist.

right: 159.
Isamu Noguchi. *Kouros*. 1944–45.
Pink Georgia marble,
slate base; 9'9" × 2'10⅛" × 3'6".
Metropolitan Museum of Art,
New York (Fletcher Fund).

East to the West." In France, Noguchi got himself hired as an assistant to the great Brancusi, at the same time that he also helped Calder construct the famous wire circus and made contact with Giacometti, just as the Swiss artist was entering his Surrealist phase. Thus, when he returned to New York in 1928 Noguchi had already been actively engaged with three important modern traditions: the monolith of serene, perfected form, the constructed, weightless open form, and form as a resonant emblem of some timeless, primordial mystery.

Blending his Asian studies—which included Chinese calligraphy and brush drawing in Peking as well as pottery and gardens in Tokyo and Kyoto—with Western modernism, Noguchi learned to do still more with still less. Crucially, he developed a profound feeling for the soul of such materials as wood and marble, which served him well in his desire to re-endow sculpture with something of its archaic, elemental, even practical function as a medium of the spiritual life. Back in New York, a signal opportunity to effect his ideas arrived when he became the principal set and costume designer for the pioneer modern-dance choreographer Martha Graham, thereby making art a participant in theater performances meant to explore the modern psyche through a ritualized re-enactment of ancient archetypes. In individual sculptures, however, Noguchi felt free to bring his work into "more direct involvement with the experience of living." For one extraordinary piece entitled *Death* or *Lynched Figure* (fig. 158), he all but joined the Social Realists, at least in the topicality of his savage theme. True to his own vision, however, Noguchi so recast the unmistakable physiognomy of a black man that its grimly contorted rigor mortis might be at home in one of Giacometti's own cages, swinging there like the twisted vertebrae in the 1932–33 Surrealist masterpiece *The Palace at 4 A.M.* And uncharacteristic as its protest subject may be, the sculpture displays what would remain Noguchi's signature touch, complete with severe, craftsmanly elegance, obvious love of elementary shapes and materials, biomorphic mass combined with airy geo-

metric structure, pedestal-free conception, and timeless clarity of statement, all betraying a sensibility as informed by Brancusi and Calder as by Japanese traditions.

During the 1940s Noguchi came more surely under the Surrealist spell, this time cast by his friends Arshile Gorky and Julien Levy, and emerged as a major stone carver. Once again he proceeded as both a constructor and a shaper of smooth monolithic forms, now however replacing literal representation with abstract morphologies. These he interlocked as tall structures connoting figures, but figures of a totemic, ceremonial sort like that implied by the Greek title *Kouros* (fig. 159). For the work seen here the artist chose sheet marble in a lyrically beautiful flesh tone, carved it into a variety of organic shapes, and then arranged them as a slotted assemblage of right-angle planes, with some of the pieces hanging free like the lynched figure in *Death*. Moreover, they resemble bones, so that the sculpture seems a fantastic skeleton plucked from one of Tanguy's ossuary dreamscapes. At a time of world-wide calamity, Noguchi created a ghostly reincarnation of a prehistoric cult image, its quietude and delicate equilibrium projecting an aura of solemn presence.

The Surrealist Legacy in Sculpture

Orthodox Surrealism fared poorly in the postwar years, in part because its leadership had fled occupied Paris, making them seem less than heroic upon their return, and in part because the Surrealists' jokier sadomasochistic concerns appeared absurd in the aftermath of genocidal barbarism. More important perhaps, the movement lost considerable ground by reason of its contempt for form, which ran utterly counter to the interests of a younger generation seeking a new visual language substantial and supple enough to bear the weight of an independently but generally held tragic vision. In sculpture, moreover, Breton and his followers had encouraged what they called "objects of desire," assemblages of found materials or ready-mades whose juxtaposed incompatibility projected into the everyday world a tangible and disorienting manifestation of the Surrealists' ideal world, a dream or fantasy realm like that expressed in the oft-quoted line from

below: 160. Max Ernst. *Capricorn*. 1964 (cast of 1948 concrete original). Bronze, 7′10½″ high. Donald M. Kendall Sculpture Gardens at PepsiCo, Purchase, N.Y.

right: 161. Frederick Kiesler. *Galaxy*. 1951. Wood, 12′ high. Collection Mrs. Nelson A. Rockefeller, New York.

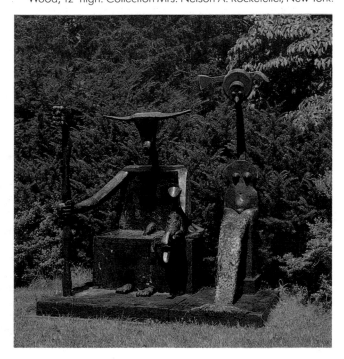

Lautréamont: "Beautiful as the chance encounter of a sewing machine and an umbrella on an operating table." Such happenstance constructions could only have offended the few major sculptors intimately associated with Surrealism. Thus, Arp moved increasingly towards Abstraction-Création, while Giacometti in 1935 renounced his splendidly imaginative Surrealist sculptures and recommenced working from the figure, the dramatic consequences of which will soon be encountered in this chapter. But though Giacometti might eventually look upon his Surrealist period as a "Babylonian captivity," certain of the more committed Surrealists survived and even adapted to the soberer mood of the postwar years. One of them was Max Ernst, whose *Capricorn* (fig. 160) provides a case study in how Surrealism could transform assemblage into a three-dimensional or sculptural counterpart of the automatism that proved to be Surrealism's most valuable gift to Informal and Abstract Expressionist painting. The lesson is valid because once cast in the unifying, eloquent medium of bronze, the composite image metamorphoses into something more than a whimsical, symbolic group portrait of the artist, his wife, and their two dogs. With its allusions to astrology and the rites of birth and rebirth, the confrontational figuration becomes a strange, archetypal eminence psychically inhabited by the kind of primitive, archaic spirit that would seize many of the younger sculptors either making their mark or maturing at mid-century. Among the many sculptors who blended Surrealism with Constructivism and thereby

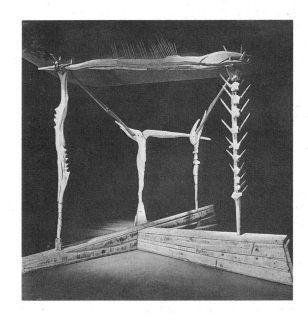

gave the art of the early postwar period its special quality, a few would realize their uniqueness by allowing the intensely subjective, Surrealist component to play a relatively more significant role.

A forerunner of this particular compound of rival interests was the Austrian-American architect Frederick Kiesler (1896–1965), whose long involvement with both De Stijl and Surrealism made him the perfect designer for Peggy Guggenheim's Art of This Century Gallery in New York (1942–47). And it made him similarly effective in his installation of what proved to be mainstream Surrealism's last hurrah, the International Surrealist Exhibition organized in 1947 by Breton and Duchamp at Paris' Galerie Maeght. On both occasions Kiesler projected paintings from walls on arm-length pivots and placed sculpture on tables and chairs, his purpose being to insert the works as part of the viewer's own space and thus present their reality as glimpses into the psychological underpinnings of the real or everyday world. Overall, what Kiesler sought was an expression of space-time continuity, which became the informing principle of his Galaxies, walkthrough, live-in works that synthesize painting, sculpture, and theater in a grand, environmental whole (fig. 161). The Galaxy seen here,

with its skeletal framework supporting a vivid totemic iconography of fishbone anatomies and beak-like details, could be a three-dimensionalization of Dali's *Soft Construction with Boiled Beans.* But Kiesler himself described it best when he wrote: "My sculptures I also see as consisting of divergent chunks of matter, held together yet apart, appearing like galactic structures, each part leading a life of coexistence, of coreality with the others. . . . These 'endless' paintings and sculptures lead a life of inner cohesion." Calling for a "Corealist" art, Kiesler in both his thought and his forms became one of the first to take up environmental issues that would increasingly captivate artists throughout the postwar years. "The era of experimentations in materials and forms over half a century has run its gamut," he wrote towards the end of his life, "a new era has begun, that is an era of correlating the plastic artists within their own realms but with the objective of integrating them with a life freed from self-imposed limitations. . . . The environment becomes equally as important as the object, if not more so, because the object breathes into the surrounding and also inhales the realities of environment no matter in what space, close or wide apart, open air or indoor."

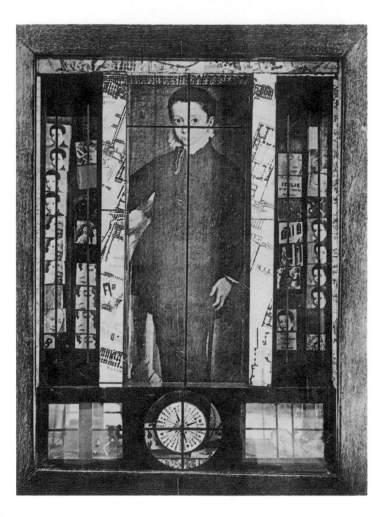

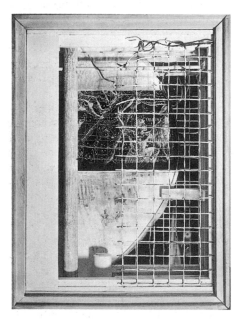

left: 162.
Joseph Cornell.
Central Park Carrousel—1950, in Memoriam. 1950.
Construction in wood, mirror, wire netting, and paper;
20¼ × 14½ × 6¾".
Museum of Modern Art, New York (Katharine Cornell Fund).

right: 163.
Joseph Cornell. *Medici Slot Machine.* 1942.
Mixed-media construction,
15½ × 12 × 4⅜".
Private collection.

Sharing Kiesler's Surrealist predisposition but on a more personal, less architectural scale were the inimitable Joseph Cornell (1903–72) and Louise Bourgeois. In a manner seemingly peculiar to Americans, Cornell became one of the great isolates of modern art—not unlike Poe, Ryder, Still, or even Pollock and David Smith—who from near-hermetic remove created an art of such spellbinding independence that he achieved the very universality so passionately sought by the Abstract Expressionist generation. There is, however, a clear logic in this paradox, for while no artist ever fashioned anything quite like Cornell's magical miniature world—with its handmade boxes containing precisely orchestrated arrangements of evocative trivia gleaned from junk and antique shops, beaches, and backyards (fig. 162)—few active during the mid-century made so many, if unintended, connections with the immediate past, present, and evolving concerns of the modernist tradition. Despite his prestigious prep-school education, Cornell had no formal training in art, but grew up in a close-knit family that took great pleasure in music, theater, and the life of the mind and imagination. It was also stricken, by the early death of Cornell's father, by his brother's long and paralyzing illness, and by his own consequent need to take an uncongenial job as a woolen salesman in Lower Manhattan. Living with his mother, sister, and bedridden brother in a modest bungalow on Utopia Highway in Flushing, Queens, Cornell found an outlet for his poetic spirit by ex-

ploring the wonders of New York City, from the second-hand stores, Oriental shops, and used-book stands of the East Side to the theaters, opera houses, concert halls, and museums of the West Side. He also discovered "the profound and suggestive power of the silent film to evoke an ideal world of beauty." And so Cornell collected movie memorabilia, just as he made countless small acquisitions—maps, marbles, bangles, butterflies, figurines, printed cards and papers, jars, glasses, reproductions of famous people and art from the historical past, compasses, stuffed birds, toys, trinkets, pipes, dried flowers—wherever his roving curiosity took him. He had also begun to read art magazines and through them to discover modern French painting, with the consequence that when the Depression deprived him of gainful employment, Cornell was ready to make the most of his discovery, in 1931, of the Julien Levy Gallery, recently opened and devoted to the avant-garde. Inspired by Max Ernst's collages in the album *La Femme 100 Têtes,* he drew from his magpie hoard of images and objects and made his first collages, works which so impressed Levy that he included several of them in a Surrealist group show in early 1932. By 1936, when MoMA chose Cornell for the historic exhibition entitled "Fantastic Art, Dada and Surrealism," the artist had already developed his distinctive forms of collage and shadow-box construction. From the latter genre came Cornell's most celebrated works, glass-fronted cabinet-like microcosms of strange, incongruous, but poetic associations presented in their tiny spaces with all the refined formal command of an artist as steeped in Constructivist principles as he was in Surrealist fantasy. But as the masterpiece entitled *Medici Slot Machine* reveals (fig. 163), Cornell treated every element like a rare personal treasure, not an anonymous building module or a bit of *merz* detritus *à la* Kurt Schwitters. And enigmatic as the juxtapositions may be, the gentle seductiveness of their effect discloses strategies far removed from the shock tactics of the mainstream Surrealists. With sweetness and nostalgia, what Cornell systematically achieved in his

art was a bold exploration of the unconscious and its power to fuse time and space, employing found materials and assemblage as his means. He was like a pictorial or sculptural Proust, allowing ordinariness and intimacy to set off a chain of free associations that transform the unity and finiteness of momentary reality into a vastly expanded, elaborated realm of the human psyche. It is a mental space crowded with disjunctive leaps from one outpost of memory to another, all occurring in sequential, thus temporal, order, yet ultimately equalized or unified by their common availability to the same inner mindscape. As Rosalind Krauss has pointed out, a work like *Medici Slot Machine* becomes a model of the unconscious and its processes, a model whose smallness of scale serves to make the conundrum of its irrational contents more accessible to viewers imbued with notions of spatial and temporal continuity. Concatenated in this box are a compass, a jack, a map of Rome's Palatine Hill, and a reproduction of a portrait painted by the Renaissance artist Moroni. All are real, not simulated, but while the jack and compass are actual objects, the map and reproduction represent other realities distant in either time or space. Moreover, the jack and compass differ in their respective realities, since the one would normally move through space as it is being played with, while the other must remain stationary in order to perform the function of measuring far more territorial reality than ever it could occupy. Yet whatever their divergences, all are equally present in Cornell's box, rival entities cohabiting a common setting transformed by a train of associations that occurred in time. To elide this fourth dimension of experience with the three physical dimensions of his shadow box, and thus complete his model of psychological space, Cornell provided symbolic movement in the form of film-strip repetitions of images, as well as actual movement, which unfolds once the box is tilted and turned, causing the jack to tumble along various passageways and compartments. In other works, time takes its toll as sand runs through the waist of an hourglass, as rings slide along bars, or as the observer moves objects the artist has clearly set out for that purpose. So, along with his intelligence and psychological insight, child-like charm, and sophisticated aesthetics, Cornell could also be seen as a moralist, alluding to human destiny not only in his shifting sands but in many other forms as well, among them the astrological charts of sun, moon, and planets that he loved to collage into his gallimaufries of precious bric-a-brac.

164. Louise Bourgeois. *One and Others*. 1955.
Painted wood, 18¼ × 20 × 16¾".
Whitney Museum of American Art, New York.

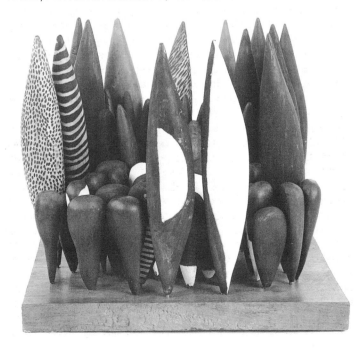

Even more isolated artistically than Cornell—though certainly not as lonely in her personal life—was Louise Bourgeois (1912—). A well-educated Parisian who arrived in New York in 1938 as the bride of the art historian Robert Goldwater, Bourgeois remained to bring up three sons and become, with Lee Krasner, one of the few female members of the original New York School. But so utterly did she move out of step with the dominant Abstract Expressionist mode, as well as with its Pop and Minimal successors, that only since the pluralistic seventies has her steadily evolving work been viewable in anything like its actual complexity, range, and volume. Still, Bourgeois was a known and respected talent in mid-century New York, having appeared there with both Cubism and Surrealism so absorbed into her life's blood that she could articulate them, in word and paint alike, with easy, independent authority. Moreover, it was in New York that Bourgeois emerged as a professional artist, owing in substantial part to the courage the essentially reticent artist gained from the refugee Surrealists to create forms uniquely responsive, at whatever risk, to her deepest psychological urgings. These, it turned out, were powerful indeed, welling up as they did from rage and frustration generated during early years torn between a calm, nurturing mother and a charming but volatile father caught up in a liaison with the family's live-in English tutoress. And so just as the New York painters were shredding figuration in order to transform subjective feelings into universal, abstract statements, Bourgeois did quite the opposite. Turning away from painting towards sculpture, she sought to realize in three-dimensional, quasi-figural images a more concrete or explicit projection of the subconscious and thus exorcise its seething anxieties. First, this led to the "fantastic reality" of her rather rough-hewn and elementary stick, plank, or pole totems, notched and carved just enough to imply a head, a waist, or limbs and thus confer upon the forms a symbolic human or animate presence. With their simplicity and their aura, such sculptures bore an obvious kinship to the primitive, which made them all the more effective as vehicles of brutal, bottled-up emotions. Even when grouped in a gallery, the tall, swaying, self-protective effigies spoke of painful solitude and thwarted communication, all the while that the installation represented one of the first late-modern attempts at exploring the environmental possibilities of sculptural space. In the 1950s Bourgeois would refine as well as elaborate the thematic and formal concerns announced in the earlier stick figures. With this, she also intensified the feeling of lonely repression by fattening the images into shuttles or spools (reminiscent of the Bourgeois family's tapestry business) and then huddling them together in the tight confinement of a shallow, platform base, as rudimentary as a hangman's scaffold (fig. 164). As Bourgeois herself pointed out: "My works grow from the duel between the isolated individual and the shared awareness of the group. At first I made single figures without any freedom at all . . . now I see my work as groups of objects relating to each other. . . . But there is still the feeling with which I began—the drama of one among many."

Giacometti and the Survival of the Figure in Postwar Sculpture

In the uncertain world of postwar Europe no artist appeared more exemplary than Alberto Giacometti, whose late bronze figures, with their solitary frames ravaged by the voracity of an immense space, were seen by many, first of all Sartre, as the epitome of Existential Man, naked, alone, bereft of all props and comforting myths (fig. 165). Moreover, the figures issued from a long and lonely process of rigorous research, which had begun as early as 1935, when Giacometti found the courage to acknowledge his own necessity and defy Surrealist dogma by ceasing to work exclusively from the imagination. This was a brave act indeed, given that the conceptual approach to form approved by Breton had enabled Giacometti to produce the remarkable works seen in Chapter 1 and thus become Surrealism's most important sculptor. What prompted him to renounce this brilliant

precedent and seek a fresh departure was a growing sense that little if anything distinguished his semi-abstract Surrealist art from the vases and lamps he was making for an interior designer. And so whereas for the preceding ten years Giacometti had realized, as he said, "only such sculptures as presented themselves to my mind in a complete state," he now revived his earlier practice of working from the model and sought to "render only what the eye sees." Soon, however, the artist found himself in great difficulty, for it turned out that his objective was nothing less than a wholly new, almost primordial vision, one that entailed giving three-dimensional form not to, for instance, a human head as he *knew* it to exist but rather to his *perception* of the motif. Eventually, Giacometti declared this to be "impossible," for in order to materialize a pure perception he would need to suppress not only knowledge and memory of the subject but, in addition, all the established conventions for representing its tangible volume, conventions developed by sculptors from the Romans through Maillol. Further, the task involved capturing the effects of light and atmosphere on the head, as well as those of space and distance. But no one articulated the problems more lucidly than Giacometti, as he revealed in an interview with the British art critic David Sylvester:

> If I didn't know that your skull had a certain depth, I couldn't guess it. Therefore, if I made a sculpture of you absolutely as I perceive you, I would make a rather flat, scarcely modulated sculpture that would be much closer to a Cycladic sculpture, which has a stylized look, than to a sculpture by Rodin or Houdon, which has a realistic look. I think we have such a received idea of what a head is in sculpture that it's become completely divorced from the real experience of seeing a head.

If the rendering of pure optical phenomena might seem more easily accomplished in painting, Giacometti found it no less impossible, as we learned in Chapter 3 (fig. 134). Still, he persevered, driven by a near-mystical conviction that art being no match for reality, the only art worth doing was that whose style endowed it with the credible equivalence of a living presence experienced as a sudden apparition in time and space.

For the next eleven years, until 1946, Giacometti exhibited no new works, which made him seem all the more a living legend, for during long evenings at Paris' Left Bank cafés, often in the company of Picasso, Sartre, and de Beauvoir, he never ceased to speak of his struggles, always in the bardic voice of an artist whose power of poetic expression was almost as great in verbal as in visual language. "I worked from the model throughout the day from 1935 to 1940. Nothing was like I imagined it to be." No better response could have been made to the Surrealists, who had rejected him for having repudiated imagination. Then he went on:

> I began to work from memory. . . . But wanting to create from memory what I had seen, to my terror the sculptures became smaller and smaller, they had a likeness only when they were small, yet their dimensions revolted me, and tirelessly I began again, only to end several months later at the same point. A large figure seemed to me false and a small one equally unbearable, and then often they became so tiny that with one touch of my knife they disappeared into dust. But head and figures seemed to me to have a bit of truth only when small. All this changed a little in 1945 through drawing. This led me to want to make larger figures, but then to my surprise, they achieved a likeness only when tall and slender. . . .

When Giacometti returned to Paris from Geneva after the war, he is said to have carried the entire contents of his studio in six match boxes, but by 1947 he could exhibit bronze figures measuring almost 6 feet tall. Among these were versions of two themes that would occupy him endlessly: the standing woman, tall, inscrutable, and enduring as a tree (fig. 166); and the striding man, forever in search of fulfillment. He combined them both in a small but haunting work of 1948 entitled *City Square* (fig. 165), reminding us, by contrast as much as by similarity, of *The Palace at 4 A.M.*, the artist's Surrealist masterwork of 1932–33. The most obvious point of convergence is, of course, the composition staged upon a platform, which because of its relatively large size in *City Square* serves to make the tiny figures seem remote from the viewer. Reinforcing the sense of distance are the statuettes' simplified features, which uncannily have lost recognizable detail without denying the images their identity. By now Giacometti had learned from his phenomenological investigations that he needed to represent not merely the space apprehended in front of an object, but also the space surrounding and separating it from other objects, extending in perception as far as the eye's field of vision permits.

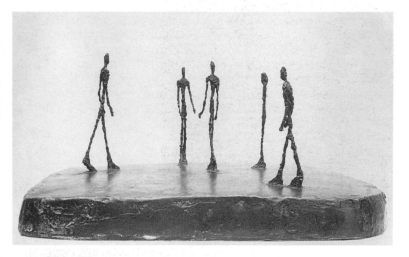

above: 165.
Alberto Giacometti.
City Square. 1948. Bronze,
8½ × 25⅜ × 17¼".
Museum of Modern Art, New York (purchase).

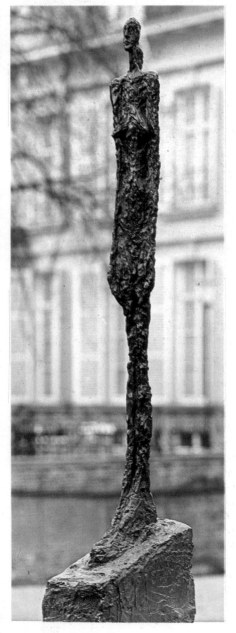

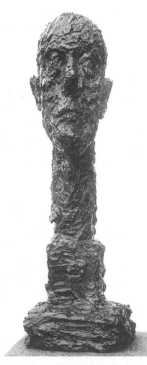

left: 166. Alberto Giacometti.
Figure from Venice II. 1956.
Painted bronze, 47½" high.
Middeheim Museum, Antwerp.

above: 167.
Alberto Giacometti. *Diego*.
1960. Bronze, 37½ × 12 × 15".
Hirshhorn Museum
and Sculpture Garden,
Smithsonian Institution (gift of
Joseph H. Hirshhorn, 1966).

Thus, relative to the stretch of space on either side, the figure seen at a distance appears decidedly thin, which in turn makes it appear exceptionally tall.

Beginning with the eloquent homage paid by Sartre to Giacometti's figures covered with "the dust of space," much has been made of how a work like *City Square* offers a desolating metaphor for the anxiety and loneliness of the individual lost within the immense, depersonalized complexity of modern urban life. With its telescopic view of attenuated human beings crisscrossing a vast emptiness, or simply standing stark still, while staring straight ahead and never making eye or physical contact, the scene has left numerous viewers moved by what they see as a monument to the tragedy of human alienation. But it could also be viewed as a culmination of all the artist's efforts since his break with Surrealism, about which Giacometti wrote in 1947: "I saw afresh the bodies that attracted me in life and the abstract forms which I felt were true in sculpture. But I wanted the one without losing the other. . . . And then the desire to make compositions with figures." Now, therefore, in his elongated, seemingly gnawed, weightless, massless, and featureless effigies, he had broken through inherited sculptural conventions and found a totally new, personal style, a style promising durable form to fleeting appearances. Further, it had proved as effective for complete compositions as for single heads or figures seen frontally (fig. 167). This becomes most apparent when a work like *City Square* is viewed patiently and from a remove comparable to that taken by the sculptor during his work on the piece. Thus encountered, the figures seem to lose their stiff, crusty gauntness and come full-bodily, individually alive, somewhat distant as the models had been and as art must remain, yet pulsating with the countless touches left by the hands of an artist tirelessly working and reworking his plaster form in the frantic hope of achieving the impossible. Once life and spirit are sensed stirring in the inert bronze, the viewer can psychologically move along and identify with the figures, which by signaling their separateness appear not so much to recoil from the space they inhabit as animate it. Meanwhile, pairs of massive feet anchor the frail, vertical silhouettes to the solid, horizontal fixity of the earth, as if to assert Giacometti's despairing yet elated determination to root his art in reality, even though a reality destined to elude his grasp.

For Giacometti, the thinness and isolation of his figures functioned to concentrate their power or "pent-up energy," thereby placing them at the fulcrum of a delicate, oscillating balance between visual and conceptual experience, between skepticism and affirmation of life. Eventually, he conceded that working from nature was really working from memory, since the artist can only record what he recalls after looking, however instantaneous and direct the eye-hand coordination. In the 1950s Giacometti gradually ceased dematerializing his figures so severely and began allowing them enough bulk to engage the viewer in mutual confrontation. Using his wife Annette and his brother Diego as subjects, he modeled busts recalling such Classical prototypes as the huge, spiritualized portraits of the Roman Emperor Constantine (fig. 167). As this would imply, the most salient characteristic of Giacometti's later, more volumetric works is the inescapable force of their life-like gaze, an expression so piercing that it seems not only to acknowledge the observer but also to look right through him towards another, perhaps greater reality. Instead of shrinking from space, the busts seem to dominate it by their vital, almost hieratic presence, even conferring a sense of the sacred upon whatever composition or environment they may enter. There is evidence that Giacometti long contemplated one grand summary work in which his tree-like standing woman, his walking, ever-seeking man, and a monumental all-seeing head would be combined in an imposing symbol of eternal nature, passing or momentary life, and the visionary, creative observer. In this encounter between Reality and Art the latter may perhaps be understood as an exalted manifestation of the mysterious energy compelling anxious humanity not only to think, speak, love, or strive for something forever beyond one's reach, but also and sim-

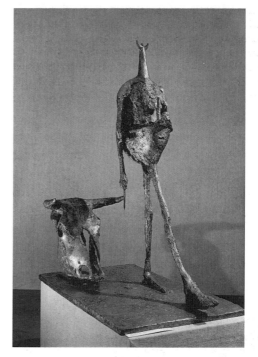

168.
Germaine Richier.
The Bullfight. 1953.
Bronze, 46" high.
Maison de
la Culture, Caen.

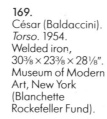

169.
César (Baldaccini).
Torso. 1954.
Welded iron,
30⅜ × 23⅜ × 28⅛".
Museum of Modern
Art, New York
(Blanchette
Rockefeller Fund).

ply to go on living. As Giacometti once said: "It's the totality of this life that I want to reproduce in everything I do."

Because of their disintegrating and haunted appearance, the sculptures of the French artist Germaine Richier (1904–59) have often seemed close to those of Giacometti (fig. 168). In fact, they derived from a totally different inspiration, coming as they did out of a desire not to fix the realities of visual perception, but rather to invent metaphors for humanity wasted and degraded by fear of the savagery that Richier had come to know only too well during the early 1940s. Moreover, they were decomposed from within, as well as corroded from without, their pitiful state made all the more dramatic for having been registered by hands clearly schooled in the heroic-humanist tradition running from Greco-Roman times through Rodin and Bourdelle. What sustained her Kafkaesque fantasies—of human and beast forms that invade, devour, torment, and finally become one another—and saved them from melodrama was not only authenticity of feeling but also a supreme technique, so accomplished that rotted masses and frayed tentacles could be cast in bronze of shell-like, bat-wing delicacy.

If Richier could be seen as the granddaughter and daughter of Rodin and Bourdelle, then her fellow Méridional César Baldaccini (1921—) might be viewed, as several critics did, as the son of Richier.

Actually, César claims to have descended from Picasso, by way of Gargallo, one of whose welded-metal sculptures first inspired him to give up carving and modeling in favor of assembling or building up forms from scrap metal and machine parts, which were about the only materials the impecunious Marseilles-born artist could afford (fig. 169). Assemblage led to figures whose episodic surfaces, skeletal forms, and truncated anatomies do indeed seem akin to Richier's decimated mutations. César, however, was more interested in creating a survivor's sense of life than in expressing human decay, and, like Picasso, as much in humor as in the horrific effects of metamorphosis.

France's Jean Ipoustéguy (1920—) also broke open form, "to show," as the artist said, "something inside the figure to excite the imagination of the viewer," but only after he had shaped it as a dense, monumental mass finished to gleaming, Old Master perfection (fig. 170). The Basque-born Ipoustéguy began as a painter, designing tapestries and stained-glass windows throughout the 1940s. Only in 1949 did he make the shift to sculpture, possibly for its ancient figural associations and the power of their encounter with modern Expressionist abstraction to convey feelings of distress and alienation. An avowed Freudian and Surrealist, Ipoustéguy characteristically arranged rather brutal confrontations of vertical and horizontal images, often smoothly ovoid but roughly fissured as if exploded from within either by burgeoning life or by festering decay. The ambiguity inherent in such oppositions suggests what the artist regards as "the mystery of life," the meaning of which he wants the beholder to probe. A key work is the one seen here, *David and Goliath*, where the victorious boy appears as a pile of interlocking, polymorphous units, composed to imply a proud torso crowned by a helmeted head flung back in triumph over the fallen giant. Goliath too consists of similarly polished, ruptured lumps, but while these seem already to have been reclaimed by the earth as a kind of anonymous landscape, the erect David, even though faceless and limbless, appears ready to burst free of the inchoate bronze and claim his identity as hero and King. Ipoustéguy, thanks to the audacity of his conceptions, to his mastery of form and technique, and to his powerful questioning of their purposes, has managed to evoke archaic prototypes and themes yet endow them with new mythical significance in an age of profound doubt, making his achievement one of the most admired in postwar French sculpture.

170. Jean Ipoustéguy. *David and Goliath.* 1959.
Bronze; David 47⅞" high, Goliath 30⅜" high.
Museum of Modern Art, New York (Matthew T. Mellon Foundation Fund).

171.
Marino
Marini.
*The Concept
of the Rider.*
1955.
Polychromed
wood,
7'4½" high.
Collection
the artist.

Much more than other European artists, Italian sculptors have had the humanist tradition of figural sculpture running in their blood. This is a natural birthright, left to them by millennia of high Mediterranean civilization, with its accumulated wealth of carved and cast work inherited from Egyptian and Greco-Roman antiquity, as well as from the Renaissance, Baroque, and Neoclassical genius of Donatello, Michelangelo, Bernini, and Canova. Still, as the Futurist movement demonstrated, Italian artists have passionately wanted to be active participants in the modern experience. But rather than proceed by rejecting or reviling the past, as the Futurists did, postwar Italian sculptors attempted to integrate it with their acute sense of the present. Preeminent among these was the Tuscan-born but Milan-based Marino Marini (1901–80), who adopted the most heroic, even imperial, of all sculptural themes—the equestrian group of horse and rider (fig. 171)—and progressively reinterpreted it as a metaphor of modern Europe's fall from grace, or what the artist called "the twilight of mankind." Aiding him were the numerous contacts he made with the School of Paris during trips to France in the 1930s as well as in Switzerland during the war, where he met Giacometti and Richier. By then, Marini had already discovered his principal motif, an inspiration partly ignited by a Han dynasty tomb horse. Initially, the artist carried it through a *stagione felice* in which man and beast were clearly distinguished in a form of rather simplified but full-bodied, peasant-like naturalism. The war, however, brought an end to this "happy phase," whose serenity the artist replaced with extreme tension, forcing his horse and rider into stripped-down, stretched-out postures that seemed to re-enact the agony of Picasso's *Guernica*. At times they might also imply an aggressive sexuality, as if to assert the human will to survive and overcome. Finally, the series gave way to tragedy, with the animal and human figures increasingly abstracted into a collapsed, undifferentiated heap, a monument to universal sorrow. At first, Marini declared himself an "Etruscan," so completely did he believe that "Etruscan art is not history but human truth." Finally, however, he admitted having been most moved by the homeless crowds of ordinary Milanese desperately fleeing on horseback before the Allied advance in the last days of the war. Marini often enhanced the expressive effect of his work with color, which he applied like a painter to both

wood-carved and bronze forms, sometimes further mixing media as he used a chisel to texture and patinate the metal.

Another self-proclaimed "Etruscan" was Giacomo Manzù (1908—), even though he originated in Bergamo well north of Tuscany and had little of the formal art training—historical or technical—experienced by Marini. Instead, Manzù simply found his own way, spontaneously drawing and modeling while growing up as a younger son in the oversized family of an impoverished cobbler. All were intimately involved with the Roman Catholic Church, an institution whose images would remain constant throughout Manzù's oeuvre (fig. 172). Moreover, a sense of the sacred would permeate even his sensual nudes, embracing couples, and matter-of-fact still-life arrangements. But if the mature sculptor seemed capable of whatever effect he wanted to achieve, it was in part owing to his mastery of and respect for craft, acquired during a series of teenage jobs with a carpenter, a woodcarver, a gilder, and a stucco worker. To this he added a bit of study undertaken at the Accademia Cignaroli while on military

174.
Elisabeth Frink. *Horse and Rider*. 1950. Bronze, 30" high. Courtesy the artist.

below: 172.
Giacomo Manzù. *The Cardinal*. 1952. Bronze, 30¾" high. Private collection.

left: 173.
Giacomo Manzù. *The Artist and His Model*. 1961. Bronze, 27⅜" high. Private collection.

duty in Verona, as well as a devotion to Donatello, Michelangelo, and Maillol, whose work he knew mainly through books and reproductions. In order to meet Maillol the aspiring artist made an abortive journey to Paris, but the closest he came to advanced French art was his discovery of the Impressionists. After settling in Milan in 1930, Manzù found his artistic destiny when he won a commission for a cycle of decorative reliefs illustrating Biblical scenes for Catholic University. He would in fact become the period's leading exponent of relief sculpture, but it was with a long series of freestanding Cardinals, begun in 1936 and continued throughout more than fifty variants until 1958, that Manzù made his initial and most lasting mark. Only one of these statues, however, was an actual portrait, for the artist seems to have been as much interested in the rhyming shapes of the triangular robes and pyramidal mitre as in the veracity of his observation. Since the emphasis on abstract shape endows the realism with a note of warm Italian humor, some viewers have found the Cardinals anticlerical, but Manzù neutralized such an interpretation by declaring that the sculptures represent "not the majesty of the Church but the majesty of form." "In a way," the supposedly retardataire artist declared, "they are my abstractions."

Perhaps because he developed outside both the academic and the avant-garde systems, Manzù could work with Renaissance conventions and unself-consciously combine them with a modern taste for reductive form, thereby producing art works that are refreshingly free of artifice and cliché. The personality of his touch may be even more apparent in the reliefs (fig. 173), where the artist displayed a command of Donatello's intaglio illusionism, Bernini's "painterly" textures, and something of Medardo Rosso's sensibility to light, yet instilled the whole with his own discreet ardor of feeling.

Elisabeth Frink (1930—), the youngest of many new English sculptors to emerge after World War II, was only sixteen when she decided on a career in art after reading a book on Rodin. At the Chelsea School and throughout the first years of her professional life, she honored the French master by emulating his rough textures and dramatic figuration, albeit in an urgent, aggressive manner consistent with the desperate period in which she emerged (fig. 174). With Marino Marini, Frink shared a devotion to the horse-and-rider theme, but

Sculpture at Mid-Century

105

subjected it to an unmistakably personal interpretation that leaves the images looking eroded, shriveled, and ghostly. "I was brought up in Suffolk where the air force was stationed," she once said. "A lot of bombers crashed near us. By the time I was fifteen I knew about Belsen: it couldn't fail to make an impression. Artists are recorders of the times." But while her vestigial, mummified men and beasts appear to have been severely attacked or tormented, they also seem prepared to resist, and therein may lie the source of their mute, heroic power.

Henry Moore and the Flowering of British Sculpture

The premier sculptor of late-modern art has been the English master Henry Moore (1898–1986). And his achievement seems all the more remarkable given the fact that when he won the International Prize for Sculpture at the first postwar Venice Biennale (1948) Moore bestowed upon British sculpture a status in the world that it had not enjoyed since the Middle Ages. So fertile indeed was the field opened to English genius by the accomplishments of Moore and his close associate Barbara Hepworth that, to this day, it has never ceased to regenerate and flower with unwavering vigor. But such access might just as well have occurred before the war, except for the hostile environment in which British modernists had to struggle, since by the early 1930s both Moore and Hepworth had already found their distinctive artistic personalities. Still, talents like these were noticed and nurtured, if not by a derisive public or a reactionary establishment, then certainly by family, teachers, the critic Herbert Read, important contacts on or from the Continent, and, perhaps most of all, the small, mutually supportive circle the artists formed among themselves. Moreover, they had the example and encouragement of Jacob Epstein, a hardy and prolific survivor of Britain's brief but explosive Vorticist movement, which, on the eve of the Great War, had brought forth, in the paintings and sculptures of Wyndham Lewis, David Bomberg, and Henri Gaudier-Brzeska, as well as Epstein, some of the most radically new art to be seen anywhere.

Although born into the working-class milieu of coal-mining Yorkshire, the precocious Moore received sufficient encouragement at home that he had no difficulty acknowledging his destiny in a Sunday-school story about Michelangelo, "the greatest sculptor in the world." So firm was his determination to become a sculptor that it survived World War I, an ordeal that subjected Moore to gassing at the front but also brought a study grant enabling the ex-serviceman to enroll in 1919 at the Leeds School of Art. Here he found little value in the rigid, uninspired teaching, although much in the collection of modern art assembled by Leeds University's Vice-Chancellor. Equally significant was his encounter with Hepworth, a classmate, and his discovery, at the Leeds Public Library, of Clive Bell's writings on modern art and Roger Fry's *Vision and Design*, a book that contained two key essays, "Negro Sculpture" and "Ancient American Art." Here Moore gained respect for the plastic power of objects that in Britain had been examined only for their archaeological or ethnographic interest. It was an all-important insight that went with him when he received a scholarship to the Royal College of Art in London and began to frequent the British Museum, studying his way through the Egyptian, Archaic Greek, Etruscan, Sumerian, Pre-Columbian, and African collections.

Years later, Moore would say: "Picasso and the British Museum were the only sources I ever really needed." And so when he adopted the "truth-to-materials" principle then current among London's progressive artists—a principle revived from the Victorian Arts and Crafts movement, but in reaction against Rodin's modeling technique that ended by falsifying hard bronze and stone to resemble soft flesh—it was through the forms of non-Western art that he found a way to make expressive use of direct carving and active involvement with materials. Encouraging him in this was, of course, the example of Picasso, who, as Moore would, had succeeded in devising a formal language capable of conveying something of the vitalism—the magical,

ritual content—that the Spaniard had been so shocked and illuminated to discover in "primitive" art. Moore, nevertheless, disliked this term, for its misleading connotations of the crude and the naïve, and insisted upon viewing African and Pre-Columbian works as belonging to "the main world tradition of sculpture." Here he also included European Romanesque and early Gothic, but not the "realistic ideal of physical beauty in art which sprang from fifth-century Greece," which, like the Classicizing Renaissance, he considered "only a digression." Never doctrinaire however, Moore, during a visit to Florence, succumbed to the spell of Masaccio's majestic figures in the Brancacci Chapel frescoes and the powerful rhythms of Michelangelo's recumbent nudes in the Medici tombs. In Paris, meanwhile, he also identified with the sophisticated primitivism and simplicity in the sculptures of Brancusi and Modigliani, as well as in Cézanne's Great Bathers, whose nudes appeared to him "as if they were cut out of mountain rock." Fortunately, Moore was entirely equal to the rich array of his disparate sources, and by the time his own art matured in the late 1920s, the artist had so assimilated every influence that the peculiar synthesis he realized of European and non-European traditions possessed a vitality, a grandeur, and a mythical quality that would remain the hallmark of his extraordinary oeuvre for the next sixty years. This can be seen to full effect in the 1929 *Reclining Figure* (fig. 175), executed in brown Horton stone and a mere 33 inches long, but altogether as monumental in impact as the truly colossal—or even the miniature—versions of the same theme that would come forth in the postwar period (fig. 153). Clearly the human figure would be central

to Moore's work, and for the particular organization achieved here the artist drew upon a cast he had seen in Paris of a Chacmool (Rain Spirit) sacrificial urn from Chichén Itzá in the Yucatan. Being alien to the mystery of the old Mexican piece, the recently married artist could freely substitute his own personal "obsession" and sensuously feminize the stiff angularity of the male prototype—a Toltec warrior priest—while retaining its timeless archetypal quality. Englishman that he was, Moore also endowed his work with a pantheistic feeling, analogizing the recumbent figure's rounded, undulant forms to the mountains, hills, and valleys of the natural landscape. As Moore himself said: "The human figure is what interests me most deeply, but I have found principles of form and rhythm from the study of natural objects such as pebbles, rocks, bones, trees, plants, etc."

In 1928, Moore executed his first public commission, a controversial stone relief carved for London's new Underground Railway headquarters, and held his first one-man show at the Warren Gallery. Two years later he joined the Seven and Five, an artists' society then transforming itself into a force for avant-garde ideas, and in 1933 he helped form Unit One, a group whose only exhibition did much to make the British public aware of the "contemporary spirit." To the related book, *Unit One: The Modern Movement in English Architec-*

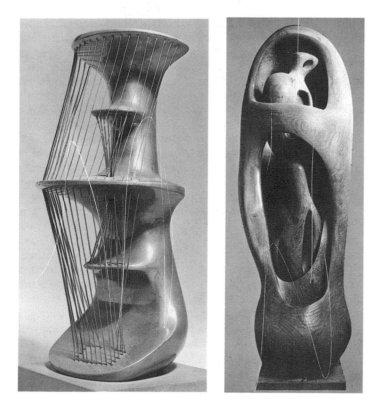

ture, *Painting and Sculpture*, published under Read's editorship, Moore contributed what may be his most revealing statement about his own art:

Vitality and power of expression. For me a work must first have a vitality of its own. I do not mean a reflection of the vitality of life, of movement, physical action, frisking, dancing figures and so on, but that a work can have in it a pent-up energy, an intense life of its own, independent of the object it may represent. When a work has this powerful vitality we do not connect the word Beauty with it.

Beauty, in the later Greek or Renaissance sense, is not the aim of my sculpture.

Between beauty of expression and power of expression there is a difference of function. The first aims at pleasing the senses, the second has a spiritual vitality which for me is more moving and goes deeper than the senses.

Because a work does not aim at reproducing natural appearances it is not, therefore, an escape from life—but may be a penetration into reality . . . an expression of the significance of life, a stimulation to greater effort in living.

In 1932 Moore founded the Sculpture Department at London's Chelsea School of Art and taught there until 1939. Also in 1932, he took a block of dark African wood and, following the example of Hepworth a year earlier, carved his first sculpture with a hole in it, a seminal work that was immediately acquired by Kenneth Clark. To explain this innovation, the artist said: "The hole connects one side to the other, making it immediately more three-dimensional. A hole can itself have as much shape-meaning as a solid mass. The mystery of the hole—the mysterious fascination of caves in hillsides and cliffs." Yet for all their telluric associations, the forms Moore chose generally correspond to the essentials of the human anatomy, whether prone or erect. Year after year in so many different versions and materials—wood, cast metal, and stone—he investigated the rhythmical relations of massive or attenuated solids and voids, with open, "negative" passages treated as sensitively as the positive densities (176). Very soon, Moore elaborated the issue by allowing secondary elements to inhabit the primary ones, as in the towering "peapod" of *Internal and External Forms* (fig. 177). Now the female image became still more a fertility symbol, assuming the character of the ancient Great Mother even where facial features have been reduced to blankness or heads as well as limbs eliminated entirely, all for the sake of greater formal coherence and its attendant expressive effect. The mythic dimension gains in complexity once the child in the womb simultaneously comes to seem a figure in a tomb.

As all the foregoing would suggest, Moore managed to forge an independent position for his art more or less halfway between what appeared to be the mutually contradictory tendencies of Surrealism and Constructivism. Such was his success in this enterprise that both camps welcomed him, as he joined the International Surrealist Exhibition held in London in 1936 and in the following year contributed to *Circle*, the Constructivist manifesto edited in London by Gabo and Ben Nicholson. In a famous statement made at this time Moore gave voice to his uncanny gift for accommodating formalist structure with the Surrealists' love of bold juxtapositions and analogies, of pierced and dismembered forms: "Since the Gothic, European sculpture had been overgrown with moss, weeds—all sorts of surface excrescences which completely concealed shape. It had been Brancusi's special mission to get rid of the undergrowth, and to make us once again more shape-conscious." But, Moore concluded, " . . . it may now be no longer necessary to close down and restrict sculpture to the single (static) form unit. We can now begin to open out, to relate and combine together several forms of varied sizes, sections, and directions into one organic whole." A manifestation, in addition to those already seen, of this urge to excavate and elaborate form, while controlling

opposite: 175. Henry Moore.
Reclining Figure. 1929.
Brown Hornton stone, 32¾ × 22⅜ × 20¼".
Leeds City Art Galleries.

above left: 176. Henry Moore.
The Bride. 1939–40.
Cast lead and copper wire, 9⅜ × 4⅛".
Museum of Modern Art, New York (acquired through the Lillie P. Bliss Bequest).

above right: 177. Henry Moore.
Internal and External Forms. 1953–54.
Elmwood, 8'7" × 2'10" × 3'.
Albright-Knox Art Gallery, Buffalo (general purchase fund).

right: 178. Henry Moore.
Shelterers in the Tube. 1941.
Pen and ink, chalk, and watercolor; 15 × 22".
Tate Gallery, London.

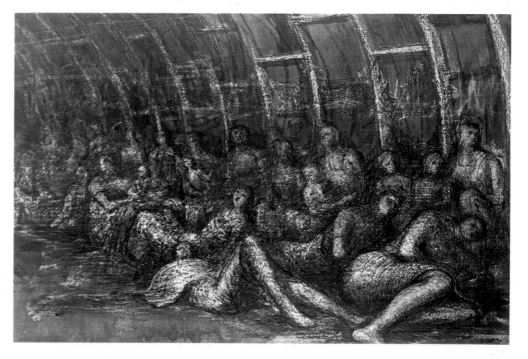

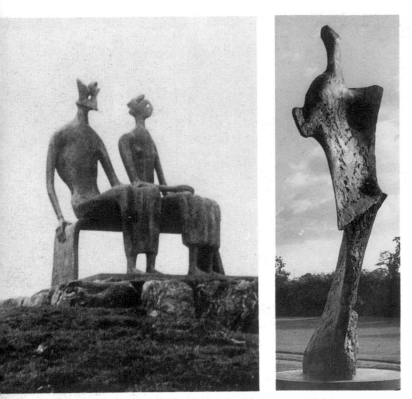

the process to assure "one organic whole," came in the late 1930s with the hollowed masses that Moore harp-strung as a means of stressing yet also resolving interior-exterior tensions, of integrating outer facts with inner mysteries without compromising the sense of a figure opened out rather than closed (fig. 176). The result is a free, abstract image that seems to have developed geometrically through a voluptuous interaction between the containing mass and the palpitating organ—a pregnant void—cradled at its core. Here the vitalist notion of inert matter suddenly made animate by spiritual essence, the truth-to-materials search for an interdependence of sculpted object and its organic medium, and the Constructivist ideal of clear, even transparent congruence between exterior volume and interior skeleton coalesce to produce a monumental metaphor of growth, a metaphor whose seductions are both sensuous and conceptual.

A total artist, Moore excelled in drawing almost as much as in sculpture, producing sheets filled with studies of bones, shells, or pebbles progressively transformed into pure sculptural shapes, often without specific relationship to a known three-dimensional work in hard material. His most celebrated drawings, however, developed in response to a commission from the War Artists' Advisory Committee (fig. 178). As Londoners fled German bombs and spent long nights fitfully sleeping on the platforms of the Underground Railways, Moore followed them into the gloomy depths, there evolving a special graphic style for capturing the poignancy of his subjects' anonymous, serried ranks and the surreal nightmarishness of the endless tunnel shelters. While somewhat related to Seurat, evidently Moore's favorite draftsman, the style's massive simplifications also recall England's magnificent Gothic sculpture, particularly the recumbent tomb effigies of fallen Crusader knights..

The Blitz also drove Moore and his family from the Hampstead studios where they had lived, adjacent to Barbara Hepworth and Ben Nicholson, since the early 1930s. This took them to a farm in Hert-

fordshire, which became their permanent home and a place offering the artist space in which to create the immense public monuments that a peacetime world would commission by the score. Once again, Moore adapted to altered conditions and, while continuing his favored practice of direct carving, began to model forms in plaster clay for scaling up and final casting in bronze, but always hand-finished by the master himself. The process, in turn, permitted major works to be multiplied as a means of satisfying increased demand. Not only did the prodigious Moore expand the size and number of his creations, he also enlarged his themes to embrace family ensembles, as in the *King and Queen*, a 1952–53 piece that takes flattened "tubular" figures from the closed-in Underground period and enthrones them as monarchs surveying an open, weather-freshened landscape (fig. 179). Simultaneously, he could also select from his bone collection and recast one of its concrete forms as an upright, abstract figure with shallow concave-convex planes terminating in blade-sharp edges (fig. 180). Most dramatic of all, perhaps, are those "groups" derived from the old recumbent female, now revisualized as vast mountainscapes broken apart and scattered across the terrain, sometimes a sheet of reflecting water (fig. 181). But even though the "boulders" can be walked, or canoed, about and the "caves" entered, the arrangement of the whole still evokes the peaks, cliffs, and valleys of the human body, with the result that the compositions, however great their scale, continue to assert the artist's enduring humanism, his Shakespearean breadth of sympathy and sense of marvel at the ultimate oneness within life's infinite variety.

Although no one is likely to confuse their notably independent work, Barbara Hepworth (1903–75) and Henry Moore, together with Ben Nicholson, Hepworth's onetime husband, will always be closely associated in the history of modern English art. Not only were the two sculptors born in Yorkshire and then educated together at the Leeds School of Art; they also received scholarships in the same year (1921) to the Royal College of Art in London. During the 1930s they lived next door to one another in the Parkhill Road studios in Hampstead, there forming the generative nucleus of avant-garde activity in Britain. It provided a haven for such pioneer Constructivists as Gabo, Mondrian, Calder, and Moholy-Nagy, when the threat of war drove them from Paris to London. Further, Hepworth too was an English nature poet as well as a passionate advocate of truth to materials and direct carving. But while Moore would absorb the "barbaric" power

above left: 179. Henry Moore. *King and Queen.* 1952–53. Bronze, 5'4½" high. Collection W.J. Keswick, Glenkiln, Scotland.

above right: 180. Henry Moore. *Standing Figure: Knife Edge.* 1961. Bronze, 9'4" high. Henry Moore Foundation, Much Hadham.

below: 181. Henry Moore. *Lincoln Center Reclining Figure.* 1963–65. Bronze, 16' high. Lincoln Center for the Performing Arts, New York.

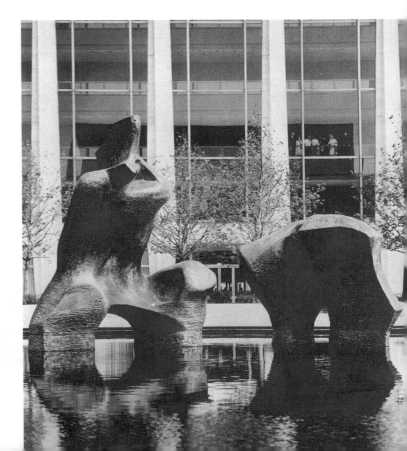

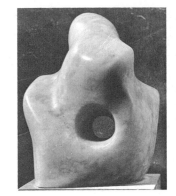

right: 182. Barbara Hepworth.
Pierced Form. 1931 (destroyed
during World War II). Pink alabaster, 10" high.

below: 183. Barbara Hepworth.
Sculpture with Color and String. 1939–61.
Bronze. Private collection.

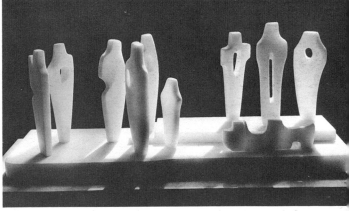

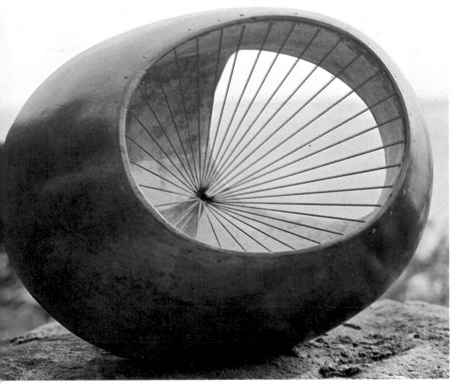

top: 184. Barbara Hepworth. *Porthmeor: Sea Form.* 1958.
Bronze, 30½" high. Hirshhorn Museum and
Sculpture Garden, Smithsonian Institution, Washington, D.C.
(gift of Joseph H. Hirshhorn, 1966).

above: 185. Barbara Hepworth. *Group III (Evocation).* 1952.
Serravezza marble, 9" high. Pier Arts Center, Orkney, Scotland.

of works in the British Museum's non-Western collections, and eventually that of Picasso, Hepworth discovered the elegant severity of Cycladic idols and learned to work in marble during a two-year sojourn in Italy. Although she adhered to a somewhat naturalistic idiom throughout the 1920s, Hepworth and Nicholson felt so drawn towards Continental formalism that in 1933 they joined Abstraction-Création in Paris and made contact with Picasso and Braque, Mondrian, Brancusi, and Arp. With the last two as her particular lodestars, Hepworth returned to London and in 1933 boldly relinquished figuration for pure abstraction, albeit an abstraction permeated with a sense of the natural world. Reifying this absorbed naturalism was the artist's love of beautiful materials—alabaster, white and colored marbles, exotic, even fragrant woods—finished to perfection for the sake of bringing out their essential qualities. Already Hepworth had found her style and, for *Unit One* in 1934, could articulate the principles that would forever inform it: "In the contemplation of Nature we are perpetually renewed, our sense of mystery and our imagination is kept alive and, rightly understood, it gives us the power to project into a plastic medium some universal or abstract vision of beauty." To her mature manner Hepworth brought the sculptural potential of the hole—the pierced or hollowed-out form—an original departure that she had made in 1931, following Archipenko's experiments of 1912. It was to have profound artistic implications for both its innovator and Moore (fig. 182). Before the end of the decade Hepworth would also add to

her work such signature touches as color and harp-stringing, but because of motherhood and the war, she did not, on the whole, produce her most ambitious or acclaimed pieces until the mid-1940s and thereafter. Virtually all of this development would occur in St. Ives, Cornwall, where the Nicholsons moved in 1939, once again to create a center of artistic activity that, for a time in the postwar years, would be perhaps the most important in Britain. Hepworth remained the heart of it even after she and Nicholson divorced in 1951.

With her intimate ties to Constructivism, Hepworth had a more pronounced sense of pure, even geometric abstraction than Moore, an awareness so deeply ingrained that it was merely reinforced by the sculptor's emotional rapport with the primal Cornish countryside. The "pagan landscape" between St. Ives and Land's End—not only the rugged coastline, with its steep cliffs and curving inlets, but also the Neolithic menhirs dotting the adjacent moors—inspired many of her pieces, complete with cavernous, angled interiors painted or patinated sea-green and strung to express feelings of tension between wind, water, land, and the human presence (fig. 183). "The colour in the concavities," she said, "plunges me into the depth of water, caves, of shadows deeper than the carved concavities themselves." Without betraying her devotion to formal purity, Hepworth gave in to an equally intense affinity for natural rhythms in *Porthmeor: Sea Form,* its surging shapes and verdigris textures inspired, as the artist said, "by the ebb and flow of the Atlantic" (fig. 184). This piece, so like

an eroded, tide-washed grotto, also registers Hepworth's rediscovery of modeling, a process that permitted her, just as it did Moore, to work more spontaneously, yet on a larger scale for casting in bronze and display in public places. Saturated as she was in England's romantic landscape tradition, Hepworth had an especially strong response to the peopled piazzas of Venice when she went there for her exhibition at the 1950 Biennale. The visit brought forth such complex but lucidly organized works as *Contrapuntal Forms*, a blue limestone monument created for the Festival of Britain (1951), and the smaller, tabletop Group series (fig. 185). While the Italian marble of these compositions seems magically radiant with southern light, their resolution of the vertical-horizontal opposition replaces Giacometti's Surreal or Existential alienation with an affirmative, English, pantheistic vision of a humanity spiritually triumphant through its integration with the natural or man-made environment.

British sculpture blossomed following World War II, thanks not only to the stirring example of Moore and Hepworth but also to vastly expanded educational opportunities and patronage then enjoyed by younger artists. Key among these was the 1951 Festival of Britain, a popular and prolonged event on London's South Bank designed to enlist all the arts, as well as science and industry, in raising British spirits after years of war and austerity. Along with the contributions of established artists like Epstein, Moore, and Hepworth, Reg Butler, Lynn Chadwick, and Eduardo Paolozzi saw their works installed as celebratory embellishments throughout the fair site. Thereafter many additional commissions came from architects requiring sculptures to enliven public spaces in the new towns built to replenish the stock of British housing depleted by German bombings. By 1952, four years after Moore had won the International Prize for Sculpture at the first postwar Biennale, the curators of the British pavilion at the new Venice exhibition could surround the master with the works of eight unfamiliar sculptors whose combined impact moved MoMA's Alfred Barr to report that "it seemed to many foreigners the most distinguished national showing. . . . '' Again, Butler, Chadwick, and Paolozzi appeared, but so too did Robert Adam, Kenneth Armitage, Geoffrey Clarke, Bernard Meadows, and William Turnbull. Noting their spiky forms and anxious mood, so at one with the period's existential foreboding and so at odds with the serene bulk of Moore, Herbert Read wrote of "images of flight, of ragged claws 'scuttling across the floors of silent seas,' of excoriated flesh, frustrated sex, the geometry of fear." While the mellowing effect of time has now made some of the works seem less attenuated and fraught than Read imagined, there can be no question that the successors to Moore and Hepworth shared a common intent to assert their identities by reacting against the senior artists, against their love of and fidelity to traditional media, as well as their poetic identification with sensuous nature and its beneficent, organic processes.

The new British sculptor who seemed most defiant of Moore was Reg Butler (1913—), the older artist's assistant for a brief period in the late 1940s. This relative of the great Irish poet William Butler Yeats brought to sculpture a long academic and professional background in architecture, the practice of which Butler did not entirely give up for sculpture until 1950, when he was already thirty-six. Meanwhile, he had also acquired an impressive range of metal-working skills and a sense of archaic mystery present within farm implements, both the consequences of his wartime service as a conscientious objector performing the duties of a village blacksmith in Sussex. In sculpture, smithing and architecture alike prepared Butler to create skeletal structures of forged iron, their open, linear form and assemblage process worlds apart from the biomorphic mass and direct carving or modeling so important to Moore (fig. 186). Technically and aesthetically, this new sculpture had its ancestry in the iron works of González and Picasso, but there could be no mistaking its spiritual identity with the tense Cold War era. A prime example is the piece seen here, Butler's winning entry in the 1953 ICA competition for a monument to the "Unknown Political Prisoner." Designed to be viewed from all sides and at distances both near and far, the great drawing in space was to have risen at least 100 feet on a natural rock formation. According to the artist, the tripod support symbolizes three women who remember a prisoner so unknown, anonymous, or absent that he can be represented only by an empty cage suspended high above the ground like a schematic, see-through television set. The wiry "antenna" soaring aloft may suggest "the capacity of man to rise beyond" the "tyranny of persecution" that Butler assumed to be a potential lying within the ambient town. Unorthodox technique combined with abstract imagery and a potent theme to launch Butler's art in a storm of protest. It came not only from an irate Hungarian refugee who vandalized the model while on display at the Tate Gallery, but also from Parliament, whose members moved to suppress plans for erecting *Monument to the Unknown Political Prisoner* on the Dover Cliffs.

Still closer to Herbert Read's "geometry of fear" were the startlingly original sculptures created in the early 1950s by Lynn Chad-

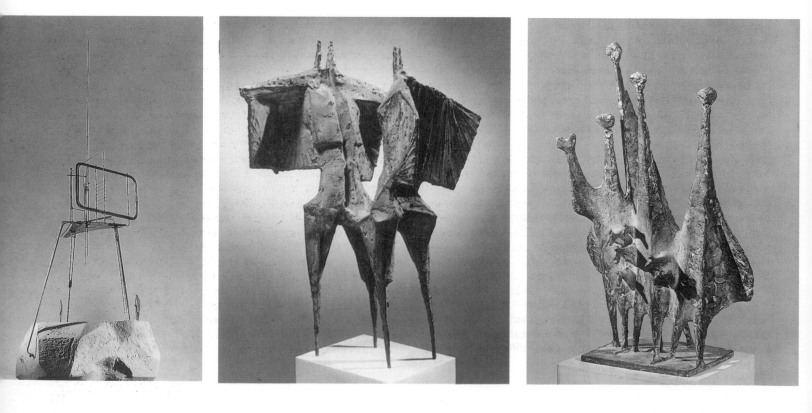

wick (1914—), who too reflected the disruptive effects of war by coming to sculpture rather late and with preparation in a different field, once again architecture. He also ran counter to Moore's sensuously carved or modeled volumes and calm, affirmative mood, in this instance by assembling armatures and thin sheets of cut metal into open, winged, long-legged bird-insect hybrids that could be mechanistic cousins to the monsters in Francis Bacon's fantastic *Figures at the Base of a Crucifixion* (figs. 187, 137). Chadwick excelled at technical innovation, perhaps because of his freedom from academic training, and much of the drama of his early sculpture seems now to have been generated less by formal or thematic daring than by the novel processes through which the works came into being. When this shifted in the 1960s to more impersonal, industrial methods and the smoother, more abstract surfaces or silhouettes they created, the sub-

personal identification with modern art. After the war, this placed him in direct conflict with the retardataire, academic teaching at London's Slade School, where he enrolled in 1946. The following year Turnbull escaped provincialism and moved to Paris, there making contact with Hélion, Léger, Giacometti, and Tzara. He also visited Brancusi in his legendary studio and took an active interest in the Art Brut assembled, as well as practiced, by Dubuffet, then the most provocative artist in Europe. Subsequently, he found himself drawn to primitive art, the paintings of Paul Klee, and Calder's mobiles. But for his own linear or stick forms modeled and dribbled in plaster and cast in bronze, he "wanted to make sculpture that would express implication of movement (not describe it), ambiguity of content, and simplicity." He characterized his purpose as "the opposite of the grand manner and means of the romantics. A sort of transistorized version of creation." Still,

opposite far left: 186.
Reg Butler. *Working Model for the Monument to the Unknown Political Prisoner.* 1955–56. Bronze, metal, and plaster; 34⅝ × 33⅝". Tate Gallery, London.

opposite center: 187.
Lynn Chadwick. *Winged Figures.* 1955. Bronze, 22" high. Tate Gallery, London.

opposite right: 188.
Kenneth Armitage. *People in a Wind.* 1950. Bronze, 25⅜" high. Tate Gallery, London.

right: 189. William Turnbull. *Horse.* 1954. Bronze, rosewood, and stone; 44" high. Tate Gallery, London.

far right: 190.
Eduardo Paolozzi. *The Philosopher.* 1957. Unique bronze, 5'11⅜" high. British Council, London.

stance of the work, which remained relatively constant, lost much of the excitement and angst that had made Chadwick the winner of the International Sculpture Prize at the 1956 Venice Biennale.

One of the least melancholy of the new British sculptors was Kenneth Armitage (1916—), who followed Moore, fifteen years later, into the Leeds School of Art and ultimately into the Egyptian and Cycladic collections at the British Museum. In London, however, Armitage attended not the Royal Academy but rather the Slade School, where he began in 1946, after six years of service in the British Army. Having made a late start, Armitage held his first London exhibition in 1952 at the age of thirty-six. But what he showed was worth the wait, since it consisted of small bronze works marked by amiable, human warmth, a charming originality of conception, and great plastic freedom within a context of structural control (fig. 188). For such freshly imagined themes as children playing, people leaning into England's blustery climate, or a group listening to music, Armitage replaced Moore's mass with a thin line of figures linked together in an irregular, freestanding screen sprouting curious sepal limbs and stamen-like necks and heads.

The Scottish sculptor William Turnbull (1922—) developed a taste for simplification and compression during the late 1930s when he worked as a magazine illustrator in his native Dundee, while also attending night classes in drawing. Through his reading of books and magazines, Turnbull soon transformed a natural affinity into a strong

Turnbull, like the Informalist painters of the time, allowed imagery to well up from the materials and accidents of his working process, an approach that promised a measure of distance as well as an activated, Expressionist abstraction. After the mid-1950s Turnbull gave up modeling, did away with the conventional base for his sculptures, and sought to convey not movement but rather the stillness of a totemic idol (fig. 189). Often he would block out the most rudimentary forms in different media, shape them with a minimal degree of personal handling, and combine several in simple stacks that reflect his abiding admiration for Brancusi. However, such titles as *Oedipus* and *Agamemnon* disclose mythic preoccupations at one with the haunted postwar era, a time far removed from the Romanian artist's witty search for the Platonic essence of ordinary things.

Defying both Moore's monumental, becalmed vitalism and the monolithic minimalism of Turnbull, a friend and fellow Scot, Eduardo Paolozzi (1924—) developed his life-long habit of hoarding "lowly" popular imagery into a variety of collaged maximalism. This, however, was a manifestation of vulgar plenty with a radical difference, undermined, Dada fashion, in figural assemblages of discarded machine parts so burnt out that the penetrated, robotic image seems a monument to industrial man rendered obsolete by his own technology—if not shattered by the engines of war (fig. 190). As pack-rat as Cornell in his obsession with non-art ephemera, but utterly original in

the fertile ambivalence of his impishly subversive yet opulent imagination, Paolozzi began amassing his cornucopia of sources at an early age, while employed in the ice-cream shop operated by his immigrant Italian parents in Edinburgh. There he found himself the beneficiary of countless cigarette cards and comic books given by the shop's clients. Also feeding his insatiable appetite for demotic expressions was a steady stream of pulp novels, science-fiction stories, and American films. Eager to become creatively involved with this vivid world of vernacular culture, Paolozzi began attending classes in commercial art. After his demobilization in 1944, however, he entered the Slade School of Fine Arts, which had been evacuated from London to Ruskin College, Oxford, taking with it a curriculum rather too stilted and academic for Paolozzi's tastes. To compensate, the young artist studied Picasso and explored the African collection at the Pitt-Rivers Museum, thereupon initiating a process of open, far-reaching inquiry that has never ceased. It took him, in the company of Turnbull, to Paris, where he met leading members of the avant-garde—Giacometti, the Dadaist poet Tristan Tzara, Miró, Ernst, Arp—and found inspiration in the Art Brut paintings and collection of Dubuffet. Simultaneously, Paolozzi also discovered that the scrapbooks he habitually made up from his burgeoning stockpile of cheap, mass-produced imagery—comics, sheets torn from glossy magazines, reproductions of classical paintings and sculptures, all pasted together on the pages of second-hand books—constituted a fresh variation on the collage art that had long been taken seriously by the School of Paris. He realized moreover that, with his Surrealist instinct for synthetic fantasy, collage or assemblage should be the foundation stone of his creative enterprise. Lacing his visual repertoire with ads and illustrations from postwar America's kitschy, consumerist media, Paolozzi returned to London in 1949, found a teaching post, and perfected an original printmaking process, based on silkscreen and photographic development, for replicating his collages of drawn and found imagery as large-scale prints. At the same time that he mechanized his art, Paolozzi also became increasingly aware of the progressive mechanization of modern life and the unprecedented capacity this brought for destruction. And so in prints and sculptures alike, he conceived an affinity for an iconography of wheels, gears, crankshafts, and other fragments of superannuated engineering, assembled by the artist to suggest human or animal life disfigured by barnacled accumulations of broken-down technology scavenged from the waste heaps of the mid-century metropolis. Created with a combination of plaster, wax, and metal casting, the figure seen here makes a tragi-comic presence, assailed and polluted yet somehow possessed of a brave, if battered dignity. At the first meeting of the ICA's Independent Group in 1952, Paolozzi presented his assemblage aesthetic in a now-famous "lecture" composed of numerous found images projected in random order and without verbal commentary. As we shall see, the event became a landmark in the nascent history of Pop Art.

The Continent's New Abstract "Painterly" Sculpture

After Calder and Newman (fig. 211), the mid-century sculptors who came the closest to releasing their art entirely from its figural past were a group of Continental artists closely aligned with contemporary painting. In reliefs and freestanding forms alike, they managed to create a kind of "painterly" sculpture, working as spontaneously as obdurate materials allowed and aiming for coloristic or gestural effects comparable to those in Informal, Tachist, or even Abstract Expressionist painting. One of the most successful of the new "pictorial" sculptors was Romanian-born Zoltan Kemeny (1907–65), who emerged into postwar prominence after a long career that included architecture and painting studies in Budapest, followed by a number of years as a designer in first Paris and then Zurich. Kemeny had already been collaging such opportunistic materials as sand, iron slag, rags, pebbles, and dried vegetables when, in 1954, he discovered the power of metal and learned to use welding tools as if they were painter's

brushes (fig. 191). A salient feature of his style was the repetition of the same form or component—T-section, I-beam, drum head, wire—throughout a composition, but so arranged over the field as to create variable wave patterns of growth and development more like those found in organic nature than in the technological sources of the media actually employed. Kemeny in fact considered himself primarily a painter or a muralist, rather than a sculptor, a view reflected in his coloristic use of copper, zinc, brass, and aluminum, blow-torched to heighten or enrich their qualities. Counterbalancing his designer's disciplined sense of form with the liberating possibilities he discovered in metal *trouvailles* and welding, the artist contrived to work freely and yet make the resulting abstract image look as inevitable as the textured, submicroscopic world of stress, refraction, and molecular distribution. In the end, something magical seems to have occurred in this transmutation of engineering's properties and processes into aesthetic objects of extraordinary range and invention.

Two other artists seeking sculptural counterparts for postwar Europe's Informal or Tachist painting were the brothers Arnaldo and Gio

Pomodoro, who grew up in Pesaro on northern Italy's Adriatic coast but made their careers in Milan. Arnaldo Pomodoro (1926—), like his brother, brought to sculpture a background in architecture, engineering, stage design, and goldsmithery, all of which would feed the abundant sense of structure, drama, and elegance the artist conferred upon his monumental bronzes (fig. 192). When he began making them in 1953 Arnaldo would have liked to emulate Brancusi and Arp but "realized that their perfection of form in our time was inappropriate, and it had to be destroyed. . . ."

The action in my sculpture, the destruction, was a very important moment. First, I thought to explore the solid geometric shapes, cones, spheres (cubes); I thought I could investigate the column and try to get beneath its skin, and I wanted to find what is inside a form which seems so perfect and absolute, superficially. They were there because I essentially wanted to investigate the energy inside of a form.

Right away, in the early relief columns, Arnaldo sought to express the volatile life within the serene perfection of forms by adopting a tall geometric, but decidedly phallic, shape and so reticulating the frontalized surface with brittle, abstract imagery that it resembles an electromagnetic field of frozen, crystallized energy. If this seems a three-

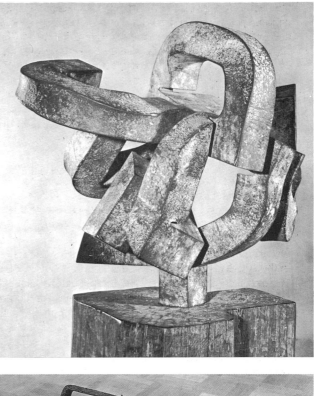

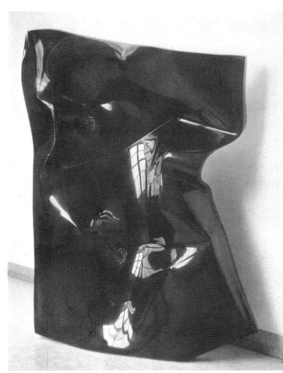

opposite above: 191. Zoltan Kemeny. *Lines in Flight 2.* 1960. Cut, bent, and beaten metal, soldered to metal base; 35½ × 45½". Private collection, Rome.

opposite below: 192. Arnaldo Pomodoro. *Rotating First Section.* 1966. Polished bronze, 46⅝" diameter. Private collection, Boston.

right: 193. Gio Pomodoro. *Tensione,* 1959. Black fiberglass, 5'11" × 4'3" × 1'10". Courtesy David Anderson Gallery, Buffalo.

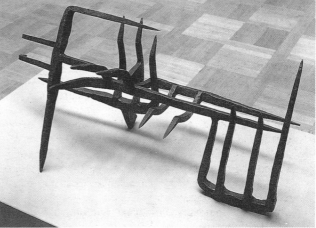

top: 194. Eduardo Chillida. *Dream Anvil No. 10.* 1962. Iron on wooden base, 17⅛ × 20½ × 15⅛". Kunstmuseum, Basel (Emanuel Hoffmann Foundation).

above: 195. Eduardo Chillida. *Silent Music.* 1955. Bronze, 2'1" × 4'10½". Kunstmuseum, Basel.

dimensionalization of the pictorial art of Vedova or Burri, it also recalls the banded pictographs of Paul Klee, one of the first modern artists discovered by Arnaldo, at a time when Fascist policy made access to advanced art difficult if not impossible. Better known, however, are the sculptor's fractured spheres, colossal forms realized with a jeweler's polish and detail. The version seen here—a masterpiece of bronze casting—is vertically divided by a thick, mid-section disk on either side of which the globe's cool, rational form, with its gleaming, satin-smooth skin, cracks open along jagged fault lines to reveal the dark mystery of a honeycombed, intricately decayed interior. Because "monumentality and sculptural beauty seem unrelated to life or to reality," Arnaldo has said that he "hope[d] to strike a balance between an absolute artistic quality, as in a museum experience, and the sense of being in the midst of life, a part of its movement and its hope for change."

Gio Pomodoro (1930—) looked beyond Informalist painting to find inspiration as well in the canvases of America's Pollock, Kline, Newman, and Rothko. But whereas the bitten textures created by Ar-

naldo might be compared to the gestural linearism of Action Painting, Gio favored a Color-Field-like unity or continuity of surface, varied only in its slow, voluptuous undulations (fig. 193). Once burnished to a mirror finish, the bronze or marble reliefs offer a feminine fluidity of form that stands in striking contrast to the phallic rigidity and interior roughness of Arnaldo's spheres and columns.

Although Spain's Eduardo Chillida (1924—) first emerged in the School of Paris, he has lived and worked mainly in his native Basque country near San Sebastián. Like Gargallo, González, and Picasso before him, Chillida found that his natural medium lay in forged and welded iron, the material and its process having long been perfected by Spanish metalsmiths, if not for purposes of high art, then certainly for weapons, tools, and decorative objects of the finest craftsmanship. As his compact arrangements of interlocking shapes would suggest (fig. 194), Chillida had also mastered the Cubist idiom so brilliantly articulated by the three sculptors just mentioned, but in his earlier work he also seemed to find poetry in such rugged artisan products as plows, rakes, and winnows. Once recast by Chillida, however, peas-

ant implements assumed a tough, tensile grace, so that bent claws and combs resemble wind harps or perhaps harrows made to cultivate heaven even more than the earth (fig. 195). Sturdy and muscular enough to stand on their own, free of a base as in the welded-metal sculpture then being created by the American David Smith (fig. 203), these small open-form pieces fill the air like music while touching the ground with a dancer's rhythmic lightness and élan. The urge to discover sonority in iron and thus to evoke transcendence finds verification in the title of the work seen here—*Silent Music*—taken from a poem by the great 16th-century Spanish mystic Saint John of the Cross.

With his training as an engineer, Berlin-born Hans Uhlmann (1900–75) quite naturally gravitated towards Constructivism when he began making sculpture in the mid-1920s. After visiting the Soviet Union early in the following decade, he became the first German artist to construct abstract sculpture from metal sheets, wires, bars, and rods. For all these reasons, plus his leftist politics, Uhlmann found himself accused of high treason and imprisoned by the Nazis. Both this experience and the bold independence of his art made him an all-important bridge figure between the original pre-Nazi phase of German abstraction and the triumph of nonfigurative forms in postwar Germany. However, his remained an older sensibility, unsympathetic to Expressionism, even though convinced that artistic authenticity derived less from calculation than from creative acts of a direct and spontaneous nature. Thus, while his sculptures retained an almost cerebral austerity, they also exhibited an element of surprise—a complex, irrational coloristic or calligraphic quality—closely attuned to the intuitive or automatist processes so universally adopted by the first generation of late modernists (fig. 196).

An almost electrically dynamic expression of the space-time concerns present in the works of Uhlmann and Chillida came from the Düsseldorf sculptor Norbert Kricke (1922—). Aware of "line as a form of movement," this artist began working with wire and tubing so thin and in organizations so shallow that his freestanding sculptures seemed quite literally like drawings in space, or even drawings made on whatever surface lay behind them. At first the lines were curvilinear, racing, tied in knots, and bundled in the manner of Pollock's meandering skeins. In reproduction they could be diagrams of wind or water currents. For a better-known series, introduced around 1955 (fig. 197), Kricke began clustering his straight, random-length rods in broad, flat planes and stacking these in angled, counterbalanced relationships that suggest exploding thunderbolts or hovering flocks of bright, wide-winged birds. Mass and momentum become integral with ambient void, as the splintered ends of multi-directional shingles shaft into atmosphere, or as strong sunlight strikes the glinting, corrugated surfaces, visually dissolving matter into pure, incorporeal energy.

The Sculpture of the New York School

The postwar sculptor to whom art history, if not the public at large, has accorded a legendary status almost as mytho-heroic as that of Pollock is the late David Smith (1906–65). And indeed there are captivating points of comparison between these two American contemporaries, who in actual life appear hardly to have known one another except through common associations within the New York School. Still, both men emerged from unpromising provincial backgrounds with an uncanny, seemingly inborn awareness of their need to make ambitious art (figs. 41, 145). Abundantly gifted, they not only absorbed Cubist modernism more rapidly and completely than anyone else of their generation; they also, with the liberating aid of Surrealist free-association, so utterly reinvented what they received or appropriated that in its fearless originality their art staked out fresh territory vast enough to beckon experimental artists even today. From inner lives riven by anguished conflict, Smith and Pollock alike wrested art works that are at once improvised yet controlled, radically abstract yet

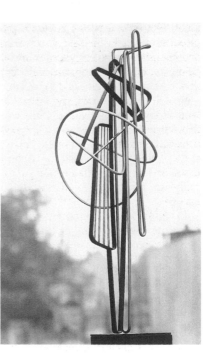

right: 196.
Hans Uhlmann.
Steel Sculpture. 1951.
Steel and aluminum,
painted red and black;
4'3⅝" × 1'7½" × 1'4¾".
Wilhelm Lehmbruck Museum,
Duisburg, West Germany.

below: 197.
Norbert Kricke.
Space Sculpture. 1958–59.
Stainless steel, 9'4½".
Municipality, Leverkusen,
West Germany.

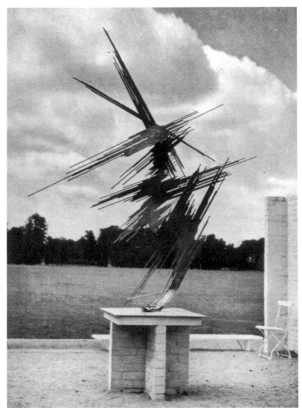

strangely anthropomorphic, aggressively robust yet startlingly subtle, open in form yet dense with meaning, aesthetically pure yet made with the rawest of non-art means. After gaining the awestruck respect of their New York peers, first Smith and then Pollock took refuge in private, rustic retreats, there to realize their finest works and remain in god-like, if impoverished, seclusion, save for occasional reappearances in town to slake Olympian thirsts for strong drink and new art. Finally, both artists suffered tragically untimely deaths in automobile accidents, Smith at the somewhat more advanced age of fifty-nine but unequivocally at the height of his powers and still avid for creative challenge. If this set him apart from Pollock, so did the powerful individuality that he, like any great artist, possessed in spades, a factor that counted far more decisively than generational parallels in the makeup of his artistic persona and the unique marvel of his achieve-

ment. Not only was this oeuvre a prodigious one, in which every piece, however inconsequential, seems alive with a special strength and intensity; it also embraced tremendous numbers of drawings and paintings, as well as sculptures carved in marble, modeled in clay, cast in bronze or aluminum, and, of course, constructed of welded metal, the medium that allowed the artist's genius its fullest scope. As this would suggest, Smith sought universality of quite a different sort from that pursued by the Abstract Expressionist painters, even though he considered himself one of them, believing that much of the best modern sculpture had been made by such pictorial masters as Degas, Matisse, and Picasso. Trained in painting but largely self-taught in sculpture, Smith hoped to conflate the two disciplines in hue-enhanced structures that would "beat either one."

In 1933, when Smith borrowed equipment and executed the first forged- and welded-iron sculptures in America, he employed the process with the natural ease of one who had, so to speak, metal bred into his very genes. Born in Decatur, Indiana, a onetime frontier town then buzzing with new machine-shop technology, and descended from a pioneer blacksmith-settler, Smith had already worked as a factory welder and riveter while searching for a school where he could study art in a serious, experimental manner. Once this goal eluded him in Indiana, Ohio, and Washington, D.C., he moved to New York. Shortly after his arrival there in 1926, Smith met Dorothy Dehner, a beautiful young woman who was not only studying at the Art Students League but also following the latest advances in music, dance, and literature. Her early influence on Smith, whom she married in 1927 and lived with for almost a quarter of a century, may well have been as crucial as that of Krasner on Pollock over a decade later. For the next several years the couple studied painting together at the ASL under a variety of able teachers, the most important of whom Smith considered to have been Jan Matulka. During this time the Smiths also discovered Bolton Landing, an old fox farm in Upstate New York, which they bought for almost nothing, and where after 1940 they would do their most significant work. They also came to know the Russian émigré John Graham, that all-important conduit for the flow of European avant-gardism to adventurous American artists. Along with introducing Smith to current ideas about primitivism, abstraction, Marx, Freud, Jung, and the collective unconscious as a source of creativity, Graham also, around 1930, gave the junior artist copies of *Cahiers d'art*. It was here that Smith first saw illustrations of welded-metal sculptures by Picasso and González, an epiphany that would be reinforced during the same year when Graham added a González to his own collection. Simultaneously, Smith and Dehner, together with such forward-looking intimates as Stuart Davis, Arshile Gorky, Willem de Kooning, Adolph Gottlieb, and Jean Xceron, eagerly absorbed everything shown at the recently opened Museum of Modern Art and the small but growing number of commercial galleries committed to modern movements. Explaining his development, Smith wrote:

While my technical liberation came from Picasso's friend and countryman, González, my esthetics were influenced by Kandinsky, Mondrian and Cubism. My student period was involved only with painting. The painting developed into raised levels from the canvas. Gradually the canvas became the base and the painting was a sculpture. I have never recognized any separation between media except one element of dimension.

Soon, however, Smith would jettison the canvas and begin translating Matulka's Cubist system of interlocked but texturally differentiated planes into freestanding assemblages of wire, coral, wood, and stone. This, it seems, made him all the more ready to perceive a whole new world of possibilities upon discovering the metal art of Picasso and González. Although Smith explored them in a variety of directions throughout the thirties and early forties, both at Bolton Landing and at the Terminal Iron Works in Brooklyn, he also carried out WPA assignments, made a year-long tour of Europe, including a side trip to the Soviet Union, and, finally, worked full-time during the war as a machinist and welder in a tank-assembly plant.

Not until 1945, therefore, did Smith have the freedom to give his extraordinary powers of formal and thematic invention full reign, even though a characteristic force of feeling and capacity for visual metaphor were already present in such earlier, smaller works as the Medals of Dishonor and *The Rape*. Made on the eve of World War II, the intaglio seal-like Medals were overt social-protest works, in which the artist resorted to the most traditional form and the most explicit imagery of his career, the better to propagandize the outrage he felt towards political, social, and military violence. Unrepresentative as these aesthetically conservative works may be, they nonetheless brought forth themes—birds, cannons, dismembered figures and architecture, composite monsters—that Smith would employ again and again in more abstract, subtle, and imposing form. A particularly imaginative treatment of the bird, cannon, and mutilated-figure motifs came soon thereafter in a series of small bronzes similar to *The Rape* seen here (fig. 198). In this nightmare drama of a prone female—sometimes almost as split open and spread apart as Giacometti's *Woman with Her Throat Cut*—menaced by winged and wheeled phallic artillery, Smith transformed the Leda myth into a wittily punning, albeit angry denunciation of brutality and aggression, armed or sexual. Interpreting the surreally mutant imagery as a manifestation of Smith's interest in Joyce's *Finnegans Wake*, Stanley Meltzoff has speculated: "Smith's cannon is 'sexcaliber' and 'camiballistic'. The cannon, like Joyce's Sir Tristram, is a '*violer d'amores*', an amoral musical amorist, part viola and part 'violater'."

It may well have been a personal identification with violence—a recognition of the macho or bellicose drives he most feared and struggled to control in his own nature—that enabled Smith to endow his mature works with their deepest expressive power. Rosalind Krauss has argued, most persuasively in relation to a work entitled *Blackburn: Song of an Irish Blacksmith* (fig. 199), that the artist's love-hate

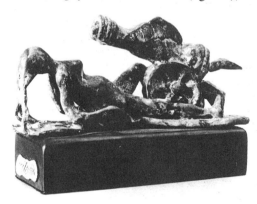

left: 198.
David Smith.
The Rape. 1945.
Bronze, 9 × 5⅜ × 3½".
Private collection.

below: 199.
David Smith.
*Blackburn:
Song of an Irish
Blacksmith*. 1949–50.
Steel and bronze,
46¼ × 49¾ × 24".
Wilhelm Lehmbruck
Museum, Duisburg.

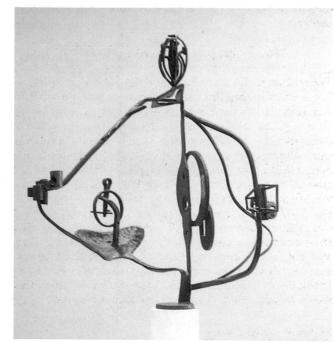

feelings appear even to have influenced his choice of medium. "Possibly steel is so beautiful," Smith wrote, "because of all the movement associated with it, its strength and functions.... Yet it is also brutal: the rapist, the murderer and death-dealing giants are also its offspring." While the tensile flexibility of metal allowed the sculptor to make three-dimensional drawings in air with something like the fluency enjoyed by painters and draftsmen, the very modernity of metal construction also helped to emancipate him from the past. "What it can do in arriving at a form economically, no other material can do," Smith said around 1952. Then he went on: "What associations it possesses are those of this century: power, structure, movement, progress, suspension, brutality." Moreover, the attraction-repulsion conflict expressed here made itself felt in the very form that welding and forging permitted Smith to give his sculpture. For the frontal view of *Blackburn* Constructivism's machine system and additive principle have yielded openness and clarity, as might be expected, but they also produced, not the crystalline geometry that orthodox Constructivism sought, but rather a flowing linearity like that in Action Painting, with most of the incident kept to the perimeters of a central, transparent void. Once viewed in profile, however, all the serene activity around the rim suddenly tumbles into the center, filling it with a riotous, Pollock-like weave of cursive movement (fig. 200). By the disjunctiveness of the information disclosed from various perspectives, and the consequent rupture in the expectations this arouses, *Blackburn* subverts the Constructivist notion that three-dimensional structures should not only be intellectually derived but also largely self-evident or predictable from every angle. Equally involved in this reveal-conceal strategy is the way Smith, still faithful to his machine aesthetic, created a whole by accumulating separate parts and by incorporating those parts from the industrial world—bent steel rods, cotter pins, hinge sections. "In fact," he said, "my beginning before I knew art had already been conditioned to the machine—the part of the whole, by addition...." But whereas Picasso, in his collaged or constructed sculpture, exploited the tension between the real and the contrived, as a device for making the latter seem more remarkable, Smith so transformed his found objects that they became subservient to the new, art context in which the sculptor placed them. This arises in part from his painterly respect for the language of color, which in *Blackburn* assumes the unifying character of dark burnished steel, highlighted and humanized by a Miróesque biomorph in verdigris bronze. More important, disparateness resolves into wholeness through the artist's potent yet infinitely nuanced and inventive touch, which charges the entire form, animating its solids and voids alike with an overriding sense of personality and presence. Such signs of inner spirit, fully as much as the lines and shapes themselves, make it possible for the abstract configuration to become a totemic head and torso with outstretched arms, at least when seen frontally. Here Smith adopted the kind of content that had obsessed the Surrealists, only to depart quite sharply from it, just as he departed from Constructivism. By giving effect to radical discontinuities, the artist created a work that denied Constructivism's lucid symmetry, with its Utopian content, and simultaneously gave formal expression to aggressive-destructive feelings. But while the Surrealists reveled in these, Smith sought the essence of an older, more primitive kind of totemism and used it as a metaphor for his desire to thwart or taboo what he found dangerous in both society and himself. For a sculpture that communicates powerfully through both objects and space assimilated from the human-inhabited world, the translation of totemism into a language of form serves to redistance the sculpture as an independent work of art, thus as something symbolically beyond possession, like the behavior *Blackburn* attempts to prohibit. As Krauss has written: "The goal of this formal endeavor seems to have been to contravert the by-then established transactions between viewer and sculptural objects, which . . . had developed into a system of either intellectual appropriation as in Constructivism or sensuous possession as in the work of Henry Moore."

Beginning with *Blackburn*, Smith would explore comparable thematic and formal concerns on a much-expanded scale and in ever-greater variety of expression, thanks to Guggenheim grants as well as to his regular, energetic work habits, brought to the studio from earlier days in assembly plants. Another legacy from factory life were the great stockpiles of machine parts and construction materials the artist kept about him, using them as visual triggers to association and invention. In 1961 Smith described his creative process as a dialectic of experience and the chance encounter:

I try to approach each thing without following the pattern that I made with the other one. They can begin with a found object, they can begin with no object. They can begin sometimes even when I'm sweeping the floor and I stumble and kick a few parts and happen to throw them into an alignment that sets me off thinking and sets off a vision of how it would finish if it all had that kind of accidental beauty to it. I want to be like a poet, in a sense. I don't want to seek the same orders. Of course, I am a human being. I have limited ability and there's always an order there. People recognize my work even if I think I've really been far out in this work.

Volatile by nature—droll, tender, fractious in turn—Smith would now labor apace to project his sensibility in series after series, works that transcend their fantastic variety to remain autographic. Each of them, as the artist insisted, "is a statement of identity, it comes from a stream, it is related to my past works, the three or four works in process and the work yet to come." In the early 1950s Smith developed his aerial calligraphy into a medium so versatile that he could easily bypass the human figure, sculpture's long-time principal subject, and give expression to such pictorial themes as landscape, or to great mythical birds that like *Australia* seem to embody the map of their strange continental habitat (fig. 201). Here, among dynamic balances sprung from a single fulcrum, space has completely replaced mass, to such a degree that this "negative" element becomes a "positive" one as integral to the overall sculptural image as the linear framework itself. While this kind of synthetic vision flowed from the instincts of an artist trained in painting, it also absorbs the viewer's own spatial reality as only a freestanding, penetrated sculpture would. Thus, even though basically two-dimensional in conception, *Australia* invites the viewer to investigate it three-dimensionally, to move about the form as its egg shapes and bony antennae slowly reveal a complex personality shifting interchangeably from playful to predatory.

With his voracity for work and the ideas it stimulated, Smith characteristically explored, Picasso-like, the idioms of several different,

left: **200.** David Smith. *Blackburn: Son of an Irish Blacksmith.* 1949–50. Side view of fig. 199.

opposite left top: **201.** David Smith. *Australia.* 1951. Painted steel; 6'7½" × 8'11⅞" × 16⅛", base 1'2" square. Museum of Modern Art, New York (gift of William Rubin).

opposite left below: **202.** David Smith. *Zig IV.* 1961. Steel, painted red-orange and chartreuse; 7'10⅞" × 7'¼" × 6'4½". Lincoln Center for the Performing Arts, New York.

above left: 203. David Smith. *Tanktotem IX*. 1960.
Painted steel, 7'6" × 2'7" × 2'¼". Collection Candida and Rebecca Smith.

above right: 204. David Smith. *Cubi XIX*. 1964. Stainless steel, 9'3¾" × 4'10¾" × 3'4".
Tate Gallery, London.

managing large, heavy industrial matter (fig. 203). These "figures" evince the confrontational, hieratic quality evoked by their titles and already seen in *Blackburn*, as well as a geometric spareness that makes their watchful air seem all the more sentient and haunting. Even though composed of appropriations from the non-art world and standing on its own legs, pedestal-free in the same space as the viewer, *Tanktotem IX* declares its "otherness" by looking like nothing but its enigmatic self, while simultaneously reverberating with ambiguous yet multiple associations.

In the Cubis, his final, most monumental, and probably most famous series (fig. 204), Smith renewed his art yet again, this time by replacing the whole quirky mix of found elements with pristine geometric building blocks, and by readmitting something of the real, rather than implied, volume that modernist sculpture had begun to reject thirty years earlier. The *trouvailles* had always meant more to him for their animated and suggestible plasticity than for any allusions they might make to the outside world, allusions that tended to be neutralized once the appropriated pieces were rehabilitated in sculpture. In the Cubis, neutralization began with the component parts, sleekly reductive "boxes" and "cushions" welded together from precut lengths of gleaming stainless steel. But having thus distanced his material, Smith simply refocused the search for paradox or discontinuity by assembling his solid geometries in balances so eccentric as to suggest that even the slightest adjustment would bring them crashing down. And set against this tense yet perfect equipoise, with its alternating play of sculptural silhouettes, is the excited dazzle of the surfaces. Wire-brushed in wild, swirling patterns, the variously angled metal planes catch the light and scatter it, optically dissolving the blocky volumes while also drawing into the sculpture a fiery, refracted illusion of the colorful world without. If the gesturalism of the surface treatment seems akin to Action Painting, the arrangement of the clean-edged masses often suggests abstract still lifes on tabletops, hence the intimist realm of earlier Cubism. But while the Cubis' simplified vocabulary derived more directly from Cubism's later, more radical Constructivist phase, it is, in certain works, scaled to the august proportions innovated by postwar American art. Here scale combined

overlapping, and ongoing series all at the same time. In the Agricolas he used scavenged pieces of farm equipment, sometimes posed on long wavering stems thrust up from an elevated horizon like stalks of young growth. The Zigs, on the other hand, comprise tilted sheet steel supporting an interplay of concave and convex planes (fig. 202). Although resembling mortars or fortresses in their massing—or *The Rape* recast in purely abstract terms—these enormous works nonetheless offer brief see-through accesses hinting at features that become apparent only from other vantage points. Equally consistent with Smith's desire-denial content is the surface color, a painted supplement that tends to counter strongly differentiated forms, either by the singleness of its hue or by hues so varied as to scramble the expected effects of advancing or receding shapes. For other groups Smith built towering abstract structures that suggest the full-length human figure without in the least reverting to the clichés of traditional monolithic statuary. Among these, the Sentinels are fashioned of intersecting stainless-steel plates, while the Tanktotems take their strange and inimitable silhouettes from disk-like boiler heads or caps, assembled with all the ease and confidence possessed by an artist accustomed to

below: 205. Ibram Lassaw. *Clouds of Magellan*. 1953.
Welded bronze and steel, 4'4" × 6'10" × 1'6".
Collection Philip Johnson.

bottom: 206. Herbert Ferber. *Cage*. 1954.
Lead, 4'6" high. Courtesy the artist.

right: 207. Seymour Lipton. *Sorcerer*. 1958.
Nickel-silver on monel metal, 5'¾". Whitney Museum
of American Art (gift of the Friends of the Whitney Museum).

far right: 208. Theodore Roszak. *Sea Sentinel*. 1956.
Steel brazed with bronze, 8'9" × 3'6" × 3'9".
Whitney Museum of American Art, New York.

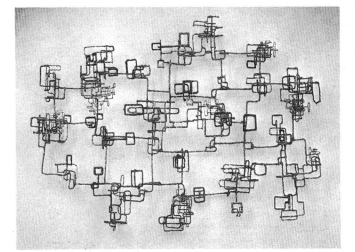

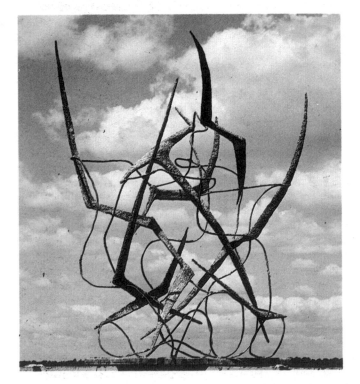

mopolitan and intellectually sophisticated background. Born in Egypt of Russian-Jewish parents, Lassaw had been in New York since he was eight years old, and by the age of fourteen he was already a serious student of sculpture, attending classes at the Clay Club and soaking up not only art history but also imported journal articles on such advanced European modernists as Brancusi, González, Lipchitz, and the Bauhaus masters. Of particular importance to him were the theories of Moholy-Nagy. If the WPA Art Project helped keep Lassaw alive and artistically independent during the 1930s, the US Army did the same in the early 1940s, most critically when it taught him the technique of direct welding. Subsequently, Lassaw went on to study the physical sciences and Zen Buddhism, which together enabled him to conceive of reality as a process, a process identifiable with a universal religion and expressible in sculpture created as part of a physical-spiritual continuum. And so for works like the wall relief seen here Lassaw used the oxyacetylene torch to invent form as he constructed it spontaneously, using thin, flexible wires and rods, welding them together with molten, dripping alloys, and coloring as well as texturing the delicate, aerated maze with acids and alkalis. While the extemporized procedure, if not the actual technology, originated in Surrealism, the overall grid- or cage-like armature reflects the artist's knowledge of Constructivism. Both, however, have been transcended to produce an organic, asymmetrical image referring not to objects or things but rather to forces, to ephemera, galaxies, clouds, or other distant phenomena, such as the underlying principles of nature. Using gestural line to compose instead of displacing space, Lassaw sought to unify humanity, nature, and the cosmos in his biomorphic structures. For him, "the relationships of all created things . . . are a complete, ever-evolving organism which the artist apprehends and 'creates'." Thus, Lassaw worked slowly and reflectively, more like Guston or Tobey than Pollock, and far from giving way to Expressionist vehemence, he made something refined, magical, or bejeweled of his sculptures, enriching them with a palette of colors ranging from burnished gold and copper to corrosive greens and rusty magentas of somber brilliance.

If Herbert Ferber (1906—) embraced open-form welded-metal sculpture as Lassaw did, he also eschewed the small scale and reticence of the latter artist to make bold gesture and monumentality as much a part of his artistic nomenclature as did the Abstract Expressionist painters (fig. 206). It could scarcely have been otherwise,

with Platonic formalism seems to yield intuitions of the sublime already seen in Abstract Expressionist painting. For some viewers, this transforms the tabletop still-life assemblages into symbolic monstrances or sacrifice-laden altars, while the two-legged towers become totemic figures and the more earth-rooted "gates" grand portals leading to mysterious infinity (fig. 380).

The artist who in the 1950s developed the closest sculptural equivalent of Pollock's mystical webbings was Ibram Lassaw (1913—; fig. 205). Ironically, Lassaw had actually made his breakthrough to open-form abstraction as early as 1933, long before the painters of the New York School. Sustaining him in his precocity was an unusually cos-

given that Ferber found his primary inspiration not in meditative, Oriental philosophy but rather in the politically aroused Expressionism of the 1930s, an experience shared, and soon rejected, by most of the New York School. Yet, Ferber counted among the few members whose relative affluence freed him to make art as he wished without dependence on the WPA. This was because he had earned a DDS at Columbia University and could both teach and practice dentistry all the while that he was studying sculpture in night school. Beginning as a wood carver, Ferber discovered his first models in Maillol and Zorach, but after a trip to Europe in 1928, he found himself moved by Barlach, German Expressionism in general, the Negro sculpture in Paris' Musée de l'Homme, and the powerful, compact form and emotional intensity of Romanesque sculpture. All of them contributed to his early Expressionist style as he transformed individual figures and groups into vehicles of social protest. By 1945 the distortions Ferber imposed upon his images had become so violent and anti-natural that it seemed logical enough for him to take the next step and break completely with representation. Easing the transition was Henry Moore, whose example helped Ferber to reduce and penetrate the mass of his figures until the bronzes were little more than linear cages filled with vigorously carved air. Another facilitating factor was his acquisition of soldering equipment, by means of which he shredded his surfaces into an aerial network of such radically narrowed elements as brass wire and fragile strips of lead or beaten copper. All would be shaped by Expressionist feeling and the signature vocabulary of commas, exclamation points, serpentine meanders, scythes, boomerangs, and forked-lightning shapes that Ferber developed in dialogue with Abstract Expressionist painting. This organic calligraphy remained constant as the artist reworked it in V-shaped troughs of beaten copper sheets and used these fleshier ribbons to expand his cages to architectural scale. Now, thanks to a commission from an architect, he would let the sculpture defy gravity, lift off the base, and touch or suspend from the ceiling. The concept of a roofed cage filled with trapped, writhing rhythms finally led Ferber to create what may have been the period's first environmental sculpture. Supported by the Whitney Museum in 1961, the artist prepared a room in which he unleashed the springing movement of his much-aggrandized line to assume heroic proportions and twist or flow throughout the cubic space, thereupon becoming a sculpture that the viewer does not circulate around but rather enters and moves about within. Not only does the work envelop the viewer, like a giant tropical plant; it also defines the area he may inhabit and thus qualifies and animates the whole labyrinthine enclosure.

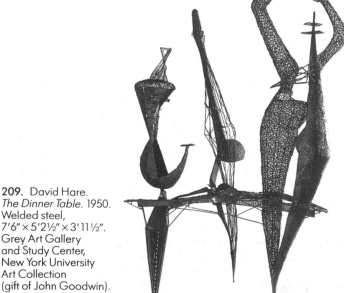

209. David Hare. *The Dinner Table.* 1950. Welded steel, 7'6" × 5'2½" × 3'11½". Grey Art Gallery and Study Center, New York University Art Collection (gift of John Goodwin).

Seymour Lipton (1903–86) too could earn a living in dentistry, at the same time that he actively acknowledged his compelling urge to make sculpture, despite a lack of formal schooling in art or its techniques. What drove him was the conviction, prompted by his discovery of Matisse and the Cubists, that the eternal dialectic of opposites in life—the colliding forces of the creative and the destructive—could be dealt with as expressively in sculpture as in poetry, philosophy, or science (fig. 207). Lipton's feelings about the Manichean struggles of modern humanity ran deep, as such titles as *Lynching* and *The Dispossessed* reveal, both given to early Barlach-influenced figural works carved in wood. By 1949–50 Lipton had brought his art to full strength, characterized by large, simple rolled or curving shells combined with sharper, more angular ones in open-form, interior-exterior, folding and unfolding relationships. It was an art made possible by the sculptor's masterful use of sheet Monel—a rust-proof, white-bronze alloy—cut with metal shears, hammer-molded, bonded and then finally brazed throughout with an oxyacetylene torch. Brazing involved rich, variegated applications of bronze and nickel silver to achieve glowing surfaces in a wide range of color and texture. Frequently the image was foliate, floral, or pod-like, but in *Sorcerer* Lipton returned to the vertical stance of the human presence. Now the totem has been cut into as if by its own vertebrae of stacked, knife-edged disks, whose menace the figure seems to confront and exorcise with its encircling upper members, tubular forms raised like ''arms in ritual incantation.'' As Albert Elsen has noted, *Sorcerer* may be understood as the artist's private symbol of the yin-yang principle expressing what the artist called the ''tragic crosscurrents in man.''

Unlike most of the artists who emerged within New York's Abstract Expressionist orbit, Theodore Roszak (1907–81) had already achieved a fully mature, sophisticated art—a sleek, Art Deco variant of Constructivism—before war so disillusioned him with mechanization that he abandoned the lucidity and optimism of Bauhaus aesthetics for its polar opposite: the tortured, angst-ridden, direct-metal hybrids of plant and animal forms for which the sculptor is now known (fig. 208). Facilitating this radical shift was the de Chirico Surrealism that Roszak had come to know, at the same time as his contact with Constructivism, during a grant-supported period he spent in Europe in 1929–30. It also helped that he discovered the possibilities of the welder's torch. With this instrument, Roszak learned to translate carefully detailed, but freely formed, plans into organic armatures of iron or steel, as well as to braze the surfaces of the spiky, convoluted skeletons with appropriately nervous, complex, painterly applications of nickel-silver, bronze, or brass. What the sculptor hoped to realize in these menacing yet romantic and often eloquent works were ''blunt reminders of primordial strife and struggle, reminiscent of those brute forces that not only produced life, but in turn threaten to destroy it.'' He felt that, ''if necessary, one must be ready to summon one's total being with an all-consuming rage against those forces that are blind to the primacy of life-giving values. Perhaps by this sheer dedication, one may yet merge form and grace.''

No postwar American artist was more closely involved with Surrealism than the sculptor David Hare (1917—). Educated in chemistry but self-taught in art, Hare joined (as a photographer) with the refugee Surrealists in their only American group show (1942), and then edited, with the help of Duchamp, Breton, and Ernst, the Surrealist periodical *VVV* (1942–44). He also migrated to France, took part in the last official Surrealist exhibition in Paris (1947), and remained abroad to experience Surrealism's evolution into Sartrian Existentialism. More important perhaps, Hare quickly adopted and never relinquished the Surrealist commitment to the unconscious and the automatist process of mining it for mythic content expressed in combinations of freely associated, or disassociated, images, usually elemental or biomorphic in form. With the arrival of the 1950s, Hare, inspired by González and Picasso, followed the trend towards direct-metal sculpture (fig. 209). Using a welder's torch, the artist found steel so flexible that he could make it almost as responsive to the work-

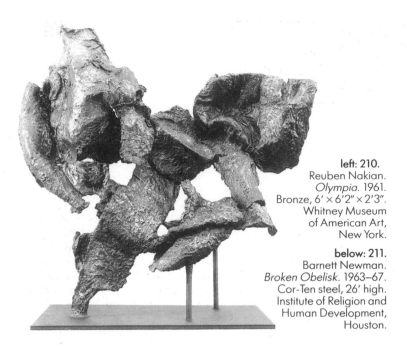

left: 210.
Reuben Nakian.
Olympia. 1961.
Bronze, 6' × 6'2" × 2'3".
Whitney Museum
of American Art,
New York.

below: 211.
Barnett Newman.
Broken Obelisk. 1963–67.
Cor-Ten steel, 26' high.
Institute of Religion and
Human Development,
Houston.

ings of the subconscious as paint. In his hands, the material stretched into long, thin filaments and, without loss of apparent strength, allowed itself to be woven into lacy webs evoking abstract figures that imply mass even as their mesh construction reveals open yet mysteriously complex interiors. For MoMA Hare wrote in 1946: "I believe that in order to avoid copying nature and at the same time keep the strongest connection with reality it is necessary to break up reality and recombine it, creating different relations which will take the place of relations destroyed. These should be relations of memory and association." But while Hare often, as here, let fantasy take off in self-supporting, pedestal-free constructions, he rarely created images so obscure as to defy visual translation by the attentive observer.

Reuben Nakian (1897–1986), one of the most venerable of contemporary American sculptors, seemed to hit his full, generous stride only in the 1950s, when he took fire from younger members of the New York School and all but outgunned them with his late and rather baroque Abstract Expressionist sculpture (fig. 210). However, the process of shifting from streamlined academicism to adventurous modernism had already commenced in the mid-1930s, thanks to the example and persuasive argument of a fellow Armenian-American, Arshile Gorky. The move was a major one for Nakian, and it took time, since his was already a seasoned talent long recognized in the New York art world. Thus, until the late 1940s Nakian was best known for his series of smoothly stylized animals and an equally stylized group of portrait sculptures representing President Roosevelt, his cabinet officers, and, most famously, Babe Ruth. Then, after more than a decade of relative quiescence, he rebounded with a series of large terra-cotta plaques incised with voluptuous drawings of erotic themes from Classical mythology, relief works that have frequently been compared to the Pop Expressionism of de Kooning's coeval Women paintings. Seeking greater scale, textural range, and expressive freedom, Nakian in the 1950s began to improvise with burlap applied over chicken wire, then dipped in liquid adhesive and quick-setting plaster. In this way he created and stabilized billowing abstract forms whose casting into thin shells of bronze entailed prodigies of technical skill. Needless to say, armatures made with soft materials and casual methods represented an innovative departure from the direct-metal sculpture of the 1950s.

The Abstract Expressionist era would seem to have come full circle when, late in his career, that painter's painter Barnett Newman demonstrated the growing interpenetration of all the arts and gave three-dimensional expression to his long-held belief that art should be philosophical in content and thus purely abstract in form. Moreover, the

form should give access to "the essence of things" by registering its origin in the dualities of feeling and intellect. The culminating work from Newman's brief excursion into sculpture is *Broken Obelisk*, first designed in 1963 · but not executed until 1967, when the Lippincott steel works finally calculated a way to engineer it (fig. 211). By themselves, the technical problems suggest the conceptual audacity of a work—the artist's largest—that one critic ranked among "the most impressive monumental sculptures of the 20th century." It comprises a square base plate supporting an isosceles pyramid joined apex to apex with an upside-down obelisk the profile of whose inverted summit continues the lines initiated by the silhouette of the pyramid below. At the X-crossing where the two triangular masses meet or separate— like the hands of God and Adam in Michelangelo's Sistine Ceiling— a tremendous spark of visual energy seems to send the obelisk shaft hurtling aloft, its thrust arrested only by a shattered edge schematized, as Thomas Hess has noted, in a kind of draftsman's shorthand implying progression beyond, perhaps to the stars. Simultaneously, however, the bit of irregularity, like the roughly burnt edges of the base, joins with the contrasting perfection of the two primary forms to effect that combination of the sensuous and the cerebral, the planned and the opportune which Newman viewed as the elementary male-female components essential to the generation of all art and creative existence. And so, while *Broken Obelisk* might seem funerary in its image, perhaps memorializing the eclipse of Abstract Expressionism by an altogether contrary inspiration, albeit one derived in part from Newman's reductive simplicity, the sculpture actually embodies a totally different kind of ancient Egyptian symbolism. Taking both pyramid and obelisk as emblems of first life and then new life, and their kissing juncture as a flash point comparable to that visualized in the Genesis of Michelangelo, Newman sought not to mourn but rather to celebrate life, birth, and renewal, in art and in man. As Hess concluded:

[*Broken Obelisk*] celebrates the faith of the artist in his art, in his ability to break through dead styles, to find his own forms and subject, his own past and present. It is an affirmation. If it says anything, it says "Be!" If it is addressed to anybody, it is to each of us: *Vir Heroicus Sublimis*.

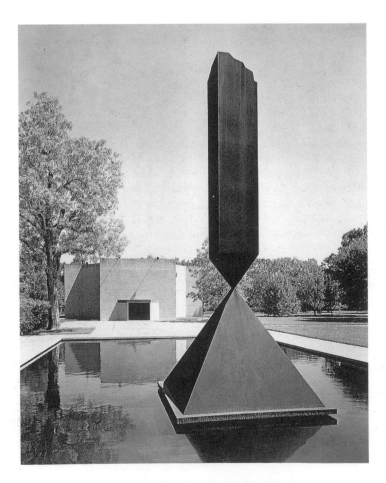

Into the Sixties: Pop Art and New Realism

5

The very fragility of the balance struck by Jackson Pollock in his great whirlpools of dribbled pigment—each a compound of freedom and control, surface and depth, gestural linearity and field-like color, profound feeling and rarefied, abstract form—makes it seem inevitable that such exquisitely unstable art would be pulled apart by the rivalries of its own internal components. Pollock himself sensed and registered the precariousness of this pictorial dialectic when, in order to anchor his aerated illusions in material reality, he went beyond merely slapping the encrusted surface with his own oily handprints and began studding it with such mundane debris as cigarette butts, matches, buttons, and keys. In *The Wooden Horse* (fig. 69) he even fitted the head of a hobbyhorse into the tracery of one of his most disembodied, lyrical skeins, as if to demonstrate how readily his autonomous drawing-painting could reconnect with its referent in the phenomenal world. Thanks, moreover, to the liberating effects of automatism and his own innovative pouring technique, Pollock found it possible to enlarge nonobjective painting from easel dimensions to mural scale and thus achieve, in purely abstract or holistic terms, a sense of environmental, viewer-immersing vastness, an effect reminiscent of Claude Monet's late *Waterlilies*. However, as the flotsam of his concrete appliqués suggests, the environment known and evoked by Pollock was not only soaring, metaphysical infinity but also the down-to-earth, junk-strewn realm of America's mid-20th-century urbanscape, a world remote from the pond-like purity and calm of late-19th-century bucolic France. De Kooning too had felt and expressed the teeming fleshpot of urbanized New York, both in the jammed, frenzied violence of such abstract works as *Excavation* (fig. 57) and in the billboard grossness of his Women paintings, especially the version with the smiling, lipsticked mouth collaged from a cigarette ad (fig. 212), or others accidentally newsprinted while still wet and temporarily protected with sheets of some daily periodical. Of course, for Pollock and de Kooning, almost as much as for Monet, painting that appeared to emulsify reality while simultaneously acknowledging its sensuous presence constituted a civilized refuge from the brutalizing encroachments of a vulgar, aggressively materialistic society. By the early 1950s, however, when even Pollock and de Kooning could no longer resist pressures from a postwar ambience increasingly bombarded with consumer products and media-proliferated imagery, the tight little island of avant-garde art was being invaded, in Europe as well as the United States, by younger talents who, having never experienced the more harrowing aspects of either economic distress or armed combat, felt little compulsion to view the world as tragic, a place to be transcended in an art of sublime feeling. Far from isolated and embattled, overheated, or hostile to industrial culture, the newcomers were cool in mood and objectively fascinated, even when offended, by the rising tide of man-made abundance, as well as its attendant hype, waste, and the technology that produced them both. But just as the Abstract Expressionists had divided, generally, between the extroverted Action painters, committed to such physical factors as gesture and texture, and the more introspective Color-Field painters, intent on applying pigment to seem either atmospherically dissolved or ascetically flat, their successors also fell into two opposite but complementary camps. While the one would

engage in neo-Dada attempts to make art ever-more inclusive of the most ordinary reality, the other adopted a program of systematically excluding from art all but its own most irreducibly essential properties. Common to all, however, was the savvy realization that the achievement of the Abstract Expressionist generation was too heroic or awesome to emulate. Moreover, those worth their salt also understood that junior masters unendowed with an authentically sublime vision could only transform Action-style spontaneity into empty formula or, worse, unintentionally comic parody. To prove it, Robert

212.
Willem de Kooning. *Study for Woman.* 1949. Oil, enamel, and charcoal on paper, with pasted photoengraving; 14⅝ × 11⅝". Metropolitan Museum of Art, New York (jointly owned by the Metropolitan Museum of Art and the heirs of Thomas B. Hess).

Rauschenberg, one of the first Americans to "move out" from the almost overpowering influence of the first New York School, executed a painting replete with "inspired" passages of pure gestural painting—then set about copying it swipe for swipe, runnel for runnel. Of at least equal interest to him were the picture's collage elements, images fished from the flood of endlessly media-duplicated material then being loosed upon the postwar world in unprecedented quantities. At the same time that the "found" allusions documented that world, they also joined with the twinned painterliness to question the Abstract Expressionists' assumption that for an art work to be worthwhile it must not only appear transcendent but also evince the uniqueness or originality of having evolved from an all-or-nothing, go-for-broke existential struggle. In a statement about his early work Rauschenberg said: "I don't want a painting to be just an expression of my personality. I feel it ought to be much better than that." Then a bit later: "I don't want a picture to look like something it isn't. I want it to look like something it is. And I think a picture is more like the real world when it's made out of the real world." With this, the witty and articulate Rauschenberg spoke for the whole of what would become the sixties generation, whether bent on making their art open to every possibility or closed to everything but its own exclusive physical na-

ture. By disdaining the cloudy solemnities or feigned subjectivity of the Pollock–de Kooning clones—at the very moment, in the late 1950s, when the real thing was being universally hailed as the most impressive new art of its time—"maximalists" like Rauschenberg and his Pop brethren, together with the Minimalists to be seen in a later chapter, guaranteed that they would be working in a spirit of deadpan irony and paradox. For the Pop figures, moreover, it seemed apparent that their aesthetic operations would involve a process as critical of itself as of its immediate antecedents and the urban-industrial-admass environment whence Pop would draw both its themes and techniques. Incidentally, Pop Art would also offer a good measure of the trendy, effervescent, "shock-the-bourgeoisie" fun and scandal that the media quickly co-opted to such superficial effect, all the while remaining ignorant of the art's wonderfully ambiguous, even learned richness and complexity.

One of the many ironies to be savored in Pop is that as both a term and a concept it was first defined in England, even though the principal subject and often the means of Pop Art everywhere derived from the popular, consumer-oriented culture that was uniquely America's during years when austerity still gripped postwar Europe. Moreover, the names most immediately associated with the development—Rauschenberg, Johns, Oldenburg, Rosenquist, Warhol, Lichtenstein—were uniformly American, for all manner of reasons to be considered later. Nevertheless, it was in Britain—a Britain still straitened by the cost of its victory in war—where distance made it possible for a group of artists and intellectuals to regard imported American movies, rock recordings, science fiction, and glossy, ad-filled magazines with something other than the horror and disdain felt by their kitsch-hating counterparts across the Atlantic. The more progressive British, in fact, tended to see in America's commercial abundance a kind of exotic paradise, a world of inexpensive, machine-produced, democratically available plenty whose leveling multiplicity of choice offered a welcome cultural alternative to an established tradition in which concepts of good and bad, or high and low, had always been as hierarchically ranked as the nation's long-rigid caste system. Lawrence Alloway, the English critic who first spoke of "Pop Culture" and then coined the phrase "Pop Art," put it this way in 1959:

Mass production techniques, applied to accurately repeatable words, pictures and music, have resulted in an expendable multitude of signs and symbols. To approach this exploding field with Renaissance-based ideas of the uniqueness of art is crippling. Acceptance of the mass media entails a shift in our notion of what culture is. Instead of reserving the word for the highest artifacts and the noblest thoughts of history's top ten, it needs to be used more widely as a description of "what society does."

Such ideas had already been mooted as early as 1954–55, when members of the Independent Group (IG) within the Institute of Contemporary Art (ICA) decided to make the urbanized commercial environment the theme of their discussions and public program for that season. Those involved in choosing the subject were Alloway, the architects Alison and Peter Smithson, architecture critic Reyner Banham, photographer Nigel Henderson, writer John McHale, and the artists Richard Hamilton and Eduardo Paolozzi. Enthusiastic admirers of Hollywood, Detroit, and Madison Avenue, all of these discussants hoped to take Pop culture out of the realm of "escapism" and treat it with the seriousness of art. By formulating an "aesthetics of expendability," they also sought to mount an aggressive attack on idealist or absolutist theories of art. Providing a background for this scheme were the canvases of Francis Bacon, the only British painter of an earlier generation whom younger artists could regard as relevant to what they were doing in the 1950s. Perhaps even more important was Paolozzi himself, who in turn had undergone influence from Dubuffet and the Surrealists during a two-year sojourn in Paris shortly after the war. While Bacon, beginning around 1949, had based certain of his paintings on photographs—the screaming head from the film *Battleship Potemkin* and Eadweard Muybridge's studies in human and animal motion (figs. 138, 139)—Paolozzi, as we saw in Chapter 4 (fig.

190), was not only an assembler of poignant yet hilarious machine-part robots but also a life-long hoarder of American-type ephemera. As early as 1947, Paolozzi had even made a collage of ads, a postcard, and a magazine cover that prophetically included the word "POP!" (fig. 213). By 1949 he was converting this magpie process into a major art form realized as large-scale prints. Then, in 1952, at the first meeting of the IG, the artist demonstrated his assemblage aesthetic in a famous "lecture" composed of numerous found images projected in random order and without verbal commentary. Thereafter, in 1953, with the "Parallel of Life and Art" exhibition, and again in 1955, with the "Man Machine and Motion" show, the IG members, singly or in various combinations, used photographic or photographically reproduced material in profuse, maze-like, non-hierarchical combinations as a means of exploring not only the postwar image-explosion, but also its power to evoke a subject imaginatively while also documenting it scientifically. Even more crucial to the emergence of Pop Art was a celebrated 1956 exhibition called "This Is Tomorrow," again sponsored by the ICA but this time held at the Whitechapel Art Gallery. With its dozen different, even competing pavilions, the image-drenched show seemed to transpose the street right into the gallery, thereby bringing to momentary climax a whole range of efforts designed to reconceive the relationship between timeless art and topical life as a mutually enhancing continuum rather than a stand-off, rivalrous dichotomy.

For reproduction in the "Tomorrow" catalogue and blow-up in a related poster, Richard Hamilton (1922—) prepared a collage whose tiny size is in dramatically inverse proportion to the momentous place it came to occupy in the history of late-modern art. Called *Just what is it that makes today's homes so different, so appealing?*, the work measures a mere 10 by 9 inches but proved capacious enough to announce virtually all the terms in which the new image-intoxicated art would operate (fig. 214). Not only did the ironically titled picture include the printed word "POP", long before anyone applied it to what artists were doing; the work also embraced the subject matter of Lichtenstein's comic-strip canvases, Warhol's branded-package paintings, Oldenburg's *Bedroom Ensemble*, Rosenquist's vast billboard spreads, and Wesselmann's Great American Nudes, none of which would be

seen by the public before 1962. Here, moreover, Hamilton had revived the collage technique that many other Popsters would employ as a device for extending the environmental concerns of the Abstract Expressionist generation to embrace the competitive multiplicity and layered fragmentation of the postwar urban, admass culture. What the process allowed him to explore on this occasion was the world of consumerist fantasy, played upon as it was, and still is, by media-induced confusions of eros and technology's promises of satisfaction. This alone would have been sufficient to make the tiny picture notorious. But Hamilton heightened the effect by handling his mixed bag of found, promotional imagery with such elaborate, punning wit and idea-packed deliberation, as well as with such refined concern for the abstract needs of color, balance, and surface, that the finished work succeeded, as all Pop Art would aim to do, in transforming the ephemera of low, everyday life into the stuff of high, enduring art. A performance of this sort could not, it seems, but challenge and enlarge our understanding of both realms. By thus asserting the ambiguity or relative value of all modes of communication—not to mention the meanings they convey—Hamilton also achieved a kind of cool, highly conceptualized poetry that would insinuate its teasing presence throughout the Pop experiment. And this is only the start of what could be said about a truly seminal work, whose problem-posing and -solving purpose will become clearer once something has been learned of the anti-elitist but exceptionally sophisticated artist who created *Just what is it . . . ?*

By 1956, Hamilton had become one of the most broadly experienced and informed artists of his generation. A Londoner born, he began attending art classes when only twelve and was still studying, at the Slade School, as late as 1951. Hamilton had also been doing commercial work since he was fourteen, at first while attending night classes at St. Martin's School of Art and Westminster Technical College. The Royal Academy admitted Hamilton as a student immediately before and again after the war, but then expelled him for flouting its tradition-bound, academic standards. The trouble reflected the aesthetic independence—the analytical and pragmatic know-how—the artist had acquired from engineering draftsmanship, learned in 1941 and then used during the war in jig and tool design. The tendency such work encouraged could only grow once a fellow Slade student introduced Hamilton to d'Arcy Thompson's book *On Growth and Form* and Duchamp's *Green Box*, both of which gave witness to the value of approaching all givens in a spirit of relentless critical inquiry. Hamilton spent several years preparing an exhibition based on the Thompson work, which opened at the ICA in 1951. Simultaneously, he was also illustrating James Joyce's *Ulysses* (1947–56), in a long series of etchings whose numerous shifts in style, from the minutely descriptive to the most abstract, captured the mercurially punning visual/verbal plays that fairly dance throughout the original text. The enterprise could hardly have prepared Hamilton more brilliantly for his protracted and fruitful involvement with Duchamp, which climaxed in the Englishman's typographic rendering of the *Green Box* and his two-year reconstruction of the *Large Glass* for the Tate Gallery's Duchamp retrospective, a 1966 show organized by Hamilton himself. Meanwhile, he taught at the University of Newcastle, and there assembled, with his students, the somewhat neo-Futurist exhibition called "Man Machine and Motion," which, as cited earlier, drew on all manner of visual material—but mainly photography—in order to explore the facts and fantasies of contemporary society's deepening involvement

with machines. Mounted in 1951 at the ICA, the show served as a prelude to the historic "This Is Tomorrow" exhibition of 1956.

Like the "Tomorrow" exhibition, *Just what is it that makes today's home so different, so appealing?* acknowledged—even saluted—both the 1950s popular, consumer-oriented culture and the image-proliferation this new environment spawned (fig. 214). But what made the little picture a virtual manifesto of Pop Art was the successful attempt it represented to re-enact the contemporary urban drama of competing elements within a pictorial context bespeaking the qualities of fine art. Iconographically, the collage answers the title with a taxonomy of images surveying what the media promoted as the period's most engrossing interests. Salient among the assembled items are the comic hung on the wall as a painting, a can of ham displayed as a tabletop sculpture, an ideal or muscle-man head-of-the-house and his nude, equally ideal pinup lady, a lampshade bearing the Ford logo, and a magnetic-tape recorder in the foreground. Visual puns and double-entendres abound, not only in the obvious spoof of ads using sex, implied or overt, to sell products like meat, automobiles, and television, but also in the picture window providing a view onto the "pictures," where "The Coming of Sound" in 1927—a technological breakthrough comparable to the latest audio electronics also evident in the collage—can be experienced in *The Jazz Singer*, just beyond the hunk holding his explosive, word-balloon lolly-POP. Such Duchampian wit continues, somewhat more quietly, on the ceiling, where a high-altitude shot of the planet earth doubles as a kind of *faux-marbre* wallpaper pattern, or on the floor, where the carpet too plays a dual role, its nubby "texture" produced by a mass of humanity photographed on a beach. And if Duchamp could draw a moustache on Leonardo's *Mona Lisa*, suggesting that for art to remain vital the sacred must be mixed with the profane, then Hamilton would hang a portrait of John Ruskin on the wall of "today's home," whence the 19th-century aesthetician might at least find favor with the smooth and subtle way in which Hamilton has integrated his public and private spaces, his Mannerist variety of scale. Indeed, it was thanks to his taut control of structure and technique, as well as concept, that Hamilton could, even in a miniature format, give such full account of his principal issue—communication. The theme reverberates throughout a

Pop Art and New Realism

compendium of modes, ranging from words, printing, and painting to symbols, from photography, film, television, and telephone (imaged on the TV screen) to diagram and finally recorded sound.

In January 1957, Hamilton drew up a now-famous list identifying what he considered to be the characteristics of Pop Art, then viewed quite simply as the sort of admass culture illustrated in *Just what is it . . . ?* The desiderata cited were: "Popular (designed for mass audience); Transient (short-term solution); Expendable (easily forgotten); Low Cost; Mass Produced; Young (aimed at youth); Witty; Sexy; Gimmicky; Glamorous; Big Business." From that point on, the author would create works of an unquestionably fine-art nature but so derived from commercial-art sources as to be consistent with his list-definition of Pop—more or less, that is, save expendability. Thus, the first works known as Pop in the present sense of the term came from Hamilton's studio during the same year, beginning with *Hommage à Chrysler Corp*, the very title of which suggests the importance of everyday Americana as the subject matter for the new figuration, in Europe as well as in the United States. An early and major painting made under the novel dispensation was the 1958 *$he* (fig. 215), whose dollar-sign title signaled the intimate relationship that Hamilton had detected between female seductiveness and the styling as well as presentation of such popular merchandise as cars, refrigerators, and toasters. From this confrontation of the hot and the cold, Hamilton created what he called "a sieved reflection of the admen's paraphrase of the consumer's dream." And how he went about this we know from a candidly elucidating account published by the artist in the October 1962 issue of *Architectural Design*. As always with Hamilton, the painting had its primary source in a concept, which this time arose from a noted difference between the image of contemporary woman found in art and the image of her presented by ad men. "Art's Woman in the fifties was anachronistic," Hamilton wrote, "as close to us as a smell in the drain; bloated, pink-crutched, pin-headed and lecherous; remote from the cool woman image outside fine art." In advertising, however, "she is truly sensual but she acts her sensuality and the performance is full of wit. Although the most precious of adornments, she is often treated as just a styling accessory. The worst thing that can happen to a girl, according to the ads, is that she should fail to be exquisitely at ease in her appliance setting—the setting that now does much to establish our attitude to a woman in the way that her clothes used to." Meanwhile, Hamilton continued, "sex is everywhere, symbolized in the glamor of mass-produced luxury—the interplay of fleshy plastic and smooth, fleshier metal." Alert to this prevailing reality, Hamilton dismissed what he deemed the phoniness of the female image normally presented by artists. In its place, he adopted the commercial variant and then made this the subject of *$he*, a strategy designed to invest his own fine art with a fuller sense of contemporary experience. But it also permitted him to reintroduce into modern painting one of art's most ancient themes and, moreover, make it live again with fresh allure.

In the *Architectural Design* article, Hamilton, with great forthrightness, also disclosed his visual sources, the most important of which may have been an *Esquire* photograph of a comely model known as Vikky ("The Back") Dougan, who specialized in backless dresses and bathing suits. Much taken with the effect of her garment, cut so low as to expose the upper cleavage of her bottom, Hamilton commented: "The only pin-up I can remember having a greater impact in art circles was Brigitte Bardot spread piecemeal through *Reveille* in October 1957." To complete the image of a self-promoting mix of the cool and the combustible, Hamilton introduced the appliances that models like Vikky Dougan were so often coupled with in American space ads and explanatory booklets. On the chillier side of things there is a giant refrigerator, standing as open and come-hither as the woman it appears to embrace and delight. For this image, which the artist described as "a brilliant high spot of the cornucopia refrigerator," Hamilton went to an advertisement for an RCA Whirlpool fridge/freezer, whose layout he also appropriated as the overall design

215. Richard Hamilton. *$he*. 1958–61.
Oil, cellulose, collage on panel; 24 × 16". Tate Gallery, London.

of his picture. Meanwhile, two other ads, one for a Westinghouse vacuum cleaner and the other for General Electric small appliances, yielded the wonderful *repoussoir* visual pun in the foreground—a POP-up toaster. But what saves such wit from the topical and translates its vehicle into an aesthetic object rich enough to reward continuous inquiry is the dazzlingly varied and sophisticated manner by which Hamilton has processed his imagery. For the smoothly carnal hue of the refrigerator door he "adopted with enthusiasm" the "Cadillac pink" in the original ad, but for the Coca-Cola bottle cooling on the door's interior shelf he seems to have reverted to an older form of still-life painting, in the tradition of Chardin or Manet. This contrasts with the foreground still life, a composite toaster and vacuum—or "Toastuum," to quote Hamilton—whose plump little plugged-in oven has been crisply airbrushed in aluminum paint. To link this fire-and-ice unit to the fridge door, Hamilton simply indulged himself in a passage of pure, gestural painting, so liberated that it even dribbles down the surface, like a conscious acknowledgment of Pop's debt to Abstract Expressionism. Hamilton also airbrushed—this time "lovingly"—the model's shoulder and breasts, aiming for the exact tone and texture that women's flesh appeared to have in glossy magazines. Then, as if to state the collage principle at work throughout his composition, the artist turned to a totally different technique and fashioned the figure's skirt in relief, using a plywood piece so delicately worked or modeled that, as Hamilton said, it invites exploration by hand as much as by eye. Another bit of collage is the fridge's freeze compart-

ment, a blown-up image that too originated in an ad photograph before being applied to the painting surface. In a rather more subtle manipulation of his sources, Hamilton gave way to the wish fulfillment of a female image that combined the best of all possibilities—that is, Vikky Dougan's backside, which the artist called ''too good to miss,'' and the breasts essential, in the Marilyn Monroe–Jane Russell era, to the admass vision of woman. True to his method of finding rather than inventing imagery, Hamilton went to another pinup for his breasts, but then slyly mocked them by allowing the shape on the left to read not only as a shoulder but also as a pendulous mammary culminating in a dark, pointed nipple, a touch of warm, peasant reality in the glacially pristine, distinctly urbanized kitchen. Equally double-entendre is the plunging line of the model's skirt, which not only evokes the flesh it was meant to reveal, but ''it also,'' wrote Hamilton, ''suggested an apron in the negative: this was nice—an apron, however minute, is fundamental to the woman-in-the-house image.'' Yet more like ''soundless laughter'' than this appliqué may be the figure's single eye, which became part of *she* only after the artist had been at work on it for some two and a half years. As alert to chance as he is controlled—like his idol Duchamp—Hamilton underwent an epiphany when a friend from Germany gave him a winking plastic eye, which he immediately collaged into the painting. There it joined with the dotted flight path popping out of the Toastuum to activate the picture's still, chill world with an element of hot, dynamic energy. At the outset of his remarks about *she*, Hamilton stated: '' . . . I would like to think of my purpose as a search for what is epic in everyday attitudes. Irony has no place in it except insofar as irony is part of the ad man's repertoire.'' Given the presence of the winking eye and the visualized trajectory of toast bounced completely free of the picture, that repertoire must be seen as extending far into irony, at least when reprocessed by an artist with Hamilton's sardonic gift. For in the end, what he has explored is not only the popular culture of his time but, even more, the language of art itself. By doing this through such a virtuoso range of media or techniques, he produced a combined effect that—especially now when the shock value of the allusions has dissipated—leaves the work to disclose its formal power and painterly finesse even more than the revolutionary fact of its vulgar sources. As a consequence, the painting continues to convey a preoccupation with meaning as nuanced and layered as the images themselves.

Meanwhile, during the late 1950s, ''Pop Art'' became common currency among artists in London, where Hamilton, virtually alone, completed what Alloway called the first phase of British Pop. As the works just seen demonstrate, it was marked by a serious, albeit ebullient, taste for popular culture, a belief in the multivalent quality of images, and a sense of interplay between technology and society. Even though Paolozzi stood somewhat outside the Pop mainstream, by preferring to cast found objects in a common material like bronze, instead of allowing them to maintain the tension of their juxtaposed unalikeness, he captured the essential character of early English Pop when he wrote: ''SYMBOLS CAN BE INTEGRATED IN DIFFERENT WAYS. The WATCH as a calculating machine or jewel, a DOOR as a panel or an art object, the skull as a death symbol in the west, or symbol for moon in the east, CAMERA as luxury or necessity.'' But this was only the beginning, for, as we shall see later, British Pop had generated enough momentum to roll on through at least two additional, extraordinarily brilliant phases.

American Pop

Since it was the contemporary American scene that Pop artists the world over plumbed for much of their non-art subject matter—and frequently unorthodox techniques—it seems better to discover what Hamilton's New York cousins were up to before giving further consideration to Pop developments elsewhere. And they were up to quite a lot, creating major works of Pop Art long before London's ideas or terminology took root abroad. Among the Americans, critical support lagged woefully behind the creative impulse, which expressed itself in Pop-like reactions against Abstract Expressionism altogether as early as in Britain, even though few, if any, in New York spoke of ''Pop Art'' before 1961 or 1962. For their 1950s work, Rauschenberg and Johns generally earned the epithet ''neo-Dada,'' often with the original Dada's negative connotations intact. In New York, therefore, practice outstripped theory by a long measure, with would-be Pop masters springing up unbidden, certainly unwelcome, and largely in solitary isolation until they were already fully formed. Much later, Henry Geldzahler, speaking with Andy Warhol, would characterize the situation in somewhat Yeatsian terms: ''It was like a science-fiction movie—you Pop artists in different parts of the city, unknown to each other, rising up out of the muck and staggering forward with your paintings in front of you.''

Perhaps in part because of the strong indigenous thrust of its New York phase, Pop Art ultimately came to seem an overwhelmingly American phenomenon. After all, Americans knew Pop's principal source material as a living experience, whereas overseas artists had to approach it like anthropologists studying an alien, exotic, or even primitive culture. Moreover, it was in the United States that artists, buoyed by the triumphs of the New York School, could so handle ''low'' motifs and means that they resulted in ''high'' works with all the large-scale, single-image impact of Abstract Expressionist paintings. Further reinforcing them was a native vernacular tradition in both folk and sophisticated art. The latter went back at least as far as the late 19th-century ''pin-board'' still lifes of Peto and Harnett, then continued through the American Scene painters to such advanced formalists as Gerald Murphy and Stuart Davis, with their jazzy cubifications of filling stations, cigarette packets, and pocket watches. Also active in the New York equation were the later paintings of Fernand Léger, who while in the United States during the 1930s and early 1940s had absorbed something of America's cartoon and billboard art into his own distinctive brand of urbanistic, machine-style Cubism. Nothing, however, counted for more than the powerful, long-time presence of Marcel Duchamp, the Dada ''pope'' who in 1917 had ''designated'' his urinal *Fountain* in New York, thereupon introducing Americans to the possibility of a ''found'' art in which concept, context, multi-layered visual/verbal play, and witty paradox would take precedence over form or pure aesthetic delectation. Attractive exemplars of the principle, for younger postwar Americans, were such Dada or Surrealizing collagers as Kurt Schwitters, Joseph Cornell, and Robert Motherwell, but the veritable guru of the new attitude was John Cage, the composer of aleatory music and a dedicated student of both Duchamp and Zen Buddhism. Hostile to the Abstract Expressionists' ''elitist'' sense of themselves as existential heroes and of their art as a body of holy objects, Cage called for an expression not aloof from ordinary life but integral with it, somewhat like Duchamp's ready-mades. He insisted that the true sources of art lay not in subjective feeling and the creative process, but in the everyday physical environment, for the purpose of art was, above all else, ''the blurring of the distinction between art and life.'' Preferring laughter to tears, he saw art as ''a purposeless play . . . [which] however is an affirmation of life—not an attempt to bring order out of chaos, nor to suggest improvements in creation, but simply a way of waking up to the very life we're living, which is so excellent once one gets one's mind and one's desires out of its way and lets it act of its own accord.'' As this would suggest, Cage, unlike Duchamp, was not subversive but positive in his conception, thus more in tune with Zen, which saw the relationship between art and life in a joyous, if brash and always unsentimental, manner. While Cage encouraged the use of accident and discontinuity, as did the Abstract Expressionists, he also rejected the older artists' dependence upon automatism as a means of suspending conscious behavior in order to arrive at deeper truths. Rather, he viewed chance as nature's own forming principle, one that required the artist to avoid the rational creation of patterns, hierarchies, and points of climax, in favor of repetition and a kind of all-over related-

ness. In his devotion to an accident-determined art, Cage has often seemed to pursue an almost pantheistic line of thought, suggesting that by closing the gap between art and life, the artist would achieve a kind of self-elimination. Eventually this helped provide an ideological underpinning for the formal rigors and serialism of Minimal Art. It also led, in the opposite direction, to the all-inclusive theater-like Happenings of Allan Kaprow and, with more Duchamp than Zen, to the visual/verbal puns, paradoxes, and games of Conceptual Art. However, the most immediate impact of Cagean ideas was felt in a series of brilliant Pop works, redeemed from the startling vulgarity of their sources by the virtuosity of the handling, as in the great "combine" paintings of Rauschenberg and Johns, who wasted no time in asserting that their authenticity lay not in angst but rather in irony.

Art of such a radical and challenging nature could not be readily understood either by formalist critics, who denounced it as a betrayal of everything the New York School had struggled so long to accomplish, or by the burgeoning American media, which simplistically rejoiced at finding in Pop a combination—of high-art cachet and "friendly" or "camp" subject matter—certain to entertain a newly affluent, culture-conscious mass audience. The truth of what was missed by both of these extreme positions is likely to seem clearer after we have considered three of Pop's most important American progenitors. First there was the many-talented Larry Rivers (1923—), who as early as 1947 or 1948, while studying with Hans Hofmann, challenged the German master's insistence that a work of art could be experienced only as an aesthetic totality. Citing the pleasures afforded by surviving "fragments" of partially destroyed Old Masterworks, he forced Hofmann, Sam Hunter tells us, to concede that the artist's "psychological insight" counted wherever it might be revealed, in parts or in wholes. Not only did such a conception violate Abstract Expressionist dogma, with its devotion to the indivisibly unified, holistic field, it also reasserted the validity of figuration at a moment when the completely nonobjective image was thought to have been irrefutably established as the *sine qua non* of serious painting, at least within the purlieus of the New York School. But for all manner of reasons—among them a desire to match himself against the giants of art history, an innate need to attract attention, a deeply felt sense of art and life as an integrated but nonetheless multi-faceted affair—Rivers succeeded in breaking out of the Abstract Expressionist pack with a style as jazzily—even grandly—autographic as any in late-modern art (figs. 216, 217).

Actually, it was through jazz that Rivers entered the visual arts, having grown up in the South Bronx as the only son of a Russian-Jewish emigrant family in which music constituted the main cultural interest. Born Yitzroch Loiza Grossberg, but called Irving, the artist began on the piano, later switched to saxophone, and with that instrument began touring at eighteen as a professional jazz musician. When a creative emcee at a Catskill night club announced the current combo as "Larry Rivers and His Mudcats," the suddenly redubbed star accepted the accident of his new name just as readily as he would let his art embrace happenstance of every sort. Following a wartime stint in the US Army Air Corps, Rivers resumed playing in bands. In the summer of 1945, while on a gig in Maine, he met the painter Jane Freilicher, whose husband was the group's pianist, and gained his first insight into the New York world of advanced art and literature. With characteristic swiftness, Rivers joined his new friend in sketching sessions, and by 1946 he had separated from his wife of barely a year and their newborn son, begun studying with Nell Blaine in Manhattan, and learned about Hofmann, in whose studios he would work through 1948, all the while continuing to support himself as a musician. He also met the Cedar Bar crowd, including de Kooning, but even more than the Dutch master, it was his discovery of Pierre Bonnard, at MoMA's 1948 retrospective exhibition, that took him decisively away from Hofmann-like semi-abstraction towards the opulent, painterly figuration in which he would excel. When shown at the Jane Street Gallery in 1949, Rivers' Bonnard-inspired canvases moved Clement

Greenberg, the smartest critic then looking at new art, to call the painter an "amazing beginner," in whose work "the similarity [to Bonnard] is real and conscious, but it accounts really for little in the superb end-effect of Rivers' painting, which has a plenitude and a sensuousness all its own."

Then in 1949–50, during an eight-month sojourn in Europe and back in New York at another MoMA retrospective, Rivers experienced a fresh epiphany, this time in the art of Chaim Soutine, the School of Paris Expressionist *maudit* who, after having been a major source for postwar Europe's Informal Art, would influence not only Rivers but also de Kooning in his Women pictures. Soutine as well as Gustave Courbet's *The Burial* left Rivers painting with a deep, resonant palette and a slashing, aggressive stroke. This new, tougher manner brought him an affiliation with John Bernard Myers, director of the Tibor de Nagy Gallery in New York, which showed not only the artist's own, highly personal version of *The Burial* but also his equally free rescension of Emanuel Leutze's *Washington Crossing the Delaware*, a once-admired "masterpiece" whose grandiose aspiration had been debased by over-familiarity to the status of a corny school-book illustration (fig. 216). Here, in a pair of ambitious salon "machines," Rivers made it known that he was now armed to engage both the masters of the past and those of the present, the Abstract Expressionists. In one of his most revealing statements, Rivers told Frank O'Hara: "I was energetic and egomaniacal, and what is even more important, cocky, and angry enough to want to do something that no one in the New York art world could doubt was disgusting, dead and absurd. So, what could be dopier than a painting dedicated to a national cliché—Washington crossing the Delaware?" As Helen Harrison has written, this enterprise "signalled a new direction for Rivers, one that allied the emotionalism and spontaneity of Action Painting to the rationality of a carefully planned and credible narrative." But for that very reason, advanced opinion greeted *Washington* with unbridled scorn, less than two years before Jasper Johns began painting his Flags, which, once exhibited in early 1958, would throw the doors wide open to an exploding Pop repertoire of stereotypical Americana.

By this time Rivers had taken up residence in the Hamptons on Long Island, to gain breathing room for a life that Frank O'Hara, an intimate, once described as a "Bohemian household . . . of staggering complexity," composed of his former mother-in-law and frequent model, Bertha "Birdie" Burger, his son Stephen, and Joseph, his ex-wife's son by an earlier marriage. Also in orbit around the thirty-year-old painter was a rich miscellany of lovers and close friends, among whom figured not only jazz musicians and fellow artists but, most prominently, John Bernard Myers and the poets O'Hara, John Ashbery, and Kenneth Koch. Rivers painted a fragmentary, gorgeously elided portrait of the scene in *The Studio* (fig. 217), a 16-foot-long can-

vas that once again evoked Courbet but, unlike that master's *Studio* of 1855, excluded the artist. In the central position taken by Courbet himself, Rivers placed a black female dancer, whose muscular nudity anchors the frontalized, stage-box composition as it unfolds left and right. Cubism asserts itself both in the structuring grid of the background and in the multiple, "time-lapse" views of every figure, all of whom have been so fleetingly realized that they seem to dissolve even as their forms coalesce on the canvas surface. Drawing and coloring, wiping the results down with turpentine-soaked rags, and then recommencing, Rivers made no effort to disguise his process of continuous revision, declaring that his work "grows out of an abundance of dissatisfactions." Crystalline details, sweeping erasures, and pure painterly brio float in alternating order across the canvas, making it both light and alive, focused and yet unfocused, the jazzy, melodious ambiguity of it all intended frankly to save both the artist and his audience from the ennui of literalness. Such virtuoso indifference to finish invites the viewer to become involved in—actually to complete—the artist's decision-making. In 1961 Rivers, with a characteristic mix of bravado and self-mockery, said: "I thought of a picture as a surface the eye travels over in order to find delicacies to munch on: sated, it moves on to the next part in whatever order it wishes. A smorgasbord of the recognizable, and if being the chef is no particular thrill, it was as much as I could cook up."

Finally, it was just this cooking up that set Rivers apart from both his predecessors, the Abstract Expressionists, and his contemporaries, the Pop artists. For while he responded to external stimuli as would Andy Warhol, Roy Lichtenstein, and James Rosenquist—that is, with Dadaesque disregard for the orthodox requirements of fine art—he did so in a subjective manner of almost Abstract Expressionist intensity. In fact, the artist thought of his creative activity as a kind of exorcism. Possessed of a jazz musician's mercurial quickness and spontaneity, the easily bored Rivers often abandoned both subjects and processes just as he had mastered them. With Pop-like openness, he would move into such vernacular imagery as cigar boxes, *Life* photographs, and images labeled as in foreign-language textbooks, working them up in relief constructions, lithographs, video, or cast, carved, even assembled sculpture. Along the way, however, he also continued to evince a nostalgic identity with tradition—with Géricault, Delacroix, Rembrandt, with Russian and Jewish history—and the medium could be play acting, collaboration with poets, lectures, teaching, or symposia. Always, however, Rivers remained the sensuous and rather flamboyant adventurer—a "hard-core picaresque," as Grace Glueck unforgettably put it—whose genius manifested itself most consistently in fusing perception and invention, fluent draftsmanship, delicious color, and painterly vitality in a single complex image within the two-dimensional confines of the picture plane. As for the special quality of that surface, de Kooning once said that looking at it was "like pressing your face in wet grass," while a critic for Brit-

ain's *Manchester Guardian* cited Rivers' "portraits of cigarette packages [painted] with the serious grace of a Tiepolo." And when confronted with the choice between abstraction and representation, Rivers quite simply abjured it, saying: "I want to emphasize that this is a false choice between simple, homey interest in things, and worldly, *bad* overemphasis on surface and style. Do not make it easy for yourself: not only doesn't the choice exist, you aren't even in a position to choose. And the other wide happy highway to visual glory, abstract painting, is still another oversimplification of choice. Better we get rid of these dead bodies; perhaps we can resurrect something with a nastier, but more precise, quality of meat on it."

If by 1963, more than a decade after his first one-man exhibition, Robert Rauschenberg (1925—) could be called, as one London critic did, "the most important American artist since Jackson Pollock," it was because this young master, earlier and more decisively than anyone else, "broke the ice" for the sixties generation, just as de Kooning said Pollock had done for the Abstract Expressionists. Like Pollock, moreover, Rauschenberg became the chief catalyst of his artistic moment by refusing to emulate anyone, least of all the elders of the New York School, whose achievement he would not imitate out of fear of insulting what he actually held in reverent awe. Thus, Rauschenberg's greatness derived not from rebellion, but rather from a zestful, sensuous desire to test the outer limits of art still more radically than his illustrious predecessors had. He even used their improvisatory techniques, not however for the purpose of transcending the real world but rather to annex as much of it as the chance encounters of time and place offered him. Far from appalled by the postwar scene, Rauschenberg found its accumulating glut of vivid graphics and vulgar objects almost erotically seductive, especially when used, discarded, and somewhat decayed. "There is no poor subject," he declared. "A pair of socks is no less suitable to make a painting than wood, nails, turpentine, oil and fabric." Open to every possibility, including his own virtuoso command of Action Painting's spill and spatter, as long as it remained "surprising" or "unfamiliar" to him, Rauschenberg sought to express not so much his inner life and personal taste as the ebullient delight he took in "collaborating" with whatever environment moved him to work creatively. Yet more than the Abstract Expressionists, he found his identity through process. In the great "combine" paintings of 1954–62, however, the process his appropriating instincts required was less the noble, unifying medium of liquid color, which he actually exploited to brilliant effect, than the collage or assemblage technique originated by Picasso in 1912 and further developed by every new movement thereafter (fig. 218). Never before Rauschenberg, though, had anyone made "multiplicity, variation, and inclusion" the themes of monumental painting by assembling junk-jammed congeries of such ready-mades or found materials as cardboard cartons, striped barrier-poles, sea-tar, mangy stuffed animals, broken umbrellas, worn-slick tires, shaving mirrors, old post-

opposite: 216.
Larry Rivers.
Washington Crossing the Delaware. 1953.
Oil on canvas,
6'11⅜" × 9'3⅜".
Museum of Modern Art, New York.

right: 217.
Larry Rivers.
The Studio. 1956.
Oil on canvas,
6'10" × 16'1".
Minneapolis Institute of Arts.

cards. Nor had anyone left such life-size and incongruous salvage so unmodified, other than by juxtaposition and savory touches of de Kooning-like brushwork. Instead of transforming or refining his "pedestrian" givens—as Picasso, Paolozzi, and David Smith did by coloring or bronze-casting them—Rauschenberg preferred the Cagean aesthetic of allowing the concrete world to be reported in all its wondrous, self-regenerating disorder. The artist, in his most famous statement, has been quoted as saying that "painting relates to both art and life. Neither can be made (I try to act in the gap between the two)." Rejecting the heroic ego, while expanding the heroic scale, that had been an integral part of Abstract Expressionism, Rauschenberg endeavored simply to work with, not impose an alien or superior order upon, the antic chaos he harvested from all about him. In the end, however, he created a poetry of rubbish, revealing it through his powerful sense of design, a grasp of form so unerring that it could hold the most disparate images and objects in tension, yet allow each to assert its own particular freshness and vitality. Thanks to the bravura sureness of his balances, this "aesthetic tightrope walker" could exploit the ambiguity of meaning generated by commingled painterly illusionism and concrete reality, while also reveling in the visual delight afforded by jumpy, to-and-fro shifts between color and texture, rawness and refinement, beauty and ugliness. Although relatively indifferent to the big ideas of Art and Life, Rauschenberg broke so much new ground within the "gap" between them that he prepared the way not only for Pop Art but also for such continuing offshoots as Conceptual, Performance, and Earth or Environmental Art.

This "protean genius," as Robert Rosenblum characterized Rauschenberg, was born and reared in Port Arthur, Texas, a steamy oil-refining town on the Gulf of Mexico where art meant the comics or gaudy chromo-litho holy cards tacked to the living-room wall. A shy-rebellious misfit who "excelled in poor grades," loved school plays, and drew constantly, young Rauschenberg did not see an original oil painting until wartime service in the US Navy took him to southern California. There he stumbled into the Huntington Library and experienced a revelation upon beholding three grandly formal 18th-century portraits by England's Thomas Gainsborough, Joshua Reynolds, and Thomas Lawrence. Suddenly it occurred to him, for the first time, that the quick portrait sketches with which he had been amusing his fellow recruits might involve something that could be done for a living. Discharged in 1945, Rauschenberg took advantage of the GI Bill to enroll in the Kansas City Art Institute, but by 1947 he was in Paris for a brief period of unrewarding study at the Académie Julian. In 1948 he returned home with an equally disenchanted fellow

student, Susan Weill, his future wife and the mother of his only son. Inspired by an article in *Time* magazine about Josef Albers, the pair soon left for Black Mountain College in North Carolina, where the great Bauhaus master of geometric abstraction was teaching. Although Albers deplored Rauschenberg's exuberant, liberated approach to art, he left the student grateful for having been taught discipline and thus saved from the dead end of self-indulgence. But though Rauschenberg accepted Albers' teaching about how to know the true nature of *matière*—not only charcoal, watercolor, and oil but also newspaper, straw, leaves, stones, old tin cans, bicycle wheels, string, or wire—he nonetheless rejected the purpose of this knowledge, which was to exert a kind of formal control totally at odds with the freedom so instinct to Rauschenberg. Reinforcement of that freedom came later in 1949, when the young artist arrived in New York, just as trendy teachers and students were beginning to fling or trowel paint in the manner of Pollock and de Kooning. While studying at the Art Students League and getting to know senior members of the New York School, Rauschenberg and his wife had so little money for art supplies that they started experimenting with wide sheets of blueprint photographic paper costing only one dollar each. In what was an early instance of collaboration that Rauschenberg has ever since cultivated—not only with another artist but also with "available" materials—one member of the duo would lie nude on a sheet of the paper while the other scanned the entire field with a portable sun lamp. The ghostly negative image this yielded, once the paper had been developed, made the process seem like painting with light (fig. 219). Moreover, it involved just enough risk and surprise to satisfy the need Rauschenberg felt to discover his own approach, applying Albers' analytical techniques while also eschewing the German master's notions of order and domination.

Impressed by such independence, Betty Parsons, the most courageous of the dealers showing the Abstract Expressionists, offered Rauschenberg an exhibition after the young artist approached her with a selection of his recent paintings. Parsons saw still more independence when the show opened with works totally unlike those she and Clyfford Still had selected for the May 1951 event. Characterized by one critic as "large-scale, usually white-grounded canvases naïvely inscribed with a wavery and whimsical geometry," and by another as made with "bits of looking glass, stylish doodles in black and white, and liberal helpings of silver paint," the series found no buyers and later would almost entirely disappear in a fire. Within the same season that Parsons exhibited Pollock's *Lavender Mist* and *Autumn Rhythm* and de Kooning's "finished" *Excavation*, Rauschenberg, as the

dealer remarked, clearly "was on his own tangent" and not "influenced by anyone else or in the school of anything."

In the spring of 1951 Rauschenberg also met John Cage for the first time, thereupon establishing one of the most fruitful relationships in late-modern art. It would unfold not only in New York but also at Black Mountain College as well as on tour with Merce Cunningham's dance company all over the world. So closely did Rauschenberg become attuned to the aleatory composer's detached, ironic, yet affirmative belief in art as an ongoing, participatory process of discovery that Cage could say: " . . . there have been times, for example on a lecture platform when Bob was answering questions from the audience, that I've had the feeling I would have given the same answer, in almost the same words." Encouraged by Cage, Rauschenberg began to rid his canvases of everything that could be construed as subjective choice, gradually reducing his palette until it consisted of nothing but white. Albers believed, Rauschenberg said, "that if you thought one color was better than another, you were just expressing a personal preference. I really didn't trust my own taste, and I didn't want to do something that I knew would be just a personal preference of mine. I didn't want color to serve me, in other words—didn't want to use green to intensify red, because that would have meant subordinating green." Thus, for one group of paintings Rauschenberg used red lead, knowing that the color would change—escape his control—once it had been applied. For the famous "White Paintings" of 1951, the artist rolled ordinary house enamel onto a set of identical canvas panels, some of which he joined to make works measuring as long as 9 feet (fig. 220). Because Rauschenberg knew the commercial medium would yellow, and was prepared to have others (including Brice Marden) repaint the panels stark white, the totally image-free paintings may be seen as an early manifestation of not only Minimalism but also neo-Dadaist Conceptualism, both of which would develop in the course of the 1960s. However, Cage called the White Paintings "airports for lights, shadows, and particles," meaning that their emptiness, as the artist intended, was actually illusory, since reflections from the outside world filled the art with moving life. Here already were certain essential elements that would remain constant throughout Rauschenberg's prolific and richly varied oeuvre: the shadowy or veiled character of the reflected imagery, the interaction of an Albers-taught discipline with the accidents of environment, and, most important of all, paradox, which in this instance takes the form of a void that can never be truly empty.

In 1952, Rauschenberg figured prominently in John Cage's *Theater Piece #1*, a now-legendary "Event" staged at Black Mountain College during a summer when the likes of Merce Cunningham, Buckminster Fuller, Robert Motherwell, Franz Kline, Jack Tworkov, Cy Twombly, the pianist David Tudor, and the poets Charles and Mary Caroline Richards were in residence. Many of these stellar avant-gardists joined with Cage and Cunningham in an experimental theatrical work meant to expand upon the established Cage–Cunningham collaboration, which normally occurred only in performance after music and choreography had been created independently of one another. This time, however, the piece would involve a number of non-connected activities unfolding within the same time frame. While Cage stood on a ladder delivering a lecture, his score was being played by Tudor, as Cunningham danced around the audience, followed by a small dog, and the two poets read their verses. Rauschenberg contributed by playing scratchy old phonograph records on a horned Victrola, simultaneously that movies and still photographs were being projected on his White Paintings suspended from the rafters. The Event would enter history as the first of numerous multimedia spectacles, happenings, and other performances put on by artists during the late 1950s and early 1960s.

In 1953, following separation from his wife and a sojourn in Europe with Cy Twombly, Rauschenberg entered a period of extreme economic poverty that soon developed into the richest artistic phase of his career. By the end of 1954, while living as a pioneer loft-dweller in Lower Manhattan, he had shown his White Paintings at the Stable Gallery, become the regular designer for the Merce Cunningham and Dance Company, exhibited a "grass painting" made with seeded earth that grew when watered, notoriously erased a drawing by Willem de Kooning, and in a series of "Red Paintings" created his first masterpieces. All of it combined to make him the generally dismissed *enfant terrible* of the New York School, but nothing contributed to his reputation more than the de Kooning piece. Having found the Dutch master friendly and supportive, Rauschenberg so idolized him that he once stole a drawing from his mentor's wastebasket. Still more daring, he paid de Kooning the somewhat Dada, or perhaps Freudian, tribute of asking him for a drawing so that he, Rauschenberg, could erase it! Once again, the purpose was to explore yet another outer boundary of art, where it might even be possible to make a drawing with an eraser instead of a marking instrument. "I had to start with something that was a hundred per cent art, which mine might not be," Rauschenberg said, "but his work was definitely art. . . . I couldn't use the drawing I'd stolen from him, because the process required his cooperation." The dismayed but finally agreeable de Kooning gave his "collaborator" a sheet so thoroughly worked, "done with a hard line, and also with grease pencil, and ink, and heavy crayon," that it took a month and forty erasers before Rauschenberg realized the ghostly and quite exquisite residue that he framed in gold leaf and titled *Erased de Kooning Drawing*. "I felt it was a legitimate work of art," he concluded, "created by the technique of erasing. So the problem was solved, and I didn't have to do it again."

Incapable of either imitating or repeating, Rauschenberg soon moved beyond the monochromy of his White Paintings—as well as that of his Black Paintings (summer 1952), works notable for their rumpled surfaces collaged from torn newsprint soaked in tarry black medium—into brilliant, red-dominated chromaticism. Now he would paint with a bravura energy worthy of de Kooning himself but in an additive context foreign to the fluid unities of Abstract Expressionist holism. The culminating work among the Red Paintings, first seen in late 1954, was *Charlene* (fig. 218), a canvas marked by what Calvin Tomkins has called "a great, circus-like variety of collage elements—a sort of summation of [the artist's] ideas, images, and techniques up to that point." It was as if early restraint had to be counterbalanced by elaboration, always however with nuance and refinement, even when image-packed and flamboyantly coloristic. For *Charlene* Rauschenberg assembled not only newsprint but, in addition, a whole "palette" of collage materials and objects, an inventory that includes personal and family photographs, reproductions like those

once found on parlor walls in Port Arthur, patches of gingham and lace, an old umbrella opened and spread out like a spoked wheel. Although wildly heterogeneous, the collection overall seems redolent with nostalgia for a rapidly receding childhood spent on a rainy southern coast, a place full of heat, humidity, and ''bad'' taste, thus all the more the seedbed of an explosive but discriminating talent. Nostalgia can also be sensed in the rectilinear, frontalized structure, whose loosely painted, surface-adhering planes of red, yellow, and green, like the whole, vigorously activated grid mosaic of found images and discrete color planes, recall Albers' purified geometries, only for them to be undermined by the sheer vigor and freedom of the artist's glittering facture. In this rough yet ravishing disquisition on the poetics of trivia, high Abstract Expressionist painting has been accorded equality—neither more nor less—with the accumulated artifacts of one person's experience, thereby making art and life seem interlocked as never before.

It was for works like *Charlene*, and the still more adventurous ones that would follow in the years 1955–64, that Rauschenberg coined the term ''combine painting.'' With this he once again placed himself in the ''gap,'' the locus of his eager attempts to achieve a tense equivocation between what lay on either side—fact and fiction, delicacy and daring, innocence and sophistication. After *Charlene*, however, the artist abandoned the familiar terrain of his personal past and turned to his insistent personal present, the gritty, waste-strewn, media-dominated urbanscape of New York. Like the ''new historians'' of more recent times, Rauschenberg had discovered that societies reveal themselves as much in what they throw away as in their overt statements of higher culture. In a major three-panel combine with the clue-like title *Rebus* (fig. 221), he issued a virtual screed on how the language of junk can be made to divulge its secrets, at least to an imaginative interpreter like Rauschenberg. Although John Cage insisted that his friend's images have no special or precise meaning, others more intent upon ''reading'' the great combine works have been rewarded with narrative messages of philosophical substance emanating from what Charles Stuckey termed ''the resonances between the images.'' Calling Rauschenberg ''a superb ironist'' in whose art we find ''what we do not at first expect,'' Stuckey has proved spectacularly successful in decoding *Rebus* as ''one of the most extravagant visual-verbal diagrams in the history of art.'' True to its title, *Rebus* would indeed seem to be a riddle wherein words or sounds and images constitute experiences that can be approached only through one another, a ''veiled'' process like those utilized in the shadowy reflections of the Blueprint and White paintings, or in the gauze Rauschenberg stretched over the pictures collaged to the lower half of the work seen here. Reading from left to right, Stuckey took account of the torn poster printed with THAT REPRE, and then related it to the adjacent photograph of two runners superimposed on a second copy of the first poster, a situation suggesting ''twos'' and thus ''deuces'' with its sound like ''duces.'' Together the ''resonances'' between the letters and figures of the first images yield ''That reproduces.'' Thereafter Stuckey systematically combined syllables and sound- or word-evoking colors and iconography until—straight across the painting's chain of posters, comics, magazine photos, art reproductions, pieces of cloth, etc., interlinked by latherings of free, gestural painting—he had scanned the following sentence fragment: ''That reproduces sundry cases of childish and comic coincidences to be read by eyes opened finally to a pattern of abstract problems.'' Well beyond this, however, the painting contains numerous plays within plays, such as the black and white runners who in their pairing denote two different races engaged in a common race, a race quite unlike the one being run by the political candidate promoted in the ripped campaign poster. Overall, the reverberating visual/verbal sport in *Rebus*, Stuckey concluded, ''force[s] an awareness of how we see, by making us share the tangents and confusions, childish, comic, and coincidental ones, which [Rauschenberg] himself endured while facing the abstract problems of making art.''

Rauschenberg began, he said, by wanting to realize ''a concentration'' of the particular part of Lower Manhattan where he found him-

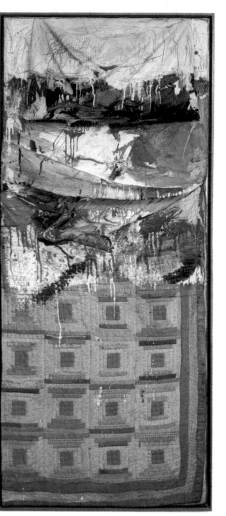

opposite: 221.
Robert Rauschenberg.
Rebus. 1955. Oil, pencil,
paper, fabric on canvas;
8' × 10'10½" × 1¾".
Collection
Hans Thulin, Sweden.

right: 222.
Robert Rauschenberg.
Bed. 1955. Oil and pencil
on pillow, quilt,
and sheet; lifesize.
Collection Mr. and Mrs.
Leo Castelli, New York.

far right: 223.
Robert Rauschenberg.
Monogram. 1955–59.
Freestanding combine,
3'6" × 5'4" × 5'4".
Moderna Museet,
Stockholm.

saw Duchamp's wheel on a stool in the same room with Brancusi, and I didn't know which I thought was more beautiful." Here was the very kind of sensuous, aesthetic response that prompted Duchamp to retort: "I threw the *urinoir* into their faces, and now they come and admire it for its beauty." Yet Rauschenberg, despite his affirmative rather than iconoclastic stance, generated quite as much scandal as Duchamp's first ready-mades when, in 1958, he showed *Bed*, a combine created after the artist ran out of canvas and spontaneously decided to substitute the bedding from his own cot (fig. 222). The work confused, outraged, and challenged viewers, for the very good reason that while stretched, painted over, and hung on the wall like a picture, the image is unmistakably that of a life-size bed, moreover a bed whose pillow, sheet, and turned-back blanket still bear the impress—the ghost—of the body that once slept in it. In addition, the red-dominated paint dribbled over the patchwork quilt's own found colors and patterns seems to transform the bed into a lurid, Bacon-like scene of sadomasochistic mayhem (fig. 140). Compounding the irony, a perplexed Rauschenberg responded by saying: "I think of *Bed* as one of the friendliest pictures I've ever painted. My fear has always been that someone would want to crawl into it."

If anything further were needed, Rauschenberg sealed his reputation as an *enfant terrible* with *Monogram*, which he began in 1955 but finished, after several versions, only in 1959 (fig. 223). Now he reversed the situation in *Bed* and placed on the horizontal what would

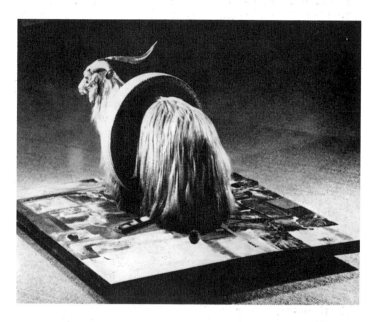

self during the particular week in 1955 when he created *Rebus*. Thus, the materials collaged into the painting were things he happened to find lying about his studio or picked up in the neighborhood. The outside haul netted several cans of unlabeled paint, purchased because they cost less and also permitted the artist to rely on their chance contents, rather than personal choice, for the makeup of his palette. Little wonder, therefore, that the picture resembles a weathered city wall, a surface pasted over with ads and posters of diverse origin and age, heightened by ragged, graffiti-like slashes of what the artist called "pedestrian color." But if Rauschenberg believed, as he said, that "a picture is more like the real world when it's made out of the real world," he also felt, conversely, that "there's no reason not to consider the world as one gigantic painting." And so he worked accordingly, collaborating with his found or ready-made colors to make certain they march across the canvas as an aesthetically coherent ordering of the primaries blue, yellow, and red, loosely coordinated not only with the appliqués of dyed fabric but also with the division of space into three vertical zones. Meanwhile, the string of color samples, acquired along with the unmarked tins of paint, also partakes, despite its mechanical sequence, of the larger chromatic subtleties already noted. Furthermore, they echo Duchamp's *Tu m'*, the grandfather of the very kind of visual/verbal conundrum and combine painting that Rauschenberg brought to climax in works like *Rebus*.

Clearly, the paradoxical spirit of Marcel Duchamp found vibrant new life in Rauschenberg's art, although a direct relationship between the old French Dadaist and his American heir did not develop until 1959. Even then, however, their warm, mutual regard could not resolve the profound positive/negative differences that make it impossible for Rauschenberg or his Pop contemporaries to be labeled "neo-Dadaist." About his first encounter with Dada, Rauschenberg said: "I

normally hang on the wall, a relatively legitimate Abstract Expressionist painting, this one however transformed into a "flatbed" surface or "pasture" for a stuffed Angora goat with an old tire looped about its midsection. The work very quickly became the artist's most famous creation, seizing and holding imaginations everywhere, not only because of its thrillingly abrupt interpenetration of art and non-art, painting and sculpture, but also because of the prankish pun sensed lurking in the animal and wheel monographically interlaced in a way confirmed by the title. And once again, enigma solicits decipherment, which the critic Robert Hughes has provided by referring to the biography of the artist, who had suffered a childhood trauma when his father destroyed a pet goat. Thus the beast in *Monogram*, like the numerous stuffed fauna incorporated whole into Rauschenberg's combines, becomes "a mute emissary from Eden—a survivor of Nature in a flood of Culture, an innocent witness to events before the Fall." Even more to the point of the work's enduring power to startle and intrigue may be the paradox of "innocent witness" that also survives as a symbol of the sexual nature of those prelapsarian doings, given that the ram can only be seen as an age-old signifier of rampant

priapic energy. Here, however, he is plugged, thereby becoming all the more highly charged, but also self-deprecating, even hilarious, as an observation on the vicissitudes of lechery, the kind of sly reference so often found seeded throughout the oeuvre of not only Duchamp but Picasso as well.

From 1954 until 1962, both Rauschenberg and Jasper Johns experienced what may have been the most audaciously creative period for each of them, all the while "so attuned to one another," as Ileana Sonnabend once said, "that sometimes it was hard to tell who was who." But if their closeness recalled that of Picasso and Braque in 1909–14, when these early modernists created Cubism while collaborating "like two mountaineers roped together," Rauschenberg and Johns exploited intimacy as a means of making certain that artistically they remained as independent of one another as their totally different sensibilities. In the practical matter of earning a living, however, they blended into the single personality of "Matson Jones," the pseudonym under which they designed a long series of famously trompe-l'oeil display windows for Tiffany and Bonwit Teller, two of the poshest stores on New York's Fifth Avenue. Meanwhile, in the early

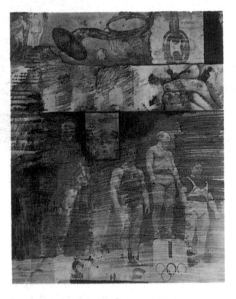

left: 224.
Robert Rauschenberg.
Canto XXXI,
from Thirty-Four
Illustrations
for Dante's *Inferno*.
1959–60. Red and
graphite pencil,
gouache, and transfer
on paper; 14½ × 11½".
Museum of Modern Art,
New York
(given anonymously).

right: 225.
Robert Rauschenberg.
Persimmon. 1964.
Oil and silkscreen
on canvas, 5'6" × 4'2".
Collection Mr. and Mrs.
Leo Castelli, New York.

spring of 1958, Johns and Rauschenberg also tailed one another into the recently opened Castelli Gallery, there making sensational debuts in solo exhibitions that marked the end of Abstract Expressionism's hegemony over the New York School. Though Johns' almost unqualified critical reception and the usual *succès de scandale* accorded Rauschenberg simply underscored the sharply divergent character of their work, the extrovert Rauschenberg did move, at least for a year beginning in late 1958, towards the more concentrated, reflective approach of his friend. This was for a series of thirty-four drawings illustrating Dante's *Inferno*, a project completed in large part while the artist remained isolated like an anchorite monk in a Florida shack. What drove him was the hope of producing a masterwork strong enough to gain more serious attention for the whole of his oeuvre, including not only the combines just examined but also, for instance, *Factum I* and *Factum II*, a pair of 1957 collage paintings so identical—down to the last drip—that they seemed to transform Abstract Expressionist spontaneity into a myth and then explode it. In the Dante cycle, which did indeed realize its full promise, becoming the first of the artist's works to be acquired by MoMA, Rauschenberg undertook to unite his love of drawing with the assemblage processes he had developed in painting (fig. 224). Here too an avid curiosity about what art could be yielded fresh departures, which now took the form of newspaper or magazine photographs offset or chemically transferred, rather than collaged, to drawing paper. To achieve this result Rauschenberg developed the labor-intensive technique of steeping the

originals in solvent, laying them face down on the paper support, and then burnishing their backs with an empty ballpoint pen. It made the imagery integral with the paper and thus produced an even surface normal in the small-scale, intimate world of drawing. Such "transfer drawings" also left a veiled, ambiguous impression, thereby allowing Rauschenberg to wring poetry from even the most pedestrian material. Further contributing to the overall silvery evanescence of the Dante drawings is the artist's freehand pencil work, which, like the passages of smutched and runneled colors in the combines, stitches the whole together in a delicately balanced pictorial structure of legible images and pure graphic invention. What it all served was a quite literal interpretation of Dante's vivid word paintings of scenes in Hell, but the language of American popular iconography, complete with politicians (Adlai Stevenson for Virgil, Nixon for one of the Violent boiling in blood), racing cars (Hell's terrible roar), handless clocks (eternity), and masked, helmeted police (torturing demons). By merely following Dante's text and plucking its visual equivalents from current photo-saturated media, Rauschenberg could collaborate with worlds outside himself, but not subject them to some personal sense of superior order.

By 1962, after eight years of making ever-larger combines, the later ones with such incongruous "givens" as ladders, electric fans, and radios (three of these in *Broadcast*, each tuned to a different station), Rauschenberg began to feel crowded by his own influence, which was luring more and more artists into assemblage. With the process threatening to replace Abstract Expressionism as the new academy, Rauschenberg decided to investigate less familiar territory. This took him wholeheartedly into the realm of the flat surface first explored in the *Inferno* drawings, a surface articulated with a collage-like concatenation of heterogeneous figurations, not however by relief-like assemblies of three-dimensional objects but rather by the more purely illusionistic device of transfer or printed imagery. However, to gain flexibility of size and ease of labor, Rauschenberg gave up the frottage technique used in the Dante project, with its newsprint

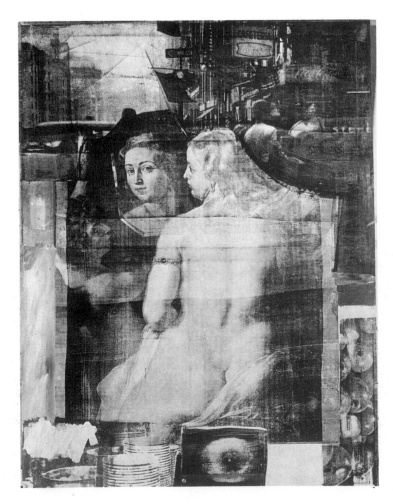

one-to-one scale and endless rubbing, and adopted commercial silk-screen, a printing process first employed for painting by Andy Warhol in 1961. Always fascinated by and even active in photography, Rauschenberg found this new access to it immensely liberating. Thanks to the photosensitive nature of the technology, he could scale ready-made imagery to any size and thus create huge silkscreen paintings, composed like collages but realized entirely with liquid color—ink or oil—on canvas (fig. 225). Moreover, the process delighted Rauschenberg by limiting the colors he could work with, thereby forcing him to collaborate with found materials instead of giving way to the self-indulgence of idiosyncratic taste. Very quickly he built up a large repertoire of templates or screens, derived from clippings but also from his own snapshots of ordinary neighborhood scenes, and used them repeatedly, though almost never in the same painting. Rather, he made different selections for each work, organized or superimposed the motifs in different relationships, and applied them with various colors as well as degrees of weight. Because enlargement accentuated the granular quality of photoengraved imagery, it gave Rauschenberg another welcome *donné*, a new version of his cherished veiling or ghosting, which he could further develop, positively or negatively, by the amount of medium squeegeed through the silkscreen. With such immaterial lightness automatically ''available'' to him, even where the subject is fully formed, the artist felt free to recultivate an agglomerated density of image first seen in *Charlene* but rarely in the combines, which had to be kept relatively spare owing to the heaviness of their three-dimensional attachments. So emancipating did silkscreen become for Rauschenberg that he found it possible to work on several gigantic canvases at once, moving from surface to surface, rolling on one squared, flattened segment of imaged reality after another, and joining as well as nuancing his myriad elements with interstitial swipes and pours of deftly free, abstract painting. Yet, in the best silkscreen paintings his powers of concentration appear never to have faltered. This can be seen in *Persimmon* (fig. 225), where the conflicting worlds of high, historical art—Rubens' *Venus at Her Toilet*—and the scenes of vernacular life surrounding it hold one another in a state of ironic tension, showing Rauschenberg in full pyrotechnical command of overall pictorial design. Furthermore, the painting can be ''read,'' at least in terms of self-reference, for Rubens too, as Lawrence Alloway has noted, was a master of extraordinary facility and international range of activity. And since the mirror Cupid offers Venus reflects the world unselectively, the majestic nude may be an impishly symbolic autoportrait by a late-modern painter who made his art an open, voluptuous receptacle for whatever the environment had to offer, splendor as well as squalor.

After 1958, when shocked officials allowed *Bed* to be shown only in a storage room at Italy's Festival of Two Worlds, Rauschenberg increasingly looked to the entire world not only for his public but also for his palette of colors and materials. While in Paris in 1961, to attend

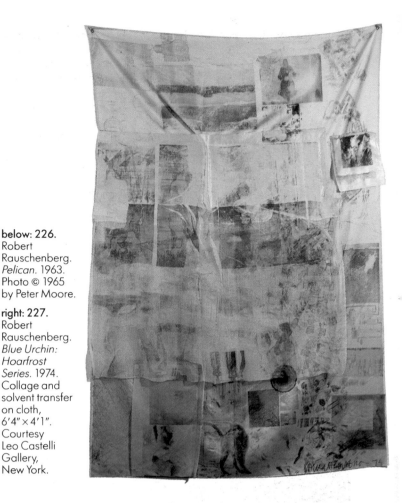

below: 226.
Robert
Rauschenberg.
Pelican. 1963.
Photo © 1965
by Peter Moore.

right: 227.
Robert
Rauschenberg.
*Blue Urchin:
Hoarfrost
Series*. 1974.
Collage and
solvent transfer
on cloth,
6'4" × 4'1".
Courtesy
Leo Castelli
Gallery,
New York.

the opening of his first show there, he improvised as usual and, to compensate for a memory failure, submitted to Iris Clert's gallery an invitational portrait in the form of a telegram that read: ''This is a portrait of Iris Clert if I say so—Robert Rauschenberg.'' Often regarded as an opening chord of the later Conceptual movement, the ''portrait'' also helped reintroduce France to the Dada wit of Marcel Duchamp, then long known in New York far better than in Paris. In 1964, when Rauschenberg became the first American to win the Grand Prize for painting at the Venice Biennale, he happened to be present for the announcement, a coincidence of his function as set, costume, and lighting designer for Merce Cunningham and Dance Company during its world tour. Not only did involvement with this group satisfy Rauschenberg's love of collaboration, it also permitted the artist to treat the stage as a very large canvas. To work on it—that is, create the sets and lighting for each gig along the way—he simply relied on his spontaneous, practical inventiveness—his innate sense of theater—to improvise from whatever he stumbled upon in the performance space or its adjacent streets and alleys. As one of the dancers said of Rauschenberg's methods: '' . . . you work with what's available, and that way the restrictions aren't limitations; they're just what you happened to be working with.'' The artist too commented on his enthusiasm for public improvisation: ''Theater remains one of the most demanding and purest forms of art. There is no separation of life and work. The individual is the medium.'' As a result, Rauschenberg also brought forth some of the first performance pieces created by a visual artist, regarding his own inadequacies in choreography and dance as just what he ''happened to be working with.'' For *Pelican* he performed on roller skates while harnessed with a vast umbrella-like ''landing gear'' and moving to his own taped collage of sounds from radio, movie, and television sources (fig. 226). Still on the prowl for bigger canvases and a broader palette, Rauschenberg in 1966 joined with the Bell Laboratories scientist Billy Klüver to form EAT (Experiments in Art and Technology), a nonprofit foundation set up ''to catalyze the in-

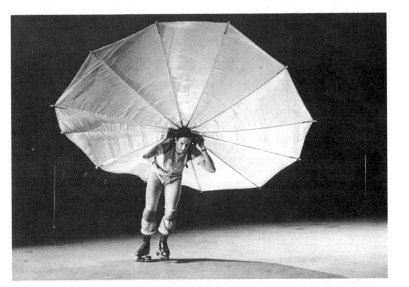

Pop Art and New Realism

evitable involvement of industry, technology, and the arts." Among the more interesting pieces to come from the artist's "participation with technicians" were *Soundings* (1968), in which lights activated by the sound of spectators' movements illuminate Plexiglas panels silkscreened with images of chairs, and *Mud Muse* (1968–71), a rectangular basin of air-injected drilling mud that bubbles in response to both gallery noises and a programmed soundtrack created by Rauschenberg and Petrie Mason.

Collaboration with science and engineering appeared to give Rauschenberg a renewed sense of simplicity more urgent than he had experienced since the White and Black paintings of the early 1950s. For the Cardboards, a series executed in 1971, the artist simply collected used cardboard containers, then spread out, ripped, and stapled them into wall-adhering forms that seem to represent nothing more than a fresh stage in the ever-changing life cycle of commonplace materials. The only "painting" or "drawing" to be found in these pulpy pieces are the printed brand names and addresses, as well as random stains or lacerations, already present when Rauschenberg appropriated the cartons for art. If time seems poignantly captured in such testaments to survival and regeneration, it also shimmers among the multiple veilings of the Hoarfrosts, a 1974–75 group of ravishingly lyrical works fashioned of transfer-printed silk, chiffon, muslin, taffeta, or cheesecloth layered and loosely hung to ripple with every passing zephyr (fig. 227). Peering into their gauzy, translucent depths, one seems to encounter a pastel, apparitional world gently afloat in an atmosphere of crystalline delicacy. Closer looking, however, reveals the irony of clear-cut but trace-like overprinting collaged from the unblinking reality of the artist's familiar image bank, presented, as Rauschenberg wrote, "in the ambiguity of freezing into focus or melting from view." With this sweet, subtle interplay of light and opacity, precision and diffusion, harshness and refinement, Rauschenberg appears to be observing, as he once did, "that everything is relative, that everything is acceptable, and that you don't have to be afraid of beauty, either." Little wonder, then, that one critic could write that Rauschenberg's retrospective exhibition in 1976–77 was "jammed with enough major works to flesh out a dozen careers," adding that the artist "is to mid-century America what Picasso was to Paris in the early years of this century."

The Braque of a mid-century America claiming Rauschenberg as its Picasso would have to be Jasper Johns (1930—), the slightly younger artist who during the years 1955–58 joined with Rauschenberg in a "roped-together" relationship so fertile that it enabled each of them, in their common isolation, to break free of Abstract Expressionism's overwhelming influence and launch new art along paths it would explore for the next twenty years or more. However, it was in the very character of their shared adventure that Johns and Rauschenberg, unlike Braque and Picasso in the co-invention of Cubism, would produce no team or group manner, except in the window-display work they undertook for the meager living and free time it gave them to paint as they wished. Rather, they functioned, in the words of Rauschenberg, as "each other's first serious critics," reciprocally granting themselves "permission to do what we wanted," as they both sought to "move out" from Pollock and de Kooning and thus escape the trap of a major style gone stagnant in the hands of its numerous mimers. Hence, the greatest impact that Rauschenberg had on Johns may have been in persuading the latter, as he himself said, "to stop becoming, and to be an artist." But if Rauschenberg succeeded, by his courageous example, in recruiting for advanced art one of the most remarkable talents of the sixties generation, it was because progressively the two men discovered much that would draw them together. Not only did they both come from the South and endure poverty in the same Lower Manhattan loft building, they also shared a natural affinity for the ideas of John Cage and Marcel Duchamp. This, in turn, could only reinforce their coordinated search for a self-critical art based on the paradoxical interdependence of concrete reality and abstract form, thus for an ironic art coolly free of the tragic and the self-expressive,

but devoted instead to thought-provoking questions about the nature of perception and the aesthetic experience. Nevertheless, while Rauschenberg would go about this in the spontaneous, theatrical, brilliantly decisive, Picasso-like way already seen, Johns proceeded as if he were indeed Georges Braque reincarnate, a radical conservative whose bold tide-turning innovations flowed from a patient, ruthlessly logical intellect, buttressed by a technical virtuosity capable of *belle peinture* effects as stunning as those of Braque himself. And so from the very start, Rauschenberg and Johns moved inexorably towards divergent artistic poles, the one painter opening ever wider to the world at large, the other edging always deeper into himself, thus into an art of increasing closure, hermeticism, and self-reference. This could only make for enigma still more daunting than that of Rauschenberg's work, since Johns too evaded overt subjectivity by allowing formal clarity to emerge from a clever, intricate, even hide-and-seek interplay with arbitrary "givens"—images, objects, materials—plucked from the mundane realm of everyday life. As the world knows, Johns' riddling aesthetic won instant fame with the very first pictures exhibited, in 1958, by the twenty-eight-year-old artist, who had chosen to paint flags and targets for the logically contradictory reason that they were "things which are seen and not looked at" (figs. 228, 229). Meanwhile, viewers—even severe formalists—found themselves compelled to look, mesmerized as they were by a universally familiar, thus anonymous image suddenly revealed by the singularity of its having been hand-painted full-scale and presented in exact physical coincidence with the shape and flatness of the canvas supporting it. Moreover, the binder making possible this uncannily efficient congruence of illusion and reality turned out to be a painterly, encaustic surface as sumptuous and aristocratic as the subject-object was blatantly literal and banal. Undecided whether they were witnessing a representation, a pure abstraction, merely a reproduction, or perhaps all three in one, viewers confronted with such simple yet complex painting could only ponder anew the old Duchampian question: What is art? As in the case of Rauschenberg, it caused Johns to be mislabeled "neo-Dadaist." But even though the younger master drew closer to Duchamp after 1959, often making his art a cat's cradle of teasing visual/verbal puns, Johns clearly was far too sensual a being to accept the notion of art as a purely intellectual construct. For him painting and sculpture would always issue from both mental and retinal experience, from the working process as well as from cerebral calculation. And so while Rauschenberg performed his delirious balancing acts, using a carnival multiplicity of heteroclite elements, the introspective, deeply read, methodical, craftsmanly Johns quested after his own, quite different identity. "I had a feeling that I could do anything. . . . ," he said. "But if I could do anything I wanted to do, then what I wanted to do was find out what I did that other people didn't, what I was that other people weren't. . . . It was not a matter of joining a group effort, but of isolating myself from any group. I wanted to know what was helpless in my behavior—how I would behave out of necessity." Finally, Johns would create paradoxically, by contraries, declaring: "My work became a constant negation of impulses."

In becoming what "other people weren't," Johns enjoyed the advantage of being largely unburdened by a conventional art-school education. Born in Augusta, Georgia, but reared in various small South Carolina towns by one relative or another, Johns grew up without ever seeing a museum-quality picture. Still, his grandmother painted, and somehow he always knew that art would be his life. After attending the University of South Carolina for a year and a half, Johns spent six months at a commercial art school in New York City, but withdrew upon learning that he would receive a scholarship simply for reasons of hardship, despite the lack of merit the dean saw in his work. In 1954, thanks to the GI Bill earned through a year of US Army duty in Japan, Johns tried again, this time at New York's City College, but once more he dropped out, now after only one day in classes for which he felt totally unprepared. Late that year, however, half-starved and lonely in his evening job at a Marboro bookstore, Johns happened to

meet the gregarious, already-known *enfant terrible* Robert Rauschenberg, and the rest, as they say, is history. "Bob was the first person I knew who was a devoted painter, whose life was geared to painting," Johns later said. "I had never met anyone like that." Soon thereafter, Johns signaled his own whole-hearted commitment to being an artist by destroying all his work that he could lay hands on, much of which evidently consisted of boxed assemblages that might have been inspired by Schwitters or Cornell crossed with Rauschenberg. Having thus negated a wrong—that is, imitative—impulse, the artist seemed to sit for hours in his studio just thinking, or indulging his technical interests, among them the hot-wax painting medium called "encaustic" and plaster casting. Then, using the encaustic, Johns began to work, in response to a dream in which he had seen himself painting a large American flag. Already Johnsian paradox was at work, for in a wholly impersonal, truly public image discovered by chance and in an ancient but seldom used process encountered at random in a book at

paint is dry. And paint takes too long to dry. I didn't know what to do. Then someone suggested wax. It worked very well; as soon as the wax was cool I could put on another stroke, and it would not alter the first." The medium served Johns well because even hardened wax is translucent, allowing light to irradiate its heaped deposits and reveal them as the record of a sequential or continuous process. With this the artist compounded the paradox of his picture, since the crusty build-up of luminescent brushmarks endows an utterly flat and static image with a sense of both depth and movement through time. Also thanks to encaustic, such literal ironies could be complemented with the *illusion* of history and tactility contributed by the veiled presence of a newsprint ground showing through the waxy surface's translucent thickness. Before painting the flag, Johns had first collaged it to the canvas with wax-soaked strips cut from a daily periodical and assembled in a monochromatic version of the familiar red, white, and blue scheme. As in Cubist collage, newsprint—an anomalous abstract-

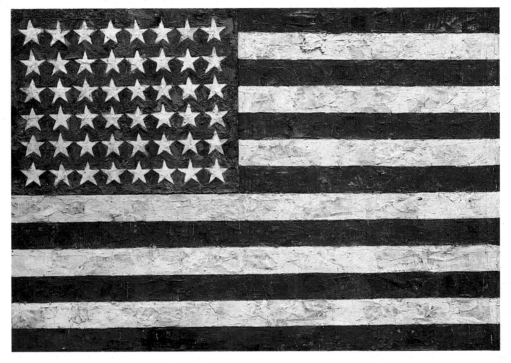

228. Jasper Johns. *Flag.* 1955. Encaustic, oil, and collage on fabric; 3'6¼" × 5'⅝". Museum of Modern Art, New York (gift of Philip Johnson in honor of Alfred Barr).

the Marboro shop, the artist found, as he said, "something that I could do that would be mine." And indeed Johns made both the American nation's ensign and a classic, Greco-Roman medium uniquely his own, first of all by taking the improbable step of combining the two (fig. 228). In this way a visual cliché was transformed into a fresh experience, the product of its having been re-presented not only with a delicately manipulated fine-art means but also with a formal rigor characteristic of the most advanced abstract painting. However, the formalism too came ready-made right along with the image, derived as this was from a concrete object structured as a two-dimensional rectangular field whose internal flat-pattern design—itself a pure geometric abstraction—eliminates every distinction between figure and ground. Further squeezing out illusionistic space is the exact overall fit between the image and the painting support, a thing made of cloth very much like that of a regular flag. But just as the expected distinction between an art object and an ordinary object becomes confused to the point of dissolution, Johns reasserted it in the sensual beauty of his brushwork, creating an eventful surface as aesthetically rewarding as those of Cézanne and Monet. Even here, though, Johns remained the lucid problem-solver. "It was very simple," he said. "I wanted to show what had gone before in a picture, and what was done after. But if you put on a heavy brushstroke in [oil] paint, and then add another stroke, the second stroke smears the first under the paint unless the

concretion like the Stars and Stripes—brought to the hermetic confines of reductive art an echo of its own past in the grimy quotidian world, as well as the purely optical "texture" generated by its chiaroscuro pattern of black lines on white paper. Yet, complex and charismatic as this layered facture may be, it is methodical and modulated, yielding a controlled, all-over touch resembling late Impressionism more than the wide-swinging, spontaneous gesturalism of the Action painters. If for no other reason than this, *Flag* would have commanded attention in the late 1950s, compelling the art world to re-examine an image constantly "seen and not looked at," for by its very sobriety the opulent substance in which the motif was embodied posed a bracingly corrective challenge to the flabby heroics of second-generation Abstract Expressionism. During the Cold War, moreover, the American pennant stood for something special, as did Abstract Expressionism, which in its triumph abroad, as well as at home, had come to seem a kind of flag-waving lesson in what wonders could be achieved by artists free of Marxist-style totalitarian control. And so when Johns allowed neither his flag nor his technique to flap loose, he created an art of such tautness and clarity that it could not but concentrate the minds of those accustomed to viewing both Old Glory and the works of the New York School as sacred objects. By fusing, or perhaps confusing, art and reality in the fresh, startling way he did, was this young unknown mocking a pair of national treasures, or, on

Pop Art and New Realism

the contrary, reinvigorating them through a process guaranteed to cause an intense reconsideration of each? Here, then, is a suggestion of what Johns meant when he said: "Using the design of the American flag took care of a great deal for me, because I didn't have to design it. So I went on to similar things like targets—things the mind already knows. That gave me room to work on other levels."

In the target Johns discovered an image even more abstract, and certainly more anonymous or universal, than the American flag since it consists merely of concentric rings, which, unlike a national ensign, can be of any color (fig. 229). But for these very reasons, plus the all-important one of its purpose, which is to be aimed at or focused upon, the target gave Johns an ideal subject, a flat, ready-made abstraction whose bull's eye had always drawn fixed attention without the total form—the outer rings—ever being noticed. The artist readily changed this—that is, demonstrated how a sign having everything to do with perception could be reperceived—by the simple act of embedding it in a continuous, uniformly delectable skin of creamy encaustic. With the dead-center focus now shifted to overall scanning and with a functional object thus converted to an aesthetic one, Johns had liberated himself "to work on other levels." As a clue to his method of going about this, he once noted in his sketchbook:

> Take an object.
> Do something to it
> Do something else to it
> " " " " "

And so having appropriated the target and aestheticized it for the work seen here, Johns proceeded to install atop the painting's upper edge a row of small cubicle-like boxes with hinged drop-doors, each containing the plaster cast of a different body part—a foot, a mouth with nose, a male nipple, an ear, a penis, etc. Once again, he had taken objects and done something to them, but in a way altogether at variance with that employed for the target or flag. Far from anonymous, the anatomical bits were truly personal, all but one made on the artist himself or on friends, but then turned into specimens, first by fragmentation, next by casting, and finally by dipping into paint of various monochrome colors. In *Target with Plaster Casts,* as Robert Hughes wrote, "two systems of seeing are locked in perfect mutual opposition, the sign becoming a painting and sculpture becoming a sign." Each serves to make the other more fascinating and thus "looked at," a process that may begin with the trap doors, as these stir the viewer's curiosity to renounce passive looking, come forward, and take the active, voyeuristic step of investigating one by one the secret parts concealed within. Here Johns found the ideal metaphor for his hide-and-seek approach to art and its meaning, for having denied the target its singular, concentrated focus, he restored it to the painting elsewhere. But the casts too provide so many different focal points that the dispersal of interest commences all over again, thereby equalizing or counterbalancing the two visual systems in a paradox of contending values left, significantly, to be resolved by the now-aroused viewer himself. As the critic Max Kozloff would write, Johns reduced his Flags and Targets to "merely so many abstract forms upon which social usage had conferred meaning, but which now, displaced into their new context, cease to function socially. From this tremendous insight alone have sprung the momentum of Pop Art and the huge quantities of abstraction that is emblematic in character."

Faithful to his own severe logic, Johns had scarcely entered the history of art when he abruptly abandoned the techniques, imagery, and concerns that placed him there. To explain this bold maneuver, Barbara Rose has suggested that since the audience, both informed and uninformed, had been so eager to swallow Johns' first images without questioning, the artist believed himself forced to engage in auto-criticism. Now, in a matched pair of works called *False Start* and *Jubilee* (figs. 230, 231), he replaced familiar subjects with an ambiguously disassociative combination of words and color patches, realizing them in oil rather than encaustic, while forfeiting a regular, controlled Impressionist stroke for a broader, looser system of paint-

erly flares reminiscent of once-rejected Action Painting. What remains constant, however, is the artist's pervasive irony, which slyly reveals itself in the closely interlocked, jigsaw pattern determining the all-over distribution of the superficially free color bursts. And once it becomes obvious that every hue has been misidentified by the stenciled labels, there can be little doubt that both the gestural and the color-field branches of Abstract Expressionism have been more parodied than emulated. Further, the narcissism of the style, or indeed of all art, is wittily acknowledged in the reflecting-pool, negative-positive relationship between *False Start* and *Jubilee*, which in everything but the full chromatics of the former and the black-and-white monochromy of the latter appear to be virtual duplicates of one another. Echoing Duchamp, Johns said: "There are no accidents in my work. It sometimes happens that something unexpected occurs—that paint may run—but then I see that it has happened, and I have the choice to paint it again or not. And if I don't, the appearance of that element in the painting is no accident." In *False Start* and *Jubilee* Johns would therefore seem to have been more interested in illustrating the concept of randomness and spontaneity than in actually practicing them. But by this demonstrative act he departed from Duchamp, who would have been content with the idea alone, whereas for Johns a critical notion could not really exist apart from its embodiment in a memorable work of art. For present purposes he began by saying: "The flags and targets have colors positioned in a predetermined way. I wanted to find a way to apply color so that the color would be determined by some other method." Thus, instead of relying on known objects for his form, Johns turned to another factor so familiar by then as to be "looked at and not seen"—the high, splashily applied color of late Abstract Expressionism. With this, the artist made a component of his recognizable subjct matter a subject unto itself, following a deductive process that virtually guaranteed a result as implacably abstract as the Flag, Target, and Number-Alphabet paintings. According to Johns,

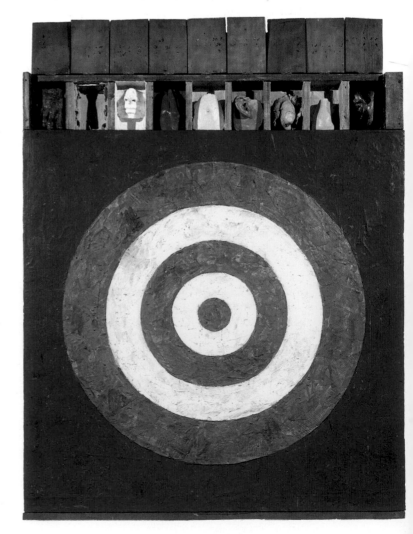

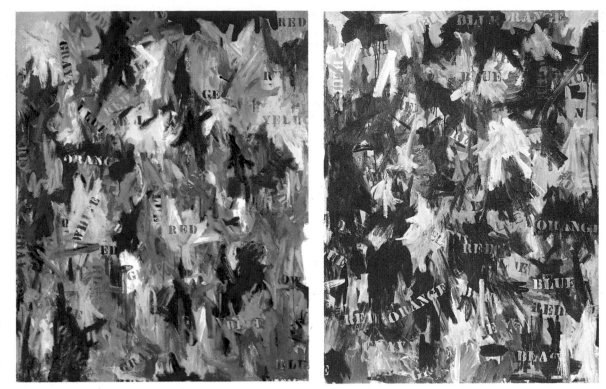

opposite: 229.
Jasper Johns. *Target
with Plaster Casts*. 1955.
Encaustic and collage
on canvas with objects,
4'3" × 3'8". Collection
Mr. and Mrs. Leo Castelli,
New York.

right: 230.
Jasper Johns.
False Start. 1959.
Oil on canvas, 5'7½" × 4'5".
Collection Mr. and Mrs.
S.I. Newhouse, Jr.,
New York.

far right: 231.
Jasper Johns. *Jubilee*.
1959. Oil and collage
on canvas, 5' × 3'8".
Collection Mr. and Mrs.
S.I. Newhouse, Jr.,
New York.

below: 232.
Jasper Johns. *Painted
Bronze (Ale Cans)*. 1960.
Painted bronze, 5½" high.
Kunstmuseum, Basel
(Ludwig Collection).

''the decisions in [*False Start*] aren't based on visual sensation primarily. The idea is that the names of color will be scattered about on the surface of the canvas and there will be blotches of color more or less on the same scale, and that one will have all the colors—but all the colors by name, more than by visual sensation.'' And so while the explosions of red, blue, and yellow appear at first glance to be as full-bodied as de Kooning's swelling masses, they in fact consist of extremely flat, unblended strokes, strokes that cling to the surface almost as stubbornly as the lettered labels stenciled thereon. Also robbing the pigments of their power to evoke volume is the odd coupling of the actual colors and the colors signaled by the labeling, a visual/verbal misalliance that mates a red WHITE with an orange lake or a blue GREEN with an island of blue. They were further disarmed by the separation of hue from value, another act of deductive analysis that made the primaries and their chiaroscuro equivalents mutually exclusive subjects divided between the brilliant *False Start* and the elegantly somber *Jubilee*. Meanwhile, all the colors—including some, like green, not among the actual pigments—have been accorded a conceptual presence in both paintings by the labels, just as Johns promised, which in turn makes the works' titles seem less perverse or contradictory than a positive contribution to enriched, paradoxical meaning. Thereafter mirror imagery would become fixed among the repertoire of devices perfected by Johns for negating impulses. It gave him a subtle means by which to reassert, following Abstract Expressionism's descent into dogmatic subjectivity, the modernist conviction that in an age of doubt the artist is at his most authentic when engaged in a distanced, dialectical process of auto-criticism and evincing it in works of self-sufficient, unresolved complexity. Commenting on the irony at the heart of Johns' enterprise; especially with regard to the mock expressionism of *False Start* and *Jubilee*, Barbara Rose has written: ''Irony is not a tool of superficial ridicule for Johns, but an essential means to emphasize his awareness that history repeats itself: his understanding that repetition is a rule rather than an exception in history, both as autobiography and as an abstract record of human events.''

Around the same time that he painted *False Start* and *Jubilee* Johns undertook a further shift from the literal flatness of his early images and began making sculpture as a way of exploring the language and literal volumes of three-dimensional reality (fig. 232).

Once again it was commonplaceness that provided the occasion, chanced upon in a casual aside about Leo Castelli. ''Somebody told me,'' Johns remembered, ''that Bill de Kooning said that you could give that son-of-a-bitch two beer cans, and he could sell them. I thought, what a wonderful idea for a sculpture.'' Working in plaster of paris, casting some parts, modeling others, recasting the whole in bronze, and then hand-painting the final form, Johns used every technique at his considerable command to create the illusion of two Ballantine Ale cans, one open and the other still inviolate, resting side by side on a slab base. Throughout, however, he remained confident that the work would ultimately disclose the process of its own creation and thus betray itself as an aesthetic object, not a manufactured one. ''Doing the ale cans,'' Johns later told Michael Crichton, ''made me see other things around me, so I did the Savarin Can. I think what interested me was the coffee can used to hold turpentine for the brushes—the idea of one thing mixed with another for a purpose'' (fig. 233). The brush-filled can also provided a more complicated subject whose variety of colors and textures demanded the very sort of technical expertise that Johns loves to cultivate. But hardly had the

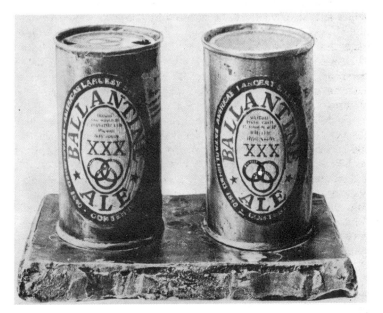

artist silvered, or "tinned," the bronze rim of his vessel than he undercut the whole panoply of illusionism by leaving a thumbprint on the oil-painted form. In what emerged as a classic studio still life rendered as a representational sculpture, Johns found so much meaning that he repeated the image in a number of different media and contexts—paintings, prints, posters—until finally this "one thing mixed with another for a purpose" became a kind of emblematic self-portrait.

At the same time that he was making sculptures, Johns had also begun to attach ordinary objects to his canvases. This new development enabled him to contrast and interrelate the realities of both the flat painting surface and three-dimensional things, the illusionism with which artists have long attempted to fill the gap in between, and the various modes of perception the three different systems entail. Since the objects chosen for incorporation were such rudimentary, ubiquitous items as cups, forks, brooms, paint brushes, or rulers, they arrived freighted with so many associations in life as to become virtually empty of specific personality, like the canvas the artist started with. Thus, meaning arises not from the sub-art appropriations but rather from the internal relationships they establish with the facts of painting and the artist's manipulations of them. Here, Johns took inspiration not only from Duchamp but also from Ludwig Wittgenstein (1889–1951), the Viennese linguistic philosopher whose writings on verbal and visual language provided the artist with specific iconography as well as intellectual constructs. Together the two European ironists form the basis of Johns' *According to What*, a large, ambitious picture of hallucinating complexity that has now been brilliantly analyzed by Barbara Rose. In this vast assembly of relationships—between words and images, the literal and the illusory, concepts and their negation—the artist paid homage to Duchamp's *Tu m'*, of 1918, while also summarizing his own work of the previous years (fig. 234). Like the enigmatic *Tu m'*, *According to What* begins with an ambiguous, inconclusive title and proceeds to embody it in painting realized as an open-ended catalogue of perceptual modes whose rivalrous interaction may pose the question but finally, like the title, leaves it unanswered. Strewn across a joined set of six tall panels, and held in suspension with a serene daring worthy of Rauschenberg, or indeed the great 19th-century salon painters, are found objects, real and trompe-l'oeil shadows, depicted images, perspectival views, reproductions, and replications, all made to cohabit and inform one another on the same flat, two-dimensional surface. Seated in a sawed-off chair hung upside down in the upper left corner is the hollow life cast or negative replica of a human leg. Added to these two different yet

paired realities are the shadow actually cast by the combine pieces and its representation in paint. Something similar occurs in the lower right half of the painting, where a real bent-back hanger casting an illusionistic shadow dangles from an ordinary wire attached to an appropriated spoon, both accompanied by their own natural shadows. The eating utensil would seem to restate what Johns himself once said: "My work feeds upon itself." Along either side of the vertical divide between the second and third panels appear RED YELLOW BLUE spelled out in hinged, three-dimensional letters and then mirrored in both shadow and paint of the relevant colors. Just beyond the third divide, the spectrum cited by the lettering marches up a vertical strip of color-filled circles overlaid with the template used to paint them. Spread across the third, fourth, and fifth panels is a narrow band of white paint silkscreen-printed with a repeated page of newsprint, whose black-and-white monochromy unfolds in a smoothly gradated value scale painted in broad, horizontal strokes the full height of the canvas. Altogether, the abstract idea of color—the product of light, the medium through which vision operates—has been represented in the conceptual form of words and then in the concrete, scientific, or analytical form of hue and value scales. Meanwhile, to the left and right, as well as in between, color remains the subject, this time in a simulated variety of Abstract Expressionism, complete with a Hofmannesque compound of gesturalism and the flat color planes of field painting (fig. 88). Once again, Johns has created a work of art as he might an object, by taking something and adding something else to it, a process clearly demonstrated in the discontinuous color scale, where blue plus yellow equals green, or violet minus blue equals red. Even the title has been added on in the lower left corner, there stenciled to the back of a small, secondary canvas reversed and hinged as if to involve the viewer in discovering what may lie concealed on the main face. The actively curious will find a silhouetted profile portrait of Duchamp himself. One can almost hear the old skeptic chortling over this world made self-sufficient by its unique, cat-and-dog mix of crossbred optical, verbal, and intellectual elements that interlock and cohere according to . . . what? The only possible answer would seem to be the genius of Jasper Johns, who, having found sensuous equivalents for a whole complex of abstract ideas and composed them with logic-defying virtuosity, stood apart from both Duchamp and his own contemporaries. Against the one he affirmed the continuing significance of painting as a vehicle of meaning, while against the other he rejected the obviousness of Pop iconography, as well as the extreme reductivism of "nonrelational" Minimalist abstraction, where the only significance lay in form. Fundamental to the meaning of *Accord-*

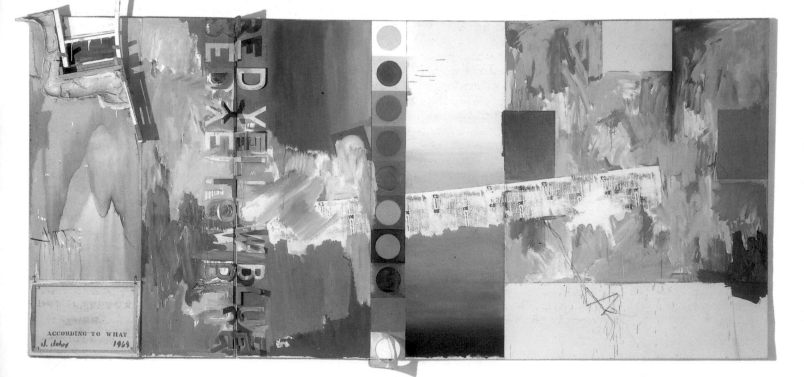

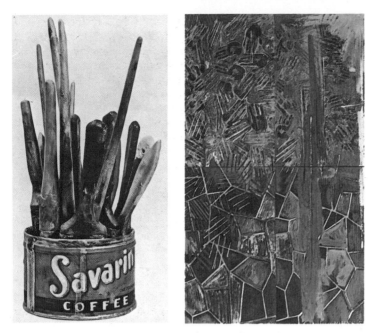

above left: **233.** Jasper Johns. *Painted Bronze (Savarin)*. 1960.
Painted bronze, 13½ × 8″ diameter. Collection the artist.

opposite: **234.** Jasper Johns. *According to What*. 1964. Oil on canvas with
objects, 7′4″ × 16′. Collection Mr. and Mrs. S.I. Newhouse, Jr., New York.

above right: **235.** Jasper Johns. *Céline*. 1978.
Oil on canvas, 7′1⅝″ × 4′¾″. Kunstmuseum, Basel.

ing to What was the occasion it provided for the kind of self-reappraisal that Johns had already experienced in 1954 and again in 1959–60. As before, this new summary work launched the artist into fresh territory filled with unexplored conceptual problems and visual ideas.

In 1967 and again in 1972 Johns happened onto fresh images so "seen and not looked at" that he could make them his own, without truly revealing himself, at the same time that their pre-established design left him free "to work on other levels." Both came in a flash, the first when the artist was traveling by taxi through Harlem en route to the airport and suddenly glimpsed an exterior wall that had been painted to resemble flagstones. The second also presented itself through the window of a speeding vehicle, this time on a Long Island highway where the artist spied an automobile painted with an all-over pattern of cross-hatching. For his purposes the images seemed perfect: not only were they real and ready-made; they also represented a kind of necessity, since whoever painted them probably did not have "to conform to anything except their own pleasure." Thus, while naïve and blandly anonymous in appearance, the flagstones and hatch marks had proved their power to be carriers of meaning. And even though their original significance could never be known by Johns' uninformed viewers, the confidence the artist had in these givens freed him to invest them with new meaning, through a process of nuancing and recontextualization. Since both of the *trouvailles* were flat, repeating patterns, such transformations would occur along with a revived Cubist-like interest in the shaped two-dimensionality of the canvas. As always, however, Johns proceeded according to his own inscrutable logic, which meant presenting the obvious in such a manner that it slyly implies a more complex experience submerged within bland, surface clarity. In *Céline* (fig. 235), for example, Johns so combined his flagstone and cross-hatch motifs that, despite their differences, they transform the painting into an intricately self-referring, self-sufficient object. Moreover, he implanted his own handprints and analogized them to the hatch marks, thereby identifying himself with the personal content he had sensed in the original pattern. With the spill of the cross-hatching into the flagstone section, the aura of self-revelation extends to the entire painting, just as it does in the long, shad

owy arm slipping through the painted masonry and into the painted tweed, or even in the mirror-like relationship between the upper and lower, as well as left and right, halves of the canvas. As a result, the complexity of surfaces like that in *Céline*, together with the unfolding experience they offer, assumes the quality of a metaphor for the human psyche and the process of unraveling it. Lest this appear rather too simple, just consider that the real mirror effect occurs only in the upper, hatch-marked zone, and there only between the narrow vertical panel on the far left and the left portion of the far right panel. The giveaway clue lies in the separation between the left and right handprints, themselves mirror images of one another. Meanwhile, the narrow panel finds a kind of mock reflection below, in the flagstones, where the two unequal parts neither match up nor image one another. However, if the viewer can imaginatively move the right panel leftward so that it overlaps the adjacent one by the measure of the upper far-left unit, the flagstone pattern becomes continuous, physically concealing a space—painting within a painting—that is no less covert even when fully exposed. And so even where relatively more involved with modernist issues, Johns has still set himself the task of fusing what in any other context would seem inimical and, for that reason, doing it through *rusé*, viewer-seducing games of discover, cover, and recover. Hence the title, which refers to Louis-Ferdinand Céline (1894–1961), the notoriously misanthropic French writer whose novels *Journey to the End of the Night* (1932) and *Death on the Installment Plan* (1936) Johns is known to have read at the time. It seems possible that a painter intent upon cloaking his emotions by creating art from things "not mine but taken," only to manipulate them until they become as personal as handprints, would identify in some way with Céline, not only for the surface beauty of his prose but also for his view of the creative faculty as virtually amoral in its driving sense of imperative. Such was the faculty, Jasper Johns would perhaps say, possessed by the inventors of his flagstone and cross-hatch designs, primitives who did not have "to conform to anything except their own pleasure."

Years ago Barbara Rose, a long-time and extremely close witness to Johns' developing oeuvre, remarked:

[Johns is] perhaps the only artist operating today in the dimension of a mental physics, that is of a true metaphysic. We infer that Johns sees no separation between decisions made in art and those made in life. His decisions have unmistakable moral implications, for he is among those artists for whom the activity on the canvas is the exemplar of his understanding of right human conduct.

By taking something and adding something else to it, Johns works as the world works; by dealing in paradox and enigma, he pictures things as they are—an ambiguous, contradictory mix of levity and seriousness, beauty and banality, intellect and sensuality, the simple and the complex, the received and the invented, history and present, onrushing time. Further, by doing this through a convoluted, hermetic maze of visual/verbal puns, permutations, and recombinations, he liberates the viewer from passive response and teases him into an active, decision-making engagement with the painting comparable to that experienced by the artist himself. Still, as Johns once said, "The problem is not doing something, the problem is knowing what one wants to do." By restating this in his self-critical art, he acknowledged the moral relativism of the age, and with it the dilemma confronting individuals and society destined to live, or die, with the consequences of their behavior, choices, and creations. What Johns has evidently wanted to do in his latest work is meditate upon the tragedy of this condition, a concern that returns him to his origins in the Abstract Expressionist era, but always in a spirit of irony and reticence quite unlike the bravura emotionalism of his esteemed predecessors.

Here, then, is the essence of Pop, which transposed into a fine-art context the most disparate of found, often non-art elements—images, objects, styles, and techniques—and, instead of resolving the incongruities, left the paradox of their chance encounter in a condition of tense dialectic. Thus relocated and confronted, the various unalike-

nesses yield an enigma that challenges every sort of preconception about their individual or joint significance. But by offering multiple possibilities of interpretation, they also engage the viewer in an open-ended critical process touching upon both art and life. Rauschenberg and Johns have long been closely associated in the history of late-modern art, but, clearly, what they shared consisted of neither manner nor motif, nor yet mood, but rather of structure, a structure created by what Umberto Eco called "transposition." As Carol Ann Mahsun has recently pointed out, such a procedure prevailed throughout Pop, albeit varied in type from artist to artist. It might involve the insertion of real objects—ready-mades—into the abstract world of oil on canvas, as in Rauschenberg's combine paintings, or the exact duplication of a familiar item like the American flag in every detail except medium, which Johns changed from dyed and sewn fabric to pigmented encaustic. In the case of Lichtenstein, it would be a matter of scaling up and subtly nuancing comic strips, or of converting their Ben Day screens into hand-painted dots. Another method was multiplication, which Warhol exploited, by means of silkscreen printing, for his grid-like arrangements of soup cans, Marilyn Monroes, highway disasters, and so forth. Most dramatic of all, perhaps, were the transpositions realized by Claes Oldenburg, who endowed hard, mechanical objects—typewriters, toilets, electric fans—with an unexpected, loony, vulnerable humanity by reconstructing them in soft, collapsible materials. Through quotation or annexation, the Pop artist could detach himself from the worlds he dealt with and become a strategist, maneuvering and manipulating his mix of found materials as if they were "pawns" and his canvas a game board.

A distancing device, transposition guaranteed a nonsubjective, "factual" art, but also an art of such irony that it even allowed for transcendence, albeit transcendence of a totally different order from the mystical flights sought by the Pollock–Rothko generation. This was the wonder or higher awareness that came from contemplating alien realms whose unprecedented collision—irrational or logic-defying associations—forced open once-closed worlds and permitted them to be known by something other than "hard facts" or old perceptions. When Lichtenstein transposed cartoons from a miniature, newspaper format to the environment of monumental oil painting, he invited viewers not only to see art in a more involved, less constricted or conventional way, but also to take account of unsuspected potential within everyday surroundings. Meanwhile, polar realities fused by means of a paradoxical structure also served as challenges to one another, which meant that Pop Art embodied and adapted to new ends modernism's principle of self-criticism. Thus, rather than accept as doctrine the emerging formalist theory that art was historically predestined to eliminate all but the essentials of its medium, Pop bound together the real and the artificial, depiction and abstraction, words and images, fine and adulterated materials. In this way it made the self-critical theory concrete and even moved beyond theory to criticize not only modernist practice but society as well. And since paradox functioned best when its irreconcilable borrowings remained relatively literal—that is, untransformed—Pop questioned received notions of uniqueness or originality, for now the creative factor had shifted from transformation or handling to the realm of idea or conception. Any skilled, perhaps factory-trained person could sew and stuff Oldenburg's giant hamburger, but only the artist foresaw the multivalent wit and satire that such sculpture would possess. If this demystified the artist and relieved the art work of its semi-divine aura, it also translated the viewer into a creator, presented as he was with paintings and sculptures whose antithetical foundation left them rich with alternative but unresolved meanings and thus accessible to diverse assessments.

For the same reason, however, only the most creative viewers got the maximum benefit from Pop, for by its very nature, paradox presents a resistant, ambiguous, contradictory situation. In the early 1960s, for instance, it escaped all save a few that Pop artists were as interested in form—even large single-image or gestalt form—as the formalists. But instead of pursuing it through the latter's aloof, elitist, self-starving purity, they cultivated the regenerative possibilities of democratically mixed modes held or unified in a state of maximum tension. Thus, while established critics dismissed Pop Art as little better than the camp, kitsch, or commercial world it drew upon, the philistine communications industry co-opted it as friendly, optimistic, and entertainingly scandalous—a welcome antidote to high-art stuffiness. As if to elude both of these extreme misperceptions, many Pop artists, as early as 1963, began setting them against one another in works exploring the "art-about-art" theme. Here, by basing their Grünewalds, Leonardos, Rubenses, Picassos, Brancusis, Mondrians, or de Koonings on printed reproductions, they enjoyed images doubly precoded or distanced—by cliché art history and by the media—only for this depleted status to be dispelled and the subjects revived through the reflexive structure or process seen everywhere else in Pop. Indeed, as Mahsun has written, "the pattern found in the art-about-art theme—the return to life, the reincarnation of the past masters—carries out the more general theme of the restoration of art to life that occurs repeatedly in Pop Art." Oldenburg, with his inimitable gift for vernacular poetry, put it this way: "I am for an art . . . that does something other than sit on its ass in a museum."

After their sensational solo exhibitions at the Castelli Gallery in early 1958, first Johns and then Rauschenberg won both avid collectors and a serious following among younger, more venturesome artists. However, Pop as a christenable development did not present itself in the United States until 1962, that *annus mirabilis* when Dine, Indiana, Lichtenstein, Oldenburg, Rosenquist, Warhol, and Wesselmann all made debuts in major New York galleries. A confirmation

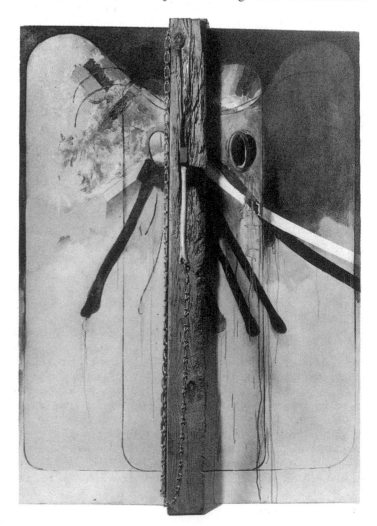

236. Jim Dine. *Hatchet with Two Palettes, State No. 2.* 1963. Oil on canvas with wood and metal, 6' × 4'8" × 1'. Harry N. Abrams Family Collection, New York.

Pop Art and New Realism

that something momentous as well as novel had occurred came in November with the Sidney Janis Gallery's "New Realism" show, which, by marshaling Pop or Pop-related works from five different countries, made it clear that Abstract Expressionism would no longer remain unrivaled in the world. The consternation this caused may be judged by the first American writing on Pop to appear in a professional art journal, whose critic, though remarkably insightful, concluded by asserting that "the art galleries are being invaded by the pin-headed and contemptible style of gum chewers, bobby soxers, and worse, delinquents." Finally, at the very end of 1962, MoMA held a symposium on the issues raised by the Janis exhibition, only for its moderator to announce that Pop's embrace of the American consumer culture demonstrated "profound cowardice." Since both critic and curator were, and are, among contemporary art's most astute observers, their initial reactions to the new trend merely testify to the challenge posed by works as deceptively simple yet revolutionary as those seen here. The formalist values then dominating informed opinion could in no way cope with an art in which conception yielded quite as much meaning as style or execution. Thus, Rivers, Johns, and Rauschenberg, with their love of pure, gestural painting, seemed sufficiently involved with Abstract Expressionism to be considered apart from the "new vulgarians." Now, of course, their mastery of transposition make them appear far more central to mainstream Pop, right along with the masters about to be discussed. Some of these—Oldenburg and Dine especially—worked in as painterly, or draftsmanly, a fashion as Rivers, Rauschenberg, and Johns, and almost none of them liked the Pop label any better than the three pathfinders.

Although among the youngest of the New York Popsters, Jim Dine remained almost as firmly attached to traditional modernist, or Abstract Expressionist, concerns as Rivers, even as he embraced Dadaesque, non-art imagery and objects in painterly combine works akin to those of Rauschenberg and Johns. Arriving in New York in 1958, classically art-educated at Ohio University, Dine, like Rivers, was a "natural" artist with a true gift for freehand rendering and vivacious brushwwork. He also came equipped with a love of the tools and fixtures he had sold in his grandfather's hardware and plumbing-supply store—hammers, saws, shovels, mowers, wrenches, sinks—all of which would become central themes in his art, reworked in countless, richly inflected variations (fig. 236). Dine also appropriated such mundane items as ties, hats, hearts, trees, and bathrobes, but never because they were merely available within the common environment. Instead, the artist took an autobiographical approach and selected things that he could use "as a vocabulary of feelings." "Pop," he explained, "is concerned with exteriors. I'm concerned with interiors." This can be seen to blunt effect in the work reproduced here, a pair of palettes joined along a central axis by a plank of rough, weathered wood driven into and split by a chained axe. In this rude image, art and life seem to have been rammed together with a brutal, rapine force, the sexual implications of their congress carried through in the juxtaposition of thumb holes and the real as well as painted shadows of the lethal hatchet's hard, phallic handle. Still, a simple poetry emerges from the rhyming concrete and illusionistic forms, as well as from the loosely feathered, smudged, and bleeding pigments. In other works, Dine complicated the punning layers of facticity and fantasy by spelling out their identities in stenciled labels echoing those introduced by Johns. But the device simply invested his relatively candid work with a straightforward wit quite unlike Rauschenberg's rebuses and the riddles of Johns. Piece by piece, however, the mood has shifted from the violence just noted to, for instance, a series of elegiac trees, another of romantic-ironic hearts, or the famous bathrobes, intimate but mysteriously empty garments that the artist frankly confesses are self-portraits.

Nobody has sensed or satirized the waste and want, the grotesqueness and grandeur of the contemporary American scene more pungently—indeed more hilariously—than Claes Oldenburg (1929—), perhaps because he brought to his task the double nature of one par-

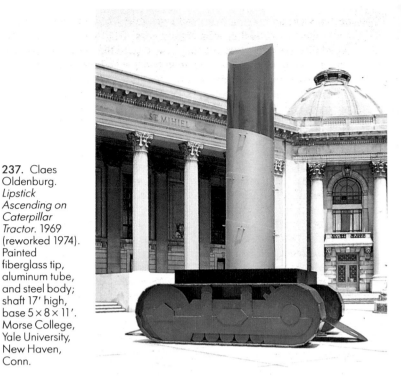

237. Claes Oldenburg. *Lipstick Ascending on Caterpillar Tractor.* 1969 (reworked 1974). Painted fiberglass tip, aluminum tube, and steel body; shaft 17' high, base 5 × 8 × 11'. Morse College, Yale University, New Haven, Conn.

tially formed abroad prior to his accidental albeit wholeheartedly willing Americanization (fig. 237). The son of a Swedish diplomat, Oldenburg was born in Oslo but spent his first three years in New York before returning with his family to Norway until 1936, the year the senior Oldenburg became Sweden's Consul in Chicago. There, uprooted and unable to speak English, the seven-year-old Claes found refuge in a fantasy life that would forever yield a wealth of material for his art. Already his was an environmental consciousness, expressed in a half-Swedish half-English tale of the imaginary country of "Neubern," whose history, geography, sociology, economics, and science the boy invented in a score of scrapbooks filled with maps, documents, lists of streets, and import-export indices. He also embellished the volumes with hundreds of colored scale drawings, many of them illustrating the airplanes, flags, and guns that would often recur in his developed oeuvre. Thus, it was more than mere facetiousness that prompted Oldenburg to assert in 1966: "Everything I do is completely original — I made it up when I was a little kid." As Barbara Rose has remarked: "Like the work that Oldenburg was to produce as a mature artist, Neubern was a parody of reality, providing a counterpart cosmos that paralleled the real world instead of imitating it." After his graduation from the Chicago Latin School, as well as from the low-life school along Rush Street's burlesque row, Oldenburg went on to Yale, where he studied literature and theater. Meanwhile, he was also converting scrapbooks into journals filled with all manner of observations and self-analysis, expressed in rhetorical styles ranging from the mock-heroic to the mock-plebeian. Only in his senior year did Oldenburg begin formal study of art history, figure drawing, and composition. Back in Chicago from 1950 to 1954, he worked as a cub reporter covering the city streets, did illustrations and even cartoons, became an American citizen, attended art classes at the Art Institute, and met a number of local artists, among them Leon Golub, H.C. Westermann, and Robert Indiana.

In June 1956 Oldenburg arrived in New York, an impecunious newcomer who soon found himself lodged in a Lower East Side store front and employed at the library of the nearby Cooper Union Museum and Art School. Inspired by this institution's treasure trove of facsimile master drawings, Oldenburg began loading his sketchbook with quick studies of the ambient slum life in all its vitality and raw excitement. Within this context he met Allan Kaprow, Red Grooms, Robert Whitman, Lucas Samaras, George Segal, Tom Wesselmann,

and Jim Dine, all of whom were captivated by Kaprow's ideas about Happenings as a logical way of extending Pollock's environmental painting into actual space and time. Since the whole issue of Happenings, whether by Oldenburg or others, is to be examined elsewhere, let it suffice here to say that these multimedia performance events epitomized the atmosphere of intellectual ferment and aesthetic frontiersmanship generated by younger artists who around 1960 were seeking to break through the impasse posed by late Abstract Expressionism. On his own, Oldenburg also proved symptomatic as he used Freudian free-association to launch upon a campaign of rigorous analysis involving not only his own psychology, talents, and limitations, but also the main lines of American thought and the history of modern art. In notebook after notebook he developed what became the seedbed for virtually every idea that would subsequently emerge in his sculpture, drawing, theater, graphics, and film. Torn by conflicting urges—towards, on the one hand, a traditional kind of art committed, like that of Rembrandt, Goya, Daumier, and Picasso, to universal statements about the human condition and, on the other, towards modernist radicalism of the most advanced sort—Oldenburg decided to aim for an art in which paradox and its precarious resolution would be central. Now analysis became catharsis as he strove to distill from the social and artistic milieu as well as from his own obsessive sensuality a single synthetic form into which all his resources could be funneled. For Oldenburg, however, form gained significance only insofar as it flowed from and fed back into life. This meant that he would always remain, to one degree or another, a figurative artist, an artist intent upon making modernism a vehicle for conveying, in its essence, a content as chaotic and irrational, as complex, organic, and changeable as nature and its human inhabitants. Ultimately, he would start with commonplace objects and then so re-imagine or metamorphose them that they come to possess a double or even a multiple identity as items familiar to everyone, as abstract forms, and as something totally or comically unexpected, such as a giant lipstick that, once erected on a tractor bed, resembles a phallic, red-tipped warhead (fig. 237).

Like classic high comedy, Oldenburg's mature art offered laughter as a way of venting the sorrows of tragic experience, which the artist saw all about him in the Lower East Side's demimonde of littered streets and crumbling tenements teeming with bag ladies, Bowery bums, bohemians, petty criminals, and other varieties of poor or outcast humanity. Indeed, it was more pessimism than humor that prevailed in the first major work created by Oldenburg. Called *The Street*, this was a gallery environment designed in 1954 as a pendant to *The House*, a thematically related piece by Jim Dine. Appropriately enough, Oldenburg fashioned it almost entirely from materials found in the street—string, rope, scraps of burlap and corrugated or plain cardboard (fig. 238). Further, he employed such street techniques as bending, tearing, or fraying in order to shape and construct a whole population of flat, jagged silhouettes variously charred at the edges, brown in color, battered in texture, and ephemeral-looking, like the tatterdemalion slum-dwellers who had inspired them. But he also drew, as well as painted, in a *faux naïf* manner reminiscent of Klee and Dubuffet, reinforcing the effect with phrases and labels graffiti-scrawled in cartoon balloons. As for humor, Oldenburg clearly preferred something black, providing commentary on city life as mordantly ironic or even macabre as the gritty vision evoked by Céline's *Death on the Installment Plan*, which the artist had in fact been reading. However, the humor lightened somewhat, and thus forecast the future, in the character of Ray Gun, whom Oldenburg first introduced in *The Street* as emblematic alter ego for himself. At first Ray Gun merely pinned random notes to the bulletin board at the Judson Gallery during the exhibition of *The Street*, reminding himself, for instance, to "look for beauty where it is not to be found," or, prophetically, "to make hostile objects human." Then came "Ray Gun Poems," "More Ray Gun Poems," "Spicy Ray Gun," and finally, "Ray Gun Spex," a series of six group performances or Happenings staged at the Judson Gallery in early 1960. A person as well

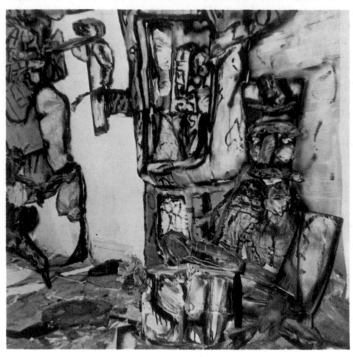

238. Claes Oldenburg. *The Street*. 1960. Environmental installation at the Judson Gallery, Judson Memorial Church, New York.

as an object with both sinister and comic-strip associations, Ray Gun spoke for Oldenburg's desire to create three-dimensional works with a multiple identity. When expressed in relation to American culture, this double persona—a tragic clown like Pagliaccio, Pierrot, or one of Beckett's or Céline's anti-heroes—could be: "I detest it—to begin with—those who pretend to 'love' it are fake or shallow. But I neither avoid it nor love it. I try to discover the human in it." Thus, Ray Gun became the metaphor for a new kind of art, one that would transform everyday commodities into art and by this means "spiritualize American experience."

Ray Gun, it seems, could be an optimist as well as a pessimist, and he proved it during the summer of 1960, when Oldenburg departed New York's raucous lower depths for the sun-bathed serenity of Provincetown, Massachusetts. To support himself in this artist's colony, he took a job as a night dishwasher, and while scraping uneaten morsels off plates he began to imagine the food metamorphosed into art. Back in New York with Ray Gun to goad him, Oldenburg set about realizing his fantasy in a new environment, this one called *The Store*, which would sell "spiritualized" items of food and clothing, and since these would be reproductions or three-dimensional illusions, their actual sale must reveal the true function of art in a materialistic society (fig. 239). Given this, the artist could not but recognize himself as an entrepreneur with a product line, which made it only logical and ethical that he incorporate his business as "The Ray Gun Manufacturing Company," whose purpose was "the protection of art through reversals and disguises. From the bourgeois, from commercialism, from rivalry, from all the forces that might destroy art." When *The Store* opened in December 1961, the artist accomplished his objectives with a flair worthy of both the theater man he had long been and the small-time mercantilist this Yalie among the yahoos proposed to become. Rather than a proper gallery, the exhibition took place in an actual shop front at 107 East Second Street, which thereupon became a prototype of the numerous "alternative spaces" where artists of a new generation would often try to escape co-option by the commercial gallery–public museum system. What it displayed, moreover, consisted of real-scale replicas of the very kind of merchandise—pies, cakes, candy, vegetables, meat, apparel, jewelry—that Oldenburg saw all about him in the delicatessens, pushcarts, and discount ba-

zaars on Orchard Street and lower Second Avenue. But while arrayed on shelves and countertops, and certainly for sale, just as in life, these commodities and products had been neither grown nor manufactured, but rather made by hand and then art-priced accordingly, with a plate of meat going for $399.98, oranges for $279.89, a sandwich for $149.98, and a man's sock for $199.95. Like all late-modern art, the pieces candidly evinced the process of their own creation, which involved plaster-soaked cloths dropped over chicken wire and then, once dry, slapped with brilliant descriptive colors straight from cans of cheap house-paint enamel. The rippled, lumpy, extruded shapes—reminiscent of Reuben Nakian's sculptures—and the flung-on Action-style painting revealed not only the artist's origins in Abstract Expressionism but also his over-riding concern for color and form. Even so, the impact of vivid, "excruciatingly banal" subject matter and the trompe-l'oeil character of its handling sufficed to make the "goods" irresistible to thieving neighborhood kids—a nice instance of the confusion between art and life so eagerly sought by Pop. Yet, had the dripping, gloppy "cheeseburger with everything" or "banana cream pie" succeeded in arousing addicted tongues to watery expectation, the hard, tasteless simulacra would have mocked the appetite or even broken the mouth of anyone who actually gave way to temptation. Self-cancelling desire and repulsion generate the very meaning of such ironic formalist illusionism, for as Oldenburg said: "I do things that are contradictory. I try to make the art look like it's part of the world around it. At the same time I take great pains to show that it doesn't *function* as part of the world around it." By adopting a double view, both for and against the "satanic" awfulness of the American scene, and by fashioning "the extraordinary out of the ordinary," Oldenburg hoped to realize a freshly coherent vision, one in which art would demonstrate how creative activity may enable sensitive individuals to preserve sanity and objectivity even though besieged by an unremittingly hideous, competitive, and hostile environment. No less a metaphor for what he had in mind was his own performance, since *The Store* constituted a one-man operation wherein the artist acted out a personal fantasy of becoming not only the capitalist entrepreneur but also the proletarian baker, plasterer, house painter, tailor, window dresser, shop clerk, and lighting expert.

When *The Store*, along with a related series of Happenings called *The Ray Gun Theater*, attracted so much attention that the Green Gallery on 57th Street gave it a rerun the following summer, Oldenburg conceived the idea of expanding his enterprise to fill the larger uptown space as spectacularly as the grand pianos and latest-model automobiles in their nearby showrooms. Now, with the indispensable help of his talented wife, as well as that of such "factory hands" as Park Avenue matrons, professional seamstresses, and penniless dancers, Oldenburg recast his inedible edibles on a gargantuan scale, realizing

above: 239. Claes Oldenburg. *Pastry Case, I.* 1961–62. Enamel paint on nine plaster sculptures in glass case, 20¾ × 30⅛ × 14¾". Museum of Modern Art, New York (Sidney and Harriet Janis Collection, fractional gift).

below: 240. Claes Oldenburg. *Giant Hamburger with Pickle Attached, Slice of Iced Layer Cake,* and *Ice Cream Cone.* 1962. Installation of one-man exhibition at the Green Gallery, New York.

them as soft sculptures cut from canvas, sewn, stuffed with foam rubber, and finally painted (fig. 240). When the exhibition opened, the 10-foot ice-cream cone, the 9-foot slice of layer cake, and the 5-by-7-foot hamburger made the gallery look as if Magritte's paintings of monstrous, room-sized apples or toilet articles had been three-dimensionalized. For some, the floppy, elephantine pieces recalled Dali's melted watches, but while Oldenburg had indeed projected his fantasy life, that life invariably originated in reality, not in the hallucinatory dream world so meticulously depicted by the Surrealist master. Like Magritte and most of the Popsters, however, Oldenburg has consistently distorted everyday objects as a device for questioning our perceptions of the world or for satirizing its follies. But even as he mocked the grossness of American taste—the American impulse towards brashness, power, and size for their own sakes—Oldenburg also made his new art an occasion for significant formal and technical innovations. Not only had representation been transformed into the period's first giant Minimal sculptures, the results even anticipated such post-Minimal efforts as Robert Morris' felt pieces. Although constructed and environmental in scale, the *Giant Ice-Cream Cone*, the *Giant Blue Men's Pants*, etc., were also stitched from canvas and painted, which made them mixed-genre or multimedia works that elided painting with sculpture and both of these with architecture. Thus, at the same time that some viewers, enchanted by the Brobdingnagian dopiness of *Floor-Cake*, have seen Oldenburg as the Swift or Disney of the gallery-museum world, others look to his baroque inclusiveness, his amplitude, and label him the Bernini of the Pop generation.

While the art world was gobbling up Oldenburg's decoy delectables—large and small alike—the artist further expanded the Ray Gun Manufacturing Company's operations to include the product lines of advanced industry and technology. In *The Store* the enterprise had made the soft hard, only to resoften some of the same subjects but at dropsical proportions in the Green Gallery show. Now Oldenburg would render the hard soft, or again the soft hard should he encounter it, and in every conceivable size—immensely dilated, one-to-one, miniaturized—as well as in various positive-negative reversals of color and/or texture. The consequence was the comedy of crisply smooth, rigid, inanimate machines or equipment so anthropomorphosed as to become endowed with all the vulnerability—the tired,

Pop Art and New Realism

143

above: 241.
Claes Oldenburg.
Model (Ghost) Typewriter.
1963. Cloth, kapok,
and wood; 27½ × 26 × 9″.
Courtesy Sidney Janis
Gallery, New York.

left: 242.
Claes Oldenburg.
*Colossal Monument
to Park Avenue:
Good Humor Bar.* 1965.
Crayon and watercolor,
23¼ × 18″. Collection
Carroll Janis, New York.

above right: 243.
Claes Oldenburg.
Clothespin. 1976. Cor-Ten
steel with stainless-steel
base, 45′ high. Center
Square, Philadelphia.

rather quirkily benign or amiable, thanks to cybernetics, which, unlike the old factory technology, no longer transformed human beings into machines, but instead bestowed upon machines all the problem-solving and -creating, comic-heroic capacities of the people who invented them. The contrast between the stiff and drooping double light switches is especially telling, for whereas the one suggests an aggressive, priapic male, the other connotes a middle-aged female with pendulous mammaries. Meanwhile, the variants' dull and shiny materials reveal a sensitivity to surface qualities as pronounced as that claimed by contemporary Minimalist painters. The same could be said for line, which, even though translated into sewn edges and seams, Oldenburg calculated for its hard straightness or its soft fluency altogether as judiciously as he did in his magnificent drawings. Thus, in style and medium alike, Oldenburg continued to function like a Baroque master, remaining no less democratically open to multiple possibilities than in matters of subject and meaning.

Oldenburg draws as compulsively as he takes notes, studying and restudying his ideas before executing them, and always with a combination of dynamic line and delicate wash that evokes the summary, bravura touch of Watteau or Tiepolo, facsimiles of whose drawings he once pored over at Cooper Union. In this way Oldenburg prepared the *Bedroom Ensemble*, a 1963 environment to be seen in the next chapter, and began visualizing notions for a grand series of "monuments," truly colossal projections of such Pop subjects as a melting, skyscraper-tall *Good Humor Bar* for Manhattan's Park Avenue, a toilet-ball float for the heavily polluted Thames, a pair of castration-fear scissors to replace the phallic obelisk erected in memory of the American nation's father, George Washington, the giant lipstick, cited earlier, for Yale University (fig. 242). Being pure fantasies triggered by the inane realities of life itself (as well as by the visionary drawings of France's early 19th-century architects Ledoux and Boullée), these schemes gave form to an exceptionally fertile imagination whose genius for caricature prompted the Marxist philosopher Herbert Marcuse to declare that if anything so unfeasible and unrealistic were actually built, it would "indeed be subversive. . . . I would say—and I think safely say—this society has come to an end. Because then people cannot take anything seriously: neither their president, nor the cabinet, nor

sagging lumpiness—of the average, unidealized, human body (fig. 241). "Sanding the wooden typewriter keys," Oldenburg noted in his journal, "I feel like a manicurist." Such a work could not but have personality, expressed most obviously in a broad, toothy grin, or even a kind of androgynous sexuality, emanating from the coupling of a receptively wide-open, labiumed orifice with the rod and ball-ends of a flaccid platen. Not only typewriters but also electric fans, pay telephones, toilets, bathtubs, and light switches flowed from Ray Gun's assembly plants, fabricated with such efficiency that "hard" pieces had in fact been the models from which canvas pattern or "ghost" versions were made for the ultimate "soft" vinyl works. But whether it was simply geometry that determined form in the firm, static sculptures or the chancier element of gravity in the fluid, collapsible ones, the spirit of Rabelaisian satire prevails throughout. In the post-Romantic sixties, machines no longer seemed alien or threatening, but

the corporation executives. There is a way in which this kind of satire, of humor, can indeed kill. I think it would be one of the most bloodless means to achieve a radical change.'' But since the Pan Am Building did in fact rise, why not Oldenburg's *Good Humor Bar*, which would have blocked out no more air, light, or view than the pretentious horror now in place? Meanwhile, it would have offered the unparalleled virtue of using deadly charm to make perfectly clear the values at work not only in brutally overscaled International Style architecture but also throughout much of the ambient mid-20th-century culture. Contrary to Marcuse's surmise, however, several of the monuments have actually been constructed, even in Philadelphia during the Bicentennial Year when the 40-foot-high *Clothespin* was unveiled (fig. 243). Yet, more than a decade later the US Republic has not toppled, perhaps because there is always considerably more to Oldenburg's art than devastating parody. As for *Clothespin*, parody begins with the punning title, which suggests that ''Claes' Penn'' constitutes an alternative to the academic bronze portrait of William Penn (created in 1894 by Alexander Calder's grandfather) rising 37 feet above Philadelphia's City Hall. Here again, an utterly ordinary object has been transposed—kidnapped from its natural context, scaled up and repositioned to monumental status—and by this means transformed into a grand, humanoid metaphor, this time for a great leader of men, standing tall, full front, with feet and legs set firmly apart. It provides a devilish but perfectly coherent answer to the age-old American question of how to celebrate heroes in a supposedly egalitarian bourgeois society, where classical sculpture, or its elevated style, means, as Oldenburg said, little more than ''bulls and greeks and nekkid broads.'' For the cognoscenti, however, the Philadelphia monument offers something more, a *frisson* of recognition that Oldenburg found in the common clothespin a Pop analogue for the elegantly refined formalism of Brancusi's *The Kiss*. And once more a dual reading is possible, for while the spring clip signifies the sexual fusion of a passionately embracing couple, it may also imply a gesture of self-denial characteristic of pre-sixties American puritanism.

James Rosenquist (1933—) has been called ''Pop Art's dark horse,'' an artist whose indifference to the flat image and whose pure, irony-free romanticism left him without a critical following among either the formalists or the ''neo-Dadaists.'' Still, once in command of his own special brand of figuration, Rosenquist immediately found himself in the front ranks with the major Popsters, for not only was he—as early as anyone in New York after Rivers, Rauschenberg, and Johns—fishing imagery from the same media ocean harvested by his colleagues, he was also projecting it on a far more ambitious scale, a truly environmental scale reflecting his real-life experience as a vir-

tuoso billboard painter (fig. 244). In this CinemaScope painting, however, what his viewers saw was not necessarily what they got—unlike the effect claimed by Frank Stella for his Minimalist canvases or implied by Lichtenstein's Mirrors (figs. 248, 321). That Rosenquist hand-painted collage-like compositions from wildly disparate shards of commonplace reality seemed obvious enough, but when the relationships among the image fragments proved stubbornly resistant to easy interpretation, the art was often deemed empty of significance or sophistication. This ''problem'' combined with that of the sign painter's deliberate slickness of handling to make Rosenquist seem, for many, a Surrealist manqué or, worse, an overreaching *naif*. Only with time would it become convincingly evident that here were canvases by an artist who could define painting as ''the ability to put layers of feeling on a picture plane and then have those feelings seep out as slowly as possible. . . .''

The feelings that Rosenquist would layer into immense, compartmented canvases began with his birth on the vast, empty plains of North Dakota. They continued to accumulate throughout a childhood divided among eight different Midwestern grammar schools, followed by an adolescence more or less settled in Minneapolis. There, at the age of twelve, Rosenquist won a scholarship to the Art Institute school, and at eighteen he converted his ability to render exactly into a career as an outdoor sign painter. With this as a part-time means of livelihood, he began studying at the University of Minnesota, but then transferred, in 1955, to the Art Students League in New York. Two years later, for reasons of economic necessity, he made billboard painting a full-time occupation, practicing it all over New York City—even in Times Square itself—until a close colleague was killed in a fall from a scaffolding high above Union Square. By now Rosenquist had become one of the best billboard artists in town, a crack professional. More important, the experience had taught him to prepare carefully for the sake of working rapidly thereafter, to transpose a small photographic image to a large partial one, using only eye-hand coordination, and to cherish the mind-bending effect of layering one potent image over another. Thus equipped, Rosenquist left commercial art forever in 1960 and moved into a Lower Manhattan studio near a circle of emerging artists that included not only such new realists as Rauschenberg, Johns, and Indiana, but also the hard-edge abstractionists Agnes Martin, Ellsworth Kelly, and Jack Youngerman. Throughout his period as a figurative sign painter, Rosenquist had worked privately in a thickly painted nonallusive mode. Now he found this a dead end, and, wanting to re-commence from ''below zero,'' he decided to start using imagery again. Here he was swayed by Johns, who made abstractions of real objects, as well as by Kelly,

244. James Rosenquist.
F-111 (detail). 1965.
Oil on canvas, 10 × 86'.
Private collection, USA.

who distilled abstractions from enlarged details of actual things. But in formulating his own distinctive language, Rosenquist also drew heavily from his background in billboards, especially from the bizarre, dislocating sensation of painting one subject over another, of working so big that the image could be seen only in fragments, and of perceiving the fragment so close-up that it assumes a mysterious aura, as if, for instance, the gigantic cheek of a movie actress had become the Great White Whale.

By 1961 Rosenquist had become so articulate in his new language that, even with a mere half-dozen paintings completed, he found himself the object of urgent desire on the part of the new dealers and collectors fired by the sensational debuts of Rauschenberg and Johns. In early 1962 the Green Gallery gave Rosenquist his first one-man show, and in 1965 the artist spent eight months producing the masterpiece of his sixties period: *F-111* (fig. 244). Eighty-six feet long and designed to hang on four walls as a wrap-around work, this was Pop's largest painting and its most political, having been inspired by anti-Vietnam War sentiment surrounding the Pentagon's announced plans for a supersonic fighter-jet designated simply as the F-111. In discussing the work, however, the artist seems scarcely ever to mention politics; rather, he dwells at length on matters of form, which is perfectly logical given his view that, as he once stated, "the image is not important. I don't separate color from form. Color and form are the same thing." Reading across the painting's fifty-one separate but interlocking pieces (forty-nine on canvas and two on aluminum), the eye quickly apprehends the color-forms as a hotchpotch assemblage of unrelated promotional imagery, mostly painted in stridently garish hues, including a Day-Glo pink and a gratingly shrill chartreuse, and held together by a transparent rendering of the plane's fuselage, its wondrous but lethal technology stretching the full length of the great polyptych. Among the gigantic details are a roiling sea of vermicular, canned-goods-orange spaghetti, a helmeted underwater diver, a beach umbrella opened above the belching red hell of a thermonuclear blast, the diabolically sweet, child-star face of a little girl coiffed in a hair dryer shaped like the glistening nose of a jet, pastel light bulbs and broken egg shells, a deeply treaded Firestone tire, a crater-like angelfood cake emblazoned with its ready-mix "nutrients," and wallpaper patterns rolling down like polluted rain onto sections of both canvas

and aluminum. Thanks to the *F-111* title, the clamorous onrush of discordant, intimidating or disgusting themes, the jangled psychedelic colors, and the multiplication of it all by the reflecting aluminum panels left little doubt about a content of concern over a society on a suicidal course with its own mindless consumerism and military-industrial power. But if the announced subject was timely, its impact came from the artist's billboard mastery of the grandest pictorial strategies, which in this case allowed a maelstrom of diversely scaled forms to burst illusionistically free of the wall, yet remain fixed within the unified plane of an intricately compartmented but subtly controlled design.

A tour-de-force in the art of balancing servile illustration against autonomous structure, *F-111* made a spectacular albeit controversial addition to the Metropolitan Museum's 1968 exhibition entitled "History Painting—Various Aspects." Indeed, when seen in the company of such certified masterworks of older art as Poussin's *The Rape of the Sabine Women* (c. 1634–35) and David's *The Death of Socrates* (1787), as well as the Leutze painting that Larry Rivers had glossed in his *Washington Crossing the Delaware*, *F-111* created a furor, prompting a *New York Times* critic to call the work "cheerful, overblown, irredeemably superficial." It "leaves the spectator feeling," the writer went on, "as if he ought to be sucking a popsicle." With time, however, the slow "seepage" the artist spoke about has occurred, as closer and more informed observers discover new, deeper layers of meaning, such as that arising from the presence in the painting of innocent, even pleasurable technology as well as the destructive sort. And since the *F-111* was never built, the painting would also seem to contain musings on the ultimate futility of all technology, which in a viciously competitive world so often proves obsolete even before it can be applied. More important perhaps is the poetry that flows from the peculiar "gap" in which the artist chose to work, not Rauschenberg's no-man's-land between art and life, but rather the far more ambiguous area separating displaced imagery from the meaning its selection and unexpected assemblage should convey. "Color and form are the same thing," Rosenquist said, disclosing the compulsion he felt to translate one reality into another and by this means to distance personal experience while intensifying his expression of it. Thus, rather than convey sensations, ideas, or anecdotes into colors

left: 245. James Rosenquist.
Pistil Packin' Ladies. 1984
Oil on canvas, 5'6" × 7'6".
Collection Art Enterprises, Ltd., Chicago.

opposite: 246. Tom Wesselmann.
Long Delayed Nude. 1967–75.
Oil on canvas, 5'7¾" × 8'5½".
Collection Dieter Brusberg, West Germany.

and then narrate their story by orchestrating them as an overall chromatic harmony, Rosenquist found his pictorial equivalents in the color-forms of dismembered figuration and his compositional techniques in the dissonant coupling intrinsic to collage. Even though abstracted not only from their original contexts but also by their varying scales and vast but textureless enlargement, the images would all be perfectly legible, in everything, that is, except the broken syntax of their linkage across the canvas. Over time, the viewer may well perceive that such collage paintings embody something of the artist's constant preoccupation with the rival and legitimate demands of love, nature, and technology, with environmental space and peripheral vision. But meanings of this sort could never be more than elliptical and metaphoric, given the disorientation of the process through which they have been conceived and communicated. Owing to the jumbled clarities of his oxymoronic language, Rosenquist succeeded in creating a long series of complex pictorial machines that now seem strangely specific yet abstract, private yet universal, dense with impacted feeling yet veiled in mystery (fig. 245).

Although he never painted billboards, Ohio-born Tom Wesselmann (1931—) often used them as collage elements, especially after expanding the scale of his work to that of the Happenings in which he was an early participant while enrolled at Manhattan's Cooper Union. However, he went about things in a more orderly, structured fashion than his friends Dine and Oldenburg, revealing, from the outset, a Mondrian-like command of pictorial architecture, even as he assembled such raw still-life objects as a whiskey bottle, a packet of cigarettes, and a coffee tin. By 1959 Wesselmann was experimenting with "portrait collages," which would soon evolve into the works for which he is best known, the prolific, erotically ripe, and ever-vital series of paintings called "The Great American Nude" (fig. 246). For this mesmerizing theme his models seem to have been the serenely sensual odalisques of Modigliani and Matisse, especially the latter's *Pink Nude* of 1935, with its arabesque line, flat silhouette, and boldly direct yet aloof stance towards the viewer. But Pop master that he was, Wesselmann translated the sumptuous hedonism of his Parisian prototypes into American deadpan, using imagery, garish colors, and a slick facture appropriated from *Playboy* magazine, movie posters, and ubiquitous come-on advertisements, among other things. These sources also provided material for the collage passages that remained in his pictures until these became so large that the artist had to depend more and more and then entirely on painting. Frequently the collage formed a painting within a painting, placed like an admired masterwork by, for instance, Leonardo, Renoir, or Matisse hung on the background wall. Then, as the scale of his work continued to grow,

Wesselmann started converting collage into multimedia assemblage or combine paintings that approached life-size stage-set environments, complete with painted figure posed against an illusory tiled wall and surrounded by such real objects as a rug or bathmat, a radiator, a wall telephone, and a red door with a coat hanging on it. Sometimes the telephone would ring, or a tape recorder emit street sounds, while a radio or a television set established whatever mood happened to emerge from the tuned-in show. Yet concrete as all this may seem, Wesselmann insisted that his was a fantasy world projected in painting, not an environment. "My rugs," he declared, "are not meant to be stepped on." Eventually Wesselmann would de-emphasize subject matter and stress "aesthetic content," using, as he said, "blunt Pop images and simple, clear colors to take on the traditional subjects of painting—the nude, the still life, the landscape." All these appear in certain of the large works just cited, but always it is the mischievously provocative female that dominates, her features reduced to erogenous zones—swollen, cherry-red mouth, rubbery super-nubile nipples, and bushy pubis—often loomed over by a phallic vase filled with a bouquet clearly ready for deflowering. Eros would seem to have been corrupted by a consumerist society. Close-up and yet remote, Wesselmann's Great American Nudes skirt pornography but ultimately veer away from it, thanks in generous part to the artist's cleverness in transforming his sexy caricatures into metaphors for the almost innocent, truly erotic pleasure he obviously finds in making art.

Other artists—among them Paolozzi, Hamilton, Rauschenberg, Johns, and Warhol—had made use of the comics, but only Roy Lichtenstein (1923–1997) so translated their flat, diagrammatic form and low subject matter into the stuff of high, even classical art that they will forever remain uniquely "his," just as the American flag now "belongs" to Jasper Johns quite as much as it does to his fellow citizens (fig. 247). The miracle of Lichtenstein's achievement derives from the insight—which must have struck the artist like one of his VAROOM! thunderbolts—that within cartoons lurked a commentary about abstract art and its entanglement with information. Grasping the irony of this truth—that the schemata of comics constitute a debased version of modernism's conceptualized simplifications—Lichtenstein saw the possibility of reintroducing figuration in a context as flat and reductive as anything in traditional modernism, yet distanced enough to be a gentle parody of as well as a nostalgic homage to its sources, both immediate and ultimate. With this, he created something wonderfully fresh and entirely of its time. Further, he perceived that in the cartoonist's heavy black contour lines, bright, flat, primary colors, and Ben Day dot screens lay the rudiments of a tough yet elastic style through which any visual data could be restructured, just as the popular, commercial media absorb every artifact and re-present it as kitsch. Ironist and Popster that he was, Lichtenstein, however, would appropriate this process but then reverse it, monumentalizing and refining his ready-made, vulgate manner until, with wit and humor, it became as grandly distinctive, and succinct, as the formal purities of Poussin, Cézanne, and Seurat. Indeed, it grew into an exaltedly droll vehicle capable of absorbing and recasting every conceivable theme into an encoded and idea-drenched format. Consistent with this tactic, the themes themselves would be appropriated, and once again from the mass media, usually, as the oeuvre evolved, in the guise of glossy reproductions of hallowed masterworks of ancient or modern art (fig. 249). Thus, in form and content alike, Lichtenstein satirized the romantic myth of originality, even as he reasserted it by the very independence of his own potent and infinitely fecund style.

Although born in New York City and long re-established there, Lichtenstein received most of his thoroughly orthodox art training at Ohio State University, initially under Reginald Marsh, the American Scene painter with whom he had first studied at the Art Students League. Then, while teaching in Upstate New York and at Douglass College in New Jersey, Lichtenstein made the obligatory journey through Action Painting. This continued until 1960, when in response to a dare from one of his young sons, the artist painted a large picture

entitled *Look, Mickey, I've hooked a Big One!* It portrayed Donald Duck gleefully peering off the edge of a dock while tugging at a fishing pole with its hook caught in the rear hem of the jacket worn by the angler himself. At this time his source was a bubblegum wrapper, but Lichtenstein soon discovered the far richer vein of popular imagery offered by comic books, a lode he mined with the encouragement of such teaching associates as Allan Kaprow and George Segal. Through Kaprow, Lichtenstein joined the Pop stable at Leo Castelli's gallery, and by 1963 he had translated the cartoon genre into a fully integrated, large-scale painting mode. The logical—and ironic—procedures it offered for endowing representational art with something of contemporary abstract painting's visual clout cured him forever of Expressionist subjectivity, otherworldliness, and spatial play. Indeed, clarity, or aim, and impact are fundamental to the subject of *WHAAM!* (fig. 247), a painting whose lean, mechanical look belies the irony of an effect achieved, unlike its mass-produced source, by the same intimate, time-consuming techniques that painters had practiced for centuries. When, for instance, stencils failed to yield a simulated dot screen as clean-edged and systematic in appearance as its small-scale prototype, the artist hand-corrected the results. Through countless covert adaptations, moreover, he transformed a narrative image into a monumentally iconic one. Note, for instance, how the force or directional line tracking the fired missile to its target parallels the painting's horizontal format, thereby locking both the foreshortened aircraft and the wildly irregular explosion to the rectangular shape and two-dimensionality of the picture plane. Further stabilizing the action-packed scene is the placement of the "squared" conversation balloon in the left panel and the onomatopoetic WHAAM! in the right one, both hung from the upper edge of the canvas and thus merged with the overall flatness of the design. Then comes the continuity of their lines with those of the adjacent or underlying forms, a unifying strategy borrowed from Cézanne but now serving to elide the multiple significations of the painting's verbal and visual elements. Far from passively uniform, the dark, bounding contours are as lithe, supple, and nuanced as they are elegantly streamlined, thus making a static image seem alive with a sort of contained energy, perhaps a filtered or modulated version of the comics' own raw vigor. Most sophisticated of all may be the grand equilibrium struck between the flamboyant colorform on the right and the monochromatic sleekness of the aeroplane on the left. Counterbalanced and linked as they are, these abstract and figurative motifs invest the diptych with an emblematic simultaneity or completeness quite unlike anything in the cartoon strip's crankedout, onrushing narrative sequences. Altogether, therefore, Lichtenstein did not merely replicate either the style or the imagery of his popular sources; rather, he re-created them generically through his own

high-art means and taste. In this way, the artist converted topicality into timelessness, but with a deadpan humor whose coolness allowed him to reconsider such major subjects as war and love, yet escape the unwanted emotionalism and metaphysics of the Abstract Expressionists' approach to the same subjects. A number of contemporary critics, failing to see that here was a highly conceptualized interpretation of a popular genre, accused Lichtenstein of pandering to dumb, base appetites like those served by the reprobated originals. Professional cartoonists knew better, pointing out how the artist had failed to get their work "right," even as they tried to sue him for piracy. A quarter of a century later, the authentic subversiveness of the cartoon paintings has been reversed, for it is what once lay masked—the art's elegant simplicity that now masks the vulgarity which so stung the modernists of the early 1960s and dominated their outraged response.

If Lichtenstein could use his pseudo-industrial style to exploit the comedic aspects of Abstract Expressionism's self-indulgence, he would do the same for Minimalism's self-denial, all the while retaining his own commitment to legible subject matter appropriated from printed sources. Turning to advertisements in newspapers and furniture catalogues, he painted a series of Mirrors, pictures whose image, like Johns' *Flag*, could be made identical with the shape and flatness of the painting support (fig. 248). Along with this actual and conceptual concretion, moreover, came the possibilities of even greater abstraction than that of the Flags, since the mirror effect is created solely by planes of line-free, tonally graded black and yellow dots jump-cut and contrasted to suggest nothing but the flash or twinkle of beveled edges and glassy sheets of reflected light. But just as the literalness of abstract field painting has been turned into the ultimate imitation, the failure of the surface actually to reflect—to give back anything more than what has been painted on it—denies its own trompe-l'oeil to restate, ironically in the language of illusionism, the famous Minimalist dictum, as uttered by Frank Stella: "What you see is what you see."

As this would suggest, Lichtenstein was no more interested in neo-Dada anti-art gestures than he was in Abstract Expressionist solemnity. At the time, however, the artist seemed to grow in irreverence once he replaced subjects from the comics with the more elitist, but no less found and scarcely less familiar, imagery of canonic modern art, and then proceeded to factor it through his cartoon-derived schematics. Fearlessly, he took on that most spontaneous of manners—Action Painting—and reinvented it as a monumental cliché, its broad, fatty swipes and overload of feeling wrung dry and bonded to the surface with the same stylized fixity as that employed for the symbolic burst of flames in *WHAAM!* (fig. 249). In Lichtenstein's paraphrase of de Kooning, buttery ridges of impasto have been rendered as open skeins of black lines, richly variegated colors as rubbery

above: 247. Roy Lichtenstein. *WHAAM!* 1963. Magna on canvas, two panels; 5'8" × 13'4". Tate Gallery, London.

right: 248. Roy Lichtenstein. *Mirror #1.* 1971. Oil and Magna on canvas, 6 × 3'. Courtesy Leo Castelli Gallery, New York.

Pop Art and New Realism

below: 249. Roy Lichtenstein. *Big Painting VI.* 1965.
Oil and Magna on canvas, 7'8½" × 10'9".
Kunstsammlung Nordrhein-Westfalen, Düsseldorf.

left: 250. Roy Lichtenstein. *Woman with Flowered Hat.* 1963.
Magna on canvas, 4'2" × 3'4". Private collection.

bottom: 251. Roy Lichtenstein. *Artist's Studio, the "Dance."* 1974.
Oil and Magna on canvas, 8' × 10'8".
Collection Mr. and Mrs. S.I. Newhouse, Jr., New York.

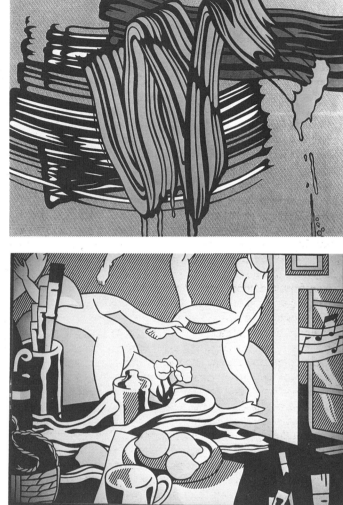

swaths of uninflected ''process'' hues, and the unprimed canvas support as a field of black-on-white dot screen.

The ironies of Lichtenstein's art could only complicate once he began to make art itself his topic, especially when the art appropriated was that of Picasso, the first of the postwar appropriators of earlier masterworks (figs. 250, 93). Here, the double-take became a triple-take, and the compounding of signification increased further as Lichtenstein launched into a long series of ambitious pictures composed like collages of generic, as well as specific, quotations from ''key monuments in the history of art,'' works the media were then reducing, through multiple reproductions, to a form of culture almost as popular as the comics. Lichtenstein even succeeded in translating the pulsating screens of free color touches in Monet's Rouen Cathedral series into his own handwrought but mechanical-looking dot system, paradoxically a far more labor-intensive process than Monet's quick-study, *plein-air* improvisations. The results made Impressionism look like Pointillism recast in an American Pop idiom, thereby assuring the presence of the layered past in the present. Elsewhere, as in *Artist's Studio, the "Dance''* (fig. 251), Lichtenstein continued to see form mainly through the shaping power of the clean black line that unifies virtually the whole of his oeuvre, from *Look, Mickey* through the grand salon machine just cited. Now lines, drawn in a closely parallel diagonal, have replaced dots as a Ben Day variant representing shadow, texture, highlights, depth, or any number of other phenomena. This pristine linearity binds Matisse's *Dance* of 1910 to an entire cornucopia of images quoted from Lichtenstein's earlier series, including the Brushstrokes, Still Lifes, and Offices, the latter drawn from illustrations in office-supply catalogues. Not only did Matisse's own Studio paintings of 1911, with *Dance* in the background, authorize such a composite image; so did the critical and market value increasingly placed on Lichtenstein's work. As *Artist's Studio, the "Dance''*

demonstrates, Lichtenstein fell in love with modern European art, and, instead of struggling to overcome it as the Abstract Expressionists did, he cheerfully used annexation as a means of paying court to his admired sources. But rather than make him a derivative artist, appropriation of pre-existing signs and systems proved to be a form of originality. Borrowing in fact permitted Lichtenstein to create a body of work that is unmistakably autographic in its fine-art treatment of base-born mechanized process, its florilegium of plebeian and patrician images, its additional strata of perception, like that in the bar of music signaling the famous pendant to Matisse's *Dance*. Glueing it all together, moreover, is the powerful style, itself a ''modified ready-made'' and thus as much a theme as the imagery it supports, for it was through rock-solid yet flexible style that Lichtenstein integrated his many rival elements in a classically balanced, harmonious whole. What such clear yet complex painting would seem to convey, above all else, is the artist's conviction that, in an age of total information, art is best made with means and iconography as democratically profuse and provisional as the turbulent ocean of mixed messages flooding a media-driven world. Fundamental to the art's warm, witty allure, however, is the covert wisdom and skill with which Lichtenstein acknowledges the ineluctable discrepancy between image and

Pop Art and New Realism

the imaged. Here, therefore, humor becomes intrinsic, arising from the reality that mechanical replication cannot but turn every subject into parody, while simultaneously leaving the parody to seem, by virtue of its aggressive presence, more authentic than the rarely confronted original. In the ultimate incongruity, Lichtenstein's handcrafted quotations, or transpositions, would seem to restore some—perhaps crazy—measure of "aura" and authority to masterworks depreciated by their industrially manufactured and far better-known surrogates.

Andy Warhol (1928–87), having been "damned as America's greatest charlatan and praised as its greatest visionary," may for that very reason be the most representative Popster of the cool yet turbulent sixties. Certainly he was the most famous artist of his generation, famous as only an impenetrable enigma could be in the age of total, "hang-out" openness. Ghostly pale, prematurely bald, silver-wigged, and deceptively blank in appearance, Warhol was a closet workaholic whose energy and shrewdness, as well as talent, made him not only one of the most productive and influential artists of his time, but also one of the wealthiest, most self-promoting, and singularly identifiable. Although he contended that "the less something has to say, the more perfect it is," Warhol contrived to image, if not comment upon, almost every aspect of a consumerist, celebrity-crazed, sensation-seeking society, from its crowded stockpiles of Campbell's Soups to the electric chair, from Marilyn Monroe to the grieving, shell-shocked Jacqueline Kennedy, from Dick Tracy and dollar bills to Mao Tse-tung, "Jews of the Twentieth Century," and the mushroom cloud of an atomic explosion (figs. 252–255). Moreover, he treated it all with promiscuously even-handed dispassion and allure. For as a star-struck provincial making his way in the "art capital of the world," Warhol viewed everything as a "superstar"—Brillo pads, the FBI's most wanted men, jet-set glitterati—once the subject had been acknowledged, paid or unpaid, by the media, which the artist predicted would eventually make everyone "famous for fifteen minutes." The laconic Warhol even said, "I want to be a machine," and always referred to his studio as the Factory, where, like a latter-day Raphael or Rubens, he employed numerous assistants or "kids," only to exercise, just as the Renaissance-Baroque masters had, an imperious control over the quality of whatever would bear his signature. Before this could occur, he added the final touches himself, making

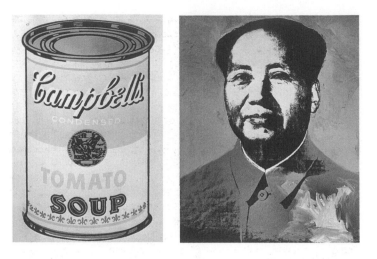

certain the piece reflected the standards of an artist who, during an early decade of commercial success, had won the top awards then available to a New York illustrator. On the one hand, these criteria most often required impersonal screen-printing of camera-made imagery; on the other, they also entailed off-register Fauve colors or slathered brushwork betraying a covert Abstract Expressionist taste for managed accident. Declaring "it's so boring painting the same picture over and over," Warhol in 1965 announced that he would retire from painting and devote most of his time to making motion pictures, all of them, it would turn out, rather tedious, studiedly inept exercises in cinéma vérité. But unlike Duchamp, who had "retired" a half-century earlier, the American Pop master was still "painting the same picture over and over" at the end of his life, with, that is, important differences, as the titles Retrospective and Reversal affirm. A Mass-attending Catholic, Warhol fled every intimacy—indeed could not bear to be touched—but voyeuristically surrounded himself with and passively filmed, or manipulated, an exhibitionist coterie of what Robert Hughes called "cultural space-debris, drifting fragments from a variety of sixties subculture (transvestites, drugs, S&M, rock, Poor Little Rich, criminal, street, and all the permutations.) . . ." In 1968 one of them, a deranged feminist, shot and almost killed the artist, a

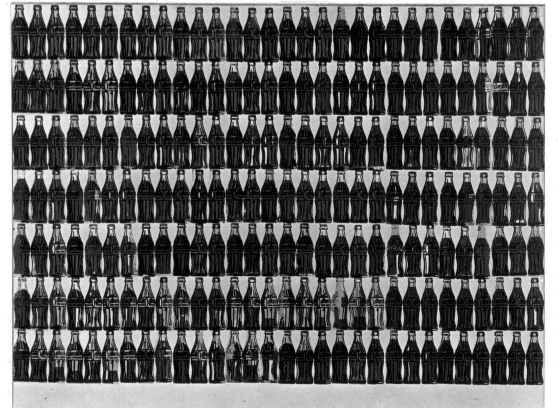

above left: 252.
Andy Warhol. *Campbell's Soup.* 1965. Silkscreen on canvas, 3 × 2′. Courtesy Leo Castelli Gallery, New York.

above right: 253.
Andy Warhol. *Mao.* 1973. Acrylic and silkscreen on canvas, 14′8″ × 11′4″. Courtesy Leo Castelli Gallery, New York.

left: 254.
Andy Warhol. *210 Coca-Cola Bottles.* 1962. Oil on canvas, 6′10½″ × 8′9″. Collection Martin and Janet Blinder.

opposite: 255. Andy Warhol. *Marilyn.* 1964. Silkscreen and oil on canvas, 40″ square. Courtesy Leo Castelli Gallery, New York.

man so laid back and nonviolent that he was seen by some as "anaesthetized." When he died, Warhol had long since become more famous or notorious than most of the "superstars" whose own fame or notoriety he either created or celebrated in the gossip tabloid *Interview*, another product packaged and merchandised by the Factory. With him, Barbara Rose wrote, "the American avant-garde might presume to have its own Salvador Dali, a sign both of its maturity and its decadence." Yet Warhol—a living cult icon, if ever there was one—allegedly succumbed as a result of neglect by the medical staff at one of New York's major hospitals. Even though frequently accused of glamorizing indifference—of making, admittedly with wit and unfailing deadpan charm, what the artist himself called "no comment" art—the "Warhol situation" was clearly soaked in irony. Not the least of it is the paradox wherein an artist of legendary inarticulateness could find words that again and again caught the tone of the times with pitch-perfect accuracy. "Pop Art," Warhol once said, "took the inside and put it outside, took the outside and put it inside."

Among his many other quotable utterances, Warhol once said: "If you want to know about Andy Warhol, just look at the surface of my paintings and films and me, and there I am. There's nothing behind it." On another occasion he admitted to being "obsessed with the idea of looking into the mirror and seeing no one, nothing." Distancing, it would seem, began at an early age, for by the time he took up painting in 1960, Andrew Warhola had long since departed Western Pennsylvania, where his Czech-born father labored in the coal fields. Moreover, after graduating from Pittsburgh's Carnegie Institute of Technology in 1945, he had rapidly made it to the top of the New York commercial art world, there renowned for his ad campaigns on behalf of I. Millter Shoes and twice honored with the Art Director Club's highest award. Evidently aware that he was capable of something tougher, Warhol around 1956 announced that he wanted to be Matisse, an ambition that began to seem less preposterous once the stars of Rauschenberg and Johns appeared in the artistic firmament. Now there would be room on high for something other than Abstract Expressionist pieties, perhaps even for a "low" subject like Popeye, provided the artist could present it with the grand optical impact of a Matisse. While thus engaged, Warhol used his substantial income to collect modestly priced examples of the new art that Castelli was showing. One day, during a visit to the gallery, he saw a painting by Roy Lichtenstein and, a bit shocked, said: "Ohhh, I'm doing work just like that myself." Not only had he done a Popeye, a Dick Tracy, and a Superman, but he would soon go on to such blatant ephemera as before-after pictures of nose jobs, dance diagrams, and do-it-by-the-numbers-painting images. All were projected onto 6-foot canvases and cold-bloodedly copied, in a somewhat loose, nebulous version of his familiar impersonal manner, from funny papers, space ads, and commercial kits. Unredeemed by Lichtenstein's modernist finesse, the earliest Pop works painted by Warhol were too much—too crude—even for Castelli. Warhol and the great dealer would get together only after the Ferus Gallery in Los Angeles and New York's Stable Gallery had created a series of art-world "scandals" with such Warhol trademark variations as the Campbell's Soup Cans, Coca-Cola Bottles, Marilyn Monroes, Car Crashes, Mona Lisas, Jackies, and the free-standing Brillo Boxes (fig. 252). The first quake was felt, suitably enough, in Los Angeles, where the Soup Cans prompted a Ferus rival to display a stack of actual Campbell's tins with a sign reading: "Get the real thing for 29¢." What struck the attracted and the repelled alike, in New York as well as Los Angeles, was the almost brutal force with which the crass imagery, hard-edge drawing, and flat silk-screened color trampled on Abstract Expressionism's high seriousness. When well-meaning critics chose to see a canvas painted like a wall neatly and solidly stacked with Campbell's varieties as an indictment of consumer glut, Warhol subverted their sociology by saying that the subject interested him because he "used to have the same soup lunch every day for twenty years." While some viewed the row upon row of Coke bottles as a cynical put-on, others perceived them as an

entertaining, but nonetheless savage, commentary on the base level, depersonalized standardization of contemporary American society (fig. 254). Warhol, however, simply admitted to being fascinated by the prospect of making art from the kind of monotonous repetition that he had long known in the commercial world. To him, the Coke bottles and their serried duplication were as legitimate a subject for art as the apples that Cézanne had painted over and over. "I painted things I always thought beautiful," he said, "things you use every day and never think about." Here, then, is what Warhol meant when he averred that "Pop Art took the inside and put it outside, took the outside and put it inside." For whereas Abstract Expressionism had offered a refuge from hamburger stands, girlie magazines, advertising, and television, Warhol and his fellow Popsters not only refused to ignore the hard reality of such meretricious but overwhelmingly popular culture; they even insisted on bringing it right into the sacred high-art temple so recently purified by the heroic but now-horrified priests of

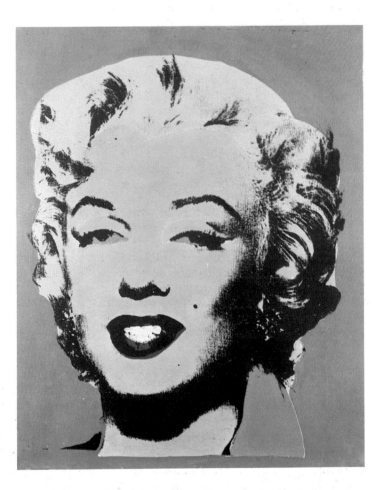

aesthetic integrity. Simultaneously, the Pop masters resublimated all the subjective feelings that the Pollock-de Kooning-Rothko-Newman generation had objectified in sublime fields of gesture and color. Although eager to paint whatever he found beautiful, Warhol refused to say why he found it beautiful, always and adamantly resisting every temptation to moralize or make his art a vehicle of self-revelation. However, the artist left clues to what made him and his work tick, as in the foxy way that he seemed to cultivate forms and techniques almost as blunt as his subject matter, all the while making them part of a bold strategy calculated to give banal ready-made imagery the scale and authority of the most ambitious of abstract painting. In *210 Coca-Cola Bottles*, nothing could be more rudimentary than tiered ranks of filled glass containers, laid down by simple hand-cut stencils over roughly corresponding patches of brown paint. But absorbed and codified within this elementary, self-evident scheme is the all-over configuration apotheosized by Pollock, as well as the underlying Cubist grid

Pop Art and New Realism

that gave it structure and meaning. Further, the brown underpaint that seems so random actually makes the bottles wink and sparkle as they would in reality, which in turn allows the entire painting surface to vibrate with a kind of sporadic or spontaneous energy like that expected in Action Painting. Contemporary modernism seems equally present in the large blow-ups of a lone soup can or a studio still of Marilyn Monroe, where the big, clear, field-filling image sought by the New York School has been recast in figurative terms (fig. 255). Celebrated in these pictures is neither more nor less than the clever professional work—label design, hair-styling, make-up—of commercial types like the pre-Pop Warhol, who had now acquired not only a starry status comparable to that of the film queen but also the power to confer it through his art. The irony here is that while ruthlessly enlarging and thus parodying the mechanisms of come-on or glamour—as in garish blocks of flat, unregistered color overprinted on Monroe's face—Warhol also made them the instrument of a visual effect so po-

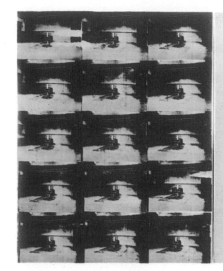

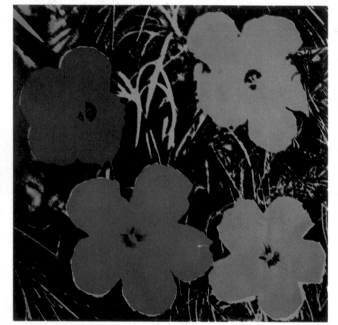

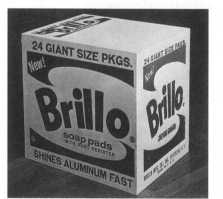

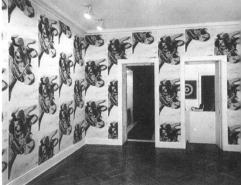

top: 256. Andy Warhol. *Blue Electric Chair*. 1963. Acrylic and silkscreen on canvas, each of two panels 8'11" × 6'8¼". Saatchi Collection, London.

left: 257. Andy Warhol. *Flowers*. 1964.
Acrylic and silkscreen on canvas, 4' square. Courtesy Leo Castelli Gallery, New York.

above left: 258. Andy Warhol. *Brillo*. 1964.
Painted wood, 17 × 17 × 14". Courtesy Leo Castelli Gallery, New York.

above right: 259. Andy Warhol. *Cow Wallpaper*. 1965. Installation, Leo Castelli Gallery.

tent that more often than not it has left viewers completely disarmed. Henry Geldzahler, a close observer of American Pop's advent, recently put it this way: "As early as 1964 an air-conditioning delivery man asked me in passing of a painting of Marilyn Monroe in my apartment, 'Is that an Andy Warhol?' "

If for no other reason than the fact that he made his canvases a shimmering collective mirror for contemporary mass culture, Warhol permitted more somber, even sinister themes to be reflected thereon as the overconfident sixties plunged into war, assassination, and civil disorder (fig. 256). With the Death and Disaster pictures came grainy tabloid images of highway accidents, race riots, New York's "ten most wanted men," and JFK's stoic widow still attired in her blood-stained Chanel. But while the media trivialized calamity by reporting it with inane repetition, Warhol seemed to recover some degree of shock power merely by bestowing upon a grimly empty electric chair, for instance, the same design éclat he employed for every other issue, such as the primrose blossoms derived from a seed catalogue about the time the antiwar "flower children" came on the scene (fig. 257). Repeated but in a serialized, late-Cubist grid—inspired, actually, by the neatly subdivided black squares of that arch formalist Ad Reinhardt (fig. 91)—the electric chair assumes a silvery, monochromatic elegance, the abstraction and dead silence of it all further objectified by the absolute blankness of the adjoining panel. In the world of surfaces and flat photomechanical images, the great equalizers, this painting would appear to say, are stasis and muteness, or perhaps the

artist's unerring gift for drowning all emotion in the spectacular impersonality of his presentation.

At first Warhol hand-painted his pictures, but, master of commercial techniques that he was, the artist soon shifted to "drawing" with found imagery applied to canvas by the silkscreen process. It was after Warhol's example that Rauschenberg immediately saw and realized the epic potential of silkscreen painting. In 1964 Warhol used silkscreen to produce a series of trompe-l'oeil sculptures representing shipping cartons of brand-name packaged goods (Brillo, Kellogg's Corn Flakes, etc., fig. 258). Installed, the "boxes" appeared to transform a gallery space into a warehouse or stockroom, thus giving Warhol the last word with the Los Angeles dealer who had mocked his Soup Cans by displaying a sale-priced stack of the real thing. From hindsight the Brillo Boxes also look like prefigurations of Minimalism's primary forms, which would not appear until 1965. This was the year that Warhol announced his "retirement" from painting and penetrated further into the environment by making more of the underground films that had first engaged him in 1963. Carter Ratcliff has written that Warhol, being obsessed with stardom, found his abiding subject in "glamour and how to generate it." With movies the artist no longer needed to borrow prepackaged "aura"; instead, he manufactured the product himself, using the Factory as a studio and creating overnight "superstars"—truly "supermarket" consumer items—of artist-friends like Marisol and Robert Indiana, such would-be celebrities as Viva, Ondine, and Baby Jane Holzer, or the genuinely lu-

minous, but "stoned" and doomed, socialite Edie Sedgwick.

Never one for stubborn consistency, Warhol was also painting, contrary to his stated intentions, but now on an increasingly environmental scale. At the suggestion that he paint a cow, a subject with a long history in genre, Warhol not only made the picture but also created his Cow Wallpaper—the artist working as a machine—and made a background of it for the Paris exhibition of his Flower paintings (fig. 259). The total ensemble or décor this produced seemed a Pop reinvention of the grand decorative schemes so often created by the French, most notably in modern times by Monet and Matisse. For Warhol, it provided a further opportunity to blur the distinction between fine and commercial art, thereby reaffirming his long-held belief that everything in life is art. In the pictures, themselves, beginning with the Maos, the equation became one of a grittily factual, mundane subject rendered in the most artfully synthetic colors, of an impersonal, mechanically reproduced, repeated, and gridlocked imagery applied over an ever-more personal, painterly, and abstract surface. This, finally, became the style that Warhol progressively amplified and elaborated for the remainder of his career, which throughout the seventies focused mainly on portraiture, a once-noble kind of art but then devalued by New York School modernism almost as severely as décor (fig. 260). Here, each unit within the compositional grid might contain a different Polaroid snapshot view of the subject, which all together allowed a more complex personality to emerge, only for this to be steamrolled by the flattering magic of the artist's cosmetic colors,

left: 260.
Andy Warhol.
Leo Castelli. 1975.
Acrylic and silkscreen on canvas, 40" square.
Collection Leo Castelli, New York.

below: 261.
Andy Warhol. *Reversal Series: Retrospective*. 1979. Acrylic and silverprint on linen, 29 × 38". Collection Burda, Offenburg.

above: 262.
Robert Indiana.
LOVE. 1966. Acrylic on canvas, 6' square.
© Indianapolis Museum of Art (Roberts Fund).

inventively nonchalant montage, and expansive repertoire of brushy underpainting. On this modish surface, relatively unknown socialites found themselves as transformed into glamorous presences as the authentic celebrities—Liza Minnelli, Mick Jagger, Roy Lichtenstein—whom Warhol painted by the score. A richly mature style, it culminated in the late Reversals and Retrospectives, enormous canvases that found the artist in a nostalgic mood (fig. 261). Now the environment became that of his own oeuvre, whose key themes Warhol would re-view afresh by a process of literal reversal and recombination. While this could entail flopping the images as well as switching their values and colors from positive to negative, it might also, as in the *Retrospective (Reversal Series)* seen here, loosen the familiar slippage of the artist's grid system until the design evinces a baroque freedom consistent with the broadly gestural brushwork underlying it.

This indeed is the Warhol canvas treated as a mirror held up to a fraught and alienated life, playing host, with unflappable cool, to images of highway violence, the ever-quizzical bovine, a flower painting, a self-portrait of the artist as a young man, and various trademarked products, including a gridded, once-golden Marilyn reversed into a dusky Rembrandtesque chiaroscuro. So arresting is Warhol's way with this aleatory assemblage of disconnected, substitute, and arbitrarily juxtaposed reality that, like much good packaging, the exterior may offer more rewards than the contents. If such flirtation with nothingness implied, and continues to imply, something about contemporary culture at large, it also illuminated the art scene itself, whose glamour-mill aspects Warhol was among the first to accept and exploit even as he exposed them. Charles Stuckey, an unabashed Warhol apologist, has called the art boundless in scope, "for whatever it has to say, it always says the reverse as well. If his art is intentionally mindless, it is nevertheless saturated with irony; if superficially it seems to be careless, it seems as well to be laced with innuendo. His art is both naïve and sophisticated, deadpan and slapstick, both clumsy and lyrical, garish and ravishing, boring and provocative, trivial and profound."

If Pop Art produced a more famous image than Warhol's Soup Cans, it would have to be *LOVE* by Robert Indiana (*né* John Clark, 1928—), whose art is as flat and razor-edged as Lichtenstein's but even more abstract, owing to imagery composed almost entirely of words and numbers (fig. 262). Indiana, moreover, presented his signs

Pop Art and New Realism

with absolute heraldic frontality, and often in blazing colors contrasted to yield scintillating retinal flickers like those generated by Op Art, or even the Hard-Edge abstractions of his Lower Manhattan neighbors Ellsworth Kelly and Jack Youngerman. As the title *LOVE*, or the pseudonym he assumed from his "Middle America" home state, suggests, Indiana nursed a profound yet ironic sense of identification with the American Dream, the announced subject of his principal series of paintings and prints. Even the devotion to words and numbers reflects a hope that his paintings might sing with something like the verse of Melville and Whitman, albeit in the demotic visual/verbal poetry of monosyllabic commands, such as EAT, LOVE, and DIE. Here was transcendental Americana of a vernacular sort seen in signage—and so memorably noted by Humbert Humbert and his Lolita—all over the continental USA. No less mythic is the genesis of the signs, which Indiana began painting after he found a set of packing-case stencils stowed away in his old waterfront loft.

American Pop may have originated in New York, but California, with its Hollywood glamour mills, its big-sign, freeway, and surfboard culture, its hot-rodders driving "customized" cars, very quickly transformed itself from a source of Pop imagery into a breeding ground for an indigenous brand of Pop Art. Such was its receptivity to the new idiom that earlier than New York, Los Angeles' Ferus Gallery, as we have seen, recognized the potential of Andy Warhol, becoming the first gallery anywhere to exhibit his Soup Can paintings. But even the more sedate climate of San Francisco generated a Pop school of major import, headed by Wayne Thiebaud and Mel Ramos. In Los Angeles, meanwhile, Ed Ruscha (1937—) emerged as one of Pop's most gifted exponents of visual/verbal paradox. This "Magritte

of the American Highway" discovered his Pop identity while motoring back and forth, along Route 66, between Oklahoma City, his home town, and Los Angeles, where he attended the Chouinard Art Institute and subsequently remained. What captivated him, during long night drives undertaken to avoid the hellish heat of day, was the highway culture of automobile fueling stations, diners, and motels that punctuated the vast, empty Western terrain like surreally illuminated, machine-age oases in a dark, lunar landscape (fig. 263). Even his struggles to become an Abstract Expressionist triggered a powerfully ironic gift to perceive the unintended comedy of gestural automatism, preparing him for a new kind of art derived from a totally different realm of experience. About the instruction he received at Chouinard, Ruscha commented: "They would say, face the canvas and let it happen, follow your own gestures, let the the painting create itself. But I'd always have to think up something first. If I didn't, it wasn't *art* to me. Also it looked real dumb. They wanted to collapse the whole art process into one act; I wanted to break into stages. Whatever I do now is completely premeditated, however off-the-wall it might be." Nothing could be more deliberate than the surgically precise isometrics of *Standard Station,* where word and image have been so transvalued that the sign becomes quite as much an object as the architecture, which itself is so manifestly "standard" as to become more a sign than a unique bit of reality. This alone should have alerted viewers seeing yet another put-down of the commercially dehumanized American scene that something more was at work here. Ruscha, David Hickey reminds us, rendered not only Standard Stations but also Norm's Restaurants, which, as Southern California franchises, became so utterly a part of everyone's subliminal experience that the artist had the wit to translate them into the language of what he called his Bureau of Standards and Norms. But as Nabokov in *Lolita* and the architects Robert Venturi and Denise Scott Brown also discovered "out West," normalcy even in a world of would-be standardization becomes, upon close examination, a thicket of wild complexity and contradiction. Thus, Ruscha painted *Standard Station* as if an icon of averageness deserved to be glamorized in the same way that 20th Century–Fox did its famous logo, another verbal/visual equation painted by Ruscha to resemble an Art Deco space ship streaming out of the "wide blue yonder."

Wayne Thiebaud (1920—), one of the senior figures associated with Pop, had been a successful commercial artist for a decade when, at the age of thirty, he began studying for a degree in art history and painting at California's San Jose State College. A natural draftsman with a flair for caricature, as well as for film-making, sports, and academic administration, Thiebaud already had the independence to realize, soon after his arrival for a year-long sojourn in New York (1956–57), that the attempts he and many others were making to be "artful"—to emulate the Abstract Expressionists—could only leave him without a creative soul of his own. Gradually, as if in protest at their exclusion, simple vernacular forms began to bob up and stay afloat in the swirling, abstract flood of his spattering brushwork. As luck would have it, Thiebaud saw the vulgar intruders—slot machines, cigar boxes, gum-ball dispensers, pie servings, iced cakes—as universal, elementary shapes, figurative equivalents of circles, squares, triangles, and crescents. By focusing exclusively on the motifs, masking out their background, and presenting them as either single monoliths or repetitive, all-over patterns, Thiebaud discovered that he could satisfy his need for both popular subject matter and modernist form (fig. 264). But he also retained his love of thick, buttery pigment, a strong, tensile line, and lavishly stroked surfaces, all of which combined with his rediscovered interest in allusion to make him look beyond the New York School to the tradition of loaded-brush realism exemplified by Vermeer, Chardin, van Gogh, Eakins, Hopper, Morandi, and Balthus. Where Thiebaud gained his own identity was not solely in corner-drugstore iconography but also in the paradoxical way he rendered objects to seem both palpable and abstract. Contributing to this illusion are the absence of modeling and the contradictory

presence of shadows treated, like everything else throughout the painting surface, as bricks of creamily impastoed medium. Another factor is the emphatic contouring, which defines forms as solid while simultaneously flattening them. Much of the painting's aura of quiet mystery radiates from these seams, as they periodically rupture to seep underpainting whose brilliant colors contrast, Fauve-style, with the flat, candy-hued palette used on either side. Another secret of this stark yet appetizing work was revealed by the artist himself when he wrote: "I like to see what happens when the relationship between paint and subject matter comes as close as I can get it—white, gooey, shiny, sticky oil paint [spread] out on top of a painted cake to 'become' frosting. It is playing with reality—making an illusion which grows out of an exploration of the properties of materials."

A student of Wayne Thiebaud, Mel Ramos (1935—) too possessed an oily virtuosity in his command of firm drawing and delicious facture, but came into his own by candidly reinforcing the eroticism of such technique with imagery taken straight from the girlie magazines, especially the centerfold pinup fantasies rendered by Petty and Varga (fig. 265). Earlier the California artist had painted the hypertrophied heroes and heroines of comic books—Batman, Crime Buster, and Glory Forbes-Vigilante. With the economy of a true artist, however, he soon sloughed off the males, replaced them with such phallic emblems as Coca-Cola bottles, spark plugs, corn cobs, pelicans, gorillas, or pumas, and used these as props for images of nude women with the overdeveloped attributes and brazen attitudes fostered by the Freudian fantasists of Hollywood and Madison Avenue. Often such cheesecake would be coyly lounging or perched upon the real thing. When this happened to be the brand-name processed or pasteurized variety, the parody seemed clear and complete—two varieties of cheap, synthetic product fetishized by the mass media for the mass market. Saving the work for art, however, are the sheer, ironic command of ideas and means, both of which could refer, in other paintings by Ramos, to classic precedents in figure, still-life, and landscape painting.

Ramos' mock pinups appear like milk-fed innocence itself compared to the authentic whiff of decadence that Richard Lindner (1901–78) brought to his pictorial view of the American Pop scene (fig. 266). As Hilton Kramer wrote in 1978, "it was part of the comedy of his career—a comedy Lindner savored with appropriate irony—that art

history, after first shunning him for what he was, then acclaimed him for something he was not." In the years immediately following his arrival in New York in 1941, the Hamburg-born Lindner could find no gallery in the abstraction-infatuated city to exhibit figurative paintings that were still redolent of the Weimar Germany in which he had matured. But with the rise of Pop, an iconography derived from the urban menace and erotic display of Times Square or Coney Island won Lindner his first one-man exhibition. Moreover, the art triumphed even though its bizarre, exaggerated imaginings evinced an obsessive subjectivity and a macabre social commentary remote from Pop cool but still immersed in the 1920s *Neuesachlichkeit*, or New Realism, of Otto Dix, George Grosz, Berthold Brecht, and *The Blue Angel*. Secure in a success he had never known in Europe, Lindner could give up both his commercial art practice and his teaching post at Brooklyn's Pratt Institute to concentrate on painting one corrosive and hypnotic psychodrama after another, all smoothly disciplined in technique but highly charged in content. Performing them downstage and full front was an archetypal cast of corseted, black-stockinged whores, pimps or gangsters in leather jackets and bat-winged eyeglasses, and the inevitable victims, dreamy boys in uniform. Outrageous as this fantasy may seem, Lindner made it inescapably compelling by the force of his slick forms, slippery surfaces, and feverish, honky-tonk colors. With their feral vitality and underworld glamour, Lindner's scenarios rang

right: **265.** Mel Ramos. *Kar Kween*. 1964. Oil on canvas, 5 × 4'. Hirshhorn Museum and Sculpture Garden, Washington, D.C. (gift of Joseph H. Hirshhorn, 1966).

left: **266.** Richard Lindner. *New York City IV*. 1964. Oil on canvas, 5'10" × 5'. Hirshhorn Museum and Sculpture Garden, Washington, D.C. (gift of Joseph H. Hirshhorn, 1966).

true for many a viewer aware of the violence and perversity that so often explode under the pressures of conformity, whether imposed by American mass culture or German authoritarianism.

British Pop: Second and Third Generations

In Britain, meanwhile, the original Pop Art movement was expanding apace, from the one-man phenomenon launched by Richard Hamilton in 1956–57 to a multi-figure second generation represented by Peter Blake, Richard Smith, Robyn Denny, William Green, and Roger Coleman. All of them attended the Royal College of Art, which had grown rather more hospitable to the sort of ideas embraced by Hamilton than when this artist found himself invited to depart. Indeed, under Denny's editorship (1956–57), *Ark*, the RCA student publication, ceased serving as a vehicle for traditional arts-and-crafts interests and became quite a lively affair, much taken up with the Pop issues then being debated by the ICA's Independent Group. But while these continued to focus on the desirability of accepting industrial culture into art, painters like Blake and Smith sought to work within a context decidedly more abstract and less overtly intellectualized or experimental than Hamilton's. Once again, a transatlantic influence could be felt,

not only from American mass media and products but also from the formal simplifications of the New York School's big-format painting.

The British Popster who became almost as familiar as the admass culture he co-opted was Peter Blake (1932—). And such celebrity might well have been his even without the unforgettably apt and charming record cover that Blake designed for the Beatles' *Sergeant Pepper's Lonely Hearts Club Band*. As this 1967 collage brilliantly demonstrated, Blake possessed a remarkable, perhaps characteristically English gift for mingling reality and fantasy, past and present, exuberant naïveté and subtle restraint in such a way that they made a convincing visual, even conceptual whole. It helped, of course, that he also possessed an English capacity to love and respect not only his figurative material but also his craft, the latter honed throughout a long preparation that began at the Gravesend Technical College and School of Art in Kent. Following a period in the RAF, Blake completed his education at the RCA (1953–56), where his training in graphic design

right: 267.
Peter Blake.
On the Balcony.
1955–57. Oil on canvas, 47¾ × 35⅗".
Tate Gallery, London.

left: 268.
Peter Blake.
Got a Girl. 1960–61.
Enamel, photo collage and record;
3'1" × 5'1" × 1⅝".
Whitworth Art Gallery,
University
of Manchester.

prepared him to treat the current surge of enthusiasm for popular Americana within a context of formal rigor. So precocious was Blake in discovering his artistic personality that it was fully evident even in 1956, when Roger Coleman, writing in *Ark*, called Blake "a romantic naturalist" and noted that "very often Blake's pictures are littered with the small objects of our urban civilization, the things that pass through our hands a dozen times daily, the cigarette packs, the detergent box, sweet wrappings, watch-boxes, bus tickets, and so on; the world of the throw-away object. Blake transforms these things into images of the most compelling sort, so that we look at them a little harder next time, just to see [if] they are as real as he makes them." Coleman could have had in mind what still remains Blake's most celebrated and complex painting, *On the Balcony*, the subject of which had been set by the RCA as an obligatory diploma composition (fig. 267). Begun in 1955, but completed only two years later, *On the Balcony* is a trompe-l'oeil collage, a meticulously hand-painted assemblage whose constituent images are as dense in associative reference as their presentation is rich in visual syntax. Selecting from a democratically diverse assortment of largely identifiable sources, or inventing allusions to them, Blake managed to introduce about twenty-seven variations on the designated theme, ranging from a *Life* magazine cover and news photos of the British royal family on the balcony at Buckingham Palace to Manet's famously enigmatic painting called *The Balcony*. Also present are flattened perspective views that transform a park bench and schoolroom desks into balconies supporting cards, pinups, pennants, and solemnly well-behaved young folk. Together they combine with the pin-board composition to evoke not only the subject but also the scholastic or homework nature of its choice. Conspicuously absent are dictators saluting or haranguing the masses from balconies, and properly so, for Blake's world would al-

ways remain quite coherently a place of knowing but nonetheless genuine innocence. Symptomatic of this sly sweetness or witty but largely irony-free humor are the affectionate tributes paid to friends in the form of paintings within the painting, each realized in the suitably eponymous style of Robyn Denny, Leon Kossoff, or Richard Smith. Moreover, the tabletop still life in the lower left quotes the "kitchen sink" painting of John Bratby, an "angry young man" then much written about by a critic for the *New Statesman*, a copy of which can be detected among the "breakfast table" clutter. Not one to miss a good show, Blake included a self-portrait, but Hitchcock-fashion, as a tiny reflection in the eyeglass of the boy holding the framed reproduction of Manet's painting. Touchingly, he also added the portrait of his tutor, John Minton, who committed suicide while *On the Balcony* was in progress. Here, then, in an early but amazingly complete work, Blake had already established the hallmark quality of his art, what Marina Vaizey has described as "a kind of simplified elaboration, or elaborated simplification." Carried out with more gusto than deadpan, as well as with a craftsmanly touch and a graphic artist's command of clear, two-dimensional design, it would also involve a non-hierarchical mixture of images both old and new, ordinary and extraordinary, factual and fanciful, the better, it would seem, to reinforce our perceptions of both.

In 1956–57, Blake traveled in the Netherlands, Belgium, France, Italy, and Spain on a Leverhulme research grant to study popular art, but even for *On the Balcony* his primary inspiration had been American, a painting by the Realist artist Honoré Sharrer that contained simulacra of many other paintings. And, by the time of *Got a Girl*, a fully fledged Pop work of 1960–61, the mass culture that Blake had succumbed to was also American, this time the recorded music of those founding rockers, Elvis Presley, Fabian, Frankie Avalon, Ricky Nelson, and Bobby Rydell (fig. 268). Blake actually confessed to having been less a fan of Presley the performer than of his legend, and something of this fastidiousness appears to have invaded the picture. Here, on one level at least, the real and the ideal have been isolated from one another, with the collaged photographs of the stars aligned in a band across the top and the remainder, or lower two-thirds, of the picture given over to a triptych field of pure design. Yet, closer looking reveals that the red, white, and blue chevrons, instead of emulating the mint perfection characteristic of sixties abstraction, actually seem almost as weather-blemished as old hoardings, the very sort of blunt reality that Rauschenberg and Johns loved to abstract from the urban environment and rehabilitate in art. Meanwhile, the portraits made by the realistic medium of photography represent little but an adolescent

dream-boat world, thereby propounding the dilemma at the heart of the painting. But where it beats most strongly is in the record collaged in the upper left corner, an abstract shape that, if played, would reproduce the actual sound of the Four Preps singing ''Got a Girl,'' the plot of which describes a teenage heroine who can only think of the Pop stars when her boyfriend wants a kiss. In form and feeling alike, therefore, *Got a Girl* can claim transatlantic cousinage with Johns' 1955 *Target with Plaster Casts* (fig. 229), but, for the most part, Blake remained a more distinctly English artist than the early sixties work would suggest. And this was true not only in his exquisite workmanship, which encompassed a vast range of media, but also in his nostalgic love of Victoriana, including Lewis Carroll's *Alice in Wonderland* and *Through the Looking Glass*, both fantasies rooted in the absurdities of reality and thus destined for a place in Blake's art. So too was *A Midsummer Night's Dream*, whose author, William Shakespeare, mingled kings, queens, clowns, jesters, and yokels together with the ordinary mass of humanity, just as Blake continues to do in an oeuvre notable for the special edge it gives to both imaginative artifice and acute observation by bringing them together in works of great formal distinction.

As the quotation in *On the Balcony* would suggest, Richard Smith (1931—), a native of Hertfordshire, was one of Blake's closest friends at the Royal College of Art. With his powerful intellect and verbal command, he also became a major apologist for art based on the popular imagery then flowing into Britain from postwar America. In his own painting, however, Smith chose to convey media experience in a formal idiom closely allied to the ''big picture'' language of American abstract painting (fig. 269). For two years beginning in 1959, when he received a Harkness Fellowship, Smith could pursue this goal in New York, where the Green Gallery gave him his first one-man show in 1961. In works like the one seen here, it was as if Smith had decided not to describe objects from the everyday commercial world, but rather to evoke them in terms of the vast, amorphous environment they created or inhabited. Thus, while such titles as *Product*, *Soft Pack*, *McCall's*, and *Revlon* confirm an eagerness to preserve some degree of subject-matter legibility, Smith tested that degree to the limit. His technique was to liquefy his touch and expand the scale of his image until the painting embraced or immersed *and* involved the viewer like a close-up, unfocused view of a late Monet, a mural-size Pollock, a billboard advertisement, or the wide-screen cinema, the latter then very much at the center of aesthetic discussion among London's second-generation Pop masters.

The third phase of British Pop also flowered at the RCA, most decidedly in 1961 during the ''Young Contemporaries,'' the annual exhibition selected and hung by the students themselves. A particularly liberated, hedonist group—as well as intellectually curious, cosmopolitan, and dauntingly gifted—these newcomers mixed figuration and abstraction with exhilarating freedom, which meant that they were much too independent to be characterized in a simple, catchphrase manner. However, most seem to have been affected, in one degree or another, by the erudite, paradoxical mingling of diverse modes and messages practiced by their eldest member, who urged his classmates to follow their own interests wherever they might direct. This unofficial leader of Britain's Young Contemporaries was in fact an American, the Cleveland-born R.B.Kitaj (1932—), who had become an expatriate in London, very much after the manner of such earlier artist-intellectuals as James, Whistler, Sargent, Pound, and Eliot. In a sense, Kitaj may also be considered a citizen of the world—a true cosmopolite—for not only has he accepted periodic teaching assignments back in the United States; he has also studied, lived, painted, or otherwise worked his way over much of the globe—always with an alert, inquiring mind as open to poetry, politics, philosophy, and economic issues as to visual aesthetics. The process may have begun at the Cleveland Museum, but it continued at New York's Cooper Union and Vienna's Academy, as well as through several years of reading Conrad, O'Neill, Kafka, and Borges while shipping out as a merchant seaman. Thanks to two years with the US Army in Europe (1955–57), a twenty-five-year-old Kitaj could take advantage of the GI Bill to become an ''artist-scholar'' at Oxford's Ruskin School of Drawing and Fine Art. While the School made him a practicing draftsman for life, at least intermittently, the University's Edgar Wind left him a believer in the capacity of images to give form to ideas. Together they reinforced his inclination towards the Dada-Surrealist faction within modern art, with its faith ''in the disinterested play of thought'' and its concomitant reliance on the techniques of both ''psychic automatism'' and collage. Thus, by the time he entered the Royal College of Art for the years 1957–61 Kitaj was already a well-seasoned and richly experienced artist about whom his fellow student Allen Jones could

left: 269. Richard Smith. *Quartet.* 1964. Oil on canvas, 4'8" × 6' × 1'8½". Walker Art Center, Minneapolis (Art Center Acquisition Fund, 1964).

above: 270. R.B. Kitaj. *Arcades (after Walter Benjamin).* 1972–74. Oil on canvas, 5' square. Courtesy Marlborough Gallery, New York.

Pop Art and New Realism

record: "I learned more, I think, about an attitude to painting merely from watching him. I didn't speak to him very much, but suddenly I thought this was something vital in comparison to everything else at the College. In other words, the influence wasn't one of imagery but of a dedicated professionalism and real toughness about painting." What Kitaj determined to do was reject the formalist idea that painting is simply an abstract, self-referential arrangement of colors, lines, and planes whose form is its content. His content too would derive from process, but a process of hand-painted collage that allowed him to transform his canvas into a web of historical, mythological, literary, and topical allusions—always clear in appearance but often obscure or inderterminate in meaning. By this device he hoped to re-endow pictorial art with something of its ancient, pre-modern capacity to communicate life experience, complete with the layered, interconnecting but contradictory moments of memory and feeling, knowledge and imagination, love and violence that we all know. Not until 1962, however, did Kitaj begin to take real satisfaction in his painting, which, as *Arcades* demonstrates (fig. 270), would offer a vivid patchwork of images interspersed with pockets of pure, abstract color, the whole fused by a kind of intensely personal vision that makes the canvas seem a pictorial counterpart of Pound's *Cantos* and Eliot's *Wasteland*. In this instance the vision was informed by the artist's fervent reading of a 1936 essay written by the German writer Walter Benjamin and entitled "The Work of Art in the Age of Mechanical Reproduction." For Kitaj the essay proved exemplary not only for "the impossible-to-categorize quality of [its] creative, highly fragmented texts," but also for the author's uncanny presentiment, some twenty-five years before the Pop era, of the media's impact on the artist and the sovereign uniqueness of his work. By portraying the bespectacled Benjamin in *Arcades*, Kitaj also evinced his growing preoccupation with Jewish experience, because as a Jew the writer had fled Nazi Germany for France, where he composed the essay just cited, and where he would commit suicide once his safe haven fell to the German Army. All about the figure are other portrait-like images whose various physiognomies suggest that the artist wished to reverence those segments of humanity most threatened by barbarism's rise to power in prewar Europe. Thus far, the painting seems legible enough, and to encourage interpretation, Kitaj has frequently amplified his pictorial allusions with inscribed lines of poetry. Ultimately, however, image and word alike are so permuted by their scattered and disjunctive, oddly cinematic, or dream-like combinations that meaning seems destined to remain ambiguous, even as the same factors solicit imaginative speculation. Part of the inducement comes from the artist's preference for intellectually complex and emotionally intense subjects, often involving such marginal types as visionary reformers, political outcasts, prostitutes, and mobsters. But it also derives from his sense of the world as a fragmented, collage-like realm alive with countless nodes of interconnected but woefully uncoordinated energy. Thus, Kitaj finds his own paintings full of mystery; moreover, he regards them as never entirely finished, thus always available to new relationships with the outside world. As the artist once said: "Some books have pictures and some pictures have books."

While Kitaj was establishing himself as an American painter in London, his close friend and fellow RCA graduate, David Hockney (1937—), found a second home in Los Angeles. As with British colonials of yore, residence abroad seemed to confirm Hockney in his Englishness, given that he remains an artist of unfailing craftsmanship, genial wit, and wiry, if diffident, stylistic grace, however boldly confessional his themes or disparate his vast repertoire of borrowed pictorial conventions. Much of this technical security—indeed virtuosity—may have been an aptitude thoroughly prepared during the traditional training he received at the College of Art in his native Bradford, an industrial city in the north of England. Certainly he was in a high state of readiness to assimilate modernism when, after two years of hospital service, in lieu of military duty, he entered the RCA in 1959. There a twenty-two-year-old Hockney met the slightly older and considerably more experienced Kitaj, whom he credits with having released him from his push-pull struggle with figuration and abstraction, a conflict arising in part from an early encounter with Alan Davie's painting, the first contemporary work he had seen. Soon Hockney could say: "I paint what I like, when I like, and where I like . . . landscapes of foreign lands, beautiful people, love, propaganda, and major incidents (of my own life)." With this, he became the undisputed star of the Young Contemporaries, not only winning the RCA's Gold Medal but also achieving celebrity status and commercial success even before he graduated in 1962. Encouraged by Kitaj to respect literature and to pursue his own most compelling obsessions, Hockney read the poetry of Walt Whitman, visited New York City in 1961, investigated the luridities of Times Square, and returned home a kind of English Warhol, a highly visible Pop-youth dandy styled in peroxide hair, granny glasses, and gold lamé jacket. Happily, this cool charmer with the working-class Yorkshire accent was also a steady, dazzling producer, and thus, along with the Beatles, he became an ongoing media as well as critical event throughout London's swinging sixties.

While packaging himself, Hockney, like Warhol and Richard Smith among many other Popsters, discovered themes in packages and painted a shaped canvas based on a Ty-Phoo tea packet. Although coloring and labeling the image as in reality, he also embellished it with graffiti scribbles and the figure of a naked boy, the latter represented as if illusionistically present inside a transparent container. Exhibited together with several other "Demonstrations of Versatility,"

this early work announced two of Hockney's most abiding concerns: homoeroticism and the manifold ways of making art. They both flowered in the artist's landmark work entitled *A Rake's Progress* (1961–63), a cycle of sixteen etchings that updated Hogarth to narrate the amorous misadventures of David Hockney in New York, the place and the experience viewed alike with spare, ironic whimsy. Equally characteristic of the early Hockney is *We Two Boys Clinging Together* (fig. 271), a painting whose title derived from a Whitman poem, used, however, to echo a current newspaper headline about a mountaineering accident, "Two boys cling to cliff all night," which moved the punning artist to think of them as fans of the pop singer Cliff Richard! Supporting this chain of external references is the multivalent, *faux-naïf* style concocted by a most sophisticated painter from graffiti, of course, but also from children's art and Dubuffet, from Francis Bacon, Picasso, and possibly even Larry Rivers, a recent visitor to London. In the end, however, what holds the eye and mind is a mesmerizing artistic sensibility compounded of elements both primitive and refined, even a bit precious.

At the end of 1963, Hockney began dividing his life between London and Los Angeles, a modification that he accompanied with a shift from oil paint to acrylic, also with an increasing use of photography.

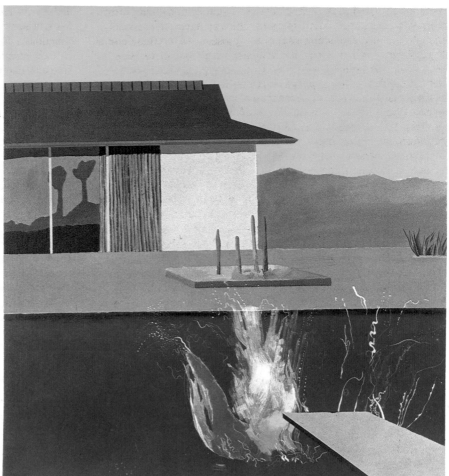

Inevitably, these developments had thematic as well as stylistic consequences, as the planar colors and immaculately edged forms of the pool-side scene in *The Splash* indicate (fig. 272). Like a Noël Coward Englishman in the midday sun, Hockney found himself enraptured by the brilliant light, the lush gardens and lawns, the aquatic facilities and laid-back atmosphere of Southern California. While linking up with other distinguished expatriates, such as Christopher Isherwood, he also continued to express his enthusiasm for handsome human flesh, here disappeared below the surface and leaving a high, plume-like splash in its wake. But distinctive as the West Coast motif may be, it also looks as if viewed through European eyes, eyes schooled in Matissean flat-pattern *luxe, calme et volupté*, albeit rendered with a deadpan poetry that may be the Pop equivalent of English reserve. As for the painterly brio of the eponymous splash, it seems to quiver with the spirit of Francis Bacon, but not without a touch of wry humor, registered by Hockney himself when he noted his bemusement over the brevity of the water's leap into the air, contrasted to the extended duration required to freeze the momentary image in paint. The suspended animation of such effects prompted one critic to describe the distinctive character of Hockney's art as the "epitome of expectant stillness."

This Ektachrome vision of a bright, high-noon world poised or crystallized between dream and reality was made possible by Hockney's habit of working from photographs. Infatuated with the Polaroid, the artist has recently been using it to re-explore the riches of the space-time equation investigated by Braque and Picasso in Analytic Cubism (fig. 273). Hockney so loves the camera that he once starred in his own movie—entitled, no less, *The Bigger Splash*—and favored his viewers with the sight of him playing a scene in the heroic altogether. To whatever extent this may represent a failure of taste, he has more than made up for it in the Ingres-like perfection of his drawings,

especially in the numerous portraits of family and friends (fig. 274). A rare aesthetic judgment is also to be seen in his etched illustrations for the poems of C.P. Cavafy, six tales by the Brothers Grimm, and Wallace Stevens' poem *The Man with the Blue Guitar*, which in turn was inspired by Picasso. A lover of the theater, Hockney, like a latter-day Bakst, Picasso, Matisse, or Chagall, has been brilliantly successful in his designs for such operas as Mozart's *The Magic Flute*, Strauss' *Der Rosenkavalier*, the Satie-Poulenc-Ravel-Stravinsky mixed bill called *Parade*, and even Wagner's *Tristan und Isolde*. In tandem with Kitaj, Hockney made an early decision to regard modernism not as an ever-more rigorous process of self-purification, but rather as a treasure trove of ideas rich and complex enough to provide any artist with the materials for a personal synthesis. Accepting modernism's spirit of open, experimental inquiry, he has found material for his art not only in the work of admired older masters, but also in direct observation, in poetry, photography, and all manner of graphics. For its substance, he most often looks to his own life, and by creating an oeuvre as diaristically unbuttoned as Picasso's, he has made it an equally luminous mirror of his time. However, like so many others of the Pop generation, Hockney is also captivated not just by the facts of contemporary existence, but also by the myths we entertain about it, by the way Ektachromes, films, and real-estate brochures shape our notions of what a hedonist paradise is supposed to be.

Southampton-born Allen Jones (1937—) proved so difficult as a student that the RCA "ejected" him at the end of the single year he spent there (1959–60), but not until after 1964 would such extreme conflict become evident in his painting. The crux of the "problem" lay in a powerful mentality, on the one hand, and, on the other, a libidinously sensual approach to art, its content as well as its form. However, common to intellect and instinct alike was the stimulus both received from Jones' extensive reading of Nietzsche, Freud, and

Jung, which prompted the artist to seek ways of adapting Abstract Expressionist automatism to the needs of figurative painting. In 1962, he did this by selecting a subject—public buses—that was simply available as part of his everyday routine and then by so shaping the canvas that its static image would suggest forward acceleration. Within the rhomboidal format, loosely drawn figurations tilting parallel to the support, blurred or "out-of-focus" passages of pure painting, and target-like wheels attached on a separate diptych all reinforce the sense of movement, while simultaneously doubling as abstract pattern. Here, as elsewhere, Jones always insisted that his art originates "as a formal picture and that leads me to the imagery. The shapes themselves suggest the subject, not the subject the shapes." But in 1964, a year the artist lived in America, the shapes began to generate an altogether more aggressive iconography after David Hockney drew Jones' attention to the commercial fetishism that flourished on every side of New York's Times Square. Equating the sheer pleasure he derived from painting with the pleasure evoked by sexually provocative images, Jones permitted his Matissean mix of lush colors, caressing contours, and ravishing surfaces to form isolated emblems of charged femaleness, especially well-shaped legs sheathed in transparent stockings and high-arched feet shod in spike heels (fig. 275). To express the universality of the erotic impulse, he often combined these signifiers with male ones, such as the necktie, which Jones called a "phallic totem image." With this he created a sort of androg-

ynous world, where hose, pumps, bras, ties, and fedoras weave together like interchangeable parts of a voluptuous, metamorphic puzzle, which an ambiguous intermingling of unfinished areas invites the viewer to solve or decode imaginatively. Sometimes body or clothing parts meld into rainbows or parachutes, abstract shapes that serve as metaphors for the euphoria possible in both sex and art. Increasingly, however, the images would become more obsessional, not only explicit and slickly stylized, like hard-sell advertising, but also exaggerated in the swell of bosoms or the length of thighs, and even clad in leather girdles and lethal-looking stiletto heels. The trend towards kinkiness seemed to climax in the notorious *Green Table*, where the image of desire became an object, a freestanding, brightly enameled sculpture of a semi-nude girl down on all fours with a sheet of glass on her back. Even though the tabletop was shaped like a palette, suggesting woman's role as muse, the overall effect proved too steeped in perverse male fantasies for many viewers, most particularly feminists. But in defense of his art, Jones once said: "Eroticism transcends cerebral barriers, and demands a direct emotional response—confronted with an abstract statement people readily defer to an expert; but confronted with an erotic statement everyone is an expert. It seems to me a democratic idea that art should be accessible to everyone on some level, and eroticism is one such level."

Given the violently flashing rhythms and neon colors, the colliding leather-jacket and drag-strip imagery, the aggressively impersonal machine-style handling favored by Peter Phillips (1937—; fig. 276), it is difficult to imagine that this artist had begun to paint under the influence of that "romantic naturalist" Peter Blake. But such was the gap that yawned between the second and third generations of Britain's Pop artists. In the case of Phillips, the difference can in part be traced to his early training in technical drawing, acquired before he entered the Royal College of Art for the years 1959–62. Still, it would seem to have been Blake's appealing amalgams of rock stars, record covers, and pinball machines that launched Phillips upon his brutal departures from what he deemed the time-worn formulas of fine-art painting. The tendency assumed its full thrust after the artist moved to New York for the years 1964–66, where he learned airbrush painting, a technique that enabled him to render his power-plant motifs—sexual or industrial—with something like the hard, enameled surfaces and knife-sharp edges of custom-engineered products. This tough, urban manner also involved elaborately compartmented structures that Alloway characterized as "half-way between a games board and a Sienese altarpiece." When they combined with the jukebox palette of implacably flat, synthetic hues and a repertoire of zigzags, stripes, and spirals, Phillips' exploding agglomerations of tires, motors, circuit boards, helmeted guys, and cheesecake girls create the impression of paintings that could just as accurately be called abstract as figurative. However this Pop fantasy may tilt in the viewer's eye, the results are bright, jazzy, decorative, and thus replete with visual impact.

When Patrick Caulfield (1936—) arrived at the RCA in 1960 he had already spent four years studying at London's Chelsea School of Art. If such preparation set him apart from the other Young Contemporaries, so did his mature painting, which neither depended on popular sources for its imagery nor expressed any strong degree of personal involvement with the subjects actually preferred, usually rather traditional still-life and landscape motifs (fig. 277). As the emphatic contouring and flat colors of their presentation would suggest, Caulfield sought to assert the linkage he felt between his art and that of such pioneer modernists as Gris and Léger, while also claiming his place in the here and now by certain measures of strategic updating. Thus he made the ironic move of matching thematic cliché with an extreme banality of process, which consisted of using ordinary house paint on hardboard and applying it in an utterly bland, stroke-free manner. The distancing effect of unmodulated color areas bounded by dark lines of uniform thickness, plus the occasional quotation from high art, has often provoked comparisons between Caulfield and Roy Lichtenstein, even though the English artist sedulously avoids Pop

275.
Allen Jones.
Pleated Skirt. 1965.
Oil on canvas,
46⅝" square.
Private collection,
Brescia.

left: 276.
Peter Phillips.
*Custom Painting
No. 3.* 1964–65.
Oil on canvas,
7' × 5'9".
Des Moines Art
Center (gift of
the American
Republic Insurance
Co., 1982).

opposite: 277.
Patrick Caulfield.
View of the Bay.
1964. Oil on Platex,
4 × 6'. Centro
de Arte Moderna,
Fundação Calouste
Gulbenkian, Lisbon.

subject matter. But certainly the two artists share a common interest in making style as much a subject of their art as its figurations, which in the end prove no more important than the rigorously abstract formal structure through which they are conveyed. While Caulfield has never attempted the brash and overwhelming impact of Lichtenstein's monumental comics, the effect of his radically simplified language is to create a cartoony version of the world, as if the painting were a single frame snipped from an animated film. Almost gumdrop sweet, as well as vibrant, in color, Caulfield's paintings are even more decorative than his American counterpart's and wonderfully quiet about it.

New Realism: Pop Art on the Continent

On the Continent too, Expressionist abstraction eventually generated a revolt against its excesses of anguished subjectivity and roiled paint surfaces. As in Britain and America, this led, on the one hand, towards a more restrained or severe form of pictorial autonomy and, on the other, towards an accommodation of art with the facts of postwar urban culture. The latter development found an enthusiastic and articulate apologist in the Parisian critic Pierre Restany, who called it *le nouveau réalisme*, or New Realism, a term that in late 1962 still seemed sufficiently synonymous with Pop to serve as the title of the historic Janis exhibition in New York. But even while this affair included a number of Restany's New Realists, the very fact that in 1960 they had organized as a semi-official "school," under the leadership of Restany and Yves Klein, set them somewhat apart from their Pop cousins in the Anglo-Saxon world. Restany even supported his group in the classic manner of Europe's avant-garde, by composing and publishing a pair of manifestos. The first, which appeared in April 1960, stated that from then on the "vision of things should be inspired by the feelings of modern nature, which is that of the factory and city, publicity and mass media, science and technology." As such rhetoric would suggest—with its stress on "vision," "feelings," and "modern nature"—the New Realists approached the commercialized world with something of the romanticism evinced towards industrialization by Fernand Léger, who in the late 1920s had first used the term "New Realism" to characterize his machine aesthetics. Another clue to the special quality of Continental Pop came with the very title of Restany's second manifesto, published in May 1961 as *40° above Dada*. What resulted was a new respect for the Duchampian ready-made, but a ready-made now freighted not so much with anti-art attitudes as with a touch of the *engagé* or revolutionary Utopianism embraced by both the original Dadaists and Léger. The artists who signed the first manifesto, at Yves Klein's Paris apartment in October 1960, were the Frenchmen Arman, François Dufrêne, Raymond Hains, Klein, and Jacques de la Villeglé, as well as the Swiss Daniel Spoerri and Jean

Tinguely. Subsequently, they would be joined by César, seen earlier in Chapter 4, Christo, Gérard Eschamps, Mimmo Rotella, and Niki de Saint-Phalle. Once again the majority were French, but Christo hailed from Bulgaria and Rotella from Italy. Eventually, the New Realist umbrella spread, in the minds of most observers, to cover virtually all Continental artists working with popular imagery, found materials, assemblage, or such nontraditional processes as photomechanical printing, airbrush, and spray painting. Thus, it stands to reason that the New Realists would display even less homogeneity—despite the formality of their original organization—than the Popsters of Britain and America. Indeed, some of the most important among them—Arman, Christo, and Tinguely—developed assemblage to the point where, for present purposes, their art must be considered in other chapters. Aggressively avant-garde, and therefore competitive as well as righteous about their respective values, the New Realists quarreled from the start, thus dissolved their group shortly after Restany issued his second manifesto. Needless to say, each of the artists went right on creating precisely as he felt compelled to do, before, during, after—and regardless of—their involvement with one another as a labeled "movement."

The central, but perhaps least representative, figure among the New Realists was Ives Klein (1928–62), a charming, charismatic autodidact who, in a brief career of only seven or eight years, became one of the great legends of late-modern art. What most distinguished Klein from his immediate contemporaries was the obsessive longing he had conceived, at a very early age, for the Void, a weightless, limitless spiritual space "beyond" the material and existential conflicts of here below. When he conveyed this in utterly abstract, evenly painted monochromatic pictures—his best-known creations, usually executed in the purest, most saturate ultramarine—Klein seemed a soul fellow of older artists like Rothko, Newman, and Reinhardt (fig. 324). However, he also made himself anathema to these very masters by choosing to play the "Conquistador of the Void" and help bring on "paradise now" in a series of works—statements and "gestures" as well as objects—so provocative, so pivoted between the sublime and the absurd as to make Dada seem born anew. In other words, Klein felt such urgent need to reconcile his dream of destiny and everyday reality that he was willing to fake it, even his promise to demonstrate transcendence by levitating or "leaping into the Void" (fig. 478). Moreover, the work would subtly but deliberately allow the alert to understand that the literalism offered for their consideration was, alas, nothing more, or less, than a clever, sometimes beautiful, often entertaining illusion. When, for instance, Klein developed his signature variety of electric blue, it was to symbolize the infinite immateriality of the heavens. Forthwith, however, he not only applied this ethereal hue in the most solid, chunk-like pictures, but also limited its use to himself by patenting the color as International Klein Blue. Somewhat like Rauschenberg in *Factum I* and *Factum II*, Klein then took the unprecedented step of filling a gallery with paintings—blue Monochromes—that in every way appeared to be exactly alike. While this mocked Informalism's contention that meaning derived from the unique, unpremeditated stroke, it also implied that the real value of art lay in the invisible—beyond what one can see or touch. And Klein's viewers proved it by asking the price of, and thus expressing an affinity for, one or another among canvases that seemed indistinguishable. Klein had anticipated this phenomenon, since "the prices were," as he subsequently wrote, "all different, of course." Because the Monochromes belong to the history of abstract painting, they will be discussed elsewhere, but clearly those ironic works, as well as the figurative ones considered here, embodied something of the same critical and self-critical theme as that already seen throughout much of British and American Pop. And so, despite his occult mysticism, Klein played an all-important role in what come to be known as New Realism from the mid-1950s right into 1962, when, just as Pop was coming into full flower, the Promethean death that Klein had prophesied for himself actually occurred, at the prime age of thirty-four.

above: 278.
Yves Klein. *People Begin to Fly*. 1961. Dry blue pigment in synthetic resin on paper on fabric, 8'1" × 13'1½". Menil Collection, Houston.

left: 279.
Yves Klein. *Making Anthropometries of the Blue Period*. March 9, 1960. Photo by Harry Shunk, New York.

Klein. In a speech titled "The Monochrome Adventure" (1959) Klein put it this way:

I loathe artists who empty themselves into their painting, as is quite often the case today. Morbidism [sic], rather than thinking of the beautiful, the good, the true in their painting: they express, they ejaculate, they spit out every horrible, rotten, and infectious complexity in their painting as if relieving themselves and putting the burden on others, "the readers of their works," of all their sorry failures.

Then he added: "I execute my paintings very quickly, in very little time." And this was because to him the idea—the aerial, free thought—captured in the painting counted for vastly more than its formal or material execution.

Nowhere are the coolness and candor of Klein's passion more evident than in the Anthropometries (fig. 278), body prints resembling those of Rauschenberg (fig. 219), albeit made by an even more direct means than photosensitive paper. Like the American Popster, Klein used live models as his "pencils" or "brushes" and thus avoided the personal involvement—as well as the technical problems—of traditional drawing. Having the nude coat her body in IKB and then impress it on paper, or simply instructing her to pose against or lie upon the support while he sprayed IKB around her silhouette, Klein obtained an image that not only represents the subject but also constitutes an actual trace of her physical, if temporary, presence. As in Johns' negative castings or Rauschenberg's *Bed* (figs. 222, 234), the evidence of presence also connotes an ambiguous absence. In the Anthropometries the curious result of such enigmatic literalism is the haunting illusion of a figure liberated from its own corporeality and set afloat in boundless depth. Process was crucial to the effect, since spray-painting and body-printing left no lines, which, unlike the "good" space-evoking qualities of color, Klein regarded as "evil" by reason of their capacity to define forms, bind, limit, and ultimately imprison. Thus, not only in the nonobjective Monochromes but also here, in abstract reserve figures rendered from ready-made templates in the form of live human beings, Klein achieved that critical interface or tense fusion of the real and the ideal. The better to engage viewers in the paradox of his art—perhaps also to dispel the mystery of the artistic enterprise and direct attention to that conjured by the ghostly image it produced—Klein on one notorious occasion created a series of Anthropometries before an audience gathered at a prestigious avant-garde gallery in Paris (fig. 279). While a string chamber group played the artist's *Monotone Symphony*—a Cage-like single-chord composition of adjustable duration—Klein, dressed in tuxedo, white gloves, and the Order of Saint Sebastian, directed his "collaborators," as Rauschenberg would have called the models, to lie, twist,

The azure empyrean in which Klein sought release originated in the glorious, cloudless sky over Nice, the French Mediterranean city where he was born and grew up as a kind of "holy child." Equally adored by his creative, bohemian parents and his pious, bourgeois aunt, Klein found himself alternately spoiled and rejected as he traveled to and fro, between cold, wartime Paris and the sunny South, between the economic necessity of one household and the emotional need of the other. Gradually, the troubled youth escaped into Buck Rogers-type comics, stories of knights in chivalrous derring-do, hooliganism at school, and reveries of personal omnipotence. Seeing the unobstructed freedom of empty, or outer, space as his true realm, Klein took up judo and learned to be tossed—to fly—safely through the air. When he proved too restless and undisciplined to pass the baccalaureate exam, Klein compensated by studying Rosicrucianism. At that time, nothing moved him more than its Kabbalistic aspiration towards an ego tamed or purified into readiness for reunification with the seamless, transparent Void, out of which Rosicrucians hold that material forms first arose. As capable of practical action as of philosophical reflection, Klein spent months in Ireland working as a stable boy and preparing to ride a horse all the way to the judo academies of Japan! Finally arriving by ship, he became a true spiritual warrior, immersed in Zen meditation and earning the diploma of fourth *dan* black belt. Only when this achievement failed to make him acknowledged in Europe as "One Who Has Attained" did Klein overcome his resistance to his parents' careers in painting and declare himself an artist. Having never been trained in either drawing or painting, he could easily follow his natural bent and reject both the sensuous *belle peinture* practiced by the senior Kleins and the *matière* of the Informalist Georges Mathieu, another painter-knight who several years earlier had taken a Zen-judo approach to painting (fig. 110), but with dramatically different results from the still, unimpeded depth envisioned by

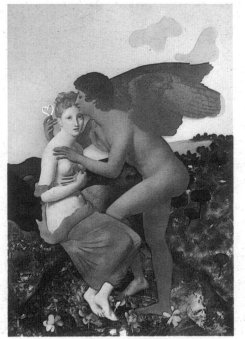

left: 280.
Martial Raysse. *Tableau simple et doux*. 1965. Photographic montage, neon, and objects; 6'4" × 4'2¾". Private collection, Paris.

opposite: 281.
Alain Jacquet. *Déjeuner sur l'herbe*. 1964. Trichromatic screenprint on canvas, each of two panels 5'8½" × 3'2". Australian National Gallery, Canberra.

drag, sit, or roll until the desired graphic effects had been realized. Not only did the performance challenge the authenticity of the public paroxysm that Mathieu had staged at the Théâtre Sarah Bernhardt; with photographers hired to film the entire episode, it also seemed even to ridicule the near sanctity of Hans Namuth's celebrated film of Jackson Pollock in the full swing of pouring a picture spread over the studio floor (fig. 68). In the wake of a demonstration like Klein's, which entailed quite as much base exploitation as visionary Utopianism, viewers might well consider the significance of works offering an image of transcendence—of palpable life transfigured into a weightless, airborne state at one with blue, incommensurate space. Such consideration, finally, may have been the artist's overriding purpose, since Klein cast himself in a messianic role, undertaken in the hope of fulfilling the Rosicrucian promise of a return to primal unity and freedom. By playing it through Monochromes and Anthropometries, he partook of the sixties' two mainstreams: Minimalism and Pop Art, or New Realism. However, when he painted Anthropometries in a theater-like setting, he also created a Happening, and even anticipated Performance Art. Pushing to still greater extremes, Klein would empty a gallery and then open it as an exhibition entitled *le Vide*—the Void. Afterwards he sold some of the contents—zones of empty space previously impregnated with his own sensibility—to willing collectors, for gold ingots no less. With this Klein contributed towards the advent of Conceptualism, which would climax only in the early seventies. Klein, as we have seen, had himself trick-photographed soaring into the blue, but truly it was his imagination that made the great leap.

The golden boy of the New Realists was Martial Raysse (1936—), a Niçois, like Klein, who prepared for a career in art by assisting his parents at their pottery. It also helped that he had an early encounter with Matisse during the great colorist's late phase devoted to cut-paper paintings. Not only would the collage or assemblage process remain fundamental to his own art, but after several years of working with the most ubiquitous of modern materials—neon, plastic, aniline dyes, photographic prints—Raysse became known as "the Matisse of neon and fluorescent painting." Both media served in such "totems of today" as *Raysse Beach* (1962), a room-size environment jam-packed with consumer products, among them plastic beach toys and an inflatable child's swimming pool, the whole crowned with a neon sign flashing the piece's title. In other works, the accumulations of detergents, kitchen utensils, and beauty aids were "sold" by seductive women, often in the form of photomontages taken from magazine advertisements. Later these clotheshorses or bathing beauties became subjects in their own right, painted or overpainted in lurid, luminescent colors and lighted with neon. For his most memorable series,

Raysse made photographic blow-ups of celebrated master paintings and then "modernized" the images by reprocessing them with his favorite media (fig. 280). Thus, in *Tableaux simple et doux*, based on François Gérard's *Cupid and Psyche* (1797), a great favorite of the Louvre public for over a century and a half, he painted the marmoreal flesh of Psyche an acid lemon yellow and then placed a shocking-pink neon heart in Cupid's hand. In this way he revitalized Neoclassical artifice with an injection of contemporary artificiality, not as an act of contempt towards either but rather as one of respect for things as they are. Declaring that "beauty is bad taste," Raysse created "hideous pictures" as a means of striking a blow against bourgeois notions of "good taste" and for the honest vulgarity of admass culture. For the ballet *Paradise Lost* this witty, exuberant artist designed a production in which Rudolf Nureyev and Margot Fonteyn found themselves upstaged by a neon serpent. After the political disturbances of 1968, Raysse lost some of his enthusiasm for consumerist values, once they seemed to become dominant in art's support system, and committed the greater part of his creative energies to film-making.

Alain Jacquet (1939—), a slightly younger French artist than Raysse, also, on occasion, found motifs among the established masterworks of older modern painting. In re-presenting Manet's *Déjeuner sur l'herbe* (fig. 281), however, he simply staged the scene with live models in contemporary dress, photographed it, and then printed the image by an offset process whose exaggerated dot screens seem to "deconstruct" the original, over-familiar theme even as they renew it for jaded eyes. Like the art of Hamilton, Lichtenstein, Raysse, and others in the Pop generation, Jacquet's *camouflage* painting—to use a term coined by the artist—would appear to be an illustration of what Walter Benjamin had long before foreseen as "art in the age of mechanical reproduction."

Niki de Saint-Phalle (1930—), a Frenchwoman reared in New York City, returned to France in 1951 and began to paint the following year. But with her lack of training, the artist soon found in assemblage a process most congenial to her febrile imagination, then flowering into an extravagant, even macabre fantasy. Stimulating this develop-

above: 282. Niki de Saint-Phalle. *Black Venus.* 1967. Painted polyester, 9'2" high. Whitney Museum of American Art, New York.

right: 283. César. *César's Thumb.* 1967. Bronze, 34½" high. Hirshhorn Museum and Sculpture Garden, Smithsonian Institution, Washington, D.C.

Pop Art and New Realism

far left: 284. Raymond Hains. *SEITA*. c. 1965–66. Wood, formica, red matter, and etched glass paper; 3'3⅜" × 1'3¾". Courtesy Galerie de Paris, Paris.

left: 285. Mimmo Rotella. *The Assault (L'assalto)*. 1962. Torn Elvis Presley poster on canvas, 4'5" × 4'10½". Staatsgalerie, Stuttgart.

below: 286. Öyvind Fahlström. *Roulette, Variable Painting*. 1966. Oil on photograph, paper, vinyl, cardboard, and magnets; 5' × 5'5⅜". Museum Ludwig, Cologne.

ment was the long-time relationship that Saint-Phalle began in 1960 with Jean Tinguely, the Swiss master of boisterously humorous "metamatic" sculptures. Right away the artist won a *succès de scandale* by assembling a "Saint Sebastian," an "altar," and other mock-religious pieces that were to be "completed," often before an audience, when hit by darts or rifle shot, which ruptured pockets of paint buried within the thickness of the target. Together the violent or destructive act and the spattered, running colors of these "surprise" works constituted a neo-Dadaist gesture of disregard for the near-divine inspiration claimed by the Abstract Expressionists and the sense of their splash-and-spill works as holy relics. In 1965, Saint-Phalle redirected her creative energies into a series of goofy, gamboling earth mothers called *Nanas*, meaning roughly "Dames" or "Broads" (fig. 282). Fashioned of papier-mâché on chicken-wire or synthetic armatures, the pin-headed *Nanas* always have elephantine proportions and clothing or skin peasant-patterned in bright colors already familiar from the artist's "surprise" assemblages. Restany called them "Dubuffet revised and corrected by Appel," and their potential for outrageous invention came to an early, hilarious, yet grotesque climax in *Hon* ("She" in Swedish; 1966). Erected, in collaboration with Tinguely and the Swedish sculptor Per Olaf Ultvedt as a temporary installation at the Moderne Museet in Stockholm, this colossal *Nana* measured 82 feet long, 20 feet high, and 30 feet across as she lay sprawled on her back, with legs spread wide to permit the public to enter through a yawning birth canal. Backtracking into the capacious womb, visitors found themselves involved with a fun-fair environment offering everything from a "lovers' nest" to a cinema showing Garbo films, a Coca-Cola automat, and a mill for grinding the used bottles. Like all the *Nanas*, *Hon* formed part of an ongoing theater of the absurd created by a feminist with a bull's-eye bead on certain key shibboleths and fetishes of the post-Freudian world.

If Saint-Phalle objectified both her femininity and her creative instincts in the *Nanas*, the ebullient Marseillais César would seem to have found an image for his masculine and sculptural self in the man-size enlargements he made of his own thumb (fig. 283). For this new image, he switched from welded-metal (fig. 169) to casting processes

and from truncated anatomies to a single, vastly monumentalized digit, which by reason of its isolation and expansion became a powerfully male emblem with particular relevance for a sculptor. Rodin, it may be recalled, had cast his own hand and then placed in its grasp a small, palm-size sculpture formed by the model, the purpose being to illustrate the difference between art and life. César seems to have achieved a similar result, but in far more ambiguous, Pop terms, not only by scaling up but also by allowing the hallucinatingly real member to gleam like the gold-looking material it is made of. As we shall see in the chapter on Assemblage, this detour into Oldenburg territory was but one of many way stations touched by César in his long journey of celebration through life.

It was through his attempt to make abstract photographs that Raymond Hains (1926—), with his friend and fellow artist Jacques de la Villeglé, discovered the expressive potential of layered and mutilated

posters. What he had been seeking was an image broken up or fragmented in the manner of Cubism, an effect he initially created by photographing subjects reflected in a cluster of small mirrors. Then, while shooting in Saint-Germain-des-Prés, a "found" variant of the desired image came to him in the form of poster-encrusted walls and fences. By choosing to detach and reassemble political sheets deliberately violated by a hostile public, Hains created what he called *décollages* (the opposite of collages) or *affiches déchirées* ("torn posters") that now seem more neo-Dada than Pop. Although less celebrated, the giant matchboxes that Hains exhibited in 1964 merged more comfortably into the mainstream of Pop Art (fig. 284). On the first of these he illustrated the fable of "The Donkey Dressed in a Lion's Skin" (as a tribute to Venice's Lion Gallery where it was exhibited). For subsequent ones the fable consisted of the pseudonyms under which the works appeared, Seita and Saffa, names that "matched" the initials of the French and Italian state tobacco agencies, which, Hains said, were to matches what he was to walls and fences.

When Italy's Mimmo Rotella (1918—) began exhibiting with the Parisian *affichistes* he had already been making "lacerated posters" (*manifesti lacerati*) since the early 1950s. First attracted by billboard art during a Fulbright-financed sojourn in Kansas City, Rotella returned to Rome and saw new visual as well as social meaning in the palimpsests of shredded, peeling announcements pasted to walls everywhere in postwar Italy. On the one hand they looked like found or urban/environmental versions of Tachist paintings, while on the other they seemed perfect symbols of a Europe still shabby from its years of political and military turmoil. Yet, even as he stripped materials directly from public walls and attached them to canvas, his interests remained primarily formal, since content emerged powerfully from the process itself, which involved further distressing once the tattered sheets had been recontextualized (fig. 285). By the time Rotella made his debut with the New Realists, images were beginning to dominate among the broad areas of overlaid color and texture. Because these often derived from film posters, the results made Rotella seem a high-spirited, rather baroque or Tachist version of Andy Warhol.

In his short life of forty-eight years, tragically terminated by cancer, Sweden's Öyvind Fahlström (1928–76) spanned the worlds of Brazil, where he was born, Stockholm, where he lived, studied, and worked from 1939 to 1961, and New York City, the principal locus of his mature career in art. Fahlström also roamed, vigorously engaged, through the cultural-intellectual worlds of Aztec-Mayan epigraphy, semiotics, game theory, concrete music and poetry, Pop-pulp literature, experimental theater, Happenings, and anti-war politics. All found their place in his visual art, which consisted mainly of im-

mense, loose collages teeming with an anarchic blend of *Mad* and *Batman* comics, sci-fi rockets, lurid obscenities, human innards, zeros, coffins, and unmade beds (fig. 286). So consistent was the illogic of the juxtapositions that Fahlström succeeded in transforming his legible but wildly unsyntactical figurative language into a variety of anti-formalist abstraction—a pictorial equivalent of Joyce's *Finnegans Wake*. Since the intricate, puzzle-like works also reflected the aleatory compositions of John Cage and the "cut-up, fold-in" prose of William Burroughs, their overall effect was of a conceptual and visual intensity to persuade many viewers that chaos offered the best of all possible ways to express the brutal discontinuities of contemporary experience. The better to convey the ultimate meaning of his vividly irrational image-mosaics, Fahlström finally realized them as "variable paintings" whose magnetized components, like those of board games, could be moved about according to the dictates of the viewer's own imagination. In response to critics who found his art both obfuscating and overly propagandistic, Fahlström replied: "Apparently it is difficult for them to accept that—even though my sympathies are clear—my work is about certain facts, events and ideas, rather than for or against them. . . . I see myself as a witness rather than as an educator."

A New Realist as political as Fahlström, and at infinitely greater personal risk, was Spain's Juan Genovés (1930—), who reacted to life under the repressive Franco regime in a powerful manner, but one quite different from the passionate abstractions of Tàpies. Profoundly moved by the films of Sergei Eisenstein, especially the Odessa Steps sequence in *Battleship Potemkin* that had meant so much to Francis Bacon, Genovés began hand-painting photographic scenes of crowds fleeing as if from the gunsight through which the hopeless, terrified people appear to be viewed (fig. 287). With their microscopic humanity swarming like cockroaches, under the bead of an enemy as anonymous as his victims, Genovés' paintings emit a quiet but desperate mood of Kafkaesque horror. As perhaps Goya would have in his equally somber times, Genovés considered himself a "pictorial journalist" devoted to the human condition, but with a telescopic distance remote from the earlier master's romantic anguish.

left: 287.
Juan Genovés.
The Prisoner. 1968.
Acrylic and
oil on canvas,
6'6¾" × 4'11⅛".
Hirshhorn Museum
and Sculpture Garden,
Smithsonian
Institution,
Washington, D.C.

above: 288.
Konrad Klaphek. *The Logic of Women.* 1965.
Oil on canvas,
3'6⅞" × 2'11⅛".
Louisiana Museum
of Modern Art,
Humblebaek,
Denmark
(gift of Celia Ascher).

Pop Art and New Realism

left: 289. Valerio Adami.
Studio Latrine in Times Square. 1968.
Enameloid on canvas, 2'11" × 3'11".
Courtesy Studio Marconi, Milan.

below: 290. Michelangelo Pistoletto.
He and She Talk. 1964. Collage of photograph
on polished stainless steel, 3'11¼" × 7'6⅝".
Collection the artist, Turin.

Across the Rhine in Düsseldorf, Konrad Klapheck (1939—) reacted against Informalism as early as 1955, later saying: "I wanted to confront vagueness with something hard and precise, to set a prosaic hyper-representational style against lyrical abstraction." The subject that became the first vehicle of his rebellion was an old typewriter, which the artist rendered with enough cold fidelity to qualify the painting as a forerunner of seventies Photo-Realism. But thereafter some inner, surreally poetic force took over and "surprised" Klapheck into simplifying, isolating, and otherwise subtly distorting his bathroom taps, flatirons, sewing machines, telephones, and, always, typewriters until each loomed against deep, abstract space like some monstrous, magical engine (fig. 288). But for all its sleek, airbrushed stylization, the image assumes an almost clownish, anthropomorphic identity, a quirky persona more akin perhaps to the machine aesthetics of Léger and Picabia—or a science-fiction Disney—than to Pop, ad-mass culture.

Italy's Valerio Adami (1935—) painted in what seems a dialect of the cartoon language already observed in the work of both Roy Lichtenstein and Patrick Caulfield (fig. 289). But to a much greater extent than these artists, Adami looked to Pop's origins in Surrealism and subjected his vernacular imagery of hotel rooms and public toilets to random, sly, almost imperceptible metamorphoses. Often they leave recognizable forms looking not only transparent but also on the verge of melting into hybrids of one another, if not into something either indefinable or unmentionable. A further dislocation occurs between the spatiality implied by the perspectival drawing and the abstraction of the poster-flat, decoratively synthetic, intermediate colors. As a clue to his meaning, Adami titled a 1965 show in Milan "Private Massacres," which had its source in a line by the poet W.H. Auden: "Behind each sociable home-loving eye the private massacres are taking place."

Convinced that one's first experience of figurative imagery comes with self-recognition in a mirror, Michelangelo Pistoletto (1933—) produced a haunting new variant of collage art when he began pasting photograph-based figures on metal surfaces polished to reflect the contents of whatever environment they may inhabit (fig. 290). Since the figures are life-size and their feet positioned near the floor, viewers who approach may well perceive themselves as participants in an exchange between lovers or as eavesdroppers on the telephone conversation of a young woman sitting in the nude. Meanwhile, the whole character or mood of the subjects depends on whether the space their mirror-grounds register is that of an empty gallery, an elegant salon, or a disorderly boudoir. Pistoletto arrived at his remarkable technique for compounding factuality with invention as a consequence of training he first received under his father, a fine-art restorer who frequently had to gild, varnish, and polish. This feeling for gleaming surfaces

evidently carried over into a series of self-portraits the young Pistoletto executed in acrylic coated with plastic varnish, a complex medium whose reflectivity seemed to bring the whole outside world right into the painting. Next he made somewhat grisaille drawings based on photographs, then painted on the onion-skin supports, and finally bonded the cut-out silhouettes to thin sheets of highly burnished stainless steel. The epiphany offered by the finished work is the realization on the part of the viewer that it is he who endows the static picture with its living, dynamic element. In this instance, the contribution happens to be in the form of a mirrored presence, but it functions splendidly as a metaphor for the reality that art comes alive—assumes meaning—for any spectator only insofar as he or she may become actively engaged with the work, its language, subject, and content. Here, then, is what the Pop masters meant when they announced their desire to create art works so viewer-involving that the effect would be to close or narrow the gap between art and life.

Assemblage, Environments, Happenings

6

Pop Art, by all odds, may have been the most important development to emerge from the triumphant "combines" of Rauschenberg and Johns. Yet, before Pop could become fully fledged in 1962, a variety of artists, including such future Pop masters as Dine and Oldenburg, saw in the environmental aspects of Action Painting the possibilities of working even more exclusively, as well as more candidly, with found materials and the collage technique than had either Rauschenberg or Johns. First came the Assemblagists who, like America's Richard Stankiewicz, John Chamberlain, and Louise Nevelson, Britain's John Latham, or France's Arman, tended to juxtapose urban discards or other concrete items in reliefs and freestanding sculptures that appeared to literalize the gestural drama of de Kooningesque painting. Taking the concept to still more logical extremes, other artists, beginning with Allan Kaprow, enlarged Assemblage until it became an Environment, an all-over, gallery-wide work that did not so much confront as envelop the viewer with the brute but recontextualized facts of reality. However, when brought to maturity by, for instance, Edward Kienholz, George Segal, Marisol, and Red Grooms, Environments would come to resemble stage-set tableaux, furnished with *objets trouvés* and populated by human surrogates, portrait-like sculptures ranging in personality from surreally grim victims of social pathology, or ghostly, romantically white life casts of ordinary individuals, to three-dimensionalized cartoons parodying heroes of both art history and popular culture. Meanwhile, Kaprow together with Dine, Oldenburg, Grooms, Carolee Schneeman, and Wolf Vostell, among many others, preferred to fill their Environments with breathing bodies—role-playing artists and their viewers—which introduced into late-modern art a kind of improvised non-narrative, multi-media "painter's theater" called Happenings. Here, not only had Abstract Expressionism's evident potential for infinite expansion—its metaphysical as well as physical "desire" to overcome the two-dimensionality and rectangular shape of the canvas—been literalized, but so too had the element of spontaneous performance, or action, especially as this was to be seen in films made of both Jackson Pollock and Georges Mathieu in the full, existential swing of their automatic painting process (fig. 68).

Like the Popsters, virtually all the artists to be seen in this chapter professed a longing to avoid the bankrupt mannerisms displayed by the de Kooning imitators, who had made a mockery of the master's bravura style by failing to capture its motive spirit. Many, indeed, were skeptical that subjective states could be transmitted at all. Further, most realized that theirs was a freer, more confident moment than the traumatic era in which the Abstract Expressionists had matured, thanks to the growing recognition accorded these older artists' achievement, as well as to the improving world economy and a gradual thawing of the Cold War. By 1958, moreover, John Cage's theories about the interchangeability of art and life were beginning to spread well beyond the confines of Black Mountain College. In New York that year Cage not only held his twenty-five-year retrospective concert; he also taught at the New School for Social Research, his course in experimental composition becoming a major revelation for Allan Kaprow, George Segal, Al Hansen, George Brecht, and other close contemporaries. Reinforced by the reading Cage recommended—

D.T. Suzuki's volumes on Zen Buddhism, Motherwell's anthology entitled *The Dada Poets and Painters* (1951), and Mary Caroline Richards' translation of Antonin Artaud's *The Theater and Its Double* (1958)—this new generation felt secure enough to take the world as they found it, rather than as something to be transcended in painting of quasi-religious import, and generally gave themselves over, as the early Happener Yvonne Rainer would later write, to "a dare-devil willingness to 'try anything,' the arrogance of our certainty that we were breaking ground, the exhilaration produced by the response of the [tiny but] incredibly partisan audience. . . . '' Common to those "dare-devils" responsible for Assemblages, Environments, and Happenings was a determination to make their work an embodiment of life's relentless, metamorphic process of change, particularly as it could be experienced in the metropolitan world of technological innovation, waste, decay, renewal, and proliferation. To reflect the purposeful randomness of this cycle—what Kaprow called the "nameless sludge and whirl of urban events"—the artists seen here exploited the old Dada principle of chance or accident as an essential spur to creative, unconscious impulse, allowing intuition or perhaps even wisdom to perceive meaningful relationships in the surprising juxtaposition of the most unlikely and incongruous participants—objects, figures, or events—in a given stretch of space or time. Thus, if the principle of extension beyond the established characteristics of painting and sculpture ran like a continuous thread through all such alternatives as Assemblage, Environments, and Happenings, the ultimate purpose they shared was, to quote Kaprow once again:

. . . [the] release [of] an artist from conventional notions of a detached, closed arrangement of time-space. A picture, a piece of music, a poem, a drama, each confined within its respective frame, fixed number of measures, stanzas, and stages, however great they may be in their own right, simply will not allow for breaking the barrier between art and life. And this is what the objective is.

Assemblage

As we saw earlier, the term "assemblage" seems to have been coined by Jean Dubuffet as late as 1953–54, but the technique of making the artificial precincts of art host to startling recombinations of the real began with the first collages created by Picasso and Braque in 1912. Then, in 1913, the real became the "ready-made" when Duchamp selected at random a mass-produced article—a bicycle wheel—and exhibited it as a work of art, transformed into such merely by having been isolated and thus rendered dysfunctional within a gallery setting. Thereafter, collage—either in the pictorial form launched by Picasso and Braque or in the sculptural one initiated by Duchamp—would evolve through the whole rich history of Cubist, Futurist, and Surrealist experiments to the metal constructions welded together and otherwise assembled during the immediate postwar years by so many of the artists seen in Chapter 4. Here, David Smith offered the preeminent model, not only in the machine parts that he frequently incorporated into sculpture, but also in the powerful formalism of his work, which assured the art's enigmatic "otherness" even when the absence of a pedestal made a freestanding piece seem an object present within

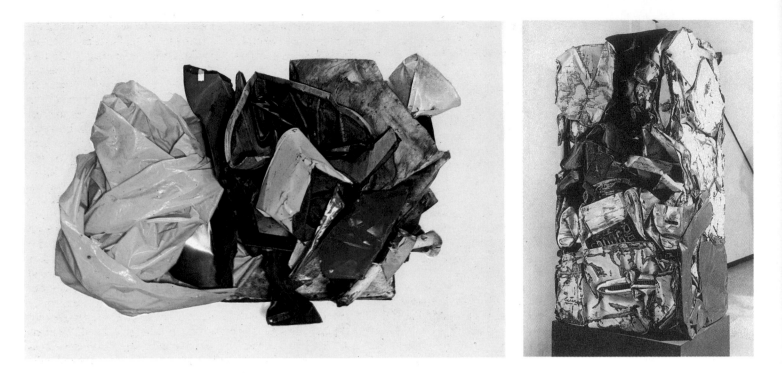

a universe of objects. For the most part, however, Assemblagists would abjure the existential or Surrealist content as well as the vestigial figuration often discernible even in the most abstract of fifties sculpture. Furthermore, the new ''junk'' sculptors, to a far greater degree than had ever seemed acceptable, chose to take their raw materials straight, unmodified by Smith's painted and patinated colors, the unifying effect of Paolozzi's bronze casts, or the excited de Kooning-esque brushwork that Rauschenberg lavished on his found objects. What the Assemblagists scorned utterly was the welded-metal work of New York artists like Ibram Lassaw, Herbert Ferber, Seymour Lipton, Theodore Roszak, and David Hare, whose hybrid, biomorphic forms, elaborated and precious surfaces, subjective mood, and fanciful metaphors had become as cliché-ridden as the painterly painting of de Kooning's followers. But in their sharp reaction against this precedent, the Assemblagists used rubbish with such clarity and directness that the results struck many as slabs of urban life unseemly enough to suggest New York's Ash Can School of painting—those so-called ''apostles of ugliness'' who first gained attention around 1908–10—revived and re-presented in three dimensions. Worse, the overt, apparently happenstance mixes of crude urban detritus provoked numerous accusations of Dadaist iconoclasm. Thus challenged, Richard Stankiewicz, according to notes taken by Irving Sandler, responded:

I am not Dada. I don't want to shock anyone. It is natural for me to do and use what I do, just as natural as a South Sea islander uses shells. Maybe you are disturbed that my work is too accidental. I find most of the materials that I use, but I throw most of these away, even after keeping them a long time. I select very carefully. Nothing happens that I don't want to happen.

Eventually, it became obvious that however raucously the undisguised, non-art media might proclaim their previous lives in the mundane sphere, they had been reorganized as abstract structures whose aesthetic qualities would make Assemblage considerably more than a brief, passing episode in the story of a generational attempt to liberate art from the deadly grasp of depleted values.

No artist made a more direct connection between Abstract Expressionist painting and new possibilities for sculpture than John Chamberlain (1927—), yet another sixties figure who caught fire while studying at Black Mountain College. Even though he had already shifted from painting to sculpture, as a result of encounters with works by Giacometti and David Smith in Chicago, it was the example of Franz Kline at Black Mountain combined with Albers' course on experimental media that prepared Chamberlain to assemble works

that look like de Kooning canvases exploded into three dimensions (fig. 291). This process began in 1957, during a visit to Larry Rivers' place on Long Island, where Chamberlain suddenly felt drawn, first, to the remains of an old 1929 Ford lying about the grounds and, then, to a wealth of similar material piled high in nearby junkyards. Not only did these offer plentiful supplies of ready-painted sheet steel, but for a penniless artist, the discards also possessed the added attraction of being free. Now he abandoned the tensile force of his Smith-like welded-metal calligraphy for the compressive, crushing, crimping, and soldering the enameled and rusted body parts, then supplementing their found chromatics with fresh sprayed-on or dribbled color. Often too he would highlight the mix with the glinting inclusion of a chromium-plated bumper. In sum, it was a matter of putting one thing next to another, never violently as the abstract imagery might suggest, but with infinite care and aesthetic discrimination, until it all fit together as perfectly as the words in a poem. Sometimes the results would be enormous freestanding monuments, but they could also deliver more modestly scaled wall reliefs, which, as here, do actually seem like de Kooning's baroque energies and colliding brushstrokes expanded into real volume, which they always appear ready to assume, and then quick-frozen as sculpture. Conversely, the poly-chromed metal Assemblage looks painterly enough to melt into the fluent medium of oil on canvas. In this idiosyncratic dialogue between genres, Chamberlain revealed his overriding interest, which lay more in art-as-art than in sermonizing on the baleful consequences of consumer excess, the kind of content so many have been tempted to read into the smashed-automobile compositions. But even a cool Minimalist like Donald Judd found these ostensibly ''hot'' works so self-referential, or anti-expressionist, that he included them among what he called ''Specific Objects,'' right along with his own industrially fabricated boxes (fig. 376). Later Chamberlain would make his intentions somewhat clearer as he worked with relatively neutral materials—transparent synthetic polymer resin, aluminum foil, polyurethane foam, paper bags, new-car parts, and even a group of crushed Judd boxes made of stainless steel—without ever relinquishing his Abstract Expressionist assemblage process.

By 1960 the French sculptor César, already met as a fifties Expressionist and again as a sixties New Realist (figs. 169, 283), had expanded his range of found materials to include scrapped automobiles. Now, quite independently of developments in America, he abandoned figuration and worked abstractly, using a giant industrial compressor

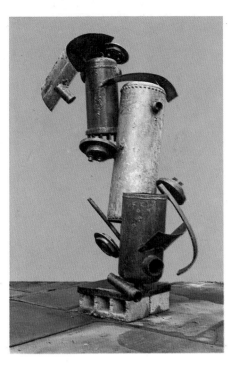

to pack the painted steel into cubic masses that look as if Judd had turned the tables and recast Chamberlain's flaring constructions into Minimalist cubes (fig. 292). As always, César acted on inspiration from a new process, and more for the sake of demonstrating the artist's power to transform or regenerate than of moralizing on the horrors of waste and decay. Thus, it was important to him that he succeed, as he did, in so controlling his work that it come forth as a very specific disposition of forms and colors. But hardly had the avid, nimble-witted master achieved satisfaction in his *compressions dirigées* ("controlled compressions") than he was taking delight in the pantograph and using human, rather than automobile, body parts to create the kind of large figurative gestalt seen in the last chapter.

In 1959 the critic/painter Fairfield Porter wrote that the welded-junk Assemblages of Richard Stankiewicz (1922–83) are "to sculpture what the collages of Schwitters, glued together from transfers, tickets, wrappings, and pieces of advertisements, are to painting." Then Porter added: "As Wallace Stevens in *The Man on the Dump* associates nouns and adjectives one would not naturally associate, so Stankiewicz associates a spring, a weight, and the casting from the top of a gas cooking stove to make a non-machine frozen into immobility by its own rust" (fig. 293). Following an early tech-school education in Detroit, several years of wartime military duty, and postwar studies under Hofmann in New York and Zadkine in Paris, this poet of late 20th-century urban refuse quite literally "uncovered" his true medium while digging in a garden, which yielded up the kind of "rusty, iron things" that he would thenceforth make the stuff of sculptures-in-the-round marked by formal distinction and infectious, Dadaesque whimsy. At first, the compositions suggested satiric figures, as in the metal constructions of Picasso and González, but very soon Stankiewicz returned to the abstract idiom he had mastered in painting. While relishing the evocative charge, as well as the ready-made abundance of surface texture and mottled color, eventful line and monumental shape, possible in degenerated machine and boiler parts, Stankiewicz assembled object-like structures that seem more about the inextinguishable life and beauty of forms, whatever their derivation, than symbolic works with subtexts on the ironies of technological progress.

Mark di Suvero (1933—), an American born in China of Venetian Sephardim, constructed sculpture in the open-form, Cubist-derived manner perfected by David Smith, but on a scale so vast and monumentally abstract, as well as with materials so identified with engi-neering and industry, that he seemed to span the distance between the relatively intimate, Expressionist sculpture of the fifties and both the large Assemblages and the Minimal works of the sixties (fig. 294). In sheer quality, moreover, he was thought to lag only Smith himself or perhaps Caro, even though the Minimalists (to be seen in Chapter 8), by virtue of their total rejection of "drawing in space," garnered the lion's share of avant-garde attention. Di Suvero developed as an artist mainly in California, where he majored in philosophy at Berkeley even while remaining active in studio work, but matured in New York City, which claimed him in 1957. By 1959 he had made his first signature constructions, using a mélange of brute or found materials—heavy, rough-hewn planks, steel rods, chains, chairs, tires—and assembling them in daringly asymmetrical compositions that thrust into space like three-dimensional counterparts of Kline's powerful, painterly gestures. While the works soared overhead, as if to compete with the bridges and skyscrapers of the surrounding urbanscape, they also invited the viewer inside, offering him shelter and sometimes a ladder to climb or a hoop to swing in. If more environmental than David Smith's work in their large scale and their inclusion of junk *trouvailles*, the early di Suveros were equally so in the greater complexity of their organization, which tended to balance not upon a single, central axis, but rather to interlock at and then fling out in all directions from several nodes or stress points. Firmly rooted, tautly as well as grandly designed, self-supporting and pedestal-less, a piece like the one seen here is also free enough to include floating or mobile parts, which, like the clenched joints and open, receptive interior, grant a viewer-involving, human dimension to an awesome, architecturally scaled construction. The humor and humanity of such works would remain largely intact even when, later, di Suvero entered more completely into the Minimalizing spirit of the sixties and gave up scrap for freshly milled steel beams (fig. 388)

The empress of Assemblage was Louise Nevelson (1899–1988), who chronologically belonged to David Smith's generation but achieved her great breakthrough in the late fifties, at which time, as Hilton Kramer wrote, "she transformed the reigning genre of open-form sculpture into an art of closed-form structures." And what structures!—extended wall-high stacks of variously sized milk, lettuce, or liquor crates, each filled with an intricately abstract relief composition of found objects: newel posts, chair splats, and table legs, wooden disks, cylinders, and spheres, bowling pins, balusters, and finials, elaborate mouldings, even unfinished boards. Unifying this cellular profusion, while clarifying surface details and deepening interstitial shadows, was a continuous, light-absorbent skin of matte black paint, which completed the overall conception as a twilit dreamscape-poem with as many stanzas as there were cubic boxes packed with mystery

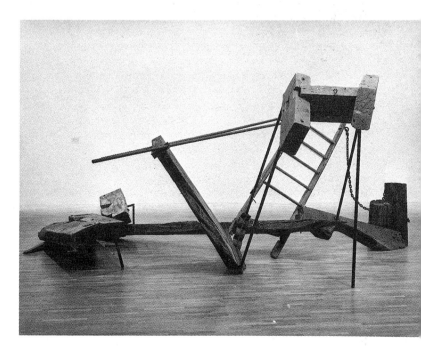

and magic (fig. 295). Although Nevelson entered art history relatively late in her long career, she had been an artist born if ever there was one. An immigrant from Kiev, Nevelson grew up in heavily forested Maine, where both her father and grandfather were in the lumber business, which surely accounts, at least in part, for the keen sense of identification she would later develop with wooden salvage. Long before this occurred, however, Nevelson escaped, through marriage, to New York, studied singing, acting, and modern dance, along with practically all the visual arts, and went to Munich, where she joined Hans Hofmann's atelier and performed as an extra in German films. Back home in Depression-stricken New York, Nevelson assisted in the mural work then being done by Ben Shahn and Diego Rivera, traveled to Mexico, and added pre-Columbian as well as African art to her vast storehouse of European cultural reference. From this rich, eclectic heritage she fused a compelling personal amalgam of Cubist collage and Constructivist syntax, mythic content and architectural scale, private feeling and theatrical gesture to create an entirely new kind of sculpture—an environment—that, when presented as a gallery-wide installation, received the spectator like an enchanted realm. Once success allowed, Nevelson had her boxes cabinet-made, all the same for each wall sculpture, which, by endowing the works with a sleek, hard-edged sixties look, simply heightened the aura of almost religious solemnity emanating from nonobjective sculpture conceived like a tall, majestic cathedral honeycombed with sumptuously furnished miniature chapels. Consistent with her romantic theme of dawn versus dusk, Nevelson painted some of the wall pieces white and gilded others, but if the latter resemble Baroque altars, their splendor, to quote William Seitz, "is as much that of Versailles as of Burgos."

For her dramatically disquieting reliefs Lee Bontecou (1931—) collected old laundry bags, tarps, and even canvas unwound from a fire hose and ironed flat. Then, matching the pieces to the faceted and orificed design of a welded-metal armature, she sutured her fabric planes together with a surgical precision comparable to that of Alberto Burri, seen in Chapter 4 (figs. 296, 119). But while the Italian restructured the experience of an army field doctor patching together the battle-wounded, the younger Bontecou, maturing in the era of cold rather than hot war, sought to express "the fear, hope, ugliness, beauty, and mystery that exists in us all and what hangs over all the young people today." Thus, at the center of her compositions, and in satellite formation thereabout, she stretched the canvas remnants round circular holes, usually deep, black, and raised at the edge like burnt-out volcanoes or atomic-bomb craters, but sometimes sealed with grinning sawteeth reminiscent of Picasso's Surrealist image of the *vagina dentata*. Fundamental to the power of these works is their extreme elegance, achieved with a tonal palette of gray, black, rust, and tan but also with ingenious, perfectionist craftsmanship. This, however, assumes a primitive or even savage force once the delicate stitchery discloses the hooks, barbs, and twisted wires with which it has been accomplished. At the same time, canvas pulled taut and sewn over a rigid framework and about what could be seen as a propeller-shaft insert evokes pioneer aircraft, or perhaps the model airplanes that Bontecou liked to make. Yet, a bright alternative reading can only enhance the secrecy and ambiguity that, together with the brilliant originality of the form, are the enduring qualities of Bontecou's Assemblage art.

Within the various "environmental" arts considered here, the clearest claim to universality may have been staked out by one of the youngest practitioners, Lucas Samaras (1936—), who embraced and mixed so many different media that he entered art history not only through Assemblage but also through Environments and Happenings. And this is to say nothing of the post-modernism of more recent years. Born in Greece but resident in New Jersey and New York since the age of twelve, Samaras survived harrowing wartime years in Macedonia to become an artist of such obsessive reclusivity and narcissism that his entire creative impulse seems to have been towards uncloseting and making public his own most private, psychic self. Here was a consciousness formed in a desperately conflicted world of religious, Byzantine splendor and guerrilla warfare, lavishly costumed parades and chronic illness, family festivities and immigrant displacement. Finally, the mature Samaras would say: "I cannot separate beauty from pain." And so it would be throughout his oeuvre, beginning with the gorgeously encrusted but cutthroat-perverse boxes that remain the artist's most celebrated works (fig. 297). As Joseph Cornell had shown

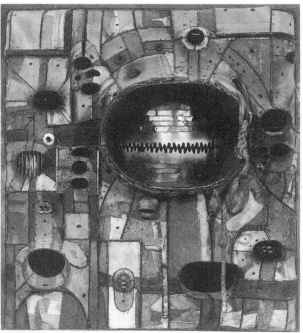

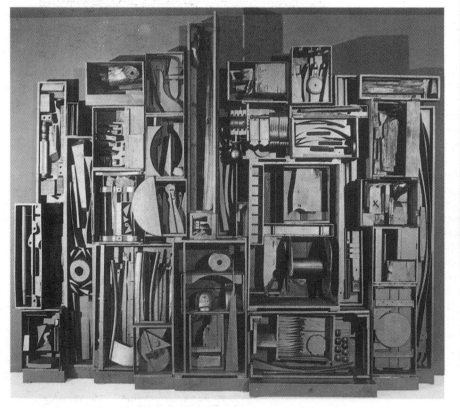

left: 295. Louise Nevelson.
Sky Cathedral–Moon Garden Plus One. 1957–60.
Black-painted wood, 9'1" × 10'2" × 1'7".
Collection Arnold and Milly Glimcher, New York.

above: 296. Lee Bontecou. *Untitled.* 1961.
Canvas and welded metal, 6' × 6'6¼" × 2'2".
Whitney Museum of American Art, New York.

left: 297. Lucas Samaras. *Untitled Box Number 3.* 1963. Wood, pins, rope, and stuffed bird; 24½ × 11½ × 10¼". Whitney Museum of American Art, New York (gift of Howard and Jean Lipman Foundation, Inc.).

right top: 298. John Latham. *M.F.I. Bing.* 1967. Books, plaster on board, and canvas bond; 3'11½" × 2'11⅝". Courtesy Lisson Gallery, London.

right bottom: 299. Daniel Spoerri. *Dinner by Dorothy Prodber.* 1964. Mixed media, 21⅜ × 25⅛ × 10⅞". Museum of Contemporary Art, Chicago (gift of Mrs. Robert B. Mayer).

long before, boxes can be transformed into treasures of romantic associations, but while the older master assembled tropes memorializing the tenderest of sublimated yearnings, Samaras set traps, seducing his viewers with erotically alluring materials, textures, colors, and craftsmanship, only to reward their gaze with voyeuristic complicity and their touch with porcupine thickets of steel pins, gleaming arsenals of knives, razor blades, and open scissors, even dangling, rainbow-hued ropes to hang themselves by. Still, despite the hothouse fantasy and fetishism of his Assemblages—dismayingly primitive yet delicate concatenations of beads, buttons, and broken mirror glass, whorling patterns of prismatically colored wool, kitsch figurines, dismembered rubber fingers, plastic skulls, satin pumps—Samaras seems always to have been too sixties-smart, too much the cool, devilish strategist to qualify for the Surrealist label many have wanted to stamp him with. Peter Schjeldahl found the artist "serpent-subtle," an extraordinary and controlled talent whose "boxes function like the come-hither odors of a carnivorous flower, the kind that induces insects to explore a container which, as it turns out, is for them."

England's John Latham (1921—), an assemblagist intent upon making art a polemical instrument for changing the world and the conceptual base normally used to deal with it, created works not as independent aesthetic objects for their own sakes but only as the residue of events—events that posed questions and challenged assumptions. Inspired by the ideas of C.C.L. Gregory and Anita Kohsen, who proposed to overcome the divisive specialization within science by viewing the fundamental unit of the universe not as an atom, a special phenomenon, but rather as an event, a boundary-crossing phenomenon in time, Latham turned to books as the guardians or promoters of isolated, self-serving interests and assembled what he called SKOOB art (fig. 298). In one of the most notorious of his "event structures" Latham built a Skoob Tower, a statuesque sculpture composed entirely of books, and then ritualistically torched it near the British Museum, the home of one of the world's greatest libraries. Hitlerian as this may seem, the artist insisted that such pyromania should be understood "not in any degree [as] a gesture of contempt [for] the books or literature . . . [but] to put the proposition into mind that perhaps the cultural base has been burned out." Fortunately, Latham also found it possible to make his point in more durable works, reliefs of such arresting beauty that they overcome the shock caused by their materials—codices mutilated and defaced in all manner of ways—to

engage the eye as well as the intellect. With the short-sighted profiteering of industry as his particular target, Latham singed, bludgeoned, ripped, and even spray- or brush-painted books before tethering them with tubes, wires, and cords into field-like Assemblages—perhaps a new kind of "matter" painting—of Abstract Expressionist brilliance. If they suggest the horrors of a post-atomic world, they would also seem to embody hope for a better environment reconceived as a nonfragmented, time-based totality.

Daniel Spoerri (1930—), a Romanian-born Swiss and a particularly eager, frolicsome participant in New Realist activities, transformed his obsession with food—everything from cookery to consumption and decay— into art, often by staging a dinner party and then fixing the tabletop remains as a found composition ready to be hung on the wall like a painting or Rauschenberg's *Bed* (figs. 299,

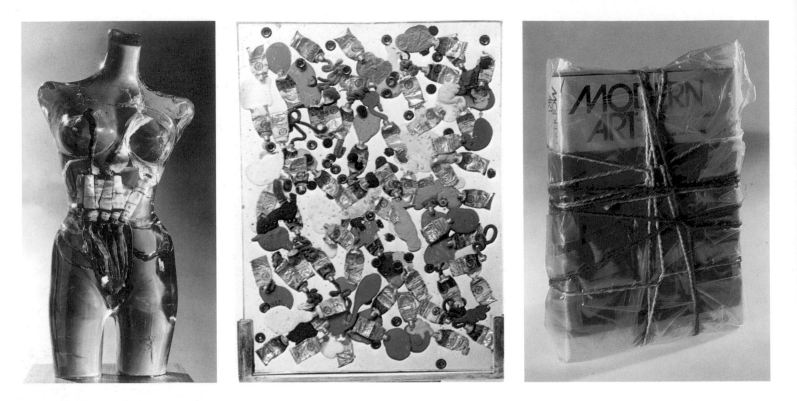

222). In these Assemblages—what the artist called *tableaux pièges* ("snare pictures")—Spoerri left everything as his diners had, complete with soiled dishes, scraps of food, disarrayed cutlery, and rumpled napkins, stub-filled ashtrays—in the hope of entrapping reality unadorned and endowing this with the poetry of artistic designation. In his most oft-quoted statement, Spoerri said: "To buy a tomato while realizing that it's a work of art that one is buying is participating in a great spectacle. In a spectacle what is false becomes true, provided one enters the game." That this was a game with metaphoric potential became clearer when, years later, Spoerri created a snare picture at an "art park" outside Paris merely by burying the remains of a meal consumed on the spot. The grass that now grows over this art-fertilized grave serves as a "constant reminder of continuity."

As we saw in the last chapter, Paris-based Nouveau Réalisme included several artists, Hains and Rotella among them, who had invented a new, found variant of collage called *décollage*, which involved stripping layered, weather-tattered, and graffiti-scarred posters from public walls and remounting them on canvas (fig. 285). Meanwhile, a fellow New Realist known simply as Arman (1928—) expanded the principle to three dimensions and enriched Assemblage with some of its most stylistically distinctive objects, both sculptural and pictorial. An intimate of Yves Klein since the two met as teenagers studying at a judo academy in Nice, Arman (*né* Armand Fernandez) had been a conservative modernist until around 1955, when he appropriated from the immediate environment a common rubber stamp and ink-printed it in an evenly distributed manner all over the flat support to create abstract, Pollock-like compositions called *cachets*. However, his real breakout arrived in 1959 with the first *accumulations* that would soon become *poubelles*. For these "trash can" or "dustbin" works, Arman packed the contents of discard baskets—often found in the studios of artist friends—into transparent containers, a clever stratagem for citing the complex interrelationship between objects and their consumers in an increasingly littered world. Such poetics of waste, echoing those of Schwitters and Rauschenberg, assumed dramatic proportions in 1960 when Arman filled Iris Clert's Paris gallery with thirty tons of random rubbish. Calling the exhibition *le Plein*, meaning "Full" or "Plenty," Arman made a witty, counterbalancing response to Klein's notorious *le Vide*, an exhibition of nothing but the same white-walled gallery two years earlier

"emptied" by the artist of everything but space "impregnated" with his own sensibility. In more characteristic accumulations, however, Arman expressed problematic abundance by acquiring an immense quantity of identical or similar objects—everything from rubber stamps, bottle caps, and ball bearings to dollar bills, crucifixes, eyeglasses, and cameras—and drowning the generalized, chance array in tabular or sculptural masses of liquid but quick-freezing, crystal-clear polyester. In the freestanding *Glove Torso* of 1967 he allowed a collection of rubber gloves to float through and find their place in a body of molten element poured into a mannequin-like mould. The results suggest a shapely female molested by the same sort of excess—medical or erotic—as that imposed on the environment by refuse. When the

objects were a clutch or a pictorial scatter of painter's colors squeezed from their tubes, the parodied incontinence would seem to have been the rivers of medium and emotion flooded onto canvas or metal armature by the frenzied artists of the Existentialist fifties (figs. 300, 301). In a still more subversive gesture Arman produced his *colères*, "tantrum" accumulations of musical instruments—especially violins—shattered by the artist's own hand and then reassembled in sparkling baths of rapidly solidifying Plexiglas. Given the preciousness of these ready-mades and the violence wreaked upon them, Arman would seem to have been even more anti-art than his spiritual ancestor, Duchamp. Still, he professed "no desire to renounce aestheticism." On the contrary, the sheer technical brilliance with which Arman preserved waste and destruction generates a sense of haunting nostalgia for the bountiful goodness of human creativity and a vexing uncertainty about the prospects of its survival.

After the Bulgarian artist Christo (Christo Vladimirov Javacheff; 1935—) arrived in Paris in 1958, following brief periods of study in Prague and Vienna, he brought to Restany's New Realist circle a background rich in experience totally different from the romantic, Judo-Rosicrucian enthusiasms that gripped Klein and Arman. It included a contradictory mix of his once well-to-do, entrepreneurial family's intellectualism and the conservative art education and Marxist values imposed by the Soviet-backed regime that had seized power in Sofia at the end of World War II. With characteristic aplomb, Christo used Assemblage as a device for resolving the new conflict that now arose between his Social Realist, collectivist past and the present he discovered in the abstraction-dominated, competitive West. Thus, while working with concrete ready-mades—bottles, tin cans, boxes—he took care that many of them would be purely geometric in form. Moreover, he veiled their earlier life in everyday reality by wrapping them in resin-soaked cloth and string, which allowed something of the objects' found Tachism—colorfully corroded surfaces—to show through and be savored. But if this also seemed to comment on waste in the free West, Christo did not spare the authoritarian East either, once he marshaled his most famous Assemblage, an "iron curtain" of 240 empty petrol barrels stacked across the Rue Visconti, one of the French capital's oldest and narrowest streets (fig. 302). Despite the obvious reference to the scandal of the Berlin Wall, erected the year before, and the ephemerality of the piece, which lasted only a few hours on a June evening in 1962, *Wall of Oil Drums—Iron Curtain* enraged the neighborhood and involved Christo in the sort of public relations that would become an increasingly important part of his ever-more ambitious projects. Meanwhile, as if to prepare for the now-familiar wrappings of entire buildings and vast acres of landscape, Christo shifted his interest and made *empaquetages*—Assemblages treated like "packages"—of objects as commonplace as chairs, motorcycles, automobiles, and nude models "wrapped" in translucent plastic, rope-tied, and thus rendered as disquietingly mys-

left: 304. Eduardo Paolozzi. *Wittgenstein at Casino*. 1964. Painted aluminum, 6′ × 4′6⅛″ × 1′7¼″. Leeds City Art Galleries.

right: 305. H.C. Westermann. *Memorial to the Idea of Man If He Was an Idea*. 1958. Wood and metal, 4′7″ high. Collection Mr. and Mrs. Lewis Manilow, Chicago.

terious as the sewing machine that the Dadaist Man Ray had wrapped in 1920 and entitled *The Enigma of Isidore Ducasse*. The most original of his human-scale *empaquetages* may have come in response to a question posed by *ARTnews* in 1975 to almost one hundred living artists: "What specific work(s) or artist(s) of the past 75 years have you admired or been influenced by—and why?" Christo, feeling indebted to *all* of 20th-century art, sent a copy of a new history of modernism wrapped in Pliofilm, lashed together with hemp, and inscribed on the packaging: "Your answer is inside" (fig. 303).

England's Eduardo Paolozzi joined the sixties by translating his battered scrap-heap totems into a new kind of "mechanical men," tall fetishistic images made from machine parts—this time clean, hard-edged ones—cast into steel or alloy and then often embellished with brilliant, Pop-like polychromy (figs. 304, 190). As always, Paolozzi managed, even in the cooler clime of the laid-back decade, to make machinery and architectural Assemblage transmit a mystic, as well as comic, presence.

Combining workmanship of Hepplewhite perfection with a taste for folk-quirky, comic-macabre themes, H. C. Westermann (1922–81) created beguilingly eccentric, quasi-abstract Assemblages that inspired one critic to dub him the "Fabergé of funk" (fig. 305). As for

Assemblage, Environments, Happenings

the fastidious craft, it was that of a compulsive whittler, perhaps a sailor or even a Marine, which Westermann had been during World War II, an experience that provided him with his most abiding subject—the irony of the macho warrior reduced to quaking fear by the horrors of battle. Authentically absurdist and self-mocking, Westermann left uniformed service but then re-enlisted for the Korean War because, as he said: "I wanted to see if I was still a coward—I was!" Here, in a work titled *Memorial to the Idea of Man If He Was an Idea*, Westermann rendered the he-man-clown disparity in what could be a one-eyed, Cyclopian jukebox with arms set in a "high-noon," on-the-hips attitude. Helmeted in a castellated structure like the famous Water Tower in Chicago, a city where Westermann studied, lived, and planted deep roots over a period of thirteen years, the figure reveals itself, once the beautifully finished cabinet door-torso had been opened, to be pregnant with a headless baseball player and a hanging trapeze artist in a sea of Pepsi-Cola bottle caps. Such holy craziness calls sanity itself into question, which made Westermann something of a shaman for a good many off-beat artists, particularly the funkier ones of Chicago and California.

Environments

If Assemblage could be understood as three-dimensional collage, then Environments become room-size, habitable Assemblages. Indeed, Allan Kaprow (1927—), the great theorist of all the alternatives to late Abstract Expressionism seen in this chapter, wrote that:

Assemblages and Environments . . . are at root the same—the only difference is one of size. Assemblages may be handled or walked around, while Environments must be walked into. Though scale obviously makes all the experiential difference in the world, a similar form principle controls each of these approaches, and some artists work in both with great ease.

One such versatile master was Kaprow himself, the first artist to reconstrue his Action Painting as first Assemblage and then a series of Environments before moving on to Happenings, where Kaprow would gain his firmest foothold in history. However, by the time he encountered Cagean aesthetics, in a 1957 course taught by the composer at Manhattan's New School for Social Research, Kaprow was already a professor of art history at Rutgers University as well as an exhibiting member of the cooperative Hansa Gallery, sponsored, as the name would imply, by a group of Hans Hofmann's former students. With his mural Assemblages, made of such primitive stuffs as tar, wrapping paper, and bushels of leaves, projecting farther and farther into the viewer's own space, Kaprow simply went with the flow and, in 1958, created an encompassing, maze-like Environment. Here, the precedent could be found in Kurt Schwitters' *Merzbau* as well as in the Galaxies and Surrealist exhibition settings created by Frederick Kiesler (fig. 161). Still, the immediate spark came from Action Painting, whose energy, free-associational procedures, and haptic surfaces Kaprow wanted to translate into concrete, junk materials as a strategy for contracting the distance between art and grubby, disordered life. In his debut Environment, visitors discovered themselves groping through ribbons of slashed and painted fabric hung from the ceiling in rows, interspersed with sheets of translucent plastic, crumpled cellophane, and tangled skeins of Scotch tape and Christmas lights. For one of his most visually striking Environments, Kaprow filled the courtyard at the Martha Jackson Gallery with hundreds of old, discarded automobile tires (fig. 306). But once he invited spectators to pick their precarious way across the rubbery pile, Kaprow had yet again extended his art, this time into the audience-involving "theater of mixed means" called Happenings.

Another pioneer of Environments, one of the most important artists to come under Kaprow's influence, was Claes Oldenburg, who, as we learned in the last chapter, created *The Street* and *The Store* in order to "spiritualize American experience" by transforming the exterior and then the interior of New York's Lower East Side into art (fig. 238). By 1963, Oldenburg had grown weary of slum life and departed

for a six-month stay in Los Angeles. There, settling into a "stucco replica of St. Mark's in our phony Venice," he began to dream up "The Home," as a kind of pendant to *The Street* and *The Store*, and with this the Ray Gun Manufacturing Company soon found itself turning out a new "product" line, consisting of such domestic items as *Soft Toilet*, *Soft Washstand*, and *Soft Bathtub*. First, however, came the showcase piece called *Bedroom Ensemble*, an Environment inspired by and built in Los Angeles but scaled to the precise dimensions of Sidney Janis' front gallery on New York's 57th Street (fig. 307). Stimulated perhaps by the ersatz character of his studio and the surrounding neighborhood, Oldenburg remembered "a famous motel along the shore road to Malibu, 'Las Tunas Islas,' in which (when I visited it in 1947) each suite was decorated in the skin of a particular animal, i.e., tiger, leopard, zebra. My imagination exaggerates, but I like remembering it that way: each object in the room consistently animal." And so just as the artist literalized his painterliness in the gloppy frosting of *The Store*'s pastries and his linearism in the sewn seams of the soft sculptures, he now literalized pictorial perspective in the rhomboidal foreshortening of the furniture in *Bedroom Ensemble*, a true Environment whole and indivisible unlike either *The Street* or *The Store*. Here a representational system designed to make the unreal (a two-dimensional image) look real (a three-dimensional object) now made actual freestanding forms and deep space appear false. At the same time, however, it offered the integrity of being consistent with the make-believe reality found everywhere else in *Bedroom Ensemble*, which because of the fakery was true to its motel source! The "satin" sheets are made of white vinyl, covered by a dark leatherette spread. "Zebravelour" simulates the tiger skin used for the couch's upholstery and the decorative pillows piled on the bed. Equally synthetic are the leopard coat thrown over the couch and the white fur rug on the floor. Metal serves for the mirror on the vanity, which, like the bedtables, has been "marbleized" with vile-green Formica. Most bizarre of all may be the "Pollocks" hung on the walls, their drip pattern supplied by textiles bought in a Venice shop for 29 cents a yard. In *Bedroom Ensemble* Oldenburg concretized not only the conventions of pictorial representation but also the notion of art as an imaginative restructuring of experience, which, in the aerospace and dream-factory world of Southern California, required that the artist relinquish the "cottage industry" process he had used in New York and have the Environment fabricated by outside technicians using his plans and specifications. Thanks to the irony of its several transpositions, the work critiqued a certain, rather dominant segment of American society and its kitsch taste. Moreover, it both took up and sent up Minimalist-style modernism's overwhelming preoccupation with literal form and impersonal, or even industrial, materials as well as techniques.

Even though George Segal (1924—) owned the farm, near Rutgers University, where Allan Kaprow staged the first Happening, he never made a Happening of his own, unless one could agree with Lucy Lippard and call the artist's haunting Environments, fashioned of white-plaster life-casts posed in banal, found-object settings, "quick-frozen Happenings" (fig. 308). A proud proletarian from the Bronx, where his father operated a kosher butcher shop, Segal in 1940 moved with his family to a New Jersey chicken farm across the road from the one on which he has long lived and maintained his studio. Spurning the poultry business, young Segal pursued his artistic interests at Rutgers, Cooper Union in Manhattan, Pratt in Brooklyn, New York University, and finally in the studio of Hans Hofmann. Too sensuous in his painting touch to feel comfortable with Abstract Expressionist spirituality, and yet obsessed with the need to achieve a personal grasp of pictorial space, Segal acknowledged his concern for "the presence of man in his daily life" and began transforming Kaprow's space-time, total-environment concepts into formally taut, mood-drenched, slice-of-life tableaux like the one seen here. Initially, he worked as if he were a realist Reuben Nakian, creating roughly defined figures from masses of wet plaster slapped onto armatures

made of chicken wire, wood, and burlap. In 1961, when given a supply of medical bandaging meant for setting broken bones, Segal conceived the idea of creating figures from live models wrapped, like mummies, in gauze dipped in liquid plaster. The great innovation lay in accepting the immediate, calcified result as the final sculpture, rather than as a mould for bronze-casting the negative form within. Thus, the ghostliness of Segal's "pillars of salt" emanates not only from the white medium but also from the ironic sense of absence—of life vacated—that ends by endowing the figures with an uncanny presence. In this, the active, hand-worked surfaces play an important role, emerging as they did from the vigorous, high-speed gesturalism of a onetime Action painter. For the settings, Segal scavenged everywhere until he found the bicycle, the Hebrew meat market, the bus-driver's seat, the bathtub, and the subway benches of his most celebrated pieces. When it came to *The Diner*, Segal assembled a Formica

left above: **306.** Alan Kaprow. *Yard.* 1961. Environment of old tires, courtyard of the Martha Jackson Gallery, New York, during "Environments, Situations, and Spaces." Photo by Robert R. McElroy.

left center: **307.** Claes Oldenburg. *Bedroom Ensemble.* 1963. Wood, vinyl, metal, artificial fur, cloth, and paper; c. 17 × 21'. National Gallery of Canada, Ottawa.

above: **308.** George Segal. *The Diner.* 1964–66. Plaster, wood, chrome, Formica, Masonite, fluorescent lamp; 8'6" × 12' × 7'3". Walker Art Center, Minneapolis (gift of the T.B. Walker Foundation, 1966).

left below: **309.** Edward Kienholz. *State Hospital.* 1964–66. Cast plaster and fiberglass figures, hospital beds, bedpan, hospital table, goldfish bowls, live goldfish, lighted neon tubing, steel hardware, wood, paint; 8 × 12 × 20'. Moderna Museet, Stockholm.

counter, a leatherette stool, a coffee urn, soda dispensers, among other archetypal essentials, and then illuminated the two-character vignette with the cold, indifferent light of an overhead fluorescent fixture. Turned away from one another and seemingly lost in anomie and loneliness, the spooky figures—"tinged," as Robert Hughes wrote, "with the pathos of the chrysalis"—could be fossilized versions of those in Edward Hopper's *Nighthawks*, a masterpiece of American Scene painting executed a quarter of a century earlier. Indeed, Mark Rothko once referred to Segal's Environments as "walk-in Happenings," although the artist himself insisted, in a conversation with Phyllis Tuchman: "There's as much happening with abstract formality as there is with the literary or psychological. . . . I'm trying to weave them together until they can't be separated."

While most sixties artists disdained overtly activist art as "poor art for poor people," to quote Gorky from a statement made during the prewar heyday of American Scene painting, Edward Kienholz (1927—) succeeded, almost alone, in producing works fresh and powerful enough in their visual interest to convey the full force of an outraged social conscience (fig. 309). Having grown up on an impoverished farm in eastern Washington State and spent several years drifting through a series of downscale jobs—hospital orderly, bootleg-club manager, window-display artist, vacuum-cleaner salesman—Kien-

Assemblage, Environments, Happenings

holz found it rather "effete" to work with oil on canvas, even in the Abstract Expressionist mode he essayed. Gradually, he turned away from painting and developed a personal variant of the old waxworks tableau as the best vehicle for venting memories of the pathos and alienation he had known among the sub-middleclasses of modern America. Totally unaware of Schwitters and such contemporary Assemblagists as Rauschenberg, Westermann, and, in Europe, Jean Tinguely, Kienholz began making relief constructions in the mid-fifties, using junk materials that he would later call "the leftovers of human experience." By 1961 he had created his first major environmental tableau, *Roxy's*, a surreally meticulous reproduction of an infamous Las Vegas brothel as Kienholz remembered it from the wartime year 1943. Equally well thought out and carefully crafted is the repellent but spellbinding *State Hospital* of 1964 (fig. 309), a gray anonymous box viewable through a barred window and occupied by a pair of identical old men lying naked in stacked bunks, their wrists chained to the iron beds and their heads represented by illuminated fishbowls filled with black fish aimlessly afloat like the inmates' disintegrated minds. The upper figure inhabits a neon-delineated thought "balloon" as if he were a materialization of the lower one's painfully egocentric psyche. Thanks to this sort of inventive detail, like that of the fishbowls or the discrepancy between the lifesize mannequins in their real beds and the dollhouse space containing them, Kienholz' art creates an aesthetic world all its own, remote from the waxworks, dioramas, and performance tableaux to which it seems related. In the more humorous but equally disenchanted *Barney's Beanery*, a 1965 masterpiece of *bricolage* replicating a well-known Los Angeles bar, at one third its actual scale, the figures all have clock heads with the hands arrested at 10:10, suggesting the standstill in lives so empty as to be spent hanging out in a tavern. Even though the environments can and sometimes should be entered, Kienholz further ensures their formal distance by coating every surface with fiberglass resin, the slimy look of this pervasive veneer serving to reinforce the sense of a specific, vernacular realism trapped in a state of horrific desolation and decay. Fundamental to the tension of such art is the risk that its fetishistic explicitness may transform a moral critique into a lurid, voyeuristic attraction, especially in works like *Roxy's* and *Barney's Beanery*.

That Kienholz could play a dangerous game without losing control of it made his work the best of California's so-called Funk Art, a movement centered mainly in San Francisco and dedicated to rude subversion of everything the New York scene stood for, especially its purist formalism, temple-like galleries, and priestly caste of critics (fig. 310). Unlike either Kienholz or Westermann, another important influence, Funk artists—among them William Wiley, Robert Hudson, William Allen, Bruce Nauman, and Robert Arneson—cultivated ephemeral as well as cheap materials, sloppy execution, weird eccentricity, and outrageously vulgar fun poked at everything sacred, from religion, patriotism, and pets to art, sex, and politics.

If, within the Environment genre, Kienholz could be viewed as a master of Grand Guignol horror theater, Red Grooms (1937—) would seem to pose a bright, fun-loving antithesis, as if he were a latter-day P. T. Barnum or Walt Disney, albeit crossed with Marcel Duchamp, capable of reinventing urban America as an absurdist, circus-like parody of itself. Fully trained artist that he was, Grooms possessed all the technical skill necessary to convert his early sardonic Happenings (fig. 316) into theatrical installations, a freshly original kind of environmental sculpture that he dubbed "sculpto-picto-ramas." At the same time that the move towards permanence betrayed the underlying, almost reverential seriousness of Grooms' comic gift, so did the subject the artist chose for his first "stick-out" tableau. Entitled *The Banquet of Douanier Rousseau*, the 1963 work offered an idiosyncratic restaging of the studio dinner given by Picasso in 1907, an historic event attended not only by the *naïf* painter Henri Rousseau—the guest of honor whose sophisticated primitivism Grooms has often appeared to emulate—but also by such early 20th-century vanguardists as Braque, Apollinaire, Marie Laurencin, Gertrude Stein, and Alice B. Toklas. Painting on cardboard cut-outs, Grooms treated the whole event like a three-dimensional cartoon in which he portrayed each of the celebrated characters with all the humorous economy and precision of a born caricaturist—a caricaturist steeped in the history of early modernism. By 1967 Grooms, with his wife Mimi Gross, felt ready to take on an entire metropolis, creating in situ *The City of Chicago*, a mixed-media extravaganza covering a 25-foot area large enough to allow the spectator to stand in a Lilliputian version of Michigan Avenue, complete with the Loop's elevated train, the Wrigley Building, the Chicago River, and, farther along, the Gothic-Revival Water Tower, a lone survivor of the great fire of 1871 (fig. 311). Also present are Mrs. O'Leary and her cow, which, legend holds, started the conflagration by kicking over a lantern, Louis Sullivan, Chicago's father of modern architecture, the 1920s gangster Al Capone, the suffragette Jane Addams, Mayor Daley, and *Playboy* publisher Hugh Hefner, the last two scaled almost to the viewer's own Brobdingnagian

above: 310. William T. Wiley.
Tubeathe Devil. 1972. Wood, paper, leather, metal, rock, and pins; 5'11" × 6'4½" × 2'3".
Courtesy Frumkin/Adams Gallery, New York.

right: 311. Red Grooms and Mimi Gross.
The City of Chicago. 1967.
Mixed media, c. 12 × 25 × 25'. Art Institute of Chicago (gift of Mrs. Maggy Magerstadt Rosner).

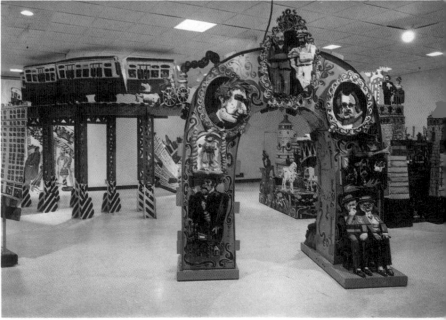

Assemblage, Environments, Happenings

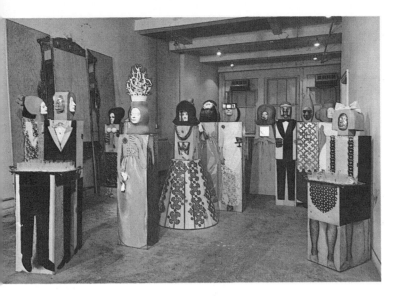

proportions. So accurate are the details—down to the stone lions outside the Art Institute—and so subtle the distortions, of scale, wildly expressionist color, and slapstick funkiness, that there can be no mistake about the unique personality of the place evoked, however antic the mockery or prankish the miniaturization. As the critic Paul Goldberger wrote in 1987:

The genius of [Grooms' tableaux], beyond the sheer visual pleasure that they give, is in their ability to walk so fine a line between fantasy and reality, between magic and truth. The Grooms city is never so endearing as to be cute or sentimental; there is always a sharpness to it, not quite cynicism but something just this side of it, that keeps sentimentality at bay and gives these works their strength.

Wry humor, rather than Grooms' raillery, animates the environmental assemblages of figures made by the Venezuelan-American sculptor Marisol (*née* Marisol Escobar; 1930—); an artist whose fame during the 1960s rivaled that of her close friend Andy Warhol. Although schooled almost entirely in the United States, where a period of study under Hans Hofmann proved especially important, Marisol compounded a uniquely personal language from such non-European sources as figurated pre-Columbian Mochica jars, small Mexican boxes containing painted, hand-carved figurines, and a collection of Early American folk art owned by the sculptor William King. But as the social satire called *The Party* discloses (fig. 312), Rauschenberg and Johns had also been exemplary, not only in their use of mixed media and combine elements, but also in Johns' innovative juxtaposition of the abstract and the concrete, the latter provided by plaster casts of human body parts. In the work seen here, as well as throughout her oeuvre, Marisol made her own face and figure the model on which she shaped almost every image, except in portraits of the famous, for which her ability to capture a subject with caricatural concision proved altogether as blithe as Grooms'. But however exact the self-portrayal, it has been sufficiently varied—through trompe-l'oeil drawing, painting, and photography, as well as through life casts with eyes open or closed, with the mouth grotesquely dislocated or clasped shut by a manicured, claw-like hand—for the handsome visage to impersonate an entire company of diverse characters, from the liveried butler and hair-ribboned maid to socialites coiffed like Nefertiti and even Medusa. Working with plastic, terra-cotta, papier-mâché, Plexiglas, gilt, rich fabrics, carved and carpentered wood, Marisol exercised a technical virtuosity as great as her formal daring. For this, the viewer has only to note the breathtaking shifts from two-dimensional rendering to the three-dimensionality of ready-mades, reliefs, and sculpture-in-the-round, from the boxy geometry of bodies to the full-blown organicism of heads and, in an instance or two, hands and bosoms. Binding it all together is the pervasive sense of mystery and ancient ritual generated by the ubiquitous presence of the artist's own

enigmatic, Garbo-like features. When this quest for an elusive identity brought accusations of narcissism, Marisol replied that, quite apart from the fact that every artist puts himself into his work, she co-opted her own person because it was easier: ''When I want to make a face or hand for one of my figures, I'm usually the only person around to use as a model.''

Having exploited the everyday urban environment as a stage (Happenings; fig. 318), complete with props and costumes (Assemblage; fig. 297), on which to uncloset himself in all his narcissistic obsession with fused beauty and pain, Lucas Samaras in the later sixties created a series of Environments in the form of walk-in, closet-like boxes completely faced—walls, floor, ceiling, and the furniture placed therein—with a gridwork of glittering mirrors (fig. 313). Here, the viewer may not be threatened with pincushion clusters of needles

left: 312. Marisol. *The Party.* 1965–66. Mixed media, 9'11" × 15'8" × 16'. Collection Mrs. Robert Mayer, Winnetka, Ill.

right: 313. Lucas Samaras. *Mirrored Room.* 1966. Mirrors on wooden frame, 8 × 8 × 10'. Albright-Knox Art Gallery, Buffalo, N.Y. (gift of Seymour H. Knox, 1966).

and knives, but he does stand witness to the breakup of his own image into myriad, fiery-edged fragments racing away into a stellated infinity of staccato replications. In this disorienting illusion, one is, to quote Samaras himself, ''embedded,'' trapped in a ''feeling of suspension . . . polite claustrophobia or acrophobia . . . fakery or loneliness.'' In regard to one of the Mirrored Rooms, Peter Schjeldahl, perhaps this polymath artist's most imaginative interpreter, wrote:

The metaphor of lure and pain—Odyssean siren song and shipwreck—is comically palpable. This metaphor, or syndrome, is consistent throughout Samaras' art, enacted on some level in even his gentlest pastels and most modest objects. Taken as a whole, Samaras' work makes the profound suggestion that this erotic mechanism is a secret engine of all art.

Happenings

While Assemblages and Environments literalized the generative, opening-out, all-embracing qualities of Abstract Expressionism, Happenings literalized the action in Action Painting. That is, they took the notion of painting as a spontaneous event and recast it as a kind of improvised theater staged in real space and in real time, the environment and the performance both as dependent on chance, indeterminacy, and found materials as Assemblage, or Abstract Expressionism, and far more audience-engaging. Indeed, Allan Kaprow once described Assemblages and Happenings as ''the passive and active sides of a single coin.'' And he should know, having been the first to see in Cage's *Theater Piece #1* (p. 129) exciting new possibilities

Assemblage, Environments, Happenings

for a "total art" even more responsive than Assemblage and Environments to advanced American painting's demands for flux and process. Drawing on Cage's Zen-based doctrine of art as "a purposeless play," or an activity whose purpose should be "the blurring of the distinction between art and life," Kaprow defined a Happening thus:

. . . an assemblage of events performed or perceived in more than one time and place. Its material environments may be constructed, taken over directly from what is available, or altered slightly; just as its activities may be invented or commonplace. A Happening, unlike a stage play, may occur at a supermarket, driving along a highway, under a pile of rags, and in a friend's kitchen, either at once or sequentially. If sequentially, time may extend to more than a year. The Happening is performed according to plan but without rehearsal, audience, or repetition. It is art but seems closer to life.

A crucial factor in this development, which one observer likened to "junk assemblage come to life," was Hans Namuth's film of Jackson Pollock dancing round and even *in* his canvas as he painted it by fling-

left: 314.
Kazuo Shiraga.
Making a Work with His Own Body. 1955. Mud.

right: 315.
Allan Kaprow.
Soap. Performed at Sarasota, Florida, in February 1965.

ing and dribbling liquefied medium (fig. 68). The film, of course, helped to transform a behind-the-scenes studio act into a public performance. Something similar occurred in Japan, where, as early as 1955, the Gutai group saw, via television, the French Informalist Georges Mathieu in the throes of executing one of his immense thrust-and-parry canvases before a live audience (fig. 110). True to the moment, the Japanese artists took Mathieu's showy technique to a generational extreme and regaled their spectators by lobbing balls of pigment at blank canvases, wallowing in mud as a means of shaping it, disporting themselves in electric-light costumes, and stomping out the 400-foot-long *White Vinyl Footprints* (fig. 314). As this would suggest, Happenings may have offered the most radical of all the redefinitions of art as a multi-media affair, and for this very reason it attracted relatively few practitioners, several of whom must be counted among the strongest artists to emerge in the sixties. Claes Oldenburg, Jim Dine, and Red Grooms all made Happenings early in their careers, and young Lucas Samaras performed in a number of them. Given the powerful individuality of these creative talents, it seems to follow that Happenings would prove a highly variable genre, but, as Barbara Haskell has noted, almost all the events appeared to amalgamate the junk materials of Assemblage, the gestural vocabulary of Abstract Expressionism, and Cage's theories of non-narrative performance. As for viewer participation, it was imperative, and it could also be active, especially in Kaprow's own Happenings, but often such involvement became a matter of close proximity between audience and performance, an intimacy forced by the small loft or other "alternative" venues in which most Happenings unfolded during their climactic years, which ran from 1959 to about 1965.

Allan Kaprow, for all his commitment to the new "theater of mixed means," was a visual artist, and however dominant the temporal or gestural component, the visual ingredient—the Environment—remained important enough in Happenings that these events

Assemblage, Environments, Happenings

may indeed be understood as a logical extension of Action Painting rather than merely a footnote in the history of avant-garde theater. The proof of it lies in the step-by-step way that Kaprow himself evolved, beginning with a move from a particularly vehement form of Abstract Expressionist painting to Assemblages and then Environments. As soon as the viewer entered the first of these enveloping, attention-grabbing art works, a quasi-Happening automatically came into play, a fact that Kaprow acknowledged by performing in the gallery each afternoon during the exhibition. A few months earlier in 1958, the year he showed his first Environment, Kaprow had joined with several of his own students to stage an experimental "event" reminiscent of the famous one of 1952 involving Cage, Cunningham, Rauschenberg, et al., at Black Mountain College. Seizing on the occasion of a Hansa Gallery picnic, at the New Jersey poultry farm owned by one of the students, George Segal, Kaprow directed his cast in a variety of simultaneous and unrelated exercises, such as jumping through sheets stretched over lumber frames, rattling noisemakers while perched in chicken coops, and collectively painting a picture. Like the Conceptual artists of a decade or more later, Kaprow also explored, or documented, his own development in a series of public statements, letters to art journals, and articles, among them two seminal pieces entitled "The Legacy of Jackson Pollock" (*ARTnews*, October 1958) and "Notes on the Creation of Total Art" (Hansa Gallery exhibition announcement, 1958). Although insisting that he was engaged in art-making, rather than in Dadaist anti-art activities, Kaprow concluded that in the aftermath of Pollock and his sharp break "with the tradition of painters back to at least the Greeks . . . [there] may well be a return to the point where art was more actively involved in ritual, magic, and life than we have known it in our recent past." No longer "satisfied with the *suggestion* through paint of our other senses, we shall utilize the specific substances of sight, sound, movements, people, odors, touch. . . . [We will show], as if for the first time, the world we have always had about us, but ignored, . . . [and will] disclose entirely unheard of happenings and events in garbage cans, police files, hotel lobbies, seen in store windows and on the streets, and sensed in dreams and horrible accidents . . . all will become materials for their new concrete art" (fig. 315).

NOTES TO *SOAP*

1st morning and 1st evening: Each person privately soils some article of his own clothing. This is essential, for it refers to one's real experiences as an infant. In this act the person mingles his own water with the water of the sea or laundromat and consequently makes the cleansing of his clothing inescapably personal.

2nd morning: Cars should be methodically and thoroughly smeared with jam, within sight of passers-by. The washing should be done as diligently. If a commercial car-wash is used, one should have this done as though nothing were out of the ordinary. Any questions asked should be answered in as noncommittal a way as possible.

2nd evening: A vacant stretch of beach is best. Either couples or individuals may perform this. There should be long distances between each individual or couple. In the case of couples, one person covers the partner (who is preferably naked) with jam, digs a hole for him (or her), covers him (or her) with sand to the neck, and sits quietly watching until the tide washes the partner clean. They then depart.

left: 316. Red Grooms. *The Burning Building*, performed at the Delancey Street Museum, New York. 1959. Photo by Max Baker. Courtesy the artist.

center: 317. Claes Oldenburg. *Injun, I*, performed by the artist and others at the Ray Gun Manufacturing Co., New York. 1962. Photo by Robert R. McElroy.

right: 318. Robert Whitman. *The American Moon*, performed by Lucas Samaras and others at the Reuben Gallery, New York. 1960. Photo by Robert R. McElroy.

For his first public Happening, entitled *18 Happenings in 6 Parts* and held in 1959 in the second-floor loft space of the Reuben Gallery in New York, Kaprow issued invitations advising his guests that they "will become a part of the happenings" and "will simultaneously experience them." Moreover, he announced, "some guests will also act." What the audience found upon arrival were three "rooms" formed by translucent sheet plastic but "each different in size and feeling." Collaged materials, panels of scrawled words, or rows of synthetic fruit covered some walls, while strings of Christmas-tree lights dangled throughout the subdivided space. From chairs arranged in circles and squares facing in different directions, visitors were required, by instructions sent beforehand or given on cards at the gallery, to change their seats several times in the course of the performance and move through the various rooms. Divided into six parts, during which three happenings occurred at once, the performance commenced with amplified sounds and six players making a single-file march down the narrow passages between the makeshift rooms. Like these, all movements had to be made parallel or at right angles to the outside wall. While some of the actions repeated those of everyday experience, like squeezing oranges, others proved to be as special as an "orchestra" of toy instruments or a pair of painters, such as Robert Rauschenberg and Jasper Johns, rising from the audience to paint on either side of an unprimed canvas. Among other actions, slides were projected onto the wall of one room, or, in another room, two performers read from hand-held placards: "I was about to speak yesterday on a subject most dear to all of us—art . . . but I was unable to begin." Finally, after ninety minutes of eighteen concurrent happenings, four 9-foot scrolls toppled off a horizontal bar between male and female players reciting monosyllabic words: "but . . . ," "well" Then, two rings from a bell signaled the end, leaving guests to interpret the collage of experiences—fragmented in both time and space—as they wished, forewarned by Kaprow that "the actions will mean nothing clearly formulable so far as the artist is concerned." Even the term "happening" was to be considered meaningless, intended as it had been to indicate "something spontaneous, something that just happens to happen," despite the fact that the entire piece had been rehearsed for two weeks prior to the opening. As Michael Kirby would write, "the action in Happenings is often *indeterminate* but not improvised."

Yet, for all their open-ended plotlessness and contingency, Happenings were ripe with intentionality, the message of chaos and disorientation as much the product of their wildly mixed, cobbled-together media and moments as anything that McLuhan himself might note in the sixties. Moreover, the general purpose varied quite markedly from artist to artist, beginning with Tennessee-born, Chicago-educated Red Grooms (1937—), the youngest of New York's Happeners and probably the most energetic, madcap, and improvisational. Not only had Grooms seen photographs of Mathieu in action and heard about Kaprow's "picnic" at the Segal chicken farm; as a boy, more-

over, he had been so enamored of the Ringling Brothers Circus that he spent an entire summer building and operating a backyard version. Inspired perhaps by his own tousled mop of flame-colored hair, Grooms entitled his first performance piece *Play Called Fire* (1958) and his first Happening *The Burning Building* (fig. 316). On the latter's opening night, the artist arrived without a match to light the all-important candle and, in honest necessity, requested help from an obliging audience, a bit of "found" action that became canonic for the remainder of the run. Otherwise, *The Burning Building* had Grooms playing the clownishly pyromaniac Patsy Man in a kind of silent-film, slapstick contest with a pair of inept Firemen. In the course of the ten-minute Happening—which rolled on like a fast-moving comic strip—the Firemen did a clumsy dance, the Patsy Man discovered a girl in their den, and the Soundman read a love poem. Finally, while the Firemen gorged themselves on turkey, the Patsy Man hid, but then escaped by somersaulting through the window—to the audience's vociferous delight.

Following the lead of Kaprow and Grooms, Claes Oldenburg ventured into Happenings while *The Street*, his 1960 installation at the Judson Gallery, offered a proper Environment. There, in a series called "Ray Gun Spex," Oldenburg sponsored Happenings devised by Kaprow, Jim Dine, Robert Whitman, and others. It included his own *Snapshots from the City*, illuminated by periodic flashes of light so that, for the rather brutalized audience, the thirty-two debris-strewn scenes of urban apocalypse became a kind of living tabloid. "The performances," Oldenburg explained, "were intended to add the ultimate note of actuality to *The Street* with the artist's actual presence in his creation." In early 1962, after *The Store* closed at the Ray Gun Manufacturing Company on East Second Street, Oldenburg organized the Ray Gun Theater on the same premises. Now he presented a cycle of ten Happenings, the most memorable of which may have been *Injun*, its title taken from Mark Twain's corruption of "Indian" and its sardonic content from the rich history of American myths, foibles, follies, and violence (fig. 317). Such was the success of *Injun* that it even had a sequel, *Injun II*, commissioned by the Dallas Museum for Contemporary Arts. Now Oldenburg involved the audience to the point where the police arrived, in response to a riot alarm, and, by interrogating the participants, became part of the extemporized action. Nothing could better illustrate what Barbara Rose called "Oldenburg's dictum that disorder and the unexpected must also be accepted as part of existence."

Assemblage, Environments, Happenings

Although Grooms, Oldenburg, and Dine soon abandoned the ephemerality of Happenings for the relative durability of works like those in Chapter 5 or in figs. 307 and 311, Robert Whitman (1935—) followed his professor, Allan Kaprow, in long continuing to work in so-called "painter's theater." Possibly he found greater satisfaction in the genre by reason of his having approached it not only more abstractly but also more visually. Even in his early junk Assemblages, Whitman managed to refine away rawness and endow the works with gentle quietude and transcendent form. In *The American Moon* (fig. 318), one of the most original of the Happenings, he used leaves of plain white typing paper mounted in grid formation on translucent plastic sheets to create a theater-in-the-round, designed as tunnel spaces for a divided audience turned, like spokes on a wheel, towards a central, oval-shaped performance area. This meant that each segment of the assembled company witnessed a different aspect of the events, which included huge, view-blocking balls of paper rolled across the stage, film imagery broken into abstract facets by projection onto screens gridded with typing paper, and, finally, a man swinging upside down above an audience now crowded at the center and thus brought into the climactic action.

Sexual liberation—one of the sixties' most energetically cultivated themes—came to the fore and, generally, remained there in the Happenings produced by Carolee Schneeman, whose most sensational work may have been *Meat Joy*, performed at the Judson Memorial Church, the venue for so many of the early New York Happenings. Called "a sort of spectacular multi-media orgy" by Adrian Henri, the piece had little difficulty attracting a trendy Uptown audience to its mass "lovemaking with paint brushes" carried out by a writhing heap of naked or near-naked participants. When repeated in Paris, *Meat Joy* became a "flesh celebration" reminiscent of Artaud's Theater of Cruelty and "French butcher shops," complete with carcass blood instead of paint.

In Europe, where the ideas of both Cage and Kaprow quickened a new interest in the earlier 20th-century tradition of artists' theater—from the Futurists and the Russian avant-garde to the Dadaists, the Bauhaus, and the Surrealists—Happenings often aimed to shock in a far more confrontational manner than the somewhat ribald irony fairly characteristic of New York Happenings prior to the Vietnam War. This was especially true in the case of the German artist Wolf Vostell (1932—), who first captured attention in 1956 with *décollages* bearing a family resemblance to those seen within the ambience of Paris' New Realist movement (fig. 285). Indeed, Vostell appropriated the term in 1954 from a French newspaper headline about the crash of an airplane immediately after its *décollage*—literally its "ungluing" or "unsticking" from the ground but also, in common usage, its "takeoff." Together, word and event reminded Vostell of the destructive violence entailed in the process he used to rip weathered, graffiti-scarred posters off public walls with the aim of recontextualizing them in art. For his Happenings, Vostell emulated Kaprow and literalized the "ac-

above: 319. Wolf Vostell. *9 Decollages*, performed in Wuppertal, West Germany. 18:22, 14 April 1963.
below: 320. Mark Boyle and Joan Hills. *Theatre*, performed in Potter Lane, London. 1964. Photo courtesy the artists.

tion" part of his work by transferring it from the synthetic realm of depiction to a "real" environment (fig. 319). In the German's case, this often meant moving out of galleries or studios and into the public domain, even the street. There Vostell allowed no passive spectators but, rather, insisted that all become engaged in tearing away layers of fixed attitudes, to get at the awful truth of the social, political, or cultural situation, particularly as this was being affected by technology. Although prepared to assimilate into Happenings whatever noise, movement, object, color, or psychology chanced to present itself along the way, Vostell usually scored his pieces for such archetypal features of the machine age as television, trains, and cars. By mistuning or shattering a television set, or crashing an automobile into a railway engine, or yet creating a sculpture from a wrecked car and fixing it to the spot where the smash-up had occurred, Vostell managed to confront his audience with the destructiveness—the accident waiting to happen—present within so much of what the complacent unquestioningly accept as progress.

In Britain, Happenings tended to merge with nascent rock music, which, as the career of John Lennon illustrates, incubated to a considerable extent in art schools. And this can hardly surprise given the support that such multi-media work received from the Arts Council of Great Britain. Moreover, just as rock developed primarily in the provinces, so did British Happenings, which proved rather too counter-cultural for the relatively staid London scene other than at the Pop-friendly ICA. According to Adrian Henri, the first English Happenings took place in Liverpool in 1962, the epicenter and the year of the Beatlemania explosion. After reading an article by Kaprow, Henri too saw the logic of extending his Assemblages into Happenings, which, during the Merseyside Arts Festival, became part of a mixed poetry, folk-rock music, and Assemblage event. Yet, the most memorable of British Happenings may be those staged by Mark Boyle (1934—) and Joan Hills, who, for one Sunday afternoon action in 1964, led a group of people down London's Pottery Lane to a dilapidated rear entrance marked "Theatre." Once inside, Boyle and Hills invited their company to be seated on kitchen chairs ranged before a set of blue plush curtains, which opened upon a performance composed of nothing more, nor less, than the ongoing, everyday activity of the street outside (fig. 320). But, as J.L. Locher would write, "it was not the life in the street itself but the unexpected connection with the theatre form that induced an aesthetic sensation." Unlike Cage, Boyle and Hills have always been very much involved with objects, but their approach remains the Cagean one of celebrating the found and the available—whether a snowflake or a dustbin—by tampering with its natural state as little as possible.

Post-Painterly Abstraction

While those members of the cool generation responsible for Pop Art reacted against the overheated sublimities of postwar abstraction by making their work ever-more inclusive of the most banal reality, others within the same new, anti-expressionist wave employed what seemed to be the very opposite tactic, which was to eliminate from art all but its most intrinsic or irreducible conventions. When first detected in the mid and late 1950s, the two tendencies—"purist" and "impurist"—struck most as so divergent as to have nothing in common save their realization that Action Painting or Informalism had been corrupted by its secondhand practitioners into mere stylistic formula as empty and academic as any that had ever preceded it. In time, however, as Irving Sandler was the first to note, it became evident that, far from antipodal in their differences, sixties artists of every persuasion were also at one in a variety of other important ways, not the least of which was a shared urge to replace self-revelation with a revelation of phenomena external to the creative individuals themselves. In the case of Pop, this became a matter of transposing into art things or images of things appropriated from the human-made world. "Not mine but given," as Johns declared. Among the purists or formalists—the Post-Painterly Abstractionists—to be seen here, the strategy was to divest painting of everything extra-pictorial and thus make it so self-referential that its reality as an object—aesthetic, of course, but nonetheless an object among other objects—would become undeniable. To quote Sandler:

Indeed, artists of the sixties did look at things for what they actually were and not as metaphors of human feelings, what Ruskin had termed the "pathetic fallacy." Thus there was a shift—from symbol to sign—to seeing things as they literally are and "saying it like it is," a catchphrase of the sixties.

The Pollock-Rothko generation had sought authenticity in the degree to which abstraction—whether attained through spontaneous gesture or through deeply pondered expanses of barely modulated color—provided a true record of otherwise ineffable personal experience. For their sixties successors, however, authenticity would depend upon the critically acknowledged "rightness" of the preconceived ways they chose not only to "move out from Pollock," as Rauschenberg and Johns said, but also to keep edging forward in an unfolding, interlinked series of pictorial problems and solutions. Rauschenberg, of course, had opened the door to Pop with his combine paintings, but still earlier, in 1951, he had also foreshadowed the radicality of sixties formalism in his White Paintings, works empty of all but the environmental lights and shadows cast upon their featureless, monochromatic surfaces (fig. 220). Johns too had realized a double breakthrough, to both Pop and Post-Painterly Abstraction or even Minimalism; moreover, he had done it in the same work, the Flag seen in fig. 228, which so conflated the found yet abstract image with the shape and flatness of its physical support that subject became object—an object recognizable as aesthetic largely by virtue of the artist's Old Masterish handling of the encaustic medium. Thus, Popsters and Post-Painterly Abstractionists were additionally joined in their intensification and acceleration of modernism's critical process, even though the former dealt with life as well as art, while the latter concentrated on issues exclusive to art itself. In fact, it was in the arena of self-criticality that purists and impurists clicked together most tellingly, as Johns in his

Flags went so far towards solving the key modernist problem—the problem of how to enunciate the picture not as an illusion but as a reality unto itself—that a Minimalist master like Frank Stella could take it virtually the whole way. Finally, the would-be yin-yang branches of the sixties mainstream matched one another in their competitive reach for the heroic statement—the big, clear, single-image or gestalt form—even while eschewing heroic emotions. And they succeeded resoundingly, for by opening their art wide to the full flood of confident energy flowing from what came to be called the Abstract Expressionist "triumph," Popsters and formalists alike achieved works of great and often overwhelming presence. If this was a presence generally devoid of the older art's mystical overtones, it would more than compensate in sheer, dazzling opticality or in obdurate, aggressive physicality. Meanwhile, of course, the variables distinguishing Post-Painterly Abstraction from its complementary companion, Pop Art, are almost too marked to mention. Foremost among them, however, would be Pop's unblushing embrace of figuration—often figuration of the most exuberant grossness—and its biting, relentless irony, all of which stands in contrast to formalism's resolute faith in nonobjectivity coupled with a solemn, unwavering quest for quality.

With the world becoming ever-more a planetary village, Post-Painterly Abstraction proved to be as international in scope as almost every other late-modern development, but this time the leadership role fell quite decisively to the younger members of the New York School. Among the factors impelling them to the fore was the increasingly dominant position of the United States in global affairs, which could not but lend prestige to the Manhattan art scene, then a recently evolved phenomenon flush with virgin success—financial as well as critical—and ripe with a sense of boundless potential. More fundamentally important, however, were the powerful role models offered by Still, Rothko, Newman, and Reinhardt, whose own rigorous aesthetics demonstrated what direction the most fruitful new possibilities would be likely to take. For years, moreover, the cranky Reinhardt had been openly advocating art for art's sake, all the while that he also ridiculed, with scalding wit, the Abstract Expressionists' "transcendental nonsense, the picturing of a 'reality behind the reality'." Then too, formalism, unlike Pop, enjoyed the vigorous support of the most informed and persuasive critic active at the time in the realm of modern art. This was the New York-based Clement Greenberg, whose "superficially improbable achievement," as the British art historian Charles Harrison wrote in 1986, "was to recover what was coherent in the Modernist tradition and in its concept of autonomy and to reformulate it in terms of a theory of artistic development as practical self-criticism." Honing his ideas in a long series of articles and reviews, one of the most basic published as early as 1939, Greenberg held that modern painting, from the moment of its inception in Impressionism, had evinced an overriding desire to become "pure," meaning that its creators had always sought, and should continue to seek, an art based with increasing exclusivity on those characteristics or conventions uniquely and indisputably its own: "the flat surface, the shape of the support, the properties of pigment." Thus, Greenberg rejected "painterly painting" because its tactility and value contrasts must inevitably create illusionistic space and therefore work against picto-

rial flatness. Prompted by this rationale, he also dismissed Cézanne and the Cubism that master inspired, and encouraged progressive painters of his own time to rediscover Monet, long ignored by reason of his presumed lack of structure, and see the later Waterlilies as a prophecy of contemporary Color-Field Painting. Because Impressionism, with its generalized distribution of small strokes, "is not broken by sharp differences of value or by more than a few incidents of drawing or design," Greenberg wrote, "color breathes from the canvas with an enveloping effect, which is intensified by the largeness itself of the picture."

With his historically determined conception of modernism as a mainstream of avant-garde styles, each of them progressing towards a more purified state of self-definition, Greenberg—as well as, and most particularly, the critics influenced by him—turned against de Kooning, at the very moment when he seemed to be at the peak of his powers as the "model Abstract Expressionist." From the Greenbergian point of view, however, "de Kooning-style" painting had become retrogressive, its painterliness, its Cubist or relational structure, and its vestigial imagery all giving rise to illusionistic effects and thus subverting the pictorial flatness "desired" by the reality of the canvas support. Worst of all, de Kooning had emerged as the most emulated of all living artists. Thanks to his dramatic struggle to re-create his art with every stroke, his consequent openness to figuration as well as to abstraction, his verbal skills and alluring accessibility, de Kooning appeared to be the surest point of departure for scores of the ambitious young, both those gravitating towards Pop and others identifying with formalism. Unfortunately, the latter, being unendowed with genuine tragic vision, could only transform the master's existential way of working into mannerism or yet unintentional parody. As a result, "painterly painting" became a term of opprobrium and Post-Painterly Abstraction one of approval, coined by Greenberg to characterize the less "accessible" and "available"—that is, the more difficult or challenging approach—suggested by the first-generation Color-Field painters as well as by what were seen as their logical antecedents in Monet and Matisse. However, the great breakthrough for the new Field painters dawned with the discovery that Pollock's painting, instead of being so personal or complete as to seal off all further development, actually constituted a gateway to a vast new world of aesthetic opportunity. This came not only from the great all-over webs of poured Duco, which, as Frank Stella would say, forced "illusionistic space out of the painting at a constant rate" and thus provided a key inspiration for Minimal painting, a highly conceptualized variety of pictorial art as nonrelational, nonallusive, flat, and "framelocked" as any ever created (fig. 321). It would even be triggered by the late black-and-white canvases, originally deemed "problematic," because of their figurative elements, but suddenly rediscovered in 1952 as profoundly liberating works, paintings in which Pollock, carrying further certain tentative efforts in pictures like *Autumn Rhythm* and *Lavender Mist*, virtually invented the technique of staining liquid medium directly into raw canvas (figs. 41, 67, 70). By this means he realized an image of great, Matisse-like openness, but freer and far more fluid. Staining, moreover, enabled him to make figure and ground so integral with the support that the distinctions between them ceased to be either tactile or spatial and became purely optical. Translating stain painting into color painting, Helen Frankenthaler, Morris Louis, Kenneth Noland, and Jules Olitski—the artists most favored by Greenberg—did not so much preconceive their images, as Stella and the Minimalists would; rather, they tended to discover them, as Pollock did, in the process of working with materials. What this produced for the new Field painters was a purely chromatic image whose utter abstraction and transparency work the wonder of making it seem as disembodied as colored light, *even* as those same characteristics also declare the woven materiality of the light's source: the reflective, all-over white of the uniformly flat, rectangular canvas (fig. 322). Whether sensuously lyrical as in the case of Frankenthaler or crisply structural as in the work of Noland, the sheer hedonist beauty of sixties Color-Field Painting betrayed its filial allegiance to Matisse, especially the Matisse of the late, monumental, brilliantly decorative painted-paper cut-outs (fig. 94).

Also among the French master's progeny were such Hard-Edge painters as Ellsworth Kelly, Jack Youngerman, and William Turnbull. In their variant of Field Painting, color would generally claim the entire surface, not soaked in but stretched over the canvas like a taut skin. Here, holism or unity arose from a flat abstract pattern whose large, simple shapes are so uniformly present, in their blazing hues, suave, scissor-sharp contours, and reciprocal, airtight fit, that instead of breaking up into figure-ground relationships, they lock together to form one smooth, continuous plane (fig. 323). The term Hard Edge, introduced in 1959 by the California critic Jules Langsner but then made canonic by the British writer Lawrence Alloway, was meant, as the latter wrote in 1966, "to refer to the new development that combined economy of form and neatness of surface with fullness of color, without continually raising memories of earlier geometric art."

For Greenberg, the overriding issue to be considered in relation to a work of art was its quality, an intangible factor, in a realm of logical-positivist aesthetics, having less to do with the concretions of style than with inspiration and taste. But given the conception of modernism as a steady progression towards self-refinement, quality must in some measure be contingent upon the extent to which taste or inspiration seem to have served the ideal of pictorial autonomy. As formalist thought evolved during the sixties, especially in the writing of Michael Fried, inspiration, taste, and the quality they produced would be tied to a somewhat broadened conception of modernism, eventually seen as an ongoing sequence of responses to limitations in the current avant-garde style and the exploitation of them as new opportunities for further stylistic advancement. As Fried wrote in 1964: "The chief function of the dialectic of modernism in the visual arts has been to provide a principle by which painting can change, transform, and renew itself." Self-regeneration, of course, meant formal renewal, since extra-aesthetic values—humanist or "life" concerns, whether the inner, subjective ones dear to Expressionists or the objective ones engaged by Realists—did not lend themselves to the historically determined kind of analysis devised by the late modernists. Moreover, viewing the picture as a symbol of something it was not could only obscure the factuality of the painting as a physically present object. The quality of the work as an aesthetic thing assumed surpassing importance, for, whatever its ultimate significance, "only an art of constant formal self-criticism," Fried wrote on another occasion, "can bear or embody or communicate more than trivial meaning." Nevertheless, while subject, content, and aesthetic worth might

321. Frank Stella. *Tomlinson Court Park.* 1959. Enamel on canvas, 7'1" × 9'1¾". Collection Robert A. Rowan, Pasadena.

top: **322.** Morris Louis. *Point of Tranquility*. 1958.
Acrylic on canvas, 8'5⅜" × 11'3". Hirshhorn Museum and Sculpture Garden,
Smithsonian Institution, Washington, D.C. (gift of Joseph H. Hirshhorn).

above: **323.** Ellsworth Kelly. *Red White*. 1961.
Oil on canvas, 5'2¾" × 7'1¼". Hirshhorn Museum and Sculpture Garden,
Smithsonian Institution, Washington, D.C.

late, distinguished exponents of traditional geometric art, as well as the best of their antithetical brethren, the later "painterly painters" for whose beautiful, if slightly retrograde, work Greenberg had so little tolerance. Transcending all the categories, by virtue of anticipating so many of them, were the two European masters here called "proto-Minimal" as a way of signaling their jump-start as well as shortfall position in the history of sixties abstraction.

Proto-Minimalism

If Post-Painterly Abstraction turned out to be more life-involved than its more doctrinaire ideologues would have wished, the new formalism also failed to march forward, from impurity to purity, in the neatly progressive, stepwise fashion that certain critics seemed not only to describe but sometimes even to prescribe. Prime examples of art's unpredictability were Rauschenberg's White Paintings, so *tabula rasa* in their figureless, anti-subjective, monochromatic flatness that they may be called *proto*-Minimal only because their astonishingly early date—fourteen years before the term Minimalism gained currency in 1965—and their consequent isolation, even within the artist's own oeuvre, make them appear simply maverick, or neo-Dada, rather than the beginning of a new formalist advance. Slightly less precocious but equally proto-Minimal were the uncompromisingly abstract monochromes painted by two of Europe's most illustrious *nonpareils*—Yves Klein, seen earlier as the leading New Realist (figs. 278, 279), and the already-senior Milanese master Lucio Fontana. Owing to their very real concern for the "reality behind the reality," as well as to their fearlessly reductive canvases, both Klein and Fontana might be at home with Rothko and Newman, except for the Pop-style irony or antics with which they attempted to help nonobjectivity convey its meaning.

Within the context of sixties art, France's Yves Klein achieved a universality perhaps even more complete than that of Rauschenberg. Not only did he glitter at the heart of New Realism, as we noted in Chapter 5, but in his life-long yearning for *le Vide*, he also seems to have been a Minimalist born, even though his untimely death in 1962 occurred well before this term could be applied to the radical abstractions painted by his generation. Believing himself called to help humanity recover something of the primal Void, a spiritual space where the purified consciousness might fly free of the troubled world of matter, the esoteric Klein sought to experience or demonstrate levitation in all manner of ways. At first he would soar by means of judo and Rosicrucian or Zen meditation, but once he embraced art the great "leap into the Void" would be undertaken through paradoxical works designed to make the ethereal seem not only real but also concrete and thus viewer-engaging. Given his arcane turn of mind, it seems logical enough that Klein became a painter not because of his mother—Marie Raymond, a well-established member of the Bissière-Bazaine-Manessier circle—but because, as he said, "one discovers suddenly that that is what one is!" It also follows that while his most celebrated works may be the beautiful but utterly imageless Blue Monochromes seen here (fig. 324)—pictures that made few technical demands on an artist always stubbornly resistant to training in his parents' profession—they would be accompanied by a prodigiously inventive range of Dada-like texts and statements, gestures, acts, and photographic documentation (figs. 460, 478). All of them, especially the proposal for an "Architecture of the Air," reflect a minimalizing bent that produced not only the Monochromes but also forerunners of almost everything that would subsequently emerge within the broad, dematerialized realm of Conceptualism, from Body and Process works to Performances. In a lecture delivered at the Sorbonne in 1959, Klein called it "The Evolution of Art towards the Immaterial." Ironically, the Monochromes are almost pugnaciously object-like, for the didactic reasons cited above as well as in Chapter 5, but the artist created them as pure idea long before he ventured to apply color to canvas. First there was a notebook entry made in 1951, the year that

be *sought* solely within painting's demonstrable plastic attributes, not even Frank Stella, who notoriously insisted that in his Minimal paintings "what you see is what you see," could altogether escape the metaphoric or expressionist implications of his work. Black itself is a richly evocative color, as is the heraldic form Stella gave his early Black-Stripe paintings, some of them like stilled, geometricized versions of Pollock's whirling linear vortices, and all of them identified by titles with undertones of threnody or threat. Further, certain equally bona fide Minimalists—among them England's Bob Law and America's Agnes Martin—were almost as preoccupied with spiritual or poetic content as the Abstract Expressionists. When a viewer protested that no game was to be seen in Martin's gridded painting entitled *Wild Geese Descending*, the artist replied: "I painted the emotions we have when we feel gray geese descending."

As labels, Field, Hard Edge, and Minimal may function well enough to denote the three principal currents of mainstream Post-Painterly Abstraction, but they hardly account for the whole of modernist activity during a decade when the energy driving radical formalism would send it rushing to what so far has been its own climactic, over-the-cliff phase. Also very much in the swim were the

324. Yves Klein. *Blue Monochrome (IKB 42)*. 1960. Dry pigment in synthetic resin on fabric on board, 6'6⅜" × 5'¼" × 1". Menil Foundation Collection, Houston.

Rauschenberg created his White Paintings. Three years later, in 1954, Klein began the process of materialization with *Yves Peintures*, a little 9½-by-7½-inch book embellished with ten captioned plates purporting to reproduce a series of one-color paintings in a variety of hues and a "Preface by Pascale Claude." A revision of his poet friend's names, Claude Pascale, and a preface that consists of nothing but horizontal black lines, broken into "sentences" and indented "paragraphs," slyly give it away that the "reproductions" are merely tipped-in rectangles of commercial paper. This, in turn, makes them the "originals" of "unicolor" works that Klein would not actually begin to paint until 1955, the year he moved permanently from his home in Nice to Paris. While *Yves Peintures* mocked the notion of originality so passionately espoused by the Informalists, which they actually betrayed by allowing their tough and energetically textured works to be illustrated in satin-paper *livres de luxe*, the mini joke monograph also had the serious effect of asserting that its own idea was valid enough to warrant publication. And this idea, which would remain constant throughout Klein's highly miscellaneous oeuvre, held that the true worth of art lies beyond what can actually be seen or touched. Since for Klein the locus of that value is where imagination or idea itself enjoys free play, or in its ultimate state, where all matter, according to Rosicrucian belief, will resolve into pure but spiritually rich nothingness, sheets of uniform color made the perfect image, whatever the medium used to obtain it. However, the possibility of stimulating speculative thought increased dramatically once Klein began exhibiting his large-scale Monochromes. A few of them were carmine pink and others gold-leafed, but most would be possessed by the famously electric ultramarine, which, with the first two colors, com-

pleted Klein's personal variants of the primaries red, yellow, and blue. By 1960 the scale had increased to 6 by 5 feet, but large or small, the paintings all came forth unabashedly naked of everything—composition, drawing, contrast—but resonant, unitary, evenly applied color, color so vibrantly present that it seems to invade the viewer's own space, yet so deep that it evokes both the ocean and the heavens above. Part of this magical effect arose from the medium itself, which Klein invented, with the aid of Rhône-Poulenc chemists, by suspending pure, dry pigment in crystal-clear synthetic resin and compatible solvents. Unlike traditional binders, the new colorless carrier did not smother or "kill" the individual particles of hue but left them free to sing out with all the sonority of raw, powdered pigment. Moreover, the novel medium was versatile enough to be brushed, sprayed, rolled, or even thickened and built up like Fautrier's *haute-pâte*. Finally, it quick-dried to a fragile-looking but in fact durable, matte finish that, like velvet, offers a plush, light-absorbent surface that paradoxically seems to dissolve into dark, glowing liquid depth. The contradictions multiplied once Klein adopted boxy, round-cornered, frameless panels projected several inches from the wall and then painted them all over—sides as well as frontal plane—in the same shocking ultramarine, which the artist patented in 1960 as International Klein Blue. In such a format, abstract color could scarcely be more physically or even chunkily asserted; yet the very purity of IKB leaves the image so volatile—so full of ambiguous optical dazzle—that it cannot but escape the fixity of both binder and support. And this was why Klein considered unhampered color "good," as opposed to the "evil" of lines, which, in his view, do not generate a sense of free, fluid boundlessness but, instead, contour or delimit forms and thus hold them captive in solid matter. Klein even tested the unifying power of IKB in a group of "lunar reliefs" realized with sponges soaked in blue medium and attached to a similarly drenched Monochrome panel, thereupon creating a cool outer-space image consistent with the artist's overall urge to make infinity present in reality.

In 1957, when Klein had the Dadaesque audacity to exhibit a series of eleven Blue Monochromes that appeared to be absolutely identical, there was method in his madness. Not only did this unprecedented show, mounted by the Galleria Apollinaire in Milan, leave viewers wondering what such art could mean; it also forced them to realize that if they found one of the pictures more compelling than the others—more impregnated with "pictorial sensibility"—its significance must emerge from something other than material form. When reactions did prove variable, Klein, as we saw in Chapter 5, was prepared, with prices that were "all different of course." If IKB made it seem as though Klein were fashioning objects of Mediterranean air or sky, the other elements too came into play as he painted with fire and rain, both of which carried him further along the Minimalist route towards dematerialization, towards an art enigmatically compounded of the mundane and the divine, thus poised for a "leap into the Void."

In Milan, Klein found an early collector in Lucio Fontana (1889-1968), a much older artist who had been bringing on the "new" for almost thirty years, and who, like Klein, produced an immense, wide-ranging, often preposterous body of work rife with anticipations of Conceptual developments he would not live to witness. Even before the advent of Pop, Fontana had declared that his intention was to "destroy the conventional with its own weapons." But what first gave the Milanese artist more than local prominence and initiated the process of his still-growing influence were the monochromatic, proto-Minimalist canvases that he began to paint *and* lacerate in 1958 (fig. 325). As deeply meditated and almost as spiritual in content as Klein's Blue Monochromes, these *Concetti spaziali* ("Spatial Concepts"), with their deceptively simple scheme of flatness penetrated by ambient depth, issued from a long, steadily active and innovative career that commenced with youthful studies in Milan, where Fontana had been taken as a child from his native Argentina. Then and until age fifty, he worked as a sculptor, an artist whose critical turn of mind compelled him to subvert every style he adopted, from Futurism at the

start to Abstraction-Création in the 1930s. While in Argentina during World War II Fontana led a group of disciples in an "art protest" that can now be seen as a forerunner of Happenings. Shortly thereafter, in 1946 and still in Buenos Aires, he issued the *Manifesto Blanco* ("White Manifesto") prophesying a future art emancipated from its enslavement to the painted canvas and fashioned of such media as neon and video. A year later in Milan came the artist's *Manifesto spaziale* ("Spatial Manifesto"), which formalized a Fontana-inspired movement whose aim was to create a "greater art" by merging Informalist abstraction with Dadaist strategies, sculpture's three dimensions with painting's two, and these not only with architecture but also with science and technology. Collaborating with the architect Luciano Baldessari, Fontana in 1949 constructed his first Spatialist work (*Ambiente spaziale*), a dramatic room-size installation darkened save for numerous fluorescent-colored forms suspended in mid-air and glimmering under lamps of "black" ultraviolet neon. Only now did Fontana become a painter, at first with gestures so exaggerated as to mock the Informalists, the thrust and parry of whose methods he critiqued by perforating or slashing the unified canvas with rapier-like strokes. The better to stress the principle of violation, Fontana soon evolved the kind of surface seen here, its thinly painted, utterly flat matteness offering a condition of such passive, virginal purity that it seems an open invitation to the artist's sadomasochistic attacks, carried out with nails, awls, or even a fencer's foil. But destructive as this action may appear, it also constituted a creative gesture, which, by integrating the aestheticized canvas with the rough reality of its actual environment, demonstrated the sculptural potential of painting. At the same time, given Fontana's life-long Catholicism, a seductively pristine, abstract plane violated with an equally seductive elegance and simplicity also lends itself to metaphysical interpretation as an emblem of martyred innocence, of life and art transcending the deadly strictures of their established conventions. A few weeks before he died, Fontana said:

below: 325. Lucio Fontana. *Concetto spaziale*. 1965. Waterpaint on canvas, 21⅝ × 17⅞". Courtesy Fashion Concepts, Inc., New York.

right: 326. Jean Dewasne. *La Demeure antipode*. 1965. Enamel on masonite, 3'1⅞" × 4'2⅞". Solomon R. Guggenheim Museum, New York.

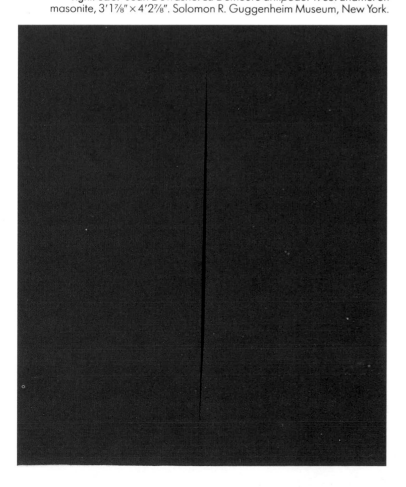

"The intelligence of man . . . is the only thing in which I believe, more than in God. . . . For me God is the intelligence of man . . . and so, since I have faith in the intelligence of man, I am convinced that in the future man will know a world completely transformed by art."

The Surviving and Thriving Geometric Tradition

The "earlier geometric art" that Lawrence Alloway hoped to distinguish from what he called Hard-Edge Painting was in fact alive and even flourishing, if not a dominant mode, throughout the fifties and into the sixties. As we saw in Chapter 3, the lucid, chaste pictorial geometries of artists like Auguste Herbin, Ben Nicholson, and Victor Pasmore (figs. 98–100) did much in the postwar years to make abstraction seem ethically as well as aesthetically superior to realism of any kind, even though the abstraction finally preferred by the Age of Anxiety would be expressionist. As angst subsided, and along with it the allure of painterly turmoil, the rationality and precision of art derived from the geometric tradition—meaning Cubism's extremist heirs in Constructivism, De Stijl or Neoplasticism, Parisian Abstraction-

Création, and their descendants—provided a model of aesthetic rectitude even for painters with an obsessive love of form but little or no interest in the older art's messianic zeal. For the most part, however, sixties abstractionists would avoid Cubism's "relational design"—an asymmetrically balanced structure of disparate, separable, even if analogous, parts—and cultivate the kind of nonrelational, holistic, or indivisible image developed by Pollock. Still, relational organization suited a number of major artists perfectly well, among them de Kooning and many of his painterly followers, but also a mature geometricist like France's Jean Dewasne (1921—). As closely involved with Paris' Réalités Nouvelles Constructivists as Herbin and as fully committed to their socialist agenda, Dewasne was nonetheless young enough to make history primarily in the 1960s. As the work here discloses (fig. 326), Dewasne had also examined the Machine Style and imagery, as well as the billboard colors, of Léger, all of which he reconceived as an aerially viewed traffic map, perhaps one serving a stadium, an airport, or an industrial complex. Although he worked improvisationally, in active collaboration with his materials, and deliberately opted "for the most unforeseen probability," Dewasne always ended with a composition in perfect counterpoise, its dynamic world of oval racetracks, converging autoroutes, parallel runways, and hangar or plant sites stilled and forever fixed in an industrially smooth, lacquer-hard surface. Also contributing to the effect is the relationship between the proportional sizes and bold colors of figure and ground, so balanced

far left: 327.
Al Jensen.
A Circumpolar Journey. 1973.
Oil on canvas,
8' square.
Courtesy
Pace Gallery,
New York.

left: 328.
Ludwig Sander.
Chincoteague II.
1961.
Oil on canvas,
4'8" × 4'2".
Courtesy Rosa
Esman Gallery,
New York.

that negative and positive become interchangeable and thus self-canceling into gridlocked stasis on the same focal plane. With this, Dewasne entered aesthetic territory staked out by the Hard-Edge painters, as well as the Optical artists to be seen in Chapter 9. He also liked to paint on the spray-enameled surfaces of disassembled, or unassembled, automobile backs, the parts for these "Anti-Sculptures" provided in later years by the artist's most loyal patron, Renault.

Late Constructivism found one of its most exotic practitioners in Alfred Jensen (1903–81), born early enough to have participated in the original Bauhaus experiment, but far too independent to have arrived any sooner than he did, which was in the 1960s (fig. 327). And such was the meandering odyssey by which Jensen came to the mature work seen here that it gathered up and reinvested in geometric abstraction a richly abstruse content reminiscent of the mystical, Utopian ideals embraced by Constructivism's Russian founders. After growing up in Guatemala and Denmark, Jensen began his art education in San Diego, only to depart in 1926 for Europe, where he studied with Hans Hofmann in Munich and then at the Académie Scandinave in Paris. Supported by a steadfast patron, Jensen subsequently traveled to Africa and Spain, absorbed the French moderns, learned about Goethe's color theory from Herbin, and read innumerable books on physics, hieroglyphics, and astronomy. Also feeding his intellect, imagination, and ultimately his hypnotic grid patterns of eye-dazzling, deeply tufted color were such arcana as Oriental philosophy, Peruvian calendars, ancient number systems, and Islamic decorations. As all this might connote, Jensen thirsted after universal truths and the nature of their dualities; fortunately, it made him as driven and even primitive in his art as he tended to be in his tendentious pronouncements. However high-flown the content, the canvases seem gripped by a lunatic conviction riveting enough to place them somewhere near the Art Brut world plumbed by Dubuffet. The happy consequence is painting so obsessive—brilliant, intricately plotted plaids dabbed on in layers as thick as cake frosting, often laced with graffiti-scribbled enumerations, equations, quotations, or axioms—that it holds the eye like a magnetic field of color, form, and materialized feeling. Thus, viewers need not be versed in the I Ching, the Rosetta Stone, or Tantric diagrams in order to find ravishment in the mesmerizing optical effects that Jensen derived from his rarefied sources.

Also old enough to have actually studied with Hans Hofmann in Munich was Ludwig Sander (1906–75), an American artist whose faithful yet subtly inventive devotion to Mondrian left his art seeming as quiet as Jensen's is noisy with ancient music cross-tuned from myriad esoteric sources. With Mondrian-like patience and method, the aging Sander brought his Neoplasticist painting to splendid culmination in the sixties, realizing it as a warmly colored, somewhat eccentric translation of the Dutch master's scheme of subdividing the pictorial field into an asymmetrical gridwork of rectangular planes (fig. 328). But once a master of this language, Sander made it entirely his own in an idiom of the thinnest, most delicate, slightly off-level or unplumb lines separating monochromatic planes coloristically differentiated only by value or intensity. The sheer openness of the image, as well as the monochromy, makes Sander's late work very congruent with abstractions painted by artists considerably younger and more directly identified with the 1960s.

When England's John Walker (1939—), one of the youngest artists to attain stylistic maturity in the sixties, chose to investigate Constructivism, he performed in an automatic or free-associational manner more reminiscent of Abstract Expressionism or even Surrealism than of the calculated cerebrations typical of Constructivist procedure (fig. 329). Morever, he preferred to complete a painting in a single session, the better to ensure that the work become an unadulterated manifestation of whatever he happened to be "into at the time." At the moment Walker executed the work seen here, it was the origins of 20th-century abstraction that claimed his mind and spirit. And so he reinvented Malevich's black square, mainly by free-floating it in an atmospheric, nonillusionistic dream space shared by two other plane geometries. If the black square seems to function like a black hole, absorbing all light and referring to nothing but itself, the other elements appear to signify everything but themselves. While the long "strip" suspended at the left optically ripples, like a ribbon, right through the gamut of color painted on it, the trapezoid—a favorite Walker shape—rests solidly at the base of the field, implying a weight and a movement into depth altogether at variance with its own flatly painted, two-dimensional self. Here then is Constructivist simplicity and universality rather thoroughly recomplicated and made personal by sensibilities nurtured on the ambiguities of postwar experience.

No artist either before or after the war explored the laws of optical perception and pictorial illusionism more scientifically than Josef Albers (1888–1976), the great Bauhaus master who, following his departure from Germany in 1933, re-established the Bauhaus foundation course in the United States, first at Black Mountain College (1933–49), then at Harvard, and finally at Yale (1950–60). Having taught artists as diverse as Robert Rauschenberg, Kenneth Noland, Robert

Mangold, and Richard Anuszkiewicz, Albers influenced American art of the sixties quite as profoundly as Hofmann had the first-generation New York School. Born into a family of artisans, Albers evinced a life-long respect for elementary materials and a craftsman's determination not only to understand but also to control them for aesthetic purpose. This drew him wholeheartedly into the Bauhaus program of treating the fine and applied arts as equal and interrelated. At Dessau, Albers taught furniture design as well as drawing, all the while that he also spent many years working with glass, a substance he found ideal for investigating light, color, and the perspective illusionism possible in geometric shapes defined, but then mutated, by outlines and clear as well as frosted planes (fig. 424). However, for his most celebrated series Albers concentrated on so-called ''nonperspective'' spatial sensations, meaning the purely retinal effect of depth and movement generated through the interaction of different, juxtaposed colors. Entitled ''Homage to the Square,'' this exercise began in 1949 and continued for the remainder of the artist's life, yielding literally hundreds of paintings (fig. 330). In them, Albers reduced form to the basic square—or rather a set of three or four concentric, superimposed squares, each of them identified solely by color—since this of all shapes most distances a work from nature and leaves it unquestioned as a human-made object. Furthermore, the very simplicity of the nested, symmetrical, gravity-bound structure freed him to carry out the most elaborate investigations of other matters, such as how subtly varied hues cause their containing shapes to expand or contract, advance or recede, or yet create the fiction of other colors not at all present. Convinced that art should present, not represent, Albers even applied color with a palette knife to avoid leaving a ''personal touch,'' a quality he deplored not only in German Expressionism but also in Abstract Expressionism, whose fall from favor he both hastened and celebrated. But in exploring the properties of optical illusionism, he was also exploring their psychological impact and meaning. Thus, Albers declared, in the true Utopian spirit of the original Bauhaus: ''The reason for aesthetics is ethics, and ethics is its aim.'' Then he added: ''When you see how each color helps, hates, penetrates, touches, doesn't—that's parallel to life.'' Geometric in his form language but nonrelational in his systemic or modular design, obsessed with the power of abstract color to move the viewer, scientific in method but classical and meditative in mood, Albers was one of the great and legitimate progenitors of sixties color painting, whether in the Field, Hard-Edge, and Minimal variety to be seen here or the Op branch to be considered later. But when the taxing yet always stimulating Albers acted upon his belief that ''good teaching is more a giv-

ing of right questions than of giving right answers,'' he became an all-important mentor not only to sixties formalism but also to Pop. A living witness to the fact is Rauschenberg, who in the early 1970s said: ''Albers was a beautiful teacher but an impossible person. His criticism was so devastating that I couldn't ask for it. But 21 years later, I'm still learning what he taught me.'' A forerunner along so many paths converging on the sixties, Albers also led the way in giving late modernism its first true serial art, since Homage to the Square assumes its full glory only when experienced as an ensemble of several works, together providing a theme stated and restated with inexhaustible variety, nuance, freshness, and surprise (fig. 423).

Painterly Abstraction

Grace Hartigan (1922—) very aptly captured the dilemma of New York's younger gestural abstractionists when she said: ''I began to get guilty for walking in and freely taking [Pollock's and de Kooning's] form . . . [without] having gone through their struggle for content, or having any context except an understanding of formal qualities. . . .'' Still, scarcely anyone in the early and mid-1950s, other than her mentor de Kooning, used power-packed, calligraphic brushwork with more directness or feeling than Hartigan, possibly because she did struggle for substance, finding it in the grimy, raucous pushcart world of New York's Lower East Side (fig. 331). Simultaneously, she also sought meaning in the grand, painterly tradition that ran from Rubens and Velázquez to Tiepolo and Goya. And so as her command of form and turbulent facture became more secure, the image itself entered a state of constant flux, resolving periodically into near-recognizable figures or urban fragments—symptoms of what the artist called the ''vulgar and vital in American life''—even as they seemed to melt back into the maelstrom of surging strokes. Naturally enough, Hartigan was close to the circle around Larry Rivers, but instead of adopting his jazzy, proto-Pop manner, irony, and subject matter, she cultivated her own free, lyrical variant of de Kooning's *gravitas*.

So completely did Joan Mitchell (1926—) absorb the de Kooning aesthetic that Harold Rosenberg, Action Painting's chief apologist,

left: 329. John Walker. *Tense II.* 1967.
Acrylic on cotton duck, 7' square. Collection John Golding, London.

above: 330. Josef Albers. *Homage to the Square.* 1964.
Oil on masonite, 30" square. Courtesy Sidney Janis Gallery, New York.

Post-Painterly Abstraction

would write of her, years later, as "a kind of companion figure to de Kooning in the diptych of younger and older continuators of this mode" (fig. 332). Morever, the Chicago-born and Art Institute-trained Mitchell has never wavered in her commitment to subjective, emotion-laden abstract gesturalism, for the very good reason that, in her case, it was not an acquired mannerism but, rather, a pure, un-willed exposition of sincere feeling. This sense of oneness with her work began early, when as a child Mitchell grew up in an apartment overlooking Lake Michigan and found herself spellbound by the vast waterscape, placidly blue in summer and frozen white, storm-tossed, and broken up in winter. After arriving in New York in the late 1940s, Mitchell drew on this ingrained awareness of nature to translate de Kooning's urbanism—his broad, violent rhythms and congested

below: 331. Grace Hartigan. *City Life*. 1956. Oil on canvas, 6'9" × 8'2½". National Trust for Historic Preservation, Nelson A. Rockefeller Collection.

below: 332. Joan Mitchell. *George Went Swimming at Barnes Hole, but It Got Too Cold*. 1957. Oil on canvas, 7'1¼" × 6'6¼". Albright-Knox Art Gallery, Buffalo (gift of Seymour H. Knox).

space—into fields of white-ground openness activated by loose, tangled fretworks or trellises of color strokes and counterstrokes, alternately bunched and sparse, graceful and awkward, some long and arcing, others short and blunt. Augmenting the sense of fresh, buoyant nature were the artist's crisp greens, reds, and ochres, a palette that subsequently veered towards blue, after Mitchell moved to France in 1958, became active in the Riopelle circle, and, in time, took up residence near Monet's old house in Vétheuil.

Even though de Kooning's senior by four years and Pollock's by twelve, Jack Tworkov (1900–82) came into his artistic own among such younger Abstract Expressionists as Joan Mitchell and Grace Hartigan, mainly because he rejected passionate self-revelation in favor of a calmer, more discreet or lyrical gesturalism. Born a Jew in Old Russia but reared in Poland before immigrating to New York at the age of thirteen, Tworkov declared that, having known alienation all his life, it held no romance for him. Still, his was an "open" image, like that of de Kooning, to whom he was close during the years 1948–53, a time when Tworkov developed a restless but controlled weave of flame-like strokes dancing across the picture surface in steady, balanced, easy rhythms (fig. 333). Often he organized them as blocks or fields of color that seem to come alive through a kind of mutual, internecine rivalry. However, "by the end of the 1950s," the artist said in 1977, "I felt that the automatic aspects of Abstract Expressionist painting of the gestural variety, to which my painting was related, had reached a stage where its forms had become predictable and automatically repetitive. Besides, the exuberance that was a condition of the birth of this painting could not be maintained without pretense forever." From 1963 until 1969, Tworkov served as chairman of the art department at the Yale School of Art and Architecture, where, with the help of such gifted students as Jennifer Bartlett, Richard Serra, and Jonathan Borofsky, he developed a more structured format, but one in which spontaneous, pulsating brushwork might still play a role, "somewhat analogous to the beat in music" (fig. 334). From Bartlett he even learned to use mathematical progressions, striving for "a geometry of area, but not of shape." Now delicate but cable-taut lines would rule off carefully calibrated rectangular and diagonal fields that overlap, unsettle one another, but finally resolve into equilibrium. The result is gridded painting whose plane geometries seem to hover in the air, snowflake-light and noiselessly breathing together like "the beat in music."

When Robert Rauschenberg departed for Rome in 1952, his traveling companion was Cy Twombly (1928—), a fellow student at Black Mountain College and, like Rauschenberg, a veteran of that ur-Happening, John Cage's *Theater Piece #1*. But while Rauschenberg went through the Eternal City's streets scavenging materials for his "Thought Boxes and Personal Fetishes," Twombly trailed along looking at the ancient public walls, transfixed by the strangely poetic effect of their multi-layered signs, symbols, Latin inscriptions, hieroglyphics, and common graffiti. In this stilled Babel of images and information, accumulated throughout millennia, Twombly found a fluidly evocative language that he quickly made his own in an art of unabating freshness and personality (fig. 335). Thus, it seems only natural that, beginning in 1957, he would become an American expatriate in Rome, forever renewed by the Mediterranean world's antiquity, modernity, and the vagaries of a long, intervening history. However, Black Mountain College had prepared him just as it did Rauschenberg, for while the latter studied with Albers, learning to fashion art from all manner of odd discards, Twombly worked with Motherwell and Kline, whose mastery of spontaneous gesture he acquired, only to make it as much an instrument of cultural recall as of immediate, subconscious impulse. Indeed, it has been suggested that Twombly simply replaced the soul-to-hand connection with an intellect-to-hand connection, and then truncated it so drastically that after more than thirty years of practicing automatism, he remains as innocently authentic in his painting as children, primitives, or the extremely sophisticated. Meanwhile, he held to his teachers' black-

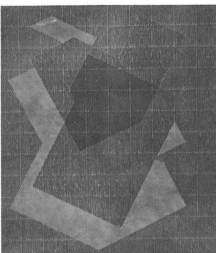

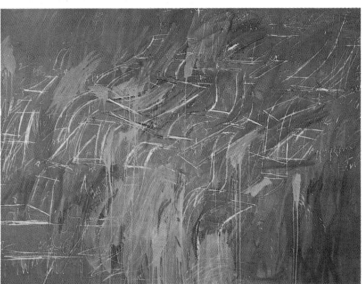

335. Cy Twombly. *Untitled*. 1968. Crayon and oil, 6'6" × 8'7". Whitney Museum of American Art, New York (gift of Mr. and Mrs. R. B. Schulhof).

and-white palette, love of line, and all-over distribution of accent, but then muted or veiled this aesthetic to basic gray. Often the tonality would be realized as a slate-like tablet covered with chalky doodles and smears, but elsewhere as loose, fine-spun webs of lead pencil or colored crayon incised in a plaster-white surface. As titles imply, Twombly could be dreaming of Homer, Herodotus, Sappho, or Ovid, Fragonard or Mallarmé, or all of them together in a time warp of myth, magic, history, and civilization. Sometimes, however, he seemed to dwell on the scrambled roots of logic itself, in paintings where randomness leaves numbers yet incapable of squaring planes that drift through space like messages from some archaic, unheeded sibyl. In an echo of Rauschenberg, Twombly has frequently transformed erasure into a creative act. Reducing the Abstract Expressionists' high-decibel, high-velocity statement to slow, lazy lightness, it yields a trace image at one with the ragged, alternately focusing and dissolving realities of an erudite mind in thrall to memory, free-association, and quicksilver feeling.

Sixties Color-Field or Field Painting

The trailblazer among the sixties' open-form, Color-Field painters was Sam Francis (1923—), the son of a California medical-musical family who took up art as therapy while in a San Francisco VA hospital recovering from spinal injuries suffered during wartime service as a fighter pilot. Almost immediately, it seems, Francis discovered his own highly distinctive pictorial image—a luminous white field spotted with cloudy masses dripping fiery, crepuscular color (fig. 336)—which came as he lay in bed, flat on his back, watching the play of light on the ceiling or across the wide Pacific sky. By the time he was well enough to enroll in fine arts at Berkeley, Francis had already worked ''automatically'' to paint his first pure, gestural abstractions, thanks to the example of Gorky, Still, and Rothko, all of whom had

been in San Francisco either to exhibit or to teach. Within two years, however, he was spilling or spattering liquid color in the loose, open manner pioneered by Pollock and on a gigantic scale rivaling that of the most ambitious New York painters. The breakthrough came in *Opposites*, a 1950 canvas stretched to 8 by 16 feet, white-gessoed, and then stained with corpuscle-like patches of translucent, blood-red medium. This brilliant, bejeweled field became still lighter and more aerated after Francis moved to Paris that summer and discovered the late art of both Matisse and Monet. So completely did Francis align his sensuously lyrical colorism with ''the Watteau-to-Matisse tradition of French hedonism'' that he remained in France, more or less permanently, for the next twelve years, often exhibiting with Riopelle and other members of Informal/Tachist circle. During the early 1950s Francis tended to work monochromatically, in a palette ranging from white on white to red or blue on black, applied in an all-over cellular pattern as if a bed of raspberries or blueberries had been crushed against the canvas and allowed to dribble down the plane. But swamped as the canvas was, it tended to be relatively free of pigment towards the bottom, creating an open, light-filled space that Francis, beginning in 1956, would relocate to the center of his field. Around this sea of soaring white he floated his famous islands or archipelagos of flung, weightless color, ''controlled accidents'' clustered like hanging wisteria and drenched in mauves, scarlets, oranges, greens, and blacks as gem-toned as the Byzantine mosaics the artist had come to

Post-Painterly Abstraction

189

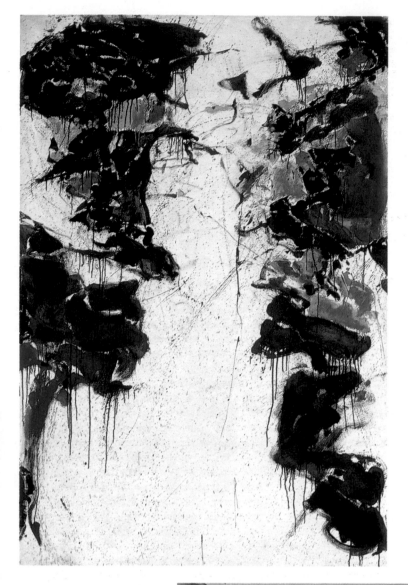

love. In Japan, the Oriental ink painters and calligraphers recognized Francis as one of their own, at the same time that the Western master began to regard his airy, whitened space as a Zen void, physically empty but energized and as limitless as the universe. Still, Monet's Waterlilies remained a prime inspiration, prompting Francis to say he wanted to "make the late Monet pure"—that is, a landscape image cleared of all but its dazzling colors.

It was, however, in the work of Helen Frankenthaler (1928—) that the first major breakaway came for the second-generation New York abstractionists. A native Manhattanite, Frankenthaler had discovered her painting vocation while a "preppie" studying under Mexico's Rufino Tamayo at the Dalton School. The commitment could only grow during her college years at Bennington, which taught a rather academic brand of dark, impastoed Cubism, but encouraged students to spend nonresident semesters working in the real art world of New York City. Thus, following graduation, Frankenthaler very quickly found her way into the Downtown scene, which in 1950 was electric with a sense of exhilarating possibilities, created not only by Abstract Expressionism but also by the critical and gallery support system it had generated. Fundamental to the euphoria were the extreme youth, ambition, optimism, and number of artists like Frankenthaler. No one understood this better than the powerful Clement Greenberg, who soon recognized Frankenthaler as an exceptional talent, introduced her to "everybody," and, most important of all, imparted to his young friend "the ability or the hope of feeling and experiencing painting." "In this," she said, "he was a giant." By 1951, when John Bernard Myers of the Tibor de Nagy Gallery gave Frankenthaler her first New York show, she was painting in a fluent but eclectic manner reflecting a sensitive, personal response to Gorky's linear grace and luminous biomorphism, Miró's lightsome spirit and amoeboid shapes floated in a flat, unreal space, the free, swirling forms of Kandinsky's Improvisations, and Hofmann's or Pollock's all-over, activated canvas. But the great revelation for her would be Pollock, whose climactic art of 1947–50 had so overwhelmed most younger painters that they looked to de Kooning for inspiration. In the eyes of Frankenthaler the Pollock who once again "broke the ice" was the 1951 painter of the problematic black-and-white works, the vast openness and direct staining of

above: 336.
Sam Francis.
Shining Black. 1958.
Oil on canvas,
6'7⅜" × 4'5⅛".
Solomon R. Guggenheim
Museum, New York.

right: 337.
Helen Frankenthaler.
Mountains and Sea. 1952
Oil on canvas,
7'1⅝" × 9'9¼".
Collection the artist, on
extended loan to the
National Gallery of Art,
Washington, D.C.

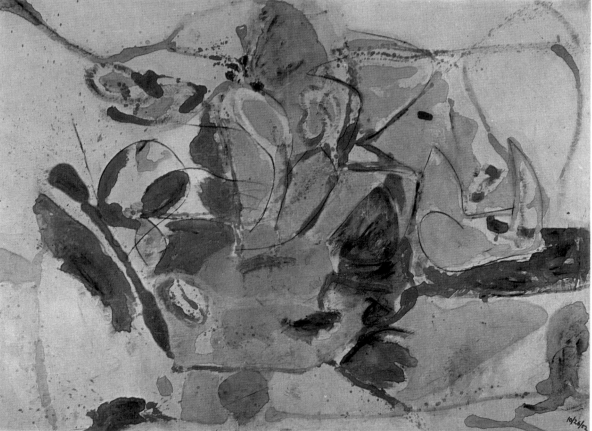

338. Helen Frankenthaler. *Moveable Blue.* 1973. Acrylic on canvas, 5'10" × 20'3". Citizens Fidelity Bank and Trust Company, Louisville, Ky.

which suggested to her a potential that the master himself had only begun to explore (fig. 70). That spring Frankenthaler visited Pollock, felt his dedication and observed how he worked, spreading unprimed canvas over the floor, flinging paint from all four sides, and then encountering the results on the wall, there to control, "edit," or "censor" them by deciding which side should be up, framing the good part, and discarding the rest. In the autumn of the following year Frankenthaler made all this very much her own, but only after a summer of painting watercolors in the cool, blue sea light and wide-rolling hills of Nova Scotia, an environment that made her think of John Marin, with his prismatic watercolor renditions of the northern landscape and his wish "to give paint a chance to show itself entirely as paint." Then came Pollock's *Number 12*, a 1952 work containing many passages as thinly stained as a Rothko. Soon thereafter, with Pollock, Marin, and Nova Scotia on her mind, Frankenthaler tacked a 7-by-10-foot length of unsized, unprimed cotton duck to the floor of her studio and, using oil paint diluted almost to the consistency of watercolor, took one day to execute *Mountains and Sea*, the masterpiece of her early career and a catalytic work for the whole of post-Pollock abstraction (fig. 337). Like Pollock, Frankenthaler let the picture happen quite as much as she made it, with the color guiding her hand and her hand guiding the color. But this was feasible because, as she later said: "I had the landscape in my mind and shoulder and wrist." Frankenthaler also, like Pollock, spilled her liquefied medium, from a hole in the bottom of a coffee can, but in translucent washes whose softly romantic pink, blue, and green colors, simple, swelling shapes, and lyrical relationships reveal the artist to have been no abject imitator of her model's high-tension, linear density. All-overness arose not from a gyring mesh of dribbled filaments but, rather, from the uniform weave of the raw fabric support, which absorbed the watery pigments and made them one with its own continuous texture, thereby leaving color as the sole distinction between figure and ground. Further unifying the field was the inner light radiating from the off-white canvas, a radiance tinted in paint-soaked areas and direct in the generous passages of exposed cloth. Pouring had enabled Pollock to translate line into color and thus drawing into paint, but Frankenthaler took the process a step further with her spreading blots, which she puddled, rubbed, and sometimes brushed until color shapes assumed the fluency and function of gesture, line, or drawing. And so even in stain painting, where the fusion of chroma and canvas yielded an image of uncompromising planarity, Frankenthaler found the means to create an illusion of volume, its "false space" the product of colors that appear atmospheric yet remain physically flat. Pollock had achieved similar effects by the same technique, but only in brief stretches, since for the most part his skeins lie on the surface, rather than in it, and thus give the impression of hovering within a shallow depth free of the ground. In Frankenthaler's painting, the "play of ambiguities" originates not in tactile variations but in purely optical phenomena occurring on an open, expansive field. The artist thought of them as a kind

of "magic," for abstract though the painting may be, its horizon line and billowing forms appear alive with the memory of a summer landscape in hilly, sea-freshened Nova Scotia.

In 1963 Frankenthaler switched from oil to acrylic paints, a change of medium that eliminated the turpentine haloing of her color pools and made them appear all the more disembodied (fig. 338). With this the painting expanded into ever-greater openness, especially in works where an assimilated Cubism re-emerged as painterly emphasis on the rectilinear edges or margins of the field. At the center, however, Frankenthaler deployed a vast, evolving repertoire of effects, ranging from delicate intricacy to baroque, sweeping breadth, from concentrated streaks to diaphanous veils. Essential, always, to the drama of her art is the element of high risk, assumed with great courage in order that the flooding hues may be sufficiently governed by both the accidental and the personal as to seem inevitable.

Helen Frankenthaler also figured large when the next breakthrough came in the strategy of attrition recommended by Greenberg to painters searching for ways to go beyond what had immediately preceded them. Indeed, Morris Louis (1912–62), a Washington, D.C.-based artist some sixteen years her senior, called Frankenthaler "a bridge between Pollock and what was possible," for it was in *Mountains and Sea* that Louis experienced a revelation enabling him, shortly thereafter, to bring "fully autonomous abstract painting," as John Elderfield wrote in 1974, " . . . into its own for really the first time, and . . . in paintings of a quality that matches the level of their innovation." This next link in formalism's chain of ever-more reductive events snapped into place in 1953, when Louis, accompanied by his fellow Washington colorist Kenneth Noland and Clement Greenberg, visited Frankenthaler's studio only months after *Mountains and Sea* had been painted. Almost immediately, it seems, Louis imagined that by staining with even thinner pigments he could make raw canvas absorb color still more uniformly and thus yield a more purely optical or chromatic image referring to nothing but its own physical presence and the process by which this came into being (fig. 339). That is, an even flow of highly diluted medium should so dye the unsized, unprimed duck that the result—a flooded homogeneous plane of diverse colors—would utterly dissolve the Cubist-derived tactile or tonal armature still present in the painting of both Pollock and Frankenthaler, however atomized in the one or enlarged and loosened in the other. Thanks to the transparency of the soaked paint, the automatically generated image, once fully realized, would allow the white canvas to breathe through the hues, thereby declaring its own flatness and opacity even as its fusion with the immaterial color created the illusory effect of an aerated, unimpeded spaciousness. As a consequence, the painting would appear to open or expand still further the field-like organization achieved by Mark Rothko, Barnett Newman, and Clyfford Still. Not coincidentally, this vision also encompassed a new retinal beauty of Matissean hedonism and opulence, but pure, luminous, fluid, and incorporeal as never before.

left: 339. Morris Louis.
Saraband. 1959.
Acrylic on canvas, 8'5⅛" × 12'5".
Solomon R. Guggenheim Museum,
New York.

below: 340. Morris Louis.
Horizontal III. 1962.
Acrylic on canvas, 2'3½" × 8'8½".
Courtesy André Emmerich Gallery,
New York.

opposite: 341.
Kenneth Noland. *Whirl.* 1960.
Magna on canvas, 6'10¾" × 6'9½".
Des Moines Art Center
(Coffin Fine Arts Trust Fund, 1974).

Chronologically, Louis belonged to Pollock's own generation, and in fact he had intersected with, but evidently failed to meet, Pollock in New York during the late 1930s while experimenting with Duco enamel in Siqueiros' studio and participating in the WPA art project. In 1940, however, the shy, retiring Louis returned to his native Baltimore. There and later in Washington, where he began teaching in 1952, Louis practiced a painterly variety of late Cubism until the more gregarious and New York-oriented Noland arranged for the two of them to be taken by Greenberg to their now-legendary rendezvous with Frankenthaler. What prepared Louis, in part, to see even beyond *Mountains and Sea* was his experience with Magna, a new oil-like synthetic medium that he had been using since 1948. Not only could Magna be thinned to the transparent consistency of watercolor; it was also quick-drying, which meant that, within a single painting session, colors could be layered into the fabric of the canvas without muddying it or concealing the woven surface. The Magna factor was crucial because, as A.J. Carmean wrote in 1976:

Many examples of 20th-century art reveal a new expressive ability or a new direction based on the use of a novel technique or material. We can cite pasted newspaper in Braque and Picasso collages, painted paper in a Matisse découpage, the painterly poured line of Pollock's classic abstractions, or David Smith's welded stainless steel. For Morris Louis the staining technique was such a breakthrough.

However, for his vision of a totally optical color space to be attained, Louis had also to devise ways of staining that would not involve either brush or gesture, with the implications of personal touch and tactility

they left in both Frankenthaler's art and Action Painting. For the first series in which he truly succeeded, the Veils of 1954 and 1958–59, Louis loosely tacked canvas to a vertical scaffolding and then poured medium down the surface, allowing gravity, controlled by his own tilting actions, to direct the color streams into graceful, fan-like patterns of pale, subtly blended striations (fig. 339). Even more exhaling and diaphanous were the Florals of 1959–60, spilled from all four sides of the support towards the center but, in a visual-kinetic effect, flowing outward like gauzy blossoms or butterflies adrift in a slow-motion atmosphere (fig. 322). Simpler and less overlapped, the Florals are also brighter as well as more transparent than the Veils, thus more expansive. In these works Louis combined, but carried further, Pollock's interlaced, centralized, all-over image and Frankenthaler's airy zones of impasto-free painterliness. In a famous analysis of Louis' art Greenberg wrote:

Abandoning [his prior Cubism] . . . [Louis] began to feel, think, and conceive almost exclusively in terms of open color. The revelation he received became an Impressionist revelation. . . . His revulsion against Cubism was a revulsion against the sculptural. Cubism meant shapes, and shapes meant armatures of light and dark. Color meant areas and zones, and the interpenetration of these, which could be achieved better by variations of hue than by variations of value. . . . The crucial revelation he got from Pollock and Frankenthaler had to do with facture as much as anything else. The more closely color could be identified with its ground, the freer would it be from the interference of tactile associations; . . . Louis . . . [leaves] the pigment almost everywhere thin enough, no matter how many different veils of it are superimposed, for the eye to sense the threadedness and wovenness of the fabric underneath. But

"underneath" is the wrong word. The fabric, being soaked in paint rather than merely covered by it, becomes paint in itself, color in itself. . . . [Moreover] Louis usually contrives to leave certain areas of the canvas bare. . . . It is a gray-white or white-gray bareness that functions as a color in its own right and on a parity with other colors; by this parity the other colors are leveled down as it were, to become identified with the raw cotton surface as much as the bareness is. The effect conveys a sense not only of color as somehow disembodied, and therefore more purely optical, but also of color as a thing that opens and expands the picture plane.

But not only did Louis return to the Cubists' source in Impressionism, with its conception of the surface as a sheet of varicolored and molecularized atmosphere; he also subsumed the color-soaked painting of Matisse, especially his mural-scaled works that translated Renaissance fresco, itself a soak-stain art, into the language of modernism. As Elderfield has pointed out, paintings like the Floral seen here combine the lyrical intimacy of Impressionism and Matisse with the public, architectural grandeur of classic fresco. Resplendently gorgeous, the Veils and Florals offer immense sensual pleasure, but by virtue of their capacity to appear liberated from base matter, they also become metaphors for spiritual release. "The questions we always discussed," Noland remembers about his conversations with Louis, "was what to make art about. We didn't want anything symbolic like say, Gottlieb, or geometric in the old sense of Albers. The Abstract Expressionists painted the appearance or symbol of action, the depiction of gesture. We wanted the appearance to be the result of the process of making it—not necessarily to look like gesture, but to be the result of real handling." In their overlapped clarity and cool, arabesque expansiveness, the Veils and Florals depict nothing but how they were made, and thus become a self-reflexive art. Yet when the story told by the sumptuous image is one of techniques and materials transcending their limitations, the painting emerges as an abstraction of the world outside, a world of layered but coherent continuities and forever evolving. If the Veils and Florals, like their precedents in the high-color luminism of both Gothic stained glass and Venetian painting, suggest plenitude through the very means that make them seem incorporeal, they also echo Western humanity's age-old dream of revisualizing the world as an Edenic paradise.

In his final two series, the Unfurleds (1960–61) and the Stripes (1961–62), Louis continued to synthesize intimacy and monumentality (fig. 340). Now, however, he attained a radical, almost Minimalist simplicity evincing, perhaps, a heightened awareness of Matisse's late cut-out murals as well as Barnett Newman's heroically severe Color-Field painting. For the Stripes, his technique was to bundle long bars of saturate colors so closely harmonized that their dazzle endows crisply planar forms with an aura of almost Titianesque painterliness—then add jump to their energy by including one, two, or more stripes strongly contrasted in either hue or value. Owing to the smaller format adopted for the long, narrow Stripes, the weave of their support appears more visible in the staining, just as the asymmetrical placement of the color fasces bestows upon the ground a more dynamic presence. But this only makes it appear all the more susceptible to interaction with the pent-up power of the compressed, radium-hot bands, leaving the entire field to assume the character of a high-velocity beam of brilliant light. Because of the unprecedented absoluteness of such opticality, Louis is often thought to have produced the first truly abstract or autonomous pictures. Not even Kandinsky, Malevich, Mondrian, Pollock, or Newman accepted all the implications of abstract art so completely as did Louis, since for each of those painters it always seems possible to discover some *a priori* subject or idea necessary to an understanding of the work's structure. Louis, on the other hand, made art by relying almost exclusively on the logic of his means—free of imagery, established ideology or preconceived style, personal "handwriting" and its light-dark or surface variations—all the while that he also succeeded in painting pictures of ravishing loveliness and superlative quality. But such art, Elderfield has written, "comprises not so much a temptation of the senses as a deliverance

through the senses, which is to say no more and no less than that is the condition toward which the best in modern painting has aspired."

For the lucidity and directness with which he was able to structure color in the Stripe paintings, Louis was somewhat indebted to his younger associate Kenneth Noland (1924—), a Washington, D.C., colorist who, even though much involved with the New York vanguard, arrived at his boldest "solutions" after Louis' death in 1962. But as this terminology would imply, Noland all but ushered in sixties abstraction by taking as his very subject matter modernism's self-critical tendency to concentrate on the disadvantages of any style until the "problem" has been solved, which then offers new possibilities to explore until *their* limitations require yet different remedies yielding another set of breakthrough opportunities (figs. 341–343). Fortunately, Noland not only conceived of painting as an open-ended series of linked problems and solutions, all of them determined by the painting process itself; he also brought to his enterprise a fabulous, profoundly intuitive gift for color, an intelligent, freely innovative approach to its use, and a conviction that abstract painting, by its progressive elimination of old complexities, delivers new kinds of revelation never before available in pictorial experience. However, much of his problem-solving had to do with structure, for if an open, all-over field design could be made so elementary—so flat and completely identified with the painting surface—as to become self-canceling, the artist would, as he said, enjoy "more freedom to exercise the arbitrariness of color." Thus suspended in tension between chromatic splendor and a layout of drumhead tautness, the pictures evince a sheer, ungraspable opticality that simultaneously, as if by magic, asserts a vibrant abstract presence.

Like so many others who made the arts what they were in the 1960s, Noland grew up artistically at Black Mountain College, less than 15 miles from his hometown, Asheville, North Carolina. Beginning in the fall of 1946, he studied primarily under Ilya Bolotowsky, an American Neoplasticist whose relatively liberal, tolerant attitudes seemed preferable to Albers' "scientism" and "jeering manner." Still, no one at Black Mountain could entirely escape the influence of Albers, not even, as we have seen, Robert Rauschenberg, a far more rebellious student who first appeared in North Carolina shortly after Noland had left. And so, however indirectly absorbed, Albers' ideas and practice would be amply confirmed by the mature Noland, in his planar colorism and hard-edged, symmetrical designs, as well as in

his serial, problem-solving, and process-involved way of making art. Bolotowsky, if a less inventive colorist than Albers, was certainly more experimental in matters of structure, thanks to his derivation from Mondrian, and this would prove enormously liberating for Noland. However, the precursors who moved him most profoundly were Paul Klee and Henri Matisse, the latter encountered mainly in Paris, where Noland spent an otherwise unsatisfactory year studying under the rather old-fashioned sculptor Ossip Zadkine.

In his most evolved work, Noland would fuse the two modernist traditions that had engaged him first in North Carolina and then in Paris—the puritanically ideal, geometric painting of Mondrian, Albers, and Bolotowsky and the voluptuous, painterly art of Klee and Matisse. However, this did not occur until after he had commenced teaching in Washington, while spending summers back at Black Mountain College, where he met numerous members of the New York avant-garde, none of whom would make a greater difference than Clement Greenberg and Helen Frankenthaler. Equally important was the relationship Noland began in 1952 with Morris Louis, an older fellow teacher in Washington and an artist as passionately interested in Jackson Pollock as Greenberg had now caused Noland to become. From Louis, Noland learned to paint with Magna, instead of oil, but only after April 1953, when the two artists had their epiphanic encounter with Frankenthaler's *Mountains and Sea*, did either of them abandon heavy-handed gesturalism in favor of the stained, translucent colors that would become the means of their historic, respective breakthroughs. By 1958, when Louis was painting his most important Veils, Noland too had arrived, in a series of Targets whose concentric geometry, brightly saturate, juxtaposed colors, clean-edged interiors, softly gestural perimeters, and exposed canvas support suggested Albers and Bolotowsky transformed by long, concentrated looking at Klee, Matisse, and Pollock (fig. 341). Of all these influences, the last, finally, proved decisive, for it was by working on canvas spread over the floor, where he could approach it from every side, just as the great Abstract Expressionist had done, that Noland discovered his own unconscious impulse towards centrality, symmetry, and their expression in nested, repeating circles. Then too by staining pure, utterly flat color directly into raw duck, in a radical variant of the aerated colorism that Frankenthaler had developed from Pollock's late black-and-white paintings, Noland made the ground's continuous weave an essential reification of the unifying, Pollock-like all-overness already asserted in the centrifugal rings of color. Energized by the light reflected from this virgin surface and through them, as well as by their own purity and dramatically contrasted relationships, the Fauve-like hues seem to pulsate and expand from the center, opening the picture outwards and even overcoming its square shape as a delimiting container. Simultaneously, however, the dead-centeredness of the image anchors its buoyancy to the square support, thus reinforcing the paradoxical effect of radiant, volatile, translucent colors fused with the fixity of a tautly stretched, even-textured fabric. Similarly, while hard-edged and planar geometry lends crispness to the disembodied effect of soaked colors, the staining invests geometry with a kind of lyrical, poetic softness. The mutually enhancing complementarity of this relationship proves especially vital wherever Noland finished the outer ring with an Action-style flourish. One such painting inspired a viewer to say: "It draws you into the center like a target and then throws you out to the edge like a pinwheel."

As we saw in the case of Johns a few years earlier (fig. 229), targets offered a design so simple, familiar, yet anonymous that it gave the artist "room to work on other levels." For Noland this meant "more freedom to exercise the arbitrariness of color," granted by an eminently logical solution to the problem of the need for a "self-canceling" structure. It came, however, not as a ready-made—what Johns would call something "the mind already knows"—but rather as a consequence of the artist's working process, which, beginning in 1962, Noland would carry out first in New York and finally in Vermont. And since the working process was self-critical as well as em-

pirical or innovative in nature, it soon revealed the problem within the solution, which consisted of the empty corners left by a circular shape placed within a square format. For the sake of the greater abstract presence that would come with a more complete identification of image and support, Noland could either change the shape of the canvas—that is, adopt a tondo format—or alter the motif itself. After attempting the former with only intermittent success, he eventually broke into his Chevrons (fig. 342), whose image—with its variably acute angle and straight rather than circular bands—allowed emphasis to be shifted from the center point to the central axis and the format from square to tall or even horizontal. This yielded greater flexibility, at the same time that it also tied the abstract image more thoroughly to the shape of the concrete support—even making their edges and corners coincident at the top of the frame.

Once the asymmetrical Chevrons seemed to reinsinuate the old gap between figure and ground, Noland moved on, finally, in 1965, arriving at the Horizontal Stripe paintings, for many viewers the most

perfect of all his solutions (fig. 343). Here, as the artist himself said, was "the payoff . . . no graphics, no systems, no modules, no shaped canvases. Above all, no *thingness*, no *objectness*. The thing is to get that color down to the thinnest conceivable surface, a surface sliced into the air as if by a razor. It's all color and surface, that's all." Indeed, by eliminating both curves and angles in favor of a single tiered bank of parallel bands, Noland made stained color the determinant of format, both its size and its shape, with the result that color, structure, and surface locked together with exquisite completeness and logic. In the Horizontal Stripes, the literalness of the canvas support joined with the utter abstractness of the color-structure to endow painting with a new and highly unified, vivid immediacy. Having reduced tension between interior and exterior, Noland was now free to use more colors in more inventive combinations and proportions, always with the purpose of making soaked, translucent pigments the life-giving variable in the static world of flat painting. In the dialectic of strict but simple structure and the immense freedom it allowed color, Noland discovered an almost infinite range of creative posssibilities. Here, as almost everywhere else in his art, aesthetic invention went hand in glove with technical innovation, which for the Horizontal Stripe series entailed painting over and then stripping away tape as a means of tightening, or even brightening, the overall image with sharply precise edges. This meant that medium could be rolled on by an assistant,

leaving the artist free to conceptualize his color schemes and their respective moods with still greater feeling or imagination than ever before.

In the Stripe paintings, with their lateral sweep and their ventilating, interstitial ribbons of reserve canvas, the artist's critical thought produced a nonhierarchical structure whose vertical rise of banded colors and repeated horizontality finally coalesce in the eye as an open, expanding whole, a whole that possesses the entire surface, rendering it continuously assertive. Noland sometimes thought of this ambiguous, holistic space—a palpable plane inhabited by crisply edged but elusive, airy color—as an abstract landscape, a pictorial world that translated Pollock's linear, indivisible mesh into the language of pure color. Because of the sheer opticality of its nonrelational structure—an all-over, focus-free image realized entirely with color, free of the real or implied tactility of Pollock's chiaroscuro gesturalism—the serial painting created by Noland must be seen as abstract to a degree beyond anything available in his distinguished models—Mondrian, Albers, Bolotowsky, Klee, Matisse, or even Pollock. It is also more abstract by virtue of its lack of *a prioris* in either myth or nature. But what Noland's work shares with all great painting is a sense of compelling presence and the inducement this offers to experience a picture in entirely new ways.

Of all the sixties Color-Field painters, the most hedonistically sensual in his aesthetics was Jules Olitski (1922—), in part because, unlike Noland for instance, he was deeply cultivated in traditional easel painting and felt compelled to preserve something of its painterly, structural drama. And this was true even as he wholeheartedly embraced post-Pollock abstraction, complete with emphasis on process, flatness, large-scale openness and all-overness, optical color, the support and its shape (fig. 344). Although born in Russia, Olitski grew up in Brooklyn and began his art studies at the borough's Pratt Institute, before transferring to the National Academy of Design, where he learned all the Old Master techniques—scumbling, glazes, impasto—that would contribute so much to his fully seasoned formalist painting. Moreover, they remained with him when, aided by the GI Bill, he went to Paris in 1948 and, a year earlier than Noland, studied sculpture with Ossip Zadkine. In an attempt to find a way out of his own Rembrandtesque painting, Olitski developed a highly original variety of Surrealist automatism and produced a series of ''blindfold paintings,'' which, because executed in the dark, made the whole creative enterprise dependent upon medium and surface. What resulted were heavily textured pictures that, not unsurprisingly, had affinities with the *matière* abstractions of Fautrier, de Staël, and Dubuffet. They constituted the core of the artist's first solo exhibition, held in 1950 at

opposite: 342.
Kenneth Noland. *Every Third.* 1963.
Magna on canvas, 6' square.
Collection Alaister McAlpine,
London. Courtesy the artist.

above: 343.
Kenneth Noland. *Via Mojave.* 1968.
Magna on canvas, 3'9½" × 10'2".
Collection the artist.

right: 344.
Jules Olitski. *Green Goes Around.*
1967. Acrylic on canvas,
5'1½" × 7'5½".
Private collection, New York.

left: 345. Gillian Ayres. *Lure.* 1963.
Oil on canvas, 5' square. Arts Council of Great Britain, London.

above: 346. John Hoyland. *17.7.69.* 1969.
Acrylic on canvas, 6'6" × 12'. Courtesy Waddington Galleries, London.

Paris' Galerie Huit. Back in New York in 1951, Olitski continued to experiment, and by 1961, he had caught up with American painting at its most advanced, mainly through his adoption of the stain technique applied to bare, oversize canvas. At first, he employed brilliant, strongly contrasted colors to form rather loose, languid versions of the target shapes that both Johns and Noland had found so liberating. In order to obtain a more homogeneous, all-over color image, while also preserving a sense of the density, chromatic variation, and asymmetry offered by these pictures, as well as by their more traditional predecessors, Olitski modified his stain technique and used a spray gun to apply thinned, water-based synthetic pigments. Because spraying permitted color to be broken up and scattered as tiny, molecular drops, Olitski could now merge or modulate one hue into another without drowning their purity in the sort of dusky veil that results from staining hue into hue. In addition, he could vary the thickness of the layered pigments and yet not seriously disrupt the softly continuous spread of medium across the picture plane. Now, the surface's unifying principle was once again paint, as it had been in Abstract Expressionism, rather than the weave of the fabric support preferred by Louis and Noland, but paint so lightened or etherealized that Olitski thought of his new pictures as color sprayed into the atmosphere and then stabilized to remain there suspended. At the same time, he also wanted to acknowledge the shape and flatness of the field, albeit a field that seems to open and expand as if suffused with inner light. And so along one edge or another, sometimes at a corner, Olitski began adding a few broad, buttery strokes of rich pigment, Fauve-like flares of hue and value whose pungent contrast with the sprayed evanescence not only declares the self-contained, rectilinear two-dimensionality of the pictorial space; they also energize its languorous, Impressionist opticality with a touch of Baroque tactility and dramatic imbalance. As Kenworth Moffett has observed, Olitski seemed to fuse Rothko's abstract colorism with the gestural abstraction of Pollock and de Kooning, finally producing what many have regarded as a nonobjective reinterpretation of Monet's late Waterlilies. Meanwhile, the artist also realized his objective of recovering for autonomous Color-Field Painting something of the plastic fullness—the *belle peinture* sensuousness—of older art, but with an unapologetic beauty rarely equaled in any period. Breathtakingly decorative, Olitski's immense pictures seem to dissolve the prosaic tautness of stretched canvas into a cloudy, fugitive romance of melting lavenders, apricots, nocturnal blues, and pistachio greens.

In the wake of the widely circulated "New American Painting" show in 1958–59, as well as of the particularly strong representation of recent American art at the 1959 Documenta in Kassel, large-scale Field Painting became very much an international style. Not only did the example of Pollock, Rothko, Still, Newman, and Kelly, Francis, Frankenthaler, Hartigan, and Rauschenberg help solidify aesthetic positions already taken in Britain by such artists as Patrick Heron and Richard Smith; it also lent crucial support to younger English painters prepared to exceed even the St. Ives abstractionists in their disavowal of all subject matter or content save that generated by process itself. The Londoner Gillian Ayres (1930—), for instance, had rejected the "Euston Road" Realism of her teachers at the Camberwell School of Art and, after meeting Roger Hilton (fig. 123), had developed a vividly personal variant of the free Informalist manner. Further contributing to her search for painterly autonomy was the example of Jackson Pollock, whose technique of pouring liquid medium onto canvas spread over the floor encouraged Ayres to give up brushes and to become more physical in her engagement with the canvas. Then, following her encounter with the "newer" American painting, she adopted acrylic and began staining it, as well as oil, into canvas often stretched to no less than 6 feet square (fig. 345). Symptomatic of her imagery in this rapidly maturing phase were veils of gem-toned color floated across a neutral field like "blimps" hovering in thin air. Still, however pure and transparent the hues, they seem never to become so disembodied as in the painting of Frankenthaler, Louis, and Noland, but rather to evince themselves as physical substances actively modeled by an artist possessed of an unshakable faith in the instinctive gesture or in painting as a creative act.

The occasion that brought Gillian Ayres and the more radical among British abstract painters to prominence was the Situation show held in 1960 at London's RBA Galleries. Organized by the participating artists themselves, the exhibition also offered a catalogue in which Roger Coleman explained that, to qualify for inclusion, "the works should be abstract (that is without explicit reference to events outside the painting—landscape, boats, figures—hence the absence of the St. Ives painters, for instance) and not less than 30 square feet." Enhanced scale, the author stressed, came as a logical and necessary result of artists' acceptance of the literal flatness of the painting surface, which seemed quite naturally to spread both vertically and horizontally as illusionistic depth was ironed out. Not only would a flat image respect the reality of the opaque, two-dimensional canvas, but, in addition, its greater size would engross the viewer more truly than the old make-believe window onto deep or shallow space. Without becoming an actual mural, the big abstract painting promised to become a kind of "environmental" experience, filling the observer's field of

vision to the point "where in some cases a turn of the head of several degrees right or left is needed before it can be fully incorporated into his experience."

Joining Ayres in the Situation group was John Hoyland (1934—), who had found himself responding more creatively to Rothko than to Pollock. Then, with an expressive range characteristic of his entire career, Hoyland would also discover affinities not only with Louis and Noland but with Hans Hofmann as well, suggesting a conflict of interest that the English painter quite elegantly subdued in the work seen here (fig. 346). Against a dark, softly streaked ground reminiscent of Louis' cascading stains, Hoyland hung a trio of color planes, rectangular sheets of dense pigment as flat-seeming as those of Noland but stroked on with a powerful, surface-smacking emphasis worthy of Hofmann. But rather than push or pull against the plane, they appear to tilt slowly back and forth before resolving there as in Analytic Cubism, or indeed in Hofmann. At the same time, moreover, that advancing, saturated fields and stained illusory depth threaten to pull apart, passages of color from each invade or intrude upon the other, thus binding them together as a complex, albeit harmonious and subtly integrated, whole.

It would be difficult to imagine a painter more single-mindedly, or more poetically, obsessed with field-like color than West Germany's Gotthard Graubner (1930—). Born in Erlbach, Vogtland (now East Germany), trained in Berlin, Dresden, and Düsseldorf, and long active as both teacher and artist in Hamburg and Düsseldorf alike, Graubner first expressed his passion for color in geometric forms. By 1957, however, he had begun using pads as well as brushes to spread pigments in the all-over manner of the New York School, but going further than Rothko in his elimination of shapes, even while developing his own variant of the American's way of layering thin, vibrant films of contrasting or complementary hue from edge to edge (fig. 347). Thus, viewing a mature Graubner is rather like looking into a room filled with colored fog, a romantically spatial effect produced by light suffused through countless dissolving tissues of translucent pigment so nuanced as to create the illusion of slow, atmospheric movement. To intensify the sense of tinted, cloudy depth, Graubner would soon elaborate his technique by painting on absorbent foam rubber mounted on canvas and then covering the "pillow" surface with a stretched sheet of clear Perlon fabric. To ensure that the literal volume

left: 347.
Gotthard Graubner.
*Blue-Rose
Color-Space
(Farbraum blau-rosa).*
1961–62. Mixed
media on canvas,
5'3" × 4'3¼".
Kunstmuseum,
Düsseldorf.

right: 348.
Jack Bush.
Tall Spread. 1966.
Acrylic polymer on
canvas, 8'10¾" × 4'2".
National Gallery
of Canada, Ottawa.

of color will optically interact with—*breathe* in—the surrounding environment, Graubner has been known to create a painting on the floor at the very site of its intended display. As a result, the viewer, like the painter in his creative act, may find himself, as Graubner once wrote, "exalted to a process of meditation."

The late-blooming Jack Bush (1909–77), English Canada's most distinguished modernist, had been a professional artist for more than thirty years, passing through Realist, Cubist, Expressionist, and even Abstract Expressionist phases, when in the early 1960s he won international acclaim for Field paintings strong and independent enough to hold their own in the company of such like-minded artists as Noland and Olitski (fig. 348). Following a suggestion from Clement Greenberg, Bush made his all-important breakthrough by cultivating the stripped-down aesthetic he had already achieved through watercolor. In the famous Sash and Fringe paintings, this became a matter of full, direct color often applied as a flat, stained ground playing host to clean-edged but broadly brushed stacks of multicolored bands. Jaunty yet controlled, bold without being brash, Bush's painting proclaims nothing so much as the joy of personal, artistic fulfillment in radiant chromatics and fresh, inventive shapes.

The West Coast painter Richard Diebenkorn (1922—) experienced his first moment of artistic truth when he came upon a color reproduction of Edward Hopper's *House by the Railroad*, and something of that work's clarity and spareness—its symmetry and logic used as a vehicle for understated emotion—seems to have informed the whole of the Diebenkorn oeuvre, even as it evolved through three distinct phases. But in his search for what he once called "a feeling of strength in reserve: tension beneath calm," Diebenkorn has paid homage to a number of other masters, betraying an unerring sense of quality and a quiet determination to remain as independent as the artistic giants he admired. Thus, however great his love for Cézanne, Ma-

Post-Painterly Abstraction

tisse, and Picasso, Bonnard and Vuillard, de Kooning, Motherwell, Gottlieb, Still, and Rothko, Diebenkorn succeeded in compounding their diverse influences into a form and content uniquely his own, an aesthetic that had less to do with sudden, subconscious impulse than with what, years later, he would characterize as "a problem-solving thing." Thus, in 1956, after ten years of painting in an abstract mode acclaimed for its sumptuous, blond-hued, firmly structured gesturalism—a blend of California cool and School of Paris deliberation—Diebenkorn broke his sojourn in New York, settled in Berkeley, and shocked the East Coast avant-garde by exhibiting a group of new figurative works (fig. 349). In Abstract Expressionism, "it was almost," he later said, "as though I could do too much too early. There was nothing hard to come up against. And suddenly the figure paintings furnished a lot of that." In 1966, however, Diebenkorn once again transcended the recent past when he moved to Los Angeles and took over Sam Francis' studio in the Ocean Park district of Santa Monica. Immersed in sunlight filtered through sea foam and salt air, he launched upon his third and ongoing phase, devoted to large-scale paintings still more nonallusive than his Abstract Expressionist ones, but pungent with a sense of specific place and so fertile that the Ocean

Park works now number well over 150 (fig. 350). Reconciling the taut and the diffuse, the perceived and the felt, an outer framework of geometry and an inner realm of moist, diaphanous color, Diebenkorn endows his Ocean Park pictures with the complex reality of his own experience, a lifetime of alert, sensory responses to art and nature, of problem-solving ruminations on how to translate these into a richly cultivated but fresh and uniquely personal statement. With the grand, classical equipoise of the Ocean Park series, Diebenkorn continues in his own serene, analytical manner the heroic balance between gestural and field painting, passion and intellect, intimacy and alienation originally struck by more emotionally driven artists, the mixed-style Abstract Expressionists.

Hard-Edge Painting

The so-called "father" of Hard-Edge Painting was Ellsworth Kelly (1923—), who however denied his alleged paternity by insisting: "I am not interested in outlines but in masses and color." "The outline," he continued, "serves me only to give quietness to the image" (figs. 323, 352). For "quietness," one might very well substitute the word "elegance," because while no artist in New York during the sixties painted more ruthlessly distilled pictures than Kelly, the works also evince a sensuousness along with their toughness that betrays the six postwar years the artist spent in Paris, absorbing these very qualities from such exemplary modernists as Brancusi, Arp, Mondrian, and Matisse. As this would suggest, Kelly, unlike most of his Hard-Edge brethren, never cut his art entirely free from the phenomenal world, even though the bit of reality he took as the subject of a painting may itself have been so abstract or abstracted as to prove virtually unidentifiable except by the artist himself. But however great the Parisian factor, the New York-born Kelly had early developed an eye for nature's shapes and colors while bird-watching in New Jersey and studying the works of John James Audubon. That eye developed unusual acuity during World War II, when, following a brief period of study at Brooklyn's Pratt Institute, Kelly found himself drafted into a US Army camouflage unit. There he learned and then practiced, all along the French and Luxembourg fronts, the art of constructing and deconstructing the visible, its shadows as well as its forms. Meanwhile, the glimpse he had of modern art's historic capital lured him back to Paris in 1948, after two years at the Boston Museum of Fine Arts School left him dissatisfied with the Expressionism taught there by the German artist Karl Zerbe. With the GI Bill as a source of funds, Kelly enrolled at the École des Beaux-Arts, but, in common with most American artists in Paris at the time, he ended by working on his own in one cheap hotel room after another. However, if the instruction or the new Informalism/Tachism proved unrewarding, the artistic culture of France held Kelly spellbound. In the Byzantine Institute he pored over Russian and Greek icons and illuminations, savoring the strong, supple contouring and brilliant, flat colors. As for their conceptualized forms rendered as shapes tightly fitted into other shapes, he sighted them again in the mandorla reliefs and pendentive paintings still preserved in the great Romanesque churches along the southwestern Pilgrimage Route. Another important focal point was Matthias Grünewald's polyptychal *Isenheim Altarpiece* in Colmar, a great unified work of many parts, each of which is as mysterious yet revealing as the whole. In Paris itself Kelly began creating a bank of notebook sketches devoted to such fascinating details or patterns as shadows and stains, shifts in color from one material to another, deepset windows and their shadows, openings in walls, chimneys scaling the exposed sides of buildings, light reflections on the Seine and the catenary arches of the bridges over it. Soon Kelly would abandon everything he had brought from Boston—the human figure as subject, expressionist brushwork, a "camouflage" palette of brown and green—and recommence by drawing on or monumentalizing the reserves of abstract observation deposited in his notebooks. But what triggered this departure was the discovery he made in 1949 of such

left: 349.
Richard Diebenkorn.
Woman in the Window.
1957. Oil on canvas,
4'11" × 4'8".
Albright-Knox Art
Gallery, Buffalo (gift of
Seymour H. Knox).

below: 350.
Richard Diebenkorn.
Ocean Park No. 66.
1973. Oil on canvas,
7'11" × 6'11".
Albright-Knox Art
Gallery, Buffalo (gift of
Seymour H. Knox).

above right: 351.
Ellsworth Kelly. *Meschers*. 1951.
Oil on canvas, 4'11"
square. Collection the artist.

above left: 352.
Ellsworth Kelly. *Red Blue Green*.
1962. Oil on canvas,
7'11" × 11'4". La Jolla Museum
of Contemporary Art. (gift of
Dr. and Mrs. Jack Farris).

right: 353.
Ellsworth Kelly.
Untitled (SF4) Aug 57. 1957.
Graphite on paper, 23¼ × 17".
Courtesy BlumHelman
Gallery, New York.

Surrealist techniques as chance and psychic automatism, which came to him not from a French source but from a Boston friend who arrived in Paris after having learned of developments among the yet-to-be-named Abstract Expressionists in New York. At the same time that automatic drawing helped Kelly achieve still greater freedom in his already brilliant draftsmanship, the "laws of chance" encouraged him to trust the telling detail and to exploit it as a means of making connections between the world of reality and the world of abstract art. Thus, in his notebooks he discovered that what his eye had consistently "chanced" upon was pure shape and the tension between a single, simple shape within or in some contiguous relationshp with another shape of equal but different singularity and simplicity. Symptomatic of his Mondrian-like seriousness and probity, Kelly at first worked solely in white and black as he concentrated upon, enlarged, and continually refined shapes until they constituted the whole of his subject, form, and content. Gradually, however, the logic of spectral extremes called for intense color, which returned in paintings like the cerulean and ultramarine *Meschers*, a scrambled view of the Gironde River fleetingly observed through the screen of a pine forest (fig. 351). Created from a color sketch that was cut into squares and then rearranged by chance into a grid of undecipherable but immensely decorative relationships, the painting itself could very well be seen as a full-scale model for a stained-glass window at Matisse's chapel in Vence. While evoking the excerpted reality that inspired it, *Meschers* describes scarcely anything recognizable, but instead asserts its independence as abstract painting.

In the grid assembly of paintings like *Meschers*, Kelly came as close as he ever would to the Constructivism with which his pristine yet decidedly undoctrinaire art has often been compared. And while *Meschers* and related works won Kelly his first solo exhibition, at the Galerie Arnaud, representation in group shows at the important Galerie Maeght, also in Paris, and major collectors, it was not until he had arrived in New York in 1954 that his art would consolidate into the large scale, controlled tension, banner-like brilliance, and simplicity of his best-known works (fig. 352). While living at Coenties Slip, in the same ancient riverfront complex inhabited by Rosenquist, Indiana, Agnes Martin, and Jack Youngerman, Kelly became intrigued not only by the shape of a window in his studio but also by the shape of its distorted reflection in a window across the street. One result was *Red Blue Green* seen here, which came after a prolonged period of work during which the artist honed and rethought his opportune motifs until their red rectangular and blue ovoid shapes were in such perfect equilibrium, with one another as well as with the eccentric shape

of the intervening green field, that all seem to lie on the same plane. While the suave contouring locks the tripartite image together as a continuous surface, the carefully adjusted color intensities keep the several "masses" from separating illusionistically into foreground, midground, and background. It also helps that the shaped primaries are visually laminated to the same uniform ground by the coincidence of their outer edges with those of the support itself. Thus, blue and green overcome inherent recessiveness to achieve the same degree of blazing presence as the red, even as their cooler associations contribute, like the chaste "outlines," towards the overall "quietness" of a work actually fraught with inner tension. But what also endows such immaculate art with richness and complexity is the content of feeling derived from the extended, deeply intuitive process through which the artist essentialized an obscure but literal fragment of reality into a grandiose pictorial abstraction. A carefully balanced combination of the utmost calculation and the unexpected, *Red Blue Green* would seem to have brought to some absolute state the potential for pure color painting foreseen, more than a half-century earlier, by Matisse in such Fauve paintings as *Dance* and *The Red Studio*. And like Matisse, Kelly might well say: "A rapid rendering of a landscape represents only one moment of its appearance. I prefer, by insisting on its essentials, to discover its more enduring character and content, even at the risk of sacrificing some of its pleasing qualities."

As the sixties unfolded, Kelly increasingly satisfied his need for the "pleasing qualities" of nature in an ongoing series of line drawings devoted to plants, works whose naturalism is as purified in its own way as the virtually autonomous paintings (fig. 353). The drawings, in turn, seem to have freed the artist to paint still more abstractly than before, until certain works bear a superficial resemblance to the

above: 354. Ellsworth Kelly. *Blue Green Yellow Orange Red.* 1966. Acrylic on canvas; each panel 5 x 4'. Solomon R. Guggenheim Museum, New York.

right: 355. Jack Youngerman. *July White.* 1966.
Acrylic on canvas, 9'1" x 6'7". Corcoran Gallery of Art, Washington, D.C.
(gift of the Friends of the Corcoran Gallery of Art,
and the friends of the late Fleming Bomar in Memory of Fleming Bomar).

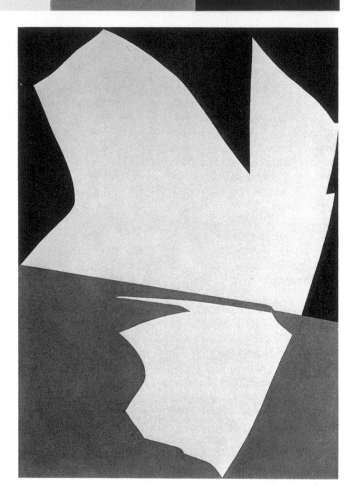

kind of color chart that Duchamp had incorporated into *Tu m'* or Rauschenberg into *Rebus* (fig. 354). But even though Kelly called his spectrum paintings exactly that, they actually echo his early admiration for Le Corbusier's Unité d'Habitation in Marseilles. This was the famous postwar exercise in Utopian apartment design whose somewhat brutalist modernism found relief in walls honeycombed with boxy, deep-set window reveals—things snugly fitted under tension into larger things—which were painted alternately in both the primary and the secondary hues. For the Spectrum seen here, Kelly opted for a truncated scale that progresses from blue through green, yellow, and orange to red. Not only does this allow relatively weak yellow to occupy dead center, and thus to hold its own as a shape comparable to the shapes of the more structural colors; the value and intensity of every hue has also been fine-tuned to establish or express a regular series of shapes, not to materialize some Minimalist theory by monumentalizing a standard color scale. Thus, with its abrupt, leap-frog jumps along the spectrum, with its unexpected subordination of sensuous, dominant-seeming chromatics to the rigorous demands of geometric shape, a bland line-up of abutted, same-size, but variously colored rectangles offers—camouflage style—enough viewer-entangling surprises to evince what E.C. Goossen has called Kelly's "principle of abated tension."

Enamored of shape as he has always been, Kelly eventually adopted such unorthodox formats as triangles, rhomboids, fans, and diamonds. He would also bend supports into the third dimension, which took his art into sculpture (fig. 417).

If Kelly used line drawing to slake his thirst for the naturalism he denied himself in painting, Jack Youngerman (1926—), Kelly's close friend during the Parisian years and a co-habitant of Coenties Slip in New York, so combined the two interests in large-scale Hard-Edge painting that his entirely imaginary shapes seem, ironically, rather more referential than the very real but totally covert subject in, for example, *Red Blue Green* (figs. 355, 352). As the work seen here confirms, Youngerman came into very full possession of School of Paris modernism as practiced not only by Matisse, Arp, Brancusi, and Calder, but also by such Abstraction-Création artists as Kandinsky, Herbin, and Sophie Taeuber-Arp. Even more than Kelly and most other GI Bill scholars in Paris during the 1950s, Youngerman mastered the French language and the rubrics of French culture, having married the actress Delphine Seyrig and thus entered a family headed by the director of French Museums. But despite steady progress in Paris, which included regular exhibition at the all-important Maeght Gallery and stage designs for the Barrault-Renaud acting company, Youngerman appears to have needed the impact and holism of the new American painting, which he quickly developed following his return to New York in 1956. At least, it was here that he produced his most

characteristic work, memorable for its flowing, exotically colored leaf, blossom, or wing shapes chastened by blade-sharp edges, matte surfaces of rolled-on flatness, and compositions so fused that figure and ground seem to flip in and out of a positive/negative relationship. As in Matisse's art, especially the late painted-paper cut-outs, Youngerman cultivated the large, simple, erotically undulant form, then pinned it like a butterfly to the planarity and perimeters of his format. To increase the tension within this fused dialectic, he often made the shape of the support—diamond, tondo, ellipse—as active as the painting's internal elements. Typically American, however, is the radicality of the treatment—the emblematic directness of the image, the high-energy, poster-like vibrancy of the colors, the billboard scale, the silkscreen smoothness of the hand-painted surface—all of which Youngerman managed without losing a touch of the metaphoric poetry that had become his during a decade of near-total assimilation into the School of Paris.

One of the few Americans to make a truly masterful transition from Action Painting to a nongestural style was Al Held (1928—), possibly because this powerful, Brooklyn-born painter was as devoted to Mondrian as to Pollock. The first break came in 1959, when Held

adopted acrylic in place of oil, gave up blended colors for a clarified palette of black, white, and the three primaries, shaped them into geometric rather than ambiguous forms, and took the cacophonous street world of Yellow Cabs as a metaphor for the jammed, high-energy, down-to-earth content that he had always sought to express (fig. 356). Filling his 31-foot-long painting surface with a riotous visual mix emblematic of traffic signs, flashing signals, and fender-bending, horn-blaring racket, Held worked with the driven, automatic impulse he had developed while under the influence of Abstract Expressionism, but also with a new jazzy, syncopated rhythm like that of Mondrian in his *Broadway Boogie-Woogie*, or of Matisse in the brilliant cut-paper series called *Jazz*. Such was the momentum towards change struck in the four huge Taxi Cabs that Held simply rolled the pictures up, left them unexhibited until 1987, and proceeded to perfect the neat, Hard-Edge idiom that continues to engage him even now.

Although now hailed as some of the strongest works painted in the late fifties, the Taxi Cabs served at the time mainly to clear the way for the major shift that Held, along with his contemporaries, would make from faith to pragmatism, from romantic release to hard-nosed calculation. In literally cleaning up his act, Held did not so much reduce the amount of heavy pigment he had always loaded onto his canvases as sand it down until the infrastructure he sensed lying deep within came to the fore and finally tightened into a kind of sharply defined geometry. But so individual and non-Euclidean was this geometric imagery that it seemed actually to have absorbed the subjective, expressionist content formerly borne by the impassioned brushwork. From 1960 to 1967 Held articulated his pavement-dense but glossily polished surfaces with the simplest of circles, squares, and triangles, only to particularize them with edges of almost tactile keenness, with flat, vivid, strongly contrasted colors, and with a scale grand enough that the overall effect is weighty, confrontational, and impacted (fig. 357). Such aggressively physical effect could scarcely have been more at odds with the pure, immaterial opticality of, for instance, stain painting. The figure might sometimes be a letter of the alphabet, but realized as a shape so broad and planar that its identity derives almost exclusively from small nicks cut into the field at its perimeters.

By 1967, however, Held felt a need for greater openness and renewed elaboration, which he attained by translating his elementary geometries into illusionistic volumes structured not by plane but rather by line, with this varied in thickness to suggest multiple systems interwoven and simultaneously active within the same expanded, even planetary space (fig. 358). For the sake of still greater airiness and transparency he eliminated color to produce a series of immaculate black-on-white or white-on-black paintings that now seem almost classical in their daringly occult but ultimately serene balances. When Held reintroduced color, its shrill intensity, unmodulated flatness, clarity, and precise, anonymous handling would join with line and perspective to heighten the tension of works in which the imagery's lucidity arouses expectations of Renaissance formal and spatial logic, only for this to be frustrated by Surreal, Piranesi-like contradiction and ambiguity. And so, as in the *perpetuum mobile* of Pollock's gestural complexity, the eye gives up trying to sort out the irresolutions and accepts the special unity or indivisibility—the holism—of the total configuration, whose coherence, for Held, lies in its unyielding incongruity. Now, instead of movement through space, the viewer experiences a sense of timeless present. True to their modernist aes-

below: **356.** Al Held. *Taxi Cab II.* 1959. Acrylic on paper mounted on canvas, 8'11" × 14'. Courtesy Robert Miller Gallery, New York.

right: **357.** Al Held. *Mao.* 1967. Oil on canvas, 9'6" square. Collection Mara Held, New York.

below right: **358.** Al Held. *Volta I.* 1976. Acrylic on canvas, 7' square. Collection Mr. and Mrs. Neil Rosenstein, Beverly Hills.

359. William Turnbull. *No. 1.* 1962.
Oil on canvas, 8'4" × 12'4". Tate Gallery, London.

thetic, the pictures deny all meaning outside themselves, communicate nothing beyond their own literal presence, and thus urge the viewer to discover his own internal unity, even while surrounded by an empirical world riddled with doubt and dissension.

In William Turnbull, the Scotsman seen earlier as a sculptor (fig. 189), the Situationists gained one of their most fearless and authentic practitioners of Color-Field Painting (fig. 359). Profoundly moved by Rothko's work, both at the Tate in 1956 and in New York in 1957, Turnbull began painting pure monochromes—great soaked, "totally silent" spreads of unadulterated chroma but executed with enough surface incident to achieve a goal the artist cited in 1960: "I'd like to be able to make one saturated field of color so that you wouldn't feel you were short of all the others." Perhaps for this reason, Turnbull readmitted a welcome degree of complication in the canvas seen here, even while perpetuating the terse simplifications and concentrated inwardness already witnessed in his celebrated sculpture. Not only does the painting consist of two juxtaposed planes of blue and green, the support has been physically divided at a point different from that separating the paired hues. By thus seeming to overlap, the color fields generated an element of spatial complexity, or at least ambiguity, more characteristic of contemporary European art than of its American counterpart. As the hard edges both real and painted imply, Turnbull had expanded his range of pictorial interest to include the work of Ellsworth Kelly. A student of Eastern philosophy and a publisher of Japan's haiku poet Bashō, Turnbull once described his field painting as "large environmental shields changing our lives . . . provocations to contemplation and order."

Minimal Painting

Although well advanced by the figureless, field-like austerities of Rothko, Newman, and Reinhardt, as well as by Rauschenberg's White Paintings and Yves Klein's Monochromes, the aesthetics of exclusion did not evolve into hard-core Minimalism until a twenty-three-year-old Frank Stella (1936—) made his debut at MoMA in late 1959, the youngest of the emerging artists selected for the museum's historic "Sixteen Americans" show (figs. 321, 360). So cold-bloodedly, albeit deceptively, simple-minded, so flat both in their abstract design and in their methodical execution did Stella's quartet of black "pinstripe" paintings seem that many observers thought these shockingly "smart-aleck" works had not only repudiated romantic, painterly Abstract Expressionism; they had done it, moreover, with a brutality likened by one writer to "a slap in the face." Still, for certain viewers sophisticated in the fine art of detecting the authentically new, among them MoMA's Alfred Barr and the dealer Leo Castelli, Stella

offered a stern but potent solution to the "crisis of painting," to the problem of a "spontaneous" mode reduced by its imitators to empty, turgid formula. The faith placed in a "difficult" performance like the one seen here would not be betrayed, for Stella became and continues to be one of late modernism's most prodigiously ingenious and energetic masters, pushing his art from strength to strength, forever unpredictable in moves that almost always prove stunningly logical once revealed in all their characteristic authority and daring.

Crucial to his continuing success may have been the go-for-broke start that Stella made at the end of the fifties, when he took the astringent measure of wiping the canvas clean of Abstract Expressionist "slosh" and then replaced it with something like the ABC basics of painting. Even in an exhibition that included such cool, anti-expressionist progressives as Nevelson, Rauschenberg, Johns, and Kelly, Stella stood forth as an uncompromising radical. Whereas de Kooning-style gesturalists had gloried in ambiguity, intuitive process, randomness, asymmetrical balances, and "smudge, smear, spatter" brushwork, the newcomer offered clarity, preconception, modular repetition, symmetry, and neutral, humdrum facture. Equally important, however, was the conviction on the part of Stella that in purging his art of everything extra-pictorial—of all but its prime essentials—he was engaging not so much in a "reductive" exercise as in a creative one, undertaken for the sake of reopening painting to fresh and unexpected possibilities. Ultimately, his goal was to paint pictures that in their own time and way would appear as endowed with immediacy and impact as those of such admired predecessors as Pollock, Reinhardt, and Johns. What his own time and way required was a purely formalist, "problem-solving" art having little to do with the sublime, apocalyptic vision of Newman or Still, and this became briskly clear in Stella's most famous statement:

I always have arguments with people who want to retain the "old values" in painting—the "humanistic" values that they always find on the canvas. If you pin them down, they always end up asserting that there is something there besides the paint on the canvas. My painting is based on the fact that only what can be seen there is there. . . . If the painting were lean enough, accurate enough or right enough, you would just be able to look at it. All I want anyone to get out of my paintings, and all I ever get out of them, is the fact that you can see the whole idea without any confusion. . . . What you see is what you see.

As for emotional response, Stella simply assumed in advance that it would be forthcoming, provided he had addressed a valid issue and made a good pictorial case for it:

It does not matter that for a painting to be successful, it has to deal with problems that are always given to painting, meaning the problems of what it takes to make a really good or convincing painting. But the worthwhile qualities of painting are always going to be both visual and emotional, and it's got to be a convincing and emotional experience. Otherwise it will not be a good—not to say, great—painting.

And indeed those first captivated by Stella's hauntingly bleak and enigmatic Black-Stripe canvases—works of such coherent, intellectualized singleness that external shape and flat-patterned interior seem the perfect coefficients of one another—responded to them in emotional terms, as did William Rubin, who wrote of "being almost mesmerized by their eerie, magical presence." Over ten years later and still fascinated by the pictures' "ubiquitous blackness"—their uncanny capacity to absorb, refract, and emit light, all simultaneously—Robert Rosenblum would observe that the paintings "can evoke a mood of somber mystery; it is also a matter of iconic structure, whose binary, cruciform, or concentric symmetries create an unworldly, hypnotic fixity, as of immutable, venerated emblems." Ironically, the overriding source of mystery may well have been the blunt, unnerving candor with which Stella had realized paintings so self-referential—so utterly free of both illusion and allusion—that they could not but be accepted as physical facts or objects, even as he managed to invest them with all the aura of important art. Contributing to the effect was the works' colossal, disconcertingly self-confident scale, a scale cer-

tain to ring home the exquisite simplicity with which a relevant pictorial problem had been acknowledged and resolved. Once Stella demonstrated himself capable of accomplishing this in an ongoing, ever-more ambitious series of interlinked problems and solutions—each flowing from its predecessor with the apparent inevitability of a mathematical progression—it became evident that he would enter history as what Irving Sandler has called "the paradigmatic post-painterly painter" (figs. 360–363).

Stella could be said to have got everything right from the very start, born as he was into a Massachusetts family prepared to educate him at a pair of elite institutions—Phillips Academy, Andover, and Princeton University—liberal enough to allow a precocious student to develop an entirely abstract style of painting. At Princeton, moreover, Stella experienced the triple good luck of studying under the Abstract Expressionist painter Stephen Greene, William Seitz, an art historian who had written his doctoral thesis on the New York School, and Robert Rosenblum, a young professor of art history and one of the first critics to appreciate both Pop and Post-Painterly Abstraction. None of it was lost on Stella's intelligence and ambitious, well-integrated personality, with the consequence that by the time he had graduated in 1958 and moved to New York, the young man already understood, as he would later say, that "the idea of being a painter is to declare an identity. Not just my identity, an identity for me, but an identity big enough for everyone to share in." Since no strong, new identity was any longer to be found in Abstract Expressionism, Stella set about formulating an innovative way of making pictures totally different—virtually point by point—from the gestural abstraction then thought to be the only language in which painters might achieve a truthful, modernist statement. The challenge, as the artist put it in a 1959–60 lecture, was, first, "to do something about relational painting, i.e., the balancing of the various parts with and against each other." And he would produce the required post-Cubist composition in the most "obvious" way, with symmetry—"make it the same all over." Then came the nagging question "of how to do this in depth," which arose because "a symmetrical image or configuration placed on an open ground is not balanced out in the illusionistic space." Apart from "color density," the best solution Stella could devise for dealing with the ambiguous spatial relationship between figure and ground was to force "illusionistic space out of the painting at a constant rate by using a regulated pattern." Now, he had only "to find a method of paint application which followed and complemented the design solution." And "this was done by using the house painter's techniques and tools." Here, it helped that Stella had been earning his way as a house painter, which practice left him unpersuaded by all the value the de Kooning school had attributed to "action." For Stella, "a good pictorial idea is worth more than a lot of manual dexterity." Even more reinforcing for his ultimate aim, which entailed forcing "illusionistic space out of the painting at a constant rate," was the example of the all-over, nonrelational, or holistic image created by Rothko, Newman, and Pollock. The last loomed especially large after Stella considered his synoptic skeins closely enough to compare them, in a Princeton essay, to the interlace pattern of Hiberno-Saxon illumination. In "*Die Fahne Hoch!*", for instance, it is as though he had observed Pollock's translation of drawing into painting and then taken it further (fig. 360). Spreading the lines until they became broad, Hiberno-Saxon straps, Stella slowed and regularized their centrifugal, chiaroscuro meander until it became a static, rigorously predetermined cruciform scheme of parallel black paths separated by narrow strips of white reserve canvas. And just as Pollock's vortex took its overall shape from that of the support, Stella's heraldic geometry stands fixed before the eyes like the structural skeleton or a reiterating visual echo of the rectangular canvas. For this reason, it seems absolutely bonded to the painting surface as if every last vestige of Pollock's or Rothko's shallow, atmospheric space had been vacuum-sucked away, right along with the emotionalism of vehement, Abstract Expressionist gesture, now ironed flat in stoic, nested sets of somber, quadrilateral banding.

No less important to Stella in his search for an artistic identity "big enough for everyone to share in" were Johns' Flags, exhibited just over a year earlier than the "Sixteen Americans" show. In their incredible rightness as painting, the Flags gave license to artists like Stella eager to believe that significant art could be made from images found somewhere other than in the painting process. Moreover, they appeared to declare that, rather than provide a vehicle for agonized self-expression, painting might also become the embodiment of ideas, specifically thought-provoking questions about the nature of perception and aesthetic experience. And Stella, more than anyone else, saw how Johns, in choosing a ready-made, essentially abstract subject at concrete one with the shape and flatness of its support, had moved far towards solving the central formalist problem of how to articulate the picture, not as an illusion of some external reality, but, instead, as a reality unto itself—a two-dimensional thing. But whereas Johns had thoroughly blurred the distinction between a painting and the object it depicts, Stella contrived virtually to make them one, merely by allowing the support to generate its own image. "The thing that struck me most," he later remembered, "was the way [Johns] stuck to the motif . . . the idea of stripes—rhythm and the interval—the idea of repetition. I began to think a lot about repetition." And so Stella appropriated the most rigorously formal aspect of Johns' Flags—the striations running parallel to the canvas' horizontal axis—eliminated their distinctive colors, and created a purely nonobjective design illustrating

360. Frank Stella. *"Die Fahne Hoch!"* 1959. Enamel on canvas, 10'1" × 6'1". Whitney Museum of American Art, New York.

nothing but the physical condition—the two-dimensional rectangularity—of the surface it is painted on. Not only do the serial stripes recapitulate the literal facts of the container, but the 3-inch module even takes its width from the 3-inch depth of the canvas stretcher. With this reference, the picture, like Klein's Monochromes, seems to gain a literal, rather than illusory, third dimension, making it appear all the more like an object among other objects in the world. However, there could be no question about the special, aesthetic nature of this object, painted as it is in monkish, monochromatic black and in a geometric design of Platonically ideal purity. And while displaying none of the *belle peinture* qualities of Johns' encaustic facture, "*Die Fahne Hoch!*" has clearly been painted freehand, along channels plotted by penciled guidelines, a system of "painting within the drawing" that, as Walter Darby Bannard wrote, replaced the Action painters' "drawing with paint."

Ad Reinhardt had offered Stella a model in his ambition to create a totally self-referential art of stern boldness. However, this occurred as much through the older master's art-for-art's-sake philosophy as through his drastically intellectualized and reductive monochromes (fig. 91), which, furthermore, did not assume their legendary blackness until a year after Stella had shown the nocturnal works discussed here. And when they appeared, Reinhardt's black paintings, with their cruciform structure all but lost in penumbral haze, could scarcely have been more ambiguous, whereas Stella aspired to a clarity of pictorial statement even greater than Johns'. And he achieved it, thanks to his "frame-locked composition" of fugal stripes, which permitted him to assay the terrain of the painting surface with a frankness like none ever seen before. Empowered by his system of side-by-side, repeating, and identical units, Stella deftly and even mercilessly banished all such traditional hierarchies as major and minor accents, chromatic and atmospheric refinements, spatial overlap, discrete forms seen against a ground plane, and all their attendant load of tactile, narrative, or emotive associations. As a summary of his aesthetic intentions, the artist once commented: "I tried for an evenness, a kind of all-overness, where the intensity remained regular over the entire surface."

Yet more unitary than Johns' Flags and Targets or Reinhardt's monochromes, the Black-Stripe paintings also surpassed them in the heroic scale their creator had adopted from Barnett Newman, another mentor, who, like Reinhardt, finally came in for full critical recognition partly because of the immense potential Stella had discovered his art to possess. Giant size was paramount for an art whose deadpan forthrightness largely concealed the complexity of its conception, part of which was to capture for a cooler, more objective, analytical, and concrete kind of painting all the self-confident, even aggressive presence attained by the Abstract Expressionists. If for Stella "presence" meant challenging formal problems brilliantly solved, more than the sublime transcendence sought by the Pollock-Newman generation, his Black-Stripe paintings were, however, not without their poetic content, as the works' titles suggest. Hitlerian in overtone, "*Die Fahne Hoch!*" seems to make an heraldic grillework of dark bars on a white ground shudder with a frisson of both menace and mourning. Other titles, such as *Tomlinson Court Park, Arundel Castle, Zambesi,* and *Club Onyx,* derived from depressed neighborhoods or subcultural hangouts encountered by Stella in the course of his house painting. Together, they seem to echo, however distantly, the radical politics for which radical abstraction, from its roots in Russian Constructivism, has often tended to serve as a splendid, if covert, metaphor. With time, this modicum of subjective, "humanist" association, so at odds with the artist's strategy of formal and intellectual rigor, appears increasingly plausible, as the ambivalence of the handling itself becomes more apparent, especially in the stripes' shimmering soft edges and nuanced, variable matteness or reflectivity, produced by a mechanical-seeming but nonetheless freehand process. Preconceived, nonreferential, all-over, field, or gestalt in design, indivisible, literal, direct, and grandly object-like, finally even connotative, Stella's art, as Robert Rosenblum wrote in 1970, "directly intersects almost every important pictorial preoccupation of his time."

So convincingly did Stella make his pictures declare their objecthood that a number of fellow Minimalists theorized that painting had come to the end of its history—had in fact died—and that authentic new art—an art free of illusionism—could now be made only in the concrete three dimensions of sculpture. But when these literalists pointed out the slab- or relief-like effect created by the Black-Stripe canvases' deep stretchers, Stella replied that he never painted them, only the surface plane, the better to hold it off the wall and thus assure its existence as painting—a separate two-dimensional reality. Further, he began to notch the canvas at the corners or cut out the center in order to flatten the rippling, recessional illusionism of parallel bands "jogged" about a right angle or a concentric pattern (fig. 361). Such cuts, moreover, eliminated the incompleteness—the "leftovers"—at the outer or inner extremities of the design and thus yielded a tauter or more consistent fit between the shape of the support and the configuration set upon it, making each seem the ineluctable function of the other. Also working against whatever sense of depth the image might

generate was the metallic paint—first aluminum, then copper—that Stella soon made the medium of his stripes. With its low sheen, the surface now seemed to be sealed, except for the all-important breathing space of its raw-canvas interstices, with an industrial, inorganic finish meant to repel every impulse to penetrate beyond. And if metallic paint and image-shape reciprocity increased the overall abstractness of the new paintings, so did Stella's decision to brush along ruled rather than freely drawn lines. With the shaped canvas, however, Stella had made a major breakthrough, for instead of converting painting into sculpture, it liberated the artist from the tyranny of the picture plane's traditional rectangularity and into a vast new world of pictorial opportunities. Even the titles became more upbeat, as Stella set about, with his characteristically methodical intelligence, to investigate one conceptual theme after another, always in a series of artistic variations each of which, Rosenblum has written, ''provided a unique solution to the problem posed by the group as a whole.'' Needless to say, only a representative few of Stella's many solutions can be mentioned within the limited confines of the present survey.

While the notching of the Aluminum paintings left the underlying rectangle largely intact, the Copper works eliminated so much of the old format that the resulting silhouette proved as eventful as the right-angle surface bands it slavishly followed into unprecedented U, L, T, and H shapes. Having thus tested the limits of painting conventions in regard to the traditional rectangular support, Stella next took up the square, a format so basic and regular that it freed him to begin exploring a totally different but equally fundamental element of painting—color. For the sake of color, he even risked the spatial illusion that came with stripes construed in series of five concentric bands, each of the sequences painted in gradations of either pure hue or pure value. In the most monumental variations on this theme, he paired a hue and a value panel, creating diptychs that confirmed the altar-like implications already sensed in the first Black paintings. When programmatic analysis appeared to be less successful in color than in matters of structure, Stella renewed his evergreen interest in the shaped canvas, now venturing into trapezoids, pentagons, hexagons, and triangles. Color remained, however, reduced to monochrome but a monochrome of fluorescent purple smacking of a Pop vulgarity unexpected in the intellectualized realm of Minimal Art. Moreover, the intuition and sensation that color requires would increasingly vie with the cerebration demanded by structure, a development that began in earnest with the Dartmouth series, in which Stella hoped ''to open with color and metallic surface at the same time.'' Owing to their constant sheen, the metallic colors produce an all-over, unifying ''tonality'' that al-

lowed Stella to indulge polychromy without creating the recessional effect he could not avoid in the square nests of banded color progressions. Meanwhile, shape too continued to evolve, becoming in fact as modular as the traveling, vector-like stripes. This occurred when Stella joined wedge or chevron fields to create star-, Z-, or X-shaped paintings as well as a great variety of ''Notched-V'' compositions of great complexity, some coloristically uniform but others shifting in hue from unit to unit (fig. 362). With their angular, activated edges, their close-valued color jumps, and their sharp as well as frequent, speeding shifts in direction, all magnetized into high-tension stasis not only by the counterbalanced ''force fields'' but also by the overall flattening effects of surface facture, shimmer, and serial pattern, the Notched-V canvases must be counted among the most successful of Stella's works. The artist himself spoke of them as his ''flying wedge'' paintings, while Rosenblum found them as ''clean and breathless as a jet take-off,'' deadlocked by the ''jigsaw-puzzle clicking into place . . . of the divergent and convergent energies of the component fragments.''

Color of Matissean lushness became paramount in the Protractor series (fig. 363), for which Stella used the eponymous mechanical-drawing tool to create 93 different variations on ''interlace,'' ''rainbow,'' and ''fan'' themes, all so openly decorative in color and design, yet so architectonic in structure, control, and scale that the artist had every reason to declare: ''My main interest has been to make what is popularly called decorative painting truly viable in unequivocal abstract terms. Decorative, that is, in a good sense, in the sense that it is applied to Matisse. . . . Perhaps this is beyond abstract painting . . . but that's where I'd like my painting to go. . . . [and] it seems to me that at their best, my recent paintings are so strongly involved with pictorial problems and pictorial concerns that they're not conventionally decorative in any way.'' In adopting circular geometry for the first time, it was as if Stella wished to convert into his own highly conceptualized, but increasingly vibrant and sensuous, aesthetic the early interest he had evinced in the relationship between Pollock's maze-like pourings and the labyrinthine curvilinearity of Hiberno-Saxon illumination. However, with their special combination of discipline and opulence, the Protractor works, as well as their titles, also reflect the return that Stella had recently made to the Islamic sources that lay behind Matisse's arabesque brilliance. As was increasingly his practice,

363. Frank Stella. *Takht-i-Sulayman 1.* 1967. Polymer and fluorescent polymer paint on canvas, 10 × 20'. Menil Foundation Collection, Houston.

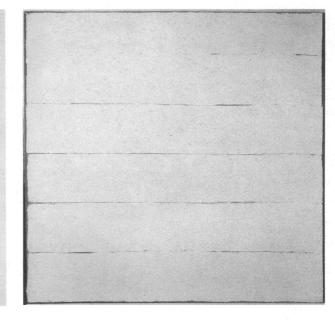

Stella exercised near-mathematical precision to plot the numerous permutations of his rule-and-compass theme. But once structure had been enlarged to stretched canvas, he invented the color schemes with a jubilant improvisation worthy perhaps of Matisse, but in a startling Day-Glo palette unique to the psychedelic sixties. And so, as the 12-inch stripes thrust upwards like 10-foot piers or spring in great double arcs across the full, 20-foot measure of the triptych seen here, the tart yellows, electric greens, and shocking pinks, the cool olives and acid indigos become so volatile that they all but burst free of the ultimately triumphant armature of tight aesthetic engineering. At first, however, the structural bands seem positively to race as they interweave in fictive depth until finally they entangle one another in a typical Stella flat-pattern stalemate—a stalemate wracked by explosive internal energy. Adding to the sense of pent-up, barely contained pressure is the soaked condition of the colors, which, as in the luminous Field Painting of Louis and Noland, leaves hues seeming both impalpably free yet tenaciously—paradoxically—integral with the physical fabric of the picture plane. With his eye-popping Protractor series Stella brought to culmination the fertile logic first announced in the Black-Stripe paintings of almost ten years earlier, a scheme whose symmetry and geometrical clarity remained intact, though severely tried, even as its elusive, underlying complexities became ever-more dumb-foundingly elaborate and exhilarating. Thereafter, as we shall see, Stella would pursue a dramatically different line of development, always however in the lucid and serially systematic way established in the initial decade of his long and productive career.

In purely formal terms, the great ancestress of Minimal Art was Agnes Martin (1912—), but in reducing her pictorial language to a fine-tuned, all-over gridwork of pallid, fragile lines—an image she had formulated as early as 1957—Martin could scarcely have been more at odds with Stella's technocratic "what you see is what you see" philosophy. Far from merely reifying the opaque reality of the flat, rectangular surface, the celebrated delicacy of Martin's blue-ochre graphs seems to dematerialize it into light and air of the driest, most intoxicating purity (fig. 364). Indeed, the artist herself has said: "When I cover the square with rectangles, it lightens the weight of the square, destroys its power." Clearly, the presence sought and rhapsodically achieved by Martin had little to do with physical or optical impact; rather, it drew energy from the same deep, meditational sources that had nourished such generational peers as Rothko and Newman. Moreover, the mandarin essence seen here had long been under way before finally it arrived, which, extraordinarily enough, occurred not in the New Mexico desert, where Martin lived and taught for many

years, but during the decade she spent in New York (1957–67), living at Coenties Slip surrounded by such cool but anti-mystical loft mates as Kelly, Youngerman, Rosenquist, and Indiana. Having distilled her art from its origins in rather traditional illusionism through Gorky-like biomorphic abstraction, Martin understood the liberating potential of an aesthetic scrubbed clean of all but the most elementary pictorial necessities. Thus, within the confines of a square, white-gessoed canvas whose axial coordinates are rearticulated as a slightly "off" screen of interlocking modular rectangles, Martin discovered an abstract theme that she would explore in what has become a virtually endless series of variations. Owing to the faint dissonance between the format and its interior design and a subtle tremor in the ruled drawing—penciled lines overpainted in thin washes of pinkish buff or azure-gray—the entire field appears to have come alive as a luminous atmospheric shimmer, sparked here and there with soft, barely visible yet dazzling pale fires. According to Thomas Hess, a visitor to Martin's New Mexico studio reported that one evening, while glancing out a window, he saw the sky and the desert assume the precise configu-

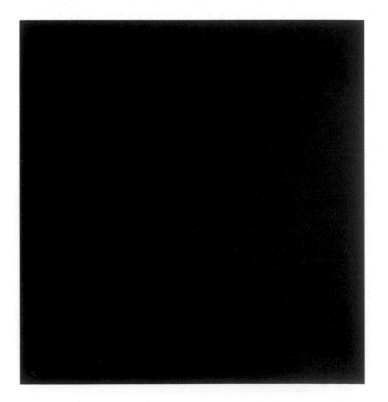

367. Robert Mangold.
W Series Central Diagonal I (Orange). 1968.
Acrylic and black pencil on masonite, 4 × 6'.
Saatchi Collection, London.

ration and colors of her paintings. "She's a realist," he exclaimed. Though anything but naturalistic, Martin's reserved yet authoritative works nonetheless signify explicit moods engendered by the desert world to which the artist returned in 1967.

When Ad Reinhardt, in 1960, declared his black-square painting to be *the* ultimate picture, and thus painted it repeatedly for the remainder of his life, he did not reckon with Robert Ryman (1930—), who took *white* to be the point of no return for pictorial art, yet discovered so many ways to vary it through process that his oeuvre as a whole has become an endlessly fruitful investigation of the spectral reality that, far from neutral, white is the embodiment of all color (fig. 365). Ryman narrowed his palette to white because, as one of Minimalism's paragons, he "didn't want anything in the paintings that didn't need to be there," and what truly could not be done without, as long as the issue remained painting, became more manifest once all specific colors had been banished. For Ryman, the irreducible essential of painting was the act of laying on medium, as he made pellucidly clear in his most oft-quoted statement: "There is never a question of what to paint, but only how to paint. The how of painting has always been the image—the end product." With this Ryman seemed to place himself at polar variance with the Abstract Expressionists, who had insisted that how they painted derived from what and why they painted. Yet a funny thing happened on the way to pictorial concreteness, for the more Ryman systematically emptied painting of all ineffables—the better to assert its most material conventions—the more the work appeared to be preeminently about such ineffables as light, the unavoidable product of white, and touch, the unavoidable, particular technique used for applying white. Indeed, Ryman developed the how of painting to such a fine and complex degree that, in his art, reductivism appears to have yielded a variety of subtle re-elaboration. Not only has he explored the effects of various media (oil, baked enamel, paper, vinyl acetate emulsion) combined with different brush widths and supports (canvas, linen, cotton, wood, paper, cardboard, steel, copper, aluminum, Mylar, fiberglass, Plexiglas); he has even considered the how of hanging works as part of the picture. Thus, when Ryman used bolts and brackets to hold a painting an inch or more away from the wall, it was as if he wanted to literalize the illusion of floating that the great "silent" white squares seem always to produce. Having rid painting of its romantic or Utopian trappings, Ryman proceeded to romance what survived—frame, stretcher, surface, medium—with such ardor that the coolest of cool painting begins to emit an unexpected warmth, its pervasive white so nuanced that monochromy appears, imperceptibly, to break up into a rainbow array of

chromatics. Gifted as he is with a true sorcerer's touch, Ryman could well afford to stake the whole of his art on process, even to allow a rigorous, deconstructive analysis of painting-as-painting to generate a presence that is as lyrical as it is objective. Although once called "a conservationist of the angelic literal," the artist himself would insist: "I didn't have anything else in mind, except to make a painting."

In 1960, the year that Reinhardt began restricting his palette to black and a year after Stella had exhibited the notorious quartet of Black-Stripe pictures, the English painter Bob Law (1934—) executed the first of his midnight-dark, starkly nonrelational near-squares, canvases so Minimal in form that they threatened to displace Reinhardt's as the last of all paintable pictures (fig. 366). This, however, was a Minimalism with a reactionary difference, for by layering thin, evenly painted sheets of violet, black, blue, and then black again, Law realized a black of such mysterious richness and depth that the pictures seemed to have become icons of spiritual as well as aesthetic contemplation. Indeed, Law's inky canvases could well be viewed in the same context as the Color-Field paintings of Mark Rothko, which had quite directly inspired them, or even the Blue Monochromes of Yves Klein, expect for the cool, sixties-style objectivity with which Law regarded his own admittedly metaphysical art. "If you openly go to [the black paintings] and you are a receptive type person for this sort of work, they may swallow you up and take you inside," the artist said, but then added, almost in the diction of Frank Stella: "If you don't like them, it's too bad. I don't care. They're just things." Although largely self-taught, Law had matured among the St. Ives abstractionists seen in Chapter 3, but then moved beyond them into pure field painting after visiting the "New American Painting" show at the Tate in 1959. This in turn prepared him to exhibit alongside Gillian Ayres and John Hoyland at the "Situation" show in 1960. But however significant his exposure to the New York School, Law preferred to work on a "human" scale no greater than a man with his arms outstretched. A humanist in a positivist decade, Law steeped his art in a content drawn from wide, cogitative reading in all manner of poetry, mysticism, Eastern and Western philosophy, psychology, and paleontology. Thus, while Rothko's great planes of luminous, disembodied color appear to open up and expand, Law's somber squares seem to close in and become densely self-absorbed, an effect strengthened by the firm, confining edge the artist took pains to establish all the way round the color field. It is also relevant that he worked with the utmost concentration, superimposing his acrylic colors one after the other in a single session. In this way Law hoped to make certain that nothing would interrupt his thought or its expression in a continuous, unified spread of grave, complex color he called "a kind of environmental chart, a thesis of ideas, energies, transmutations."

Rather than the icy conceptualist normally expected in a Minimal painter, Robert Mangold (1937—) regards himself as simply an "involved" maker of objects or images. Hardly had the New York-born, Cleveland-educated artist compounded a personal synthesis of various Abstract Expressionist manners when he rejected it all as irrelevant to his own sense of what counted in the early 1960s. The Yale School of Art under Albers and regular contact with the Manhattan scene helped Mangold to realize that what stuck throughout his various stylistic experiments was a deepening love of Mondrian and a sure, almost architectural feeling for two-dimensional structure. Finally, like the true Minimalist he became, Mangold threw everything out and reformulated his painting in the starkest, most rudimentary terms. Among the first of his new works to attract serious attention were the powerful object-like Areas, the flattest of flat pictures constructed of standard 8-by-4 Masonite panels, a material that imposed the pre-formed reality of a seam every 4 feet (fig. 367). Not only did

Post-Painterly Abstraction

207

this introduce a kind of found drawing; the section line also declared the picture plane instead of implying a volumetric or recessional figure. Moreover, by bringing an edge to the center of the field, it called attention to the picture's outer edges and the unorthodoxy of the format's upside-down fan or semicircular shape, a shape reminiscent of the Vence chasubles designed by another of the artist's models: Henri Matisse. Perceiving the psychological effects of the inside-outside dialectic of curved and rectilinear geometry, Mangold began to add the complicating factor of his own ruled lines, which became illusionistic by comparison with the literal lines of the seams and edges. Still more potent as an interplay of fact and fiction was the sprayed-on, industrial-looking surface, which in its reflectivity, tended to act like a mirror, dissolving even as it asserted a hard, resistant, almost enameled materiality. Serial in conception, the Areas, as in so much of Minimal Art, seemed to have their greatest impact when viewed all together, a situation that revealed the imagery of each work as part of a continuum in which the sequence of patterned events formed the whole. Entranced by the various types of counterpoised illusionism/literalism in his work, Mangold would soon recharge Minimalism by allowing it to be subverted from within by an "error" in the overcalculated "mechanical" drawing. Reinforcing the sense of an internal image and an external shape struggling to re-establish their independence, Mangold began to think of his pictures as separate rather than serial entities. Simultaneously, he would also endow their surfaces with a more tangible, idiosyncratic quality, not only in painterly touch but also in such lyrical, Matissean colors as monochrome sky blue, chocolate brown, mustard yellow, and dove gray.

In the art of Brice Marden (1938—), Mangold's slightly younger classmate at Yale, the ultimate failure of the Minimalist agenda to deny painting its power to evoke became almost irrefutable (fig. 368). Here, for instance, was visual constraint so unremitting that it verged, at one extreme, on a form of sensuous self-indulgence and, at the other, on a variety of heroic selflessness. As a sophisticated student of art history, with a special affinity for the controlled rapture of artists like Newman, Johns, and Francisco Zurbarán, the great Spanish Baroque master, Marden from the very beginning displayed a gift for undermining formalism's positivist attitudes while simultaneously appearing to accept its proscriptions against drawing, spatiality, and the ineffable. To an even greater degree than other artists seen in this chapter, he carried out a refined strategy of transforming Minimalism's rigid definitions into personal expressivity. This can be seen most directly in medium, color, and facture, where Marden chose hues of the most voluptuous sort, only to mute or gray them in a binder of beeswax mixed with oil. Meanwhile, he used a spatula to apply paint in such dense, matte, smooth layers that only concentrated looking reveals within the taut and thoroughly palpable surface the vitality of a narrow-range but nonetheless active, personal touch—or what the artist himself calls "drawing." When treated as a broad monochromatic field supported on deep stretchers, the waxy, paint-laden picture could look as substantial as a wall plaque, even though the chilled warmth of invented, wholly intuitive color left frustrated critics struggling with the poetics of descriptive terms like "putty," "orange-plum," and "elephant's breath." The artist himself spoke of "a dark black green seen slightly after a foggy dusk." As for structure, Marden initially favored a simple Johnsian image consisting of a single spread of lustrous pigment pulled, rather like a window shade, all the way down within an inch or so of the "sill." Here bare canvas, exposed underpaint, and dribbled medium not only disclosed the process of the painting's evolution; it also invested the rather distanced, ego-averse perfection of the surface above with an element of untamed, romantic feeling. Later, when he adopted such intellectually derived, symbol-rich compositional systems as the Golden Section or trinitarian post-and-lintel assemblages of differently colored panels, Marden left little doubt concerning the universal, even mystical content of an art ostensibly given to the systematic exploitation of formalism's purposeful limitations. Titles confirmed the extra-pictorial import, as in the Annunciation series of 1977. For eyes literate in the idiom of Minimalist reduction—an idiom that Marden articulated with a vocabulary of tall panels varied only in color and breadth as they moved across canvases 7 feet high and 8 feet wide—the Annunciation pictures narrated the Virgin Mary's traditional and successive states of mind as lucidly as the great didactic cycles of figurative paintings executed in the Middle Ages and Renaissance, or as movingly as Barnett Newman evoked the *Via Dolorosa* in the totally nonallusive manner of his *Stations of the Cross*, executed in the late 1950s and the 1960s. To quote John Russell, "the whole story was there—not so much described, as summoned to our awareness."

A one-time student at Black Mountain College (the student whose old patchwork quilt Rauschenberg used in *Bed*), Dorothea Rockburne understood not only the possibilities of nonobjective form but also those of discovering it through unorthodox materials and systems.

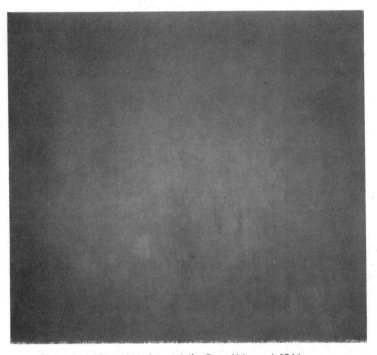

above: 368. Brice Marden. *4:1 (for David Novros).* 1966. Oil on canvas, 5' × 5'5". Saatchi Collection, London.

right: 369. Dorothea Rockburne. *Neighborhood.* 1973. Wall drawing, pencil and colored pencil with vellum; 13'4" × 8'4". Museum of Modern Art, New York (gift of J. Frederick Byers III).

Thus, when pure painting failed her, Rockburne began folding and flattening brown paper against the wall in crisply triangulated squares and rectangles, all combined and permuted according to the mathematics of set theory (fig. 369). Now, with shape, edge, line, color, and structure all absolutely literal and absolutely systemic, pictorial Minimalism would seem to have reached an apogee of clarity and equipoise. However, Rockburne chose to complete the work by the illusionist device of drawing ruled lines designed to integrate the real geometries both internally and with the real space of their supporting wall. As this attests, Rockburne considered herself a marginal Minimalist at best, convinced, as Blaise Pascal wrote in the 17th century, that ''Reason's last step is the recognition that there are an infinite number of things which are beyond it.'' And so, concrete though the folded, gathered, and creased forms may have been, their *arte povera* or ''impoverished'' means condemned them to a poignant, even romantic life of fragility and impermanence. Moreover, there would always be as much faith and imagination as science in the process by which Rockburne has continued to expand her fundamental principle of ''making parts that form units that go together to make larger units.'' In later, considerably more durable pieces and installations, she has replaced the poetry of ephemera with that of luxuriant color and sumptuous brushwork, always, however, with her original purpose in mind, which was to create art so serenely self-evident yet mysterious that, as Rockburne recently said, the work ''looks as though I had nothing to do with it . . . when something else took over.''

Cued by the esoteric science of Southern California's aerospace industry, Ron Davis (1937—) forsook oil and canvas in favor of liquid polyester resin and fiberglass cloth. With this he created a surface so object-like—so manifestly impermeable, smooth, reflective, and shaped—that, without fear of compromising his work's material thereness, he could indulge another obsession: Renaissance illusionism (fig. 370). Referring to the *mazzocchi* (multifaceted armatures used as tests in perspective exercises) painted by the 15th-century Florentine master Paolo Uccello, Davis exploited the principles of one-point linear perspective to invest his two-dimensional surface with the image of what would appear to be a solid object. Also contributing to the illusory volume are the colors, applied *behind* the rigid, glassy plane in mottled or marbleized layers, whose variously transparent and opalescent qualities function to trap light as though in a jewel-toned prismatic space. What results is a tough, industrial interpretation of not only Northern Renaissance glazing but also of Frankenthaler-like stain technique. In Davis' strikingly original art, the new aesthetics of Minimalist technology and literalism have been asserted, only to be challenged by a kind of visual make-believe that, owing to its strange new context, appears almost as intriguing as when first discovered over 500 hundred years earlier.

Having spent his first eleven years in East Germany, before crossing over to the West, Blinky Palermo (1943–77) had to cope with a kind of conflict—political and psychological as well as aesthetic—that would inform the art of many younger Germans yet to be encountered in this story. Unlike virtually all the others, however, Palermo conceived a strong and lasting identity with Minimalism, but given his personal experience, he also felt bound to reinvest it with a depth of content analogous to that once claimed for radical nonobjectivity, from Malevich's white-on-white square through European as well as

American Abstract Expressionism. Abetting him in this was his professor at the Düsseldorf Academy, Joseph Beuys (figs. 479–482), the famously shamanistic Pied Piper of seventies Conceptual-Performance Art, who saw even the most ordinary phenomena as potent with redemptive energy waiting to be released by the artist's magical touch. In his attempts to identify and elucidate the signs or symbols dormant in his own formalist geometries—actually to transform pictures not only into objects but also in aurated fetishes—Palermo created serial works that achieved coherence only when seen together as an installation or environment at the very site for which they had been designed. Two-part works composed of bundled rods and a circular form evoked lance and shield as well as palette and maulstick, therewith repossessing for art and its creator something of the mythic, salvational role they once played. In painting like the one seen here (fig. 371), the strategy was to make the simplest, thus the most absolute,

Post-Painterly Abstraction

work absolutely intelligible—absolutely literal—by coloring as well as texturing the surface with commercially dyed fabrics sewn together and then stretched like canvas. Almost as charismatic as Beuys, Palermo (christened Peter Schwarze, but then adopted by a couple named Hiesterkamp) acquired his professional name from a devoted circle of fellow students, who jokingly saw in him an uncanny physical resemblance to a notorious boxing promoter and *mafioso*. To the everlasting grief of all who knew him, the artist died at the untimely age of thirty-four while on a visit to the Maldives.

If Blinky Palermo harked back to the Utopianism of the pioneer Constructivists, he also anticipated the Conceptualism that would dominate the early 1970s. In the late Minimal Art of the American Richard Tuttle (1941—) the new trend was already well advanced, producing works so stripped down that they consist of nothing but an abstract color-form cut free of both frame and ground, then simply tacked to the wall, rather like a scrappy bit of laundry hung out to dry (fig. 372). While this may have rendered concrete what had always been an illusion, the modest size, the naïve craft, and the inartistic materials also tended to critique or deconstruct high formalist art, its literalism, elegance, and overweening ambition. Here, as Roberta Smith has written, is ''an art that seems to be purely formal and exceedingly poetic [yet] comes around to the political by the back door.''

Late Stella: From Minimalism to Maximalism

Meanwhile, as we saw in the Protractors (fig. 363), Frank Stella had already begun to depart from his Minimalist strategy of testing the degree to which painting could be purified of all but its most indispens-

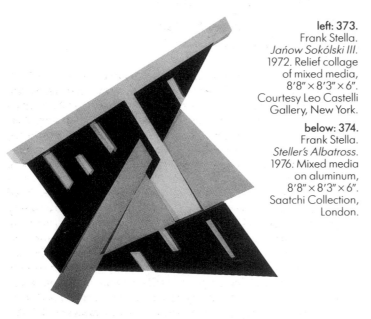

left: 373.
Frank Stella.
Jańow Sokólski III.
1972. Relief collage
of mixed media,
8'8" × 8'3" × 6".
Courtesy Leo Castelli
Gallery, New York.

below: 374.
Frank Stella.
Steller's Albatross.
1976. Mixed media
on aluminum,
8'8" × 8'3" × 6".
Saatchi Collection,
London.

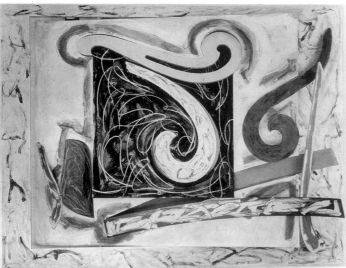

able properties. Increasingly thereafter, while die-hard Minimalists were narrowing their pictorial options to the point of disappearance, or taking flight—from painting's irremediable illusionism—into the most literal, material form of sculpture, or into the utterly dematerialized realm of Conceptualism, Stella was reconfirming his faith in abstract painting and vigorously demonstrating its power of self-renewal as a corporeal presence. Beginning in the early 1970s, he would do this with all the system and logic that had characterized his earlier work, but in reverse order, until finally his approach became the ''maximalist'' one of testing just how impure painting could become and yet remain both painting and abstract. As phrased by Rubin, Stella would pose the questions: ''How much could he subsume from the neighboring plastic arts of sculpture and architecture and still be making pictures? And how many of the lapsed conventions of painting itself—in the realm of configuration, spatial structure, and even narrative form—could be redeployed in an art that still remained wholly abstract?'' Always in the urgent hope of ''making it better,'' Stella strove to demonstrate that nonfigurative painting could be as richly diverse as figurative art, and indeed, throughout the seventies and eighties, he would progressively expand the stylistic range of his oeuvre until it achieved a brimming, Picasso-like inclusiveness. Still, the artist has remained the literalist he always was, in that his post-Minimal painting would continue to evince an earthy materialism as resolutely at war with the romantic or Platonic spirituality of earlier abstraction as his increasingly profuse, symphonic forms would counter the stoic, bare-bones distillations of his Black-Stripe, Aluminum, and Copper paintings. The process of recomplication began in earnest with the Polish Village series of 1971–73, in which Stella so literalized the spatial ambiguities of the physically flat Protractors that the new pictures became genuine reliefs (fig. 373). Even so, he called them, like all his works, paintings, given that whatever their organization, it is always pictorial—that is, a frontalized, wall-backed format of a certain size and shape. As the Slavic titles suggest, Stella was looking eastward in his Polish Villages, actually towards the pioneer efforts of the Russian Constructivists, some of whose qualities he wanted to repossess for nonobjective painting. This meant forfeiting the nonrelational singleness or holism so fundamental to sixties abstraction. In its place Stella constructed the pictures as interlocked, asymmetrical clusters of irregular geometric planes, their opposing shapes, colors, and thicknesses, oblique angles and thrusting vectors so perfectly balanced as to make the entire dynamic silhouette stabilize within the axiality of an implied rectangle. If the banal ''pragmatism'' of the various materials used to distinguish the different parts—felt, paper, and canvas applied to plywood, pressboard, Masonite, Homosote, or aluminum—also recalls Russian Constructivism, the intricate carpentry with which they have been assembled seems to evoke the historic wooden structures the titles commemorate—Poland's Jewish synagogues destroyed by the occupying Germans during World War II.

The pictorial rectangle merely implied by the Polish Villages resumed explicitness when, beginning in 1975, Stella needed it to contain and nail to the wall the whirlwind complexities of his Exotic Birds (fig. 374). The source of this exuberant, and immensely popular, series was a set of ''irregular'' or ''French'' curves the artist happened upon and decided to appropriate for art, very much as he had the regular geometries of the protractor. Inspired by the extensive variety of ready-made arabesques available from these mechanical-drawing devices, Stella took flight, rather like his new ''abstract figuration,'' and allowed himself for the first time to compose in a spontaneous, rather than *a priori*, manner and to work almost exclusively with a vocabulary of asymmetrical curves. Still, method prevailed even in the new-found delirium, which began with the artist shifting his templates about on a sheet of graph paper until he found a workable motif, after which he traced its shapes and then completed the composition by establishing the rectangle of its framing edge. Having now made figure and ground, as well as inner design and overall shape, separate if in-

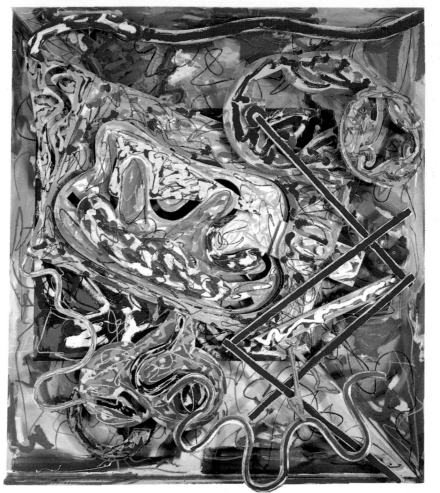

375. Frank Stella. *Shards III*. 1983. Mixed media on aluminum, 11'4½" × 9'10¾" × 2'½". Courtesy Leo Castelli Gallery, New York.

terplayed entities—quite unlike the all-embracing unity of his Minimal works—Stella proceeded to dramatize the sense of layered depth and multidirectional movement they generate. This occurred first in a three-dimensional FoamCore maquette, whose cut-out, skeletal forms Stella tilted and turned against the ground plane, and finally in the scaled-up aluminum version, which he hand-painted in brash colors, using a combination of de Kooningesque brushiness and a racing, linear, Pollock-like scrawl. While the all-overness of the painting provides a foil to the relational composition, it also gives organic life to the mechanical cursives of the found imagery.

In 1983, when Stella went to Harvard to deliver the six lectures required of the Charles Eliot Norton Professor of Poetry, an annual appointment made on other occasions to such luminaries as T.S. Eliot, Igor Stravinsky, Ben Shahn, and R. Buckminster Fuller, the demand for tickets was such that for the first time the event had to be transferred to a large auditorium, which remained uncharacteristically filled to the rafters throughout the series. The intelligentsia who attended so faithfully, many of them traveling great distances, seemed persuaded that to be there was to encounter one of the authentic geniuses now at work in contemporary art. History, of course, will determine the justice of their perception, but Stella himself left no doubt about the historical geniuses whose lofty achievement must somehow be matched in modern terms if abstraction is to fulfill its promise as the 20th century's major contribution to visual art. Modernist painting must, in Stella's view, recover the vitality, drama, and spatial complexity it possessed in the art of the Abstract Expressionists, just as Caravaggio and Rubens had recaptured those qualities following the collapse of the High Renaissance into 16th-century Mannerism, an aesthetic interlude Stella equated with the Minimalist painting of the 1970s. For him, it becomes imperative that painting move away from the largely cerebral and spiritual ideas the Pollock-Rothko generation had received from northern European masters, such as Kandinsky, Malevich, and Mondrian, and seek a new source of inspiration in "the

tough, stubborn materialism of Cézanne, Monet, and Picasso,'' all southern Europeans who based their art more on pictorial values than on ideas. The late-modern abstractionist must learn to "make painting real"—real like the painting that flourished in 17th-century Italy. Also in 1983, almost as a demonstration of his thesis, Stella commenced the Shards, which would deliver to the world some of the most shamelessly baroque yet insistently abstract paintings ever seen (fig. 375). Once again the titles are telling, since they point to a key source of the swarming, even vulgar plenitude so evident in the work reproduced here. Captivated by the scraps and leftovers strewn about the factory where his maquettes had been translated into large-scale aluminum forms, Stella decided to forgo the careful preplanning theretofore normal in his process and simply improvise with the available "shards." This accounts for the "negative" versions of the irregular curves encountered earlier and the straight edges of the metal sheets from which they have dropped away. Entirely new, however, are a pair of distinctive shapes also appropriated ready-made from the mechanical draftsman's kit—the Flexicurve and the pantograph—which together not only epitomize the snaking rhythms and lightning-bolt impact of Stella's late art, but also serve as metaphors for his serial and systematic way of working. While the Flexicurve was designed to yield a smoothly arcuated line, the parallelogram pantograph is an enlarging instrument of the sort used in rescaling works like Stella's. Thus, for all its free, billowing energies and buoyant relief, its scalloped forms, glitzy hues, and scrawling graffiti, *Shards III* remains the product of an ironclad aesthetic will, a formalist will determined that however spontaneous-seeming a relief may be, the work must in the end clarify itself as painting aligned frontally against the wall and within the structuring, rectangular format traditional to high pictorial art. After prolonged looking at this characteristic, though escalated, tug-of-war between the forces of rule and rebellion, we realize, as Rosenblum has written, that Stella's "wildest exuberances . . . finally tick away with the same clockwork order as his most taciturn reductions.''

Post-Painterly Abstraction

211

Minimalism: Formalist Sculpture in the Sixties

Increasingly, as cool, formalist painting in the sixties approached the status of an object unto itself, thus becoming less and less a fictive image of something else, the more it appeared to certain avant-gardists that the ultimate destiny of modernism would be attained in the real, object-like three-dimensionality of sculpture. As Stella acknowledged in his Protractor series, the very flatness of the picture plane made it inescapable that painting would always harbor some degree of illusionism, however vestigial. Even Klein's Blue Monochromes, perhaps the most radically abstract and unitary canvases ever painted, could be read as utterly flat or as infinitely deep, like the sky or sea. For Noland, Olitski, and Stella, among other advanced painters seen in the last chapter, the problem resolved itself in the renewal possibilities they found in a tense dialectic between the tactile materiality of the painting surface and the tendency of the colors steeped therein to render it immaterial or purely optical. Also coming to the fore, however, were artists even more literal-minded than Stella in his Black, Aluminum, or Copper pictures, and these reacted against their own painterly painting by co-opting Clement Greenberg's argument for a totally autonomous art—an art purged of everything foreign to its own inherent physical nature—and by declaring that only in sculpture would it be feasible to realize an aesthetic object free of all "dishonest" allusiveness and extraneous metaphor. According to this ideology, moreover, the modernist "desire" for an objecthood of overwhelming immediacy and impact could be satisfied most effectively in sculpture so self-evidently basic, unified, modular, or systemic that it could scarcely signify or symbolize anything but its own presence. In practice, which began to emerge in New York during

the years 1963–65 with the solo exhibitions of Donald Judd, Robert Morris, Dan Flavin, and Carl Andre, the new so-called Minimal sculpture would characteristically consist of single or serial volumes as simple and geometric as a cubic box or a standard fluorescent tube (figs. 376, 377). Placed, without base or other support, directly on the floor or wall, Minimal sculpture clearly occupied the same space as the viewer, to whom it therefore offered free, unimpeded access. Symmetrical and holistic instead of relational in design, preconceived, prefabricated or industrially produced, and thus machine-finished rather than textured like process-derived sculpture, and displaying only non-colors or colors found in the material used, this unprecedentedly reductive art also earned the label "Primary Structures," a term taken from the title of a landmark exhibition mounted at New York's Jewish Museum in 1966. Barbara Rose, one of the movement's most lucid apologists, spoke of "ABC Art," in a key article of 1965, and by this she meant sculpture "whose blank, neutral, mechanical impersonality contrasts so violently with the romantic, biographical Abstract Expressionist style which preceded it that spectators are chilled by its apparent lack of feeling or content." On these very grounds, however, ABC works had triumphed, fulfilling their creators' aspiration that they be distinguished, as Rose averred, by

. . . no more than a literal and emphatic assertion of their existence. There is no wish to transcend the physical for either the metaphysical or the metaphoric. The thing, thus, is presumably not supposed to "mean" other than what it is; that is . . . to be suggestive of anything other than itself.

Writing elsewhere, Rose declared that Minimalists wanted to make "objects that are *presented* rather than depicted or represented." Ini-

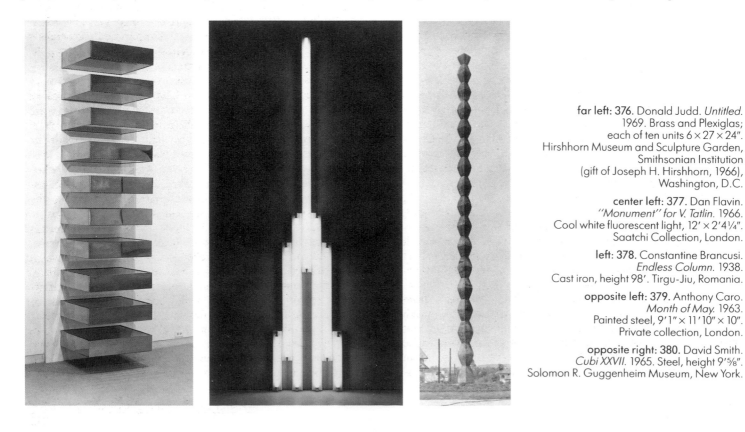

far left: **376**. Donald Judd. *Untitled.* 1969. Brass and Plexiglas; each of ten units 6 × 27 × 24". Hirshhorn Museum and Sculpture Garden, Smithsonian Institution (gift of Joseph H. Hirshhorn, 1966), Washington, D.C.

center left: **377**. Dan Flavin. *"Monument" for V. Tatlin.* 1966. Cool white fluorescent light, 12' × 2'4¼". Saatchi Collection, London.

left: **378**. Constantine Brancusi. *Endless Column.* 1938. Cast iron, height 98'. Tirgu-Jiu, Romania.

opposite left: **379**. Anthony Caro. *Month of May.* 1963. Painted steel, 9'1" × 11'10" × 10". Private collection, London.

opposite right: **380**. David Smith. *Cubi XXVII.* 1965. Steel, height 9'5⁄8". Solomon R. Guggenheim Museum, New York.

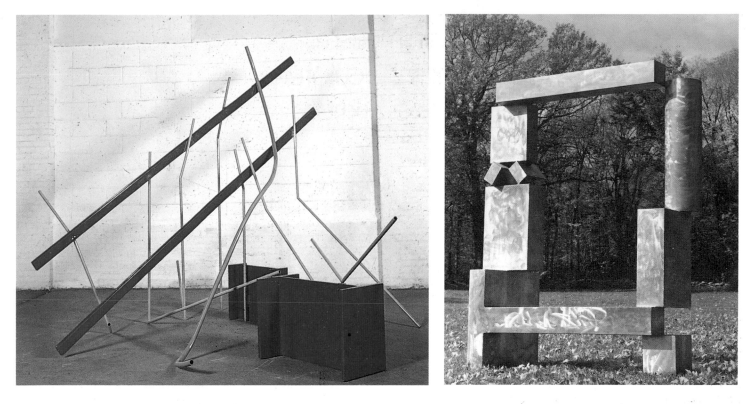

tially, this struck many a nonspecialist viewer, with all the directness the Minimalists had hoped for, as a kind of nihilism or an "aesthetics of boredom" run amok, only for its stubbornly matter-of-fact works slowly, and ironically, to reveal themselves as rather elegant, classical, or aristocratic. By this time Minimalism had already established itself as a dominant, even aggressive force, to such a degree, moreover, that in subsequent reactionary years the sixties would often be regarded as the Minimalist Age. But if such problematic art came through at all, it was owing in large measure to the tough conceptualism informing the work and the juggernaut rhetoric used to argue both for and against what so far has proved to be modernism's climactic phase.

For all its involvement with common industrial modularity, fabrication, and materials—not only steel and fluorescent tubing but also fiberglass, Plexiglas, chrome, plastic, firebricks, and Formica—Minimal sculpture originated, like contemporary formalist painting, in the rarefied, art-for-art's-sake theories of Clement Greenberg. Also in the background were, of course, such minimalizing precedents as Russian Suprematism and Constructivism, the repetitive, chain-like *Endless Column*, as well as the mirror-surfaced monoliths, of Brancusi (fig. 378), Duchamp's ready-mades, Cage's serialism, and the more evolved developments within the New York School, particularly those of Pollock, Still, Rothko, and Newman, Reinhardt and David Smith. Even the "new novel" or "literal literature" of Alain Robbe-Grillet and Marshall McLuhan's announcement that medium and message were one played a role. For the more cerebrally precocious, so did the positivist/structuralist thought flowing from such European intellectuals as Ludwig Wittgenstein, Claude Lévi-Strauss, Michel Foucault, and Roland Barthes. Rejecting the Existentialist generation's overriding preoccupation with content—with moral or spiritual issues—as unverifiable speculation, the structuralists, especially, declared it more rewarding to focus on form, or the language of form, and to treat it as the all-important agency of meaning. Within the realm of vanguard art, however, this shift from ontological concerns to epistemological—or phenomenological—ones could be found closer at hand in the critical writings of Greenberg. And this was true even though the esteemed critic appeared to experience a failure of nerve when it came to applying his formalist notions to sculpture. As we saw in the last chapter, Greenberg held that the goal of mainstream modernism had always been a progressive divestiture of everything but the in-

alienable within each of the plastic arts. As regards sixties painting, this culminated, for Greenberg at least, in the Color-Field pictures of Louis, Noland, and Olitski, who worked almost exclusively with a flat, rectangularly shaped canvas and the colors stained into it. But what most pleased Greenberg was the paradox whereby color, which he deemed the essence of painting, tended to dematerialize the canvas even as the soaked-in hues revealed it to be concretely present. When it came to sculpture, a still greater inconsistency occurred, for instead of the weight and physicality that would seem to be qualities most native to the art, Greenberg abandoned theory and relied on taste to justify his preference for the kind of "drawing in space"—the open-form, welded-metal construction—perfected by David Smith, then monumentalized and made still more abstract by England's Anthony Caro in the sixties (figs. 379, 380). With its linear and planar elements suspended in air, often within what appeared to be a shallow relief-like depth, late constructed sculpture could be regarded as essentially pictorial, clearly an object but nonetheless an object that created the illusion of being almost as transparent and weightless—as anti-monolithic—as Pollock's skeins. Moreover, it was relational in design—an asymmetrical whole cobbled together from unalike parts—in the manner long traditional to Cubism and Constructivism. Thus, the principal feature that Greenberg disallowed in his search for ever-greater sculptural purity was "painterly," emotively inflected surfaces, like those in the soldered assemblages of Smith's New York contemporaries—Ibram Lassaw, Theodore Roszak, Herbert Ferber, and Seymour Lipton. If Greenberg did not like painterly painting, neither would he favor painterly sculpture, despite the fact that tactility might be considered as proper for sculpture as it may be improper, in purist terms, for the more visual realm of painting. Seizing on this inconsistency, while also acting on the positivism licensed by Stella, Donald Judd and Robert Morris called for and then began to exhibit sculpture reduced utterly to what they believed would uniquely distinguish it as sculpture—objecthood, meaning a monolithic, gravity-bound form physically present within the same, real depth or space as the viewer himself. To satisfy the formalist demand for gestalt clarity and indivisible wholeness, the form should be chosen from the more regular polyhedrons, such as cubes and pyramids, entities simple and familiar enough to be grasped even before the spectator has explored the mysterious unknown of a three-dimensional object's "other" or

Minimalism: Formalist Sculpture in the Sixties

381. Ernest Trova. *Study: Falling Man (Carman)*. 1966. Polished silicone bronze and enamel, 7' × 2'4" × 1'8".

experience offered by music, literature, or, of course, theater.

The critical debate raged on throughout the mid-sixties, with Minimalist rhetoric attaining its most totalitarian extreme when one writer declared that since painting could never match the visual intensity radiating from abstract works made, like much Pop Art, of "actual materials, actual color, and actual space," it was doomed to die. As posterity knows, the forecast of painting's imminent demise proved quite spectacularly premature, despite the crisis of confidence the forecast itself caused many painters to suffer during the late sixties and early seventies.

As a term, "Minimalism" superseded all other attempts to characterize the growing bent towards cool reductiveness and detachment after Richard Wollheim, a noted Professor of Logic at London University, published an article entitled "Minimal Art" in the January 1965 issue of *Arts Magazine*. However, it would not be applied so broadly as did Wollheim, who grouped under his rubric all manner of works that he saw as possessing "minimal art content"—that is, displaying little or no evidence of the personal, craftsmanly skill and expressive inflection long considered to be the hallmarks of fine art. To Wollheim, Andy Warhol and Roy Lichtenstein, who appropriated prefabricated imagery, could be regarded as Minimalists quite as much as Tony Smith, Donald Judd, and Robert Morris, who had their "original" works fabricated at industrial plants. "Examples of the kind of things I have in mind," Wollheim wrote, "would be canvases by [Ad] Reinhardt or (from the other end of the scale) certain combines by Rauschenberg or, better, the non-'assisted' ready-mades of Marcel Duchamp." But as the argument surrounding Minimalism grew evermore heated—thanks in generous measure to the surpassing quality of the art involved—it soon burned away the Pop and Dadaist works embraced by Professor Wollheim. Even so, there could be no denying that the Minimalist impulse was active in more than just "object sculptures"; it also gave life to three-dimensional forms created in a more traditional organic or relational idiom at odds with ABC radicality. Thus, whether a neo-Arp piece by Étienne Hajdu, a mathematically permuted relief construction by Mary Martin, or a monumental, freestanding steel assemblage by Mark di Suvero or Anthony Caro, sixties formalism of whatever stripe would join with Minimalism in

"blind" side. And since sculpture, unlike painting, has the potential to become an open-air public monument, it should possess nothing "intimacy-producing," such as Cubism's hierarchical, small-to-large, part-to-part relational structure or the sensuous, hand-worked signs of process that Greenberg had already denounced. However, once the aesthetic object no longer had internal relations, its relationship with the environment—not only the surrounding space and illumination but also the spectator perambulating within it—seemed to become disproportionately important. Further, if sculpture achieved impact according to the circumstances of its situation, the work could be said to have lost something of its long-sought independence as an object. With this, Minimalists found themselves counter-challenged by Michael Fried, a formalist critic conceptually allied with Greenberg, who decried the "situational" factor as anti-modernist, which indeed it would become with the advent of Earth Art. Far from enriching sculpture with new "freedoms," Fried maintained that obsessive literalism had impoverished it, transforming a major visual art into a kind of theater, where the work's effect depended upon setting, lighting, and the performance of the viewer, who by approaching the static subject from diverse angles became a kind of "actor." For Greenberg and Fried the truly creative advance had been made not by the Minimalists but rather by those artists who managed to synthesize materialism and illusionism. In painting this meant, preeminently, Stella and in sculpture Anthony Caro. Because of its see-through form, the latter's work, quite as much as Stella's, had "presentness"—a wholly manifest all-at-onceness—that constitutes the essential common denominator of all the visual arts, in contrast to the unfolding, temporal

above: 382. Yves Klein. *Blue Sponge*. c. 1959. Stone and metal, 29 × 12 × 10". Solomon R. Guggenheim Museum, New York.

right: 383. Étienne Hajdu. *Adolescence*. Marble, 35½" high. Hirshhorn Museum and Sculpture Garden, Smithsonian Institution, Washington, D.C.

opposite left above: 384. Pietro Cascella. *Temple of the Bull*. 1969. Travertine, 2'3½" × 2'3½" × 3'7¼". Courtesy Galleria Arte Borgogna, Milan.

opposite right above: 385. Max Bill. *Endless Ribbon from a Ring I*. 1947–49, executed 1960. Gilded copper on crystalline base, 14½ × 27 × 7½". Hirshhorn Museum and Sculpture Garden, Smithsonian Institution, Washington, D.C. (gift of Joseph H. Hirshhorn, 1966).

opposite right below: 386. José de Rivera. *Construction # 107*. 1969. Stainless-steel forged rod, diameter 5'9⅞" × 3'4". Hirshhorn Museum and Sculpture Garden, Smithsonian Institution Washington, D.C. (gift of the artist through the Joseph H. Hirshhorn Foundation, 1972).

aiming for a concrete, abstract statement purified to a degree—usually a totality—beyond even that achieved by David Smith in his late Cubi series (fig. 380).

Biomorphic Abstraction in Sixties Sculpture

The sixties found no more telling or ubiquitous symbol of the period's reductive tendencies, or its entanglement with industry, than the sleek, robotic, machine-controlled Falling Men of Ernest Trova (1927—), a self-trained but craftsmanly artist long resident in St. Louis (fig. 381). Developed in painting and graphics as well as in sculpture, and in series that ran through endless variations from 1961 to 1972, the mannequin-like image lacks arms, facial features, and sex but seems unmistakably to represent Everyman—the Everyman, that is, of a late 20th-century humanity de-individualized, immobilized, but finally wheel-driven and dominated by its own technology. This was Minimalism as science fiction might have conceived it, and for that reason immensely effective at the time of the art's creation.

In his moon-flower sculpture made of a single sponge saturated with IKB and speared onto a wire stem (fig. 382), Yves Klein affirmed the Duchampian spirit at work throughout the sixties, its irony yielding rich content for the whole of Pop and its love of the ready-made spreading to the very core of Minimalism. Klein, as we have seen, anticipated both developments (figs. 278, 279), and both are very much present in the little Dubuffet-like work seen here. It came into existence when the artist discovered that the sponges he used to paint the Blue Monochromes, like the one in fig. 324, became as impregnated with glowing ultramarine as he hoped his viewers would be with the Rosicrucian sensibility—the longing for worldly resolution in the spiritually ripe Void—imparted by his paintings. Having made several hundred sponge sculptures, Klein provided a material answer to questions about the differences in quality among his many, superficially identical Blue Monochrome panels. It came, principally, at a 1959 exhibition in which numerous sculptures were grouped together as a kind of forest, each of whose "trees" appeared to be unique even though it clearly partook of the same phylum of found object.

By the 1960s Étienne Hajdu (1907—), a Romanian-born School of Paris veteran, had refined his art until it seemed the ultimate distillation of acknowledged influences assimilated from such richly varied sources as Cycladic idols, Brancusi, Léger, and Arp (fig. 383). Eliminating the moderns' rebellious wit but moving even further into ab-

straction, Hajdu produced hammered-copper reliefs and polished, freestanding marbles as serene in mood as their supple, undulant surfaces and silhouettes are lustrously, even tenderly finished. Gentle to an extreme degree, "they exist," as the artist once wrote, "only because of the light."

Like Henry Moore, Pietro Cascella (1921—) descended from the stone-carving, figure-obsessed tradition of both Michelangelo and the primitive, sources that he made personal and contemporary by working them through Constructivist conventions of simplified, interlocking forms (fig. 384). Italian that he was, however, Cascella felt no need to analogize his abstract figurations to landscape, nor any reticence about the sexuality of their content. Moreover, the grand, well-rounded, full-bodied statement came naturally to him, which resulted in his being kept busy with a series of large public commissions, projects that sometimes required assistance from his brother, Andrea Cascella, an almost equally well-known sculptor with compatible ideas and stylistic inclinations.

Late Constructivist Sculpture

The Bauhaus had no more faithful witness to its principles than Max Bill (1908—), the Swiss architect who studied at Dessau and, as he had been taught, became a master of almost every art—not only architecture but also industrial design, typography, painting, and especially sculpture. Like many good Constructivists of his generation, Bill believed that sculpture meant the creation of clear, concrete models giving effect to a mathematical conception of form as a self-revealing, symmetrical growth outward from a generative core (fig. 385). One of his favorite devices was the endless loop known as the Möbius strip, a spiral sure to overcome all sense of stasis by offering the viewer no one, frontal aspect, but rather an unfolding sequence of

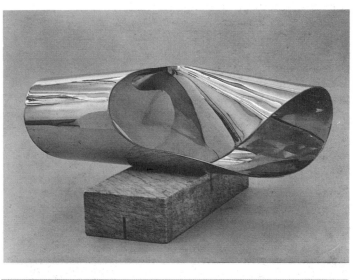

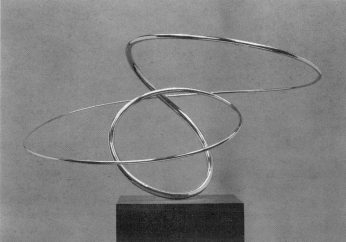

aspects, each of which seems right even as it impels the viewer to investigate the complete circuit. In the work seen here a single ribbon of polished brass became a topological figure whose continuous, twisting convolutions serve to describe the nature of a sphere. Simultaneously complete and unresolved, the sculpture embodies Bill's ideal of closing the gap between science and art, intellection and intuition.

If the self-educated American Constructivist José de Rivera (1904——) did not attend the original Bauhaus, he nonetheless mastered the scientific theories of the De Stijl sculptor Georges Vantongerloo. This in turn enabled him to formulate his own notion of the open, self-evident gestalt figure, a form whose clean, continuous lines—a gleaming lasso in space—and industrial manufacture seemed to endow technology with feeling (fig. 386). At the same time, it proposed a bracing corrective to the existentially improvised, welded-metal, relational sculptures of the David Smith generation. His was indeed an art for art's sake, since, as de Rivera said: "The content, beauty, and source of excitement is inherent in the interdependence and relationships of the space, material, and light, and is the structure."

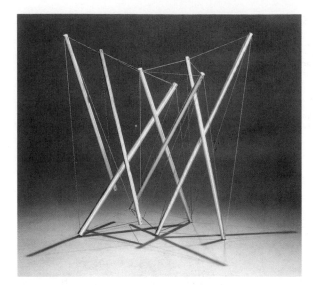

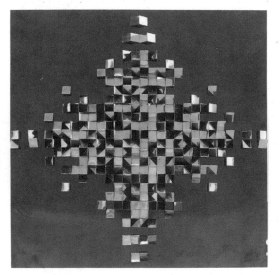

left: 387.
Mary Martin. *Cross.* 1968. Stainless steel and wood, 4'5⅛" square. Walker Art Gallery, Liverpool.

above: 388.
Kenneth Snelson. *Maquette for a Sculpture.* 1976. Aluminum and stainless-steel wire, 17⅜ × 16 × 8⅜". Hirshhorn Museum and Sculpture Garden, Smithsonian Institution, Washington, D.C.

In England, pure Constructivist abstraction had been powerfully launched in the 1930s by Nicholson and Hepworth, but then gave way, under the force of turbulent times, to the postwar impulse towards the varieties of neo-romantic, quasi-figurative abstraction seen in Chapters 3 and 4. Countering this trend, however, was Victor Pasmore, whose switch, in 1951, from an organic to a geometric idiom and from painting to constructed reliefs stunned the British art world (fig. 100). Very soon, however, he found himself joined by a rare group of like-minded converts, exhilarated by their encounter with Constructivist aesthetics after long, professional years in representational painting. Outstanding among these were Kenneth and Mary Martin, the one noted for his mobiles, which will be seen in the next chapter, and the other for her mathematically derived but exquisitely calibrated reliefs (fig. 387). Mary Martin (1907–69), unlike Mondrian, for instance, but in keeping with most of the artists to be seen henceforth in this chapter, did not merely simplify or stylize an object already present in the world. Rather, she projected into the world an original object materializing—making concrete—a purely abstract or intellectual construct. As Kenneth Martin put it in 1951:

What is generally termed "abstract" is not to be confused with the abstraction from nature which is concerned with the visual aspect of nature and its reduction and distortion to a pictorial form; for, although abstract art has developed through this, it has become a construction or concretion coming from within. The abstract painting is the result of a creative process exactly the opposite to abstraction.

Further, the inner source plumbed by the new English Constructivists was not the unconscious but, rather, the conscious, rational mind,

which preconceived or designed the image instead of discovering it through active engagement with materials. And while many postwar artists experimented with nontraditional media, the substances favored by Mary Martin would often be the new synthetic or industrial ones compatible with the Corbusier-type architecture in which a number of her works served to help create a kind of modern Utopia. For Martin, as for Pasmore, the constructed relief—an art form halfway between painting and sculpture—offered a means to escape the illusionism and ambiguity found in modeled or carved sculpture as well as in painting. A relief like the one seen here eliminates the ambiguous factor of freestanding sculpture's concealed side, and the spatial relationships among its planes are all concrete, not implied. To increase the clarity and order of their work, the English Constructivists frequently employed transparent plastic, allowed only the white, black, and gray colors inherent in their materials, and based compositions on such proportional schemes as the Golden Section. Martin took the cube as the basic unit of her formal vocabulary, its right angle echoing that of the wall and floor. For variety, she first sliced the cube in half, then sometimes sliced it again along the angle of its hypotenuse, which together literalized the shallow depth and illusory tilting of the planes in Analytic Cubism. Finally, in later pieces, she composed the halved and triangulated cubes according to mathematical permutations, which control the progression of modular cells so that the eye is led through a logical, though inventive and surprise-filled, exploration of what the artist called the "parting from and a clinging to a surface." Yet, once Martin began sheathing her geometries in satin-finished stainless steel, the rhythm of the underlying mathematical system tended to dissolve into the elusive visual poetry of an intricately faceted surface glittering with irrational or unpredictable, ever-shifting reflections.

A more visionary and yet more scientific exponent of late Constructivism is Kenneth Snelson (1927——), who, like so many Americans of the sixties generation, discovered himself artistically at Black Mountain College. This, however, did not occur in the classes of Josef Albers but rather in those of the futuristic architect R. Buckminster Fuller. So completely did Snelson identify with Fuller in his preoccupation with the liberating structural possibilities of tension combined with compression—or what would soon be called "tensegrity"—that he made a significant contribution to the master's triumphant achievement of the polyhedral geodisic dome. But while Fuller hoped to save the world through rational, scientific design, Snelson used mathematics, physics, and engineering for largely aesthetic ends (fig. 388). Thus, some of his energetic geometries based on the principle of tensegrity—rigid, compressive aluminum or stainless-steel tubes and tensile steel cables sustained in equilibrium—may be as simple and clear as a regular crystal, even as other such airy, open-form construc-

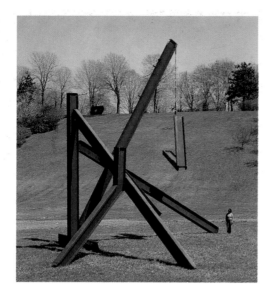

389.
Mark di Suvero.
Are Years What?
(for Marianne
Moore). 1967.
Steel, 40 × 40 × 30'.
Collection
Enrico Martignon.

tions offer the capricious complexity of a spider's web or a kind of frozen acrobatics.

Constructed Sculpture after David Smith

Mark di Suvero, a sculptor presented earlier as one of the most monumentalizing of the Assemblagists (fig. 294), lost none of his humor and humanity when he entered so fully into the Minimalist spirit of the sixties that he gave up scrap for steel beams (fig. 389), while nonetheless continuing to evoke de Kooning and Kline, as well as to describe his work as "painting in three dimensions with the crane as my paintbrush." Now the compositions became starker, more purely structural and more centrally focused, the better to support the kinetic elements that a stronger medium allowed. Still, even at their most majestic, di Suvero's steel-girder constructions beckon viewers to push, bang, spin, ride, or clamber over them—on one occasion actually to lie on a mattress—all the while that they vault to rapturous, gravity-defying heights. In attempting to make private experience compatible with Utopian aspiration, di Suvero gave his work political content, which became overt when he moved to Venice in 1971 and remained there for the next four years as a protest against the war in Vietnam.

In Britain, abstract art took a bold step forward in 1960, the year that saw not only the debut of the Situation painters (figs. 345, 346) but also the first open-form, welded-steel, entirely nonfigurative constructions made by Anthony Caro (1924—), the lavishly gifted Eng-

lish artist whom Clement Greenberg would designate heir to the mantle of David Smith. Although Caro had studied at the tradition-bound Royal Academy and had first encountered modernism in the sensuously carved or modeled, anthropomorphic monoliths of Henry Moore, his employer for two years, he was somehow prepared to grasp, almost instantly, the possibilities of a nonobjective, structuralist idiom once these were revealed to him by Greenberg in 1958, during a visit by the American critic to St. Martin's School of Art, where Caro had been teaching since 1953. It may have helped that he came to sculpture with a Cambridge degree in engineering, for even in his early Moore-inspired figures the formal liberties Caro took with the human image betrayed an approach to plastic issues even hardier and vastly more unsentimental than anything displayed by the "geometry of fear" sculptors seen in Chapter 4. For Caro, Greenberg's aesthetic theories were made manifest in living art when, thanks to a Ford Foundation grant, he arrived in New York for a two-month stay in the winter of 1959–60. Following discussions with Smith, Kenneth Noland, Helen Frankenthaler, and, again, Greenberg, Caro returned to the United Kingdom and taught himself to weld, using prefabricated steel because it was "anonymous, arbitrary, and . . . cheap." Very quickly and with characteristic panache, he achieved a mature art in soldered and bolted assemblages of I-beams, boiler heads, aluminum tubing, and expanded mesh, works whose self-supporting, horizontal sprawl made them seem like Smith Tanktotems toppled onto the floor (fig. 390). They were also likened to bare-bones skeletons of Moore's recumbent giantesses stripped not only of flesh but also of their pedestals. Meanwhile, the constructions' rectangular planes suspended aboveground and the bright monochromatic color used to unify the piecemeal array of mismatched components evoked the Field paintings from which Caro took much of his inspiration. However, behind all such constructed sculpture lay the welded-iron works of Picasso and, of course, González, whose phrase "drawing in space" could never be more aptly applied than to a Caro masterpiece like the one seen here. Equally pictorial in effect is the apparent weightlessness of the construction, a purely optical effect created by the very thinness of the literally heavy, powerful members, as well as by the absence of mass in a see-through structure built of nothing but planes, edges, and lines. Adding to the sense of a Rube Goldberg contraption hovering lightly just above grade is the wit with which Caro confused structural and pictorial elements, so that while the plinth-free work clearly inhabits the viewer's own space, it also animates the world in a manner

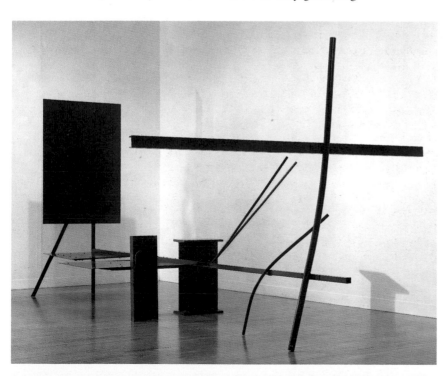

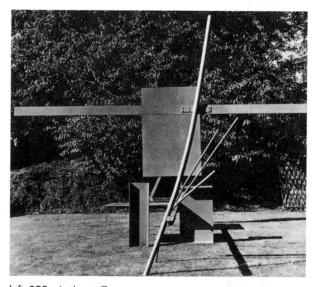

left: 390. Anthony Caro.
Early One Morning. 1962.
Painted aluminum and steel, 9'6" × 20'4" × 10'11".
Tate Gallery, London.

above: 391. Anthony Caro. *Early One Morning.* 1962.

Minimalism: Formalist Sculpture in the Sixties

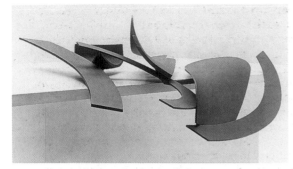

left: 392.
Anthony Caro.
LXXXII. 1969.
Steel,
57½ × 17½ × 47½".
Tate Gallery,
London.

left below: 393.
Anthony Caro.
Veduggio Sound.
1972–73.
Rusted and
lacquered steel,
91 × 80⅞ × 52".
Kunsthaus,
Zurich (gift of
Dr. W.A. and
H.C. Bechtler).

bottom: 394.
Phillip King.
Genghis Khan.
1963. Fiberglass
and plastic with
steel supports,
7 × 9 × 12'.
Tate Gallery,
London.

opposite above:
395. Phillip King.
Call. 1967.
Fiberglass and
painted steel;
two pieces each
14'6" × 6" × 6",
two pieces each
5 × 6 × 3'.
Courtesy
Juda Rowan
Gallery, London.

There are a lot of different ways I work now, but when I began I'd have a bit of steel and I'd stick it up, maybe put a block of wood under one end, and say, well, it needs something to make it work. So you keep on going until it works. Really, you discover what you've done afterwards. Art's to do with discovery.

Following a suggestion from Noland, Caro found it especially fruitful to develop series, only a token few of which can be mentioned here. A remarkable one of the mid-sixties involved tabletop sculptures (fig. 392), works whose small scale made the horizontality, linearism, and planarity already seen in *Early One Morning* appear all the more pictorial. Resting on the edge of the support and even tumbling over it, the compositions suggest landscapes or still lifes, but revealed anew through the abstract language of steel and oxyacetylene torch. Many of the tabletop pieces contain scrap metal transported from David Smith's rich stores at Bolton Landing after the American died in 1967.

In 1972–73 Caro accepted an invitation to work at a steel mill in Veduggio, Italy, where access to raw malleable steel and an electric hoist enabled him to realize effects of an unprecedented painterliness, using rough, fluidly shaped cut-offs dropped by the rollers (fig. 393). Enraptured with the magnificent rawness of the metal sheets, Caro often composed them vertically, and instead of adding color, merely sealed the surfaces with a coat of clear varnish. This helped distinguish the works as sculptures even as their lyrical, biomorphic edges echo those in the Field paintings of Helen Frankenthaler, who in fact had worked in Caro's studio for a short while just prior to the Italian experience. As deft, open, and avidly experimental in his teaching as in his artistic practice, Caro became a major catalyst for the brilliant stream of highly individual sculptors who would emerge, one after the other, at the St. Martin's School of Art.

England's "New Generation" Sculptors

The first to benefit from Anthony Caro's incandescent example were England's "New Generation" sculptors, so-called for a 1965 exhibition in which they starred at London's Whitechapel Art Gallery. The earliest to emerge had been Phillip King (1934—), a Cambridge grad-

so distinctive that its existence as something special—a work of art—cannot be questioned. What Caro seized upon as essential in Smith's sculpture was, as Rosalind Krauss has argued, the "formal strategy of discontinuity," like that observed in *Blackburn* (figs. 199, 200) and here presented in *Early One Morning*. While the view from almost any angle discloses the work to be a complex, three-dimensional, physically present object belonging to the same universe as the viewer himself, a frontal stance transforms the sculpture into quite a different sort of experience (fig. 391). Instead of concrete, the work becomes an illusion, one in which real depth appears collapsed as if all the disparate, strung-out components had resolved upon a single plane, either as fields of flat color or as a network of linear, draftsmanly gestures. This, as much as anything, sets Caro's sculpture apart from Moore's—where, as in Constructivist works, the outer form seems, whatever the vantage point, to be a clear, direct expression of an inner, generative core—and identifies it with a social context considerably less harmonious than the Utopian one cherished by older modernists. For Caro, coherence derives, of course, from the uniform color and the industrial nature of all the materials and techniques, but also from the unfailing élan with which the artist could discover clarity and poise even within the episodic syntax of compositions marked by high-risk invention and extreme asymmetry.

Another revelation that came to Caro from David Smith was the assurance that abstraction might be as much about feelings as about ideas. "I didn't have to represent, and I could still put my feelings into it," the English artist said. This accounts in part for the sense of release generated by works like those seen here (fig. 379), a sense that also flows directly from the zestful, confident way in which Caro creates. Unlike Smith, Caro has never made models or drawings:

below: 396.
William Tucker.
Memphis. 1965–66.
Plaster, 30 × 58″.
Tate Gallery, London.

bottom: 397.
Tim Scott. *Wine.* 1968.
Steel tubing,
acrylic sheet;
180 × 156 × 66″.
Tate Gallery, London.

uate like Caro, but in languages, rather than engineering, and culturally enriched by the first eleven years of his life spent in Tunisia. Although drawn to the St. Martin's School by Caro's position there, King entered so fully into the new problem-solving approach that his own sculpture could be seen as a virtual critique not only of Caro but also of Moore, in whose studio King too underwent an assistantship. Although as committed as Caro or his own fellow New Generationists to an autonomous, object-like sculpture, King looked to Brancusi, rather than to González, Picasso, or David Smith, and concentrated on closed, rather than open, form—a quasi-geometric form quirky enough to flirt with, while also remaining independent of, both Minimalism and Pop. In *Genghis Khan*, for instance (fig. 394), he avoided the cube in favor of its first cousin, the cone, and used steel only for the armature, which he covered with purple fiberglass and then embellished the simple, overall mass with a pair of Oldenburgian antlers or batwings and a flared skirt that spreads over the floor like rippling liquid. As theatrical and exotic as an Oriental tent, *Genghis Khan* bespeaks a memory steeped in the Islamic world of North Africa. However, King declared himself disinterested in metaphor, but obsessed with the notion of a sculpture whose special qualities of volume, stability, shape, and color encourage the viewer to perceive a unique "character" or an "identity" in the process of self-revelation. Later in the decade the artist moved a bit closer to Minimalism, both in the elementary, serially repetitive, boxy forms he now preferred and in the sense of characterful space or environment the multi-partite works attempted to establish (fig. 395). But a piece like *Call*, with its bright, glossy colors and rocking, bowing, or dancing relationships, animates an insouciant world delightfully different from the static solemnity evoked by orthodox Minimalism.

Also born in North Africa—at Cairo, actually—but then educated in Britain, right through Oxford, where he read history, William Tucker (1935—) gave New Generation sculpture its most stringent expression, not only in objects but in extensive critical writing as well (fig. 396). For the piece seen here, he recovered something of sculpture's traditional *gravitas*, a quality dispersed in the weightless-seeming, open-form structures welded or bolted together by Caro. Like the Minimalists, Tucker worked with modular units, albeit invented, biomorphic ones, but then painted each of them a different color and stacked the lot in what seems a random manner. Citing "physicality" and "visibility" as the paramount factors of sculpture, Tucker said:

I use the word visible, visibility, *here not as synonymous with* perceptible, *that is simply open to perception in the manner of the perceptibility of all objects, but to designate an active quality of work—it goes out to meet, is made to attract and hold our sight.*

After Tucker wrote that "sculpture is a proposition about the physical world, about a finite order (completeness), and by implication about our existence in the world," his co-New Generationist Tim Scott (1937—) replied: "Sculpture acts by displacement; it is the *state* of being, the *state* of feeling, the *state* of experience, the *state* of physical awareness and sensation, the *state* of confrontation by physical phenomena; not these things themselves or an interpretation of them."

As this would suggest, Scott longed to make his sculpture as much a psychological as a material presence, and to this end he often assembled large-scale works in which similar and dissimilar elements—bulky geometric solids and thin transparent panes, flat cut-out shapes and their fugal echoes in bent-tube outlines—played off one another in a counterpoint of the delicate and the brutal (fig. 397). Adding to this antiphonal dialectic of like and unalike were such mixed, theretofore non-art media as fiberglass, sheet acrylic, glass, and metal piping, as well as a "swinging London" array of bright, untraditional colors. Clearly, Scott was attempting to move beyond not only Caro and David Smith but also Brancusi, who, of course, had heightened the aura of his polished organic essences by setting them forth in symbiotic juxtaposition with primitive, rough-cut abstract bases.

Minimal Sculpture

With his BS in philosophy and his MA in art history, both from Columbia University, Donald Judd (1928—) entered the avant-garde scene as one of its best-informed and most articulate members, an artist who would earn a reputation for his bluntly ideological criticism, published between 1959 and 1965, before ever he proved himself as a Minimalist sculptor par excellence. Just as this was occurring, however, Judd issued his two most influential and oft-quoted articles: "Local History" (1964) and "Specific Objects" (1965). In them he made clear the inspiration he had found in Stella's slab-like Black, Aluminum, and Copper paintings, but then went on to argue that the very quality he most admired in these works—their "amplified inten-

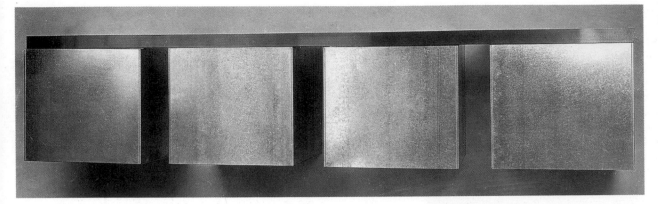

left: 398. Donald Judd. *Untitled.* 1966. Galvanized iron and painted aluminum, 33 × 141 × 30". Courtesy Leo Castelli Gallery, New York.

below: 399. Donald Judd. *Untitled.* 1969. Anodized aluminum and blue Plexiglas, each of four units 47½ × 59⅞ × 11⅞". City Art Museum of St. Louis.

sity'' or unimpeded physical/visual impact—could be more perfectly achieved in genuine three dimensions. Still, if painting of any variety suffered from the fatal flaw of illusionism, sculpture as it had been practiced, even by modernists, was so relational in its part-to-part composition, whether modeled, carved, or constructed, that it could not but disclose itself gradually, rather than with all the immediacy possible in what Judd chose to call ''Specific Objects.'' As exemplified in Judd's own work, Specific Objects would be unitary or indivisible in shape, color, and surface, thus utterly present in their objecthood and ''intense, clear, and powerful'' in their appeal. Judd had abandoned painting in 1961, but not until 1964 did he begin to find his characteristic form, a relief-like ''arrangement'' of open, modular boxes cantilevered from the wall, stacked vertically or hung from a horizontal bar and always at regular intervals (figs. 376, 398). Because industrially prefabricated in galvanized iron, the boxes' color was integral with the material they were made of, a manufacturing medium with none of the humanist associations attached to wood, marble, bronze, or even the hand-welded metals favored by David Smith and his contemporaries. Furthermore, the very thinness of the galvanized iron quite literally declared the box to be shell-like and its interior to be precisely what it was: empty. Projected from the wall as they are, Judd's Specific Objects require no base, and this, as well as their gravity-defying lightness and structural tension, keeps them from evoking the human figure, either reclining or standing. Equally nonreferential—or self-referential—is the mathematically derived progression of the repeated, identical units, which by eliminating the hierarchical structure of traditional composition, with its counterbalanced major and minor elements, also dispensed with the outside world it reflected. In place of the old complexity, Judd offered clarity, which he deemed essential if his art was to be absolutely direct in its engagement with the viewer. Although suspended in space and obviously hollow, the light-weight boxes are also bolted to a solid wall, which makes them seem utterly immobile rather than floating, an illusory kind of movement as alien, in Judd's aesthetics, to static visual art as spatial illusionism. The impression of monumental fixity would become even more pronounced in the late sixties, when Judd recast his serial boxes as large, freestanding floor pieces (fig. 399). Meanwhile, he also recast them in a great variety of other materials, including perforated and stainless steel, brass, and copper. A venturesome colorist, Judd would sometimes spray-paint the surfaces with Harley-Davidson motorcycle enamel and lacquer. As in fig. 376, he might also seal the boxes top and bottom with sheets of colored Plexiglas, a permissible elaboration because the hue is integral and the material transparent enough to leave the interiors clearly visible, not veiled in mystery. But with his increasing use of tinted Plexiglas and polished metals, Judd—once considered the most puritanical of Minimalists— seemed to be indulging a long pent-up taste for luxury and elegance, a development that prompted Hilton Kramer to accuse him of having ''been a closet hedonist all along.''

In contrast to Judd's Specific Object, a hybrid semi-relief that the artist himself said ''resembles sculpture more . . . but is nearest to

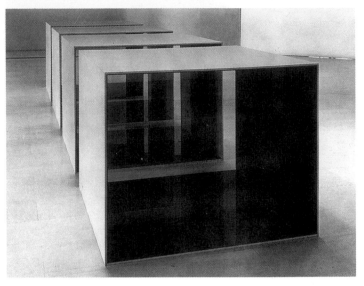

painting,'' the Unitary Object that Robert Morris (1931—) called for would be sculpture purified—like the new formalist painting—of everything extraneous to its own unique physical condition. In Morris' view, sculpture-as-sculpture meant a literal, monolithic, three-dimensional, gravity-bound presence with ''its own, equally literal space—not a surface shared with painting.'' However, in arriving at such autonomous purity, Morris had traveled through a richly miscellaneous experience, which included academic preparation comparable to Judd's, an early career as a painterly abstractionist, and involvement in a variety of improvisational theater and Rauschenberg-type performances. Endowed with a mercurial intellect and a chameleon capacity for operating at the cutting-edge, wherever art sliced during the last quarter-century, Morris wrote some of the most orthodox of all formalist statements, at the same time that he also embodied them in Unitary Objects whose pure Minimalist appearance he often subverted with an irony betraying his former life in the world of Duchamp, Cage, and Johns. For instance, when he failed in painting to make a finished work reveal the process of its creation, Morris solved the problem through a series of constructions entitled ''Box with the Sound of Its Own Making.'' Here, as far as the eye could tell, was a legitimate Unitary Object, in the form of a plain walnut box, which, however, contained a three-hour tape that could be activated to replay the sound of the container's fabrication. Not only had process and product been rendered continuous, but so too had present, real time, in which the Unitary Object exists, and past, historical time during which it came into existence. Far more notorious, however, was the Unitary Object entitled *I-Box* (fig. 400), which came forth as a box indeed, but one fitted with an I-shaped door that, if opened, presented the self-photograph of the grinning artist frontally posed in the heroic altogether. Not only does the shape of the door mimic or mock the I-beam structural member favored by sixties Constructivists and Mini-

malists alike, but the image it frames also sends up both the existential self-revelation so cherished by the Abstract Expressionists and the narcissistic self-referentiality of Minimalist forms. Moreover, here was process-product continuity with a vengeance, since the creation appears to have consumed its creator. This alone should clue us that far from a mere joke, the *I-Box* with its image of a naked man also recalls medieval and Renaissance tomb sculpture, which, as in all sixties art, raises a question, this time of just what the paradoxically live *gisant* had to smile about? The human dilemma, evidently never distant from Morris' mind even at Duchampian moments, would become quite dramatically overt in subsequent series—especially the Turneresque, firestorm paintings of the 1980s—after the artist had witnessed what seemed to have been the death of modernism itself.

Beginning in 1964, however, Morris muted his inveterate irony and preoccupation with process in order to answer the emergent siren song of formalism, which he did in words as well as works, the former published in a trio of *Artforum* articles entitled "Notes on Sculpture." Now the Unitary Objects became considerably more so, forms that appeared to be truly purified into what only sculpture could be. Among the "simpler polyhedrons" that Morris fashioned were cubic, circular, oval, wedge, and various beam shapes, usually presented in serial arrangements, but the most modular of all the ensembles would be a set of L-beams (fig. 401). Identical in scale, proportion, shape, and mass, these gestalt forms—forms so obvious that, as Morris wrote, "one need not move around the object for the sense of the whole . . . to occur"—were also consistent in their uniformly neutral or light-gray tonality. Such overall colorlessness reflected Morris' belief, which ran counter to Judd's, that hue, being "essentially optical, immaterial, non-containable, non-tactile [in] nature . . . is inconsistent with the physical nature of sculpture." Industrially smooth in finish, the L-beams resembled nothing so much as mass-produced, standardized elements used in heavy construction. Yet, as Morris explained, "simplicity of shape does not necessarily equate with simplicity of experience." Thus, while the right-angle volumes seemed to possess all the monumentality of public sculpture, their anonymous surfaces could not altogether conceal the fact—a fact deliberately left ambiguous—that the sense of solid mass was an illusion created by paint applied to hollow, hand-carpentered plywood box-forms (later remade in stainless steel). Moreover, the impression of timeless, static monoliths was undermined by the diversity of their postures—standing, prone, tipped—which together suggested a narrative progression through time. As a result, even the most unitary or nonrelational objects could not, by virtue of their very self-referentiality, but create tension, and thus a relationship, with the spatial setting. Into this context now stepped the circling viewer, who would inevitably experi-

ence the "constant known shape" as a sequence of intricate variations on a given, very simple theme. Once Morris and his Minimalist brethren took account of this expanded or recomplicated "situation"—entailing the "variables of object, light, space, body"—they were already on their way towards sculpture liberated into a total, out-of-doors environment—even to Earthworks—a post-modern development more fully identified with the 1970s.

Meanwhile, Morris permuted his shell-like Unitary Objects through a wide range of other, often non-art materials—granite, wire mesh, aluminum, fiberglass, heavy timbers, concrete—but the most premonitory of all was gray felt, an Oldenburg- or Beuys-type substance so inherently formless that its use signaled a shift of interest from form to what Morris considered its dialectical opposite, matter (fig. 402). Although as preconceived and as geometrically cut as his rigid Unitary Objects, the new felt works could not be predetermined in their ultimate shape, which in fact would never be final, thanks to the collapsible, ever-changing nature of the medium. Like Richard Tuttle in painting, Morris—ever the cunning, cerebral strategist—was now taking Minimalism to a point where it could only meld into its opposite, the anti-form mode of the Conceptual seventies, when Duchamp would again be in the ascendancy, this time over Greenberg.

Compared to Morris, with his terrorizing combination of severe ideology, uningratiatingly blank, anti-historical forms, and corrosive irony, Dan Flavin (1933—) could be taken as one of Minimalism's few romantics. Here was an artist, for instance, who used ready-made fluorescent tubes not only to achieve Minimalist literalness, but also to express nostalgia for Russia's pioneer Constructivism (fig. 377), as

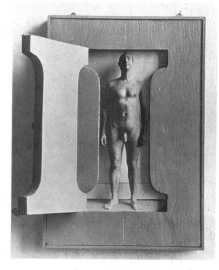

right: 400. Robert Morris. *I-Box.* 1962. Mixed media construction, 19 × 12¾ × 1⅜". Collection Mr. and Mrs. Leo Castelli, New York.

below right: 401. Robert Morris. *Untitled (L-Beams).* 1965. Stainless steel, 8 × 8 × 2'. Whitney Museum of American Art, New York (gift of Howard and Jean Lipman).

below left: 402. Robert Morris. *Untitled.* 1967. Gray felt, 12 × 4'. Courtesy Leo Castelli Gallery, New York.

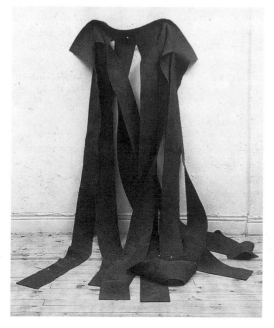

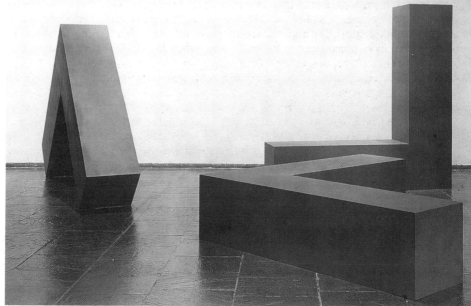

well as for ancient mystical notions of light as a medium of transcendence, especially in its power to transform a gray institutional space by flooding it with decorative refulgence (fig. 403). Columbia-educated in art history but self-taught in studio practice, Flavin too embraced Duchamp, at least to the point of working with mass-produced artifacts and calling the results, not sculptures, but "proposals" sketching out preconceived ideas. Irony, however, could not flourish in the sensibility of an artist capable of fashioning reliefs as systemic and object-like as anything in Minimalism, only to call them "icons," because they seem to celebrate barren rooms, and entitle his first fluorescent piece with the diaristic phrase *the diagonal of personal ecstasy (the diagonal of May 25, 1963).*" For the work seen here, Flavin employed standard strips of fluorescent light as his modular units, their specific lengths and colors chosen to create the "primary structure"—a rectangle outlined in red, blue, and yellow—designated by the title. Simultaneously as the work evokes early Constructivism, with its unprecedented use of industrial materials and its conception of art as science, *A Primary Structure* also seems to comment on Kelly's *Red Blue Green* (fig. 352), as if to demonstrate that, when generated by real illumination, the primary colors—the product of light—are of a higher order than when merely painted. Soon, however, Flavin shifted from a "spiritual" conception of light's transfiguring potential to a more phenomenological one, inspired perhaps by Tatlin, Johns, and Stella, but nonetheless justified with a reference to William of Ockham, the medieval English scholastic who had reasoned that "reality exists solely in individual things, and universals are merely abstract signs." Increasingly thereafter Flavin concentrated on the facts of his medium and its physical effect: the tube itself, which, on close looking, always remains a steady, specific, material presence, whether switched on or switched off; the disembodied radiance it emits and is optically all but dematerialized by; and the impact of the light on the immediate environment. Now, as Flavin wrote in 1965:

. . . the entire interior spatial container and its parts—wall, floor and ceiling, could support this strip of light but would not restrict its act of light except to enfold it. . . . Realizing this, I knew that the actual space of a room could be broken down and played with by planting illusions of real light (electric light) at crucial junctures in the room's composition.

The literalism of Flavin's commercial hardware seems truly lightweight in contrast to the dense, heavy metal slabs with which Carl Andre (1935—) assembled his modular, floor-hugging "carpets" (fig. 404), works designed to eliminate the "illusion" that material forms might forever, unaided, defy the ultimate reality affecting their existence: gravity. Not for Andre either the hollow boxes created at one time or another by almost every Minimal sculptor, nor the drawing in space so deftly wrought by David Smith and Anthony Caro. In Andre's aesthetics, volume counted for little, relative to the overriding importance of physical matter and its weight. Disdainful of elitist virtuosity and the preciousness traditionally ascribed to sculptural materials, Andre wrote that his work "is atheistic because it is without transcendent form, without spiritual or intellectual qualities; materialistic because it is made out of its own materials without pretension to other materials. And communistic because the form is equally accessible to all men." Hidden within this last point, however, is a conceptual trap, for according to Andre, modern sculpture had developed first as "form," then as "structure," and now had become "place." However, once a piece consists of nothing more than 29 feet of aligned but unmortared firebrick (fig. 405), the only place in which it could assert its identity as sculpture would be the specialized environment of gallery or museum, sites far from "equally accessible to all men." As Robert Hughes wrote:

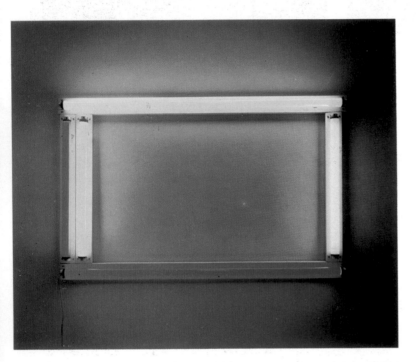

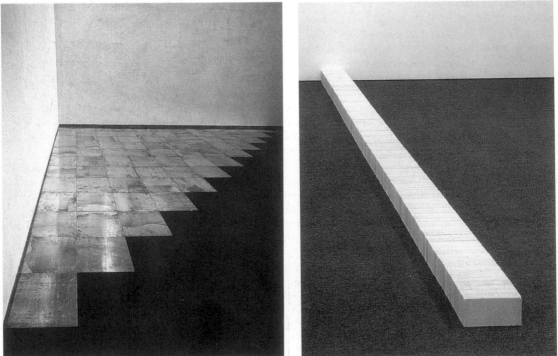

above: 403. Dan Flavin. *A Primary Structure.* 1964. Red, yellow, and blue fluorescent light; 2 × 4'. Collection the artist.

right: 404. Carl Andre. *Twelfth Copper Corner.* 1975. Copper; 78 plates, each 19½" square. Courtesy Sperone Westwater Gallery, New York.

far right: 405. Carl Andre. *Lever.* 1966. 137 firebricks, 4½" × 8⅞" × 29'. National Gallery of Canada, Ottawa.

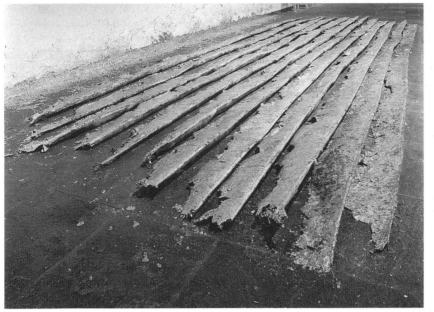

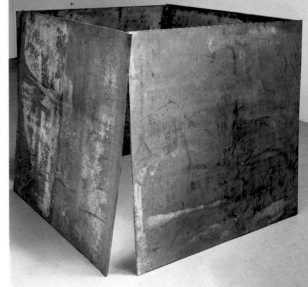

left: 406. Richard Serra. *Casting* (destroyed). 1969. Lead, 25 × 15'. Courtesy Leo Castelli Gallery, New York.

below: 407. Richard Serra. *One-Ton Prop (House of Cards)*. 1968–69. Lead plates, 4'7" square. Saatchi Collection, London.

The essential difference between a sculpture like Andre's . . . and any that had existed in the past is that Andre's array of bricks depends not just partly, but entirely, on the museum for its context. A Rodin in a parking lot is still a misplaced Rodin; Andre's bricks in the same place can only be a pile of bricks. . . . the paradox of such works was that they staked everything on the institutional context for their effect, while claiming to have the density and singularity of things in the real world.

But if modern sculpture did not evolve quite as Andre believed, certainly his own did, beginning with piled-up timber pieces for which Brancusi's *Endless Column,* with its almost infinitely repeating, rough-hewn, modular diamond shapes, had been "the supreme inspiration." Another critical "teacher" was Frank Stella, a one-time classmate at Andover who, for a while, allowed the studioless Andre to work in his Lower Manhattan loft. Watching Stella develop the gestalt simplicity of the Black-Stripe paintings, Andre arrived at what he called the principle of "anaxial symmetry," in which "any part can replace any other part." Stella also brought him to the realization that the thing he "was cutting into was the cut." And so "rather than cutting into the material," he began to "use the material as the cut in space." At first Andre stacked the cuts, but then he abandoned this structural process for the definitive one among his preferences, which was to employ the materials "in a way that would be place-generating." This made them "situational works," since, as noted earlier, their presence as sculpture hinged upon the site in which they could be so arranged as to create a special sense of place. In 1966, when the first of the floor-oriented, site-specific works was exhibited—the 137-firebrick "cut" noted above—it caused an uproar among viewers concerned that their credulity may have been abused. To this Andre responded: "All I'm doing is putting Brancusi's *Endless Column* on the ground." Soon, however, the sensualist that seemed to lurk within every puritan Minimalist asserted itself, as Andre submitted to the beautiful colorism of aluminum, steel, and iron, magnesium, copper, zinc, and lead, having the materialized hues delivered to him in standard, prefabricated squares of metal and using them as "a kind of palette." Adding to the impression of discreet opulence was his decision to acknowledge gravity—as well as the flat, ponderous, plate-like character of his medium—and assemble the "particles" on the floor, where, as a checkerboard pattern of systemic units, they became a sculptural equivalent of a rich Persian rug. Not only did Andre believe that "copper is more profoundly different from aluminum than red is from green"; he also appreciated the very real differences among metals, each with its own weight, mass, texture, and conductivity. To share this with viewers, the artist urged them to walk on his pieces, thereby offering a totally different kind of experience—leveling,

democratic—from that of the vertical, pedestaled, domineering, anthropomorphic sculpture. "Most sculpture is priapic with the male organ in the air," he said. "In my work, Priapus is down on the floor. The engaged position is to run along the earth." In a summary comment, Irving Sandler has recently written: "Andre's contribution to sculpture was to make a piece simultaneously an object, a base, and a site."

Like Andre, as well as Morris in his felt pieces, Richard Serra (1939—) allowed the force of gravity to become the forming agent of his sculpture. First, however, he demonstrated the idea in a film, thereby approaching plastic art, as Morris had, through performance. Called *Hand Catching Lead* (1969), the film provided a three-minute, real-time record of just that—the artist's hand in the concentrated, repeated attempt to seize falling strips of lead, one after the other. Although still more monotonous than a Warhol movie—or perhaps for that very reason—the performance did serve as a temporal expression of the simplicity, literalism, and serial repetition so fundamental to Minimalism's new, anti-traditional way of composing pictures and sculptures. Next, Serra used performance to create a site sculpture (fig. 406), splashing molten lead along the right-angle juncture between floor and wall, pulling the cooled, solidified material towards the center of the room, and then repeating the two-part act until the piece had been completed as a sequence of similar, if not precisely alike, metal strips. Altogether, *Casting*, as Serra called the work, resembled a rough, floor-bound relief version of the rippling stripes in Stella's frame-locked Aluminum paintings (fig. 361). Frequently violent in its rhetorical attack upon formalist problems, Minimalism had now recaptured some of the gestural violence, as well as the emphasis on process, once so prized by the Action painters. But rather than materialize personal, interior experience, as the Abstract Expressionists had, Serra, like most Minimalists, hoped to create meaning through engagement with the facts and workings of the external, physical world.

In Serra's *One-Ton Prop (House of Cards)* gravity, the process of its inexorable effect on matter, and heavy metal all came together in what, at first, may seem another Minimalist box (fig. 407). Very quickly, however, all sense of timeless, Platonic ideal is shattered once the viewer realizes that here was Abstract Expressionist or romantic sublime with a radical difference—serene, Platonic perfection shot

Minimalism: Formalist Sculpture in the Sixties

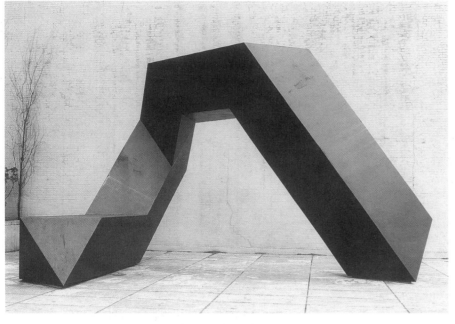

through with terror. Anything but timeless, this cube and its viewers are threatened with imminent disaster, since the piece coheres only by virtue of the precarious balance struck among four 500-pound lead slabs merely propped against one another, not permanently attached. Totally contingent, minute by minute, upon its tense equilibrium to resist the ultimately irresistible force of gravity, *One-Ton Prop* maintains structural integrity only so long as it fails to collapse and damage whatever thing or person may be close by. As for metaphoric significance, Rosalind Krauss has written:

With this work Serra seems to be declaring that we ourselves are like the Prop. *We are not a set of private meanings that we can choose or not choose to make public to others. We are the sum of our visible gestures. We are as available to others as to ourselves. Our gestures are themselves formed by the public world, by its conventions, its language, the repertory of its emotions, from which we learn our own. It is no accident that the work of Morris and Serra was being made at the time when novelists in France were declaring, "I do not write. I am written."*

Although Tony Smith (1912–80) belonged to the generation of David Smith, Pollock, Rothko, Newman, and Reinhardt, and even took many of his aesthetic cues from them, he had been a practicing as well as teaching architect, initially trained at the Chicago Bauhaus, until the 1950s. Then, eager to articulate his ideas in forms less vulnerable to alteration than buildings, Smith began painting more seriously than he had since his student days, a shift of interest that proved to be a mere prelude to his climactic work, which arrived in 1960 when sculpture finally claimed him, at the age of forty-eight. For about two years, Smith tested his plastic abilities in cardboard and wood maquettes, which, combined with his experience as an architect, made him especially well prepared to respond to a Newark billboard advertising the Industrial Welding Company, which stated: "You specify it; we fabricate it." When Smith phoned the company and ordered "a six-foot cube of quarter-inch hot-rolled steel with diagonal internal cross-bracing," he virtually ushered in, without knowing it or without its being known to the art-critical world, the Minimalist era of what, by 1966, would be termed Primary Forms or Structures. Calling one of his prototypical black boxes *Die* (fig. 457), Smith explained that the size of the piece had been determined by the famous Leonardo da Vinci drawing of a man whose outstretched hands and feet describe the corners of a square. With this he revealed not only an architect's cultivated sense of scale but also a generational bias towards the sense of anthropomorphic presence so vigorously eschewed by younger, hard-core Minimalists, among them his own student Robert Morris. In retrospect, moreover, Smith projected his monadic geometries on a

colossal, assertive scale more like that of engineered structures—bridges or skyscrapers—than the passive, gallery-bound modules favored by Judd, Morris, Flavin, and Andre. Also, he expanded from the cube to tetrahedrons and octahedrons, which, as Smith said, allowed him to create "something approaching the plasticity of more traditional sculpture, but within a continuous system of simple elements. . . ." Arching up, over, then down and finally turning on itself, *Cigarette*, for example, suggests a mathematical concept extrapolated, as in a process of crystallization, until the geometric had become organic (fig. 408). Unlike classic Minimalism, the sculpture is also heroic as well as romantic in its stretch and complexity, an extended, asymmetrical form permitting human passage through its own space and offering itself from multiple perspectives, none of which discloses the complete work in its entirety. With their rough, black surfaces colored, or discolored, by rust, Smith's steel scaffoldings seem often to evoke, in modern industrial terms, such primitive monuments as menhirs, earth mounds, and megalithic Stonehenge. Occasionally they even appear to translate into Minimalism's sober geometric idiom something of the wit and humor of Calder's comic-monster stabiles (fig. 157).

Tony Smith's vital forms seem stable indeed compared to the illusion of almost baroque energy emanating from the epically scaled structures invented by Ronald Bladen (1918–88), a Canadian-born art-

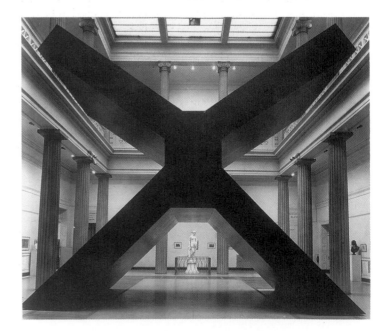

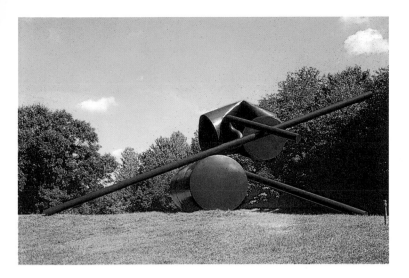

The Minimalist whose name in later years has become almost synonymous with monumental sculpture is Beverly Pepper (1924—), Brooklyn-born and Pratt-educated but long resident in Italy. Although a sculptor still discovering the full range of her powers, Pepper first won critical attention with a series of stainless-steel boxes whose Minimal look—a look of stubborn, physical thereness—very quickly dissolved under the impact of the eventful world reflected on their gleaming surfaces and the anomalies of both their configuration and their assemblage (fig. 411). In *Venezia Blu*, the stacked, see-through cubes serve as frames for viewing whatever environment lies beyond, at the same time that the forms' mirror-polished blue-enameled interiors constitute a set of nonreflective planes that declare nothing but their own flatness, thereby providing a foil to the real and fictive depth

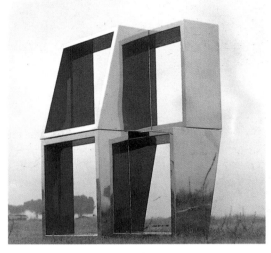

ist active in San Francisco and then in New York. For the theatrical piece entitled *The X* (fig. 409), Bladen permitted the limbs of Leonardo's modular man to break free of their containing square or box, leaving it to become an abstract torso suspended in space as the four extremities thrust outwards to a width of 24 feet and a height of 22. Here gesture and structure have become one, for, as Stephen Ellis recently remarked, Bladen made it the core issue of his art to reconcile the fifties' mythopoetic concerns with the phenomenological ones of the Minimalist sixties.

Something comparable might be said about the Russian-born American artist Alexander Liberman (1912—), who, however, could just as well be ranked among the Assemblage or Junk sculptors, since he worked very much as Mark di Suvero—an acknowledged influence—did in the early 1960s. Nonetheless, when Liberman first exhibited in 1953 it was with paintings so flat, so hard-edged, so "primary" in form, and so enameled or industrially finished that they subsequently came to be esteemed as Minimalism *avant la lettre*. Indeed, at the very moment when subjective Abstract Expressionism utterly dominated New York art, Liberman declared that "the ego is hateful" and sought to achieve an "art of anonymity" capable of being "repeated like music" or even re-created by an assistant should the original disappear. By 1953 Liberman went so far as to "order" a sculpture made from specifications given over the telephone, a radical process that Tony Smith and his Minimalist brethren would take up only a decade or more later. Yet, while Liberman revered the formalist tradition of Cézanne, Brancusi, and the Russian Constructivists, he also valued Duchamp, Arp, and the importance they placed on the role of chance in art. Thus, when he began assembling colossal sculptures from junk, the particular junk he favored happened to be tank drums, boiler heads, giant pipes, and steel beams of a sort that could be treated, sliced up, or joined as a classical vocabulary of columns, circles or disks, squares, and triangles (fig. 410). But when it came to composing these modular units, he once again depended upon the operations of chance to dictate a baroque syntax of multidirectional thrusts into space—often like bursts from a central, circular core—that Liberman likes to view as abstract variations on the powerfully dramatic gestures found in Michelangelo's *Adam* and Bernini's *Saint Theresa*. Meanwhile, he has engineered his mammoth sculptures to be as firmly structured, base-free, and self-supporting as the architecture he learned to design while a student at Paris' École des Beaux-Arts. By painting his big outdoor works a uniform red, Liberman hoped to reinforce the transformation of junk into art, and thus mute the nostalgic echo of the materials' former life favored by orthodox Assemblagists. A polymath, high-energy virtuoso, Liberman has earned distinction not only in painting and sculpture but also in photography, commercial design, and the editorial direction of all Condé Nast publications, including, for many years, *Vogue*.

experienced elsewhere in the sculpture. Adding to the complex interplay of form and space are not only the mutual, narcissistic reflectivity of the modular cells' own surfaces, but also the stepped-back composition and the oblique angle at which some of the boxes have been cut on one side. If such irregularity of surface, shape, and structure endows open, crystal-clear geometry with an unexpected degree of volatile ambiguity, it is for a reason, which Pepper once explained thus:

. . . I realize now that (my decisions) came from the same emotional source that has formed all my work. I want the sculptures to seem to be creating relationships which are very simple, yet at the same time are beyond the viewer's grasp. I want it to seem as though an inexplicable coherence works inside the sculpture to generate external aspects of its physical being which are always unexpected because they are unpredictable.

With her illusionistic devices and concern for content, Beverly Pepper could not be seen as an orthodox Minimalist, nor could the great Noguchi, whose natural versatility and Oriental love of formal purity made it relatively easy for him to shift, in certain works, from his usual biomorphism (fig. 159) to the boxy form-language that Minimalism all but made universal during the mid and late sixties. Thus, when commissioned to create a piece for the public plaza fronting a major bank's new skyscraper headquarters near Wall Street, Noguchi offered *Red Cube*, one of his most abstract designs, but pivoted the huge monolith on one corner, instead of letting it rest flat on the ground (fig. 412). In this way, color and posture combine to endow the geometric mass with a splendid sense of weightlessness and élan. By animating the Minimalist cube, Noguchi also humanized a brutally harsh and overscaled commercial environment, for to him art, always, should function as a medium of the spiritual life. The commission, moreover, gave the sculptor a long-sought opportunity to bring to a Western public space a touch of the celebratory ethos he had found in the Zen gardens of Japan.

Minimalism: Formalist Sculpture in the Sixties

Minimalism found its West Coast monarch in Larry Bell (1939—), who reconceived the epistemological cube as a transparent, delicately iridescent crystal, primarily for the sensuous, visual pleasure it offered, rather than to satisfy some heavy-metal theory propounded in New York (fig. 413). Los Angeleno that he was, Bell made light his all-important subject; moreover, he served it by exploiting the high-tech resources of the local aerospace industry. Vacuum-coating six identical squares of glass with various metallic compounds, Bell bound them together with stainless-steel strips and then installed the glazed cage atop a clear Plexiglas stand, which allowed the box's interior to admit illumination from every side. As the viewer looks through the work in order to see it, he realizes how introspective the experience is, the consequence of discovering himself, as well as the environment, reflected, counter-reflected, or blocked off in a shimmering maze of fleeting effects from alternately opaque and transparent sheets of tinted glass. Ultimately, the hard-edged, brittle object seems to dematerialize, leaving the viewer romantically suspended between real and purely optical presence.

As Bell's rainbow boxes suggest, Southern California Minimalists had become very much involved with the latest research in perceptual psychology, none of them more scientifically than Robert Irwin (1928—), Bell's teacher at the Chouinard Art Institute in Los Angeles. An unsparingly self-critical artist, Irwin seemed not to achieve satisfaction in his attempts to reduce and clarify his means until the late 1960s, when he began exhibiting a series of reliefs that created the impression of dematerializing before one's very eyes (fig. 414). As solid matter, each of the works consisted of nothing but a convex acrylic disk, covered with light-sensitive pigment, projected from the wall, and there suspended in space. However, it assumes complex, even magical existence once light beamed from four different directions causes the circular form to cast a quatrefoil of overlapping, symmetrically arrayed haloes, which together both frame and echo the luminous disk itself. To anchor the floating, evanescent play of light and shadow, Irwin bisected the work seen here with a sharp-edged horizontal bar. If the artist's lambent reliefs, like Bell's light boxes, appeared to push Minimalism beyond its original obsession with objecthood towards anti-materialist Conceptualism, his "site-specific" works—to use a term coined by Irwin himself—could be seen as going virtually the whole way (fig. 415). In these environments or installations—each exemplifying a kind of "objectless" Minimalism—

412. Isamu Noguchi. *Red Cube*. 1969. Painted welded steel and aluminum, 28' high. 140 Broadway, New York City.

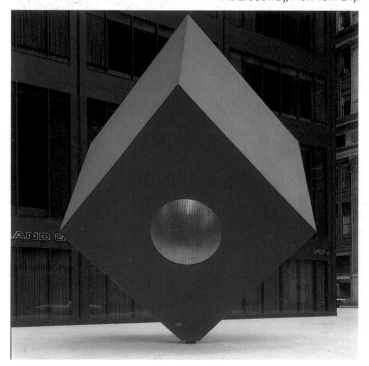

left: 413.
Larry Bell. *Untitled*. 1967.
Mineral-coated glass
and rhodium-plated brass
on Plexiglas base;
20" cube, base 37" high.
Whitney Museum of
American Art,
New York (gift of Howard
and Jean Lipman).

opposite left above: 414.
Robert Irwin. *Untitled*. 1968.
Acrylic on cast acrylic,
4'6" diameter.
Fort Worth Art Museum.

opposite left below: 415.
Robert Irwin. *Untitled*.
1971. Fluorescent light and
scrim. Walker Art Center,
Minneapolis
(gift of the artist).

opposite center: 416.
John McCracken.
Untitled. 1967.
Fiberglass and lacquer,
7'10" × 1'2¼" × 1¼".
Saatchi Collection, London

opposite far right. 417.
Ellsworth Kelly.
White Angle. 1966. Painted
aluminum, 6 × 3 × 6'.
Solomon R. Guggenheim
Museum, New York.

Irwin worked with taut, illuminated scrims of cheesecloth or nylon, which, when viewed from a tape-demarcated zone, presented the viewer with a clearly defined structure utterly different from the original space, yet looked as though made of nothing but a nontactile field of contained light.

When John McCracken (1934—) began tilting his vividly monochromatic, brightly lacquered wood or fiberglass planks against gallery walls, it seemed as though he had three-dimensionalized a Newman canvas and thus literalized the Minimalist conviction that purist, abstract painting "wanted" to become sculpture (fig. 416). But if the work proved attractive for vanguard reasons, it also appealed by virtue of the casual, laid-back posture, the Pop colors, and the surf- or diving-board connotations, all of which seemed entirely appropriate in the oeuvre of a California artist. However, while McCracken did combine formalist rigor with West Coast informality, he also escaped the strictly phenomenological corner in which hip critics wanted to place him. Indeed, the artist saw his glistening, unitary slabs as "meditation devices," works capable of drawing and sustaining interest but, like Klein's chunky Blue Monochromes, simple enough to be looked "through" and "beyond" towards the "total universe 'picture'."

Phenomenologists could perhaps more legitimately claim the New York–based Ellsworth Kelly, who, as we saw earlier (figs. 351–354), was a Minimal painter before the fact, but he also became a Minimal sculptor, mainly by following his own logic and literalizing the shapes he had long been making congruent with the two-dimensional picture plane (fig. 417). In this way, Kelly offered viewers a doubly enriched experience, allowing them to re-live something of the process followed by the artist himself in his search for new and interesting silhouettes in shadows or reflections, which deliver a readily accessible subject but in a form distorted by the surface over which its image has been cast. Thus, in sculpture, Kelly clarified his central preoccupation with, as E.C. Goossen wrote, "how the truth of a phenomenon is often withheld by an appearance that has its own equally valid truth, how something that is normally bent . . . when flattened

presents a new face, and how a thing that is normally flat when bent does the same.''

In the furniture-like Formica-veneered objects fashioned by Richard Artschwager (1924—), Minimalism seemed to fuse with Pop Art, a cross-fertilization, or hybridization, that has enabled the artist to keep his oeuvre blooming, as well as seeding one new movement after another, throughout the last quarter-century (fig. 418). For the seminal work seen here, Artschwager inlaid a Minimalist cube with a pattern of colored Formica that transformed the abstract form into a simulated plywood table covered with a pink cloth. So complete is the paradoxical image—a reconstructed ready-made in which black Formica depicts the void between the table legs—that it includes the detail of a cloth just small enough to miss covering the tabletop's four corners. For this union of concretion and illusion, of painting, sculpture, and object, of the hand-made and the mass-produced, of high art and popular culture, the ultimate prototypes could be found, of course, in Johns' Flags and Targets or in Warhol's Brillo Boxes. Some have even seen Artschwager's slyly adulterated Primary Structures as Hard-Edge cousins to Oldenburg's soft sculptures. But while Pop recontextualized, confronted, and thus critiqued a wide range of contemporary art and life, Artschwager, a perfectionist cabinetmaker before he became a full-time artist, focused on the universe of ersatz materials, especially trompe-l'oeil wood graining submerged in the inorganic slickness of Formica. With a wit to match his craftsmanship, he appropriated this pseudo-reality as a sculptural medium and thus rendered the generic thing it embodied as phony as the fetishistically perverse substance itself. But while employing abstraction to empty a utilitarian object of its utility, Artschwager also mocked Minimalism for its indifference to social context, a context in which the modern world, owing to industrial and media technology, seemed increasingly to withdraw from reality, experiencing it more through surrogates like *faux bois* Formica than through direct encounter. Hence, as early as 1964 Artschwager was already projecting formalist criticality far into the seventies' anti-formalist Conceptualism and the eighties' passion for appropriations and simulacra, developments in which Artschwa-

418. Richard Artschwager. *Table with Pink Tablecloth.* 1964. Formica on wood, 25¼ × 44 × 44". Saatchi Collection, London.

ger would be regarded as a hero, if not by the challenge-resistant public, then by a newly aggressive avant-garde.

With Sol LeWitt (1928—), who appeared on the New York scene in 1965 at the height of formalism's hegemony, object-obsessed Minimalism could be said truly to have evolved into its opposite, object-averse Conceptualism, but not before this new artist had endowed the Minimal canon with some of its most visually exhilarating structures (figs. 419, 420). Indeed, LeWitt considers himself a Conceptualist, convinced that the most important component of his work is the idea that sparked it. After all, LeWitt wrote in 1967, once ''the planning and decisions are made beforehand,'' as they had been in Minimalism from the start, '' . . . the execution is a perfunctory affair.'' But if

Minimalism: Formalist Sculpture in the Sixties

LeWitt's sculptures and drawings emerged as things of elegance and, yes, great beauty, it was no doubt thanks to the creative freedom of the mental activity that preceded their mechanistic production. Indeed, the artist insisted that when it came to conception, the process must be completely intuitive and, like purposeless play, reach beyond logic, for only "irrational judgments lead to new experience." Given this, "irrational thoughts should be followed absolutely and logically." A key element in LeWitt's thinking about idea-derived art was that physicality play a reduced role, to prevent its distracting from the quality of the concept embodied therein. As a result, LeWitt disallowed both new, attention-grabbing materials, as "another kind of expressionism," and "complex basic forms" because they would have "disrupt[ed] the unity of the whole." Instead, he adopted Minimalism's modular grid and its three-dimensional counterpart, the cube, most often realizing this not as a dense volume but rather as an open framework of joined beams. Quite arbitrarily, LeWitt decided to finish the members in an anti-subjective baked-enamel white and to allow a ratio of 8.5:1 between the solids and the intervening space, but once the system had been established, he followed it slavishly. Reinforcing him in this resolve was a rich array of acknowledged precedents, among them the sequential photographs of Eadweard Muybridge's 19th-century studies in human and animal motion; Albers' Homage to the Square series; the serial music of Schoenberg, Webern, Philip Glass, and Steve Reich; and the modular buildings of such International Style architects as I.M. Pei, for whom LeWitt once worked as a draftsman. Altogether unique to LeWitt, however, was the extravagant imagination with which he caused rigorous mathematics to so permute his module, through endless variations of both form and order, that what began as a standard, innocuous grid frequently came to resemble a

mad Platonist's vision of an overgrown, out-of-control tropical jungle. Disposing the cubes in various degrees of openness or closure, completeness or incompleteness, rotating, mirroring, reversing and cross-reversing, juxtaposing and superimposing them, sometimes in contrasts of two and three dimensions, LeWitt subverted the logic of his system even as he adhered to it—so strictly in fact that the resulting structure refers to nothing but the system or, better, to the idea that had activated it. As Mel Bochner, a fellow Conceptualist, remarked in 1966 concerning LeWitt's open modular cube: "Old art attempted to make the non-visible (energy, feelings) visual (marks). The new art is attempting to make the non-visual (mathematics) visible (concrete)." Again, however, at the origin of it all lay the artist's overriding interest in generation or even regeneration, a simple enough idea (which had also gripped Pollock), but one that could nonetheless be demonstrated only with the greatest intricacy, the visual reality of which nobody would ever find more surprising than its instigator. Still, the "art is pure information," as LeWitt said. Thus, given the simplicity of the basic unit and the systemic character of its manipulation, the viewer could, theoretically, experience the whole process in reverse, starting with the object and working back through the concept to the idea that had ignited both concept and object. For one structure/book piece, Lucy Lippard tells us, "he posed the problem to a mathematician, who discovered some 251 permutations for one part of the piece (five cubes touching each other at least at one corner), and around 571 for the other part (five cubes touching each other at least at one side)." Having propounded an hypothesis and had it extrapolated mathematically, LeWitt next assigned the project to his "Japanese army" of assistants for materialization as an aesthetic presence, which in more elaborate instances may end up looking as if a

complete philosophical system had been translated into a purely formal language. To quote Robert Rosenblum: "If anyone could perceive the structural beauty of, say, Descartes' or Kant's treatises and then go on to re-create them as exclusively visual metaphors, it is surely LeWitt." Herein, finally, lies the difference between this artist and a late Constructivist like Mary Martin (fig. 387), who too permuted modular cubes into works of exquisite beauty, which however bore within them a content of faith in the power of rationally ordered structures to reflect universal truths and thus serve as a visionary paradigm of a more perfect world. In contrast, Minimalists used set theory and science as a means of making art-as-art. For LeWitt the starting point would always be an intuitive leap beyond reason, a never-ending search for "new experience," and so logic has often functioned in his work "only to be ruined" (fig. 459). According to Lippard:

LeWitt's work is rich in contradictory material, which operates at times as a mental and at times as a visual construct. He confronts concepts of order and disorder, open and closed, inside and outside, two- and three-dimensionality, finity and infinity, static (modular) and kinetic (serial).

Viewing his art as "pure information," LeWitt has found it natural enough to work in the medium of books, there combining words with images, just as he would on an architectural scale in his celebrated wall drawings (fig. 421). For these, LeWitt conceives each work as a verbal proposal, then leaves it to be carried out by others at whatever site the piece has been designed for. The proposal might be as precise yet free as: "Within the six-inch squares, straight lines from edge to edge using yellow, red, and blue pencils." Here again, no one would be more astonished than LeWitt by the consequence of such instructions, an experience that could be repeated with each new rendering in a different place by a fresh team of assistants. With the art thus regenerating itself endlessly, LeWitt suffers no agony when, after only a brief duration, the drawing must be painted over to liberate the gallery wall for the next exhibition. As for the quality of LeWitt's wall drawings, Rosenblum has captured it unforgettably:

More phantom than substance, these boundless, gossamer traceries appear like mirages on walls and ceilings, and seem to be simultaneously nowhere and everywhere. But the magical shimmer and mysterious mathematical symbols of these environmental fantasies are also subject to the kind of simple rationalization that permeates all of LeWitt's work, as if the roles of primitive sorcerer and geometer were combined. The formulas given are easy enough . . . and the execution can be entrusted to any number of competent draftsmen . . . yet the experience of the completed works is not one of dry cerebration but, as Jean-Louis Bourgeois phrased it in 1969, "like yard after yard of exquisite gauze."

Although at one with the sixties in his formalist reaction against postwar expressionism, George Sugarman (1912—) occupies a prominent place in the decade even more maverick than that of LeWitt and equally prophetic of the future. This, however, would be a future utterly divorced from LeWitt's dematerializing Conceptualism, but closely allied with the kind of anti-Minimalist, ebulliently decorative trend anticipated by Stella in his Protractor series. Yet, for all his idiosyncrasy, Sugarman very much belonged to the decade now under review, if for no other reason than the contact, however slight, he made with so many of its developments—to such a degree that he could be seen as a kind of summary figure. It all began in 1955 when the artist returned to New York from Paris, following a year's study with Ossip Zadkine, and found himself struck anew by "the conglomerate but somehow cohesive structure of the city." "These two factors," he said, " . . . helped me work toward the idea of a sculpture structured by disparate forms. At the same time, a renewed awareness of the country beyond the city, the openness of the plains, made me look for less formal, even open-ended relationships in sculpture." Shortly thereafter Sugarman also rediscovered Stuart Davis, the pioneer American Cubist who had written: "Color must be thought of as texture, which automatically allows one to visualize in terms of space. . . . Every time you use a color you create a space relationship." Thus, when Sugarman hit his artistic stride in the early sixties it was with rambling, crawling, climbing—almost clattering—assemblages of wildly inventive, multicolored forms—all different in size and shape—that seem quite as much about generation or self-regeneration as LeWitt's permuted cubes (fig. 422). Sawing or carving into hand-laminated wood, Sugarman created an immense diversity of abstract figurations—some organic, others geometric, every one unique—and then chain-linked them in "families," each of which he painted a vividly distinguished hue. Modular or systemic in the uniformity of the process used, in the flat, abstract color applied to every surface, and in the unabating quirkiness of the personality expressed, *Two-in-One*, the sculpture seen here, also engages the environment as Minimal works do, while animating it in energetic ways more like those of David Smith's or Caro's constructions. With its highly original morphologies, the piece recalls Hajdu but also England's New Generationists, or even Kelly and Youngerman. Once the analogy with painting has been made, Matisse's painted-paper cut-outs and Stuart Davis' jigsaw patterns come to mind, making Sugarman's sculpture look as though *Jazz* or *Blips and Ifs* had been recast in three dimensions. And if the open-endedness matches that of LeWitt's proliferating grids and cubes, it also recalls the sense of boundless potential generated by Pollock's whirling webs and Stella's Black Stripes. Polychromed like Chamberlain's crushed-automobile assemblages, *Two-in-One* is, however, formalist art devoid of the sociological commentary implied by junk materials, and while as high-spirited as Pop Art—sometimes as comic as Oldenburg's floppy sculptures—it is much too autonomous to traffic in irony. Given such multivalence within independence, such order within chaos, Sugarman was right when he wrote in 1974: "I tend to think of [my works] as meeting places, where forms invented to please the visual imagination find their right colors and are organized into a space that invests them with their most suggestive relationships."

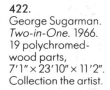

422.
George Sugarman. *Two-in-One*. 1966. 19 polychromed-wood parts, 7'1" × 23'10" × 11'2". Collection the artist.

Op, Kinetic, and Light Art

A salient characteristic of 20th-century modernism has been the tendency to isolate or abstract one of art's constituent elements—line, plane, color, shape, surface, gesture, mass, even the frame—and then systematically explore its every possibility for yielding unprecedented formal, expressive, or thematic impact. In the late 1950s, as the high-romantic energy stored in gestural abstraction spun off a dizzying sequence of brilliant counter-responses, a number of artists caught the spirit of the times by taking energy, motion, or movement itself as an issue potent enough to become both the subject and the form of significant new art. Such deliberate exploitation of kinetics may also be seen as yet another manifestation of the period's desire to literalize whatever had been merely represented or evoked in prior art, especially the action in Action Painting or the slow, dematerializing expansiveness in Color-Field Painting. As the earlier references to Gabo's *Kinetic Construction: Vibrating Spring* (fig. 439), Moholy-Nagy's *Light-Space Modulator* (fig. 447), and Albers' Homage to the Square series might suggest, the emergence of an art devoted exclusively to optical or physical dynamics came from the heirs of Russian and Bauhaus Constructivism—or, rather, from a line of development ancillary or subsequent to the one already seen in the work of such postwar Constructivists as Auguste Herbin, Victor Pasmore, Alexander Calder, Max Bill, José de Rivera, Kenneth Snelson, and Mary Martin. Thus, the aesthetics of mobility loomed larger in Europe than in the United States, and while it did produce several major American artists, these generally eschewed the social or egalitarian interests fundamental to European Constructivism and identified with the high-art ambitions then dominant in American painting and sculpture.

Nevertheless, it was in New York that both pictorial and sculptural kinetics received their authoritative, term-giving formulations, the first in William Seitz' 1965 MoMA exhibition entitled "The Responsive Eye" and the second in a 1967 book, *Constructivism: Origins and Evolution*, by George Rickey, an American sculptor whose work will be seen in this chapter. What "The Responsive Eye" show addressed was illusory or perceptual kinetics—the sensation of motion or emphatic change—generated by paintings made up of juxtaposed high-intensity colors or contrasting monotonal patterns. Because the forms themselves remained static—as in all painting, however great the energy invested in its creation—even while they set off unstable optical effects, Seitz and others called the new, truly sensation-seeking pictorial illusionism Optical or simply Op Art. In sculpture, of course, movement—like solid form and deep space themselves—could be real, rather than purely retinal, whether activated by the spectator himself, by motors, as in the experiments of the first Constructivists, or by the wind, as in Calder's mobiles. For this more direct utilization of space, time, and motion, the appropriately direct term Kinetic Sculpture came into general usage. Meanwhile, light itself—the medium through which all visual experience occurs—posed an irresistible opportunity for certain artists who too saw energy, dynamics, technology, and the environment as so central to modern life that they had to become no less central to art.

Op Art, Kinetic Sculpture, and Light Art—all would be as non-objective, usually as hard-edged and geometric, as anything in con-

423. Josef Albers. *Homage to the Square: Glow.* 1966. Acrylic on fiberboard, 4' square. Hirshhorn Museum and Sculpture Garden, Smithsonian Institution, Washington, D.C. (gift of Joseph H. Hirshhorn, 1972).

424. Josef Albers. *Stufen (Steps).* 1931. Study for etched-glass panel, gouache with pencil underdrawing on paper; 18¼ × 23¼". Hirshhorn Museum and Sculpture Garden, Smithsonian Institution, Washington, D.C. (gift of Joseph H. Hirshhorn, 1966).

temporary painting and sculpture. Moreover, their deliberate and dramatic provocation of the senses, if not the intellect, was done for the same reason as all the other bold, tradition-shattering measures taken by modern artists—to engage the viewer more immediately and thereby perhaps liberate him from the shackles of conventional seeing, feeling, thinking, and/or even living.

Op Art

The most original aspect of Op may have been its almost instantaneous as well as simultaneous acceptance on both the esoteric and the popular fronts once the new art arrived in the autumn of 1964. Two years earlier Pop had won powerful gallery support and vast media attention, only for serious critical interest to come much later and then very gradually. Op Art, with its bold, relentlessly vibrating designs, would appear to have been made for a media-driven age now addicted to regular fixes from the world of vanguard art, which seemed inexhaustible in its ability to generate innovative and ever-more newsworthy "breakthroughs." Thus, in the two or three months prior to the January 1965 opening of "The Responsive Eye," *Time* and *Life* had already endowed Op Art with household familiarity, its advent further heralded by the commercial adaptation of tricky motifs to everything from fabrics and window displays to pavements and utilitarian objects. Along with this fun, meanwhile, came the prestige of the MoMA show and Seitz' erudite essay in the accompanying catalogue, which in turn drew not only on manifestoes issued by such European

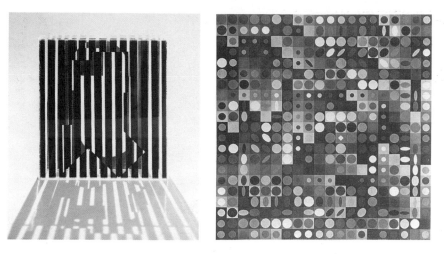

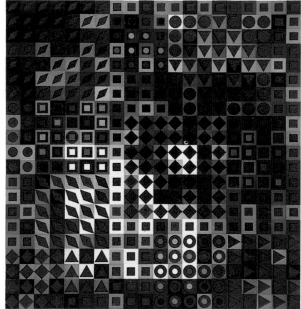

far left: **425.** Victor Vasarely. *Transparence.* 1956. Painted plastic, 13⅜" high. Hirshhorn Museum and Sculpture Garden, Smithsonian Institution, Washington, D.C. (gift of Joseph H. Hirshhorn, 1966).

left: **426.** Victor Vasarely. *Orion MC.* 1963. Oil on canvas, 6'10¾" × 6'6½". Courtesy Denise René Gallery, Paris.

below: **427.** Victor Vasarely. *Orion Noir.* 1963–70. Oil on canvas, 5' 6" square. Courtesy Denise René Gallery, Paris.

Op groups as Zero and GRAV but also on a long, distinguished tradition going back, at least, to Seurat and his Neo-Impressionist or Pointillist followers. Among the most immediate progenitors would have to be included Josef Albers, the great Bauhaus master who in Homage to the Square (1949–76), a series numbering hundreds of canvases, had explored the nonobjective illusionism—the retinal and psychic effects of depth and movement—created by nested squares in different, abutted colors (figs. 330, 423). Long before this, moreover, Albers had already carried out similar investigations but in a vocabulary of black or white lines on clear, frosted, or opaque grounds (fig. 424).

The Op masters too would use both chromatic and monotonal schemes to create an art of pure sensation, a trompe-l'oeil art par excellence designed to fool the eye into accepting an illusion quite at variance with physical facts. However, in relation to Albers' calm, comfortable squares and fugal sequences of thin and thick lines, Op Art's aggressively flickering moiré patterns, shrill color contrasts, and spooky after-images appeared blatantly theatrical and occasionally downright unnerving. For this reason, as well as the reliance of some of the European artists on mass production and its social implications, Op Art fared, on the whole, rather poorly in American critical opinion. Rosalind Krauss, for instance, dismissed it as "perceptual gimmickry," the effect of which "could have been achieved using objects taken from the workshops of the Bauhaus or the diagrams of *Gestalt* psychologists." It did not help that Seitz had included such respected Color-Field and Hard-Edge painters as Ellsworth Kelly, Morris Louis, Kenneth Noland, and Frank Stella in "The Responsive Eye." This outraged Krauss, who declared that Op artists "have nothing to do with opticality as it has emerged in the most important modernist painting of our time." Indeed, "the conceptual groundwork for Op Art and *optical* painting are in fact very far apart," since Op Art, by making trompe-l'oeil illusionism so integral with its very content and overriding objective, appeared to traffic in outworn, academic values. By contrast, the New York brand of optical abstraction, Krauss wrote, "explores and defines a mode of vision based first on Pollock and then on Newman."

For their part, the European artists—among them Heinz Mack, Otto Piene, and Günter Uecker or Julio Le Parc and François Morellet—believed that, by working in anonymous, collective groups like Zero and GRAV, by adapting the methods of science, technology, and industry to artistic purposes, and by making it their purpose to create an art dynamically involved with space, time, motion, and light, they would be sure to engage a great mass of humanity more directly in the Utopian process of fashioning a better, brighter world. In brief, they saw themselves as committed to the laudable enterprise of not only rejecting Informal/Tachist egoism and messy, self-indulgent "gesture" but also of endowing cold geometric abstraction with a human, democratic, activist dimension. This general European trend was also called *la Nouvelle Tendance*—sometimes even the "movement movement"—and its arguments as well as its jazzy, optimistic art prevailed, especially at the 1966 Venice Biennale. Here, as if to rebuke New York's puritanical aesthetics, the judges awarded the Grand Prize for painting to Julio Le Parc, a Paris-based Argentine artist whose work hung in "The Responsive Eye," rather than to Helen Frankenthaler, Ellsworth Kelly, Roy Lichtenstein, or Jules Olitski, the painters chosen to represent the United States in Venice.

At the MoMA show, meanwhile, it was a cluster of strong independents, rather than the collectivists, who dominated, just as they continue to dominate the history of Op Art. Senior among these was the Hungarian-French master Victor Vasarely (1908—), a prolific as well as protean artist generally credited with having "fathered" perceptual abstraction quite as much as Albers. Vasarely had in fact been cultivating this particular field since 1928, the year he enrolled at the Budapest Bauhaus and began studying under Alexander Bortnyik, a onetime student of both Albers and Moholy-Nagy at Dessau. With his intimate feeling for "movement in a plane," Vasarely readily absorbed Constructivist principles and their entanglement with science, technology, commerce, and the betterment of the human condition, all of which prepared him for an audacious career in advertising and design after he made a permanent move to Paris in 1930. Throughout the following decade Vasarely experimented with trompe-l'oeil effects that made flat images—checkerboards, Harlequins, zebras, leopards, prisoners in striped uniforms—seem to occupy and activate a volumetric space totally different from the static two-dimensionality of the supporting surface. Sometimes, the illusion would be created by means of patterned, black-and-white sheets of transparent cellophane overlaid and then shifted about, a technique that the artist quickly brought to perfection in the postwar years, using more permanent materials, such as glass and mirror (fig. 425).

For his *Yellow Manifesto* of 1955, Vasarely coined the term *plastique çinétique*, by which he meant abstract, mathematically controlled forms and colors created and organized to generate optical sensations free of all psychological associations. In keeping with his own practice of *cinétisme*, Vasarely followed the lead of Auguste Her-

bin (fig. 98) and completed what he termed his "planetary folklore," an alphabet of some thirty colors and geometric forms meant to be combined and recombined, with all the infinite, flexible range of letters, to create new color-form unities as coherent as syntactically perfect sentences. With his index of circular, oval, square, rhomboidal, and triangular shapes in particular hues, Vasarely assembled checkerboard grids of variously colored squares and then transformed them into complex mosaics by collaging at the center of each a totally different color-form. The system climaxed in the huge, staggeringly intricate Orions of the mid-sixties (figs. 426, 427), "periodic structures" composed of as many as 400 squares all set with solid cir-

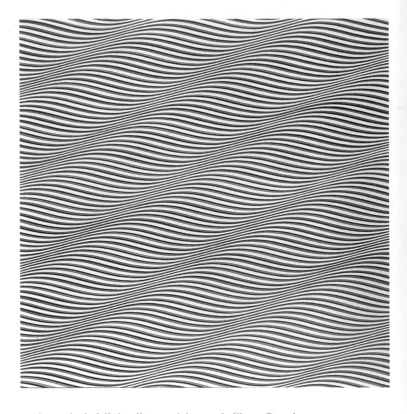

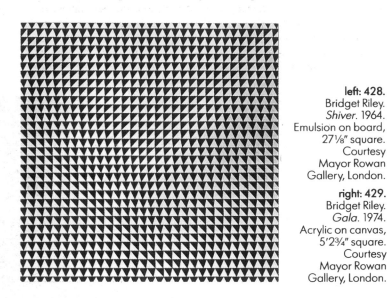

left: 428.
Bridget Riley.
Shiver. 1964.
Emulsion on board,
27⅛" square.
Courtesy
Mayor Rowan
Gallery, London.

right: 429.
Bridget Riley.
Gala. 1974.
Acrylic on canvas,
5'2¾" square.
Courtesy
Mayor Rowan
Gallery, London.

cles and ellipses, save one whose small square or diamond shape deviates from the general rule to increase the overall retinal sizzle released by myriad formal manipulations relentlessly permuted throughout the plane. Just as the concentric bands of sequentially larger or smaller circles imply a space both ballooning outward and retiring into depth, the ellipses suggest circles rotating in place, at the same time that the tilted ones create the illusion of lateral movement. Simultaneously, graduated values connote a smooth, cinematic progression along the surface, while sharply contrasted complementaries appear to jump, leaving the eye not only startled but also tantalized by after-images. But the ultimate effect of this pulsating, syncopated matrix could be likened to a plane geometer's vision of the heavens, an Orion constellation glittering with stars and swept by clouds of drifting nebulae. For Vasarely, such visual dynamism became a substitute for the animated qualities supplied by handwrought processes, which the artist, with his advanced conception of Bauhaus ideals, had rejected in favor of more industrial techniques. Indeed, Vasarely, a man as gifted in business management as in aesthetics, believed that, in order to make art more integral with society, the Picasso-style solitary genius—the creator of unique, precious objects—should give way to the conceptualist, whose coded designs could be executed and endlessly replicated by other hands or by machines, always in pursuit of a "new city—geometrical, sunny, and full of colors."

Although England's Bridget Riley (1931—), with her intense, high-octane optics, created an even greater sensation than Vasarely at MoMA's show, she worked from an inspiration so foreign to the impersonal, "communal" situation urged by her Continental colleague that when a New York dress manufacturer had one of her paintings translated into a fashion textile, she slapped him with a lawsuit. Meanwhile, Riley protested how her work had been "vulgarized in the rag-trade. . . . 'The Responsive Eye' was a serious exhibition, but its qualities were obscured by an explosion of commercialism, bandwagoning, and hysterical sensationalism." No wonder, she went on, "this alienated a section of the art-world." Riley may plot her designs with

mathematical, Minimalist precision and, like a Renaissance master, consign them for execution by an atelier of assistants, but they are handmade to the *n*th degree, from models, furthermore, whose point of departure has always been as poetically subjective and romantic as an Expressionist's (fig. 428). Indeed, behind the boldly dramatic black-and-white, thrillingly jittery masterpieces of the early 1960s lay a personal crisis so grave that the twenty-four-year-old artist suffered a mental as well as physical breakdown. But if self-doubt triggered the collapse, the process of recovery brought artistic self-discovery, through the therapy of teaching small children to make pictures from simple abstract elements, through copying Seurat's pointillist *Bridge at Courbevoie*, and, most decisively, through travel abroad. While crossing a piazza in Venice, for instance, Riley found herself captivated by the patterned splendor of pavement made from interlocking black-and-white marble slabs. Suddenly, just when the formal rigor of this ancient scheme seemed mesmerizingly permanent and pervasive, a storm broke, flooding the square with rain whose sprays and eddies of water made the measured beauty underfoot look as if it were breaking up and scattering in chaotic disarray. Then, just as abruptly as it had begun, the atmospheric violence abated, allowing the light-and-dark stones to resume their cadenced, timeless rhythm. Here, Riley found not only a metaphor but also a universally expressive image for the experience of traveling through the elemental force of inner, personal tempest and surviving to recover a degree of equilibrium. But however unsettling it may be to pick one's way across the treacherous, shifting, lightning-struck terrain of a Riley surface, the artist could scarcely be more lucid in her explanation of how she achieved such remarkable balances between order and disorder:

The basis of my painting is this: that in each of them a particular situation is stated. Certain elements within that situation remain constant. Others precipitate the destruction of themselves by themselves. Recurrently, a result of the cyclic movement of repose, disturbance and repose, the original situation is re-stated.

Gradually, beginning in the late sixties, Riley moved towards less catastrophic polarities, articulating them first in grays and silvers, but then more and more in full color (fig. 429). If the tall, spear-like shafts or waving reeds of hue were as systematically construed as the earlier black-and-whites, the system would also be enlarged and warmed by its inclusion of "optical bleed," the phenomenon by which colors are

so handled as to dupe the eye into seeing not only them but also their non-present, "echoing" complementaries. With much of the pictorial drama now assigned to color, Riley in her later work would simplify the abstract themes until often they consist of stripes and chevrons similar to those of Noland and Stella, but still charged with an optical as well as psychic vitality quite unlike the cultivated cool of American Color-Field or Minimal painting.

Like Robert Rauschenberg, Allan Kaprow, and George Segal, Larry Poons (1937—) sought to extend the environmental possibilities demonstrated by both Jackson Pollock and John Cage, but only Poons—among the younger figures just cited—stuck to pure painting, painting of such implications that it could be identified not only with Op Art but also with its alleged antithesis, the Color-Field formalism of Kenneth Noland, Jules Olitski, and Frank Stella (fig. 430). Though Poons began as a serious student of Cagean aleatory music composition, he discovered by the late 1950s a more satisfying outlet for his creative urge in painting, there achieving a stunningly autographic manner synthesized from the hue-saturated planes of Rothko, Pollock's open, all-over abstract image, and the kind of controlled chance advocated by Cage. More than anything else, perhaps, it was the last influence that enabled Poons to endow the sensuous intensity of abstract color painting with the retinal vivacity of Op Art. The fruit of this alliance can be seen here, in a canvas that had been diagonally gridded in lightly penciled lines before receiving its uniform stain of flat color. Next came the impastoed dots, scientifically placed—for instance, two to a square at opposite corners or sides—but in random order from square to square, so that the pattern seems chaotic even as an informing method can be sensed. Adding to the picture's jumpily disordered order are the elliptical shape and tilted angle of the dots, the push this gives to the diagrid's own axial movement, and the strident complementarity between the color of the brilliant ground and those of the overpainted, particolored "jumping beans." When, in his earlier paintings, Poons learned from friendly observers that his superimposed, color-contrasted circles generated after-images—an effect never seen by the artist himself—he began literalizing the illusion in actual painting. If this new step further complicated his process, without compromising its systematic character, it also accounts for the deceptive arbitrariness of the egg-like units' clustered, serial, or solitary incidence. So consistent was Poons in his method that, unlike Pollock for instance, or his disciples in later Color-Field Painting, Poons allowed the overall image to extend beyond the support's edge, which

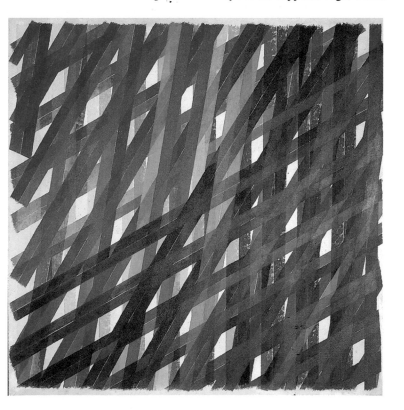

simply sliced it off in mid-motif. For Poons, "the edge defines but doesn't confine the painting," and by treating the design as run-on, as if it were wallpaper stretched over the canvas, the artist revealed his sympathy with the open-ended, expansive spatiality painted by the Abstract Expressionists and developed into Assemblage, Environments, and Happenings by Kaprow and others indebted to the ideas of John Cage. Soon, however, Poons suppressed optical dynamics, although not the overflow principle, and merged more completely into a Greenbergian formalism akin to that of Olitski.

Piero Dorazio (1927—) too could very well be claimed for late Color-Field Painting, if only the warm, Italian vitality and elegance of his work were not sufficiently at odds with aesthetic self-denial to make a work like the one reproduced here look comfortable in the context of Op Art (fig. 431). Still, Dorazio's visual dynamics often seem more classically baroque than retinally disturbing, especially in the canvases structured as large, open palisades or lattices of bright,

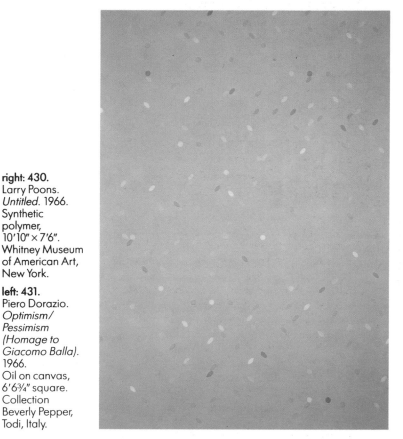

right: 430.
Larry Poons.
Untitled. 1966.
Synthetic polymer,
10'10" × 7'6".
Whitney Museum of American Art,
New York.

left: 431.
Piero Dorazio.
Optimism/ Pessimism (Homage to Giacomo Balla).
1966.
Oil on canvas,
6'6¾" square.
Collection Beverly Pepper,
Todi, Italy.

transparent ribbons. And when the image assumes the character of an all-over, monochrome mesh of tightly woven linear strokes, the rhythm sometimes accelerates to the speed of a Futurist painter turned abstract. If the one manner evokes stained-glass windows, the other, more mesmerizing style could be compared to a fertile bed of organic matter, perhaps a dense, well-trimmed, synthetically colored lawn.

As regards pure retinal excitement, no American artist associated with Op had more success in producing it than Richard Anuzkiewiscz (1930—), who studied at Yale under Albers but once declared himself to have been, probably, the Bauhaus master's worst student (fig. 432). By this, Anuzkiewiscz perhaps meant that, in an unconscious endeavor at self-preservation while subject to the most dogmatic kind of instruction, he did not abandon figuration for abstract color painting until after his graduation. Still, he emerged as one of the pioneers of what in 1965 came to be known as Op Art, doing so with a personal variant of Albers' system of optical color—that is, pure colors so chosen and laid side by side that, in perception, they seem to recombine and thus alter both themselves and the space they occupy. During the

Op, Kinetic, and Light Art

sixties, Anuzkiewiscz accomplished this by working in series of geometric formats characterized by uniform ground colors overlaid with stripes, dots, or thin lines consistent in all but their graduated colors and the progressive density of their intervals. When, for instance, this resulted in grids of concentric, linear squares, the interior hues interacted to create the illusory, after-image effect of vibrantly glowing haloes. Often, with his limitless repertoire of abstract motifs, Anuzkiewiscz could produce ingenious screen-like networks of diagonal rhombi and cuboid modules whose disorienting consequence was to explode Constructivist structure, destroy perspective, and give the impression of a flat surface rendered concave or convex. Like all great colorists, he had a special gift for black and white, creating monochrome canvases, like the one seen here, positively shattering in their impact on the eye.

Somewhat similar to Riley's "cyclic movement of repose, disturbance and repose"—a sort of optical re-enactment of the Hegelian progression from thesis to antithesis to synthesis—occurs in the "metamorphic" paintings of the School of Paris–Israeli artist Yaacov Agam (1928—), who, while studying in Zurich, came under the influence of the Bauhaus masters Johannes Itten and Max Bill. Like all the major artists associated with Op Art, Agam found in the techniques of virtual kinetics an endlessly fertile mode largely because they proved capable of evoking a deep sense of spiritual or broadly human experience. For Agam, a fixed image assumed the qualities of an idol, whereas a mutable, viewer-engaging one seemed to embody the very essence of a religious, Hebraic belief that the only constants are tenuousness and change. To create the "polymorphic" picture seen here (fig. 433), Agam structured his painting surface as a closely aligned series of vertical, triangular-shaped strips marching across the wall like the pleats of a very large accordion. Then, on either side of these corrugations, he painted a different geometric or Constructivist design, so that as the viewer moves from left to right, or vice versa, the separate schemes unfold, one after the other, but not before fusing at the center like a momentary pause in the evolving pattern of a steadily rotated kaleidoscope. So complex are the polymorphics that several of them incorporate as many as eight distinguishable themes, all intricately and sequentially meshed to generate in the viewer moving through time a sense that he partakes of a formal metaphor for the birth, growth, flowering, and resolution of life itself. Acting on the Jewish conception of God as an omniscient power who "has no one

432. Richard Anuzkiewicz. *Inflexional II.* 1966. Acrylic on masonite, 36″ square. Hunter Museum of Art, Chattanooga (gift of the artist).

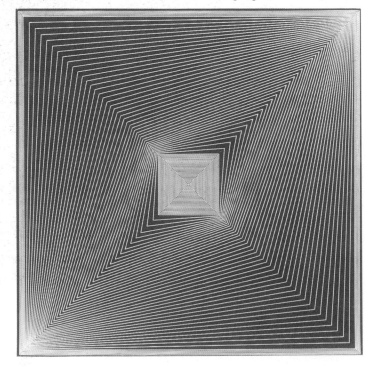

form, no static image," Agam, according to the artist himself, sought to realize "a visual form that doesn't exist. The image appears and disappears, but nothing is retained." "I try," he continued, "to transmit the feeling that change is a normal process of living, cause for joy, not discontent. . . . My endeavor has been to create a kind of painting existing not only in space but in the time in which it develops and evolves, thus producing a foreseeable infinity of plastic situations flowing out of one another, whose successive apparitions and disappearances provide ever-renewed revelations."

Like Agam's polymorphic picture, many Op works remain still but require literal movement on the part of some outside agency—light and shadow, for instance, or the viewer himself—before their own optical mobility comes into full play. Such active involvement of both spectator and environment was particularly important to Germany's Zero Group, artists who as early as April 1957 took inspiration from Yves Klein as well as Jean Tinguely and began to defy the established mode of Expressionist abstraction by exploring kinetics and monochromy, while also working collectively and scientifically in the manner described earlier. All of this, including a predilection for series, reflected by artists' youthful desire to break with tradition, achieve a new level of simplification, and, finally, to reach a zone of silence—a "point zero"—from which to launch new artistic ventures. As we shall see, the two founding members of Zero—Otto Piene and Heinz Mack—would go far towards abandoning concrete form in favor of creating effects with pure light and color. However, the third and most celebrated Zeroist, Günter Uecker (1930—), forged a less radical but more enduring approach, once he had migrated, at age twenty-three, from East Germany to Düsseldorf in the West. The tool with which Uecker re-invented his art from scratch was none other than the carpenter's common nail, which he used to fashion bristling reliefs that, far from steely menace, simulate visions of purity, beauty, and, indeed, silence (fig. 434). Very quickly, Uecker transformed his tough, non-art means into an expressive instrument as subtle and sensitive as the traditional painter's oil and brushes. Aiming for the "condition of totality" sought by Zero, he painted the nails white and then drove them into canvas-covered wood, but with such nuance and inflection that his hedgehog surfaces would evince all the gentle, swirling movement, weightlessness, and immateriality of natural forces—light, wind, water, fire, even smoke. Varying their density, height, and direction, he might so pattern their angle as to evoke a waving field of grain or an ocean, a formation of marching troops or a milling crowd, all manner of geometric figures, even human ones or still-life motifs—everything but the sadomasochistic implications of Lucas Samaras' pin-cushion assemblages (fig. 297). Traps for light and shadow, Uecker's nail-studded works draw the viewer into an optical, metamorphic drama by changing—sometimes dizzyingly—

monochrome canvas over the nail heads, rather than the support itself (fig. 435). A more conceptual artist, influenced by Lucio Fontana as well as by Yves Klein, than the romantic Uecker, Castellani favored a gridded order, instead of the circular flow seen in the German's Nail Relief. Yet, he too sought a visual metaphor for time fused with space, a dynamic reality conjured through the continuous luminary play across a smooth, taut membrane embossed as if by tent poles.

In 1960, two years after the Zero Group held their first exhibition, the Nouvelle Tendance produced an organization in Paris with similar aims but more than twice as many members. Most often referred to simply as GRAV, the *Groupe de Recherche d'Art Visuel* ("Group for Research in Visual Art") brought together such artists of various nationalities as Julio Le Parc, François Morellet, Francisco Sobrino, Joël Stein, Horacio García-Rossi, and Yvaral. Not only was the last-named the son of Victor Vasarely, but every member of the association, to one degree or another, would take Vasarely—his ideas and oeuvre—as a point of artistic departure. This can be seen in the work of François Morellet (1926—), a leading GRAVist whose Sphere Screens resemble three-dimensionalizations of certain Vasarely grids. Simultaneously, they could also be seen as denser, matchstick versions of Sol LeWitt's jungle-gym cubes, but topiary-shaped at the periphery like cellular, honeycombed balls (fig. 436). Thanks to the greater density of Morellet's homogeneous structure of identical elements, the work reproduced here seems to explode with energy as the observer moves his eyes or vantage point, causing the cage's lines to jangle visually and fire the optical nerve. By making his art dependent upon an elementary, serial system and the startling, chance effects this causes the spectator to experience as a consequence of his own activity, Morellet hoped to release his audience from vassalage to "great genius" and allow it the dignity of discovering that "works of art are like picnic areas or Spanish inns, where one consumes what one takes there himself."

Among the unaffiliated artists within the Nouvelle Tendance, none produced a more impressive body of work or ideas than Venezuela-born and -educated Jesús Rafael Soto (1923—). Long before he reached Paris in 1950, Soto had been captivated by the space/

with every shift in vantage point. For the artist, monochromatic white held the power of prayer, a prayer, like Yves Klein's, for a humanity relieved of its gross materialism and renewed in all its primary, innocent potential for limitless meditation and consciousness. Genuine artist that he is, Uecker gradually evolved, until in later work he has become less mystical or more Utopian and more objectively concerned with using his famous means to express trauma, pain, grief, and failure.

Italy's Enrico Castellani (1930—) also created abstract relief patterns by hammering nails into wood panels, but then stretched the

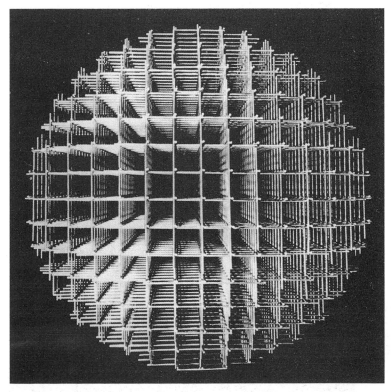

436. François Morellet. *Sphere Screen.* 1967. Aluminum, 7'1½" square. Courtesy Denise René Gallery, Paris.

Op, Kinetic, and Light Art

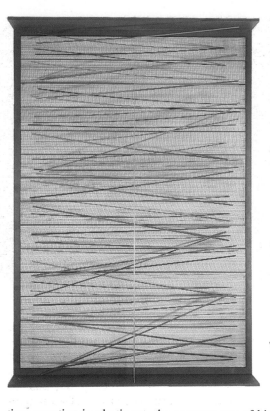

437. Jesús Rafael Soto. *Cardinal*. 1965. Wood, metal, and paint; 5′ × 3′4″. Tate Gallery, London.

world into a shimmering, musical web of shredded lines and chiming sounds.

Kinetic Sculpture

The reliefs fashioned by Agam, Uecker, Castellani, Morellet, and Soto may require literal motion in order for their energies to be fully activated, but the motion is that of the spectator passing before the work and viewing its three-dimensional forms from varying angles. Meanwhile, the object itself remains stationary—except for the slight quiver in Soto's dangling elements—and the kinetics essentially optical. True Kinetic Sculpture, on the other hand, does not merely give the *impression* of moving. Rather, it actually moves; moreover, it assumes significant form as well as meaning almost entirely through movement. Artists have always—as far back as the Lascaux Caves—found ways to *represent* athletes, animals, or vehicles in motion. As we have seen, the Futurists made the dynamism of modern life not only the subject but also the very content of their Cubist-inspired art. In the *Futurist Manifesto* of 1909, Marinetti declared: "A roaring motor-car that looks as though running on shrapnel is more beautiful than the Victory of Samothrace." However, the artists subscribing to that statement did little more than aggressively exploit age-old techniques for *depicting* changes involved in objects passing through space and time. Boccioni, for instance, departed from tradition mainly by presenting not just one arrested moment in a dog's running progress but, instead, a whole sequence of such moments, all in the same picture. In 1920, Marcel Duchamp took a more radical approach to the possibilities of motion in art and, with his *Rotorelief* (fig. 438), demonstrated that when spun a staggered relief of three transparent glass strips painted with concentric circles takes on the appearance of something quite different—a solid, opaque circle. Also in 1920, the Russian Constructivists Gabo and Pevsner issued their *Realistic Manifesto* wherein they called for "a new element in pictorial art, kinetic rhythms, as the basic forms of our feeling for real time." Thus, while Gabo was making constructions in space whose gridded lines and planes become optically charged—as Morellet's do—when viewed by an ambulating spectator, he also undertook a single experiment in actual motion, the *Kinetic Construction* of 1920 (fig. 439). Here a straight metal rod, set perpendicular to the ground plane, transforms itself into a spiraling, luminous wave curve of pure energy once vibrated by an electric motor concealed in the base. Discouraged by the primitive technology available for endowing constructions with dynamic temporality—a fourth dimension—Gabo abandoned kinetics, leaving the field open for triumphant exploration by Alexander Calder, who, however, made serious progress only after 1932, when he too gave up machine action for the chance operations of wind and atmosphere. With this simple, elegant solution to the problem of motive power, Calder invented the mobile, already discussed in Chapter 4 (fig. 156), and became the true father of Kinetic Sculpture.

No one understood this better than George Rickey (1907—), whose 1967 book entitled *Constructivism: Origins and Evolution* be-

time equation in plastic art, the consequence of his having first encountered modernist painting in one of Georges Braque's Cubist still lifes. This prepared him for Mondrian, whose work he discovered in France, but, like Alexander Calder twenty years earlier, he imagined how enthralling it would be if only the dynamic interrelationships of a De Stijl composition could become genuine movement. Still, Soto remained close enough to early Braque that he cultivated a linear, chiaroscuro image, rather than the planes of bright primaries preferred by Mondrian and Calder. Further, while Calder activated his mobiles by allowing their suspended, counterweighted parts to swing in the breeze, Soto forewent overt physical motion in favor of sensory vibration, set off by the viewer's own movements in relation to a static relief structured as an open screen of curved wires or straight rods dropped before a surface tightly packed with parallel vertical or horizontal lines (fig. 437). To intensify their scintillating moiré effect upon the bedazzled retina, he sometimes let the foreground elements dangle in a state of gentle but perpetual quiver. Eventually, such magical translation of matter into energy became so liberating for Soto that he felt free to introduce solid, flat fields of positive color, mainly in the backgrounds. Subsequently, he would also create rain-forest-like environments of translucent plastic tubes, so densely hung that viewers entering these Penetrables feel themselves caught in a milky shower whose palpable as well as illusory kineticism seems to dissolve the

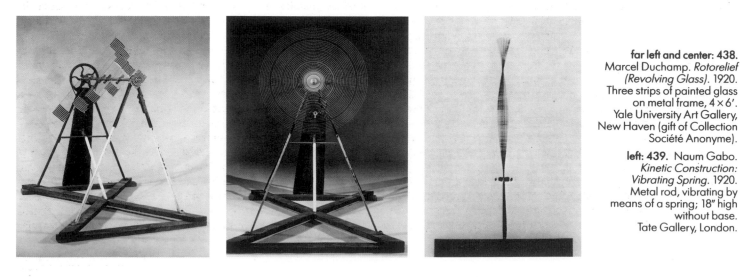

far left and center: 438. Marcel Duchamp. *Rotorelief (Revolving Glass)*. 1920. Three strips of painted glass on metal frame, 4 × 6′. Yale University Art Gallery, New Haven (gift of Collection Société Anonyme).

left: 439. Naum Gabo. *Kinetic Construction: Vibrating Spring*. 1920. Metal rod, vibrating by means of a spring; 18″ high without base. Tate Gallery, London.

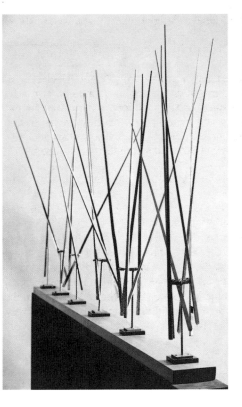

came the authoritative history of the tradition it addressed. Despite or perhaps because of his classical British education, from a Scottish public school all the way through Balliol College, Oxford, the American-born George Rickey proved to be a late, if impressive, bloomer in Kinetic Sculpture, finding it hospitable terrain for his particular talents only after twenty years of painting. But thanks to the academic training, as well as to a broad background in European culture, Rickey gave motion art and Constructivism in general one of their most eloquently articulate spokesmen. Meanwhile, Rickey had been drawing and painting since his Oxford days, when he attended classes at the Ruskin School, and his studies, during the early 1930s, in the Paris academies directed by André Lhote and Amédée Ozenfant. Finally, in 1945, after a decade of familiarity with Calder's work, Rickey made his first mobile, but not until he enrolled, in 1948, at Chicago's Bauhaus-indoctrinated Institute of Design did the forty-one-year-old artist discover the true strength of his mechanical genius. By 1960, after learning to weld with David Smith, Rickey had been so successful in achieving his own signature style of dynamic sculpture that he appeared to offer a classical alternative—solemn, straight-edged, silver-toned—to the colorfully gay, romantic biomorphism of Calder's mobiles (fig. 440). Combining Constructivist techniques, mathematical permutations, and systemic arrangements with nature's chance activity, he mastered the art and science of pivoting, on a single knife-narrow spar, long, tapering shafts of polished steel, blades whose sly to and fro movements—often within a single axis—suggest high grass swayed by a breeze. What holds the interest in the artist's monumental outdoor pieces is the progressive way in which motion becomes expansive form, suggesting, first, linear drawing in space, then planes, and finally volumes. So exact are Rickey's calculations that the works survive gale-force winds, continuing throughout, at varying rhythms, their graceful, balletic, but random performance, as each spear rises to a climax at the apex of its path, there hovering in suspense until driven by gravity to fall slowly towards a natural, corresponding pause at its nadir.

In 1951, a bit later than Rickey, the senior British artist Kenneth Martin (1905—) made his first kinetic constructions, a product of the sensational conversion to pure, geometric abstraction that he, at the age of forty-four, had made in 1949, after many years of painting in a

figurative, if increasingly anti-naturalistic, vein. As we saw earlier, this aesthetic shift was a collective event, shared by Martin, his wife Mary (fig. 387), and Anthony Hill, all of whom followed the lead of Victor Pasmore in accepting the persuasive arguments in Charles Biederman's recently published *Art as the Evolution of the Visual*. To help make the belated radicalism of their position clear, the Pasmore-Martin-Hill group preferred to speak of "Constructionism," thereby distinguishing themselves from the relatively romantic, nature-oriented Moore-Hepworth generation of English Constructivists. As Kenneth Martin wrote, "a rational objective basis is necessary to the wildest flights of fancy, to improvisation and to the irrational in order to create the work of art." Thus, for his glittering Screw Mobiles (fig. 441), Martin created form from movement by a process that began not in observation of natural phenomena, but rather in a series of mathematical calculations designed to control the changing position of an essentially unchanging unit. But once the system had been set, Martin allowed himself considerable freedom in its execution, for, to quote the artist once again, he sought a "natural, orderly invention into which disorder can enter too." The Screw Mobiles, moreover, constitute a perfect metaphor for Constructivism's principle of building "outward from a nucleus, the nucleus being a forming idea." In the present instance, that idea would seem to have originated in the ancient Fibonacci series (1, 1, 2, 3, 5, 8, etc.), an arithmetic expression of organic growth that determined the placement of brass strips on a central upright rod. The result is a rising and falling sequence of banded lights and shadows, their periodic occurrence made thrilling by an unexpectedness paradoxically derived from the structural regularity of an air-turned spiral.

Although an admirer of Duchamp and his pioneering interest in kinetics (manifest not only in the *Rotorelief* but also in the earlier *Bicycle Wheel* of 1913), the Greek artist Takis (Panyiotis Vassilakis; 1925—) joined neither the great Dadaist nor his disciple Tinguely (figs. 445, 446) in mocking technology. Rather, he cooperated with both scientists and poets to create "cosmic flowers," electromagnetic sculptures whose capacity to make polarized objects engage in a perpetual, gravity-defying dance of attraction and rejection serves as a poetic metaphor for the invisible and ultimately secret forces at work in the universe (fig. 442). The Athens-born Takis saluted Thales of Miletus, the ancient Greek savant who, six centuries before Christ, had first described magnetism and electricity, but it was the fascinating performance of stop-and-go signals at a Calais railway station that launched him in the mid-1950s into experiments designed to make visible the unseen, immaterial energy that controls all of life. First came the Signal series, consisting of small flashing lamps mounted atop long, upright rods of steel that, once agitated, remained in a con-

Op, Kinetic, and Light Art

stant state of vibration. By 1959, however, the example of radar scanners, magnetized to swing full circle in response to signals from metallic bodies in space, led Takis to electromagnetism. This, he soon discovered, would liberate him not only from the kind of illusory motion traditionally seen in art, but also from traditional methods of construction, methods employed even by the most advanced kinetic sculptors. For his structure, Takis used the same kind of field or network of energy as that driving and sustaining the planetary system. Thus, when switched on, a Takis sculpture releases a pole of energy capable of attracting whatever positive magnets lie within its range and of repelling the negative ones. Switched off, the piece allows positive and negative magnets—balls, cones, cylinders, needles—to drift towards one another. The work becomes fully expressive, however, only when "signaled"—alternately supplied and denied power—at regular, rhythmic intervals, which activates all the elements in a continuous, freely choreographic interplay of sound, light, and motion, the latter floating in some works and frenzied in others.

In the kinetic works of Pol Bury (1922—), form itself is strikingly significant, a quality essential to the sculpture's success, given that only after prolonged, close looking does the viewer perceive that what seems stationary actually moves—ever so slowly as in a dream or a trance (fig. 443). The shock of discovering this affords a rude excitement delightfully at odds with what has appeared to be an object of quiet, seductive elegance. As one might suspect, Bury had his artistic beginnings in Surrealism, which enjoyed a vigorous postwar life in the ominously calm paintings of a fellow Belgian, René Magritte. Bury spoke of "dilating" time, which, in his earlier works, he accomplished by causing balls and other units to move at a rate totally in defiance of gravity as it should operate within the situation presented. In a beautifully crafted piece of tiered cabinetwork, for instance, dark wooden balls rest, contrary to all physical logic, on a steep incline, which they may proceed to *climb*, slowly as if inhabited by snails. At the top they reverse and roll down, but barely, barely until at the perilous, immobile moment of dropping into the void, some unseen "prime mover" rescues them to recommence their stately ascent. In such works, the miracle arose from a kind of puppetry, with electric motors winding and unwinding nylon threads attached to the spheres. Later, Bury, somewhat like Takis, used magnetic fields to energize metallic globes, a technology that permitted the units to ambulate with utter unpredictability, each at its own inexplicable speed and direction across a surface charged from below by magnets moving under motor power. Attracted or released by the magnet's travels, the balls behave in an ever-changing manner, at times rolling away in isolation, at others crowding together, in a nudging, teasing, caressing fashion that

once prompted Bury to say: "We dare henceforward speak of the activity no longer in terms of geometry, but also in the language of the boudoir."

The tall, swaying metal grasses or lazily dangling loops of ribbon steel fashioned by Len Lye (1901–80) seem scarcely more volatile than Bury's snail-paced works, until suddenly and spasmodically they erupt in furious, sometimes shrill motion, as if swept by a hurricane or hit by a bolt of lightning (fig. 444). Then, just as suddenly, the terrifying storm passes, and, with their pent-up, barbaric energy now spent, they relax into a new period of quiescence. For his "tangible motion sculptures," Lye combined not only grace and violence but also art and technology. But they came towards the end of the artist's long career in abstract film-making, the consequence of a roving curiosity that took Lye from his native New Zealand to Europe before he finally settled in the United States in 1944.

Jean Tinguely (1925—) might just as well have been considered among his fellow New Realists in Chapter 5, or yet among the Assemblagists in Chapter 6, but for his passionate dedication to the problems of motion in art. So completely did Tinguely embrace the idea of change as reality's sole constant—the only true "static" in life—that his most notable "junk-mobiles" attained full meaning and expression only when their recycled engines drove them, through wildly unpredictable actions, until finally the mechanical, bizarrely beautiful monsters destroyed themselves. Characteristically, their suicide occurred in spectacular, tragi-comic frenzies of shrieks, shuddering, sputtering, thrashing about, malodorous explosions, clouds of smoke, and sometimes even flames. With their hilarious yet melancholy performances, Tinguely literalized in sculpture the dematerialization that movement—whether physical or optical—brings to solid forms. The process took him close to Yves Klein, who in 1958 joined Tinguely not only in Pierre Restany's New Realism group but also in an exhibition called "Pure Speed and Monochrome Stability," which consisted of Klein's Blue Monochromes—those pictorial emblems of pure essence (fig. 324)—spun round and thus rendered visually immaterial by Tinguely's mad machines. But far from a transcendence-seeking Rosicrucian like Klein, the Basel-born Tinguely, with his joyous, innate love of anarchic freedom, seemed to be a genuine, albeit romantic neo-Dadaist reacting—even in Paris—against the discipline, efficiency, and orderliness of his native Switzerland, where, for similar reasons, the original Dada had come into existence during World War I.

Too rebellious to tolerate regular schooling, Tinguely nonetheless had the good luck to be accepted at the Basel Art School and there to study under Julia Ris, a teacher evidently as committed as Albers to

exploring the expressive possibilities of rubbish, of non-art materials like sand, scrap metal, old rags, kitchen pots and pans. Moreover, she imparted to an eagerly susceptible Tinguely her love of Kurt Schwitters, the German Dadaist who had so brilliantly demonstrated how street discards—found objects—could become both material and subject matter for art made within the context of the 20th century's urbanized, industrial society. Still, it was kinetic art—and its potential as a metaphor for total liberty—that, from the very start, seems to have obsessed Tinguely, who later said to Calvin Tomkins: "Life is movement. Everything transforms itself, everything modifies itself ceaselessly, and to try to stop it, to try to check life in mid-flight and recapture it in the form of a work of art, a sculpture or a painting, seems to me a mockery of the intensity of life." Then, he added: "I want only to involve myself in the moving object that forever trans-

forms itself." At first, Tinguely fashioned "meta-machines," non- or anti-machines that went "beyond machines" as well as beyond Calder, who had wanted to make a Mondrian painting move, and constructed automated reliefs with units shaped to imitate the abstract morphologies of Arp, Kandinsky, and Malevich. By 1959 Tinguely had transformed his meta-machines into the famous Metamatics, robots assembled from old automobile parts and viewer-activated to weave and bob, emit clangorous noises, make abstract drawings, or create Assemblage-type sculpture—sometimes even to jump off their pedestals and strut around (fig. 445). Since these automatons were fitted with asynchronous gears, they could not but move in an unstable and thus nonrepetitive manner. Such "fundamental use of chance," as Tinguely called it, meant that, unlike what the late Tachist and Action painters had been accused of doing, no Metamatic would ever, for instance, paint the same picture twice. Thus, not only did the animated Rube Goldberg contraptions—often resembling Schwitters or Stankiewicz assemblages come to life—parody the Swiss-watch precisionism of postwar technology; they also sent up the pretensions to sublime uniqueness espoused by contemporary Informalists, for, as Tinguely told a reporter, his Metamatic "proves that anyone can make an abstract picture, even a machine."

The apotheosis of the art-making machine—nonrepetitive to the crazily logical point of self-annihilation in one act of glorious abandon—came in early 1960 when Tinguely persuaded MoMA officials to allow him to build and turn loose in the museum's garden a vast Metamatic entitled *Hommage à New York* (fig. 446). Although the product of feverish, weeks-long labor in freezing weather, the huge doomsday dragon—a towering, ramshackle, strangely exquisite skeleton white-painted to be visible in winter darkness—reduced itself to fuming shambles in less than a half-hour on a snowy evening in mid-March, to the mixed dismay and delight of some two hundred select guests led by Governor Nelson Rockefeller. "The skyscraper itself is a kind of machine," Tinguely said, adding:

The American house is a machine. I saw in my mind's eye all those skyscrapers, those monster buildings, all that magnificent accumulation of human power and vitality, all that uneasiness, as though everyone were living on the edge of a precipice, and I thought how nice it would be to make a little machine there that would be conceived, like Chinese fireworks, in total anarchy and freedom.

After raiding the secondhand electrical shops on Canal Street and the dump sites of northern New Jersey, Tinguely amassed scores of bicycle and baby-carriage wheels, dozens of used motors, a powerful electric fan, steel tubing, a big orange meteorological balloon, a child's bassinet, and a washing-machine drum, a workable radio, an upright piano, an ancient Addressograph machine, and a bedraggled American flag. Scarcely had all these derelict treasures, and many more, been assembled as *Hommage à New York* when the work's *danse macabre* was to begin, making "the end of the construction and the beginning of the destruction . . . indistinguishable," as Billy Klüver wrote. Among the many antics prepared for it, the machine was supposed to beat a steady, thundering din on the bassinet and washing-machine drum, switch on the radio at maximum volume, and send a horizontal roll of paper down a sheet-metal trough, there to be attacked by two large brushes held by an elaborately constructed painting arm and then blown into the audience by the electric fan. Meanwhile, ten armatures of bicycle parts were to strike the piano's keys in sequence, at the same time that two pairs of spindles would wind and then rewind scrolls of writing. Adding to the syncopated clamor were to have been a bell and the Addressograph machine, whose ringing and clatter would help to set off numerous other things, such as the stink- and smoke-producing chemicals stored in the bassinet, the silver-dollar "thrower" contributed by Robert Rauschenberg, the orange balloon exploding atop a 20-foot mast, and, at the end, a wheeled, flag-waving, cable-drum carriage careering forward to drown in the reflecting pool reigned over by Maillol's monumental female nude personification called *The River*. Few of these particular

Op, Kinetic, and Light Art

"events" ever took place, owing to immediate and chronic break-down, which almost invariably happened in Tinguely's Meta-matic performances, but all kinds of other wonders did come to pass, which, being unexpected, struck Tinguely as far superior to anything he had programmed. Moreover, *Hommage à New York* ultimately perished not from its own actions but, rather, at the hands of a fireman and two museum guests who intervened after a can of gasoline overturned on a burning candle inside the piano. But this could be counted among the many miracles of chance that the artist and his audience had been given to remark at—a veritable "catabolic Götterdämmerung" of smoke, ear-splitting racket, satanic smells, spinning cogs and crank-shafts, quaking and collapsing joints, flaming parts shooting into the garden, and a mournful dirge calmly plunked out on three of the ivo-ries. It all left Tinguely positively ecstatic, for the very reason that *Homage à New York* had gone about destroying itself not as planned, but in its own perverse, unforeseeable way. To him, Calvin Tomkins later wrote,

> . . . the machine was anything that anyone said it was—social protest, joke, abomination, satire—but, in addition, it was a machine that had rejected it-self in order to become humor and poetry. It was the opposite of the skyscrap-ers, the opposite of the Pyramids, the opposite of the fixed, petrified work of art, and thus the best solution he had yet found to the problem of making something that would be as free, as ephemeral, and as vulnerable as life itself. It had evolved, after all, "in total anarchy and freedom," and he had been as surprised as any other spectator by this evolution.

Light Art

In Gabo's *Kinetic Construction* light performed an all-important role to the degree that its reflection, together with the motorized vibrations, had the sculptural effect of transforming a thin metal rod into a radiant

density of quite different shape. Ten years later, another Constructiv-ist, László Moholy-Nagy, completed his *Light-Space Modulator*, the first electrically powered sculpture that emitted light (fig. 447). Here, light not only played on the open-form work's complex of perforated disks and wire-mesh planes; it also projected from within the sculp-ture, sweeping out to energize and "sculpt" ambient reality quite as much as the moving parts gave dynamic definition to a certain volume of space. In this way, Moholy-Nagy's *Space-Time Modulator* realized the Constructivist doctrine that fine art must become integral with the world at large. Thirty years later, it offered a paradigm for some of kineticism's most fruitful attempts to embrace spectators and make

far left: 447. László Moholy-Nagy. *Light-Space Modulator*. 1923–30. Kinetic sculpture of steel, plastic, wood, and other materials with electric motor; 57½ × 27½ × 24″. Harvard University Art Museums, Cambridge, Mass. (gift of Sibyl Moholy-Nagy).

left: 448. Julio Le Parc. *Continuel-Mobile, Continuel-Lumière* (2 states). 1963. Motorized lights, 5'3″ high. Tate Gallery, London.

them active participants in an artistic process designed to reveal and enhance the human realm.

The Argentine Julio Le Parc (1928—), one of GRAV's most dom-inant members, brought to kinetics and light all the zeal of a "cultural guerrilla" passionately committed to the notion that only a destabil-izing and disorienting art could serve the revolutionary purpose of rendering society less apathetic and more open to beneficial change. A living exemplar of the principle, Le Parc energetically progressed, with imagination and no little success, from one experiment to another in every conceivable aspect of light, movement, and illusion (fig. 448). At various times this involved surface patterns modified to yield ambiguous peripheral visions, mobiles with Perspex cubes and prisms designed to produce kinetic-light murals of constantly shifting reflec-tions and shadows, rotating reliefs composed of elements different both in their reflectivity and their speed, and total environments whose very form came into sudden and unexpected being by virtue of parts the viewers were invited to adjust or manipulate. Operative through-out seemed to be what might be called a "games aesthetic," the pur-pose of which was to make the observer an active participant in the creative process, even if this meant crawling through labyrinths while orienting mirrors or rolling balls along circuitous paths. On occasion, Le Parc's spectators might find themselves asked to put on distorting spectacles, sit in collapsible chairs, or wear spring-loaded shoes. Such was the prestige garnered by such contrivances—or at least the idea behind them—that in 1966 the judges at the Venice Biennale honored Le Parc with the Grand Prize for painting, an award so controversial that a new one was not made for some years thereafter.

Zero took form in 1957 primarily as a result of collaborative activ-ities undertaken by Düsseldorf artists Otto Piene (1928—) and Heinz Mack, who would be joined the following year by Günter Uecker.

When Piene, the group's senior member, returned to "point zero"— that place in art before it assumed all the heavy, overdeveloped complications of Informal/Tachist painting—he chose light itself as the medium most likely to evoke the creative, harmonizing energy common to all art, life, and technology. Determined to make light perceptible as a natural force, Piene produced a series of Screen Pictures in which he applied monochromatic oil medium to canvas by squeezing it through a sieve, the scintillating, deep-pile, all-over distribution of pin-point deposits meant to relieve color of form and to capture "the purity of light" (fig. 449). Soon he would abandon these relatively conventional means for the real thing, light projected through pre-cut stencils to throw luminous abstract images onto the wall, ceiling, and floor. In a further integration of art and mechanics, he automated the "light paintings" to move and become Light Ballets of revolving, overlapping patterns accompanied by jazz. Meanwhile, Piene also

sought light in the form of fire, often exploiting it in conjunction with the other "elements"—earth, air, water, and human beings. For some of his "fire paintings" he returned to the mesh template, placed a sheet of paper over it and a candle underneath, and let the smoke create a sooty, tremulous, chiaroscuro version of the first Screen Pictures. By the end of the 1960s Piene had begun to spend part of every year in the wider, more open spaces of America, which prompted a gigantic increase in the scale of his work. Now came the "sky events" involving great numbers of hot-air balloons illuminated by powerful arc lamps beamed into night's darkness. With this kind of vast, environmental work, the artist hoped to gain the attention of many and thus place art in the service of a Utopian ideal, a dream of cities and societies rebuilt through the constructive interaction of science, ecology, and aesthetics. More recently, Piene has worked with lasers, especially at the Massachusetts Institute of Technology, whose faculty he first joined in 1972.

A Zeroist as devoted to an art of light and movement as Otto Piene, Heinz Mack (1931—) found a fruitful means of realizing it when he accidentally stepped on a sheet of metal foil and thrilled at the all-over relief pattern imprinted thereon by the mass-produced floor mat. Enchanted by the quicksilver play of light over this rippled, reflective surface, particularly as it was shifted about, Mack began producing and elaborating the effect in glass, aluminum, or other modern material (fig. 450). Often he enhanced it with a rotating plate whose movements interact with the translucent, corrugated foreground to generate a sparkling, mutable moiré of eye-teasing vibrancy.

Even earlier than Dan Flavin (figs. 377, 403), the Greek-American artist Chryssa (1933—) chanced upon the sculptural promise of emitted rather than reflected light. However, by her choice of

neon, with its linear fluidity and infinite range of colors, she disclosed an aesthetic sensibility quite different from Flavin's Minimalist love of the ready-made, rod-like modularity offered by fluorescent fixtures (fig. 451). Like so many of the Pop or Pop-related figures—Rosenquist, Hockney, Lindner among them—Chryssa discovered poetry in the commercial signage of New York City's Times Square, but instead of the vulgar imagery to be seen there on such a vast, densely packed scale, it was the equally aggressive medium of pulsating neon, as well as the verbal messages it conveyed, that seized her interest. At first, she aestheticized the effect of abstracting a single letter—W, A, or the ampersand—and then repeated it in echoing, serial banks of units identical in all but their rainbow chords of refulgent color. Later, she literalized the visual kinetics by programming the lights to come and go at regular intervals, controlled by electrical circuitry clearly visible within the same darkly elegant Plexiglas box housing the parallel festoons of neon energy. With their memory and anticipation, and with their candid juxtaposition of refined form and raw process, the later lightboxes made by Chryssa engaged the viewer even more powerfully than the earlier, more metaphoric ones.

Stephen Antonakos (1926—) also experienced a revelation while observing the neon flamboyance of Times Square. Yet, he did not so much extract art from neon signs common to the commercial environment as use neon to create an aesthetically structured environment. Initially, he programmed his tubes to go on and off in varying patterns that, sequentially, express one aspect and then another of a room (fig. 452). Later, and still working against the trend set by Chryssa, Antonakos ceased programming his work and allowed the brilliant hues and their radiation to captivate the viewer merely by immersing him in colored light.

left: 449.
Otto Piene.
Light Yellow Light.
1958. Oil on
canvas, 27⅝ × 67".
Westfälisches
Landesmuseum
für Kunst und
Kulturgeschichte,
Münster.

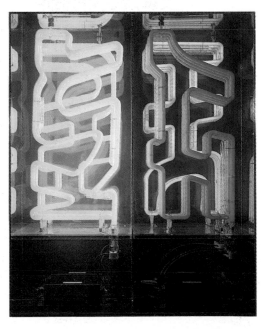

right above:
450. Heinz Mack.
Silber-roter.
1963. Glass,
metal, and motor;
4'8" square.
Folkwang
Museum, Essen.

right: 451.
Chryssa. *Study for
the Gates Series,
No. 2.* 1966.
Neon and
colored Plexiglas,
43 × 34 × 27".
Whitney Museum
of American Art,
New York
(gift of Howard
and Jean Lipman
Foundation).

More than any other artist exploring light and motion in the 1950s and 1960s, Nicolas Schöffer (1912–) succeeded in the Nouvelle Tendance aim of fusing art, science, and technology and of projecting the results on a viewer-inducting, environmental scale. Hungarian-born and -trained like Moholy-Nagy and Vasarely, Schöffer too pursued his career in Western Europe—mainly in Paris—and made Bauhaus values relevant for the postwar world. Aesthetically, he worked very much in the Constructivist mode, building each sculpture as a central core from which branches a variety of perpendicular elements whose lines and planes sculpt a virtual or apparent volume (fig. 453). And like Moholy-Nagy's *Light-Space Modulator*, the whole edifice—usually a scaffolding of polished metal or even mirror—turns and reflects light, but now in a totally random manner generated by an electronic brain acknowledging all sorts of luminary or sonic influences from without. As Jack Burnham has argued in *Beyond Modern Sculpture* (1968), art works that exist by virtue of modern cybernetics—as Schöffer's do—imitate life, as traditional sculpture always did. However, it is not appearance that they mime but, rather, the human organism's sentient capacity to respond to external stimuli, made possible in art by a sophisticated use of computers and artificial intelligence. Reacting to ambient light and sound—either those programmed to

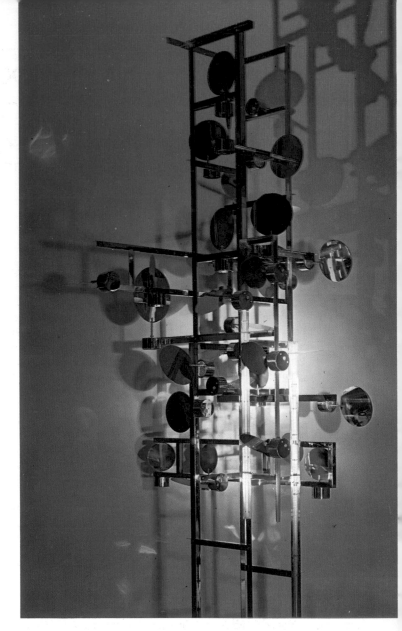

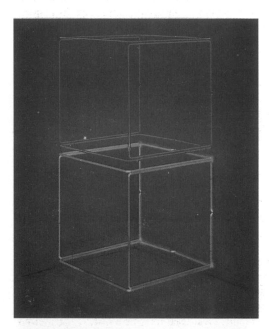

left: 452
Stephen Antonakos.
Red Box over Blue Box. 1973.
Neon, 2'1" × 2' × 2'.
La Jolla Museum of Contemporary Art.

right: 453.
Nicolas Schöffer.
Chronos 8. 1967–68.
Stainless steel and motors,
9'9⅛" × 4'1¼" × 4'3⅛". Collection the artist, Paris.

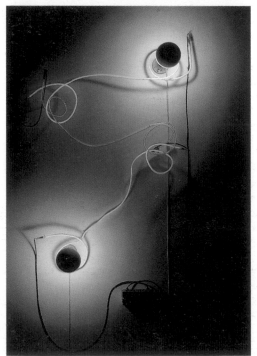

454.
Keith Sonnier.
Neon Wrapping Incandescent Light: Triple Loop. 1969. Neon and silver-tipped incandescent bulbs, 96 × 53 × 15". Collection Sylvan Perlstein.

bombard them or those arising from the busy world all about—Schöffer's abstract, iconic towers may spin rapidly or lie still, subside into somber silence or coruscate like a musical waterfall of colored light. In this way, the "cybernetic-spatiodynamic constructions" intersect, from a Constructivist stance, with the interests of such divergent contemporary artists as the environmentalists and happeners seen in Chapter 6 or the Popsters in Chapter 5, especially Rauschenberg through both his performances and his collaborations with EAT.

While studying under Robert Morris at Rutgers University, Keith Sonnier (1941–) conceived a fascination for the kind of "eccentric abstraction" already seen in Morris' felt pieces (fig. 402), especially since its casualness and unpredictability complemented an abiding interest in primitive cultures and mystical associations. Still, Sonnier felt compelled "to contain [his] information in a real 20th-century, machine-age context." And neon provided the ideal medium, which the artist remembered from his youth in Louisiana's bayou contry as potent with a kind of religious power generated by colored waves breaking through the thick midnight fogs. For the early work seen here (fig. 454) he combined the harsh, bright light of incandescent bulbs with the softer, more suffused illumination from meandering, encircling neon and the line drawing produced by its wires and shadows. Equally integral with the overall composition of the piece was a fully exposed, humming transformer, which gave effect to Sonnier's desire for a multisensory art, one that would soon incorporate words and letters as well as sounds, thereby helping to usher in the Conceptualist seventies.

The Post-Modern Reaction: Conceptual, Performance, and Process Art 10

The creative energy and forward-looking exhilaration so characteristic of the sixties gradually drained away, sapped by political assassinations in Dallas and Los Angeles, by Red Brigade "kneecappers" in Italy and Baader-Meinhoff kidnappers in Germany, by ban-the-bomb rallies in Trafalgar Square, and by student riots everywhere from Berkeley, Kent State, and Columbia to the Sorbonne. For younger artists emerging in the latter part of the decade or in the early years of the next, the times could scarcely have been more confusing, since high above the fray Minimalism reigned supreme, its Olympian machine-like perfection and mathematical logic serenely indifferent to a world that by 1968 had become dangerously polarized. Caught between hawks and doves on either side of the Vietnam War, between a white, male-dominated society and the demands of disenfranchised blacks and women, between the old nuclear family and the Me Generation's drive for individual choice, the talents destined to make the next move in art found little to satisfy their expressive needs in an aesthetic whose very appeal had been its dismissal of every value save that of remorseless self-purgation. Despite the clamor of the age, this extreme variety of supernally confident modernism had, thanks to its undeniable impact and the lucidity of its apologists, come to seem the dominant mode during much of the previous decade, almost as a defiant antidote to universal malaise. Concurrently, of course, Pop Art had continued along its own exuberantly ironic path, gathering as it went a still larger constituency of admirers, paradoxically because Pop observed modernist tenets even as its "impurities"—its appropriations from admass culture—appeared to sabotage them. Not only did Johns' flags and Lichtenstein's comic-strip scenes look flat enough to be confused with the real things, as well as to coincide with the rectangular two-dimensionality of the painting surface; Rauschenberg's found objects, once "combined" within the context of abstract painting, also endowed high art with a literalness and a candor that the Minimalist box could only confirm. Moreover, they ratified the pure materiality of the paint surrounding them and the nonillusionistic character of the artist's free, painterly brushwork. But while Pop shared, in addition, the same cool, auto-critical mood as Minimalism, the unresolved openness of its dialectical art/life, visual/verbal strategies and the sheer democracy of its mixed media made Pop works seem less central to the ongoing modernist movement than Minimalism's claim to timeless self-sufficiency and monolithic, unitary "presentness" (fig. 457).

Charging the almost totalitarian power exercised by Minimalist art and criticism were, as we have seen, the views of Clement Greenberg. Since the late 1930s this New York writer had systematically examined the modernist tradition and extracted from its urge towards autonomy—painting and sculpture that represented itself more than external reality—a theory of artistic development as practical self-criticism. According to this orthodoxy, the mainstream evolution of the Western visual arts during the preceding century must be understood as a relatively steady progression in which every move had been made either in positive or in negative reaction to a maturing sense that the aesthetic object would possess meaning only insofar as it declared its own inherent nature and process of creation. By 1965 Greenberg could write: "The essence of Modernism lies, as I see it, in the use of

the characteristic methods of the discipline to criticize the discipline itself—not in order to subvert it, but to entrench it more firmly in its area of competence." Twenty years earlier the Bauhaus architect Mies van der Rohe had anticipated Greenberg in the famously succinct dictum "less is more," the Utopian optimism of which sprang from a conviction that, reinforced by ever-more efficient technology and scientific procedure, modernism could promise not only an endless succession of stylistic advances but also a beneficial effect on the gradual betterment of humankind. As this would suggest, no new worthwhile art, not even aloof, self-reflexive Minimalism, can escape its context in social circumstance and visual history, which the artist absorbs and reformulates in the act of making his own creative decisions. Indeed, as Minimal objects finally demonstrated, the more art becomes less, the more it depends upon context for meaning—meaning derived not only from the light, space, and movements but also from the ideas and attitudes of the world mirrored on surfaces composed of aluminum paint or polished metal. Alas, what a new wave of artists saw reflected there was not Utopia, but, instead, a world whose natural environment had turned toxic from years of pollution by industrial waste, an urban scene where immense Bauhaus-inspired housing developments had to be dynamited, owing to the failure of their rational planning to induce rational behavior in vandalizing inhabitants, and an art profession so oblivious to these realities that Minimalism resembled not so much the logical outcome of the modern, formalist principle as the last gasp of a once-glorious, albeit now depleted and decadent, tradition. In an impure world, afflicted by stagflation, dropouts, oil embargoes, drug and consumerist addiction, endemic racism and sexism, purity of form came to seem less an emblem of the heroic and the sublime than a neurotic escape from life. Worse, the modernist vision, which had originated in an egalitarian desire to emancipate humanity from the tyranny of old hierarchies, had itself become elitist, as specialized as science and just as poorly understood by the public. Moreover, it had grown individualistic, competitive, and utterly materialistic, all of which transformed art objects into commodities, and progress—that never-ending drive for originality and newness—into an insatiable appetite for novelty, its addictiveness affecting artists and patrons alike. Obsessed with structure, modernism seemed to lose track of substance, and instead of opening up possibilities, it tended increasingly to close them off, becoming, like technology, both coercive and brutal. In other words, by the early 1970s self-reducing modernism was poised to self-destruct, prompting much discussion about the "death of painting" and the New York critic John Perreau to write: "Presently we need more than silent cubes, blank canvases, and gleaming white walls. We are sick to death of cold plazas, and monotonous 'curtain wall' skyscrapers . . . [as well as] interiors that are more like empty meat lockers than rooms to live in."

Even in 1967, as Barbara Rose recently wrote, there could be no denying "the widespread assault on the dogma of modernism as an exclusively optical, art-for-art's sake, socially distanced, formalist phenomenon that inevitably tended towards abstraction." In 1970, California artist John Baldessari would abjure the "aesthetics of boredom" by destroying thirteen years of his own accumulated paintings—everything from portraits and landscapes to Pop-style pictures

and radical abstractions—and having the ruins cremated at a mortuary. The following year, still exasperated by Minimalism's stubborn hegemony, Baldessari scrawled the first of his "I will not make any more boring art" pieces (fig. 455), a work in which he filled the support with a neat reiteration of the same phrase, like a boy forced to remain after school and atone for some infraction by chalk-writing his promise never to repeat it hundreds of times on the classroom blackboard. However, the most dramatic of all the early anti-formalist statements may have been made by the British Assemblagist John Latham, who, in 1965—a year before he executed the SKOOB picture seen in fig. 298—risked losing his part-time teaching position at London's St. Martin's School of Art in order to protest the Greenbergian aesthetics then dominant in a sculpture department reigned over by Anthony Caro. After withdrawing a copy of Clement Greenberg's *Art and Culture* from the college library, Latham organized a "STILL & CHEW" event at his home, where he and his equally antagonistic guests—mostly artists, students, and critics—each tore a page from the book and proceeded to chew it. However, instead of swallowing the masticated remains of the American critic's ideas, the participants in this performance piece dropped them into a bottle of acid, where, as "several months went by with the solution bubbling gently," it was distilled into a clear liquor. When the librarian requested the return of the borrowed volume, Latham submitted the distillation (or perhaps digestion), bottled and labeled with a full disclosure of the contents. The following day he received a letter from the Principal regretting that his services as a teacher would no longer be required at St. Martin's. Not to be outdone, Latham next assembled both the bottle and the letter of dismissal in a leather case, *à la* Duchamp, and sold the entire assemblage to MoMA (fig. 456). There it resides, with its chemical residue that seems, as critic Eleanor Heartney recently wrote, "both a parody of Greenberg's essentialist attitude toward art and a witty put-down of the delusion that art and culture are intellectually packageable. Instead, as the organic nature of Latham's book transformations suggests, knowledge should be viewed as a productive force rather than as an acquirable commodity."

Beset by attacks upon its most sacred doctrines, contemporary art made a slow but irreversible entry into what has come to be known as its post-Minimal or post-modern phase, a time when Greenberg and "the dogma of modernism" would be supplanted by the ideas and example of Marcel Duchamp. As we saw in Chapter 1, Duchamp had foreseen the "death" of painting—a full half-century before the Minimalists prematurely declared it a fact—at the same time that he had also shown how it was feasible to "speak another language" and still create art pregnant with meaning. In 1913 Duchamp invented the ready-made and, with one stroke, shifted art's focus from appearance

to conception, from the kind of language used to the message it might convey. Subsequently, modernist formalism itself would arrive at a similar position, as it progressively stripped away almost everything but content, only for this to fade once the idea had been absorbed, even as the trivial structure survives. When, in 1917, Duchamp purchased a white porcelain urinal from Mott Works in New York and submitted it for exhibition as a sculpture, entitled *Fountain* and signed "R. Mutt," he destabilized traditional aesthetics forever. With *Fountain*, as well as with the earlier *Bicycle Wheel* and *Bottle Rack*, he reduced the creative act to the shockingly rudimentary level of simply designating this or that object or activity as "art." But if art came into being merely through designation, it clearly had far more to do with intentionality than with craftsmanship or style. Such a notion could not but challenge the whole panoply of critical criteria and patronage that had evolved since the French Revolution in the late 18th century, when the

left: 455.
John Baldessari.
I Will Not Make Any More Boring Art. 1971.
Lithograph, 22¾ × 29".
Museum of Modern Art, New York
(John B. Turner Fund).

right: 456.
John Latham. *Art and Culture*. 1966–69.
Assemblage: book, labeled vials filled with powders and liquids, letters, photostats, etc., in leather case;
3⅛ × 11⅛ × 10".
Museum of Modern Art, New York (Blanchette Rockefeller Fund).

emergence of secular society resulted in a modern world increasingly driven by opportunistic and competing interests. If the artist could decide what may or may not be art, he then became—to some extent, at least—both critic and creator, thereby overriding the professional tastemakers in control of galleries, museums, and the media. And if the essential value of art lay in its conception, rather than in plastic form, then it might no longer be a thing subject to aesthetic valuation and thus to commodification—commercially exploitable by the tastemakers' clientele, the moneyed status-seekers. In the end, of course, the latter prevailed, for, as a dismayed Duchamp would finally admit: "I threw the *urinoir* into their faces, and now they come and admire it for its beauty."

Like many an earlier moment in art's long history, classical balance—in the case of Minimalism, struck between the most literal, material kind of form and the most rarefied intellectual or even spiritual content—gave way to the polar extremes of its own binary components and produced, on the one hand, severe restraint and, on the other, overelaboration. At first, it was the blunt objecthood of Minimal Art that could not be endured, together with the market-oriented hype that had overtaken the art scene, for by emphasizing the objectivity of their nonobjective art, the Minimalists had contrived to clutter an overcrowded world with still more objects, thereby catering to the media-triggered cravings of an uncritical consumer society hungry for the latest artistic "scandal," however "difficult," or even hostile to that very culture (fig. 457). Spurning commercialism and groping for the moral high ground traditionally occupied by the avant-garde, certain anti-formalists abandoned object-making altogether, except as documentation—texts and/or photographs employed as simple signs, symbols, or book-like vehicles for information. This ushered in Conceptualism, which considered a "piece" finished as soon as the artist had conceived the idea for it and had embodied this, not in material,

object form, but rather in verbal statements, proposals, or game plans. Along with Conceptualism came Process Art, which undermined Minimalist stability by submitting it to the eroding forces of nature, such as the steady downward pressure of gravity or the caprices of atmospheric change (fig. 458). Soon, the Minimalist cube would waste away until it became the bare-bone frameworks permuted by Sol LeWitt (fig. 459), the Minimalist who foresaw hard-core Conceptualism when, in 1967, he wrote that once "the planning and decisions are made," as they were in Minimalism, " . . . the execution is a perfunctory affair." In Italy, meanwhile, the critic Germano Celant discovered artists working with stones, twigs, rags, newspapers, earth, and wood, and labeled the movement *arte povera*, meaning "poor art" admirable for the simplicity of its organic, perishable materials and the anti-establishment tenor of its content. Cousins to such Process Art were Earthworks, or Land Art, for which artists fled the studio and gallery world entirely and re-established themselves in fallow nature, there to create art by imposing form on natural formations within a carefully chosen site. For Earth Art, documentation played a crucial role, since it was only through texts and photographs that most viewers could gain access to geographically remote and inaccessible pieces. Meanwhile, as some artists turned outwards to various kinds of wilderness, others turned inward, to their own bodies, which too became "sites," albeit intimate ones, for procedures comparable—sometimes painfully or even lethally so—to those worked upon the environment. But when Body Art became Performance Art, onetime studio-bound talents confronted their audience directly, unmediated by either galleries or critics, and communicated their ideas not in documents but rather in temporal, theater-like pieces, made up of recitations, songs, dance, and, sometimes, anarchic mayhem, usually accompanied by instrumental or electronic music, light spectacles, and video. Having thus become both "post-object" and "post-studio," Conceptual Art of every persuasion frequently pursued its enterprise in such nonprofit or low-budget venues—"alternative spaces"—as store fronts, derelict schools, empty industrial lofts, and the public byways of cities all over the globe. And whatever form or nonform it took, the new art could scarcely be called "collectible" or "commodifiable" in the usual sense, although for Conceptualists to survive, they had to be supported, sometimes, curiously, by the very patrons and systems whose commercial or bureaucratic power the artists had striven to evade and subvert.

Simultaneously, as Conceptualists vacated studio and gallery, other post-Minimalists took their places and revived oil-and-brush (or airbrush) easel painting with a vengeance, rendering the phenomenal world in such sharp focus that Photo-Realism became an instant label. And apt it was, for this trompe-l'oeil imagery derived not from direct observation of reality but rather from photographs (color slides, ac-

bottom: 457.
Tony Smith. *Die.* 1962. Steel, 6' cube. Courtesy Paul Cooper Gallery, New York.

above right: 458.
Hans Haacke. *Condensation Cube.* 1963–65. Acrylic plastic, water, climatological conditions of the environment; 11¾" cube. Collection the artist. Courtesy John Weber Gallery, New York.

below right: 459.
Sol LeWitt. *Semi-cube Series.* 1974. White-painted wood, each part 8 × ¾ × ¾". Courtesy John Weber Gallery, New York.

tually), a kind of documentation universally favored among the iconoclastic Conceptualists. Further, the uncanny and contradictory sense of flatness evoked by the deeply spatial Photo-Realist picture made the new illusionism appear all the more post-modern—that is, passed through and ironed out by formalism's steamrolling reductiveness.

With Photo-Realism in the ascendant, Greenbergian formalists could well believe that the lid on Pandora's Box had been blown away, setting free all the devils that modernism had struggled so valiantly to exorcise, not only Duchampian anti-aestheticism but also narrative, social engagement, pattern, and even decoration. By 1980 there would be Neo-Expressionism, Neo-Surrealism, and subway-spawned Graffiti Art, which should indicate the still-vigorous form-averse stance of the new decade, as well as the one element shared by virtually all the art to emerge in this rampantly "pluralistic" period: an overriding conviction that, once Minimalism had exhausted the possibilities of style, style alone can no longer suffice for art made in an era wracked by chronic social, political, economic, and, not least, aesthetic crisis.

Ironically, as self-starving formalism attained the limits of its known potential—that is, self-eradication—it also achieved broad public recognition and acceptability, thanks to the sensation-seeking tactics of the popular media. By their very nature, however, these factors brought down the curtain on art's role as an avant-garde expression operating on the fringes of society and there serving as a corrective irritant to a vulgar, philistine world. By 1970 modernism had become almost banal in its ubiquity, throughout an urbanscape studded with glass-box International Style structures, buildings often adorned—if not filled as in the case of the many new museums built in the sixties—with the monumental works of Henry Moore, Barbara Hepworth, and Anthony Caro, Sol LeWitt, Frank Stella, Ellsworth Kelly, and Kenneth Noland. Moreover, the market confirmed their value, as newspapers and television alike gave headline coverage to the latest record-breaking auction prices. Having been thereby conditioned to embrace anything the art world did as significant, the pub-

Conceptual Art

lic very quickly revealed itself ready to acknowledge whatever came in the wake of Minimalism's self-destruction, even if this meant ephemeral Process works or wall hangings quilt-stitched from old gingham scavenged along New York's Canal Street. However, such co-optation by a culture desperate to be "with it" meant that the mere possibility of a vanguard had vanished along with the purist style it had nurtured for more than a century, to the point, ultimately, of fatal success. As Irving Sandler wrote in 1980: "Elitists may question the motives of the mass audience for art and the quality of its esthetic experiences—but not its sympathy."

Without a dominant mode to use as its instrument of measure, criticism became either more problematic or easier, depending on the readiness or ability of the critic to determine quality at a time when each new work tended to create its own standards. For a whole school of "new critics," however, quality, along with such matters as form, universality, originality, and seamless, evolutionary advance, had become a secondary, dead, or even pariah issue. Often it would be preempted by criteria and analytical tools borrowed from neo-Marxism, post-Freudian psychology, feminism, and the linguistics of Ludwig Wittgenstein, from the structuralism of Ferdinand de Saussure, Claude Lévi-Strauss, and Roland Barthes, and, later, from the "post-structuralism" and semiotics of other French intellectuals, mainly Michel Foucault, Jacques Lacan, Jacques Derrida, and Jean Baudrillard. What this reflected, of course, was the altered character of new art itself, which, being post-modern, rejected ahistorical exclusivity, reductionism, and removal from societal and cultural concerns in favor of their opposites: inclusivity, impurity, and direct involvement with the content of both history and contemporary experience. Primary sources for much of this development were, of course, the artifacts and sibylline sayings of Marcel Duchamp, but also the utterances of John Cage, and the essays of Walter Benjamin, the ill-fated German-Jewish critic whom Kitaj memorialized in *Arcades* (fig. 270). Writing as an exile in Paris during the 1930s, Benjamin foresaw the dilemma of "art in the age of mechanical reproduction," when the facility of image multiplication made it seem probable that art would lose the "aura" or "authenticity" once bestowed by originality. With his rather Proustian belief that the auratic could be redeemed through memory shocked by what has been lost, Benjamin helped inspire the "appropriations" and "layerings" developed by Pop but then elaborated by post-modernism into one of its autographic properties. In Benjamin, who liked to explore the stratified meanings in every text, certain post-modernists would also find an exemplar for their will to disclose the "inter-textuality" or "subtexts" of appropriations, often for the purpose of critiquing or "deconstructing" them.

As Benjamin would have wished, the very openness of the post-modern era has allowed even Minimalism and Pop to survive. Indeed, Caro, Serra, Stella, and Ryman, Rauschenberg, Johns, Hockney, and Lichtenstein, among others, remain at the peak of their power and prestige, exhibited, commissioned, and collected like the Old Masters they seem to have become. And few artists could be said to exercise more influence on new art than the late Andy Warhol. Moreover, post-modernists would revel in modernism's internal process of unremitting criticism, but in the paradoxical, contextually mixed way developed by Pop and directed towards modernism itself as well as towards culture and society in general. Salient within an extremely broad range of post-modern characteristics have been an eagerness to expose or deconstruct the "real-life" myths and "coded" languages of the popular media; a realization that fine art, even at its most abstract or "autonomous," cannot but exemplify the overall human realities prevalent within its time and place; the identification and analysis of the usually hidden contexts of art—museums, markets, government or corporate funding, and critics; and a recognition that in order to reflect current, ambient life, art must resist a priori dogmas about what is "allowable" and insist upon whatever approach—historical, psychological, narrational, political, diaristic, decorative, metaphys-

ical, "simulacral," or even formal—seems best suited to the artist and his purpose. The critic Kim Levin put it this way: "The feeling against style and objectivity proved more subversive than the antipathy toward objects and form: post-modernism arose out of conceptualist premises—that art is information—while protesting its modernist aridity."

Conceptual Art

A gradual and progressive "dematerialization of the art object," as Lucy Lippard called the anti-form movement, may be seen at work in the comparison already noted in figs. 457, 458, and 459, where Tony Smith's massive, solid-looking cube seems to melt away in Hans Haacke's transparent, streaming Weather Box before ending as the bleached, skeletal block permuted by Sol LeWitt. However, the aggression against art as material form or object had already been launched at least as far back as Rauschenberg's *Erased de Kooning Drawing* of 1953, or his 1961 "portrait" of the Parisian avant-garde dealer Iris Clert, which, as we saw in Chapter 5, consisted merely of a Dadaesque telegram: "This is a portrait of Iris Clert if I say so." Three years earlier, Yves Klein had emptied Clert's Left Bank gallery and declared it an exhibition entitled *le Vide*, or the Void, thereby dramatizing his conviction that art's importance lay beyond what could be seen or touched (fig. 460). For Klein, the Void meant free, open, boundless space—like the dazzlingly azure Mediterranean sky or an infinite field of Klein's own patented IKB (fig. 324)—out of which Rosicrucians hold that all forms arose and to which an evolved humanity is destined to return. In a messianic desire to engage his public, Klein not only sold the "contents" of the Void show—zones of empty space impregnated with his own sensibility—but at the opening he also served cocktails that left those who attended urinating blue for a week! Persuaded that transcendence deserved to be expressed in word as well as in image or gesture, Klein went to the Sorbonne in 1959 and delivered a lecture entitled "The Evolution of Art towards the Immaterial." More memorable, because more visual, was the swan "leap into the Void" that Klein made from a high wall in 1960 (fig. 478). But even while this act responded to a pent-up spiritual longing for weightlessness and levitation, Klein behaved like the good Conceptualist he was, making certain that his Pollock-like compul-

460.
Yves Klein. *Le Vide* (being re-created by the artist at the Musée d'Art Moderne de la Ville de Paris). January 6, 1962. Photo courtesy Harry Shunk.

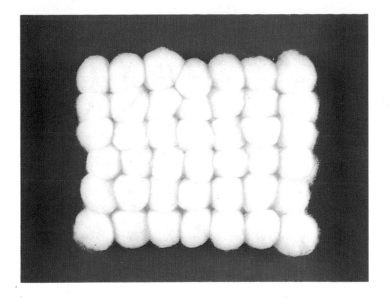

sion to risk everything would be documented. The resulting, somewhat doctored photograph gave Conceptualism and Performance Art one of their most stunning images.

Piero Manzoni (1933–63), an aristocratic Milanese disciple of both Klein and Lucio Fontana, as well as the *matière* painter Alberto Burri, contemplated the infinite, where matter and metaphysics would merge, until it led, in fatalistic progression, to suicide. However, this desperate end did not come before Manzoni had prefigured antimaterialist Conceptualism in some of art's most radical and ironic gestures or works. As early as 1957, Manzoni—like his close associate Enrico Castellani (fig. 435)—rejected Informalist notions of the painting surface as a passive receptacle for the artist's existential outpourings. Instead, he invented the "achrome," a support spread with white, often kaolin-covered substances—cotton, fiber, bread, felt, rabbit fur, stones, polystyrene—arranged in grids or folded and stretched taut from side to side (fig. 461). For Manzoni, the continuous space this produced constituted an elementary sign, signifying or representing nothing but its own existence—"simply being." As an absolute, totally self-sufficient entity, the achrome eliminated or demystified the artist, and would survive him to last until it died, all of which attested to the infinite existence of the art work as meaningful in itself. In his *linee*, or "Lines," of 1959, Manzoni used an ink-soaked pad to draw a continuous line on a role of paper, rewound the roll, stored it in a cylindrical container, and labeled this with the length of the piece and the date of its execution, which became the title. One title was "line of infinite length," which meant a work that could exist only in the mind as a concept. While Manzoni did not project himself into his creations, insisting that they have independent lives, he nevertheless identified with them by living a parallel relationship. Thus, he became so detached towards his own body that he regarded it precisely as he did one of his canvases, a thing whose association with him validated it as autonomously significant art. The notorious consequences of this idea were the ninety cans of *Merda d'artista*, each filled with 30 grams of Manzoni's own excrement, accurately labeled, numbered, and signed—a product made in Italy and unadulterated by preservatives! Reminiscent of Klein, who sold the contents of *le Vide*—zones of empty but spiritually filled space—for gold ingots, Manzoni marketed *Merda d'artista* at the same price per gram as gold. Eventually, he enlarged his concept of art to include the entire world, where unadulterated individuality itself becomes art. To confirm this, Manzoni created *The Base of the World*, an iron parallelopiped that, because upside down, may be seen as supporting the whole earth. Finally, therefore, art becomes a phenomenon of the purest sort; everywhere and nowhere, it simply is. "There is no need to say anything," Manzoni concluded, "being is all that matters."

As an above-ground concern, however, art's steady dematerialization surfaced only about 1970, the same year that MoMA mounted an exhibition called simply "Information." As the title suggests, ideas had once again come to the fore and, in the esteem of many new as well as older artists, taken precedence over form as the paramount issue in artistic matters. A year earlier, the artist Joseph Kosuth, a co-curator of "Information," had decided that "all art . . . is conceptual in nature because art only exists conceptually." Two years before that, moreover, the Minimalist sculptor Sol LeWitt had already used the term "conceptual art," perhaps for the initial time in this context, while characterizing his grid and cube works as "pure information" and thus Conceptualist (figs. 419, 420). This was in the first of two theoretical essays—"Paragraphs on Conceptual Art" (1967) and "Sentences on Conceptual Art" (1969)—that would have tremendous impact upon artists coming of age under the yoke of Minimalism. "In Conceptual Art," wrote LeWitt, "the idea or concept is the most important aspect of the work. . . . all planning and decisions are made beforehand and the execution is a perfunctory affair. The idea becomes the machine that makes the art." To prove it, LeWitt banished solid mass and realized his Minimalist cube not as a dense volume but, instead, as an open structure of joined beams, not all of which had to be there in order to establish the form as a clearly defined, albeit virtual, presence (fig. 459).

Still, even while granting that "the idea itself, even if not made visual, is as much a work of art as a product," LeWitt insisted that his writings "comment on art, but are not art." Joseph Kosuth (1945—), on the other hand, so extended the sixties' obsession with epistemology that he regarded serious writing about art as virtually equivalent to art itself, since ideas and the discourse about them were inseparable from their material embodiment in an object. And by ideas, Kosuth meant original thoughts designed to question the nature of art, an endeavor that he believed to be the only one worthy of the true artist. By

above: 461.
Piero Manzoni.
Achrome. c. 1960.
Cotton balls on felt,
13½ × 17¾".
Courtesy Marisa del Re Gallery, New York.

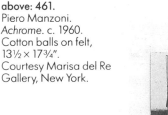

above right: 462.
Joseph Kosuth. *One and Three Chairs.* 1965. Wooden folding chair, photograph of chair, and photographic enlargement of dictionary definition of chair; chair 32⅜ × 14⅞ × 20⅞", photo panel 36 × 24⅛", text panel 24⅛ × 24½". Museum of Modern Art, New York (Larry Aldrich Foundation Fund).

below right: 463.
Joseph Kosuth. *Art as Idea as Idea.* 1966. Mounted photostat, 4' square. Courtesy Leo Castelli Gallery, New York.

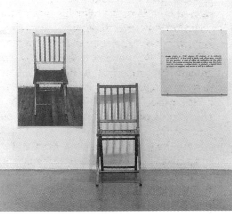

subject, adj, n, v; subjection, subjective (adj, hence n). In E, as for F *sujet*, the adj precedes the n; both of the E uses come from F; the F (MF *suget*, OF *sugez*) comes from ML *subjectus*, pp of *subjicere*, L *subiicere* (*subicere*), to throw, hence to bring or place under: *sub*, under+-*i*(*i*)*cere*, c/f of *iacere*, to throw, the active aspect of *iacēre*, to lie down: f.a.e., JET.—'To *subject*' derives from MF *subjecter*, ML *subjectāre*, L *subiectāre*, freq of *subiicere*; *subjection* and *subjective* derive from OF-MF *subjection* (ML *subjectiōnem*, acc of *subjectiō*, L *subiectiō*, from the pp *subiectus*) and late MF-F *subjectif*, f -*ive* (ML *subjectivus*).

this standard, the formalist painting of Greenberg's followers—especially Louis, Noland, and Olitski—appeared "mindless," because it had been made with the "handed-down 'language' of traditional art," all of which required a "minimal creative effort." Moreover, formalist critics, by merely describing the physical attributes of particular works, could not "add any knowledge (or facts) to our understanding of the nature or function of art." Meanwhile, Conceptual Art "at its most strict and radical extreme . . . is such because it is based on . . . the understanding of the linguistic nature of all art propositions, be they past or present, and regardless of the elements used in their construction." As if to offer a paradigm of how art could break the optical barrier and move beyond the object into the dematerialized realm of language, science, and worldly data, used as the sum and substance of art, Kosuth produced *One and Three Chairs* (fig. 462). Composed of an actual chair, a full-scale photograph of the same chair, and an enlarged dictionary definition of "chair," the piece leads the viewer from the real to the ideal, thereby exploring all the essential possibilities of "chairness." Clearly, the artist was preoccupied with investigating the mechanics of meaning, which in the world of objects involves linking a visual percept with a mental concept. To use the terminology of semiotics—the general science of signs that so captivated Kosuth and many of his fellow Conceptualists—we might say that the signifier (percept or word "chair") and the signified (concept or meaning) collaborate to yield the sign *chair*. But by displaying, together with the "referent" (a common folding chair), a surrogate for the visual percept (the photograph) and a stand-in for the mental concept (the dictionary definition), Kosuth transformed analysis into art and thus brought forth a new, higher, more transcendent sign, or metasign, which in turn stimulates further analysis of how art means. Persuaded that "art is the definition of art," a human product which "exists for its own sake" free of concern "with questions of empirical fact," Kosuth represented the idea of representation as this may occur in photography or words. Composed of three equal parts—a "readymade" chair bracketed by its mechanically reproduced image and its linguistic definition (text)—*One and Three Chairs* comprises a series of straightforward statements, not merely about external reality, but, more important, about the means to register it.

With a lust for the new typical of the period, Kosuth would soon eliminate the first two steps of his analytical process and aim straight for the metasign. Calling this streamlined, economical methodology "art as idea as idea," he made a series of photostat blowups of dictionary definitions of art-associated words (fig. 463), which, once mounted and exhibited in a gallery setting, demonstrate how the *verbal* and the *mental* may become *visual* art. Ironically, they also assume an object-like aesthetic quality comparable to that of Minimalism's clean, elegant beauty, as well as something of its repetitive seriality.

In the recent Canceled Text series Kosuth has eliminated this precious, portable, marketable quality by recasting his metasigns on a prodigious scale (in languages appropriate to the installations' various locales) and making them as inseparable from their architectural support as a Renaissance fresco (fig. 464). For the New York version he vastly enlarged a single paragraph from Sigmund Freud's *The Psychology of Everyday Life* and then had it repeated in paint thirty-one times, until the type became a total environment covering the walls of Castelli's cavernous Greene Street annex from floor to ceiling. Next he "canceled" every line with a thick, black deletion bar, which still left the text readable, if only through the teasing process of mentally restoring the letters from their fragments still evident above and below the dark horizontal scoring. Appropriately enough, the paragraph came from a chapter entitled "Slips of the Pen," in which Freud discusses a telegram from his publisher that reads, "Provisions received, invitation X urgent," whereas it should have acknowledged receipt of a preface and requested a promised introduction. "We may assume," Freud wrote, "that it had fallen victim to a revision by the telegraphist's hunger complex, in the course of which, moreover, the two halves of the sentence became linked more closely than the sender had intended." By recontextualizing this particular text—about transcription mistakes caused by unconscious longings—within the world of art and then obliterating it, Kosuth would seem to have exemplified the transaction that occurs between the artist and his work, the work and its viewers. At the same time that the finished artifact seems never to emerge as more than an echo of its own creation, it also appears never to mean anything more than the total of the preexistent, unconscious desires projected upon it by the audience. Since it is just such slips or misconnections that constitute the problems the artist is forever attempting to solve, Kosuth not only deleted the phrases but reiterated them endlessly, side by side, in German and then in English, thereby further interrupting the normal experience of reading. But while this manifestation of unabating effort plagued by

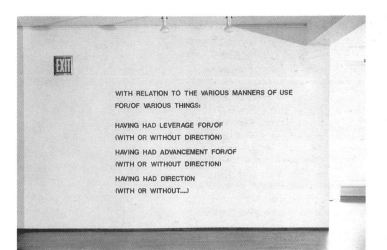

cial exploitation. As a result, a book or, particularly, a catalogue would become not only a source of primary information about a show, for instance, but also the exhibition itself. A case in point is *The Xerox Book*, published by Siegelaub, together with John Wendler, and composed of a series of twenty-five-page pieces made, for the most part, on Xerox copy machines by Kosuth, LeWitt, Robert Morris, Carl Andre, Robert Barry, Douglas Heubler, and Lawrence Weiner.

"Without language, there is no art," proclaimed Lawrence Weiner (1940—), after he gave up painting in 1968 in favor of compiling a notebook full of proposals, twenty-four of which he published in that year as "statements." Seeing language as competent to represent—

left: 466.
Lawrence Weiner. *With Relation to the Various Manners of Use for/of Various Things.* c. 1974. Wall statement. Courtesy Leo Castelli Gallery, New York.

right: 467.
Lawrence Weiner. *A 36 × 36" Removal to the Lathing of Support of Plaster or Wallboard from a Wall.* 1967. Collection Seth Siegelaub.

unrelenting error may force the viewer to concentrate his mind on the meaning of it all, the gallery-wide ensemble, with its dramatic black-on-white scheme, brightened by colored paragraph numbers, could be seen as the Conceptualist's answer to the magisterially decorative, sensual, full-color environments that Monet made of his late Waterlily paintings. Yet, even Kosuth's title—a pun in which *Zero & Not* could be heard as redundant, self-canceling *Zero & Naught*—reflects a way of thinking about how and what art signifies, since, for Kosuth, "art is the definition of art," and "exists for its own sake." Thus, he made a work so site-determined that while *Zero & Not* may have gratified the eye as well as the mind, it denied the hunger of the market for a consumable, salable commodity.

After Donald Judd, rephrasing Duchamp and Manzoni among others, declared that "if someone says it's art, it's art," the statement soon became the battle cry for a large and unruly army of post-Minimalists whose "post-studio" or "post-object" works ranged from the temporality of Performance and Process Art to the rootedness of Land Art. Common to them all, however, was an unprecedented commitment to ideas and their communication through some medium other than a unique, permanent, and transferrable (hence limitlessly marketable) prestige commodity: the art object. "The ideal Conceptual work," as formulated by Mel Bochner, could be experienced entirely through its description; further, it should be infinitely repeatable, therefore free of precious "aura" and uniqueness. The French Conceptualist Daniel Buren (1938—) demonstrated the principle when he reduced his painting to a uniform, neutral, and internal system of commercially printed vertical stripes measuring 8.7cm (about 3½ inches) wide, a "zero-level" structure that readily lent itself to infinite replication and exhibition in any environment without this changing the initial concept (fig. 465). Variety came not in the form itself but rather in the context, which for a long while was more likely to be street hoardings or subway billboards than a museum wall. "Right from the start," Buren asserted in 1980, "I have always tried to show that indeed a thing never exists in itself." The work might also vary in color, but with the blue, green, yellow, red, brown, orange, or gray bands invariably alternating with white ones. Moreover, the very sameness of the stripes, whether pasted up like wallpaper, hung awning fashion, or even hand-painted on canvas, robbed them of their intended anonymity and conferred an identity as irrefutable as a signature. This would become particularly evident after a more mature Buren undertook to adapt his all-purpose Minimalism to the ambitious aims of a monumental, site-specific piece integrated with a great and revered work of historic architecture (figs. 518, 519).

Afflicted with what Seth Siegelaub, one of Conceptualism's most loyal supporters, characterized as the problem of how "to make someone else aware that an artist has done anything at all," many Conceptualists resorted to print, a medium through which the message seemed least likely to suffer either distortion or undue commer-

that is, stand for—something, Weiner decided to let it stand on its own as sculpture. Thus, for him, statements like "One Quart Exterior Green Institutional Enamel Thrown on a Brick Wall" were sufficient to yield both visual form and meaning. Eventually, Weiner would materialize his pieces as stenciled or Letraset words mounted on the walls of exhibition spaces (fig. 466). Also among his tersely articulated ideas was *A 36 × 36" Removal to the Lathing or Support of Plaster or Wallboard from a Wall* (fig. 467), which, as the documentation confirms, did come into being, despite the artist, who maintained that he cared little whether his statements would ever be executed, by himself or anyone else. Like all of Weiner's proposals—or those of LeWitt for sited wall drawings—this one could have produced any number of possible results. Fundamentally, Weiner left the decision to implement the idea, as well as the way in which it should be implemented, to the "receiver" of the work, who in the piece seen here appeared intent upon making a Minimalist relief or in reopening the window into depth that modernism had so decisively closed. "Once you know about a work of mine," Weiner wrote, "you own it. There's no way I can climb into somebody's head and remove it." Thus, Weiner freed his work not only from environments specifically designated for art but also from any one frame of reference, which must inevitably differ with each person who comes to possess it.

Also much given to proposals was Douglas Heubler (1924—), who switched from Minimalism to Conceptualism at the relatively early date of 1965. Three years later, with the zealous conviction of a convert, Heubler made his new attitude towards form brusquely clear in a now-famous pronouncement: "The world is full of objects, more or less interesting; I do not wish to add any more. I prefer, simply, to state the existence of things in terms of time or of space." In *Location Piece #14,* for example, Heubler proposed that each of the states between New York and Los Angeles be photographed from an airplane window. The piece would then be completed once the twenty-four photographs had been bound together with a map of the world and the artist's statement, which, however, warned: "The owner of the work will assume the responsibility for fulfilling every aspect of its physical execution." But even when taken, the photographs proved indistinguishable from one another, which left the work to be experienced

largely in the observer's mind. At the conclusion to another typewritten piece, presented as documentation, Heubler said: "An inevitable destiny is set in motion by the specific process selected to form such a work freeing it from further decision on my part." In his Location, Duration, and Variable Pieces, Heubler found not only ways to distance himself from traditional procedures for constructing an art work;

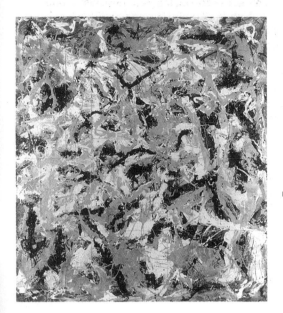

right: 468.
Art & Language
(Mel Ramsden).
100% Abstract. 1968.
Photostat.
Courtesy Lisson
Gallery, London.

left: 469.
Art & Language.
*Portrait of VI Lenin
in the Style of
Jackson Pollock II.*
1980. Oil and enamel
on board
mounted on plywood,
7'10" × 6'11".
Courtesy Lisson
Gallery, London.

he also introduced the possibility of generating visual relationships, derived from reality, that would not otherwise have occurred. Yet, the resulting work is one "that has no privileged position in space."

Still more fugitive, though imbued with the charm of whimsy, were such "telepathic" works as the following prepared by Robert Barry (1936—) for MoMA's "Information" show:

> ART WORK, 1970
> *It is always changing.*
> *It has order.*
> *It doesn't have a specific place.*
> *Its boundaries are not fixed.*
> *It affects other things.*
> *It may be accessible but go unnoticed.*
> *Part of it may also be part of something else.*
> > *Some of it is familiar.*
> > *Some of it is strange.*
> > *Knowing of it changes it.*

Devoted to invisible media, such as ultrasonic sound, citizen-band radio transmitters, or, on one occasion, two cubic feet of inert helium gas released into the atmosphere, Barry even maintained that, for him, "the most potent thing in the world" was a void or simply "nothing." As a trope for the delusiveness of objecthood, Barry's airwaves served wittily well, for while invisible, their reality could not be disputed, nor could any other medium have been more materially effective in delivering information. Once tuned in to such disembodied work, "viewers" could not but come alive to the suspension of disbelief upon which the whole aesthetic enterprise depends.

Of all the artists functioning in the purified medium of words alone, the most radical and uncompromising may have been those associated with an Anglo-American group known as Art & Language, which came into being with the founding of the Art & Language Press in 1968 and the publication of the first issue of its journal *Art-Language* in 1969. Members included Joseph Kosuth, Terry Atkinson, David Bainbridge, Michael Baldwin, Ian Burn, Charles Harrison, Harold Hurrell, Philip Pilkington, Mel Ramsden, and David Rushton, all of them devoted to investigating the "language of

art," first in print but soon on tape, microfilm, and posters (fig. 468). Eager to scuttle modernism, especially "art for art's sake" and the attendant notion of individualism or originality, collective Art & Language decided that "conversation, discussion, and conceptualism" should become "their primary practice as art," believing this to be the most effective way to investigate "those fraudulent conceptualisations by means of which normal art was supported and entrenched." With analytical philosophy, the ideas of Wittgenstein, and Marxist theory as key tools of thought, Art & Language typically "collaged" their findings together in impenetrable treatises that struck some as humorous and others as infuriatingly narcissistic and futile. As the seventies evolved, however, the group became less anti-visual, if for no other reason than to give their revolutionary aims greater impact. As a result, even the paintings they now executed came forth as critical of formalist art and the "fiction" of its autonomy as their written texts (fig. 469). In *Portrait of V.I. Lenin in the Style of Jackson Pollock*, for instance, American and Russian codes of representation have been appropriated and mixed, evidently for the sake of pictorializing a contemporary Marxist claim that "spontaneous" Abstract Expressionism had "triumphed" in part because of its alleged appropriation and co-optation by the American government as a weapon for waging the Cold War. In the mid-eighties, and still working through their "index" of styles, Art & Language have painted some quite remarkable pictures and applied their deconstructive techniques to more plausible villains.

Just as structural linguisticians like Ferdinand de Saussure objectified language by analyzing and dissecting it, Ed Ruscha, the Popster seen in Chapter 5 (fig. 263), anticipated Conceptualism's use of words as objects when, in 1959, he began introducing solitary nouns, verbs, names, or short phrases into painting and treating them as representational subject matter (fig. 470). In these works Ruscha remained within the traditional confines of painting, but departed from convention and further objectified his nonobjective representations by executing them in such non-art media as egg yolk on moiré silk.

More often than not, however, Conceptualists were as sanctimonious as Puritans in their stern denial of the sensory pleasures offered by "outmoded" painting and sculpture. Still, compensation of a sort came with the lush rain forest of new possibilities they discovered within the narrow field of language and linguistically analogous systems. Not only books, catalogues, and maps, but also newspapers, magazines, charts, and advertising, postal and telegraphic messages were commandeered as vehicles for information and opinions about art and, particularly, the art world's mounting resistance to the Vietnam War. Perhaps more than any other print medium, however, it was photography that claimed the Conceptualist's most enduring attention, especially after the kinetic forms of film and video became economical enough to be readily accessible. Before long, the non-unique visual image would seem almost as ubiquitous in Conceptual Art as words, a development that, once again, had been foreshadowed by Ed Ruscha. At the same time that this Los Angeles artist was painting his crisply cool pictures packed with visual/verbal paradox, he was also combining words and images into documentary codices of deadpan directness. Eventually, Ruscha lost interest in typography and concentrated on iconography, made with his own hand-held camera, as in *Every Building on the Sunset Strip* (fig. 471). "I have eliminated all

text from my books," he once said, because "I want absolutely neutral material. My pictures are not that interesting, nor the subject matter. They are simply a collection of 'facts'; my book is more like a collection of ready-mades."

Like Ed Ruscha in *Every Building on the Sunset Strip*, the German artists Bernd (1931—) and Hilla (1934—) Becher employ the camera to produce the essential raw material of their work. Since the late 1950s the Bechers, functioning as a team, have traveled through the industrialized West and documented or portrayed its blast furnaces, grain elevators, water and cooling towers, lime kilns, coal silos, etc. (fig. 472). Treating the camera as an instrument of exclusion as well as of inclusion, they systematically edit away such "artistic" accessories as trees and cloud formations in order to focus on the subject as objectively as possible, from every angle, usually close up and always head-on. By this means, the Bechers can take advantage of forms already powerfully shaped by function, but then render them aesthetic through a rigorous formal exercise, which involves scaling the images to the same size—frontal, side, or three-quarter views, in detail or in whole—and presenting them in meticulous gridlock. What results in these chains of counterbalanced repetition and variation is a "grammar"—as the Bechers would call it—for comparing and understanding quite remarkable, though unlovely, structures normally not only out of sight but also actively avoided.

Even without words, Ruscha's noncommittal stills unfold across the page to become a tale told entirely through visual images. But in the Conceptual genre of Story Art the virtuoso master would be another Southern Californian, the wry, humorous-serious John Baldessari (1931—), who turned to camera-generated imagery, combined with texts, when established modes of art-making proved too slow and inchoate to satisfy his desire for a new kind of narrative art, one capable of presenting difficult ideas in a disarmingly clear, if far from direct, manner. "I really care about meaning in art," he once said. "I want things to look simple, but to raise issues, and to have more than one level of comprehension." Fed up with every aspect of the conventional, Baldessari, as we saw earlier, ritually burned and buried all the pictures he had painted between 1953 and 1966. Then, in 1971, he became so exasperated with Minimalism in specific that he scribbled the first of his "I will not make any more boring art" pieces and, right away, made good on his promise by subjecting systemic reiteration to a free, all-over calligraphic treatment wittily reminiscent of the humanistic, content-rich paintings of both Pollock and Cy Twombly

(fig. 455). Yet, when he had others execute variants of the work at sites as far away as Nova Scotia, Baldessari achieved as much critical distance from his art as had the Minimalists. In this punning conflation of the visual and the verbal, he disclosed a consuming interest in Duchamp, of course, but also in the great European fathers of modern linguistics—Ludwig Wittgenstein, Ferdinand de Saussure, Claude Lévi-Strauss, and Roland Barthes. From them Baldessari gained his belief in the structural connections between things of disparate nature and the power this gives to both for illuminating and conditioning—critiquing—one another. Barthes, in particular, provided a beacon, especially through his strategy of probing beneath the ordinary to uncover its real meaning or value. Information theory also captivated Baldessari's idea-hungry mind, filling it with a sense of how information divides into the semantic and the aesthetic, the one logical, structured, predictable, and translatable into words or pictures, the other a general state of mind, internal, unforeseeable, and resistant to translation. Convinced, like his sources, that both the semantic and the aesthetic, the visual and the verbal coexist in every message and there partake of a game-like interplay, Baldessari prepared a videotape in which he set a series of erudite statements by Sol LeWitt on Conceptual Art to such popular, even hackneyed tunes as "Camptown Races" and "Some Enchanted Evening." The results were hilarious, for, as Marcia Tucker has written, "the 'natural' priority of aesthetic information in music is subverted by discourse inappropriate to the task at hand, and conversely LeWitt's 'semantic' information is subverted by Baldessari's 'aesthetic'." In what may be the most celebrated example of his early Story Art, *Ingres and Other Parables* (fig.

right: 470.
Ed Ruscha. *Virtue*.
1973. Oil on
canvas, 4'6⅛" × 5'.
Courtesy
Leo Castelli
Gallery, New York.

below: 471.
Ed Ruscha. *Every
Building on the
Sunset Strip*. 1966.
Artist's book,
7⅛ × 5⅝" (closed).
Courtesy the artist.

left: 472. Bernd and Hilla Becher. *Blast Furnace Heads*.
1988. 9 black-and-white photographs, mounted;
each 20 × 16". Courtesy Sonnabend Gallery, New York.

Conceptual Art

color, and a single color for each of the six spectral hues. Next, Baldessari invited friends to join him in assigning a word to each image, after which he had the word-coded pictures filed alphabetically and thus made ready for use according to a given set of conditions:

Black-and-white photos with words starting with color wheel initials (R,O,Y,G,B,V) in sequence, but starting with any color that makes sense as a sentence, are chosen. The color order ordains the syntax of the single color photos, but the photos used must make sense also as a sentence, plus using as a rule the added difficulty of each word having to start with the same letter and all the words having to be alphabetized. What intrigues me here (and this is a method in most of my work) is establishing a set of conditions that make things difficult to occur but not so difficult that they couldn't possibly occur. It should be noted that I use the first images I find in my image dictionaries that fulfill the structure requirements, regardless of whether I personally care for either the image or the word.

The purpose of such transpositions—such complexity disguised as simplicity—is always to surprise viewers, make them see things they would not otherwise, and, ultimately, encourage them to rethink all kinds of common assumptions. The process recalls Lewis Carroll's "jabberwocky," nonsense verse that begins to make a marvelous new kind of sense because its grammatical structure remains correct even though the component words are strange. If works like *Blasted Allegories* seem difficult, as well as amusing, it is because, in Baldessari's opinion, the difficult and the entertaining induce learning. Clearly, this Story Art, with its sly commentary on making art and conveying information, is profoundly didactic in nature. Indeed, Baldessari, who has always taught, does not distinguish between communication by teaching and communication through his own work, for either way, he says, "I am getting essentially the same message out, I hope." His hopes have been fulfilled, for, as we shall see, some of the most notable among younger American artists to emerge in the 1980s have studied under Baldessari at the California Institute of the Arts ("Cal Arts") in Valencia.

473), Baldessari once again achieved the comic by a sober strategy of colliding the semantic and the aesthetic, the ordinary and the exceptional, the linguistic and the pictorial until they recontextualized one another, becoming mutually both dominant and subordinate. For this series of "gnomic expressions," bound together as a catalogue or codex, he adopted a Biblical or omniscient voice to narrate ten short riddles—about artists and the contemporary art world—each of which concludes with a clearly stated moral. And like most Bibles, *Ingres and Other Parables* would be illustrated, as here in a story entitled "Art History," whose text is accompanied by a standard textbook reproduction of a "key monument," Egypt's three great pharaonic pyramids. Thanks to the parable form, with its God-like perspective, Baldessari removed himself from the content of his tale while simultaneously making it as trenchant and ironic as only an insider could.

For the later and more complex *Blasted Allegories* (fig. 474), Baldessari found stimulus in Saussure's contention that "each word is like the center of a constellation; it is the point of convergence of an indefinite number of co-ordinated terms." Now, as before, he would break all pre-established rules but also fix new ones by which to work. First, he randomly photographed television images in black-and-white, full

A poet who remade words and books into Conceptual works of art was Belgium's Marcel Broodthaers (1924–76). Offended less by

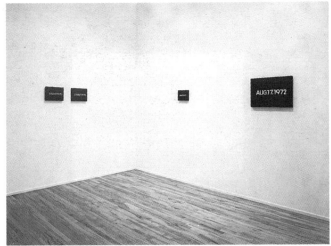

far right: 476.
On Kawara. *Today.* Ongoing series begun in 1966. Courtesy Sperone Westwater, New York.

right: 477.
Hanne Darboven. *Four Seasons* (panel 2). 1973. Ink on paper, 8 framed sections, each containing 42 pages; each section 5'10¾" × 4'11⅛". Courtesy Leo Castelli Gallery, New York.

mainstream modernism than by the aggressiveness with which American Pop Art was being promoted in Europe, the forty-year-old Broodthaers decided to act on his love of René Magritte—especially the Magritte of *Ce n'est pas une pipe*—and create what became a formidable array of enigmatic visual/verbal objects, assemblages, installations, prints, and books whose punning interplays seemed to outdo Rauschenberg and Johns by the very gentleness and elegance of their proliferating but imprecise meanings. As a very simple demonstration of an exceedingly cerebral and complex art, there is the print entitled *Citron-Citroën*, for which Broodthaers appropriated an old poster illustrating and listing the allures of Belgium's northern coast (fig. 475). With a Duchampian gesture, he designated it art merely by adding the two words of the title, while assonance creates a tautology doubling the sense of pleasurable anticipation evoked by the original graphic. *Citron*, of course, means "lemon," with which the vacationer would sting his oysters into full, sparkling flavor, while *Citroën* names the kind of family sedan in which the good bourgeois would travel to their seaside holidays. Often, however, Broodthaers, like so many Conceptualists, contrived to make ironic comment on the art "situation" and its many contradictions.

On Kawara (1931—) re-invented narrative art by treating language itself as an essence as well as an image. On July 4, 1966, Kawara, a Japanese artist active in New York, painted the first of his Today pictures, an ongoing series that now numbers more than 2,000 works, each of them featuring nothing but the date on which it was painted, set forth large, full center, and in white on a flat plane of color (fig. 476). If "language is the ultimate abstraction," as Kawara once said, then time must be the ultimate among intangible realities. By fixing date after date after date on individual canvases, he could be said to have rendered both words and moments concrete, at the same time that the series as an open-ended whole acknowledges both the overwhelming presentness and the inevitable ephemerality of *now*. Like a Zen Buddhist, Kawara succeeded in accommodating mutually exclusive propositions within the same realm of possibilities. Here, the problem of how to deal with the fourth dimension was treated in more or less philosophical terms, rather than in the literalizing, sensory manner developed by the Op and Kinetic artists. Yet, a certain sensuality clings to the Today pictures, since Kawara hand-painted each of them, which makes his oeuvre rare indeed within the object-resistant precincts of Conceptualism. The element of personal touch also offers a witty, ironic foil to the pictures' apparent anonymity.

Germany's Hanne Darboven (1941—) too gave narrative new life, now in wall-size images composed of nothing but script scrawled by her own racing hand (fig. 477). Filling page after page with abstract calligraphy and strange, permuting numeration, often derived from the calendar, Darboven marked the evolution of time and her experience of it. As the letters and digits add up, multiply, and weave

together, they envelop the viewer in a complete environment symbolizing his own trance-like involvement with time's relentless advance.

Performance Art

When written words and static media proved too materially confining, some Conceptualists broke free into the utter temporality of Performance Art, which transformed narrative into a variety of theater. Happenings, of course, were the immediate, and somewhat disheveled, source, but true Performance works had been created at an early date when Yves Klein made his photographed leap into the Void (fig. 478) or used live "brushes" to paint Anthropometries before an invited au-

478. Yves Klein.
The Leap into the Void. 1960.
Performance photographed by Harry Shunk.
Menil Collection, Houston.

dience (fig. 279). After this came, among other Performance events, Rauschenberg's extensive labors with the Merce Cunningham and Dance Company (1955–65) and his own landmark piece entitled *Pelican*, executed in 1963 by the artist moving round a rink on roller skates while harnessed to a huge umbrella-like "landing gear" (fig. 226). In the 1970s so many artists embraced Performance that it has been called the art form most characteristic of the period. To explain the phenomenon, Jack Burnham took an historical view and saw that "the erosion in the plastic arts toward theater was in progress early in the beginning of this century, though never so evident as when critics began to describe in detail the activities of Pollock and de Kooning in front of or over a canvas [fig. 68]. . . . For a century the artist has chosen to be not only his best subject matter, but in many cases his only legitimate subject." For the Vietnam generation, which felt an urgent

need to repudiate the recent past, Performance provided an opportunity for exploring an arena where visual artists might venture totally unburdened by experience or tradition. More important, Performance held the promise of liberating artists from the art object, simultaneously as it also freed them to adopt whatever medium, material, or subject matter appeared likely to serve their purposes. Further, it allowed them to "exhibit" at any time, for any duration, at all manner of sites—often the street—and in close contact with their viewers. As a result, artists could make their pieces directly accessible to the intended receivers, thereby gaining control over the display and consumption of their work without the mediation of critics, curators, and dealers. In sum, Performance seemed to offer the optimum possibility for converting art from a luxury item into visual communication: a vehicle for ideas and action. Lucy Lippard went so far as to call Performance "the most . . . immediate art form . . . for it means getting down to the bare bones of aesthetic communication—art/self confronting audience/society."

No artist active in the 1960s and 70s realized the heroic potential of Performance more movingly than Joseph Beuys (1921–86), the charismatic German sculptor, happener, teacher-guru, and fantasist who may well have been the most influential figure in post-modern European art (figs. 479–482). If Beuys could so reconceive sculpture that even his lectures seemed invested with plastic worth and mythic import, it was in large part because virtually everything he did assumed the character of autobiography, an autobiography replete, moreover, with the Germanic gift for poetic fancy, abstract formulation, absolute values, and endless perseverance. But unlike so many others possessed of these attributes, Beuys devoted the whole of his life and work not to careerist ambition or coercive power-seeking, but

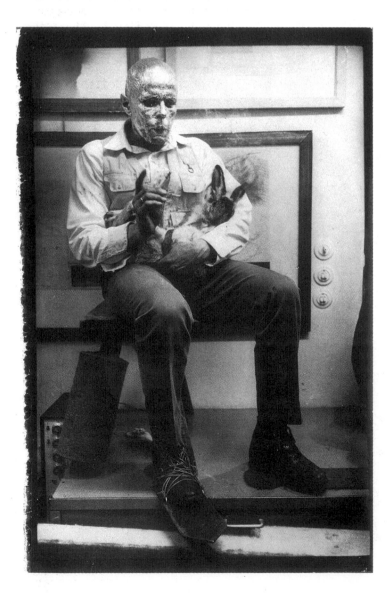

rather to the goal of mutual understanding and free human exchange. Born in Krefeld but reared in Cleves, a little town in the extreme northwestern corner of Germany, Beuys grew up close, on the one hand, to the Dutch world of those late-medieval visionaries Hieronymus Bosch and Pieter Bruegel and, on the other, at the beginning of the endless Eurasian plain that sweeps eastward from the Rhine all the way to the foothills of Mongolia. In this natural habitat of the nomad, a land variously occupied by Romans, Batavians, Franks, Germans, Frenchmen, and Spaniards, folk memory reaches back to legends of Lohengrin and Genghis Khan, as well as to the prophetic significance of the swan, the stag, and the hare. "The stag appears in times of distress," Beuys once wrote. "It brings a special element: the warm, positive element of life. It is endowed with spiritual power and insight and is the companion of the soul." As mystically redemptive in his aims as Yves Klein and as imbued with a sense of ritual, Beuys too sought the secrets of natural phenomena and longed to release their energies as a metaphor for the individual human being reborn—really self-determined—into a freer, less egocentric, more harmonious and creative condition.

The central trauma through which all this came to focus in his artistic consciousness occurred during World War II, when Beuys, while serving as a *Luftwaffe* fighter pilot, was shot down and given up for dead in the blizzard-swept Crimea, only to be rescued by nomadic Tatars who, throughout the war, went on with their lives disdainful of Soviet and German armies alike. Once restored to life, Beuys not only identified with their independent outlook; he would also and forever recall how they had covered his frozen, shattered body in fat to rekindle warmth, wrapped it in felt for insulation, and nursed him in a felt-walled tent smelling of cheese, fat, and milk. Many years later, when Beuys began to make sculptures as emblems of healing or regeneration, fat and felt would become the materials that for him seemed most alive with meaning. Meanwhile, he studied at the State Academy of Art in Düsseldorf, suffered considerably from the aftermath of his wartime experiences, but in 1961 joined the sculpture faculty at the Düsseldorf Academy. Eager to rehumanize both art and politics, Beuys began viewing his works "as stimulants for the transformation of the idea of sculpture or of art in general." Most particularly, he wanted them to stir thoughts about what art can be and how the concept of art-making may be "extended to the invisible materials used by everyone." Beuys even wrote about "Thinking Forms," concerned with "how we mold our thoughts," about "Spoken Forms," addressed to the question of "how we shape our thoughts into words," and finally about "Social Sculpture," meaning "how we mold and shape the world in which we live: Sculpture as an evolutionary process; everyone is an artist." "That is why," he continued, "the nature of my sculpture is not fixed and finished. Processes continue in most of them: chemical reactions, fermentations, color changes, decay, drying up. Everything is in a *state of change*." So keen was his sense of process and change as the realities with which to confront and convert reality—like the homeopathic method of "healing like with like"—that Beuys in 1962 joined Fluxus, a loosely knit, nonconformist, international group largely inspired by Duchamp and Cage and noted for their Happenings, mixed-media events, publications, concerts, and mailing activities. By the end of 1965, however, he had severed relations with Fluxus, because "they held a mirror up to people without indicating how to change anything." In a characteristic action Beuys took chalk and scrawled across a blackboard: "The silence of Marcel Duchamp is overrated." While Duchamp may have destroyed the language of art, Beuys, it seemed, would create a new one, based, like most newborn languages of art, on raw feelings, on pain and pleasure, used as reasoning devices and the mind as an instrument of feeling. To achieve this he would employ whatever means or materials seemed potent enough to make form appear sentient. Thus, he began piling unsymmetrical clumps of animal grease in empty rooms and then wrapping himself in fat and felt, an act that ritualized the materials and techniques employed by his Crimean saviors. Then, in 1965

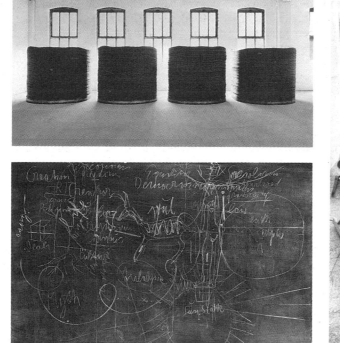

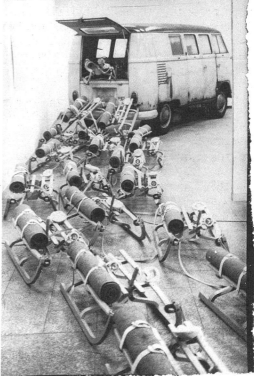

at Düsseldorf's Schmela Gallery, the artist created one of his most poignant and unforgettable performances in a work called *How to Explain Pictures to a Dead Hare* (fig. 479), for which he sat or strode about in an empty room surrounded by his familiar media of felt, fat, wire, and wood, his head covered in honey laced with gold leaf, and a dead hare cradled in his arms. Urgently murmuring to the small moribund creature, Beuys appeared to break the Duchampian silence and imply that to recover his voice, the artist had only to return to that ever-fresh fountainhead of all truth and honesty: personal experience, however wounded. Masked as he was, the sculptor also seemed to have assumed the role of shaman, one anointed with substances meant to transform desiccated intellect into live intuition. Like the stool leg wrapped in felt, the radio made of bone and electrical components placed under the stool, and the magnetized iron plate tied to the artist's right foot, every part of the complex and poetic piece strove to reactivate the mind through a charged appeal to latent instinct, symbolized by the dead hare. Thus, as Beuys clanked about the gallery and whispered to the furry little corpse, his audience remained outside straining to hear over a barely audible wavelength. Not only did this compel them to rely on and stimulate their imaginations, it also, as Beuys later remarked, stressed "the problem of explaining things, particularly where art and creative work are concerned." Further, "even a dead animal preserves more power of intuition than some human beings with their stubborn rationality. . . . Imagination, inspiration, intuition, and longing all lead people to sense that these other levels also play a part in understanding." Acting as a healer who through magical incantation would work the miracle of bringing warmth to a world frozen in its vicious circle of greed and violence, Beuys tried to "seek out the energy points in the human power field rather than demanding specific knowledge or reactions on the part of the public." Although *How to Explain Pictures to a Dead Hare* had few eyewitnesses, it yielded some of Beuys' most resonant images.

Scarcely less sacramental are the numerous installation pieces that Beuys created, as in *The Pack* (fig. 480). For this 1969 sculpture, he took a battered Volkswagen bus and filled it to tumbling overflow with archetypal implements of escape and survival, mainly small sleds laden with felt for protection, fat for food, and flashlights for guidance. In other pieces Beuys could also be not only mythic but also as literal as the Minimalists (fig. 481). Here he assembled massive cubic stacks of felt and then weighed them down with sheets of copper. Stretched out in a row, they could be a work by Donald Judd, except that for Beuys the dumb, inert, muffled density of the felt piles suggested batteries stored with "static action," energy, or accumulated warmth, all ready for release through the metal's conductivity. As Caroline Tisall writes: "At the very time when Minimal Art has exhausted itself while still being the latest movement, Beuys demonstrates how Minimal Art can be integrated and overcome."

Like a wandering friar, Beuys traveled throughout Europe, from Naples to Edinburgh, and finally to the United States, always an hypnotic presence whether lecturing, dialoguing, performing, or exhibiting. In this way he hoped to extend the notion of sculpture to that of social sculpture and his theory of sculpture to an *Energy Plan for Western Man*. Everywhere Beuys used the common schoolroom blackboard and a long chalk-pointed marker—sometimes a shepherd's crook—to make elaborate drawings giving visual form to ideas that would otherwise have remained inchoate at an abstract verbal level (fig. 482). In a characteristically faint, even febrile line, often ghosted by erasures and overdrawing, he alternated mysterious scribbles and diagrams with Lascaux-like traces of animals, figures, or landscapes, as if all creation were connected by a single flow of energy. Even though ineffable and unique, the ultimate effect might be described as something of a cross between Cy Twombly's atavistic scrawls, the systemic wall drawings of Sol LeWitt, and street graffiti. Progressively, the blackboard drawings trace Beuys' campaign to rehabilitate individuals—not parties or factions—into a balance of thinking, feeling, and will power capable of bringing about a more humane alternative to both private (Western) and state (Eastern) capitalism. As envisioned by Beuys, this would be a "direct" democracy or parliament of the nonaligned, the product of a society evolved into a higher state through the mobilization of all its members' latent creativity. The key to the *Energy Plan for Western Man* was language, but language expanded and transformed so far beyond conventional usage that it may become an implement of freedom. This would entail—to quote Tisdall once again—"a world of sound and form impulses, a language of primary sound without semantic content, but laden with completely different levels of information."

Much closer to Fluxus anarchy than Beuys, but a genuinely original talent, was the Korean-born Performance artist Nam June Paik (1932—), long resident in Germany but intermittently settled in New York. Paik began his career as a classical pianist and electronic-music composer, but in 1959, after meeting John Cage, he won a certain prophetic notoriety when, at a Dada-like concert, he arranged for the piano to tip over, prompting Allan Kaprow to label him a "cultural terrorist." In the early 1960s Paik switched to video, through which he hoped to explore and expand music's visual potential. Like a vaudevillian in love with the dramatic one-liner, he proclaimed that just "as collage technique replaced oil paint, the cathode ray tube will replace the canvas." In 1970, Paik, together with Suya Abe, invented a video-synthesizer that permitted him to make his own collage of images from a range of television cameras, transforming, as Calvin Tomkins wrote, "the familiar screen into an electronic canvas for an artist whose brush consists of light" (fig. 483). However, what appealed to Paik the Conceptualist was the notion of subverting a technology intended to make passive consumers of its mass audience and of converting it into a medium responsive to his own artistic will, or the will of whoever may wish to develop a more active relationship to the video medium. A model of how this might emerge came when Paik made a tape of a Johnny Carson routine, one in which the comedian did a send-up of the "wacky" avant-garde, and then, by merely laying a live wire across the reeled tape, erased minute segments of the recorded material at progressively more frequent intervals as the replayed tape unwound towards the core. With this Paik demonstrated his power to reach into the cultural environment and there force recognition that he had in some measure altered that reality. A warm and

charming collaborator, Paik generated new scandal with several of the semi-erotic pieces he created for the cellist Charlotte Moorman. One of these had the statuesque musician play her instrument while harnessed into a brassiere made of two miniature TV sets, which some wit inevitably dubbed "boob tubes." As the tones changed during Moorman's performance of works by Paik and other composers, so did the images on the little three-inch screens. However, some of the fun went out of the Paik-Moorman collaboration after the cellist was arrested while performing *Opera Sextronic*, which required her not only to play music but also to disrobe. Like many Performance works,

above: 483. Nam June Paik. *Solomon Island.* 1985. Laser photo of Charlotte Moorman performing *Bra for Living Sculpture.* Courtesy Holly Solomon Gallery, New York.

far left: 484. Bruce Nauman. *Self-Portrait as a Fountain.* 1966–70. Photograph, 19¾ × 23¾". Courtesy Leo Castelli Gallery, New York.

left: 485. Bruce Nauman. *Punch & Judy (Kick in the Groin/Slap in the Face).* 1985. Neon and glass tubing mounted on white aluminum, 6'5" × 5'1" × 1'2". Courtesy Leo Castelli Gallery, New York.

far left: 486. Chris Burden. *Doorway to Heaven.* November 15, 1973. Performance in which the artist crossed two live wires and pushed them into his chest. Courtesy the artist.

left: 487. Chris Burden. *The Reason for the Neutron Bomb.* 1979. 50,000 nickels and matchsticks, 30 × 17'. Courtesy the artist.

Opera Sextronic survives mainly in documentation, which includes photographs of the sensational event and the presiding judge's ten-thousand-word statement. Here the long-winded justice referred to "those 'happeners' whose belief is that art is 'supposed to change life' as we know it.'" In his summation, he also availed himself of a London Sunday *Times* editorial in which "life as we know it" seemed to have its revenge by characterizing the current art scene as "a kind of brothel of the intellect."

When Performance evolved into Body Art, it forced an intimacy between actor and audience that often left viewers outraged, amused, or queasy, but almost never neutral. Yet, Body Art dramatized the extreme narcissism at the heart of the self-searching involved in the production of art with pretensions to originality. Thus, Bruce Nauman (1941—), a California Conceptualist, stripped, stood before a camera, spat water in a high arc, and, *pace* Duchamp, designated himself a fountain (fig. 484). The documentation gave literal, as well as ironic, dimension to Nauman's consciously ambiguous definition of his chosen course in life: "The true artist is an amazing luminous fountain." Soon thereafter Nauman translated body work into the medium of neon tubing, a material with which he continues to contour overlapping lifesize figures whose off-and-on-again flashing makes the silhouettes seem alternately to love and violate one another, but never really to connect (fig. 485). The tawdry neon joins with the images' jazzily syncopated electronic performance to suggest the frenzied but sterile seediness of modern existence in general.

Body Art soon attracted a number of high-risk-takers who used Conceptualism's vaunted cutting edge to penetrate the world of sadomasochistic exhibitionism. Young Chris Burden (1946—), for example, undertook a series of death-defying acts, beginning with five days spent jammed into a 2-by-2-by-3-foot locker at the University of California in Irvine. During the same year, 1971, he performed *Shooting Piece*, which required that an intrepid friend fire a revolver at his arm from a range of 15 feet. The photographic documentation—harrowing in its matter-of-factness—shows that, instead of grazing the artist's arm, the bullet tore off a good strip of flesh! Yet, Burden insisted that he carefully calculated his risks; moreover, he professed to find them energizing. Far from gratuitously thrill-seeking, Burden meant his dangerous games to "re-enact certain American classics—like shooting people." "It was an inquiry into what it feels like to be shot," he said later. "Two or three thousand people get shot every night on TV, and it has always been something to be avoided. So I took the flip side and asked, 'What if you face this head on?' " In 1973, Burden again literalized the underlying ideals of artistic enterprise, while at the same time bestowing upon Conceptualism one of its eeriest, most spectacular images—a contemporary martyr icon—when he performed *Doorway to Heaven* (fig. 486). Accompanying the documentary photograph is this text:

At 6 PM I stood in the doorway of my studio facing the Venice [California] boardwalk. A few spectators watched as I pushed two live electric wires into my chest. The wires crossed and exploded, burning me, but saving me from electrocution.

In later work, Burden shifted from his own body to the body politic, as in *The Reason for the Neutron Bomb* (fig. 487), a field of 50,000 nickels each with a matchstick glued to it and each standing for one Soviet tank, a force so much greater than the West's that it becomes the official justification for an Armageddon weapon. Here too, the "sculpture" yields strikingly beautiful documentation, vibrant with moiré patterns recalling those of Bridget Riley's Op paintings. And, as before, Burden hoped to translate abstract knowledge—televised gun-slinging, uncountable numbers of tanks—into concrete experience. Finally, like much good Conceptual Art, *The Reason for the Neutron Bomb* raises questions while remaining ambiguous about answers, since the piece seems to argue for the dreaded nuclear arsenal quite as much as condemn it.

In London, meanwhile, a pair of artists known simply as Gilbert (1943—) and George (1942—) pronounced themselves "living sculp-

below: **488.** Gilbert & George. *The Red Sculpture: "Bloody Life and Dusty Corners."* Performance March 23–27, 1976. Courtesy Sonnabend Gallery, New York.

bottom: **489.** Gilbert & George. *May Man.* 1986. Hand-dyed photograms, 7'11" × 8'3⅝". Courtesy Sonnabend Gallery, New York.

tures" and brought to the overstressed late sixties a welcome grace note of stylish, if somewhat edgy, good humor. Taking their cue from old-fashioned English music hall, which they simultaneously sent up and milked, Gilbert & George donned outrageously proper "responsibility-suits," slicked down their hair, took up walking stick and gloves, placed themselves on a table-top plinth, and, to taped accompaniment, proceeded to mime ("sculpt") as if they were motorized puppets rendering a comically out-of-date song, like "Under the Arches" or "Bloody Life and Dusty Corners" (fig. 488). To make sure they could not be mistaken for anything other than "continuous sculpture," the duo also covered their faces and hands with bronze, copper, gold, or red paint. Thus, while closing the gap between art and life, Gilbert & George also set themselves apart, fashioning their entire lives into art. If this parodied the sophisticated London scene, it also reflected a passionate desire—common among all serious creative talents—to remain true to their own experience.

Gilbert & George still feature themselves but only in the documentary form of grandly scaled "photo-pieces" made of photographs and photograms, brilliantly hand-dyed, mounted, and framed (fig. 489). Moreover, their approach yet consists of making an exaggeratedly polite presentation of audacious material. Thus, a quite explicit homoerotic theme, involving the artists in a composition with barrow

boys from their tough East End neighborhood, may come forth surrounded by voluptuous flower and vegetable imagery and contained within a structure of stained-glass colors, window-like mullions, and mandalic or cruciform patterns.

Bruce McLean (1944—), a classmate of Gilbert & George at the St. Martin's School of Art and a student of those eminent modernists Anthony Caro and Phillip King, reacted to formalism with unalloyed disgust: "I began to understand what it was all about, which was noth-

left: 490.
Bruce McLean. *Pose Work for Plinths 3*. 1971. Photographs on board, 29½ × 26⅝". Tate Gallery, London.

right: 491.
Laurie Anderson. *United States (Part II)*. 1980 performance at the Orpheum Theatre, New York.

ing. All the discussion centered on the proclamation that sculpture should be placed on the floor and not on a base. It seemed to me quite daft that adults should spend their time like that. It dawned on me that what it was really about was the making of a name for oneself." To avoid this pitfall, McLean used water to create works whose antiformal impermanence can be imagined from titles like *Floating Sculpture* and *Splash Sculpture*. In performance, McLean often struck poses that parodied not only the works of his former teachers but even Henry Moore's archetypal reclining figure (fig. 490). The climax of this satiric vein came in 1972 with *King for a Day*, a one-day "retrospective" that the twenty-seven-year-old artist accepted from the Tate Gallery. Later he joined with two students to form "Nice Style," or "the World's First Pose Band," and expanded his outrageous mockery to embrace the careerism and bureaucracy of both the art world and society. But for all his eagerness to debunk, McLean was not without serious ambitions of his own, displayed in such mini spectacles as *Sorry! a Minimal Musical in Two Parts*, undertaken in 1977 with Sylvia Ziranek. Later than Gilbert & George, if more decisively, McLean too "returned" to painting, but with the prop-and-pose imagery of his Performance works still in place, now translated into the Neo-Expressionist idiom of the 1980s.

The music hall evoked by Gilbert & George is precisely where Chicago-born Laurie Anderson (1947—), a beautiful, multitalented, and worldly-wise second-generation Conceptualist, has focused her performances, disdaining the coterie, gallery-loft world where "the same three hundred people [crowd into] the same artspace every year." Eager to have her ideas touch society, and acutely aware that even the truly interested public had become less willing to accept just any feeble or absurd gesture as art, Anderson took to the streets in a piece called *Duets on Ice*, which she performed all over New York City and even in Genoa, Italy. For each performance, Anderson donned a Pierrot-like smock, stepped into a pair of ice skates embedded in blocks of ice, and played a violin obbligato to nostalgic cowboy songs emitted from a tape cassette hidden in her instrument—until the ice melted, leaving her unable to stand on the bladed skates. Here would seem to have been a trope about the fragility of art's message in the great, boisterous outside world and the need to harken before it is

too late. To Anderson, the message was and remains an important one, concerned as it is with the dangers of life in an era completely dominated by corporate power, a problem she once articulated in a characteristically witty and extended simile:

. . . it's kind of like sitting at the breakfast table and it's early in the morning and you're sitting there not quite awake eating cereal and staring at the writing on the cereal box not really reading the words just sort of looking at them and suddenly for some reason you snap to attention and you realize that what you're eating is what you're reading but that then it's much too late. . . .

Equating the coercive business mind with macho heroics, Anderson chided Chris Burden, after his *Shooting Piece*, in a work that included the refrain: "It's not the bullet that kills you, it's the hole."

Already a student of Egyptology and, of course, the violin, Anderson gradually expanded her range of competence to include semiotics and every other aspect of communication—poetry, song, rock rhythms and sound, plus the whole arsenal of modern audiovisual devices—harmonizers, filters, and electronic organs, complete with flashing diodes, switches, and calibrated dials. Beginning in 1979, she brought it all together for a continuing performance series called *United States* (fig. 491). In this *Gesamtkunstwerk*, Anderson deals in half-hour segments with the themes of transportation, politics, money, and love, all set against a giant schematic map of the USA emblazoned with out-of-sync zone clocks. Alternating or juxtaposing images and text, sound and technological invention, the artist sweeps her audience through a zestful sequence of whimsical-ironical "talking songs," turning the trip into a ride on a magic carpet sped along by such wonders as custom-made instruments, a slide show that miraculously comes and goes with the stroke of a neon violin bow, and glowing red lips that suddenly float in the dark. With humor, trickily sardonic, vernacular language, impeccable timing, dazzling style, and a theatrically savvy, spiked-hair, hip-androgynous persona, Anderson has brought the high seriousness of Conceptual Art to an audience large and universal enough to include admirers from both the intelligentsia and the general public. Right off in the opening number, entitled "O Superman," they hear the keynote of the entire piece. Humanizing semiotics with simple, folkloric wisdom, Anderson dedicated "O Superman" to Jules Massenet, the 19th-century French opera composer, whose aria *O Souverain* appeals to the Almighty for help, just as Anderson implores a modern deity to save humankind from a superpower permeated with both overt and covert "authority"—family, home, work, the military, and, always, the media:

> *When love is gone there's always justice*
> *And when justice is gone there's always force*
> *And when force is gone there's always. . . .*
> *Mom (Hi, Mom!)*
> *. . . so hold me Mom in your long arms*
> *So hold me in your electronic arms*
> *In your automatic arms. . . .*

Process Art

Like Performance, Process Art countered Minimalism—its preconceived, factory-made timelessness and structural clarity—with works so bound up with actual time that they would assume form as well as meaning from conditions of impermanence and mutability. But whereas Performance folk tended to make their own persons their medium and personal action their means, artists associated with "process" chose external but organic substances—oil, rubber, wood, grass, ice, sawdust, even cornflakes—as their materials and for their principal means allowed natural forces—time in collusion with gravity, temperature, atmosphere—to so affect the materials that the works remain forever subject to the waning or waxing stresses of change. As did the Abstract Expressionists and Tachists before them, Process artists hoped to wrest meaning from matter and the individual's active, temporal engagement with it. In their own way, the Popsters had continued the trend, beginning with Rauschenberg, who, with his Albers-taught love of *matière*, had learned to work with whatever was "available," however vulnerable it might be to alteration. In 1954, as we saw earlier, he even exhibited a "grass painting" made with seeded earth that grew when watered. Thereafter, decay and renewal often came with the materials adopted by the Pop, Assemblage, and Junk artists. But they also operated in the fragile Minimalism of Richard Tuttle's wrinkled, loosely tacked canvases (fig. 372), as well as in the overtly post-modern works of Joseph Beuys, who introduced fat and felt into art for the very reason that "process continues . . . in them: chemical reactions, fermentations, color changes, decay, drying up." Meanwhile, in 1967, the protean Robert Morris also appropriated felt, using it, furthermore, as a means of rendering geometrically pure forms—Unitary Objects—formless albeit more genuinely physical, doomed to collapse from the effects of gravity on their own heavy, structureless, inert matter (fig. 402). A year later he would give Process Art its most fully articulated rationale, arguing, in *Artforum*, against Minimalism because preconceived, durable unitariness and seriality did not inhere in the media the forms were made of:

The process of making itself has hardly been examined. . . . Of the Abstract Expressionists only Pollock was able to recover process and hold on to it as part of the end form of the work. Pollock's recovery of process involved a profound re-thinking of the role of both materials and tools in making. The stick which drips paint is a tool which acknowledges the nature of the fluidity of paint. Like any other tool, it is still one that controls and transforms matter. But unlike the brush, it is in far greater sympathy with matter because it acknowledges the inherent tendencies and properties of that matter.

Now, Morris left felt objects behind and moved into situations of extreme indeterminacy, where order gave way to chance effects of piling, stacking, hanging, and scattering, all possibilities independently explored, to great effect, in California by Barry Le Va (1941—; fig. 492). Soon Morris would even experiment with such intangible, volatile, and uncontrollable media as steam. Yet, within the apparent disorder of "scatter pieces," Morris, as well as Le Va in the "dispersion" work reproduced here, perceived the kind of order— a "continuity of details"—for which Pollock's all-over, holistic painting offered an au-

thoritative model, because Pollock had been the first "to recover process and hold on to it as part of the end form of the work." As a result, Pollock, like Morris and Le Va a generation later, went "beyond the personalism of the hand to the more direct revelation of matter itself." In writing thus, Morris seemed to remain the literalist he had always claimed to be, but in hindsight, he may not have been so far removed from more romantic Process artists who viewed the perishability of materials as somehow suggestive of the human condition, with all its powerlessness and brevity.

Today, apart from Beuys, the most celebrated artist associated with Process may be German-born Eva Hesse (1936–70), who first came to notice in New York, where she died at the disastrously early age of thirty-three. In 1966, Hesse found herself grouped together with artists like Louise Bourgeois and H. C. Westermann (figs. 164, 305) and presented in a gallery show that critic Lucy Lippard organized under the rubric "Eccentric Abstraction." Yet, even more than her coexhibitors, Hesse had produced work that retained Minimalism's clear, modular, grid-like structure but rendered it "eccentric," thanks to materials whose pliancy and perishability allowed neo-Surrealist implications of psychological or erotic self-revelation (fig. 493). Having worked through LeWitt-type Minimal and Conceptual Art, Hesse saw in process—especially as available in such organic, malleable, feminine techniques as sewing, lacing, or bandaging—a way of opening Minimalist codes to a less exclusive, more humanist range of values than those offered by cerebral, male-prescribed aloofness and monumentality. Guided by memory, sexuality, intuition, and humor, she permitted forms to emerge from the interaction of the process inherent in her chosen media—rope, fiberglass, latex, rubberized cheesecloth, and flabby, cheap, unappealing synthetics—with such natural forces as gravitational pull. Consequently, her pieces droop from pole to pole, hang from the ceiling, sag and nod towards the floor, or lean against the wall. Often they seem like dream visions of intimate parts—pendulous breasts or yawning vaginas—so that simple, dangling strings suggest umbilical cords or streaming milk. Oth-

left: 492.
Barry Le Va. *Arrangement, Re-arranged, Borrowed, Exchanged.* 1967. Studio installation with gray felt and aluminum, c. 2'6" × 5'. Courtesy the artist.

right: 493.
Eva Hesse. *Contingent.* 1969. Reinforced fiberglass and latex over cheesecloth, each of 8 units 9'6"–14' × 3–4'. Australian National Gallery, Canberra. Courtesy Robert Miller Gallery, New York.

ers may evoke remembrance of things past, even to the cobwebs that festoon old possessions stored away in attics. Eager to reactivate a situation that had shut down, Hesse cultivated contradictions and avoided unitariness. Like an Existentialist, she thought the work might be good because: "I could take risks. . . . My attitude toward art is most open. It is totally unconservative—just freedom and willingness to work. I really walk on the edge." But by trying to penetrate

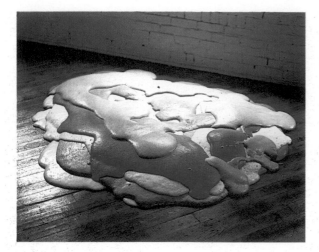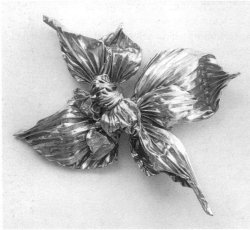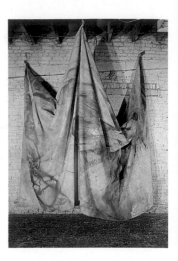

to "what is yet not known, thought, seen, touched," she created works so immersed in process that they have, like many others forever engaged in "making themselves," proved all too susceptible to time's entropic or disintegrating effects.

Lynda Benglis (1941—) as well, along with many other women artists, found heavy-metal Minimalism inadequate to her communicative needs. Thus, she too proved a bold explorer of process, finding its intrinsic fluidity a means not only to new form but also to new content. In the early 1970s Benglis became fascinated by the interrelationships between painting and sculpture, an issue that moved her to start pouring liquid rubber onto the floor, as if she were Jackson Pollock turned sculptor and spilling molten bronze (fig. 494). But rather than shape it with a mold, she allowed the material to "dictate its own form," aided, however, by the artist, who mixed and puddled into the free-flowing mass a startling rainbow array of "fluorescent oranges, chartreuses, Day-Glo pinks, greens, and blues." In this way, Benglis discovered a sculptural equivalent of the color-stain painting technique invented by Morris Louis, complete with all its sumptuous beauty but charged with a provocative element native to Benglis. More recently, the artist has made pictorial sculpture in the dramatically plastic form of bow-knotted wall reliefs finished in some richly decorative manner, such as gold leaf or a patina of dark verdigris (fig. 495). With their pleating, graceful if complicated folding, and Greek titles, these visually stunning works ignore Conceptualist austerity to become abstract, feminist evocations of such Classical figures as the *Nike of Samothrace*.

Sam Gilliam (1933—), a Washington, D.C., colorist like Louis and Noland, carried on his own "dialogue with sculpture," mainly by spattering highly liquefied color onto stretched canvas, somewhat in the choreographic manner of Pollock, and then hanging the unstretched canvas support from the ceiling (fig. 496). Draped and swagged, the painting became literally free-form and plastic, thereby transposing, as Benglis' floor piece did, the easel tradition questioned by Abstract Expressionism into an actual environment.

In one of his most celebrated pieces Jannis Kounellis (1936—), a Greek artist active in Italy's Arte Povera movement and deeply influenced by the process-related works of Lucio Fontana, Alberto Burri, and Piero Manzoni, stabled horses in a Roman art gallery as a way of dramatizing the contrast, and necessary relationship, between the organic world of nature and the man-created, artificial world of art. Also present, as always in art made on soil as rich in history as Italy or Greece, is the inevitable sense of the Classical past (the horse) and the present (the white gallery environment). The same ideas inform *Cotton Sculpture* (fig. 497), a piece in which the soft, white, perishable fluffiness of cotton has been combined with the dark, indestructible rigidity of steel to create an ongoing dialectic of nature and culture. Also present in Kounellis' work is the desire to politicize art by using "poor" materials—iron, wax, fire or smoke, charcoal, wood, ani-

mals or their wool, burlap—as a way of referring to common humanity. With their metaphysical dimension, the mass of simple folk represented, for Kounellis, a solitary constant firm enough to withstand the flux of historical and cultural fragmentation. In *Cotton Sculpture* their energy, sensed as latent in Beuys' stacks of felt, seems to break out of its bounds and truly become a regenerative force.

In Mario Merz (1925—) Arte Povera found its own Beuys, an artist who took inspiration from the ancient nomadic tribes that invaded Italy and integrated barbarian culture with that of Rome. A metaphysician and thus heir to de Chirico, Merz presented himself as a kind of witch doctor offering remedies for a materially rich but spiritually impoverished world. They came in the central image of his art, the igloo, which Merz sees as a "globe and its balance" or as a synthesis of nature and architecture, which he constructs with a metal framework and covers with clay, wax, slate, broken glass, wire mesh, or branches (fig. 498). Sometimes Merz adds political slogans, literary refer-

above left: 494. Lynda Benglis. *Bounce II.* 1969 (destroyed). Pigmented polyurethane, c. 6' square. Courtesy Paula Cooper Gallery, New York.

above center: 495. Lynda Benglis. *Apus.* 1986. Aluminum mesh and aluminum, 3'11" × 4'6" × 10½". Courtesy Paula Cooper Gallery, New York.

above right: 496. Sam Gilliam. *Counterpane.* 1969. Acrylic on canvas, 9'8" × 20'. Courtesy the artist.

below: 497. Jannis Kounellis. *Cotton Sculpture (Cotoniera).* 1967. Steel and cotton, 3'11¼" × 3'11¼" × 4'11". Courtesy the artist.

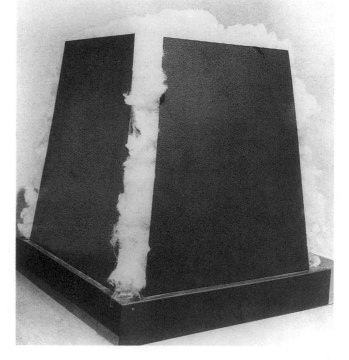

ences, or Fibonacci numbers in neon lettering, the messages always in keeping with the igloo, a metaphoric form for viewing art as an eternal process of changing and becoming, like nature itself. Thus penetrated by dynamic energy, the igloo offers symbolic protection for the modern nomad lost in the corporate, industrial wilderness. Merz fuses process and principle even in his installations, frequently ordering them according to the Fibonacci series, a mathematical progression that formalizes the growth rate found in everything from leaves to shells and the skins of reptiles.

Arte Povera arose, to quote Germano Celant, its most faithful apologist, "from a combination and dovetailing of contradictory entities, such as the embrace between embroidery and electronics, the fusion of tracings and fires, the vertigo of igloos and fruits. . . . "

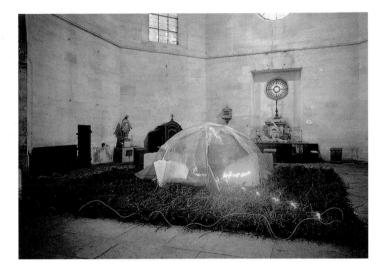

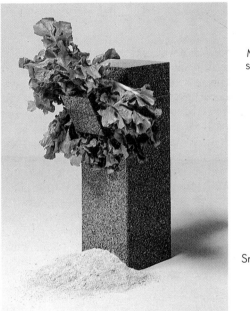

While Mario Merz built melting igloos on steel frames, Giovanni Anselmo (1934—) dealt with the vertigo of vegetables and stones, so conjoined in interdependence that with the decaying effects of time, one of a pair of stones must fall over, releasing a moment of energy into life's cyclical process of death and regeneration (fig. 499). As Luciano Fabro, another member of Celant's circle, phrased it, Arte Povera imitates nature "in order to transform the world according to human ideas."

Among artists associated with Process, the German-American Conceptualist Hans Haacke (1936—) may have realized the greatest success in transforming art into an instrument for heightening social and environmental awareness. However, he substituted the term "system" for "process" and called his works "real-time systems." In them Haacke brings together elements—conditions, words, forms, materials, styles—lifted from the world outside art, which by virtue of their strange new context yield up ideas, implications, and interdependences hidden and unsuspected within everyday experience, natural, social, or political. At first, it was the systems of nature that engaged him, resulting in Weather Boxes like the 1963–65 version seen at the outset of this chapter (fig. 458). Through the transparent Plexiglas walls of the cubiform container the viewer could observe the effects of atmospheric change within, as water condensed or evaporated in reaction to the variable climate without, its light, air, and temperature. Here, timeless Primary Form had not been so much dismissed as assimilated into the workings of time, thereby dethroning the visual as the crowning feature of aesthetic enterprise. In the 1970s Haacke shifted to socio-political systems and their links to the art system. This led to the historic *Manet Project* (fig. 500), a 1974

piece that Haacke conceived in response to an invitation from the Wallraf-Richartz Museum in Cologne. It would have consisted of Manet's *Bunch of Asparagus* displayed on an easel and surrounded by wall panels citing the identity and social/economic status of every collector through whose hands the painting had passed, from the time the artist sold it in 1880 until its purchase by the Wallraf-Richartz with funds from the Friends of the Museum. Despite curatorial support, Haacke's idea failed to pass muster with the exhibition committee, owing to fear of the Friends' chairman, whose tentacular corporate connections were to be spelled out on one of the panels. Daniel Buren attempted to offset the rejection by pasting small versions of *Manet Project* onto a set of his stripe paintings then in another show at the Cologne museum. However, the directors merely had the reproductions themselves pasted over, which then prompted other artists to withdraw their submissions in protest. In the end, however, Haacke prevailed, since the blaze of publicity generated by all the rejections and counter-rejections served to bring his work and its message the very attention a force for social change desires. The critic Kay Larson has called Haacke "conceptualism's Robin Hood; having bitten the hand that might have fed him, he tends to hide out in Sherwood Forest, perfecting his aim." In more recent times this has been directed at such targets as New York's Guggenheim and Metropolitan museums, as well as at both Prime Minister Thatcher and President Reagan. To the question forever put to Haacke, as well as to virtually all of Duchamp's heirs—"Is it art?"—Larson has replied that a work like the one seen here "is unthinkable *except* as art—that is, pure thought." Even though slum-lord trustees, governments, and cultural institutions may not alter their policies because of what Haacke exposes about them, he is nonetheless "engaged in a ritual perfection of the paradigms of art. The truth may not set you free," Larson argued, "but the act of embracing it is a wonderful purgative."

Earth and Site Works

Other than the human figure, art may have no subject more ageless than landscape. If this reality was obscured by late modernism's increasing preoccupation with technology and non-objectivity, it could not be altogether denied in the vast, "environmental" abstractions of Pollock and Still, Mathieu, Hilton, Lanyon, and Heron, Frankenthaler, Olitski, and Agnes Martin. Moreover, a sense of the natural world subtly permeates the great *matière* works of Dubuffet, de Staël, Burri, Tàpies, Schumacher, and others, as well as many of the most autonomous sculptures of Moore and Hepworth, Kemeny, Chillida, and Kricke, David Smith and Anthony Caro. Beginning in the late 1960s, when Happenings and Environments had already set a liberating precedent, certain Conceptualists allowed earth or land consciousness to emerge quite literally above ground, come out in the open, and take art away from both gallery and society, fixing it within some far-off wilderness. Called "sculpture in the expanded field" by Rosalind Krauss, the development could be seen as a corollary of Process Art, whose exponents, as we have noted, strove to integrate organic, real-time systems into their works, the better to make the inner truths of both nature and culture more accessible. An annunciatory symptom could also be found in scatter works, whose all-over, nonrecurring spreads or accumulations called to mind a "landscape mode," as Robert Morris wrote in *Artforum*. Still earlier, Minimalism itself had virtually predicted a move into the environment, not only by the gravity-bound, ground-hugging physicality or literalness of Primary Forms, but also by the way their lack of internal relationships seemed to invite relationships with the outside world, even as such unitariness, paradoxically, implied aloof self-sufficiency. Inevitably, it would therefore seem, Earth or Land Art tended to be Minimal in style, but on a colossal scale beyond anything possible in a studio, loft, or gallery, all the while that Earthworks robbed Minimalism of its timeless stability and made it subject to the vicissitudes of both temporality and meteorology.

Also contributing to the development of Earthworks was the notion that "progress" had so exploited the landscape that what remained unspoiled should be revered as only art could and what had been devastated restored by the same agency. In Europe—particularly in England—where long habitation and dense settlement made virgin terrain seem all the more precious, the tendency was to alter nature as discreetly as possible and in no way inconsistent with its own organic workings. In the United States, however, fallow territory still abounds, whether natural or industrially induced, with the result that artists, inspired by plenty, felt free to operate on the heroic scale innovated by the Abstract Expressionists. Thus, while Americans intent on working *in* the landscape, instead of merely evoking it, may have avoided the portable-, valuable-object marketing system of traditional art, they became heavily dependent on engineers, construction crews, earth-moving equipment, and even aerial-survey planes, the field equivalent of the factory-bound procedures used by Minimalists, with all the high finance that entailed. As in Minimalism, such problems served mainly to enhance the sense of challenge posed by the possibility of taking art beyond all pre-established boundaries. Further, land reperceived as raw canvas or a medium for sculpture held great meaning at the time, for just as Performance seemed to reintroduce an element of sacred ritual and mystery into willfully secular modern society, Earth Art promised to formalize the revived interest in salvaging not only the environment but also such spiritually rich, archaeological wonders as Stonehenge, Angkor Wat, and pre-Columbian burial mounds. Given these consecrated sites as models, it even seemed feasible that new Land Art might recover for contemporary experience something of the pantheistic sanctity that human beings, from time immemorial, once felt to be active within the natural sphere. Eventually, concern for the environment expanded to embrace the urban-scape, where, in the aftermath of central-city decay and the brutalism of International Style planning, the need to improve public spaces could scarcely have been more urgent, especially since paradigms were at hand in the great 19th-century local and national parks, or in such vast *plein-air* projects as Brancusi's war-memorial complex at Tirgu-Jiu in Romania (fig. 378). Now, artists began creating Site Works, but whether placed within the man-made realm or outside in the primeval domain, the forms to be considered here were, for the most part, conceived to be integral with their respective surroundings and to derive much of their content from the particulars of that condition. And, whether aggressive or discriminating in their approach, Earth, Land, or Site artists generally sought to combine symbolic form with a given environment for the sake of creating differentiated and evocative places meant to make the world seem revealed anew. Often, however, as in most Conceptual Art, revelation must occur through documentation—photographs, maps, drawings, videotapes—especially for colossal, immobile works in locations too remote for the average viewer, or for effects too delicate or ephemeral to survive other than in the secondary form of a record. Ironically, the documents sometimes present a rather disconcerting fine-art, pictorial quality, for once artists recommended making monumental forms, they tended to fall back not only on Minimalist geometry but also on age-old principles of orderly design.

Earth or Land Art

Tony Smith's oddly complex Minimalism—a cube crystallized and expanded into black tetrahedrons and octahedrons roughened from exposure to the elements—succeeded in making the geometric resemble the organic (fig. 408). However, the telluric sensibility implicit in the sculpture became explicit when, during a night drive on the unfinished New Jersey Turnpike, it struck Smith that the "artificial landscape without cultural precedent" offered aesthetic possibilities of a fresh and immensely challenging sort. After the revelation became known, through a 1966 article in *Artforum*, Robert Smithson (1938–73) hailed Smith as "the agent of endlessness" and used his own role as artist-consultant involved with the development of a gigantic Texas airport to visualize the project not as a place in which to install art works but, rather, as a total, aesthetically imminent site. Soon thereafter, in 1968, Smithson pursued his new interest in a "dialectic" of what he called "site and non-site," implementing it in a series of gallery pieces for which he constructed simple, Minimalist containers and then filled them with raw organic material—earth, gravel, rocks. For the work seen here (fig. 501), he fashioned the "non-site" as a

two-sided, lidless, mirror-lined box and made its far corner a receptacle for a pile of sandstone shards gathered from an exterior ''site,'' which happened to be Sandy Hook Quarry in New Jersey. In this way the abstract gallery setting gained something of the real world's particularity, at the same time that the amorphous mass of found elements assumed the clear, abstract shape of a cone, thanks to its reflection in a synthetic environment. And just as nature seems amputated from an immense, universal whole and thus arrested in its normal process of ceaseless, geological alteration, the mirrored enclosure doubles the excerpt illusionistically, thereby affirming its true, infinite potential for change, in character as well as context.

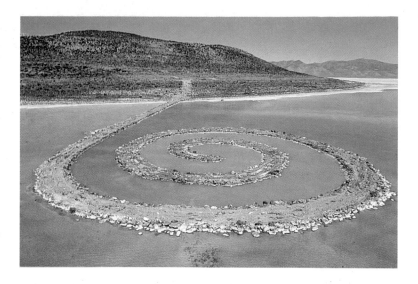

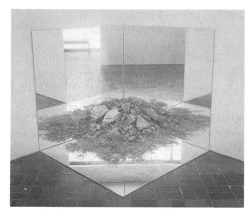

left: 501.
Robert Smithson. *Red Sandstone Corner Piece.* 1960. Red sandstone and three mirrors, 4' square. Courtesy the artist's estate and John Weber Gallery, New York.

right: 502.
Robert Smithson. *Spiral Jetty.* 1969–70. Black rock, salt crystal, and earth; spiral 1,500' long. Great Salt Lake, Utah.

Subvened by the Dwan Gallery in New York and the Ace Gallery in Los Angeles, Smithson abandoned non-sites in order to concentrate on the extraordinary allure of a real site on the shore of Utah's Great Salt Lake. Here, in what he described as ''an impassive faint violet sheet held captive in a stony matrix, upon which the sun poured down its crushing light,'' Smithson discovered the inspiration for *Spiral Jetty*, probably the most famous and romantic of all Earthworks (fig. 502). Wrecked by oil prospectors but also wasted and corroded by its own inner dynamism, the site offered Smithson a perfect opportunity to create a huge but ravishing metaphor for his fascination with entropy—the rate at which all matter decays:

Irregular beds of limestone dip gently eastward, massive deposits of black basalt are broken over the peninsula, giving the region a shattered appearance. It is one of the few places on the lake where the water comes right up to the mainland. Under shallow pinkish water is a network of mud cracks supporting the jig-saw puzzle that composes the salt flats. As I looked at the site, it reverberated out to the horizons only to suggest an immobile cyclone while flickering light made the entire landscape appear to quake. A dormant earthquake spread into the fluttering stillness, into a spinning sensation without movement. This site was a rotary that enclosed itself in an immense roundness. From that gyrating space emerged the possibility of the Spiral Jetty.

Clearly, Smithson was as poetically visionary in words as in concrete images, and, with this evolved sensibility, he quickly identified analogues for the ''immobile cyclone'' in the crystallized surfaces of lakeside rocks and in a whirlpool that, according to legend, welled up at the center from an underground tunnel linked to the Pacific Ocean. Thus, drawing on mythology as well as on both macroscopic and microscopic properties, Smithson shaped *Spiral Jetty* as a gyre, a coil that does not expand into a widening circle but, rather, winds inwards, as if it were matter collapsing into its own dead or decaying center. Yet, like the embers of a fading fire, *Spiral Jetty* gave off a wonderful light, its pink, blue, and brown-black coloration joining with the graceful purity of the curling shape to reward the viewer with endless aesthetic delight, simultaneously as the ideas embodied therein move one to ponder the melancholy realities of all creation. Even the beautiful reddish tonality, the product of a micro-organic infestation, arises from a deep reading of the site as a self-destroying as well as self-regenerating phenomenon. If the cursive, Minimal form seems to

echo Ohio's ancient *Serpent Mound*, the tracks left by the giant earth-moving equipment—used to relocate some 6,650 tons of material—came to symbolize or memorialize, in modern industrial terms, the great but long-gone dinosaurs that once roamed prehistoric Utah. Unexpectedly, *Spiral Jetty* also re-enacted entropy in real time, as the lake began to rise, gradually engulfing the earth sculpture in several feet of water. Before this could happen, Smithson himself perished, in a plane that crashed during an aerial inspection of a site in Texas.

As Robert Morris would later write, Smithson and Michael Heizer (1944—) took Barnett Newman's notion of the sublime ''back to nature where it originated in 19th-century American landscape painting.'' Thus, Heizer too fused ''Abstract Expressionism's impulse for grandeur . . . to Minimalism's emblematic forms,'' a process made dramatically evident in *Double Negative* (fig. 503), for which the artist, aided by Virginia Dwan and bulldozers, excavated 240,000 tons of rhyolite and sandstone from Nevada's remote Mormon Mesa. Now, instead of building an Earthwork, as Smithson had, Heizer used displacement to create one, at a site offering ''that kind of unraped, peaceful religious space artists have always tried to put in their work.'' Here, he and his construction team sliced into the mesa's surface and made two ramp-like cuts to a depth of 50 feet, the cuts facing one another in an implied line across a narrow canyon. Altogether, the piece measures 1,500 by 42 feet, giving it a scale to rival that of the great cliff tombs in Egypt's Valley of the Kings, where the symbiotic relationship between natural and man-made forms would seem to have provided spectacular antecedents for *Double Negative*. A native

503. Michael Heizer. *Double Negative.* 1969–70. Earthwork, 1,500 × 50 × 42'. Mormon Mesa, Nev. Courtesy Museum of Contemporary Art, Los Angeles.

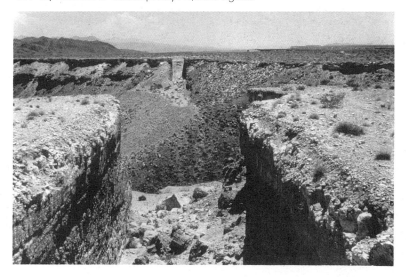

Westerner at home in the immensity of the American landscape, Heizer agreed with most Conceptualists that "the position of art as malleable barter-exchange item falters as the cumulative economic structure gluts. The museums and collections are stuffed, the floors are sagging, but the real space exists."

In England, with its millennial history of nature worship in poetry, painting, and garden or park design, a number of artists contemporary with Smithson and Heizer also looked to landscape as a means of creating art instead of marketable commodities. There, however, financial constraints and the intimacy of an ancient, island nation—densely populated, heavily industrialized, rigorously ordered and protected—obliged Land artists to exercise heredity or taste and, contrary to the Americans, treat nature in a delicate, unobtrusive, decidedly anti-heroic manner. Like Wordsworth in the Lake District, Richard Long (1945—) made his presence felt in nature mainly by rambling through it. In the course of these walks, he seeks an "intensely physical" as well as "an emotional one-on-one engagement" with real time, real movement, real distance, and real site, even though this may entail little more than making marks on the earth, plucking blooms from a field of daisies, or rearranging such found objects as stones, sticks, and seaweed (fig. 504). Working more like a gardener than a bulldozing Heizer, Long effects simple, elementary shapes similar to those familiar throughout the world wherever civilization has settled: straight lines, circles, spirals, zigzags, crosses, squares. He also documents his work, not only in maps recording the paths and the dates on which they were taken (rather in the ritualistic manner of Performance Art), but also in photographs, whose strongly pictorial, formal character reveals the lingering influence of Anthony Caro and Phillip King, the teachers under whom Long studied at the St. Martin's School and against whose obsession with objecthood he rebelled. By now Long has expanded well beyond the insular confines of England to wildernesses all over the world, from Lapland, Ireland, and Scotland to Africa and Australia, from Bolivia and Peru to Tennessee, Alaska, and the Himalayas. "A walk is just one more layer," Long asserts, "a mark laid upon the thousands of other layers of human and geographic history on the surface of the land." Frequently the layer imposed by Long is reabsorbed into the pastoral scene no later than the next rainfall or strong wind. Yet, his photographic documents are permanent. as well as salable enough; moreover, his "post-structural structures" sometimes comprise up-ended stones or slabs that resem-

ble toy versions of the prehistoric dolmens, megaliths, menhirs, and mounds that stud southwest England, the Scottish Highlands, and Ireland. Like the geomancers who regard these neolithic monuments as belonging to a carefully plotted network of holy places, Long draws inspiration from such evidence of England's pantheistic, pre-Christian past, convinced that "art should be a religious experience." Although Long began by taking sculpture into nature, he also takes nature into the world of art by creating indoor works as site-sensitive as those he fashions within the open landscape. Given his penchant for circles and spirals, with their connotations of endless beginning and return, Long proved remarkably at home in the ramped, snail-shaped gallery designed by Frank Lloyd Wright for New York's Solomon R. Guggenheim Museum. On the main floor, where it became the focus of the building's great well of light, he assembled Red Slate Ring, an immense, pictorially flat sculpture whose every stone the artist personally set in place. He then echoed it on a nearby wall in the 15-foot-wide Avon Mud Circle (fig. 505), which, like Red Slate Ring, was meant to last no longer than the exhibition itself. For the mural, Long

far left: 504. Richard Long. A Line in Ireland. 1974. Courtesy Anthony d'Offay Gallery, London.

left: 505. Richard Long. Avon Mud Circle. 1986. Installation. Solomon R. Guggenheim Museum, New York.

below: 506. Jan Dibbets. Dutch Mountain, Big Sea 1'A'. 1971. Eleven color photographs on aluminum, 2'10" × 4'11". Museum of Modern Art, New York (purchase).

try fragrance permeating a stale urban environment. In *Lightning Field* (fig. 508) De Maria combined the ephemerality of European Land Art with the sublimity of both scale and conception typical of American Earthworks. Here the principal material consists of thunderbolts, brought into play not only by the site—a high, unpopulated plateau in the New Mexican desert noted for its atmospheric electricity—but also by De Maria's scientific, state-of-the-art planning. What resulted is a mountain-girt basin studded with a grid-pattern forest of 400 stainless-steel poles, averaging 20 feet tall but each of them rising to exactly the same height relative to sea level, regardless of the fluctuations in the desert floor. The piece comes most spectacularly into its own when great, black storm clouds roll across the landscape, "sense" the polished-steel "high-energy bars," and strike them with a fiery, crackling wrath worthy of Wagner's *Götterdämmerung*. By articulating the trackless New Mexican expanses with deliberately in-

took sod from the banks of the Avon whose tidal ebb and flow he had observed throughout a childhood spent in Bristol. For this painting, the artist could scarcely have experienced a more "intimately physical" or "one-on-one engagement with nature," since he applied the mud with his bare hands—throwing it, drawing with his fingers, or, like artists since the age of Lascaux, using the imprint of his palms. But however primitive the technique, the results bespeak a measured all-overness, a sense of both freedom and control, and, most of all, a ritualized reverence at one with the art created not only by Long's Druidic ancestors but also by a far-off modernist like Jackson Pollock.

Heir to a terrain even more constricted than that of England and a culture equally rich in traditional landscape painting, the Dutch artist Jan Dibbets (1941—) too deals with the facts of the natural world as well as with the conceptual aspects of perception, all of which makes him a son not only of Rembrandt and Ruysdael but also of Saenredam (Holland's 17th-century proto-abstract painter of church interiors) and the great Mondrian. In the post-modern seventies, however, Dibbets chose to work not with paints, brushes, conventional trompe-l'oeil illusionism, or the realities of the two-dimensional painting surface, but, instead, with the camera and a sense of how it could be used to transform a real image into an abstract one, while also retaining a visually abundant reference to reality (fig. 506). Earlier Dutch landscapists had "corrected" the "problem" of the Lowlands' unrelieved flatness by filling the immense sky with mountainous clouds. Determined to find a new solution, Dibbets photographed the native polder serially by mounting his camera on a tripod and rotating it 30 degrees for each of twelve shots, all the while progressively tilting the instrument. When aligned side by side, the sequential color images represent the platitudinous Dutch horizon as a slow wave curve or extended mound. Thus, without resorting to earth-moving equipment, Dibbets reshaped the Lowlands and created mountains, at least in the metaphorical manner possible with Conceptualist documentation.

For his first Earthwork, Walter De Maria (1935—) rented a bulldozer equipped with a 6-foot blade and made a 4½-mile-long cut in the desert floor of Nevada. In 1968, however, he turned reticent, went indoors at the Galerie Heiner Friedrich in Munich, and there imported 1,760 cubic feet of moist earth to carpet the entire exhibition space with rich, aromatic topsoil spread some 2 feet deep. Subversive as the piece and a later New York version might seem (fig. 507), they achieved, in many respects, precisely what serious art has always sought to do—that is, seize the viewer's consciousness and expand it, while also providing fresh aesthetic rewards. The latter came, in part, with the light-dark contrasts of sensuously textured, black-brown dirt set against a gleaming white interior, as well as with the pungent coun-

509. Stuart Brisley, with Christoph Gericke. *Survival in Alien Circumstances.* 1977/81. Performance, London/Kassel. Courtesy the artist.

510. Charles Simonds. *Dwelling.* 1974. East Houston Street, New York. Courtesy the artist.

duced discharges of lightning, De Maria created an art work that involves both earth and sky, yet intrudes upon neither. In this way, *Lightning Field* becomes a magnificent affirmation of the artist's conviction that "the invisible is real."

In *Vertical Earth Kilometer*, created in 1977 for the Kassel Documenta 6, De Maria displayed an even greater European reticence but with an American excess of cost when he had a 1-kilometer brass rod sunk into the German substrata with nothing visible except the top end, a small brass disk measuring 2 inches in diameter. Despite its material and size, this "conceptual Earth Work" could exist almost solely in the viewer's mind, but unforgettably for anyone aware of the grandiose idea, which entailed a half-million dollars worth of deep drilling paid for by the same Texas-oil-rich foundation that had underwritten and now maintains *Lightning Field*. The proof of the work's impact came immediately when the British Conceptualist Stuart Brisley (1933—) created his own piece for the same exhibition. Judging De Maria's contribution to be nothing more than a profligate whim, Brisley countered it with *Survival in Alien Circumstances*, which consisted of a hole in the ground that the artist, aided by Christoph Ger-

left: 511. Alice Aycock. *Walled Trench/Earth Platform/Center Pit.* 1974. Concrete blocks and earth; outside wall 21'4" square and 3' above grade; center well 5' deep. Courtesy John Weber Gallery, New York.

below: 512. Nancy Holt. *Stone Enclosure: Rock Rings.* 1977–78. Hand-quarried schist; outer ring 40' across, inner ring 2' across, ring walls 10' high. Western Washington University, Bellingham.

bottom: 513. Christo. *Surrounded Islands, Biscayne Bay, Greater Miami, Florida.* 1980–83. 6 million square feet of polypropylene fabric. Photograph by Wolfgang Volz. © 1980–83 Christo/CBM Corporation.

icke, dug with his own hands and then occupied for two weeks (fig. 509). In its quiet but powerful way, the work suggested the rudimentary state to which Western civilization may one day be reduced by its mad wastefulness.

Back in the grimy, overcrowded, crumbling slums of New York City's Lower East Side, Charles Simonds (1945—) displayed something of the Europeans' economy of means and pantheism in a brilliantly original variety of Earth Art, launched in 1971 when the artist had himself filmed crawling naked from the primordial ooze. In this performance piece Simonds gave ritual birth to himself and his near-mystical belief in the earth as the giver of all life. Since that time he has prowled his proletarian neighborhood, like some ancient bard, creating the epic of his "Little People," an imaginary civilization of miniature folk who live, unseen but keenly felt, in sacred and sexual relationship with the soil out of which the artist builds their pueblo-like dwellings and villages, tiny brick by tiny brick and always on some randomly chosen, freely available site—window sill, crack in a broken wall, street gutter (fig. 510). Even though vandals and weather eventually destroy all of Simonds' publicly situated works, the continual appearance of new ones in nearby locales offers a model for the regeneration of an entire district, decayed and burnt out perhaps but still alive with the soul of human aspiration left by wave after wave of immigrants.

In her sited works, Alice Aycock (1946—) builds quasi-architectural structures whose forms and spaces defy modernism's functionalist view of shelter to present absurdist arrangements offering scant physical comfort but rich, if risk-fraught, opportunities to explore the intimate psychological spaces of the mind. Viewing the post-modern age as a time of imbalance, anxiety, and fear, Aycock works accordingly and draws on personal experience, literature, and history for the informing metaphors of her ingenious but disturbing pieces. To create "moment[s] of absolute panic," as when she found herself caught in a huge revolving barrel at an amusement park, Aycock constructs ambivalent sanctuaries that mix terror with enticement: a welcoming staircase that leads to a precipitous ledge over a void; a doorway that opens to solid walls or claustrophobic crawl spaces; a cozy little cottage posed inaccessibly on stilts. *Walled-Trench/Earth Platform/Center Pit* (fig. 511), for instance, resembles a primitive fortification, composed of three concentric 5-foot walls made of concrete blocks, with the space between the inner pair filled to make an earthen platform. All together, walls and negative as well as positive spaces enclose the central pit or shaft, which beckons the curious but can be reached mainly by vaulting across the 52-inch width of the dry moat. Once on the terra firma of the inner platform, the visitor discovers another lure at the bottom of the pit—a tunnel opening into what turns out to be a very dank inner chamber. Stage sets for mental drama, works like the one seen here trigger a vast range of memory and fantasy buried deep within the human psyche.

When Nancy Holt (1938—) began making Land Art, at the same time as her husband, the late Robert Smithson, she brought to the genre her long experience with photography, an art whose sighting technology places the viewer in near-voyeuristic intimacy with a specific bit of outside, even distant, reality. Camera optics, in fact, moved Holt to conceptualize her monumental forms as seeing devices, fixed points for tracking all manner of celestial bodies. *Stone Enclosure*, for instance, comprises two nested rings formed of masonry walls 2 feet thick and 10 feet high, the one at the center defining a cylindrical space and the outer one an annular corridor running between the two rings (fig. 512). Within this precinct, four 8-foot arches and twelve 3-foot "portholes" pierce the walls, apertures whose carefully calculated NE, SE, SW, and NW perspectives combine with the work's circular plan and true-north relationship to evoke Stonehenge, a prehistoric, utterly site-specific monument evidently constructed, at least in part, as an instrument for deciphering terrestrial and astronomical mysteries. The piece even looks as if it had always been there, an impression

left: 514. Isamu Noguchi. Hart Plaza. 1975. 8 acres. Detroit.

center: 515. Isamu Noguchi. *Dodge Memorial Fountain*, Hart Plaza. 1975. Stainless steel with granite base, 24' high. Detroit.

right: 516. Claes Oldenburg. *Batcolumn*. 1977. Welded steel bars painted gray, 100' high. Social Security Administration, Chicago. Courtesy Leo Castelli Gallery, New York.

reinforced by the construction material, a 230-million-year-old schist indigenous to the site, on the campus of Western Washington University. In addition, however, the work acknowledges the ephemeral in the constant play of light and shadow on circular shapes, a luminary drama caused by the earth's own rotation. Through its intricately plotted structures and massive masonry, *Stone Enclosure* correlates form to context in a way that discloses both only in fragments of time and space, making it an ingenious symbol of how time perceived from finite moment to finite moment may lead to a realization of time as an infinitely continuous, therefore wholly unified, reality.

In the years since *Wall of Oil Barrels—Iron Curtain*, his early venture into environmental art (fig. 302), Christo has expanded his concept of *empaquetage* to encompass vast public monuments and many acres of open landscape. Having learned from the neighborhood outcry against *Wall of Oil Barrels*, Christo, together with his faithful wife and collaborator, Jeanne-Claude, now concentrates on public relations as much as on aesthetics, not to mention collective effort and high finance of industrial scope. To create *Surrounded Islands* in Miami's Biscayne Bay (fig. 513), Christo and company assembled a war chest of $3.5 million, largely through the sale of preparatory drawings and project-related photographs, books, and films. It paid for, among countless other things, two attorneys, one marine biologist, two ornithologists, four engineers, and 430 untitled workers. What they set before an awestruck public for a mere fortnight in May 1983 was Christo's most painterly "event," an *hommage* to Claude Monet fashioned of 6 million square feet of glistening, flamingo-pink fabric so deployed around eleven small islands as to transform them into epically scaled waterlilies calmly afloat on 7 miles of Florida's emerald-green coastal waters. When *Surrounded Islands* vanished on schedule, leaving the ecology totally unspoiled, the work's disappearance generated as much dismay as had its arrival. For Christo, however, the "nomadic" factor simply guaranteed the event a more enduring "presence," in minds, that is, now stimulated to consider less habit-bound ways of seeing, feeling, and thinking.

Site Works as Public Monuments

Progressively throughout the sixties, late modernism's environmental urge combined with "whole earth" activism to generate a broad public awareness that art as well as architecture could serve as an agency of renewal in a postwar world afflicted with the baleful effects of both overexploitation and underdevelopment. Thus, as the seventies unfolded, artists and patrons alike tended away from Earth and Land works integrated with some inaccessible corner of the world—whether the unpopulated Highlands stalked by Richard Long or the crowded Manhattan slums minicolonized by Charles Simonds—and towards forms made independently of but in relation to a genuinely public—that is, social—space. If such "sited art" suggests a return to the Minimalist obsession with objectness that Conceptualists had sought to eradicate from art, the objects now produced by environmentally minded artists remain largely immune to commodification, relatively free of the old purist egocentricity, and still imbued with something of the ecological spirit fostered by Land Art. Inevitably, conflicts have arisen, albeit less than might have been anticipated, given that most of the new sited pieces have been created under public commission or within the public domain, which takes art into the risky, slow-moving, rough-and-tumble realm of politics, requiring that sculpture or painting strike some tolerable balance between its own need for internal coherence and the needs of immediate surroundings, cultural as well as physical. Once art has been subsidized by tax money, it must, to one degree or another, take account of the discrepancy between the essentially private, enigmatic character of 20th century aesthetics and the expectation that art placed in the public arena be truly accessible—that is, expressive and meaningful—to the public at large. While the new public monuments, if they are to be taken seriously, dare not relinquish art's obligation to challenge conventional values, they also dare not prove so aggressive or unaccommodating as to defeat their purpose, thereby alienating the very constituency most susceptible to or in need of liberating experience.

Given his profound feeling for the "soul" of materials, it seems credible enough that Isamu Noguchi would be one of the first late-modern sculptors to rethink his art in environmental terms. For years, Noguchi evinced this tendency not only in theater and furniture designs, but also in models for playgrounds, the first of which he produced in 1933 but none of which came into being until 1965. But shortly thereafter Noguchi began to receive one commission following another for public spaces, projects that enabled him to give monumental expression to his longtime desire to blend Western modernism with Asian, even archaic traditions, the better to make art a medium of the spiritual life (figs. 158, 159, 412). The environmental opportunity that most fully exploited Noguchi's many talents was Hart Plaza in Detroit, an urban renewal area bounded on one side by the Detroit River and on the other by a mix of the most appalling decay and such would-be sublimities as the Renaissance Center (fig. 514). From the centerpiece fountain he was originally asked to design, Noguchi gradually expanded his involvement with Hart Plaza until he had taken over the entire 8-acre site, making it not only a splendid setting for his monumental sculpture-fountain but also a forum for all

manner of public activity. To endow the great open expanse with a sense of intimacy and human scale as well as spaciousness and grandeur, Noguchi orchestrated a fan-like arrangement of such public facilities, among them an amphitheater (which in winter doubles as a skating rink), green and paved areas, a subterranean restaurant and performance space, and, at the entrance to the plaza, a 120-foot torsioned pylon made of polished aluminum. All, however, orient visitors towards the fountain, a technological as well as sculptural wonder that rivals the Neptune spectacle at Versailles, at the same time that it also glorifies a city whose engineering and industrial breakthroughs transformed life in the 20th century (fig. 515). A fat stainless-steel halo held 25 feet above a circular granite basin by two tall, inward-tilting legs set boldly off center, the fountain has the capacity to release a great column of water either as a plunging cataract or as a surging geyser. Several dozen computerized programs allow the monument to play through a seemingly infinite variety of aquatic routines, from a fine, romantic mist to a dense, thundering torrent. Here, as Noguchi said, "a machine becomes a poem," while the plaza itself becomes "an horizon for the people."

If monumental sculptures have sprouted more like weeds than poems across the American landscape, it is largely owing to the United States General Services Administration's Art-in-Architecture program, which allows one-half of one percent of the cost of constructing a new federal building to be allocated for the installation of art works designed to enhance the structure and its site. As a result, official patronage of the visual arts in the US now assumes greater importance than at any time since the WPA's Federal Art Project kept the Pollock generation alive during the Depression-plagued 1930s. Beginning in 1972, the GSA program has commissioned more than 200 paintings, sculptures, tapestries, and fiber pieces, by artists ranging from those of local repute to such international figures as Louise Bourgeois, Alexander Calder, Mark di Suvero, Richard Hunt, Louise Nevelson, Isamu Noguchi, George Rickey, George Segal, Tony Smith, and Frank Stella. A perhaps surprising number of these federally sponsored monuments have proved successful in every way that could be wanted for such enterprises, among them Claes Oldenburg's *Batcolumn*, a 100-foot openwork steel shaft erected in a brief plaza fronting the new Social Security Building on the north edge of Chicago's Loop (fig. 516). With this surreally overscaled representation of a banal object, the Pop master created a pendant to his Yale *Lipstick* and his Philadelphia *Clothespin* (figs. 237, 243), which, as we have seen, made realities of what were once deemed merely fantastic "proposals" for revitalizing the urban world with skyscrapersized baked potatoes, teddy bears, bananas, and Good Humor bars (fig. 242). Like *Clothespin*, *Batcolumn* could scarcely have been more symbolic—in Pop terms—of its host city, a metropolis celebrated not only for the game played with such profane gusto in Wrigley Field, but also for its historic, colonnaded Beaux-Arts architecture and the bristling smokestacks sung by Carl Sandburg—not to mention Chicago's much-vaunted masculine prowess. And as so often in Oldenburg's oeuvre, *Batcolumn* pays a sly, mock-heroic tribute to earlier art, in this instance Brancusi's *Endless Column* and Gabo's Bijenkorf construction (figs. 154, 378). From the latter's skeletal structure he may also have discovered how to honor the Windy City by constructing *Batcolumn* as a diagrid lattice, thus permitting the shaft to stand by allowing the gales to blow right through it.

The GSA program has also spawned a cultural tragedy, Richard Serra's *Tilted Arc* (fig. 517), a 120-foot-long, 12-foot-tall, 72-ton slab of unadorned, curved, and canted steel commissioned, at the cost of $175,000, for the federal building complex (Federal Plaza) in New York City's Foley Square and installed there in 1981. Eight years later, under the cloak of night, the proud *Tilted Arc* was dismantled and removed, a radical, unprecedented action carried out in response to the demand of local civil servants, who denounced the work as a "hideous hulk of rusty scrap metal," an "iron curtain" barring not only passage across the plaza but also every other activity that once took

place there, such as jazz concerts, rallies, and simple lunchtime socializing. It was even thought to be a potential boon to terrorists, at least by one security officer who stated: "It could vent an explosion inward and in an angle toward the buildings." But the removal occurred in the face of the near-universal opposition to it mounted by the professional art community, which supported Serra in his contention that to relocate a piece he considered utterly "site specific" would be to destroy it, and that such an event would constitute a breach of the moral, as well as legal, agreement the government had made to maintain the work permanently as the artist conceived it. Some even suggested that all concerned, including the public, would be best served if the eyesore federal buildings were torn down and replaced by structures equal to the quality of *Tilted Arc*. As for that quality, the critic Michael Brenson has written most eloquently of a sculpture he regards as a thing of great complexity and imagination, an inspiring work flexible and subtle enough to accommodate and even overcome an exceedingly confused and disjunctive space:

517. Richard Serra. *Tilted Arc.* 1981 (removed in 1989). Hot-rolled steel, 120' long. Federal Plaza, Foley Square, New York.

The work has provoked so much enmity in part because it can seem to thump its chest, raise its fist and pound its way head down across the pavement. Its remarkable attentiveness and versatility emerge slowly. Tilted Arc *is confrontational. But it is also gentle, silent and private. It is an intimidating block of steel, but it is also a line, a bolt through space. It does seem to be breathing down on us, but it also lies down and shuts up and offers us a refuge. Almost always, it seems to be gesturing, reaching out—speaking—asking us to consider where we are and what we think. . . . What also makes* Tilted Arc *appropriate to its site is its content. The work has a great deal to do with the American Dream. The sculpture's unadorned surface insists upon its identity as steel. The gliding, soaring movement recalls ships, cars, and, above all, trains. As with many enduring works of American art and literature, behind the sculpture's façade of overwhelming simplicity and physical immediacy lies a deep restlessness and irony.*

But such close, refined analysis is anathema to the philistine spirit, the reactionary handmaiden of every advanced society, and in this instance its voice was shrill enough—even in New York, the very seedbed of the American avant-garde—to drown out those of more reasonable minds. The latter, while agreeing that a heavy metal wall was the last thing needed in an enclave populated by wage-slaves who daily commute in "steel tubes" and work in "steel cubicles," contend that the case against *Tilted Arc* should have been made before, not after, it had been installed. In this way it might have been discovered

that the gap between art and life still yawns much wider than would have been suspected by a post-Pop vanguard convinced of its co-optation by popular acceptance. Such a view is readily disabused by the transcript of the *Tilted Arc* hearings, a record laced with phonetic spellings—"minibalist," "Grancoosi," "DeSuveral," "Modelwell," "Manwhole"—invented by a *literate* stenographer totally unfamiliar with names and terms long current within a world whose physical center lies no farther than a brisk ten-minute walk from Foley Square.

During the massive rebuilding that took place all over the globe after World War II, many states became active patrons of public sculpture—mostly "plunk-down" pieces in barren plazas—but no regime could match France's Mitterand-led Socialists (1982–87) for the number and grandeur of their fine arts commissions. And here too controversy erupted, particularly in regard to *Deux Plateaux* (figs. 518, 519), a decidedly site-specific environmental sculpture designed by Daniel Buren to replace a convenient but unsightly car-park within the courtyard of Paris' venerable Palais Royal. Now the revolutionary Conceptualist shocked progressives and reactionaries alike by converting his ubiquitous stripes—those eminently repeatable emblems of anti-individualist, anti-hierarchical anonymity and ephemerality (fig. 465)—into a sculptural installation as permanent and grandly scaled as its historic architectural setting. Eventually, however, the piece revealed itself to be an elegant compromise, one that translated a familiar machine-printed awning into the equally pedestrian medium of concrete shaped as a cut-down forest of freestanding, Pop-Doric columns echoing the Palais Royal's own long, reiterated peristyles. And while Buren's zebra pillars—their striations created by black marble embedded in the concrete—suggest the archaeological ruins of a destroyed temple, and thus imply a threat to the real temple still standing all about, closer consideration makes it clear that in their very stumpiness the 260 cylinders, graduated from "visitor-friendly" seat to shoulder height, leave the view open to the Palais Royal's own galleries and their dramatically parallax vistas. Moreover, if the black-and-white shafts generate a kind of visual racket, classical calm is restored by the steady murmur of water flowing through canals sunk below steel grates along three of the alleys linked together in an H-like formation. Several pillars stand hidden within the channels, while others thrust up from beneath the grating. Together the two levels they penetrate—surface and subterranean—make *deux plateaux*. These in turn are fundamental to the magic of the work's all-over environmental pull—upward in the surging columns, horizontally along the rhythmically converging orthogonals, and downward towards the gurgling waters below one's feet. After dark, magic becomes sheer enchantment, as blue fluorescent lights illuminate the underground stream and 200 small green or red "runway" lights twinkle at every corner of the "checkerboard" matrix.

In the aftermath of the *Tilted Arc* debacle, artists and patrons alike have tried increasingly to extract a more favorable risk/reward ratio from the challenge of bringing art and society into mutually illuminating juxtapositions. A 1987 project in the United Kingdom proved especially rewarding when a television company collaborated with its regional arts association to commission art works for a number of public sites "more expansive and more demanding"—places culturally, industrially, and politically less neutral—than the safer venues normally explored. One of the participating sculptors was Antony Gormley (1950—), who found himself assigned to an environment positively fraught with long-accumulated and present conflict—a 17th-century fortified rampart overlooking Derry in Northern Ireland and garrisoned by British soldiery charged with surveying the city's desperately divided Protestant-Catholic population. As always in his art, Gormley had a figure cast from his own body, but this time he took iron as the medium and doubled the image, placing the two forms back to back, their arms stretched outward in cruciform position and their open, all-too-vulnerable eyes staring in opposite directions (fig. 520). Modeled as it was upon the artist himself, such sculpture could scarcely be more personal, yet by casting the outer mold or shell, rather than its interior, Gormley transcended subjectivity to achieve a representation of Everyman. To his great satisfaction, the Derry piece was immediately recognized as a plea for reconciliation, for within days of its installation, burnt tires had been slung round the necks and graffiti scrawled upon the limbs. Thanks to its tough, defensive material, the twinned statue withstood the assaults, a witness to the possibility of overcoming and to art's potential for getting through where all else might fail.

Resurgent Realism, Photo-Realist Painting, Hyper-Realist Sculpture

12

To the modernist dictum "less is more," uttered by Mies van der Rohe in the 1920s, a number of post-modernists retorted, "less is a bore," as did the architect Robert Venturi in 1962. Indeed, it was Venturi's ideas and structures that inspired the very term "post-modern," by virtue of their having condemned the International Style's overscaled, stripped-down, slab-like buildings as too governed by purist ideology to satisfy a generation increasingly aware of its own diversity. Except in the hands of masters like Le Corbusier and Mies himself, Bauhaus modernism had degenerated into little more than an opportunist's chance to shortchange and charge more, all in the name of Utopian ideals. Confronted with the failure of concrete bunkers and steel-and-glass boxes to acknowledge such realities as context, living patterns, individuality, and cultural memory, Venturi and his architect wife Denise Scott Brown decided that old-fashioned Main Street was "almost all right," its "complexity and contradiction" signifying a wealth of creative, although chaotic, environmental energy totally at odds with the static, dispiriting effects of aloof, reductivist aesthetics. Even the "vernacular architecture" or commercial "strip" roadways of Las Vegas provided a superior model for the future, their urban/suburban sprawl viewed as accommodating rather than excluding, as messily vital instead of obviously unified, as human in scale more than monumental, as multivalent and ambiguous rather than single or clear in meaning, like life. In architecture, however, change occurs at a relatively glacial rate, owing to the exigencies of high finance, bureaucratic red tape, feasibility studies, etc., and only recently has Venturi been permitted to embody his notions in major public works, such as the new wing of Britain's National Gallery. Meanwhile, in the late sixties and early seventies, a number of painters and sculptors also became post-modern not only by rejecting authoritarian, formalist dogma—as evinced in Minimalism—but also by registering anew the world as the eye beholds it, a place indeed fraught with complexity and contradiction. "When art is in trouble," Stendhal wrote, "realism comes to the rescue." And so hardly had Minimalists declared painting dead, of its inability to suppress illusionism and become as literal as an object, and scarcely had Conceptualists abandoned studios and object-making when other anti-Minimalists extended their studio leases and re-embraced the very kind of handwrought trompe-l'oeil painting and sculpture that mainstream modernism had anathematized as irrelevant to art's higher purposes. To the art-critical community, this constituted a counter-revolutionary development with far more shocking implications than the iconoclastic strategies undertaken by the Conceptualists. Yet, resurgent verisimilitude could not be ignored, for at the same time that it offered collectible works with thrillingly recognizable imagery—portraits, still lifes, landscapes—rendered with a skill and a precision not generally seen for years, it also proved to be as cool, process-derived, conceptually tricky, and even formally rigorous as virtually anything to be found in the most "now" art.

The new "new realism" came to the fore along several paths, all of them cleared by the old New Realism—Pop Art, with its appropriations from admass culture—and even by Minimalism's insistence upon literal materials, techniques, and objecthood. What informed every approach was an eagerness on the part of its creators to give a fuller account of perceptual experience than had either Pop or Minimalism. For the painters and sculptors to be seen here, this meant resubmission to a kind of Shakespearean view of art as "a mirror held up to nature," a conception that generally prevailed from the Renaissance until the advent of high modernism. Thereafter depictive art switched places with its subversive rival, running underground but parallel to abstract or nonreferential painting and sculpture, which in the 20th century emerged aboveground as the mainstream. By the 1950s, however, modernism itself had become the new academy, an "official" or establishment art as thoroughly entrenched and intolerant of difference as the old mimetic tradition had been during the 19th

521.
Elaine de Kooning.
Harold Rosenberg #III.
1956. Oil on
canvas, 6'8" × 4'11".
Courtesy the artist's
estate and Edvard
Lieber, New York.

century. Thus, in the ironic way characteristic of contemporary culture, what once seemed retrograde—painted and modeled imitations of life—now became the rebellious avant-garde, insofar as a vanguard could be said to exist in an age almost indiscriminately open to whatever the media deemed newsworthy. Of the several realisms now making the news, some appeared to be absolutely continuous with historic antecedents, dating as far back as 15th-century Flanders or no further than the late Impressionism of Vuillard, or American Scene painting of the 1930s, or yet Balthus in the 1950s. All, however, would reflect their own time in one way or another, by giant scale, by an anti-rhetorical, even if obsessive, concern for appearances (fig. 522), or by the extent to which the painter still allowed process to dominate subject in the overriding interests of form (fig. 521). In all such revived naturalism, visualization occurred in the age-old manner of direct and prolonged examination of the model or motif. However, if any of this neo-traditionalism gained attention, it was in some degree thanks to the blaze of publicity generated by a genuinely new

style of realism, one so exact in its one-for-one replication of the visible world that the dealer Sidney Janis dubbed it ''Sharp-Focus Realism,'' while his commercial peer Louis K. Meisel called it ''Photo-Realism,'' the term that has stuck. By moving from found objects to primary forms and thence to in-the-flesh performances and process works, art had reached such a literalist extreme that it could come full circle and pass into its opposite—hand-painted make-believe reality. However, for this particular resolution of the ''crisis in painting'' to work, it needed to be realized not by a straw-hatted *plein-airiste* with his easel set up before a haystack, but rather by a child of the media age, an artist more at home with reality as encountered in a photograph than through immediate contact with the world at large (fig. 523).

Photography, of course, had come into being almost at the dawn of modernism, after which it developed alongside modernist, or proto-modernist, painting as the scientific counterpart of art's labor-intensive, eye-hand, genius-dependent methods of transcribing onto a flat surface visual information gathered from the three-dimensional world. And no one felt the impact of photography more acutely than painters, who right off acknowledged the new technology as a threat to their own validity as imagists. Moreover, this was true despite the irony whereby, for generations, photographers sought artistic legitimacy by mimicking painting in its most academic or retardataire forms. Pressured by photography, however, painters responded with increasing invention, using the rival medium as an almost magical aid to recording the palpable world more faithfully, or seeing that world in novel ways, or, indeed, as justification for liberating themselves from the need to represent anything other than personal fantasy or some notion of ideal form, leaving mimesis to the greater fidelity of the camera. Yet, only with Photo-Realism did figurative painters attempt to make pictures that resemble less the phenomenal sphere than a photograph of it, entire with all the abstract qualities of monocular vision, stop-action stillness, extreme spatial foreshortening, variable or indeed uniform focus throughout the visual field, smooth, emulsion-like surfaces, and sparkling luminosity. Meanwhile, by disciplining themselves to duplicate a ready-made two-dimensional duplicate of perceptual reality, the Photo-Realists made process and flatness, even in an image given to depth illusion, just as much the determining conventions of their art as did the modernists. Modernism—in its candid, intellectualized, and relentless effort to cleanse art of all but its own most elementary, physical properties—appeared to be forever daring viewers to make an act of faith that they were not being taken for fools. Illusionistic realism, on the other hand, is pure artifice or counterfeit, fashioned precisely to dupe viewers into accepting the picture or sculpture for what art can never entirely be—life. Photo-Realist painting, moreover, entangles its audience in a double deception, for while it may—momentarily—look more lifelike than anything ever seen before in art, it is in fact what so many in the 1980s, following the ideas of Jean Baudrillard, would call a *simulacrum*, a representation not of life but rather of a blown-up photographic image of life. If modernism asked that we disabuse ourselves of naïveté, realism would appear to demand that we re-indulge our-

right: 522.
Lucian Freud.
Night Portrait.
1985–86.
Oil on canvas,
36½ × 28⅝".
Hirshhorn
Museum
and Sculpture
Garden,
Smithsonian
Institution,
Washington,
D.C.

below: 523.
Richard Estes.
Double Self-Portrait. 1976.
Oil on canvas,
24 × 36".
Museum of
Modern Art,
New York
(Mr. and Mrs.
Stuart M.
Speiser Fund).

selves in it. At a time of compounding paradox, a comic melodrama of mistaken identity may be one of the most intoxicating of all the possibilities available to art in the age of photomechanical reproduction.

The Continuing Realist Tradition

Realism of a sort that Jan Vermeer or Edward Hopper could have identified with found vigorous exponents even during the Abstract Expressionist fifties. This was especially true in Europe, where some of the era's strongest artists worked in figurative or quasi-figurative modes, among them, of course, Giacometti and Balthus, Sutherland, Bacon, and Guttuso, Henry Moore, Richier, Marini, Manzù, and Frink. Also coming to the fore in that generation and now matured as one of the most powerful of contemporary realists is Lucian Freud, the London School's ''Existentialist Ingres'' already seen here in Chapter 3 (fig. 142). During the years since he painted *Interior near Paddington* Freud gradually loosened the tight, icily smooth manner of his fifties work, until by the seventies he was brushing on fat, granular medium with rude energy and forthrightness (fig. 522). Today Freud is virtually unrivaled in his mastery of the loaded brush or in his compelling sense of human flesh as the vessel of a complex psychological situation. Together spiritual penetration and audacious technical command have enabled Freud to render his vision of vulnerable humanity with increasing strength and freshness. If the earlier figures seem relatively remote, the later ones—especially the sprawled, ungainly nudes—appear urgently, almost unbearably present, the creatures of an artist's naked, libidinous involvement with his painterly surface. Still, they remain anonymous, however ferociously Freud may have explored their blue-veined, adipose carnality, cataloguing sins with high-wattage intensity and an hallucinating range of hues: vermilion pink, olive gray, russet, blue, salmon, and every ochre or umber imaginable. Surreally inventive at close range, from across the room the pummeled and kneaded palette resolves into brilliant accuracy. Such wizardry of eye and hand prompted the critic Kay Larson to characterize the Freud canvas as ''a seismic record of shock waves set off when the observing mind witnesses the world's otherness, and wonders why.'' The artist himself put it this way:

I want paint to work as flesh, *which is something different. I have always had a scorn for* la belle peinture *and* la délicatesse des touches. *I know my idea of portraiture came from dissatisfaction with portraits that resembled people. I*

would wish my portraits to be of the people, not like them. Not having a look of the sitter, being them. I didn't want to get just a likeness like a mimic, but to portray them, like an actor. . . . As far as I am concerned the paint is the person. I want it to work for me just as flesh does.

Along with Bacon and Freud, Frank Auerbach (1931—) and Leon Kossoff have also helped give the School of London its special lustre—the lustre of painterly figuration serving as a vehicle for individual expression rather than for some didactic or narrative purpose. Thus, while devoted to what Auerbach calls the "recalcitrant, inescapable thereness of . . . everyday objects," the London realists are also as convinced as any modernist that an equally potent subject is to be found in the painting process, in medium so handled as to possess a compelling "thereness" all its own. In his earlier work Auerbach applied paint in such heavy layers that the canvas acquired the thickness and weight of a massive relief. Later, as in the picture seen here (fig. 524), he continued to build *haute-pâte*, but then scraped it down and recommenced with each new attack upon the surface. As a result, the subject can become all but totally submerged in densely impastoed color, color that is often synthetically monochrome but true in its overall atmosphere. For the artist, however, this must be recalled from drawings, memory, or imagination, since the kegs of paint that he needs to complete a picture could never be lugged to an outdoor urban motif. Frequently the subject is a bombed, demolition, or construction site somewhere about London, reminiscent perhaps of the destruction that befell Germany, whence Auerbach immigrated to Britain in 1939, just before the outbreak of war. Thanks to his facture, the commonplace image may seem almost operatically grand, and if the maelstrom of his vehement strokes reveals the logic of its structure only slowly, the ultimate effect is to bind the subject inescapably to the medium in which it has been rendered.

Closely identified with Auerbach is Leon Kossoff (1926—), another Anglo-Jewish artist who too exercises a gift for transforming decidedly unpicturesque aspects of London—proletarian streets, back lots, tube stations, indoor public pools—into scenes of near-epic grandeur (fig. 525). Kossoff, moreover, does it without eliminating the capital's bustling humanity. But far from gay, both image and mood seem elegiac, the issue of powerful, perhaps Biblical feeling, expressed in awkwardly naïve but emphatic contour drawing, dour colors, and swept, flicked, dragged, and dribbled paint that proclaims its own substantiality quite as much as it describes form. Kossoff once evoked the content of his London paintings thus:

The strange ever changing light, the endless streets and the shuddering feet of the sprawling city linger in my mind like a faintly glimmering memory of a long forgotten, perhaps never experienced, childhood which, if rediscovered and illuminated, would ameliorate the pain of the present.

If Freud, Auerbach, and Kossoff provided a bridge between earlier Realist or Expressionist traditions and their revival in the 1970s and 80s, other European painters stood firm as sentinels of academic continuity in a late-modern world of ever-more volatile artistic experi-

ment. An artist positively steeped in knowledge of the Old Masters is the Paris-trained Israeli Avigdor Arikha (1929—), who, in fact, switched from essences to appearances only in the mid-1960s. And even now a sense of the abstract lingers in his choice of near-anonymous themes, such as a nude self-portrait from the back, where modernism's search for autonomy seems exemplified in an image combining both subject and object, painter and painted (fig. 526). Yet, the painting reaches out, not only through the sheer presence of the nervously active surface, but also through the figure's arm extending beyond the canvas, as if to invite viewers to follow and share in the creation of the work now set before them. Arikha completes each painting in a single day-long burst of inspiration, ignited by a spark

right: 528.
Alice Neel.
*Red Grooms and
Mimi Gross, No. 2.*
1967.
Oil on canvas,
5'1⅛" × 4'2¼".
Courtesy Robert
Miller Gallery,
New York.

below: 529.
Romare Bearden.
*Blue Interior,
Morning.* 1968.
Collage on board,
3'8" × 4'8".
Collection
Chase Manhattan
Bank, New York.

above: 530. Fairfield Porter. *October Interior.* 1963. Oil on canvas, 4'8" × 6'.
Collection Olga Bellin Roebling. Courtesy Hirschl & Adler Modern, New York.

issuing from his total absorption in centuries-old traditions of color and composition.

While Arikha disciplines himself to finish a painting in one day, Spain's Antonio López-García (1936—) may spend more than twenty years on an oil (fig. 527). Thus, whatever the subject—still life, cityscape, portrait, genre—his pictures seem always to be meditations on time, its power to erode as well as to create meaning captured in small, painterly strokes so considered and nuanced, during so many encounters of mind, eye, object, medium, and surface, that light itself appears to have been transformed into solid matter. Thus, even a still life by López assumes the power of narrative as the work draws close lookers into the history of its own making. Equally exact in both detail and overall balance, a picture like the one seen here becomes a ravishing demonstration of detachment charged with anxiety.

In the United States too—where, according to Barbara Novak, American artists, from the limners on, "guarded the unbroken integrity of the objects or things of this world, which became, very often, vessels or carriers of meaning"—a pragmatic fixation on material reality proved too deeply ingrained to die out, even as postwar American painting and sculpture withdrew into total, self-referential abstraction. Throughout this period Alice Neel (1900-84), for instance, stubbornly dedicated her art to an unflinching examination of life's victims, calling herself a "collector of souls" intent upon recording not only secret hurts but also the wounded's retaliation against them (fig. 528). For many years, Neel found her subjects in Spanish Harlem where she lived and worked, a lone white woman in a dark and alienated world. But once "discovered" in the 1960s, this pretty, indomitable artist turned her penetrating gaze and deep feeling for the human psyche towards the age's better-known personalities, revealing them anew in a style reminiscent of German Expressionism. The better to concentrate on the face, where "everything shows," Neel painted it fully, frequently with olive modeling, but elsewhere left much of the canvas bare, except for blue contour lines and rough, sporadic patches of thick color. If Neel felt her sitter to be stressed by inner conflict, she might convey such tension by making one eye appear anxious and the other rational, or one hand reaching out aggressively and the other holding back defensively. Jack Beal, a much younger New York realist (fig. 549), likened Neel to "Velázquez, capturing Philip and those Hapsburgs," but would never sit for her: "I'd be terrified she'd see things in me that I think I've hidden from the world successfully."

New York's Harlem nurtured other important realists, foremost among them Romare Bearden (1914–88), who came to broad public notice only around 1970, despite strong beginnings as far back as the 1930s under the tutelage of George Grosz, Weimar Germany's great New Realist then on the faculty of the Art Students League in New York. Encouraged by Grosz, Bearden began to compose by analyzing Old Master art, to work in collage, and to make black culture his all-important subject matter. By the early 1940s, moreover, Bearden had already formulated the essential conditions of his unique manner, achieved with the help of Stuart Davis, the master of Americanized Cubism. From Davis he learned to translate the colors and rhythms of jazz music into a brilliantly syncopated, essentially Cubist language of fragmented images appropriated from contemporary Afro-American life mixed with flat, vividly colored, hard-edged planes (fig. 529). Extemporized within a firmly interlocked structure, Bearden's assemblages never fail to evoke finger-snapping jazz, with all its free-form riffs flying high and cool above the heat of a steady, pounding rhythm. In this way, the artist universalized his memories of urban Harlem and rural North Carolina, while also glorifying mainstream modernism, which, with his racial recall, he returned to one of its deepest roots, in the African tribal art discovered by Matisse and Picasso at the very outset of the 20th century.

When critical interest shifted entirely to abstract art, American realists found the darkness into which this cast them lighted by a rare beacon, held aloft by Fairfield Porter (1907–75), an artist as well-educated and privileged as Robert Motherwell. Thanks to a capacity for identifying with Pollock and Rothko even while painting figuratively, Porter enjoyed almost universal esteem, at least within the coterie world of New York art (fig. 530). He earned it not only with his fluent,

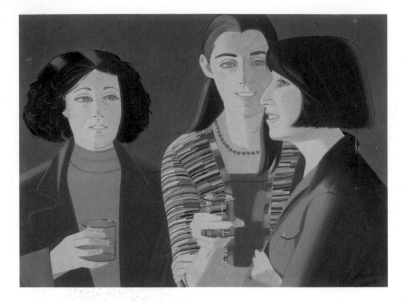

suously laconic, "pulled" surfaces. Indeed, his figures seem not so much to communicate as simply to bask in one another's presence, or that of the all-seeing artist. "My theory is," Katz once said, "that if you get the surfaces right, you get everything else right. I want style, the manner of painting to be the dominant function. Style is part of the thing of elegance, the look that New York painting has. You find the epitome of it in Jackson Pollock. Big, not small or fussy." Fundamental to this very high style would be cropping and perspective of a radical sort first licensed by photography and perfected in the late 19th century by the Impressionists Edgar Degas and Gustave Caillebotte. Although faces and figures may be recognizable—most notably those of Ada, Katz' handsome wife—the artist regards his subjects less as individuals than "symbols," images that may be "perceived and ambiguous, with multiple meanings." Thus, Ada may signify herself but also beauty, motherhood, charity, sexuality, and so forth. In *Trio*, for

left: 531. Alex Katz. *Trio.* 1975. Oil on canvas, 6 × 8'. Private collection. Courtesy Marlborough Gallery, New York.

right: 532. Alex Katz. *Swamp Maple, 4:30.* 1968. Oil on canvas, 12' × 7'19". Courtesy Robert Miller Gallery, New York.

opposite top: 533. Neil Welliver. *Old Avalanche.* 1982. Oil on canvas, 3' square. Collection Judy and Ken Robins, Denver. Courtesy Marlborough Gallery, New York.

grandly composed interiors, landscapes, still lifes, and numerous portraits, but also with the lucidity and enlightenment of the writing he did in support of the New York School. "The important thing for critics to remember," Porter declared, "is the 'subject matter' in abstract painting and the abstraction in representational work." Something of an American Vuillard, Porter too combined his love of medium with his love of visual reality in boldly scaled intimist pictures devoted almost exclusively to his own private realm, populated by family, poets, and fellow artists, all casually gathered in Maine, the Hamptons on Long Island, or the studio enclaves of Lower Manhattan. To explain the splendid radiance of these painted environments, one might cite the artist's craftsmanly habit of grinding his own colors. However, Porter himself put it this way: "I was never one to paint *space*. I paint air." Thus, his big fields of green-gold, pink, orange, and blue push "out through the open spaces of his pictures like a dense fog that shreds when it reaches the boundaries of things," as Kay Larson wrote in 1984. Unflagging in the freshness of his vision, Porter insisted that "the extraordinary is everywhere," with the result that he could find sudden inspiration in "the way the dishes are on the table at the end of a meal," and then paint it as if "the world starts in this picture."

Moved by Porter's example, Alex Katz (1927—) defied the Abstract Expressionist aesthetic held as virtually sacred in the New York School, where he occupied a highly visible if anomalous place, and around 1957 took the boldly maverick decision to get not his psyche but "what you could see into paint." Moreover, Katz would embrace realism in a way to match the impact of postwar abstraction, primarily by retaining the Action painters' "big-picture" scale while articulating it with images as planar, clean-edged, and clear as anything in the Color-Field canvases of, for instance, Barnett Newman. Aiming for "bland power," Katz painted only what he knew from everyday experience—friends together in loft studios or the summer scene in Maine (figs. 531, 532)—but then represented these worlds of innocent ordinariness with a sophistication reflecting not only a mastery of modern pictorial strategies but also an educated love of such Old Masters as Giotto, Piero della Francesca, and Raphael, as well as of newer masters like Matisse and Milton Avery. Convinced that new realist painting could stand up to Abstract Expressionism only if treated with formalism's own rigor, Katz forged a unique style of epic simplicity and grandeur, rendering portraits, figural groups, and landscapes in broadly brushed color modeling and hard-edged fields of vivid hue. As this would infer, he developed a remarkably exclusionary eye, prompting Irving Sandler to write: "It was as if Katz asked, 'How much detail does a realist picture need to convey a convincing illusion?' And he has provided just that amount." As for content, he sought it neither in narrative nor in "expression" but, rather, in sen-

instance, the painting could be easily dated by the exactness of the clothes and hair styles; yet with their frozen, iconic poses and the lucid, rectilinear harmony of their profile and frontal relationships, the figures also inhabit a noble, ideal realm transcending the specifics of time, place, and person. As Robert Rosenblum wrote in 1978, "these three young women—Rosalie, Laurie and Jane—almost seem the contemporary descendants of the Three Graces or perhaps a trio of silent, motionless saints who stand forever in the limpid geometric spaces of a Quattrocento altarpiece. Unexpectedly, the casual becomes solemn, and even the grave, stepwise ascent of hands on glasses takes on a ritual character."

Nevertheless, Katz had always been quite particular about light, for, as he has said: "My idea of realism has to do with light—getting it right, like Matisse, whose overall light was very specific, and whose surfaces seem silk over flesh." A case in point, made by the artist himself, is the enormous landscape entitled *Swamp Maple, 4:30*, which depicts a lakeside scene in Maine on a hazy August afternoon (fig. 532). Here, behind a starkly silhouetted tree that bisects the tall format dead center from top to bottom, like "a Barnett Newman zip," as Richard Marshall commented, Katz painted the sky a pure golden yellow and the water "a yellowish blue that isn't green." To those wanting a blue sky, Katz replied that "people don't bother looking at the sky. They accept the sky as blue . . . [but] artists can show you the way things look." With their strange amalgam of bravura and classical measure, humdrum detail and sweeping, imperial breadth, with their

Compared with the stop-action stillness and sharp-focus immediacy and detail of Photo-Realist painting, the works of all the relatively traditional realists just reviewed are impressionistic, the products of as many looks, long and short, as it would take to render the directly perceived subject in an optically persuasive manner by a skilled master of drawing and color. In this way, much of the older realism has built within it a sense of ongoing time or duration—as pointed out especially in the work of Antonio López-García—that is utterly at variance with the snapshot instantaneity of the typical Photo-Realist picture. Ironically, a Photo-Realist canvas, unlike the *fa presto* works of Arikha, may actually require weeks or even months to execute, a fact nowhere better illustrated than in the art of Chuck Close (1940—; figs. 534, 535). When this onetime Abstract Expressionist

right: 534. Chuck Close. *Keith.* 1969–70. Acrylic on canvas, 9 × 7'. Courtesy Bykert Gallery, New York.

below: 535. Chuck Close. *Linda.* 1975–76. Acrylic on canvas, 9 × 7'. Akron Art Museum.

glowingly serene surfaces, fearless cropping, and crisp, authoritative design, Katz' monumental pictures are indeed celebrations of style, of realism and abstraction so resolved into one another as to become art that conceals art. Thanks to their big, cool, movie-screen look, paintings like those seen here helped set the stage for Pop Art, but share none of this movement's irony and obsession with admass culture. For the same reason, they also stand comfortably within the ambience of sixties Field Painting, even while renouncing self-absorption for the sake of delicious engrossment in a private universe of perceptual facts.

While Alex Katz strove to become a modernist figure painter, Neil Welliver (1929—) has wanted to be a modernist landscape painter, working *plein-air* "to make a natural painting as fluid as a de Kooning" (fig. 533). His was the easier challenge, for, as Braque and Picasso discovered at the outset of their proto-Cubist experiments, landscape, unlike the human image, constituted a subject sufficiently neutral to permit an objective analysis of form and space without generating an unwanted expressionist content. But for the very same reason, Expressionists too—along with pantheists, Romantics, and others eager to convey their emotional states and sublime intuitions—found landscape the perfect vehicle, altogether as conducive to the distortions of subjective feeling as to those of disinterested formal order. Welliver drew on both traditions as he liberated himself from the exclusivity of his own abstract painting, developed while studying under Josef Albers at Yale. For the sake of a more inclusive, feeling-filled art, Welliver retired into the forests and swamps of Maine, where, like Thomas Cole, the early 19th-century Anglo-American master of Romantic landscape, he hoped to capture the myth and spirit of primeval nature. By immersing himself in that unspoiled world, Welliver could exploit his extraordinary technical command to paint epically scaled views in which a wealth of precise data yields not only a resonant sense of place and time but also lines and colors whose ramified patterns appear almost as decoratively flat, yet open and airy, as the paintings of the fifties abstractionists. Sensuous and symbiotic as his involvement with wilderness may be, the artist paints it in what might seem a remarkably systematic or even mechanical fashion, beginning the canvas at the top and, day by day, progressing downward to the bottom. Along the way, however, he manages to bathe a limpidly pure, pre-industrial scene in crystalline light, its special poetry compounded of joy in so much quiet beauty and fear for its survival.

found himself trapped in other people's painting styles, he broke free by formulating self-imposed restrictions that could not but force him into "new ways to make marks that make art." Like the Minimalists, Close would submit his painting to the control of a modular grid, and, like Process artists, he would also allow technique or procedure to assume paramount importance, to the point of becoming as much a subject as the image it renders. Still more radically, he sought to wean himself from stylistic dependency by deriving his process from photography and photomechanical printing, which introduced the discipline of a fixed model that told exactly what the picture should look like even before it had been started. In addition, Close decided to work exclusively from black-and-white images, thereupon cleansing his palette of sensuous color, and even to mime the smooth, impersonal surface of a photographic print or slide. To achieve this effect, he gave up bristle brushes and thick, luxurious paint, adopted the airbrush, and permitted himself only a few tablespoons of medium for each canvas, even though it retained the billboard scale made canonic by both Pop and Field painters. But however efficient photography may be as an image-making device, relative to the time-consuming observation and manual drawing practiced by older realists, Close recomplicated the situation and committed himself to the long, tedious, labor-intensive experience of transferring a standard-size, tightly gridded photographic image and all its information to an enormous, similarly sectioned canvas on a ratio of about 1 to 10. In this way, he echoed the dot screen through which tonal variations may be achieved in industrial printing, at the same time that he also gave a new twist to the ancient technique for relocating a composition from one surface to another. After graphing both the photo and the canvas in exact proportion to one another, the artist then projected the "copy" on the desired scale and proceeded to reproduce its image on the canvas, ¼-inch square by ¼-inch square. Such is the reliability of the method that it would work even if each of a thousand squares was masked off from all the others and marked by a different person skilled enough to match the value of the corresponding square in the original. When completed, the picture has become a painted photograph of such preternatural accuracy that it even replicates variations in focus caused by limited depth of field, an element of objectivity that ends by questioning the objectivity of photography. But as if to counteract the machine-like impersonality of his process, Close determined to paint only portraits and only portraits of intimates—his friends or simply himself. Moreover, the subjects would be seen only from the neck up, at excruciatingly near, eyeball-to-eyeball range, and, as already noted, on a scale to rival anything in the New York School. Locked in a shallow, airless space and mercilessly exposed in all their porous, hirsute, flawed reality, the subjects yield up their self-effacing trust in the artist, ratifying a relationship that had to intensify during the months it took for Close to execute so much as one of his big Photo-Realist likenesses. Thus, far from dehumanizing the sitters, Close's method managed, despite its distancing, cold-blooded mechanics, to reveal some of the most awesome figures of their time—mainly artists, poets, composers—as touchingly vulnerable members of the human race. Paradoxically, the portraits—thanks to their mural size, utter frontality, and gestalt simplicity—look as iconic as anything in early American portraiture, as defiant as police mug shots, and as exalted as a colossal sculpture head of the Emperor Constantine. Warhol too did mug-shot portraits (fig. 260), but usually of "media" figures and with screen-printed tabloid effects that disallowed the intimacy of either significant hand work or extensive personal involvement.

By 1970 Close had readmitted color, but only within the confines of his system, which required that he paint or overpaint the image three times on the same canvas, layering cyan, magenta, and yellow versions in imitation of the separations used not only in color photography but also in full-color printing (fig. 535). The more Close experiments, however, the more he tends away from camera-precise realism towards ever-greater engagement with process, until the image may seem all but devoured by a dominant, voracious grid and a

resurgent richness of touch. Where this post-modern pointillism occurs, art and its techniques fuse with subject to close the gap between figuration and abstraction.

"My concern has always been with rendering," says California artist Ralph Goings (1928—), who pursued this goal with almost as much system as Chuck Close, albeit a different system and one more consistently adopted by hard-core Photo-Realists. He simply projected a 35mm color slide onto the canvas and there painted over the reflected image, using bristle brushes, rather than airbrush, to produce an image of such seamless, glossy perfection that it could be described as a brilliant reduplication of what is itself a duplicate of reality (fig. 536). However, once this artificiality had been placed in the service of a mass-produced reality as synthetic as the highway culture Goings preferred—a Formica-veneered, stainless-steel world of pickup trucks, house trailers, and fast-food stands—it tends to induce a chilling sense of emptiness, anonymity, and alienation. Pop Art had also assimilated this territory but never without alteration, through both context and redemptive wit, but in Goings' art a rootless, counterfeit environment appears all the more lethal for having been rendered in an illusion of such unsparing, photographic neutrality and exactitude. Still, irony may slip in by the side door, left open by the incongruity of a pictorial gift of almost timeless authenticity committed to subject matter as time-bound and transient as any year's latest model of motor vehicle, dispensing machine, or road sign.

In the canvases of Richard Estes (1936—) Photo-Realism gave the 20th-century urban world its own Vermeer or Canaletto, a vedutist whose work seems most thoroughly to translate camera optics into painting, yet whose techniques remain, in crucial part, as traditional as those of Manet (fig. 537). Estes began to use his own photographs as visual sources because of their efficiency in yielding an abundance of information that would have taken him months to gather by means of direct observation. But if his photo-based pictures offer what appear to be perfect, facsimile representations of their luminous, transparent models, it is largely owing to the freedom and invention with which the artist has created the effect of photographic veracity rather than a painted duplicate. Estes, for instance, works not from one shot but rather from several of the same scene, combining them in various ways until his own composite view has the correct "feel," something more complex and thus more convincing than the camera's monocular, mechanical eye could ever record. A masterful, if covert, composer, Estes subtly, perhaps imperceptibly, reorders photographic data until he achieves a still higher sense of perceptual reality, disclosing things that the camera cannot discover in the randomness of the natural or human environment. Among them are diptych-like divisions of the pictorial field, extreme wide-angle vistas, and window reflections

opposite: 536. Ralph Goings.
Blue Tile with Ice Water. 1987.
Oil on canvas, 4' square.
Courtesy O.K. Harris Works
of Art, New York.

right: 537. Richard Estes.
*Prescriptions Filled (Municipal
Building).* 1983. Oil on canvas,
3 x 6'. Private collection.
Courtesy Allan Stone Gallery,
New York.

below: 538. Audrey Flack.
Invocation. 1982
Acrylic on canvas, 5'4" x 6'8".
Courtesy Louis K.
Meisel Gallery, New York.

that obscure what lies beyond by telling so much about what exists on the opposite side of the street or even *behind* the viewer (fig. 523). Preeminently, however, the magic springs from Estes' unerring pictorial instinct and his deft, painterly touch, which conspire to lead the eye about the canvas through a cleverly nuanced counterpoint of line, color, tone, and sparkling highlights, all together bringing into uniformly sharp focus, as a camera could never do, a vast amount of visual information, near or far. And Old Masterish or Guardi-like as the virtuosic facture may be—so unlike the smooth transitions and suppressed handwriting favored by Goings, for instance—its power to resolve the whole of an infinitely detailed image upon the same focal plane makes Estes' art a very modern kind of trompe-l'oeil. Moreover, reinforcement of the planar emphasis comes from the broad sheets of plate glass that Estes has made a hallmark of his work, those gleaming surfaces whose capacity to transmit as well as reflect the contents of depth makes the world seem turned inside out. Equally contemporary is the very richness of the image, which only photography permits, since not even the most skilled painter could render all that Estes has in a single work, or with such clarity and precision, merely by examining the motif *in situ*. By the time he got it all down, everything would have changed—light and shadow, weather, season, people, traffic, and certainly the commercial displays. Nor could traditional realism, with its slow, painstaking, step-by-step methods, freeze a modern urban jumble at one split second of time. The better to give the impression of the momentary made timeless, Estes has almost invariably eliminated human figures from his scenes, allowing them to be signified by the plethora of their handiwork. "It's funny," the artist remarked in 1972, "all the things I was trained to paint— people and trees, landscapes and all that—I can't paint. We're living in an urban culture that never existed even fifty years ago." Candid enough to call that culture "hideous," Estes adds: "I don't enjoy looking at the things I paint, so why should you enjoy it?" But one does, in part because he has eschewed overtly moral comment and contented himself to use his breathtaking artistry to render optical complexity as an icily beautiful vacuum, the consequence of an unusual ability to balance and satisfy the rival demands of mimetic precision and painterly freedom.

When Audrey Flack (1931—) painted *Kennedy's Motorcade* in 1964, she produced what may have been the first Photo-Realist picture. It was an intrepid act, not because she had derived her image from a photograph, a strategy already familiar in Pop Art, but rather because of the uncool, moralistic content that she reintroduced into realism from her years as an Abstract Expressionist. Thanks to the sexist atmosphere of the early New York School, Flack became a passionate feminist with an urgent desire to paint pictures capable of reaching beyond a male-governed vanguard to all levels of humanity. For models, she turned to Counter-Reformation inspirational painting and rediscovered the *vanitas* picture, that didactic reminder of mortal transience. Reviving the genre, she began a remarkable series of still-life compositions full of such signifiers of feminine vanity as jewels, cosmetics, and mirrors heaped together with memento moris like skulls, calendars, and burning candles (fig. 538). With the force of kitsch, the whole garish ensemble pronounced the futility of greed and narcissism. "I approve of sentiment, nostalgia, and emotion (those heretical words for modernism)," Flack said in 1981. ". . . I use *vanitas* symbols in order to increase communication on both conscious and subconscious levels." For the same reason, she employs a rainbow palette of the lushest, almost Technicolor opulence, declaring that "an apple is never red enough, nor a sky blue enough." As jammed and cropped as Mannerist still lifes, her compositions, like those Old Master works, count for more than hedonistically pleasing arrangements; indeed, every object in the cluster constitutes a symbol deeply encoded with a quite specific meaning. But if Flack composes in a traditional way, her process thereafter belongs very much to its own time, for after achieving a suitable arrangement of motifs, she takes up the camera, makes a slide, projects it onto the canvas, and then paints over the image with an airbrush, concentrating on one passage at a time while masking all the rest. With their hot colors, romantically variable focus, prismatic highlights, and emotion-triggering contents, Flack's Photo-Realist paintings use photography to subvert photographic neutrality in the service of a powerful mes-

sage. Interestingly enough, Flack's heirs would not be women artists so much as men like Julian Schnabel who came to dominate Neo-Expressionism in the early 1980s.

Independently of Audrey Flack or anyone else, Malcolm Morley (1931—) invented a variety of Photo-Realism all his own, for which he coined the term Super-Realism in 1965. The pictures it labeled launched one of post-modernism's great careers, but only after a Dickensian start for the English artist, who spent several years at sea and a few more in the slammer, where he took up painting, through a correspondence course that eventually led to full-time enrollment at London's Royal College of Art. Profoundly affected by the new American painting he saw at the Tate in 1956, Morley moved to New York two years later, and he remains there today, albeit with his British passport still in hand. By 1964 Pop Art had carried him away from abstraction and finally into the Super-Realist works with which he gained a foothold in history. At first, Morley made his verisimilitude look almost as literal as Goings'; soon, however, he paralleled Flack and began to examine the world through the camera's lens with far less noncommittal eyes than those of orthodox Photo-Realists. As for process, Morley worked somewhat in the molecular manner of Close, but with quite a different effect, for instead of harmoniously fusing formalism and realism, he painted the graphed image cell by cell in order to violate and thus demystify both subject and surface (fig. 539). The hostility began with the artist's choice of what to paint—postcards or posters of battleships, for example, or the bourgeoisie in mindless play at a time of grave social unrest—and continued in the act of painting, which not only involved a loaded-brush, expressionist attack but also a subject that had been turned upside down. However bizarre, the approach nonetheless offered the dual advantage of liberating the artist from the cliché tricks of trompe-l'oeil painting, while also guaranteeing that the abstractly rendered image would display something of the reality reflected in its source. Meanwhile, to acknowledge the artificiality of that source, Morley sometimes painted in the white border that ordinarily frames a color reproduction or a photographic print, which automatically declared the illusionism to be the double falsification it was—a signifier and signified all in one, making a removal twice over from the referent in reality. In turn, the reality validated is that of the painted surface and the artist's sensuous engagement with it, in addition to the power they amass to magnify or symbolize the

below: 539. Malcolm Morley. *Beach Scene.* 1968. Acrylic on canvas, 9'2" × 7'6". Hirshhorn Museum and Sculpture Garden, Smithsonian Institution, Washington, D.C.

left: 540. Gerhard Richter. *Helga Matura.* 1966. Oil on canvas, 5'10⅜" × 3'6¼". Art Gallery of Ontario, Toronto (gift from the Volunteer Committee Fund).

opposite left: 541. Gerhard Richter. *Troisdorf.* 1985. Oil on canvas, 2'9½" × 3'11¼". Private collection. Courtesy Sperone Westwater and Wolff Galleries, New York.

opposite right: 542. Gerhard Richter. *Abstract Painting (#417).* 1977. Oil on canvas, 7'4" × 6'7". Art Gallery of Ontario, Toronto.

ersatz quality of contemporary life and the nostalgia this generates for an authenticity of experience that may always have been more mythic than real. But even nostalgia finds momentary satisfaction in Morley's Super-Realist painting, since from a distance the impenetrable, densely gridded and impastoed surface/image resolves and reverts to the fake transparency of the original poster or postcard. Thus, at the same time that Morley simulated a counterfeit of reality, he also exploited his abstract eye and vehement, painterly stroke to subvert it from within, all of which prepared him to become a central figure in the art of the 1980s, not only as a Neo-Expressionist but also as a prophet of Neo-Conceptualism's appropriations and simulacra (fig. 621).

The art of the hand-painted photograph gained a true master in Germany's Gerhard Richter (1932—), one of the most multifarious and fascinating artists to emerge in the post-modern seventies. Born and educated in Dresden, Richter found himself at such odds with the repressed social/aesthetic conditions of East Germany that he crossed over into a no less, if different, alien world in the West. With this, Richter—even more than Blinky Palermo, his close friend and fellow refugee from the Communist East (fig. 371)—experienced an inner schism that would become the central issue of his painting, an enigmatic, Janus-faced art whose excitement derives from a dialectical structure in which rival modes—photography and painting, for instance—cohabit and critique one another without ever resolving their differences. As we shall see, here and in a later chapter (figs. 540–542), the ambiguous counterpointing occurs both in paintings that virtually replicate photographs and in others so autonomous as to be considered Minimalist. Richter began as a proper Social Realist, rigorously trained in traditional trompe-l'oeil painting at Dresden's Art Academy, where the curriculum proscribed modernism in all its forms save those of a few official Communists like Picasso. When the latter prompted a suggestible Richter to experiment, the resulting scandal persuaded the younger artist that he should try living and working in a more open environment. Scarcely had he arrived in West Berlin in 1961 when the notorious wall went up behind him, leaving no doubt about where his future would have to be made. At first it did not seem too promising, given the values that Richter encountered following his scholarship admission to the State Academy of Art in Düsseldorf, where, for all the political reasons seen earlier, Informalism/Tachism held sway in a manner almost as authoritarian as that of the Soviet Bloc's Socialist, or Social, Realism. However, with his natural facility and old-fashioned technical command, Richter readily mastered the style but failed to rediscover himself in it. Thus, once again he became an outsider going against the grain, although wiser

for having learned that freedom of expression could impose its own restrictions, like those of an avant-garde compulsive in its oedipal contempt for the past and near-promiscuous pursuit of the new. By 1962–63, this accelerating process of cultural evolution had ushered in American Pop, whose challenge to totalitarian reductiveness received vigorous reinforcement in Germany from Joseph Beuys and the Fluxus group. Now, as the gap narrowed between life and art, Richter chanced upon an imaginative demonstration of the principle in a series of Roy Lichtenstein's cartoon paintings reproduced in an issue of *Art International*. Suddenly, he realized that for a cross-over German eager to express the conflicted dualities of his artistic/personal/political reality, nothing could be more suitable or necessary than high art made with unconventional as well as irreconcilable images and methods. Spurred by the cocky neo-Dadaism of Fluxus, Richter declared: "I'll paint a photo!" And, indeed, since 1962 he has executed scores of "photo/paintings," each of them representing the artist's attempt to counterpose a desire for anti-aesthetic radicality and a no less compelling desire for classical beauty, a beauty of both handling and subject forever fixed in Richter by his conservative training in Dresden (fig. 540). Calling his new post-exile work "Capitalist Realism," Richter, like Andy Warhol, appropriated tabloids, as well as snapshots, and painted them as a way of reconnecting his art to the contemporary social world. But to make the connection worthwhile, art also had to be served, with the result that Richter avoided the deadpan, hands-off, photomechanical look and lavished on Capitalist Realism the whole vast repertoire of his painterly means. Whether in full color or monochromatic sepia, the image might be delicately glazed and scumbled to suggest a timeless candlelit moment or its surface smudged and dragged to create the impression of a flash in the torrent of media images.

In the earlier photo/paintings Richter so valued photographs as devices for liberating his art from conventional criteria—formalist or realist—that, in an often-quoted statement, he said: " . . . I wanted to possess [the photograph] and show it—not to use it as a means for painting but to use painting as a means for the photograph." Around 1969, however, the emphasis shifted as Richter began to make photographs the means for painting, painting moreover that evoked the Northern, Romantic landscape tradition from Ruysdael to Friedrich (fig. 541). But if drenched in nostalgia, these misty, light-suffused, softly tinted pictures—marvels of technical finesse—owe their special qualities to the precision with which the artist conveyed into paint on canvas the flawed characteristics of his own grainy, blurred, or overly contrasted photographs. By this dialectical process and structure, Rich-

ter could meditate on a kind of pastoral beauty long barred to modern art without, at the same time, becoming enslaved in a reactionary, traditionalist vision the landscapes themselves seem to propose.

Beginning in 1976, Richter carried dialectical tension to a new, convoluted power when he discovered how to transform photographs into a totally abstract painting of the very gestural sort he had rejected in favor of Capitalist Realism (fig. 542). For the *Abstrakte Bilder*, the artist made slides of small sketches, projected them onto large canvases, and painted the freely brushed images one after the other on the same support, meticulously reproducing every splash and spill, sometimes slightly out of focus like the projection itself. If the process recalls Rauschenberg's anti-heroic *Factum I* and *Factum II* (see p. 132), or the frozen spontaneity of Lichtenstein's *Big Painting VI* (fig. 249), it also presented the kind of layered look so characteristic of post-modern painting, from the storefronts of Estes to the Neo-Expressionist and Neo-Conceptualist works of the 1980s. Now the dialectic rages not only between painting and photography but also between superimposed hot and cold colors, smooth and slathered facture, and, always, light of various intensities trapped in a translucent sandwich constructed of film-thin, filtering strata of luminous spaces. Here too Richter used the photography/painting equation to create an original variant of Photo-Realism—really Photo-Abstraction—that makes Abstract Expressionism appear suddenly re-endowed with fresh possibilities. Even after 1980, when he began painting *Abstrakte Bilder* directly—without the intervention of photography—Richter had so internalized the photographic experience that his later gestural abstractions retain, in sharper focus and in even greater baroque extravagance, the same kind of dissonant relationship among overlaid tissues of competing color, space, and texture (fig. 663). Too disabused by his early life under Marxism to partake of the leftist, Utopian politics practiced by Beuys and his numerous followers, yet equally put off by the hedonist materialism of the West, Richter found an independent way by making high-tension, internally self-questioning ambivalence the very content of his art.

Hyper-Realist Sculpture

"Abstraction had been attacked many times before, but never as comprehensively," wrote Joseph Masheck in an early review of what he termed the "verist sculptures" of Duane Hanson (1925—) and John DeAndrea. So dead-ringer accurate were these freestanding, full-size replicas of actual human beings that their failure to speak often caused shocked dismay in viewers encountering them for the first time (fig.

543). Yet, Hanson had been an abstract painter for many years when, at age forty-three, he began life-casting stereotypical Americans in fiberglass-reinforced polyester resin, a process designed to reproduce every wrinkle, bulge, and boil with ruthless fidelity. He then painted the casts in Photo-Realist detail, complete with bruises, varicose veins, and sunburn. Finally, he clothed the figures in the very ready-made attire the originals would themselves have worn. Initially, Hanson conceived his effigies as participants in tableaux staged as stop-action scenes of war, race riot, or mob violence. Around 1970, however, he abandoned overt theatrics and allowed the drama of waste to unfold in recognizable American specimens presented alone or in pairs, their bloated dishevelment and dull, unfocused look signaling an all-too-familiar history of junk-food binging and mental starvation. But along with Florida retirees came everyman images of

far left: 543. Duane Hanson. *Traveler with Sunburn.* 1986. Oil-painted bronze and mixed media, lifesize. Courtesy O.K. Harris Works of Art, New York.

left: 544. John DeAndrea. *Allegory: After Courbet.* 1988. Mixed media, 5'8" × 4'10" × 5'10". Courtesy Carlo Lamagna Gallery, New York.

above: 545. Philip Pearlstein. *Two Female Models on Mexican Blanket with Mirror.* 1972. Oil on canvas, 5 × 6'. Courtesy Frumkin/Adams Gallery, New York.

workers, football players, and artists, counterfeit people who, by virtue of their weary but dignified repose, often prove even more disturbing once the promise of warm-blooded, sentient life turns into something like rigor mortis. Just as the gap between art and life appears to have closed with a loud snap, the chasm suddenly yawns anew, right along a fault line that grows ever-more edgy as artifice assumes the artlessness of reality. With their uncompromising banality, Hanson's sculptures have much less in common with Edward Kienholz' caricatures than with the figure sculptures of George Segal, who too casts from live models (fig. 308). Segal, however, avoids serious confusion between fact and fake by permitting the all-white mold to stand as the final form, whereas Hanson, adhering to tradition, takes the next step and casts the negative, body-vacated shape within. Moreover, Segal appropriates concrete objects only for the environmental context of his figures, while Hanson applies them to the figure itself, not merely clothing but also accessories like cameras, shopping bags, and tools. Yet, by failing to breathe as they seem ready to do, Hanson's Hyper-Realist statues appear more spooky than Segal's ghost-white plasters, static works brought to visual life by a hands-on process that left the unpainted surfaces vital with the fluctuating effects of "painterly" modeling. As Kim Levin wrote: "The tension between the formal and the lifelike that existed in the work of Segal has shifted to a tension between lifelike and alive."

Even more than Hanson, John DeAndrea (1941—) extracts something bizarre from the tense ambiguity between the realness of artifi-

ciality and the artificiality of reality, mainly because he leaves his true-to-life figures in the nude and with no context other than the public one inhabited by viewers themselves (fig. 544). What distances his plinthless body casts and renders them aesthetic is the choice of models, invariably handsome men and, mostly, women in the springtime of life, unlike the late-autumn world from which Hanson usually plucks his lumpy specimens. Further, DeAndrea poses these lithesome people in a graceful, harmonious manner that, despite the total absence of idealization, makes them seem modern, biologically accurate variants of Classical statuary. But if Hanson's middle-aged and senior citizens look as if they had been robbed of their souls, perhaps by the Body-Snatchers, DeAndrea's give the impression of having never had souls, so closely do they resemble glass-eyed and bewigged store-window mannequins.

The New Perceptualism

The age of mechanical reproduction made itself felt even in the art of certain realists who, like their fellows encountered at the outset of this chapter, scorned photographic mediation and worked directly *sur le motif.* Still, having absorbed and internalized photographic vision, they managed to paint so veristically that their illusionism often seems as frozen and tight-focused as true Photo-Realism. There would, however, be significant differences, beginning with the absence of the camera's flattening effects and the presence of such solidly fleshed,

well-rounded subjects as the nudes painted by Philip Pearlstein (1924—). A fellow conspirator with Alex Katz in the campaign to revive figure painting, Pearlstein too prevailed by avoiding the overwrought but worn-out gesturalism of de Kooning's retinue and by accepting the rigorous control of facts carefully observed and candidly set down (fig. 545). Nonetheless, both Katz and Pearlstein achieved this without the aid of a camera lens, whose perceptual abilities they deemed inferior to those of the human eye, which, by scanning, sees more and, by seeing more, allows the painter to produce imagery that looks animate rather than dead. Like Katz, moreover, Pearlstein displayed all the cool and capacity for grand scale shown by his contemporaries in Pop and Post-Painterly Abstraction. Yet, his remained an assertively independent sensibility, seen, first of all, in a hearty preference for Courbet over Manet and thus for meaty plastic forms more than color planes. Although Pearlstein shares his generation's concern for system, "big-picture" two-dimensionality, hard-edged handling, and commonplace, if not admass, subject matter, he also identifies with the great tradition of academic painting and, by struggling to master it, reached his artistic maturity only about 1970. This together with his devotion to the nude made him, like John DeAndrea, heir to Renaissance trompe-l'oeil classicism, which Pearlstein gradually modernized by composing and cropping very much as in the neo-Mannerist fashion made not only possible but also permissible by photography. Thus, all the while that he renders his figures in full, sexual explicitness, Pearlstein also cancels their potential for expressionist overload by a process of depersonalization, which involves a system—not unlike that practiced by Photo-Realists—of reproducing only one small part of the subject at a time. If, however, he avoided all-overness in process, the artist ultimately realized a kind of all-over image, simply by letting it branch out towards the edges of the canvas and discover them wherever it might. This, of course, resulted in the loss of extremities, a further de-individualization that seems particularly acute when it comes to the head. Like the tilted perspective, arbitrary cropping helps flatten both the massive forms and the anonymous space they occupy, while unifying the surface in a rhythmic structure that links human part to human part throughout the visual field. Pearlstein has spoken of his pictorial manipulation of the figure as "a sort of stilled-action choreography," which he composes and recomposes with all the limitless invention of a Georges Balanchine. If Pearlstein—with his glacial surfaces, harsh lighting, unsensuous contours, and anticlassical poses—refuses to romanticize or ennoble the nude, he nevertheless boldly thrusts it forward, magnifies it well beyond lifesize, and finally monumentalizes the whole.

One effect of photographic stills was to open the way for a stunning reappearance of still-life motifs in painting, echoing the important role they played in early 20th-century modernism, when artists favored inanimate, anonymous subjects as more tolerant of formalist manipulation than, for example, the human image, with all its heavy moral and psychological baggage. In the scintillating still lifes painted by Janet Fish (1938—), however, trompe-l'oeil craftsmanship emerged in a manner to evoke not so much the studio setups of Cézanne, Matisse, Picasso, and Braque as those of 17th-century Dutch masters, especially their obsession with optics and the rendering of reflected or refracted light (fig. 546). But while eager to reveal the radiant beauty present in the most commonplace objects, Fish made certain to obviate old-fashioned didactic symbolism, which she handily did by concentrating on neutral artifacts of Pop-like familiarity and composing them with an unmistakably modernist, distancing rigor. For a typical canvas, Fish arranged in crowded, serial ranks such modular forms as fruit jars, gin bottles, dishes, tumblers, and goblets, viewed the scene from above, and then so flooded it with light that the transparent, prismatic shapes become an all-over, coruscating pattern of analogous but unpredictable accents. To complete the image, Fish set her bravura display of perceptual painting against the near, plain background of a shallow bas-relief space, thereby guaranteeing the art's contemporaneity while also maximizing the brilliant, generalized

dance of light flowing across and through jeweled overlays of cut or molded glass, clear liquid, and glistening wet surfaces.

The English-born, American-educated Rackstraw Downes (1938—) brings to urban- and landscape painting the sort of microscopic scrutiny required to discern the all but imperceptible geometries in the black paintings of Ad Reinhardt, his mentor at Yale. Downes, however, focuses not on an abstract field but rather upon the full sweep of the phenomenal world, with the result that his painstakingly crafted pictures could be mistaken for Photo-Realism, a Photo-Realism, moreover, obtained through a fish-eye lens capable of yielding panoramic views wide enough to register the earth's curvature (fig. 547). Yet, the very modesty of the lap-size formats, despite the vast amount of detailed information loaded into them, gives it away that Downes paints *plein-air*—on site—just as the Barbizon and Impressionist masters did. This means that in order to satisfy his desire for an exact transcription of the light and atmosphere present at the outset of his work on a canvas, he may need to develop the picture over weeks or even months before climatic conditions allow him to complete it in all the particulars essential to what he considers a full account of the chosen subject. And the longer Downes takes to encompass the terrain, the more he becomes aware of lateral vision, which the artist acknowledges by adding to the support at either end and recording a perceived arch or dome in the horizon line. If he ends, finally, by painting reportage, the intensity of his minute curiosity saves the image from dryness and endows it with an intimacy comparable to that of the much less objective landscapes of Vuillard and Porter. Repeated and total absorption in the motif also permits him to energize every inch of the painting with his own dynamic experience of both theme and surface, which leaves the painted realm seeming spacious and alive, a world to enter and explore, unlike the flat, frozen, depopulated scenes characteristic of orthodox Photo-Realism.

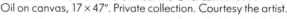

bottom: 546. Janet Fish. *Eight Water Glasses Under Fluorescent Light.* 1974. Oil on canvas, 4'6" × 6'. Courtesy Robert Miller Gallery, New York.

below: 547. Rackstraw Downes. *The Oval Lawn.* 1977. Oil on canvas, 17 × 47". Private collection. Courtesy the artist.

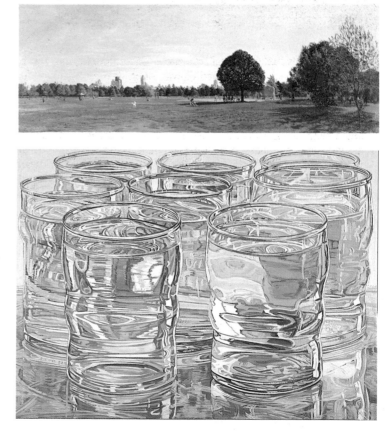

Resurgent Realism/Photo-Realism

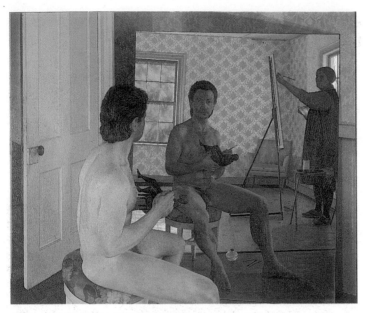

above: 548. Catherine Murphy. *Self-Portraits.* 1985.
Oil on canvas, 3'2" × 3'9". Courtesy Lennon, Weinberg Gallery, New York.

below: 549. Jack Beal. *The History of Labor in the United States,
18th Century, Settlement.* 1975–76. Oil on canvas, 12'3" × 12'6".
Collection US General Services Administration,
Department of Labor. Courtesy Frumkin/Adams Gallery, New York.

Catherine Murphy (1946—) may spend years on a single canvas, but instead of expanding into panorama, she concentrates so intensely on a corner of her private domain that the representation of it comes to seem a place somewhere, as the artist once said, "between surrealism and realism" (fig. 548). In reproduction, Murphy's landscapes, still lifes, and figure paintings often pass for photographic, but, in actuality, the artist begins each picture in a loose, free, expressionist manner. Then, working all over the surface and gradually, layer after layer, she lets it all "come up" together, from distant to close, until every leaf, light, fold, or hair has been grasped not only in its deepest particularity but also as part of a greater whole. Thus, while resembling a slender slice of existence at a rare moment of tranquillity, as if preserved in amber, a painting like the one seen here has an extraordinary presence, a plenitude suggesting that it contains even more than meets the eye. The effect comes, in part, from utter devotion to a reality so intimately known—the interior of the Murphy house, views through its windows, portraits of self and friends—that the subject exists as much in the artist's subconscious as in the space before her eyes. But it also derives from a virtuosic talent for treating representation and firm pictorial order as two aspects of the same creative enterprise. *Self-Portraits*, for example, is positively Eyckian in its fine-grained verisimilitude, at the same time that it is also like a shuffled deck of Mondrian's abstract planes, all echoing the rectangular flatness of the picture's own surface, even as they challenge and activate it with their sly out-of-plumb tilting. Finally, however, Murphy candidly admits the artifice of her pictorial wizardry by allowing it to be restated in the large sheet of mirrored glass, where the whole complex of volumetric data—forms, spaces, textures—resolves upon a two-dimensional surface, an optical phenomenon whose illusionism Murphy mimed on the canvas itself. Here, in a double trompe-l'oeil, she gives us one of painting's great subjects—artist and model in a studio setting—glorified by masters from Vermeer through Courbet to Matisse and Picasso. In Murphy's hands it also becomes a double-take, for while the artist assumes the role of the once all-dominant male form-giver, she has also replaced the nude female subject with her own husband—the sculptor Harry Roseman—who, unlike his gender-opposite predecessors, is far from passive. Indeed, he studies the looking glass not in narcissistic self-absorption but, rather, in hum-

ble obedience to the image he presently sculpts with both hands. Thus the plural title: *Self-Portraits*. Meanwhile, Murphy remains in shadow, far from the limelight so often taken by her male counterparts in such scenes. Content to play the "painter as voyeur," she lets the picture itself speak for her power, while also paying homage to the life companion whom she cherishes as "the only person I can take criticism from."

While Murphy invented her own representational method in order to paint the history of an everyday world, Jack Beal (1931—) spent long hours in libraries trying to reconstruct the Renaissance apprentice system, all in preparation for a commissioned cycle of four huge murals entitled *The History of Labor in the United States* and now installed at the Department of Labor building in Washington (fig. 549). Thanks to the same government-sponsored Art-in-Architecture program responsible for Richard Serra's *Tilted Arc*, Beal gained an opportunity to discover how the Old Masters operated in factory-like workshops, as well as under stringent contracts specifying not only subject but also design, and nonetheless "turned out the greatest works of art the world has ever seen." A past master of Renaissance-Baroque practice, Beal applied his vast repertoire of representational techniques to the Labor series in the triumphant, missionary spirit of a zealot determined that art be a force for good in the world, a purpose best served through faithfully depicted images of man and nature dynamically involved in allegories of great moral import. But while the Italian Renaissance may have governed the handling of figures and the space they occupy, Dutch 17th-century genre painting provided a model for the brilliant, wide-ranging colorism, the powerful Caravaggesque play of light and dark, and a kind of vitalism that energizes everything from ducks feeding on the ground through workers hard at their tasks to skies filled with billowing clouds or smoke. Nor is the rhetoric any less pronounced than in those antecedents, as Beal leads 20th-century viewers through costume dramas—Colonization, Settlement, Industry, and Technology—designed to demonstrate and affirm the value of solemn, dedicated endeavor. Here, he might well seem a throwback to Thomas Hart Benton, the 1930s Social Realist who taught Pollock, but for the post-modern irony with which he observed that "bad art" may be closer to the truth than his own work. In a comment made to Gerrit Henry in 1984, Beal admitted that he and like-minded "realists" were "trying to make something out of life that doesn't really exist—a total functioning organism in which everything has its place. I'm making a fantasy about real life and trying to make that fantasy as real as I possibly can. I really try to paint only things that I think are beautiful or lovely or uplifting."

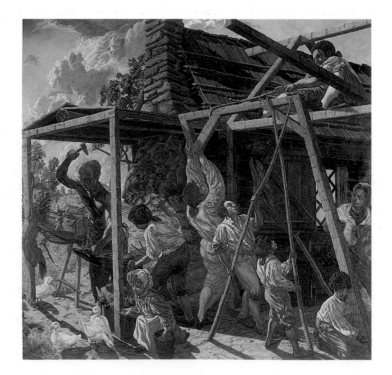

Pattern and Decoration

When Minimal objects became so unitary or nonrelational—so lacking in internal relationships—that they could not but establish relationships with their environment and thus take meaning from it, modernism opened art to anything, as Donald Judd boasted, albeit without anticipating the runaway pluralism that would follow. For the persuaded, of course, such openness reinforced their view of Minimalist stillness, silence, and simplicity as ripe with potential content. Others, as already noted, saw the same qualities quite differently, if not as a dead end, then a gaping void, vast as the monumental scale favored throughout late-modern art and begging to be filled with a richly varied, even noisy abundance of pattern, decoration, and *inherent* content. Here was rebellion with an heretical vengeance, not only against formalist exclusivity and flatness but also against Conceptualism's glum, anti-form theorizing, the two trends dominating new art when, in the mid-seventies, they found themselves challenged by ideas, terms, and styles that, almost since the dawn of 20th-century modernism, had frequently been dismissed as beyond all claim to serious consideration. Within this frame of reference, words like "pattern" and "decoration," still more than "illusionism," had long been encoded as negative signifiers. Remarkably, the taboo persisted even though pattern (a systematic repetition of motifs used to cover a surface in a decoratively uniform way) may have an effect altogether as flattening as any of the devices employed by Minimalists (fig. 550). However, such a configuration suffered the fatal defect of traditionally having been worked by anonymous artisans, not individuals of acknowledged genius, and often for the purpose of investing everyday or utilitarian objects with an element of sensuous pleasure and delight, attributes generally thought to be minor relative to the spiritual or intellectual values sought by those called to create the purely aesthetic, or nonpractical, works of high art. Thus, despite Duchamp, whose ready-mades proved—certainly to Pop and Conceptual artists—that context can make the art, skeptical purists wondered how objects fashioned from designs, materials, and techniques associated with crafts, folk art, and "women's work" could be rehabilitated into bearers of significant content.

Like many questions whose time has arrived, this one provoked all manner of answers, which came flooding in with the new "Pattern and Decoration" movement, sometimes identified as the "New Decoration" or just P&D, the stirrings of which could be felt as early as 1970 before they coalesced as a major development in the second half of the decade. If the responses made themselves known over a chorus of well-rehearsed condescension, it was thanks in great part to a generation of artists whose BFA and MFA degrees prepared them to understand that, overall, art consisted of much more than the rationalist, problem-solving, self-reducing process initiated by the Cubists a mere sixty years earlier. First of all, there was Matisse, a proud "decorator" in the grand French tradition, who dared to use the terms "abstraction" and "decoration" interchangeably. Moreover, it was his late brilliantly colored and patterned paper cut-outs that brought new joy to religion at the Vence Chapel, at the same time that they also provided radiant models for 1960s Color-Field Painting. Further, Matisse had virtually launched 20th-century modernism when, three years before giving Cubism its name at first sight, he exhibited the blazingly

550. Joyce Kozloff. *Omaha—Persian Series* V. 1983. Glazed tile on plywood, 24½" square. Courtesy Barbara Gladstone Gallery, New York.

colored, vehemently brushed canvases that one shocked critic called *Fauve* ("Wild Beast"), but which in fact were serenely decorative in all save the violence of their emancipated color and handling. Later, the onetime King of the Fauves would evince his lifelong search for *bonheur de vivre* in sumptuous paintings notable not only for their arabesque drawing and Oriental colorism but also for their borrowings from ornament as well as from such non-Western sources as African sculpture and Moorish interiors. In the view of P&D, Matisse had synthesized the fine and decorative arts, just as he had also reconciled naturalism and abstraction, thereby opening a way for postmodernists desperate to escape the puritan aridities of both Minimalism and Conceptualism. With the universally honored Matisse as a model, P&D's art-historically aware practitioners could justify their attraction to the fretworks of Islam's intensely metaphysical art, the pantheistic interlaces of the medieval Celts, and the symbol-drenched geometries of Native American art, all recently brought into relevatory prominence by important exhibitions. Finally, but perhaps most beneficial of all, Miriam Schapiro and Robert Zakanitch, Kim MacConnel, Robert Kushner, and Rodney Ripps, Valerie Jaudon, Joyce Kozloff, and Ned Smyth found inspiration in the so-called "craft" works—carpets, quilts, ceramics, embroidery, mosaic, wallpaper—increasingly made visible by the emerging power of women and the Third World. In addition to its irrefutable beauty, such patterned, decorative, and pragmatic "folk" art won esteem for its content, its value, that is, as witness to the courageous determination of

long-disenfranchised segments of humanity to satisfy innate aesthetic needs, despite relentless exclusion from the mainstream of cultural experience. Indeed, it was feminist artists and critics, perhaps more than any other faction, who articulated the clear perception that a Eurocentric, male-dominated art-historical canon so narrow, aloof, and self-centered as to become self-eliminating could scarcely function as the expressive agency for more than a tiny portion of humankind. Not only did feminists bring new ideas, materials, and methods into high art; they also introduced a new, emotive content as well, mined from women's experience as nurturers and designed not to exclude and reject but rather to reach out, include, embrace, and *move*.

Living poor in a funky realm of small factories and discount fabric shops along Downtown Manhattan's Canal Street, the younger members of what would be Pattern and Decoration could easily identify with the laborious lives of history's nameless decorators, adopt such available materials as cheap gingham and glitter, stitch them into colorful, fantastically painted wall hangings, and even wear the pieces for shamanistic performances (fig. 551). If these mocked the visual destitution of Minimalism, they also commented on that of Conceptualism, especially the jeans-clad, Beuys-like wandering minstrels. By such means P&D found metaphors with which to replace the content that inevitably evaporated once forms appropriated from alien traditions had been recast in a Western high-art mold. Still, the borrowings had to be self-evident, given P&D's desire to demystify the creative act and reject the concept of the artist as genius whose work is, as Clyfford Still once wrote, "a journey that one must make walking straight and alone." For the most part, P&D—its male as well as its female exponents—adopted the feminist position that in order to change culture, artists must join it. As a result, pattern painters have sometimes worked collectively to produce large environmental works or public, site-specific monuments, for the modest yet ambitious sake of humanizing the late 20th century's brutal urbanscape by applying the lessons of the past to a problematic present.

As John Perreault, an early champion of P&D, rightly observed: "In terms of continuity, pattern painting can be seen as a logical outgrowth of allover painting (Jackson Pollock) and grid painting (Agnes Martin), both of which broke with relational composition (Picasso, Mondrian)." To the degree that P&D overtly acknowledged its layered sources and made fruitful connections with world history, the movement must be seen as genuinely post-modern—that is, an artistic enterprise at radical odds with one of modernism's most sacred tenets. This held that each new generation of artists must re-enact the oedipal myth and "slay"—critique, eliminate, and supplant by solving the "problem" of—the immediate predecessor if it was to entertain hope

of achieving recognition as the latest avant-garde. Making it new by denying the past had been the driving force of modernism from the very start, a force fundamental to both its excitement and its astonishing achievement. Now, having seen modernism "commit suicide," P&D would attempt to heal the accumulated wounds, piecing culture together like a quilt made of remnants gathered from shattered traditions all over the globe. This ecumenical, egalitarian art would exclude little and embrace much, not only the glistening tiles of Teheran and the sculptural friezes of Mayan Mexico, but also the gorgeously decorative painting of Gustav Klimt and Paul Gauguin, Frank Stella's exotic Protractor and Indian Bird series, and Lucas Samaras' rainbow-spectrum yarns and glitz. As if to help the cause, Samaras virtually joined P&D when he again reached into the environment and found a gaudy array of printed textiles with which to run up a series of

left: 551. Robert Kushner. *Every Day Is Sunday,* from *Persian Line Part II.* 1975. Courtesy Holly Solomon Gallery, New York.

right: 552. Lucas Samaras. *Reconstruction #27.* 1977. Sewn fabrics, 7'3½" × 8'9". Courtesy Pace Gallery, New York.

patchwork pictures that seemed to offer a vital new variation on Field Painting (fig. 552). Also mixed into the democratic P&D pot were the rhythmically patterned sprawls of George Sugarman's polychrome sculptures, Japanese kimonos, and Yves Saint-Laurent's "peasant style," introduced at the turn of the seventies. Writing in 1978, the critic Carrie Rickey succinctly caught the richness as well as the rigor of this paradoxical and polyvalent art:

This is an art defiant in its dialectic and diversity. Pattern can be, at the same time, an assertion of a system and an intimation of chaos. Patterning could be seen as an opulent response to the austerity and sterility of minimal and reductive art, as an extension of the "all-over" sensibility that characterizes both Abstract Expressionism and environmental art, or as geometric abstraction with exponential variables. It could be read as a positive brand of cultural imperialism that heralds rather than anonymously appropriates the designs of other (mostly Third World) cultures, and it could audaciously suggest that a utilitarian object is as worthy of contemplation as the customarily non-utilitarian art work. These are just a fraction of the statements pattern painting seems capable of making. Patterning's energy source is its refusal to eliminate any possibilities. Since it's never a domain of either/or decision making, pattern painting always seems to be saying, "but/and" This is its strength.

As these comments and those of John Perreault would suggest, P&D enjoyed broader and more enthusiastic critical support than did the contemporaneous activities of the Photo-Realists. Formalists, of course, displayed almost unqualified contempt for the new pattern-makers, who however could take comfort in the enlightened advocacy they received not only from Rickey and Perreault but also from Jeff Perrone and the late Amy Goldin. Indeed, Goldin, who was deeply moved by the aesthetic and philosophical import of Islamic and Oriental art, became a catalytic figure in P&D when she spent the 1970–71 academic year teaching at the University of California in San Diego, with whose art department Miriam Schapiro, Robert Zakanitch, Kim MacConnel, and Robert Kushner would all make contact

below: 553.
Miriam Schapiro. *Heartland*. 1985. Acrylic, fabric, and glitter on canvas, 7'1" × 7'10". Courtesy Bernice Steinbaum Gallery, New York.

right: 554.
Robert Zakanitch. *Follow the Prussian Blue Road*. 1976. Acrylic on canvas, 3 × 7'. Courtesy Holly Solomon Gallery, New York.

before emerging into the full flower of their decorative styles. Meanwhile, the scene shifted to New York, where the various artists all met to discuss common interests and plan their own first group exhibition. Simultaneously, they also gained the attention of Holly and Horace Solomon, whose "alternative space" at 98 Greene Street provided a haven for fledgling P&D. Several of its participants then formed the core stable when the Solomons opened a commercial gallery on West Broadway in 1975. From this point on Pattern and Decoration, which drew so avidly on world culture, became almost exclusively a New York phenomenon, which gave late modernism a new irony when the movement's first major collectors turned out to be European.

If Pattern and Decoration became a movement with a place in history, it was in large measure owing to Canadian-born Miriam Schapiro (1923—), a well-seasoned artist who brought to the challenge of closing the gap between fine arts and domestic crafts all the passion of a recent convert. Moreover, she proceeded with energies charged by a double conversion, to feminism and simultaneously to a kind of art designed to validate long-degraded "women's work" by assimilating it into the ranks of high modernism. Like so many artists of her generation, Schapiro had begun as a painterly abstractionist who then developed a cooler, more austere aesthetic, which in her case meant hard-edged, computer-aided abstract illusionism. In the late 1960s Schapiro entered the women's movement, while at the same time relocating from New York to the San Diego area, where she and her husband, the artist Paul Brach, both joined the faculty at the Univer-

sity of California. In 1971 Schapiro and Judy Chicago cofounded the Feminist Art Program at the California Institute of the Arts in Valencia. During the fourteen months of this project's duration, twenty-one women students rehabilitated an old, abandoned mansion in Hollywood into an exclusively female environment, filled with art works and alive with performances giving effect to women's dreams and fantasies. Since then, Schapiro has drawn her imagery, materials, and techniques from the history of women's "covert" art: buttons, thread, rickrack, sequins, and yarn, silk, taffeta, cotton, burlap, and wool, all sewn, embroidered, pieced, and appliquéd into useful but decorative objects. Assembling them as dynamic, baroque, almost exploding compositions, Schapiro creates what she calls "femmages," a contraction of "female" and "image" (as well as the French words *femme* and *hommage*) that connotes something of the collage, découpage, and photomontage techniques used to make these grandly scaled works (fig. 553). Explaining her strategy, the artist said in 1986:

I wanted to explore and express a part of my life which I had always dismissed—my homemaking, my nesting. . . . The collagists who came before me were men who lived in cities and often roamed the streets at night scavenging, collecting material, their junk, from urban spaces. My world, my mother's and grandmothers' world, was a different one. My "junk," my fabrics allude to a particular universe, which I wish to make real, to represent.

Thus, for Schapiro, scale and formal rigor became imperative, since by monumentalizing what had always been dismissed as minor, such qualities would also give new legitimacy to modernism itself. In one collage painting after another, Schapiro developed and expanded her new style, a synthesis of abstraction, feminist iconography, such as eggs, houses, and kimonos, architectural framework, and decorative motifs in the form of bouquets, lacy borders, and floating flowers. Singularly successful have been the heart and fan series, wall-size, shaped canvases collaged with a carnival wealth of patterned materials, collected from every corner of the earth and ranging from upholstery to cheap cotton and luxurious brocades, all combined to simulate the heart's romantically tapered lobes or the spreading folds of a real fan. An orchestrated dialectic of art and craft, painting and collage, structure and decoration, abstraction and concretion, public as well as private politics, thought and sentiment, the work reproduced here summarizes not only one artist's life and career but also an entire history of civilization viewed from a new perspective. It also embodies Schapiro's ardent desire to reunite humanity and make it whole again. In reviewing a 1976 exhibition of femmages, the critic David Bourdon headlined his piece in the *Village Voice*: "Decoration Is Not a Dirty Word." Never before in postwar American art had the word "decorative" been used in a positive critical context.

After Schapiro and Robert Zakanitch (1935—; fig. 554) met in 1975, during the latter's term of guest teaching at the University of

California in San Diego, their respective interests in décor as a way out of the modernist box began to coalesce into the possibilities of a movement, which became reality the following year, once the two artists had returned to New York and jointly organized the Pattern and Decoration Artists. Right away, the group planned and then sponsored "Ten Approaches to Decoration," an exhibition that opened in 1976, proving that more painting was being done than Minimalists or Conceptualists had permitted anyone to believe. When Zakanitch adopted ornamental imagery he integrated it with the structural grid and color sophistication of his earlier work in Minimalism and Field Painting. Now the grid melted into a free, often organic diagrid, or lattice pattern, interwoven with floral motifs rendered with a painterly "lavender-and-plum" palette lush enough to rival the opulent chromatics of Jules Olitski. So completely had Zakanitch succumbed to the aesthetics of patterned decoration that he sought models not in nature but rather in wallpaper designs. This, in turn, gave him a strong conceptual base on which to build a new heroic style, composed of sensuously painted, diamond-celled walls studded with large, exotically colored blooms, all executed with a gestural, rhythmic grandeur to match, in unexpected, even antipathetic terms, the aspiration and achievement of the Abstract Expressionists, the reigning masters of the New York School when Zakanitch first appeared in its midst.

Another productive encounter occurred at the University of California in San Diego when an Oklahoma-born student named Kim MacConnel (1946—) fell in with the artist Miriam Schapiro and the critic Amy Goldin. Spurred by Goldin's ideas about the spiritual and intellectual significance of Oriental motifs, MacConnel began applying polka dots to his rigidly geometric, abstract paintings. This, however, proved to be a mere prelude to the riot of exotic signs and symbols that soon came booming into his art, everything from primitive hieroglyphics and suave arabesques to American Indian and Asian rug design (fig. 555). MacConnel then anchored these hallowed emblems to the vulgar here and now by setting them within a context of "bad" decoration, made up of cheesy machine-printed textiles cut in strips and crudely stitched together. Finally, perhaps as a mediating blender for such high and low ingredients, MacConnel enriched their outrageous combination by superimposing his own breezy, cartoonish images of birds, beasts, and fruits, radios, record-players, and music notations. However unpromising, the various strategies nonetheless colluded to yield a new egalitarian art of surprising beauty and repose, its air of sumptuous calm within visual uproar a product of the demo-

above: 555. Kim MacConnel. *Fundamental.* 1980. Acrylic on cotton with metallic paint, 7′10″ × 6′8″. Courtesy Holly Solomon Gallery, New York.

below: 556. Kim MacConnel. *Bedroom.* 1989. Installation, old furniture, fabric, and acrylic paint. Courtesy Holly Solomon Gallery, New York.

cratic, nonhierarchical manner in which all elements had been treated alike. When hung loose on the wall like a tapestry with panels of uneven length, the complementary assemblage of jangled parts discloses repeating patterns whose effect is to entice the eye vertically, while dazzling color contrasts and formal analogies pull it laterally, for a dynamic, all-over exploration of surface evoking a sense of generous but nonillusionist spatiality. Commenting on his urge to transform funk into fine art, MacConnel said in 1979:

Good decoration plays off what is around it. In the sense much good art can in fact be bad decoration. It doesn't relate to anything around it. It is self-contained, self-referential. Further, I think bad decoration can be good art in that even though it may be bad art it can somehow transform an environment into something interesting.

As good as his word, MacConnel has frequently transformed the environment by assembling the tackiest of outdated, junk-shop furniture and lavishing his brilliant colors and patterns over every surface, from leatherette seats and backs to chromium-plated or wooden arms and legs (fig. 556). It is as if a Pop artist had decided to literalize Matisse's celebrated fantasy: "What I dream of is an art of balance, of purity and serenity, devoid of troubling or depressing subject matter . . . a soothing, calming influence on the mind, something like a good armchair which provides relaxation from physical fatigue."

When MacConnel worked through Minimalism to P&D, he was accompanied by Robert Kushner (1949—), a fellow student at San Diego who brought to their common endeavor a substantial painting culture gleaned from his mother, a well-known West Coast artist. Thus prepared, Kushner quickly sensed what Amy Goldin's ideas could mean for his own art, to such a degree that in 1971 he joined the critic on a tour of Iran, Turkey, and Afghanistan, which turned into an epiphany. "On this trip," he admitted, "seeing those incredible works of genius, really master works which existed in almost every city, I really became aware of how intelligent and uplifting decoration can be." However, as an outsider artist going against the dominant

right: 557. Robert Kushner. *Sunlight*. 1983. Mixed fabric and acrylic on cotton, 8'5" × 13'7". Courtesy Holly Solomon Gallery, New York.

below: 558. Rodney Ripps. *Gay Princess*. 1980. Oil, wax, and cloth on wood; 4'4" × 4'3" × 8". Courtesy Holly Solomon Gallery, New York.

Minimal-Conceptual trend, Kushner could scarcely dream of expressing his love of arabesque fluency and grace in stone or mosaic. The medium that did present itself in affordable plenty was textile, overflowing in the bargain shops bordering the Lower Manhattan loft districts where so many younger artists and dealers found their "alternative spaces" in the 1970s. Like MacConnel, Kushner tacked his fabrics together in loose, free-falling arrangements, exploited their "found" colors and patterns, and overpainted them with his own motifs, in this instance leaf, vine, seed pod, floral, and, eventually, beast and human imagery. Furthermore, he too indulged a preference for horizontal alignments of vertical panels, but before treating his assemblages like tapestries, he first acknowledged their past by donning them for mock fashion shows (fig. 551). With their richly varied patterns and original, atonal color harmonies, these Arte Povera garments produced an effect of barbaric splendor reminiscent of the ancient, imperial Orient or the exotic world created by Léon Bakst for Diaghilev's Ballets Russes. When Kushner paraded through the Holly Solomon Gallery in sequences of as many as fifty costumes, to end by lifting each off his otherwise nude body and hanging it on the wall, he

sent up not only fashion but also burlesque, strip-tease, and, most of all, the visually deprived performances then being staged by Conceptualists. Ultimately, however, he hoped to raise both fashion and decoration to a higher aesthetic status, just as Pop had elevated commercial art.

Kushner also makes autonomous wall pieces, structuring them too from fabrics layered with figurative contour drawing/painting and left free to billow against the vertical plane (fig. 557). Here, he reveals himself to be an unabashed acolyte of Matisse, who found a model for his own *luxe, calme et volupté* in Islam, where no distinction is ever made between fine and decorative art. But like the French master, Kushner learned to counterbalance Orientalia with the West's classical, humanist devotion to the nude, modernistically flattened and almost lost in a crazy quilt of competing but subtly coordinated patterns, only to be disclosed, sometimes in mirror-image reversals, as much by the patterns themselves as by the artist's drawing. Yet, given his manifest command of collage and his taste for wallpaper-like patterns, obtained from a heady mix of gorgeously embroidered kimono silk, dotted dimity, and scatterings of common glitter, Kushner would seem to find his aesthetic antecedents in Synthetic Cubism as well as in Matisse's monumental decorations. And so, despite the anti-elitist stance of P&D, Kushner admits to being "a very old-fashioned modernist who is using a different vocabulary of materials," an artist willing to section and obscure the human image for the sake of such purely formal concerns as line, edge, color, balance, and harmonious composition. Still, once these elements close, the palimpsest figurations they yield up appear well worth contemplation. Not only do the images emerge as voluptuously erotic; being literally embedded within the work's very stuff, they also seem to symbolize flesh and spirit fused in something like an Eastern ideal of nirvana.

When Rodney Ripps (1950—) entered what has been called P&D's Canal Street *schmatta* culture (*schmatta* being a Yiddishism for rags), he embraced Downtown kitsch with enough ardor to burn away whatever Minimalist asperity remained in his work. Appropriating fake leaves, circus colors, and gold foil as his media, Ripps attached them to gridded panels and then painted their heavily tufted surfaces with a thick mixture of pigmented oil and wax (fig. 558). While the leaves transform the plane into a shaggy relief, their own intrinsic flatness seems to three-dimensionalize and thus demystify the loaded brushwork once so extravagantly admired in gestural Abstract Expressionism. At the same time, their gridded organization vulgarizes the continuous, all-over, modernist field, its literalized chromatic shifts providing a P&D version of Monet's Waterlilies. In these rug-like works, which also resemble floral blankets placed over

coffins at funerals, Ripps gives effect to what Donald Kuspit once called his "cosmetic transcendentalism," a tragicomic evocation of the romantically sublime American landscape that inspired not only the 19th-century Hudson River School but also, in part, the Pollock-Rothko generation. Now, however, in the wake of devastating and perhaps irreversible exploitation, nature of infinite freshness and expanse can be recalled only in an art made with fashion discards reassembled in a manner whose obvious nostalgia for a grand style seems to preserve it as a mortician might, in the aftermath of formalist overkill.

559.
Valerie Jaudon.
Caile. 1985. Oil
on canvas, 48 × 40".
Courtesy
Sidney Janis
Gallery, New York.

Valerie Jaudon (1945—), a Mississippian art-educated in Memphis, Mexico City, and London, gives P&D its only pure abstractionist, for in taking up the new aesthetic she merely translated the decorative aspect of her Color-Field Painting into flat interlacements derived from both Islamic and Celtic prototypes. Although more faithful to her sources than most contemporary pattern painters, Jaudon reinvents them anew. At first, the designs consisted of ribbon paths traced over and under one another along arcs and angles reminiscent of Frank Stella's Protractor series, even if more like his Stripe paintings in their monochromatic copper, silver, or gold coloration. Concentrically ordered, clean-lined, and densely woven, Jaudon's earlier mazes also suggest hard-edged counterparts of the all-over, holistic fields realized by Pollock in his freely poured, organic gyres. In later work, Jaudon has opened her compositions and made her bands structure a kind of asymmetrical Moorish-Gothic-Deco architecture, its airy scaffolding posed against a solid background of contrasting color and carrying the eye through canvas-length, arabesque sequences of parabolas, verticals, and stairsteps (fig. 559). Although lightened and expanded, the image now clearly rests on an implied ground plane and rises only to be capped by domes, pointed steeples, and ogival arches. Contributing to the sense of gravity and depth is the sheer quantity of paint rhythmically stroked onto every strap or track. The ridged thickness this creates breaks up light as it rakes across the relief surface, a three-dimensional reality foiled, in turn, by the illusionism of interlocking geometries and their resolutely flattened "folds" and "knots."

Together with the other women artists seen here, Joyce Kozloff (1942—) discovered in feminism a powerful impulse to shift from severely reductive abstract painting—with its male-defined high-art codes of exclusivity and purity—towards a more accessible as well as more available art, rich in cultural reference, social context, educational possibilities, and sensuous beauty. For Kozloff, patterned decoration appealed because, as a "third category" lying halfway between abstraction and representation, "it could incorporate ele-

ments from the other two categories, but wasn't bound by their rules, and it had its own history." By drawing on both abstraction's intellectuality and the populism of illustrational art, Kozloff sought to create decorative ensembles capable of serving as a genuine public art, rigorous enough in form as well as in content to be sustaining to anyone who must view it day after day, yet sufficiently open in its appeal to the collective sensibility to escape the disastrous fate that would befall an egocentric "masterwork" like Richard Serra's *Tilted Arc*. Eager to obliterate arbitrary distinctions—between fine and applied arts, Western and non-Western traditions, past and present—Kozloff began, somewhat as Jaudon did, by taking a studious approach to prototypes and copying them quite faithfully, convinced that recontextualization alone would endow her work with fresh meaning (fig. 550). The process began in Mexico, where Kozloff rejoiced in 18th-century Churrigueresque churches and made paintings based on the spectacular patterning—primitive yet sophisticated—of their brick and tile façades. Soon, however, she turned directly to the origins of Churrigueresque in Morocco and other parts of Islam, creating not only wall-size paintings but also large-scale environmental works. Although still gallery-bound, these complex installations spread intricate, run-on, brilliantly colored, and totally abstract patterns over every surface—ceilings, floors, walls—realized in an egalitarian as well as elegant range of materials, including fabric, tile, and glass.

In the 1980s Kozloff has gone truly public and even monumental in a series of commissions executed at rail or air stations in San Francisco, Buffalo, Wilmington, and Cambridge, Mass. For the Harvard Square subway station in Cambridge, she created a veritable panorama in glistening tiles, stretched along 83 feet of wall space above a heavily traveled pedestrian ramp and iconographically surveying the economic, social, cultural, and ecological life of early industrial New England (fig. 560). The imagery ranges from purely abstract quilt and wall-stencil patterns to representations of weather vanes, clipper ships, silhouettes, gravestones, milltowns, farm animals, and the flowers and trees of open nature, all stylized, in the *naïf* manner of the old Yankee limners and decorators, to fit within a grid system composed entirely of hand-painted, glazed ceramic tiles variously shaped as eight-point stars, octagons, and squares. To counterbalance the rigidity of these dovetailing matrices, Kozloff orchestrated colors and themes to flow freely through a kind of narrative sequence, moving from the mauves, blue-greens, and cool yellows of the tombstones and sailing vessels through the mossy greens, violets, and oranges of the landscape to the stencil patterns rendered in deeper oranges, greens, purples, siennas, and ultramarines. Equally varied is the mood, which alternates between the cemetery motifs at either end and pastoral charm or the humor of parading cows and pigs. The artist also displayed a virtuoso breadth of handling, which modulates to encompass the bright linearity of the samplers and the warm, almost atmospheric painterliness used for the farm scene. Finally, at the same time that the rare illusionism of this passage—a folk-like painting within a painting, complete with schematic woods, farmhouses, and picket fence—appears to render the opaque tiles transparent, the tiles' own glassy surfaces all but dematerialize the whole in shimmering light, just as they do in Islam, with something of the same opulently decorative and uplifting effect. In her site-specific station works, Kozloff has created an authentically post-modern art—a layered concatenation of painting, sculpture, and architecture, elevated aesthetics and common craftsmanship, exotic sources and local history, all of which combine to ennoble urban spaces while delighting and perhaps even informing those who rush through them to whatever their destinies may be in a troubled time. And as triumphant art outside an art context, they also question the formalist notion of art as a precious object made for museums or the privileged few.

No less concerned for the reintegration of human experience, in all its once-seamless totality, is Ned Smyth (1948—), an American artist with a European upbringing in what he calls a "heavy art-historic situation," the consequence of his father's position as director of Villa

560. Joyce Kozloff. *New England Decorative Arts* (detail). 1985. Tile mural, 8 x 83' overall. Harvard Square subway station. Cambridge, Mass. Courtesy Barbara Gladstone Gallery, New York.

I Tatti, Harvard University's center for Italian Renaissance studies in Florence. Like Kozloff, Smyth aspires to work on an architectural scale, sometimes to create entire Edenic settings or site works on the order of the romantic, pseudo-Egyptian ''ruin'' commissioned for New York City's Battery Park Esplanade (fig. 562). But even in a gallery-exhibition work like *The Tree of Life* (fig. 561) he stacked and joined his repertoire of papyrus capitals to suggest an archaeological fragment salvaged from some ancient, three-story temple. True to the P&D aesthetic and its goal of rescuing art from sterile solipsism and reinvigorating it with warm, humanist relevance, Smyth lavishly decorated his two-unit arboretum with Adam and Eve figures performing their rituals in a lush Garden of Paradise. Suitably enough, he adopted for these scenes the medium used since time immemorial by painters called upon to lend architectural forms a decorative or narrative element—mosaic—fashioned from the natural colors of marble and stone or from the more intense, jewel-like tonalities of glass. In the story told here, Smyth elaborated his long-standing interest in the reverent-garden theme to present an archetypal drama of human ascendancy. Embedded within the tesselated patterns spread right around the tree-columns, a nude man, crouching above the dead, buried world of fossilized creatures, drinks from a life-giving spring, while a woman, higher on the twin shaft, observes him as if in a state of awakening consciousness.

In the light of the work just examined, the rich multivalence of Smyth's Battery Park site piece becomes more evident (fig. 562). Measuring 75 feet long and 40 feet wide, the colonnaded courtyard or roofless temple is called *The Upper Room*, and indeed it encloses a rectangular table like the one depicted in Renaissance scenes of the Last Supper, the momentous meal that took place in an upper room in Jerusalem two millennia ago. But for a *faux* temple installed at the very doorstep of Wall Street, even while oriented outward to the breathtaking sweep of the Hudson River, the secular must reign. And so the concrete table has been inlaid with six checkerboards, along with the mosaic glass that veneers every form rising above *The Upper Room*'s flagstone-paved platform base. However, a spray-top tree—a papyrus column—grows out of the table, while another sprouts at the center of a small pergola, a four-columned, pyramid-capped temple within a temple on its urban side. Thus, while the table may evoke betrayal and death—a gamble ritualized with every game played on the checkerboards—the stone trees could symbolize life, knowledge, and their renewal, in the same way that the colorful, light-refracting mosaic cladding generates a sense of Byzantine spirituality enhanced by opulence. Obviously inspired by Greek, Roman, Romanesque-Gothic, and Hindu as well as Egyptian architectures, Smyth has also spoken of desert oases as contributing sources. In the overcrowded desert of New York's money-changing temples *The Upper Room* provides a quiet oasis, a new kind of ''power spot,'' for brown-bagging brokers at workaday lunchtime and for picnicking lovers over the weekend. All about them stand glittering concrete columns that seem to link hands as in a peasant dance like those performed by countless immigrants entering the New World by way of Ellis Island across the bay within clear sight of the Battery Park Esplanade. As Smyth once said, eclectic P&D signified a spiritual idea even more than a stylistic one:

Decoration is particularly valid not because it takes a ''low art'' and makes it high but because decoration is a rich tradition invented to communicate. Decoration is a vehicle that acknowledges our past and glorifies the environment that has supported us.

right: 561. Ned Smyth. *The Tree of Life.* 1984. Concrete and marble mosaic on wood, each column 20'5"x4'2"x1'9". CIGNA Museum and Art Collection, Philadelphia.

below: 562. Ned Smyth. *The Upper Room.* 1987. Concrete, glass, stone, mosaic; 40x75x20'. New York.

New Image Art

In late 1978 the Whitney Museum of American Art mounted an exhibition entitled "New Image Painting," which, though less than a critical triumph, provided a label for a number of emerging artists whose works had little in common save their recognizable but distinctly idiosyncratic imagery, presented for the most part in untraditional, nonillusionistic contexts. Viewed at the time as somewhat timid, a bit retrograde, or perhaps transitional, the art of the so-called "New Imagists" has looked better and more auspicious ever since, a reconsideration mandated by the admirably steady growth of almost every member of the original group. Yet today, while honoring Minimalism's formal rigor, love of system, and emotional restraint, the artists associated with New Image also tend to betray their roots in Conceptual Art, through a continuing involvement with elements of process and performance, narrative, Dada-like wit, art-critical and social-psychological issues, sometimes even verbal modes of expression. And while all this may reflect a post-modern sensibility, New Imagists have almost invariably produced works that tend to favor form in its wavering balance with content, which generally leaves content, as so often in modern art, more evocative than obvious or specific. Because this development proved more universal than the landmark New Image show could acknowledge, the present chapter will range rather broadly, beyond the original participants, among them Susan Rothenberg, Jennifer Bartlett, Joe Zucker, Neil Jenney, Nicholas Africano, and Robert Moskowitz, to include painters and sculptors, European as well as American, whose work in the late 1970s and early 1980s also fused abstraction, figuration, and conception in ways suggesting that the aesthetic object might ultimately survive its supposed death in the late 1960s. Characteristic of virtually all the art to be considered here is a sense of fresh seeing, a rediscovery of art's primary sources, an ambitious, if appealingly tentative, affirmation of faith in studio practice, in the possibility of artistic progress, of one generation developing directly from its predecessor, and in creative engagement with sensuous materials. As Richard Marshall wrote in the catalogue to the Whitney show, New Imagists felt "free to manipulate the image on canvas so that it can be experienced as a physical object, an abstract figuration, a psychological associative, a receptacle for applied paint, an analytically systematized exercise, an ambiguous quasi-narrative, a specifically non-specific experience, a vehicle for formalist explorations or combinations of any." Fortunately, artists working in the New Image spirit, wherever this might be, were, in highly diverse ways, on the right track, laying, as it turned out, the foundations of their present critical eminence, as well as of the explosive eighties' more dramatic approach to both figure and form.

If New Image art gained almost instant legitimacy, it was thanks in part to the prophetic switch that Philip Guston, one of the most prestigious members of the original New York School, had made around 1970 from his shimmeringly refined "abstract Impressionist" style to a rather raucous form of figuration that seemed to ape not only the primitive, heavy-handed manner of 1930s strip cartoons but also their narrative order and broad, goofy humor (fig. 563). Meanwhile, Guston himself could claim a measure of legitimacy, for his "scandalous" fall into Pop territory, from the precedent set when Giacometti abandoned his imagination, which had given Surrealism its greatest sculp-

tor, and began working exclusively from the model, in a desperate attempt to "render only what the eye sees," which gave the postwar School of Paris its most haunting image of Existential humanity. Defying art-world expectations, as de Kooning and Pollock had done in the early 1950s, Guston too acted out of inner necessity, as a major Abstract Expressionist must, and swung towards a far-out, reactionary extreme within his own long-practiced aesthetics of doubt and indecision, of anxiety over art's inveterate hostility to or persistent compromise with reality. In the wake of the momentary resolution struck in paintings like *To B.W.T.* (fig. 87), with its tremulous balance of tentative plus-and-minus strokes, Guston found himself reversing Giacometti and reifying not visual reality—the reality of a flat, rectangular surface—but rather the promptings of an imagination that, at the very outset of his career, had already expressed itself in cartoons and comics. To explain his departure from high-minded formalism, Guston said simply: "I got sick and tired of that Purity! Wanted to tell Stories." After an exhibition of the "underground" art by one of late modernism's paragons, the *New York Times* critic Hilton Kramer called Guston "a mandarin pretending to be a stumblebum." Gradually but surely, however, younger artists began to comprehend that, far from cynical or ironic, Guston's "Bad Painting," as numerous fond imitators termed it, derived from an impulse just as valid, and perhaps even more courageous, than the one behind the evanescent, universally admired abstraction. As automatist as ever, the process even reconjured the hooded Klansmen who had rampaged through Guston's Social Realist work of the Depression thirties, but this time, during the Nixon years, as buffoon bullies whose antic doings exemplified what Hannah Arendt had labeled "the banality of evil." Yet, the new images also sprang from an intellect positively saturated in art history, an intellect wise enough to understand that the problems of art are never terminally solved—contrary to current beliefs spawned by Minimalism—but continue to regenerate themselves as part of a living, ongoing cultural experience. Just as the Baroque had unfolded in the shadow of the High Renaissance, late modernism as a whole, as well as post-Minimalism in specific, found itself struggling with the aftereffects of a glorious past, a modernist past whose revolutions had produced not Utopia but, instead, a society shot through with grotesque incongruities, political, economic, and aesthetic. Longing for the wholeness that his youthful idealistic self had believed possible, Guston reclaimed the humanist imagery, style, and activism of his early work, but, as an antidote to nostalgia, treated them with corrosive, Goya- or Grosz-like humor and the same ambivalent touch that had yielded such different effects in *To B.W.T.* This meant that, as always, he identified totally with his art, to the point of admitting: "I almost tried to imagine that I was living with the Klan. What would it be like to be evil? To plan, to plot." Plotting and planning, Guston also imagined what it would be like "to be the last painter," as Minimalists might have considered him, or, better still, "the first painter." As he said to Harold Rosenberg in 1966: "I imagine wanting to paint as a cave man would, when nothing existed before." Yet, living in a "museum without walls," as he did, the erudite, hopelessly un-naïve Guston could only aspire to break free of dictated norms into unpremeditated possibilities. "In this condition of not knowing," he com-

may require longer to appreciate the silken perfection of the painting's surface and the brilliance of the palette, as daring and sophisticated as anything to be seen in Matisse or indeed peasant art. With his boldly distorted figuration, sanctioned by both the formalism and the fantasy of modern art, and his multiple, independent references to Old Master art, Botero provided another model of how to discover a new, conceptually solid image.

Among the Whitney's New Imagists, Susan Rothenberg (1945—) may be the closest to Guston, having created an original and moving art by allowing it to evince her urgently felt attraction to polar opposites, to a Mondrianesque purity of form, on the one hand, and, on the other, to an eroded Giacometti-like imagery, conjured in the act of painting, as if her canvas were a Ouija board (figs. 565, 566). And Guston, with his probing Abstract Expressionist brush, sooty palette,

left: 563.
Philip Guston.
City Limits. 1969. Oil on canvas, 6'5" x 8'7¼".
Courtesy David McKee Gallery, New York.

below: 564.
Fernando Botero.
El Arrastre. 1984. Oil on canvas, 6'11" x 6'6⅝".
Courtesy Marlborough Gallery, New York.

right: 565.
Susan Rothenberg.
Pontiac. 1979.
Acrylic and flashe on canvas, 7'4" x 5'1".
Private collection.

mented, ''you arrive not at a state of ignorance but at a state of knowing only the thing you know at the time—and that is concrete.''

Had it been looking for one, New Image could have found another leading indicator in Colombia's Fernando Botero (1932—), who too came to New York for the sake of sharing in the Abstract Expressionist experience, only to discover that the personal truth sought by the New York School encouraged him to paint in an anti-modern figurative mode. While this condemned him to work in grim isolation from the vanguard mainstream then burgeoning in Lower Manhattan, Botero persevered nonetheless, until by 1970 he had become the author of one of post-modernism's most recognizable, marketable, yet critically ignored styles (fig. 564). Famous for its adipose plasticity and candy-sweet, folk-art colorism, the Botero manner never fails to transform Latin American strongmen, whores, bourgeoisie, and religious dignitaries, icons of European high art, family members, dogs, and cats into amusingly irreverent parodies, some clearly affectionate, others devastating in their power to expose inflated self-importance in all its grotesque reality. With a background of study and work in Mexico City, Madrid, Florence, and Paris, Botero could forge a unique approach to the human comedy by drawing on his knowledge of Goya, Velázquez, Piero della Francesca, and Ingres, as well as the mural art of Rivera and Orozco. Like the latter or their antecedents in medieval art, Botero never hesitates to scale his figures large or small according to their relative importance within the scene, even though the pneumatic bloating remains consistent throughout the composition, allowing the artist to protest: ''I don't paint fat people. They look rather thin to me.'' Nevertheless, the ''Boteromorphs'' so capture the eye that it

and blunt poetry, would again appear to be echoed in the way Rothenberg fills her canvas with a dense, silver-gray mass of nervously reiterating, painterly strokes. Together, ravaged imagery and obsessive handling have sometimes made this artist seem more an expressionist than her origins in the cool, formalist sixties would have countenanced. However, when Rothenberg found it impossible to work with an abstract vocabulary and opted for one ''physically relating to this world,'' she looked not to the world's eternal angst but rather within, allowing her own poetic spirit to yield up a figure as she engaged in the vigorous, muscular process of applying medium to firmly backed canvas. The motif that repeatedly volunteered in her first major series, running to some fifty canvases, was the horse, an heroic form soaked in myth yet intimately bound up with human history, obedient and loyal but also potent and wild, and, in Romantic painting, a frequent surrogate for human feeling (fig. 565). In the 1970s, after Minimalism had made it almost impossible for younger artists either to paint or to deal with the human face and figure, Rothenberg found the horse to be ''a way of not doing people, yet it was a symbol of people, a self-portrait, really.'' Still, her concerns, like Giacometti's, were more formal than thematic—the problem of how to accommodate heady, private inklings to the discipline of radical abstraction. First, Rothenberg distilled her image to a schematic essence, consisting of little more than a dark contour line, which she then spread and absorbed into the surrounding field by drawing/painting it with the same scrubby, compulsive brushwork employed throughout the paint-

New Image Art

ing. Over the empty silhouette she sometimes laid vertical and/or diagonal bars whose two-dimensionality affirmed that of the surface on which they were painted, and whose loose brushiness further flattened the figure by echoing the color and gesture of its outline. Being arbitrary, they also reinforced the sense of mystery in painting where an identifiable though uncertain motif collaborates with a tentative but sensuously energized plane to charge the whole with emotional immediacy, albeit an immediacy resistant to the lures of expressionist abandon. As Robert Storr wrote in 1983:

Rothenberg's simplifications and corrections are, like Giacometti's, part of a search for the essential characteristics of form, but they represent a process of cautious addition to the realm of signs, rather than a reluctant subtraction from the world of appearances; thus her gesture is more a matter of anticipation and release than of desperation.

In the 1980s Rothenberg has switched from acrylic to oil and permitted human images to well up in the glimmering underwater ambience of her ever-more agitated and painterly surfaces. Floating as freely as the interactive, exploratory eye, mind, and hand that produce them, the new visionary forms seem even more poetically spectral than the horses (fig. 566). Still, they enter the same realm of universal expressivity, this time, however, less through the haunted image than through a new Rembrandtesque luminosity and a filtering of positive color. In this translucent blizzard Rothenberg has fully claimed territory peculiar to painting, and found a metaphor for describing it as a fluid, unsettled ground where eye and mind anchor their skittering, but subtly coordinated, intuitions of the unseen and the unknowable.

In London, meanwhile, Christopher LeBrun (1951—) was also discovering a horse—a winged, flying steed like the mythical Pegasus—through the elementary process of elaborating his canvas surface with an extraordinary repertoire of painterly touches, ranging from delicacy to opulent plenty (fig. 567). The image did not come altogether unbidden, for LeBrun had swum against the Minimalist current and reinvented for himself the great British legacy of Romantic or Impressionist colorism inherited from Turner, Constable, and Whistler. But while savoring the beauty offered by his secretly acquired techniques, he also discovered the metaphoric possibilities of a phantom, feathery wing-beat in an age fearful that painting had self-destructed. Nostalgic for the roots of history painting, LeBrun came upon what would seem to be one of the few non-ironic means to readmit them into late-20th-century art—as a haunting specter, a quivering echo from the dead. The key to his success lay in an evolved command of painterly spontaneity, the one vital, enduring link between the Romantic past and the skeptical present. LeBrun has said that he wants to express the "condition of painting," which accounts not only for the ghostly, archaic imagery, but also for its ultimate reabsorption in the fluctuating weave of endlessly varied brushwork. With

its deep, muted, atmospheric richness, the textured surface allows the motif to drift in and out of vaporous abstraction, even as it declares the field voluptuously and factually present. But far from facile, the performance seems to have been one of countless challenges sought, confronted, and overcome. It is as though, Donald Kuspit wrote, "Le Brun were performing a life-or-death operation on the painting, every touch giving it life while risking its death."

Caught at an impasse between Minimal and Conceptual art, Jonathan Borofsky (1942—) began his well-known counting series, in which he sequentially numbered blank sheets of paper, an ongoing process—now well beyond the 3-million mark—that enabled the artist simultaneously to make and not make art. For Borofsky, *Counting from 1 to Infinity* constituted art in that its obsessiveness and repetition mirrored an essential aspect of creative endeavor. Moreover, it led to his doodling on the sheets and thence to offhand drawings that gradually evolved into a now-famous inventory of images, for the most part emblems of fear, impotence, and, finally, will—will enough, that is, to generate the counting series and what would become an immense body of work, so prolific and various that it succeeds best not in individual objects but rather in whole gallery-wide installations (fig. 568). When given such an opportunity, Borofsky transforms the space into a carnival of materials, techniques, and images, spread over ceilings and windows, around corners, and all about the floor. With prodigal abandon, he offers the entire contents of his mind, his studio, and even the history of his own art, beginning with a still life made at the age of eight. For continuity and a bit of rational coherence within this messy, pluralistic abundance, there is always the counting, a series that went beyond the original blank sheets to number every one of the artist's other pieces, thereby joining the whole of his miscellaneous oeuvre in one grand *Gesamtkunstwerk*. A further unifying element consists in a pair of psychic dualities—aggression/passivity and strength/weakness—that seem to charge whatever Borofsky touches, until his overall achievement becomes an almost narcissistic exploration of human frailties and, by implication, those of humanity

at large, especially its more creative members. Like the counting and the doodling, each installation begins in the kind of free-association so cherished by the Surrealists and ends by including a giddy mélange of drawing, painting, sculpture, audio work, and written words, all rendered in a naïve, even banal style and noisily driving home the artist's persistent themes. One doodle became a dog with pointed ears, blown up by an opaque projector and painted as a spill-over image on walls and ceilings, there hovering above the scene like a guardian beast at the gates of Dante's *Inferno*. Countering this signifier of aggressive evil appeared a large cut-out ruby, which the artist saw in a dream and adopted as a symbol of passive but steady good. On occasion, Borofsky has installed a Ping-Pong table and advised viewers that they should "feel free to play," an activity that ritualized life's dichotomous rivalries while also implying the paradoxical oneness in which they are bound up. To endow the concept with political import, the artist painted the table in camouflage pattern and on either side stenciled the defense budgets of the United States and the Soviet Union. For the giant, freestanding, two-dimensional Molecule Men the Ping-Pong balls seem to have turned into lethal scattershot, drilling the figures full of "cheese" holes (fig. 569). Although wounded, one Molecule Man runs away, briefcase in hand, at the same time that another flies into the rafters. Both could be frightened by five Hammering Men with motorized arms that originated in a memory of the artist's father, on whose lap young Jonathan sat while listening to "giant stories." But of all Borofsky's metaphors for dialectical impotence and power, the most striking may be the androgynous *Dancing Clown at 2,845,325,* a creature with an Emmett Kelly head and soft, gangling, tutu-clad body that dances to the tune of "My Way" (fig. 570). Hangdog and humiliated above but triumphantly active below, this transvestite hobo could scarcely be more counter-crossed in his/her sexual identity, but so much the better for expressing the maverick will that transformed weakness into strength and overcame Minimal/Conceptual stereotypes to make marks that, as Chuck Close once said, make art. As a kind of interstitial tissue serving, like the endless numeration, to link his disparate images, Borofsky littered the floor of the Whitney Museum with crumpled fliers, which happened to be copies of an actual letter recounting the difficulties of an ordinary life, the document a "found" work found by the artist on a California sidewalk. Also permeating the Borofsky circus—its madcap atmosphere whipped up by chattering, chimes, mantra-like chants, and chains of blue neon loops flickering in sequence overhead—is a consciousness of Pollock's all-over approach to painting a canvas, expanded to encompass whole environments. "My work," Borofsky has said, "is concerned with the three-dimensional interior structure, and I try to make people aware of the place they're in, in a holistic way." However, the ultimate binder for such all-embracing randomness and untidy multiplicity—far exceeding anything in Conceptualist scatter works—is Borofsky's dreamy, automatist mind, which visitors to his installations often feel they have explored even more than the exhibition itself. "It's all about the politics of the inner self," the artist explained, "how your mind works, as well as the politics of the exterior world."

If not a major cause in critical debate, New Image and its pluralistic nature may, at least, be understood as partaking of a rapidly growing interest in post-structuralist ideas, an interest fueled by recent translations of European critical theory, particularly the works of the Frankfurt School, Continental feminists, and the Frenchmen Roland Barthes, Michel Foucault, Jean Baudrillard, Jacques Derrida, and Jacques Lacan. At the risk of oversimplifying what still remains a complex and exceedingly disputatious body of thought, let us say for present purposes that post-structuralism seems best understood as stemming from a revolutionary development within structuralism itself, which occurred in the late 1960s, more or less in tandem with a revival of Marxist and New Left thought. Derived from the writings of Ferdinand de Saussure, the father of modern linguistics already encountered in Chapter 10, structuralism fostered an extreme variety of formalist ideology, applying linguistics to objects and activities other than verbal language itself and thus viewing each as a system of signs, the ultimate meaning of which would become evident once structuralist analysis had revealed the laws by which they relate to one another through their differences. In other words, structuralists evinced less concern for the referent in the real world—a person, a flower, an event—than for the meaning available from its representation by a sign—made up of a "signifier" (word, color, image) and a "signified" (concept, meaning)—within a structure or "text" (poem, painting) composed of other signs, all recognizable by their differences from one another and signifying—yielding signification—by virtue of their particular combination. "In the linguistic system," Saussure wrote, "there are only differences," meaning, for instance, that "dog" signifies not in and of itself but rather because it is not "bog" or "god." Moreover, the relationship between signifier and signified, as well as between the sign and its referent, is totally arbitrary, determined by cultural and historical convention, a fact borne out by the great numbers of different languages in the world. For certain formalists, structuralism proved irresistible, given its view of the artifact as a self-sustaining system of "binary oppositions" (high/low, light/dark, nature/culture, dog/cat), a structure in which a fully sufficient message might arise from the interlocking, complementary differences among signifiers. Ignoring the surface appearance of the piece

left: 568. Jonathan Borofsky. *Installation.* 1984–85. Whitney Museum of American Art, New York.

above left: 569. Jonathan Borofsky. *Molecule Man with Briefcase at 2,845,323.* 1982–83. Aluminum, 8'1¼" × 5'1¼" × ¼". Courtesy Paula Cooper Gallery, New York.

above right: 570. Jonathan Borofsky. *Dancing Clown at 2,845,325.* 1982–83. Mixed media, 11' high. Courtesy Paula Cooper Gallery, New York.

New Image Art

as little more than a reflection of its concealed depths—its subtext—structuralist critics could be said to engage in the ironic act of shutting out the material world in order to illuminate our consciousness of it. Even when addressing things of the world—comic books, films, television—they mine deep import from analyzing not what the signs actually "say" but how they relate to one another in synchronic "discourse." By the 1950s structuralism had so penetrated advanced thinking in the West that Terry Eagleton, writing in 1983, could assert: " . . . language, with its problems, mysteries and implications, has become both paradigm and obsession for 20th-century intellectual life."

In the 1970s, aided by the Czech linguist Roman Jakobson, the term "structuralism" more or less merged with "semiotics" and "semiology," at the same time that the critical process they designated evolved until it had "decentered" the structure or "text" not only from its referent but also from its "subject"—that is, the author/artist. With this, the source of meaning migrated from the creative agent or his/her intentions and into, again, the text, encoded as its subtext inevitably was with all the myths or values that the subject had, of necessity, inherited along with the language he/she used but did not invent. As a result of this scientific "demystification" of culture, the individual author/artist came to be viewed less as the producer of language than its product and the work/text less an expression of the individual mind than a product of certain shared systems of signification. And like Minimalism's Primary Form, which had become so nonrelational or unitary that it could not but solicit relations with the ambient world, the cultural product itself would, under structuralist scrutiny, appear to be, like the author/artist, not unique or autonomous but, rather, thoroughly bound up with wider systems of meaning, in culture or in society as a whole, however decentered or abstracted the sign or representation from any identifiable referent. Thus, death would seem to have claimed both painting and painter, text and author—except for the fact that, like cockroaches, "subjects" eventually adapted and learned to create anew, or at least to mimic the act, in large part by using structuralist strategies to deconstruct structuralist logic, especially as embodied in such monolithic, exclusionary systems of thought and work as Minimalism. With this, art and criticism entered the post-structuralist age, now decentering the signifier from the sig-

nified, by virtue of a new awareness that signification born of difference—of what it is not—is never immediately present but always, to some degree, absent. "Dog" usually refers to the family pet, but it may also signify a holding device, pretentiousness, a starry constellation, feet, or a theatrical flop. Dispersed or "disseminated" along a whole chain of signifiers, meaning becomes forever elusive and flickering, both present and absent in a layered, web-like, open-ended play that never resolves into a single center or essence. As post-structuralism thus cast doubt on all classical notions of truth, reality, or knowledge, it also questioned all modes of representing them, be the signs verbal or visual, realistic or abstract. Far from autonomous or literal—"what you see is what you see"—the Minimalist cube, for instance, revealed itself, through subtextual analysis, to be very much the product of a long, historical process of arbitrary, progressive exclusion, a perfect metaphor or trope for all kinds of self-serving power systems, not only aesthetic but political, economic, racial, and sexual as well, which too "foregrounded" themselves as simple and direct, the better to remain justified, undetected, or unchallenged in the exercise of power's covert and coercive ways. Viewing originality and autonomy as myth, New Imagists almost took pride in inventing little or nothing; instead, many cheerfully accepted the givens of culture, both low and high, or those of process itself, often deconstructing them by means of appropriation, recontextualization, recombination, and layering throughout a field as dispersed and egalitarian as Pollock's all-over skeins, or post-structuralism's conception of the "signifying chain" (fig. 571). As already seen in the art of Rothenberg, LeBrun, and Borofsky, New Imagists respected their intuitions but tended to sport with inventiveness while profoundly interrogating it, along with canons of taste, subject, and form. Following the example of Pop, some would also treat older art like an image bank, but modestly and more in unsentimental homage than mockery, as if art or mark-making were a kind of common denominator of human experience, something beyond individual control and simply at large in the universe. Along the way, the artists to be seen here displayed all the avidity of their Pop seniors and the cannibalistic appropriators to come in the eighties, while evincing an admirable reticence and refinement entirely their own—"careful consideration," as Rothenberg later said, " . . . of the rules being broken." Beyond this, or their tendency to regard representation and abstraction as complementary, even interchangeable signifiers and signifieds—frequently in the form of schematic silhouettes set against painterly grounds of deep, monochrome color—New Imagists produced no common or "school" style, determined as they were to be released from a priori straightjackets into what Barthes might call an ecstatically diffused self. As Guston said: "In this condition of not knowing, you arrive . . . at a state of knowing only the thing you know at the time—and that is concrete."

Among New Image's charter members, the artist who most completely exemplified post-structuralist ideas was Jennifer Bartlett (1941—), a painter with a voracious appetite for exhibition space to rival Borofsky's. Luckily enough, Bartlett could also boast the analytical intelligence, wide-ranging skills and curiosity, the industrious work habits to fill entire galleries with one grandly encyclopedic opus after another, each a mind-boggling exploration of representational strategies finally willed, through serial structure, into a spectacle of unified complexity. When the first of these exhaustive works, a 988-unit painting entitled *Rhapsody* (fig. 572), came before the public in 1976, at Paula Cooper's SoHo gallery, it created the sensation of the decade, endowing Bartlett with an overnight celebrity far more symptomatic of the theater than the small world of cutting-edge aesthetics. True to her generation, the California-born, Yale-educated New Yorker had evolved from Action Painting to Process and Conceptual Art, reaching a state of frantic eagerness to find her own way by un-

571. Nancy Graves. *Xive*. 1983.
Oil, encaustic, and glitter on canvas with aluminum shadow sculpture; 6' × 5'4" × 1½". Courtesy M. Knoedler & Co., New York.

far right: 572.
Jennifer Bartlett. *Rhapsody* (detail). 1975–76. Enamel and silkscreen on steel plates; 988 1'-square plates, 7'6" × 153'9" overall. Collection Sidney Singer, New York.

right: 573.
Jennifer Bartlett. *Rhapsody* (detail).

below: 574.
Jennifer Bartlett. *Spiral: An Ordinary Evening in New Haven.* 1989. Oil on canvas with free-standing steel and painted-wood sculpture; painting 9 × 16'. Courtesy Paula Cooper Gallery, New York.

dertaking a work that would provide the self-educational experience of having "everything in it." That Bartlett possessed the capacity for such a vast enterprise had already been manifest in her lifelong habit of compulsive, omnivorous reading, as well as in her manuscript—already a thousand pages long and still growing—for an all-inclusive novel, self-mockingly entitled *The History of the Universe*. To be equally productive in art, Bartlett eliminated whatever she disliked about painting—canvas-stretching, the paraphernalia of oil—until the starting point of her process had been simplified to the basic module of a 1-foot-square steel plate, its flat, uniform surface commercially coated in baked-on white enamel (suggested by New York subway signs) and silkscreened with a grid of light-gray lines (like the graph paper on which she had been drawing). This liberated Bartlett to concentrate on the fastidious, labor-intensive act of painting with Testors enamel, a hobby-store medium offering twenty-five colors, which she pared to six—the primaries plus green, black, and white. Having invented a system entirely her own, Bartlett determined to let it generate the painting, its ideas, and ultimately its content. At first, she created an image by applying colors in grid formation, combining and permuting them in patterns that ranged from extremely simple to elaborately complex. Although clearly a Minimalist who had passed through Conceptualism, Bartlett viewed her system and its mathematics very much as she did her materials, significant only insofar as they offered a direct and mess-free method of getting into and staying with painting itself. When finally assembled an inch apart on spacious loft walls, large coordinated, gridwork sets of finished plates—as many as sixty in a set—yielded multi-part, serial compositions whose bouncing color-dots beguiled the eye as well as the mind, in brilliantly decorative ways unimagined in Minimal, Conceptual, Optical, or even P&D art. When she came to *Rhapsody*, Bartlett expanded her palette, not only adding more colors but also mixing and superimposing them. The better to include "everything," the artist decided to admit figurative as well as nonfigurative images. For the one category she chose, in their most essential or archetypal form, a house, a tree, a mountain, and an ocean; for the other, a square, a circle, a triangle—Cézanne's "cylinder, sphere, and cone" two-dimensionalized. Moreover, Bartlett would scale them small enough to fit on individual plates as well as large enough to spread across a number of squares. Also to be included were passages devoted primarily to color, others to line (horizontal, vertical, diagonal, curved), and some to various methods of drawing or painting (freehand, dotted, ruled, naïve, impressionistic). Finally, Bartlett decided that she would retain or reject each plate within twenty-four hours of finishing it, in order for "the piece to have a kind of growth that was actual rather than aesthetic." Brought into being by such incremental moves, the overall painting gradually assumed a symphonic character, or better yet a novelistic one, conceptualized and orchestrated from the start so as to create the pictorial

equivalent of a conversation, with the interlocutors' voices rising and falling, taking up, dropping, and then reintroducing topics in an ongoing, variable weave of human thought and utterance (fig. 573). Once finished and installed, the great painting unfolded section by section, beginning with the introduction of all the motifs and continuing until each of the various images, lines, colors, drawing and painting techniques had been individually explored, sometimes overlapped, and cumulatively blended until the whole climaxed in a 126-plate ocean sequence incorporating 54 different shades of blue, a true release into the "ecstatically diffused self." Bartlett had produced a genuine blockbuster, a fluent, dazzlingly profuse set of serial variations on a limited yet evocative set of stylistic, symbolic, and coloristic themes, all suspended in a matrix of resonant formal and intellectual values. When an English friend suggested calling the nearly completed work *Rhapsody*, Bartlett liked the idea, for, as she admitted with a characteristic touch of self-deprecating humor, "the word implied something bombastic and overambitious, which seemed accurate enough." Stunned by *Rhapsody*'s incredible plenitude, its nearly thousand enameled squares filling Paula Cooper's gallery to a glove-like fit, the first viewers found themselves immediately drawn into a work like nothing they had seen in years, a visual narrative that demanded to be "read" from left to right, a story so absorbing that one could become momentarily lost in the harmonic flow of gathering, ever-more inclusive "conversation." In a famous review, the *New York Times* critic John Russell hailed *Rhapsody* as "the most ambitious single work of art that has come my way since I started to live in New York," a work moreover that "enlarges our notions of time, and of memory, and of change, and of painting itself."

Too energetic and alert to rest on her laurels, Bartlett quickly moved beyond *Rhapsody* in a continuing, prodigiously creative search for new problems through which to test or enlarge her skills, while simultaneously examining the numerous ways through which the human mind translates the world of nature into culture—filters and

575. Pat Steir. *The Brueghel Series (A Vanitas of Style)*. 1982–84. Oil on canvas; 64 panels, each 28½ × 22½". Collection the artist.

recovering, in a purely post-modern fashion, the very kind of art history, stylistics, and oil-and-brush painting that Minimalism as well as idea art had declared moribund. As a student of Richard Lindner at Brooklyn's Pratt Institute, Steir came of age in the radical sixties with her love of paint and painting's tradition miraculously intact, at the same time that Pop was showing how to make it new by quoting from everything, including past art. Also very much at play was, of course, the formalist belief in art's Darwinian evolution towards self-reflexive autonomy, ironically helping young Steir to become all the more conscious of the reality that art always flows from older art, giving culture a vocabulary of current forms, which each painter or sculptor inflects with subtly or sharply different meanings. In this way artists graft themselves onto the living tissue of the past, legitimately claiming continuity. A poet as well as a painter, Steir explained it thus:

I feel there's really very little difference between the stylistic modes of art-historical periods. Hints of all are evident in all, and it's all the same thing—painting. The "alphabet" is the same—red, yellow, blue, black, white—but not the "handwriting." The difference is in the scale, in the use of space. Small black and white strokes that make up detail—that's Rembrandt. Expand them and it's Kline. Scale up Van Gogh's color and mark, and it's de Kooning. All art-making is research, selection, a combination of thinking and intuition, a connection between history and humanity.

Even Steir regards *The Brueghel Series*, with its revelatory subtitle, *A Vanitas of Style*, as something of a textbook demonstration of her principle, given that the multipartite painting views an Old Master work through the eyes of almost sixty different artists or "schools," ranging from the Byzantine through 14th-century German, Rembrandt, and Watteau to Ingres, Turner, Picasso, O'Keeffe, Rothko, and Jean-Michel Basquiat. Always interested in flowers and painting about painting, Steir began what developed into a two-year project when she chanced upon a poster reproduction of a still life by the 17th-century Dutch master Jan Brueghel, or Bruegel, the Elder, a work now in Vienna's Kunsthistorischesmuseum, depicting a fat blue vase filled with a bursting variety of fresh flowers beset by a pair of butterflies above and other insects below. Next, she laid a grid over the image and divided it evenly into what would become 28-by-23-inch sections. Steir then reinterpreted each in whatever manner the original passage inspired her to associate with it, until the finished work became, as the artist wrote, "almost like a visual crossword puzzle with hundreds of connections between artists, styles, and times." In homage to each of her chosen models, Steir attempted to see and paint precisely as those earlier eyes and hands would have. Thus, while Whistler may reign over the bell bottom of a buttercup, the solid yellow of a hard-edged, Kelly-like segmental disk takes over and concludes the image in the panel above. Suitably, a butterfly flutters to life from the delicate touch of Botticelli, a spider web has been spun as if by Pollock and LeWitt, the action of a furious ladybug caught by a generic Futurist, the abstract pattern of the blue vase set down in the resolved style of David, and a dark corner filled with a black-on-black Reinhardt. One horizontal passage reads like a monograph on interacting sources and influences, as the panels progress, from edge to edge right through the flowery mass, in the idioms of De Stijl, Abstract Expressionism, Courbet, Manet, de Kooning, van Gogh, *japonisme*, and, finally, Pat Steir herself. As this sequence would suggest, Steir gathered the most painterly styles at the heart of the bouquet, creating a kind of pictorial vortex, like the eye of a maelstrom. Here, in the words of Michael Brenson, "Steir has made it seem as if all the artistic voices that began speaking when she took the lid off Brueghel's still life were both shouting her down and giving her the energy and will to persevere." Although a celebrated virtuoso of the brush, Steir calls her art "conceptual," albeit in no way Minimal, since it starts with and builds on a limitation in the hope of transcending it—in the "hope that some-

encodes it into systems of signs and conventions. As in *Rhapsody* or *In the Garden*—the latter comprising several hundred drawings, based on a disheveled French garden dominated by a peeing Cupid, and encompassing every conceivable style and mannerism—Bartlett usually works with a constant theme, which anchors the project as she explores no end of media and how shifts from one to another dictate changes in style. Using oil on canvas, enamel on glass, charcoal, pastel, and colored pencil on paper, *papier collé*, casein on freestanding plaster walls, and, of course, Testors colors on enameled steel plates, Bartlett has worked through series designed to rediscover, in sequential order, Impressionism, Expressionism, Realism, Rayonism, Matisse, Mondrian, and Pollock, often in pairs, quartets, or quintets of contrasting but interrelated canvases or panels, sometimes with the imagery spilled over into concrete, three-dimensional forms (fig. 574). By this means, she became one of the very first of post-modernism's appropriators, an artist who used a Conceptualist approach—her intellectual curiosity—to override Conceptualist, as well as Minimalist, prohibitions and re-engage with modernism and the act of painting on a grandiose scale, all the while maintaining a cool, anti-expressionist distance that transforms her work into a post-modern critique of whatever it appropriates. Thus, Bartlett's work acquires distinction not from personal style, but rather from an unswerving anonymity, analytical intelligence, overflowing generosity, and willful execution. In summary comment, Roberta Smith wrote: "Bartlett doesn't want to forge a style out of a mélange of appropriated ones, the way Salle [fig. 602] or Borofsky (in a completely different way) does. She is willing to get lost every time she tries something new, and then gradually find herself in it—a new part of herself."

In *The Brueghel Series*, a 64-panel assemblage rising from floor to ceiling, Pat Steir (1940—) produced another vast, summary work that became almost as much an art-world event as Bartlett's *Rhapsody* (fig. 575). Furthermore, Steir too employed a Minimalist grid and a controlling Conceptualist idea, only to deconstruct them in the course of

pleasure consists in endless recopying'.'' For Le Gac, then, as Kate Linker concluded in her lucid discussion of this fascinating but elusive figure, ''art is a function of inflection, of intonation—the brief caesura posed between what once existed and what never was before. In the terrain left by the myth of originality, the painter is left to repeat, to echo—and to find in the tremulous strayings of those echoes the source of artistic pleasure.'' But however minor by this definition, the pleasure must be real, certainly for viewers, presented as they are with an elegiac view of human capacity—the demystification of the artist

where in there a human element comes in, and that that will be the transcendent fact.''

If the prolific Bartlett and Steir rejected the modernist or Western view of art as a history of style, indeed of ''signature'' styles, by appropriating many different styles and signing their names to all of them, the French artist Jean Le Gac (1936—) approached the problem from an opposite angle, by creating an unproductive, therefore style-free, alter ego and allowing him to appropriate many different signatures. Although long active in art, Le Gac became what might be called a ''new imagist'' only in 1981, when he discovered a box of his daughter's pastels and some old cardboard, a combination of materials that filled him with a nostalgic desire to evoke youthful poverty by copying illustrations in books first read in childhood (fig. 576). But however naïve the imagery, it came from the hand of an exceedingly sophisticated artist, one with a mind steeped in the arcana of Jacques Derrida's deconstruction theory, which holds language to be so slippery and uncertain as a vehicle of meaning that it robs the author of the authority once attributed to him, and his text not only of ''presence'' or ''aura'' but also of all meaning save that read into it by others, which changes with each new reader and reading. Furthermore, by suggesting that all representational systems, including the visual, are inherently language-like, Derrida also declared artistic practice to be fatally undermined—deconstructed—by the same ambiguity as words or names. Thus denied the ''myth'' of his own originality, Le Gac abandoned painting in 1967 and began collaging photographs and texts concerned with the paradox of the absent artist whose presence nonetheless remains immanent in art, thanks to the pleasure such an image gives not only to the public at large but even to Le Gac himself. Casting his ideas in the form of illustrated narratives involving a stereotypical 19th-century artist, complete with beret, paint pots, and studio patois, Le Gac delineated a whole artistic career marked by ambition, sincerity, aesthetic vision, and all manner of incident—foreign travel, mountain climbing, horseback riding—yet devoid of real artistic production. It was enough that the character's existence and exploits gave rise to accounts and fictions that constitute the reality of the artist in modern culture. Therefore, the narratives became a kind of *roman policier* (''detective novel'') whose search is for clues to the artist's identity, complicated by the numerous identities—among them Robert Nerac, Asfalto Nozaro, Francis Benedict—that Le Gac permitted his mythical painter to assume. Once he renewed drawing, in *The Painter's Pastime*, the work from which the present detail came, Le Gac juxtaposed his handwrought works with photographs of the ''originals'' he had copied, a photograph of an ''artist'' at his leisure, and a brilliantly incisive text likening the ''author'' to an Oriental calligrapher or medieval monk, ''meaning a painter 'whose greatest

and his work—that is virtually, or ironically, canceled by the sheer originality of Le Gac's own performance. Gentle in wit, charming in its imagery and handling, clear in design, *The Painter's Pastime* also delights by virtue of the clever perfection with which the artist interlinked his several, palimpsest layers of signification.

If originality be myth, except in the mind and imagination of the viewer/critic, whose reading of art's subtext post-structuralism values more than the artist's intentions, then Jane Kaplowitz (1949—), one of the earliest post-Pop appropriators active in New York, would relish her role as viewer/critic to re-create modernism after her own well-trained artistic instincts and ripe sense of humor. In *Art in the Solarium* (fig. 577) Kaplowitz has, for instance, given a sharp new twist to the notion of historical culture as one big ''image pool,'' pictorially assembling the kind of swimming-pool house that Robert Stern or Michael Graves might wish to design, but that not even the wealthiest collector could possibly afford in these inflated times. Arranged in Agnes Martin-like tiers, rather than in the familiar circles, Matisse's musicians and dancers of 1910 have doubled in number but retained their brick-red skin, bottle-green turf, and sapphire-blue backgrounds, to cavort about and above a pool surging with Hokusai's Great Wave, run amok to become three! This makes one for each of the gamboling figures in Picasso's *Bathers with Beach Ball* (1928) hung on the wall above a pair of lounge chairs. Upholstered in the same kind of Buren stripes as those worn by the Surrealist seaside buddies, the furniture reminds us, once again, of Matisse's dream of an art ''like a good armchair which provides relaxation from physical fatigue.'' In this ''artscape,'' so filled with ''artful humor, with art, of art, about art,'' as Charles Stuckey once wrote, we are also reminded by the overwhelming presence of Matisse and Picasso that long before Lichtenstein and post-structuralism, both of the great pioneer modernists—the one with his art-crowded studio scenes and the other with his free interpretations of Old Masters (figs. 18, 93)—had triumphantly reconfirmed that art is always about art, moreover that the message is

all the sweeter for being delivered with lean, witty candor. By adopting not only their *replicatif* and *recombinatoire* techniques but also their gift for playful homage, Kaplowitz could successfully turn her own mastery of brilliant color and clear design to the task of transforming post-modernism's deconstructive irony into the reconstructive humanity of an art alive with a richly informed, comic sense of how art's future is, as ever, to be found through creative accommodation with its past.

Accepting the modernist theory that serious art must, above all else, evince the process and properties of its own creation, Joe Zucker

578. Joe Zucker. *The Cotton Gin*. 1979. Acrylic, cotton, Rhoplex on canvas, 4' square. Courtesy Holly Solomon Gallery, New York.

(1941—) chose to deconstruct the whole concept by interpreting it literally—as only a Chicago-born humorist could. If painting's cotton support had to be forthrightly acknowledged, then Zucker would do so with clunky obviousness, re-creating the material and its woven structure in wax-soaked cotton balls applied to canvas in a rough approximation of not only the underlying fabric's warp and woof but also Minimalism's ubiquitous grid (fig. 578). And if the most "absorbing" subject available to a painting was the story of how it came into being, then Zucker would make his pictures narrate the centuries-long epic of cotton and in imagery constructed, or inlaid like a mosaic, with the cotton balls themselves, presoaked in color. The result is a bumpy, folkish pointillism in which the modernist penchant for self-reference—as in the autonomous brushstroke—has been both honored and parodied, with the history of cotton so thoroughly absorbed into its own substance that figure and ground have indeed become one, quite as much as in the color-stained abstractions of Helen Frankenthaler, Morris Louis, and Kenneth Noland. In Zucker's oddly beautiful, complex art, almost every element invites a double or even a triple reading, as Eastern intellectuality merges with Midwestern populism, modernist formalism with compulsive craft, and Duchampian irony with visionary zeal.

Donald Sultan (1950—) too, and for much the same reason, sought a motif ratified by the materials used to represent it, in his case vinyl tiles, tar, latex, and Spackle. If Minimalism, as well as Duchamp and Pop, had opened art to such non-art means, it also shut out the whole of painting's traditional subject matter—landscape and still life, for instance—that certain New Imagists hoped to recover, in, of course, Conceptualist terms made imperative by sixties abstraction. But instead of appropriating imagery, in the way of so many post-Pop artists, Sultan determined on teaching himself to draw—a skill not stressed

during the figure-averse years he spent at Chicago's Art Institute school—while also earning his way as a handyman at Denise René's New York gallery, in the course of which he stumbled upon the media that have given post-modernism some of its most boldly, even morbidly beautiful works. The breakthrough came when Sultan undertook to retile his employer's floor with vinyl. Fascinated not only by the material's weight and thickness but also by its ready-made colors and mottled patterns, he found himself even more attracted by the unexpectedly sensual way in which the cold, brittle tiles became soft and pliant when cut with a blowtorch. Moreover, he fell in love with the tar—called "butyl butter"—used for fixing the tiles. Finally, vinyl tiles, their special colors, blowtorch cutting, and tar combined to suggest a variety of new subject matter, which Sultan began to draw and paint on a vinyl surface, taking as his medium the same tar with which he fixed the tiles to a support. Soon he was covering the vinyl with a thick coat of butyl butter, which he then used as a surface to paint on with oil, or indeed to carve into, which meant creating an image by relieving or revealing the vinyl color that lay below. When this happened to be a flecked blue, the exposed bit of tile might serve as a white-capped sea or a sky full of scudding clouds, which the pitch-like surround encouraged the artist to develop into the visual pun of a factory scene, the fiery emissions of its smokestacks produced by swirls of latex brushed on and washed in turpentine (fig. 579). With his image clearly metamorphosed from the materials and mechanisms of its fashioning, Sultan could join Frank Stella and say, as he was wont to do, that in his own work "only what can be seen there *is* there."

right: 579. Donald Sultan. *Polish Landscape II, January 5, 1990*. 1990. Tar and latex on tile over Masonite, 8' square. Courtesy M. Knoedler & Co., New York.

below: 580. Donald Sultan. *Lemons May 16, 1984*. 1984. Tar, plaster, and oil on vinyl composite tile on Masonite; 8'1" × 8'1½". Virginia Museum of Fine Arts, Richmond (gift of the Sydney and Frances Lewis Foundation).

Few things could seem more physically present to the eye than the colossal lemon that soon appeared in Sultan's art, an orb of golden, solidified light, in the stuff of chalk-white plaster yellow-stained like Renaissance fresco, asserting itself against the tar's hellish black (fig. 580). Like an emblem of acid rain from Sultan's romantic visions of industrial progress, the swollen, voluptuously nippled lemon both grew and increased, to become caressing pairs and parties of fruit, finally to turn as startlingly black as eclipsed suns. Thus embedded in absorptive tar, the color of the bright lemons seems all the more luminous, at the same time that its flat silhouette appears all the more illusionistically spherical for being lightly tinged with sable traces of butyl butter. To create such anomalous grandeur, Sultan carved the shape out of the layered muck, filled it with plaster, overpainted in yellow, and rinsed everything with solvent. And if this process revealed the roots of the image it materialized, the subject and its erotic overtones permitted Sultan to satisfy a desire to make new art enriched by identification with historical antecedents, which, for the great lemon, had been located in a small Manet seen at New York's Metropolitan Museum. By building up, relieving, and then filling in a surface founded upon a grid of joined tiles, Sultan, like Manet, managed to produce pictures that seem spatially deep while remaining unequivocally flat and free of retardataire illusionism. But the sense of weight and substance also has its source in the objective reality of a massive architectural framework, comprised of the support glued to heavy plywood backing attached by steel rods to rectangular stretcher bars. What it projects, well away from the wall, is "clear painting," as Sultan calls it, painting marked by absolute coherence of image, means, and informing tradition. Meanwhile, some observers have also seen Sultan's dark poetry as ominously coherent with its own time, with a media culture in which beauty and brutality have been so confused through intermingling that, as here, blazing smokestacks may easily reverse into Wagnerian sublimity or even the loveliness of a poppy field, while unappetizing tar and Spackle transform bitter lemons into images of enticing lusciousness.

Neil Jenney (1945—) worked through Minimal Art to become one of post-modernism's most elusive and respected artists, a painter of riddle-like "events" presenting, without interpreting, the evidence of how one reality is contingent upon and dramatically manifested through its relation to another. A self-proclaimed realist engaged with the problems of modern life, Jenney resumed painting, despite the "day after" mood created by Minimalism, for the sake of exploring social issues in images so radically simple as to invoke the elemental (fig. 581). This called forth a famously "Bad" style of painting, developed by Jenney in the hope that form would not overwhelm the content it had been summoned to bear. Characteristically, the crude, juicily faceted handling seemed to draw an uneasy analogy between finger painting and Cézanne's structural stroke or de Kooning's gesture, just as the austerely formal black frame created an odd rift with the cartoony drawing and painting it surrounded. Also juxtaposed in their unalike modes were the ever so clear title, emblazoned on the frame's lower edge, and the mystery that both the title and its figurative counterpart spell out. Eventually, however, the simplicities of the various contradictions unify, in works like *Sawed and Saw*, *Rake and*

Leaves, *Husband and Wife*, *Girl and Doll*, *Them and Us*, or *Here and There*, as signifiers and signifieds interact to suggest that the missing link—the mystery or referent—must be neither more nor less than a prior "event" that left cut timber strewn on the ground next to a chain saw, a couple with their backs turned to one another, or grass split by a fence. If cool and reportorial, as well as delightful in the ambiguity of its Duchampian visual / verbal play, Jenney's art is also subtly incriminating of all who approach, for by prodding viewers to supply an explanatory "flash-back" scene, it symbolically implicates them as perpetrators of the action whose consequences they see.

With a cause-and-effect logic like that implied by his subject matter, Jenney followed the "Bad" paintings with a continuing series of "Good" ones, beginning in 1971–72. Now he reversed the relationship between imagery and frame, enlarging the latter until it rendered the picture as object-like as anything in Minimalism (fig. 582). Massive, dark, and funereal, the new frame allows little more than a slit—a gun-turret view—through which to glimpse an eerily glowing, chillingly realistic sliver of landscape. And when the monumental label reads *Acid Story*, *American Urbania*, or *Meltdown Morning*, there can be scant doubt about the work's content, soaked as this appears to be in nostalgia for a paradise already lost, possibly beyond recovery. Also suggested by the coffin-frame is mourning for the world as it may appear—like a rare, archaeological fragment preserved in a museum showcase—following nuclear winter. Here, then, is political art raised to a new power, at least in terms of quality, by the thrilling virtuosity with which Jenney repossessed trompe-l'oeil painting and placed it against a flat, bleakly abstract sky as a means of expressing not only a global problem and its cause but also the possibilities of a last-chance solution. If real painting, reminiscent of Romantic, 19th-century American landscape art, can revive in a hostile post-Minimal climate, there may yet be hope for the endangered earth and its dangerous inhabitants. Given a subject as major as ecology and the doomsday bomb, Jenney could justify cultivating an art as exquisite as his impeccable illusionism and cabinetwork frame, the better to transform his work into a "social science" or a language through which to convey "allegorical truths." Calling Pop "the most profound art in American history," Jenney adopted its strategy of so combining discrepant orders of things—physically real frame, conceptually real title, per-

ceptually real image—that they become interdependent for whatever signification or meaning their unresolved conjunction may offer. And by merely presenting "an event by its evidence," Jenney provokes his spectators to imagine a less ambiguous linkage between the various realities of his work, until they find themselves interlinked with the event itself, the aftereffects of which the artist has presented with such unsettling force.

Determined that his paintings "be about something, as opposed to being about nothing or being about themselves," Nicholas Africano (1948—) dismissed Minimalism as "ground zero" and made "subject matter [his] primary concern as an artist." Africano also countered the Conceptualists and gave up words for figures in order to realize, a more "direct and immediate" image, simultaneously reinforcing it with his gift for narrative. Painting, in fact, transformed him from an aspiring writer into a pictorial playwright, intent upon staging mock-heroic dramas in as many as ten acts, each presented on the vast, empty stage of 7-foot monochromatic canvas at the center of which performs a cast of one or two characters (fig. 583). But far from devoured, like Giacometti's tiny figures, by a voracious space, Africano's actors gently assert themselves against the menacing void, aided by their projection in compact relief fashioned of painted beeswax and sometimes even by a line of dialogue, such as: "I get hurt." With titles like *Daddy's Old, Battered Women, Dr. Jekyll and Mr. Hyde, The Girl from the Golden West, Petrouchka,* and *Evelina,* Africano's narratives mimic the world of not only fiction but also opera and ballet. From painting to painting, the cycle turns inexorably through episodes of trust, betrayal, revenge, and atonement, as Africano confronts his viewers with the old, but rarely heeded, tale of how intimate relations decay into estrangement. Plots unfold slowly and incrementally, in brief seriocomic moments of foolishness and vulnerability, intensified by the sophisticated artist's lumpy, *faux-naïf* manner and the microscale of his figures, the effect of which is to stress the poignant humanity of the characters, and with this the universality of their predicaments. All about, meanwhile, spreads the great void, its

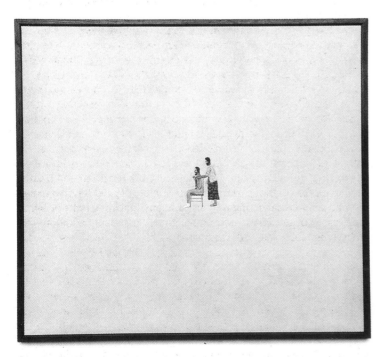

indifference an issue not only of the neutral, solid color but also of virtual continuity with the spectator's own space, leaving no doubt that the isolation in which the minifolk encounter destiny is as much ours as theirs. Carefully staging his quirky scenes of crime and punishment, hope and despair, sweetness and sorrow, Africano treads a tightrope, but holds his precarious balance between soap opera and the very real dilemma of the human condition. Overall, he has created

what one informed observer called "an art of secular morality for an unbelieving era."

Robert Moskowitz (1935—) clarified the rather amorphous atmosphere in which New Image flourished when he said: "Most of the images I use have been so stamped on my brain that they are almost abstract." And "by adding an image to the painting," he went on, "I was trying to focus on a more central form, something that would pull you in to such an extent that it would almost turn back into an abstraction." This led him to choose and isolate a motif of banal familiarity—a natural or cultural icon like Myron's *Diskobolus,* the Empire State Building, or the Seventh Sister in Yosemite National Park—strip the form bare of all but its own primary shape, and then integrate it with a pictorial structure as drumhead taut as any by Clyfford Still, Barnett Newman, or Ad Reinhardt (fig. 584). In the work seen here, the last artist is recalled through the way a nearly black-on-black figure and ground so complement one another in their equality of weight and emphasis that the flat, interlocked silhouettes may even exchange roles, elusively flipping back and forth rather like a gestalt experiment. As if to explain his strategy, Moskowitz commented: "In all good work there is a kind of ambiguity, and I am trying to get the image just over that line." Still, he never lets it go so far as to escape eventual recognition as a monument rediscovered by virtue of its having been puzzled out and pulled back from "just over that line." Often the title helps, but so too does a silhouette as unmistakable, though as enig-

far left: 583. Nicholas Africano. *The Scream.* 1976. Oil, acrylic, and wax on canvas, 6'4¾" x 7'1½". Courtesy Holly Solomon Gallery, New York.

left: 584. Robert Moskowitz. *Giacometti Piece.* 1983–84. Oil on canvas, 9' x 3'5½". Courtesy BlumHelman Gallery, New York.

New Image Art

opposite: 585.
Elizabeth Murray.
Beginner. 1976. Oil on
canvas, 9'4" × 9'5".
Saatchi Collection,
London.

right: 586.
Elizabeth Murray.
Open Book. 1985.
Oil on 5 canvases,
8'9" × 11' overall.
Collection
Seibu Corporation,
Japan. Courtesy
Paula Cooper
Gallery, New York.

matic, as Giacometti's *Standing Woman*, a figure so consumed by its surrounding space that the latter may appear more tangible than the solid form. When this becomes optical or psychological reality for the involved observer of the Moskowitz painting, *Standing Woman*'s elongated, frontal silhouette takes on the abstraction and absoluteness of a Barnett Newman zip, complete with something of its power to energize the entire picture field. Contributing to the sense of refreshed vision and grandeur is the epic scale on which Moskowitz casts his essentialized form, together with his tendency to cut it free of the ground, which in turn makes the image appear truly out of this world, soaring and mythic. Finally, there is the enchanted world of the painted surface, a gorgeous display of dextrous handling, variously silken, flickering, dragged, scraped, or luminous, glorifying the flatness of the plane and seducing the eye to explore the image declared thereon. ''When people look at my work,'' Moskowitz has said, ''I want them just to discover it in a quiet way—not unlike when you're walking across the street and see something and then realize it's just there, in a very physical or literal way.''

Scarcely had Elizabeth Murray (1940—) arrived in New York in 1967 when Minimalists pronounced painting dead, an unwelcome bit of cutting-edge pretentiousness that the twenty-seven-year-old newcomer treated with the healthy skepticism of a provincial educated at Chicago's Art Institute school and Mills College in California. ''Well, to hell with that,'' she replied. ''I'm painting.'' And indeed she has, with steadfast intelligence, industry, riskiness, and dedication, not only to late modernism's sources—Cézanne, Picasso, and Gris, Kandinsky and Miró—but also to the integrity of the direct, personal impulse that had stimulated them. Like the Abstract Expressionists, Murray would synthesize Cubism and Surrealism, subsuming figuration into abstract form, albeit with an invigorating admixture of Pop humor and unruly feminine instinct. ''It's not enough,'' Murray explained, ''that you learn how to paint—anybody can do that—but you must learn how to be *expressive* in paint.'' With this as her guiding principle, she eagerly explored Minimalism and Conceptualism, only to find herself more naturally drawn to the abstract illusionism of Al Held and the shaped reliefs of Frank Stella. Yet whatever the affinities, Murray filtered them through an early and firmly held insight that the only possible approach for her was, as she declared, ''painting with all my heart and soul . . . for better or worse, that was my strategy.'' Thus committed to an existential process of reinventing her art with each new work, she looked within for the means and discovered no end of contradictions, including the explosive realization that her capacity for Disney-like fantasy all but equaled her formalist love for the earthy, sensuous painting of Cézanne. ''All my work,'' Murray admits, ''is involved with conflict—trying to make something disparate

whole.'' This can be seen in the generously scaled mid-seventies painting entitled *Beginner* (fig. 585), where the ''mediating'' pink spiral of an ''umbilical cord''—the smallest and most complicated element in the picture—binds together all the contrasting colors, textures, and moods of the other, much larger and simpler, oddly incompatible shapes. And so, while the big ''bloopy'' biomorph, an Arplike figure in deep, heavily impastoed purple, nuzzles or cowers against the right edges of the rectangular field, the little flesh-colored ''pretzel'' appears slowly to uncoil within the warm, dark womb or foetus and venture into the storm of gray strokes loosely scumbled over the cocoa world without. To humanize the abstract image and endow it with thought and feeling, Murray, as always in later work, avoided bravura display and preserved the slight, Cézannesque awkwardness of her engaged, hands-on, trial-and-error search for original, expressive structure.

In 1978–80, while overcoming a series of personal crises, Murray also realized a major breakthrough in art, one that successfully tested the outer limits of her power to resolve conflict. First, she ''shattered'' the once-coherent support into an archipelago of island canvases spread over the wall, which thereupon entered the fray as one more competitor for the viewer's eye. Then, to make everything whole again, she drew on her academic background, reintroduced figuration, and imposed upon the entire flotilla of fragmented fields an image simple enough to be detected as a unifying factor. Here, it was as though the three elementary forms seen in *Beginner*—loopy line, kidney shape, and rectangular ground—had cross-fertilized and bred a new race of eccentric, evocative shapes. Not only did the line metamorphose into meandering ribbons of steam, crackling bolts of lightning, ropes of intestines, or even hangman's nooses; in addition, the embryonic blob expanded, contracted, or branched into cups, hands, paintbrushes, palettes, penises, dogs, dirigibles, and clouds. Meanwhile, the old squarish format fractured into the planes of furniture, architectural spaces, or several things at once, as in the wave-curve spread of an open book, which proves to be a room with cut-out windows that make the piece look like a great pair of harlequin glasses (fig. 586). However, the painting may remain primarily a glorious airborne banner of green-edged blue except to observers sufficiently attentive to ''read'' the relief map of separate entities and visually as well as conceptually piece them all together like a puzzle. Murray says: ''I want the panels to look as if they had been thrown against the wall, and that's how they stuck there.'' Thus, she painted in teardrop bursts symbolically set off by the jolt of two panels slammed together and interlocked, with aftershocks trailing across both fields to culminate into a distended balloon over the right eye. In the creative act, however, Murray works much more deliberately than her tossed-

against-the-wall metaphor would suggest. She begins by making full-scale drawings of imaginary shapes on huge sheets of paper tacked to a vertical surface, overlapped, reshuffled, and spliced together until the final, satisfactory arrangement comes into being. Thereafter the drawings serve as templates for plywood supports, set on 4-inch moldings, over which the canvas is stretched across the plane—often an erotically undulating one—and down around the deep edges to make a three-dimensional painting surface of extreme plasticity. From this point on, the artist proceeds *alla prima* and by free association, allowing the shaped canvas to pull from within her the images that go into the picture. Increasingly the formats suggest Analytic Cubism made literal or as object-like as Minimalism's Primary Forms, but with a new lucidity of subject comparable to what emerged with Synthetic Cubism. As in her endearing ungainliness, Murray seems more and more to value a certain lack of finish, especially evident in the feathering out of color and brushwork at format extremes, there leaving the bare canvas, staples, and frayed ends fully exposed. Just as she stubbornly resists all attempts to classify her work as either abstract or representational, Murray wants her painting to offer "possibilities," to remain open and indeterminate even when signed and sold. "I think that's the beautiful thing about [my work]," she says, "that it's so vulnerable. Something is exploded out of the ordinary context into a new state."

Like the Conceptualists with whom she studied at Yale and then entered the New York art scene, Nancy Graves (1940—) has consistently exploited modernism's subversiveness to subvert modernism itself. Most spectacularly, however, she has also subverted Conceptualism by using its modernist logic to extend modernism's possibilities in an unabating flow of aesthetic objects, sculptures and paintings as remarkable for their prodigious numbers as for their wit, originality, and, often, breathtaking beauty. With Picasso, Calder, and David Smith as her models, Graves ransacks science, nature, and the man-made for her forms and subjects, industry for her materials and techniques, and post-modernism for the licentious freedom to transform non-art appropriations into gloriously decorative art works. This burgeoning œuvre, moreover, comprises not only paintings and sculptures but also prints, films, and stage design, all as permuted as a Minimalist serial but for the anti-Minimalist purpose of conveying a

powerful sense of the recalcitrant mysteries of life and its evolutionary, metamorphic processes. Such protean, polymath range comes to Graves by virtual birthright, inasmuch as she grew up in Massachusetts' Berkshire Museum, an institution directed by her father and devoted to art, history, and science displayed side by side. Here, the young Nancy developed respect for natural and human creation alike, for the craft involved in constructing dioramas and animal models, and for the spirit of open inquiry, all of which fed a desire to excel and thus to cultivate a native talent for drawing and painting of scientific, or "Eyckian," exactness. And so, when in Florence, with Richard Serra, her husband at the time, and struggling to liberate her own work from the historical art she was studying, Graves almost reflexively sought relief in the natural-history museum, where, in an epiphanic encounter, she discovered the wax effigies of Clemente Susini, an 18th-century anatomist who mixed art and science to surreal effect in life-size models of human bodies. In the curiously romantic female figures, laid on pink satin with their chests cut open and their natural hair dressed in pink ribbons, Graves saw the potential for a new kind of sculpture and through it an escape from her problems with painting. Working like a taxidermist, but with altogether different intentions, the artist began making a menagerie of small stuffed animals, among which she came upon a now-famous breakthrough image—the Bactrian, or double-humped, camel. With its enigmatic personality, the camel offered a resonant metaphor for the secret life of sculpture, and because "specific," as the Minimalists would say, it left the artist "free to investigate the boundaries of art-making" (fig. 587). The Bactrians became the first step in a long, unfolding line of development, one that most immediately took Graves into fresh territory, ancient, mythical, and fascinating, yet unco-opted by Western art. Although naturalistic enough to seem more camel-like than any real, individual beast might be, the freestanding pieces transcend taxidermy to become original creations, made without reference to actual prototypes and brought into existence by the artist's own handwork and her meticulous, Eyckian regard for detail, texture, and proportion. While Duchamp might have bought, signed, and exhibited a stuffed camel as a trick for demonstrating the arbitrariness of high-art categories, Graves rejected such a strategy as too exhausted by the sixties' vanguard, beginning with Rauschenberg's *Monogram* (fig. 223), to be genuinely subversive.

Working on the Bactrians, Graves also discovered that only by understanding her subject from the inside out could she permute or synthesize it. Almost obsessively, she studied fossils, skeletons, and

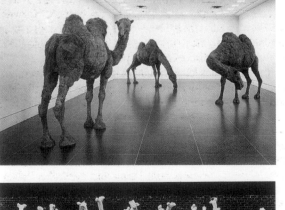

far left above: 587: Nancy Graves. *Camels VI, VII, VIII.* 1968. Wood, steel, burlap, polyurethane, animal skin, wax, and oil paint; 7½ × 12 × 4', 8 × 9 × 4', 7½ × 10 × 4'. National Gallery of Canada, Ottawa (gift of Mr. Allan Bronfman).

far left below: 588. Nancy Graves. *Variability and Repetition of Similar Forms II.* 1979. Bronze on Cor-Ten steel, 12 × 16 × 6'. Akron Art Museum. Courtesy M. Knoedler & Co., New York.

left: 589. Nancy Graves. *Molucca Seas.* 1972. Acrylic and ink on canvas, 8'6" × 6'. Courtesy M. Knoedler & Co., New York.

opposite top: 590. Nancy Graves. *Zaga.* 1983. Cast bronze with polychrome chemical patination, 6' × 4'1" × 2'8". Nelson-Atkins Museum of Art, Kansas City (gift of the Friends of Art).

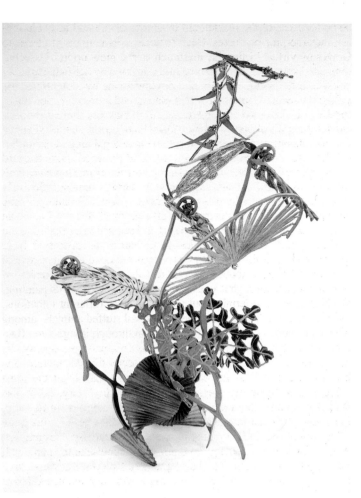

of visual and structural economy into an aesthetic process (fig. 590). Like Frank Stella in his later reliefs, Graves has let herself be carried forward on a tidal wave of fantasy and invention, pouring energy into one exuberantly open-form, polychrome, freestanding construction after another. Although extemporized and wittily pirouetting as well as filigree-light in appearance, each of these one-of-a-kind pieces constitutes a sober, sophisticated study in balance, weight, and counterbalance. Such art is also a genuinely post-modern, hybridized fusion of the real and the ideal, for while fully present in shape and minute surface detail, the found and the ready-made have also been thoroughly abstracted and aestheticized, not only by appropriation, casting, and recontextualization, but also by a camouflage of brilliant, symbolic color. Subversive to the end, Graves colors her bronzes as freely as she combines wildly dissimilar forms, thereby permuting each category of the latter and introducing a new element of surprise in works the very purpose of which is to provide that "something beyond the given." Using surprise, humor, and risk, Graves leads the viewer from slow recognition of the familiar to an enhanced realiza-

below: 591. Barry Flanagan. *Leaping Hare.* 1980. Gilded bronze, 26¾ × 27¼ × 6¾". Southampton Art Gallery.

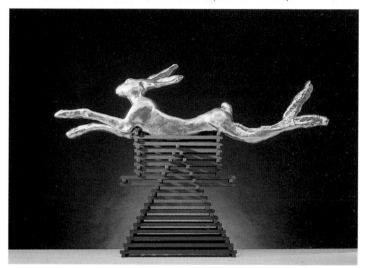

tion of how strange and wonderful it all is. In addition to the lasting delight of ordinary things metamorphosed into heavy metal and then into graceful, gravity-defying, chromatic drawings in space, Graves' mature sculpture also exhilarates by the way it embodies a questioning process whose challenge to the assumptions of history, eye, and intellect continually yields new discoveries and possibilities.

For Graves, the search has led back into painting, where inventive, free-hand chromaticism can truly blaze, as the artist permutes the new imagery yielded by bronze-casting not only in grandly meandering contour drawing, often profusely layered against broad, flat fields of color, but also in lightweight aluminum or fiberglass combine elements attached to the support (fig. 571). Unraveling and mixing organic metaphors in two and three dimensions alike, so that the concrete and the abstract become both literal and symbolic "shadows" of one another, Graves prompted the critic Kay Larson to compare her way of art-making to "the replication habits of DNA—linkages that seem elemental and mysterious. . . . As with DNA, the organisms that emerge bear no obvious resemblance to the information that was encoded in their 'genes'."

Although ineligible for the Whitney's "New Image" show, mounted in a museum devoted exclusively to American art, the British sculptor Barry Flanagan (1941—) has given post-modernism one of its most engaging and versatile new images, a hare that could have jumped straight out of a hat, but in fact surged up in clay as the artist was squeezing it (fig. 591). And this wild yet oddly civilized creature

bones, which quickly assumed the character of organically abstract forms, interesting in their own right and readily subject to aesthetic reordering, for thematic variations or serial repetition, for parts used synecdochically to evoke wholes, for kinetic effects (fig. 588). Perceiving her *faux* fossils as laden with symbolic worth, signifying primal mystery disturbingly introduced into the alien, living present, Graves expanded her idea of science used to probe the irrational and moved beyond anatomy as well as paleontology into botany, meteorology, anthropology, and ethnology. For Graves, with her increasingly associative way of thinking, camels in nature led to bones in the ground, a place rich not only in archaeological evidence but also in geological information. Now determined to work from the specific to the general, to transform the concrete into the abstract, Graves in 1971 initiated a series of Camouflage paintings, based on actual maps—of the ocean floor, Mars, the moon, aerial photographs of Antarctica—whose pulsating air and water currents the artist simulated with a dancing pointillist touch (fig. 589).

For a bronze version of a bone sculpture, commissioned in 1976, Graves came to know the Tallix Foundry in Peekskill, New York, an encounter that would prove as catalytic as the one with the Bactrian camel. Thanks to the founders' expertise in lost-wax casting and in color patination, Graves could convert almost any natural or man-made object into an instant fossil, and she promptly did so, building a stockpile of bronze forms that includes everything from fiddlehead ferns, squid, crayfish, palmetto leaves, and warty gourds to Chinese cooking scissors, pleated lampshades, chair backs, and potato chips. Most evocatively for art itself, Graves even casts the plastic bubble-wrap used to pack her works for shipping and such foundry discards as broken equipment, old plumbing fixtures, and spillages of molten metal. With this ever-expanding repertoire of quick-frozen elements available to her, Graves ceased to draw or diagram her sculptures and began to assemble them directly in bronze, thereby turning her sense

seems ready and able to caper its way through every conceivable situation, rather like Flanagan himself, an artist who explored painting, dance, and various Process works before achieving fame as a sculptural imagist. With his irrepressible capacity for invention, wit, and poetic association, Flanagan quite naturally gravitated towards substances—hessian, rope, felt, sand, stone, and, of course, clay—whose manipulable qualities appeared likely to yield or "unveil" a motif in the course of being handled or shaped. By proceeding in this light, organic, figurative way, Flanagan joined with such contemporaries as Gilbert & George, Bruce McLean, and Richard Long to rebel against the constructed-metal formalism taught by Anthony Caro during their student days at the St. Martin's School of Art. Insouciantly disdainful of this Greenbergian program, Flanagan produced a series of rolled fabric works whose clumped, clustered, and folded compositions, together with titles like *Heap*, *Pile*, *Stack*, and *Bundle*, left scant doubt about their excremental connotations. He even called one of the pieces *aiing j gni aa*, as if to make a Cockney reference to Caro's engineering background and methods. Next, Flanagan turned to clay, squeezed a lump of it in his hand, and had the moist, plastic shape translated into stone, thereby restoring to the hard material a look reminiscent of its origins in molten fluency. In the early 1980s, Flanagan found the hare "unveiling" itself in the clay as he rolled and squeezed it, and once there, the figure proved as fecund in art as its real-life counterpart has always been in reality. Frisky but also lithe and lanky, Flanagan's long-eared genus *Lepus* bounds through the air, shadow boxes on hind legs, prances about, and generally exhibits all the eccentricities of the March Hare himself, becoming finally an emblem of the artist's own spontaneity, openness, and free-spirited good humor. While resonant with myth and history, this humanoid image with the alert eyes, straining ears, and tearaway energy sags, pirouettes,

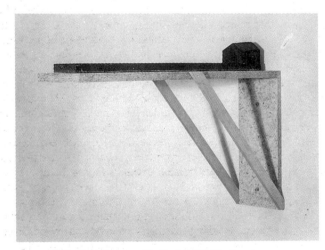

above: 592. Joel Shapiro. *Untitled*. 1973–74. Cast iron, 3 × 27½ × 2⅝". Courtesy Paula Cooper Gallery, New York.

right: 593. Joel Shapiro. *Untitled*. 1980–81 (fore), 1980–82 (aft). Bronze; 52⅞ × 65 × 45½", 23¾ × 13 × 8⅛". Courtesy Paula Cooper Gallery, New York.

and goes lickety-split in blithe but purposeful ways that viewers cannot but feel kinesthetically within themselves.

By the time Joel Shapiro (1941—) encountered Minimalism, at its most intoxicating moment, he had already been to India as a Peace Corps volunteer and beheld the sculptural wonders of Ajanta, Elura, Mahamallapurum, and Tanjore. With these "generous outpourings of work representing the whole range of human experience" unforgettably lodged in memory, Shapiro felt it imperative that, in adopting a rigorously abstract glossary of forms, he replace Judd-style preconception and disengagement with an intuitive, Abstract Expressionist approach and human content. For Shapiro, boxy Minimalism would function primarily as a generic language through which to universal-

ize the sharp particulars of personal feeling, while also preserving his work from expressionist overstatement. Initially, therefore, the figure itself seemed too loaded a subject to address directly, and so the artist proceeded more obliquely, through a series of tiny houses executed in the early 1970s. Right away, Minimalism lost its heroic, impersonal scale as Shapiro sought a different kind of monumentality, compact and simplified like the archetypal masses of Primary Forms, but also miniaturized to the dimensions of Charles Simonds' "little people" or Jennifer Bartlett's rudimentary abodes (fig. 592). However, just as cozy, doll-house cuteness threatens, the sculpture seems to shrink into itself, a brooding, withdrawn presence whose doorless and windowless exterior denies all access, physical or psychological. Cast in iron or lead and heavy with gravity even in appearance, Shapiro's cottages hug the floor as if they came with it, or perch precariously on chipboard shelves, sometimes at the end of a metal path projected into the viewer's space more like an executioner's plank than a welcome mat. The miracle is that while scarcely representing the family home of fond recall, these Tom Thumb dwellings possess a density of presence that does exactly what Minimal objects have always managed to do, which is foment associations beyond their external values.

Gradually, Shapiro permitted the imaginary inhabitants of his toy bungalows to break free and claim the space whose scale their shelters seemed to have radically altered (fig. 593). Clean-lined, diminutive though knee-high in stature, and attitudinally conflicted, these stick figures leave no question about what nest they sprang from. The sculptures also reveal the artist's passage through Process Art, constructed as they are of square-cut posts whose wood grain, knotholes, and all continue to texture the forms even after being cast in iron or beautiful reddish-gold bronze. Not surprisingly, the images overcome Minimalist restraint to pivot, writhe, dance, collapse, and crawl, as if to re-enact in anti-heroic, Constructivist terms the whole gamut of theatrical pose and gesture invented a century earlier by Auguste Rodin. But they can also claim ancestry in the anatomical essences of Brancusi, the skeletal people of Giacometti, especially the latter's *Walking Man*, and even in the covert figuration of David Smith's Cubis. True to post-modernism, however, Shapiro expanded his repertoire of expression to include the bittersweetness of clownish pratfalls, making the figures look joyous from one angle, despondent from another, and yet totally abstract from a third. But whatever their mood, the images appear all the more poignant for having the rationalism of their Minimal/Constructivist anatomies buffeted by psycho-physical complexities generally associated with Expressionism. In this sense Sha-

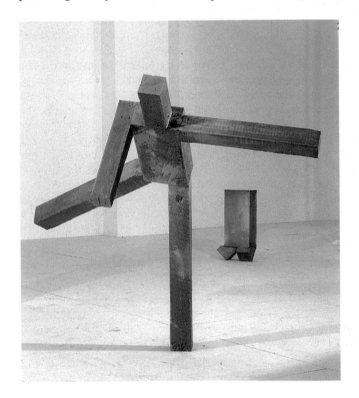

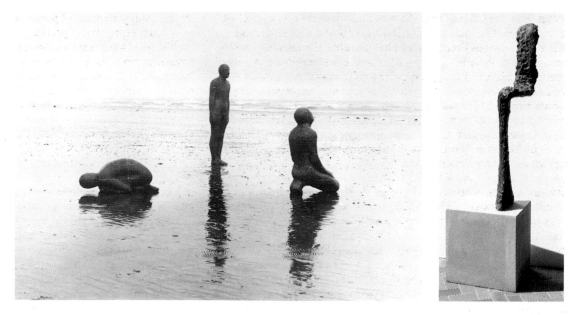

right: **594.** Antony Gormley. *Land, Sea, and Air.* 1982–83. Lead and fiberglass; 3 over-lifesize figures. Private collection, New York. Courtesy Salvatore Ala Gallery, New York.

far right: **595.** Bryan Hunt. *Small Twist II.* 1978. Cast bronze on limestone base; 4'9" high, base 2'10" high. Courtesy BlumHelman Gallery, New York.

piro has truly succeeded in the modernist ambition of making less become more.

Like George Segal, Duane Hanson, and John DeAndrea, Antony Gormley recovered the figure for post-modern sculpture by making body casts, with the crucial difference that, as we saw in his *Derry Sculpture* (fig. 520), the body he casts is almost always his own tall, lithe frame (fig. 594). Yet, he poses himself in a way that the resulting statue possesses a unitariness as reminiscent of Minimalism as Shapiro's post- or lintel-like members. For Gormley, the sensuous experience of spiritual beings is common to all humanity, divided as humanity may otherwise be by social and cultural differences. From this belief emerged the unique process whereby he converts his own nature into culture, beginning with a pose simple or basic enough to embody a feeling so deeply personal as to pass into the universal. Having now fused form and content, Gormley has his wife mold his nude anatomy in plaster-soaked scrim, after which the artist or a technician reinforces the sectioned mold by coating it in fiberglass. When this substance has cured, Gormley applies or hammers a thin sheet of lead over all the parts, which he then reassembles, sealing the joints with neat ridges of bright solder. Thus gridded along its main axes, the slightly over-lifesize figure retains its integrity as art even as it seems to become all too human in such mood-provoking activities as staring into distance, walking, crouching, sleeping, curling up like a foetus, or embracing another mirror-image figure. With its facial features generalized into a mask and its fingers as well as toes into mitten-like solidity, the figure has ceased to be an individual and become Everyman, a sign or symbol of the emotion felt by the absent person whose presence can still be sensed in the pose. Pieced together as it is, the funereally gray skin could be a body garment, like a diver's suit, designed for the nuclear age, because, as the artist admitted, lead is "completely impenetrable visually, radioactively." Like Beuys, Gormley evinces an almost mystical belief in the metaphoric value of materials, especially lead, and in process as a kind of shamanistic performance, which here involves mummification and rebirth, followed by months of bringing each sculpture into its own, a labor-intensive experience filled with violence and tenderness, intimacy and team or "tribal" effort, rank trust and clever calculation. All combine to place Gormley's Everyman in quite a different part of the late 20th century from that occupied by Trova's dehumanized version (fig. 381), and his poses at considerable remove from the ironic, Dadaist, art-about-art poses performed by a slightly older fellow Briton, Bruce McLean (fig. 490). By striving to "make concrete the life that goes on within the head"—to keep intellect tied to sensation—as a "kind of antidote to rationalism," Gormley has transformed the figure—sculpture's oldest

subject—into a radical new image and himself into one of the most radical artists of his time.

As a young sculptor both oppressed and inspired by extreme formalist orthodoxy, Bryan Hunt (1947—) sought to recover some of the things once revered in pre-Minimal sculpture—imagery and touch, for instance—but only through an ironic channel opened by Minimalism itself when the movement expanded into Earthworks. Reinforced by his own dual experience as a draftsman actively involved with the classical nude and also employed, for a while, in the space-age world of Cape Canaveral, Hunt managed to reconcile a desire for imagery with Minimalist criteria by isolating some historic form in the real world and rescaling it for replication in a gallery setting. Once stripped of their natural environments and recontextualized in an exhibition space, the Empire State Building with a dirigible moored to its top mast (as was originally intended), the Great Wall of China, and the mass of water contained within a lake became as monumentally abstract yet as literal as Primary Forms. The Great Wall, without the hilly terrain to justify its unique contours, wriggles down a vertical surface like an oddly jointed snake, while the lake, rendered as a solid bronze volume with a flat top and a basket-like bottom, seems to transform the viewer's own space into the absent earth, the real lake's natural container, which becomes a powerful, even if metaphoric presence. By thus blending the heroic and the ironic, Hunt also hit upon a conceptually respectable way of re-engaging with the kind of gestural, Rodinesque handling scarcely seen in new art since Giacometti. But if the mimetic requirements of a lake's wave-rippled upper surface and irregularly contoured lower extension authorized such expressive modeling, a waterfall would serve the purpose even more brilliantly, especially since the tall, wide, but shallow form evoked and thus provided an abstract entree into a kind of figuration as reminiscent of Giacometti himself as of Classical Greek statuary with its flowing, body-clinging "wet" draperies (fig. 595). In what is now a signature image, Hunt clearly chose to represent a freestanding cascade—sometimes stepped, shifted sideways, or divided—for the identity of subject and process it offered, since molten bronze pours just as water does, suggesting, finally, that in Hunt's finished Waterfalls the bronze depicts bronze quite as much as it does a form abstracted from nature. Eventually, the illusionism reveals itself to be still more complex, given that its production required much stroking of the wet plaster model and even carving or cutting after the form had dried. More recently Hunt has further complicated his sculpture by mixing media to include welded metal, for the sake of open-form constructions that appear to translate waterfalls into classical, white-clad caryatids and dark armatures into spatial drawing.

New Image Art

"All my work is a rebuke to the art world," Scott Burton (1939–89) once said, meaning that by endowing his austerely simple sculpture—virtually Primary Forms—with the qualities of usable furniture—tables, chairs, chaises longues—he has not only upgraded the environment but also reminded creative people of their responsibilities as social beings (fig. 596). In actuality, a much-respected and well-integrated member of the art world, Burton began to revisualize furniture in purist terms during his early days as a Performance artist specializing in "found" body movements that involved "found" props, such as the Queen Anne chair left in his apartment by a previous tenant. After having this reproduction reproduced in bronze, Burton went on to rediscover De Stijl, whose pragmatic, Utopian ideals encouraged him to return Minimal sculpture to its source in early modernism. Far from naïve, however, about the relationship between form and function, Burton wrote of Gerrit Rietveld, the master of De Stijl design: "His furniture's rigor of form and intensity of structural definition give it an idealism, an epiphanic concision, even a sublimity, that is far from popularizing; yet its materials (mostly common stock wood and bright-colored paint), its scale and its very simplicity give it an unpretentious attractiveness of democratic character." Determined to improve taste rather than accommodate it, Burton created his most characteristic pieces in a series of Rock Chairs, made of such heavy, obdurate materials as granite or lava and left in the rough except for two right-angle surfaces cut into the stone to provide for sitting and a third to stabilize the bottom. While from the back the sculpture could be taken for a perfectly normal if impressive part of the natural environment, from the front it displays the smooth shapes and proportions of a practical, even inviting chair. In other, more complicated pieces, some with as many as six units, parts interlock, rub together, mount one another, or invite entrance in ways so suggestive as to recall that, in his Performances, Burton once employed furniture as a metaphor for contemporary society's perverse habit of treating people like objects and objects like people. But where he most succeeds in his goal of encoding well-crafted formalist design with a moral subtext may be in his numerous and expansive, publicly sited works. Often the unsophisticated mistake them for art while the informed consider them insufficiently aesthetic, thereby suggesting that Burton may indeed have elided the infamous gap between art and life.

Within this "extended field," as Rosalind Krauss calls postmodernism's sculptural domain, Scott Burton often encountered and sometimes collaborated with Siah Armajani (1939–), a self-described "architect/sculptor" born in Teheran but long since resettled in Minnesota. There Armajani attended Macalester College and transformed himself into an old-fashioned "populist" committed to the egalitarian values once indigenous to Middle America. Meanwhile, he also remains an Iranian at heart, and the dialectic between the extreme polarities of his native and adopted cultures—one ancient and

597. Siah Armajani. *Dictionary for Building: Closet Under Stairs I.* 1985. Painted wood, shellac, and rope; 9'1½" × 3'4" × 7'1½". Courtesy Max Protetch Gallery, New York.

complex, the other relatively young and simple—runs through the whole of his art, filling it with piquant incongruities, all treated with wit, sophistication, and Duchampian ambiguity. The art also evinces profound humanitarian purpose, especially in the public works, which, like Burton's, constitute the very antithesis of the intrusive, confrontational aesthetic of Richard Serra's *Tilted Arc*, replacing it with creations notable for their usefulness, neighborliness, and accessibility. Here Armajani finds inspiration not only in the Utopianism of De Stijl and Russian Constructivism but also in the post-modern theories taught by Vincent Scully and practiced by the architect Robert Venturi. For his gallery pieces, however, Armajani permits irony and ideas to prevail over social function in architecture/sculptures replete with Venturi-like complexity and contradiction (fig. 597). In the artist's opinion, "there is a difference between making a work of art available and making it accessible," since the inalienable right to learn entails a corresponding responsibility to concentrate the mind. Thus, in *Closet Under Stairs*, the door may be invitingly open, but the space defined by the work cannot be penetrated, any more than the structure's second level can be attained, given the stair's tilt and the toy scale of the "elevator" hung in the closet. Yet, the astute observer may receive a "lift" from identifying the little pulleyed "rostrum" as one designed by the Russian Constructivist G.G. Klucis (1896–1944) for use by "radio orators" at the Fourth Congress of the Communist International (1922). With its elegantly economical form determined by a revolutionary movement's need to preach the word from every corner, the reconstructed pulpit combines with Armajani's glossary of American vernacular building—balloon frame, white clapboard siding, cedar chests, Shaker furniture, widow's walks—to plead for a culture in which gifted persons may feel fulfilled when engaged in a process directly concerned with the well-being of the entire human community. But while *Closet Under Stairs* may communicate as painting does, through metaphorical rather than literal experience, it displays nothing of the formal coherence normally expected in Western art; instead, the work presents a kind of intricacy reminiscent of Persian design. And so, even though nostalgically evoking and urging

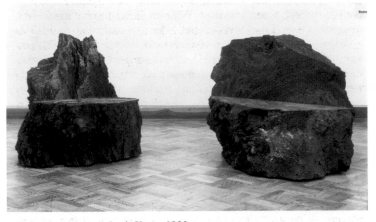

596. Scott Burton. *Rock Chairs.* 1980. Bluish-red lava rock (left), 41 × 44 × 35"; orange-red lava rock (right). Courtesy Max Protetch Gallery, New York.

the democratic ideals of a long-gone pioneer society, *Closet Under Stairs* introduces an exotic element and with this a private, contradictory quality characteristic of high art. To help elucidate the open/closed nature of his work, Armajani has treated pieces like the one seen here as entries in his *Dictionary for Building*, a general "reference source" for a man-made environment as commonsensical as that of 19th-century America. Moreover, he often turns conceptual and litters his works with quotations from classical American writers, such as John Dewey, who warned that "as long as art is the beauty parlor of civilization, neither art nor civilization is secure." For the sake of both, Armajani gives new life to Utopian ideology by interfacing traditionally alien genres and cultures, thereby achieving a measure of universality, but a universality of such quirkiness as to remind us that the society Armajani would serve consists of neither more nor less than a crowd of individuals.

As mindful as Armajani of what Heidegger called Western civilization's "mass forgetfulness of being," the French artists Anne and Patrick Poirier (1942—) began to transform the remains of Greek and Roman antiquity into a variety of haunting, memory-drenched postmodernism after discovering that even in Rome contemporary society had lost contact with its cultural roots (fig. 598). To restore the missing link by stimulating the collective unconscious, the Poiriers appropriate—that is, re-create—ancient artifacts for site works or gallery installations whose very nature as simulacra makes them, and by association the past itself, seem parallel to present experience. Although working scientifically to explore ancient ruins and myths, these artists hope to achieve the metaphysical, overcome the tyranny of time, and regain access to what once seemed utterly beyond reach, a Classical world so at one with its art that even great public monuments served for private contemplation. In a highly charged piece, entitled *Pegasus*, the mythic winged horse that gave rise to the arts, by slashing Mt. Helicon with his hoof and releasing the spring of the Muses, rises phoenix-like from the carbonized ruins of a vanished civilization. Equally metaphoric is *Fall of the Giants*, a site work composed of a great staring eye, splendidly carved in gray, white-veined marble as if it once belonged to some colossal statue, a tomb entrance blocked by marble shards, an erect column fragment, a toppled section from it, and several giant polished-steel arrows, the latter signifying the cosmic struggle that left the terrain in such poetic disarray. For some installations, tall, freestanding, verdigris-bronze letters spell out ROMA, which from the correct angle can also be read backwards, thereby paying homage not only to the Imperial City but also to love, including love of the past. "The human soul is made of memory and forgetfulness; these constitute being," the Poiriers have written. "Without memory, man is nothing but an amnesiac living in a perpetual present, nostalgic for a past that has escaped, exiled from himself and his origins."

When Rauschenberg and Warhol silkscreened photographic images directly onto the same surface that received their original brushstrokes, it became apparent that the old prejudice against photography as a mode of creative enterprise could be sustained only with the greatest difficulty. Shortly thereafter, Photo-Realists would make the photograph their very subject, at the same time that they also questioned its vaunted factuality by demonstrating how the painter could hand-copy a camera-made image and make the result appear more veristic or lifelike than the original. Meanwhile, photography became indispensable to anti-form Conceptualists as a means for documenting the immateriality of their texts, processes, and performances. Thus, in the 1970s, when the desire for image-making overcame even Conceptualists, it seemed natural enough that photography would move to the fore and, for many artists, not just photographers, become a pictorial medium preferable to drawing and painting themselves. As the Conceptualist and sometime painter William Wegman (1942—) said: "[The camera] took care of the need for making graphic things, composing things, dealing with formal issues." It also appealed to his most

below: 598.
Anne and Patrick Poirier. *Fall of the Giants*. 1989. Marble and stainless steel, 12 × 47 × 30'. Storm King Art Center, New York.

right: 599.
William Wegman. *Talent Scout*. 1979. Polacolor II film exposed in a Polaroid Land camera, 24 × 20". Courtesy Holly Solomon Gallery, New York.

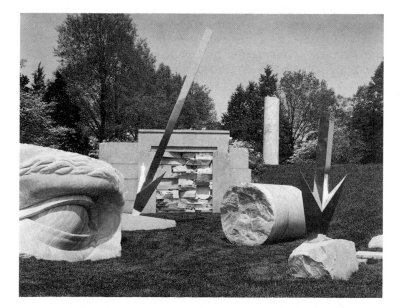

famous subject, a Weimaraner whose performances before Wegman's witty lens gave the decade of the seventies some of its most irresistible new images (fig. 599). Far from exploiting his pet, Wegman merely accepted a presence that would not go away once the stage was set and the lights turned on. Naming his dog Man Ray, for the Dada/Surrealist photographer/painter, the artist revealed the source of his absurdist strategies, at the same time that he also punned himself into switching parts with the dog and becoming his—Man's—best friend. From 1970 until early 1982, when Man died, Wegman found the photogenic Weimaraner to be a gallant and sensitive actor in a continuous comedy of manners for video as well as, and most memorably, for the still camera, at first an ordinary Polaroid but then a large-format Land instrument. One by one the pictures show their star costumed and fully rehearsed to impersonate everything from the Minimalists' Primary Forms to Brooke Shields in a jeans ad, a *vanitas* figure proudly displaying his/her red-polished nails, or yet an object in a Picassoid still life, with the dog's position next to a Blue Period picture suggesting, perhaps, the place of art and artists in contemporary society. By casting the noble Weimaraner, with his manifest dignity and intelligence, in situations readily seen in everyday art journals, space ads, fashion photography, and even life, Wegman rendered them farcical and thus created an hilarious but nonetheless astute parable on social role-playing. With gentle mockery, he also revealed the fiction embedded in every representation, visual or verbal, thereby reifying poststructuralist theory.

Fin de Siècle: From Neo-Expressionism to Neo-Abstraction

As the final century of the second millennium AD entered its penultimate decade, the post-modern world became ever-more retrospective and thus pluralistic, to the point where painting—so recently deemed the stalest of art forms—suddenly disclosed fresher possibilities than anyone had dared to imagine since the mid-1960s, during the glory days of the Color-Field school. "I came to understand," said David Salle, one of the period's most lionized newcomers (fig. 602), "that because painting is so charged, so weighted down by history, so lumbering, so *bourgeois,* so *spiritual*—all these things that had made [it] so 'incorrect'—I came to see this is what gave painting such potential." From hindsight, the abruptness of the development, which resolved into focus around 1980, was more a matter of perception than reality, for, as the last three chapters revealed, painting simply refused to die. And this was true despite the contract let on its life by Minimalist/Conceptualist godfathers, who, on the one hand, viewed pigmented canvas as insufficiently object-like and, on the other, dismissed it for being too much an *objet d'art,* thus subject to hype and commodification by an increasingly voracious market. Yet, neither Minimalism nor Conceptualism succeeded in making itself appreciated by more than a coterie audience. Indeed, it could be said that, far from waging an effective argument for transformative ideas, Minimalists and Conceptualists alike managed to alienate the greater universe they would have wished to change for the better, with most Conceptualists ending up, ironically, as art-world bound as the elitist system—the aesthetic arrogance—they had set out to evade and unsettle. It seemed self-defeating, therefore, to renounce pictorial media when these promised more potent means of achieving the post-modern agenda, which remains, in broad, even simplistic terms, the creation of viewer-engaging, nondeterministic art as valuable for its open, critical involvement with culture and meaning—with information and ideas—as for the particulars of its plastic quality.

That significant yet sensuous art could be made not by inventing forms, as modernists struggled to do, but rather by imitating or appropriating images and styles, had already been announced, in the wake of object-intolerant Conceptualism, by the Photo-Realists at the turn of the seventies, by P&D halfway through the decade, and, at the very end of it, by "Bad" and New Image Painting. All came to the fore in New York, but what endowed them with the retroactive allure of brave precursors was the arrival, in global consciousness, of a bold new figurative painting from Berlin, Düsseldorf, Venice, Florence, and Rome, after long gestation beginning, for some of the artists, as early as 1960. Dramatically gestural, heroically scaled, primitivizing, rich in content—private, historical, nationalist—and paceset by Germans, the new European art bearing the names of Georg Baselitz, A.R. Penck, Sigmar Polke, and Anselm Kiefer quickly provoked the label Neo-Expressionism (fig. 600). It also ignited a dealer/collector frenzy and, across the Atlantic, inspired or helped valorize the generation of painters—Julian Schnabel, David Salle, Eric Fischl—who would dominate the New York scene during the first half of the eighties. Such was the whirlwind effect of Neo-Expressionism—a development that placed European art in the vanguard for the first time since World War II—that it swept up the remarkable "Three Cs" of Italy's *transavanguardia*—Francesco Clemente, Sandro Chia, Enzo Cucchi—even though only the last regularly displayed expressionist traits, while the former pair could just as easily be called Neo-Surrealist. Having shattered the Conceptualist taboo against both painting and objecthood, Neo-Expressionism went on to open the way for counter-reactions to its own excesses, which soon came forth in the post-Minimal, "endgame" formalism of the Neo-Geoists, the "born-again objects" of England's newest "new" sculptors (fig. 601), and the "quotational" paintings, photo-based panels, materialized texts, assemblages, simulacra, and installations of Neo-Conceptualists everywhere, includ-

left: **600.** Anselm Kiefer.
Nürnberg—Festspiel—Weise. 1981.
Oil, straw, mixed media on canvas; 9'2¼" × 12'5⅝".
Eli and Edythe L. Broad Collection,
Los Angeles.

opposite left: **601.** Tony Cragg.
Leaf. 1986. Plastic, 5'6" × 5'2" × 1½".
Courtesy Marian Goodman Gallery, New York.

opposite right: **602.** David Salle.
Landscape with Two Nudes and Three Eyes. 1986.
Acrylic and oil on canvas, 8'6" × 11'7".
Courtesy Mary Boone Gallery, New York.

ing—*mirabile dictu*—the Soviet Union. Finally, if all these Conceptually indoctrinated artists courted co-optation by an investment-hungry market, it was, in part, because post-structuralist theory had taught them how their work, once absorbed into the ambient culture, might critique its myriad pathologies and their empowering myths from within. As one critic wrote: "... since painting is intimately concerned with illusion, what better vehicle for subversion?"

Critical theory abounded, moreover, just as it did a century ago, during that earlier *fin de siècle* when the classical harmony of Impressionism's group style—often seen as the first modernist breakthrough—gave way to the corrective diversity of the first "post" style—Post-Impressionism—introduced by Cézanne and Seurat, Gauguin and van Gogh. And while these too anticipated the 20th century—now by privileging concept over percept—they also looked back in nostalgia, not only to Impressionism, their point of departure, but, even further, to the rational structures of Raphael and Poussin, on the one hand, and, on the other, to the emotional chromatics of Titian, Rubens, Delacroix, and, long before them, Gothic stained glass. In the 1880s and 90s, again as today, the dismaying plethora of new as well as reactionary experiments invited ideological explanation, which in turn produced that symbiotic, though much-troubled, relationship between radical aesthetics and radical politics, left or right, so characteristic of contemporary civilization. Thus, while the anarchist Félix Fénéon and Paul Signac supported Seurat's Neo-Impressionist painting—the first art to win that particular prefix—in the interests of science and social progress, Maurice Denis, a Gauguin disciple and Symbolist, scorned science, as well as naturalism, and combined Catholic mysticism with French lucidity of thought to foresee 20th-century abstraction. Whether objective in their analysis, as were the followers of Cézanne and Seurat, or subjective, like the heirs of Gauguin and van Gogh, modernists propounded the kind of totalizing, progressive, self-critical, and self-purifying art—a *high* art wary of the popular and almost wholly dependent upon the exceptional talent, almost invariably white and male—that would, by the logic of its own deterministic process, end in self-destruction. When this, supposedly, occurred, at the end of the 1960s, younger artists believed they had witnessed the end of history, a sense that, once coupled with the millenarianism of the moment, left them regretful perhaps—that they had failed to participate in modernism's exalted sense of mission—but also relieved of the obligation to advance, exclude, excel, and self-deny. After dematerializing Conceptualism—really the last gasp of modernist or Minimalist reductivism—proved too arid for all but the most committed, the notion of art as idea remained. And this seemed all the more ready for embodiment in palpable forms by virtue of the

exemplary models available from such neo-Duchampians as Rauschenberg and Johns, who had long since perfected the technique of fashioning new, critical art by appropriating the most disparate of found, frequently non-art elements and so assembling, or recontextualizing, them that they remain forever energized by a chance, dialectical encounter bound to challenge every preconception about their individual or joint significance. But if artists felt free to mix and match—images, objects, styles, media—with a promiscuousness beyond anything attempted by the New Imagists (fig. 602), it was because they acknowledged an ever-more powerful and insistently present model in the contemporary world itself.

And what a world the eighties brought! It began with New Wave music and art, Thatcherism in Great Britain, Reaganomics in the United States, and the Green Party in West Germany, Soviet occupation of Afghanistan, Sandinista rebellion, shuttle space flight, the first public offering of Sotheby's common stock, and the first reported cases of a strange, sinister new virus. At the end came the Helms amendment, a "kinder, gentler" President, ozone-layer depletion, the collapse of totalitarian Communism in Eastern Europe, free elections in Nicaragua, the invasion of Panama, superconductivity at 30°K, van Goghs, Picassos, and Renoirs auctioned for scores of millions, and an art community ravaged by AIDS. In between, those who survived the turbulent course found themselves riding the highs and lows of the longest rally, followed by the quickest crash and rebound, in Wall Street history, Three Mile Island, Chernobyl, Solidarity, *glasnost* and *perestroika*, the Falklands War, Ethiopian famine, the Jarvik heart, mounting resistance to Apartheid, and, in "cutting-edge" art, one passionately touted, briefly cresting "neo-ism" after another. Since universal television made it all seem equally intimate or alien, ideologues tended to regard the boiling stew of disparate, far-flung events as symptomatic of the "post-industrial" or media age. Frequently called "late capitalism," this was, and remains, a globalized, multinational, ubiquitous, centerless world so liquid and monetized in its operations that it seems to flow through, suffuse, confuse, or even fuse the public and the private, the personal and the political. As for commerce and culture, their interpenetration may be understood, especially, in the accelerating degree to which economic activity has shifted from material goods and services to their representations in cultural forms—images, signs, symbols, and styles. Just as capital, long ago, became separate from labor, so the argument goes, modernist art, with its permuting, self-referential succession of signature manners, assumed a lofty position at such free-floating remove from everyday life that, come the "total-information society," it proved as co-optable or commodifiable as every other human-made product. With this, mod-

ernism, like the rest of high art, lost its prized autonomy, an advent reinforced by semiotic or post-structuralist analysis, which, as we saw in the last chapter, exploits linguistics as a methodology for understanding all aspects of culture. For post-structuralists, the materials the artist deals with—ideas, motifs, forms—constitute a language, that is, a sign system whose signifiers are as isolated—"decentered"— from their referents in the real world as capital is from labor. Similarly, the art work itself—the "text"—appears to be less an expression of originality than the consequence of the commonly available language used to produce it, which leaves meaning to emerge less from the artist's intentions than from whatever the viewer may, at any one moment, make of the work's deeply imbricated subtextual discourse among signifiers forever locked together in a dispersed web of unstable, complementary differences. But with signification born of difference, of something that is never immediately present but always to some extent absent, every representational system—visual, verbal, behavioral—becomes so slippery and uncertain as a vehicle of meaning that it would appear to strip the author/artist of the authority once attributed to him and his text of both "presence" and "aura."

While triumphant relativism resolved the "crisis in painting," as soon as pictures appeared to be neither more nor less culturally entangled than Minimalism's presumptively autonomous Primary Forms, it ushered in the "crisis in representation" and the "crisis in meaning." Oddly enough, the thickening air of criticality, which became so characteristic of the eighties, making the decade seem all the more beleaguered, arose not only from market excitement over the fresh supply of salable art works. It derived as well from critics sufficiently persuaded of the newfound license, granted by semiotic methodology, to demystify almost everything held sacred in Western civilization—even as this civilization *uniquely* assured the right of its critics to pursue their enterprise—that they sometimes made Greenbergian, or formalist, dogma seem positively laissez-faire. But at the same time that ideologies hardened, into vigilant, hairsplitting concern for the "correctness" or "incorrectness" of art's form and content, the various positions managed to decenter one another, which, fortunately, left the situation as open as the operative word "post-modernism" implies, a term reiterated throughout the decade until it assumed the force of group mantra. Also heard with chant-like regularity were "appropriation," "deconstruction," and "simulacrum," all having to do with the process whereby artists might continue to produce in what the oft-cited Walter Benjamin had characterized as "the age of mechanical reproduction," when mass-media replication would undermine the distinction between original and copy, thereby further robbing the former of its preciousness and questioning all traditional notions of creativity. Disillusioned perhaps, but also liberated from modernist

imperatives, the artists of the eighties did produce, with explosive abundance, in part because, as post-structuralists might explain, of an unassuageable longing to fill the void left by the sense that meaning in the substitute or metaphorical world of art—with its "signifying chain" of shifty, interactive differences—must always remain elusive or ambiguous. Of course, there were accomplished and respected figures whose strategy, like that of the painter Elizabeth Murray (figs. 585, 586), was simply to work with their entire "heart and soul" in order "to make something whole again" from the shards of shattered tradition. Also sharing this stubborn faith in the efficacy of personal impulse and in the scrambled messages of history were certain Neo-Expressionists, especially the Germans, whose urgent need to fathom their nation's loaded mythology, tragic past, and divided present encouraged a romantic or idealist will to transcend, even while acknowledging the effort and its result as fiction. It helped, conceivably, that theirs was the language of T.W. Adorno and, again, Walter Benjamin, those onetime stars of the Frankfurt School. In his *Aesthetic Theory,* for instance, Adorno wrote that Benjamin "refused, at least in conversation, to reject contemporary painting completely, despite his advocacy of mechanical reproduction, arguing that the tradition of painting must be maintained and preserved for times less somber than these." Still, few of the new artists anywhere—at least in Europe and the United States—escaped the influence of the Parisian structuralists and post-structuralists, Messrs. Foucault, Barthes, Derrida, Lacan, Baudrillard, et al., whose conviction about the cultural codedness of all representational systems, together with a concomitant skepticism about the viability of any attempt at direct feeling or independent thought, prompted many younger artists to ape the media, avoid innovation, and make art simply by appropriating or simulating images and forms.

A peep into the studio of Mike Bidlo (1953—) might suggest that some gallery or museum were preparing to hang an exhibition of key monuments in the history of modern art, the selections ranging from Matisse, Picasso, Duchamp, Man Ray, Morandi, Mondrian, Chagall, and Léger to Pollock, Gottlieb, Lichtenstein, and Warhol (fig. 603). However, each of these famously aurated works is a copy, carefully hand-made by Bidlo to exact scale, not from the original itself but rather from a photomechanical reproduction. Ironically, Bidlo's facsimiles take weeks to realize, in contrast to the surge of inspiration that allowed Picasso or Pollock to complete a painting in a single session, not to mention the instantaneity of Duchamp's "designation" of a ready-made. Plagiarism therefore becomes a variety of tribute, an act

above: 603. Mike Bidlo. The artist's studio. January 1985.

below: 604. Cindy Sherman. *Untitled Film Still.* 1979. Black-and-white photograph, 8 × 10". Courtesy Metro Pictures, New York.

opposite top: 605. Michael Nelson Tjakamarra. *Possum Dreaming at Wapatali.* 1989. Acrylic on canvas, 4' × 4'11½". Courtesy John Weber Gallery, New York.

of "genius envy" that Picasso himself sanctioned, not only by his stylistic eclecticism and variations on Old Master art (fig. 93) but also by his statements, happily cited by Bidlo:

What does it mean for a painter to paint in the style of So-and-So or actually to imitate someone else? What's wrong with that? On the contrary, it's a good idea. You should constantly try to paint like someone else. But the thing is, you can't! You would like to. You try. But it turns out to be a botch. And it's at the very moment you make a botch of it that you're yourself.

In Bidlo's case, the botch appears all too evident in the flat, labored quality of the execution, by contrast with the breathtaking directness and fluency of the handling in, for example, the works of Picasso and Pollock, a contrast that can only reconfirm the sense of ineluctable presence generated by those prototypes. Given this reality, the post-modern ironist would seem to be a romantic *manqué*, for by hand-rendering a blown-up reproduction, complete with its distortions of color, detail, and texture, and thus converting a copy into a signed original, Bidlo reinstated, if only in reverse, the old modernist program, phrasing it as follows: "It's about progress in art. It's about extending the boundaries of what's accepted as art. It's my own original contribution." In addition, Bidlo's Picassos and Pollocks revitalize modernism's oedipal love-hate relationship with the past, yet in a way consistent with the post-modern ethic. For, by systematically appropriating and simulating modern art's most cherished icons, Bidlo helps to deconstruct them—trivialize their power to hold the imagination—thereby contributing to that "strange new perspective," as Rosalind Krauss wrote, from "which we look back on the modernist origin and watch it splintering into endless replication."

More often, appropriation, simulation, and deconstruction occurred in the collage or assemblage manner initiated by Rauschenberg and Johns, following the much earlier examples of Picasso and Duchamp, but now carried to what has been called "cannibalistic" extremes. By scavenging, recontextualizing, and manipulating every kind of image and process—as if the entire world of high art, low kitsch, comics, and graffiti, advertising, television, and pornography had become a vast, on-tap reservoir of poetic vocabulary—artists like Sigmar Polke and David Salle (figs. 602, 612) assert that, at a time when mass media have made authentic experience difficult if not impossible, almost anything mediated constitutes a more convincing analogue than nature. This kind of pastiche or quotational art, with its strata of disconnected yet forcibly interconnected themes and styles that defy all attempts to "read" them, could not but comment, with terrifying relevance, on the chaotic state of life in the total-information age.

More political as well as more aggressive than Pop, the deconstructionist mode found major exponents in feminist artists, who, while adding the French psychoanalyst Julia Kristeva to their cross-cultural mentors, became acutely aware that to present an image out of context is to alter its meaning forever. This tactic became a well-honed weapon in the hands of the "Other"—women and minorities—persuaded that identity derives from representation and eager to expose it as fantasy perpetuated by the media in the interest of white-male-dominated power relations. The better to interrogate the primacy of authorship, originality, and form—all fundamental to the grand "metanarrative" of the artist as solitary hero—Sherrie Levine and Francesco Clemente, among numerous men and women artists, work in several or even many different styles. For the same reason, feminists like Cindy Sherman and Barbara Kruger have made photography their medium of choice (fig. 604), which, with its neutral surface, helps diminish rare, personal touch—that guarantor of stylistic consistency, hedonist pleasure, universal expressivity, and, thus, cachet desirability for the label-conscious—as the all-important criterion of value. With quality thereby sidelined as a determining issue, post-modernism opened the way for the "margins" to move closer to the "center," there making space available to all manner of message-filled "outsider" art—graffiti, black, Third World, and, especially, aboriginal (fig. 605). The impact of this "remapping" of the above-ground world of art could be felt not only in extensive, albeit much-disputed, reconsideration of the "canon" of timeless masterworks traditionally studied in mainstream art history, but also in the new eccentric, metaphorically formal sculpture, with its fresh reintegration of art and ritual, art and life, art and craft. By the end of the eighties, art without an overt text—AIDS, ecology, drugs, gender, poverty, consumerism, the media, the "system"—appeared scarcely worth notice, at least by

right: 606. Andy Warhol. *Camouflage (Last) Self-Portrait.* 1986. Acrylic and silkscreen on canvas, 6'8" square. Metropolitan Museum of Art, New York (purchase, Vera G. List Gift).

below: 607. Joseph Beuys. *From Berlin: News from the Coyote.* 1979. Sculptural environment, including felt blanket, gloves, walking stick, flashlight, chime, hay, *Wall Street Journal,* hat, coyote hair, plaster rubble, 10 acetylene lanterns on stocks, arc light, and sulphur. Courtesy Ronald Feldman Fine Arts, New York.

the new avant-garde, which evolved, despite its post-modern repudiation of such an elitist stance, by appropriating modernism's historic role as a cultural David taking righteous aim at the Goliath status quo. As for subtext, it too remains paradoxically modernist, obsessed, that is, with what Arthur Danto has called a century-long "collective investigation by artists into the philosophical nature of art."

Finally, no one, it would seem, not even the French and German theorists, commanded such wide, reverential respect as did Joseph Beuys and Andy Warhol, presences who, by dying in, respectively, 1986 and 1987, gave the decade its most haunting absences. Recently characterized as "the two poles around which the history of postwar art turns," Beuys and Warhol appear indeed to form a paradigm of binary or complementary signifiers, defining one another by their polar differences and giving witness to the new globalized discourse. In Warhol, the deconstructionists and other purposeful skeptics found a father figure, the artist who had, unequivocally, acknowledged the impact of the media, by the mundane device of co-opting their appropriative and mechanically replicating processes. Moreover, it was Warhol who most decisively, and coolly, registered the terrible loss this entailed, the loss of faith in the kind of visionary subjectivity that had moved the Abstract Expressionists to reach for, and sometimes even attain, the sublime. The consequence may be felt not only in the riveting hollowness of Warhol's art—particularly in the Brillo Boxes, those leading indicators of post-modern simulacra (fig. 258)—but also in the cold, pale, deadpan stare of the late self-portraits, with their look of insatiable, inarticulate yearning for the unrecoverable (fig. 606). Like the Abstract Expressionists, Beuys knew tragedy in the flesh, where it remained for him, thanks to his culture's romantic tradition as well as the ongoing evidence, provided by the infamous Berlin Wall, of how fatally flawed that tradition had been. Thus, while he too appropriated whatever lay most pressingly at hand—fat, felt, heat-conductive copper—it was not in order to be dominated by medium but, rather, to "heal like with like," in the homeopathic manner of the Tatars who, during the war, had saved him from death in the blizzard-swept Crimea (fig. 607). Playing the alchemist or enchanter, Beuys sought to release the energies of natural phenomena as a metaphor for frozen humanity thawed into a warmer, less bureaucratic, and more creative condition. In this way, he made his many students and followers, among them the Neo-Expressionists to be seen here, the true heirs of American Abstract Expressionism, if not its nonobjectivity, then its sense of the universal within the individual, of the metaphysical within the physical. Yet, together, the passive, ironist American and the activist, mystical German ended by showing how a blend of high art and the commonplace might become a transgressive force more powerful than the marketplace.

Neo-Expressionism

European Neo-Expressionism arrived by way of several important international exhibitions, beginning with the 1980 Venice Biennale and continuing with Documenta 7, held at Kassel in 1981, "The New Spirit in

Painting" mounted by London's Royal Academy, also in 1981, and, finally, the Berlin "Zeitgeist" of 1982. The senior artist among the "discoveries" at all these events was Georg Baselitz (1938—), whose grandly scaled canvases also proved to be the most distinctive, a status conferred not only by the upside-down orientation of their imagery but as well by their exceptionally full, ripe color and fluid, almost autonomous brushwork (fig. 609). As spectacles of meaningful figuration struggling to come into being through formal disruptions that all but obliterate it, Baselitz' pictures offered a metaphor for a Germany, or a world, crazily divided against itself. Yet, in addition, they exuded a Renaissance dignity and presence suggesting a culture determined to become whole again through inventive reintegration with its rich but problematic past, especially the golden age of German modernism, the pre-1914 Expressionist phase that embraced both the primitivizing Kirchner and the spiritualist Kandinsky. Nolde, despite his complicity with the Nazis, yet because of his suffering under them, appears to hold particular importance for Base-

litz, who appropriated both the older master's *malerisch* colorism and his Christian themes, as here in *Veronica's Veil.*

Having fatefully returned to East Germany, from a one-day visit to his fellow Saxon Georg Baselitz in West Berlin, on the very eve of the Wall's erection in 1961, A.R. Penck (1939—) found himself trapped for the next nineteen years within the cultural and political "ice age" that a totalitarian regime imposed upon its unhappy citizens. As an underground progressive excluded from art-school education, and every other aspect of institutional life, Penck developed a system of painting very much akin to his own free-form jazz music. Like jazz itself, the process evolved as a means of expressing the dynamic interdependence of the individual and the collective, a dynamic cruelly blocked in the Communist sphere by its monolithic collectivization of everything. But however spontaneous the technique, Penck also steeped his oeuvre in cybernetics, or information theory, as well as in philosophy, literature, and mathematics, thereby transforming it into a continuous discourse on sign-making and the problems of signifying (fig. 610). With its all-over, hieroglyphic mix of letters, numbers, symbols, patterns, and simple stick figures, often recalling the art of Klee, Picasso, Pollock, and Twombly, each picture clearly presents messages within messages within messages and thus solicits narrative readings. Yet the work invariably remains more cryptic and personal than linguistically translatable, which finally becomes part of the message, concerned as this is with the difficulties of the self representing itself to the world at large, especially when the purpose is to change that world.

Like his co-expatriate from the German Democratic Republic, and sometime co-exhibitor, Gerhard Richter (figs. 540–542, 663), Sigmar Polke (1941—) discovered in American Pop a means to escape the spell in which Informal/Tachist abstraction held advanced German painting throughout the fifties and early sixties. Yet, no less appalled by the banalities of the West's consumer culture, especially the German taste for kitsch, than by those of the Marxist East, Polke (who, with his family, had migrated to the Federal German Republic in 1953 at the age of twelve) adopted the Ben Day screen already appropriated by Roy Lichtenstein but then made it very much his own in a series of *Rasterbilder,* or "Screen Paintings," rendering the all-over matrix as dancing "Polke dots" while also resisting the American's tendency to aestheticize photomechanical technology. Whereas Lichtenstein treated Ben Day as a kind of developed pointillism, thus as a device for deconstructing the system and reclaiming icons of high art trapped therein by media exploitation, Polke simply hand- or stencil-copied, "naïvely," a true media image, complete with off-register imperfections and tabloid subject matter, but enlarged until abstracted from both their original focus and their original meaning (fig. 611).

In 1966, meanwhile, Polke moved closer to the mystical Beuys, whom he had known at the Düsseldorf Academy, after finding himself as eager to break free of irony as he had been to throw off the shackles of Expressionist abstraction. With his will taken over by what he called

"higher beings," Polke began to work in a "higher," abstract, or "spiritual" manner, even as the *höheren Wesen* allowed him to continue his impish compulsion to improvise, becoming finally an automatist, not of gesture, but of found images and materials. This meant a shift from Capitalist Realism to the capital of the artist's fantasy, or, as Donald Kuspit phrased it, "from the blatantly social to the covertly personal, from the exoteric to the esoteric." Almost deliriously, Polke began lifting images from wallpaper design and comic books, employing unorthodox grounds like woolen blankets, furs, and printed yard goods, painting thick and thin, large and small, with media both stable and unstable, compounded of ingredients so secret or even toxic and in colors so synthetic as to evoke the alchemical. By the 1980s his paintings had become palimpsests of fluent line drawings, translucent silhouettes, and splashy, free-form brushwork overlaid on crazy quilts of appropriated patterns, the whole rather like the Surrealist Transparencies of Francis Picabia, an artist frankly admired by Polke (fig. 612). As with the older master, the younger seems to have been willing to make a Faustian pact with the Devil if this would help him save his art from the pathological banality of modern life, through a process of merging various banalities until they achieve a degree of chaos bordering on the abstract and the sublime. Indeed, the idea received monumental treatment in *Paganini,* a baroque pastiche of a painting in which the great 19th-century Italian violinist appears to lie in a trance, behind a dark, tomb-like door while serenaded, on his own violin, by the very Demon through whom he was believed to have gained his mesmerizing, Mephisto powers of pyrotechnical virtuosity. Mimicking Paganini's music, the picture fairly pulsates with the visual analogues of arching, sinuous melodies, tricky harmonics, swirling roundels, fiery pizzicati, and long-arm bowing, all held to tempo by the steady continuo of an underlying, all-over diamond grid. Lest one doubt that Polke's higher beings "meant business," the close observer has only to note the skull-juggling skeletons on the left, but also the spidery swastikas that infest everything, from the diamond grid to the shields held by the domestics on the left, the candle flame and water glass on the night table, the musical lines flowing from Paganini's hands and the furiously played violin. Here, as in so much of his later painting, Polke would appear to be a neo-Dada/Surrealist intent upon making art a haven from the clichés of contemporary existence, including those of Nazi-haunted Germany and irony-obsessed, deconstructivist post-modernism, by colliding them until they make a back-door entry into an oddly jocular realm of enigma and mystery. For this inventive, enor-

mously influential artist, even parodied transcendence, like that in *Paganini*, is better than none at all.

Among the new Middle European painters seen here, the most universally celebrated happens also to be the youngest, as well as the most thoroughly German, not only in the Teutonic, even Fascist themes and grand, Wagnerian designs of his immense pictures but also in their high romantic mood, a terrifying combination redeemed by the irony of subtexts as searingly critical as any to be found in post-modern art. This extraordinary "poet in paint" is Anselm Kiefer (1945—), born in the Black Forest during the final, firestorm weeks before the Allies reduced the Third Reich to a smoldering ruin. Reared a Catholic, as were his idols Joseph Beuys and Andy Warhol, Kiefer gave up studies in law and French to become an artist while enrolled at the University of Freiburg. After a controversial start in Conceptual/Performance Art, Kiefer took up painting, encouraged by Beuys who, though no painter, understood that, for contemporary culture, painting could work like magic, at least if made by such trusted seers as van Gogh, Picasso, and Pollock. Kiefer, in addition, found models in Caspar David Friedrich, Rodin, Rilke, and, especially, Hölderlin with his insistence that one must master the innate in order to achieve the universal. Fearlessly, Kiefer used these and other civilized beacons—Wagner, Mahler, and Bach, Tacitus, Nordic, Greek, and Egyptian mythologies, Goethe, Hegel, Nietzsche, Joyce, and Shakespeare—to illuminate the dark, sinister ideology into which the Nazis had twisted German nationalism. "You cannot just paint a landscape after tanks have passed through it," he once said. "You have to do something with it." What Kiefer did with *Nürnberg* (fig. 600), named for the Nazis' great rallying ground, was cover the surface with a composite photograph of a vast open field, its furrows racing away, in steep perspective, to converge towards a high, distant horizon. Next, he reified the lines and textures of nature with thickly braided deposits of acrylic, emulsion, and straw. In other, related works Kiefer has overpainted or applied images of palettes and great wings, as if to proclaim the right of art to soar aloft and invade whatever territory may attract the artist's imagination, particularly if this means reclaiming for contemporary life whole domains of glorious culture contaminated by the deadly Fascist disease. Hence, while straw-thatched canvases like *Nürnberg* look rutted and scorched as if from centuries of mindless battle, they also suggest fields cleared by fire, ploughed, and ready for replanting. Central to the wonder of such works is their uncanny, paradoxical sense of both surface and distance, for as Peter Schjeldahl wrote, "in 40 years no other European artist—not one!—has so thoroughly assimilated and advanced the esthetic lessons of Jackson Pollock, specifically Pollock's doubleness of spatial illusion and material literalness on a scale not just big but exploded, enveloping, dis-composed."

Drawing from Goethe's *Faust* and the Old Testament's Song of Solomon, the imprisoned Czech poet Paul Celan wrote *Death Fugue*, a Holocaust memorial whose key image is summarized in the final couplet: "your golden hair Margarethe/your ashen hair Shulamith." For Kiefer, the German maiden and her Jewish sister became metaphors signifying a once integrated society now rent by history and sorrow. Working conceptually or abstractly, as usual, Kiefer allegorized the blue-eyed Margarethe in a series of pictures displaying long ropes of straw plaits ominously flame-tipped and dangled against an azure ground (fig. 613). In a parallel series, ashy incrustations represent Shulamith, and in one unforgettable tribute to this symbol of Hebrew womanhood, he appropriated Wilhelm Kreis' Funeral Hall for Nazi war heroes, its wall torches blackened, by collaged woodcuts, and its smoke-stained central vault arching high above a distant altar lit with the seven fires of the Biblical menorah (fig. 614). Here too a sensuously physical, almost Cubistically gridded surface works against itself to pull eye and mind, along plunging orthogonals, far into the picture's real and imaginary depths. "But, you see, that is the point of the illusion," Kiefer said recently to Steven Henry Madoff, "—to draw people in. There's a connection to Warhol in this, even if you don't see it. He was so superficial in such a precise way that he went very deep. It's the same with me. [The] painting is very superficial with the perspective, with the illusion, to get

left: 613. Anselm Kiefer. *Margarethe.* 1981. Oil and straw on canvas, 9'2" × 12'6". Saatchi Collection, London.

above: 614. Anselm Kiefer. *Shulamith.* 1983. Oil, emulsion, woodcut, shellac, acrylic, and straw on canvas; 9'6¼" × 12'1¾". Saatchi Collection, London.

opposite above: 615. Francesco Clemente. *Two Painters.* 1980. Gouache on 9 sheets of handmade paper with cloth backing, 68 × 94⅛". Collection Pellizzi, New York. Courtesy Sperone Westwater Gallery, New York.

opposite below: 616. Francesco Clemente. *The Fourteen Stations: III.* 1981—82. Oil and encaustic on canvas, 78 × 95". Saatchi Collection, London.

you *into* the layers of the image, to the conceptual part, to the idea of the land and what has happened there. The more you go back, under, the further forward you can go."

Like the Germans, the leading Italian artists associated with Neo-Expressionism—Clemente, Chia, Cucchi—seized international attention at the 1980 Venice Biennale, where they created a sensation in the "Operto" section. The new painters benefited enormously from the apologetics of an important critic, Achille Bonito Oliva, who characterized the group as the *transavanguardia,* suggesting their desire to move forward by turning back, away from Arte Povera's minimalizing bent and towards the rich cultural heritage that late modernism had rejected. Almost as an antidote to the progressive purism of postwar art, climaxing in Conceptualism, the Transavantgarde again paralleled their German counterparts in revisiting fractious personalities from the past, as if the outcasts of art history had more to teach the post-modern world than the over-assimilated mainstream. Thus, while Sigmar Polke found a model in the "decadent" Picabia of the Surrealist Transparencies, rather than the Picabia of the innovative Machine pictures, Francesco Clemente (1952—) identified not with the Caravaggio so admired by Frank Stella, but, instead, with the "effete" 16th-century Mannerists against whom Caravaggio launched a full-blooded Baroque reform. Similarly, the long-scorned, "classicizing" de Chirico of the Fascist years captivated the Transavantgardists, who now dismissed the early de Chirico of the great Metaphysical works. Indeed, the Neapolitan-born, aristocratic Clemente calls himself a "dilettante," independent, like Picabia and de Chirico, from all system or prescribed logic and thus free "to maintain the integrity of [his] inquiry," wherever this may lead through quicksilver, nomadic shifts in subject, medium, style, format, and scale (figs. 615–617). Blessed with prodigious facility, Clemente quickly emerged as the most fluently prolific among the Transavantgardists, as well as the most kaleidoscopic in his roving fantasy and range of recondite analogies. Central to it all, however, is the artist's obsessive, psychodramatic process of self-investigation, often explicitly or even weirdly erotic. "I trust all those who have 'thought' with their bodies," he once said, and

so his pictorial narcissism unfolds in tandem with countless enigmatic cross-references to metaphysics (Christianity, alchemy, astrology, mythology, Tantrism, the Tarot) and historical art (Egyptian, Greek, Roman, Renaissance, Hindu, Expressionist). Ever in pursuit of meaning and thus in flux, Clemente, together with his wife and children, commutes annually between studio-residences on three continents, in Rome, Madras, and New York, remaining at each for extended periods of work. And in each the work becomes a reflection of the artist totally absorbed in his host culture—its images, ideas, and media. As polymorphous-perverse in matters of style as in those of human behavior, Clemente created the witty *Two Painters* by drawing on primitive, popular, and even kitsch sources, from both East and West, to symbolize the transmigration of culture (fig. 615). In strident, opportunistic New York, far from serene India, he taught himself oil technique for *The Fourteen Stations* (fig. 616), here evoking Christ's agony in a dream-like, sometimes scatalogical, often turbulent intermingling of personal psychology, self-portraiture, cultural history, and religious symbolism.

Equating familiarity with meaninglessness and diversity with truth, Clemente has roamed with predatory license not only from continent to continent but also from medium to medium—oil, fresco, encaustic, pastel, watercolor, monotype, gouache—conquering each with patrician aplomb. Common to all is the artist's great gift for drawing, in a delicate, febrile line that tends to fray and bleed into sweetly colored, luminous grounds, just as the figures they define like to invade and become one another in every possible, often unimaginable way. This can be sensed even in a large, geometrically abstract work like *Fraternità* (fig. 617), realized in the ancient fresco technique that Clemente prefers when working in Rome, where Mediterranean equilibrium elicits a radically different response from the one demanded in clamorous New York. Since the monumental, domed architecture of Imperial Rome depended upon its builders' mastery of brick construction, Clemente has portrayed a brick wall of dovetailing, interlocked bricks like those which, for centuries, served as the support for Greco-Roman-Italian fresco painting, until the market-driven world of today replaced permanence with mobility and a taste for the very kind of simulacrum offered in *Fraternità*. Yet while this painting may satirize post-structuralist ideology—its insistence upon the surrogate as well as the dispersed, decentered character of modern reality—the work illustrates that ideology with remarkable clarity, while simultaneously pressing issues perhaps more dear to Clemente himself. Among them may be a fraternal tribute to Jasper Johns (fig. 235), who too painted inscrutable masonry walls, together with handprints and arms, and, in the covert way of his more circumspect generation, adopted Tantric onanism as a metaphor for the narcissistic compulsiveness of the creative urge. But since Clemente would dissolve closet doors rather than erect them, his Minimalist rampart appears ready not only to crack asunder but also to surrender its opacity to the effects of liquid brushwork and the transparency of radiant, stained-glass color. The palette, moreover, ranging from deep brick red through pink and gold to spring green, coincides with *Fraternità*'s tripartite division to evoke, with the reverence of Christian altarpieces, the eternal cycle of birth, death, and regeneration that informs everything made by Clemente, in whose view decadence contributes altogether as much to the process as transcendence.

When, in late 1980, Leo Castelli joined with a young, glamorous New York dealer named Mary Boone to represent the painter Julian Schnabel (1951—), thereupon granting his coveted imprimatur for the first time in over ten years, he helped launch the career of what may be the most controversial and thus most characteristic artist of the feverish eighties. It began in a now-famous "bankable" style, one of the most sensational to appear since Minimalists had declared painting dead (fig. 618). Although a bankable or signature manner is what many an aspiring artist wants, few would have been at such length in their reach for it as to risk, as Schnabel did, alienating modernists and post-modernists alike. Still, the broken-crockery surfaces and sublime overtones were perfectly consistent with the division that Brooklyn-born, Texas-bred Schnabel has said lies at the very core of his consciousness. "I've always had the

617. Francesco Clemente. *Fraternità (Brotherhood).* 1988. Fresco, 9'10" × 19'8". Private collection. Courtesy Anthony d'Offay Gallery, London.

sense of being in two places at once. I'm always in the past as well as in the present. I'm both urban dweller and small-town delinquent." However, it was neither in New York nor in Brownsville, Texas, but rather in Barcelona that he conceived the notion of expressing his paradoxical vision in a language of fractured dishes. There, of course, he saw the Art Nouveau wonders of Antoni Gaudí's Güell Park, with its curvilinear benches completely covered in mosaics of inlaid tiles. But instead of smooth planes needed for furniture, Schnabel decided to create a heavingly disruptive surface, edge to edge, that would both literalize the gesturalism of Action Painting and mimic its unifying all-overness, like a field of enlarged pointillist dots. "I wanted to make something that was exploding," he later said, "as well as I wanted to make something that was cohesive." And so, at the same time that the shards serve to define shapes and even model form, they also break up the image and absorb it into the generalized flicker, like a primitive, encrusted version of the figure-in-pattern effects of Gustav Klimt, Gaudí's Austrian contemporary, or of Robert Kushner, Schnabel's own, much-admired contemporary (fig. 557). On the stage of this operatic art have appeared martyred saints, mythological figures, and images from popular magazines, frequently mixed and all presented like excavations from the multilayered strata of an archaeological site. And like such evidence, Schnabel's semantic overlays eventually disclose their relationships and thus yield meaning, as here in *Blue Nude with a Sword,* where the theme of fragmentation emerges from three levels: the broken ground, the representation of Classical ruins, and the quotational or pastiche nature of the historical fragments. As interpreted by Thomas McEvilley in 1986, the iconography may be read as follows:

The nude warrior poised on the two columns like a living sculpture is a figure from Pollaiuolo's Battle of Naked Men. *The incense or oil-burning column is copied from a paper coffee cup. The merging of high and low cultural elements from different eras acts out the randomness of cultural dichotomies and sequences. Human selfhood falls to the passage of time as the blood-red head falls to the ground. The swordsman's apparent heroism is mocked by his placement on a sculpture pedestal: heroism is presented as an artifice. His is not a free, personal exercise of will; it is the process of time and change working through him. It is the violence that drives history, or is history, that sends the bloody head to the ground beneath the swordsman's stroke as beneath the scythe of time.*

Though born in Oklahoma, just north of Schnabel's South Texas, David Salle (1952—) arrived in New York with few if any romantic illusions, thanks to his education at Cal Arts under that arch-ironist John Baldessari. Still, he and Schnabel found much in common, not only unblinking ambition but also side-by-side jobs as cooks in a SoHo restaurant and the invaluable, joint attentions of Mary Boone and Leo Castelli. Unlike Schnabel, however, Salle (pronounced Sally) very quickly won important critical support, mainly by painting on canvas (for the most part), rather than on an aggressively eccentric surface, and by creating

works of undeniable presence and force even while making them object lessons in post-structuralist aesthetics (fig. 602). Pursuaded that originality is myth, Salle works as a collagist or assemblagist, as did his acknowledged models—Picasso, Picabia, de Kooning, Rauschenberg, Johns, Rosenquist, and, especially, Sigmar Polke. Nonetheless, he has succeeded in creating an oeuvre of indelible singularity by the cold-blooded fearlessness with which he appropriates iconography, objects, styles, and techniques from the antipodal extremes of high art and low schlock, then juxtaposes or layers them in ways that invite interpretation but ultimately deny it. What, for instance, is one to make of the mammoth diptych entitled *Miner* (fig. 619)? Yet even more daunting than the enigmatic *Miner* are the paintings in which Salle has collided excerpts from

art-historical masterpieces with the kind of raw pornography—nude women in provocative poses—that he used to lay out, in double-page spreads rather like his diptychs, for *Stag* magazine. In *Landscape with Two Nudes and Three Eyes,* for instance (fig. 602), the bare bottom of a recumbent female model greets the spectator in the lower right panel, a sure-fire attention-getter, only for the misogyny and vulgarity of the image to be neutralized by almost every other aspect of the painting, especially the wide, full-color quotation from a late 17th-century landscape

by the Dutch master Meindert Hobbema, which in turn seems newly charged with energy, from the irritant of its proximity to something slightly obscene. Equally counterbalancing, self-canceling, or mutually redemptive are the abstract (painterly as well as hard-edged) and descriptive passages, the chromatic and monotonal colors, the disembodied but solidly rendered hazel, blue, brown eyes and the logo-like cross medallion. And just as this last element confirms, by implication, that everything in the picture is a mere sign—a substitute for reality—Salle has confessed that, for him, the *Stag*-type woman serves as an alter ego, as a signifier of someone whose works are also salable objects of visual scrutiny. Moreover, the prevalence of eyes and ovals in his paintings also suggests that, however steeped in post-structuralist ideology, the pictures remain primarily visual, sensuous experiences of a higher, concentrated order. And if the media have over-reproduced and thus stripped every image of value—even a venerated work like the landscape seen here—until authentic creation comes to seem impossible, then Salle would deconstruct cultural paralysis by mixing and matching until his promiscuous, enigmatic borrowings fuse into enough power to illuminate a meretricious age with something like the brilliance that Hobbema, Watteau, Géricault, Manet, and Picasso—to cite only a few of the masters whose works Salle has appropriated—brought to their own, perhaps less chaotic or spiritually bankrupt times and worlds.

From a superficial glance at their mature art, one might conclude that Eric Fischl (1948—) and David Salle shared nothing at Cal Arts but a studio, study under John Baldessari, and faith in semi-pornographic imagery as a powerful hook for snaring the viewer's curiosity (fig. 620). Yet, despite his commitment to figure painting in a free, spatially coherent manner scarcely radical since the mid-19th century, Fischl succeeds in creating large-scale pictures whose power simultaneously to incite and frustrate viewers all but equals that of Salle's *Landscape with Two Nudes and Three Eyes*. This may be obscured, momentarily, by the conventional realism—the apparent lucidity—of a scene from some recognizable corner of white bourgeois America, until one attempts to resolve the divergent discourses set off by activities and relationships of a desperate, furtive sort regularly encountered in the fictions of Updike, Cheever, and Roth, or indeed in life itself—but never before in ambitious, realist painting. Moreover, the effect derives from an appropriate-and-assemble

technique that differs from Salle's primarily in its unwavering reliance on photographs of contemporary existence, often snapshots taken by the artist himself while prowling the nudist beaches of southern France. The resulting ambiguity within evident clarity can be seen in *The Old Man's Boat and the Old Man's Dog,* where naked Mom and Dad relax on their pleasure boat, the one eyeing her equally bare adolescent sons and the other his teenage daughter, even as the boys and the frantically barking Dalmatian fix on something outside the picture's frame, while the life-jacketed girl looks in the opposite direction, there to take note of a huge wave swelling towards the party from an ominously dark sky. If thus threatened in the ostensible harmony of their Sunday outing, the nuclear family would seem to be no less jeopardized by their own incestuous collision with what passes for middle-class normality. Yet, stern moralist though Fischl may be, using titillation to raise questions about right and wrong, he would also have us empathize with the subjects of his mordant disclosures—the victims of a graceless and sterile even if affluent social structure—for ''central'' to his work, as he stated in 1982, is

the feeling of awkwardness and self-consciousness that one experiences in the face of profound emotional events in one's life. These experiences, such as death, or loss, or sexuality, cannot be supported by a life style that has sought so arduously to deny their meaningfulness, and a culture whose fabric is so worn out that

above: 619.
David Salle. *Miner.* 1985. Acrylic, oil, wood, and metal tables on fabric and canvas; 8' × 13'6¼". Courtesy Mary Boone Gallery, New York.

left: 620. Eric Fischl. *The Old Man's Boat and the Old Man's Dog.* 1982. Oil on canvas, 7' square. Saatchi Collection, London.

opposite: 618.
Julian Schnabel. *Blue Nude with a Sword.* 1979. Oil, plates, and bondo on wood; 8 × 9'. Courtesy Pace Gallery, New York.

Fin de Siècle

its public rituals and attendant symbols do not make for adequate clothing. . . . Each new event is a crisis, and each crisis . . . fills us with much the same anxiety that we feel when, in a dream, we discover ourselves naked in public.

As his conflicted background in images of violence (battleships) and controlled Super-Realist rendering would suggest, the British-American artist Malcolm Morley brings to painting a manic disposition capable of the most erratic extremes—of feeling, form, and idea—not only in his overall development but also in individual works. Thus, after he began, in 1970–71, to liberate his once-tight stroke and replace pictorial unity with disjunctive themes, scales, styles, and spaces, Morley came to seem the father of Neo-Expressionism (fig. 621), just as his early poster- or postcard-based canvases had left him charged with having sired Photo-Realism (fig. 539). And the sexual metaphor is apt, for Morley has frequently spoken of painting in erotic terms, a process wherein the artist finds release for a suppressed yet aggressive libido, which in turn gives birth to works evincing their creator's heterogeneous enthusiasms. In *Day Fishing at Heraklion*, for example, Morley chose a title that left him consorting with the Picasso of *Night Fishing at Antibes*, while in the work itself he coupled with several of his other, ardently admired mentors—van Gogh in the shoes on deck, de Kooning in the rather abstract, bravura passage at the center, Newman in the zip-like mast, Bosch, Chagall, Magritte, or Miró in the huge, white, smiling fish (phallic as well as Christian emblems), and Greek sculpture in the bearded face over which they swim. Delacroix, Monet, or even Sam Francis get embraced in the ripe, exotic color, and Pollock in the open or densely woven webs of trailed and spattered pigment. Yet, untrammeled as

this Expressionist lust for the life of art may appear, it sprang from a model as fixed and foreseen as those used for the Super-Realist works. Now, however, the prototype happened to be the artist's own vivacious watercolors, whose luminous, Turneresque qualities Morley captured as completely as he did those of the seamless photographs he formerly depicted. Moreover, *Day Fishing at Heraklion* overcomes an excess of borrowed culture to register an impression as distinctive as any of its sources. This may be characterized, at least in part, as a picture brimming with disparate images, allegories, and techniques, with fantasy, ambition, visceral intensity, riskiness, and self-parody, a pluralistic abundance ultimately salvaged or unified by a system the artist has likened to Schoenberg's twelve-tone scale or even to masonry. "All of my paintings are tightly bonded walls," he said in 1984. "There isn't a gesture that isn't planned or part of a structure: The ship paintings were rehearsals in structure, but now I know the score."

Graffiti and Ghetto

Where eighties post-modernism most sensationally opened the center of art-world interest to activities from the margins was in the East Village, as the shabby but picturesque "ethnic" neighborhood on Manhattan's Lower East Side came to be known, in contradistinction to Greenwich Village, the old, established bohemia on the opposite side of town. Long host to immigrants, the quarter now found itself colonized by students from the School of Visual Arts, who gravitated there in search of low-cost housing and alternative exhibition/performance spaces like that discovered by Claes Oldenburg in the late 1950s. Being the New Wave generation, the students also gave rise to a number of small, experimental nightspots, most importantly Club 57, a church basement converted by its parishioners into an outreach facility for the district's young people. Here, they could wax nostalgic about their not-so-distant childhood by restaging old TV variety shows and Hanna-Barbera animated cartoons. In this "funky retro" atmosphere, the SVA crowd also got high on various substances, semiotics, anti-Minimalist/Conceptualist ideas, and, particularly, New Wave rock. Soon, the last would attract some of the city's roving bands of teenage graffitists, those ghetto-bred, self-taught artists or "writers"

left: 621.
Malcolm Morley.
Day Fishing at Heraklion. 1983.
Oil on canvas,
6'8" × 7'6".
Courtesy Pace
Gallery, New York.

right: 622.
Keith Haring.
Art in Transit. 1982.
Courtesy Estate of
Tseng Kwong Chi,
New York.

opposite: 623.
Keith Haring.
Untitled. 1984.
Acrylic on canvas,
5' square.
Collection Tony
Shafrazi, New York.

who vented a rage to communicate by "bombing"—spray-painting or felt-tipping—their "logos" (initials, nicknames) and "tags" (messages) in baroque, festooning scrawls all over New York City's subway trains. Seeing this indigenous expression, with its folk-heroic defiance of law, as a wellspring of raw, primal energy like that drawn upon by Pollock, Dubuffet, Twombly, and Frank Stella, mainstream students made common cause with the outsider Rustoleum masters. While this enabled SVA enrollees Keith Haring and Kenny Scharf to soak up "authenticity" from one of the most compulsive of all graphic modes, it also permitted the underground autodidacts to gain access to the above-ground world of dealers, curators, and collectors. Furthering the cross-over was Fashion Moda, a South Bronx storefront gallery that, with NEA (National Endowment for the Arts) support, had been providing an outlet, other than the vandalized subway cars, for one-time "bombers" with exotic pseudonyms like Futura 2000, Crash, Zephyr, and Toxic. Finally, in 1980, the interface produced the "Times Square Show," a wildly raffish affair in an old Midtown massage parlor, cosponsored by Fashion Moda and CoLab, an East Village artist's collective, that launched almost every career to be seen here under the current heading. By 1983, Graffiti with a capital letter had become a movement, acknowledged not only by the blue-chip

New York dealer Sidney Janis but also by Rotterdam's Boymans-van Beuningen Museum. Oddly enough, the most remarkable talent to move in from the periphery was Jean-Michel Basquiat, who did indeed "tag" New York but never in the subway, only on SoHo walls, which he targeted with sure careerist instinct. Meanwhile, the East Village, where Basquiat, Haring, Scharf, and many others first showed at their best, became a speculator's feeding ground, until around 1987, when the artists outgrew the tiny spaces of some fifty galleries—with names like Fun, Civilian Warfare, Gracie Mansion, Nature Morte, International with Monument—and relocated to SoHo. Meanwhile, so many currents had crossed that SoHo celebrities on the order of Francesco Clemente, Leon Golub, Ross Bleckner, and Sherrie Levine had begun to participate in East Village shows. Clearly, more came out of the East Village phenomenon than the kitsch and "backlash trash" generally associated with it, as we shall see in the tough-minded Conceptualism of the Neo-Geo artists, who made their debuts at Nature Morte and International with Monument.

The linchpin figure of Graffiti was Keith Haring (1958–90), who traveled with hipster ease from small-town Pennsylvania to New York's SVA, streets, subways, and outer boroughs, finally into elite galleries and museums all over the world. Along the way, he made himself anonymously famous on MTA (subway) platforms by appropriating the black wall panels used to "cancel" obsolete advertising and employing them as slate-like surfaces on which to make quick chalk drawings that combined the protest vigor of vernacular graffiti with the grand scale and formal elegance of New York-style high art (fig. 622). Here the artist perfected his horror-vacui style, realized with a unique vocabulary of firmly contoured cartoon figures—radiant child, barking dog, dolphin, flying saucer, praying man—intermingled with such common signs as the cross, the halo, the pyramid, the heart, all rendered with good cheer and generosity but also with an unmistakable note of moral alarm. Confronted with a dog yapping at a UFO as it zapped a praying man at the base of a "pulsating" pyramid, New York's straphangers understood the message even without knowing that Haring came from Kutztown, well within the fallout range of Three Mile Island.

By 1984 Haring had made his mark as well as his point in the subways and thereafter operated mainly in the "legitimate" aboveground world, elaborating his idiomatic black-and-white doodles into a richly colored "New Wave Aztec" manner that seemed to merge the

symbolism of A.R. Penck with the all-over image of Jackson Pollock (fig. 623). As his anonymity gradually evolved into global fame, Haring abandoned plain chalk for sumi ink and unleashed his prodigious capacity for graphic invention on everything from paper, oak tag, fiberglass, and vinyl tarpaulins to buttons, T-shirts, pottery vases, and plaster casts of such cliché monuments as Botticelli's *Venus*. At the same time, the level of anxiety always evident in his work rose, steadily, as the pictographic creatures began falling into manholes, spilling their guts, leaping through one another's empty midsections, flaunting their swollen manhood or their ready-to-burst pregnancies. Moreover, he used his old love of working in public spaces to create such youngster-directed billboard messages as CRACK IS WACK or "Fill Your Head with Fun, Start Reading." By the time he died of AIDS-related complications, at the age of thirty-one, Haring figured among the most revered artists of his time, having produced, as Donald Kuspit wrote, "an art that, while full of social necessity, exists for its own sake," a genuinely populist achievement that proved as effective in museums as on the ramparts of social action.

Among the vagabond graffitists met by Haring at Club 57 was the even more short-lived, now legendary Jean-Michel Basquiat (1960–88), who, albeit no art-school graduate, was neither underclass nor homeless nor naïve (fig. 624). Indeed, Basquiat came from a bourgeois Haitian-Hispanic family, comfortably established in a good Brooklyn neighborhood; moreover, after being expelled from private school for unruliness, he took up graffiti writing on public walls as a deliberate strategy for launching himself into a career modeled on, no less, Picasso, Johns, and Warhol. Thus, seventeen-year-old Basquiat went not into the subways but, rather, straight for the streets of Manhattan's SoHo, where he formed a partnership with fellow dropout Al Diaz and began Magic Marking public walls with poetic, symbol-embellished messages and tagging them SAMO©. After systematically leaving their logo wherever the right celebrities might appear for an art opening or a hot new club, SAMO© managed to join the "Times Square Show" during the summer of 1980. By the beginning of 1981 Basquiat had struck out on his own and made it into P.S.1's "New York/New Wave" exhibition, with a set of unprimed canvases sparely marked with child-like scribbles in crayon and paint. Soon thereafter

624. Jean-Michel Basquiat. *Untitled.* 1984. Oil, acrylic, and paper collage on canvas, 5'6¼" × 5'. Collection Dr. David Ramsay, New York. Courtesy Vrej Baghoomian Gallery, New York.

he produced some of his strongest work, pictures in which words—verses, dangling phrases, lists spelled out in rugged, boxy, handwritten capitals—metamorphose into images—dreadlocked, mask-like skulls, mechanistic figures, crowns, grids, arrows, rockets, skyscrapers—and finally fuse in a vastly assured variant of New York School ''big-picture'' aesthetics. Within this amalgam of graffiti, African art, and Abstract Expressionist improvisation seethe the pride of the black outsider and a passion to make inside and outside meet. Here, it happens in a pictorial field unified not by any logical relationship among the various images, signs, and symbols but rather, as in the art of Polke and Salle, by generalized, ''hip-hop'' vibrations arising from so many disjunctive elements. With a need for drugs equal to his generational appetite for fame and fortune, Basquiat did not long sustain this degree of jagged power—even in a collaboration with Andy Warhol—al-

left: **626.** John Ahearn. *Maria's Mother.* 1988. Oil on cast fiberglass, 4'3" × 4'4" × 4'. Courtesy Brooke Alexander Gallery, New York.

right: **627.** Faith Ringgold. *Bitter Nest Part 5: Homecoming.* 1988. Acrylic on canvas, printed, tie-dyed, and pieced fabrics, 6'4" × 8'. Courtesy Bernice Steinbaum Gallery, New York.

though he seemed on the verge of achieving it at the very end, just prior to his death from an overdose of heroin.

If Graffiti succeeded in making it from street to gallery, reversing the trend initiated a decade or more earlier by many Conceptualists, it was in significant part owing to the organizational prowess of CoLab (Collaboration Projects, Inc.), a group established in 1977 by some thirty young New York artists totally locked out of the dealer/critic/curator system. And if the ''Times Square Show,'' essentially a Co-Lab affair, altered this condition for a number of such artists, it was partially due to the special gifts and energy of the Kansas-born sculptor Tom Otterness (1952—), a key activist in CoLab as well as an exemplar of its overall desire to make art a universally accessible language through which to comment on the human dilemma. A post-modernist par excellence, Otterness not only rejected modernism but also sought to evoke a primordial, if not so innocent, time when, according to the

artist, humanity had the undifferentiated, generic look of a ''Pillsbury's Doughboy'' and a perverse tendency to cavort with Cézanne's cones, cubes, and spheres while romping through mythopoetic sagas of labor, mass uprising, primal sex, and group bestiality. It was as though an ''Alley Oop'' race or Charles Simonds' invisible ''little people'' had assumed soap-carved form in order to lampoon, in cartoon-like frieze compositions, such grave issues as aggression, sexism, and alienation in the technological age. Soon favored by critics and collectors alike, Otterness ceased to issue his work in plaster and began casting it in magnificently finished bronze, as in the theatrical tour de force entitled *The Tables* (fig. 625). Here, the sculptor deconstructed Minimalism by using its Cor-Ten steel plates to structure a trio of picnic tables, complete with built-in benches from which viewers may feast their eyes upon a kind of three-ring circus, staged as a morality play about the rise and fall of undeserving civilizations. The drama proceeds under the shadow of a cracked and burnt-out globe ridden by the Grim Reaper and held precariously aloft by pulley and guy, at least until two tiny fiends below can finish sawing the taut wire in two. One hopeful note seems to sound in a giant human effigy striding forward, like Yeats' ''rough beast'' towards Bethlehem, yet wielding hammer and sickle. If Otterness re-enacts Revelations in the style of Disney, it serves to concentrate the mind, for while chuckling over the toy-like chronicle of human folly, one cannot escape the disquieting sense of having seen it all before, not only on Saturday morning children's television but also in everyday corporate life, which appears less and less a picnic as post-bomb society seems ever-more bent on overkill.

625. Tom Otterness. *The Tables.* 1986–87. Bronze and Cor-Ten steel, 11'6" × 38'1" × 9'6". Courtesy Brooke Alexander Gallery, New York.

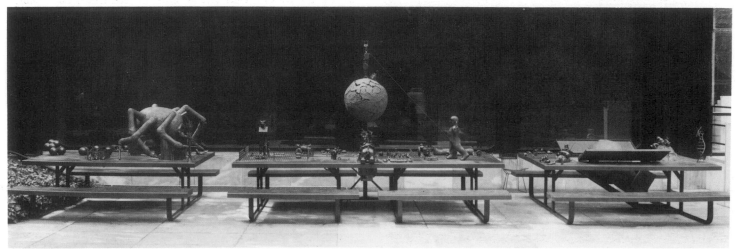

Following a brief period with CoLab, John Ahearn (1951—), an Anglo artist from Upstate New York, found his way to the destitute South Bronx and there initiated a new collaboration, this time with Rigoberto Torres and dedicated to an ongoing series of painted reliefs that render ordinary folk extraordinary by portraying them exactly as they are (fig. 626). In other words, Ahearn belongs to that select group of sculptors—George Segal, Duane Hanson, Antony Gormley among them—who cast from life, and in his case, what life! It teems with policemen, lovers, children playing "Double Dutch," and street sweepers, whose indomitable subjectivity—sometimes ferocious dignity—fairly radiates from dusky faces made luminous not only by their inherent qualities but also by the magic of the artist's brush. The master of a richly synthetic palette, Ahearn manages to evoke the very heat, as well as the ambient lights, of black and Hispanic skin. The effect is to transform representations into amplified presences, which so moved the critic Peter Schjeldahl that he called them "Rembrandtian."

While Ahearn and Torres portray the people of the Bronx ghetto, Faith Ringgold (1930—) has succeeded Romare Bearden as Harlem's history painter, in a series of quilt works begun in 1982 (fig. 627). Already a mature artist and teacher when she launched upon this grand narrative, Ringgold had worked in many different media but finally settled on painted, dyed, and quilted fabrics, not only because of their feminist connotations but also because, like Rauschenberg (fig. 222), she saw in the brilliantly patterned geometries of quilts a means of reinvesting modernism with human content. For the same reason, Ringgold adds handwritten texts, of her own invention, that expand the range of representations in each painting, the better to multiply or layer its levels of expression and meaning. Just as the texts consist of autobiography, social comment, fiction, folk chronicle, and reportage, the imagery brings together colorful abstraction, descriptive figuration, spatial illusion, and black-on-white calligraphy in an ambitious, yet warmly intimate, statement about the giddy mix of fact and fantasy that is everyone's experience of life, in Harlem or elsewhere.

Sculpture in the Eighties

As the forceful works of Otterness and Ahearn attest—together with those of Graves, Flanagan, Shapiro, Gormley, Hunt, Burton, Armajani, and the Poiriers, all seen in the last chapter—sculpture bucked the anti-object bias of the early, Conceptual seventies and staged an impressive comeback, especially in the eighties, right along with painting and well

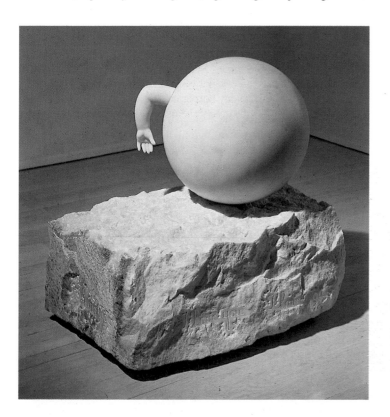

beyond it. Once Neo-Expressionism dispelled the taboos of both Minimalism and Conceptualism, sculpture—with its real, multiple dimensions and vastly enlarged repertoire of media—proved irresistible as an occasion even more promising than painting to make aesthetically valid works reflecting the rich diversity of contemporary life. Benefiting from all the new permissions granted by Beuys' "social sculpture" and what Rosalind Krauss called the "expanded field"—sculpture as Process and Eccentric Art, Arte Povera, scatter, earth, and site works—artists found themselves free even to exploit Minimalism, at least for its formal simplicity, theatrical presence, and environmental reach, as long as the emptied core could be replenished with vibrant inner life. Indeed, it might be said that during the eighties sculptors redid Minimalism and Conceptualism, crossbreeding them in formally coherent, though hybridized volumes made significant less by their stylistic daring than by their content and contingency. With the language of sculpture thus governed by both text and context, style can offer no guide to whatever the many new sculptors of the eighties have in common, particularly at a time almost obsessed with "difference" and the "Other." Unlike the sculptors associated with New Image, the artists to be seen here could take or leave figuration, depending on the point to be made and the process involved in making it. For Magdalena Abakanowicz, the freestanding human figure serves as a vehicle for rendering her loomed reliefs more expressive of the human condition in stricken Poland. Elsewhere—in the works of Tony Cragg, Bill Woodrow, Judy Pfaff, and Ange Leccia, for in-

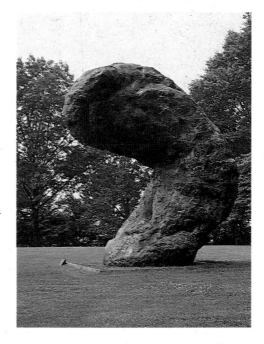

right: 628.
William Tucker.
Okeanos. 1987–88.
Bronze, 12'7" × 9'8" × 6'7".
Courtesy David McKee
Gallery, New York.

left: 629.
Louise Bourgeois.
Untitled (with Hand).
1989. Pink marble,
31 × 30½ × 21". Courtesy
Robert Miller Gallery,
New York.

stance—images come in the form of found objects, or figures made from such objects, frequently urban discards, as a way of commenting on the increasingly out-of-balance relationships between nature and culture. But if this makes for an exceedingly abstracted kind of figuration, abstraction itself often appears so animate with human energy as to be on the verge of becoming a torso, hand, arm, head, or all these things at different times from different angles. A case in point is *Okeanos* by William Tucker (fig. 628), the great English disciple of Anthony Caro who refashioned his hard-edged, taut-skinned, industrial aesthetic (fig. 396) into a hand-modeled, bronze-cast organicism that suggests an inchoate evocation of Rodin or a Greek creation myth. Another, earlier and truly inspirational, paradigm was the senior artist Louise Bourgeois (fig. 164), who used her discovery by feminists as moral, as well as financial, fuel with which to re-ignite a Surrealist compulsion to turn the human psyche inside out and expose its raw interior, a world of almost shocking privacy now made public in flesh-pink, blue-veined marble as exquisitely carved and finished as a statue by the Neoclassicist Canova (fig. 629).

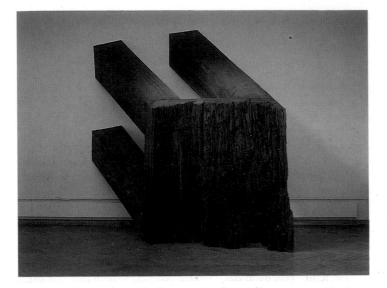

left: 630.
Magdalena Jetelová.
Table. 1988. Sipo wood,
9'5" × 8'10¼" × 5'1".
Courtesy John Weber
Gallery, New York.

right: 631.
Anish Kapoor. *Half.*
1984. Polystyrene,
cement, earth, acrylic
medium, and pigment;
5'7" × 3'2". Courtesy
Barbara Gladstone
Gallery, New York.

Even the Minimalist cube came in for humanization, the result of Jackie Winsor's loading it with the intimacy of personal craftsmanship and a literally soul-searing conception. Meanwhile, Reinhard Mucha too makes boxes, but with salvage from Germany's pre-Nazi past, thereby reflecting one of the decade's most constant themes—an aching sense of loss, of the Warholian void, mingled with flickering hope for recovery. Clearly, materials could be anything, including traditional bronze and marble, both prohibited by Minimalism, in addition to equally orthodox wood, which Martin Puryear bends and staples in open-form structures whose awkward grace echoes African tribal art as well as the modernism that drew nourishment from it. Barcelona's Susana Solano employs steel to fashion cages, for birds or prisoners, while Prague's Magdalena Jetelová joins the natural trunks of great oaks to make giant tables or chairs, half-finished or half-ruined, with cage and furniture both serving as images of survival in a repressive world (fig. 630). In London, Anish Kapoor appropriated pure powdered pigment from India (fig. 631), while Richard Deacon seeks no farther than the local building supplier for his linoleum, Masonite, and screws; yet both artists utilize their decidedly physical materials to form semi-abstract, vaguely anatomical shapes whose effect, however, is more poetic than descriptive. As Deacon's media suggest, architecture continued to provide a major analogue for sculpture, just as it did for Minimalism. But whereas unitary, nonrelational Minimalism could not but relate to the immediate, architectural environment, the source of its industrial materials and techniques, the new assembled, highly relational sculpture would identify with another kind of architecture. Carpenter-built like balloon frames or cabinetwork, handwrought as in iron gates and grilles, pieced together mosaic fashion or in sculptural equivalents of pastiche, quotational painting, wired like an automatic alarm, or plumbed with copper pipes proliferating in a kind of daft, man-made genetics (fig. 632), the sculptures to be seen here often derived from an almost cultishly intense, personal involvement with process. This too would be a source of meaning, since, even where the labor consisted of nothing more than confronting a pair of television sets as if they were lovers, the purpose was to work the alchemy of transforming inert matter—degraded, unrefined, manufactured, or electronic and brand-new—into vital metaphors for life still astir, or stirring anew, in the embers of a burnt-out, "post-industrial" millennium.

Reared in aristocratic, prewar privilege, Poland's Magdalena Abakanowicz (1930—) suffered the horror of seeing her mother's arm shot off by German soldiery breaking into the family château, only to be further victimized by a postwar Communist regime unable to tolerate either the nobility or a talent for the poetic and the imaginary. Still, the feisty artist (whose name descends from a remote ancestral link to Genghis Khan) managed to get an education and even to gain recognition abroad, if not at home, first for her woven reliefs but then, most dramatically, for her huddled masses of stoop-shouldered, half-hollow burlap

figures, actually mere backs deprived not only of fronts but also of heads, arms, legs, and even gender (fig. 633). Though modeled on a single form, the effigies evince an astounding variety and thus individuality through the random seams, twists, and wrinkles of glue-stiffened fabric laced with meandering hemp twine. Rendered unable to think, fight, or procreate, the images become monuments to mute human endurance against the dehumanizing forces of regimentation and repression. "People ask me," Abakanowicz has said, "is [the *Backs*] the concentration camp in Auschwitz or is it a religious ceremony in Peru or is it a ritual dance in Bali, and I can answer all these questions 'yes,' because it is everything. It is about existence in general."

Judy Pfaff (1946—), like Jonathan Borofsky, Barry Le Va, and many another artist of the post-modern generation, sought to literalize or three-dimensionalize Abstract Expressionism. Few, however, brought such riotous joy to this enterprise as the English-born, Yale-educated Pfaff, who translated Pollock's all-overness into whole site-specific environments, improvised in frenzied, round-the-clock marathons that left whatever gallery she commandeered resembling an underwater world afloat, not with aquatic life, but rather with such crazily mixed media as barbed wire, neon, contact paper, wood, and steel mesh. Once painted in intense Day-Glo colors, Pfaff's mad yet grandly orchestrated installations allowed viewers to roam, dry-footed, through what could indeed be described as a Pop variant of a snorkeler's paradise burgeoning with tropical flora and fauna. In the nostalgic atmosphere of the eighties, Pfaff found that she missed her big seventies pieces, each of which had to be destroyed at the end of its exhibition. Now, instead of improvising, she

632.
Joel Otterson.
*Scientifiquement
Vivant.* 1985.
Copper, brass,
wood, plastic,
and photo;
6'11" × 1'7" × 1'3".
Courtesy
Jay Gorney
Gallery,
New York.

detonating an implant of dynamite! To fashion her Primary Forms—squares, grids, spheres, and cylinders in addition to cubes—Winsor has engaged in months of ritualistically repetitive activity, unraveling and rewinding massive old ropes, hammering 50 pounds of nails into 50 pounds of 1-by-1-inch sticks, or covering a plywood box with 50 coats of paint. For the work seen here (fig. 635), she started with the dream image of a burning house, then proceeded to build it as a framework of wooden slats sufficiently reinforced with wire mesh to support alternating bands of concrete. To complete the work, Winsor fired its innards and allowed the wood to burn away, thereupon mating the rational to the alchemical, the destructive to the creative, the known to the unknown. Despite a clear preconception, "I was unable," the artist said, "to see how the piece would look until the moment of completion." Having charged lifeless matter with latent energy—with the residue of her own thought, feeling, and unsparing effort—Winsor contrived to make it overt, which the viewer may experience by touching the rough, sandwich-textured exterior, as well as by viewing and smelling the charred guts through square "portholes" on all four sides of the now-skeletal cube.

The term "post-industrial," though generally known as a synonym for "information age," has also been used to specify yet another new wave of new British sculptors, this one surging up at the outset of the eighties and brilliantly led by Tony Cragg and Bill Woodrow, who appropriated obsolete technology for works that seemed to critique materialism in the wake of economic decline. Of course, Eduardo Paolozzi had already innovated such a process back in the mid-1950s, when he assembled broken machine parts into dysfunctional robots like *The Philosopher* (fig. 190). But while Paolozzi assured his proto-Pop assemblage a high-art status by casting it in bronze, Cragg and Woodrow treat their shards like ready-mades, or yet archaeological fragments recovered as if from some buried, prehistoric civilization. Meanwhile, other members of Britain's much-acclaimed "post-industrial" group—Antony Gormley, seen earlier in figs. 520 and 594, Richard Deacon, and Anish Kapoor (fig. 631)—scarcely qualify for the label, since they have always sought visual poetry elsewhere than in the detritus of conspicuous consumption that so engaged, first of all, Tony Cragg (1949—). Following a start in science, Cragg switched to art once he found it a more tangible means than mathematics of dealing with such abstract concepts as the particle nature of matter. For his breakthrough piece, a 1978 work entitled *New Stones—Newton's Tones*, he collected, color-sorted, and so arranged on the floor a great quantity of plastic refuse—broken toys, tools, kitchen utensils—that the rectangular carpet of vivid fragments recapitulated "Newton's Tones," the familiar rainbow spectrum into which the 17th-century physicist first refracted white light. In *Leaf* (fig. 601) Cragg again exploited the found colors and shapes of plastic scraps (this time various greens laid out pictorially on a wall) as atoms with which to build a whole—a model, that is, for thought enabling humanity

began to compose permanent and portable wall works, some of them so huge and jutting that they almost miniaturize the largest of Frank Stella's aggressive, space-hungry reliefs (fig. 634). And, if possible, the sense of carnival has heightened, as the artist finds inventive use for such appropriated and brilliantly colored items as woks, lattices, and "signage," Buren-like stripes, beach balls, disks of every size, color, and surface pattern, shiny, simulated apples and pears, hoops, grids, grills, fake-brick veneers, and the occasional lamp or bit of furniture. If the jubilant energy of their relationships threatens to spin out of control, the compositional vortex ultimately holds everything together as surely as the Cubist aesthetic that the artist has not only mastered but also internalized.

A pioneer post-modernist intent upon sabotaging formalism from within, Canadian-born Jackie Winsor (1941—) adopted the Minimalist cube and obsession with permuted seriality only to deconstruct everything they signified. Characteristically, she crafted the box in the most hands-on, labor-intensive manner, each time by a different process, and then opened its mysterious interior to exploration from without, once by

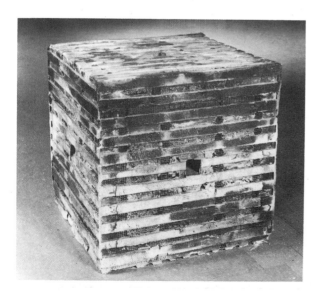

top: **633.** Magdalena Abakanowicz. *Backs.*
1976–80. Burlap and resin, 80 lifesize figures.
Courtesy Marlborough Gallery, New York.

right: **634.** Judy Pfaff. *N.Y.C.–B.Q.E.* 1987.
Painted steel, plastic laminates, fiberglass, and wood;
15 × 35 × 5'. Courtesy Max Protetch Gallery, New York.

above: **635.** Jackie Winsor. *Burnt Piece.*
1977–78. Concrete, burnt wood, and wire; 36" cube.
Courtesy Paula Cooper Gallery, New York.

to consider its world afresh. Together, image and materials appear to comment on nature seen through as well as ravaged by culture. Yet, the reclamation process adopted by the artist yields a poetics of decay, even a trope for the possibilities of life beyond the death of modernism in both industry and art. As this would suggest, Cragg is far from a one-note artist; indeed, he has shown himself to be a prodigiously gifted eclectic, conveying his love of open-ended discourse in a vast range of ideas, media, and styles, with wit and elegance always present as the essential components of their common, underlying DNA. True to his role as both artist and scientist, Cragg has even spoken of making ''an erotic response to the external world,'' which never seems more successfully realized than in his numerous freestanding, fossilized flasks and test tubes, often fabricated, in bronze, iron, glass, or clay, rather than scavenged, and huddled together like fertility idols (fig. 636). If such images refer as much to alchemy and commemorative monuments as to technological excess, it should not surprise, given that Cragg teaches at the Düsseldorf Academy where Beuys long served as ''cultural storm trooper'' battling institutionalized rationality.

In 1981, after an early period under the influence of Richard Long, Bill Woodrow (1948—) turned away from nature and began to make sculpture by cutting and shaping representations of objects from other objects, primarily outmoded, thrown-away technology (fig. 637). For the most part, he also left the ''mother'' and ''child'' attached by an

''umbilical cord,'' bound together in reciprocal judgment as witty as it is oedipal. Referring to his new urban source, Woodrow said:

What I find more interesting about the work is that these items are material for me that is found in my environment, it's not recovered in any sense, it deals directly with my life and the majority of my experiences, whereas walks in the countryside and rural atmospherics don't play a very large part in my life.

Determined that content emerge from context, Woodrow prefers to make each piece ''ambience-specific,'' that is, fashioned close to where it is to be exhibited and from materials discovered in local streets, alleys, junkyards, and second-hand shops. In affluent, tidy La Jolla, California,

top left: 636. Tony Cragg. *Instinctive Reactions.* 1987. Cast steel, 8 × 21 × 15'. Courtesy Lisson Gallery, London.

above: 637. Bill Woodrow. *Trivial Pursuits.* 1985. Car door, enamel, and acrylic paints; 3' × 4'8" × 2'5". Private collection, La Jolla. Courtesy Barbara Gladstone Gallery, New York.

top right: 638. Richard Deacon. *Listening to Reason.* 1986. Laminated timber, 7'5" × 1'8" × 1'7". Courtesy Marian Goodman Gallery, New York.

left: 639. Martin Puryear. *Lever #3.* 1989. Ponderosa pine, painted; 7'1½" × 13'6" × 1'1". National Gallery of Art, Washington, D.C. Courtesy Margo Leavin Gallery, Los Angeles.

he had difficulty finding junk of any sort, but when something usable did turn up, it proved to be, appropriately, a downgraded upscale product—the driver's side door from a late-model Porsche 928. Much taken not only with La Jolla's wealth but also with its artificial landscaping, gorgeous ocean-side weather, obsession with security, and rather un-American neatness, Woodrow used his metal shears, pliers, and paints to make the Porsche door panel play host to symbolic reproductions of all such aspects of Southern California life. Indeed, *Trivial Pursuits* would appear to return culture to nature, by means of a trio of leaf-bearing branches cut and bent away from the automobile body. As the negative shapes reveal, the door's metal siding also yielded the objects hanging from the branches: a locked box (wealth), a pistol (active security), a pink padlock (passive security), and a blue hummingbird sucking nectar from while also picking the lock (forbidden fruit). Working intuitively rather than programmatically, Woodrow engenders a kind of unnatural evolution, forcing the old to give birth to the new in metaphorical narratives calling for greater harmony between the world and the consumer glut now on the verge of overwhelming it.

Although not found, the materials preferred by Richard Deacon (1949—) are common, readily available building goods—wood, Masonite, steel, linoleum (fig. 638). And while not descriptive, his lyrically organic, essentially nonreferential works manage to evoke things beyond themselves, particularly such primary sensory organs as the eyes, ears, and mouth. Moreover, their hollow or open-form structure echoes the ceramic vases, linear drawings, and improvised, performance-related installation processes out of which Deacon forged his mature art. Behind it all, meanwhile, lies the poetry of Rainer Maria Rilke, whose gift for using ordinary words to compose eloquently simple verses of deep allusive resonance served as a model for sculptures like *Listening to Reason*, an abstract, penetrable, self-evident form articulate with meaning complex enough to be "both confirmed and denied." As clear and rational-seeming as a Gabo construction, Deacon's work flouts reason not only through its flowing, mercurial lines but also through the instability of its profile, which changes with every shift in viewing angle. Too, the five "ear" lobes may lean or converge towards the eye of a center, like sentient beings caught up in a lucid exchange of ideas, but they soon become as entangled and confused with one another as the competing interests of life itself. Finally, if the graceful "drawing in space" seems light and airy enough to float, the candidly exposed fabrication technique anchors it firmly to the ground, where the rough edges of nineteen thin layers of blond, laminated plywood ooze glue like cream from the stacked, flaky leaves of a *mille-feuille* pastry. Elsewhere, Deacon has battened his homely materials down—given his sculpture a "built" look—by such devices as riveting, screwing, and bracing, which somehow transcend their clunkiness to become rather absurdly suave.

The most impressive new sculpture to come from an American in the 1980s may be that of Martin Puryear (1941—), an artist of unusual variety, both in his life and in his elegantly austere, organically abstract but culturally rich and idiosyncratic works (fig. 639). From a black middle-class background in Washington, D.C., where he majored in painting at Catholic University, Puryear went on to serve as a Peace Corps volunteer in Sierra Leone, whose woodcraft tradition he not only absorbed but also developed further at Sweden's Royal Academy and shipyards, as well as at Yale and in Japan. Though almost shamanistically involved with materials, especially wood, tar, and steel mesh, and with process as a means of fusing form and content in one meaningful whole, Puryear also creates with a fully assimilated knowledge of the biomorphic vein of high modernist sculpture, running from Brancusi and Arp to Hague, Noguchi, and Bourgeois. As in their art or in the tribal works of Africa, every line or volume shaped by Puryear radiates a profound sense of animistic presence, the consequence, in part, of his compulsion to mix grace and ungainliness, tension and ease, sensuous finish and the rawness of roughly planed or staple-marked surfaces. With its power to suggest bird or beast, ship or shelter, as well as pure, distilled form, a sculpture like the one seen here remains mysterious and hermetic even as it seems openly engaged with nature and universal, human feeling.

Neo-Conceptualism

Just how far eighties-style Conceptualism diverged from its ascetic forebears in the seventies may be measured by the art of Mark Tansey (1949—), who matches Joseph Kosuth in his preoccupation with semiotics, theory, and criticism, but goes beyond him by "regressing" to the old maxim that a picture is worth more than a thousand words. Which is to say that Tansey is a painter, unlike most of the original, anti-form Conceptualists. Moreover, instead of making letters and words the sole, sufficient image of a panel or mural, in the manner of Kosuth and others, he translates abstract philosophical texts into pictorial narratives that could be mistaken for skilled renderings of old black-and-white photographs (fig. 640). Yet, however much they may suggest a grisaille variety of Photo-Realism, Tansey's paintings derive from a totally different process, one that involves what the artist has called *bricolage* or "reverse collage." By this he means a pieced-together model, made with photomechanical imagery re-replicated on a copy machine and composed into such seamless coherence that it obscures, for all but the sharpest eye and mind, discrepancies as surreal as those in traditional collage. And rather than narrowly concentrate on issues of perception, as did Photo-Realists and numerous late modernists alike, Tansey has sought to reconsider the entire history of modernism in much broader terms, defined not only by post-structuralist ideas but also by the early modernists themselves, especially Cézanne, whose Mont Sainte-Victoire theme provided the background image as well as the title of the work seen here. Knowing Cézanne's painting to be as rich in content as in the proto-Cubist innovations so dear to 20th-century abstractionists, Tansey has introduced into the foreground, of what the great Post-Impressionist painted as pure landscape, a scene of French military stripping and bathing in a clear, still lake. This conceit too originated in Cézanne, as the arching trees on the left confirm, since they are a quotation from the Philadelphia Museum's *Large Bathers*, a work whose female nudes caused the repressed Cézanne such difficulty that he may have based them on a group of soldiers he once discovered splashing in a forest stream. After literalizing this possibility, Tansey made the trees a

640. Mark Tansey. *Mont Sainte-Victoire.* 1987.
Oil on canvas, 5'8" × 8'10". Courtesy Curt Marcus Gallery, New York.

clue to further riddling enhancements, given that the emblematic forest reads correctly, relative to *Large Bathers*, only in its watery reflection. Turning the picture upside down to prove it reveals that, as reflected in the lake, the thrusting mountain has become a dark, recessive cave and the male bathers female, figures who instead of stripping appear to be dressing, from left to right. In a further clue, Tansey discloses the sources of his strategy in the portraits of Baudrillard, Derrida, and Barthes among the soldiers busy divesting themselves of their distinctive representa-

tions, just as Tansey, a close reader of the French theorists, has divested Cézanne's painting of the largely formalist representation made of it by mainstream art historians. In its place, he would demonstrate that behind the momentous formal discoveries lies an even greater revelation, that meaning emerges from a discourse of differences, not only surface and depth, color and line, but also chaotic feelings and orderly ideals, sensation and realization, the feminine and the masculine, a dialectic whose tension Cézanne did not so much resolve as disperse as erotic energy displaced into the "exciting serenity" of a pictorial field pulsating with an all-over distribution of analogous strokes. With this screen of prismatic color eliminated by the copy-machine process, Tansey unifies his image with monochromy, a red filter that matures into a metaphor for the inescapable, even if unstable, relationship linking such mythical opposites as present and past, motion and arrest, the anecdotal and the timeless.

Tansey may find his sculptural counterpart in Robert Gober (1954—), whose sinks, urinals, and baby cribs resemble something they are not—Duchampian ready-mades—until their sly anomalies give them away as artful simulations, loaded with issues quite sharply different from those of the art-historical referent, in this case Dada. By no means merely designated, the sinks climbing the wall in fig. 641 were carefully hand-

left: 641.
Robert Gober.
The Ascending Sink.
1985. Plaster, wood,
wire lath, steel and
semigloss enamel paint;
30 × 33 × 27" each
of two pieces.
Private collection,
New York. Courtesy
Paula Cooper Gallery,
New York.

above: 642.
Cindy Sherman.
Untitled. 1990. Color
photograph, 4' × 3'2".
Courtesy Metro Pictures,
New York.

made, one by one, not of porcelain or enameled iron but rather of plaster, wire, and paint. Together, material and process bestow upon the banal objects an unexpected, pristine beauty that transcends the utilitarian image to conjure a domesticated Minimalism, perhaps a figurative variant of Judd's stacked boxes. But if this quality relieves the sculpture of the need for specialized context, which ready-mades require in order to be understood as art, the old-fashioned, tenement-style sink emulated evokes the time of the first ready-mades. This was a relatively innocent, almost pre-modern age when cleanliness meant godliness, an association that survives in the American obsession with hygiene. Yet, while real sinks permit the soiled to be washed clean, Gober's fictions lack taps and drains, implying the American capacity to deny reality, especially when this involves disease and death, which no amount of soap and water can forever delay. In the era of AIDS, the implications of such sculpture attained a new intensity once Gober transformed his classic sinks into a pair of urinals aligned side by side.

Cindy Sherman (1954—), in her long series of photographic simulations, has played many parts but none seems more impressive than her

role as heroine of post-modernism's huge critical industry. The first performances came in 1978, when Sherman undertook "one-frame-movie-making," stepped before her own camera, and starred in an expansive repertoire of female stereotypes appropriated from the B-grade flicks, space ads, TV shows and commercials of the 1950s and 60s (fig. 604). In preparation for what became a versatile send-up of cultural convention, recorded in 8-by-10-inch black-and-white prints and called simply *Untitled Film Stills,* Sherman also did the props, lighting, makeup, wigs, costumes, scripts, and direction, succeeding in all these activities just as in those of actress, photographer, and conceptualist. Thus liberated from control by the men traditionally in charge of such functions, Sherman has subsequently expanded both her themes and her techniques, embracing Cibachrome color, 6-foot formats, and scenes fabricated from girlie magazines, children's fairy tales, and grisly horror films, often with the leading lady disguised under false, even grotesque noses, breasts, and bottoms or marginalized by dummies in key roles. Most recently, she has abandoned popular fare and taken up art history, decking herself out as subjects, male as well as female, in paintings from the "schools" of such Old Masters as Holbein, Watteau, Goya, or, as here, Caravaggio (fig. 642). By extending her range in this manner, Sherman also enlarges the history of photography to include styles that preceded the camera's invention, a medium whose democracy is reflected in the Sherman oeuvre, where social and aesthetic hierarchies crumble as the artist explores with equal interest throughout a great dispersion of differences among genres and idioms. Not only does this assert the multiple-personality syndrome endemic to a culture as alienated or mediated as ours; it also reflects the fact that artifice lies at the heart of culture, distinguishing it from nature. Thus, for all their obvious contrivance, Sherman's images eventually come to seem, for post-modern eyes, not so much fake as hyper-real.

One of the several scandals associated with deconstruction erupted when it became evident that the ideology itself could be deconstructed, by an artist, naturally, who ranked among the most adept at carrying out the deconstructionist "project." This was Sherrie Levine (1947—), an avowed feminist deeply versed in the latest Continental theory and determined to interrogate modernism's sacrosanct notions of originality, progress, and the masterpiece. For a notorious start, she rephotographed reproductions of celebrated works by famous male photographers—Eliot Porter, Edward Weston, Alexander Rodchenko—and exhibited the matted, framed prints as her own, not in homage or in self-abasement but

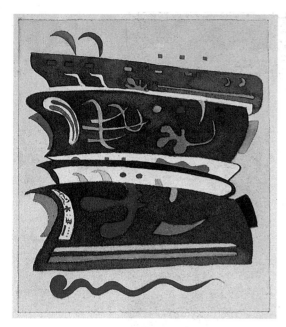

rather in bold assertion that all art, far from autonomous, is the product of history, memory, and culture. When accused of copyright infringement, Levine cited Barthes, who had written that "a picture is a tissue of quotations drawn from innumerable centers." To prove it, the artist could point out that in pirating Weston she had also confiscated ancient Greek sculpture, which Weston appeared to have copied in the photographs he made of his young son's nude torso. Not only did Levine foreground the oedipal relationships in this male dynasty; she also interrupted the chain of command in order to link herself to it. For a new series of appropriations, Levine replaced the camera with watercolor and hand-copied reproductions of paintings by such masters of high modernism as Malevich, Kandinsky, Mondrian, and Léger (fig. 643). Here, by using small scale, delicate touch, and a medium traditionally associated with women's art, she expanded her feminist critique of aesthetic patriarchy. Ironically, the process also allowed the art to evince a degree of poetry or originality, which could not but scandalize the ideologues who had appropriated her as their paradigm of the post-modern artist denying creativity in order to escape commodification. In response, Levine commented, in an interview with Gerald Marzorati: "I never thought that I wasn't making art, and I never thought of the art I was making as not a commodity. . . . I believed I was distilling things, bringing out what was being repressed. . . . I was getting tired of no one looking at the work, looking inside the frame. And I was getting tired of being represented by men."

To articulate her position more clearly, as well as elude a new variety of male domination, Levine reinvented formalist painting in a series of "generic" abstractions that synthesize the entire family of stripe painters, Daniel Buren as well as Newman and Marden, without actually miming any one of its members (fig. 644). But far from backsliding into New York School heroics, she contrived to make Minimalist holism and grand self-sufficiency look funny, fragmentary, and thus significant only in relation to precedents and precepts outside itself. Since, according to post-modernism, contingency is the condition of all art, Levine dramatized this reality by moving into sculpture, for which she appropriated forms from *The Bride Stripped Bare by Her Bachelors, Even*—the legendary *Large Glass*—of Marcel Duchamp, whose "invention" of the ready-made launched the appropriation strategy (fig. 645). Recalling that Duchamp had envisioned *The Large Glass*'s nine chocolate or "malic" molds—those bizarre little signifiers of a delivery boy, policeman, undertaker, priest, etc.—as filled with "spangles of frosty gas," Levine decided to cast them in frosted glass and thus complete, at least in part, a famously unfinished modern masterpiece. Once each had been displayed in a handsome vitrine, and illuminated like a precious jewel at Tiffany's, the ensemble became a three-dimensionalization of Duchamp's flat, transparent diagram, "a feminist coup de grâce," as Roberta Smith called it, in which the artist, playing the Bride, had laid bare "the master's bachelors for all to see." With the tables thus turned, the ghostly "images of frustrated desire," brought into being by the least commodifiable of all artists, have replaced the Bride and themselves become "objects of frustrated desire"—that is, castrated from the body that gave them their original, enigmatic meaning and now rendered meaningful in a new, quite different way, as cool, impotent, opaque commodities in an overheated market.

Like John Baldessari, Joseph Kosuth, Lawrence Weiner, Art & Language, Ed Ruscha, On Kawara, and Hanne Darboven, Jenny Holzer (1952—) uses words or texts as imagery. Departing from those earlier

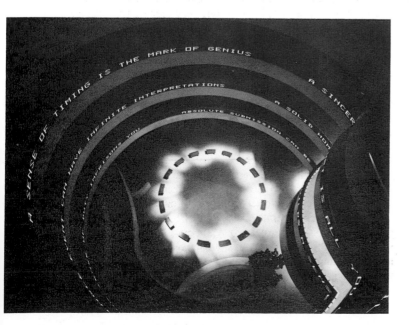

above left: **643.** Sherrie Levine. *Untitled (After Vassily Kandinsky).* 1985. Watercolor on paper, 14 × 11". Courtesy Mary Boone Gallery, New York.

above center: **644.** Sherrie Levine. *Untitled (Broad Stripe: 3).* 1985. Casein on wood, 24 × 20". Courtesy Mary Boone Gallery, New York.

above right: **645.** Sherrie Levine. *Untitled (The Bachelors: "Livreur de grand magazin").* 1989. Glass, 10 × 2½ × 2½". Courtesy Mary Boone Gallery, New York.

left: **646.** Jenny Holzer. *Installation.* 1989. Solomon R. Guggenheim Museum, New York (partial gift of the artist).

Fin de Siècle

Conceptualists, however, she follows Laurie Anderson in her search for ways to make modern technology subservient to a kind of populist, cultural critique rarely tolerated by the popular media. Thus, Holzer too has moved with increasing authority from the graffiti environment of SoHo street art into the grandest of public venues, beginning with the famous moving-message Motogram in New York's Times Square and climaxing, momentarily at least, at the Solomon R. Guggenheim Museum, where she revealed herself to be an installation artist of great power and invention (fig. 646). Along the way, Holzer has elaborated her "writing" from such "Truisms" as "MONEY CREATES TASTE" into the monologue-like narratives called "Laments," one of which begins: "THE NEW DISEASE CAME. I LEARN THAT TIME DOES NOT HEAL." These Holzer has often engraved on stone sarcophagi as if they gave voice to a woman, man, or child entombed thereunder. Yet, the granite grave-markers function mainly to anchor and lend weight to the more mercurial, and more celebrated, form she gives her slogans in computer-animated LED (light-emitting diode) machines, which convert the texts into streams of electronic red, green, and yellow racing like

right: 647.
Rebecca Horn. *Lola.*
1987. Metal, paint,
and tap shoes;
12'2" × 10" × 12¼".
Courtesy
Marian Goodman
Gallery, New York.

left: 648.
Christian Boltanski.
*La Grande Réserve
(The Great Caution).*
1988. Photographs,
tin biscuit boxes,
and electric lights;
6'11" × 12'4" × 10½".
Courtesy
Marian Goodman
Gallery, New York.

[It is] very important to go under the skin, to journey beneath the surface, to scratch about in search of something, to liberate a certain energy, to simply shake people, and wake them up. Especially in our time, you have to have a jolting attitude and then afterwards caress. It's very important to commit oneself, even to destroy certain existing values and through this destructive process discover something more meaningful and build something new.

rockets up structural posts or slowly snaking round the Guggenheim's coiled ramps. With her child-like diction, activist alarm, and sense of spectacle, Holzer, perhaps more than any other Conceptual artist, has succeeded in releasing the surreal in language, as well as in making words take command of space with something like the emotional, physical drama of a Serra sculpture.

Rebecca Horn (1944—) mixes Performance and mechanized Kinetic Art to create intuitive works designed to explore the meanings and effects of alienation, seduction, and power. The viewer, if at first amused, may soon wax uneasy in the presence of the German artist's *Lola* (fig. 647), a quirky robot that repeatedly drops a paintbrush from near the ceiling into a small pot of crimson paint, then jerks it backwards to spatter pigment all over the wall and finally onto a pair of red dance shoes suspended near the floor. Title, props, and gesture may stir emotions associated with Lola Montez, one of the 19th century's tragic heroines, or the doomed ballerina of the eternally popular film *Red Shoes,* or yet Jackson Pollock. But the footwear also triggers thoughts of Dorothy in *The Wizard of Oz,* who, with her robot, the Tin Man, survived the tornado of experience to find hope and renewal in a disordered world. With the timing of a circus master and the precision of a Swiss watchmaker, Horn characteristically entertains and unnerves her audience in a theater of eerie, surreal silence ceremonially broken by subtle, offbeat calls and responses between, for instance, a methodically revolving lance, the sudden, heart-stopping crack of a whip, plastic bugs in crashing, head-on collisions, and, finally, the gentle flutter of paintbrush wings. To illuminate the strange sadism and sensuality of her art, Horn once commented:

As in so much art made in the eighties, loss of innocence haunts the work of Christian Boltanski (1944—), with reverberations, moreover, special to Europeans who, like Kiefer as well as Boltanski, were born in the closing days of World War II. But while Germany's Kiefer translates the Nazi nightmare into operatically scaled paintings replete with mythic content, Boltanski, the son of a French Catholic/Jewish couple who barely survived the Occupation, employs "real-life" materials, mainly snapshots or school portraits of children and adolescents, *povera* "time-capsule" memorabilia, and small electric lights, to "document" the desperately poignant anonymity and numberlessness of the Nazis' victims (fig. 648). As the quotation marks imply, Boltanski functions rather like an archaeologist digging in the past; yet the means he uses to reconstruct history are those of fiction, composed from a huge inventory of faces appropriated by the artist over a period of years. And so the images may or may not portray actual victims, just as the pitiful artifacts, presented in little biscuit boxes made by the artist himself, may or may not have belonged to the war's uprooted and condemned. Steeped in post-structuralist theory, Boltanski discounts originality, authenticity, and individuality, which, ironically, enables him to deal all the more effectively with the vagaries of memory or, better yet, with memories he never had—of events that preceded his own birth—simply by fabricating or reinventing them. As simulacra, his memorials possess an almost magical hyper-reality, the consequence, in part, of the images having been rephotographed and enlarged several times over, until they become signs with neither signifiers nor referents. And when framed in old battered tin, illuminated one by one with clamped-on school-desk or votive lamps, festooned in tangled electrical cords, and mounted on walls in repetitious, serial ranks, the spectral, putative siblings of Anne Frank stare out with fixed expressions like icons in a chapel darkened as if for a seance. Sensing that photography, like death, transforms its human subjects into objects that, as with cadavers, more or less resemble one an-

other, Boltanski uses camera-made imagery as impoverished, modular material, thus potent metaphors, in altar-like assemblages whose hushed, softly aurated presence summons a disquieting awareness of the absent and the forgotten. The effect assumes *noir* overtones in one commemorative "retable" whose visages represent not only victims but also the criminals who victimized them, all mixed together like complementary signifiers and rendered indistinguishable in death by camera and resurrection by art.

Thanks to Cold War détente, the Duchampian spirit ignited a few sparks even in the dark cultural night of the Soviet Union, once Western magazines arrived in the late 1960s, bearing the news of Pop and its way of conjoining art and everyday culture in satiric, mutually critical discourse. Vitaly Komar (1943—) and Alexander Melamid (1945—), a two-man collective in Moscow's collective society, responded to Pop by inventing "Sots," which, as the term connotes, would subvert Socialist Realism, the style mandated for all Soviet artists, by using it to debunk, rather than glorify, post-Stalinist Russia. Whereas Pop poked fun at American overproduction of consumables, Sots ridiculed the Communist system's overproduction of ideology in lieu of consumer goods and services. Seventies détente being a far cry from eighties *perestroika*, Komar and Melamid soon found it expedient to emigrate, first to Israel and then to New York, where their old-fashioned academic training left them well prepared to become avant-garde, practicing Sots with a brilliant plurality of styles that few American post-modernists could match. It also enables them to satirize with wry, conceptual subtlety as in *The Origin of Socialist Realism* (fig. 649). Combining a grandly Baroque manner with Soviet-style official portraiture, Komar and Melamid recall how the Communist regime exploited the highest forms of art to legitimatize the lowest, most dastardly deeds. Yet, though Joseph Stalin has replaced the young Greek warrior in an ironic reinterpretation of a myth about the origin of painting, the scene preserves enough of the tenderness characteristic of older versions to suggest nostalgia on the part of Komar and Melamid for the would-be "Utopia" in which they grew up, even as its artificiality is metaphorically confirmed in that of the glazed and glistening picture itself.

By the time Komar and Melamid arrived in the West, the small, underground world of "unofficial" artists they left behind had taken on a life all its own, sustained not by aesthetic consensus but rather by a common resistance to the utter falsehood of state-approved "official" art. Spottily informed about Western trends and thus free of their imperatives, Russia's nonconformists strove independently, of one another as well as of history, to nurture their own particular aesthetic and philosophical tendencies, towards Constructivism, Expressionism, Surrealism, or whatever, but most outstandingly towards Conceptual Art in all its variety. So telling were the Conceptual pieces of artists like Ilya Kabakov (1933—), Erik Bulatov, and Ivan Chuikov, that, through diplomatic pouch, contact with émigrés, and visits from critics and dealers, they had

right: 649.
Komar and Melamid.
The Origin of Socialist Realism.
1982–83.
Oil on canvas, 6 × 4'. Courtesy Ronald Feldman Fine Arts, New York.

below: 650.
Ilya Kabakov.
My Mother's Life; He Lost His Mind, Undressed, Ran Away Naked.
1989–90.
Installation.
Courtesy Ronald Feldman Fine Arts, New York.

already been shown and even collected in the West by the time Mikhail Gorbachev initiated *glasnost*. And come the *perestroika*-shock of Sotheby's Moscow auction in July 1988, which generated $3.4 million from the sale of Russian art, mainly that of the contemporary underground, the entire world, including an astounded Soviet public, knew about the achievements of both Kabakov and Chuikov. The exemplary Kabakov specializes in an old Russian genre requiring that the voice and views expressed be those of someone, usually invented, other than the artist. Casting his characters in albums, text-and-found-object paintings, oils, and installations, he explores their all-too-human consciousness as it copes with the unyielding tedium of postwar Soviet life. In one New York installation, Kabakov had viewers move along a shabby, maze-like corridor painted institutional gray/brown, lit with bare bulbs hanging by their cords, and punctuated by chipped and peeling closet doors (fig. 650). The walls served as a makeshift gallery for a seemingly endless series of black-and-white scenic photographs, each accompanied by a typed statement. While the images, taken by the artist's uncle, evoked a picturesque, bucolic Russia, they appeared, for this very reason, to mock the texts, recounting as these did a tale of relentless woe. At the request of Kabakov, his eighty-year-old mother had written about her own life, spent in periodic search for a place to sleep in one communal situation after another, on floors, in trunks, on chairs but rarely in an actual bed. In the communal area at the end of Kabakov's reconstructed corridor came another installation, this one narrating the tragi-comedy of a fictitious anti-hero whose own rule-ridden organization of the shared household became so intricate and rigid that even he could not follow the schedule. As the title of the piece dryly noted, "He lost his mind, undressed, ran away naked." Impressed by the new Russian art, the New York critic Kim Levin commented:

We'd better think twice before we cry derivative. Simulation and appropriation mean something different in a place with a past diametrically opposite to ours. . . . Artists who came up behind the Iron Curtain know a lot more about our art than we do about theirs, but they also have a history of oppression far more heavy than formalism to react against, and an ingrained sense of the power of spectacle and façade. They have a subtler understanding of signs, symbols, and absurdity. The new Russian artists are jogging on a parallel track. Don't be surprised if they take their cues from us and run with them.

top: **651.** Allan McCollum. *Five Perfect Vehicles.* 1985–87. Acrylic on solid-cast Hydrocal, 19½ × 9" each. Courtesy John Weber Gallery, New York.

right: **652.** Jeff Koons. *Rabbit.* 1986. Stainless steel, 41 × 19 × 12". Courtesy Sonnabend Gallery, New York.

above: **653.** Haim Steinbach. *security and serenity.* 1986. Mixed-media construction, 30 × 31 × 13". Courtesy Sonnabend Gallery, New York.

Neo-Geo

The spectacle and façade just cited are the sort theorized in the 1930s by Walter Benjamin, who saw a great metaphor for the modern condition in Paris' glittering arcades (see fig. 270), those precursors of present-day shopping malls, where the sheer illusion of well-being, generated by theater-like offerings of seductive wares and information, kept the public entranced and thus deceived about the emptiness of their passive, manipulated lives. With the advent of electronic communications, spectacle became phantasmagoria, inciting the French philosopher Jean Baudrillard to argue that, in post-industrial society, appearances or *simulacra* had supplanted reality entirely, to the point where politicians get elected on the basis of their TV presence, while products get purchased for reasons of image rather than need. As recent auction prices confirm, the most spectacular of all such consumer items are now art works, co-opted and commodified until, according to Baudrillard, voided of meaning except as fungible objects of desire—fetishes. Meanwhile, of course, post-structuralists have denied artists their originality and stripped their work of aura, leaving post-modernists to make do with appropriations from past greatness or the popular world with which the media scramble it. Sanctioned by Baudrillard, a group of East Village artists decided around 1982 to adopt a tactic somewhat different from appropriation, especially since their immediate purpose was to counter the "regressive" painterliness, subjectivity, and overheated iconography of the Neo-Expressionists, some of whom were major appropriators. Overall, however, what Peter Halley, Ashley Bickerton, Meyer Vaisman, Jeff Koons, and Haim Steinbach aimed to achieve, in a great diversity of ways, were paintings and sculptures as thoroughly ideated as Conceptual Art yet also as visually captivating as anything available from either

formalism or expressionism, or indeed the admass culture itself. Peter Nagy, writing in a 1985 exhibition catalogue, likened the program of these Neo-Conceptualists to "Infotainment," meaning the "hybridized products of the broadcast and publishing industries, hybrids that reconcile pleasure and hard fact." A year later, at an ICA show in Boston, their strategy was called "endgame," which conjured not only the terminal play in a chess match but also Marcel Duchamp, the primal ancestor of all Conceptualists who spent his last many years at a chess board, thereby acting out late modernism's struggle to prevail with ever-more reduced means. And so, moving beyond appropriation, the artists to be seen here opted for simulation, which involved reformulating rather than merely annexing cultural products, the better to render them hyper-real, just as the media do. At the same time that simulation promised to recover for art some of the energy as well as the distance lost through commercial exploitation, it would also make the emptied art work seem re-endowed with content, with meaning comprised of social as well as aesthetic critique. Cindy Sherman demonstrated the principle in her Untitled Film Stills, Sherrie Levine in her generic abstractions, Mark Tansey in his reverse collages, Robert Gober in his sinks, Christian Boltanski in his memorials, Art & Language in their "Pollock-style" portraits, the Photo-Realists in their renderings of color slides, Pat Steir in her stylistic *Vanitas*, Jasper Johns in his *Ale Cans*, or Andy Warhol in his *Brillo*. If Halley and company managed to set themselves apart, it was not solely because of their joint shows, manifesto-like writings, and unashamed eagerness to benefit from capitalist marketing techniques while simultaneously ridiculing them. In addition, they shared a tendency—albeit a highly variable one—to reconstitute Minimalism, or even earlier forms of radical abstraction, in post-modern terms—that is, as a sign within the larger discourse of signs. Colloquially known as Neo-Geo, this kind of simulation found a model ally in Allan McCollum (1945—), whose *Perfect Vehicles*—rows of identically shaped, solid-plaster, vase-like objects—parody Minimalism's serial simplicities through representing them like mass-produced, department-store wares, articles differentiated by color in order to seduce consumers with an illusion of choice (fig. 651). Citing the "apparent antagonism" between one-of-a-kind art works and standardized products, McCollum said: "If I can dramatize that antagonism, it should reveal that these are just two aspects of the

same thing." As for the subtext of *Perfect Vehicles,* one has only to consider their resemblance to funerary urns, then recall how frequently modernism has courted its own death—its own consumption—by forever attempting to override all limits and, as Ad Reinhardt said way back in 1954, "paint the last paintings anyone can paint." Knowing that the eternal pursuit of the new entails almost instant demise and never-ending obsolescence, Sherrie Levine spoke of "the uneasy death of modernism," adding, on another occasion: " . . . there is a long modernist tradition of endgame art. . . . It's a no-man's land that a lot of us enjoy moving around in, and the thing is not to lose your sense of humor, because it's only art." Thus, Neo-Geo.

A onetime commodities trader, Jeff Koons (1955—) fairly revels in the commodified world of contemporary art, to the point where items from such retail outlets as department and sporting-goods stores, souvenir shops, and fun fairs constitute the very feed stock of his sculpture, converted into art either by display in a specially made vitrine or by refabrication in a new, costly material (fig. 652). Once isolated in Plexiglas showcases or floated dead center in aquaria, Koons' vacuum cleaners and basketballs become emblems of eternal newness, youth, innocence, purity—that is, objectifications of the kind of desire that the moneyed impure feel most tempted to satisfy, if only by paying steep prices to acquire works like the gleaming one seen here. In the present instance, however, Koons did not merely recontextualize his readymade; rather, he had an inflated bunny balloon cast in stainless steel and polished to resemble a Pop Brancusi. With this association, the piece gains a high-art allure more durable than that of context, an aura ironically refreshed by the childish, even nostalgic image, the state-of-the-art casting process, and an awareness that the thirty-two-year-old artist's breath has been forever preserved inside. Yet, complicit as *Rabbit* may be with the silly, vernacular world it would seem to critique, Koons has managed to layer his sculpture with such an abundance of fascinating metaphor, for both art and life, that he may indeed have proved himself endowed with an alchemical, Midas touch, capable of translating the light, familiar, and ephemeral into the weighty, mysterious, and everlasting. By the same agency, he transforms himself from a futures trader into a genuine artist, albeit one with a Wall Streeter's respect for the market and the strategies necessary to target it with breathtaking success.

Like Koons, Haim Steinbach (1944—) demonstrates how modernism has been so absorbed into the world's commodities that it can be reconstituted from them. Still, this is modernism with a significant difference, stripped as it is of all transcendental value and merely simulated from its surrogates in the marketplace. For Steinbach, commerce involves not only sleek shopping-mall products but also the equally sleek products of a Minimalist like Donald Judd, whose horizontal box reliefs Steinbach evokes in wedge-shaped, Formica-finished shelves (fig. 653). Brought together in displays that mimic those both in department stores and in MoMA's design department, the serial agglomerations of unmodified consumables combine with the custom-made, generic Minimalism to suggest how choices and arrangements—whether made by consumers, collectors, or curators—generate all manner of content having less to do with transcendence than with "status, sentiment, nostalgia, fetishism," as Steinbach himself phrased it. Often the implications are sly indeed, as in *security and serenity,* where utilitarian toilet-bowl brushes, thanks to the understated, sculptural elegance of their form, make a wry comment on video-blue Lava Lites, whose excruciating vulgarity would not preclude their being displayed as art in some middle-class den or living room. Steinbach acknowledged the elevated status frequently accorded the Lava Lites' degraded modernism—really a kitsch conflation of Op, Kinetic, and Light Art—by placing them a step higher than the humble yet aristocratically designed brushes.

The chief theorist of Neo-Geo, Peter Halley (1953—) is also the only pure painter in the original group, the sole member whose work

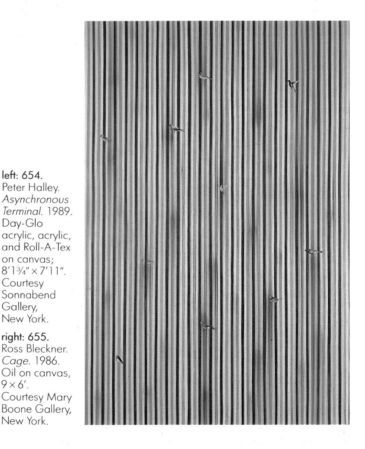

left: 654.
Peter Halley.
Asynchronous Terminal. 1989. Day-Glo acrylic, acrylic, and Roll-A-Tex on canvas; 8'1¾" × 7'11". Courtesy Sonnabend Gallery, New York.

right: 655.
Ross Bleckner. *Cage.* 1986. Oil on canvas, 9 × 6'. Courtesy Mary Boone Gallery, New York.

genuinely conforms to the identifying label, and one of the most furiously debated of all contemporary artists. Here, the problem begins with Halley's denial that his manifestly abstract canvases are "abstract," by which he means that they look abstract, not because of any outdated, self-referential formalism, but rather because their geometric imagery reflects or represents the reality of the socially constructed, urban world they inhabit. Moved by the cell-like isolation of individuals in New York City and the electronic circuitry of their support systems, Halley devised a symbolic language compounded of Albers' square, computer software diagramming, high-tech comics, complete with their "wacky" brutalism, and the huge scale as well as the confrontational address canonic in the New York School (fig. 654). He then backed one panel with another, in recognition of the network's underground location, of the hidden within the visible, of the subconscious active below the conscious. Next came

the glare of Day-Glo colors in jolting combinations applied over rippled, stucco-like Roll-A-Text surfaces, the quivering effect of which alludes to the synthetic quality of ubiquitous video light and the high, intense energy needed to power the information age. But apart from the sheer blatancy of the overall effect, Halley's paintings create scandal because their wired cells seem less obviously metaphors for the post-industrial condition than perverse homages to older modernists, not only Albers and Newman but also Stuart Davis, in his proto-Pop fascination with pipes and conduits. Rather than banish extra-aesthetic baggage in order to liberate painting into soaring life all its own, Halley cultivates an "endgame" abstraction whose appropriated forms simulate geometric styles and, by this clever, even if cynical, gambit, demonstrate just how enslaved modernism always remained to the extra-aesthetic world.

Almost as an antidote to the perceived nihilism of Koons, Steinbach, and Halley, Neo-Geo gathered into its orbit several exceptionally strong painters who wanted to simulate not merely the styles of historical ab-

far left: 656. Ross Bleckner. *Fallen Object.* 1987. Oil on linen, 4′ × 3′4″. Courtesy Mary Boone Gallery, New York.

left: 657. Philip Taaffe. *Abraham and Isaac.* 1986. Mixed media on canvas, 6′11″ × 4′7¼″. Courtesy Pat Hearn Gallery, New York.

above: 658. Philip Taaffe. *Rosette.* 1987. Mixed media on canvas, 10′ diameter. Courtesy Pat Hearn Gallery, New York.

straction but their sense of the sublime as well. Ross Bleckner (1949—), the senior among these Neo-Romantics, also gave Neo-Geo its own Hans Hofmann, gaining significant recognition only after younger painters, mainly Halley and Taaffe, had captured art-world attention and proclaimed him a major influence on their work. Again like Hofmann, Bleckner makes light and energy the real subject of his painting (figs. 655, 656), the practice of which he carries out with almost as much devotion, virtuosity, and variety as the famous older master, albeit with a black-humored melancholy and doubt altogether alien to the optimistic modernism so wholeheartedly embraced by Hofmann, as well as by his own mentors and disciples. While among these light and energy served as metaphors for the power of painting to illuminate the world and reveal its oneness, they operate in Bleckner's elegiac vision as symbols of a world in disarray, of a *fin-de-siècle* culture burnt out by its own competing interests, by loss of faith in the possibilities of resolution, by incurable disease, and by a doomsday fear of nuclear annihilation. As exposed as Salle and Fischl to the Conceptualism articulated by John Baldessari at Cal Arts, the New York-born Bleckner seemed far more torn than his classmates between a post-structuralist sense of painting as a dead or dying art and his helpless, perhaps necromantic love of doing it. Little wonder that the artist has called himself manic-depressive, an inner conflict that he learned to externalize not only by working in two quite different styles, both appropriated and already considered decadent in their own times, but also by cross-dressing them in oddly anachronistic, tension-heightening, yet glamorous ways. In neo-Op works like *Cage* (fig. 655), Bleckner increased the retinal buzz of ornately colored ribbon stripes by hand-painting them with softly blended, slightly wavering edges, which makes the light they generate seem occluded, as though the

pulsating rays of a crepuscular sun were pushing from behind gates, prison bars, or tall trees in a dense, tropical forest. If the last effect appears reinforced by the presence of tiny, realistically rendered songbirds sprinkled over the surface, rather like figurative versions of Poons' jumpy ovals, it is also canceled by the reference this makes to wallpaper, suggesting the commodified, decorative fate to which most art seems ultimately condemned.

For Philip Taaffe (1955—), one of Bleckner's most talented admirers—as well as for the ever-intriguing Sigmar Polke (figs. 611, 612)—a simulated or degraded sublime is better than none, which position he articulated as follows:

We will construct a mock-sublime to summon the sublime by indirection, because teasing or entertaining the sublime is just another way of aspiring toward sublimity. I'm interested in a sublimity which encourages laughter and delight in the face of profound uncertainty. And, finally, I do not care to argue against the possible coexistence of the sublime and the beautiful, if it can be envisioned as a terrible and awesome synthesis.

Certainly, Taaffe has provoked laughter as well as awesome rage among the many who find something sacrilegious about his quirky reinventions of modernist styles, whether these be the widely dismissed Op Art of Bridget Riley or the revered Color-Field painting of Barnett Newman. Delight, meanwhile, wells up in viewers who see *Abraham and Isaac*, for example (fig. 657), as much more than a cynical rip-off of Newman's authentically sublime *Onement II* (fig. 79). Indeed, they discover beauty not only in the image and meticulous craftsmanship set before them, but also in the oblique reference to Matisse, made through the twisted cord—a decorative motif familiar in Hermès silk scarves—that replaces Newman's Zeus-like bolt or "zip," thereby echoing P&D before stirring memories of the French master's proud definition of himself as a "decorator." Then, too, as Jeff Perrone has pointed out, Matisse's postwar *découpages* provided a procedural as well as pictorial model for Taaffe's own brand of post-modern painting, which involves hand-collaging mechanically printed linocuts or serigraphs onto canvas and then enameling the whole to form an ostensibly single or continuous surface. Finally, the beauty/sublime equation formulated by Taaffe assumes even greater in-

tricacy when one recalls, as Perrone does, that in painting *Vir Heroicus Sublimis,* Newman was himself recasting Matisse's *Red Studio,* "right down to the 'drawing' that was a band of unpainted canvas, and which was itself an inventory of a personal history of painting" (figs. 18, 80). Most important, however, it leads the artist out of the endgame trap and into an open-ended process of simulating known styles—Gothic rose windows, Arabic or Twombly-like calligraphy, field-painting colors, hard-edge abstraction—not in order to trash but rather to use them as marvelous subject matter, democratically available for recombination in fresh, even *original,* hybrids sufficiently laced with irony to assure their peculiar, synthetic gorgeousness some degree of the "terrible" and the "awesome" (fig. 658). In a recent review, Eleanor Heartney wrote: " . . . long after Baudrillard has ceased to be required art-world reading, we will still be interested in looking at work, like Taaffe's, that is visually as well as conceptually compelling."

Neo-Abstraction

If any artist emerging in the eighties had the courage *not* to read Baudrillard, he or she might very well be found among those loosely described as Neo-Abstractionist, talents still persuaded not merely of painting but indeed of nonobjective painting as an aesthetic vehicle unsurpassed in its potential for illuminating human experience. But, as we have just seen, even a few Baudrillard readers have had the courage to paint abstractions, despite the post-modern critique of it as too elitist, self-absorbed, and inaccessible—or, on the contrary, too easily commodified as a decorative object—to be an effective agency for either ideas or emotions in an age overwhelmed by the chaotic mass of popular, mediated imagery. The urge to work with color on canvas proving nonetheless irresistible, artists like Levine, Halley, Bleckner, and Taaffe simply went on doing it, convinced that, if based on post-modern strategies of appropriation and simulation, their abstract painting would defy expectations and lead to new modes of perception and thinking. Meanwhile, many other artists, like those to be seen here, heeded the same urge, with all sorts of justification, ranging from a less doctrinaire involvement with irony than that of Levine, Halley, et al., to a continuing, "innocent" belief in the integrity of pure forms and "autonomous" strokes. As Sean Scully said: "I'm interested in art that addresses itself to our highest aspirations. That's why I can't do figurative paintings—I think figurative painting's ultimately trivial now. It's humanism and no form." In other words, quality—that elusive, connoisseur value traditionally paramount in art but reviled by post-modernists more concerned with politics than aesthetics—still loomed large as a significant issue, for those, anyway, brave enough to persevere in the kind of artistic production least likely to generate critical excitement. In art, however, the pendulum of taste never rests, and however parodistic the canvases of Levine and Halley, they represent a revival of interest in abstract painting, which surfaced midway through the eighties. It arrived, of course, as part of the reaction against Neo-Expressionism, but flourished because of the quality encouraged by the marginalized position forced upon painters seeking to depict essences rather than appearances. David Reed acknowledged the paradoxical benefits:

When you're out of public view, it gives you time to learn how you want to proceed. The situation was worse when abstraction—but only abstract art about process and surface—was prominent. There was a pressure to conform. Now the situation seems open again. A lot of re-examination has been going on in abstract painting. People don't know what abstraction should be, and so it can be any number of things.

It could be anything, that is, but progressive, rigidly self-referential Minimalism or its opposite, spontaneous, sublimely extrovert Abstract Expressionism, even though both were still practiced with inspiring freshness by such aging masters as Willem de Kooning, Robert Motherwell, Ellsworth Kelly, Robert Ryman, Agnes Martin, and Brice Marden. Equally vigorous in his witness to pictorial abstraction was Frank Stella, arguing both in his book *Working Space* (1986) and in his art for abstract painting (really wall reliefs) with all the robust drama and complexity of a proto-Baroque painting by Caravaggio. However, Stella too

went his own way, as did the Neo-Abstractionists, all of them post-modernists to the degree that they resist modernism's totalizing impulse and proclaim not the autonomy or transcendence of their work but rather its contingency. As a consequence, the paintings invariably refer to something beyond themselves, usually to earlier styles, often in a combination of analytic geometry and poetic gesture, with these overlaid or layered in the manner characteristic of post-modern art (figs. 659, 660). They also reflect the world at large, whether this be the voluptuous ambience of Naples or the thorny East/West conflicts of pre-unification Germany. From the latter environment came the most celebrated of all the Neo-Abstractionists—actually one of the genuine luminaries of our time—Gerhard Richter, whose binary stylistics proved their universality by appealing to deconstructionists and reconstructionists alike. While pessimists saw the Richter oeuvre as the ultimate demystification of painting, optimists hailed it as an heroic attempt to "work through" the "death of painting" and thus extend the language of art, just as the greatest masters have always done. As this infers, some of the painting about to be seen could appear under the Neo-Conceptual heading, except that, like the sculpture reviewed earlier, the forms alone provide enough eye-filling satisfaction to engage viewers in rich discourse even before the subtext reveals a new dimension of meaning.

below: **659.** Sean Scully. *Why and What (Yellow).* 1988. Oil on canvas, 8 × 10'. Hirshhorn Museum and Sculpture Garden, Washington, D.C. Courtesy David McKee Gallery, New York.

bottom: **660.** Jonathan Lasker. *Today's Universe.* 1988. Oil on canvas, 7'6" × 9'4". Courtesy Massimo Audiello Gallery, New York.

Unfazed by post-modern pieties, Howard Hodgkin (1932—) turned English insularity to singular advantage as he slowly, quietly cultivated his own artistic turf until, during the 1980s, it yielded a harvest of work so ravishing and deeply intuited that only the most rabid anti-formalists could doubt the power of abstract painting, even now, to speak with a timely and moving voice (fig. 661). To remain so serenely secure in his commitment to an aristocratic art, Hodgkin no doubt benefited from the intellectual aristocracy of his family, an old Quaker clan replete with historians, antiquarians, a scientist after whom Hodgkin's disease was named, and Roger Fry, a founding member of the Bloomsbury circle and the pioneer advocate of Post-Impressionism in the English-speaking world. From this background he inherited a different kind of Hodgkin's disease, namely a passion for collecting, which, in his case, became symptomatic when he contracted a schoolboy, though lasting, weakness for Rajput and Mogul miniatures, a condition that would also, and delightfully, afflict Francesco Clemente. From Roger Fry, and such Bloomsburies as the painters Duncan Grant and Vanessa Bell, Hodgkin may have inherited his love of Nabis intimism, especially as translated by the Fauve Matisse into a gorgeously patterned surface constructed of sensations, memories, and their color equivalents. "I am a representational painter," the artist once said. "I paint representational pictures of emotional situations." The situation that seems most effectively to stir him is a Proustian one, heightened moments involving specific people, often the artist himself, in complex, fine-tuned relationships as well as in particular settings, usually closed, and then filtered through the purifying screen of prolonged reverie. However, for his "Neapolitan" works, executed in the early 1980s following a sojourn in Naples, the subject became pure rapture, as the artist let his northern soul open, like David Hockney's in California, to the voluptuous warmth of a southern, watered environment. The emotion remains potent even in the elegiacally titled *Sad Flowers,* where Hodgkin seems to bid farewell in a cluster of broad, flat strokes that remain refulgently sumptuous as they collapse like falling bodies, columns, or indeed large-petaled blooms, caught at the bottom by a black swath coupled with a blue one, whose Mediterranean color sings of Naples. If, while in the presence of this Rajput/Fauve splendor—a collage of color-forms free-floating in buoyant yet stable counterpoise—viewers sense themselves exploring a subtle, compact surface, gazing through a window, and peering into a mirror, all at the same time, it may be due, in part, to the solid wood panel (preferably from an old piece of furniture ripe with history) on which the whole craftsmanly enterprise began. For, according to Hodgkin, "unless you can first tell the spectator he's looking at a flat thing, you can't otherwise make a hole in it." To leave no doubt about this reality, he paints even on the built-in frame, here in an idiomatic "leopard" version of Neo-Impressionist spotting, and allows the shaggy daubs to tumble onto the central plane. Exploiting his vocabulary of blazing colors and erotic textures—applied in a virtuoso range of wavecurves, zigzags, lava flows, vaporous plumes, creamy glissades, shredded scumblings—Hodgkin leads the eye into a boxed, stage-like space and thence into infinite depth, only for this to be "canceled"—bonded to the surface—by the great earth-dense, beam-like swipes from a heavily loaded brush. Step by step, the optical progress becomes a visual analogue of layered recollections, summoned over a period so extended that the artist dates most of the paintings with double entries. Ideally, the modestly scaled picture is finished "when the subject comes back," complete with the original emo-

tion in all its force and spontaneity, as a poetic distillation—an aesthetically coherent object—of quite specific feeling, intellect, and retinal impact. This is because the paintings are, Hodgkin once said, "for just one person at a time. They're from me to you."

Unlike Hodgkin, David Reed (1946—) would seem to be thoroughly immersed in post-modern ideas. Yet, far from making his art a mere illustration of theory, or an exercise in deconstruction, he uses it to re-energize pictorial traditions dating back to the Baroque, as well as no further than Color-Field Painting or even Neo-Geo. Note, in fig. 662, the contrast between the big, passionate gestures and the cold, filmic medium in which they have been realized, between the slick, reflective surfaces and the depth of field they imply, between the hard-edged blocks of space containing lush folds of color and the expansive, almost run-on format. If all this drama, like the theatrical lighting effects, strident colors, and suave, syncopated design, pays homage to Caravaggio and Rubens, not to mention Jules Olitski and the later Larry Poons, it does so in the ironic manner of Lichtenstein when he parodied de Kooningesque Abstract Expressionism (fig. 249). Lacking real texture and ladled over a secondary color, the abstract, gestural imagery connotes fullness but looks dematerialized and translucent, as if one were examining the slide projection of a painting rather than the work itself. Thus robbed of presence, Reed's paintings come to seem emblematic, as much screeds or discourses on certain concepts about painting as physical facts. But as all who attend art-history lectures know, color slides, or images, may have even greater impact than the objects they represent. So, while distancing himself as post-modernists are wont, Reed also gains license to explore how the Baroque masters could achieve emotional power through the very process of controlling its formal expression. Having succeeded in this, he paints pictures that seem both theoretical and deeply experienced, simulated and genuine, all of which makes the work seen here an

661. Howard Hodgkin. *Sad Flowers.* 1979–85. Oil on wood, 22 × 26¼". Private collection. Courtesy M. Knoedler & Co., New York.

662. David Reed. *No. 278.* 1988–89. Oil and alkyd on linen, 2'4" × 9'4". Courtesy Max Protech Gallery, New York.

almost perfect barometer of the *fin-de-siècle* New York in which it was created.

Gerhard Richter, the German painter whose ''Photo-Abstract'' as well as Photo-Realist canvases we saw in Chapter 12 (figs. 540–542), has insisted that ''making is not an aesthetic act''; yet whatever he makes, be it descriptive or nonobjective, the aesthetic results are so remarkable that the artist joins Polke in offering a skeptical alternative to the romantic Kiefer as the foremost German artist of this generation. Indeed, by virtue of his wizard-like ability to simulate both photographic realism and Abstract Expressionism, Richter may also rival Cindy Sherman as prime grist for the eighties theory mill, which has liked to view his ''impersonal,'' polarized virtuosity as deconstructive, embodying ''a thorough demystification of painting and its pretensions to creativity.'' Yet again, given his capacity for verbal/visual dialectic, it should not astonish that in the same breath with calling ''painting completely idiotic,'' Richter has also asserted that ''art is the highest form of hope.'' Moreover, he considers the semantically diverse paintings of Francis Picabia ''cynical'' and antithetical to his own works, which ''always depict something very directly and very naïvely, and are dependent on how I am feeling.'' So gloomy were his feelings in 1968, at the height of the Vietnam War, that he resolved stylistic discontinuity into the empty, inscrutable, Zen-like unity of his *Gray Pictures (Graue Bilder).* ''Then,'' Richter observed, ''you realize after you've painted three of them that one's better than the others, and you ask yourself why that is. When I see the eight pictures together I no longer feel that they're sad, or, if so, then they're sad in a pleasant way.'' By 1976, this revelation had placed Richter in a better mood, stirring him to rebreak monochromy into its spectral components, at the same time that he resumed working in divergent styles, as we saw in figs. 541 and 542. But however mutually exclusive their involvement with vision or conception, these delicate, chromatic paintings shared a common, distancing reference to neither outer nor inner reality, but rather to the reality of a photograph, which accounts for their soft focus and surface gloss. In 1980, Richter brightened the pandemic ''rebirth''of painting by executing his abstractions directly, instead of mediating them with photography, a change that produced the clarity, brilliance, deep spaciousness, and rich complications of *Atelier* (fig. 663). Ironically, without the filter of projected imagery, the new *Abstrakte Bilder* look all the more photographic, thanks to their sharp focus, prismatic light, and the film-like sheerness or transparency of their layered events. While producing few labor-intensive Photo-Realist works, Richter carries on the rivalry they pose within the very forms of the more immediate, thus more rapidly realized and numerous, abstractions. In the first campaign of work on a canvas, he actually tries to make a finished picture, which seems always to die from his overweening search for the beauty he was taught to desire in Dresden. As a saving antidote, Richter recommences in a different mood and reflects it in a new stratum of pictorial incident, this one more visceral or vulgar than

ideal and aloof. Ultimately, the paint/repaint, advance/reverse process may recur again and again, until the artist finds the results a suitably complex yet lucid harmony of dissonant relationships. To maintain the freshness of his dualities, Richter has evolved and perfected a vast repertoire of painterly effects—troweled, scraped, flung, scumbled, masked, offset—most of which place him at a hands-off remove as great as that of Pollock in his spilling. However, it is Hofmann and de Kooning who seem evoked in the hot/cold, sweet/sour palette, even if the harmony those original Abstract Expressionists sought was holistic, or woven, not layered in a manner now classic throughout much of post-modern art. Further, the paintings of Hofmann, de Kooning, and Pollock all retained the sense of grand, deep-breathing life that had been the glory of Western art since the High Renaissance. Thus, with their frozen, photographic look, Richter's increasingly enormous, bravura canvases become not only post-modern but also heroic metaphors for the paradox of the artist's ever-more energetic and eye-filling performance, carried on despite fears that painting may be dead, as the deconstructionists insist.

As the *fin de siècle* speeds towards millennial burn-out, Doug and Mike Starn (1961—), among other young artists, have so internalized post-modernism as to be virtually free of it, liberated, that is, to exercise post-modern license without being overly determined, or terrorized, by its ideological excess. The Boston-born Starns work in photography, a

favorite medium of painting-averse Conceptualists, as well as of deconstructionists like Cindy Sherman, Sherrie Levine, and Barbara Kruger. But with a simulationist love of romantic Victorian "pictorialism," the very tradition that 20th-century photographers set themselves against, the Starn Twins, as the identical brothers are usually known, could scarcely be less in tune with post-modern cynicism, futility, and doubt. For them, Neo-Geo is a "real cop-out," and while they often recycle art history, as well as violate every convention of modernist photography, their ultimate goal is positive, to offer a "more humanistic, richer imagery that elicits feeling and fantasy" (fig. 664). To achieve the immediacy and mural scale of New York painting, the Twins begin by creating multiple images from a single negative projected onto a movable wall covered with photographic paper. Next, they "age" the developed material by splashing on toners—sepia, blue, red, green, yellow—as well as by

stunning aptness and visual power. Beginning in 1985, Tim Rollins + K.O.S., as the team style themselves, would capture both public and critical attention with their dozen or more interpretations of a late passage in Franz Kafka's fantasy novel *Amerika*. It concerns the hero Karl who, upon joining the somewhat absurdist Nature Theatre of Oklahoma, finds himself welcomed with a "confused blaring" of long, golden, glittering trumpets sounded by "hundreds of women dressed as angels in white robes." In response to Rollins' question, "If you could play a song of freedom and dignity on your own instrument, express the best of what's in you, what would it look like," each of the K.O.S. ransacked art history and made hundreds of sketches before combining with their mentor to produce the distillation seen here (fig. 665). As a metaphor for freedom and democracy, it could scarcely be brassier or more jubilant, a veritable cacophony of madly mutated horns jostled together and inter-

665.
Tim Rollins + K.O.S. *Amerika IV*. 1986. Gold lacquer and oil on book pages on linen, 6 × 15'.

Courtesy Jay Gorney Gallery, New York.

crumpling, creasing, tearing, smudging, and cropping, among other kinds of "beating up." Indifferent to the integrity of image and technique sought by mainstream photographers, the Starns then reassemble the mutilated sheet in elaborately layered collages, cobbled together with Scotch Magic Tape, and finally mount the paper mosaic, sometimes in massive frames made by the artists themselves, or just tack, bolt, or tape it directly to the wall. With the scars of process, or Conceptualist meaning and idea, as much a part of this aesthetic as the pictorialism of a dark, poetic morbidity, the Starns could be said to have achieved the stunning effects of their one-of-a-kind photographic works through a canny marriage of the contemporary and the traditional. The result is an exquisite, fragile, patchwork ruin, suggesting that in the disjunctive, post-industrial era, beauty can be apprehended only as something lost, as memory less recovered than manufactured piecemeal.

The slightly older Tim Rollins (1955—) has learned to make collectivity work on a larger scale, as a means of acting from the margins while triumphing at the center. A onetime English teacher from small-town Maine, Rollins studied at New York's School of Visual Arts, where Graffiti hatched, and then entered the public-school system as an art instructor assigned to the troubled South Bronx. There, he began working after hours with "learning-disabled" black and Hispanic teenagers who showed promise of becoming bright achievers through their passionate engagement with art—Grünewald, Goya, Turner, Redon, Ensor, Picasso, and the current luminaries of SoHo galleries. Hoping to "promote structure and discipline in the kids' lives and give them the training to use their talents toward something positive and socially responsible," Rollins denounced the Graffiti movement as "totally irresponsible." Thus, in 1982, he organized the K.O.S. (Kids of Survival), a nonprofit workshop in which he and about fifteen boys and girls would collaborate to study a classic work of literature or music—Hawthorne's *The Scarlet Letter*, Defoe's *A Journal of the Plague Years*, Schubert's *Die Winterreise*—until they could reveal it anew in a visual image of

twined like a radiant grillwork gate, stretched across and held together by a white horizontal grid made of pages taken from the book and mounted on Belgian linen. For this brilliantly original form of manuscript illumination, the creators acknowledge the specific authorship of every image—even when cleverly appropriated from Leonardo da Vinci, Hieronymus Bosch, or Uccello's *Battle of San Romano*—but compose the whole collectively. Like the process, the resulting format makes room for individual contributions at the same time that, in eighties fashion, it also denies the Renaissance myth of the isolated, unique genius. A disciple of Joseph Beuys, "who felt that art must be created by all, that it's a part of everyday life," Rollins has sought to "extend [Beuys'] teachings into a real situation in a real community." Therefore, he admits, "I couldn't do what I do without the kids; they couldn't do without me. . . . [Otherwise] I'd be just another boring Conceptual artist." When challenged in regard to the ideological "correctness" of his role as a male Anglo leading dark-skinned slum teens through high, white culture, the Spanish-speaking Rollins replied:

That's a middle-class question. These are kids that a lot of people gave up on. They don't have Pablo Neruda and Gabriel García Márquez on the coffee table at home. Their culture is Ninja movies and rap music, which is O.K. But we want to defy expectations. No palm trees, Day-Glo, graffiti, all those stereotypes of Hispanic culture. It's very important for us to make beautiful things.

By refusing to be trapped within the polarizing agendas of the politically earnest, Tim Rollins + K.O.S. have fueled their minds, demonstrated the link between creativity and effective teaching, financed the higher education of their younger members, and favored post-modernism with some of its most visually dense, vibrant, intellectually rich, and joyous works. Best of all, through the taut beauty of such endless, phantasmagoric variations on an erudite theme, Tim Rollins + K.O.S. also suggest that within nostalgic, retrospective, *fin-de-siècle* post-modernism may yet lie hope for a culture destined to open up possibilities rather than close them off.

Bibliography

The first two, unnumbered bibliographies—one on modernism/late modernism and the other on post-modernism—comprise general references providing background information for *Art Since Mid-Century* as well as for the more specialized writings assembled under the various chapter titles, beginning with Chapter 2. Since Chapter 1, "Modernism and Its Origins," is itself a general source for the rest of the book, the relevant bibliography has been integrated with the publications cited under the two broad, "umbrella" headings. For certain of these publications, subsequent citations appear in brief, rather than full, form.

Abbreviations: ACGB: Arts Council of Great Britain, London; AKAG: Albright-Knox Art Gallery, Buffalo, N.Y.; CGP: Centre Georges Pompidou, Paris; HMSG: Hirshhorn Museum and Sculpture Garden, Smithsonian Institution, Wash., D.C.; ICA: Institute of Contemporary Art, Boston, London, or Philadelphia; LACMA: Los Angeles County Museum of Art; MoCA: Museum of Contemporary Art, Los Angeles or Chicago; MoMA: Museum of Modern Art, New York; NGA: National Gallery of Art, Wash., D.C.; RAA: Royal Academy of Arts, London; SRGM: Solomon R. Guggenheim Museum, New York; TG: Tate Gallery, London; WMAA: Whitney Museum of American Art, New York.

Modernism/Late Modernism: General

Anderson, Wayne. *American Sculpture in Process: 1930-70.* Boston and N.Y., 1975.
Arnason, H.H., and Daniel Wheeler. *History of Modern Art: Painting, Sculpture, Architecture, Photography*, 3rd ed. N.Y., 1986.
Ashton, Dore. *American Art since 1945.* N.Y. and London, 1982.
———. *A Fable of Modern Art.* London and N.Y., 1980.
Barr, Alfred H., Jr. *Matisse: His Art and His Public.* N.Y., 1951.
———. *Picasso: Fifty Years of His Art.* N.Y., 1946.
Benezra, Neal. *Affinities and Intuitions: The Gerald S. Elliott Collection of Contemporary Art.* Chicago and London, 1990.
Boime, Albert. *The Academy and French Painting in the 19th Century.* N.Y., 1971.
Bowlt, John E., ed. *Russian Art of the Avant-Garde*, rev. London and N.Y., 1988.
Bowness, Alan. *The Conditions of Success: How the Modern Artist Rises to Fame.* London and N.Y., 1990.
Britt, David, ed. *Modern Art: Impressionism to Post-Modernism.* London and Boston, 1989.
CGP. *Marcel Duchamp: Catalogue Raisonné* (exh. cat., ed. by Jean Clair). 1977.
———. *Paris-Berlin* (exh. cat., texts by Günter Metken, et al.). 1978.
———. *Paris-Moscou* (exh. cat., texts by Jean-Hubert Martin, et al.). 1979.
———. *Paris-New York* (exh. cat., texts by Hélène Seckel, Daniel Abadie, and Alfred Pacquement). 1977.
———. *Qu'est-ce que la sculpture moderne?* (exh. cat., text by Margit Rowell). 1986.
Elsen, Albert E. *Modern European Sculpture, 1918-1945: Unknown Beings and Other Realists.* N.Y., 1979.
———. *Origins of Modern Sculpture: Pioneers and Premises.* N.Y., 1974.
Farwell, Beatrice, ed. *Manet*, special issue of *Art Journal*, spring 1985, with texts by Farwell, Patricia Mainardi, Ewa Burcharth, Sharon Flescher, Jacquelynn Baas, Marilyn Brown, Ronda Kasl, and Bradley Collins.
Flam, Jack D., ed. *Matisse on Art.* N.Y., 1973.
———. *Matisse, the Man and His Work.* Ithaca and London, 1986.
Franciscono, Marcel. *Walter Gropius and the Creation of the Bauhaus in Weimar: The Ideals and Artistic Theories of Its Founding Years.* Urbana, 1971.
Geist, Sidney. *Brancusi: The Sculpture and Drawings.* N.Y., 1975.
Golding, John. *Cubism: A History and an Analysis: 1907-1914*, 3rd ed. Cambridge, Mass., 1988.
Goldwater, Robert. *Symbolism.* N.Y., 1979.
Gordon, Robert, and Andrew Forge. *Monet.* N.Y., 1983.
Gray, Camilla, and Marian Burleigh-Motley. *The Russian Experiment in Art., 1863-1922*, rev. London and N.Y., 1986.
Haftmann, Werner. *Painting in the Twentieth Century*, 2 vols. N.Y., 1965.
Hamilton, George Heard. *Painting and Sculpture in Europe: 1880-1940.* Harmondsworth, Middx, 1967.
Hayward Gallery. *Dada and Surrealism Reviewed* (exh. cat., text by Dawn Ades). London, 1978.
Hicks, Alistair. *New British Art in the Saatchi Collection.* London and N.Y., 1987.
Hughes, Robert. *The Shock of the New*, rev. N.Y. and London, 1990.
Hunter, Sam. *American Art of the 20th Century.* N.Y. and London, 1973.
———, and John Jacobus. *Modern Art: Painting, Sculpture, Architecture*, 2nd ed. N.Y., 1985.
Isaacson, Joel. *The Crisis of Impressionism: 1878-1882.* Ann Arbor, 1980.
Jacobus, John. *Matisse.* N.Y., 1973.
Jaffe, Hans L.C. *Mondrian.* N.Y., 1985.
Krauss, Rosalind E. *Passages in Modern Sculpture.* London, 1977; Cambridge., Mass., 1981.
Leighton, Patricia, ed. *Revising Cubism*, special issue of *Art Journal*, winter 1988, with texts by Leighton, Daniel Robbins, Susan Platt, Edward Fry, Christine Poggi, Linda Henderson, Robert Antliff, David Cottington, and Robert Jensen.
Lodder, Christina. *Russian Constructivism.* New Haven and London, 1983.
Loevgren, Sven. *Genesis of Modernism.* Bloomington, Ind., 1971.
LACMA. *The Fauve Landscape* (exh. cat., text by Judi Freemen). L.A. and N.Y., 1990.
Lucie-Smith, Edward. *Art Now: From Abstract Expressionism to Superrealism.* N.Y., 1981.
———. *Movements in Art since 1945*, new rev. ed. London and N.Y., 1984.
Lynton, Norbert. *The Story of Modern Art.* Oxford and Ithaca, 1980.
Mainardi, Patricia, ed. *Nineteenth-Century French Art Politics*, special issue of *Art Journal*, spring 1989, with texts by Mainardi, Robert Goldstein, David Van Zanten, Nicholas Green, Nancy Roth, Jeff Rosen, Michael Driskel, Jane Roos, Tamar Garb, Constance Hungerford, Marie Aquilino, and Shane Davis.
Marks, Claude. *World Artists: 1950-1980.* N.Y., 1984.
Museum of Art. *An American Renaissance: Painting and Sculpture since 1940* (exh. cat., ed. by Sam Hunter; texts by Hunter and others). Fort Lauderdale and N.Y., 1986.
MoCA. *Individuals: A Selected History of Contemporary Art: 1945-1986* (exh. cat., texts by Kate Linker, Donald Kuspit, Hal Foster, Ronald J. Onorato, Germano Celant, Achille Bonito Oliva, John C. Welchman, and Thomas Lawson). L.A. and N.Y., 1986.
Museum of Fine Arts. *Monet in the '90s: The Series Paintings* (exh. cat., text by Paul Hayes Tucker). Boston and New Haven, 1989.
MoMA. *Cézanne: The Late Work* (exh. cat., text by William Rubin). 1977.
———. *Contrasts of Form: Geometric Abstract Art: 1910-1980* (exh. cat., texts by Magdalena Dabrowski and John Elderfield). 1985.
———. *Marcel Duchamp* (exh. cat., ed. by Anne D'Harnoncourt and Kynaston McShine). N.Y., 1973; London, 1974.
———. *Pablo Picasso: A Retrospective* (exh. cat., ed. by William Rubin). N.Y. and London, 1980.
———. *Picasso and Braque* (exh. cat., text by William Rubin). 1989.
———. "*Primitivism*" *in 20th-Century Art* (exh. cat., texts by William Rubin and others). 1984.

———. *The "Wild Beasts": Fauvism and Its Affinities* (exh. cat., text by John Elderfield). 1976.
Nairne, Sandy, and Nicholas Serota., eds. *British Sculpture in the Twentieth Century* (exh. cat., Whitechapel Art Gallery). London, 1981.
National Gallery of Art. *Rodin Rediscovered* (exh. cat., texts by Albert E. Elsen, Ruth Butler, Kirk Varnedoe, and others). Wash., D.C., 1981.
Naylor, Colin, ed. *Contemporary Artists*, 3rd ed. Chicago and N.Y., 1989.
Oppler, Ellen C. *Fauvism Reexamined.* N.Y., 1976.
Osborne, Harold, ed. *The Oxford Companion to Twentieth-Century Art.* London and N.Y., 1981.
Perloff, Marjorie. *The Futurist Moment: Avant-Garde, Avant Guerre, and the Language of Rupture.* Chicago and London, 1986.
Read, Herbert. *A Concise History of Modern Painting*, rev. London and N.Y., 1974.
———. *A Concise History of Modern Sculpture.* London and N.Y., 1964.
Reff, Theodore. *Manet and Modern Paris.* Wash., D.C., 1982.
Rewald, John. *The Hisotry of Impressionism.* N.Y., 1946, 1973.
———. *Post-Impressionism: From van Gogh to Gauguin.* N.Y., 1962.
Rose, Barbara. *American Painting: The Twentieth Century*, rev. N.Y., 1986.
———. *American Art since 1900*, rev. and exp. ed. London and N.Y., 1975.
———. *Autocritique: Essays on Art and Anti-Art: 1963-1987.* N.Y., 1988.
———, ed. *Readings in American Art: 1900-1975*, rev. London and N.Y., 1975.
Rosenberg, Harold. *Discovering the Present: Three Decades in Art, Culture, and Politics.* Chicago, 1973.
Rosenblum, Robert. *Cubism and Twentieth-Century Art*, rev. N.Y., 1976.
———. *Modern Painting and the Romantic Tradition: Friedrich to Rothko.* London and N.Y., 1985.
———. "Picasso and the Typography of Cubism," in John Golding and Roland Penrose, eds., *Picasso in Retrospect: 1881-1973.* N.Y., 1973.
———, and H.W. Janson. *19th-Century Art.* N.Y., 1984.
RAA. *British Art in the 20th Century: The Modern Movement* (exh. cat., ed. by Susan Compton). London and Munich, 1987.
———. *German Art in the 20th Century: Painting and Sculpture: 1905-1985* (exh. cat., ed. by C.M. Joachimides, N. Rosenthal, and W. Schmied). London and Munich, 1985.
———. *Italian Art in the 20th Century: Painting and Sculpture: 1900-1988* (exh. cat., ed. by Emily Braun). London and Munich, 1989.
Rubin, William. *Dada and Surrealist Art.* N.Y., 1968.
Russell, John. *The Meanings of Modern Art.* N.Y. and London, 1981.
Sandler, Irving. *American Art of the 1960s.* N.Y., 1988.
———, ed. *Modernism, Revisionism, Plurism, and Post Modernism*, special edition of *Art Journal*, fall/winter 1980, with texts by Sandler, Kirk Varnedoe, Richard Pommer, Lucy R. Lippard, Kim Levin, and RoseLee Goldberg.
———. *The New York School: The Painters and Sculptors of the 1950s.* N.Y., 1978.
———. *The Triumph of American Painting: A History of Abstract Expressionism.* N.Y., 1970.
Schapiro, Meyer. *Paul Cézanne*, 3rd ed. N.Y., 1965.
Schneider, Pierre. *Matisse.* London and N.Y., 1984.
Selz, Peter. *Art in Our Times: A Pictorial History: 1890-1980.* N.Y. and London, 1981.
Seuphor, Michel. *L'Art abstrait: Ses origines, ses premiers maîtres* (exh. cat., Galerie Maeght). Paris, 1949.
Shiff, Richard. *Cézanne and the End of Impressionism.* Chicago, 1984.
Shone, Richard. *The Century of Change: British Painting since 1900.* Oxford, 1977.
SRGM. *Art of the Avant-Garde in Russia: Selections from the George Costakis Collection* (exh. cat., text by Margit Rowell and Angelica Zander Rudenstine). N.Y., 1981.
———. *Transformations in Sculpture: Four Decades of American and European Art* (exh. cat., text by Diane Waldman). N.Y., 1985.
Spalding, Frances. *British Art since 1900.* London and N.Y., 1986.
Stangos, Nikos, ed. *Concepts of Modern Art*, 2nd ed. London and N.Y., 1981.
Steinberg, Leo. *Other Criteria: Confrontations with Twentieth-Century Art.* N.Y., 1972.
Thomson, Belinda. *Gauguin.* London and N.Y., 1987.
University Art Museum. *Anxious Visions: Surrealist Art* (exh. cat., text by Sidra Stich, James Clifford, and others). Berkeley and N.Y., 1990.
University of Washington. *Russian Art into Life: Russian Constructivism: 1914-1932* (exh. cat., texts by Richard Andrews, Milena Kalinovska, and others). Seattle and N.Y., 1990.
Varnedoe, Kirk. *A Fine Disregard: What Makes Modern Art Modern.* N.Y. and London, 1990.
Vogt, P. *Expressionism: German Painting: 1905-1920.* N.Y., 1980.
Walker Art Center. *De Stijl, 1917-31: Visions of Utopia* (exh. cat., text by Mildred Friedman and others). Minneapolis, 1982.
WMAA. *200 Years of American Sculpture* (exh. cat., texts by Tom Armstrong, Wayne Craven, Norman Feder, Barbara Haskell, Rosalind E. Krauss, Daniel Robbins, and Marcia Tucker). 1976.

Post-Modernism: General

Barilli, Renato. *Tra presenza e assenza: Due ipotesi per l'età postmoderna.* Milan, 1981.
Bryson, Norman, ed. *Calligram: Essays in New Art History from France.* N.Y., 1988.
Buchloh, B.H.D., Serge Guilbaut, and D. Solkin, eds. *Modernism and Modernity: The Vancouver Conference Papers.* Halifax, 1983.
Carrier, David. "Art Criticism and Its Beguiling Fictions," *Art International*, winter 1989, pp. 36-41.
Connor, Steven. *Postmodernist Culture: An Introduction to Theories of the Contemporary.* Oxford, 1989.
Crane, Diana. *The Transformation of the Avant-Garde: The New York Art World: 1940-1985.* Chicago and London, 1987.
Derrida, Jacques. *The Truth in Painting.* Chicago, 1987.
Douglas, D. *Artculture: Essays on the Postmodern.* N.Y., 1979.
Eagleton, Terry. *Literary Theory: An Introduction.* Minneapolis, 1983.
Foster, Hal, ed. *The Anti-Aesthetic: Essays on Postmodern Culture.* Port Townsend, Wash., 1983.
Foucault, Michel. *This Is Not a Pipe*, trans. and ed. by James Harkness. Berkeley, L.A., and London, 1983.
Frascina, Francis, ed. *Pollock and After: The Critical Debate.* N.Y., 1985.
———, and Charles Harrison, eds. *Modern Art and Modernism: A Critical Anthology.* N.Y., 1982.
Gablik, Suzi. *Has Modernism Failed?* London and N.Y., 1984.
Gottlieb, Carla. *Beyond Modern Art.* N.Y., 1976.
Hertz, Richard, ed. *Theories of Contemporary Art.* Englewood Cliffs, 1985.
Hudson River Museum. *A New Beginning: 1968-1978* (exh. cat., text by Mary Delahoyd). Yonkers, 1985.
ICA. *Endgame: Reference and Simulation in Recent Painting and Sculpture* (exh. cat., texts by Thomas Crow, Yves-Alain Blois, Elisabeth Sussman, David Joselit, Hal Foster, and Bob Riley). Boston, 1986.
Kramer, Hilton. "Modernism and Its Demise," *New Criterion*, Mar 1986, pp. 1-7.
———. *The Revenge of the Philistines: Art and Culture: 1972-1984.* N.Y., 1985.
Krauss, Rosalind E., *The Originality of the Avant-garde and Other Modernist Myths.* Cambridge, Mass., 1985.
Lamarche Vadel, Bernard. *Qu'est-ce que l'Art Français?* Paris, 1987.
Levin, Kim. *Beyond Modernism: Essays on Art from the '70s and '80s.* N.Y., 1988.
Lucie-Smith, Edward. *Art in the Seventies.* Ithaca, 1980.
Millet, Catherine. *L'Art Contemporain en France.* Paris, 1988.
MoCA. *A Forest of Signs: Art in the Crisis of Representation* (exh. cat., texts by Ann

Goldstein, Mary Jane Jacob, Anne Rorimer, and Howard Singerman). L.A., 1989.
MoMA. *An International Survey of Recent Painting and Sculpture* (exh. cat., ed. by Kynaston McShine). N.Y., 1984.
Phillipson, Michael. *Painting, Language and Modernity.* London, 1987.
Pincus-Witten, Robert. *Postminimalism into Maximalism: American Art, 1966-1986.* Ann Arbor, 1987.
Robins, Corinne. *The Pluralist Era: American Art: 1968-1981.* N.Y., 1984.
Roy, Jean-Michel. "The French Invasion of American Art Criticism," *Journal of Art*, Nov 1989, pp. 20-21.
Saltz, Jerry. *Beyond Boundaries: New York's New Art*, with essays by Roberta Smith and Petter Halley. N.Y. 1986.
Smagula, Howard. *Currents: Contemporary Directions in the Visual Arts.* Englewood Cliffs, 1983.
———, ed. *Revisions: New Perspectives of Art Criticism.* Englewood Cliffs, N.J., 1991.
SRGM. *New Horizons in American Art* (exh. cat., text by L. Dennison). N.Y., 1986.
Taylor, Paul. "How Europe Sold the Idea of Postmodern Art," *Village Voice*, Sept 22, 1987.
Taylor, Brandon. *Modernism, Post-Modernism, Realism: A Critical Perspective for Art.* Winchester, 1987.
Walker, John A. *Art Since Pop.* London and N.Y., 1975.
Wallis, Brian, ed. *Art After Modernism: Rethinking Representation.* N.Y., and Boston, 1984.
WMAA. *American Art Since 1970* (exh. cat.). N.Y., 1984.
Wolheim, Peter. "The Politics of Meaning: Re-Reading Walter Benjamin," *Vanguard*, Feb 3, 1986, pp. 22-26.

2. The New York School: Abstract Expressionism: 1945–60

Anfam, David. *Abstract Expressionism.* London and N.Y., 1990.
AKAG. *Robert Motherwell* (exh. cat., texts by Dore Ashton, Jack D. Flam, and Robert T. Buck). 1983.
Ashton, Dore. *About Rothko.* N.Y., 1983.
———. *The New York School: A Cultural Reckoning.* N.Y., 1973.
———. *Yes, But . . . A Critical Study of Philip Guston.* N.Y., 1976.
Auping, Michael, ed. *Abstract Expressionism: The Critical Developments.* N.Y. and London, 1987.
CGP. *Jackson Pollock* (exh. cat., texts by Dominique Bozo and others). 1982.
Chave, Anna C. *Mark Rothko: Subjects in Abstraction.* New Haven, 1989.
Frank, Elizabeth. *Jackson Pollock.* N.Y., 1983.
Gaugh, Harry F. *The Vital Gesture: Franz Kline.* N.Y., 1985.
———. *Willem de Kooning.* N.Y., 1983.
Gibson, Ann, and Stephen Polcari. *New Myths for Old: Redefining Abstract Expressionism*, special edition of *Art Journal*, fall 1988, with texts by Gibson, Polcari, Martica Sawin, W. Jackson Rushing, Mona Hadler, Deidre Robson, Francis V. O'Connor, and Donald Kuspit.
Goodman, Cynthia. *Hans Hofmann.* N.Y., 1986.
Greenberg, Clement. *Art and Culture: Critical Essays.* Boston, 1961; London 1973.
Guilbaut, Serge. *How New York Stole the Idea of Modern Art.* Chicago, 1983.
Hughes, Robert. "Prairie Coriolanus: Clyfford Still," *Time*, Feb 9, 1976, p. 68.
ICA. *Jackson Pollock: The Black Pourings, 1951-1953* (exh. cat., texts by Francis V. O'Connor and Stephen S. Prokopoff). Boston, 1980.
Jordan, Jim, and Robert Goldwater. *The Paintings of Arshile Gorky: A Critical Catalogue.* N.Y., 1982.
Lader, Melvin P. *Arshile Gorky.* N.Y., 1985.
Landau, Ellen G. *Jackson Pollock.* N.Y. and London, 1989.
Mooradian, Karlen. *Arshile Gorky Adoian.* Chicago, 1978.
———. *The Many Worlds of Arshile Gorky.* Chicago, 1980.
MoMA. *Barnett Newman* (exh. cat., text by Thomas B. Hess). 1971.
———. *The New American Painting* (cat. for exh. sent to eight European countries, with "introduction" by Alfred H. Barr). 1959.
———. *Willem de Kooning* (exh. cat., text by Thomas B. Hess). 1968.
O'Connor, Francis V., and Eugene V. Thaw, eds. *Jackson Pollock: A Catalogue Raisonné of Paintings, Drawings and Other Works.* New Haven, 1978.
O'Doherty, Brian. *American Masters: The Voice and the Myth.* N.Y., 1974.
Rand, Harry. *Arshile Gorky: The Implications of Symbols.* Montclair, N.J., 1980.
Reinhardt, Ad. *Art-as-Art: The Selected Writings of Ad Reinhardt*, ed. by Barbara Rose. N.Y., 1975.
Rose, Barbara. *Ad Reinhardt: Black Paintings: 1951-1967* (exh. cat., Marlborough Gallery). N.Y., 1970.
Rosenberg, Harold. "The American Action Painters," *Artnews*, Sept 1952.
———. *The Tradition of the New.* N.Y., 1959.
Rubin, William S. "Jackson Pollock and the Modern Tradition: Part One," *Artforum*, Feb 1967, pp. 14-22; "Part Two," Mar 1967, pp. 28-37; "Part Three," Ap 1967, pp 18-31; "Part Four," My 1967, pp. 28-33.
Saatchi Collection. *Art of Our Time*, 4 vols. London and N.Y., 1984.
Sandler, Irving, ed. *Modernism, Revisionism, Plurism, and Post Modernism*, special edition of *Art Journal*, fall/winter 1980, with texts by Sandler, Kirk Varnedoe, Richard Pommer, Lucy R. Lippard, Kim Levin, and RoseLee Goldberg.
Seitz, William. *Abstract Expressionist Painting in America.* Cambridge, Mass., and London, 1983.
Shapiro, David and Cecile. *Abstract Expressionism: A Critical Record.* N.Y., 1990.
SRGM. *The Fifties: Aspects of Painting in New York* (exh. cat., text by Phyllis Rosensweig). 1980.
Storr, Robert. *Philip Guston.* N.Y., 1986.
Tuchman, Maurice, ed. *New York School: The First Generation.* Greenwich, Ct., 1970.
———. *The New York School: Abstract Expressionism in the 40s and 50s.* London, 1970.
Waldman, Diane. *Mark Rothko: 1903-1970.* London and N.Y., 1986.
———. *Willem de Kooning.* London and N.Y., 1988.
WMAA. *Abstract Expressionism: The Formative Years* (exh. cat., texts by R.C. Hobbs and Gail Levin). 1978.

3. The European School of Painting: 1945–60

Ades, Dawn, and Andrew Forge. *Francis Bacon.* 1985.
Art Museum, U. of Calif. *Hundertwasser* (exh. cat., texts by Herschel B. Chipp and Brenda Richardson). Berkeley and Greenwich, Ct., 1968.
ACGB. *Giacometti: Sculptures, Paintings, Drawings.* (exh. cat., interview with the artist by David Sylvester, autumn 1964). 1981.
Barbican Centre. *Aftermath: France 1945-54: New Images of Man* (exh. cat., texts by Germain Viatte and Henry-Claude Cousseau). London, 1982.
Baxandall, David. *Ben Nicholson.* London, 1962.
Beckett, Samuel, Georges Duthuit, and Jacques Putnam. *Bram van Velde.* Paris, 1958; N.Y., 1960.
Biederman, Charles. *Art as the Evolution of Visual Knowledge.* Red Wing, Minn., 1948.
Bony, Anne. *Les Années 50.* Paris, 1982.
Bowness, Alan. *Alan Davie.* London, c. 1967.
———. *Patrick Heron: Recent Paintings and Selected Earlier Canvases* (exh. cat., Whitechapel Art Gallery). London, 1972.
———. *Roger Hilton* (exh cat., Charles Lienhardt Galerie). Zurich, 1961.

Bryen, Camille, Sylveire and H.P. Roché. *Wols* (exh. cat., Galerie René Drouin). Paris, 1945.

Causey, Andrew. *Peter Lanyon: His Painting* (intro. by Naum Gabo). Henley-on-Thames, 1971.

Centre d'Art Plastique Contemporain. *Un Art Autre/Un Autre Art* (exh. cat., text by Daniel Abadie). Paris, 1984.

CGP. *Les Années 50* (exh. cat., texts by Daniel Abadie, Philippe Arbaizan, Laurent Boyle, Claude Eveno, and Raymond Guido). 1988.

Ceysson, Bernard. *Soulages*. Paris, c. 1979.

Chastel, André, Germain Viatte, and Jacques Dubourg. *Nicolas de Staël*. Paris, 1968.

Combalia Dexeus, Victoria. *Tàpies*, trans. by Kenneth Lyons. Barcelona, c. 1986.

Des Moines Art Center. *Art in Western Europe: The Postwar Years: 1945-1955* (exh. cat., text by Lawrence Alloway). 1978.

Dorfles, Gillo. *Ultime tendenze nell'arte d'oggi*, 2nd ed. Milan, 1973.

Fallico, Arturo B. *Art & Existentialism*. New York, 1962.

Fine Arts Museum of Long Island. *The Roots and Development of CoBrA Art* (exh. cat., text by Eleanor Flomenhaft). Hempstead, c. 1985.

Frederick S. Wright Art Gallery, U. of Calif. *Alberto Burri: A Retrospective View: 1948-77* (exh. cat., essay by Gerald Nordland). Los Angeles, c. 1977.

Galleria Comunale d'Arte Moderna. *L'informale in Italia* (exh. cat., texts by Renato Barilli and Franco Solmi). Bologna, 1983.

Gohr, Siegfried. "Fautrier: Through Paint, Alone," *Artforum*, Sept 1988, pp. 111-116.

Herbin, Auguste. *L'Art non-figuratif non-objetif*. Paris, 1949.

Heron, Patrick. *The Changing Forms of Art*. London, 1955.

HMSG. *Alberto Giacometti* (exh. cat., texts by Silvio Berthored and Reinhold Hohl). Wash., D.C., 1988.

———. *Francis Bacon* (exh. cat., essays by Sam Hunter and Lawrence Gowing, organized by James T. Demetrion). Wash., D.C., N.Y., and London, 1989.

Hughes, Robert. *Lucian Freud: Paintings*. London and N.Y., 1988.

Inch, Peter, ed. *Circus Wols: The Life and Work of Wolfgang Schulze*, with essays by Jean Tardieu, Dore Ashton, Claire van Damme, Peter Inch, Roger Cardinal, and Öyvind Fahlström. Todmorden, Lancs, 1978.

ICA. *Mathieu* (exh. cat., text by Herbert Read). London, 1956.

Leiris, Michel. *Francis Bacon: Full Face and Profile*. London and N.Y., 1983.

Lord, James. *A Giacometti Portrait*. N.Y., 1965.

Mathieu, Georges. *Au-delà du Tachisme*. Paris, 1963.

———. *From the Abstract to the Possible*. N.Y., 1960.

Melville, Robert. "Projections of Intransigeance: Francis Bacon," *Times Literary Supplement*, Je 7, 1985, p. 638.

Metropolitan Museum of Art. *Balthus* (exh. cat., text by Sabine Rewald). N.Y., 1984.

Michelson, Carl, ed. *Christianity and the Existentialists*. N.Y., 1963.

Museo Carrer. *Vedova: 1935-1984* (exh. cat., text by Germano Celant). Milan, 1984.

Museum of Fine Arts. *Alberto Burri* (exh. cat., text by James Johnson Sweeney). Houston, 1963.

MoMA *Alberto Giacometti* (exh. cat., text by Peter Selz and autobiographical statement by the artist). N.Y., 1965.

———. *The New Decade: 22 European Painters and Sculptors* (exh. cat., text by Andrew Cardnuff Ritchie). N.Y., 1955.

———. *Twentieth-Century Italian Art* (exh. cat., texts by James Thrall Soby and Alfred Barr, Jr.). N.Y., 1949.

National Gallery of Canada. *Jean-Paul Riopelle* (exh. cat., texts by Pierre Schneider, John Russell, Guy Vian, and Franco Russoli). Ottawa, 1962.

National Museum of Art. *Action et Émotion: Peintures des Années 50: Informel, Gutai, CoBrA* (exh. cat., text in French and Japanese). Osaka, nd.

O'Doherty, Brian. "On the Strange Case of Francis Bacon," *New York Times*, Oct 20, 1963, p. 17.

Paulhan, Jean. *L'Art informel*. Paris, 1962.

———. *Fautrier l'engagé*. Paris, 1962.

Pellegrini, Aldo. *New Tendencies in Art*. N.Y., 1966.

Penrose, Roland. *Tàpies*. London and N.Y., 1978.

Permanyer, Lluis. *Tàpies and the New Culture*. N.Y., 1986.

Ponente, Nello. *Modern Painting: Contemporary Trends*. Lausanne, 1960.

Read, Herbert. *Alberto Burri* (exh. cat., Hanover Gallery). London, 1960.

———. "Alberto Burri," *Times Literary Supplement*, Oct 30, 1960.

———. *Contemporary British Art*, rev. ed. Harmondsworth, Middx, 1964.

Russell, John. *Francis Bacon*. rev. ed. N.Y. and London, 1979.

Sartre, Jean-Paul. *Being and Nothingness*, trans. by Hazel E. Barnes. N.Y., 1969.

SRGM. *Alberto Giacometti: A Retrospective* (exh. cat., texts by Thomas M. Messer and Reinhold Hohl). N.Y., 1974.

———. *Jean Dubuffet: A Retrospective* (exh. cat., texts by Thomas M. Messer and Margit Rowell). N.Y., 1973.

Schneider, Pierre. *Louvre Dialogues*. N.Y., 1971.

Stokvis, Willemijn. *CoBrA: An International Movement in Art after the Second World War*, trans. from Dutch by Jacob C. T. Voorthuis. N.Y., 1988.

Sweeney, James Johnson. *Afro: Paintings, Gouaches, and Drawings*. Rome, 1961.

———. "Pierre Soulages Today," *Art International*, summer 1968, pp. 90-93.

———. *Soulages*. Neuchâtel, 1972.

Sylvester, David. *Interviews with Francis Bacon*, 3rd ed. London, 1987.

Tapié, Michel. *Un Art autre où il s'agit de nouveaux dévidages du réel*. Paris, 1952.

TG. *British Painting since 1945* (exh. cat., text by Ronald Alley). 1966.

———. *St. Ives 1939-64: Twenty Five Years of Painting, Sculpture and Pottery* (exh. cat., text by David Brown). 1985.

Walker Art Gallery. *New Italian Art: 1953-71* (exh. cat., text by Giovanni Carandente). Liverpool, 1971.

4. Sculpture at Mid-Century

ACGB. *Giacometti: Sculptures, Paintings, Drawings* (exh. cat., interview with the artist by David Sylvester, autumn 1964). 1981.

Barr, Alfred H. "Kiesler's Galaxy," *Harper's Bazaar*, Ap 1952, pp. 142-143.

Berkshire Museum. *Herbert Ferber: Sculpture and Drawings: 1932-1983* (exh. cat., text by Debra Bricker Balken and Phyllis Tuchman). Pittsfield, 1984.

Cameron, Daniel. "David Hare," *Grey Gallery Bulletin*, summer 1982.

Elsen, Albert. *Seymour Lipton*. N.Y., 1974.

Geist, Sidney. *Brancusi: A Study of the Sculpture*. N.Y., 1968.

Goldberg, RoseLee. "Frederick Kiesler, Endless Love," *Flash Art*, Mar/Ap 1981, pp. 37-39.

Goosen, Eugene, Robert Goldwater, and Irving H. Sandler. *Three American Sculptors: Ferber, Hare, Lassaw*. N.Y., 1959.

Gray, Cleve, ed. *David Smith by David Smith*. London and N.Y. 1968; paperback, 1989.

Hammacher, A.M. *Barbara Hepworth*. London, 1968.

HMSG. *David Smith: Painter, Sculptor, Draftsman* (exh. cat., text by Edward Fry and Miranda McClintic). 1982.

Hohl, Reinhold. *Chillida: Sculpture, Collage, Disegni*. Milan, c. 1987.

Hunter, Sam. *Isamu Noguchi*. N.Y., 1978.

Kramer, Hilton. "Giacometti's Moral Heroism," *New York Times*, Jan 18, 1976.

Krauss, Rosalind E. *Terminal Iron Works: The Sculpture of David Smith*. Cambridge, Mass., 1971.

Henry Moore: Sculpture and Drawings. 5 vols (intro. by Herbert Read; vol. 1 ed. by David Sylvester; vols. 2-5 ed. by Alan Bowness). London, 1944, 1955, 1965, 1977, 1983.

MoCA. *Alexander Calder: A Retrospective* (exh. cat., text by Albert Elsen). Chicago, 1974.

MoMA. *Alberto Giacometti* (exh. cat., text by Peter Selz and autobiographical statements by the artist). N.Y., 1965.

———. *Joseph Cornell* (exh. cat., ed. by Kynaston McShine and texts by Dawn Ades, Lynda Hartigan, Carter Ratcliff, and P. Adams Sitney). N.Y., 1980.

———. *Louise Bourgeois* (exh. cat., text by Deborah Wye). N.Y., 1982.

Paget, Jean, and Werner Haftmann. *Ipoustéguy* (exh. cat., Artel Galerie). Geneva, 1974.

Picon, Gaéton. *Kemeny: Reliefs en métal*. Paris, c. 1973.

Read, Herbert. *Henry Moore: A Study of his Life and Work*. London, 1965.

Rewald, John. *Giacomo Manzù*. London, 1967.

Robertson, Brian. *Elisabeth Frink: Catalogue raisonné*. Salisbury, 1984.

Russell, John. *César* (exh. cat., Hanover Gallery). London, 1957.

———. *Henry Moore*, rev. ed. Harmondsworth, Middx, 1980.

SRGM. *Alberto Giacometti: A Retrospective* (exh. cat., texts by Thomas M. Messer and Reinhold Hohl). N.Y., 1974.

———. *Alexander Calder: A Retrospective Exhibition* (exh. cat., text by Thomas M. Messer). N.Y., 1964.

———. *Joseph Cornell* (exh. cat., texts by Thomas M. Messer and Diane Waldman). N.Y., 1967.

Staatsgalerie. *Norbert Kricke* (exh. cat., texts by Jürgen Morschel and the artist). Stuttgart, c. 1976.

TG. *William Turnbull* (exh. cat., text by Richard Morphet). 1973.

Waldberg, Patrick, and Herbert Read. *Marino Marini: Complete Works*. N.Y., 1970.

WMAA. *The Third Dimension: Sculpture of the New York School* (exh. cat., text by Lisa Phillips). N.Y., 1984.

Wilkin, Karen. *David Smith*. N.Y. 1984.

5. Into the Sixties: Pop Art and New Realism

Alloway, Lawrence. *Roy Lichtenstein*. N.Y., 1983.

———. *This Is Tomorrow* (exh. cat., Whitechapel Art Gallery). London, 1956.

Art Gallery, U. of Calif. *New York: The Second Breakthrough: 1959-1964* (exh. cat., text by Alan Solomon). Irvine, 1965.

Art Gallery of New South Wales. *Pop Art: 1955-1970* (exh. cat., text by Henry Geldzahler). Sydney, 1985.

ACGB. *Edouardo Paolozzi: Sculpture, Drawings, Collages, and Graphics* (exh. cat., texts by Frank Whitford, the artist, and others). 1976.

Ashton, Dore. *Rauschenberg's XXXIV Drawings for Dante's Inferno*. N.Y., 1964.

Barilli, Renato. *Dall'oggetto al comportamento: La ricerca artistica dal '60 al '70*. Rome, 1971.

Battcock, Gregory, ed. *The New Art: A Critical Anthology*. N.Y., 1966.

Bourdon, David. *Warhol*. N.Y., 1990.

CGP. *Martial Raysse* (exh. cat., texts by Pontus Hulten, Jean-Yves Mock, and the artist). 1981.

———. *Niki de Saint-Phalle: Exposition Retrospective* (exh. cat., text by Jean-Yves Mock). 1980.

———. *Raymond Hains et la Photographie* (exh. cat., texts by Pierre Restany, Otto Hahn, François Dufrêne, Marc Albert Levin, and others). Paris, 1976.

Colacello, Bob. *Holy Terror: Andy Warhol Close Up*. N.Y., 1990.

Failing, Patricia. "Ed Ruscha, Young Artist: Dead Serious about Being Nonsensical," *Artnews*, Ap 82, pp. 74-81.

Feinstein, Roni. "The Early Work of Robert Rauschenberg: The White Paintings, the Black Paintings, and the Elemental Sculptures," *Arts*, Sept 1986, pp. 28-37.

Francis, Richard. *Jasper Johns*. N.Y., 1984.

Glueck, Grace. "Rivers Paints Himself into the Canvas," *New York Times Magazine*, Feb 13, 1966, pp. 34-35, 78-83.

———. "Soft Sculpture or Hard—They're Oldenburgers," *New York Times Magazine*, Sept 21, 1969, pp. 29,100.

Goldman, Judith. *James Rosenquist*. N.Y., 1985.

Hamburger Kunsthalle. *Konrad Klapheck: Retrospektive: 1955-1985* (exh. cat., texts by Werner Hofmann, Peter-Klaus Schuster, and the artist). Hamburg and Munich, 1985.

Hamilton, Richard. "An Exposition of $he," *Architectural Design*, Oct 1962, pp. 485-486.

———. *Collected Words: 1953-1982*. London, 1982.

Harrison, Helen A. *Larry Rivers*. N.Y., 1984.

Hayward Gallery. *The Human Clay: An Exhibition Selected by R. B. Kitaj* (exh. cat., text by Kitaj). London, 1976.

HMSG. *Larry Rivers* (exh. cat., text by Phyllis Rosenzweig). Wash., D. C., 1981.

———. *R.B. Kitaj* (exh. cat., texts by John Ashbery, Joe Shannon, and Jane Livingston). Wash., D.C., and London. 1983.

Hockney, David. *David Hockney by David Hockney*, ed. by Nikos Stangos. London, 1976.

Hughes, Robert. "The Arcadian as Utopian [Robert Rauschenberg]," *Time*, Jan 24, 1983, pp. 74,77.

———. "Enfant Terrible at 50 [Robert Rauschenberg]," *Time*, Jan 27, 1975, p. 60.

Hunter, Sam. *Larry Rivers*. N.Y., 1989.

Institute for the Arts, Rice U. *Yves Klein: 1958-1962: A Retrospective* (texts by Dominique de Menil, Dominique Bozo, Jean-Yves Mock, Pierre Restany, Thomas McEvilley, and Nan Rosenthal). Houston, 1982.

ICA. *Man, Machine and Motion* (exh. cat., texts by Richard Hamilton, Lawrence Gowing, and Reyner Banham). London, 1955.

Janis, Sidney, John Ashbery, and Pierre Restany. *New Realists* (exh. cat., Sidney Janis Gallery). N.Y., 1962.

Jewish Museum. *Robert Rauschenberg* (exh. cat., text by Alan R. Solomon). N.Y., 1963.

Kotz, Mary Lynn. *Rauschenberg: Art and Life*. N.Y., 1990.

Kozloff, Max. "Pop Culture, Metaphysical Disgust and the New Vulgarians," *Art International*, Mar 1962, pp. 34-36.

Kramer, H. *The Age of the Avant-Garde: An Art Chronicle of 1956-1972*. N.Y., 1973.

———. "Richard Lindner: Artist of Two Worlds," *New York Times*, Ap 30, 1978.

Larson, Kay. "The Luck of the Draw [Roy Lichtenstein]," *New York*, My 18, 1987, pp. 98-99.

Livingstone, Marco. *Allen Jones: Sheer Magic*. London, 1979.

———. *David Hockney: Etchings and Lithographs*. London 1988.

———. *Pop Art: A Continuing History*. London and N.Y., 1990.

———. *R.B. Kitaj*. Oxford and N.Y., 1985.

Lippard, Lucy. *Pop Art* (with contributions by Lawrence Alloway, Nancy Marmer, and Nicolas Callas). London and N.Y., 1966,1967, 1970.

LACMA. *David Hockney: A Retrospective* (texts by R. B. Kitaj, Henry Geldzahler, Christopher Knight, Gert Schiff, Anne Hoy, Kenneth E. Silver, Lawrence Weschler, and the artist). L.A. and London, 1988.

Mahsun, Carol Anne. *Pop Art and the Critics*. Ann Arbor, 1987.

Musée d'Art Moderne de la Ville de Paris. *1960: Les Nouveaux Réalistes* (exh. cat., texts by Bernadette Contensou and Pierre Restany). 1986.

MoMA. *Andy Warhol: A Retrospective* (exh. cat., texts by Kynaston McShine, Robert Rosenblum, B.H.D. Buchloh, and Marco Livingstone). N.Y. and London, 1989.

———. *Claes Oldenburg* (exh. cat., text by Barbara Rose). N.Y., 1970.

Nassau County Museum of Fine Art. *Niki de Saint-Phalle: Fantastic Vision* (exh. cat., texts by David Bourdon, John Cage, and Harry Mathews). Roslyn, N.Y., 1987.

National Collection of Fine Arts. *Robert Rauschenberg* (exh. cat., text by Lawrence

Alloway). Wash., D.C., 1976.

O'Hara, Frank. *Art Chronicles: 1954-1966*. N.Y., 1975.

P.S.I. *Pistoletto: Division and Multiplication of the Mirror* (exh. cat., texts by Alanna Heiss, Germano Celant, and the artist). N.Y., 1988.

Ratcliff, Carter. *Andy Warhol*. N.Y., 1983.

Restany, Pierre. *Au 40° au-dessus de Dada* (exh. cat., Galeria J). Paris, 1961.

———. "The New Realism," *Art in America*, Feb 1963, pp. 102-104.

———. *Les Nouveaux Réalistes*. Paris, 1968.

Rose, Barbara. "Decoys and Doubles: Jasper Johns and the Modernist Mind," *Arts*, My 1976, pp. 68-73.

———. "The Graphic Work of Jasper Johns, Part I," *Artforum*, Mar 1970, pp. 39-45; "Part II," Sept 1970, pp. 65-74.

———. "Jasper Johns: Pictures and Concepts," *Arts*, Nov 1977, pp. 148-153.

Rosenthal, Mark. *Jasper Johns: Work since 1974*. N.Y. and London, 1989.

Russell, John, and Suzi Gablik. *Pop Art Redefined* (includes statements by Lawrence Alloway, John McHale, Robert Rosenblum, and numerous artists). London and N.Y., 1969.

San Francisco Museum of Modern Art. *The Works of Ed Ruscha* (exh. cat., texts by Anne Livet, Dave Hickey, Henry T. Hopkins, and Peter Plagens). S.F. and N.Y., 1983.

SRGM. *Richard Hamilton* (exh. cat., text by John Russell). 1973.

Stangos, Nikos, ed. *Pictures by David Hockney*. London 1979.

Stuckey, Charles F. "Warhol's Painted Faces," *Art in America*, My 1980, pp. 102-111.

———. "Reading Rauschenberg," *Art in America*, Mar/Ap 1977, pp. 74-84.

———. "Warhol Backwards and Forwards," *Flash Art*, Jan/Feb 1981, p.10-18.

TG. *Patrick Caulfield: Paintings 1963-81* (exh. cat., text by Marco Livingstone). 1981.

———. *Peter Blake* (exh. cat., text by Michael Compton, Nicholas Usherwood, and Robert Melville). 1983.

Tomkins, Calvin. *The Bride and the Bachelors*. N.Y., 1968.

———. *Off the Wall: Robert Rauschenberg and the Art World of Our Time*. N.Y., 1980.

Vaizey, Marina. *Peter Blake*. London and Chicago, 1986.

Walker Art Center. *Jim Dine: Five Themes* (exh. cat., texts by the artist, Graham W. J. Beal, Martin Friedman, and Robert Creeley). Minneapolis and N.Y., 1981.

Walker Art Gallery. *Retrovision: Peter Phillips: 1960-1982* (exh. cat., text by Marco Livingstone). Liverpool, 1982.

Warhol, Andy. *The Philosophy of Andy Warhol (From A to B and Back Again)*. N.Y., 1975.

———. *POPism: The Warhol '60s*. N.Y., 1980.

Webb, David. *Portrait of David Hockney*. N.Y., 1989.

Weschler, Lawrence. "True to Life [David Hockney]," *New Yorker*, Jy 1984, pp. 60-71.

WMAA. *Andy Warhol: Portraits of the 70s* (exh. cat., texts by Robert Rosenblum and David Whitney). N.Y., 1979.

———. *BLAM! The Explosion of Pop, Minimalism, and Performance: 1958-1964* (exh. cat., text by Barbara Haskell and John G. Hanhardt). N.Y., 1984.

———. *Jasper Johns* (exh. cat., text by Michael Crichton). N.Y., 1977.

Wilson, Simon. *Pop*. London, 1974.

6. Assemblage, Environments, Happenings

Art Museum, U. of Calif. *Funk* (exh. cat., text by Peter Selz). Berkeley, 1967.

Centre National d'Art Contemporain. *Daniel Spoerri* (exh. cat., texts by the artist and François Dufrêne). Paris, 1972.

Gardner, Paul. "Who Is Marisol?," *Artnews*, My 1989, pp. 147-151.

Goldberg, RoseLee. *Performance Art*. London and N.Y., 1988.

Hansen, Al. *A Primer of Happenings and Time/Space Art*. N.Y., 1965.

Hayward Gallery. *Beyond Image: Boyle Family* (exh. cat., texts by Mark Boyle and David Thompson). London, 1986.

Henri, Adrian. *Total Art: Environments, Happenings, and Performance*. N.Y., 1974. Also *Environments and Happenings*. London, 1974.

Hoelterhoff, Manuela. "Tropical Poetry: Christo's 'Surrounded Islands'," *Wall Street Journal*, My 13, 1984, p. 29.

Hunter, Sam. *George Segal*. N.Y., 1984.

Kaprow, Alan. *Assemblage, Environments & Happenings*. N.Y., 1966.

Kirby, Michael. *The Art of Time: Essays on the Avant-Garde*. N.Y., 1969.

———. *Happenings: An Illustrated Anthology*. N.Y., 1965.

Kostelanetz, Richard. *The Theatre of Mixed Means*. N.Y., 1968.

Kramer, Hilton. "Nevelson: Her Sculpture Changed the Way We Look at Things," *N.Y. Times Magazine*, Oct 30, 1983, pp. 28, 30, 69, 72-73, 81.

Kulturmann, Udo. *Art and Life*. N.Y., 1971.

Kunstmuseum und Sammlung Springer. *Arman: Parade der Objekte: Retrospektive 1955 bis 1982* (exh. cat., text by Bernhard Holeczek). Hanover, 1982.

Kunstverein Braunschweig. *Wolf Vostell: De'-coll/agen, Bleibilder, Objektbilder: 1955-1979* (exh. cat., text by Jürgen Schilling and the artist). Brunswick, 1980.

Levin, Kim. *Lucas Samaras*. N.Y., 1975.

Marck, Jan van der. *Arman*. N.Y., 1984.

McConnel, G. *Assemblage: Three-Dimensional Picture Making*. N.Y., 1976.

MoMA. *Assemblage* (exh. cat., text by William C. Seitz). N.Y., 1961.

Ratcliff, Carter. *Red Grooms*. N.Y., 1984.

San Francisco Museum of Modern Art. *Edward and Nancy Reddin Kienholz: Human Scale* (exh. cat., texts by David Shirey, Henry T. Hopkins, Lawrence Weschler, and R. Glowen). 1984.

Spies, Werner. *Christo: Surrounded Islands, Biscayne Bay, Greater Miami, Florida, 1980-83*. N.Y., 1985.

Sylvester, Julie, and Klaus Kertess. *John Chamberlain: A Catalogue Raisonné of the Sculpture: 1954-1985*. N.Y. and L.A., 1986.

Tuchman, Phyllis. *George Segal*. N.Y., 1983.

WMAA. *H.C. Westermann* (exh. cat., text by Barbara Haskell). N.Y., 1978.

7. Post-Painterly Abstraction

Adams, Brooks. "Slash and Burn: Lucio Fontana," *Art and Auction*, Feb 1990, pp. 122-127.

ACGB. *Gillian Ayres* (exh. cat., text by Tim Hilton). 1983.

———. *Jack Bush: Paintings and Drawing: 1955-1976* (exh. cat., text by Duncan Macmillan). 1980.

Barthes, Roland. "The Wisdom of Art," in WMAA, *Cy Twombly: Paintings and Drawings: 1954-1977* (exh. cat.). N.Y., 1979.

Bernstock, Judith E. *Joan Mitchell*. N.Y., 1988.

Carmean, E. A. "Modernist Art: 1960-1970," *Studio Int'l*, Jy/Aug 1974, pp. 9-15.

CGP. *Lucio Fontana* (exh. cat., texts by Bernard Blistene, Severo Sarduy, Remo Guidieri, Denys Zacharopoulos, Jole de Sanna, Dominique Liquois, Catherine Grenier, Fanette Roche-Pézard, Guido Ballo, Annette Samec-Luciani, Milena Milani, Giovanni Joppolo, Giorgio Manganelli, and Giorgio Verzotti). 1987.

Elderfield, John. *Frankenthaler*. N.Y., 1989.

Fogg Art Museum, Harvard U. *Three American Painters: Kenneth Noland, Jules Olitski, Frank Stella* (exh. cat., text by Michael Fried). Cambridge, Mass., 1965.

Frackman, Noel. "Frank Stella's Abstract Expressionist Aerie: A Reading of Stella's New Paintings," *Arts*, Dec 1976, pp. 124-26.

———. "Tracking Frank Stella's Circuit Series," *Arts*, Ap 1982, pp. 134-37.

Glaser, David J. "Al Held's Strategy of Structural Conflict," *Arts*, Jan 1983, pp. 82-83.

Hayward Gallery. *Agnes Martin: Paintings and Drawings, 1957-1975* (exh. cat., texts by Dore Ashton and Agnes Martin). London, 1977.

Institute for the Arts, Rice U. *Yves Klein: 1958-1962: A Retrospective* (texts by Domi-

nique de Menil, Dominique Bozo, Jean-Yves Mock, Pierre Restany, Thomas McEvilley, and Nan Rosenthal). Houston, 1982.

Krauss, Rosalind. "Robert Mangold: An Interview," *Artforum*, Mar 1974, pp. 36-38.

Kunstsammlung Nordrhein-Westfalen. *Gotthard Graubner: Malerei aus den Jahren 1954 bis 1986* (exh. cat., texts by Heather Eastes, Stephen Reader, and Eileen Opiolka). Düsseldorf, 1987.

Kuspit, Donald. *Al Held's Taxi Cabs: 1959* (exh. cat., Robert Miller Gallery). N.Y., 1987.

——. "Blinky Palermo," *Artforum*, Feb 1986, pp. 82.

Larson, Kay. "Heavy Traffic [Al Held's Taxi Paintings]," *New York*, Mar 23, 1987.

LACMA. *Post-Painterly Abstraction* (exh. cat., text by Clement Greenberg). 1964.

McEvilley, Thomas. " 'Grey Geese Descending': The Art of Agnes Martin," *Artforum*, summer 1987, pp. 94-99.

Moffett, Kenworth. *Jules Olitski*. N.Y., 1981.

——. *Kenneth Noland*. N.Y., 1977.

MoMA. *Ellsworth Kelly* (exh. cat., text by E. C. Goossen). N.Y., 1973.

——. *Frank Stella* (exh. cat., text by William Rubin). N.Y. and Greenwich, Ct., 1970.

——. *Frank Stella: 1970-1987* (exh. cat., text by William Rubin). N.Y., 1987.

——. *Morris Louis* (exh. cat., text by John Elderfield). N.Y., 1986.

Newport Harbor Museum. *Action the New Direction/Precision in New York: 1955-60* (exh. cat., texts by Paul Schimmel, Robert Rosenblum, John Bernard Myer, and B.H. Friedman). 1984.

Nordland, Gerald. *Richard Diebenkorn*. N.Y., 1987.

Norman Mackenzie Art Gallery. *Three American Painters: Louis, Noland, Olitski* (exh. cat., text by Clement Greenberg). Regina, Saskatchewan, 1965.

O'Doherty, Brian. *Dorothea Rockburne: A Personal Selection: Paintings 1968-1986* (exh. cat., Xavier Fourcade). N.Y., 1986.

Pasadena Art Museum. *Serial Imagery* (exh. cat., text by John Coplans). 1968.

Pennsylvania Academy of the Fine Arts. *Jack Tworkov: Paintings, 1928-1982* (exh. cat., texts by Richard Armstrong and Kenneth Baker). Philadelphia, 1982.

Phillips Collection. *John Walker* (exh. cat., text by Andrew Forge). Wash., D.C., 1978.

Pleynet, Marcelin. "Peinture et 'Structuralisme'," *Art International*, Nov 1968, pp. 29ff.

Robertson, Bryan. *John Hoyland: Painting 1960-67* (exh. cat., Whitechapel Art Gallery). London, 1967.

Rosenblum, Robert. *Frank Stella*. Harmondsworth, Middx, 1971.

Rubin, Lawrence. *Frank Stella Paintings: 1958-1965: A Catalogue Raisonné*. N.Y. and London 1986.

Sandler, Irving. *Al Held*. N.Y., 1984.

Schoenfeld, Ann. "Grace Hartigan in the Early 1950s: Some Sources, Influences, and the Avant-garde," *Arts*, Sept 1985, pp. 84-88.

Serota, Nicholas, Stephen Bann, and Roberta Smith. *Brice Marden: Paintings, Drawings and Prints* (exh. cat., Whitechapel Art Gallery). London, 1981.

Smith, Roberta. *Cy Twombly: Rewriting History* (exh. cat., Hirschl & Adler Modern). N.Y., 1986.

——. "Richard Tuttle," *N.Y. Times*, Jan 2, 1987, p. C22.

Solomon, Alan, and Clement Greenberg. *Morris Louis* (exh. cat., Whitechapel Art Gallery). London, 1965.

SRGM. *Brice Marden* (exh. cat., text by Linda Shearer). N.Y., 1975.

——. *Robert Mangold* (exh. cat., text by Diane Waldman). N.Y., 1971.

——. *Robert Ryman* (exh. cat., text by Diane Waldman). N.Y., 1972.

——. *Systemic Painting* (exh. cat., text by Lawrence Alloway). N.Y., 1966.

Spies, Werner. *Albers*. London and N.Y., 1970.

Stella, Frank. *Working Space*. Cambridge, Mass. 1986.

TG. *William Turnbull: Sculpture and Painting* (exh. cat., text by R. Morphet). 1973.

8. Minimalism: Formalist Sculpture in the Sixties

AKAG. *Beverly Pepper: Sculpture in Place* (exh. cat., text by Rosalind Krauss). 1986.

——. *Constructivism and the Geometric Tradition* (exh. cat., text by Willy Rotzler). 1979.

——. *Kenneth Snelson* (exh. cat., text by Howard N. Fox). 1981.

Baker, Kenneth. *Minimalism: Art of Circumstance*. N.Y., 1988.

Battcock, Gregory, ed. *Minimal Art: A Critical Anthology*. N.Y., 1968.

Biederman, Charles. "The Visual Revolution of Structurist Art," *Artforum*, Ap 1965, pp. 34-38.

Blume, Dieter. *Anthony Caro* (cat. raisonné in 5 volumes). Cologne, 1981, 1986.

Bochner, Mel. "Primary Structures," *Arts*, Je 1966, pp. 32-35.

Bourdon, David, and Barbara Rose. *Carl Andre: Sculptor 1959-1977*. N.Y., 1978.

Chave, Anna C. "Minimalism and the Rhetoric of Power," *Arts*, Jan 1990, pp. 44-63.

Cohen, Ronny. "From X to Now [Tony Smith]," *Artforum*, My 1986, p. 101.

Day, Holliday T. *Shape of Space: The Sculpture of George Sugarman*, with texts by Irving Sandler and Brad Davis. N.Y., 1981.

Fenton, Terry. *Anthony Caro*. London, 1986.

Fort Worth Art Museum. *Dan Flavin* (exh. cat., texts by J. Belloli and E. Rauh). 1976.

Fried, Michael. "Art & Objecthood," *Artforum*, summer 1967, pp. 12-23.

Grey Art Gallery, N.Y.U. *Robert Morris: The Felt Works* (exh. cat., texts by Thomas W. Sokolowski, Pepe Karmel, and Maurice Berger). N.Y. 1989.

Jewish Museum. *Primary Structures: Younger American and British Sculptors* (exh. cat., text by Kynaston McShine). N.Y., 1966.

Judd, Donald. *Complete Writings, 1959-1975*. N.Y., 1975.

Lippard, Lucy R. "Homage to the Square," *Art in America*, Jy 1967, pp. 50-57.

——. "Rejective Art," *Art International*, Oct 1966, pp. 33-37.

——. "The Silent Art," *Art in America*, Jan/Feb 1967, pp. 58-63.

Morris, Robert. "Notes on Sculpture," *Artforum*, Feb 1966, pp. 42-43; Part 2, Oct 1966, pp. 20-23; Part 3, summer 1967, pp. 24-29.

MoCA. *Robert Irwin* (exh. cat., text by Ira Licht). Chicago, 1975.

MoMA. *Anthony Caro* (exh. cat., text by William Rubin). N.Y. and London, 1975.

——. *Contrasts of Form: Geometric Abstract Art: 1910-1980* (exh. cat., texts by John Elderfield and Magdalena Dabrowski). N.Y., 1985.

——. *Richard Serra/Sculpture* (exh. cat., texts by Rosalind E. Krauss, Laura Rosenstock, and Douglas Crimp). N.Y., 1986.

——. *Sol LeWitt* (exh. cat., texts by Alicia Legg, Lucy R. Lippard, Bernice Rose, and Robert Rosenblum). N.Y., 1978.

National Gallery of Canada. *Donald Judd* (exh. cat., texts by Brydon Smith, Roberta Smith, and Dan Flavin). Ottawa, 1975.

O'Doherty, Brian. *Inside the White Cube*. S.F., 1986.

Pasadena Art Museum. *Larry Bell* (exh. cat., text by Barbara Haskell). 1972.

Rose, Barbara. "ABC Art," *Art in America*, Oct/Nov 1965, pp. 57-69.

——. *Alexander Liberman*. N.Y., 1981.

——. *A New Aesthetic* (exh. cat., Gallery of Modern Art). Wash., D.C., 1967.

San Francisco Museum of Modern Art. *Unitary Forms: Minimal Sculpture by Carl Andre, Don Judd, John McCracken, Tony Smith* (exh. cat., text by Suzanne Foley). 1970.

Serota, Nicholas. *Carl Andre Sculpture: 1959-1977* (exh. cat., Whitechapel Art Gallery). London, 1978.

TG. *Robert Morris* (exh. cat., texts by Michael Compton and David Sylvester). 1971.

Waldman, Diane. *Anthony Caro*. Oxford, 1982.

Whelan, Richard. *Anthony Caro*, with additional essays by Michael Fried, Clement Greenberg, John Russell, and Phyllis Tuchman. Harmondsworth, Middx, 1974.

WMAA. *Anthony Caro* (exh. cat., text by Barbara Haskell). N.Y., 1988.

——. *Ellsworth Kelly, Sculpture* (exh. cat., texts by Patterson Sims and Emily Rauh Pulitzer). N.Y., 1982.

——. *George Sugarman: Painted Wood Sculpture* (exh. cat., text by Nancy Princenthal; interview with the artist by Lisa Phillips). N.Y., 1985.

——. *Mark di Suvero, 1975-76* (exh. cat., text by James K. Monte). N.Y., 1976.

——. *Minimalism to Expressionism* (exh. cat., text by Patterson Sims). N.Y., 1983.

——. *Richard Artschwager* (exh. cat., text by Richard Armstrong). N.Y., 1988.

——. *Robert Irwin* (exh. cat., text by Robert Irwin). N.Y., 1977.

——. *Robert Morris* (exh. cat., text by Marcia Tucker). N.Y., 1970.

Wollheim, Richard. "Minimal Art," *Arts*, Jan 1965, pp. 26-32.

9. Op, Kinetic, and Light Art

AKAG. *Bridget Riley: Works 1959-78* (exh. cat., text by Robert Kudielka). 1978.

Arnheim, Rudolph. *Art and Visual Perception*. London, 1969.

Barrett, Cyril. *Op Art*. London and N.Y., 1970.

Brett, Guy. *Kinetic Art: The Language of Movement*. London, 1968.

HMSG. *Keith Sonnier: Neon* (exh. cat., text by Judith Zilczer). Wash., D.C., 1989.

Hulten, Pontus. *Jean Tinguely-"Meta"*. Paris, 1974; London, 1976.

Joray, Marcel, and J-R Soto. *Soto*. Neuchâtel, 1984.

Kepes, Gyorgy, ed. *The Nature and Art of Motion*. N.Y., 1965.

LaJolla Museum of Contemporary Art. *Stephen Antonakos: Neons and Works of Paper* (exh. cat., text by Sally Yard). 1984.

Lemoine, Serge. *Morellet*. Zurich, 1986.

Lunde, Karl. *Anuszkiewicz*. N.Y., 1977.

Malina, Frank J., ed. *Kinetic Art, Theory and Practice: Selections from the Journal Leonardo*. N.Y., 1974.

Museum of Fine Arts. *Larry Poons Paintings, 1971-1981* (exh. cat., text by Kenworth Moffett). Boston, 1981.

MoMA. *The Machine as Seen at the End of the Mechanical Age* (exh. cat., text by Pontus Hulten). N.Y., 1968.

——. *The Responsive Eye* (exh. cat., text by William C. Seitz). N.Y., 1965.

New Jersey State Museum. *Focus On Light* (exh. cat., texts by Lucy R. Lippard and Edward Ring). Trenton, 1967.

Piene, Otto. "The Proliferation of the Sun: On Art, Fine Arts, Present Art, Kinetic Art, Light, Light Art, Scale, Now and Then," *Arts*, summer 1967, pp. 24-31.

Popper, Frank. *Agam*. N.Y., 1976.

——. *Origins and Development of Kinetic Art*. Greenwich, Ct., 1968.

Rickey, George. *Constructivism: Origins and Evolution*. N.Y., 1967.

Riley, Bridget. "Perception Is the Medium," *Artnews*, Oct 1965, pp.32-33, 66.

Rosenthal, Nan. *George Rickey*. N.Y., 1977.

Russell, John. "The Cogency of Bridget Riley," *N.Y. Times*, Jan 28, 1979, p. II27.

Schmied, Wieland. *Zero: Mack, Piene, Uecker*. Hanover, 1965.

Selz, Peter. "Arte Programmata," *Arts*, Mar 1965, p. 16-21.

——. "The Berkeley Symposium on Kinetic Sculpture," *Art and Artists*, part 1, Feb 1967, pp. 26-31; part 2, Mar 1967, pp. 46-49.

Stern, Rudi. *Let There Be Neon*. N.Y., 1979.

TG. *Optical and Kinetic Art* (exh. cat. by Michael Compton). 1967.

University Art Museum, U. of Calif. *Directions in Kinetic Sculpture* (exh. cat., texts by Peter Selz and George Rickey). Berkeley, 1966.

WMAA. *Light: Object and Image* (exh. cat., text by Robert Doty). N.Y., 1968.

10. The Post-Modern Reaction: Conceptual, Performance, and Process Art

Anderson, Laurie. *United States*. N.Y., 1984.

ACGB. *The New Art* (exh. cat., text by Anne Seymour). 1972.

Barrette, Bill. *Eva Hesse Sculpture: Catalogue Raisonné*. N.Y., 1989.

Battcock, Gregory. *Idea Art: A Critical Anthology*. N.Y., 1973.

——, ed. *New Artists Video: A Critical Anthology*. N.Y., 1978.

——, and Robert Nickas, eds. *The Art of Performance: A Critical Anthology*. N.Y., 1984.

Bonito Oliva, Achille. "Process, Concept and Behaviour in Italian Art," *Studio International*, Jan/Feb 1976, pp. 3-10.

Borden, Lizzie. "Three Modes of Conceptual Art," *Artforum*, Je 1972, pp. 68-71.

Bruggen, Coosje van. *Bruce Nauman*. N.Y., 1988.

Buchloh, Benjamin H.D. "Hans Haacke: Memory and Instrumental Reason," *Art in America*, Feb 1988, pp. 97-108, 157-159.

——, Jean-François Lyotard, and Jean-Hubert Martin. *Daniel Buren: Les Couleurs, scuptures/Les Formes, peintures*. Halifax and Paris, 1981.

Burnham, Jack. *Great Western Salt Works: Essays on the Meaning of Post-Formalist Art*. N.Y., 1974.

Celant, Germano. *Arte povera: Conceptual, actual or impossible art?* London, 1969.

——. *The Knot: Arte Povera*. Turin, 1985.

Cleveland Center for Contemporary Art. *Rauschenberg/Performance: 1954-1984* (exh. cat., text by Nina Sundell). 1984.

Fry, Edward. "Hans Haacke at the Guggenheim: The Issues," *Arts*, My 1971, p. 17.

Glueck, Grace. "Laurie Anderson Now Starring at Museum," *N.Y. Times*, Jy 27, 1984, p. C21.

Graw, Isabelle. "Marking Time: Time and Writing in the Work of Hanne Darboven," *Artscribe*, Jan/Feb 1990, pp. 69-71.

Hapgood, Susan. "Language and Its Discontents [Joseph Kosuth]," *Contemporanea*, Oct 1989, pp. 45-49.

Harrison, Charles, and Fred Orton. *A Provisional History of Art & Language*. Paris, 1982.

Hendricks, Jon, and Robert Pincus-Witten. *Fluxus Codex*. Detroit and N.Y., 1989.

Henri, Adrian. *Total Art: Environments, Happenings, and Performance*. N.Y., 1974. Also *Environments and Happenings*. London, 1974.

ICA, U. of Pa. *Video Art* (exh. cat., texts by David Antin, Lizzie Borden, Jack Burnham, and John McHale). Philadelphia, 1975.

Kaiser, W.M.H. *Joseph Kosuth: Artworks and Theories*. Amsterdam, 1977.

Kosuth, Joseph. "Art After Philosophy," *Studio International*, part 1, Oct 1969, pp. 134-137; part 2, Nov 1969, pp. 160-161; part 3, Dec 1969, pp. 212-213.

Kranz, Stewart. *Science & Technology in the Arts: A Tour Through the Realm of Science/Art*. N.Y., 1974.

Krauss, Rosalind, and Eva Hesse. *Eva Hesse: Sculpture* (exh. cat., Whitechapel Art Gallery). London, 1979.

Larson, Kay. "Money Changes Everything [Hans Haacke]," *New York*, Feb 16, 1987, pp. 88ff.

LeWitt, Sol. "Paragraphs on Conceptual Art," *Artforum*, summer 1967, pp. 79-83.

——. "Sentences on Conceptual Art," *O-9*, Jan 1969, pp. 3-5.

Lippard, Lucy R. *Eccentric Abstraction* (exh. cat., Fishbach Gallery). N.Y., 1966.

——, ed. *Six Years: The Dematerialization of the Art Object*. N.Y., 1973.

McEvilley, Thomas. "I Think therefore I Art," *Artforum*, summer 1985, pp. 74-84.

Meyer, Ursula, ed. *Conceptual Art*. N.Y., 1972.

Miller, John. "Art & Language," *Artscribe*, Mar/Ap 1988, pp. 83-84.

Morris, Robert. "Anti-Form," *Artforum*, Ap 1968, pp. 33-35.

——. "Notes on Sculpture, Part 4: Beyond Objects," *Artforum*, Ap 1969, pp. 50-54.

——. "Some Notes on the Phenomenology of Making: The Search for the Motivated," *Artforum*, Ap 1970, pp. 67-75.

Museum of Fine Arts. *Douglas Huebler* (exh. cat., texts by Christopher Cooks and the artist). Boston, 1972.

Museum of Modern Art. *Hans Haacke*, vol. I (exh. cat., texts by the artist; interview with Margaret Sheffield). Oxford, 1978.

MoMA. *Information* (exh. cat., text by Kynaston L. McShine). N.Y., 1970.

New Museum. *John Baldessari* (exh. cat., texts by Marcia Tucker and Robert Pincus-Witten; interview by Nancy Drew). N.Y., 1982.

Pincus-Witten, Robert. "Lynda Benglis: The Frozen Gesture," *Artforum*, Nov 1974, pp. 54-59.

Price, Jonathan. *Video Visions—A Medium Discovers Itself*. N.Y., 1977.

Ratcliff, Carter. *Gilbert and George: The Complete Pictures, 1971-1985*. N.Y and London, 1986.

Russell, John. "The Artist as Shaman [Joseph Beuys]," *N.Y. Times Magazine*, Oct 28, 1978, pp. 38ff.

——. "Eagles, Eagles, Everywhere [Marcel Broodthaers]," *N.Y. Times*, Ap 23, 1989, p. II 35.)

——. "Joseph Beuys at the Feldman Gallery," *N.Y. Times*, Oct 3, 1986, p. C26.

——. "A Vagabond Magus Whose Specialty Was Iconclasm [Joseph Beuys]," *N.Y. Times*, Feb 9, 1986.

Schneider, Ira, and Beryl Korot, eds. *Video Art: An Anthology*. N.Y., 1976.

Selwyn, Marc. "Chris Burden," *Flash Art*, Jan/Feb 1989, pp. 90-94.

Simon, Joan, and Jean-Christophe Ammann. *Bruce Nauman* (exh. cat., Whitechapel Art Gallery). London, 1986.

SRGM. *Eva Hesse: A Memorial Exhibition* (exh. cat., texts by Linda Shearer and Robert Pincus-Witten). N.Y., 1972.

——. *Joseph Beuys* (exh. cat., text by Caroline Tisdall). N.Y. and London, 1979.

Stedelijk van Abbemuseum. *Lawrence Weiner: A Selection of Works* (exh. cat., text by Rudi H. Fuchs). Eindhoven, 1976.

Stewart, Patricia. "Laurie Anderson: With a Song in My Art," *Art in America*, Mar/Ap 1979, pp.110-113.

TG. *Hans Haacke*, vol. II (exh. cat., texts by the artist; interviews with Walter Grasskamp and Tony Brown). 1984.

——. *Marcel Broodthaers* (exh. cat., texts by M. Compton and B. Reise). 1980.

Walker Art Center. *Marcel Broodthaers* (exh. cat., texts by Marge Goldwater, Michael Compton, Douglas Crimp, Bruce Jenkins, and Martin Mosebach). Minneapolis, 1989.

——. *Projected Images* (exh. cat., texts by Regina Cornwall, Nina Felshin, Martin Friedman, Annette Michelson, Robert Pincus-Witten, Barbara Rose, and Roberta P. Smith). Minneapolis, 1974.

Weiner, Lawrence. *Statements*. N.Y., 1968.

Westfälischer Kunstverein Landesmuseum. *Hanne Darboven* (exh. cat., texts by Klaus Honnef and Johannes Cladders). Münster, 1971.

WMAA. *Anti-Illusion: Procedures/Materials* (exh. cat., texts by James Monte and Marcia Tucker). N.Y., 1969.

——. *Nam June Paik* (exh. cat., texts by John G. Hanhardt, Michael Nyman, Dieter Ronte, and David A. Ross). N.Y., 1982.

11. Earth and Site Works

Andrew Dickson White Museum of Art, Cornell U. *Earth* (exh. cat., texts by Willoughby Sharp and William C. Lipke). Ithaca, 1969.

Apgar, Garry. "The 'Colonnisation' of the Palais-Royal [Buren's *Deux Plateaux*]," *Art in America*, Jy 1986, pp. 31-35.

Ashton, Dore. "Paris Publicized and Privatized: Daniel Buren in the Palais-Royal," *Arts*, Sept 1986, pp. 18-20.

Beardsley, John. *Earthworks and Beyond: Contemporary Art in the Landscape*. N.Y., 1984.

Brenson, Michael. "The Case in Favor of a Controversial Sculpture [Serra's *Tilted Arc*]," *N.Y. Times*, My 19, 1985, pp. III, 35.

Cork, Richard. "Site Reading: British Art in Public Spaces," *Art in America*, Sept 1987, pp. 145-151.

Dixon, John W., Jr. "Towards an Aesthetic of Early Land Art," *Art Journal*, fall 1982, pp. 195-199.

Doezema, Marianne, and June Hargrove. *The Public Monument and Its Audience*. Cleveland, 1977.

Elsen, Albert. "Public Rights and Critics' Failures [Serra's *Tilted Arc*]," *Artnews*, Feb 1989, p. 174.

Friedman, Martin, R.H. Fuchs, and M.M.M. Vos. *Jan Dibbets*. N.Y., 1987.

Fuchs, R.H. *Claes Oldenburg: Large-scale Projects: 1977-1980*. N.Y., 1980.

Hobbs, Robert. "Earthworks: Past and Present," *Art Journal*, fall 1982, pp. 191-194.

——. *Robert Smithson: Sculpture*, with additional texts by Lawrence Alloway, John Coplans, and Lawrence R. Lippard. Ithaca, N.Y., 1981.

Holt, Nancy, ed. *The Writings of Robert Smithson*. N.Y., 1979.

Marter, Joan. "Collaboration: Artists and Architects on Public Sites," *Art Journal*, winter 1989, pp. 315-320.

MoCA. *Charles Simonds* (exh. cat., texts by John Hallmark Neff, John Beardsley, Daniel Abadie, and the artist). Chicago, 1982.

MoCA. *Michael Heizer: Sculpture in Reverse* (exh. cat., text by Julia Brown; interview with Michael Heizer). L.A., 1984.

Senie, Harriet. *Critical Issues in Public Art*, special issue of *Art Journal*, winter 1989, with texts by Senie, Sally Webster, Albert Elsen, John Wetenhall, Matthias Winzen, Joan Marter, Penny Bach, and Patricia C. Phillips.

Serra, Richard. " 'Tilted Arc' Destroyed," *Art in America*, My 1989, pp. 35-47.

SRGM. *Richard Long* (exh. cat., text by the artist). N.Y., 1986.

Sonfist, Alan, ed. *Art in the Land: A Critical Anthology of Environmental Art*. N.Y., 1983.

12. Resurgent Realism, Photo-Realist Painting, Hyper-Realist Sculpture

Battcock, Gregory, ed. *Super Realism*. N.Y.,1975.

Bowman, Russell. *Philip Pearlstein: The Complete Paintings*. N.Y., 1983.

Brenson, Michael. "López García Work in First Show Since '68," *N.Y. Times*, Ap 11, 1986.

Chase, Linda. *Hyperrealism*. N.Y., 1975.

——, Nancy Foote, and Ted McBurnett. "The Photo-Realists: 12 Interviews," *Art in America*, Nov/Dec 1972, pp. 73-89.

Clothier, Peter. "Avigdor Arikha," *Artnews*, Sept 1987, p. 155.

Coke, Van Deren. *The Painter and the Photograph*. Albuquerque, 1964.

Compton, Michael. *Malcolm Morley* (exh. cat., Whitechapel Art Gallery). London, 1983.

Downes, Rackstraw, ed. *Fairfield Porter: Art in Its Own Terms: Selected Criticism, 1935-1975*. N.Y., 1979.

Glueck, Grace. "Alex Katz: Painting in the High Style," *N.Y. Times Magazine*, Mar 2, 1986, pp. 37-39, 84-85.

Goodyear, Frank H., Jr. *Contemporary American Realism Since 1960*. Boston, 1981.

Harten, Jurgen, ed. *Gerhard Richter: Bilder 1962-1985* (cat. raisonné ed. by Dietmar Elger). Cologne, 1985.

Henry, Gerrit. "Jack Beal: A Commitment to Realism," *Artnews*, Dec 1984, pp. 95-100.

——. *Janet Fish*. N.Y., 1987.

Hills, Patricia. *Alice Neel*. N.Y., 1983.

Hodin, J.P., et. al. *Figurative Art Since 1945*. London and N.Y., 1971.

Hughes, Robert. *Frank Auerbach*. London, 1990.

——. *Lucian Freud: Paintings*. London and N.Y., 1988.

Kramer, Hilton. "Fairfield Porter: An American Classic," in *The Revenge of the Philistines*, pp. 157-167. N.Y., 1985.

——. "An Uncommon Painter of the Commonplace [Catherine Murphy]," *N.Y. Times*, Mar 9, 1975, p. II35.

Kuspit, Donald. "What's Real in Realism," *Art in America*, Sept 1981, pp. 84-95.
Levin, Kim. "The Ersatz Object," *Arts*, Feb 1974, pp. 52-55.
Lindey, Christine. *Superrealist Painting and Sculpture*. N.Y., 1980.
Lucie-Smith, Edward. *Super Realism*. Oxford and N.Y., 1979.
Lyons, Lisa, and Robert Storr. *Chuck Close*. N.Y., 1987.
McGill, Douglas C. "How Alex Katz Puts Power on Canvas," *N.Y. Times*, Ap 4, 1985, pp. II1,33.
Meisel, Louis K. *Photo-Realism*. N.Y., 1980.
———. *Richard Estes: The Complete Paintings, 1966-1985*, with additional text by John Perreault. N.Y., 1986.
Milwaukee Art Museum. *Philip Pearlstein: A Retrospective* (exh. cat., texts by Russell Bowman, Philip Pearlstein, and Irving Sandler). 1983.
Nasgaard, Roald, I. Michael Danoff, and Benjamin H.D. Buchloh. *Gerhard Richter, Paintings*. London and N.Y., 1988.
Nieva, Françoise. *Antonio López García: Paintings, Sculptures, and Drawings* (exh. cat., Marlborough Gallery). N.Y., 1986.
Nochlin, Linda. *Catherine Murphy* (exh. cat., Xavier Fourcade). N.Y., 1985.
———. "The Realist Criminal and the Abstract Law," part 1, *Art in America*, Sept/Oct 1973, pp. 54-61; part 2, Nov/Dec 1973, pp. 97-103.
———. "Some Women Realists: Part I," *Arts*, Feb 1974, pp. 46-51.
North Carolina Museum of Art. *Riffs and Takes: Music in the Art of Romare Bearden* (exh. cat., text by Huston Paschal). Raleigh, 1988.
Sandler, Irving. *Alex Katz*. N.Y., 1979.
Seitz, William C. "The Real and the Artificial: Painting of the New Environment," *Art in America*, Nov/Dec 1972, pp. 58-72.
Shirey, David L. "Through a Glass, Brightly [Janet Fish]," *Arts*, Feb 1974.
Stevens, Mark. "Revival of Realism," *Newsweek*, Je 7, 1982, pp. 64-70.
Storr, Robert. "Rackstraw Downes: Painter as Geographer," *Art in America*, Oct 1984, pp. 154-161.
Sullivan, Bill. "Neil Welliver," *Arts*, Mar 1985, p. 15.
Varnedoe, Kirk. *Duane Hanson*. N.Y., 1985.
Vassar College Art Gallery. *Realism Now* (exh. cat., text by Linda Nochlin). Poughkeepsie, 1968.
Virginia Museum. *Jack Beal* (exh. cat., text by John Arthur). Richmond, 1973.
WMAA. *Alex Katz* (exh. cat., texts by Richard Marshall and Robert Rosenblum). N.Y., 1986.

13. Pattern and Decoration

Boston U. Art Gallery. *Joyce Kozloff: Visionary Ornament* (exh. cat., texts by Patricia Johnston, Hayden Herrera, and Thalia Gouma-Peterson). 1986.
College of Wooster. *Miriam Schapiro: A Retrospective: 1953-1980* (exh. cat., text by Thalia Gouma-Peterson). Wooster, Ohio, 1980.
Frank, Eric. *Ned Smyth* (exh. cat., Holly Solomon Gallery). N.Y., 1985.
Goldin, Amy. "Beyond Style," *Art & Artists*, Sept 1968, pp. 32-35.
ICA, U. of Pa. *Decorative Impulse* (exh. cat., text by Janet Kardon). Philadelphia, 1979.
———. *Robert Kushner* (exh. cat., texts by Janet Kardon and Donald Kuspit). 1987.
———. *Robert Zakanitch* (exh. cat., text by Janet Kardon). 1981.
Kalamazoo Institute of Arts. *New Image/Pattern & Decoration* (exh. cat., text by Sam Hunter). 1983.
Lippard, Lucy R. "Sweeping Exchanges: The Contribution of Feminism to the Art of the 1970s," *Art Journal*, fall/winter 1980, pp. 362-365.
McGill, Douglas. "Strollers' Power Spot [Ned Smyth's *Upper Room*]," *N.Y. Times*, Sept 4, 1987, p. C20.
Perreault, John. "Issues in Pattern Painting," *Artforum*, Nov 1977, p. 33.
———. "The New Decorativeness," *Portfolio*, Je/Jy 1979, p. 46.
Perrone, Jeff. "Approaching the Decorative," *Artforum*, Dec 1976, p. 30.
Princenthal, Nancy. "On the Waterfront [Ned Smyth's *Upper Room*]," *Art in America*, Ap 1987, pp. 221ff.
Printz, Neil. *Decoration and Representation* (exh. cat., Holly Solomon Gallery). N.Y., 1982.
Rickey, Carrie. "Art of Whole Cloth," *Art in America*, Nov 1979, p. 80.
———. "Of Crystal Palaces and Glass Houses," *Village Voice*, Ap 14, 1980, p.77.
———. "Pattern Painting," *Arts*, Jan 1978, p.17.

14. New Image Art

AKAG. *Surfacing Images: The Paintings of Joe Zucker: 1969-1982* (exh. cat., text by Susan Krane). 1982.
Baltimore Museum of Art. *Scott Burton* (exh. cat., text by Brenda Richardson). 1986.
Berman, Avis. "Nancy Graves," *Artnews*, Feb 1986, pp. 57-64.
Brooks, Valerie. "Nicholas Africano," *MD*, Jy 1984, pp. 37-41.
Carlson, Prudence. "Neil Jenney," *Art in America*, Ap 1985, p. 206.
Carmean, E.A., Jr., Linda L. Cathcart, Robert Hughes, and Michael Edward Shapiro. *The Sculpture of Nancy Graves: A Catalogue Raisonné*. Fort Worth and N.Y., 1987.
CGP. *Anne et Patrick Poirier: Domus Aurea: Fascination des Ruines* (exh. cat., texts by Gilbert Lascault, Günter Metken, Daniele Sallenave, Denis Roche, and Renaud Camus). 1978.
Collins, Amy Fine, and Bradley Collins, Jr. "The Sum of the Parts [Nancy Graves]," *Art in America*, Je 1988, pp. 113-118.
Compton, Michael. *Barry Flanagan: A Developing Practice* (exh. cat., Pace Gallery). N.Y., 1983.
Cooke, Lynne. *Antony Gormley* (exh. cat., Salvatore Ala Gallery). N.Y., 1984.
Dallas Museum of Art. *Elizabeth Murray: Paintings and Drawings* (exh. cat., text by Roberta Smith). 1987.
Feaver, William. "Putting on Hares [Barry Flanagan]," *Artnews*, Ap 1982, pp. 181-182.
Freeman, Peter. *From Icon to Symbol/Imagery in American Art: 1973-1979* (exh. cat., BlumHelman Gallery). N.Y., 1986.
Gardner, Paul. "Elizabeth Murray Shapes Up," *Artnews*, Sept 1984, pp. 47-55.
———. "Pat Steir: Seeing Through the Eyes of Others," *Artnews*, Nov 1985, pp. 80-87.
Glueck, Grace. "Susan Rothenberg: New Outlook for a Visionary Artist," *N.Y. Times Mag.*, Jy 22, 1984.
Godfrey, Tony. *The New Image: Painting in the 1980s*. Oxford and N.Y., 1986.
Grimes, Nancy. "A Walk Through Borofsky's Brain," *Artnews*, summer 1985, p. 119.
HMSG. *Metaphor, New Projects by Contemporary Sculptors* (exh. cat., text by Howard N. Fox). 1981.
———. *Robert Moskowitz* (exh. cat., text by Ned Rifkin). 1989.
ICA, U. of Pa. *Siah Armajani* (exh. cat., texts by Janet Kardon and Kate Linker). Philadelphia, 1985.
Kramer, Hilton. "A Mandarin Pretending to Be a Stumblebum [Philip Guston]," *N.Y. Times*, Oct 25, 1970, p. B27.
Larson, Kay. "One from the Heart: Painter Elizabeth Murray Makes Her Own Trend," *New York*, Feb 10, 1986, pp. 40-45.
Linker, Kate. "On the Trail of Jean Le Gac," *Artforum*, summer 1986, pp. 103-105.
Lynton, Norbert. *Philip Guston: Paintings 1969-1980* (exh. cat., Whitechapel Art Gallery). London, 1982.
McGill, Douglas. "Art People [Pat Steir]," *N.Y. Times*, Mar 7, 1986, p. C19.
Moorman, Margaret. "A Gift for Being Different [Fernando Botero]," *Artnews*, Feb 1986, pp. 71-79.
Musée d'Art Moderne de la Ville de Paris. *Un Certain Art Anglais . . .: Sélection d'Artistes Britanniques: 1970-79* (exh. cat., texts by Michael Compton, Richard Cork, and Sandy Nairne). 1979.
Museum of Art, U. of Calif. *Neil Jenney: Paintings and Sculpture, 1967-1980* (exh. cat., text by Marc Rosenthal). Berkeley, 1981.
MoCA. *Donald Sultan* (exh. cat., text by Ian Dunlop). Chicago, 1987.
New Museum of Contemporary Art. *Bad Painting* (exh. cat., text by Marcia Tucker). N.Y., 1978.
Philadelphia Museum of Art. *Jonathan Borofsky* (exh. cat., texts by Mark Rosenthal and Richard Marshall). 1984.
Ratcliff, Carter. *Pat Steir: Paintings: Essay/Interview*. N.Y., 1986.
Rosenblum, Robert. *Robert Moskowitz* (exh. cat., BlumHelman Gallery). N.Y., 1983.
Russell, John. "Drawings Examine Modernism with Wit [Jane Kaplowitz]," *N.Y. Times*, My 5, 1987.
———. "On Finding a Bold New Work [Jennifer Bartlett]," *N.Y. Times*, My 16, 1976, pp. III, 31.
Smith, Roberta. "The Abstract Image," *Art in America*, Mar/Ap 1979, pp. 102-105.
———. "A Painting Landmark in Retrospect [New Image]," *N.Y. Times*, Aug 2, 1987, pp.III,29.
Storr, Robert. *Philip Guston*. N.Y., 1986.
———. "Shape Shifter [Elizabeth Murray]," *Art in America*, Ap 1989, pp. 210ff.
———. "Spooks and Floats [Susan Rothenberg]," *Art in America*, My 1983, pp. 153-158.
Stuckey, Charles. *Jane Kaplowitz* (exh. cat., Jason McCoy Gallery). N.Y., 1987.
Tuchman, Phyllis. "Bryan Hunt's Balancing Act," *Artnews*, Oct 1985, pp. 64-73.
Vassar College Art Gallery. *Nancy Graves: Painting, Sculpture, Drawing: 1980-1985* (exh. cat., texts by Debra Bricker Balken and Linda Nochlin). Poughkeepsie, 1986.
Walker Art Center. *Jennifer Bartlett* (exh. cat., text by Marge Goldwater, Roberta Smith, and Calvin Tomkins). Minneapolis, 1985.
———. *Wegman's World* (exh., texts by Lisa Lyons and Kim Levin). Minneapolis, 1982.
WMAA. *Joel Shapiro* (exh. cat., texts by Roberta Smith and R. Marshall). 1982.
———. *New Image Painting* (exh. cat., text by Richard Marshall). 1978.

15. Fin de Siècle: From Neo-Expressionism to Neo-Abstraction

Allen, Jane Addams. "Pluralism and Postmodernism: Assessing a Decade [the 80s]," *New Art Examiner*, Jan 1990, pp. 20-24.
Art Gallery of Toronto. *The European Iceberg: Creativity in Germany and Italy Today* (exh. cat., text by Germano Celant). Toronto, Milan, and N.Y., 1985.
Art Institute of Chicago. *Anselm Kiefer* (exh. cat., text by Mark Rosenthal). 1987.
Auping, Michael. *Francesco Clemente*. N.Y., 1985.
Batchelor, David. "Yearning for Unity [Gerhard Richter]," *Artscribe*, Nov/Dec 1988, pp. 95-96.
Bonito Oliva, Achille. *The Italian Transavantgarde*. Milan, 1980.
Brenson, Michael. "Grand-Scale Malcolm Morley," *N.Y. Times*, Ap 13, 1984, p. C1.
———. "A Sculptor's Struggle to Fuse Culture and Art [Martin Puryear]," *N.Y. Times*, Oct 29, 1989, pp. II37, 39.
———. "Is Neo-Expressionism an Idea Whose Time Has Passed." *N.Y. Times*, Jan 5, 1986, pp. II1, 12.
Buchloh, B.H.D. "Allegorical Procedures: Appropriations and Montage in Contemporary Art," *Artforum*, Sept 1982, pp. 43-56.
———. "Figures of Authority, Ciphers of Repressions: Notes on the Return of Representation in European Painting," *October*, spring 1981, pp. 39-68.
———. "Richter's Facture: Between the Synecdoche and the Spectacle," in *Gerhard Richter* (exh. cat., Marian Goodman/Sperone Westwater). N.Y., 1985.
Calo, Carole Gold. "Martin Puryear: Private Objects, Evocative Visions," *Arts*, Feb 1988, p. 90.
Carnegie-Mellon U. Art Gallery. *Abstraction/Abstraction* (exh. cat., texts by Elaine A. King and David Carrier). Pittsburgh, 1986.
Carrier, David. "Artifice and Artificiality: David Reed's Recent Painting," *Arts*, Jan 1, 1986, pp. 30-33.
CGP. *Qu'est-ce que la sculpture moderne?* (exh. cat., text by Margit Rowell). 1986.
Cotter, Holland. "Allan McCollum," *Art in America*, Ap 1988, pp. 203-204.
———. "Haim Steinbach: Shelf Life," *Art in America*, My 1988, pp. 156-163, 201.
Drohojowska, Hunter. "Magical Mystery Tours [Magdalena Abakanowicz]," *Artnews*, Sept 1985.
Ellis, Stephen. "The Elusive Gerhard Richter," *Art in America*, Nov 1986, pp. 131ff.
"Expressionism Today," interviews with 19 artists by Carter Ratcliff, Hayden Herrera, Sara McFadden, and Joan Simon, *Art in America*, Dec 1982, pp. 58-75.
Foster, Hal. *Discussions in Contemporary Culture, Number One*. Seattle, 1987.
———. "Subversive Signs," *Art in America*, Nov 1982, pp. 88-92.
———. "The Expressive Fallacy," *Art in America*, Jan 1983, pp. 80-83.
Gablik, Suzi. "Report from New York: The Graffiti Question," *Art in America*, Oct 1982, pp. 33-39.
Gambrell, Jamey. "Notes on the [Soviet] Underground," *Art in America*, Nov 1988, pp. 127ff.
———. "Perestroika Shock," *Art in America*, Feb 1989, pp. 124ff.
Gill, Susan. "Beyond the Perimeters: The Eccentric Humanism of Judy Pfaff," *Arts*, Oct 1986, pp. 77-79.
Glueck, Grace. "And Now, a Few Words from Jenny Holzer," *N.Y. Times Magazine*, Dec 3, 1989, pp. 42ff.
———. "'Survival Kids' Transform Classics to Murals," *N.Y. Times*, Nov 13, 1988, pp. 1, 42.
Gouma-Peterson, Thalia. "Faith Ringgold's Narrative Quilts," in *Faith Ringgold Change*: (exh. cat., Bernice Steinbaum Gallery). N.Y., 1987.
Grundberg, Andy. "A Pair of Shows for a Pair of Trendy Twins [Starns]," *N.Y. Times*, Oct 2, 1988, pp. II33,41.
Hagen, Charles. "David Reed," *Artforum*, Ap 1988, p. 147.
Halley, Peter. *Collected Essays: 1981-87*. Zurich, 1988.
———. "Notes on Abstraction," *Arts*, summer 1987, pp. 35-39.
Haring, Keith. *Art in Transit*, with intro. by Henry Geldzahler and photography by Tseng Kwong Chi. N.Y., 1985.
Hayward Gallery. *Falls the Shadow: Recent British and European Art* (exh. cat., texts by Jon Thompson and Barry Barker). London, 1986.
Heartney, Eleanor. "Homeward Unbound [Robert Gober]," *Sculpture*, Sept/Oct 1989, pp. 20-23.
———. "Nowhere to Fly [Ilya Kabakov]," *Art in America*, Mar 1990, p. 177.
———. "Philip Taaffe," *Art in America*, Sept 1987, pp. 131–132.
Higgins, Judith. "In a Hot Country [Howard Hodgkin]," *Artnews*, summer 1985, pp. 56-65.
HMSG. *Culture and Commentary: An Eighties Perspective* (exh. cat., text by Kathy Halbreich). Wash., D.C., 1990.
Hughes, Robert. "Careerism and Hype Amidst the Image Haze," *Time*, Je 1985, pp. 78-83.
ICA, U. of Pa. *David Salle* (exh. cat., texts by Janet Kardon and Lisa Phillips). Philadelphia, 1986.
———. *The East Village Scene* (exh. cat., text by Janet Kardon). 1984.
Joachimides, Christos, and Norman Rosenthal. *Zeitgeist* (exh. cat., Internationale Kunstausstellung). Berlin, 1982.
Kimmelman, Michael. "A Sculptural Circus of Whips and Suspense [Rebecca Horn]," *N.Y. Times*, Sept 23, 1988, p. C29.
———. "Soviet Artist as a Storyteller of Not-Always-Pretty Tales [Ilya Kabakov]," *N.Y. Times*, Jan 19, 1990, p. C26.
Kramer, Hilton. "Internationalism in the Eighties," in Museum of Art, Carnegie Institute, *Carnegie International* (exh. cat., ed. by C.R. Lane and J. Caldwell), pp. 84-87. Pittsburgh, 1985.
———, ed. *The New Criterion Reader: The First Five Years: Events and Controversies of the 1980s in Art, Architecture, Music, Literature, Theater, Poetry, Dance, Intellectual Life, and the Academy*. N.Y. and London, 1988.
Kuspit, Donald. "Acts of Aggression: German Painting Today," *Art in America*, Jan 1983, pp. 91-99.
———. "Keith Haring," *Artforum*, Feb 1986, p. 102.
La Jolla Museum of Contemporary Art. *Bill Woodrow* (exh. cat., text by Lynda Forsha). 1985.
Larson, Kay. "'Coming to Amerika [Tim Rollins and K.O.S.]," *New York*, Nov 20, 1989, pp. 123.
Levin, Kim. "The New Russians," *Village Voice*, Ap 17, 1990, p. 105
Liebman, Lisa. "M.B.A. Abstraction," *Flash Art*, May 1987, pp. 86-89.
LACMA. *Avant-garde in the Eighties* (exh. cat., text by Howard N. Fox). 1987.
Madoff, Steven Henry. *Abstract/Issues* (exh. cat., Sherry French/Tibor de Nagy/Oscarsson Hood Galleries). N.Y., 1985.
———. "Anselm Kiefer," *Artnews*, Oct 1987, pp. 125-130
———. "What Is Postmodern About Painting: The Scandanavian Lectures," *Arts*, part 1, Sept 1985, pp. 116-121; part 2, Oct 1985, pp. 62-63; part 3, Nov 1985, pp. 68-73.
Marzorati, Gerald. "Art in the (Re)Making [Sherrie Levine]," *Artnews*, My 1986, p. 91.
McEvilley, Thomas. "I Think therefore I Art," *Artforum*, summer 1985, pp. 74-84.
———. "The Case of Julian Schnabel," in *Julian Schnabel: Paintings 1975-1987* (exh. cat., Whitechapel Art Gallery). London, 1987.
McGill, Douglas C. "Mike Bidlo's skewed reproductions of Picasso, et al.," *N.Y. Times*, Jan 15, 1988, p. C25.
McGuigan, Cathleen. "New Art, New Money: The Marketing of an American Artist [Jean-Michel Basquiat]," *N.Y. Times Mag.*, Feb 10, 1985, pp. 20ff.
Mendel Art Gallery. *Eric Fischl: Paintings* (exh. cat., texts by Jean-Christophe Ammann, Donald Kuspit, and Bruce W. Ferguson). Saskatoon, 1986.
Millet, Catherine. *L'Art Contemporain en France*. Paris, 1988.
MoMA. *Jackie Winsor* (exh. cat., text by Ellen N. Johnson). 1979.
———. *Projects: Tom Otterness* (exh. leaflet, text by Linda Shearer). 1987.
Museum Boymans-van-Beuningen. *David Salle* (exh. cat., text by Carter Ratcliff). Rotterdam, 1983.
Museum of Modern Art. *Current Affairs: British Paintings and Sculpture in the 1980s* (exh. cat., text by L. Biggs, et al.). Oxford, 1987.
Nairne, Sandy, Geoff Dunlop, and John Wyner. *State of the Art: Ideas & Images in the 1980s*. London, 1987.
Nationalgalerie. *Neue Malerei in Deutschland* (exh. cat., texts by Jürgen Harten, Dieter Honisch, and Hermann Kern). Berlin and Munich, 1983.
Neff, Terry A., ed. *Gerhard Richter: Paintings*. London, 1988.
———. *A Quiet Revolution: British Sculpture Since 1965*, with essays by Graham Beal, Lynne Cooke, Charles Harrison, and Mary Jane Jacob. N.Y. and London, 1987.
Pincus-Witten, Robert. *Entries (Maximalism)*. N.Y., 1983.
Princenthal, Nancy. "Intuition's Disciplinarian [Martin Puryear]," *Art in America*, Jan 1990, pp. 131-136, 181.
RAA. *A New Spirit in Painting* (exh. cat., texts by C.M. Joachimides, Norman Rosenthal, and Nicholas Serota). 1981.
Ratcliff, Carter. *Komar & Melamid*. N.Y., 1989.
Rosenblum, Robert. "Eric Fischl," *Contemporanea*, My/Je 1988, pp. 62-65.
———. "Notes on Mike Bidlo," in *Mike Bidlo: Masterpieces* (Edition Bischofberger). Zurich, c. 1988.
Roustayi, Mina. "Getting Under the Skin: Rebecca Horn's Sensibility Machines," *Arts*, My 1989, pp. 58-68.
Russell, John. "Maximum Emotion with a Mimimum of Definition [Howard Hodgkin]," *N.Y. Times*, Ap 15, 1984, p. II33.
———. "Modernism and Postmodernism: A New World Once Again," *N.Y. Times*, Aug 22, 1982.
———. "The New European Painters," *N.Y. Times Mag.*, Ap 24, 1983, pp. 28-33.
Saltz, Jerry. *New York's New Art*, with essays by Roberta Smith and Peter Halley. N.Y., 1986.
Schiff, Gert. *Julian Schnabel* (exh. cat., Pace Gallery). N.Y., 1984.
Schjeldahl, Peter. "Anxiety as a Rallying Cry [John Ahearn]," *Village Voice*, Sept 16, 1981, p. 86.
———. "Our Kiefer," *Art in America*, Mar 1988, pp. 116-126.
———, and I.M. Danoff. *Cindy Sherman*. N.Y., 1984.
Seattle Art Museum. *Mark Tansey* (exh. cat., text by Patterson Sims). 1990.
Smith, Roberta. "Appropriations über Alles," *Village Voice*, Jan 11, 1983, p. 73.
———. "Holzer Makes the Guggenheim a Museum of Many Messages," *N.Y. Times*, Dec 13, 1989, p.C19.
———. "Singular Artists Who Work in the First Person Plural [Starn Twins]," *N.Y. Times*, My 10, 1987, p. II29.
———. "Sherrie Levine Enters the World of Sculpture," *N.Y.Times*, Sept 8, 1989, p.C23.
SRGM. *Angles of Vision: French Art Today* (exh.cat., text by Lisa Dennison). 1986.
———. *Refigured Painting: The German Image: 1960-88* (exh. cat., texts by Thomas Krens, Joseph Thompson, Michael Govan, Jürgen Schilling, Heinrich Klotz, and Hans Albert Peters). N.Y. and Munich, 1989.
St. Louis Art Museum. *Expressions: New Art from Germany: Georg Baselitz, Jörg Immendorff, Anselm Kiefer, Markus Lüpertz, S.R. Penck* (exh. cat., texts by Jack Cowart, Siegfried Gohr, and Donald Kuspit). 1983.
Stapen, Nancy. "Still-Rising Starns," *Artnews*, Feb 1988, pp. 110-113.
Stavitsky, Gail. "Magdalena Abakanowicz," *Arts*, Dec 1985, p. 120.
Taaffe, Philip. "Sublimity, Now and Forever, Amen," *Arts*, Mar 1986, pp. 18-19.
TG. *The Hard-Won Image: Traditional Method and Subject in Recent English Art* (exh. cat., text by Richard Morphet). 1984.
———. *The New Art* (exh. cat., text by Michael Compton). 1983.
Tate Gallery Liverpool. *Starlit Waters: British Sculpture: An International Art: 1968-1988* (exh. cat., texts by Martin Kunz, Charles Harrison, Lynne Cooke, and Iain Chambers). 1988.
Trow, G.W.S., and Thomas Lawson. *Infotainment* (exh. cat., Nature Morte Gallery). N.Y. 1985.
Wei, Lilly. "Talking Abstract [interviews with E. Murray, R. Bleckner, B. Marden, M. Heilmann, M. Hafif, G. Amenoff, G. Peck, and J. Berthot]," *Art in America*, Jy 1987, pp. 80-97.
———. "Talking Abstract, Part Two [interviews with S. Levine, P. Halley, T. Hsu, N. Haynes, M. Dryer, P. Taaffe, S. Schuyff, and Wallace & Donohoe]," *Art in America*, Dec 1987, pp. 112-129, 171.
Weinstein, Matthew. "The House of Fiction [Robert Gober]," *Artforum*, Feb 1990, pp. 129-132.
WMAA. *Image World: Art and Media Culture* (exh. cat., texts by Marvin Heiferman, Lisa Phillips, and John C. Harkardt). 1989.
Woodward, Richard B. "It's Art, but Is It Photography? [Starn Twins]," *N.Y. Times Mag.*, Oct 9, 1988, pp. 29ff.

Index